Théodore Chassériau
(1819–1856)

Théodore Chassériau
(1819–1856)
The Unknown Romantic

Stéphane Guégan, Vincent Pomarède, and Louis-Antoine Prat

with contributions by Bruno Chenique, Christine Peltre, Peter Benson Miller, and Gary Tinterow

The Metropolitan Museum of Art, New York

Yale University Press, New Haven and London

This volume has been published in conjunction with the exhibition "Théodore Chassériau (1819–1856): The Unknown Romantic," held at the Galeries Nationales du Grand Palais, Paris, February 26–May 27, 2002; the Musée des Beaux-Arts, Strasbourg, June 19–September 21, 2002; and The Metropolitan Museum of Art, New York, October 22, 2002–January 5, 2003.

The exhibition is supported by The Isaacson-Draper Foundation.

The exhibition was organized by The Metropolitan Museum of Art, New York, the Réunion des Musées Nationaux, Paris, the Louvre Museum, Paris, and the Museums of Strasbourg.

An indemnity has been granted by the Federal Council on the Arts and the Humanities.

This publication is made possible by The Drue E. Heinz Fund and the Doris Duke Fund for Publications.

Published by The Metropolitan Museum of Art, New York
English edition © 2002 The Metropolitan Museum of Art
French edition © 2002 Éditions de la Réunion des Musées Nationaux, Paris
All rights reserved

John P. O'Neill, Editor in Chief
Ellen Shultz, Editor
Bruce Campbell, Designer, after the French edition by Pierre-Louis Hardy
Peter Antony, Production Manager
Robert Weisberg, Desktop Publishing Manager

Translations from the French by Jane Marie Todd and Jean Marie Clarke

Jacket / cover: *The Toilette of Esther.* 1841. Detail of catalogue 66

Frontispiece: *Portrait of Comtesse de La Tour-Maubourg.* 1841. Detail (see Addendum, page 403)

Library of Congress Cataloguing-in-Publication Data

Chassériau. English
Théodore Chassériau, 1819–1856: the unknown romantic / Stéphane Guégan, Vincent Pomarède, and Louis-Antoine Prat; with contributions by Bruno Chenique, Christine Peltre, Peter Benson Miller, and Gary Tinterow.
p. cm.
Catalogue of an exhibition held at The Metropolitan Museum of Art, Oct. 22, 2002–Jan. 5, 2003.
Includes bibliographical references and index.
ISBN 1-58839-067-5 (hc) — ISBN 0-300-09690-9 (Yale University Press)
1. Chassériau, Théodore, 1819–1856—Exhibitions. 2. Romanticism in art—France—Exhibitions.
I. Guégan, Stéphane. II. Metropolitan Museum of Art (New York, N.Y.). III. Title.

ND553.C47 A4 2002
759.4--dc21
2002075349

Printed and bound by Kapp Lahure Jombart, Évreux, France

CURATORS OF THE EXHIBITION

Stéphane Guégan
Musée d'Orsay, Paris

Vincent Pomarède
Musée des Beaux-Arts, Lyons

Louis-Antoine Prat
Musée du Louvre, Paris

Gary Tinterow
The Metropolitan Museum of Art, New York
assisted by
Kathryn Calley Galitz
The Metropolitan Museum of Art

with the participation of

Bruno Chenique
The Getty Research Institute, Los Angeles

and

Dominique Jacquot
Musée des Beaux-Arts, Strasbourg

PHOTOGRAPH CREDITS

Lenders to the Exhibition

We wish to thank those institutions and individuals whose generosity made this exhibition possible, especially:

W. M. Brady & Co., New York: cat. 225
André Bromberg: cat. 156, addendum
Felix F. Fabrizio, M.A.: cat. 228
Walter Feilchenfeldt: cat. 211, 212
Paul Prouté S.A.: cat. 84–89
Wheelock Whitney: cat. 18

as well as those who preferred to remain anonymous:
cat. 5, 7, 14, 22, 50, 56, 59, 112, 124, 140, 153, 159, 193, 210, 214, 215, 216, 219, 220, 236, 246, 252

In addition, we express our gratitude to the following lenders:

France

Arras, Musée des Beaux-Arts: cat. 31
Avignon, Musée Calvet: cat. 69, 173
Bagnères-de-Bigorre, Musée des Beaux-Arts Salies: cat. 224
Clermont-Ferrand, Musée des Beaux-Arts: cat. 242, 244, 245
Dijon, Musée des Beaux-Arts: cat. 184
Grenoble, Musée de Grenoble: cat. 183
Lille, Musée des Beaux-Arts: cat. 188
Lyons, Musée des Beaux-Arts: cat. 19, 186, 243
Marseilles, Musée des Beaux-Arts: cat. 109
Metz, Musées de la Cour d'Or: cat. 198
Paris,
Galerie Daniel Malingue: cat. 192
Musée Carnavalet: cat. 64, 169, 174, 176
Musée d'Orsay: cat. 170, 190, 200, 232, 237
Musée du Louvre:
Département des Arts Graphiques, cat. 8, 11, 20, 21, 23, 24, 25, 26, 27, 28, 29, 32, 33, 34, 35, 36, 37, 38, 39, 40, 41, 42, 44, 45, 46, 48, 51, 53, 54, 55, 60, 62, 63, 67, 70, 71, 72, 73, 74, 75, 76, 77, 78, 80, 81, 82, 83, 100, 101, 102, 103, 104, 105, 106, 107, 108, 110, 111, 114, 116, 117, 118, 120, 121, 122, 123, 126, 127, 131, 132, 133, 135, 136, 137, 138, 139, 142, 143, 144, 145, 146, 147, 148, 149, 150, 151, 152, 155, 166, 167, 171, 172, 175, 187, 194, 202, 205, 206, 208, 213, 217, 221, 227, 229, 230, 231, 233, 234, 235, 238, 239, 240, 241, 247, 248, 249, 250, 251, 255
Département des Peintures, cat. 1, 2, 3, 4, 9, 13, 15, 17, 47, 61, 65, 66, 113, 115, 119, 125, 128, 129, 130, 177, 180, 181, 185, 189, 195, 196, 253, 254
Musée du Petit Palais: cat. 43, 164, 222, 223, 226
Quimper, Musée des Beaux-Arts: cat. 165
Reims, Musée des Beaux-Arts: cat. 30, 201
Rouen, Musée des Beaux-Arts: cat. 256
Saint-Étienne, Church of Notre-Dame: cat. 68
Saint-Jean-d'Angély, Church at: cat. 16
Strasbourg, Musée des Beaux-Arts: cat. 182, 197, 203
Versailles, Musée National du Château: cat. 134, 204

Great Britain

Oxford, Ashmolean Museum: cat. 49

United States

Brooklyn, The Brooklyn Museum of Art: cat. 10, 209
Cambridge, Massachusetts, Fogg Art Museum, Harvard University Art Museums: cat. 52
Chicago, The Art Institute of Chicago: cat. 158
Detroit, The Detroit Institute of Arts: cat. 58, 168
Houston, Museum of Fine Arts: cat. 178
Los Angeles, Los Angeles County Museum of Art: cat. 179
The J. Paul Getty Museum: cat. 207
New York, The Metropolitan Museum of Art: cat. 6, 12, 57, 141, 154, 157, 160, 161, 199, addendum
Northampton, Massachusetts, Smith College Museum of Art: cat. 191
Philadelphia, Philadelphia Museum of Art: cat. 163
Providence, Rhode Island, Museum of Art, Rhode Island School of Design: cat. 162
San Francisco, The Fine Arts Museums of San Francisco: cat. 218

Acknowledgments

The curators of the exhibition would like to express their gratitude to Pierre Rosenberg, former head of the Département des Peintures and later president-director of the Musée du Louvre, for his dedicated and informed support of the project, from its inception in 1992. The wealth of advice given by François Viatte, curator, Département des Arts Graphiques, and Jean-Pierre Cuzin, curator, Département des Peintures, helped us overcome many obstacles along the way. We thank them for the loans that made the exhibition possible. We extend special thanks to Henri Loyrette, former director of the Musée d'Orsay and now president-director of the Musée du Louvre, who followed the project with great enthusiasm.

We would like to give special thanks to M. and Mme Michel Vivaux and to Mlle Françoise Bellaigue de Ranchicourt, each of whom contributed toward making this exhibition possible. For their enthusiastic collaboration, we thank Mssrs. Mark Brady, Felix F. Fabrizio, Walter Feilchenfeldt, Paul Prouté, and Wheelock Whitney. We also thank most heartily those colleagues, especially in American museums, who allowed their paintings and drawings to be seen at all three venues, in France and in New York.

Although the loan of the great canvas from Souillac proved unfeasible, we nevertheless extend our gratitude to André Chastagnol, mayor of that city.

At the Réunion des Musées Nationaux, we wish to thank Irène Bizot, who agreed from the beginning to hold this exhibition at the Grand Palais, and to Philippe Durey, who approved this choice, and lent his knowledge and generous support, despite the many difficulties it entailed.

Catherine Chagneau and Anne Behr in the exhibition department of the Réunion des Musées Nationaux provided professional and unflagging assistance, without which this exhibition would not have been possible. Our sincere thanks go to Bénédicte Boissonnas, Jean Naudin, Marion Tenbusch, Béatrice Foulon, and Alain Madeleine-Perdrillat, who worked closely with us throughout the course of this project, as well as to Cécile Vignot, Philippe Couton, Annie Madec, and Aurélia Koloditzky. We also thank Geneviève Rudolf and Pierre-Louis Hardy for their efficient and tactful coordination of the French edition of the catalogue. We wish to express our appreciation to Philippe Renaud and Sylvie Jodar.

We would also like to offer our gratitude to Stéphane Loire, Sébastien Allard, and Anne de Wallens of the Département des Peintures at the Musée du Louvre, who facilitated the loan of works in the Louvre and were responsible for the delicate task of transporting the murals from the Cour des Comptes to the Grand Palais. Sylvain Laveissière, Jean Habert, Marie-Catherine Sahut, and Olivier Meslay all helped in the preparation of this exhibition. Aline François-Colin played a major role both in the framing and the hanging of the works at the Grand Palais, as well as in compiling the bibliography for the catalogue. We would like to thank Dimitri Salmon for his expertise in installing the works of art. The Département des Peintures, well known for the wealth of documents in its archives, was immensely helpful: For this, our thanks go to Jacques Foucart, Sylvie Dubois, Geneviève Ponge, and Marie-Martine Dubreuil.

In the Département des Arts Graphiques at the Musée du Louvre, we wish to thank especially Dominique Cordellier, Catherine Loisel, André Le Prat, Nathalie Coural, Christine André, Michèle Gardon, Brigitte Donon, Laurence Lhinares, Nathalie Albin-Portier, and Louis Frank.

Another important participant in the preparation of this exhibition was the Centre de Recherche et de Restauration des Musées de France, espe-

cially with regard to the murals from the Cour des Comptes; our heartfelt thanks go to Nathalie Volle, Odile Cortet, Véronique Stedman, Cinzia Pasquali, and Alain Roche.

At the Musée des Beaux-Arts in Strasbourg, we would like to thank Rodolph Rapetti, one of the initiators of the project, and Fabrice Hergott, director, Museums of Strasbourg, who followed the organization of the exhibition with great interest and care. We also wish to express our gratitude to the staff of the museum: Huguette Ankemann, Marcelle Cheminade, and Marie-Louise Wendling; Marie Ollier and Isabelle Rettig; Margaret Pfenninger and Mireille Goffinet; Hubert Tagland, Guy Fritsch, and Anouk Cateland; and Daniel Del Degan and Xavier Clauss. We are indebted to Anny-Claire Haus, curator, Cabinet des Estampes et Dessins, and, of course, to the entire staff of the Musée des Beaux-Arts.

At The Metropolitan Museum of Art in New York, Gary Tinterow and his French colleagues thank first and foremost Philippe de Montebello, director, for his unflagging support for the project. Without his interest, the exhibition would not have been realized in France or in the United States. Everett Fahy, Laurence Kanter, George Goldner, and Colta Ives all deserve thanks for enabling the generous loans of the works of art. Peter Benson Miller assisted with research and contributed several entries to the catalogue. Kathryn Calley Galitz ably served as supervising administrator of the exhibition and made many contributions to the English edition of the catalogue, which was produced at The Metropolitan Museum of Art. We thank John P. O'Neill, editor in chief, for overseeing the project, and Ellen Shultz, editor, for her intelligent and conscientious editing of the translation; thanks to her it reads beautifully. We are also grateful to Peter Antony, chief production manager, whose keen eye is reflected in the color reproduction, printing, and binding of the catalogue, and Robert Weisberg, desktop publishing manager, who oversaw the typesetting.

In addition, the following individuals are equally deserving of our thanks: Joseph Baillio, Sylvain Bellenger, Stéphane Belzère, Yves Berthou, Éric Bertin, Maryse Bertrand, Jean-Pierre Blin, Thierry Bodin, Philippe Bordes, Jacqueline Bret, Bernard Brochart, Pierre-Louis Cabat, André Cariou, Jacques de Caso, Laurence Castany, Isabelle Chain, Jean-Loup Champion, Frédéric Chappey, Jean-Michel Chasseriaux, Marie-Claude Chaudonneret, Nathalie Clot, M^e Coroller-Becquet, Claude Cosneau, Jean Coudane, Benoît Couturier, Isabelle and Stéphane Coviaux, Maïotte Dauphite, Anne-Marie Debelfort, Stéphane Delabre, Irène Delage, Anne-Sophie Derôme, Dominique Dollé, Douglas Druick, Bertrand Ducoureau, Charles Dupêchez, Mme Gérard Dupont, Jean Galard, Valérie Goupil, Laurent Gourdien, Sophie Grossiord, Sybille Heftler, Alonso de Heredia y Albornoz (marquis de Escalona), Daniel Jaunard, Isabelle Julia, Judith Kagan, Eric Keslassy, Medhi Korchane, Geneviève Lacambre, Hélène Launois, Véronique Laurent, Cyril Lauwereins, Nadège Lecendrier, Marie-Christine Lelu, Patrick Le Quinquis, Brigitte Lot, Bénédicte Magnin, Jean-Loup Mahé, Patrick Mansuy, Sophie Marchal, Nadine Massias, Caroline Mathieu, Hélène Mège, M. de Méneval, Marlène Mengant, Régis Michel, Anne de Mondenard, Jérôme Montcouquiol, Dominique Morillon, Marie-Renée Morin, Bruno Mottin, Sarga Moussa, Christine Nougaret, Jean-Baptiste Nouvion, Jérôme Ogerau, Mireille Pastoureau, Christine Peltre, Madeleine Pinault-Sorensen, Amélie Pironneau, Patricia Pomarède, Todd Porterfield, H. and M. Prouté, Jacques Ranc, Pierre-Louis Rey, Jonathan Ribner, Olivier de Rohan, Véronique Rollet, Guillaume Rosier, Jean-Pierre Rosier, Anne-Élizabeth Rouault, Dominique Rouet, Chantal Rouquet, Nicole Savy, Mathias Schauwecker, Arlette Sérullaz, Claire Sibille, Delphine Storelli, André Strasberg, Carole Syrota, Emmanuel Thinus, Isabelle Vazelle, Edward Vignot, Maïté Vissault, Mathias Wacek, Francine Wapler, and Guy Wildenstein.

THE CURATORS OF THE EXHIBITION

Directors' Note

Among the masters of Romantic painting, Chassériau was the only one, up to now, not to have been granted a retrospective like that devoted to Delacroix at the Musée du Louvre in 1963 or to Géricault at the Galeries Nationales du Grand Palais in 1991.

This state of affairs is all the more regrettable as the work of this painter—who died at the young age of thirty-seven—provides an original and powerful demonstration of the different trends, tensions, and contradictions in the art world in Paris during his lifetime. He cultivated a sinuous line, but was no less fond of color. Such paintings as the *Andromeda* and the famous *Toilette of Esther* display an emphatic sensuality, while his portraits of Lacordaire and of Tocqueville are noteworthy for their great simplicity. He regularly painted literary subjects, especially Shakespearean themes, in addition to religious scenes, and found inspiration in the Orient as well as in French history. The present exhibition reveals how Chassériau blazed new trails, especially in the realm of mural painting, as the fragments of the frescoes from the stairwell of the Cour des Comptes in Paris—restored specifically for this occasion—make clear. Puvis de Chavannes, now much praised for his modernity, was among the many painters whose style developed in the new direction charted by Chassériau.

Once again, the close collaboration between the Réunion des Musées Nationaux, the Musée du Louvre, and The Metropolitan Museum of Art in New York has made this exhibition possible. It is our hope that the exhibition will be instrumental in making the work of Chassériau—whose "fantastic talent" was recognized early on by his contemporaries—both better known and more widely admired.

The Metropolitan Museum of Art is particularly grateful for the kind assistance provided by The Isaacson-Draper Foundation for its support of the exhibition. We would also like to acknowledge the assistance provided by The Drue E. Heinz Fund and the Doris Duke Fund for Publications for this catalogue. We wish to express our pleasure in collaborating, for the first time, with the museums of Strasbourg.

Philippe de Montebello
Director, The Metropolitan Museum
of Art, New York

Francine Mariani-Ducray
Director, Museums of France
President, Réunion des Musées
Nationaux, Paris

Fabrice Hergott
Director, Museums
of Strasbourg

*Sappho Jumping into the Sea
from the Rock of Leucade*
1846
Detail of catalogue 171

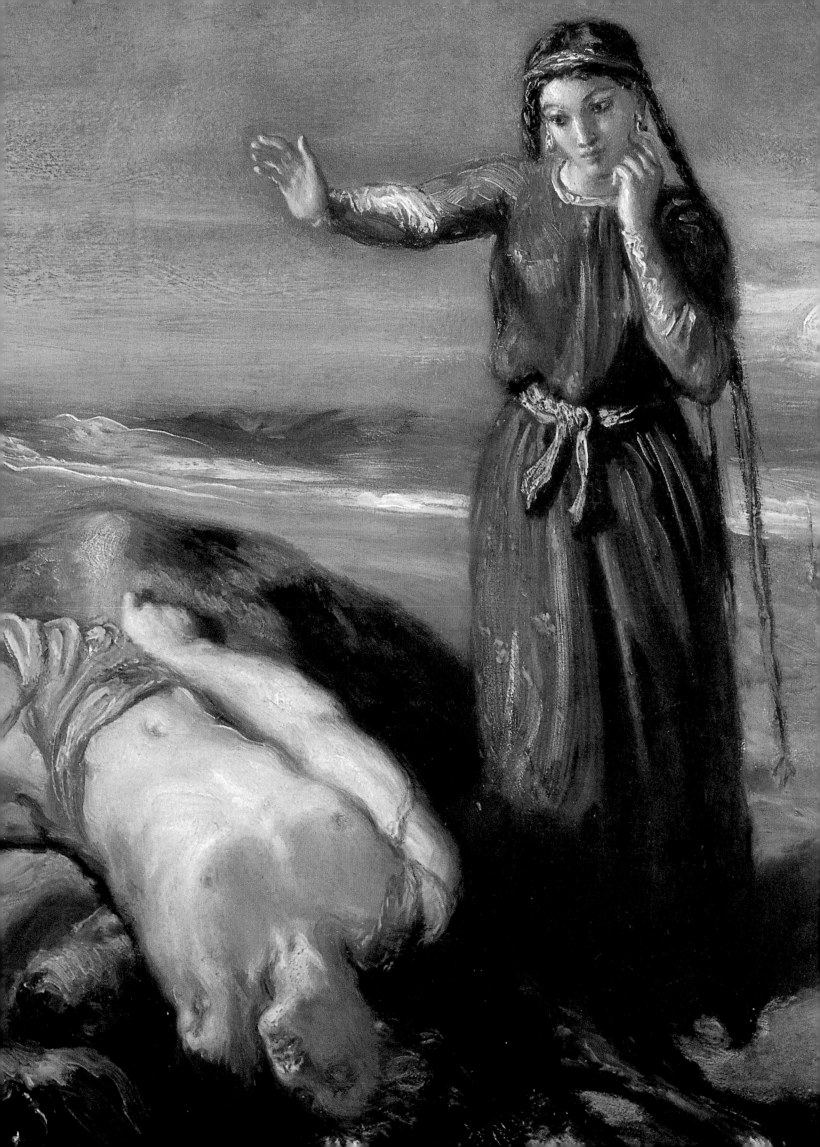

Contents

*A Cossack Girl Finds Mazeppa
Unconscious on an Exhausted
Wild Horse*
1851
Detail of catalogue 203

In memory of Baron Arthur Chassériau

INTRODUCTION
———

"The Happy Moment"

To RECONCILE THE STYLES OF INGRES AND OF DELACROIX—that is presumed to have been the ambition of Théodore Chassériau, whose art occupied a position midway between the two extremes. His paintings, which combine the graphic line and the nobility of those of Ingres—who was his teacher when he was still very young—and the blazing color and mordancy of Delacroix's canvases, are too often regarded as the intentional, or worse, the unwitting syntheses of the art of these two masters. That idea of an eclectic, indecisive, restless painter, constantly wavering, unable to come up with a style of his own, was promoted by his detractors—including, unfortunately, Baudelaire—even before 1848, and, in the twentieth century, it became a veritable topos of art history. In opposition to that thesis, which defines the artist only in relation to what he is *not*, and makes Ingres the defender of a threatened tradition rather than a full-fledged innovator as inventive as Delacroix, the 2002 Chassériau retrospective has set out to highlight the uniqueness of his art. By emphasizing that the adoption of certain conventions does not in any way imply mimicry, the aim is to situate him at the heart of the aesthetic tensions of his day.

It would be pointless, of course, to claim that the debate pitting Ingres against Delacroix never existed. It was already a leitmotif in the press, after the Salon of 1824, and the historic clash between Ingres's *Vow of Louis XIII* and Delacroix's *Massacre at Chios*. Twenty years later, when the precocious Chassériau had become a recognized painter, the supposed rivalry between the two strains of Romanticism continued to dominate critical discourse. A great deal of evidence attests to this fact: "When Paul de Saint-Victor introduced his cousin John La Farge, a recent arrival from America, to Chassériau, the American was astounded to be asked immediately, as if it were a primordial question, for his position on Ingres and Delacroix."[1] Chassériau's paintings disrupted that neat division in 1839, and even more so beginning in 1842, which was promptly acknowledged by the most perspicacious commentators of the time—Gautier and Thoré. The entries in this catalogue pay adequate tribute to them, so we need not dwell on them here. For most critics, however, Chassériau's art represented an improbable happy medium, as disconcerting as it was unrealized.

Shortly before the unveiling of Chassériau's mural decorations at the Cour des Comptes, Laurent-Jan rendered this judgment, which is typical of the inability of Chassériau's contemporaries to see the painter for himself: "With the best of intentions, I have vainly sought, in that artist's already numerous works, a single truly personal quality, a single spark of real originality. In my view, his talent has constantly shifted back and forth between one extreme of painting and the other, from M. Ingres to M. Delacroix, without gaining anything from contact with either of them."[2] Others, annoyed by the coterie the painter had managed to attract, in spite of everything, more openly accused him of plagiarism: "He makes the grave mistake of imitating M. Eugène Delacroix, if not of exaggerating both his defects and his positive qualities. . . . I fear that this artist will wander onto a disastrous path, toward which excessively admiring praise can only drive him, to an ever greater extent."[3] When his obituaries assessed Chassériau's work as a whole, some of his defenders expressed reservations about a painter whom death had "taken suddenly, amid, if not hesitations, then at least shifting aspects of a talent that had not yet settled on its style or completely expressed its own per-

sonality."[4] Charles Blanc, less a critic than a historian, formed an opinion that would ultimately take hold: "He even became one of Ingres's chosen disciples, all the while keeping something personal, rich, and bizarre that seemed to reveal an Eastern origin on his part." Nevertheless, Blanc based his analysis on the idea, which also would prevail, of a painter who "dreamed one day of reconciling two extremes, M. Delacroix and M. Ingres."[5]

Almost thirty years after the painter's death, Chassériau's early biographers were perfectly aware of the situation. Yet, for them, it was less important to deny that dual influence than to assert—with Gautier, and against the skeptics—that Théodore Chassériau had succeeded in being himself. Hence, Aglaüs Bouvenne, who had known the painter when he lived on the Avenue Frochot, wrote: "In the last years of his life, he had reached the point of forging a path that was truly his, without, however, achieving complete originality; the memory of Delacroix remained with him constantly. Few of Chassériau's works can escape comparison with those of the great colorist."[6] Nevertheless, that fruitful proximity did not rule out differences: "Chassériau was considered an imitator of Delacroix; although he did not wish to deny a kinship with that incomparable master, Théodore Chassériau did not pursue the same goal, did not have the same objective."[7] Ten years later, Valbert Chevillard asserted that "this strong and graceful artist, who sought out new paths between the two masters of his century, Ingres and Delacroix [is] a great artist because he is a complete artist [who] practiced all facets of his art with an independence, an originality, a superiority, that made him a master without forebears."[8]

In a more or less tendentious manner, this view of a painter able to surpass the role models of his youth became increasingly widespread after 1900, without altogether replacing the image of the hybrid artist. Sometimes critics had significant ulterior motives behind their offensives, in an age when anti-modern polemics prevailed. In 1909, Léonce Bénédite, an unrelenting apostle of the timeless classical ideal, wrote: "It is truly [Chassériau] who assures the continuity of the tradition, and he is the starting point for the new impulse in art to interpret the anthropomorphic reveries that haunt thinkers in every generation who love beauty and truth, when they want to give expression to the great universal ideas."[9] Jean Laran, resuming Bénédite's arguments in an article published in 1914, also situated Chassériau at the intersection of the classical tradition and modernity, but refrained from assigning him to the first category: "It has long been thought that everything had been said about Chassériau once one had shown that he had confined Delacroix's color within Ingres's drawing style, but he did not simply pursue a merging of the two techniques. Did not his words and his art attest to a higher ambition from the start? Did he not already dream of reconciling this respect for tradition—which he owed to his intensive studies and to his understanding of the modern soul, and which was awakened in him through his reading and his companions—and of placing classical nobility in the service of Romantic lyricism?"[10] Fundamentally, this represents a return—overly prudent, no doubt—to Gautier's intuitive stance. Léon Rosenthal opposed the view of Bénédite: The champion of Géricault and of the most virulent Romantics, Rosenthal did not seek to separate Chassériau from that movement, and acknowledged the artist's personal touch without wincing or expressing nostalgia for Neoclassicism: "So then, Chassériau is not indistinguishable from him [Delacroix]? Delacroix's art, whether tragic scores or luminous fanfares, overexcites us, goads us on, whereas silent Chassériau soothes us, lulls us into a state of torpor."[11]

In a memorable text, Henri Focillon definitively extricated Chassériau from the historiographical trap in which Bénédite and, to a lesser degree, Laran, had ensnared him—to say nothing of the less-inspired advocates of the perpetual Hellenism in French art. Focillon categorized Chassériau as a "composite" genius who blended form and content, citing his "feeling for distant races" as well as his dreamy ardor and "poetry of strangeness," all of which, in his view, marked him as an indeterminate painter. Focillon, above all, refrained "from explaining this rare genius in the old manner by enumerating and analyzing his different styles. Trained by Ingres, influenced by Delacroix,

achieving a harmony and reconciliation on the walls of the Cour des Comptes—that way of defining a body of work may not be inaccurate, but does it provide us with the essential, that exquisite alloy of two precious veins of metal running together and intermingling, and also that unique element, the hidden quality that incorporates and then transforms them?"[12] For Focillon, if there was any humanism in Chassériau's art, it could not be reduced to the regenerated idealism of a Bénédite: "He did not emerge fully armed with a reverence for ancient Greece but with a love of life and an affection for Man, and in the quality of his forms, the poetry of his figure types, and the noble meanderings of his thoughtfully considered and emotionally inspired compositions, he knew how to evoke the mysterious and touching aspects of our destiny."[13]

After 1930, when Chassériau's works began to be catalogued, further study became possible. Valbert Chevillard's detailed book,[14] published in 1893 and complete with anecdotes and quotations, included a catalogue of works that, despite the obvious lacunae, remains an important reference for all researchers. Subsequent to that book, Henri Marcel and Jean Laran's work,[15] more limited in its ambitions, presented detailed analyses of a selection of characteristic paintings and drawings, and, along with articles by Georges Grappe,[16] Léandre Vaillat,[17] and Lloyd Goodrich[18]—to mention only a few—assured Chassériau a place in the history of nineteenth-century art. That little "coterie" of admirers grew considerably, gradually introducing Chassériau's art to the public. This development was accelerated through the efforts of one man, Arthur Chassériau, the successor of the painter's elder brother, Frédéric, in keeping the memory of the artist's work alive—which has remained a family cause, even in our own time. Shortly before his death, Frédéric had the consolation of being able to entrust the "twenty-five-year-old man, Frédéric's cousin and the grandson of Benoît's younger brother, who is full of confidence and faith,"[19] with the task of looking after the painter's body of work. Although, according to Jean-Louis Vaudoyer, Chassériau's brother had inherited only "a few packets of sketches, family portraits," and "early scribbles" rescued after the artist's death, "Baron Arthur," Frédéric's sole heir, systematically bought back everything that came up for auction that was even remotely related to "that little boy genius"—the great painter, who was his distant cousin.

Arthur Nedjma Chassériau (fig. 1) was born in Algiers in 1850, the son of the architect Frédéric Chassériau, the namesake of the painter's brother. Cousin Frédéric was the son of Victor-Frédéric Chassériau, Théodore's uncle, who had died at Waterloo. After attending elementary school in Paris, Baron Arthur completed his secondary studies in Algeria.[20] He did not earn any "university degrees,"[21] and, for a short time, chose the military life, like most members of the family, enlisting in 1861 to fight in Kabylia. After being exempted from military service, he became involved in business, another family occupation, at which he rapidly excelled. In Paris, he worked for the Compagnie Algérienne, beginning in 1868, and held other posts in Marseilles and Algiers. He was then hired as department manager for the Compagnie Interocéane de Panama in 1881 and, in this capacity, served as Ferdinand de Lesseps's Paris correspondent. In 1887, he worked as a bank agent, and in 1898 he became senior partner to a stockbroker named M. Leuba, a position that definitively established his fortune.

Passionate about art—the baron was one of the first members of the Société des Amis du Louvre (Friends of the Louvre)—he devoted much of his wealth to keeping the painter's memory alive. He attempted in vain to save severely damaged decorations at the Cour des Comptes, before galvanizing the committee of artists and art lovers that eventually financed the removal of the fragments that could still be rescued (see cat. 115–133). At his home in the rue de la Néva (fig. 2), "Chassériau's works . . . lined the walls, from the baseboards to the cornices." The place looked like "one of those chapels dedicated to a particularly venerated saint."[22] "For almost half a century . . . and throughout the world," the painter's descendant pursued "his cousin's works, threatened with destruction."[23] Baron

FIG. I
Photographer unknown.
Baron Arthur Chassériau.
Private collection

Arthur tracked down both the artist's paintings and drawings as well as his former models—as, for example, the one who posed for the *Susanna and the Elders* (cat. 15). He met with the last witnesses: Hence, he collected a few confidences from Alice Ozy, the most famous of Chassériau's mistresses, who had since become Mme Pilloy, and was living in comfort in an opulent apartment on the Boulevard Haussmann.

Baron Arthur's unrelenting "labors" culminated in several donations to the French State,[24] and, finally, in the 1934 bequest of his collection of paintings and drawings to the Musée du Louvre—now divided among the Louvre, the Musée d'Orsay, and many French regional museums. Arthur Chassériau was also indirectly responsible for the 1933 exhibition at the Orangerie, in the Tuileries—the first retrospective of the painter's works. Comprising 244 items (paintings, engravings, and drawings), that exhibition, accompanied by a scholarly catalogue with a preface by Jean-Louis Vaudoyer and entries by Charles Sterling, aimed at definitively winning recognition for the oeuvre of Théodore Chassériau.

At the same time, desirous of completing his life's work, Baron Arthur encouraged and aided in the publication of the notes compiled by Léonce Bénédite for his classes at the École du Louvre; the resulting book was the first large-scale study devoted to the painter. Published in December 1931, it contained countless personal remembrances and documents, including a portion of the family correspondence (currently unlocatable and thus unverifiable). Bénédite nevertheless based his view of the painter's life and work on disputable assumptions, and resolutely subjected Chassériau to his own academicism, especially with regard to the Orientalist works (cat. 183).[25]

Despite the appearance of these publications, which are rich in content and ultimately indispensable, however hagiographic in tone or questionable in intent, the practice of explaining Chassériau's art "in the old manner" prevailed in the years from 1940 to 1950. The theme of the indolent and changeable Creole, developed by the Goncourts in *Manette Salomon,* began to seem troubling or to sound anachronistic, depending on one's viewpoint. Pierre du Colombier's *Histoire de l'art,* published in 1942, recognized the beauty of certain portraits, and the nobility of the murals at the Cour des Comptes, although he added bluntly: "That young Creole, who died at twenty-seven [*sic*], is almost a pathological case. . . . One cannot resist observing that the works painted at the end of his short life are far inferior to those from his early days. One may concede that Eugène Delacroix's influence, which he keenly espoused at the time as a reaction against his former teacher, was not yet fully assimilated, and that he had not recovered his equilibrium. Yet, might it not also be an instance of early burnout, such as one finds among people from excessively mild climates?"[26] Whether due to pathology, eclecticism, or a congenital incapacity, Chassériau rebelled against Ingres, and because the classical unity of his works was inconsistent, he was deemed only partly acceptable. The orig-

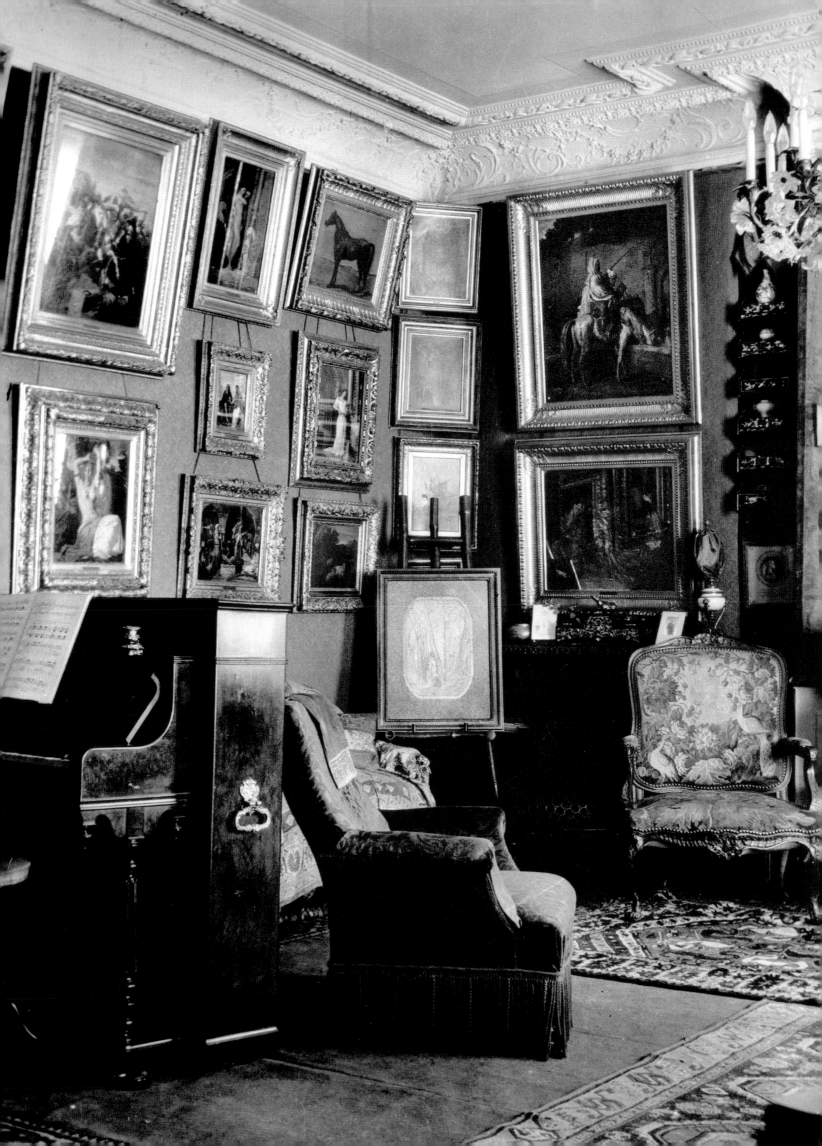

inal reproach constantly resurfaced in describing a man who supposedly "wavered throughout his life between Ingres and Delacroix."[27] Naturally, no one disputed any longer the importance of the Cour des Comptes stairwell decorations, which, in any case, had been legitimized by Puvis de Chavannes, Gustave Moreau, and Maurice Denis, who claimed to be indebted to them. Critics hailed the success of the Lacordaire portrait, and admired the sensuality and vigor of the Orientalist paintings. In the end, however, in overstating the importance of Chassériau's work as a painter of decorative scenes and of women, they obscured other components of his paintings, as well as his vast output of graphic works: the strength and ambiguity of his religious works, the historical implications of his Algerian compositions, the innovations he introduced into classical themes, and the uniqueness of his technique.

More than forty years passed between the appearance of Bénédite's monograph and that of Marc Sandoz's catalogue raisonné in 1974—years punctuated, as we have seen, by many articles of varying usefulness, by a few exhibitions (in the Cabinet des Dessins at the Musée du Louvre, the museum in Poitiers, and the Galerie Daber, for example), and by the first articles by Sandoz on the painter whom he studied devotedly during much of his working life. Sandoz's important and well-documented catalogue, informative yet at times muddled, remains useful. Beyond the admittedly numerous problems regarding dates and attributions and the sometimes poorly supported aesthetic interpretations, Sandoz's book opened up new perspectives on the artist's visual and literary culture, and on his circle. The catalogue of Chassériau's drawings and notebooks in the Louvre, published by Louis-Antoine Prat in 1988, has become the cornerstone of modern research on the subject. The two volumes by Prat, which correct Sandoz's book on many points and provide more information on the genesis of the paintings, highlight the importance of the graphic works and the countless annotations, in more or less detail, on many of the drawings.

Prat's catalogue is not the only contribution the Musée du Louvre has made in recent years to a better understanding of the painter: In 1986, the State acquired the superb *Andromeda*, which had been exhibited at the Salon of 1841 (see cat. 65); in 1992, a room bearing Chassériau's name opened in the section of the Louvre dedicated to French painting, on the third floor of the Cour Carrée; and the Louvre's Département des Peintures and Centre de Recherche et de Restauration des Musées de France studied, consolidated, and restored fragments from the Cour des Comptes paintings.

The aim of the 2002 exhibition, using this long history as its point of departure and freed from the obsession with Chassériau's dual heritage, is to provoke new research both on the artist—with regard to his life and his work—and on French Romanticism in general. Indeed, without yielding to "biographical fallacy," or the myth of Creole languor, it seemed necessary to reexamine the fate of his family, linked by so many old ties to the political, ideological, and colonial history of France in the years from 1830 to 1850; to restore the full weight of Théodore's interest in Lamennais's and Lacordaire's social Catholicism; to place Chassériau's trip to Algeria in 1846 within the political and military context of that country; and to describe the painter's social and intellectual milieu, which included such personalities as the Girardins and Alexis de Tocqueville, whose constant support Chassériau enjoyed from age twenty on.

With these objectives in mind, the texts that follow draw strength from information culled from various sources. The catalogue takes several approaches: It contains a complete chronology of Chassériau's life compiled by Bruno Chenique, whose documentary contribution to this volume, as a whole, has been decisive; detailed entries; and several more-general essays. The selection of works of art encompasses, along with the significant holdings from the Musée du Louvre, paintings and drawings from throughout France as well as from abroad; in this area, the contribution of North American museums and collections to the current reexamination of Chassériau's art is noteworthy.

In addition, there are a few rediscoveries, such as the *Diana Surprised by Actaeon* (cat. 22), which met with rejection at the Salon of 1840. Also, unlike the 1933 retrospective, this exhibition presents Chassériau's monumental ecclesiastical works: *Christ on the Mount of Olives* (cat. 16) will be seen in Paris and *The Descent from the Cross* (cat. 68) will be shown in New York; unfortunately, the artist's third altarpiece, the 1848 *Christ on the Mount of Olives*, is not included, as it could not be transported safely from the Church of Sainte-Marie in Souillac. Happily, however, the ravishing *Portrait of Comtesse de La Tour-Maubourg* (see the Addendum), which reappeared during the preparation of this project, was purchased by The Metropolitan Museum of Art, and will be on exhibit (for the first time since 1933) in the New York venue. This masterpiece joins the Metropolitan Museum's recently acquired *Scene in the Jewish Quarter of Constantine* (cat. 153) and a number of important works on paper that together form an impressive representation of Chassériau's achievement outside of France.

Throughout the twentieth century, works by Chassériau were sought by curators and collectors, yet his name remains little known in France and almost unknown elsewhere, and his reputation has always suffered from comparison with those of the dominant personalities of his day. The challenge of this exhibition, therefore, is to encourage the public—without the incentive of great celebrity or the disability of ignorance—to enjoy the work of an excellent painter. If artists such as Dosso Dossi can be rescued successfully from obscurity, then one hopes that there is a chance that Chassériau's oeuvre can be viewed without prejudice. There have been many artists greater than Chassériau, but few who have produced a body of such consistently beautiful work—work that spoke so powerfully to Puvis de Chavannes, Gustave Moreau, and the Nabis that there seems to be no reason why it cannot be heard today. We have faith in its power and in its strange grace. Chassériau often alluded to the "happy moment" (*la minute heureuse*)—of the alchemy between reality and beauty—that he sought to capture in his paintings. We hope our public will find that moment in this exhibition.

The Curators of the Exhibition

1. J. Rewald, *Histoire de l'Impressionnisme* (Paris, 1955), p. 24; quoted in R. Cortissoz, *John La Farge* (New York, 1911), p. 85; the conversation took place in 1856.
2. Laurent-Jan, "Salon de 1848. II. Peinture historique," in *Le Siècle*, no. 85, Tuesday March 28, 1848, p. 3.
3. M.-B. Bouniol, *Causeries d'un amateur. Souvenirs du Salon. Études d'art* (Melun, 1852), p. 12.
4. A.-J. Du Pays, "Nécrologie. Théodore Chassériau," in *L'Illustration, journal universel* 29, no. 733 (March 14, 1857), p. 176.
5. C. Blanc, *Histoire des peintres: Écoles française*, vol. 2 (Paris, 1865), p. 64.
6. A. Bouvenne, "Théodore Chassériau," in *L'Artiste* 2 (September 1887), p. 162.
7. Ibid., p. 163.
8. V. Chevillard, "Théodore Chassériau," in *Revue de l'art ancien et moderne* 2, no. 2 (February 10, 1898), pp. 108, 113.
9. L. Bénédite, *La Peinture au XIXᵉ siècle* (Paris, 1909).
10. J. Laran, "Un Portrait inédit par Chassériau," in *Archives de l'art français*, n.s., 8 (1914 [1916]), p. 322.
11. L. Rosenthal, *Du Romantisme au réalisme. Essai sur l'évolution de la peinture en France de 1830 à 1848* (Paris, 1914), p. 162.
12. H. Focillon, "Chassériau ou les deux romantismes," in *Le Romantisme et l'art* (Paris, 1928), p. 164.
13. Ibid., p. 184.
14. V. Chevillard, *Un Peintre romantique: Théodore Chassériau* (Paris, 1893).
15. H. Marcel, *Chassériau*, with entries by J. Laran (Paris, 1911).

16. G. Grappe, "Les Arts. Théodore Chassériau," in *Le Cahier* (November 1912).
17. L. Vaillat, "L'Oeuvre de Chassériau," in *Les Arts* (August 1913).
18. L. Goodrich, "Théodore Chassériau," in *The Arts* (August 1928).
19. J.-L. Vaudoyer, "Le Baron Arthur Chassériau. Notice lue à l'Assemblée générale annuelle de la Société des Amis du Louvre, le 17 juin 1935," in *Cabinet des Dessins, Société des Amis du Louvre* (Compiègne, 1935), p. 9.
20. On Baron Arthur Chassériau see also Prat 1988-1, vol. 1, pp. 15–20.
21. Valuable biographical information regarding Baron Arthur is contained in a letter of December 15, 1922, to L. Bénédite (archives of L. Bénédite, Paris, Musée du Louvre); quoted in Prat 1988-1, vol. 1, p. 16.
22. J.-L. Vaudoyer, op. cit., pp. 13–14.
23. Ibid., p. 14.
24. In 1906, the *Portrait of the Reverend Father Dominique Lacordaire* (cat. 47) was acquired "with the cooperation of Baron Arthur Chassériau"; in 1918, Baron Arthur and his wife donated two portraits, *Aline Chassériau* (cat. 3) and *The Two Sisters* (cat. 61), to the Musée du Louvre, as well as the *Macbeth and Banquo Encountering the Three Witches on the Heath* (cat. 200) and the *Arab Chiefs Visiting Their Vassals* (cat. 185). In 1933, Baron Arthur, whose wife had died in the meantime, donated the *Portrait of Ernest Chassériau* (cat. 4) to the Louvre, along with the painter's two self-portraits (cat. 1, 2).
25. L. Bénédite, *Théodore Chassériau. Sa vie et son oeuvre* (Paris, 1931).
26. P. du Colombier, *Histoire de l'art* (Paris, 1942), pp. 437–38.
27. See the note by A. Joubin, written in 1932, in E. Delacroix, *Journal, 1822–1863*, new ed. (Paris, 1996), p. 594 n. 1.

The Two Sisters, or *Portrait of the Mesdemoiselles C. (Marie-Antoinette, called Adèle [1810–1869], and Geneviève, called Aline [1822–1871], the painter's sisters)*
1843
Detail of catalogue 61

Essays

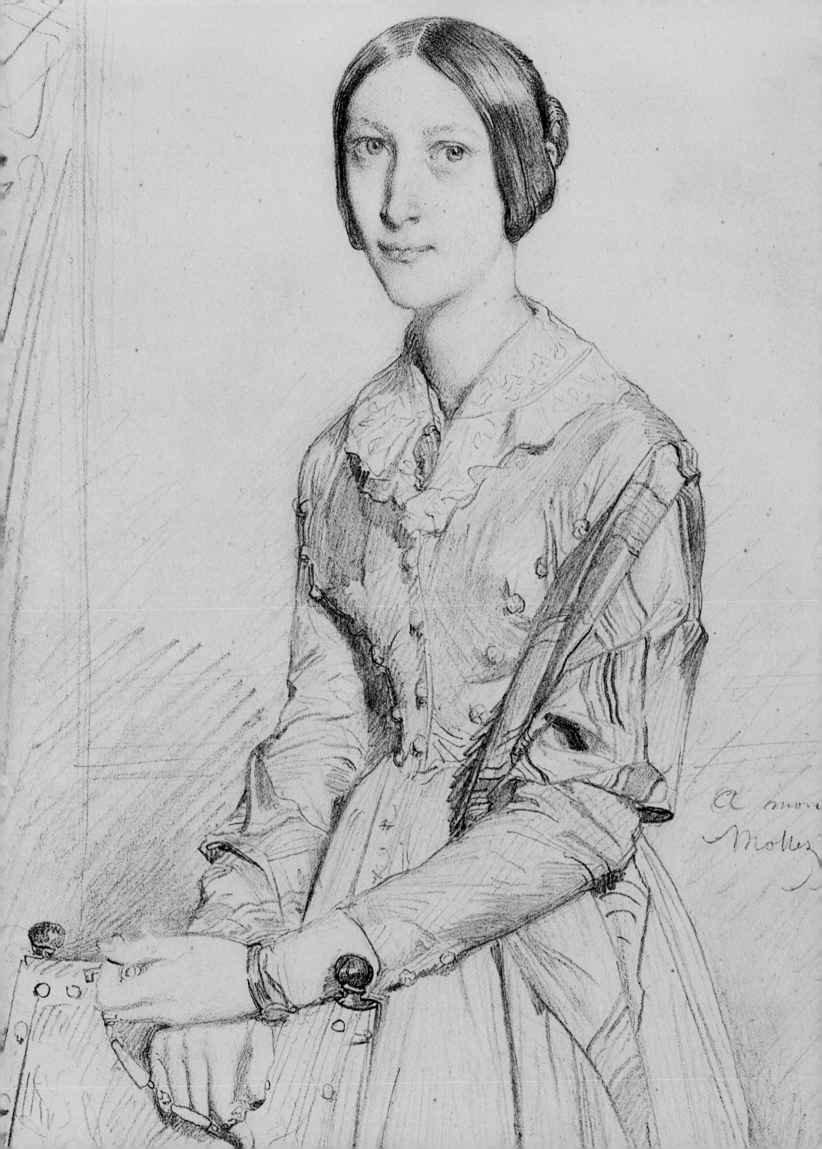

The Indian and the Chinese,
or The Two Byzantines

O<small>N THE EVE OF HIS DEATH</small>, Federico Zeri, the renowned twentieth-century art connoisseur, enumerated his regrets regarding objects he cherished but never possessed. By his own admission, this imaginary museum, virtual as well as personal, had to include "the portraits in pencil by Ingres and Chassériau, modern Byzantine icons, as it were."[1] There were none of these desired objects in his beautiful home in Mentana, Italy, except as reproductions, although he had accumulated other portraits, whether Baroque paintings on canvas or classical drawings done in chalk. For Zeri, however, the drawings he so admired remained *icons* to the end. That term evokes the almost religious attachment that true lovers of the graphic arts feel toward these very unusual works: won over by their quality, but distressed by their rarity. An ever greater part of these drawings are buried every year in the dimly lit galleries of public collections. As Byzantine as they are modern, these fragile sketches of the "foolish nineteenth century" look as timeless as the sublime effigies of Henry VIII's courtiers by Holbein, or those impressions of the bourgeoisie in the Netherlands of old that parade across the folios of Albrecht Dürer's travel notebook of 1520. It would be difficult to find other, equally valid, comparisons. The portrait drawing, a practice in disrepute for more than five centuries, and profoundly ill-used since the invention of photography, rarely yielded perfect works, even in those cases in which a single artist produced a great number of them throughout his career. The name of Clouet comes to mind, but it is not a good example since several hands, of unequal talent, seem to fall within that designation. Michelangelo? The most successful of his portraits are *ideal* (or idealized) *heads,* not likenesses taken from daily life. Lorenzo di Credi, Raphael, the Carracci? Their genius, like that of Van Dyck, was more evident elsewhere.

There are no miracles in art, but what leads us to admire these portraits—by Ingres and by his favorite pupil, overly admired yet too quickly rejected by the master—is that some of them are miraculous. The two artists, using almost identical means and approaches that were to all degrees parallel, managed to do more than was asked of them, more than to simply reproduce the features of a face. They made it possible for a soul to exist in perpetuity, for a life not to be snuffed out. In a certain way, their models triumphed over time itself.

Without these two masters, who would remember Mme Hennet du Goutel? She had the good fortune (the good idea, the right opportunity?) to have her portrait done, two years apart, by Chassériau (fig. 1) and then by Ingres (fig. 2). Mme Hennet was born in 1775, and was the mother of a young artist whose portrait Chassériau painted (Ingres simply drew him), but whose works are now all but forgotten. She was a dowager when her two portraits were made, but, curled up in the corner of a sofa facing Chassériau, she seems ten years younger than she looks, settled in a Restoration armchair before the Master of Montauban. In the first portrait, her rather loose-fitting cap lets her short ringlets show, while, for Ingres, she wears a tighter hood that quite severely surrounds her face, hiding her hair entirely and accentuating her features, her deep-set eyes like those of a very old person. Her gaze, intense and somber in the pencil portrait of 1840, seems to have become frozen in the

FIG. 1
*Portrait of Mme Hennet
du Goutel*
1840
Graphite
Bayonne, Musée Bonnat

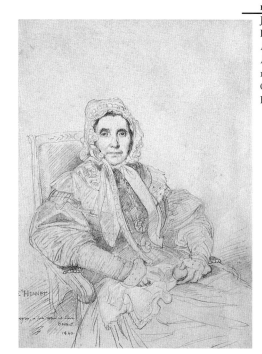

FIG. 2
Jean-Auguste-Dominique
Ingres
*Portrait of Mme
Hennet du Goutel*
1842
Graphite
Bayonne, Musée Bonnat

1842 portrait, her demeanor haughtier and more weary. However, the fullness of the clothing is practically the same, except that Ingres reveals both his model's hands, whereas Chassériau chooses to show only one.

The two sheets caught the eye of the prominent collector and artist Léon Bonnat, who paid very different prices for them: three hundred francs for the Chassériau in 1897 and fifteen hundred francs for the Ingres in 1900. In accordance with Bonnat's express wish, the two works, united in Bayonne at the museum that bears its founder's name, cannot be exhibited elsewhere. On only one occasion, in 1979, the Chassériau drawing was shown at the Louvre, but the organizers never thought of exhibiting it alongside Ingres's! Art critics, however, had indulged in that exercise for decades. In 1903, when Gustave Gruyer placed the two sheets side by side, he commented that "this proximity makes Ingres's superiority strikingly apparent."[2] Only a year later, Louis Gonse admitted that he "preferred Chassériau's drawing of the same person."[3] Closer to our own time, Arlette Sérullaz, making the same comparison, concluded: "I am tempted to prefer the extremely lively and natural character of the Chassériau portrait to the skillful mastery of Ingres's strokes."[4] Naef,[5] the famous cataloguer of Ingres's portrait drawings, who acknowledged that he often placed the two

drawings next to each other on a table at the Bonnat museum to facilitate a comparison, admitted he would rather have received Chassériau's drawing, over Ingres's, as a gift.

Whereas Ingres dedicated his work to his *friend and pupil Hennet*, Chassériau addressed his *to my friend Hennet*, which indicates the generational difference between the two artists. Ingres was sixty-two years old when he made his drawing of the model; Chassériau, only twenty-one. The older artist had already produced several hundred graphite portraits; the younger, two dozen at most.

In 1840, Ingres's portrait drawings were already famous among his friends, admired and recognized as one of the most accomplished facets of his art. He no longer worked on commission, as he had when he experienced financial difficulties in Rome after the fall of the Empire. Then, he was sought out by English travelers, who regarded him as the "draftsman of small portraits," although he himself would have preferred to be known simply as the "history painter." Nevertheless, commercial or not, his rules for a portrait prevailed: It was generally executed in four hours, two in the morning and two in the afternoon; the model was often depicted to mid-thigh, more rarely full length, sometimes surrounded by familiar objects that might indicate the sitter's profession. It was no longer fashionable for the backgrounds of portraits to contain landscapes, and Chassériau, who followed Ingres's formula quite scrupulously, also did not execute any portraits of this type.

With the required hindsight, we can identify points of convergence and difference between the two artists: Naef, in his corpus of Ingres's portrait drawings, lists four hundred and fifty-six sheets, some of them known only from having been mentioned elsewhere. He admits that there are probably a few duplications, and concludes that Ingres must have produced about five hundred portraits (only a dozen new ones have come to light since his book was published).[6] Chassériau, whose life was much shorter, proved to be less prolific, but the years from 1840 to 1841 and 1846, for example, were especially productive. Chevillard, his first biographer, wrote in 1893: "In the salons he frequented, he did countless graphite portraits in short order, prodigiously, so to speak."[7] In 1986, Sandoz published a catalogue of these portrait drawings, but he included dozens of figure studies that have absolutely nothing to do with that particular genre. The fact that it is possible to recognize the identity of the model—Clémence Monnerot, the future Comtesse de Gobineau, or one of her two dear friends, Adèle or Aline Chassériau—in a figure study for a large painting certainly does not mean that the sketch is a portrait drawing. Those drawings that intentionally were conceived as such respect the Ingresque codes for composition, scrupulous observation, and the isolation of a human figure (or two—although Chassériau very rarely drew couples or group portraits, such as the one of the wife of Admiral Duperré and her daughters [cat. 57]; a double portrait of his painter friends Cabat and Chevandier de Valdrôme in Rome, certified by Chevillard, has not come to light). These drawings generally bear a signature, date, and dedication, to which on almost all of them Chassériau added the notation "Amicicia Amiciciae"; he did not share Ingres's loathing for works of this type, which the latter once referred to as "those cursed portraits." (According to Ingres himself, as well as to his wife [see Amaury-Duval], the portraits were his only income at the time and kept him from starving to death.) Are many of Chassériau's portraits lost? I have inventoried fewer than one hundred, but a handful have reappeared that were never mentioned previously in any source. One example is the portrait of the painter William Haussoulier (fig. 3), dating from 1850, which surfaced at a Paris sale in 1988; no one had suspected its existence, and no biographer had noted the relationship between Chassériau and that artist (apart from Bénédite, who cites him as the model for Vercingétorix in *The Defense of Gaul*), one of whose paintings—*The Fountain of Youth*—caught the eye of Baudelaire at the Salon of 1845.

Undoubtedly, it would be difficult to compare at firsthand the two portrait drawings by Ingres and Chassériau of Julie Mottez, the wife of the Ingresque painter Victor-Louis Mottez and a painter herself. Ingres's pencil portrait (fig. 4) has just turned up under extraordinary conditions in a public collection in Russia and its reappearance may be the subject of disputes as to how it came into that country's possession. The Chassériau drawing (fig. 5), which dates to 1841, is now in Cambridge,

Massachusetts (Fogg Art Museum). Ingres's drawing of the wife of his friend and pupil, executed three years later, could be considered more natural and more genuine, although less sophisticated. This time, the Byzantinism is on Chassériau's part; the artist scrutinizes his model closely, even as he manipulates the forms by accentuating certain details.

Another female model whom the two artists shared was the celebrated Marie d'Agoult. In this case, however, their two portraits are farther apart in time, and differ significantly in conception. Marie posed for Chassériau (fig. 6) when he returned from Rome in 1841; she chose to be depicted by Ingres with her daughter, in her parlor, in 1849 (fig. 7). Ingres's drawing is large and ambitious, and almost oppressively skillful; Chassériau's is bizarre, showing the young woman with her mouth open, which greatly displeased Liszt, her companion at the time. In my view, Ingres's work has the advantage in a comparison, by virtue of the extraordinary care taken in rendering the details of the furnishings, the green plant, and the fireplace tools.

Both artists liked to draw children, seated in high chairs (little Ranchicourt [cat. 7], and Marcotte) or in vast armchairs (the young Charles Lethière, and Berthe de Prailly [cat. 50]), and they labored tirelessly to portray the families of their loved ones (the Marcottes, for Ingres; and the Ranchicourts and Duperrés for Chassériau). Ingres drew the woman he loved ten times, and Chassériau depicted the features of at least two of his Muses, Alice Ozy (cat. 168, 169) and Marie Cantacuzène (cat. 219) on several occasions. The critics who supported him (Gautier and Delécluze) as well as his fellow students (Flandrin, and Burthe [cat. 162]) were not forgotten. Chassériau portrayed his own family more often than Ingres did his, because he lived in close proximity to them. Ingres frequently represented the world of music, and Chassériau that of government perhaps because of an elder brother, who had risen from the ranks and through whom he hoped to receive official commissions. Despite an antagonism that began in 1840, when Chassériau's art first revealed its originality, the two portraitists remained closer in that area than in any other—so much so that a portrait of a young woman that was executed in Rome was for years believed to be by Ingres, whereas it is, in fact, a work by Chassériau (see cat. 49), from the period when they were neighbors in the Eternal City.

At this level of quality, it would be impossible to establish a hierarchy between the two artists. "The Chinese lost in Athens" and "the Indian who studied in Greece" display too many similari-

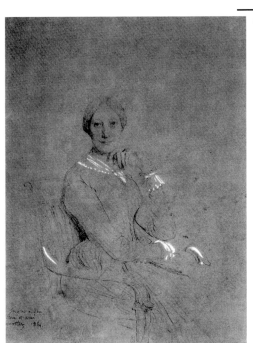

FIG. 4
**JEAN-AUGUSTE-DOMINIQUE
INGRES**
Portrait of Mme Mottez
1844
Graphite, heightened with
white, on beige paper
Moscow, Pushkin Museum

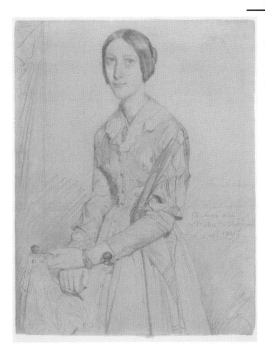

FIG. 5
Portrait of Mme Victor Mottez
1841
Graphite
Cambridge, Massachusetts,
Fogg Art Museum
See catalogue 52

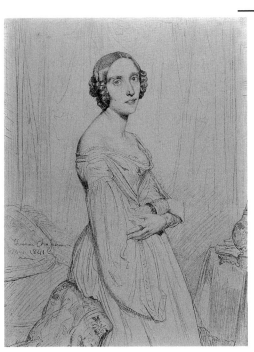

FIG. 6
Portrait of Marie d'Agoult
1841
Graphite on
cream-colored paper
Paris, Musée du Louvre
See catalogue 53

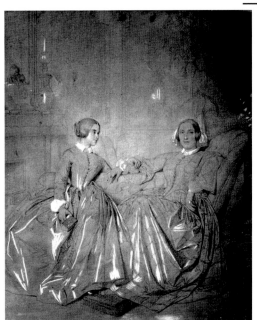

FIG. 7
**JEAN-AUGUSTE-DOMINIQUE
INGRES**
*Portrait of Marie d'Agoult
and Her Daughter Claire*
1849
Graphite, heightened
with white
United States,
private collection

The Indian and the Chinese, or The Two Byzantines **27**

ties to allow an aesthetic judgment to validate such a classification, since each master produced works that were highly successful and others that were less so. Ingres's *Albertine Hayard* or *The Montagu Sisters* triumph because of their extreme formal tension, while the most perfect of Chassériau's drawings, at least in my view—*Mme Borg de Balsan* (now in Philadelphia; cat. 163)—on the contrary, stands out by virtue of its thoroughly natural elegance. Yet all three works possess a rare quality, which Naef acutely grasped: the artist's "tact" and "respect"[8] in dealing with his model. In their best drawings, Ingres and Chassériau—and, later, perhaps Degas—knew how to capture not merely a moment in the life of an individual, but the essence of that individual, "the life of the model not in [specific] acts, but in the potentiality underlying all of them."[9] There is necessarily a distance between a painter and his model; both artists grasped it perfectly and respected it supremely.

Ingres, supported by his vindictive wife, turned his back on Chassériau once he realized that in some ways the younger artist was slipping away from him, during the autumn of 1840 in Rome. Chassériau had acknowledged that: "In a fairly long conversation with Monsieur Ingres, I saw that, in many respects, we would never be able to understand each other." In 1841, Ingres smiled with satisfaction in front of Marie d'Agoult when Mme Ingres disparaged his former pupil.[10] For his part, Chassériau appears to have ceased to mention his former professor, although he continued to pay him tribute in several paintings. In an obituary notice in March 1857, by Paul Mantz, in which he referred to the *Two Sisters* (1843; cat. 61), he readily admitted that there is, "in the heads of the young girls, a skill for reliefs that, I do not hesitate to declare, is not always found in the portraits of the master whose influence Chassériau was under at the time."[11] One can imagine the reaction of the master in question.[12]

A comparison is not an argument, and one cannot contrast perfection and lyricism. In 1986, Sandoz pointed out that "the particular virtuosity of Ingres's portrait drawings, acknowledged by all, nevertheless deprives us, it seems, of the painter's personal feelings for his model, which we find so often in Chassériau."[13] In 1988, when I published my inventory of Chassériau's drawings in the Louvre, I responded that I was not so sure of this. How can one deny Ingres's fondness for the violinist Baillot; for his in-laws, the Ramels; for the Lethières; and for the Baltards, which is so clearly expressed? Conversely, I added, Chassériau's tendency to make the female face conform to an idealized type may have sometimes led him to be less realistic. "Imagined beauty," Jean-Louis Vaudoyer aptly wrote in 1933, "envelops, permeates existing beauty."[14] This applies, in fact, to only some of his female likenesses—as, for example, to that of Princess Belgioioso (cat. 164). For many others, the scrupulous description of the subject is in no way altered by any tendency to glorify the features. Ingres's mannered approach in his female portraits diminishes visibly with time; that of Chassériau is expressed episodically, but all in all very rarely, at particular moments of tension—as, for example, in his drawings of the indigenous inhabitants of Algeria made during his stay there in 1846, in which practically every figure tends toward an ideal type.

Perhaps a future exhibition will allow us to hang the drawings of the two portraitists side by side.[15] Then we will see that, although their worlds were not the same, they sometimes intersected: one was perhaps more poetic, the other had a more focused vision (note, among the stylistic differences, a more extensive and more consistent use of hatching by Chassériau, who accents certain passages of shadow with a network of small, dry, and heavy strokes that sometimes form a kind of irregular star), but both were friendly, affectionate, and in love with life, which registers on their models' faces. Unbeknownst to them, at some points, their art crossed paths.

Unbeknownst to them, as well, was that, at least once, they both took up the same somewhat rare theme, which glorifies the creativity that they shared: A sleeping man, whose features are striking for their ugliness, is being kissed on the mouth by a beautiful queen, who leans over him; she is in love not with his illusory physical appearance but with the exquisite words that have issued from these lips. The queen is Margaret of Scotland, the sleeping poet, Alain Chartier. Chassériau evokes the scene in a wonderful wash drawing, of 1840 (fig. 8). Ingres's version—a pencil drawing, now in Montauban, whose date is unknown (Vigne, no. 2534, ill.)—is a bit more schematic (fig. 9).

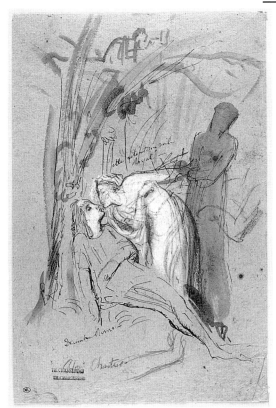

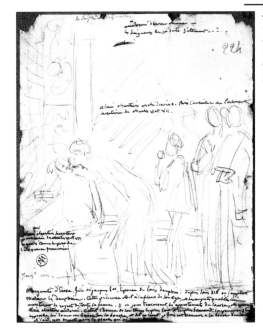

Yet, by pure chance, the treatment is similar and the compositions are almost identical. Each of the two men individually intended that the allegory they presented would serve as a manifesto, justifying the artistic act. In that declaration of the preeminence of their art, these two great figures, separated by the vicissitudes of life (by chance, misunderstandings, and the force of circumstance), come together again, and in their approach to the model, they remain forever brothers in authenticity.

Louis-Antoine Prat

1. F. Zeri, *J'Avoue m'être trompé* (Paris, 1995), p. 117.
2. G. Gruyer, "La Collection Bonnat au Musée de Bayonne," in *Gazette des beaux-arts* (March 1, 1903), p. 210.
3. L. Gonse, *Chefs-d'oeuvre des musées de France: Sculptures, dessins, objets d'art* (Paris, 1904), p. 93.
4. A. Sérullaz, *Dessins français du XIXᵉ siècle du musée Bonnat à Bayonne,* exhib. cat. (Paris: Musée du Louvre, 1979), no. 29, ill.
5. H. Naef, *Die Bildniszeichnungen von J.-A.-D. Ingres,* 5 vols. (Bern, 1977–80), vol. 2, p. 587.
6. These include three early round portraits, *Bust of a Man in Left Profile* (sale, Paris, Hôtel Drouot, April 4, 1991, no. 26, ill.), *Bust of a Young Woman in a Cap* (sale, Paris, Hôtel Drouot, September 5, 1998, no. 55, ill.), and *Portrait of Mademoiselle Adanson* (Paris, private collection). The *Portrait of a Woman, Seen in Half Length,* which sold at the second Renand auction (Paris, Hôtel Drouot, March 15, 1988, lot 33, ill.), seems authentic (from about 1805?) despite later retouching. The Roman portraits that should be mentioned include *Young Englishwoman in Three-Quarter Left Profile* (sale, London, Sotheby's, November 28, 1990, lot 3, ill.), *Mademoiselle Keating Playing the Guitar* (1816; art market), and *Monsieur de Bionval* (Washington, D.C., National Gallery of Art, Woodner Bequest). A second version of the *Portrait of Monseigneur Cortois de Pressigny* and a tenth portrait drawing of Madeleine Chapelle (London, Hazlitt Gallery, 1991), dated 1814, were included in a sale in Paris in 1992. Two additional portraits also should be noted: *Madame Godinot* (sale, Paris, Hôtel Drouot, March 20, 1990, no. 2, ill.) and *Mademoiselle de Rothschild* (sale, London, Sotheby's, June 20, 1985, no. 639, ill.) and a portrait of the engraver *Boucher-Desnoyer* (sale, Paris, Hôtel Drouot, June 18, 1993, letter A, ill.). Finally, *Portrait of a Seated Man in Three-Quarter Left Profile, Wearing an Opera Hat, with a Roman Monument in the Background,* dated 1817 (now in a Prague collection), which I know only through a reproduction, also may be an autograph work. In addition, Naef does not seem to list, in his corpus, the *Portrait of Monseigneur de Latil* (Providence, Rhode Island School of Design; 42.073).
7. Chevillard 1893, p. 159.
8. H. Naef, "Ingres Dessinateur de portraits," in *Ingres,* exhib. cat. (Paris: Musée du Petit Palais, 1967), p. xxiii.
9. Ibid.
10. H. Naef, op. cit., vol. 1, chap. 40, p. 374.
11. Quoted in Chevillard 1893, p. 77.
12. With reference to works subsequent to the rift, Chevillard (1893, p. 160) mentions that Chassériau "modernized his line, imparting to it the suppleness, grace, and elegance that were part of his artistic nature; even while remaining simple and direct, it expresses movement, abandon, the veracity of life."
13. Sandoz 1986, p. 6.
14. *Chassériau, 1819–1856,* exhib. cat. (Paris: Orangerie, 1933), preface, p. xviii.
15. At least that was the wish of Henri Focillon, in "Chassériau ou les Deux Romantismes," in *Le Romantisme et l'art* (Paris, 1928): "I am thinking especially of the drawings. How interesting it would be to compare them to the drawings of Ingres! Do the latter not have something tauter, bolder about them? These are magnificent working drawings of the soul. I mean that the soul not only is present in them but also refines them."

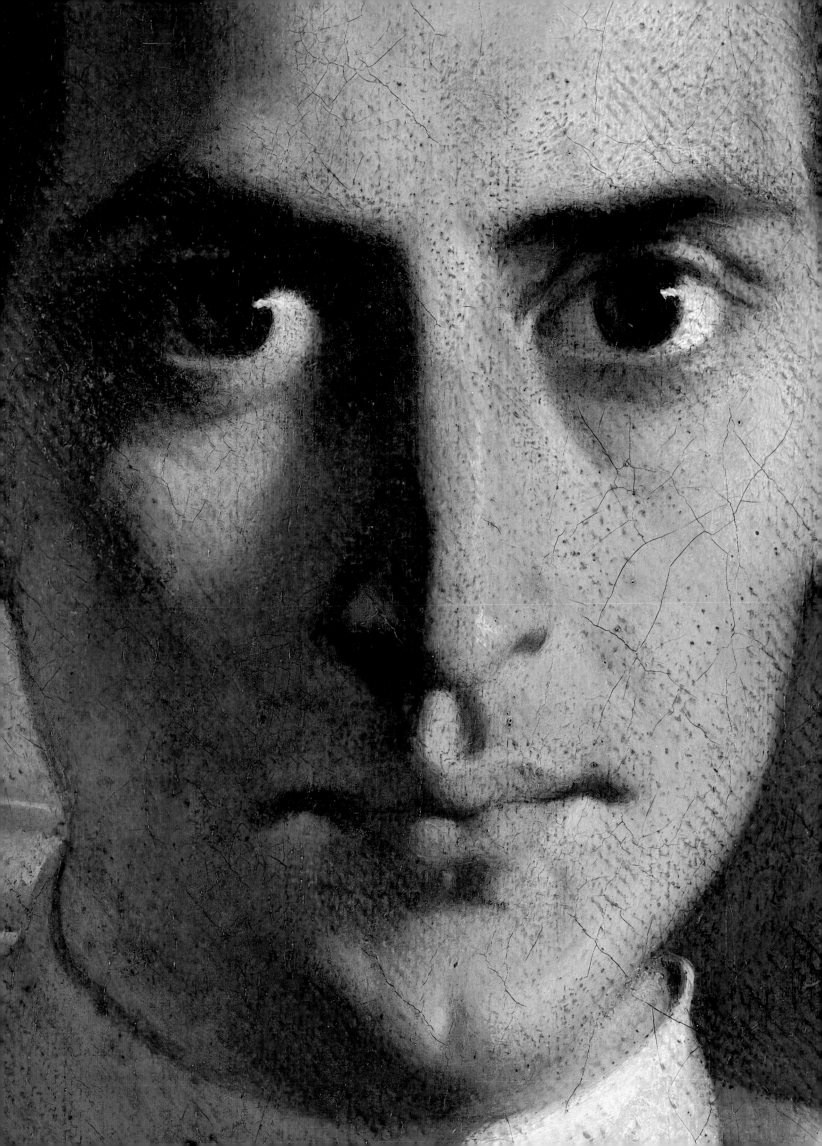

Between Paris and Algiers:
A Stubborn Believer?

In Memory of José Cabanis and of Stefan Germer

"Because the past no longer illuminates the future, the soul walks in shadow."[1]

"Lacordaire is a *romantic* priest, and I like him."[2]

CRITICS PAST AND PRESENT believe that Chassériau began his artistic career in 1839 with the exhibition of *Susanna and the Elders* (cat. 15) and the *Venus Anadyomene* (cat. 13) at the Salon—two companion paintings in which the Bible was engaged in a dialogue with the fable, the ancient Orient with the dawn of Greece, on the theme of forbidden desire, the forbidden gaze, and the forbidden body. For Gautier, among others, these two paintings revealed that the twenty-year-old painter was reaching his manhood: "M. Chassériau, although he has already exhibited several times, is a very young man, and his début must in some sense date only from this year. His early canvases showed promise, but they did not give an inkling of the entire breadth and scope of his talent; he has studied courageously and conscientiously; he has doggedly sought to find himself and has succeeded; he has extracted his true nature from the bonds of imitation, and, without further groping, has forthrightly achieved his own individuality; that is more difficult than one might think, especially for a student of M. Ingres, a master with an absorbing personality. *The Death of Abel* and *Ruth and Boaz,* M. Chassériau's earlier paintings, are really unrelated to his current manner; the transformation is complete. He has shed his old skin. The schoolboy has become an artist."[3]

The Chassériau specialists, faithful to Gautier, have long neglected these "early," groping paintings. Only Jonathan P. Ribner recently has studied them with care, and from a very pertinent psychological perspective.[4] In fact, these are not abortive works but accomplished paintings, conceived with the Salon in mind. One of them will allow us to introduce this brief consideration of the relationship between Chassériau, his paintings, and Christianity, at a time when that religion was both in decline and being regenerated, disintegrating even as its proponents were summoning up new social ambitions. In short, it was taking on a brand-new look, although it was believed—or said to be—dead. What becomes of religion in a world that is no longer organized according to its rules?[5] That was one of the decisive questions faced by the generation of 1830, which was not so much unbelieving as impatient to redefine individual belief and civil society.

The Century of Cain

At the Salon of 1836, the first in which he participated, Chassériau exhibited, along with his very Spanish portrait of the landscape artist Marilhat (Musée du Louvre), two canvases with religious subjects, *The Return of the Prodigal Son* (La Rochelle, Musée des Beaux-Arts) and *The Punishment of Cain* (fig. 1), which, as Ribner has shown, represented complementary autobiographical themes. Although both refer to family ruptures and the trauma of original sin, the responsibility is borne by the son in the first case and by the father in the second. It is not that mirroring effect that will hold our attention, but rather the expressive gloominess, already stylistically so unlike Ingres, of the *Cain*. Delécluze, who was as quick to sense new talent as to engage it, did not hesitate to put in his place the "eighteen-year-old young man [who] makes a show of depicting impoverished and sometimes repulsive figures. May he renounce ugliness!"[6] The injunction, a trifle pompous at that time, still echoed the controversy that the Romantics—Hugo, in literature; Géricault and Delacroix, in painting—had stirred up some fifteen years earlier.

One thing is certain, however: Gautier was wrong when he contrasted the radiant *Susanna* of 1839 to *The Death of Abel,* supposedly closer to Ingres. The latter canvas is not without awkwardness, but nonetheless is imbued with a sense of pathos, which, prefiguring other areas of disagreement, has few equivalents in the master's paintings or in those of his close disciples. We must believe that this young man, a regular, from 1835 on, at Nerval's and Gautier's Petit Cénacle, could not remain content for long with the discipline of his *patron*—to use Marie d'Agoult's word—and the austerity of some of his fellow students. His *Cain* (fig. 1), even as it betrays early signs of independence, followed a dark iconography that had been very much in vogue since the turn of the century. For—and this was Gautier's second error—Chassériau did not depict the death of Abel or even Cain's crime, in 1836; he represented the fatal journey of the fratricidal clan, which he cast in a muddy night scene, broken by sinister flashes of light. The subject and vocabulary were not without antecedents: although the young Fabre, in 1791, chose to paint Abel's final agony at the foot of the altar that caused his death,[7] Paulin Guérin in 1812 and Trézel two years later—emulators of the dark vision of Girodet—took an interest in the exile of the criminal, the solitude of the killer.[8] From one generation to the next, the theme had shifted from betrayed innocence to the con-

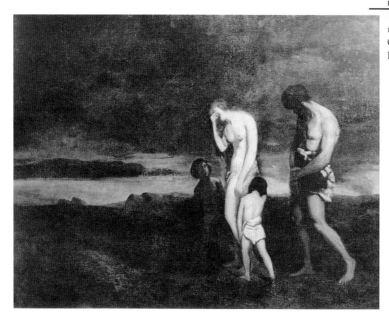

FIG. I
The Punishment of Cain
1836
Oil on canvas
Private collection

FIG. 2
After **Luis de Morales?**
Christ Bearing the Cross
About 1838
Oil on canvas
La Rochelle,
Musée d'Orbigny-Bernon

sciousness of evil and to the "death in life" symbolized by Cain's remorse, according to Agrippa d'Aubigné.[9] If we go even further, we can see the figure of the cursed man, bent over by sin, as the symbol of a fallen humanity, without a guide or destiny, the symptom of a deicidal century in search of its redemption—or, at the very least, in search of a new covenant. But which one?

Although, contrary to the works of many painters and poets in the years from 1830 to 1840, Chassériau's paintings were not explicitly inspired by the Catholic faith, and while it is still difficult to establish the nature of his feelings in that area, it is undeniable that the spiritual unrest prevalent at the time did not spare him. Devoid of any catechism or precise religious connection, part of his oeuvre nevertheless reflects the "relegitimization of the religious,"[10] which, under Louis-Philippe, was as much a response to recent history and social malaise as to the ethical vacuum that all his contemporaries experienced.[11] "After 1830," according to Anne Martin-Fugier, "the ties between the monarchy and the Church became strained and the relationship of the elites to Catholicism was liberated, thus becoming instead a matter of individual commitment."[12] Chassériau, like Lacordaire, was a long way from embracing strict orthodoxy, and perhaps, like Tocqueville, he existed outside of religion. Nevertheless, he questioned the validity of God, individual faith, and the beliefs necessary for the perpetuation of the social order. Even in his early notebooks, the over-abundance of sacred iconography is striking, encompassing biblical subjects, sacraments, and prayers. It was at that time that he executed the drawing *Saint Augustine at Ostia* (now in the Louvre), which reflects a reading of the saint's *Confessions* and accentuates the book's constitutive anxiety. Like Chateaubriand, Chassériau, an avowed reader of *Le Génie du christianisme* and of Chateaubriand's translation into French of Milton's *Paradise Lost*, regarded Saint Augustine as a kindred, anguished soul, "faced with the ordeal of earthly temporality."[13]

From now on, must we distinguish between art for the Church and religious subjects? The *Susanna* of 1839 and *Esther* of 1842 explore the female Eros and a primitive Orient rather than seeking to edify.[14] The paintings in the chapel of the Church of Saint-Merri in Paris, of 1843, despite the peaceful images of the early Church and the first sacraments, nonetheless are permeated by the sensuality of the "other" Mary, the Egyptian courtesan, and by that of the androgynous angels.

We undoubtedly also gain insight into Chassériau's aesthetic choices and his personal psychology, as seen in the countless depictions of martyrdom that mark his art and that culminated in the apsidal decorations in Saint-Philippe-du-Roule in Paris in late 1855. The perception of art as the product

of enthusiasm, of the experience of the infinite in oneself, the identification of the creative artist with Christ and his suffering (see fig. 2), and the values and the myths of Romanticism—all greatly contributed to the dominant Christian content of Chassériau's art. As it had for Shakespeare and, later, for Byron, the Bible encapsulated the drama of human existence, and, at the same time, provided the painter with many opportunities to explore the dark poetry and excesses of passion. The analysis of Chassériau's religious works obviously must take into account and respect both their plurality and ambiguity. Moreover, they belong to a particular moment in French social history, on which we should focus: Lacordaire's painter was a child of his century.

God and Liberty

Historians of every discipline and orientation, from Frank Bowman to Bruno Foucart, have dated the first milestone in what is conventionally called "the religious renewal" in Louis-Philippe's France to about 1835–37. Its manifestations varied in nature and in intensity. At issue far more than religious practice, which had been declining even before the French Revolution in 1789, were the matters of reflection on faith and the increasing relevance of the Evangelical legacy. Whether literature (apologetic or not), painting (orthodox or not), political demands (moderate or extreme), or preaching (Christ's teachings), these, more than the institution of the Church itself, encapsulated the needs and the fervor of Chassériau's generation. This dilution of the Christian heritage could not help but trouble ecclesiastical and Roman authorities. Bowman says quite rightly: "There is not just *one* Romantic Christ, there are several, varied images that convey and accentuate the themes of hope and despair. Christ was an essential point of reference for the entire series of debates: theological, aesthetic, political, and philosophical."[15] The revival of Christian art after 1830 was fed by that debate more than is generally believed today, and in accordance with ideological alliances that have not always been well understood.[16] Not since the Counter-Reformation had the Christian aesthetic been alluded to and discussed so often. The discourse on images could not be neutral once it was seen to convey, often openly, the hopes of another regeneration. That is true both of the crusade led by Alexandre de Saint-Chéron in *L'Artiste*, a journal with which Chassériau was associated very early on, and of Montalembert, whose diatribes on religious painting caused a sensation in 1837.

Saint-Chéron, having renounced "Saint-Simonianism" in favor of liberal theocracy, became the champion of the German school and its Catholic fervor; he was a radical and contemptuous opponent of art for art's sake, of a mode of painting "diverted, through the influence of literary theories, from any great religious and moral inspiration," and, as a form without an ideal, condemned either to becoming a pastiche or to "the slavish copying of external nature."[17] The beauty and unity epitomized by the decorations of the buildings in Bavaria were, according to him, cruelly lacking in such Parisian monuments as Notre-Dame-de-Lorette or the Madeleine, where the most atrocious cacophony and extreme bad taste prevailed. Montalembert also called for the reform of both the form and content of Christian art, and tirelessly championed the path to Rome forged by the German Nazarenes. In his well-known article of March 1, 1833, in *La Revue des deux mondes,* presented as an admiring letter to Victor Hugo, he insisted on an idea that he would persist in defending. Art—in effect, speech transformed into images—was, in the first place, an auxiliary to faith, the instrument par excellence through which faith would take root on both the individual and the social level. To remain faithful to the Church, Lamennais's penitent disciple held to his essential credo. The priority granted to the religious over the aesthetic, or the insistence on their necessary fusion, reached its apogee in Montalembert's programmatic text of 1837, *De l'État actuel de l'art religieux en France* (On the current state of religious art in France).[18] For that defender of "Christian genius," the only legitimate sources of inspiration predated both Michelangelo and Raphael, and even Masaccio, through whom modern naturalism had insinuated itself into Christian art; Masaccio, however, would be regarded as merely the reflection of divine and formal purity. Montalembert spared no one, not the Institute and the weight of tradition nor the bad taste of the high and the low clergy.

For him, even the images in Missals seemed to spread the poison it was believed they could combat.[19] To these degraded forms, this profanation of the sacred by images that were supposed to disseminate it, he contrasted the lessons of the ancient and modern primitives—that is, the German painters, and, above all, the "great and holy Overbeck." Their mere existence proved that modern society, however de-Christianized it might be, could still produce truly Christian artists, who were well suited, moreover, to revive the making of sacred images without diluting them or distancing them from holy tradition.

He also cited a few Frenchmen—the painters Orsel, Périn, and Roger—who prevented him from despairing. Even Ingres, assumed to be a good Christian by some members of the Catholic press,[20] did not fully find favor with him, any more than did Delacroix and Delaroche. Before Amaury-Duval, Ziegler, Mottez, the Flandrins, and the young Chassériau himself—the best that Ingres's studio had to offer—provided pictorial primitivism with unexpected support, although of varying religious orthodoxy, Montalembert believed that salvation lay only in Orsel and his circle. Strictly orthodox in religious terms, they alone maintained an equal distance between aesthetic conservatism and the progressive humanitarianism that was contaminating sacred iconography. Indeed, 1837 was also the date of Ary Scheffer's *Christ the Consoler,* a depiction of Christ that was more Menaisian than simply liberal in its references to all modern forms of slavery and servitude. At that time as well, the heretic Chenavard was already dreaming of the vast walls that would welcome his palingenesis, where the figure of Christ would symbolize humanity as well as a brotherhood and equality among men. Contrary to Montalembert, the critic Louis Viardot regarded that way of "philosophically imagining a sacred subject"[21] as the basis for a revival suited to the period. He was less concerned with defending the faith than with Jesus' ethics and the spirit of charity, which, about 1848, would become widespread in French painting, including that of Chassériau.

Montalembert, together with Lacordaire, was the most brilliant defender of liberal Catholicism. His rigor in matters of religious art, compared to his more open approach to profane painting, had to do with the very contradictions in that religious movement. If he could reconcile the Christian faith, the sovereignty of Rome, and the modern concept of freedom, he would be combating all at once the growing unbelief, the Gallican tradition of a servile clergy, and the encroachment of civil authority on the inalienable rights of the individual. He would be of his century without renouncing the religion of his elders. Such a program continually produced misunderstandings. History has shown, however—as José Cabanis and Lucien Jaume have reminded us, in different ways—that these Christians were true liberals, despite "the absolutist core" of their discourse and their submission to the pope.[22] Strengthened by the examples of Poland, Ireland, and Belgium, Catholic liberalism was forged both through the rejection of any sovereignty other than a spiritual one and through the necessary accommodation of an evolving civil society.

There were ambiguities: The Notre-Dame lectures, which launched Lacordaire after 1834, seemed dangerous even to those who shared their theocratic inspiration.[23] Their fiery turns of phrase, which the public was eager to hear, were as troubling as their mix of orthodox arguments and modern insights. Lacordaire's reminder that freedom of conscience had a metaphysical foundation and a divine origin did not detract from the support he offered the proponents of a free press and an educational system open to pluralism. Designating the monastic order as the ideal model for society, he became a Dominican friar in Rome on April 9, 1839.[24] As a friend of painters, who was anxious to have them serve the cause of God, he created the Confrérie de Saint Jean with a handful of artists on July 21, 1839, in Rome. The confraternity was placed under the patronage of Fra Angelico, and its mission was to bring artists around to the apostolic and social vocation that Lacordaire had established for himself: "French artists, touched by the spectacle presented by the world," the statutes specified, "have decided to contribute to its regeneration through the Christian appropriation of art."[25] Claudius Lavergne, Hyacinthe Besson, Cabat, Janmot, Bonnassieux, Duseigneur, and Piel lent Lacordaire their support, so long as the Dominican order had not been reestablished in France, but neither Hippolyte Flandrin nor Henri Lehmann nor Chassériau joined this avant-garde.

FIG. 4
Charity
About 1848
Oil on canvas
Private collection

Lacordaire's Painter

Since Chassériau's biography, in large part, remains to be written, and knowledge of the circles in which he moved is still in an embryonic state, any categorical assertion about his religious feelings and political positions would be rash. Despite the extreme caution of his earlier biographers, however, we must try to reexamine their efforts. His faith probably was less sure—which does not necessarily make it less demanding—than the piety of his mother and his sisters, but was he really a soul in danger? Sent at an early age to Ingres's studio, which had a reputation for moral rigor, the young painter clearly showed signs of laxity, which added to the precariousness and dangers of the artistic life. A few months before Chassériau left for Italy, Mme Monnerot, a Creole, and a close family friend, wrote to her son Jules: "My dear Jules, this morning I received your letter dated [*sic*] from Rome, I see with pleasure that you are delighted by your stay. . . . Théodore is still in paris [*sic*], endlessly saying that he is leaving for the country, for Rome, he cannot believe that you went there. . . . Mme Chassériau, whom we told this morning that you were in Rome, said, If that could only persuade him! I believe that she is counting a great deal on the trip Théodore is supposed to make there to achieve his all, in the meantime she often takes him to the <u>mois de Marie</u> [month of Mary]. he is kind enough to bring us home every evening, he is a good young man, it's too bad he stays too late, especially on Sunday, so that there's no way I can do my needlework."[26]

The letter is too ironic to settle the question of whether this was a total conversion or merely a strengthening of faith. Nevertheless, it expresses the care the painter's mother took to bring him closer or lead him back to God, by relying on the cultivation of Marian devotion. Théodore, perhaps an unbeliever, was certainly tormented by doubt, which also worried his sisters. In one of the letters Adèle wrote to her brother in Rome, while he was at work on the painting of Lacordaire and sketching many religious subjects, she added a significant postscript: "Think of the Good Lord!"[27] In reality, from the *Cain* of 1836 to the *Christ* in Saint-Jean-d'Angély (cat. 16)—a bold stroke, at the Salon of 1840—he seemed obsessed with that thought, and resolved to make a name for himself as one of the true religious painters of his time. In addition, it may not be absurd to link his painting of the Virgin (see fig. 3), which he sought in vain to exhibit at the Salon of 1838, to the Marian

cult of the Chassériau family.[28] The canvas, naïve without being insipid, is not a banal image for edification. The painter included the figure of the Virgin in the self-portrait of 1838 (cat. 2) as a reminder, no doubt, that he was not indifferent to the subject.

We also should note that, among the paintings and projects with which he was involved prior to the Algerian trip of 1846, a number contained themes related more or less clearly to charity. In particular, what are we to think of the proliferation of prisoners in chains in his work of about 1837? How are we to understand the solitary agony of their deaths, beyond the drama of the man who suffers and of the symbolism of the individual deprived of freedom? There is a great temptation to compare these images, in which captivity and deliverance exist side by side, to Victor Hugo's *Le Dernier Jour d'un condamné* (The last day of a condemned man) of 1832, but there is another possible source, which would place them within the religious context of the time—namely, Silvio Pellico's *Le Mie Prigioni* (The prisons), of the same year (1832), which was widely known, especially in Lacordaire's circle.[29] The theme of justice and of crime, whether punished or not, was about to unfold on the walls of the Cour des Comptes.

The underlying theme of charity is evident elsewhere. In addition to a drawing in the Louvre, which Louis-Antoine Prat has dated to about 1837, there is a painting that recently reappeared at auction, and seems to me to be much later in date (about 1848?), which depicts a kneeling woman of color in a conventional allegorical context (fig. 4). Such a figure was a sign of the times: From Scheffer to Laemlein, the image of a black person transformed into a universal symbol served the abolitionist cause, also recalling the benefits of Christianity, which supposedly put an end to slavery. Negritude, which in various forms permeated Chassériau's art and became part of his artistic identity, requires that we emphasize how much his family environment and his first encounters with fellow painters weighed on his choices.[30]

We must also take into account the social circles in which the young man moved, in the 1840s, when a certain Christian fervor coexisted with essentially worldly preoccupations. Princess Belgioioso (cat. 164) and especially Delphine [Gay] de Girardin, who was Chassériau's Muse and perhaps more, if we are to believe Champfleury,[31] come to mind. Mme Girardin promoted his career as much as possible, with the support of *La Presse,* the daily paper run by her husband, in which Gautier courageously and brilliantly defended the painter. Without unnecessary bigotry, she did not conceal from her loved ones her faith in God. Liszt, who was sympathetic to Lamennais's ideas at the time, attests to this in a letter to Henri Lehmann in which he mentions the works the painter submitted to the Salon of 1840: a portrait of Liszt, to be precise, and *Saint Catherine of Alexandria Borne to the Tomb:* "Gay wrote to me of her enthusiasm for your portrait, and with a somewhat sad admiration for your saint. Her Catholicism explains that feeling."[32] Thirteen years later, Delphine and Théodore, seeking God, would attend séances to make the spirits speak; they would die within a few months of each other.

About 1840, Chassériau's close friendship with two other painters, the landscape artists Louis Cabat (1812–1893) and Paul Chevandier de Valdrôme (1817–1851), also may have played a major role in paving the way for the decisive meeting with Lacordaire. Cabat, a key figure of the Barbizon School since the early 1830s and a Republican like Huet, in 1833, had begun to seek the company of artists who were convinced, as he was, of the need to combine democracy with Catholicism. There was the sculptor Jehan Duseigneur, a friend of Gautier, along with Bion, Besson, and Piel, who, like Cabat himself, probably belonged to the Confrérie de Saint Jean. In 1835, in fact, a passionate liaison and exchange of correspondence began between Cabat and Lacordaire. Pierre Miquel has spoken of the "friendly tenderness" of these letters, but that description is inadequate. They burned with a much more intense fire, and echo those Lacordaire sent to Montalembert at the time. Here and there, Romanticism aside, the same repressed sexuality and the same forbidden desires were expressed in the language of sacrifice, of the union of souls, or of political struggle.

It was through Chevandier de Valdrôme that Cabat grew close to Lacordaire and adopted his more moderate views. His landscapes, more peaceful in appearance and with a latent spirituality

like the poetry of Lamartine, yielded to that evolution in outlook.[33] Although we do not know precisely when they met, Chevandier de Valdrôme and Chassériau were close friends even before the latter's stay in Italy, both having lived for a time in the rue de La Tour-d'Auvergne in Paris. Bénédite quotes a now-lost letter of November 25, 1838, in which Chevandier, frustrated, like his friend, by his fruitless attempts at love, tries to comfort Chassériau in light of his rejection by the beautiful Clémence Monnerot. Such effusiveness was commonplace at the time, but nevertheless is the mark of a true intimacy.

The "Affair" of the Portrait

To win over Lacordaire and obtain permission to paint his portrait, Chassériau took advantage of his relationship with Baronne Hortense de Prailly, the sister of Paul Chevandier de Valdrôme, and, since 1834, the wife of the presiding judge of the tribunal in Nancy. The baroness offered her brother and Chassériau lodging in Rome in the summer of 1840; of fragile health, she regularly sojourned in Italy, surrounding herself with a coterie of French people.[34] Her extensive correspondence with Lacordaire reveals her piety and the aid she was able to offer Chassériau in his undertaking.

The circle of French artists in Rome was preoccupied with the matter of the "affair," the details of which were recounted in the letters exchanged between Henri Lehmann and Marie d'Agoult. In fact, it was with Lehmann, a fellow student in Ingres's studio, that Chassériau left Paris on June 27, 1840, for Marseilles. Lehmann wrote to Marie d'Agoult: "Chassériau and I are alone in the carriage and are going to Rome together. I am more and more pleased with his intellect, I have not often seen someone so naturally original."[35] A few weeks later, Lehmann also admitted that he had fallen under the influence of his companion's nobility of thought and feeling, originality, and keen mind: "I have had the opportunity to study Chassériau and Chevandier; they are the two most distinguished people that I have encountered recently. Franz [Liszt], I believe, will soon have the satisfaction of seeing his prediction come true about Chevandier, who is marvelously gifted. The other is a towering genius. His understanding of life, lofty yet primitive at the same time, guarantees me of that. I have faith in him as a man and as a painter."[36]

In September 1840, however, that confidence collapsed when Lehmann learned that the "charmer" Chassériau had undertaken Lacordaire's portrait, after Lehmann had admitted to his friend that he himself wanted to paint it: "You remember that Franz constantly had me promise to make the acquaintance of Abbé Lacordaire and paint his portrait. He spoke of it again in Paris and I left with that intention. Along the way, as we confided in each other our immediate and more distant projects, I let Chassériau in on my plan. . . . I know through M. Ingres that he had himself introduced to the abbé so that he could ask him about it."[37] Lehmann must have felt an equally bitter disappointment regarding the portrait of Mme de La Tour Maubourg, which he also was eager to undertake, and which eventually fell to his rival as well. In these two matters it is not clear where to lay the blame. One thing is certain: Ingres, a great talent but a petty man, fueled the animosity of his wronged pupil toward the impudent Chassériau—all the more so, as the latter had failed to show him respect.

With reference to the *Lacordaire* portrait—both the approach to the model and the significance of the painting—the letter from Chassériau to his brother, dated September 9, 1840, is of the greatest interest:

> I have found nothing Christian in Rome except the Colyseum [*sic*]: Saint Peter's does not look religious, and the pagan monuments are so prevalent, although in ruins, that it is Antiquity that always comes to mind. Since we cannot have any sympathy in our hearts for Jupiter, Pluto, Vesta, and a host of other gods and goddesses, in Rome we cannot see present-day life, and when you keep your eyes always focused on the past, you run a great risk in your work of remaining in an agreeable state of bliss that puts you to sleep. . . .

I often saw abbé Lacordaire, who is on retreat at the monastery of Santa Sabina. He is working, now that he is a predicant friar, to educate himself even more so that he can bring his word to France. You know that I asked him if I could do his portrait, which all the artists at the Villa Medici, and especially Lehmann, who is here, wanted very much to be able to paint. At first he replied that he would think about my proposal, that he had little standing in the clerical hierarchy, and that no one would be interested in seeing his portrait, etc., etc. I spoke of it warmly and said everything I could say about the curiosity and the pleasure that the public would have in seeing him as a *Dominican*. In his heart he knew it very well, since he is very perceptive. We parted without deciding anything, then, yesterday, I received a charming little note from him in which he thanked me and accepted, with pleasure. I was very happy about that, which I regard as a stroke of good luck for me in every respect. I am saving the letter carefully for you, since you collect autographs. He is a man about whom, I am certain, we will be hearing much more. He is one of the most profound intellects one could find in this world. I needed to do a beautiful portrait for the Salon. Now I'm satisfied.[38]

Beyond the opportunity of endowing his portrait with the model's celebrity, three things should be noted regarding Chassériau's words: first, that Antiquity was a (nearly) dead issue; second, that Christian monuments touched the hearts of modern-day citizens; and third, that Lacordaire was the incarnation of a new faith, of a sort of aristocracy of thought and action, which Baudelaire would speak of some twenty years later, when he sought the Dominican's seat in the Academy. Nothing is more eloquent in this regard than the drawings done during Chassériau's sojourn in Italy, in which the vestiges of Antiquity one expects to find are relatively rare, compared to the prevalence of figures of pilgrims, scenes of prayer captured from life in the manner of Géricault, views of churches, and elements derived from such milestones of Christian art as the mosaics in the Church of Santi Cosma e Damiano,[39] Tuscan primitives, the art of Raphael and of Michelangelo, and Poussin's *The Martyrdom of Saint Erasmus,* which Chassériau copied at the Vatican. Chassériau's intention was to leave no stone unturned. One of these superb sheets in particular attracts our attention: It depicts five kneeling women fervently receiving the sacrament. Chassériau's annotation, in my view, says a great deal about his fusion of the political and the religious, which is also the case with the Lacordaire portrait: It reads, "Everything I saw in Genoa was grave and beautiful and fine, like the works of art produced by Republics—the walls of the white-and-black Churches, the claws that secure the columns on their bases—everything is somber and strong and unique."[40]

This is hardly in keeping with the legend of Chassériau as the eternal young man, the melancholic soul, the sad Creole, and the "feminine Delacroix," even though we know he was "full of confidence in himself" (Marie d'Agoult) and full of energy. He did not express himself only through the languid eroticism of his dreamy odalisques. About 1838, in the margins of a sheet on which he drew a woman in meditation, he wrote the name Lamennais— alas, without comment.[41] Specialists, oddly enough, make little or nothing at all of this. The Lamennais in question was the heretical author of *Paroles d'un croyant* (Words of a believer) of 1834, which cast Jesus among the oppressed—the vitriolic writer from whom Louis Lacuria wished to distance Hippolyte Flandrin. Lamennais had denounced the 1830 confiscation and the misery of factories, the erosion of public freedom and the modern manifestation of slavery in the name of Christ, hence, championing the unconditional equality of men before God. A rebel, he was banished by the Church for his dreams of a new unity between faith and the common people—which Liszt, Marie d'Agoult, George Sand, and Ary Scheffer would later espouse. The *Christ* of 1838 was the exact contemporary of Lamennais's *Livre du peuple* (Book of the people).

Without any firmly held religious affiliation,[42] Chassériau therefore was not as indifferent to social questions as is generally argued. He met up with and depicted the coal miners of Le Creusot in his drawings of 1836, and, ironically, spoke out against "the question of the heavy cost to all rich people,"[43] in reference to the portrait of Mme de La Tour Maubourg, while still imagining his friend Ranchicourt "happy on [his] lands, leading the life of the privileged of that era, horseback riding and hunting."[44] He did not paint Lacordaire's portrait solely out of opportunism. The

finished canvas, fierce yet with a feminine aspect, combining both sensuality and fire, displeased the Dominican—or, more precisely, was undoubtedly judged inconsistent by the abbot with the less disconcerting image of himself he wished to disseminate. That painting was decidedly too original, too uncompromising, not to hurt the cause it was supposed to serve.[45] It was "rather austere," wrote Lacordaire, and would stand in the way of "the course of publicity" he was pursuing by spreading his image.[46] Hence, the fact that Lacordaire preferred the bust by the mediocre Bonnassieux (1840) does not simply betray the limits of his *Romanticism,* as Baudelaire would say. Everything suggests that he sought to limit, as much as possible, the circulation of the mediocre engraving by Monnin, after Chassériau's painting, and that he decided to have a competing plate published, based on a drawing by Hippolyte Flandrin (fig. 5).[47] A letter from Lacordaire to Baronne de Prailly reflects the anger that this scheme provoked in Chassériau: "I am distressed by the feelings that M. X***[Chassériau] showed toward you on the subject of religion and the clergy. That change may be due to the violent attacks by the press over the last four or five months, but perhaps the explanation for it should be sought in something more personal. You know that M. X*** had a falling-out with P*** [Paul Chevandier], and that he behaved very ungratefully toward me in view of my kindness to him. The lack of success of his portrait undoubtedly has embittered him, and I fear someone has spoken of me to M. X*** in a way that has alienated him from me."[48] There is no better way to express the ambiguity of Chassériau's religious feelings.

Seventh Heaven

The public rupture with Lacordaire, despite the friendship that had been quickly formed between them,[49] was quite consistent with Chassériau's volatile nature and his position regarding Christian art. Indeed, as has already been pointed out, he could not be considered a practitioner of the most

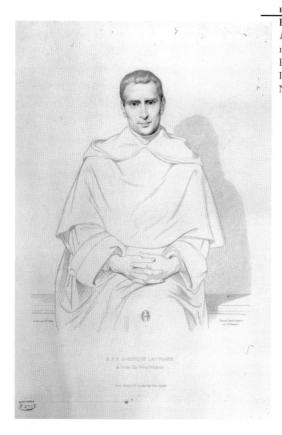

FIG. 5
Hippolyte Flandrin
Portrait of Lacordaire
1841
Engraving
Paris, Bibliothèque
Nationale de France

doctrinaire neo-Catholicism and of the didactically confessional painting to which Orsel, Périn, and Roger—and among Ingres's followers, Lacuria and Janmot—were devoted. One sign of this is that his art never reflected "the sacristy or the convent," to paraphrase Marie d'Agoult.[50] That kind of painting, distancing itself from any dogmatism, expressed "the religious and obscure torment"[51] of the time more than its pious resolution, if only in liberal colors. In short, one might say that Chassériau's religious art has a split personality: It displays, roughly speaking, a precise theological content in the large decorative programs, at Saint-Roch (cat. 222–231), adhering in its way to the propaganda of the commissions, and at Saint-Philippe-du-Roule (cat. 232), even conforming to the anti-Jewish sentiment (or worse) of the Second Empire; elsewhere, however, it reveals what could be called a more personal and more uncertain quest for God. Like Hugo and Lamartine, whose works he had read and in whose company he spent a great deal of time, Chassériau, through religious themes, conducted a metaphysical inquiry centered on the individual, the intimate dialogue with "the invisible," or the experience of his own infinity. Many of his drawings that predate 1840 resonate with a sadness or melancholy very close to the poetic accounts of his favorite writers. To take only one significant example, *Woman and Little Girl in Prayer Before a Crucifix, with an Angel,* which is said to date to about 1837, bears a few verses in the margin from Victor Hugo's *Feuilles d'automne* (Autumn leaves),[52] specifically, from "Prière pour tous" (Prayer for all), a poem that echoes Lamartine's style, as Jean-Claude Fizaine has shown:[53]

Quand elle prie, un ange est debout auprès d'elle,	*When she prays, an angel stands beside her,*
Caressant ses cheveux des plumes de son aile,	*Caressing her hair with the plumes of his wing,*
Essuyant d'un baiser son oeil de pleurs terni,	*Drying her tear-stained eyes with a kiss,*
Venu pour l'écouter sans que l'enfant l'appelle,	*Coming to listen before the child calls him,*
Esprit qui tient le livre où l'innocent épelle,	*A spirit who holds the book which the*
Et qui pour remonter attend qu'elle ait fini.	*innocent spells,*
	And who waits till she's done to ascend once more.

Here, God may be identified less with the conventional image of a heavenly child, pure because she is innocent, than with the subject, who pours out his heart; God becomes one with the heart that confides its secrets, with an almost silent voice that rises up without a clear reply. Not unlike Christ on the Mount of Olives, as described in the Gospels, the experience of this night of agony occupies a place in Chassériau's imagination equivalent to that accorded it by Lamartine and Hugo in their poetry. Gethsemane is not simply the garden of doubt and of God's silence, the first Station of the Cross; it also symbolizes sacrificial love—a subject that resonated with the Chassériau family, before and after their father's mysterious death in 1844. Beginning about 1820 until 1840, the theme of Christ and Man abandoned by their Creator was also becoming widespread in literature and painting. Claude Pichois and Frank Bowman have shown that, in part, "Romantic unbelief was experienced in regret and fear, not as the desire to annihilate the villain."[54] Writers from Musset to Quinet, and artists from Géricault to Delacroix, took up the theme of Christ in Gethsemane, God without Father and Father without Son, which heroically symbolized this crisis of the spirit through the grandeur of his solitary drama.

The subject of the prayer on the Mount of Olives was treated so frequently in French painting in the first half of the nineteenth century that its many manifestations can only be summarized very broadly here. Chassériau was responsible for two complementary interpretations of the theme four years apart. The painting now in Saint-Jean-d'Angély (cat. 16), presented at the Salon of 1840, was the culmination of research that predated the commission by the Ministry of the Interior, which it supposedly fulfilled. One of the artist's notebooks (Musée du Louvre) suggests that Chassériau's first thoughts on the subject date to January 1839,[55] some months before Cavé's department made the decision final. It is quite plausible that the painter influenced the theme of the commissioned work.

Louis-Antoine Prat has shown that several drawings document the artist's hesitation before he decided to represent Christ as resigned to die on the eve of the Crucifixion. "The Synoptic Gospels

FIG. 6
Christ Supported by an Angel
About 1839
Graphite, heightened
with white
The Fine Arts Museums
of San Francisco

related that moment. Mark and Matthew are not satisfied merely to report it: they want to show the shameful behavior of the disciples. Conversely, Luke focuses his attention on Jesus' agony."[56] The disagreement lay in the artists' understanding of the meaning of that agony, about 1830, and, hence, in the way in which they presented the theological import of the theme. In that respect, the preliminary stages of the Saint-Jean-d'Angély painting are fairly significant for the iconographical evolution they reveal, and we will discuss two of them here. In a drawing (now in the Louvre) Chassériau represents a moment following the event in an oddly exaggerated manner. Christ strikes his chest after drinking from the chalice; abandoned in his terrible solitude by the angels and the apostles, he resorts to melodrama. The inscription is very illuminating: "The angel departs again [crossed out] ascends again and enters heaven, whose pearly and luminous color in places seems to be opening partway Christ alone and lonely the chalice empty the other hand on his heavy heart which accepts the cross—alone lonely on a rock with a sad ending as in Fontainebleau."[57] Sadness and despair prevail here over the bitterly accepted sacrifice. The reverse of a sheet in San Francisco (fig. 6) shows Christ supported by an angel, an image of heavenly mercy, and being gently comforted as he suffers like the rest of humanity whom he will save by his sacrifice.[58] At the top of the page, Chassériau transcribed a passage from Luke, while, in a significant departure, in the handbook for the Salon of 1840 he quotes a passage from Mark (14: 36): "And he said, Abba, Father, all things *are* possible unto thee; take away this cup from me: nevertheless not what I will, but what thou wilt."

The scene in the painting falls somewhere between the representations in the two drawings and also approximates Delacroix's version in the Church of Saint-Paul–Saint-Louis in Paris (fig. 7): It is as if Chassériau, in finally painting "the profound and touching melancholy that the son of God feels deep within him when he offers himself as a sacrifice,"[59] sought to indicate that the confusion, the anguish that takes hold of Christ, both man and God combined, is the very drama of the Incarnation, and hence of all existence. No angel supports him now in the experience of his impending death, which he has sought in vain to avert. In Gethsemane, Christian catechism is so entwined with profane metaphysics that we will have to refrain from settling the matter for the artist.

Four years later, in the painting now in Souillac (cat. 179) he endowed the theme with a deeper meaning: There, the angels have deserted the heaven of the Passion. All that remains is the night, the master's doubt, and the mortal sleep of his disciples. The composition, of similar size, undertaken without a commission and with no assurance that it would be purchased, assumes its full meaning only when it is compared with the first painting. Jesus, after resigning himself to sacrificing his life for the redemption of mankind, bitterly observes man's indifference, and, as Pilate's soldiers approach him, led by Judas, for the second time the Son of God faces the anguish of death all alone. He had painfully bowed to the will of the Father only to discover the betrayal of his loved ones and even the pointlessness of the sacrifice.

Within a short span of time, two poets with whom Chassériau was close, although to different degrees, gave that episode of the sleeping apostles its darkest expression. On June 1, 1843, Vigny presented the readers of *La Revue des deux mondes* with his "Mont des Oliviers" (Mount of Olives), which he had been planning since 1824.[60] In depicting Jesus' abandonment on the eve of his Passion, the long poem crystallizes the doubts of its author and his revolt against an incomplete revelation that would leave man in terror of the void.[61] The skepticism of the author was projected onto his subject in such a way that Vigny makes Jesus a lonely deity filling the silent heavens with his voice. The reflection on Jesus' dual nature, central to French spirituality since Bérulle (1575–1629), nearly

FIG. 7
EUGÈNE DELACROIX
Christ on the Mount of Olives
1827
Oil on canvas
Paris, Church of
Saint-Paul–Saint-Louis

ends with "the death of God," which Nietzsche, following Chateaubriand and Baudelaire, would soon characterize as the modern condition. Vigny's poem ingeniously begins after Jesus has drunk from the chalice, anticipating Chassériau's image of the supernatural night:

Alors il était nuit et Jésus marchait seul,	*Then it was night and Jesus walked alone,*
Vêtu de blanc ainsi qu'un mort de son linceul;	*Dressed in white like a corpse in its shroud;*
Les disciples dormaient au pied de la colline.	*The disciples were sleeping at the foot of the hill.*
Parmi les oliviers qu'un vent sinistre incline	*Amid the olive trees bowed by a sinister wind*
Jésus marche à grands pas en frissonnant comme eux;	*Jesus strides, trembling like them;*
Triste jusqu'à la mort . . .	*Sad unto death . . .*
Puis regarde le ciel en appelant: "Mon Père!"	*Then he looks toward the sky, calling: "My Father!"*
—Mais le ciel reste noir et Dieu ne répond pas.[62]	*—But heaven remains dark and God does not reply.*

On March 31, 1844, Nerval published his poem "Christ aux Oliviers" (Christ in the olive grove) in *L'Artiste*, more clearly linking the agony of Christ, the silence of God, and the indifference of men:

Il se tourna vers ceux qui l'attendaient en bas,	*He turned toward those who awaited him below,*
Rêvant d'être des rois, des sages, des prophètes . . .	*And who dreamt of being sages, prophets, and kings . . .*
Mais engourdis, perdus dans le sommeil des bêtes,	*But dozing, lost in a beast-like sleep,*
Et se prit à crier: "Non! Dieu n'existe pas!"[63]	*And he began to cry: "No! God does not exist!"*

Sandoz, who liked to demonstrate the connections between images and texts, neglected to point out the almost simultaneous creation of the painting and the two poems. In addition, Nerval's poem appeared in the same issue of *L'Artiste* as the lithograph by Édouard Hédouin based on Chassériau's canvas. This was no accident, of course—but how are we to interpret this coincidence? We cannot set aside the possibility that Nerval was in some sense responding to the painting by paraphrasing it, as Fournier would do a year later, again in *L'Artiste,* with *Apollo and Daphne* (cat. 113). Keeping in mind that the subject of that painting was freely chosen, and without minimizing the many ties between Chassériau and the "modern poets," it would be best to consider these affinities rather than to spend time devising a chronological listing of influences.

What can we infer from that simultaneity? Is Chassériau, like Nerval, proclaiming the death of God or, like Vigny, the tragic distance of a God who remains forever hidden? Is he simply emphasizing, as at Saint-Jean-d'Angély, but more clearly here, the solitude of the man about to die or, as Gautier proposed, the exile of the chosen among those who reject him? In 1844, Gautier invoked neither the poetry of his friend Nerval nor that of Vigny, but the *Harmonies poétiques* of Lamartine, whose portrait Chassériau had executed that year. Gautier's long commentary is up to the challenge of that canvas, which he cited as "the most important in the Salon," and which he considered more desolate and more comprehensive than the 1840 painting: "In that despairing canvas, there is something of the feeling that M. de Lamartine gave his *novissima verba*—one discerns in Christ's gloomy and pensive gaze that, if the sacrifice were still to be made, he would not do it again."[64] It would be simpler if a friend of Frédéric Chassériau had not judged Gautier's sacrilegious hypothesis incongruous.[65] Undoubtedly, the artist was not making a profession of complete faith so much as questioning both his own difficulty in sustaining belief and his inability to live without God.

In short, everything led him back to God: the deicidal century, the social ills of the time, his political convictions—close to Tocqueville's—the Algerian reveries on biblical times and the origins of Islam, even the aesthetics of Romanticism, and then the approach of death, and spiritualist devotion.[66] Arsène Houssaye, who knew the painter very well when he was director of *L'Artiste*, attests to this in his own way, which cannot be considered conclusive:

For a few years, we lived a short walk from Mme de Girardin; we had dinner together every week; there were no secrets on either side. . . . It was then that Mme de Girardin felt the shadow of death; she threw herself desperately into spiritualism, which became household policy; she made tables and heads turn; even though I had no faith, I often sat beside her, helping things along; but a few of her friends fell under the spell of her beliefs: they saw miracles. Someone called forth Balzac, who came to report things from the next world. Mme de Girardin was delighted. One evening, Napoleon suddenly said: "Since M. de Balzac is recounting such lovely things, ask him to count my money." And he threw his pouch onto the table. Then an extraordinary thing happened: the table rapped as many times as there were napoleons in the prince's purse. Mme de Girardin was in heaven. "So, skeptic," she said to the prince, "tell us again that there is no God, no miracles. If, after that, you have doubts about spiritualism, I'll take the twenty-one louis in your purse and give them to the poor." "Well then," said the prince, "give them to the poor, along with the thousand-franc bill."

The painter Théodore Chassériau, a stubborn believer, looked at the imperial skeptic with pity; he seemed to be saying: "Unlike us, you do not see the promised land." What was strange is that very shortly [after] he followed Mme de Girardin to the land of the dead; both departed almost happy to be leaving the earth—or to be buried in it—they already saw themselves beginning their ascent to seventh heaven.[67]

In the end, painting, in order to cross the metaphysical void or to rejoin that ever-so-distant God, extended itself to encompass table turning. Such a practice was as unorthodox as Chassériau's painting. What God or what idea of God had he embraced? Once more, one must admit that it is difficult to settle the question. And what would be the point? The important thing is that his painting was as tormented by an underlying Catholicism as was the poetry of Baudelaire, for example. Both were indebted to it for the strange pungency of their art; the shifting back and forth between heaven and earth and between libertinage and guilt, this fruitful duality, was the source of their "perpetual battle."

Stéphane Guégan

1. A. de Tocqueville, *De la Démocratie en Amérique, Oeuvres complètes*, vols. 1, 2 (Paris: Gallimard, 1961), p. 336.
2. Letter from Charles Baudelaire to Sainte-Beuve, January 1862, in *Correspondance*, vol. 2, eds. C. Pichois and J. Ziegler (Paris: Gallimard, Bibliothèque de la Pléiade, 1973).
3. Gautier, "Salon de 1839," in *La Presse* (April 13, 1839).
4. See Ribner 1994.
5. This formulation is borrowed from Marcel Gauchet, "Croyances religieuses, croyances politiques," in *Le Débat* (May–August 1996), pp. 3–12.
6. D[elécluze], "Salon de 1836," in *Journal des débats* (April 30, 1836).
7. On Fabre's *Abel* see Régis Michel's excellent analysis in *Les Arts de la Révolution 1789–1799. Aux armes et aux arts* (Paris: Adam Biro, 1988), p. 35. We have yet to establish why that iconography so often attracted Freemason painters in the nineteenth century. See, for example, Orsel's *Adam and Eve with the Body of Abel* (Salon of 1824, no. 1279; Musée des Beaux-Arts, Lyons).
8. See J. J. L. Whiteley, "Light and Shade in French Neo-Classicism," in *The Burlington Magazine*, vol. 117, no. 873 (December 1975), pp. 768–73.
9. See F. Lestringant, "L'Errance de Caïn: D'Aubigné, Du Bartas, Hugo, Baudelaire," in *Revue des sciences humaines* 245 (January–March 1997), pp. 13–32.
10. I am applying to the France of the July Monarchy Pierre Nora's explanation and analysis of what occurred in the intellectual commu-

nity about 1980, when, after "the death of man," the return to God signified less a revival of faith than the revalorization of the "inalienable rights of the individual conscience." See *Les Idées en France, 1945–1988. Une Chronologie* (Paris: Gallimard, Folio Histoire, 1989), pp. 458–63.
11. In the wake of the 1830 revolution, waves of virulent anticlericalism occurred here and there that can be explained in part by the alliance between the throne and the clergy under the Restoration. The sack of Saint-Germain-l'Auxerrois and of the archbishop's palace in 1831, followed by the popular riots of 1834, rightly worried the notables and public officials. Hence, in 1835, Tocqueville, who himself believed in the moral usefulness of religion, recorded the rapprochement between the liberals of the past and the Church, the guarantor of social peace. The liberal Catholics expected more from that new alliance between the common people and the Christian faith.
12. See Martin-Fugier 1990, p. 258.
13. On the place of the *Confessions* of Saint Augustine in the Romantic consciousness see P. Labarthe, *Baudelaire et la Tradition de l'allégorie* (Paris: Droz, 1999), pp. 81–86. We should note also the proximity between "the categories of temporality in Saint Augustine" (Stanislas Boros) and the major themes in the art of Chassériau: dissolution, agony, banishment, and night.
14. On the profane interpretation of the Bible as a feature of Romanticism see Honour 1989, pt. 2, p. 156.
15. Bowman 1987, p. 7.

16. Hence, Driskel (1992) believed that he could reduce the entire primitivist aesthetic of the years 1830–70 to the Ultramontane ideology without differentiation. Aware, however, of the differences that existed among artists and within neo-Catholicism itself, he preferred to link the "hieratic mode" to "papal authority," giving preference to what he calls the "formal norm" over individual choices ("the personal intentions of the artist are of secondary importance").

17. A. de Saint-Chéron, "De la Direction actuelle des beaux-arts et de leur avenir," in *L'Artiste,* vol. 10, no. 23 (1835).

18. *La Revue des deux mondes,* 4th series (December 1, 1837).

19. We should note in passing that in 1837 Chassériau offered his friends the Ranchicourts a series of drawings designed to be bound into a Missal. See Prat 1988-1, nos. 9–20, p. 13.

20. See, for example, Ch. Villagre (the pseudonym of A. de Saint-Chéron?), "De la Direction actuelle des beaux-arts et de leur avenir," in *L'Écho de la jeune France,* vol. 4 (June 15, 1836), pp. 505–8. It should be pointed out that this Legitimist newspaper accepted the first articles by Gobineau in 1837, and that the same year the chivalrous legend of Alain Chartier, which may have inspired Chassériau (cat. 37), was the subject of an article in vol. 7, on September 1, 1837, by Ad. de Puibusque, entitled "Alain Chartier, Chronique du XV^e siècle"; could the artist have read it?

21. L. Viardot, "L'Abside de la Madeleine peinte par M. Ziegler," in *Le Siècle* (August 10, 1838).

22. See Cabanis 1982, and L. Jaume, *L'Individu effacé ou le paradoxe du libéralisme français* (Paris: Fayard, 1997), pp. 171–278.

23. The press, Catholic or not, largely cited the preachers of the time, contributing to the worldly success of these lectures, which yielded a significant financial reward for the clergy (Martin-Fugier 1990, p. 260). The sermon also verged on a literary event. The journalists enjoyed enumerating the host of writers attracted by Lacordaire's religious fervor and romantic eloquence, including Chateaubriand, Lamartine, and Hugo (so adamantly, however, in *Choses vues*)—that is, those in Chassériau's own circle. Even Philarète Chasles fell under the spell: "He believes and makes others believe" (quoted by C. Pichois, *Philarète Chasles et la Vie littéraire au temps du romantisme,* vol. 2 [Paris: Corti, 1965], p. 359).

24. He had already defended the Dominicans in his writings and he reestablished the order in France four years later. See Lacordaire, *Mémoire pour le rétablissement en France de l'ordre des Frères prêcheurs* (Paris, 1839).

25. See Foucart 1987, pp. 45–49, whose emphasis on the reference to the German Nazarenes was induced by the insistence on the French character of the artists who supported Lacordaire.

26. Unpublished letter, dated May 22, 1839, Bibliothèque Nationale de France, Paris, Département des Manuscrits, Naf. 14405, Gobineau Papers, vol. 17, Monnerot family correspondence, vol. 1, folios 55–56.

27. Letter from Adèle to Théodore Chassériau, 1840, quoted in Bénédite 1931, vol. 1, pp. 87–88.

28. See Sandoz 1974, no. 51. The canvas was sold at Christie's, London, July 1, 1975, lot 3.

29. The book by Pellico, a Carbonarist imprisoned by the Austrians, could, in fact, be read as an illustration of Christian resignation. For that reason, Lacuria encouraged Hippolyte Flandrin to read it and to avoid the new Lamennais. See *Les Peintres de l'âme,* exhib. cat. (Lyons: Musée des Beaux-Arts, 1981), p. 116. There was a copy of *Le Mie Prigioni* in the library of the Confrérie de Saint Jean, along with the writings of Pascal, Saint Augustine, Bonald, and Maistre. See Foucart 1987, p. 47.

30. Of course, the Monnerot milieu should not be overlooked. In addition to Mme Monnerot, Clémence, whom Chassériau apparently sought to please, was close to Hercule de Serres, an associate of Lacordaire; in 1846, she married Arthur de Gobineau, a Legitimist and ardent defender of the Christian religion before he allied himself with Tocqueville and championed the power retained by the people of the Orient. A contributor to the Legitimist press in his youth (see note 20 above), he published an enthusiastic commentary on Chassériau's Saint-Merri paintings in *La Quotidienne* (November 16, 1844).

31. Letter from Champfleury to Bouvenne.

32. See Joubert 1947, p. 97.

33. P. Dorbec, "Louis Cabat," in *Gazette des beaux-arts* 1 (1909), p. 324.

34. See É. Foucart-Walter's entry on Chevandier in *Nouvelles Acquisitions du département des Peintures (1987–1990)* (Paris: Musée du Louvre, 1991), pp. 137–39; and cat. 49 in the present catalogue.

35. Letter from Henri Lehmann to Marie d'Agoult, June 6, 1840, Paris; quoted in Joubert 1947, pp. 100–101.

36. Ibid., August 19, 1840, Naples; ibid., pp. 112–14.

37. Ibid., September 18, 1840, Rome; ibid., pp. 120–22.

38. Letter from Théodore Chassériau to his brother Frédéric, September 9, 1840, Rome; quoted in Chevillard 1893, pp. 42–46.

39. The standing Christ in the mosaic in the Roman Church of Santi Cosma e Damiano is the direct source of Chassériau's *Christ* (now in Souillac), and the indirect source for Ingres's *Christ Delivering the Keys to Saint Peter* (see Driskel 1981, p. 105).

40. Louvre, RF 24476; see Prat 1988-1, vol. 1, no. 1422.

41. Louvre, Alb. 2232, fol. 50; see Prat 1988-1, vol. 2, p. 817.

42. It should be noted that at the time that he was becoming close to Lacordaire, he also sought out the protection of a certain Frédéric de Falloux, an Ultramontane Legitimist and collector of paintings. In his well-known letter of November 23, in which he told his brother of his rift with Ingres, Chassériau spoke of the visit he was planning to "Monseigneur de Falloux." Frédéric de Falloux de Coudray (1807–1884), the elder brother of the comte de Coudray and less of a liberal than the future minister, entered the clergy after studying law in Paris. Ordained a priest in Rome in 1837, he subsequently became a member of the Curia, and remained faithful to Pope Pius IX, whom he accompanied to Gaeta during the latter's exile, and to Leo XIII, to whom he bequeathed his painting collection.

43. Letter from Théodore Chassériau to his brother Frédéric, November 23, 1840, Rome; quoted in Bénédite 1931.

44. Letter from Théodore Chassériau to Oscar de Ranchicourt, December 4, 1840; quoted in Bénédite 1931, pp. 141–43.

45. On the negative image of predicant friars that was widespread in French painting about 1840 see Driskel 1992, pp. 30–31. Chassériau's canvas unintentionally confirmed the fanaticism of an order marked by memories of the Inquisition. See also the following note and Lacordaire's letter.

46. See Lacordaire's letter of November 28, 1840, to Mme Swetchine, in *Correspondance du R. P. Lacordaire et de Mme Swetchine,* published by the comte de Falloux (Paris, 1864; 1876 ed., p. 256): "M. Chassériau, a young, talented painter, insistently asked to paint my portrait. He depicted me as a Dominican in the cloister of Santa Sabina; I am generally satisfied with this painting, although it gives me a rather austere appearance. M. Chassériau is planning to exhibit the painting and is to have it engraved at his own expense afterward. In February you will receive a bust of me that, for my part, I prefer to the painting, as it better expresses my true character. It is small and quite easy to stash anywhere. These are certainly vanities, dear friend, but I really consented to all of this out of a notion of duty, as a means to make our habit known, and to pursue the course of publicity we have entered upon, out of respect for the present genius of France. The sculptor, M. Bon[n]assieux, has very recently converted, and is part of a brotherhood of artists that is doing very well in Paris and in Rome."

47. See *Hippolyte, Auguste et Paul Flandrin,* exhib. cat. (Paris, 1984), p. 220, and the letter from Lacordaire to Cabat, Bordeaux, December 8, 1841: "Tell me something, my dear friend, how is the portrait by MM. Flandrin coming along? Did you like it? Is it being lithographed? If they were awaiting my return, tell them I won't be back in Paris before the autumn of 1842. I have an interest in knowing where things stand on the matter, because the portrait by Chassériau has already been sent here, and another is desired. Couldn't the one by MM. Flandrin, if he is proceeding with it, be dispatched here?" (See "Lettres inédites du Père Lacordaire," in *L'Année dominicaine,* vol. 33, no. 410 [August 1894], p. 342).

48. Letter from Lacordaire to Baronne Hortense de Prailly, Rome, September 27, 1841, in *Lettres du R. P. Lacordaire à Mme la baronne de Prailly,* published by the R. P. Bernard Chocarne of the Predicant Friars (Paris: Poussielgue frères, 1885), p. 28.

49. See the previously cited letter from Théodore Chassériau to Frédéric (note 43, above): "Abbé Lacordaire is going to arrive in Paris to spend some time there; he wanted me to leave with him and I had sent my trunks, when my latest adventure delayed my departure somewhat. He is bringing Mama, Adèle, Aline, and Mme Monnerot and her daughter the rosaries I promised. He himself had them blessed and will have them taken to you. I wanted the young ladies to have them for Christmas day."

50. Letter from Marie d'Agoult to Henri Lehmann, June 24, 1839; quoted in Joubert 1947, p. 15: "Let me tell you, however, that I don't like Overbeck's fresco. It is possible that the composition satisfies certain conditions of art, but it lacks the most essential thing in my view: it is not true to life. One senses its bias. That painting reeks of the convent or the sacristy, which doesn't suit me, but *basta!*"

51. Sainte-Beuve, "Du Mouvement poétique après la révolution de 1830," in *Le Globe* (October 11, 1830); quoted in Bénichou 1977, p. 385.

52. For the drawing see Prat 1988-2, no. 25, p. 14.

53. See J.-Cl. Fizaine, "Le Deuil de Julia ou le syndrome de Gethsémani," in *Un Ange passe. Lamartine et le féminin,* ed. J.-P. Reynaud (Paris: Klincksieck, 1997), pp. 173–87.

54. See Bowman 1988.

55. See Prat 1988-1, vol. 2, 2235, fol. 2 v. and duodecimo 3.

56. J. Potain, *Jésus. L'Histoire vraie* (Paris: Bayard Éditions, 1994), p. 448.

57. See Prat 1988-1, vol. 1, no. 21. Contrary to Sandoz's claim, the Fontainebleau reference is not to the château but to the forest, where Chassériau often spent time with his landscape-artist friends (Marilhat, Cabat, etc.).

58. See Prat 1988-2, no. 47.

59. F. Pillet, "Salon de 1840," in *Le Moniteur universel* (March 23, 1840).

60. Chassériau was introduced to Vigny in 1841 through Marie d'Agoult (see letter to Henri Lehmann, Paris, March 1 and 2, 1841; quoted in Joubert 1947, pp. 155–60).

61. See G. Chamarat-Malandain, "Le Christ aux Oliviers: Vigny et Nerval," in *Revue d'histoire littéraire de la France* (May–June 1998), pp. 417–28.

62. A. de Vigny, *Oeuvres complètes,* vol. 1, ed. F. Germain and A. Jarry (Paris: Gallimard, Bibliothèque de La Pléiade, 1986), p. 149.

63. See G. Nerval, *Oeuvres complètes* (Paris: Gallimard, Bibliothèque de La Pléiade, 1986), vol. 1, p. 736.

64. Gautier, "Salon de 1844," in *La Presse* (March 27, 1844).

65. Excerpt from a letter from a family friend to Frédéric (?) Chassériau: "A clumsy admirer, praising the sorrowful expression on Christ's face, believed he could read in it the thought that he would not make his sacrifice again. I found that idea ridiculous. I do not think Théodore wants to be praised in that way: the devotion of the victim would not be sublime if it were not complete" (see Bénédite 1931, vol. 1, pp. 223–24). Did that family friend get it right and did he know Théodore all that well?

66. We probably should have made mention in this essay of the *Christ in the House of Mary and Martha,* which was submitted to the Salon of 1852; it was stolen from the church in Marcoussis in 1973, a theft that elicited little emotion. Christ, Mary, and Martha inhabit a "Jewish interior," according to the annotation on the Louvre drawing (cat. 241)—proof, if any were needed, that the artist's fascination with his discovery of Algeria in 1846 stemmed from his religious obsession.

67. A. Houssaye, *Les Confessions. Souvenirs d'un demi-siècle, 1830–1880,* vol. 2 (Paris: Dentu, 1885), pp. 28–29. See also the letter from Laure Monnerot to her son Jules, Paris, November 13 [1853], Bibliothèque Nationale de France, Paris, Département des Manuscrits, Naf. 14405, Gobineau papers, vol. 17, Monnerot family correspondence, vol. 1, fol. 156.

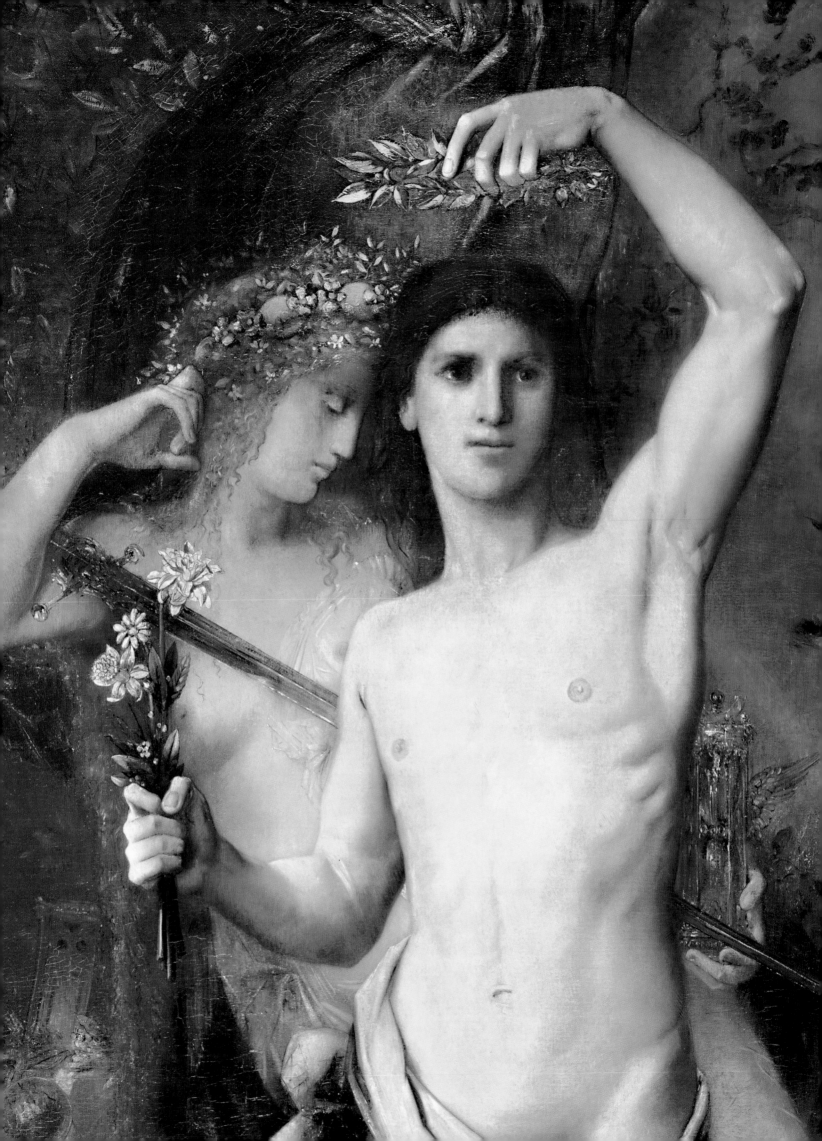

Resurrection and Metamorphosis:
Chassériau about 1900

GUSTAVE MOREAU
Death and the Young Man
1865
Detail of figure 2

A FTER CHASSÉRIAU'S DEATH in 1856, there was no "formal exhibition in which the dead artist, before definitively entering posterity, readily and without hesitation exhibited his canvases, from the first to the last."[1] Before the major retrospective of 1933,[2] it was nearly impossible "without research and traveling," as Gustave Geffroy pointed out in 1898, to "form a very complete idea of Théodore Chassériau's art."[3] The situation of the works on view was itself problematic: *Susanna and the Elders* (cat. 15), donated to the Louvre by Alice Ozy in 1884, was "a painting on the move, which the administration, in its embarrassment, shifts around to the darkest corners."[4] The provincial locations were not much better: the Avignon museum relegated the rather suggestive *Bather* (cat. 173) to the attic, and the *Christ on the Mount of Olives* (cat. 16) in the church at Saint-Jean-d'Angély "has for twenty years blocked a window open to the elements."[5] One might have expected the large decorative works, concentrated in Paris, to have created a more vivid impression, but the paintings in the Cour des Comptes (cat. 115–133) were damaged in an 1871 fire, and others lost some of their brilliance, as, for example, those in the Church of Saint-Merri (cat. 71–77): "One cannot make out a great deal in the narrow, very dark chapel, with no room to stand back. What you perceive most of all is the mildew of time."[6]

Nevertheless, when these observations were made at the turn of the twentieth century, Chassériau's works, as a result of events far removed from the classic exposure provided by retrospectives, were returning to the spotlight. This rediscovery, about 1900, although partial and unexpected, prompted a different approach to the artist—a digression in the established discourse—in short, a resurrection, sometimes more literary than artistic, spurred on by the curiosity and changing tastes of a limited but inspired public.

Paradoxically, Chassériau's return to the Paris scene was elicited by the observation that parts of the paintings at the Cour des Comptes had disappeared. Since 1879, *La Chronique des arts et de la curiosité,* a supplement to the *Gazette des beaux-arts,* had been reporting that a rescue effort was under way, and on December 24, 1881, it voiced its approval of the first initiatives: "They have begun to take down those beautiful fragments of great art in order to put them in a safe place."[7] Ten years later, in the same review, various artists—Élie Delaunay, Léon Bonnat, and Jules Lefebvre—advocated that the "frescoes" be transferred onto canvas.[8] The culmination of these efforts occurred in early 1898, with the donation of the paintings by the Compagnie d'Orléans, now in charge of the site, and was hailed by Ary Renan: "The friends of Chassériau can finally rejoice!"[9] Within a month, the panels were packed up, and the same author observed: "For the first time in a quarter century, tribute was paid [to Chassériau] from all sides."[10] The publication of several substantial essays made 1898 a "Chassériau year": Gustave Geffroy's appeared in January, Ary Renan contributed an important article to the *Gazette des beaux-arts* in February, and Valbert Chevillard was the author of two articles in the *Revue de l'art ancien et moderne.*[11] Roger Marx also penned two texts, one on the Cour des Comptes paintings, the other on a previously unpublished subject, the engravings;[12]

FIG. I
Apollo and Daphne
1846
Oil on canvas
Paris, Musée du Louvre
See catalogue 113

FIG. 2
GUSTAVE MOREAU
Death and the Young Man
1865
Oil on canvas
Cambridge, Massachusetts,
Fogg Art Museum

and Robert de Montesquiou devoted a chapter of his *Autels privilégiés,* published the same year, to Chassériau. It was thus the event more than the paintings themselves—which were "saved," to be sure, but which were subjected to a radical change in the process, having been packed away—that brought Chassériau's name back into the limelight. What this established was the future history and legacy of the artist rather than a stylistic approach to his oeuvre. The image of a ruined treasure cannot be separated from the rediscovery of the paintings, and these authors offered poetic descriptions of the palace on the Quai d'Orsay, its walls more evocative than those of the Salons. Art critics were transformed into archaeologists in front of these "frescoes," which "had assumed the aspect of Roman encaustics, those, for example, still being discovered in Pompeii or on the Palatine,"[13] or into explorers: "Someone has written a volume that is a botanical catalogue of the varieties of plant species assembled within these gates, in these hanging gardens."[14] The eccentricities of a talented man in love with freedom are thus evoked, and it is no coincidence that histories of Chassériau at the time tended to resort to vegetal metaphors: "The vocation manifested itself in a prodigiously precocious and violent manner, like those plants from the tropics that, having barely taken root, sprout their leaves and fruit in extraordinary profusion."[15] Such descriptions call to mind the colorful universe of the tale or myth: "What is touching is that, in those ruins, amid that wild vegetation and those free birds, there was a captive spirit—the reflective and sensitive soul of an artist."[16] This process of assimilation is reminiscent of those themes involving metamorphoses that had attracted the painter himself,[17] as, for example, the *Apollo and Daphne* (cat. 113 and fig. 1), a painting well known at the time through the lithograph version.[18] The resurrection of the paintings from the debris of the Cour des Comptes was represented by Gustave Moreau, in a painting shown at the Salon of 1865 (fig. 2), as an imaginary Symbolist encounter between a Young Man and Death.

It was this poetic approach that led Valbert Chevillard, a man of letters, to publish the first monograph devoted to the artist, *Un Peintre romantique. Théodore Chassériau* (1893). Apart from that publication, Chevillard's work consisted of a series of stories and comedies, most of them designed for young ladies or children.[19] The idea of writing the Chassériau book reportedly came to him "amidst the ruins of the palace on the Quai d'Orsay, in front of a fragment of a fresco that

FIG. 3
The Cour des Comptes,
Paris, after the 1871 fire
Photograph
Paris, Bibliothèque
Nationale de France

FIG. 4
View of the Grand
Staircase at the Cour des
Comptes with the panel
*Peace, Protector of the Arts
and of the Tilling of the Soil*
(partly destroyed)
Photograph
Colmar, Musée d'Unterlinden,
Archives Départementales
du Haut-Rhin

had miraculously escaped the blaze" (see fig. 3, 4).[20] It was not an illustrated volume, despite the
"catalogue" at the end: The reproduction of the artist's self-portrait of 1835, published by Braun,
and, on the flyleaf, a detail of Chassériau's face from the etching by Bracquemond were the only
accompanying documentation (fig. 5). Although Chassériau's hand was thus barely represented, his
words occupied a significant place in the "Notes and Thoughts on Art," transcribed from the
"archives . . . made largely available"[21] by his family. Alhough well informed, Chevillard's book
also contained—"too often, no doubt," as he conceded—"[his] personal impressions."[22] It would
therefore be judged harshly by Bénédite, the author of a more traditional art-historical overview
of Chassériau. Bénédite mocked "that dear Valbert Chevillard, a fine bank employee, author of short
stories, who owes his slight notoriety only to the fact that he was the first, thanks to his connec-
tions to the family, to have published a set of documents, some of them valuable, mixed in with all
sorts of wild aesthetic imaginings."[23] Several passages of Chevillard's book, indeed, deviate from the
standard monograph, such as the account of a visit to the Avignon museum where, one stormy day,
accompanied by a curator straight out of a Rembrandt painting, the author discovered the *Sleeping
Bather* in the attic. In addition, Chevillard's approach was shaped somewhat by his role as an author
of stories for young people, as indicated both by the motif of the "fragment" from the Cour des
Comptes—"a young woman kissing her infant"—and by this comment on the artist: "the grace
of his precocious childhood."[24] Finally, the references to contemporary authors—Heredia, Daudet,
Renan—indicate the literary nature of the study, which often displays a Symbolist sensibility.
Without naming him, Chevillard no doubt had Gustave Moreau in mind at the beginning of his
book, when he described "a Greek shepherd in love, wearing a crown of roses, surrounded by a flight

FIG. 5
FÉLIX BRACQUEMOND
Théodore Chassériau
Etching (published in
Valbert Chevillard,
Un Peintre romantique.
Théodore Chassériau
[Paris, 1893])

Th. Chassériau, pinx. Bracquemond, sc.

of doves"[25]—a figure reminiscent of the male figure in Moreau's *Death and the Young Man* of 1865. As a reviewer remarked at the time, Chevillard made Chassériau look like "a charming painter endowed with a poetic and tender soul."[26]

It is, therefore, not surprising that this book, in turn, inspired other writers—especially Robert de Montesquiou, in the chapter of *Autels privilégiés* entitled "Alice and Aline (A Painting by Chassériau)." The tone was polemical, of course, with the author taking offense at Chevillard's prosaic comments about this double portrait, of 1843 (cat. 61), which can be judged by this excerpt: "These girls feel they are destined to remain celibate in perpetuity because of the disfavor of nature and of fortune."[27] Montesquiou denounced "the dreadful mediocrities about that august virginal duo,"[28] but the author of *Hortensias bleus* also acknowledged that Chevillard's volume had the quality of "a vast work . . . truly inspired by the noble and charming recollections of Chassériau."[29] The two texts share certain similarities: Chassériau's writings are quoted at length by Montesquiou, whose observations also were made in a Symbolist context: For example, noting the "heart-rending bracelet woven from a plait of hair" on Aline's wrist, he remarks that "a plait identical to the one that, in the beautiful painting by Gustave Moreau, crowns the mystical figure who mourns Orpheus."[30] One no longer had to "pass through Chassériau to arrive at Gustave Moreau,"[31] but the reverse. Hence, Adèle and Aline were seen as an "eloquent and mute assemblage of two female sphinxes whose riddles had not been solved, who died without having uttered their secret of love."[32]

In late 1904, Maurice Barrès also discovered Chevillard's book, which seems to have inspired a profound interest in the artist, as attested by several passages in the *Cahiers* and by the presence in his office of the lithograph of *Apollo and Daphne*.[33] As Ida-Marie Frandon has shown, it was as much the text of the book itself as Chassériau's compositions that captivated Barrès's imagination. For his subsequent works, the *Voyage de Sparte* (Journey to Sparta) and *Un Jardin sur l'Oronte* (A garden on the Oronte), he adopted the same concept of the Orient, "classical, Greek, severe, and sober."[34] In general, it was the spirit of the monograph that shaped Barrès's image of Chassériau: The "tonality of the vocabulary of this enthusiastic idealist"[35] contributed toward placing the artist among "those in harmony with the stars"[36] and paved the way for a personal interpretation of his oeuvre, such as that presented in the *Cahiers* with regard to *The Trojan Women:* "These three words,

'Pontum adspectabant flentes' [they gazed, weeping, at the sea] are truly in harmony with my discourse on churches, my countryside, etc."[37]

Marked by the particular circumstances of their rediscovery, Chassériau's works were thus accepted somewhat differently from their reception in the past. The "Romantic painter" presented by Chevillard no longer was quite the same one who exhibited his paintings at the Salons in mid-century. Although Gautier's criticism was widely quoted in the book, Chevillard reconsidered that "enthusiastic and jealous friendship, always on the alert," suggesting that it "must have sometimes troubled Chassériau."[38] Gautier's vigilance was defended even by Montesquiou, who nonetheless was offended by the use of the word "troubled"—"the term is unfortunate and itself troubling"[39]—but its impact naturally weakened over time, replaced by other critiques and interpretations. Despite the exhibition by the Société des Peintres Orientalistes, organized by Léonce Bénédite in 1897, the ethnographic inspiration of Chassériau's works was overlooked. The confrontation between the two colossal influences, Ingres and Delacroix, too often emphasized, lost some of its importance; when it did reappear, it was in a different context, which gave it new significance: "Subsequently, an admiration for Ingres and Delacroix that was both comprehensible and passionate could also be observed in Bracquemond and in Fantin-Latour, in Manet and in Degas."[40]

Indeed, the fragmented perception of Chasssériau's oeuvre, emancipated from the weight of broad generalizations, encouraged free interpretations in which correspondences were established with more modern works. Hence, the portrait of Adèle and Aline, which "strangely troubled"[41] Paul Mantz at the Salon of 1843, now elicited astonishment of a different order, as shown by Arthur Baignères in 1886: "The current generation, which at most knew the painter's name, was surprised he had signed a portrait like the one of his sisters, which conforms to the precepts of the most contemporary naturalism."[42] In 1898, Chevillard himself, renouncing his psychological hypotheses, maintained that this painting "in some sense anticipates the return to nature, a movement out of which Bastien Lepage later emerged."[43] The same author breathed the "open air," which "seemed to be of recent creation," in the forest interior in the *Apollo and Daphne*: "Under these trees one breathes, the air circulates, and the foliage serves as a frame for the mythological scene."[44] Finally, Roger Marx detected a "sensualism" in Chassériau's Orient that gave rise to a "new interpretation of the female nude . . . [one] that can be attributed especially to three Creole artists, Chassériau, Degas, and Gauguin."[45]

These interpretations, tinged with Symbolism, nuanced by naturalism and even primitivism, and favored by circumstance, revived interest in Chassériau's work, bestowing on it the legacy hinted at in Moreau's *Death and the Young Man*. In the monograph Bénédite devoted to the artist, published in 1931, a work that is still authoritative and whose importance cannot be disputed, the author makes little use of the views of these critics, quoting more extensively from the artist's contemporaries. The words of Chevillard and Barrès and of Montesquiou and Roger Marx shaped Chassériau's posthumous reputation, contributing to the evolving view of the artist over the course of time.

Christine Peltre

1. At issue here is the 1857 exhibition devoted to Delaroche; see T. Gautier, "Paul Delaroche," in *Portraits contemporains* (Paris: Charpentier, 1881), p. 203.

2. However, several works were shown at the Exposition Universelle of 1889 and of 1900. In addition, Baron Chassériau's collection was open to art lovers. Under the "obliging and enlightened guidance" of its owner, Robert de Montesquiou visited the collection, which inspired him to write the text discussed below: "Alice et Aline (Une Peinture de Chassériau)," in *Autels privilégiés* (Paris: Eugène Fasquelle, 1898), pp. 251–67. The "metamorphosis" of Adèle into Alice was due, no doubt, to a poetic mirage. Montesquiou said he was moved by "the tinkling alliteration of their two pretty names, *Alice and Aline*" (ibid., p. 263).

Through their reproductions, the journals made a small contribution to our knowledge of the painter: For example, on the occasion of the inauguration of a monument to Lamartine, in 1886, an engraving

of the poet, after an unpublished drawing by Chassériau, appeared in one review ("Chronique," in *L'Artiste* [September 1886], p. 228).

3. G. Geffroy, "Théodore Chassériau," "16 janvier 1898," in *La Vie artistique* (1900), p. 88.

4. A. Renan, "Théodore Chassériau et les Peintures du Palais de la Cour des Comptes," in *Gazette des beaux-arts* (February 1, 1898), p. 90.

5. Ibid.

6. Geffroy, "Théodore Chassériau," p. 88.

7. *La Chronique des arts et de la curiosité. Supplément à la Gazette des beaux-arts* (December 24, 1881), p. 327.

8. "Les Fresques de Th. Chassériau," in ibid. (October 17, 1891), p. 255.

9. A. Renan, "Propos du jour," in ibid. (January 15, 1898), p. 17.

10. A. Renan, "Propos du jour," in ibid. (February 12, 1898), p. 53.

11. V. Chevillard, "Théodore Chassériau," in *Revue de l'art ancien et moderne* (1898), pp. 107–16, 245–55.

12. R. Marx, "Théodore Chassériau et les Peintures de la Cour des

Comptes," in *Revue populaire des beaux-arts* (1898); R. Marx, "Théodore Chassériau et Son Oeuvre de graveur," in *L'Estampe et l'affiche* (June 15, 1898), reprinted in *Maîtres d'hier et d'aujourd'hui* (Paris, 1914), pp. 243–60.

13. Renan, in *Gazette des beaux-arts* (1898), p. 94.

14. Geffroy, "Théodore Chassériau," p. 86.

15. R. Marx, "Théodore Chassériau et les Peintures de la Cour des Comptes" (1914), p. 244.

16. Geffroy, "Théodore Chassériau," p. 87.

17. On this subject see C. Peltre, *Théodore Chassériau* (Paris: Gallimard, 2001), p. 96.

18. The lithograph by Chassériau is illustrated by A. Baignères, "Théodore Chassériau," in *Gazette des beaux-arts* (March 1, 1886), p. 215.

19. One should note, in particular, *Avant le bal* (1892), *Mariage d'inclination* (1892), *La Châtaigne* (1902), and *La Tirelire* (1904)—works presented as "comedies" or "playlets" "for young ladies," the inspiration for which may illuminate Chevillard's comments, mentioned below, on Chassériau's portrait *The Two Sisters*.

20. Chevillard, 1893, p. 1.

21. Ibid., p. 5.

22. Ibid.

23. Bénédite 1931, vol. 1, p. 210.

24. Chevillard 1893, pp. 1–2.

25. Ibid., p. 22.

26. L[ouis]. G[onse]., "Bibliographie," in *La Chronique des arts et de la curiosité* (September 9, 1893), p. 231.

27. Chevillard 1893, p. 75.

28. Montesquiou 1898, p. 264.

29. Ibid., p. 251.

30. Ibid., p. 266.

31. R. de Montesquiou, "Le Lapidaire," in *Altesses sérénissimes* (Paris: Félix Juven, 1907), p. 13.

32. Montesquiou 1898, p. 264.

33. F. Broche, *Maurice Barrès. Biographie* (Paris: J.-C. Lattès, 1987), p. 374.

34. I.-M. Frandon, *L'Orient de Maurice Barrès. Étude de genèse* (Geneva and Lille: Droz, 1952), p. 178.

35. Ibid., p. 181.

36. M. Barrès, *Mes Cahiers, 1896–1923*, ed. G. Dupré (Paris: Plon, 1963–94), p. 1003.

37. Barrès, *Mes Cahiers;* quoted in Frandon 1952, p. 406 n. 7.

38. Chevillard 1893, p. 26.

39. Montesquiou 1898, p. 251.

40. R. Marx, "Un Siècle d'art," in *Maîtres d'hier et d'aujourd'hui* (Paris, 1914), p. 90.

41. P. Mantz, "Théodore Chassériau," in *L'Artiste* (October 19, 1856), p. 222.

42. A. Baignères, "Théodore Chassériau," in *Gazette des beaux-arts* (March 1, 1886), p. 209.

43. Chevillard 1898, p. 250.

44. Ibid., pp. 246–47.

45. R. Marx, "Théodore Chassériau et les Peintures de la Cour des Comptes" (1914), p. 253.

Portrait of Marie-Thérèse de Cabarrus
1848
Detail of catalogue 165

Catalogue

"Remember that when one has an original talent, it is always original, and there is no need to search for it" (Chassériau)

1819 – 43

—

A Precocious Talent, a Young Man in a Hurry

THÉODORE CHASSÉRIAU'S FAMILY ENVIRONMENT, with the support and emotional attachments it engendered and the patrons it attracted, played a major role in the artist's life and career. Without engaging in risky psychoanalysis or defending an ineluctable determinism, it appears obvious that his family, although splintered by the father's constant absence and the mother's apparent indifference, profoundly marked the young painter, who was reared primarily by his elder brother and sister, toward whom he directed his affection.

Evidence of these close personal ties, of Chassériau's reluctance to leave the intimate circle of his childhood, can be seen in his choice of lodgings in Paris, which were always located a short walk from his mother's and his siblings' residences, and where his father also would be welcome when he happened to be passing through. The various apartments and studios the painter rented[1] were only a few hundred meters from the family home, which shifted from the rue de Provence to the rue Cadet and, finally, to the rue Fléchier-Saint-Georges, where Chassériau died in 1856. Hence, apart from the "major" infidelity of establishing his first atelier in the rue Saint-Augustin, the artist limited his universe as a person and as an artist to the ninth arrondissement in Paris, as if the mysterious and exotic worlds he would create throughout his career needed a restricted and familiar setting—his family's neighborhood—in which to fully blossom.

In addition, throughout the "vicissitudes" of his short career, his brothers and sisters, who were the first models for his early portraits (cat. 3, 4), passionately participated in his successes and failures. His elder brother, Frédéric, used his many connections to obtain lucrative public commissions for Théodore; it was through him, for example, that the younger Chassériau met Victor Destutt de Tracy, Alphonse de Lamartine, and Alexis de Tocqueville, all of them powerful patrons, and it was as a result of efforts by the Chassériau "clan" that he received the commission for the Cour des Comptes (cat. 115–133). The closeness he shared with his brothers and sisters manifested itself at every stage of his life, as demonstrated by what they all went through when Adèle alone accompanied her parents to the island of Saint Thomas in 1829, and by Frédéric Chassériau's unending sorrow after Théodore's death: He would not allow "anyone to speak to him" about his brother, and "himself almost never spoke of him."[2] At the same time, the painter's family also assisted him in making the acquaintance of a few of the women who would matter in his life, such as Clémence Monnerot, the daughter of West Indian immigrants, and Delphine de Girardin, whom he had known when he was an adolescent and she was still Delphine Gay.

In general, that family intimacy is a determining factor, not only in defining the painter's personality, but also—and especially—in analyzing and comprehending his work. Certain themes can be understood only when viewed in the context of his family—both his forebears, and his brothers and sisters. It is, therefore, indispensable to devote a few pages to his ancestors and to reconstruct their history, which contains the seeds of certain elements of Théodore Chassériau's sensibility. Throughout the course of this veritable "saga," the painter's father, Benoît Chassériau, emerges as an intriguing individual, representative of a certain family tradition, so that we need to examine the facts about him for whatever instructive insights they can provide into his son's complex and restless character.

Between La Rochelle and the West Indies: Commerce and Exoticism

The birthplace of this astonishing family was the French department of the Charente. The "founding father," Jean Chassériau, was a tradesman, who lived and worked in the city of Saintes his whole life. One

of his sons, Henry, began the Chassériau family's great love affair with the sea, sailing up and down the coasts of the Americas and taking a wife in Port-au-Prince, Haiti.[3] Henry Chassériau's eldest son established himself as a shipowner in La Rochelle and also married an "island girl," with whom he had eighteen children. The youngest child in that large family was Benoît Chassériau. Both Théodore's great-grandmother and grandmother were native West Indians, undoubtedly born into Creole families of tradespeople or planters.

Hence, that powerful genetic predisposition, which drew the family to the sea, to commerce, and to distant lands—three themes that would be combined in the decorations for the Cour des Comptes—and that surely influenced Théodore Chassériau's fascination with the mysteries and sensuality of the East. This fascination often has been described merely as a personal character trait, although it was primarily an inherited family passion. Marrying women from the islands had been commonplace among the Chassériau men for three generations; going away for many months, or even years, and leaving one's family behind, was normal; being irresistibly in love with distant countries and civilizations was a way of life; and leading a risky and solitary existence divided between the ocean, the Americas, and France was second nature.

The fate of Henry Chassériau's fourteenth child, Victor-Frédéric (1774–1815), the grandfather of Baron Arthur[4]—the man principally responsible, as a result of his donations to the Musée du Louvre, for reviving interest in Théodore's works (see p. 17)—is a case in point. Victor-Frédéric also traveled a great deal, first to Saint Domingue, where he, too, married a young woman "from over there." He joined the army at age seventeen and fought in the West Indies, Spain, and Germany, only to be killed in the battle at Waterloo.[5] Victor-Frédéric Chassériau encapsulated the audacious spirit of the men in his family, ready to conquer the world and leave everything behind for a life of adventure. His younger brother, Benoît (Théodore's father), was a tradesman and a relentless—and, perhaps, sometimes unscrupulous—financier, a skilled and dedicated diplomat, and a courageous and enterprising man, who sacrificed his life and his children to his fascination with the West Indies, and seems to have been an equally representative heir to that astonishing La Rochelle dynasty.

"...with Love from Your Father": Benoît Chassériau, a Distant Father

In 1824, in an unpublished report sent to the Minister of the Navy[6]—on whom Benoît Chassériau's diplomatic career depended, at the time—Théodore's father (fig. 1) gave an overview of his childhood in the Charente and the difficulties he had faced in adolescence: "I was the youngest of seventeen children

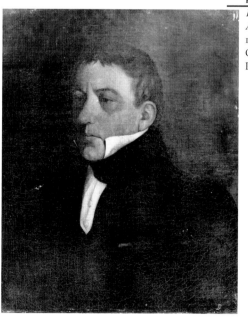

FIG. 1
Benoît Chassériau, the Artist's Father
1836–40
Oil on canvas
Paris, Musée du Louvre

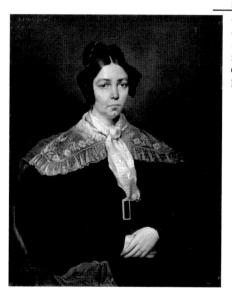

FIG. 2
Mme Benoît Chassériau, née Marie-Madeleine Couret de la Blaquière, the Artist's Mother
1836
Oil on canvas
Paris, Musée du Louvre

produced by a single marriage, and, when my father died in 1785, my mother (already very elderly) was left alone as the head of a family that still consisted of thirteen living children. I was in secondary school when, in 1794, I had the misfortune of losing my mother. Thereafter, I was altogether on my own. From that moment on, I felt the need to provide for myself and I resolved never to be a burden to anyone. I had a strong will, resolve, a love of beauty, and above all, a deep-seated unselfishness, which the wants I have often experienced since have never impaired."

Beyond the formulaic boasting and the highlighting of his own merits, his declarations appear to reflect a sincere personal conviction, almost a life plan. That ethic of resolve, that quest for self-sufficiency, and that defense of his "strong will" undoubtedly constituted moral reference points that he would try to teach his sons. These values can be found intact in Théodore's career choices. On his own, the young painter would be able to escape outside influences and professional circles, and would rely on his inner strength of character to break from the past and move in a new artistic direction. His father also considered "love of beauty" one of the qualities he wanted to foster for its own sake. These various moral considerations would come through in each of the letters the father sent his sons during his long absences.

Nevertheless, in contradiction to his declarations, an unsigned report in his official dossier pointed out that Benoît Chassériau had led a rather "unruly" life in his youth.[7] It may be because of this fact, or a budding scandal, that the young man was obliged to leave France—unless his departure was already the manifestation of his taste for adventure. In any case, through the protection of the revolutionary general Damas, Benoît Chassériau, who was living at the time "on the earnings from a minor office job,"[8] embarked for Egypt with the Napoleonic expedition in May 1798. After first serving as a "secretary," at age nineteen he was "named supervisor of the second arrondissement of Egypt, that is, he was charged with the administration of two provinces."[9] That experience reflects the precociousness that was common in the family, a quality Benoît Chassériau happily would discover in the young Théodore. A man who had been in charge of two provinces in Egypt at age nineteen would consider it natural for his son to make his debut as a painter at age eleven. That mind-set undoubtedly also explains why he considered it normal for his children to grow up without him.

Upon his return from Egypt in 1802, Benoît Chassériau immediately left for Saint Domingue, in the company of his brother Victor-Frédéric and "twenty-five thousand men, whom Bonaparte was sending . . . to repress the native rebellion."[10] There, he set to work "organizing the colony's Public Revenue Department."[11] After the uprising led by Toussaint-Louverture, a second insurrection had just erupted on the island of Saint Domingue headed by Jean-Jacques Dessalines, founder of the republic of Haiti in 1804. Benoît Chassériau, who lived in the Spanish part of the colony, had a few new "worries"; the note already cited[12] declares that he gambled and diverted about sixty thousand francs from the public coffers, and he was imprisoned by General Ferrand in 1806. The young man was then freed, reportedly through the intervention of M. Couret de la Blaquière, a rich planter from Samaná, who paid Benoît's debts. In exchange, Chassériau married the planter's daughter, Marie-Madeleine (1791–1866; see fig. 2). According to rumors at the time, documented in his internal dossier,[13] this "girl of color," aged fourteen at the time, had already been involved with Benoît Chassériau, and M. Couret de la Blaquière took advantage of the latter's imprisonment to make things legal. The "official" version provided by the painter's father is somewhat different: "Her father, a rich landowner in the French part of Saint Domingue, had just been forced to abandon his property bordering the Spanish part, and was reduced to subsisting solely on the labor of a few slaves, who had accompanied him when he fled. I had a rather comfortable salary; I considered myself lucky to be able to come to his aid."[14] In any case, Benoît Chassériau continued the family custom of marrying Creole women from the West Indies.

Regardless of the gossip repeated throughout his career—he was accused of abandoning his wife for a time[15]—this marriage seems to have stabilized the young man.[16] The couple soon welcomed their first children: Frédéric was born in 1807, Marie-Antoinette, nicknamed Adèle, in 1810.[17] In about 1809, the little "tribe" settled on the peninsula of Samaná, which was famous for its "enormous and magnificent bay advantageously located in relation to the Leeward Islands."[18] The Spanish war of independence, which erupted in 1810 and lasted until Napoleon I's defeat, destroyed those happy times and inaugurated a long period of adventure for Benoît Chassériau. His career as a "tradesman/diplomat," a sort of secret military agent, began at that time, after his property in Samaná was temporarily confiscated.[19] Traveling between Caracas and the island of Saint Thomas, sometimes by himself, sometimes with his family, he managed to hire out his services to the city of Cartagena in Colombia,[20] where he was named "Chief Captain of Engineering," and was then "given the responsibility for law enforcement, with the title of Commissioner General."[21]

At the end of the war between Spain and France, the Chassériau family returned to Samaná, where Théodore was born on the family's property on September 20, 1819.

The painter's birth thus occurred at a time when calm had returned, but the child did not grow up in this exotic landscape. A year later, on November 29, 1820, Benoît Chassériau was called back to France (the circumstances of his departure have not been explained): "On November 29, 1820, I saw the frigate *The Cleopatra,* commanded by Captain Malles, arriving in the port of Kingston. . . . The captain informed me that he had come for me and that he had orders to wait five days while I prepared for departure. I embarked aboard his ship on December 5 of the same year."[22] On January 9, 1821, the boat docked in Brest; by February 20, 1821, the Chassériau family was in Paris. Théodore would never return to the West Indies.

"My dear Papa, with All My Love and Kisses . . . Théodore":[23]
The Painter's Childhood

Théodore Chassériau, far from having been born into a stable and even influential bourgeois milieu, like some of his fellow artists—Ingres and Delacroix, for example—was the son of a man with an "adventurous temperament," who preferred "change and the unexpected to the settled security of family life," who journeyed "from island to island," was often "taken prisoner," and was adept at "escaping."[24] During his childhood, the painter, of fragile health and with a sensitive temperament, could not fail to encounter difficulties in defining himself in relation to his absent and enterprising father. Subsequently, his emotions seems to have shifted back and forth from neurosis to toughness and from loneliness to altruism. His father's absence, which shaped the son's temperament, also exacerbated his sensitivity, and his childish imagination constantly was focused across the seas, on that distant father—a prelude to the exotic dreams of his adult years.

For the Chassériau family, that Parisian period represented a few short years of peace and stability—marred, certainly, by the lack of income—giving rise to the birth of a second daughter, Geneviève, nicknamed Aline, in 1822, and to a third son, Ernest, in 1823. Nevertheless, in 1824, Benoît Chassériau, assigned to intercede politically in Colombia,[25] again embarked for the tropical lands that he loved—in the company, this time, of Frédéric. At this time, his talents for international relations and for establishing a balance of political power were clearly revealed,[26] yet, his absence worsened the material and emotional problems of Théodore's brothers and sisters. It appears that their mother did not maintain the family's equilibrium, and some critics have even accused her of being "a Creole of the indolent type, who would never be tempted by the idea of making a decision or running anything whatsoever."[27] On the contrary, she seems to have been a retiring and fearful woman, who was able to show genuine maternal affection toward her children. The fact that none of the three sons and two daughters ever married, however, attests to a certain reluctance on their part—or to a real fear—of starting their own families and to their unsatisfactory childhood.

The eldest of the Chassériau sons became the head of the family when he returned from the Caribbean.[28] His father had gone away again, and he had to look after his four brothers and sisters and deal especially with material concerns, by, among other things, finding a way to support the family: "[The apartment in the rue Cadet] costs five hundred francs [a year]. . . . A reliable middle-aged housekeeper will be procured for me. . . . That should cost a thousand francs. I will keep Ernest with me and will take charge of his education as well as of Théodore's. . . . I estimate that our little household, including the tuition for boarding school and clothes for Aline, will cost us at most about four thousand francs a year. I will pay at least a quarter of that, since, one way or another, I hope to find a means of earning some money."[29] For the young Théodore, Frédéric Chassériau was a symbol of security and stability, from childhood on; he was always at the younger boy's side, assisting him in his budding career as a painter, the value of which he grasped completely.

Indeed, during that time, little Théodore was already beginning to draw: "My dear Papa, with all my love and kisses, this time I'm sending you I'm sending you a lot of little drawings I did my dear Papa what you told me to do. Théodore."[30] In all his letters, in fact, Benoît Chassériau, whether from fatherly remorse or to support his son's nascent talent, asked for drawings from "clever Théodore,"[31] and Théodore complied by sending him his first sketches—as, for example, the one he drew of the "Jiraf [*sic*] that all of Paris is rushing to see," in 1827 (fig. 3). His fascination with this father, who was living in countries with wondrous names and whose adventures were reported back to him, albeit in distorted form, often led the child

FIG. 3
Two Orientals and a Giraffe
1827
Pen and ink and watercolor
Paris, Musée du Louvre

FIG. 4
Orientals and Soldiers
1827
Pen and ink and watercolor
Paris, Musée du Louvre

to draw Indians or Oriental figures (fig. 4).[32] In addition, the strong family connections with the army and with colonial conquests surfaced in his many drawings depicting soldiers; clearly, Théodore often had heard talk of war exploits, and military uniforms were part of his world, as a child. This did not prevent him from sketching charming little landscapes or genre scenes, encouraged by the drawing classes he regularly attended at the time, although he was not yet ten years old.[33] While his drawing technique was still somewhat clumsy and without any guiding vision, he sought to convey movement and expression; his strokes were sure and precise, and his use of watercolor reveals an obvious interest in color.

Frédéric's admiration for his brother's talent led him to oversee Théodore's developing career as a painter. The Chassériau family was related to the cultivated and influential Pineu Duvals. One member of that family had just been admitted to the Institut de France, and his son, a painter who used the pseudonym Amaury-Duval (1808–1885), was a pupil of the great Ingres, from 1825 on. Frédéric did not hesitate to appeal to that "family ally"[34] to enroll Théodore in the private classes that the master and relentless defender of ancient Greece was holding in a studio at the Institut, overlooking the rue Mazarine.

"He Is Completely Ignorant of All the Poets of Recent Times": Théodore Becomes Ingres's Pupil at Age Twelve

By this time, Ingres had been painting for more than a quarter of a century, and had become the head of a school, after struggling, under the Empire, to revive Neoclassicism. He won the battle against Romanticism with the success of *The Apotheosis of Homer* (Musée du Louvre) at the Salon of 1827–28, and was regarded as an "official painter" after completing the *Portrait of Charles X in Ceremonial Dress* (Bayonne, Musée Bonnat). The previous year, he had been named professor at the École des Beaux-Arts; he would become vice-president in 1831, and president in 1834. Famous as a portraitist—*Monsieur Bertin* (Musée du Louvre) dates from that period—Ingres was working at the time on his *Martyrdom of Saint Symphorian* (Autun Cathedral). He also headed a studio famous for its successes, and along with Chassériau his other pupils included the Flandrin brothers, Joseph-Benoît Guichard, Henri Lehmann, and Romain Cazes.[35] In spite of his fame and his heavy workload, Ingres became fond of the adolescent, in whom he discerned an extraordinary talent. According to a legend kept alive by Chassériau's biographers, his teacher forthwith nicknamed him the "Napoleon of painting."[36] Whatever the veracity of that now-unverifiable anecdote, Ingres had enough regard for his student to have him admitted to the École des Beaux-Arts at age fourteen. Through Ingres's powerful patronage, Chassériau's career began most auspiciously; only his youth prevented him from entering the competition in history painting for the Grand Prix de Rome.

The disagreement that later occurred between the two men and, above all, the hypothesis maintained by certain art historians that Chassériau broke off his relationship with Ingres after discovering Delacroix's

use of color (see p. 14), have often led to an underestimation of Théodore's great indebtedness to the lessons he received then. Generally, the master of Montauban is credited only with Chassériau's technical mastery of graphite and his discovery of the glory of Antiquity and of the Renaissance. However, it was Ingres who instructed Chassériau in oil painting, and the young man became one of the great practitioners of his time in that technique. It was Ingres, as well, who taught him to channel his keen sensitivity by achieving a mastery of his pictorial forms. Thanks to Ingres, he assembled a frame of reference for earlier art, discovering the works of Raphael and Poussin: "Take . . . Poussin as a model."[37]

In addition, like all great artists, Ingres's body of work was neither narrow nor monolithic; on the contrary, in the variety of artistic proposals and themes elaborated on by his teacher, the young Chassériau was able to find guidelines and examples throughout his career. Hence, the appeal of certain subjects—the East, the female nude, myths—dates to these formative years. Ingres also transmitted his knowledge concerning the execution of painted portraits and portrait drawings. Unlike Delacroix, for example, who during his training copied the Venetian painters of the Renaissance (Giorgione, Titian, Veronese) as well as Spanish artists (Cano, Carreño de Miranda, Velázquez) and masters from the Low Countries (Rembrandt, Rubens), and who was particularly fond of religious and mythological subjects, Théodore Chassériau, from that time on, seems to have favored copying portraits by the Old Masters. (Among the rare examples of copies in Chassériau's hand that have been identified with certainty, most are of portraits—as for example, a study of Leonardo da Vinci's *Mona Lisa,* which was identified by Sandoz[38] as having been in the Chéramy sale in 1913, and several copies commissioned by the state in 1836 and 1839.)[39] Thus, careful attention to the lessons of his teacher made Théodore Chassériau one of the most famous portraitists of his day.

Later, the relationship between Chassériau and Ingres assumed the status of a veritable crisis. The adolescent's rejection of his teacher, based surely on a profound and unequivocal aesthetic break, occurred when the young man realized the differences between his artistic conceptions and those of Ingres: "I saw that in many respects we would never be able to understand each other. He is past his prime and has no comprehension of the ideas and changes that have taken place in the arts in our day; he is completely ignorant of all the poets of recent times. That's fine for him, his art will remain as a souvenir, a reprise of the art of the past, without having created anything for the future. My wishes and my ideas are not at all like his."[40] Chassériau was twenty-one when he wrote these lines, during his trip to Italy; the personal and professional break between the teacher and the "gentleman" who took "rather too arrogant a position toward his master" was already under way.[41]

However, the student's detachment seems to have commenced earlier, probably about the time of the Doyenné, between 1833 and 1835—Chassériau was then fourteen years old—when he discovered other artistic approaches, other literary and pictorial conceptions, and experienced the pleasures of provocation and the exhilaration of passion through his exposure to Gérard de Nerval, Théophile Gautier, Arsène Houssaye, and their painter friends Marilhat, Corot, Nanteuil, and Leleux. Dazzled by the flamboyant intelligence of these young Romantic artists and their infectious joy, the young adolescent attended their evening parties, executing for one of these costume balls two oil paintings on wood depicting bacchantes. A classical painter by day in his teacher's studio, Chassériau became a Romantic by night with his new friends.

When Ingres accepted the position as director of the Académie de France in Rome, abandoning his Paris studio for the Villa Medici, Chassériau saw his departure as a betrayal, for his own career was not yet under way. Not only could he not compete for the Prix de Rome, but his period of apprenticeship had come to an end. Unlike some of his fellow students at the studio, who were wealthy enough to follow their teacher, the young man did not have the financial means necessary to relocate to Italy,[42] since his father was going through a difficult time—an administrative "indiscretion," or a plot against him, forced him to leave the island of Saint Thomas, and he had just been named honorary consul in San Juan, Puerto Rico.[43]

Of course, Théodore was not "left to himself" during this period, but he had to prepare for his debut at the Salon and find his first clients. Thus, when Ingres thought of him in Rome, and asked him to draw a famous black model, Joseph (fig. 5), from life, in preparation for the figure of the demon in a *Temptation of Christ,*[44] Chassériau was very slow in accepting the commission[45]—even though he was proud of that show of confidence—because of the work he had to do in preparation for the Salon of 1836. During the next five years, Chassériau executed many sketches and studies for paintings, seeking inspiration from authors of the past—Dante and Shakespeare—and from more contemporary writers like Byron and Stendhal. This constant toil in shaping his artistic personality further separated him from his teacher.

". . . be pure in drawing and in color":
The Early Masterpieces

His relative success at the Salon of 1836 (see fig. 6), where he was awarded a third-prize medal, was followed by his failure at the Salon of 1838, when both *The Virgin* and *Elisha Raising the Son of the Shunammite* were rejected, but finally, in 1839, the critics discovered the twenty-year-old artist's genius: two of his early masterpieces, *Susanna and the Elders* (cat. 15) and the *Venus Anadyomene* (cat. 13), were on exhibition. We can only imagine the astonishment of visitors to the Salon of 1839 when they observed that the *Venus,* a small but mannered painting, a refined and sensual jewel depicting a female figure as idealized as in an intimate and elegiac fantasy, had been painted by the same young artist as the *Susanna,* a monumental—"colossal," in the words of Paul Jamot—creation that glorified a robust and solitary woman, who seemed to scorn the desires of men. It was almost as if he chose to sum up his subsequent career in 1839—poised between small and voluptuous paintings and large decorative compositions—with these two works of art, displaying a secret erotic dream next to a modern effort to revive the classical heroines of the past. In each case, the female type he invented, sensual yet remote, unreal yet tangible, would enrich the imaginations of painters and writers, from the second-generation Romantics to the Symbolists, from Gautier and Nerval to Flaubert and Huysmans, from Puvis de Chavannes to Gustave Moreau.

"Render What Is in the Soul in a Visible, True, and Refined Manner,
Because Nature Alone Has That Freshness and Mordancy":
The Trip to Italy

With the exception of a trip to the Pas-de-Calais, a department of northern France, necessitated by his fragile health, Théodore Chassériau had never left the bosom of his family, or the center of Paris. In 1836, he journeyed south to the Gard, and then visited his cousin Frédéric in Marseilles. In 1837, a year marked by his discovery of Flemish painting after spending time with his friend Oscar de Ranchicourt (see cat. 210, 211),[46] Chassériau finally was able to break away from his intimate circle in Paris. After six years of waiting, the trip to Italy would be the culmination of his new-found independence.

Chassériau left for Italy in 1840, arriving in Naples, the first stop on his Mediterranean journey, in July.[47] Unlike the traditional Italian itinerary, which always began with a long stay in Rome followed by short excursions to the surrounding countryside—where painters were transported back to classical antiquity—in Naples Chassériau first discovered the purity and dramatic power of the Italian landscape. He admired the sober and eternal beauty of the ruins of Pompeii and Herculaneum; the elegiac sites of Capua,

Salerno, and Mola di Gaeta; and the majesty of the Greek temples at Paestum. That abrupt immersion in Italian culture was reflected in his many landscape studies, executed in watercolor, graphite, and wash (cat. 24, 25): "I made studies of the countryside, so famous for its beauty and which is so magnificent. It is unique in the world, the most beautiful and the most lofty in design, with the richest color, and with a great sadness and gravity, which becomes sublime in monumental paintings."[48] The painter's talent blossomed with his study of nature, as he followed the examples of his many predecessors, all of whom were seduced by Italian locales. He discovered a genre—landscape—that subsequently found its way into all of his history paintings and most of his Orientalist scenes, as well as into some of his portraits. A sign of his Ingresque education was that his drawings were studied directly from life, but unlike most of his fellow artists, he did not execute oil paintings out-of-doors.[49] During his stay in Italy, with the luminous Mediterranean landscapes spread before him, he defined his conception of the role of nature in his studio paintings. His landscapes would waver between the rugged realism of the painters of the Barbizon school and a poetic idealization of his subject.

"I'll return to France very rich, with many compositions for the future, and with studies for those I want to do once I get back,"[50] he wrote, shortly after his arrival in Rome in August 1840. In fact, in that period, which witnessed a full flowering of his talent, he executed two masterpieces in the portrait genre, *Father Lacordaire* (cat. 47) and *The Comtesse de La Tour Maubourg*. In Rome and in the surrounding areas—Tivoli, Olevano, Subiaco—he made studies of beautiful Italian models as well as of architecture and the relics of Antiquity. Yet, he was wary of Rome, "where sublime things are greater in number, like a city where one must reflect a great deal, but also like a tomb," and he determined that "in Rome one cannot experience real life."[51] He was still copying Michelangelo and Poussin (see cat. 36), continuing his ongoing study of the Old Masters, begun in Ingres's studio and at the Musée du Louvre at the age of twelve.

These years, in particular, were marked by his definitive emancipation from the influence of his teacher, Ingres, and he even withdrew from his circle of friends, as demonstrated by his complicated relationship with Henri Lehmann (see cat. 53). In the seven months he remained in Italy, Chassériau completed his training and developed all of the qualities that would define his rich artistic persona. Far from positioning himself for or against one artistic current or one personality or another, he asserted his own originality and very personal temperament—and that temperament became incompatible with the mere transcription of Ingres's theories.

When he returned from his Italian trip, the boundaries of his art had been drawn, with priority given to the portrait and to history painting—genres in which sensuality dominates, in any case: "I want to do a large number of portraits, first, to make a name for myself, and second, to earn money, in order to acquire the necessary independence that will allow me to fulfill the duties of a history painter," he wrote, during his stay in Rome, already setting the stage for his return to Paris.[52] Hence, the works submitted to the Salons of 1841 and 1842 alternated between mythological themes and nudes (cat. 65, 66), portraits (cat. 47)—I will not discuss, here, the *Portrait of a Lady with Large Pearl Necklaces,* one of his masterpieces—and religious paintings (cat. 68). Whether because of his temperament or through opportunism, Chassériau wished to prove that he was not a rebel but a reformer and, rather than effecting a complete break with his teacher, he preferred to express his originality by taking on a genre that the latter had not attempted—with the exception of one digression, *The Golden Age.* This was decorative painting—and, upon his return to France, Chassériau undertook his first works in that genre, at the Church of Saint-Merri in Paris (cat. 71–77).

Vincent Pomarède

1. They were located in the rue de la Victoire, the rue de la Tour-d'Auvergne, the rue Neuve-Saint-Georges, and, beginning in 1848, at 14–15, Avenue Frochot. On the apartment on the Avenue Frochot see B. Centorame, "Avenue Frochot," in *Hameaux, villas et cités de Paris* (Paris, 1999), pp. 110–11.
2. J.-L. Vaudoyer, "Le Baron Arthur Chassériau. Notice lue à l'Assemblée générale annuelle de la Société des Amis du Louvre le 17 juin 1935," in *Cabinet des Dessins, Société des Amis du Louvre* (Compiègne, 1935), p. 8.
3. These details were provided by Léonce Bénédite but were summarized by Vaudoyer (1935).
4. Baron Arthur's father, Frédéric, was born in Port-au-Prince in 1802 and died in 1896 at the age of ninety-four. The son of Victor-Frédéric Chassériau, Frédéric became an architect and oversaw the construction of the Cour des Comptes before working in Marseilles, Aix, and Algiers,

where he participated in the construction of the port on the Boulevard de l'Impératrice, and the municipal theater (see Vaudoyer 1935, p. 10).
5. The list of 273 officers of the French army mortally wounded in the battle of Waterloo included: "Chassériau. Chief warrant officer: chief of staff, fourth cavalry reserve corps" (Internet: www.histoire.org/lempire/docs/bilan/waterloo.htm).
6. Archives of the Ministry of Foreign Affairs, personnel dossier, 1st series, Benoît Chassériau, 889; letter from Benoît Chassériau, December 26, 1824, Paris.
7. Archives of the Ministry of Foreign Affairs, personnel dossier, 1st series, Benoît Chassériau, 889; internal note. This note, whose official status is unclear—it is something between an unattributed note from a detective service, a police report, and a collection of assorted unsubstantiated gossip—must be accepted with precaution. Nevertheless, it contains

information—all the more interesting because it may be false—about the personality and career of Benoît Chassériau, apparently a controversial man who made many enemies.

8. Archives of the Ministry of Foreign Affairs, personnel dossier, 1st series, Benoît Chassériau, 889; letter from Benoît Chassériau, December 26, 1824, Paris.

9. Ibid.

10. Vaudoyer 1935, p. 3.

11. In fact, new financial worries obliged him to leave "without delay" (Archives of the Ministry of Foreign Affairs, personnel dossier, 1st series, Benoît Chassériau, 889; letter from Benoît Chassériau, December 26, 1824, Paris).

12. Archives of the Ministry of Foreign Affairs, personnel dossier, 1st series, Benoît Chassériau, 889; internal note.

13. Ibid.

14. Archives of the Ministry of Foreign Affairs, personnel dossier, 1st series, Benoît Chassériau, 889; letter from Benoît Chassériau, December 26, 1824, Paris.

15. Archives of the Ministry of Foreign Affairs, personnel dossier, 1st series, Benoît Chassériau, 889; internal note.

16. Benoît Chassériau was named secretary general of Saint Domingue by General Ferrand; with his father-in-law, he established a new "residence" called La Persévérance, later destroyed by Dessalines's troops.

17. Vaudoyer (1935, p. 4) mentions seven children, two of whom died at birth or at a very young age; Louis-Antoine Prat gives the names of the other two Chassériau children: Charles and Paul.

18. Archives of the Ministry of Foreign Affairs, personnel dossier, 1st series, Benoît Chassériau, 889; letter from Benoît Chassériau, December 26, 1824, Paris. Benoît Chassériau abandoned his administrative duties at the time, and obtained a government concession to run two plantations in Samaná.

19. Archives of the Ministry of Foreign Affairs, personnel dossier, 1st series, Benoît Chassériau, 889, report 1, Kingston, March 5, 1817; attached to a letter from Benoît Chassériau, December 26, 1824, Paris.

20. Ibid.

21. Vaudoyer (1935, p. 3) later "translated" that title as "Bolivar's interior minister." Precise but unverifiable details were relayed in secret notes from the Ministry of the Navy (Archives of the Ministry of Foreign Affairs, personnel dossier, 1st series, Benoît Chassériau, 889; internal note): there is mention of a brutal expedition allegedly conducted in Portobelo, which included looting, with Benoît Chassériau barely escaping the revolt waged by the population. During the same period, he reportedly organized another expedition to the island of Santa Marta, provoking a local rebellion after he allegedly raped the "daughter of an influential cacique."

22. Archives of the Ministry of Foreign Affairs, personnel dossier, 1st series, Benoît Chassériau, 889; letter from Benoît Chassériau, December 26, 1824, Paris.

23. Letter from Theódore Chassériau to his father, Benoît Chassériau [Paris], [1827?]; Musée du Louvre, Département des Arts Graphiques, dummy album bound in red morocco.

24. Vaudoyer 1935, p. 3.

25. Archives of the Ministry of Foreign Affairs, personnel dossier, 1st series, Benoît Chassériau, 889; unsigned and undated note [December 1823]: "The mission entrusted to M. Chassériau has two principal aims. First, he must concern himself with sounding out the state of mind of the Colombians and their government leaders regarding a settlement with Spain and must urge them to ask France to mediate. Whatever the fate of the measures taken, M. Chassériau must then devote all his attention to protecting and encouraging our commercial relations with the various provinces of that colony."

26. "The meeting of the congress of Panama will probably produce results soon, and they might not be in harmony with that measure: so why rush it? The commercial situation in the various nations of South America is currently so precarious, so hampered by the errors the English committed in drowning them in merchandise [fol. 6 v.] completely disproportionate to the returns they can offer and to what they can consume, that whatever we introduced would find no outlet. Let us therefore pay due heed to the times and the circumstances: Let us wait patiently for the moment to present ourselves there in a useful and appropriate manner" (unpublished letter from Benoît Chassériau to the comte de Villèle, March 1826, Paris; private collection).

27. Vaudoyer 1935, p. 3.

28. Benoît Chassériau returned to France in 1824 (Archives of the Ministry of Foreign Affairs, personnel dossier, 1st series, Benoît Chassériau, 889; letter of September 6, 1824). On April 8, 1825, he turned down a position as a government official in Madagascar and, after sending several petitions to the minister, in 1826 he was finally named vice consul

of the island of Saint Thomas. His tenure there did not leave behind bad memories for the locals, according to the testimony of Camille Pissarro, a native of that island, who wrote to his son that "the Chassériau family were merchants on Saint Thomas" and that his father "was in business [with them] at one time" (Letter from Camille Pissarro to his son, Lucien, July 12, 1900; cited in J. Rewald, ed., *Lettres de Camille Pissarro à son fils Lucien* [Paris, 1970], pp. 478–79).

29. Letter from Frédéric Chassériau to his mother; correspondence collected by André Dézarrois; quoted in Vaudoyer 1935, pp. 5–6.

30. Letter from Théodore Chassériau to his father, Benoît Chassériau [Paris], [December 1826?]; Musée du Louvre, Département des Arts Graphiques, dummy album bound in red morocco.

31. "Yes my dear Théodore when I call for your good Mama I will have you come with her, or rather, I will join you all myself, which seems much better to me, in the meantime apply yourself to your studies, write me, send me some of your drawings" (Letter from Benoît Chassériau to Théodore, October 14 [1827], Saint Thomas; Musée du Louvre, Département des Arts Graphiques, dummy album bound in red morocco).

32. On Chassériau's childhood drawings see Prat 1988-1, vol. 2, pp. 966–73; J. P. Ribner, "Chassériau's Juvenilia: Some Early Works by un Enfant du siècle," in *Zeitschrift für Kunstgeschichte* (1994), pp. 219–38.

33. "I'm sending you a few little Drawings here are 49 lessons that I am taking I'm feeling well dear Papa" (letter from Théodore Chassériau to his father, January 23, 1828, Paris; Musée du Louvre, Département des Arts Graphiques, dummy album bound in red morocco).

34. The episode is recounted in Amaury-Duval, *L'Atelier d'Ingres* (Paris, 1924), p. 78.

35. On Ingres's pupils see, among others, P. Angrand, "Le Premier Atelier de M. Ingres," in *Bulletin du Musée Ingres,* nos. 49–50 (December 1982), pp. 19–58.

36. That anecdote is reported without any evidence in Bénédite 1931, vol. 1, p. 58; it would subsequently be repeated by all of Chassériau's biographers.

37. Autograph on a pen drawing in the Louvre (RF 26344; quoted in Prat 1988-1, vol. 2, no. 1855, p. 659).

38. Sandoz 1974, no. 22, p. 114.

39. These included the *Portrait of François IV de La Rochefoucauld* (Versailles); *Guillaume du Vair*, previously attributed to Frans II Pourbus (Louvre); *Portrait of Duke Fernando Álvarez de Toledo, Duque de Alba* (Versailles); *Philippe de France, Duc d'Orléans* and *Madame de Montpensier* (Saint-Cloud).

40. Letter from Théodore Chassériau to his brother Frédéric, September 9, 1840, Rome; quoted in Chevillard 1893, pp. 42–46; Bénédite 1931, vol. 1, pp. 135–39.

41. Letter from Marie d'Agoult to Henri Lehmann, May 18, 1841; quoted in Joubert 1947, p. 169.

42. "Unfortunate circumstances have until now prevented us from responding to my brother's wish—to go avail himself of your continuing counsel and kindness. He is heartened by the hope I have given him that this good fortune has only been postponed; and I am making arrangements so that he can leave in May at the latest" (Letter from Frédéric Chassériau to Ingres, February 1, 1835, Paris; quoted in Bénédite 1931, vol. 1, p. 59).

43. Archives of the Ministry of Foreign Affairs, personnel dossier, 1st series, Benoît Chassériau, 889. He would end his diplomatic and business careers in Puerto Rico.

44. "We must therefore find, among my students the one who best knows how to do a portrait from a model, and, if you don't find anyone better for me, I believe I can recommend the young Chassériau to you" (letter from Ingres to his friend Gatteaux, November 19, 1836, [Rome]; quoted in H. Delaborde, *Ingres, Sa Vie, ses travaux, sa doctrine* [Paris, 1870], pp. 319–20). Ingres would never complete this composition.

45. On this episode see D. Ternois, "Notes sur Ingres et Chassériau," in *Bulletin du Musée Ingres,* no. 4 (July 1958), pp. 13–17.

46. Chassériau had attended his friend's wedding. On this subject see Sandoz, "Théodore Chassériau (1819–1856) et La Peinture des Pays-Bas," in *Bulletin des Musées Royaux des Beaux-Arts de Belgique,* vol. 17, nos. 3–4 (1968), pp. 172–90.

47. The painter must have spent a few days in Rome on his way to Naples.

48. Letter from Théodore Chassériau to his brother Frédéric, September 9, 1840, Rome; quoted in Bénédite 1931, vol. 1, pp. 135–39.

49. On the Italian landscape studies Chassériau executed in Italy see Prat 1988-1, vol. 1, nos. 1092–1366, pp. 451–513.

50. See note 48, above.

51. Ibid.

52. Letter from Théodore Chassériau to his brother Frédéric, November 23, 1840, Rome; quoted in Bénédite 1931, vol. 1, pp. 139–41.

Portrait of the Artist in a Redingote
1835
Detail of catalogue 1

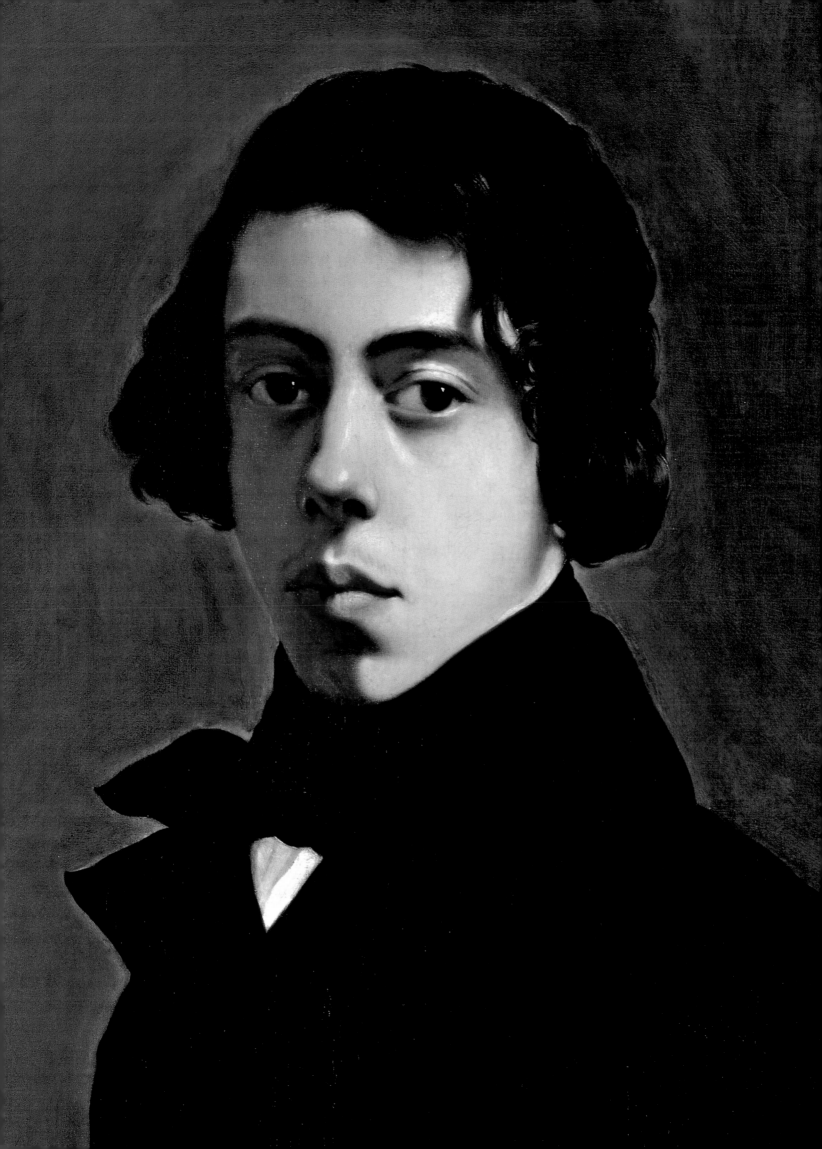

EARLY PORTRAITS

Note to the reader: Unless otherwise indicated, the works are being exhibited in Paris, Strasbourg, and New York. When the number L.443 is cited in the Provenance section, it refers to the Chassériau estate stamp.

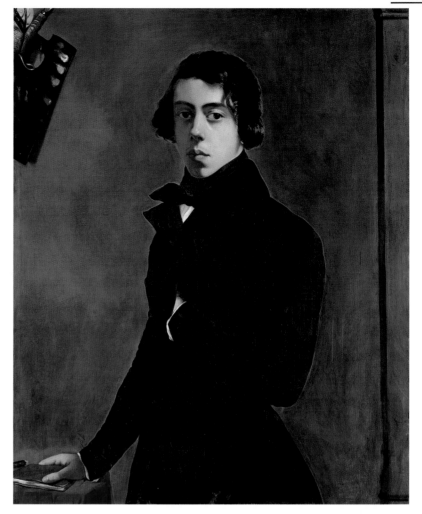

I

Portrait of the Artist in a Redingote

1835
Oil on canvas
39 x 32 ⅜ in. (99 x 82 cm)
Signed and dated, lower right: *T. Chassériau 1835;* inscribed erroneously, on the back of the stretcher: *Peint dans l'atelier d'Ingres, 1839* [Painted in Ingres's studio, 1839]
Paris, Musée du Louvre (RF 3788)

PROVENANCE:
Studio of the painter until his death; Frédéric Chassériau, the artist's brother, Paris, until 1881; Baron Arthur Chassériau, Paris; donated by the latter to the Musée du Louvre, 1933.

BIBLIOGRAPHY:
Chassériau himself referred to this painting in several albums now in the Louvre (RF 26054, fol. 23 r.; RF 26078, fol. 24; RF 26054, fol. 15 r.; RF 26080, fol. 5); Bouvenne 1887, p. 161; Chevillard 1893, no. 250, pp. 5–6; Vaillat 1907, ill. p. 188; Marcel and Laran 1911, p. 18; Burchard 1913, ill.; Vaillat 1913, p. 6, ill. p. 20; Escholier 1921, pp. 89–107; Goodrich 1928, ill.; Bénédite 1931, vol. 1, pp. 69–70, ill. p. 136; S.A.I., 282, ill.; C.P., p. 74; Sandoz 1974, no. 14, pp. 106–7, pl. 9; Sandoz 1986, pp. 84–85, 218–19, ill.; Cat. Somm. Ill., 1986, vol. 3, p. 131, ill.; Prat 1988-1, vol. 2, no. 2232, fol. 31 r., p. 811; Loire, Sahut et al. 1993, p. 141; Peltre 2001, pp. 7, 20, 52, 88, ill. 1; Rodrigo 2001, pp. 166–68.

EXHIBITIONS:
Paris, Orangerie, 1933, no. I, p. I, ill. at the back of the catalogue; Paris, 1976, no. I; Montauban, 1980, no. 136, p. 92.

Exhibited in Paris only

2

Portrait of the Artist Holding a Palette, or *Portrait of the Artist in Studio Garb*

1838
Oil on canvas
28 ¾ x 23 ½ in. (73 x 59.5 cm)
Signed and dated, top left: *T. Chassériau 1838*
Paris, Musée du Louvre (RF 3789)

PROVENANCE:
Studio of the painter until his death; Frédéric Chassériau, the artist's brother, until 1881; Baron Arthur Chassériau, Paris; donated by the latter to the Musée du Louvre, 1933.

BIBLIOGRAPHY:
Bouvenne 1887, p. 161; Bouvenne 1884, ill. p. 5; Chevillard 1893, no. 254; Marcel and Laran 1911, pp. 17–18, pl. I; Vaillat 1913, p. 6; Escholier 1921, pp. 89–107; Goodrich 1928, ill. p. 162; Bénédite 1931, vol. 1, pp. 92–93, frontispiece ill.; Udhe-Bernays 1946, ill.; S.A.I., 287, ill.; C.P., p. 74; Sandoz 1974, no. 39, p. 132, pl. 29, p. 133; Cat. Somm. Ill., 1986, vol. 3, p. 131, ill.; Prat 1988-1, vol. 2, no. 2232, fol. 31 r., p. 811; Peltre 2001, pp. 57, 59, ill. 63.

EXHIBITION:
Paris, Orangerie, 1933, no. 6, pp. 3–4.

Very few portrait drawings or paintings of Théodore Chassériau were made in his lifetime, and he appears in very few photographs. It is almost as if the man, because of some complex, pride, or the desire to maintain a polite distance, wanted to disappear behind his work. Aglaüs Bouvenne, the painter's faithful biographer, was surprised by this, and in 1893, while carrying out research on the artist of the *Tepidarium,* he prodded Nadar for a possible negative that the photographer had once taken of Chassériau:

How is it that I have not photographed Chassériau? I cannot say. It is certain that, when I began taking photographs in my large garden in the rue Saint-Lazare . . . Chassériau often came to see me. It is no less certain that, from then on, I had a receptive lens. . . . I am just as sure that I asked Chassériau to pose in the chair—and I must have done so more than once, because of the double attraction I felt for his work and toward him personally. At this distance in time, with my memory somewhat affected, I imagine that it must have been precisely his generosity, of which people could sometimes take advantage, that prevented Chassériau from availing himself of my offer. And the more I think about that selective character, that reserve, that delicacy in all things, the more I am convinced that Chassériau's discretion was the only thing that kept him from occupying a place alongside all the great painters of the time, whose pictures I have kept. For me—as for you—the absence of a portrait of him is heartbreaking. But you who loved him so much, that is, who knew him so well, don't you find that abstention just like him?[1]

The persistence of Bouvenne, who wrote several letters to Nadar,[2] and Nadar's explanations, which have a certain psychological acuity, illustrate the incomprehension of Chassériau's loved ones regarding the uneasiness the painter felt about his own image, despite the fact that he has been ranked among the most charming men of his time.

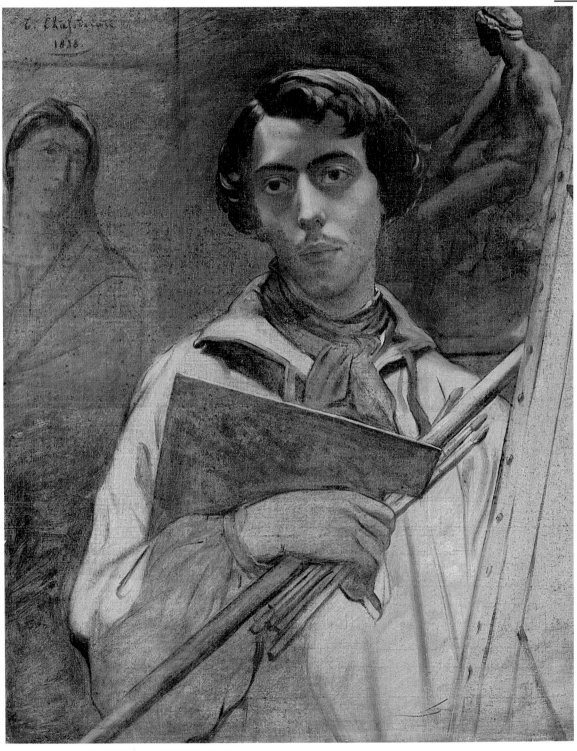

His alleged "ugliness" undoubtedly explains his attitude in part; all his contemporaries agree in acknowledging that he was not handsome. Even the women who loved him remarked on it. For example, according to Victor Hugo, Alice Ozy called Chassériau the "sapajou" (the monkey); and, forty years after the painter's death, Clémence Monnerot, then the comtesse de Gobineau, confirmed that he "was very ugly and very austere in his relationships" at the time.[3] We may also wonder whether the fact that he was Creole and perhaps "dark skinned"—to judge from the drawing from life done by A. Masson shortly before Chassériau's death (see fig. 1, p. 188)[4]—might explain, as much as his supposed ugliness, Chassériau's reluctance to have his physiognomy depicted. In any case, Jean Laran later summed up the general opinion regarding the apparent contradiction between the man's ugly external appearance and his distinguished character: Chassériau certainly "was not handsome . . . but the brightness of his gaze, the impassivity with which he disguised his restless and passionate nature, made a profound impression on all those who came near him."[5] In fact, it is certain that everyone who met Chassériau spoke more of his elegance and refinement, and of the nobility that overshadowed his looks: Clémence Monnerot, for example, insisted on the intensity of his charm, which resulted from the fact that "slovenliness alarmed him," and because he "was elegant and behaved very correctly."[6] In addition, he was commended for his courage and intelligence. Henri Lehmann, before he became violently angry with him, praised "the merit and beauty of his talent, the force of his youthful will, the sensitivity of his heart, [and] the nobility of his feelings and thoughts, which he renders with an originality and quick-wittedness that equals the charm of his naturally distinguished manners."[7] Some time later, Lehmann's mistress, Marie d'Agoult, confirmed her impressions of the painter to her lover: "The same tact, the same distinction in conversation, the ease of a man who might have spent his life in the best company. . . . What astounds me much more than his talent is his knowledge of the world, since obviously his manner of behaving is the result of reflection and of a shrewdness that I have never encountered before."[8]

Given Chassériau's aversion to seeing his unattractive physical appearance depicted and the undeniable charm that he radiated, the two self-portraits the painter executed in his youth are interesting works not only aesthetically but also in human and psychological terms.

The painter himself dated the later of the two portraits to 1835; the date of 1839, sometimes proposed by biographers and which appears in a later inscription on the stretcher, as well as the date of 1838, which seems to have arisen from a confusion with the other self-portrait,[9] are thus completely erroneous. Although Marc Sandoz, echoing Valbert Chevillard, mentions an oil sketch (now lost)[10] and a preliminary drawing, dismissed by Louis-Antoine Prat,[11] as studies for this self-portrait, the exact conditions that led to the execution of that early work remain unknown (the painter was sixteen years old at the time).

In depicting himself, Chassériau's wish seems to have been to sum up the ambivalence of his contemporaries: He did not hide the unattractiveness of his face, which is painted realistically, without concessions or embellishments, and he emphasized his thick lips and broad nose, but he also portrayed himself with a certain elegance, his left hand aristocratically concealed inside his jacket, his right hand holding a small book. At face level, and partly outside the focal point of the painting, he included a palette, the emblem of his craft. Some have spoken of his "gaze, astonishingly young and, at the same time, weary,"[12] yet the portrait is not a Romantic manifesto but rather a tribute to the classical tradition and to Renaissance portraiture: One thinks of the paintings of Raphael and of Bronzino (*Portrait of a Sculptor;* Musée du Louvre) as much as of Titian—as well as of sixteenth- and seventeenth-century Spanish examples. Its construction and balance also remind us that Chassériau was the heir to Ingres and before him to David—and, hence, to French Neoclassicism. In addition, the self-portrait has frequently been compared (by both Ternois and Sandoz) to Ingres's self-portrait painted in Rome during his youth (Chantilly, Musée Condé). In its technique, its dimensions, and the atmosphere that it describes, this self-portrait continues the tradition of family portraits painted by Chassériau before 1838 (cat. 3, 4).

The painter's other self-portrait is clearly distinguished from that Neoclassical aesthetic; one senses that Chassériau's ideas had matured a great deal between 1835 and 1838, the date on this work, which is also signed. Its date can also be confirmed by the figure of the Virgin in the middle ground, which may be the *Virgin* rejected by the jury of the Salon of 1838 (see fig. 3, p. 36). Favoring a more natural setting, Chassériau surrounded himself with the attributes of his craft—palette, paintbrush, handrest, and easel—in the act of painting in his studio in the rue Saint-Augustin in Paris. His pose is very simple, and he depicted himself in half length, behind his easel, looking into the distance, as if he were scrutinizing an imaginary model in front of him. In the background, the Virgin's head and a figure from Antiquity evoke the poetic ambiance of the studio. Unlike the earlier self-portrait, the painter seems to have idealized his image somewhat; his face is slightly in shadow, with a rather Romantic expression, the features almost embellished. The choice of grisaille further reinforces the spontaneous, natural, and Romantic aspect of this self-portrait, which, it may be said without hesitation, compares favorably to nineteenth-century masterpieces of the genre: the self-portraits by David, Ingres, Corot, and Delacroix.

V. P.

1. Letter from Nadar to Aglaüs Bouvenne, March 17, 1893, Hermitage of Senart; Musée du Louvre, Département des Peintures, Service d'Étude et de Documentation, "Fichier Moreau-Nélaton." Some time later, Bouvenne received a letter from Nadar that nevertheless mentions a portrait drawing after Chassériau: "Speaking very seriously, my friend, I declare, assert, and swear to you that all I remember about the portrait of Chassériau is that it is a . . . portrait given, and, I think, done by him, showing him in profile and wearing a hat" (Letter from Nadar to [Aglaüs Bouvenne], n.p., n.d. [about 1893–95], Musée du Louvre, Département des Arts Graphiques, aut. 3357, no. AR5 L1).
2. Sometime later, Nadar again had to defend himself from a final attack by Bouvenne on the subject, this time mentioning a caricature he himself

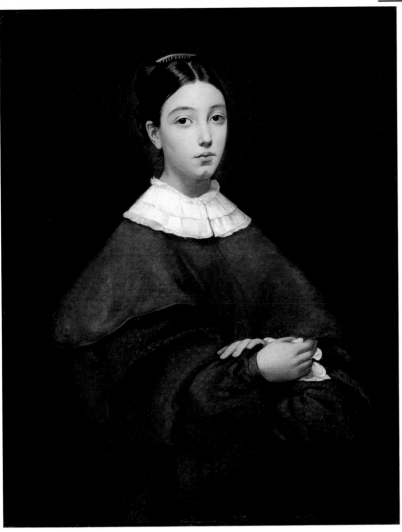

had made of the artist: "My dear Bouvenne, you possess a certain Genius for perseverance pushed to the point of obstinacy, which I would very much like to have a bit of, for my own use! . . . I have only ever remembered and I persist in only remembering a very small outline [drawing] that served as a woodcut for the issue of *Pour rire* that you have just found" (Letter from Nadar to Bouvenne, n.p., n.d., Musée du Louvre, Département des Arts Graphiques, aut. 3358, no. AR5 L2).

3. Letter from the comtesse de Gobineau (née Clémence Monnerot) to [Valbert Chevillard], Paris, July 12, 1893 (whereabouts unknown); quoted in Bénédite 1931, vol. 1, pp. 101–2.

4. Drawing illustrated in A. Bouvenne, "Théodore Chassériau," in *L'Artiste,* vol. 2 (September 1887), p. 174.

5. Marcel and Laran 1911, p. 17.

6. See note 3, above.

7. Letter from Henri Lehmann to Marie d'Agoult, August 19, 1840, Naples; quoted in S. Joubert, *Une Correspondance romantique. Madame d'Agoult, Liszt, Henri Lehmann* (Paris: Flammarion, 1947), pp. 112–14.

8. Letter from Marie d'Agoult to Henri Lehmann, March 1 and 2, 1841 [Paris]; quoted in S. Joubert, *Une Correspondance romantique. Madame d'Agoult, Liszt, Henri Lehmann* (Paris: Flammarion, 1947), pp. 155–60.

9. Marcel and Laran 1911, p. 18.

10. Sandoz 1974, no. 15, p. 106.

11. Prat 1988-1, vol. 2, no. 2232, p. 811, regarding notebook RF 26055, fol. 31 r.

12. Rodrigo 2001, p. 167.

3

Portrait of Aline Chassériau (1822–1871), the Painter's Sister, at the Age of Thirteen, formerly known as *Adèle Chassériau*

1835
Oil on canvas
36 ½ x 29 in. (92.5 x 73.5 cm)
Signed and dated, lower left: *T. Chassériau 1835*
Paris, Musée du Louvre (RF 2212)

PROVENANCE:
Family of the painter; Frédéric Chassériau, the artist's brother, Paris, until 1881; Baron Arthur Chassériau, Paris; donated by the latter and his wife to the Musée du Louvre, 1918.

BIBLIOGRAPHY:
Chassériau himself referred to this painting in several albums now in the Louvre: RF 26054, fol. 23 r.; RF 26078, fol. 24; RF 26054, fol. 15 r.; Chevillard 1893, no. 256 (described as a portrait of Adèle Chassériau); Bouyer 1920, p. 529; Jamot 1920, pp. 65–68; Goodrich 1928; Bénédite 1931, vol. 1, pp. 201–2, ill. p. 203 (described as a portrait of Adèle Chassériau); Blanche 1933; S.A.I., 286, ill.; C.P., p. 73; Sandoz 1974, no. 20, pp. 112, 113, pl. 14 (described as a portrait of Aline Chassériau); Cat. Somm. Ill., 1986, vol. 3, p. 130, ill.; Sandoz 1986, pp. 50–51, ill.; Prat 1988-1, pp. 436–37 (regarding the model and a portrait drawing); Peltre 2001, p. 18, ill. 13.

EXHIBITIONS:
Paris, Orangerie, 1933, no. 3, p. 2 (described as a portrait of Adèle Chassériau); Paris, Seligmann, 1934, no. 58; Montauban, 1967, no. 180; Poitiers, 1969, no. 3; Paris, 1976, no. 2; Montauban, 1980, no. 180, p. 111.

Portrait of Ernest Chassériau (1823–1870), the Painter's Brother, in the Uniform of the École Navale in Brest, at About the Age of Thirteen

about 1835–36
Oil on canvas
36 ½ x 28 ¾ in. (92.5 x 73 cm)
Signed, lower left: *T. Chassériau*
Paris, Musée du Louvre (RF 3787)

PROVENANCE:
Family of the painter; Frédéric Chassériau, the artist's brother, Paris, until 1881; Baron Arthur Chassériau, Paris; donated by the latter to the Musée du Louvre, 1933.

BIBLIOGRAPHY:
Chassériau himself referred to this painting in several albums in the Louvre: RF 26078, fol. 24; RF 26054, fol. 15 r.; RF 26054, fol. 23 r.; Chevillard 1893, no. 53; Vaillat 1913, p. 6, ill. p. 1; Bénédite 1931, vol. 1, ill. p. 74; Alazard 1933, ill. p. 47; S.A.I., 284, ill.; C.P., p. 73; Sandoz 1974, no. 29, pp. 124, 125, pl. 21; Cat. Somm. Ill. 1986, vol. 3, p. 131, ill.; Sandoz 1986, pp. 50–51, ill.; Peltre 2001, p. 18, ill. 14.

EXHIBITIONS:
Salon of 1836, part of no. 338; Paris, Orangerie, 1933, no. 2, pp. 1–2; Poitiers, 1969, no. 1.

Exhibited in Paris only

During his brief life, Théodore Chassériau always remained close to his family, not only because he was a bachelor but particularly as a result of the permanent absence of his parents, which had cemented the affection and trust between him, his two brothers, and his two sisters. Thus, during his adolescence and at the start of his career as a painter, he always felt an almost amorous admiration for his two sisters: the elder, Marie-Antoinette (1810–1869), nicknamed Adèle in memory of one of her aunts; and the younger, Geneviève (1822–1871), called Aline in memory of a friend of her mother's. We know that the young painter was "merciless as far as their appearance was concerned and very serious" with both of them.[1] Clémence Monnerot, the future comtesse de Gobineau and one of the painter's first loves, witnessed Théodore's jealous attentions toward his sisters, and later recounted the long sessions to which she was subjected as she posed alongside them for various paintings by the artist : "Adèle, Aline, and I were Théodore's models for many years. He drew at night under lamplight and posed us as he liked. Adèle had superb arms; they appear everywhere. . . . Well, yes! They are, too, young ladies, his two idealized sisters and their friend, whom he worshipped."[2]

For a long time, the painter's biographers believed that the present portrait, with its studied sobriety in the model's pose and superb simplicity in the treatment of light —the execution of the hands, for example, which appear as two lively bright spots against a dark ground, is unparalleled—depicted Adèle, his elder sister. Vaudoyer later remarked that the painter was "haunted, perhaps unbeknownst to himself, by [her] particular beauty," and thus she "appear[s] in most of his works": "The Desdemona in the series of etchings inspired by *Othello* is Adèle. . . . The Esther has Adèle's muscular, almost masculine, arms. The only figure that survives from *The Death of Cleopatra* is again Adèle. There she is, on the beach where the *Trojan Women* are wailing; and there, on the walls of the Cour

des Comptes, lifting the laurel branch and the lyre, or clasping a beautiful naked child to her."[3]

Blinded by their view of the almost incestuous relationship between the brother and his big sister, historians forgot to compare the present portrait with drawings by the painter, such as one in a notebook (now in the Louvre), which appears to be a quick sketch of the present portrait[4] and is annotated to indicate that it depicts Aline. In addition, scholars did not give a moment's thought to the age of each of the sisters. In 1835—the date was confirmed by the painter himself—Adèle was twenty-five and Aline only thirteen. The young girl shown here undeniably is still an adolescent. In another drawing, in graphite, of the same model as in the painting, Chassériau represents her full-face and standing, which thus definitively confirms her identity:[5] It is the younger sister, Aline, who never married, and who died during the Commune in Bordeaux, where she had sought refuge.

Marc Sandoz, the first to ascertain the true identity of the model for this early portrait, mentions Ingres's influence—this, at a time when Chassériau had recently stopped taking lessons from his master.[6] However, the portraits by Italian Renaissance artists from Raphael to Bronzino, in which brightly painted figures against a dark background are common, and works by the Spanish painters, whom Chassériau had particularly studied, are the most obvious sources of this very refined picture. Chassériau rejected the effects of color in favor of values and strong contrasts of light and shadow—an aesthetic that would be adopted by Corot, Courbet, and Millet, in their representations of the human figure.

Often, in the letters that Théodore Chassériau wrote, as a child, to his "dear Papa," he sent "kisses to Aline and Ernest," attesting to his fondness for his two younger siblings, born, respectively, three and four years after him. Throughout his life, he was also very close to his little brother, whom he used as a model for one of his first portraits, a rather clumsy painting no doubt executed very early on[7] as a first attempt for the present one, and then for the two very beautiful mature drawings, executed in 1847 and 1850.[8]

In fact, we know little about "fat Ernest," painted here at the age of twelve or thirteen, except that he was, in fact, a student at the naval academy in Brest, and later became battalion chief of the Marine Light Infantry, before being killed at the battle of Bazeilles, near Sedan, on September 1, 1870.[9] The shadow of their father's career hovered over those of his two sons, since Ernest, no doubt aided by his brother Frédéric, also worked for the Ministry of the Navy, where Benoît Chassériau had served for many years as a diplomat as well as an adventurer.

Skillfully composed, when one considers that the artist was only seventeen—Ernest Chassériau is shown slightly bent over, leaning on a chair, with all his weight on one foot—this portrait may have been selected by Chassériau to represent him at the Salon of 1836, the first time in his career that he participated in an exhibition. The same year, he exhibited two religious paintings, *The Punishment of Cain* (private collection) and *The Return of the Prodigal Son* (La Rochelle, Musée des Beaux-

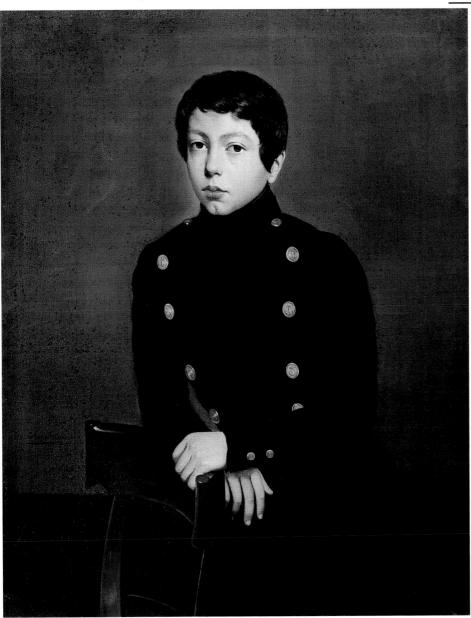

Arts), as well as another portrait, probably of Émmanuel Arago. In any case, Marc Sandoz[10] rightly insists on the parallels between this portrait—specifically, its setting and the artist's aesthetic choices—and those painted by Corot (*The Schoolboy;* Paris, Musée du Louvre) and Millet in their youth. **V. P.**

1. Letter (whereabouts unknown) quoted in Bénédite 1931, vol. 1, pp. 101–2.
2. Ibid.
3. J.-L. Vaudoyer, in Paris, Orangerie, 1933, pp. xviii–xix.
4. Paris, Musée du Louvre, Département des Arts Graphiques, notebook RF 26080, fol. 2.

5. Paris, Musée du Louvre, Département des Arts Graphiques, RF 27969. On this matter, one also should mention the *Portrait of Adèle Chassériau* (present whereabouts unknown) cited in Prat 1988-1, vol. 1, p. 42, fig. 2 [the confusion introduced in the caption to this photograph is corrected in an erratum at the back of the book].
6. Sandoz 1974, no. 20, p. 112; the author of the Chassériau catalogue raisonné points out the connection to the *Madame Place* by Ingres.
7. Paris, Musée du Louvre, Département des Peintures, RF 3854; the portrait was bequeathed by Baron Arthur Chassériau, 1934.
8. Paris, Musée du Louvre, Département des Arts Graphiques, RF 27972, RF 27973 (see Prat 1988-1, vol. 1, nos. 1075, 1076, pp. 441–42).
9. Not Buzenval, as is sometimes given.
10. Sandoz 1974, no. 29, p. 124.

5

Portrait of a Spanish Woman

(copy after a painting formerly attributed to
El Greco, known as *The Daughter of El Greco*)

1834–38
Oil on canvas
29 ⅛ x 22 ⅞ in. (74 x 58 cm)
Private collection

PROVENANCE:

Alice Ozy; studio of the painter until his death; according to
Bouvenne, Chassériau sale, Paris, Hôtel Drouot, March 16–17,
1857 (no. 28, "Drafts and various studies"), sold to an "uncle" of
the painter, no doubt his cousin Frédéric (no. 28 was sold in two
separate lots, for Fr 71 and 645, respectively, as noted in an anno-
tated copy of the sales catalogue, Cabinet des Estampes,
Bibliothèque Nationale de France, Yd 929a, in 8°; it is not clear
which of the two lots was acquired by Frédéric Chassériau);
Baron Arthur Chassériau, Paris; Alice Ozy, Paris, the gift of
Baron Arthur Chassériau (according to Bouvenne and Vaudoyer);
mentioned in no. 424 of the inventory drawn up after Alice Ozy's
death (ms. no. 6178, Avignon, Musée Calvet; acquired at the sale
of the collection of the daughter of Alidor Delzant, confidant of
Alice Ozy and executor of her will, Hôtel Drouot, November 15,
1966); bequeathed by Alice Ozy to Baron Arthur Chassériau
(according to Bouvenne and Vaudoyer); Baron Arthur
Chassériau, Paris, until 1934; his descendants, who offered it for
sale in 1995 (Copy after *El Greco's Daughter,* Christie's, London,
June 16, 1995, lot 121, pp. 64–66), but it remained with the pain-
ter's descendants; Paris, private collection.

BIBLIOGRAPHY:

Bouvenne 1887, pp. 162–63; Chevillard 1893, pp. 168–73; Vaillat
1907, p. 177; Vaudoyer 1930, pp. 67–69, 106–7; Bénédite 1931,
vol. 2, pp. 390–92, ill. p. 382; La Tourette 1931; Vaudoyer, in Paris,
Orangerie, 1933, pp. 27–28; Boyé 1946, pp. 240–41; Sandoz
1967, p. 80; Sandoz 1974, no. 6, pp. 100, 101, pl. 4; Baticle et al.,
in *La Galerie espagnole de Louis-Philippe, 1838–1848* (Paris, 1981),
no. 268, pp. 173–74 (the El Greco painting); Sandoz 1982, p. 27,
fig. 12; Randall 1995, pp. 48–49; Peltre 2001, p. 23, ill. 19, p. 231,
notes 28–30.

From the outset, when he sought paintings to study or
copy, during his apprenticeship with Ingres, Chassériau
understood the originality and creativity of Spanish
painting. This is evident in a graphite copy (Musée du
Louvre), dated September 1832—the artist was only thir-
teen years old at the time—of the *Portrait of an Infanta,*[1]
possibly attributable to Pantoja de la Cruz (according
to Sandoz). In the same period, he made another drawing,
after a Spanish portrait, which bears an annotation that
refers to Velázquez,[2] as well as a copy after a Spanish
painting previously attributed to Morales, *Christ Bearing
the Cross* (La Rochelle, Musée des Beaux-Arts). Interest
in Spanish painting was revived in France under the
Empire, as attested by a few private collectors, such as
Marshal Soult, and then, during the Restoration, by the
opening of Louis-Philippe's Spanish Gallery. The qual-
ities of realism and technical precision in these works
inspired Chassériau, who often applied the aesthetic of
artists from the Iberian Peninsula to his portraits (see
cat. 3, 12, 47). In reference to the present copy, his biog-
rapher Aglaüs Bouvenne noted in March 1884: "Théodore
Chassériau had made a copy after Domenicos
Theotocopoulos, known as El Greco, of a woman's head,
which was in the Spanish Gallery at the Louvre. . . .
Ingres, to whom the young Chassériau had shown that
copy, was so pleased with it that, from that moment on,
he wanted to take on the young artist."[3] Then Bouvenne
added a very romantic anecdote attesting to Chassériau's
love life and related to this copy: "Chassériau was very
fond of it because his Master, Ingres, had recommended

that he never part with it. . . . Madame Ozi [Ozy], whom
Chassériau loved very much, and whom he could not
refuse anything, had such a great desire to see that El
Greco copy that he was obliged to give it to her; once in
possession of the desired copy, she had it placed in a
superb frame and invited a few friends to dinner to see
this new work of art, which she hung in the dining room
in the center of the large wall. Théodore Chassériau,
being a regular visitor to the house, came early; when he
saw his cherished copy on display in someone else's home
. . . he was heartbroken and . . . turned toward the table,
picked up a knife, furiously slashed the canvas, and left;
he never went back to that house. . . . The canvas was
returned to him by its owner."[4]

Hence, the connection between the painting exhib-
ited here—which is undoubtedly the same one men-
tioned by Bouvenne, as the slash marks are still visible and
the provenance is consistent—and the copy made by
Chassériau after a painting by El Greco in Louis-Philippe's
Spanish Gallery was established by the painter's biogra-
pher in a peremptory manner. Since then, the present
work generally has been linked to the portrait called *El
Greco's Daughter,* which was said to have been exhibited
in the Spanish Gallery beginning in 1838.

Nevertheless, it should be noted that the attribution
to El Greco of the painting that had served as Chassériau's
point of reference is not self-evident stylistically. As early
as 1974, Marc Sandoz[5] asserted that the work could not
be a portrait of El Greco's daughter, and described it as
"[a painting] not currently known among El Greco's
works." On the basis of recent discoveries, he proposed
a connection, instead, to *The Lady in Ermine,* a painting
by the same artist that was, indeed, no. 268 in the Spanish
Gallery,[6] although erroneously labeled "Portrait of the
daughter of El Greco. H. 62 cm–W. 46 cm." However,
studies would follow by Jeannine Baticle, Cristina
Marinas, and Claudie Ressort of Louis-Philippe's col-
lection of Spanish paintings,[7] and, in 1981, they would
certainly confirm that the Spanish Gallery portrait did
not depict El Greco's daughter—its official title was now
The Lady in Ermine—but at the same time they
renounced any association with Chassériau's version by
publishing a photograph of El Greco's original,[8] to show
that the work acquired by Louis-Philippe is completely
different from the one Chassériau copied.

In addition, in the story recounted by Bouvenne other
facts do not add up, as, for example, the date of the
painting's execution. Bouvenne claims that the copy
was shown to Ingres, which would suggest that Chassériau
was still the latter's pupil—or at least in regular contact
with him—and would imply that the work was finished
before his teacher left for Rome in 1834. However,
Louis-Philippe's Spanish Gallery was not open to the
public—and, hence, to artists—until January 7, 1838,
and in 1834 El Greco's *The Lady in Ermine* was still in
Spain: It was brought to France with the return of one
of the missions led by Baron Taylor and the painter
Dauzats, which took place between November 1835
and September 1836 and between October 1836 and
April 1837.

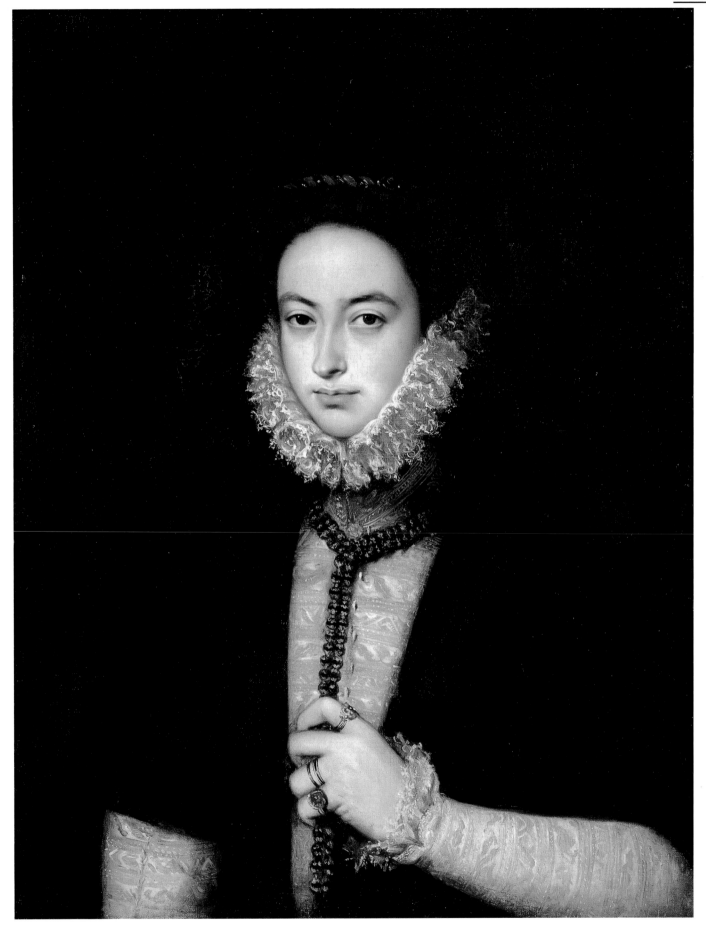

Thus, Bouvenne's anecdote appears to relate to another painting, although there also may have been some confusion among the stories concerning several of Chassériau's works. I am therefore confident that the painter, in executing the present copy, took as his model a different portrait from the one by El Greco on view at the time in Louis-Philippe's gallery, and I believe that he may have executed it either before 1838, when he perhaps had access to one of the rare collections of Spanish painting in Paris, or after 1838, working in the Spanish Gallery itself.

Certain authors (Sandoz and Randall, for example) have proposed other sources for the picture, such as the works of Alonso Sánchez Coello (1531–1588), whose aesthetic does seem quite similar. We do know that a few portraits (now lost) by that painter, which could have corresponded to the painting by Chassériau,[9] were exhibited in Louis-Philippe's Spanish Gallery. Some critics also have pointed out the similarity between the present copy and Sánchez Coello's dual portrait *The Infantas Clara Eugenia and Catalina Micaela* (Madrid, Museo del Prado).[10] In addition, the connection between the Chassériau painting and several of the portraits of women that Charles Sauvageot donated to the Louvre (MI 800, MI 807, and MI 810) demonstrates that it is that direction we need to pursue: By identifying the portrait of a lady from the court of Spain painted by Sánchez Coello or by artists associated with him we perhaps will find the painting that served as Chassériau's model.

Despite the basic uncertainty regarding the exact circumstances under which this work was painted as well as the one that served as its model, we must of course consider it a witness to the stormy relationship between the painter and Alice Ozy. The story told by Bouvenne was repeated by all subsequent authors, thus creating part of the legend of Chassériau's love affairs. Most of the painter's biographers consider the anecdote authentic,[11] both because of the slash marks still apparent on the canvas, and especially because of the belated testimony of Alice Ozy herself, reported by Baron Arthur Chassériau to Jean-Louis Vaudoyer: "Among his uncle's works, assembled by M. Arthur Chassériau with fervent patience and obstinate devotion, was the notorious 'copy of El Greco' over which the two lovers had long ago quarreled. The aged and unhappy Alice, seeing that painting, burst into sobs and fell to her knees in front of the canvas." It was following this encounter that Baron Arthur entrusted the Chassériau copy to Alice, who kept it in her home on the boulevard Haussmann until her death. "It took thirty-five years for it to come back to me! I hope Théodore has forgiven me!" she repeated at the time.[12] Upon Alice Ozy's death, the work finally rejoined the collection of Baron Arthur Chassériau, before being passed on to his descendants.[13] V. P.

1. Musée du Louvre, Département des Arts Graphiques, RF 26444; discussed and illustrated in Prat 1988-1, vol. 2, no. 2199.
2. Musée du Louvre, Département des Arts Graphiques, RF 26430; discussed and illustrated in Prat 1988-1, vol. 2, no. 2202.
3. Unpublished note by Aglaüs Bouvenne, March 1884, Paris, Musée du Louvre, Documentation du Département des Peintures, "Fichier Moreau-Nélaton." The anecdote was repeated by A. Bouvenne, "Théodore Chassériau," in *L'Artiste*, vol. 2 (September 1887), p. 163.
4. Unpublished note by Aglaüs Bouvenne, March 1884; ibid.
5. Sandoz 1974, no. 6, p. 100.
6. Sandoz gave the number as 259 in error.
7. *La Galerie espagnole de Louis-Philippe, 1838–1848* (Paris, 1981), no. 268, pp. 173–74.
8. That portrait of El Greco is now in a Scottish collection.
9. *A Lady from the Court of Philip II* (19 ¾ x 15 ¾ in. [50 x 40 cm]), no. 444, sold in 1853 (no. 367); *Queen Isabella la Católica* (dimensions unknown), no. 445, sold in 1853 (no. 148).
10. See the sale catalogue, Christie's, London, June 16, 1995, lot 121, p. 66.
11. Bénédite 1931, vol. 2, p. 391. Christine Peltre, in her recent monograph devoted to the painter (Paris, 2001), cites a beautifully written unsigned letter (Bibliothèque Doucet, carton 97: "Paris, May 4, 1887") that she attributes to Alice Ozy's lawyer and confidant, A. Delzant, who also reports on the scene: "At a time when they were getting along well, Ozi persisted in wanting and obtained it. At the dinner table the next day, she was speaking of the prize in front of Chassériau. Furious, he stood up, grabbed a sharp knife, and slashed the canvas. The slash marks in the face are still visible, despite the restoration."
12. That episode is reported in J.-L. Vaudoyer, *Alice Ozy ou l'Aspasie moderne* (Paris, 1930), pp. 67–69, 106–7.
13. "One of the painter's uncles purchased it at the sale after Theod [*sic*] Chassériau's death in 18[57]; when the uncle died, it was Baron Chassériau who inherited it [and] the painting was added to the number of studies and sketches he already owned. His son Arthur Chassériau, who was passionately interested in his cousin's fame, became the owner of that copy of El Greco. Through his research on the works of Th. Chassériau, M. Arthur Chassériau had occasion to meet the person who had owned the copy for a time. When she learned it was in the possession of M. Arthur Chassériau, she wouldn't rest until she owned it again. She achieved this through a trade, offering a painting by the same master, and again saw the painting that brought back so many memories! . . . She bequeathed it to M. Arthur Chasseriau, saying rightly that the copy ought to remain in the family" (note by Aglaüs Bouvenne, March 1884; Paris, Musée du Louvre, Documentation du Département des Peintures, "Fichier Moreau-Nélaton").

6

Portrait of Jennins

1838
Graphite
12 ½ x 9 ¼ in. (31.8 x 23.5 cm)
Dedicated, signed, and dated in graphite, lower left: *a mon ami /
Jennins / T. Chassériau / 1838* [to my friend / Jennins / T.
Chassériau / 1838]
New York, The Metropolitan Museum of Art, Rogers Fund, 1946
(46.177.1)

BIBLIOGRAPHY:
Sandoz 1974, p. 78, Wg. 30; Sandoz 1986, no. 4, ill.; Prat 1988-2,
no. 32.

Exhibited in Strasbourg and New York

This is among Chassériau's first portraits in graphite, in
the manner of Ingres. The artist was only nineteen years
old when he drew this young man, who probably was one
of his friends, but about whom we know nothing more.

L.-A. P.

7

Portrait of Raymond-Philibert de Ranchicourt at One Year Old

1839
Graphite
13 ⅜ x 10 ⅝ in. (34 x 27 cm)
Signed and dated in graphite, right center: *Th. Chassériau / 1839*
Paris, Private collection

PROVENANCE:
Given by Chassériau to his friends the Ranchicourts; the sitter's
family, until 1995; Paris, Galerie Brame et Lorenceau; Paris, pri-
vate collection.

BIBLIOGRAPHY:
Chevillard 1893, no. 299; Sandoz 1974, p. 11; Sandoz 1986, no. 229
A, ill.; Prat 1988-1, vol. 2, under no. 2229, fol. 16 r.; Prat 1988-2,
no. 37, ill.

Exhibited in Paris only

The child depicted here, with an ease of composition
that is astonishing in a twenty-year-old artist, was the
only son of the Ranchicourts, Chassériau's closest friends
(cat. 210). Born in 1838, he would die at thirty-one, in
1869. He married Marguerite Chazot, with whom he had
a son, Pierre, whose descendants—through his daugh-
ters—still survive.

When the comtesse de Ranchicourt, Raymond-
Philibert's mother, died in 1858, Frédéric Chassériau, the
painter's elder brother, sent Raymond-Philibert a very
affectionate letter that was kept in the family.

In its subject matter, the drawing can be compared
with two portraits by Ingres of Marie Marcotte, the
daughter of his good friend, at the age of fifteen months
(New Haven, Yale University Art Gallery, and Paris, pri-
vate collection); also seated in a high chair, the little girl
is seen full face and looks intently at the spectator, as
does young Raymond, here. He has suddenly been dis-
tracted from his picture book, and his particularly pen-
etrating gaze expresses an awakening curiosity.

L.-A. P

CAT. 6

CAT. 7

8

Portrait of a Young Boy Seated in an Armchair

1839
Graphite with stumping
12 ¼ x 9 ⅜ in. (31 x 23.7 cm)
Signed and dated, left center: *T. Chassériau 1839*
Paris, Musée du Louvre (RF 24465)

PROVENANCE:
See cat. 20 (no mark L. 443)

BIBLIOGRAPHY:
Chevillard 1893, part of no. 420; Bénédite 1931, vol. 2, ill. p. 497; Sandoz 1974, p. 11; Sandoz 1986, no. 230, ill.; Prat 1988-1, vol. 1, no. 1063, ill.

EXHIBITIONS:
Paris, Orangerie, 1933, no. 92 *bis*; Paris, Louvre, 1957, no. 9.

Exhibited in Strasbourg only

Critics have all agreed on the pronounced Ingresque character of this portrait. Its date is surprising, given the great skill the twenty-year-old artist displays in composing the figure.

A resemblance can be seen between the child seen here and the young Victor-Auguste Duperré, whom Chassériau depicted three years later (cat. 58).

L.-A. P

9

Portrait of a Young Boy, traditionally called *The Artist's Color Grinder*

1839
Oil on canvas
18 ⅛ x 14 ¾ in. (46 x 37.5 cm)
Signed and dated, bottom right: *Th^re Chassériau 1839*
Paris, Musée du Louvre (RF 3862)

PROVENANCE:
Gift of the painter to Alice Ozy (according to Sterling, in Paris, Orangerie, 1933); Alice Ozy, Paris, until 1893; bequeathed by the latter to Baron Arthur Chassériau (according to Sterling); Baron Arthur Chassériau, Paris; bequeathed by the latter to the Musée du Louvre, 1934; placed on deposit in the Musée National des Beaux-Arts, Algiers, October 8, 1935; returned to the Louvre, 1962.

BIBLIOGRAPHY:
Chevillard 1893, possibly no. 226 *(Head of a Young Man);* Vaillat 1913, ill. p. 4; Bénédite 1931, vol. 1, ill. p. 48; C.P., p. 74; *Catalogue du Musée des Beaux-Arts d'Alger* (Algiers, 1936), no. 1718; Sandoz 1974, no. 50, pp. 146, 147, pl. 39; Cat. Somm. Ill., 1986, vol. 3, p. 132, ill.

EXHIBITION:
Paris, Orangerie, 1933, no. 9, pp. 5–6.

Exhibited in Paris only

The identity of the model for this robust and realistic portrait is difficult to establish, since two different versions have been recorded by the painter's biographers. Charles Sterling, in the catalogue of the Paris exhibition of 1933,[1] asserts that he was a young apprentice to Chassériau, a color grinder, who became an assistant, employed by the painter for many years, and who reportedly died after a fall from the scaffolding during the execution of the decorative program at Saint-Philippe-du-Roule in Paris. Marc Sandoz[2] suggests that the sitter was instead an apprentice in Ingres's studio. In fact, the two versions are in no way contradictory, since Chassériau might very well have hired an apprentice he met in his teacher's studio to grind his colors.

In any case, the painter's precise and careful style, and the obvious desire to capture a personality and particular character traits, might lead us to consider this work a portrait as much as a preliminary study for a figure in a future composition. Adolescents are, in fact, frequently found among the figures in the painter's large history paintings, and Chassériau generally made preparatory studies for the figures by working from models, professional or not. To cite only two examples, one thinks of the groups of angels in the *Christ on the Mount of Olives* in the church at Saint-Jean-d'Angély (cat. 18, 19) or of the young boy holding a bowl at the left in the *Saint Francis Xavier Baptizing the Indians* in the paintings in the Church of Saint-Roch in Paris (cat. 223, 224).[3]

The present canvas is without doubt one of the most interesting in this series of studies, because of its realism, its simplicity, and its charm. A strange melancholy emanates from the sad eyes of the young sitter. His languor, moreover, cannot fail to evoke that of the painter himself, who was perhaps touched by the resonance between the young model's almost disillusioned expression and his own fate as a child prodigy with regard to painting. L.-A. P

1. Paris, Orangerie, 1933, p. 5.
2. Sandoz 1974, no. 50, p. 146.
3. Ibid., no. 236, p. 376.

Portrait of Mme Monnerot the Elder

1839
Graphite
10 ¼ x 8 ¼ in. (26 x 20.9 cm)
Dedicated, signed, and dated in graphite, right center: *a mon ami / Jules / T. Chassériau / 1839* [to my friend / Jules / T. Chassériau / 1839]
New York, The Brooklyn Museum of Art, Gift of John S. Newberry, 1958

PROVENANCE:
Mme Monnerot; her daughter Clémence Monnerot, Comtesse Serpeille de Gobineau; her heirs; Jacques Seligmann, New York; John S. Newberry, Jr. (*French Nineteenth Century Drawings and Watercolors at the Brooklyn Museum,* exhib. cat. [New York, 1993], no. 26, ill.).

BIBLIOGRAPHY:
Newberry 1950, pp. 161–62, ill.; Sandoz 1986, no. 7, ill.; Prat 1988-2, no. 34.

EXHIBITION:
Paris, Orangerie, 1933, no. 230.

Exhibited in New York only

Born Lucia Victoire de Tourolles, Mme Monnerot was the mother of two of Chassériau's friends: Jules, whose portrait he drew in 1852 (cat. 209), and Clémence, the future comtesse de Gobineau, who often served as his model, and was particularly close to the artist's two sisters, Aline and Adèle. A letter from Clémence de Gobineau to Baron Arthur Chassériau, published by Bénédite (1931, vol. 1, pp. 101–2), attests to the regularity and importance of the connections between the two families:

Paris, July 12, 1893
Dear Sir,
I thank you for remembering me and am very grateful for the beautiful book you sent me. I read it all and might have written it myself from start to finish, as there is not a single line that is unfamiliar to me. Reading it took me back fifty-five years into the past. From 1837 to 1840, Théodore spent all his evenings at my mother's home. We were close to his family, as you can see by the fact that he sent us rosaries from Rome through Lacordaire. My mother had large estates in Puerto Rico in Mayagüez, and M. Chassériau, the consul, begged my brother to go see his family in Paris. That was the beginning of our close relationship. Adèle, Aline, and I were Théodore's models for many years. He drew at night under lamplight and posed us as he liked. Adèle had superb arms; they appear everywhere, and the poor old woman writing to you, who was the same age as Théodore, posed entirely for his Mary of Egypt. Théodore, who made so many portraits, never wanted to do mine, although I can be found everywhere in Saint-Philippe-du-Roule, in the *Descent from the Cross.* When he returned from Rome, we saw each other less often. You say: "His creative paintbrush gave birth to unknown female forms, chaste and voluptuous at the same time, etc.—They are not young ladies, etc." Well, yes! They are, too, young ladies, his two idealized sisters and their friend, whom he worshipped. Ary Scheffer painted the portrait that he did not want to do in 1846. In Théodore's early style, there was, in my opinion, some embarrassment in rendering the general forms of his women; he was forced to imagine what his young models did not show him. I have a drawing from 1838. A young lady is holding onto a small child standing in front of her as she plays with a flower that a young,

half-naked boy, seated on a stone, is presenting to her. The young lady has my face and looks like me, but her bare arms are Adèle's, and the young boy, whose face we do not see, represents Théodore. It was always that way. Until 1844, all his works were full of the same ideas. Beginning at that time, he changed his style and also his way of life. Nevertheless, the early impressions stay with you. Shortly after my marriage, I went abroad, and when I returned from Asia in December 1856, I learned of his death through Frédéric.

We had lost sight of each other even though we had the same friends: Tocqueville, Tracy, and Arthur de Livry [probably an error in the transcription; this must be Arthur de Lucy, whose portrait Chassériau drew (now lost); see Prat 1988-2, no. 220, with earlier references], my cousin, and the Meynards.—He was very ugly and very austere in his relationships. He was getting to know Théophile Gautier, whose slovenliness alarmed him. He was elegant and behaved very correctly. With his sisters, he was merciless as far as their appearance was concerned and very serious. I still have an oil sketch of his Trojan women and every day I find a fragment of a drawing in

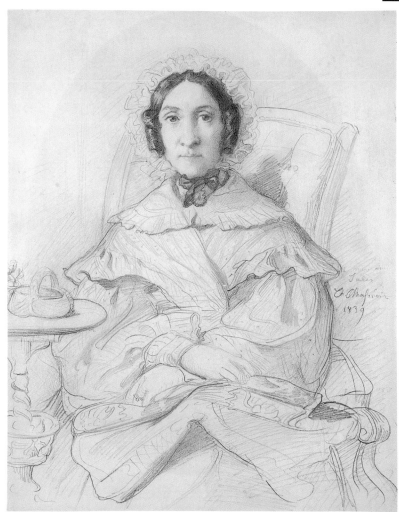

my papers. But you have such a beautiful collection that you cannot attach any importance to these trifles. Forgive me for this long letter; memories of the early years have come back to me because of your book and I shall conclude by thanking you again and congratulating you for your devotion to art and to your loved ones.

Sincerely yours,
Comtesse de Gobineau

CAT. 11

A sketch depicting Clémence Monnerot is in the Musée Carnavalet, Paris (Sandoz 1986, no. 116, ill.; Prat 1988–2, no. 108). A letter from Clémence Monnerot (see the Chronology, April 23, 1839) alludes to another portrait drawing of her mother that Chassériau supposedly "tore up."

L.-A. P.

11

Portrait of Mme Benoît Chassériau

1840
Graphite
10 ⅛ x 7 ⅞ in. (25.7 x 20 cm)
Signed and dated in graphite, right center: *Th. Chassériau 1840*
Paris, Musée du Louvre (RF 27965)

PROVENANCE:
Frédéric Chassériau, the artist's brother, Paris, until 1881; Baron Arthur Chassériau, Paris; D. David-Weill; donated to the Musée du Louvre, 1936 (L. 1886 a, lower left and right).

BIBLIOGRAPHY:
Chevillard 1893, no. 264; Vaillat 1913, ill. p. 30; Vaudoyer 1919, ill. p. 38 (as in the Petit Palais); Bénédite 1931, vol. 1, p. 22, ill. p. 23; Sandoz 1974, under no. 24, p. 11; Sandoz 1986, no. 8, ill.; Prat 1988-1, vol. 1, no. 1064, ill.

EXHIBITIONS:
Paris, Galerie Dru, 1927, no. 32; Paris, Orangerie, 1933, no. 106; Paris, Louvre, 1957, no. 11.

Exhibited in Paris only

The artist's mother, born Marie-Madeleine Couret de la Blaquière (1791–1866) in Samaná, on the island of Hispaniola, married Benoît Chassériau in 1806, and had seven children with him—three sons, Frédéric, Théodore, and Ernest, and two daughters, Adèle and Aline, survived (the other two children died at an early age). Chassériau had painted her portrait once before, four years earlier, in 1836 (Musée du Louvre; Sandoz 1974, no. 24).

Compared to the 1836 painting, the sitter here seems to have grown heavier and fleshier. The extraordinary psychological truth revealed by the portrait shows that, at twenty-one, the prodigious quality of Chassériau's portrait drawings already equaled those by his master, Ingres.

L.-A. P.

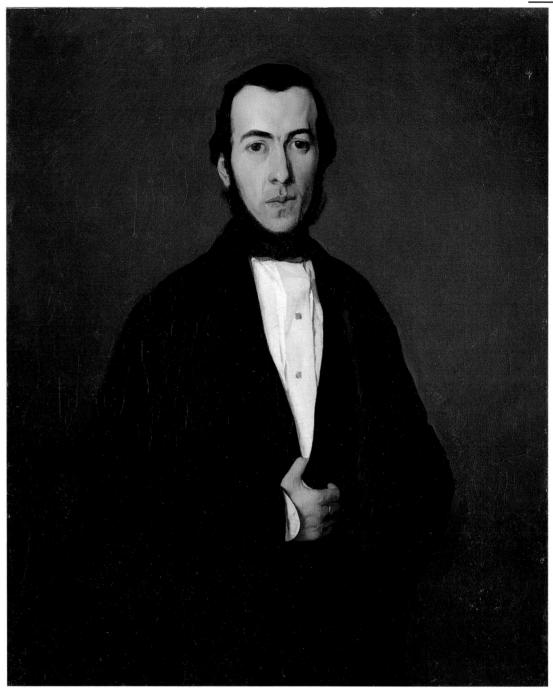

12

Portrait of the Comte de Saint-Auffage

1840

Oil on canvas
21 ⅛ x 18 ⅛ in. (53.4 x 45.8 cm)
Signed and dated, lower right: *Th. Chassériau 1840* [false signature, according to Sandoz 1974, no. 65].
New York, The Metropolitan Museum of Art, Victor Wilbour Memorial Fund, 1949 (49.110)

PROVENANCE:
J. Combe, Paris, 1947; F. Kleinberger, New York; acquired by The Metropolitan Museum of Art, New York, 1949.

BIBLIOGRAPHY:
Sandoz 1967, p. 82, ill.; Sandoz 1974, no. 65, pp. 164, 165, pl. 51.

EXHIBITION:
Hartford, 1952, no. 49, ill.

Exhibited in New York only

Little is known about this portrait, whose signature was judged to be spurious by Marc Sandoz in 1974. Its provenance before 1947 remains unknown, and the identity of the model has yet to be determined, since the name Saint-Auffage is not listed in nineteenth-century biographical dictionaries. The pose of the figure, who is depicted standing and in half length, and the style of the picture appear to be faithful to the Ingresque tradition, and in the spirit of works by numerous painters of the time, from Corot to Millet. The influence of Spanish painting is also clear, as in the family portraits Chassériau executed before 1838.
V. P.

13

Venus Anadyomene

1838

Oil on canvas

25 ⅞ x 21 ¼ in. (65.5 x 55 cm)

Signed and dated, bottom right: *T. Chassériau 1838*

Paris, Musée du Louvre (RF 2262)

PROVENANCE:

Possibly acquired directly from the painter by the Cercle des Beaux-Arts (according to E. Piot, 1844); Louis Marcotte de Quivières (1815–1898), Paris, before 1848 and at least until "a few years" before 1893 (according to Chevillard 1893); Louis Marcotte de Quivières sale, Paris, Hôtel Drouot, April 24, 1875, lot 4 (possibly bought back for Fr 3,220); mentioned as belonging to Pierre Marcotte de Quivières during the Exposition Universelle of 1900 (undoubtedly inherited, after 1898); Alfred Beurdeley (1847–1919), Paris; Beurdeley sale, Paris, G. Petit, May 6–7, 1920, no. 17; acquired at that sale by Jacques Zoubaloff (1876–1931), Paris, after the Louvre decided not to purchase the painting (see Jamot, July–August 1920, p. 72); "two days after the sale," gift of Jacques Zoubaloff ("A Friend of the Louvre"), to the Musée du Louvre, May 8, 1920.

BIBLIOGRAPHY:

Cited in the painter's notebooks in the Louvre: RF 26089, fol. 5 v., fol. 6 r.; Amans de Ch. Et A., 1839; Decamps 1839; Delécluze 1839; Gautier 1839; Haussard 1839; Janin 1839; Laurent-Jan 1839; Royer 1839; Thoré 1839; Gautier 1840; [Piot] 1842, no. 3040, p. 336; Unsigned [E. Piot] 1844, p. 336; Gautier 1848, p. 2; Pillet 1848, pp. 240–41; Gautier 1852, p. 1; Bouvenne 1884, p. 7; Bouvenne 1887, p. 173; Chevillard 1893, no. 56, pp. 24–26, 30–45; Renan 1898; Marx 1898, p. 274; Tschudi 1900, p. 9; Denis 1902, p. 146; Vaillat 1907, pp. 178, 183; Marcel and Laran 1911, pp. 6, 23–24, pl. 4 (ill. of the 1842 lithograph); Vaillat 1913, pp. 14–18; Bouyer 1920, p. 531; Jamot, July–August 1920, pp. 71–84, ill. p. 81; Escholier 1921, pp. 98–107; Tatlock 1921, p. 112; Auge 1925, p. 112; Focillon 1928, pp. 165, 167, ill. p. 168; Goodrich 1928, pp. 63, 66–67, ill. p. 67; Bénédite 1931, vol. 1, pp. 99–105, pl. 3; Grappe 1946, pp. 45–48, ill. p. 43; Huyghe 1933, no. 6, pp. 1–2, ill. p. 2; Boyé 1946, p. 245; S.A.I. 288, ill.; Sandoz 1970, pp. 51–52; C.P., p. 73; Sandoz 1974, no. 44, pp. 138, 139, pl. 33 a; Cat. Somm. Ill., 1986, vol. 3, p. 130, ill.; Prat 1988-1, vol. 1, p. 60, ill. p. 61; Loire, Sahut et al. 1993, p. 141; Pitt-Rivers 1993, pp. 135, 137, ill.; Peltre 2001, pp. 58–63, 90, 190, ill. 64.

EXHIBITIONS:

Salon of 1839, no. 340; Paris, 1848, no. 20 (collection of Marcotte de Quivières); Paris, 1900, no. 94 (collection of Pierre Marcotte de Quivières); Paris, Orangerie, 1933, no. 8, pp. 4–5; Montauban, 1967, no. 181, pl. 22; Montauban, 1980, no. 138.

"The *Venus Anadyomene* is the first of those precious paintings in which, in a very small format, the painter was able to combine the creation of a high-spirited poet with the dreams of a refined and passionate sensibility. Soon the *Apollo and Daphne* would follow, then *The Toilette of Esther*." So observed Paul Jamot in 1920,[1] in an article in which he reported that this masterpiece by Théodore Chassériau had become part of the collections of the Musée du Louvre.

Initially, Chassériau had not sought to alter the iconography of this very ancient subject, the birth of Aphrodite—who is identified with the Roman goddess Venus—a story that had been synthesized in Hesiod's *Theogony* and whose depiction had already become fixed by the Greeks in Antiquity. Hesiod related that Aphrodite was born from Uranus (Heaven), who had been emasculated by his son Cronus (Time) and whose genitals had been thrown into the sea: "And as they were carried by the sea a long time, all around them white foam rose from the god's flesh, and in this foam a maiden was nur-

tured. . . . she went on to reach sea-girt Cyprus. There this majestic and fair goddess came out, and grass grew all around her soft feet."[2] In addition to the mythic version painted by Apelles—an ancient, lost masterpiece—which is reputed to have shown the goddess emerging from the water and wringing out her hair, Chassériau could enrich his imagination by studying variants on the theme by such great masters as Botticelli (*The Birth of Venus;* Florence, Galleria degli Uffizi) and Titian (*Venus Anadyomene;* private collection); Titian's painting was well known in France because it was once part of the duc d'Orléans's collection. In addition, Chassériau had been able to study firsthand the version on which his teacher, Ingres, had been at work since 1807, during his first stay in Italy, and which would occupy him for forty years (*Venus Anadyomene;* Chantilly, Musée Condé).

Although we could cite further visual references, as Marc Sandoz proposes,[3] it is also likely that Chassériau was inspired by contemporary poetry; in fact, he had reproached Ingres for being "completely ignorant of all the poets of recent times" (see pp. 61, 64 n. 40). The theme of the Bather had been in vogue among Romantic writers since the publication of Victor Hugo's famous poem "Sara la Baigneuse" (Sara the bather) from his *Orientales:*

Elle bat d'un pied timide
L'onde humide
Où tremble un mouvant tableau,
Fait rougir son pied d'albâtre,
Et, folâtre,
Rit de la fraîcheur de l'eau . . .

Car c'est un astre qui brille
Qu'une fille
Qui sort d'un bain au flot clair,
Cherche s'il ne vient personne,
Et frissonne,
Toute mouillée au grand air! . . .

L'eau sur son corps qu'elle essuie
Roule en pluie,
Comme sur un peuplier;
Comme si, gouttes à gouttes,
Tombaient toutes
Les perles de son collier.

She strikes with timid foot
The fluid wave
In which a moving tableau trembles,
She makes her alabaster foot turn pink,
And, playfully,
Laughs at the coolness of the water . . .

Indeed, a shining star is she,
A girl
Who steps out of a bath in the bright wave,
Looks to see that no one is coming,
And shivers,
All wet in the open air! . . .

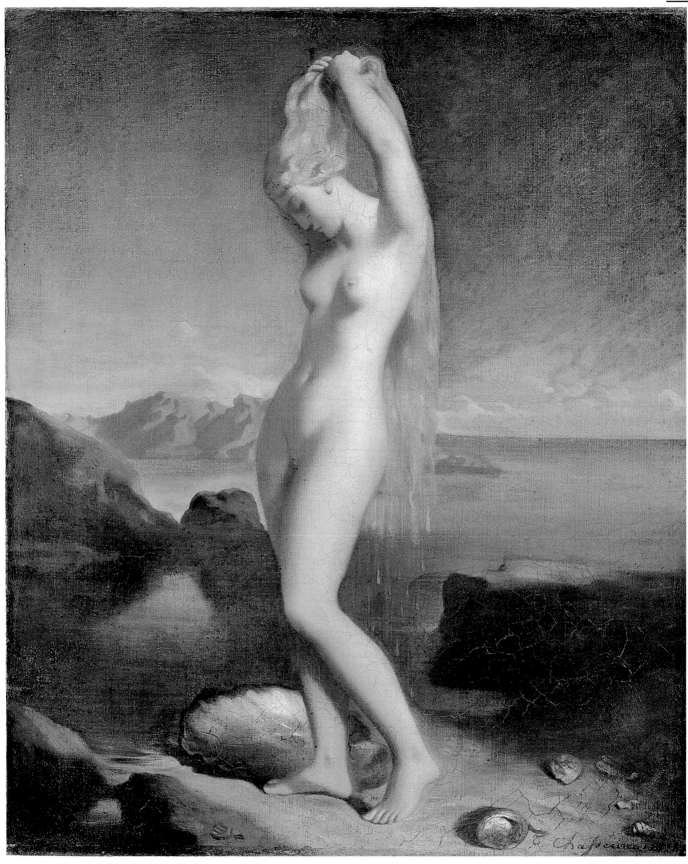

The water on her body that she wipes away
 Rolls like rain,
On a poplar tree;
As if, one by one,
 All the pearls in her necklace
Were dropping off.

Thanks to Théophile Gautier, a tireless promoter of Chassériau's works,[4] mention should be made of another literary reference: the first lines of Alfred de Musset's "Rolla," dated August 1833:

Regrettez-vous le temps où le ciel sur la terre
Marchait et respirait dans un peuple de dieux;
Où Vénus Astarté, fille de l'onde amère,
Secouait, vierge encor, les larmes de sa mère,
Et fécondait le monde en tordant ses cheveux?

Do you yearn for the time when heaven on earth
Walked and breathed in a nation of gods;
When Venus Astarte,[5] daughter of the bitter wave,
Still a virgin, shook off her mother's tears,
And fecundated the world by wringing out her hair?

Besides these indirect connections, little is known of the context in which the painting was created, since the painter left no record of his inspiration or intentions. Nor can we reconstruct the evolution of his artistic technique, since we have no knowledge of any preliminary drawings for this painting of Venus: The beautiful sanguine drawing in the Musée du Louvre[6] must be considered a preliminary study for the lithograph, published after the Salon,[7] as Paul Jamot indicated in 1920[8] and Louis-Antoine Prat in 1988, whereas the drawing that most closely evokes the composition of this *Venus Anadyomene,* according to Sandoz,[9] is a study executed in Italy during the artist's stay there in 1840,[10] although no proof exists that it served as the basis for the painting Chassériau exhibited at the Salon.

Fortunately, an oil study (cat. 14) helps explain some of the artist's motivations—although we cannot be sure whether the painting is a sketch for the *Venus Anadyomene* or an autograph replica. In any case, a comparison between this study and the definitive work clearly reveals differences in the treatment of the forms and in the choices made for each of the landscapes. Hence, the body of the goddess in the painted sketch is more elongated, quickly executed yet, at the same time, more graceful and less ungainly. It may also be more "accessible" and more realistic, as Paul Jamot remarked;[11] he noted that a flaw in the left leg—for which Chassériau was criticized at the Salon of 1840—"does not exist in the sketch, which preceded the painting for the Salon of 1839 [and where] the bent leg more naturally conforms to the body's movement: the knee is turned and is shown in three-quarter profile, as is the foot."[12] In any case, the treatment of the body of Venus in the painting at the Salon evokes classical statuary more than the sketch does—it should be noted that Chassériau had a cast of the Venus de Milo in his studio—in its skilled scumbling technique, play of light and shadow on the flesh, and sharper "sculpting" of the goddess's limbs, breasts, and even her navel.

In addition, the poetic function of the landscape in which the goddess comes to life is extremely important; it is a "lunar" landscape, accentuated by the new, almost square format adopted by Chassériau for the Salon version, whereas the study is a vertical composition. In the sketch, the sea and sky are treated synthetically, while in the final painting the vast landscape of mountains, illuminated by morning light—which creates a mysterious, bluish and light green atmosphere—is painted with technical precision. Certain evocative details have been sharpened, such as the seashells at the goddess's feet, which symbolize the conch shell in which she was born. Chassériau also enlivened the landscape in the background of the Salon version by including, in addition to the mountains on the horizon, a passage on the right more open to the sea and a section on the left blocked by a group of rocks, through which an unreal light filters.

The critics at the Salon received this composition with restraint and without admiration, observing the artist's talent but withholding their praise. Théophile Gautier noted that the painting was better displayed at the Salon than the *Susanna and the Elders* shown the same year, and, hence, was easier to appreciate,[13] and the painter's friends also seem to have admired it more than the *Susanna.* Clémence Monnerot, for example, wrote to her brother on April 23, 1839: "M. Théodore is a success, *La Presse* and *Le Temps* praise him a great deal and M. Picot the painter asked to buy his Venus at the request of the artists' society and to display it in their establishment."[14] Balzac himself, who at the time had no connection with Chassériau, regretted that he could not purchase the picture.[15] It was then that Gautier published one of his first critiques of his friend, praising the *Venus* and the aesthetic notions upheld by Chassériau: "The white goddess, in the full brilliance of her lovely classical nudity, is still all wet from the kisses of the amorous sea, wringing out the drops of water from her weeping hair and displaying, through the graceful arch of her pose, the forms of a divine beauty and youthfulness. Nearby gleams the mother-of-pearl conch shell that delivered her, and in the background stretches the peaceful azure of the sea and sky, barely separated by a line of rocks."[16] Later, Gautier used this painting as a manifesto for his defense of a new vision of Romanticism, based as much on an admiration of Antiquity as on a fascination with the Orient, and recommended an idealized aestheticism. He wrote, again in reference to the *Venus Anadyomene:* "It is like a drawing Praxiteles might have traced on the corner of a block of Pentelic marble to record an idea for a statue."[17]

The opinion of another defender of the Romantics, Théophile Thoré, seemed closer to the general feeling at the time: "Overall it [the *Venus*] is very appealing, although one notes numerous imperfections, such as the drawing of the hips and legs, but there is such delicacy and distinction in its simplicity that one admires the woman and absolves the draftsman."[18] Delécluze ended the debate, declaring that he preferred the *Venus Anadyomene* to the *Susanna,* despite the fact that he

would have liked to have found "more beauty in the forms, more firmness in the execution."[19]

Several critics indicated that Chassériau was directly influenced by the style of his teacher, Ingres.[20] Nevertheless, an equally pertinent comparison could be made with Delacroix's works, but this time, in another sense: One cannot help but notice the similarity in the way that the nude and landscape are treated in Delacroix's *Perseus and Andromeda* (Stuttgart, Staatsgalerie) and in the *Andromeda* (Houston, Museum of Fine Arts) and the manner in which they are rendered in Chassériau's *Venus*. In another painting, *The Awakening* (private collection), exhibited at the Salon of 1850,[21] Delacroix also adopted the theme of the "woman combing her hair." It is fair to wonder whether Delacroix might not, in turn, have fallen under the influence of the young man who had so admired his works.

The *Venus Anadyomene* would also exert an influence on subsequent generations of artists; in part because the sketch was kept in the painter's studio, as Aglaüs Bouvenne related.[22] Gustave Moreau and Puvis de Chavannes are just two of the artists whose paintings, like Gauguin's erotic depictions of Tahitian women, owe a debt to the sensuality and beauty of Chassériau's *Venus*.

V. P.

1. P. Jamot, "La 'Vénus marine' de Chassériau," in *Revue de l'art ancien et moderne,* vol. 38 (July–August 1920), p. 72.
2. Hesiod, *Theogony,* ll. 190–201, in *Theogony / Works and Days / Shield,* trans. Apostolos N. Athanassakis (Baltimore: The Johns Hopkins University Press, 1983), p. 18.
3. Sandoz 1974, no. 44, p. 138.
4. See the critique of the Salon by Théophile Gautier, "Salon de 1839, 8ᵉ article," in *La Presse,* Paris, Saturday, April 13, 1839.
5. Here, Musset is confusing Venus Astarte, the daughter of heaven and of the day, Hesiod's celestial Venus, with Venus, the daughter of the sea foam and of heaven.
6. Paris, Musée du Louvre, Département des Arts Graphiques, RF 26413 v.; discussed in Prat 1988-1, vol. 1, no. 10.
7. Jamot 1920, op. cit., p. 80.
8. We know of two states of that lithograph, one published by Bry and the other by Bertauts.
9. Sandoz 1974, no. 44, p. 38.
10. Paris, Musée du Louvre, Département des Arts Graphiques, RF 25686; cited in Prat 1988-1, vol. 1, no. 1386; the graphite drawing shows a woman seen from the back arranging her hair.
11. See note 7, above.
12. Ibid.
13. Gautier, 1839, op. cit., p. 3.
14. Unpublished letter from Clémence Monnerot to her brother Jules, April 23, 1839, Paris; Bibliothèque Nationale de France, Paris, Département des Manuscrits (Naf. 14394, Papiers Gobineau, vol. 6, "Mme A. de Gobineau, née Clémence Monnerot, Lettres à sa famille," fols. 43–44). We should note that the sale to the Society of Artists—the Cercle des Beaux-Arts—may have materialized, if we are to believe Eugène Piot, although less than ten years later the work was in the collection of Marcotte de Quivières, one of the painter's good friends.
15. Letter from Balzac to Mme Hanska [Tuesday, June 4, 1839, Sèvres], quoted in H. de Balzac, *Lettres à Mme Hanska, 1832–1844,* ed. R. Pierrot (Paris, 1990), vol. 1, p. 487.
16. See note 4, above.
17. T. Gautier, "Troisième Exposition de l'association des artistes. Bazar de Bonne-Nouvelle," in *La Presse,* no. 4204, Paris, Sunday, February 13, 1848, p. 2; Gautier must have been thinking of Chassériau's works when, in 1844, in his *Roi Candaule,* he described the heroine Nyssia, with her "beautiful serpentine lines, those elegant curves, those smooth thighs, those breasts that could serve as the mold for the cup of Hebe."
18. T. Thoré, "Salon de 1839," in *Le Constitutionnel,* Paris, 1839.
19. É.-J. Delécluze, "Salon de 1839," in *Journal des débats* (March 16, 1839).
20. See, for example, F. Pillet, "Beaux-Arts. Peinture, sculpture, etc. Galerie Bonne-Nouvelle," in *Le Moniteur universel,* no. 32, Tuesday, February 1, 1848, pp. 240–41.
21. We know from his *Journal* (May 3, 1847) that Delacroix had considered painting a "woman combing her hair" as early as 1847—that is, a year before seeing Chassériau's canvas at the Bazar Bonne-Nouvelle in 1848. Nevertheless, the aesthetic and poetic similarity of the two works is too obvious for Delacroix not to have had in mind, in one way or another, this work by a young artist he deeply admired.
22. A. Bouvenne, "Théodore Chassériau," in *L'Artiste,* vol. 2 (September 1887), p. 173: "As you entered that large studio and turned your back to the light, your eyes, surprised and charmed, focused first on a large painting, golden as wheat, his *Venus Anadyomene.* Above it hung the view of Athens that Marilhat had given to Chassériau."

14

Venus Anadyomene (sketch)

about 1837–38
Oil on canvas, remounted on wood
22 ⅛ x 13 in. (56 x 33 cm)
Signed, bottom left: *Thᵉ Chassériau*
Private collection

PROVENANCE:
Studio of the painter until his death; Frédéric Chassériau, the artist's brother, Paris, until 1881; Baron Arthur Chassériau, Paris; his daughter-in-law, Mme de Mondésir, before 1933 (Paris, Orangerie, 1933, no. 7); descendants of Baron Arthur Chassériau, until 1995; offered for sale, London, Christie's, June 16, 1995, lot 120, pp. 62–63, but it remained with the painter's descendants; Paris, private collection.

BIBLIOGRAPHY:
Jamot, July–August 1920, pp. 80–82, ill. p. 79; Bénédite 1931, vol. 1, ill. p. 100; Sandoz 1974, no. 45, pp. 140, 141, pl. 34; Randall 1995, pp. 48–49.

EXHIBITIONS:
Paris, Orangerie, 1933, no. 7, p. 4, ill. at the back of the book; Paris, 1976, no. 3 (collection of Mme de Mondésir).

Susanna and the Elders

1839
Oil on canvas
100 ⅜ x 77 ¼ in. (255 x 196 cm)
Signed and dated, bottom left: *Théodore Chassériau 1839*
Paris, Musée du Louvre (RF 410)

PROVENANCE:
Sent by the painter to L. de la Force, Consul General of France to the United States; reportedly offered for sale in New York, 1842; possibly private collection, New York, before 1857 (according to Sterling, in Paris, Orangerie, 1933); Chassériau sale, Paris, March 16–17, 1857, no. 1 (sold for Fr 1,700, according to the annotated copy of the sales catalogue in the Cabinet des Estampes, Bibliothèque Nationale de France, Yd 929a, in 8°); Saint Petersburg, private collection (according to Alice Ozy); Sale X, Paris, Hôtel Drouot, before 1884; acquired by Alice Ozy, Paris; donated by the latter to the Musée du Louvre, May 9, 1884.

BIBLIOGRAPHY:
Blanc 1839; Gautier 1839, p. 1; Haussard 1839; Janin 1839; Laurent-Jean 1839; Thoré 1839; Gautier 1852, p. 1; Du Pays 1857; Gautier 1857, pp. 209–11; Bouvenne 1887, pp. 164, 166, 172, ill. p. 161; Chevillard 1893, nos. 25, 55, 86, pp. 24–25, 30–34, 171; Marx, February 19, 1898, p. 274; Denis 1902, p. 146; Vaillat 1907, pp. 177–78, 183, ill. p. 178; Marcel and Laran 1911, pp. 6, 21–22, pl. 3; Vaillat 1913, pp. 14, 26; Bouyer 1920, p. 530; Jamot, February 1920, p. 69; Jamot, March 1920, pp. 71–73, ill. p. 73; Escholier 1921, pp. 89–107; Auge 1925, pp. 105–15; Hourticq 1927, p. 275; Focillon 1928, pp. 165, 166, 167; Goodrich 1928, pp. 66, 87, ill. p. 65; Bénédite 1931, vol. 1, pp. 93 ff., pl. 2; Grappe 1932, pp. 45–48; Grappe 1933; Boyé 1946, p. 245; S.A.I., 290, ill.; C.P., p. 72; Sandoz 1974, no. 48, pp. 144, 145, pl. 37; Lacambre, in Paris, 1979, p. 323; Angrand 1986, p. 149; Cat. Somm. Ill., 1986, vol. 3, p. 129, ill.; Prat 1988-1, vol. 1, pp. 60–63, ill. p. 60; Loire, Sahut et al. 1993, p. 174; Peltre 2001, pp. 58–63, ill. 65.

EXHIBITIONS:
Salon of 1839, no. 339; Exposition Universelle of 1855, no. 2693; Paris, Orangerie, 1933, no. 10, pp. 6–7; Montauban, 1980, no. 139.

Exhibited in Paris only

The well-known episode from the Bible of Susanna in the bath, followed by the equitable judgment of the prophet Daniel,[1] is a subject frequently treated in painting, since it allows artists to depict the sensual beauty of the naked body of a young woman and to caricature the faces of the two old voyeurs tormented by lust: "Depending on whether the emphasis is placed on the lubricity of the old men who come upon Susanna in her bath or on their punishment, art can extract either an erotic or a moral theme from this idea," wrote Louis Réau.[2] In his sensual treatment and in the Oriental-like aloofness of the solid and solitary figure of Susanna, Chassériau clearly wanted to emphasize the voluptuous side of the theme.

Susanna was a chaste young woman who was faithful to her husband, Joachim. In spite of herself, she awakened the desire of two libidinous old men—judges, reputed to be "sages"—who wanted to "lie with her" after spying on her every time she took her bath: ". . . as they watched a fit day, she went in on a time, as yesterday and the day before, with two maids only, and was desirous to wash herself in the orchard: for it was hot weather. And there was nobody there, but the two old men that had hid themselves and were beholding her Now when the maids were gone forth, the two elders arose, ran to her, and said: . . . consent to us, and lie with us" (Daniel 13: 15–20). The biblical tale—which explores the themes of violated innocence and of false accusation—lends itself to being represented in several different scenes: Susanna bathing; Susanna surprised and then assaulted by the old men; Susanna accused by the old men; and, finally,

Susanna saved by Daniel, who reveals the men to be liars. All the leading painters have depicted these episodes but, since the Renaissance, artists have focused especially on the precise moment when Susanna enters her bath, unaware of being observed. Tintoretto portrayed the young woman with her two servants (Paris, Musée du Louvre), and Rembrandt located the scene indoors (The Hague, Mauritshuis)—paving the way for the *Bathsheba* of 1654 in the Louvre—but both emphasized the sensuality of the story.[3] In the nineteenth century, Eugène Delacroix copied a drawing by Rubens of the subject (Paris, private collection) and, about 1850, painted his own version of the theme (Reims, Musée des Beaux-Arts).

The actual bath of Susanna, which lends itself to fantasies and to all sorts of desires, was the subject Chassériau chose for his ambitious picture, intended for the Salon of 1839. He had wanted to have the handbook for the Salon inscribed, next to the title of the work, with the passage from Daniel 13: 16 "And there was nobody there, but the two old men that had hid themselves and were beholding her." Rejecting the extrapolations on the theme, in which the young woman is shown flattered to be observed, and the violence of the assault on her—which he would retain in a later version (cat. 253)—the painter preferred instead to capture the moment of solitary reverie, when the young woman, believing she is alone, abandons herself to her thoughts and the pleasure of the bath. The violence to follow is only latent here, contained, like the eroticism of the subject.

Once again, Chassériau's inspiration was multifaceted, derived as much from the biblical text, to which he very faithfully adhered; the classical tradition; certain sensual and elegiac paintings by Prud'hon and by Girodet, in particular; and, above all, from contemporary poetry. In addition to the poem by Victor Hugo, "Sara La Baigneuse,"[4] already noted, whose influence is obvious here, the lyrical poem by Alfred de Vigny, of 1822, devoted to the story of Susanna, should be mentioned as well, since several of its details seem to appear in the painting:

Dégagés des lacets, le manteau d'hyacinthe,
Et le lin pur et blanc comme la fleur du lis,
Jusqu'à ses chastes pieds laissent couler leurs plis.
Qu'elle fut belle alors! Une rougeur errante
Anima de son front la blancheur transparente,
Car, sous l'arbre où du jour vient s'éteindre l'ardeur,
Un oeil accoutumé blesse encor sa pudeur; . . .
Dans un cristal liquide on croirait que l'ivoire
Se plonge, quand son corps, sous l'eau même éclairé,
Du ruisseau pur et frais touche le fond doré.

Freed from their laces, the hyacinth mantle
And the linen, pure and white as the lily,
Let their folds flow to her small chaste feet.
How beautiful she was then! An errant redness
Lit the transparent whiteness of her brow
For under a tree that banishes the heat the of day,
An accustomed eye offended her modesty once more; . . .
Like ivory into liquid crystal immersing itself,
Her body, even underwater illumined,
Touched the golden bottom of the pure cool stream.

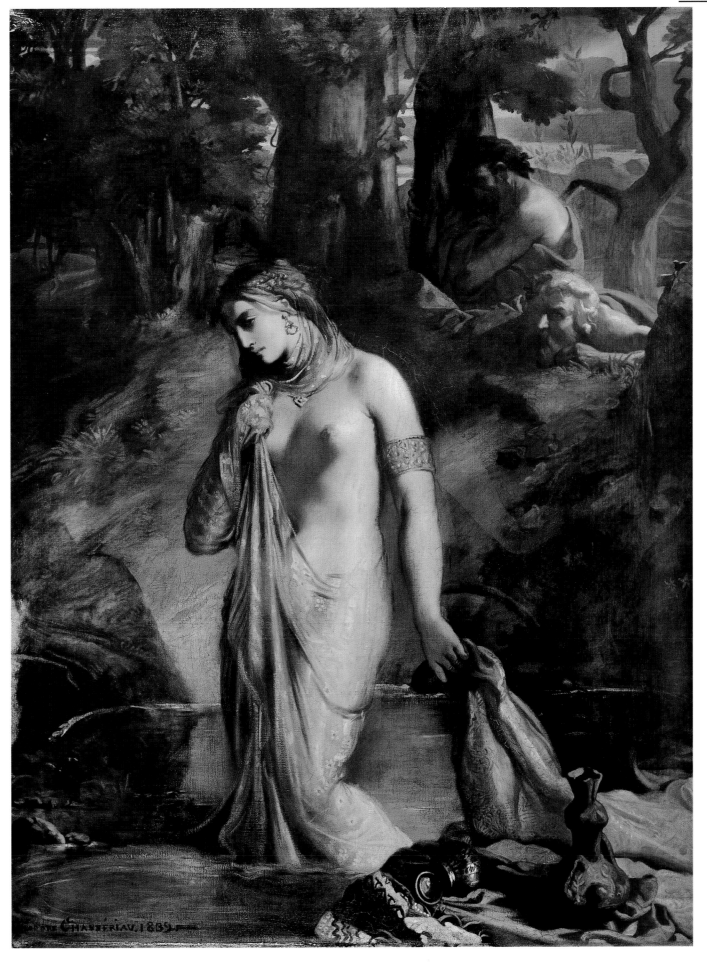

Chassériau's treatment is faithful to the traditional iconography. Susanna, in the foreground, has her back turned to the two old men, to whose voyeurism she is entirely oblivious—as described in the biblical text. The young painter, whom "nothing intimidates, and who walks with a firm step on the path he has traced for himself,"[5] also explored three pictorial genres: First, *Susanna and the Elders* is a history painting, a subtle tribute to the Venetian painters of the Renaissance, and, at the same time, a modern composition, both because of its Orientalism and because of the vibrant sensuality that emanates from the transparent veil on Susanna's hair and the play of light on her breasts and belly. Second, the painting is a fine example of landscape, which, unlike the theatrical forests or the gardens of Eden depicted by classical artists, is as realistic as the canvases of the Barbizon painters, yet as Romantic as the setting of Prud'hon's portrait of Josephine (Paris, Musée du Louvre). Finally, it is, above all, a magnificent study of the nude, since Chassériau, who celebrated women—whether eternal or the most strikingly realistic—liked to paint "goddesses, queens, and nymphs," depicting them, however, as "living creatures of flesh and blood, who provoke reveries filled with desire."[6] The vision of female anatomy Chassériau presents us with here is robust—almost masculine—idealized, and "sculpted," but at the same time it is also one of his most erotic nudes.[7]

Because of the importance of the Salon of 1839, the painter worked at length on preliminary sketches for the composition, preparing several studies in graphite and, undoubtedly, a study in oil. Some of these drawings contain references to an earlier version in which the young woman is shown arranging her hair. One graphite drawing confirms that Chassériau labored over the young woman's arm and right hand, with which she holds her garment.[8] Another graphite drawing, identified by Louis-Antoine Prat, depicts a group of women on a beach, one of whom is seen in a pose exactly like that of Susanna in a perhaps abandoned version of the composition: One hand is in her hair and the other holds her garment.[9] A superb drawing of the entire composition, in which Susanna is shown with her right hand clutching the drapery covering her hips as she runs her left hand through her hair, was adapted for the engraving.[10] Finally, in a sketch in pen and brown ink, perhaps preliminary to the engraving and also executed in 1839, the woman holding her hair with her left hand assumes the identical pose.[11] The drawings executed by Chassériau throughout his career offer other variations on this treatment of the female body; one drawing, also of a woman arranging her hair, represents yet another exploration of the subject,[12] as do two sketchbook studies that Louis-Antoine Prat dates between 1837 and 1840.[13]

These graphite studies appear to have culminated in a small oil on canvas in the Louvre[14] in which Susanna's pose differs from that in the definitive version, although it is found in most of the drawings, where the young woman arranges her hair with her left hand; perhaps it is a replica that served as a preparatory study for the engraving of the subject that Chassériau would later execute.

The question of the difference in Susanna's pose between the study and the engraving just mentioned and the work at the Salon of 1839 has taken on great importance. In fact, it is not certain that the artist initially chose to represent the female figure in the pose seen in the present work. The description of the figure provided by Théophile Gautier in *La Presse* on April 13, 1839, corresponds exactly to the oil study in the Louvre: "One of her hands is holding a drapery made of an Oriental fabric with white stripes; the other is arranging a pearl necklace that has come loose in her hair." Do Gautier's comments describe the painting in a state that existed before—or during—its exhibition at the Salon, which the painter later modified? Did he let his imagination run away with itself? Since the work was shown again at the Exposition Universelle of 1855, Chassériau might have changed the pose of the heroine in the interim, but no pentimento is visible to the naked eye nor has an X-ray examination been done.

In any case, the *Susanna and the Elders,* accompanied by the *Venus Anadyomene,* enjoyed a certain success at the Salon, marking the debut of a great artist. Among the critics, Prosper Haussard admired the works the painter submitted; Charles Blanc, in *La Revue du progrès,* classified Chassériau as a "pure Ingrist"; and, in *L'Artiste,* Jules Janin compared him to Prud'hon. Théophile Thoré also waxed enthusiastic: "His Susanna . . . has a delicious look about her; there is an indefinable nobility and voluptuousness in the undulations of her waistline. . . . The landscape in the background, where one catches a glimpse of the two heads of the curious old men, is superb, and in high style. . . . The overall color is limpid to be sure, but as weak as the pale gleam of the moon."[15] Nevertheless, the work was very poorly displayed, hung initially in a gallery at the Salon nicknamed "the catacombs." A friend of Frédéric Chassériau expressed his disappointment about this in a letter quoted by Léonce Bénédite: "I had read in the *Débats* about the acceptance of the beautiful Susanna and I was jubilant, but you cruelly dampened my joy by telling me that it has been relegated to *Tartarus.*"[16] A few weeks later, Gautier observed that "the painting has been moved," which allowed everyone to notice "its austere style . . . the refinement of the drawing and the broad execution" that characterized the canvas.[17] After the Salon, probably because of that success, the administrators were slow to return the work to its creator, perhaps hesitating over whether or not to acquire it.[18]

The subsequent fate of that large composition appears strange and poorly understood. A long letter sent to the painter's brother Frédéric by M. de la Force, Consul General of France to the United States, in 1842, seems to suggest—provided that the work in question is the same—that it was sent to North America two years after the Salon, and that the consul then tried to sell it: "But, my dear Frédéric, I do not receive this beautiful page [*sic*] as a gift, it is too beautiful a work. I am going to have it exhibited here in one of the main galleries and I will try, despite the hard times, to get a good price for it . . . and if I succeed and send him a tidy sum, I will be only too satisfied to have

rendered a service to Théodore."[19] Perhaps the painting was, indeed, sold, if we are to believe Charles Sterling's assertion in the exhibition catalogue of 1933.

In any case, the work was back in the painter's studio after 1850, when it was again described by Théophile Gautier, his excitement intact: "The Israelite beauty, ennobled by the art of Greece, never may have been rendered with greater felicity. . . . That perfect torso, which the Venus de Milo would not disclaim, through the sharper cut of the breast and the more rounded slenderness of the thigh, is Oriental in form, vaguely reminiscent of the priestesses of India in their temples, who descend to the Ganges via the white marble steps of Benares."[20] Perhaps it was about that time that the young Gustave Moreau saw the picture in Chassériau's studio, and was inspired to paint a version of his own, *The Chaste Susanna* (Lyons, Musée des Beaux-Arts).[21] However, the *Susanna and the Elders* was still in the painter's possession at the end of his life, and was finally sold posthumously in March 1857, after Frédéric Chassériau had sought unsuccessfully to have the State purchase it for the Musée du Louvre.[22]

Subsequently, the painting seems to have left France for Russia, if we are to believe Alice Ozy, its last owner, who donated it to the Louvre. On November 10, 1884, she wrote to Aglaüs Bouvenne, then at work on his study of the painter: "You will be happy to learn that the Museum *accepted* the Susanna of [1839] which *earned him the cross.* I rediscovered it in an auction house, after it came back from Russia."[23]

We close with Jean-Louis Vaudoyer's transcription of the acount of Baron Arthur Chassériau, who believed he had found the model for his ancestor's superb painting: "Baron Arthur Chassériau told us how he was once summoned to a poor dwelling on the outskirts of town. He went there, and was received by a pitiful, broken-down human being, one of those wretches the sight of which breaks your heart. Yet, this was the model for the *Susanna and the Elders.*"[24] What a strange story—romantic, symbolic, yet too good to be true—the downfall of the model who might have inspired the young artist's chaste yet sensual Susanna.　　　　　　　　　　　V. P

1. Daniel 13: 1–65 [Douay Version].

2. L. Réau, *Iconographie de l'art chrétien* (Paris, 1955–59), vol. 2, p. 395.

3. The same subject was treated by a number of other famous artists including: Ludovico Carracci (London, National Gallery), Rubens (Munich, Alte Pinakothek), Guido Reni (London, National Gallery), Santerre (Paris, Musée du Louvre), and Jean-François de Troy (Rouen, Musée des Beaux-Arts).

4. In the collection *Les Orientales,* published in July 1828.

5. J. Janin, "Exposition de peinture et de sculpture au profit des victimes du tremblement de terre de la Martinique," in *L'Artiste,* vol. 3 (1839), p. 197.

6. J.-L. Vaudoyer, in Paris, Orangerie, 1933, p. xvii.

7. On this subject see ibid., pp. xvi–xix.

8. Paris, Musée du Louvre, Département des Arts Graphiques, RF 25178 v., on the reverse of which is *Group of Figures;* see Prat 1988-1, vol. 1, no. 11, pp. 60–61. This study of the right arm holding the garment is inscribed: *M. ranguer 13 rue N^{ive} fontaine.*

9. Paris, Musée du Louvre, Département des Arts Graphiques, RF 25974; see Prat 1988-1, vol. 1, no. 12, pp. 61, 63. Susanna is raising only her left arm, while the pose of the other two women illustrates the theme, common in Chassériau's work, of the Mother and Child.

10. In this graphite drawing with white highlights (Paris, Musée du Louvre, Département des Arts Graphiques, RF 26440; see Prat 1988-1, vol. 1, no. 13, pp. 62–63), only Susanna's left arm is raised; this drawing is very similar to the engraving but in reverse.

11. Paris, Musée du Louvre, Département des Arts Graphiques, RF 26513; see Prat 1988-1, vol. 1, no. 14, p. 63.

12. Paris, Musée du Louvre, Département des Arts Graphiques, RF 25726; see Prat 1988-1, vol. 2, no. 1765, p. 635.

13. Album (Paris, Musée du Louvre, Département des Arts Graphiques, RF 26058, fols. 8 v., 32 r.; see Prat 1988-1, vol. 2, no. 2233, pp. 818–19).

14. Paris, Musée du Louvre, Département des Peintures, RF 3861; bequeathed by Baron Arthur Chassériau, 1934. See Sandoz 1974, no. 49, pp. 146–47.

15. T. Thoré, "Salon de 1839," in *Le Constitutionnel* (Paris, 1839).

16. Bénédite 1931, vol. 1, pp. 94–95.

17. T. Gautier, "Salon de 1839, 8^e article," in *La Presse,* Paris, April 13, 1839, p. 4.

18. Théodore Chassériau's unpublished receipt submitted to the administration of the Musée du Louvre [Paris], June 26, 1840: "Received from the administration of the museum my painting of Susanna bathing registered under number two thousand two hundred and which was part of the exhibition of 1839. June 26, 1840. *Th. Chassériau*" (Archives des Musées Nationaux, p. 30. Chassériau).

19. According to Bénédite, who cites this missing letter (1931, vol. 1, pp. 98–99), the work in question is the *Susanna and the Elders* exhibited at the Salon of 1839.

20. T. Gautier, "Atelier de feu Théodore Chassériau," in *L'Artiste,* vol. 14 (March 15, 1857), p. 209.

21. On this subject see D. Lobstein, "Alfred Baillehache-Lamotte et Le Legs de 'La Chaste Suzanne' de Gustave Moreau au Musée des Beaux-Arts de Lyon," in *Bulletin des Musées et monuments lyonnais,* vol. 1 (2000), pp. 31–32.

22. Chassériau sale, Paris, March 16–17, 1857, no. 1 (sold for Fr 1,700, according to an annotated copy of the sales catalogue in the Cabinet des Estampes, Bibliothèque Nationale de France, Yd 929a, in-8°). In his *Histoire des musées de province au XIX^e siècle* ([Les Sables d'Olonne, 1986], vol. 4, p. 149), Pierre Angrand recounts Frédéric Chassériau's efforts to sell the painting. The letter regarding the proposal by the painter's brother, dated November 18, 1856, is today in the Archives Nationales (F 21 70): "It would be a great consolation to his family to also see accepted into the Louvre two large paintings, which, even in my father's lifetime, were appreciated by the most enlightened judges and also by the public."

23. Signed, autograph letter, Paris, Musée du Louvre, Département des Arts Graphiques (aut. 58, no. AR5 L 18). Three weeks earlier, on October 24, 1884, the critic Ernest Chesneau had confirmed to Aglaüs Bouvenne that the canvas was included in a sale at the Hôtel Drouot that had taken place fifteen or twenty years earlier: "I am still embarrassed that I saw a large canvas sold at the Hôtel Drouot—*Susanna and the Elders,* which you have catalogued—for a shameful price, certainly less than 40 francs [fol. 1 v.]. That was 15 or 20 years ago" (signed, autograph letter, Paris, Musée du Louvre, Département des Arts Graphiques, aut. 56, no. AR5 L 16).

24. J.-L. Vaudoyer, "Le Baron Arthur Chassériau. Notice lue à l'Assemblée générale annuelle de la Société des Amis du Louvre le 17 juin 1935," in *Cabinet des Dessins, Société des Amis du Louvre* (Compiègne, 1935), p. 15.

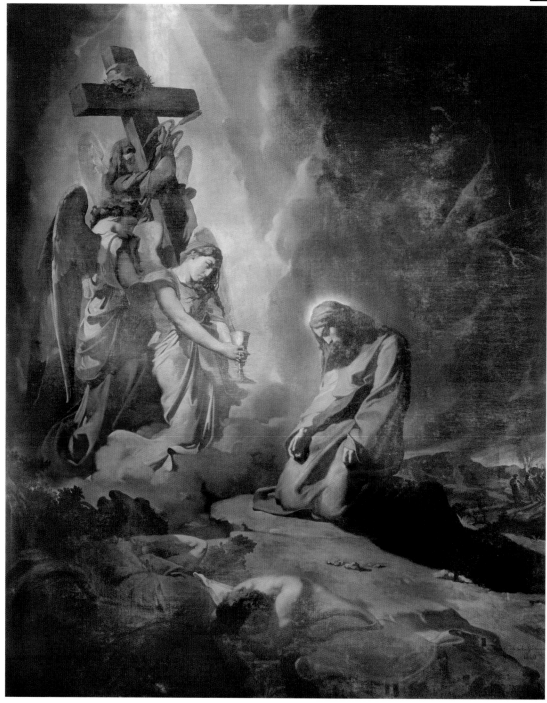

Before restoration

16

Christ on the Mount of Olives

"And he said, Abba, Father, all things *are* possible unto thee; take away this cup from me: nevertheless not what I will, but what thou wilt" (Mark 14: 36).

1840
Oil on canvas
197 x 134 in. (500 x 340 cm)
Church at Saint-Jean-d'Angély (Charente-Maritime)

PROVENANCE:
Commissioned by the Ministry of the Interior (Division des Beaux-Arts) at an unknown date for the modest sum of Fr 1,800 (AN F²¹ 496); assigned to the church at Saint-Jean-d'Angély, since 1840.

BIBLIOGRAPHY:
Tardieu, *Le Courrier français*, March 10, 1840; Royer, *Le Siècle*, March 11, 1840; Delécluze, *Journal des débats*, March 12, 1840; Gautier, *La Presse*, March 13, 1840; Unsigned, *Le Journal des beaux-arts et de la littérature*, March 22, 1840; Pillet, *Le Moniteur universel*, March 23, 1840; Unsigned, *Le Charivari*, March 24, 1840; Unsigned, *Le Corsaire*, March 27, 1840; Haussard, *Le Temps*, April 12, 1840; Janin, *L'Artiste*, vol. 5, nos. 10, 11 (1840), pp. 167, 186; Chevillard 1893, pp. 36–40; Bénédite 1931, pp. 107–14; Sandoz 1974, no. 54; Foucart 1987, p. 250; Prat 1988-1, vols. 1 and 2, nos. 18–43, 50, 72, 80, 140, 239, 1464, 1742, 1761, 1780, 1865, 1924, 1936, 2232, 2233, 2235, 2242, 2253; Prat 1988-2, no. 47; Peltre 2001, pp. 63–66.

EXHIBITION:
Salon of 1840 (no. 250).

Exhibited in Paris only

17

Head of Christ

about 1839
Oil on canvas
13 ⅞ x 7 ⅛ in. (35 x 18 cm)
Paris, Musée du Louvre (RF 3863)

PROVENANCE:
Bequest of Baron Arthur Chassériau to the Musée du Louvre, 1934; placed on deposit at the Musée National des Beaux-Arts, Algiers, 1939; returned to the Musée du Louvre, 1962.

BIBLIOGRAPHY:
Chevillard 1893, no. 189.

_____ CAT. 17

Head of an Angel

about 1839
Oil on canvas
18 ⅛ x 15 in. (46 x 38 cm)
New York, Wheelock Whitney

PROVENANCE:
Baron Arthur Chassériau, Paris; his heirs, until 1986; sale,
Sotheby's, Monte Carlo, June 21, 1986; Wheelock Whitney,
New York.

BIBLIOGRAPHY:
Chevillard 1893, no. 190; Bénédite 1931, p. 113; Sandoz 1974, no. 59.

Exhibited in New York only

Angel Embracing the Cross

about 1839
Oil on canvas
24 x 15 ⅜ in. (61 x 39 cm)
Lyons, Musée des Beaux-Arts (1986-199)

PROVENANCE:
Baron Arthur Chassériau, Paris; his heirs, until 1986; sale, Sotheby's,
Monte Carlo, June 21, 1986; Lyons, Musée des Beaux-Arts.

BIBLIOGRAPHY:
Chevillard 1893, no. 195; Bénédite 1931, p. 108; Sandoz 1974, no. 58.

Exhibited in Paris and Strasbourg

At the Salon of 1839, Chassériau enjoyed an undeniable
critical success, although officials of the Crown remained
unconvinced of his talents. His name does not appear in
the report traditionally submitted by the director of the
Louvre to the superintendent to the King's Household,
indicating the works to be acquired and the artists to be
honored. The same was true in 1840, the year the *Diana*
(cat. 22) was rejected, and when, for that reason,
Chassériau signed a petition that several personalities in the

CAT. 18

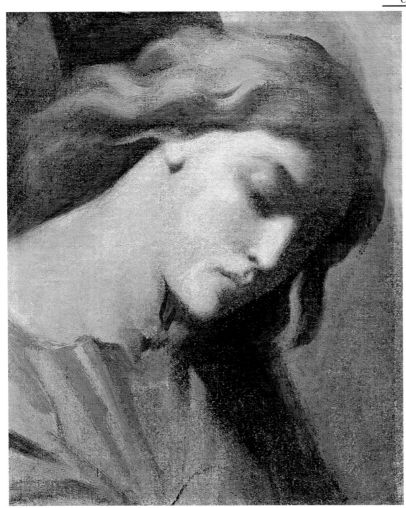

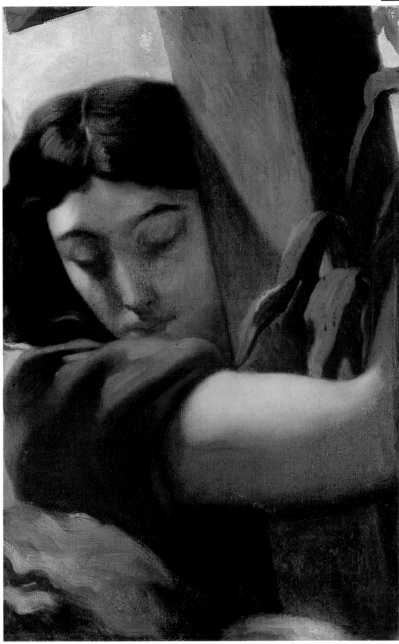

family came from."[2] Chassériau's Italian correspondence attests to how quickly the painter learned to solicit "M. Cavé" without annoying him.[3] Having failed to sell his *Susanna*, despite the recommendation of Chevandier the Elder, he obtained a commission for a painting whose subject all but changed in the course of its execution. In November 1839, Cavé asked that the figure of a saint replace that of Christ, for which Chassériau no doubt already had prepared preliminary sketches.[4] A page in one of the Louvre notebooks (2235; fol. 2) suggests that the artist had begun to think about the subject as early as January 1839, and implies that the commission came before the Salon of 1839.

The superb Moreau-Nélaton sketch (now in the Louvre; it previously belonged to Puvis de Chavannes), more colorful than the later painting and still with its arched top intact, shows that the painter changed his format only after his subject had been finalized. The tree behind Christ, which prefigures the Crucifixion, is more visible in the sketch than in the cloudy painting in Saint-Jean-d'Angély—so much so that certain critics believed it had been dispensed with during the final execution. Christ, who has come to pray, alone, in the Garden of Gethsemane, is visited by three angels, one holding the Cross and another a chalice, while the third clasps his hands. After overcoming the urge to revolt and the anguish of dying, Christ agrees to sacrifice his life for the redemption of mankind. Chassériau's interpretation here is in the tradition of the Romantic Christ so admired by Frank Bowman and Claude Pichois (see my essay, p. 41). Several of the artist's drawings document Chassériau's hesitations before he opted to depict the theme of Christ's resignation. Since 1839, he had focused on the moment when Christ, who has drunk from the chalice and whose soul has embraced death, returns to the sleeping apostles below (this is the subject of the version now in Souillac, cat. 79).

In its traditional subject, the painting in Saint-Jean-d'Angély is one of the clearest examples of the Christocentrism that dominated French Catholicism since the Counter-Reformation;[5] however, we might also mention, in this regard, the paintings Poussin executed in Rome during the papacy of Urban VIII.[6] The 1840 composition is not very far removed from Poussin, presenting the sleeping apostles at the bottom, Christ kneeling on the right, and, on the left, angels carrying the Cross and the attributes of the Passion, in a luminous halo, which splits open the black sky—and which Vigny would speak of in 1843. However, in Chassériau's painting, the soldiers, led by Judas, emerge from the right, and, not accidentally, appear behind Christ's back. In addition to French precedents (by Le Clerc, and Philippe de Champaigne, for example), which, according to Sandoz, Chassériau may have known, as well as older representations in Italian art, a primary influence was the portrayal of the solitary Christ, ordinarily depicted in prayer, submitting to God the Father or supported by an angel.[7]

Cast in shadow, the very Spanish-looking face of Christ superbly reflects his despondency. His prostrate

press and in the arts were circulating against the jury's corrupt practices.[1] It is not surprising that his name appeared next to those of Gautier, Delacroix, Préault, Daumier, and Charlet, for he now belonged to the most extreme faction of Romanticists, already far surpassing Ingres.

Christ on the Mount of Olives is thus the only work Chassériau was able to exhibit in 1840. The fact that it was commissioned by the Ministry of the Interior suggests a priori that Cavé, the director of the Division des Beaux-Arts, was more perspicacious than Cailleux in including the young painter championed by the most progressive critics. Beginning with Chevillard, Chassériau's early biographers asserted, although without proof, that he benefited in this matter from the valuable support of the comtesse de Meulan, the sister-in-law of Guizot, who supposedly also saw to it that the painting was "assigned to the part of the country where the painter's

form, elaborated on in a beautifully painted oil study in the Louvre, is all the more human and tragic. Indeed, in the Romantic consciousness, the agony of death Christ experienced in the Garden of Gethsemane is also the drama of man torn between the infinite and the finite or, as Bruno Foucart has written, "the understanding without illusions of human nature." Far from being simply sentimental, as a rapid reading of the picture might suggest, sadness for Chassériau is also metaphysical. Hence, the artist constructed the enormous canvas in Saint-Jean-d'Angély along simple, gently opposing lines, dispensing with chromatic brilliance despite the force of the chiaroscuro, to express his inner feelings.[8] The "fantastical" light (as Chassériau put it) that sculpts the handsome face of Christ also caresses the subtly androgynous angels; two studies for them exist that display an intentionally ambiguous charm, however, their latent femininity adds to their distress.

At the Salon of 1840, where Chassériau benefited from being recommended by a certain G. de Wailly,[9] the present image of Christ mobilized and divided the critics to the "utmost" (C. Monnerot). Jules Janin and Théophile Gautier best characterized their views, with the former, in a revealing choice, evoking the ghost of the great Bossuet, author of the Sermons, whose works the Romantics, from Chateaubriand to Baudelaire, are known to have read. Chassériau "chose the supreme instant when the Savior of men, conversing in private with God, his father, meditates within himself on whether he will be able to carry out the painful and bloody sacrifice. This is, strictly speaking, the first act in the great drama of the Passion of Our Lord. Of all the vast scenes in that drama, where the fate of the world is so clearly and simply in the balance, this scene is the simplest and the calmest; God is alone, without his tormentors, without his disciples. 'My soul is exceeding sorrowful. Why, if not because he saw his glory joined to his torment, an extremely harsh torment so full of opprobrium. This is the beginning of the agony that he was to suffer on the Mount of Olives, of that internal battle in which he had to fight against his torment, against his father, in some ways, and against himself.'[10] Such is the position of the bishop of Meaux himself: . . . That sadness of Christ on the Mount of Olives was very well understood by M. Chassériau. He carefully refrained from giving us the dejection of a common man, who is about to die; he was just as wary of the no-less-common heroism of dying men observed by the world; he avoided with a rare felicity all the drama that the scene might have contained. The sadness of Christ is simple and, as a result, divine. Its emotion is contained within the proper bounds. He does not tell himself: It must be; he also does not say: I will it. There is only one phrase to designate that resignation: God's will be done!"[11]

Gautier, for whom the interest of the Salon of that year lay in the clash between Chassériau's Christ and Delacroix's Trajan,[12] lingers over his description of Jesus, "collapsed on his knees, head bent, muscles flaccid, hands hanging down like a man who has run out of courage," and especially, of the angel handing him the bitter cup:

"That angel with tawny hair, dark blue eyes as blue as the sea, a thin nose, a long oval face, lips twisted in pain, with his Titan's arms, his athlete's neck, and his woman's hands, truly has a strange and supernatural look. He is not one of those coquettish little angels . . . but one of the serious and stern archangels whom God sends only on these solemn occasions. He seems to be telling Christ: Drink from this cup, into which all the sorrows of the world have been pressed like grapes, so that, when you are God, you may have pity for human weakness."[13]

Yet, Gautier also wants to defend his protégé against the reviews that had already appeared by the time he took up his pen: Tardieu, Royer, and the elderly Delécluze, even though he had been one of the first to support Chassériau, all criticized the painting's color scheme, which they found sadly uniform, and that slightly gilded fresco-like pallor that is still striking even today.[14] In response, Gautier only praised all the more, "the decisiveness and force of the choice made; no hesitation, no groping, everything is treated in large masses, and although the execution is very refined, the overall look is extremely simple, and the different groups in the composition support one another and take their places with ease and clarity. . . . Christ, the clouds, and the land are illuminated by a crepuscular, sepulchral, and terrible glow, leaden and lusterless like the glow on the temples of dead bodies, and that filters through the fissures in the large black clouds in their sinister configurations."[15] The audacity of the painting, too subtle for the conservative Journal des beaux-arts to perceive,[16] cannot be reduced to that shroud-like palette, however. Haussard notes with disapproval, for example, what he senses is a desire to reclaim a form of naïveté:

> M. Chassériau is a rather daring innovator in M. Ingres's school. He mixes the grandiose with the naïve. . . . The group of angels shines with a certain divine quality, and there is a grandeur in its despair; but it is not exempt from strangeness and exaggeration; the Christ is deeply felt, but perhaps with an overly naïve abandon. The main scene as a whole affects a natural loftiness, a noble and pure simplicity, but the most violent effects erupt around it: the earth is desolate, the light leaden, the shadows ghastly; the gigantic figures of the apostles twitch bizarrely in the shadows and in sleep, and the black and naked branches of an olive tree writhe in a funereal fog. Unquestionably, there is a force and a creativity in this work. All the same, M. Chassériau was in too much of a hurry to produce it; he ought to have tempered his imagination and the initial impetuosity of his feelings. It is only a sketch . . . full of energy, the dream of a painting, in which the beautiful glimmer of art can already be seen shining through.[17]

Five years after his early and manifold efforts at religious painting, which first attracted him about 1836, Chassériau produced a masterpiece, as personal and intense as it was true to its liturgical function. The fact that the theme was Gethsemane is confirmation of the historical alliance between the revival of sacred painting and the Romantic meditation on the deicidal century. Four years later, the painting now in Souillac would

place much greater importance on the theme of Christ's doubt, the angels would desert the heaven of the Passion, and only night, Christ's hesitation, and the mortal sleep of his disciples would remain. s. g.

1. See the Chronology, p. 176.
2. Chevillard 1893, p. 40.
3. Letter from Théodore to Frédéric Chassériau, September 9, 1840, see the Chronology, p. 179.
4. See the Chronology, pp. 175, 176, for details of the commission.
5. See J.-R. Armogathe, "Lueurs et ténèbres du 'Dieu caché,'" in Le Dieu caché. Les Peintres du Grand Siècle et la vision de Dieu, exhib. cat. (Académie de France in Rome, October 2000–January 2001), pp. 16–25. Nevertheless, the theme, despite its strong Eucharistic symbolism, is rare in painted retables at that time (see F. Cousinié, "Du Tableau au retable: Une Iconographie élargie," in ibid., pp. 58–71).
6. See J. Thuillier, Poussin (Paris: Flammarion, 1994), nos. 27, 88.
7. Under the Restoration, with the exception of works by Delacroix, the iconography most frequently adhered to was that of Christ supported in his ordeal by an angel. See the paintings of Destouches (Salon of 1822) and Rouget (Salon of 1824), in Foucart 1987, figs. 160, 161.
8. G. Guenot Lecointe, "Salon de 1840," in La Sylphide (March 14, 1840), mentions "drawing, but very little color."
9. Gabriel-Gustave de Wailly, a playwright, was born in 1804. He was named an officer of the Legion of Honor on July 30, 1832, and, under Louis-Philippe, served as inspector general of the Civil List.
10. Bossuet, Méditations sur l'Évangile, 12th day (noted by Janin).
11. J. Janin, "Salon de 1840," in L'Artiste, vol. 5, no. 11 (1840), p. 186.
12. On the reception of the Trajan see S. Guégan, "À Propos d'un Cheval rose–Note sur le Trajan de Delacroix au Salon de 1840," in Delacroix. La Naissance d'un nouveau romantisme, exhib. cat. (Rouen: Musée des Beaux-Arts, 1998), pp. 105–12.
13. T. Gautier, "Salon de 1840," in La Presse, Paris, March 13, 1840.
14. Tardieu: "M. Chassériau has created harmony in his very fine painting of Christ on the Mount of Olives, a harmony, it is true, that is easier to obtain when one is content with a uniform color scheme without brilliance. It is the composition above all that appears satisfying in this painting, by a young artist who will do even better with further study" ("Salon de 1840," in Le Courrier français [March 10, 1840]). Alphonse Royer: "M. Chassériau's Calvary is a large and severe composition, with a great purity of form. . . . When M. Chassériau has studied the colorists and no longer limits himself to just one aspect of art, I have no doubt that he will assume a preeminent place among the too-rare artists who are still devoted to great painting" ("Salon de 1840," in Le Siècle [March 11, 1840]). Delécluze: "I will say that the figures are ponderous, and that the brown tone of the painting is too uniform. In the works of M. Chasseriaux [sic] there is Northern melancholy; I would prefer southern sadness. The latter is more straightforward, more alive, more visible, which is more suitable to painting" ("Salon de 1840," in Journal des débats [March 12, 1840]).
15. See note 13, above.
16. [Unsigned], "Salon de 1840," in Le Journal des beaux-arts et de la littérature (March 22, 1840): "All that is lacking is a little originality."
17. P. Haussard, "Salon de 1840," in Le Temps (April 12, 1840). In the same spirit, an anonymous critic in Le Charivari ("Salon de 1840. Encore les ingristes," March 24, 1840), a notorious anti-Ingrist, could not bring himself to accept the fusion of earthly, even sensual, robustness with sacred mystery: "What big heads these angels have, what arms! How they struggle to move a load whose weight is necessarily only an abstraction! Far from having wasted away in his suffering, Christ is endowed with a superhuman corpulence. It would be better, however, not to stray too far from accepted beliefs in reproducing that sublime image. I do not want to worship my butcher or a commissioner from the Auvergne bursting with good health."

20

Study for the Kneeling Christ, Seen in Three-Quarter Left Profile

1840
Black pencil on cream-colored paper (loss at the lower left)
12 ⅛ x 8 in. (32.2 x 20.3 cm)
Estate stamp, lower right
On the reverse, in graphite: a mask in three-quarter left profile
Paris, Musée du Louvre (RF 24623)

PROVENANCE:
Studio of the painter until his death (L. 443); Frédéric Chassériau, the artist's brother, Paris, until 1881; Baron Arthur Chassériau, Paris; bequest of the latter to the Musée du Louvre, 1934 (L. 1886 a).

BIBLIOGRAPHY:
Chevillard 1893, part of no. 420; Prat 1988-1, vol. 1, no. 23, ill.; Peltre 2001, p. 63, fig. 68.

Exhibited in Paris only

This is a study, without variants, and with a powerful plasticity, for the drapery of Christ. l.-a. p.

21

*Male Nude Asleep, Seen in Half Length
and in Three-Quarter Left Profile,
His Head in His Arms*

1840
Black pencil with stumping and gray wash, heightened with
white on beige paper (loss lower left)
19 ¼ x 26 ⅜ in. (49.9 x 66.9 cm)
Paris, Musée du Louvre (RF 24625)

PROVENANCE:
See cat. 20.

BIBLIOGRAPHY:
Chevillard 1893, part of no. 420; Sandoz 1974, under no. 60;
Prat 1988-1, vol. 1, no. 35, ill.

Exhibited in Strasbourg only

Like another example in the Louvre (Prat 1988-1, vol. 1,
no. 37, ill.), the present drawing is a large cartoon for one
of the figures in the *Christ on the Mount of Olives*—in this
case, the apostle on the right. This figure does not appear
in the large sketch in the Louvre. L.-A. P.

22

Diana Surprised by Actaeon

1840
Oil on canvas
21 ¾ x 29 ⅛ in. (55 x 74 cm)
Signed and dated, lower right: *Thre Chassériau* / 1840
Private collection

PROVENANCE:
Larière Saint Albin (see the Chronology, May 1, 1840; p. 177);
M. and Mme Aubry-Vitet (Chevillard 1893); private collection.

BIBLIOGRAPHY:
Chevillard 1893, no. 91; Bénédite 1931, pp. 114–16; Sandoz 1968,
pp. 180–81; Sandoz 1974, no. 62.

EXHIBITION:
Rejected by the Salon of 1840; Paris, 1933, no. 18.

Exhibited in Paris only

Like Rembrandt, Chassériau based a large number of
his paintings on the theme of the voyeur and the woman
observed. Of the works that predate the artist's trip to
Algeria and that are included here, the *Venus* of 1838; the
Susanna of 1839; the *Andromeda* of 1840; the *Esther* of
1841; and even the *Cleopatra* of 1845 are all engaged in that
dialectic of intrusion on the forbidden. The body, vio-
lated or simply unveiled—seen or possessed—is the
subject all these pictures share. As a matter of fact, even
for this "painter of women," as Gautier called him, the
nudity he presents would be a very tame sight if the spec-

tator's guilt, threat of punishment, or, in psychoanalytical terms, castration anxiety could be forgotten.

Although, in Western imagery, Diana's bath, or rest, has often been charged with Sapphic allusions, depictions of the punishment of Actaeon, who was turned into a stag because he entered the goddess's cave and saw her in all her nakedness, have always conveyed a certain ambivalence. Since the Renaissance, images of Actaeon being attacked by his own dogs have signified both the dangers of sexual desire and the utter impossibility of satisfying it. In contrast to Diana, who embodies all the ambiguities of the chastity she attempts to protect, Actaeon personifies the unhappy lover devastated by the notion of impotence. His mortal condition is even interpreted as the inability to overcome that carnal obsession. In an important article, Steven L. Levine analyzed Actaeon's duality in light of the diversity of interpretations of Ovid

by painters as well as writers.[1] He also emphasized the evolution of the theme over the course of the eighteenth century, when, instead of focusing on the confrontation between the two protagonists, depictions tended to emphasize the latent licentiousness of the subject. With the generation of David's pupils, however, the inherent tension in the theme was reactivated. For example, desire and cruelty are again symmetrical concepts in André Chénier's poetry, of which the Chassériau brothers were devoted readers.[2]

That was also Chassériau's approach. In the registration book of the Salon of 1840, following the editor's listing of the "Diana Surprised by Actaeon," the artist himself added, "whom she turns into a Stag to punish him." To emphasize the outrage for which Actaeon paid with his life, Chassériau painted his most risqué canvas, its imagery within the limits of pornography revived by

Romanticism.[3] Absorbed by the spectacle of the hunter being devoured by the pack of hounds, Diana offers the spectator the charms of her "virginal body" (Ovid), which one of her attendants hastily tries to conceal. The one who sees is not seen, the one who saw will never see again. Sandoz (1968) has compared the boldness with which he represented Diana's buttocks to Jordaens's *Allegory of Fertility*, but while the latter may be a possible influence, this depiction of her anatomy belongs to the iconography of portrayals of Diana, and, even more so, to those of bathers in general. Without dismissing the hypothesis that Chassériau wanted to parody Ingres's *Grande Odalisque* (1814; Musée du Louvre), it should be recalled that Galloche, François de Troy, and even Boucher exploited these rather unfortunate back views of nude female figures in the foregrounds of their paintings.[4]

That spicy note is in keeping with the eroticism and luminosity of this little painting. The action takes place neither at the moment when Diana is taken by surprise (Actaeon has already undergone his metamorphosis) nor when the intruder suddenly emerges, inducing panic among the bathing women. In a tangled narration, which was characteristic of Chassériau's paintings until the final version of the *Deposition* in Saint-Philippe-du-Roule, the different events in the story are compressed, introducing an oneiric element within the drama. The painting has something of the quality of an erotic dream, or perhaps of an erotic nightmare. In addition to this impression of narrative wavering, there are stunning breaches of scale visible in the group on the right, as well as a color scheme bordering on the incandescent. This resolute rejection of all proportion and the petrified appearance of a few of the nymphs would hardly win over the jury.

On February 23, 1840, the jury rejected the *Diana* without putting the decision to a vote, which happened in cases of dispute (see the Chronology, p. 176). The sanction was thus a group decision. In addition, the painting was considered within the "genre" category, which amounted to a misunderstanding of the artist's goals and a confusion between format and academic designation. The painter's friends, such as Janin at *L'Artiste,*[5] were indignant. In his first article, on March 11, Gautier expressed his rage at the jury's corrupt practices, demanding "When will this scandal end?" and listing the proscribed artists: Gigoux and Cabat, "the greatest landscape artist of the French school," with Delacroix and his *Trajan* miraculously saved only at the last minute. Then he added: "Not accepted was M. Théodore Chassériau's *Diana Surprised,* a delicious painting with a classical tastefulness and purity, as deserving in every respect as *Venus Emerging from the Sea* [see cat. 13], which was rightly admired at the last salon. We must confess, we who have seen the picture in the painter's studio, that it is impossible to guess even remotely at the reason for such an exclusion: it is true that these gentlemen need no reasons, the thing has only to be beautiful."[6]

A few days later, Gautier repeated his diatribe, demolishing a commonplace that was widespread at the time: "Since M. Chassériau is a pupil of Ingres, people hastened to say he was exclusively a draftsman.—We are very annoyed that the jury rejected the *Diana Surprised by Actaeon,* with its effect of the setting sun, as golden and ruby red as gold made red-hot in the furnace.—It was the best possible response to that criticism, anticipated by the painter himself."[7] Now that the work is again available for viewing through the generosity of its owners, the impression remains of a glowing "sketch" (Bénédite) with aggressive color harmonies of red, green, blue, and pink. Nothing more was needed for Chassériau to find himself barred from the Salon and, already far removed from Ingres, for him to join the dissidents. The trip to Rome would do the rest. s. g.

1. S. L. Levine, "Voir ou ne pas voir. Le Mythe de Diane et Actéon au XVIIIe siècle," in *Les Amours des dieux,* exhib. cat. (Paris: Grand Palais, 1991–92), pp. lxxiii–xcv.
2. See André Chénier's poem "Diana," in imitation of Callimachus, in *Oeuvres complètes,* ed. Gérard Walter (Paris: Gallimard, Bibliothèque de la Pléiade, 1958), pp. 4–5; and the Chronology, July–August(?) 1837; p. 173.
3. In this regard, see the edifying examples discussed by A. Solomon-Godeau, "L'Autre Face de Vénus," in *Où en est l'Interprétation de l'oeuvre d'art?,* ed. R. Michel (Paris: ENSBA, 2000), pp. 273–301.
4. See the examples illustrated in *Les Amours des dieux,* exhib. cat. (Paris: Grand Palais, 1991–92).
5. J. Janin, "Salon de 1840," in *L'Artiste,* 5th series, no. 10 (1840), p. 170.
6. T. Gautier, "Salon de 1840. I," in *La Presse,* Paris, March 11, 1840.
7. T. Gautier, "Salon de 1840. II," in *La Presse,* Paris, March 13, 1840. As for the watercolor of *Diana and Actaeon* given to the critic by the painter, see catalogue 23.

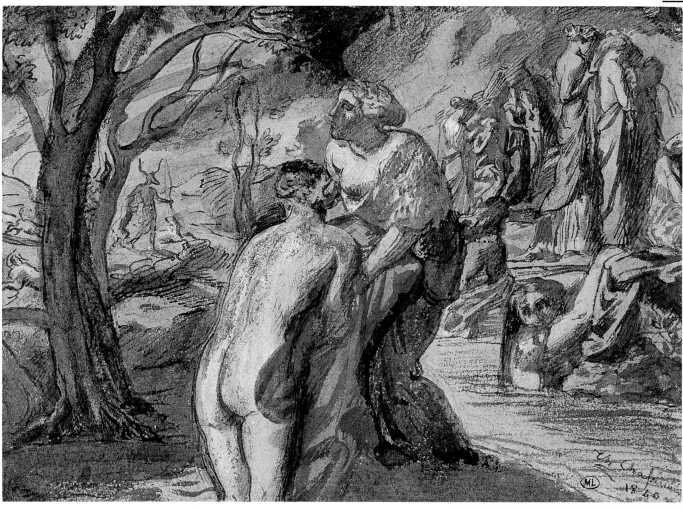

23

Diana and Actaeon

1840
Watercolor and gouache, over black pencil, with pen
and brown ink
5 ⅞ x 8 ¼ in. (14.8 x 20.7 cm)
Signed and dated in graphite, lower right: *Th. Chassériau* / 1840
Paris, Musée du Louvre (RF 24456)

PROVENANCE:
Théophile Gautier (1811–1872); sale, Paris, Hôtel Drouot, January
14–16, 1873, lot 122 (sold for Fr 85 to Patou); Baron Arthur
Chassériau, Paris; bequest of the latter to the Musée du Louvre,
1934 (L. 1886 a).

BIBLIOGRAPHY:
Chevillard 1893, no. 330; Bénédite 1931, vol. I, ill. p. 116; Sandoz
1968, p. 181 n. 28, fig. 13; Sandoz 1974, under no. 62; Prat 1988-1,
vol. I, no. 44, ill.; Peltre 2001, p. 90, fig. 100.

EXHIBITIONS:
Paris, Galerie Dru, 1927, no. 125; Paris, Orangerie, 1933, no. 105;
Paris, Galerie des Quatre Chemins [n.d.], no. 10.

Exhibited in New York only

Sandoz (1974) rightly wonders whether this is a prelim-
inary drawing or a repetition. Indeed, in spite of a few
variants (in the trees on the left), the drawing very faith-
fully repeats the composition of the 1840 painting *Diana
Surprised by Actaeon* (cat. 22), which was rejected by the
Salon. Its very accomplished appearance allows us to
suppose that it may be a replica of that work, after the fact.

L.-A. P.

24

Rocks on Capri

1840
Watercolor over graphite
11 ½ x 8 ⅝ in. (29 x 21.9 cm) (upper right corner damaged)
Paris, Musée du Louvre (RF 24396)

PROVENANCE:
See cat. 20.

BIBLIOGRAPHY:
Chevillard 1893, part of no. 420; Bénédite 1931, vol. 1, ill. p. 119;
Sandoz 1982, p. 40; Prat 1988-1, vol. 1, no. 1093, ill. and colorpl.
p. 38; Peltre 2001, p. 72, fig. 82.

EXHIBITIONS:
Paris, Galerie Dru, 1927, no. 127; Paris, Orangerie, 1933, no. 97;
Paris, Louvre, 1980–81, no. 12.

Exhibited in Paris only

CAT. 24

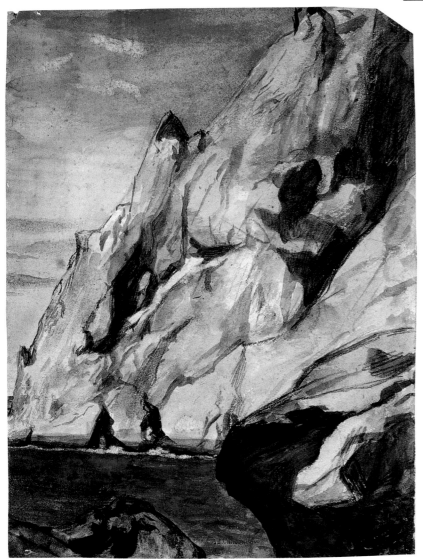

Italy attracted Chassériau, as it did many young Romantic artists. Having never competed for the Prix de Rome, which might have gained him access to the Villa Medici, he wanted to reestablish contact with Ingres, who headed that institution. Equipped with a small nest egg following the commission for the painting in Saint-Jean-d'Angély, *Christ on the Mount of Olives,* Chassériau set off from Marseilles on July 1, 1840, for a stay in Italy that would last nearly seven months.

Seeking to avoid the summertime heat and the unhealthy atmosphere in Rome, where he stayed for only a few days, he settled in Naples until August 24, visiting the surrounding areas and drawing many studies of landscapes (although he drew a large number of them, he would never paint any landscapes) and of local figures, as well as copying classical art and the works of the masters. Before leaving for Rome on August 24, he reportedly toured Herculaneum, Pompeii, Salerno, Paestum, La Cava, Palestrina, and Mola di Gaeta—all documented in drawings now in the Louvre. Ischia and Capri particularly interested him, and he painted several watercolors depicting their beaches and rocks. Totally devoid of human figures, these beautiful sheets reflect the artist's interest in rocky structures lost in a sea of deep blue. In Capri, in particular, he drew the famous rocks of the Faraglioni, which appear again in 1844 in the background of *O My Fair Warrior!,* the fifth plate in the series of "Othello" engravings. L.-A. P.

25

Study of a Nude Young Fisherman Seated on a Rock, Seen in Right Profile

1840
Watercolor over graphite
11 ½ x 8 ¾ in. (29.1 x 22.2 cm)
Inscribed in brush and brown wash, bottom center: *Capri———*
Paris, Musée du Louvre (RF 24900)

PROVENANCE:
See cat. 20.

BIBLIOGRAPHY:
Chevillard 1893, part of no. 420; Bénédite 1931, vol. I, p. 122;
Prat 1988-1, vol. I, no. 1377, ill.

Exhibited in New York only

This study was executed on Capri in 1840, but the model undoubtedly was a young fisherman from the Naples area. (Note also the graphite study of feet, which appears in the center, at the right.) Although Chassériau annotated another drawing in the Louvre (RF 25763; see Prat 1988-1, vol. I, no. 1378, ill.) *figures faites d'après des hommes de Capri* (figure studies after men from Capri), these works were actually executed in Salerno, and the models were clothed. L.-A. P.

26

Two Studies of the Head of a Young Italian Woman

1840
Black pencil and graphite on gray paper
6 ⅞ x 8 ⅞ in. (17.3 x 22.3 cm)
Inscribed and dated in black pencil, bottom right: *Rome 1840.*
On the reverse is a graphite study after an antique head of a man with his mouth open
Paris, Musée du Louvre (RF 25619)

PROVENANCE:
See cat. 20.

BIBLIOGRAPHY:
Chevillard 1893, part of no. 420; Ribner 1981, fig. 1; Sandoz 1982, p. 39; Sandoz 1986, no. 179 A, ill.; Prat 1988-1, vol. I, no. 1387, ill.

EXHIBITION:
Paris, Louvre, 1980–81, no. 8.

Exhibited in New York only

The model here is most certainly the same as that for the young woman on the left in the painting *Female Faces* (Ottawa, National Gallery of Canada; see Sandoz 1974, no. 73), which is inscribed with the location and date: *Rome septembre 1840.*

The sitter may also be the same young woman who appears in profile in a drawing in the Louvre (RF 25685; see Prat 1988-1, vol. I, no. 1384), also inscribed *Rome 1840.* The Antique classical head on the reverse of the present sheet is studied as well in the upper left of another Louvre drawing (RF 26572; see Prat 1988-1, vol. I, no. 1503). The reclining head in right profile seems to anticipate the face of one of the mothers to the left of Peace in the drawing of the complete composition *Peace, Protectress of the Arts and of Works on Earth* (cat. 126), although this figure would not be retained in the painted version. L.-A. P.

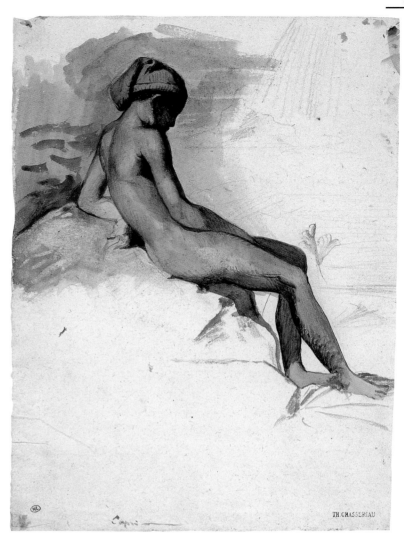

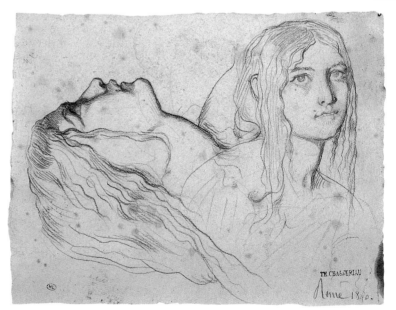

27

Three Little Girls in Olivano

1840
Graphite, heightened with white, on blue paper (affixed to
fol. 27 r. of dummy album 1)
11 ½ x 8 ¾ in. (29 x 22.2 cm)
Inscribed and dated in graphite, lower left: *Olivano / les femmes
avec des / coiffures noires et / graves—1840* [Olivano / women with /
black and sober / hairstyles—1840]
Paris, Musée du Louvre (RF 26154)

PROVENANCE:
See cat. 20.

BIBLIOGRAPHY:
Chevillard 1893, p. 239 (for the reinterpreted text), part of no. 420;
Sandoz 1986, no. 235, ill.; Prat 1988-1, vol. 1, no. 1407, ill.

Exhibited in Strasbourg only

Chevillard recorded the inscription, transforming it
slightly to make it more comprehensible.

Olivano (now Olevano Romano) is a small town, east
of Palestrina, famous for the Serpentara woods, and fre-
quented by many artists, especially Germans, in the nine-
teenth century. Chassériau drew six landscapes and six
figure studies there (Prat 1988-1, vol. 1, nos. 1222–1227,
1407–1412, ill.). L.-A. P.

28

View of the Villa d'Este, Tivoli

1840
Graphite, heightened with white, on blue paper
11 ½ x 8 ⅞ in. (29.1 x 22.3 cm)
Inscribed in graphite, at the bottom: *Villa d'Est—arrangé d'a-
près deux parties copiées / des petites / herbes—à mesure que / le
palais . . . / au fond il devient / chaud et coloré / sur un beau / ciel
plein de / soleil* [Villa d'Est(e)—composed from copies of two
parts / low grasses—as / the palace . . . / in the background it is
getting / hot and colored / against a beautiful / sunny / sky]
Paris, Musée du Louvre (RF 24804)

PROVENANCE:
See cat. 20.

BIBLIOGRAPHY:
Chevillard 1893, part of no. 420; Bénédite 1931, vol. 1, ill. p. 129;
Prat 1988-1, vol. 1, no. 1216, ill.; Peltre 2001, p. 72, fig. 85.

EXHIBITION:
Paris, Galerie Dru, 1927, no. 93.

Exhibited in Strasbourg only

The inscription seems to indicate that this drawing was
not executed from life, but from preparatory sketches. The
drawing depicts the staircase in the loggia of the Villa
d'Este as seen from the left of the façade overlooking
the gardens, but the steps are partly hidden by the trees.
The arrangement of the tree trunks to the right and left
of the architecture produces a highly decorative effect.
This drawing was probably among those seen by Marie
d'Agoult in the painter's studio on February 22, 1841:
"I am not in top form for writing. Yesterday I spent two
hours in Chassériau's studio looking at drawings of Rome,
heads of sailors from Genoa, landscapes of the Villa
Borghese, etc., etc. I returned from there sad beyond
words" (Franz Liszt and Marie d'Agoult, *Correspondance*
[2001], letter 374, dated February 23, 1841). L.-A. P.

29

Pair of Lovers in a Wood

1841
Graphite, heightened with white, on blue paper, the corners rounded
17 x 11 ⅜ in. (43.1 x 28.9 cm)
Signed, dated, and inscribed in graphite, lower right: *Théodore Chassériau / Tivoli Villa d'Est / 1841*
Paris, Musée du Louvre (RF 24399)

PROVENANCE:
See cat. 20 (no mark L. 443).

BIBLIOGRAPHY:
Chevillard 1893, no. 406; Bénédite 1931, vol. 1, ill. p. 127; Sandoz 1974, under no. 84, pl. 69; Prat 1988-1, vol. 1, no. 1417, ill. and colorpl. frontispiece.

EXHIBITIONS:
Paris, Galerie Dru, 1927, no. 38; Paris, Louvre, 1980–81, no. 14.

Exhibited in Paris only

Bénédite (1931, vol. 1, p. 132)—and, later, Sandoz—compares this drawing to a sketch entitled *The Fiancés* (formerly, collection of the duc de Trévise; present whereabouts unknown), noting that the artist "must have come across this pretty little scene in nature." Sandoz, conversely, sees the drawing as a possible illustration "of the loves of Alain Chartier and of the queen of Scotland" (see another drawing in the Louvre, RF 24475; see Prat 1988-1, vol. 1, no. 994; see also cat. 37). In fact, the landscape, which is treated in a very decorative manner, appears more imagined than observed. The study was displayed on an easel in Baron Arthur Chassériau's Paris drawing room, in the rue de la Néva (see fig. 2, p. 18). L.-A. P.

30

Studies of an Italian Woman, Seen Full Face and in Profile

1840
Oil and pencil on wood
10 ¾ x 15 ⅝ in. (27.2 x 39.6 cm)
Inscribed and dated, bottom left: *Rome 1840;* on the reverse: stamp from the posthumous sale
Rheims, Musée des Beaux-Arts (D 937.1.2)

PROVENANCE:
Studio of the painter until his death; Chassériau sale, Paris, Hôtel Drouot, March 16–17, 1857, part of lot 29 ("Studies from life done in Italy and in Algeria"), sold for Fr 628 (according to the annotated copy of the sales catalogue in the Cabinet des Estampes, Bibliothèque Nationale de France, Yd 929a, in-8°); Baron Arthur Chassériau, Paris; bequest of the latter to the Musée du Louvre, 1934 (RF 3864); placed on deposit by the Musée du Louvre in the Musée des Beaux-Arts, Rheims, 1937.

BIBLIOGRAPHY:
Bénédite 1931, vol. 1, ill. p. 141; Sandoz 1958, pp. 113–16; Vergnet-Ruiz and Laclotte 1962, Index; Sandoz 1974, no. 74, pp. 174, 175, pl. 59.

EXHIBITION:
Paris, Orangerie, 1933, no. 14, p. 8.

31

Study of an Italian Man, usually called *Young Herdsman of the Pontine Marshes,* and sometimes *Head of a Man*

1841
Oil on canvas
19 ¾ x 17 ⅜ in. (50 x 44 cm)
Inscribed and dated, lower right: *Rome / 1841;* on the reverse: stamp from the posthumous sale
Arras, Musée des Beaux-Arts (D.936.1)

PROVENANCE:
Studio of the painter until his death; Chassériau sale, Paris, Hôtel Drouot, March 16–17, 1857, part of lot 28 ("Sketches and various studies"); sold in two separate lots for Fr 71 and 645, respectively, or part of lot 29 ("Studies from life done in Italy and in Algeria"), which sold for Fr 628 (according to the annotated copy of the sales catalogue in the Cabinet des Estampes, Bibliothèque Nationale de France, Yd 929a, in-8°); Henri Lehmann, Paris (according to Chevillard 1893, no. 215); Baron Arthur Chassériau, Paris; bequest of the latter to the Musée du Louvre, 1934 (RF 3869); placed on deposit by the Musée du Louvre in the Musée des Beaux-Arts, Arras, 1937.

BIBLIOGRAPHY:
Chevillard 1893, no. 215; Vaillat 1913, ill. p. 2; Sandoz 1958, pp. 113–16, ill. p. 108, fig. 5; Vergnet-Ruiz and Laclotte 1962, Index; Oursel, 1969, p. 42; Sandoz 1974, no. 81, pp. 182, 183, pl. 66; Prat 1999, p. 74.

EXHIBITION:
Poitiers, 1969, no. 8.

During his stay in Italy, like all his foreign colleagues, French or not, Théodore Chassériau was particularly concerned with three technical exercises, while executing two masterpieces in the portrait genre, *The Reverend Father Dominique Lacordaire* (cat. 47) and *The Comtesse de La Tour Maubourg.* He copied works from classical Antiquity and by the Old Masters, as attested by the many drawings in the Musée du Louvre;[1] he practiced painting landscapes out-of-doors, for the most part in graphic mediums rather than in oil (see cat. 28);[2] and he made character studies of regional types and of Italian costumes, which he could later use in history or religious paintings.

In these last exercises, executed in oil as well as in graphite, he produced a series of studies of faces, both male and female, of a very high quality stylistically and

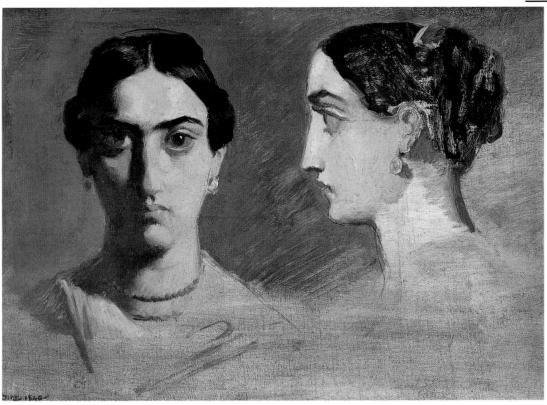

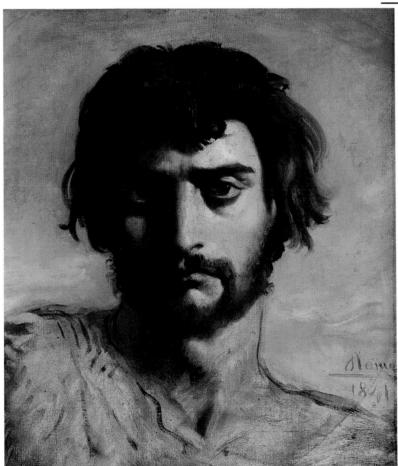
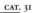

of obvious beauty. Certain of the models would reappear, sometimes in somewhat altered form, in the painter's large compositions, after 1840. These oil sketches, intended to serve as preliminary studies for paintings to be carried out in the studio, remained in the artist's collection, and were put up for auction at the posthumous sale of his work in 1857.[3] This particular group of studies, which apparently remained unsold—or was repurchased by the painter's family—was bequeathed to the Musée du Louvre by Baron Arthur Chassériau in 1934, and was later placed in several regional museums by the Louvre, so that the painter is well represented throughout France.[4]

During these sessions in Italy, Chassériau, working from life, did not hesitate to depict his model full face as well as in profile on the same canvas, as in the study entitled *Female Face,* in the Musée des Beaux-Arts, Rheims. He often mixed various mediums, first sketching the composition in graphite or ink and then completing it in oil. For the most part, it was the faces, features, hairstyles, and human types that interested him at this stage: The studies generally were bust length and the costumes were never depicted, with the exception of the beautiful painting of a woman in the Museum voor Schone Kunsten, Ghent. Although obviously realistic, these works frequently reveal a certain idealism, with the female models sometimes exuding an air of melancholy. Often, the choice of a particular figure type was dictated by ancient classical archetypes.

The two sketches presented here perfectly encapsulate Chassériau's Italian works: a study of face and hair for the Rheims painting, and a character study for the

superb male portrait in Arras, generally considered to be of a herdsman from the Pontine Marshes.

Without a doubt, the latter study is, in its vigor and realistic beauty, one of the most interesting in the series. A handwritten comment on file in the dossier in the Département des Peintures at the Louvre aptly describes the work: "Fierce and sad expression. Painted from life. Herdsman ill with malaria, for a competition among Ingres's students." In addition, Louis-Antoine Prat has indicated in a recent article[5] that the model for the Arras painting appears to bear a resemblance to the face in a sketch that appeared at auction in 1998.[6] This might suggest that these oil studies painted from life generally were accompanied by an equivalent in pencil or ink, in order to capture the particularities of a face, a feature, or an attitude in all its nuances.

Finally, according to Valbert Chevillard, the Arras study was acquired by Henri Lehmann (1814–1882), perhaps subsequent to the posthumous sale of the contents of the painter's studio in 1857. After Chassériau's death, this fellow pupil in Ingres's studio apparently had exorcised the reservations, jealousy, and resentment he had built up toward Chassériau during their stay in Italy, as attested in the correspondence with his mistress, Marie d'Agoult.[7] In acquiring this study, Lehmann was thus paying tribute to the genius of his friend, as skillful in the execution of completed works as in sketches that spontaneously capture individual faces and features. V. P.

1. Prat 1988-1, vol. 1, nos. 1468–1572, pp. 539–66.
2. Ibid., nos. 1092–1366, pp. 452–513.
3. See the Provenance, above.
4. One of the studies in this series is now in the National Gallery of Canada, Ottawa *(Female Faces, Seen from the Front)* and another is in the Museum voor Schone Kunsten, Ghent *(Bust-Length Portrait of a Woman).* In addition to the two works shown here, the others are in the Musée du Louvre *(Head of an Old Man;* RF 3865), the Musée Municipal, Cambrai *(Head of a Woman, with an Earring),* Musée des Beaux-Arts, Valenciennes *(Head of a Young Woman in Right Profile),* Musée Départemental de l'Oise, Beauvais *(Head of a Young Man Seen from the Front),* and Musée de l'Abbaye Sainte-Croix, Poitiers *(Head of a Young Man).*
5. Prat 1999, p. 74.
6. Paris, Hôtel Drouot, June 5, 1998, black pencil, inscribed and dated: *Rome 1840* (ill. no. 4, p. 75).
7. On this subject see S. Joubert, *Une Correspondance romantique. Mme d'Agoult, Liszt, Henri Lehmann* (Paris: Flammarion, 1947), p. 122.

32

Sleep and the Hours of the Night

1840
Graphite on cream-colored paper (arched at the top)
16 x 11 ¼ in. (40.6 x 28.4 cm)
Inscribed and dated in graphite, across the lower part: *Tivoli à minuit aout 1840 / le Génie du sommeil calme beau et bon—la lune derrière lui pale comme au milieu de la nuit—il faut / une couleur solide et nocturne de la variété comme cela est dans les beaux climats— à côté dans / les deux espaces qui seraient plus grands qu'ici deux paysages sans figures la / solitude de la nature—la nuit, les grands . . . la tranquillité, les animaux qui se promènent et les / fleurs qui s'ou-vrent—Deux grands paysages / Plus bas les heures de la nuit qui donnent dans leur sommeil tous les / pavots aux hommes il en faut 6 toutes belles nonchalantes et sous / un ciel très profond qui doit fuir et être tout couvert d'étoiles 9, 10, 11 peut-être 7 figures / mes trois sujets au dessous / les faire en trois compartiments et d'un ton vivace pour que le dessus seul soit / d'un ton mélancolique* [Tivoli at midnight August 1840 / the Genie of sleep calm beautiful and good—the moon behind him pale as in the middle of the night—will need / a solid and nocturnal color of the sort that is in fine climates— next to it in / the two spaces that will be bigger than here two landscapes without figures the / solitude of nature—night, the

large . . . tranquility, the animals walking and the / flowers ope-ning—Two large landscapes / Farther down the hours of the night who in their sleep give all the / poppies to the men will need 6 of them all beautiful nonchalant and under / a very deep sky that should recede and be entirely covered with stars 9, 10, 11, perhaps 7 figures / my three subjects below / do them in three compartments and in a lively tone so that only the upper part is / melancholic in tone]
Paris, Musée du Louvre (RF 24345)

PROVENANCE:
Studio of the painter until his death (L. 443); Chassériau sale, Paris, Hôtel Drouot, March 16–17, 1857, lot 94, entitled *At Midnight;* Baron Arthur Chassériau, Paris; bequest of the latter to the Musée du Louvre, 1934 (L. 1886 a).

BIBLIOGRAPHY:
Chevillard 1893, no. 384, p. 263 (text); Bénédite 1931, vol. 1, pp. 126–27, ill. p. 149 (entitled *The Hours of the Night*); Sandoz 1974, p. 11; Sandoz 1982, p. 39; Prat 1988-1, vol. 1, no. 1040, ill.; Peltre 2001, pp. 74–75, 149, fig. 88.

EXHIBITIONS:
Paris, Galerie Dru, 1927, no. 6; Paris, Orangerie, 1933, no. 99; Paris, Louvre, 1980–81, no. 15; Paris, Galerie des Quatre Chemins [n.d.], no. 33.

Exhibited in New York only

This study, executed in Tivoli in late August 1840, represents a first stage in the plan for *Sleep,* an allegorical composition for which there are several other drawings, now in the Louvre. If we go by the notes on this sheet (mis-read by Chevillard and Bénédite, who omit the essential sentence: *my three subjects below),* the composition was to include: in the upper part, the figure of the genie of Sleep; below that, the Hours of the Night; and, at the bottom, the triptych of *Rest* or of *Night,* for which the

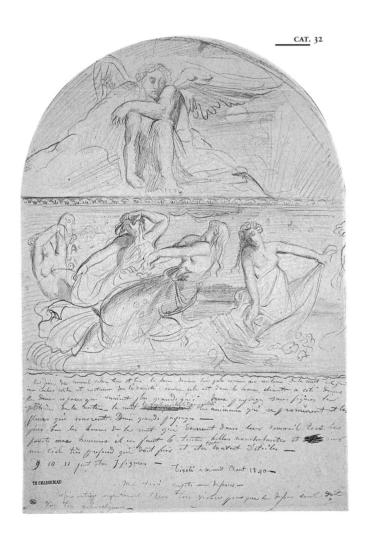

CAT. 32

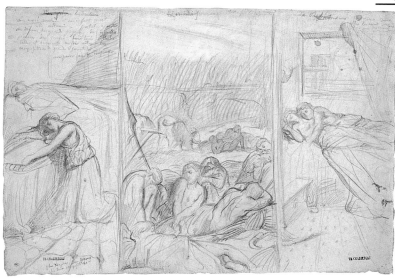

Louvre drawing RF 25578 (Prat 1988-1, vol. 1, no. 1041; cat. 33) seems to be a preliminary sketch.

In other studies, the figures symbolizing the Hours, seen here in a frieze, would be arranged around a clock-face (Prat 1988-1, vol. 1, nos. 1042–1044).

One part of the annotation on the Louvre drawing RF 25223 (Prat 1988-1, vol. 1, no. 542) refers to the plan seen here: "Caryatid-columns representing the hours of the day and night; for the day—a handsome young man with a radiant face, extending his arms covered with dew; for the night surround her with all her nocturnal companions and on all sides with the black hours who pour poppies over all the somber and tumultuous scenes."

We may therefore assume that the project included at least three registers: the genie of Sleep in the upper part, the Hours of the Night below it, and the allegories of Rest or of Sleep at the bottom. In addition, if we are to believe the annotations, landscapes were to be inserted on either side of the genie of Sleep. Lower down, there were to be two "large dream figures" and between each of the three scenes in the lower register, "large caryatids."

It is not the genie of Sleep himself (Morpheus?) but the Hours of the Night who are scattering blossoms from the opium poppy (*papaver somniferum*)—from which the narcotic morphine is extracted—over the figures. The general concept seems to have been that Sleep acts both on the unfortunate and on the fortunate: the woman in the lower left, whose husband is ill and bedridden, and who wraps her arms around her dead child's cradle, as well as the happy lovers on the right and the reapers, exhausted by their toil, in the center.

A letter to Henri Lehmann from Marie d'Agoult on March 1, 1841 (quoted in Joubert 1947, p. 158), shows that the subject must have been transposed into a painting, at the very least in the form of a sketch: "At his home, I saw a sketch of a little painting that will be charming, I believe. It is the hours of the evening fleeing at the approach of night: Four delicious figures of women intertwined in graceful attitudes descend in the firmament at the far right, with the moon on the left, and, below, a landscape that will be like a heath in full flower." L.-A. P.

33

Rest, or *Night,* or *Sleep*

1840
Graphite
11 ⅜ x 17 ⅝ in. (28.9 x 44.7 cm)
Inscribed in graphite, upper left: *Les peines* [crossed out] *les douleurs / son mari malade et son enfant mort / elle endormie—peut être ajouter / au dessous des grands paysages de grandes figures de songes / l'une triste et l'autre belle et souriante / aussi entre / les compositions de grandes cariatides—une pauvre famille misérable* [The troubles (crossed out) the sorrows / her husband sick and her child dead / she asleep—maybe add / beneath the large landscapes some large dream figures / one sad and the other beautiful and smiling / also between / the compositions large caryatids—a poor wretched family]; lower left: *plus d'espace au dessus / des deux compositions* [more space above / the two compositions]; upper center: *Les moissonneurs tout à fait le crépuscule* [The reapers total dusk]; upper right: *Le repos* [crossed out] *l'amour—la solitude d'une / ville la nuit et les deux / qui dorment* [Rest (crossed out) love—the solitude of a / city at night and both / sleeping]
On the reverse are graphite studies of a woman extending her arms, with trees behind her, and a figure in a curved arch
Paris, Musée du Louvre (RF 25578)

PROVENANCE:
See cat. 20.

BIBLIOGRAPHY:
Chevillard 1893, part of no. 420; Bénédite 1931, vol. 1, pp. 127–29, ill. p. 104 (entitled *Rest—Rest in Death—Rest of the Reapers—Rest of the Husband and Wife*); Sandoz 1974, p. 28; Prat 1988-1, vol. 1, no. 1041, ill.; Peltre 2001, p. 74, fig. 89.

EXHIBITIONS:
Paris, Louvre, 1957, no. 21, pl. 5; Paris, Louvre, 1980–81, no. 24.

Exhibited in New York only

Probably executed in Italy in 1840, this drawing is related to the one entitled *Sleep* (cat. 32) and may be considered its complement, especially if we compare the inscriptions on the two sheets; these seem to refer to a plan for a complex composition, divided into registers as here, but also including landscapes and caryatids. The theme of Sleep was to be combined with that of Night.

The device of marking the divisions in a series of compositions with caryatids or large vertical figures would be used again in the preliminary studies for the Cour des Comptes paintings (see the Louvre drawing RF 25527; see also Prat 1988-1, no. 415). The studies on the reverse of the present sheet are probably later in date. One appears to correspond to *The Assumption of Saint*

Mary of Egypt in the Church of Saint-Merri; the other to the *Peace* in the Cour des Comptes, in which the figure is shown spreading her arms—a choice of pose that was adopted by the artist only after many hesitations.

Immediately to the figure's left, a study of a young mother wearing a headband and holding her child is easily distinguished. The two trees behind the figure of Peace seem to have been blended into a single tree in the painting.

<div style="text-align:right">L.-A. P.</div>

vate collection)! The various feelings expressed by the five figures (one of them is studied again, separately, at the upper right) range from sadness to exaltation and are probably related to the different times of night.

<div style="text-align:right">L.-A. P.</div>

<div style="text-align:right">CAT. 34</div>

34
The Hours: Angels Surrounding a Clockface

1840
Pen and brown ink, and graphite, heightened with white, on cream-colored paper
10 ⅝ x 10 ⅜ in. (27 x 26.2 cm)
Inscribed in pen and brown ink, upper right: *très douloureux* [very painful]; right center: *il montre / il faut que le bras / sorte de la / fresque qu'il / recouvre la lumière très / fortement* [he points / the arm must / emerge from the / fresco that / very vigorously / conceals the light]
Paris, Musée du Louvre (RF 24435)

PROVENANCE:
See cat. 20.

BIBLIOGRAPHY:
Chevillard 1893, part of no. 420; Bénédite 1931, vol. 1, p. 129, vol. 2, ill. p. 462; Prat 1988-1, vol. 1, no. 1042, ill. and colorpl. p. 23; Peltre 2001, p. 75, fig. 91.

EXHIBITIONS:
Paris, Galerie Dru, 1927, no. 35; Paris, Orangerie, 1933, no. 164.

Exhibited in New York only

When, in Tivoli in August 1840, Chassériau conceived his plan for a composition of *Sleep* and of *The Hours of the Night*—which, however, was never executed (see cat. 32, 33)—he first imagined a sort of round dance of the Hours unfolding on a horizontal plane. In the variant, of the same date, seen here, the Hours have become more masculine and are now angels (although angels are considered to be asexual); they surround a clockface with its many divisions, but without hands (as in a famous early Cézanne, *Still Life with Black Clock,* of about 1870; pri-

35
Plan for the Tomb of Napoleon I

1840–41
Graphite and red chalk on cream-colored paper; squared in graphite
16 ⅝ x 10 ⅜ in. (42 x 26.1 cm)
Inscribed in graphite, in an unknown hand, upper left: *le dome a de 27 a 28 m de diamètre sur environ 50 m de haut—Le monument pourrait avoir 10 mètres à 12 mètres* [the dome is between 27 and 28 meters in diameter by about 50 meters high—The monument could be 10 to 12 meters high]; in red chalk and graphite, in the artist's hand, upper center and right: . . . *les tablettes / la gloire portant des palmes / sur son tombeau / deux aigles à / ses pieds* [. . . the tablets / glory bearing palm branches / on his tomb / two eagles at / his feet]
Paris, Musée du Louvre (RF 25797)

PROVENANCE:
See cat. 20.

BIBLIOGRAPHY:
Chevillard 1893, no. 346 [?]; Bénédite 1931, vol. 1, ill. p. 218; Sandoz 1958, p. 119 n. 57; Sandoz 1974, p. 11; Prat 1988-1, vol. 1, no. 999, ill.; Peltre 2001, p. 150, fig. 165.

Exhibited in Strasbourg only

This drawing is related to the plans for the tomb of Napoleon I at the Invalides, devised at about the time of the return of his ashes in 1840, for which a competition was held. I was of the opinion that Chassériau did not officially participate in that contest, but the recent publication of a letter from the painter to the editors of *L'Artiste* (Peltre 2001, p. 150) seems to prove the contrary. Furthermore, the annotations on the left refer to the dimensions of the dome of the Invalides.

<div style="text-align:right">CAT. 35</div>

The style of the drawing situates it in about 1840, either before or after his stay in Italy (construction of the tomb, designed by Visconti, would begin in 1841). The upper left part of the present drawing was repeated in a more extensive drawing of which only a fragment remains (now in the Louvre; see Prat 1988-1, vol. 1, no. 1000, ill.), and it also can be linked to an annotation on the back of another Louvre drawing (Prat 1988-1, vol. 1, no. 1004) for the same project. Chassériau's concept was quite original; he surrounded the figure of the emperor, seated on a throne, with winged genies, beneath which he added recumbent prisoners to symbolize the defeated nations. Although several sketches exist of the doge of Venice (see Prat 1988-1, nos. 1002–1003), he does not appear in this overall plan.

Included in the sale of the contents of Chassériau's studio (March 16–17, 1857), under no. 82, was a *Plan for a Tomb of Napoleon I,* but it is impossible to know whether this might have been the present drawing.

L.-A. P.

36

The Martyrdom of Saint Erasmus,
after Poussin

1840
Pen and brown ink, with brown wash, heightened with white, on greenish-blue paper (affixed to fol. 29 v. of dummy album 3)
11 ½ x 8 ⅜ in. (29.2 x 21.1 cm)
Inscribed in pen and brown ink, lower right: *le martyre ici le ciel nacré / tout le tableau sombre et / très vigoureux—Poussin—de la Galerie Chiaire—le bleu sombre et franc / septembre* [the martyr here the sky pearly / the entire painting dark and / very powerful—Poussin—from the Galerie Chiaire—the blue dark and pure / September]
Paris, Musée du Louvre (RF 26441)

PROVENANCE:
See cat. 20.

BIBLIOGRAPHY:
Chevillard 1893, part of no. 420; Prat 1988-1, vol. 1, no. 1522, ill.; Peltre 2001, p. 71, fig. 77.

Exhibited in Paris only

This is a copy, executed in Rome in September 1840, not after the famous painting by Poussin in the Vatican,

to which Chassériau alludes in an annotation on the Louvre drawing RF 24828 (Prat 1988-1, vol. 1, no. 1316) but after the sketch, identical in every respect, then in the Sciarra collection, and today in the National Gallery of Canada, Ottawa. Chassériau copied works by Poussin in several drawings (now in the Louvre; see Prat 1988-1, nos. 2188–2191, ill.) and on two notebook pages.

<div style="text-align: right;">L.-A. P.</div>

37

Alain Chartier Kissed by the Queen

1840
Pen and brown ink, with brown wash, over black pencil, heightened with white, on beige paper
11 ½ x 7 ¾ in. (29.2 x 19.5 cm)
Inscribed and dated in black pencil, lower left: *Alain Chartier / Décembre Rome;* in pen and brown ink, center: *elle étend son voile / royal* [she spreads her royal / veil]
Paris, Musée du Louvre (RF 24475)

PROVENANCE:
See cat. 20.

BIBLIOGRAPHY:
Chevillard 1893, part of no. 420; Bénédite 1931, vol. 1, ill. p. 158; Sandoz 1974, under no. 84; Prat 1988-1, vol. 1, no. 994, ill. and colorpl. p. 27; Peltre 2001, p. 33, fig. 29.

EXHIBITIONS:
Paris, Galerie Dru, 1927, no. 102; Paris, Orangerie, 1933, no. 96; Paris, Louvre, 1980–81, no. 13.

Exhibited in Paris only

Inscribed *Décembre Rome*—and, hence, dating to 1840—this drawing illustrates a legendary episode in the life of the poet Alain Chartier (about 1385–about 1433), who served as secretary to King Charles VI and King Charles VII, and was the author, notably, of *La Belle Dame sans mercy* (1424). The anecdote illustrated here was first

<div style="text-align: right;">CAT. 37</div>

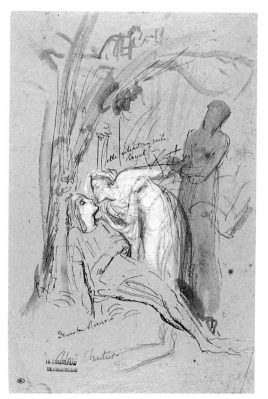

recounted by Jean Bouchet in the *Annales d'Aquitaine* in 1524: One day, the dauphiness Margaret of Scotland, wife of the future king Louis XI, kissed the poet, who was sleeping on a bench, in the presence of the court. When an envious man reproached her for kissing such an ugly man, she replied: "I did not kiss the man, but the precious mouth from which so many good words and virtuous utterances have come forth."

Also in the Louvre is a more extensive sketch for the figure of the attendant (RF 26289; see Prat 1988-1, no. 995). In addition, an allusion to this theme and to another author who reported the anecdote (Pasquier) appears in an autograph note in the Louvre (Prat 1988-1, p. 976, AU III).

A drawing by Ingres (fig. 9, p. 29) in Montauban (Inv. 867-2685) depicts the same scene, with the two protagonists in fairly similar poses. According to a notation by Ingres at the bottom of the drawing, it was in the royal apartments at the Louvre that the event supposedly took place.

<div style="text-align: right;">L.-A. P.</div>

38

Head of a Man in Three-Quarter Left Profile, His Hand Over His Mouth

1841
Graphite, heightened with white, on blue paper (affixed to fol. 40 r. of dummy album 3)
13 ¾ x 11 in. (34.7 x 27.8 cm)
Inscribed in pen and brown ink, bottom center: *l'Effrayant Orcagna* [the Frightening Orcagna]
Paris, Musée du Louvre (RF 26482)

PROVENANCE:
See cat. 20.

BIBLIOGRAPHY:
Chevillard 1893, part of no. 420; Prat 1988-1, vol. 1, no. 1530, ill.

Exhibited in Strasbourg only

This study, executed in the Campo Santo in Pisa in January 1841, is a copy of the head of the angel crouching above the Archangel Michael in the center of the fresco of *The Last Judgment,* attributed by some authors to

<div style="text-align: right;">CAT. 38</div>

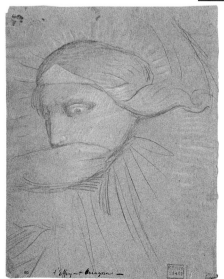

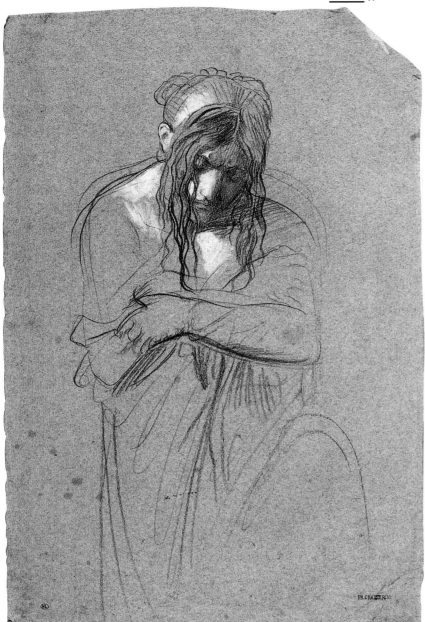

Francesco Traini. As Francis Haskell has pointed out in *Rediscoveries in Art* (1976), at the time of Chassériau's trip to Rome, a large number of Italian Gothic paintings were attributed to the generic artist "Orcagna."

Among the artists whose works Chassériau copied during his stay in are Michelangelo, Raphael, Andrea del Sarto, Veronese, Rubens, Van Dyck, and Dughet; drawings after all these artists are in the Louvre. **L.-A. P.**

39

A Woman Seen in Half Length, Her Arms Crossed and Her Head Bent Forward

1840–41
Black pencil, heightened with white, on blue paper (loss in the upper right corner)
16 ¾ x 11 ¾ in. (42.5 x 29.7 cm)
On the reverse is a black pencil study of a head of woman in right profile
Paris, Musée du Louvre (RF 25925)

PROVENANCE:
See cat. 20.

BIBLIOGRAPHY:
Chevillard 1893, part of no. 420; Prat 1988-1, vol. 1, no. 119, ill.; Peltre 2001, p. 93, fig. 103.

Exhibited in Paris only

The style and the paper indicate that this work was executed in Italy in 1840–41 and probably was intended for one of the figures in the 1841 painting *The Trojan Women.* Sandoz (1974, p. 192) notes that the drawings corresponding to this work (now destroyed), are "all different from the painting."

The Trojan Women, or, more exactly, *On a Desert Beach, the Trojan Women Mourned the Loss of Anchises, and, Weeping, They Gazed Upon the Deep Sea,* the title of the painting when it was exhibited at the Salon of 1842, is only known from an oil sketch in the museum in Beauvais (Sandoz 1974, no. 91, pl. 74), and from the more than twenty drawings in the Louvre (Prat 1988-1, nos. 97–119, ill.); in fact, the large canvas, signed and dated 1841, was destroyed in Budapest in 1945 along with other works in the collection of Baron Hatvany and the only record of the painting itself is a photograph (Sandoz 1974, no. 90, pl. 73).

Chassériau first conceived the composition about 1837, worked on it in Italy, and then developed it further after returning to Paris. The source is found in Book 5 of the *Aeneid,* in which Virgil relates that, after the death of Anchises, Aeneas's father, "cunctaeque profundum / Pontum adspectabant flentes" [all the women, weeping, gazed at the deep sea]. Several drawings in the Louvre are clearly annotated *Trojan Women* or *Virgil,* but none constitutes a direct study for any figure in the painting. Conversely, the oil study of the old woman of Cambrai (Sandoz 1974, no. 76, ill.) was adapted, practically without alteration (according to D. Stern, "Salon de 1842"), for the woman dressed in "deep violet," and flanked by two young women, in the foreground of the composition. The double oil study of heads, in Ottawa, was used for the two figures in the middle ground, on the right, in the finished work. **L.-A. P.**

40

Wailing Woman Kneeling in a Landscape, with Trees and the Sea in the Background

about 1840–41
Graphite, heightened with traces of white, on beige paper
9 ⅜ x 9 ¾ in. (23.6 x 24.6 cm)
Paris, Musée du Louvre (RF 24383)

PROVENANCE:
See cat. 20.

BIBLIOGRAPHY:
Chevillard 1893, part of no. 420; Sandoz 1974, under no. 133,
pl. 123 a; Sandoz 1986, no. 176, ill. (with erroneous dimensions);
Prat 1988-1, vol. I, no. 70, ill.; Peltre 2001, p. 90, fig. 104.

EXHIBITIONS:
Paris, Galerie Dru, 1927, no. 51 (?); Paris, Orangerie, 1933,
no. 170.

Exhibited in Strasbourg only

In about 1840–41, as several drawings in the Louvre attest
(Prat 1988-1, nos. 69–86, ill.), Chassériau was at work on
a painting of *Ariadne Abandoned,* now known only through
an oil sketch that Sandoz (1974, no. 133, pl. 123; the study
was put up for sale at Sotheby's, London, June 15, 1982,
lot 13, colorpl.) dates between 1849 and 1856, which is
untenable from a stylistic point of view. Among the pre-
liminary drawings, the one presented here is still very
different from the definitive composition in which Ariadne
would be depicted nude and turned toward the left, leaning
on a tree, while offshore the ship bearing Theseus and her
sister Phaedra is disappearing in the distance.

Ariadne and Phaedra were the daughters of Minos
and Pasiphaë. Ariadne fell in love with Theseus when
he came to Crete to battle the Minotaur, and she provided
him with the thread that would allow him to find his way
in the labyrinth. The two lovers fled after Theseus had
defeated the monster, but, once on Naxos, Theseus left
Ariadne for Phaedra. However, Ariadne did not remain
abandoned for long, since Bacchus, seduced by her
beauty, took her with him to Olympus.

In this rapidly executed study, it is primarily the rela-
tionship between the figure and the vegetation that inter-
ested Chassériau, who composed the female body and the
tree trunks using the same approach. The minuscule sail
in the distance, resembling an accent mark or a comma,
is reflected below the horizon line.

L.-A. P.

CAT. 40

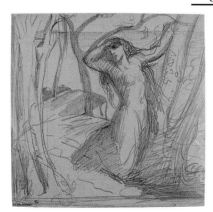

41

Nude Woman Kneeling and Leaning Against a Tree, Her Right Arm Raised

about 1840–41
Watercolor over graphite
19 ⅛ x 11 ¾ in. (48.4 x 29.8 cm)
On the reverse is a graphite study of a tree and of drapery,
and, in red chalk, an angel in right profile (?)
Paris, Musée du Louvre (RF 26047)

PROVENANCE:
See cat. 20.

BIBLIOGRAPHY:
Chevillard 1893, part of no. 420; Sandoz 1974, under no. 133;
Sandoz 1982, p. 40; Prat 1988-1, vol. I, no. 72, ill.

EXHIBITION:
Paris, Louvre, 1980–81, no. 54.

Exhibited in Strasbourg only

This study for the figure of Ariadne is very similar to
the small painted sketch *Ariadne Abandoned.* The style
of the drawing, astonishing in its monumentality, clearly
situates it in about 1840–41, and it can be associated
with another study, in the Baltimore Museum of Art
(Sandoz 1974, pl. 122 b).

The gesture of Ariadne's raised right arm can be con-
fused with a branch of the tree against which she is
leaning—a reminder that few drawings by Chassériau are
realized in such a broad, pictorial manner.

On the reverse are studies for the tree as well as for the drapery at Ariadne's feet. The sketch in red chalk seems to be related to the angel on the left in the 1840 composition *Christ on the Mount of Olives* (Sandoz 1974, no. 54).

L.-A. P.

42

A Boat Sailing Toward the Left, with a Couple, Seen from the Back, Embracing at the Prow

about 1840–41
Graphite, heightened with white, on beige paper
14 x 10 ⅜ in. (35.5 x 26.3 cm)
Paris, Musée du Louvre (RF 26041)

PROVENANCE:
See cat. 20.

BIBLIOGRAPHY:
Chevillard 1893, part of no. 420; Sandoz 1974, under no. 133; Prat 1988-1, vol. 1, no. 82, ill.

Exhibited in Paris only

This is a study for the boat in the background, at the upper left, of the *Ariadne Abandoned,* which has set sail carrying Phaedra and Theseus. The prow and stern of the boat would be decorated with crosiers in the final painting.

L.-A. P.

CAT. 42

43

The Martyrdom of Saint Philomena

1840–41
Pen and brown ink, with brown wash, heightened with white, over graphite
23 ½ x 28 ⅜ in. (59.5 x 72 cm)
Inscribed in graphite: *le clair la aussi / et temp . . . / la faire la qui / pleure / ils attendent / et il fait signe de la jeter / des cavaliers de dos / repoussent le peuple / par dessus / la mon groupe / a lencre bleu* [lightness there as well / and time . . . / put her there / weeping / they are waiting / and he signals to throw her / horsemen from the back / push back the people / above / there my group / in blue ink]
Paris, Musée du Petit Palais (P.P.D. 464)

PROVENANCE:
Studio of the painter until his death (L. 443, lower left); Frédéric Chassériau, the artist's brother, Paris, until 1881; Baron Arthur Chassériau, Paris; donated by the latter to the Musée du Petit Palais, Paris, 1907.

BIBLIOGRAPHY:
Chevillard 1893, no. 418 or 419 (with erroneous dimensions); Sandoz 1974, fig. 16; Bonn 1988, no. 19, ill.; Prat 1988-1, under no. 953; Prat 1988-2, no. 62.

Exhibited in Paris only

This drawing and catalogue 44 are studies for an ambitious composition conceived in Rome in 1840–41, but which does not seem to have been adapted to a painting.

Although Chevillard, the first cataloguer of Chassériau's works, apparently called this drawing a "repetition," it is, instead, the initial concept for this project as a whole, which may have been taken up by the artist after his return to Paris in early 1841. For a time, Chassériau considered adapting the figures for the *Assumption of Saint Mary of Egypt* in the Church of Saint-Merri (see Prat 1988-1, vol. 1, no. 229, ill. [upper part]; see cat. 75). In fact, a painting with this subject would be included at Saint-Merri, but one by Amaury-Duval, in a chapel next to the one Chassériau was assigned to decorate.

Saint Philomena was actually an invention of the nineteenth century. In 1802, in the Catacombs of Saint Priscilla in Rome, the tomb of a young woman was discovered, bearing an inscription that was altered to read *Filumena Pax tecum* [Philomena peace be with you] and was said to refer to a martyr by the name of Philomena. Shortly thereafter, a visionary invented the life of a saint whom Emperor Diocletian had had thrown into the Tiber with an anchor around her neck (this is the episode Chassériau chose to represent, although the anchor has been replaced by a heavy stone). When angels cut the rope, Philomena was saved from drowning. Archers then made an attempt to kill her but the arrows ricocheted, and she was finally decapitated.

In fact, the saint, whom the curé of Ars enthusiastically celebrated, never existed, and subsequently she was struck from the liturgical calendar and the list of saints by Pope John XXIII.

Broad and powerful in its conception, Chassériau's drawing is striking for the audacity of its style, enlivened with a number of zigzagging accents added with the tip of the paintbrush. Full of commotion and frenzy, the composition nevertheless remains legible and, in the artist's ability to express the movement of a crowd, anticipates the dynamism of his future works.

The annotation "my group in blue ink" obviously refers to another drawing shown here, the *Group*

of Wailing Figures (cat. 45), executed in pen and indigo ink, which, in the overall plan, was intended to be used for the right part of the composition. However, in the large composite drawing in the Louvre (see below, cat. 44), the figure group has been transferred to the left side of the scene.

L.-A. P.

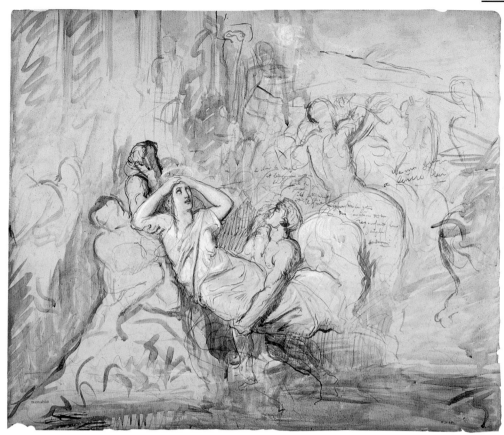

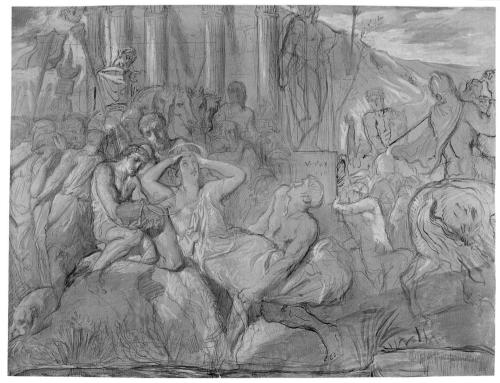

44

The Martyrdom of Saint Philomena

1840–41
Graphite, black pencil, and brown wash, heightened with white,
and retouched in pen and brown ink, on buff-colored paper
26 ⅜ x 36 ⅛ in. (66.9 x 91.8 cm)
Paris, Musée du Louvre (RF 24338)

PROVENANCE:
See cat. 20 (no mark L. 443).

BIBLIOGRAPHY:
Chevillard 1893, no. 418 or 419; Hourticq 1927, ill. p. 275;
Bénédite 1931, vol. 1, p. 132, ill. p. 143; Sandoz 1982, p. 39; Prat
1988-1, vol. 1, no. 953, ill.

EXHIBITIONS:
Paris, Orangerie, 1933, no. 112; Paris, Louvre, 1980–81, no. 18.

Exhibited in New York only

This large drawing, in the Louvre, can be considered a
further clarification of the project as mapped out on the
Petit Palais sheet (cat. 43). Here, the number of figures
has been specified, and the way that they are grouped on
the left is somewhat reminiscent of the figures in Ingres's
The Martyrdom of Saint Symphorian (1834), but, at the
same time, anticipates the depiction of the onlookers in
the scene of *The Conversion of Saint Mary of Egypt* in the
Church of Saint-Merri. Most noticeably, the horseman
seen from the back has been moved to the far right, as
suggested in a second arrangement in the previous
drawing. The emperor Diocletian, in a quadriga, is vis-
ible in the background at the left (he appears to be near
the statue shown in the background of the Petit Palais
drawing). The many studies now in the Louvre allowed
the artist to detail every element of this vast composition
(Prat 1988-1, nos. 954–971).

L.-A. P.

CAT. 45

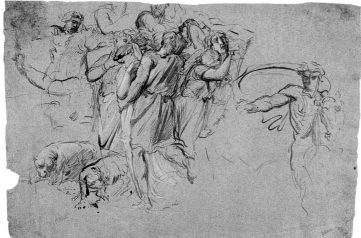

45

Group of Wailing Figures, with a Horseman and a Dog; Study of a Horseman

1840–41
Pen with brown and indigo ink, heightened with white, on blue
paper (affixed to a fragment of fol. 85 v. of dummy album 3)
11 ⅝ x 17 ½ in. (29.3 x 44.3 cm)
On the reverse is a pen-and-indigo ink sketch of a figure
Paris, Musée du Louvre (RF 26602)

PROVENANCE:
See cat. 20.

BIBLIOGRAPHY:
Chevillard 1893, part of no. 420; Prat 1988-1, vol. 1, no. 955, ill.
and colorpl. p. 31.

Exhibited in Paris only

This superb drawing is a study for the group of figures
on the left in *The Martyrdom of Saint Philomena*. The
horseman holding back the crowd appears on the right
of the present sheet in a different position. Chassériau
would reprise a theme fairly similar to this one in the panel
Return from the War at the Cour des Comptes (Sandoz
1974, no. 113 B).

L.-A. P.

CAT. 46

46

Saint Philomena Cast into the Water

1840–41
Pen and brown ink, with brown wash, heightened with white,
on blue paper (affixed to fol. 22 r. of dummy album 3)
9 ⅝ x 13 ¾ in. (24.4 x 34.7 cm)
On the reverse is a graphite study of a figure seated on the
ground (?)
Paris, Musée du Louvre (RF 26408)

PROVENANCE:
See cat. 20.

BIBLIOGRAPHY:
Chevillard 1893, part of no. 420; Prat 1988-1, vol. 1, no. 956, ill.

Exhibited in Strasbourg only

In this fiery study for *The Martyrdom of Saint Philomena,*
the crowd, including the figure straddling the parapet,
appears at the right side of the composition (see Prat
1988-1, vol. 1, no. 966).

L.-A. P.

FROM LACORDAIRE TO TOCQUEVILLE

47

Portrait of the Reverend Father Dominique Lacordaire, of the Order of the Predicant Friars

1840
Oil on canvas
57 ½ x 42 ⅛ in. (146 x 107 cm)
Signed and dated, lower left: *T. Chassériau / Rome Ste Sabine 1840*
Paris, Musée du Louvre (RF 1584)

PROVENANCE:
Comte de Vauvineux (according to Chevillard); Vauvineux sale, 1906; with the cooperation of Baron Arthur Chassériau, purchased by the Musée du Louvre.

BIBLIOGRAPHY:
Pillet, *Le Moniteur universel*, March 22, 1841; Peisse, *La Revue des deux mondes*, April 1, 1841, p. 43; Pelletan, *La Presse*, April 4, 1841; Unsigned, *Journal des beaux-arts et de la littérature*, April 11, 1841; Delécluze, *Journal des débats*, May 29, 1841; Cantagrel, *La Phalange*, May 30, 1841; G. D., *L'Univers*, June 5, 1841; Chevillard 1893, no. 59, pp. 43–44, 51–52; Marcel and Laran 1911, pp. 29–30; Jamot, March 1920, p. 68; Bénédite 1931, pp. 151–58; Sandoz 1974, no. 72; Foucart 1987, p. 10; Prat 1988-1, nos. 56, 63, 364, 1163, 1441, 2228, 2240; Driskel 1992, p. 30; Peltre 2001, pp. 83–87.

EXHIBITIONS:
Salon of 1841, no. 327; Rouen, 1841, no. 71; Paris, Orangerie, 1933, no. 15; Paris, 1935, no. 541.

For a long time, this was one of the rare works by Chassériau—along with the portrait of his two sisters—that people chose to remember, as if the identities of the sitter and the painter, two fiery individuals, had become ideally superimposed on each other. In 1906, with the help of Baron Arthur Chassériau, this portrait, which encapsulates a certain form of the Romantic absolute, entered the Louvre. Even if one were to forget everything about Lamennais's disciple, Lacordaire—the orator who captivated the crowds at Notre-Dame with the liberal Catholicism that he, along with his friend Montalembert, came to stand for—this painting would continue to fascinate us. The face, half lit and half in shadow; the feminine mouth that almost appears to speak; the body in arrested activity; the hands, so admired by Marie d'Agoult;[1] the imposing robes—all are expressions both of the man of conviction and of the devoted champion of his century, the thinker and the crusader.[2] In short, the preacher, like the painter, may have sought to emphasize this duality even in the way the painting was titled in the handbook of the Salon.[3] I have indicated elsewhere (see p. 38) how the work provoked discord between Lehmann and Chassériau and to what extent the painter embraced the values of the sitter.

The dynamic placement of the sitter in the composition, standing in the center and cut off at the knees, as is customary in portraits by Ingres and by his pupils, makes the fierceness of the novice emerge with such power that he seems to dominate the architecture of the cloister of Santa Sabina and its triple arcade, which brings to mind David's *The Oath of the Horatii*. The ancient ambulatory and the inner garden, rendered in soft ochers—to cite Sandoz—serve as a foil for the figure, which is more forcefully modeled. The entire painting is arranged in a way that reflects the dual vocation of Lacordaire, who took holy orders only to escape the conservative Church of France, but continued to exercise his authority to alert the elite classes to the dangers of their selfishness and egotism. Chassériau thus took care to introduce, at the top of his canvas, a patch of cloudy sky—a sign that monastic life is not only confinement; on the right, he placed two friars side by side, one dressed in white, the other in black, one facing life with a smile, the other meditating, the two together composing the image of the perfect Christian.

At the Salon of 1841, once again, Chassériau was subjected to the incomprehension of a good part of the press. Delécluze did not distinguish between the portrait of Lacordaire and the two other works the painter had submitted to the Salon of 1841 (cat. 65, and the *Portrait of the Comtesse de La Tour Maubourg*), reproaching them for being morose and anemic. He said the three paintings, "which have been carefully studied in detail, lack brilliance, force, and life in their overall effect."[4] For Louis Peisse, Chassériau's manner, unpleasant and bizarre, was poorly suited to the portrait genre, and the incompatibility was even more glaring in the case of the portrait of the comtesse de La Tour Maubourg: "The portrait of M. Lacordaire in his Dominican habit, executed within a different system, is less disturbing in its appearance. There is study, care, and some skill in the execution of these two works but, in matters of art, one can take into consideration only what succeeds."[5]

Fundamentally, Chassériau, despite already having distinguished his style from that of his master, suffered from the general hostility toward Ingrism. Haussard was able to recognize "strong qualities" in his work,[6] and Cantagrel noted "a sobriety of touch that does not rule out a certain effect."[7] *Le Journal des beaux-arts et de la littérature* granted that the head of Lacordaire had "a fine character, [and] a severe style, most appropriate to the costume he is wearing."[8] Nevertheless, the muted color scheme and synthetic style of drawing in that work were disturbing, not to mention the suppressed rage that could be read on Lacordaire's face. The neo-Catholic press made good use of irony in discussing the painter and his subject: "One could not imagine anything more untamed, more Lutheran, than the look of that portrait. One must not, however, limit oneself to the first glance, which is very unfavorable for M. Chassériau: an attentive examination leads us to recognize qualities of drawing and conscientious study in it that keep us from despairing about M. Chassériau's future."[9]

The most favorable opinions of the Lacordaire portrait were those of Pillet and of Pelletan; according to Pillet:

> This portrait is remarkable for an austerity of color and of character, and for a feeling of evangelical piety, which are perfectly in tune with the sitter's religious mission. The hue is a bit gray, a bit livid in the flesh tones, but that somber pallor is quite suitable to men who serve as examples to the world for every sort of abstinence and mortification I laud M. Chassériau very much for the purity of his line and his disdain for the deceptive brilliance of color; I do not blame him for his fondness

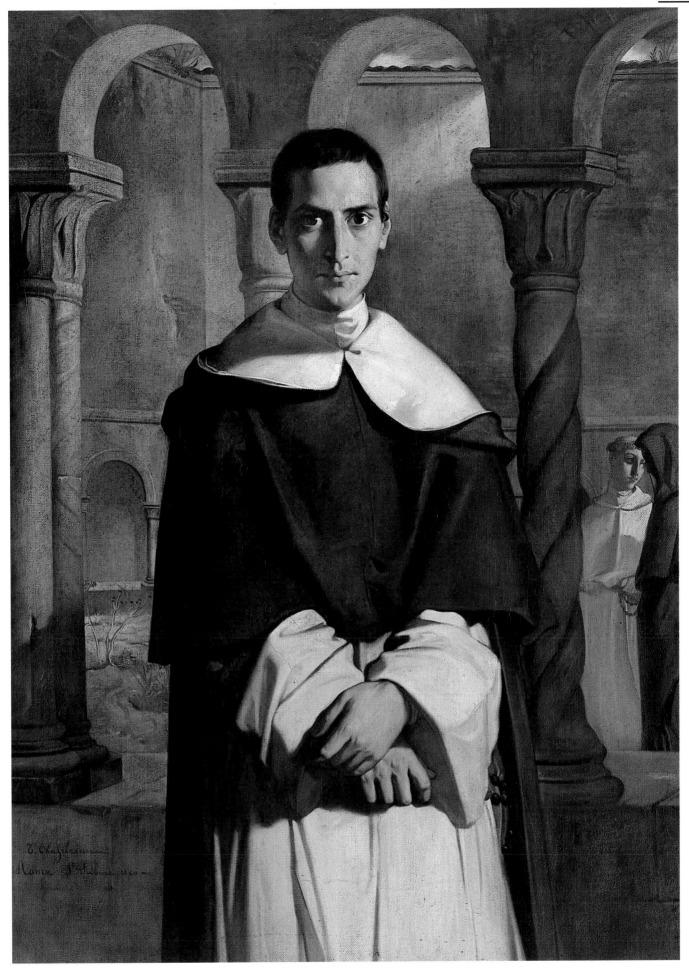

for melancholic painting, but I fear that he will get carried away by this inclination, and that he will become accustomed to casting the lividity of death onto living flesh. That would be all the more regrettable in that, I repeat, there is in this artist thought, poetry, and more than the seeds of a fine talent.[10]

Pelletan, after expressing some reservations in *La Presse* ("even his errors entail a powerful originality"),[11] more openly supported the young artist defended by his newspaper and, in the first place, by Théophile Gautier: "I have heard the criticism of M. Chassériaux's [*sic*] portraits of M. Lacordaire and Mme de Latour-Maubourg [*sic*]. I do not deny the defects in these two portraits, and am very pleased to find them in an artist; they are the excesses of excellence."[12]

In a letter to Marie d'Agoult, Lehmann, although disappointed not to have been chosen as Lacordaire's portraitist, paid tribute to the painting more than to its mimesis: "It is a beautiful and strong work, resemblance aside."[13] With regard to that strength, that "profundity of expression" (the words of Marie d'Agoult), the other portraits (by Bonnassieux, Janmot, and Flandrin; see fig. 5, p. 40) appear quite insipid and prosaic in comparison.[14] Bouvenne was correct in calling it a "history painting."[15] Few images capture so well the intellectual climate of France in the early 1840s. No other work—not even the *Balzac* by Boulanger, which Chassériau must have known[16]—expresses to such a degree the disquieting sovereignty of its creator. **S. G.**

1. "There is, in the attitude and hands of M. Lacordaire, a profundity of expression that astonished me" (Letter from Marie d'Agoult to Henri Lehmann, March 1, 1841; quoted in Joubert 1947, p. 156).
2. When the engraving by Monnin appeared, a report in *L'Artiste* noted: "There is nothing about him of the fat and coarse monks of earlier times; rather, he resembles those ardent priests of the Middle Ages, those fiery and austere preachers who led the Christian multitudes on the Crusades" ("Album de *L'Artiste*. Portrait de M. Lacordaire," 3rd series, vol. 1 [January 16, 1842]).
3. In the registration book for the Salon of 1841 (Archives des Musées Nationaux, KK. 35), the painting was listed as "Tab[au] du père Lacordaire prédicateur (Painting of Father Lacordaire Preacher)."
4. É.-J. Delécluze, "Salon de 1841," in *Journal des débats*, May 29, 1841.
5. L. Peisse, "Salon de 1841," in *La Revue des deux mondes*, April 1, 1841, p. 43.
6. P. Haussard, "Salon de 1841," in *Le Temps*, May 21, 1841.
7. Cantagrel, "Salon de 1841," in *La Phalange*, May 30, 1841.
8. Unsigned, "Salon de 1841," in *Le Journal des beaux-arts et de la littérature*, April 11, 1841.
9. G. D., "Salon de 1841," in *L'Univers*, June 5, 1841.
10. F. Pillet, "Salon de 1841," in *Le Moniteur universel*, March 22, 1841.
11. E. Pelletan, "Salon de 1841," in *La Presse*, April 4, 1841.
12. Ibid., June 3, 1841.
13. The letter is dated January 16, 1841; see Joubert 1947, pp. 143–45.
14. See *Lacordaire*, exhib. cat. (Castres: Musée Goya, 1961).
15. See Bouvenne 1887, p. 171.
16. The only record that exists of this famous painting is a study in the museum in Tours; see the catalogue raisonné by V. Moreau, *Peintures du XIX^e siècle*, vol. 1 (Tours: Musée des Beaux-Arts, 1999), pp. 90–91).

1840–41 and 1842–44
Bound notebook, covered in beige and reddish-brown speckled cardboard, with a brown sheepskin spine, containing thirty-one sheets of beige paper and one sheet of white paper numbered 1 to 32. Missing folios between folios 13 and 14 (1) and 26 and 27 (1). Stamp of the artist's studio (L. 443) on the upper part of the reverse side of the cover, on the front of folios 1–7, on the back of folio 8, on the front of folios 9–14, 16–20, and 30.
Inscribed in pen and brown ink (in the artist's hand ?), on a label on the upper part of the reverse side of the cover: *Italie*
6 x 8 ½ in. (15 x 21.5 cm) (notebook); 5 ⅝ x 8 ⅜ in. (14.2 x 21.2 cm) (sheets)
Paris, Musée du Louvre (RF 26083)

PROVENANCE:
See cat. 20.

BIBLIOGRAPHY:
Chevillard 1893, part of no. 420; Sandoz 1974, p. 468 n. 1; Prat 1988-1, vol. 2, no. 2240, ill.

Exhibited in Paris only

The notebook was used during the artist's trip to Italy in 1840–41, and, after his return to France, from 1842 to 1844.

Open to folios 19 v. and 20 r.

Folio 19 v.

Woman Standing in a Landscape, in Three-Quarter Left Profile, Her Head Viewed from the Front; Repetition of Her Right Arm

Pen and brown ink, the pen-and-brown-ink outline suggesting an oval frame
BIBLIOGRAPHY:
Sandoz 1974, under no. 87, pl. 70 a.

This important study for the *Portrait of the Comtesse de La Tour Maubourg* (sold, Paris, Sotheby's, June 27,

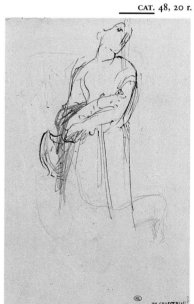

CAT. 48, 19 v. CAT. 48, 20 r.

2002, lot 165), inscribed and dated *Rome 1841* shows the sitter—the wife of the French ambassador to Rome in 1840—in a pose that differs slightly from that in the painting, where she is depicted almost full face. For a time, Chassériau had considered inscribing the portrait in an oval, but the definitive portrait is rectangular, and the position of the arms is quite different. Two other studies of the same figure appear on folios 20 r. and 20 v. of the same notebook. The position of the arms would be repeated, but in reverse, for the figure of Adèle in the *Two Sisters* (cat. 61).

Folio 20 r.

Standing Woman, Seen Almost Full Face, Her Arms Crossed

Pen and brown ink, with graphite

BIBLIOGRAPHY:
Sandoz 1974, under no. 87.

See folio 19 v. L.-A. P.

Portrait of a Seated Young Woman in Three-Quarter Right Profile

1841
Graphite
11 ⅛ x 8 ⅜ in. (28.2 x 21.3 cm)
Inscribed and dated in graphite, right center: *Rome 1841*
Oxford, Ashmolean Museum (1941.154)

PROVENANCE:
J. P. Heseltine (1843–1929); Heseltine sale, London, Sotheby's, May 28, 1935, lot 235, ill. (as by Ingres); bought by Frank Sabin (for £ 155); Max de Beer; acquired from Max de Beer (for £ 60) by the Ashmolean Museum, Oxford, 1941, as by Chassériau (J. Whiteley, *Ashmolean Museum, Oxford—Catalogue of the Collection of Drawings. Vol. VII—French School* [2000], 2 vols., no. 997, ill.).

BIBLIOGRAPHY:
Prat 1991, p. 78, fig. 5; Prat 1996, p. 579 n. 7.

Exhibited in Paris and Strasbourg

As Chassériau left Rome on January 19, 1841, it therefore must have been sometime between the first and the eighteenth of that month that this drawing was executed, unless it was completed in 1840 and dated at the time of his departure from Italy, which is not impossible, given that he inscribed many sheets *Rome 1841*. As for the sitter's identity, I have proposed that she is Baronne de Prailly, the sister of Paul Chevandier de Valdrôme

CAT. 49

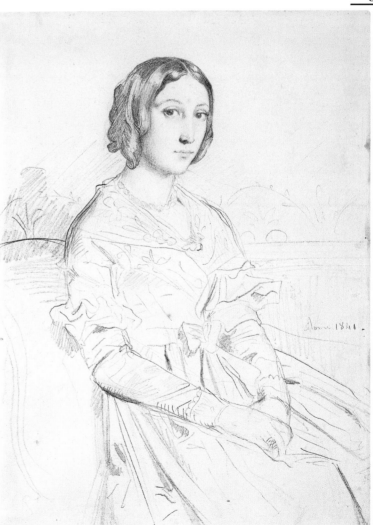

(1817–1877), an artist to whom Chassériau was very close during his stay in Rome but with whom he would subsequently quarrel.

We know that the friendship between the two young artists was very strong in Rome, as confirmed in a letter from Théodore to his brother Frédéric, dated November 23, 1840: "I still have five hundred francs of what I brought from Paris. I have not spent more thanks to Chevandier, who has two apartments and is lending me one. He wants me to dine with him or his sister almost every day." Bénédite (1931, p. 121) believed that, "in gratitude for that hospitality," Chassériau "would execute a portrait of this young woman, which he would send to her father"—that is, to Anatole Chevandier de Valdrôme, to whom one portrait drawing is, in fact, dedicated; that work has remained in the same family since 1841, and represents the baronne accompanied by her young daughter, Berthe (Prat 1996, p. 575, fig. 3; for a portrait of Berthe de Prailly alone see cat. 50). Chassériau also would dedicate a drawing, now in the Kunsthalle, Bremen, to Mme de Prailly (Prat 1988-2, no. 44).

It was during the same stay in Rome that Chassériau drew a double portrait of the two landscape painters Louis Cabat and Paul Chevandier de Valdrôme. The work, no. 273 in the catalogue by Valbert Chevillard, the artist's first biographer, is now lost, as is another portrait of Paul Chevandier alone (no. 272 in Chevillard).

Jon Whiteley maintains that the resemblance between the portrait drawing in Oxford and the one in a private collection is not strong enough to support the claim that the model is the same. In fact, some doubt remains, and the identity of this melancholic young woman, seated in front of what seems to be a decoratively patterned wall, is still unconfirmed. It is bewildering how, for a time, this study could have passed for a work by Ingres, since Ingres's drawing style at the time differed rather significantly from that of Chassériau.

With regard to Chevandier de Valdrôme, see Élisabeth Foucart-Walter's well-documented entry on the *Landscape, Plains of Rome*, a work newly acquired by the Louvre (*Musée du Louvre, Nouvelles acquisitions du département des Peintures* [Paris: Réunion des Musées Nationaux, 1991], pp. 137–39), where she states that in 1834 Hortense Chevandier de Valdrôme married Baron de Prailly, presiding judge of the civil tribunal in Nancy. Religiously inclined and in fragile health, the baronne maintained a regular correspondence with Lacordaire (*Lettres du R. P. Lacordaire à Mme la baronne de Prailly* [Paris, 1885]). Another of her brothers, Eugène, served as Minister of the Interior, under Émile Ollivier, at the end of the Second Empire. L.-A. P.

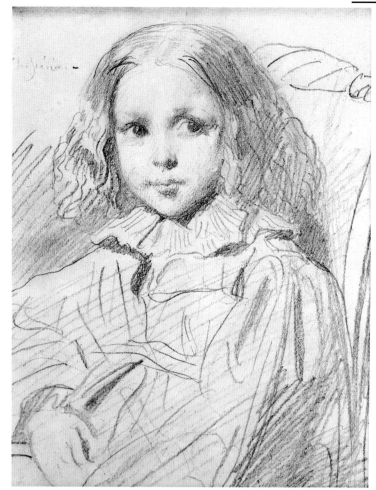

50

Half-Length Portrait of Berthe de Prailly as a Child, Her Face Viewed from the Front, Her Torso in Three-Quarter Left Profile

1840 or early 1841
Graphite with stumping
4 ¾ x 4 in. (12 x 10 cm)
Signed in graphite, upper left: *Th. Chassériau*
Geneva, Private collection

PROVENANCE:
Remained in the sitter's family until 1991; Paris, art market; Geneva, private collection.

BIBLIOGRAPHY:
Sandoz 1974, p. 36, fig. 10; Sandoz 1986, no. 234 A, ill. (as no. 233); Prat 1988-2, no. 73; Prat 1996, pp. 575, 579 n. 11.

This drawing of the daughter of Baron and Baronne de Prailly (see cat. 49) was probably executed in Rome in 1840 or early 1841, along with another, during the same session, that also shows the little girl in half length but with her torso in three-quarter right profile (private collection; see Prat 1988-2, no. 74). She appears, as well, being held in her mother's arms, in a graphite portrait made in Rome and dated 1841 (private collection; see Prat 1996, pp. 575, 579 n. 5, 582, fig. 3). Berthe de Prailly would later become the comtesse de Guichen after marrying the descendant of a family of famous seamen, the Bouexic de Guichens. L.-A. P.

51

Study of Two Hands

1841

Graphite, heightened with white, on blue paper
12 ⅛ x 13 ⅝ in. (30.7 x 34.6 cm)
Paris, Musée du Louvre (RF 24391)

PROVENANCE:
See cat. 20 (no mark L. 443).

BIBLIOGRAPHY:
Chevillard 1893, part of no. 420; Bénédite 1931, vol. 1, ill. p. 211, with the fragment of a drawing affixed to the lower right, since this drawing and the Louvre drawing RF 24342 (Prat 1988-1, vol. 1, no. 647)—a hand holding drapery—were mounted together (with three others), and belonged to Baron Chassériau, according to a photograph in the Service d'Étude et de Documentation de Peintures at the Louvre; Sandoz 1986, no. 246-2, ill., and under no. 46 B; Prat 1988-1, vol. 1, no. 93, ill.

Exhibited in Strasbourg only

The way in which the rings are arranged on the hands evokes the *Portrait of Mlle Cabarrus* (Quimper, Musée des Beaux-Arts; see Sandoz 1974, no. 115), but the position of the fingers is very different. Sandoz has established a connection between this sheet and Chassériau's depiction of Mme de Magnoncourt's hands in a portrait drawing of 1852, to which, however, the present one is unrelated—especially as portrait drawings almost never were preceded by preliminary studies of details.

On the contrary, I find these hands very similar to those of the sitter in the *Portrait of a Young Woman with a Pearl Necklace,* of 1841 (Cambridge, Massachusetts, Fogg Art Museum).

L.-A. P.

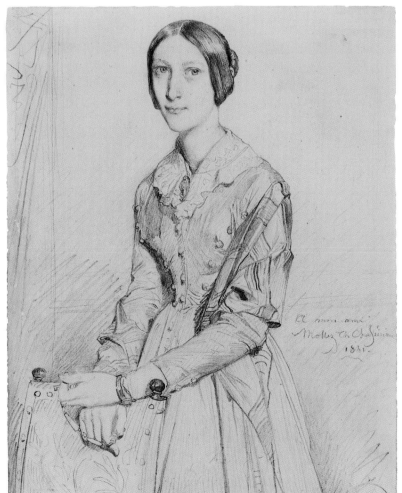

52

Portrait of Mme Victor Mottez, née Julie-Colette Odevaere

1841

Graphite
10 ⅝ x 8 ½ in. (27 x 21.5 cm)
Dedicated, signed, and dated in graphite, lower right: *A mon ami / Mottez Th. Chassériau / 1841* [To my friend / Mottez Th. Chassériau / 1841]
Cambridge, Massachusetts, Harvard University Art Museums, Fogg Art Museum (1965.240)

PROVENANCE:
Victor Mottez (1805–1897); his son, Henri Mottez; Paul Leprieur; Paul Leprieur sale, Paris, Hôtel Drouot, November 21, 1919, lot 36, ill. (as *Portrait of a Woman*); bought by H. Brame (for Fr 3,400); César de Hauke; acquired by Paul J. Sachs, 1937; Bequest of Meta and Paul J. Sachs to the Fogg Art Museum, 1965 (Mongan and Sachs catalogue, 1940, vol. 1, no. 649, vol. 2, ill.; Mongan catalogue, 1996, no. 55, ill.).

BIBLIOGRAPHY:
Chevillard 1893, no. 285; Sandoz 1986, no. 13, ill., no. 75 (*Portrait of a Woman;* artist unidentified); Prat 1988-1, under no. 1071; Prat 1988-2, no. 84; Peltre 2001, p. 48, fig. 48.

Born Julie-Colette Odevaere (1805–1845), the daughter of a Belgian painter who was a pupil of David and herself a painter, she became the first wife of the artist Victor Mottez. Mottez, a pupil of Picot, made his artistic debut at the Salon of 1835, the year that the couple left for Italy, where they remained until March 1838 (not 1842, as Agnes Mongan proposes). It was in Paris in 1841 that Chassériau executed this drawing of the young woman. Her features are well known since she served as a model for several artists, including Ingres, who made a beautiful portrait of her in graphite, dated 1844 (Naef 401; the drawing Naef cites as lost, once part of the Gestenberg

and the Scharf collections in Germany, has just come to light at the Pushkin Museum in Moscow). As for Mottez, he painted several portraits of his wife (Lille, Musée des Beaux-Arts, dated 1833; Paris, Petit Palais, dated 1841; and Paris, private collection), even one in fresco, a technique about which he was particularly passionate, on a wall of his Rome residence, about 1836–37. The work, which shows the pensive young woman in profile, her elbows on a table, won the admiration of Ingres, who had it transferred onto canvas, and in 1900, Mottez's son Henri, from his second marriage, presented the painting to the Louvre (RF 1256).

A painted portrait, supposedly of Mme Victor Mottez and attributed to Chassériau, appeared in a Stair Sainty Matthiesen Gallery catalogue ([London and New York, 1996], no. 23, colorpl. p. 83).

In the Fogg drawing, Chassériau represented Mme Mottez in a pose similar to that of the comtesse de La Tour Maubourg in the portrait of her that he had just completed in Rome. Significantly, Chassériau shows her counting the rosary beads in her hand—as Mottez himself would do, as well, in a portrait painted in 1842.

L.-A. P.

53

Portrait of Marie d'Agoult

1841
Graphite on cream-colored paper
13 ⅝ x 10 ½ in. (34.5 x 26.5 cm)
Signed and dated in graphite, lower left: *Théodore Chassériau / Mars 1841*
Paris, Musée du Louvre (RF 31884)

PROVENANCE:
Louis de Ronchaud; S. Higgons; acquired by the Musée du Louvre, 1969 (L. 1886 a).

BIBLIOGRAPHY:
Chevillard 1893, no. 284, p. 159; Marcel and Laran 1914, pp. 53–54, pl. 19; Bénédite 1931, vol. 2, pp. 370–71, ill. p. 363; Sandoz 1974, p. 41; Prat 1988-1, vol. 1, no. 1065, ill.; Peltre 2001, pp. 24–27, fig. 22, p. 202, ill. pp. 12–13 (detail).

Exhibited in Paris only

This drawing, the last of Chassériau's to enter the Louvre, is a portrait of Marie de Flavigny, Comtesse d'Agoult (1805–1876), who gained fame from the works she published beginning in 1841 under the name Daniel Stern (these included many reviews of various Salons in which she did not always spare the artist) as well as for her ten-year-long affair with Franz Liszt. The present work was executed on a large sheet of paper with the edges folded back over a strong cardboard support—a method that Ingres employed for his own portrait drawings.

The sitter is depicted here at the time of her first literary success, the publication in *La Presse* of the novella *Hervé* (1841), soon to be followed by *Valentin* (1842) and by her reviews of the Salons of 1842 and 1843 (she replaced the critic Gautier, who was traveling at the time).

The relationship between the young woman and the artist dates from that year, 1841. Marie d'Agoult's friend the painter Henri Lehmann (1814–1882) had recommended Chassériau favorably, but his feelings turned negative after Chassériau was awarded the commission

he coveted, to paint the portrait of Lacordaire. The correspondence between Lehmann and Marie, published by Solange Joubert (*Une Correspondance romantique. Mme d'Agoult, Liszt, Henri Lehmann* [Paris, 1947]; excerpts reprinted in M.-M. Aubrun, *Henri Lehmann, 1814–1882. Catalogue raisonné de l'oeuvre*, 2 vols. [Paris, 1984]), attests to these changing sentiments. At first, Lehmann is delighted to travel to Rome with Chassériau (letter to Marie, of June 16, 1840), whose intellect he finds "naturally original," which leads to Marie's request: "Tame him for me for next winter." On August 19, in Naples, Lehmann writes:

[Chassériau is] a towering genius. His understanding of life, lofty yet primitive at the same time, guarantees me of that. I have faith in him as a man and as a painter. The third day after his arrival in Rome, he drew the portrait of a woman, whom in my heart I had coveted for years as the most desirable of models. It is magnificent in conception and execution. That is what characterizes the difference in our careers: things fall into his hands, by chance and in the most fortunate circumstances, for which I would not have dared wish! Moreover, no one is more worthy than he of such a favor of fortune, through the merit, the beauty of his talent, the force of his young will, the sensitivity of his heart, and the nobility of his feelings and thoughts, which he expresses with an originality and a vivacity of spirit that equals the charm of his naturally distinguished manners.

After their rift in September 1840, Lehmann's judgment changed completely. On January 16, 1841, a few days before Chassériau left Rome, Lehmann wrote to Marie:

In the matter of benevolent illusions, my experiences are continuing. Little Chassériau is further proof of them. He is a very nasty gentleman, and, in that respect, once more, I have not given in to personal impressions; on the contrary, I alone took his part against everyone and up to the last minute, but the position was not tenable, since he had done so many improper and unworthy things. Do not make any overtures to him, or, I should say, do not offer him any welcome. . . . I fought against M. Ingres's wonderful intuition with all my might, as a good comrade, but I am now obliged to concur with it. He [Ingres] did not even go to see the portrait of the ambassador's wife, even though M. de Latour [*sic*] Maubourg begged him expressly to do so, and even though I told him I found his action perfectly harsh and unfair, and that he was thereby removing any obligation Chassériau owed him, as his student. In short, he mistreated him badly.

As to the portrait of the abbé Lacordaire, I continue to have the same opinion; it is a beautiful and strong work, resemblance aside. The [portrait] of the ambassador's wife is weak beyond expression: it is like a little sheep that dreams of the taste of the flowers in the surrounding fields and on which it seems to have grazed. It is poorly drawn, poorly painted (except for a few very fine color relationships between the hands and the gown, between the sky and the earth, etc. . . .), a poor likeness, in short, the error of a man of talent. His sojourn in Rome has been unfortunate for him; he left behind the reputation of a rather indelicate charlatan. Our trip and his stay are precious to me, since I will have paid a high price for the naïveté with which I again opened myself up to that

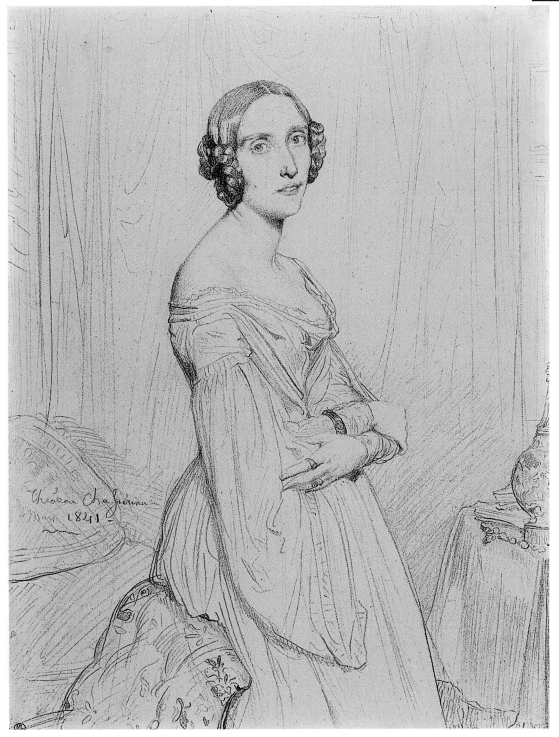

fellow! In that way, I was able to get to know him at little cost and at his own expense.

Upon his return to France, Chassériau went to see Marie, on February 5, 1841. She told Lehmann about it the next day:

P.S.—Last night, Chassériau came to see me at my home. I had company; it was one of my days [for entertaining]. I received him well; I thought I ought to know absolutely nothing and, as a result, I questioned him about M. Ingres, about you, about Chevandier. To the question: "Have you brought back any paintings?" he replied: "The Portrait of M. Lacordaire. Oh! Oh! But that's quite a story! As it turns out, I've been very close to M. Lacordaire for a long time, and he has been wanting me to paint his portrait for a very long time." Moreover, he seemed neither timid nor untamed as you said last spring, but his comportment was excellent. He looked at, praised, and criticized my portrait appropriately. As he was leaving, he begged me to come to his studio. I will go. If you were here and you found it disagreeable to run into him, I won't [sic] invite him to come to my home.

On March 1, Marie could not keep from contradicting her correspondent:

Since I suppose you are rather acutely preoccupied with Ch[assériau]., I will tell you point by point of my relations with him. You will see that my impressions up to now are in radical opposition to your opinion. I don't know how he could have responded when you offered him a letter [of introduction] (why not tell me?); what I do know is that he had not been back in Paris more than three days when he came to see me (I learned this not through him but through Théophile Gautier). Whether it was luck or premeditation, it was one of my *days*. He was, as I've already told you, perfectly well behaved; chatted well but not too little; remained the desired time and asked me to go see his studio. That was a Friday. On Monday, I was there with Sainte-Beuve and Mlle Delarue. He received us with remarkable graciousness and tact. His portraits seem superb to me: I do not at all share your opinion about the one of Mme de L. M. [La Tour Maubourg]. It may be superior to the other one, given the difficulties he had to overcome. Both are noble and simple, the compositions exquisitely tasteful. There is, in the attitude and hands of M. Lacordaire, a profundity of expression that astonished me. I invited him to dinner on Saturday with the Girardins, the comtesse d'Obreskoff, Bulwer, Sue, etc., etc. The same tact, the same distinction in conversation, the ease of a man who might have spent his life in the best company He conquered all my friends: Ronchaud, Mlle Delarue, etc. They are all mad about him. . . . The following week, he came to visit, and I introduced him to de Vigny and the Didiers; he gently insinuates he is not going anywhere, is entirely devoted to me, and asks to do a drawing for my album, a pencil portrait of me and any small portraits of my friends I might want. There was talk (after midnight, between Sainte-Beuve and Ronchaud) of Rome and of M. Ingres; he is respectful but discerning, and very naturally touched on the gossip about which, according to him, he had reason to complain. What he said, I confess, seemed to bear the stamp of truth. Knowing the mediocrities of the Villa Medici, the views expressed seemed very simple and generated by the same source (base jealousy) as those of which you were

victim. . . . In short, after considering the most unfavorable warnings, after studying his physiognomy, his conversation, his gestures, his writing, etc., etc., my impression is that he is a young man about whom one cannot believe ignoble things without convincing proof. I believe he is full of confidence in himself, but without conceit; very clever, but will that cleverness lead to intrigue and perfidy? It is impossible for me to think so. I remain on my guard, and besides, I have nothing to fear, but I believe you are influenced and deceived. In the affair of the Lacordaire portrait, there may be circumstances, troublesome coincidences, perhaps a little artistic calculation coming before friendship, but that is not enough in my view to constitute a "nasty gentleman." . . . At his home, I saw a sketch of a little painting that will be charming, I believe. It is the hours of the evening fleeing at the approach of night. . . . He showed us an enormous quantity of drawings brought back from Italy. He is a prodigious talent at 21 years of age, but what astounds me much more than his talent is his knowledge of the world. . . .

P.S. March 2.—During the interval between these two sheets of paper, I had a long conversation with Ch[assériau]. about you, the story of the portrait, etc., etc. I professed my friendship for him, and I read him passages from your letter that bear witness to your admiration and your excellent feelings for him. As always, he spoke admirably to me and explained very well the cause of your disagreement. He reproaches you for not having come to find him directly the day you believed you had a grievance against him, and for having told M. Ingres about it. You have certainly let yourself be influenced, and the friendship of M. Chevandier, whom I believe to have very noble feelings, is a more certain guarantee than the opinion of M. Ingres and company. . . . Did I tell you what he thought of my portrait? He admires the hands and the gown a great deal, but does not care for the head; he finds the color unfortunate.

To this, on March 11, Lehmann responded from Rome, with a severe warning:

The manner in which he presented himself at your home obliges me to discuss Chassériau at greater length and more seriously than I might have wished. I asked you, quite simply, not to make overtures to him because, when I said to him, in front of several people: "Since you'll no doubt see Mme d'A . . . ," he interrupted me with a very self-satisfied look: "No, not at all, because, of course, I won't go there!" I said nothing, finding that as rude to you as to me. . . . During our journey, he had spoken to me in a way that appeared charming in its naïveté, of all his fine qualities of mind, of heart, and of talent. At times, I admired his self-assurance in praising himself. "But, I said to myself, why shouldn't he share the sense of his value with a friend?" I have seen him since, "with the fine sensitivity of his heart and the nobility of his feelings," seek out, when he needed them, men he had said he held in disdain, exchange false secrets about his so-called friends to do them harm, and let people who had put themselves and their possessions entirely at his disposal—and of which he had taken full advantage—lie in their beds for a week without going to see them—and finally hold out no more than a little finger to them by way of farewell! His wit is often borrowed; at the end of six months, one knows certain of his tirades by heart. I thought he was distinguished because I found he had excellent "manners"

in the few salons where I'd run into him, but to shout into everyone's ears that you're the only proper artist around, to put your feet on the table at a restaurant, in public, among your comrades, and to scream like a schoolboy, are not good proof of that. He compelled a lady of the best society, who had lavished kindness on him, and who is the sister of his close friend, to say that she would have continued to receive M. C. were it not for her fear of wounding her brother [this is obviously Mme de Prailly; see cat. 49]. She also said she had invited M. l'abbé Lacordaire several times along with M. Chassériau, so that the latter could get to know him better, even though that deprived her of private conversation with the abbé, who "would not have wanted to pour out his heart in front of a young man he did not know very well at all." You see how that squares with the so-called long and intimate liaison! . . . his impromptu arrival at your home reinforces his pretentiousness . . . and it is my duty not to leave you with any doubts about the character and unbounded ambitions of that deceitful little joker.

However, there was nothing more to say. She would continue to see Chassériau. On March 20, Lehmann attempted a rearguard action: "I may have . . . tried conscientiously to do you a service by protecting you, you whom I believe to be good, from Chassériau, whom I believe to be bad." In the meantime, Ingres had returned to Paris, and Marie met him and his wife and described the interview to Lehmann, who was still in Rome (May 18, 1841): "I mentioned in passing that I had seen another of his pupils a few times: M. Chassériau. At that, Mme Ingres spoke up to say the worst things about him. He [Ingres] smiled with satisfaction, accusing her of calumny, then he went on to tell me: 'This gentleman has taken rather too arrogant a position toward his master.' . . . I will observe . . . [M. and Mme] Ingres and tell you about them. Until now, I see only the predisposition to praise you and the satisfaction of contrasting your obedience as a student to Chassériau's rebellion."

The portrait by Chassériau, dated *Mars* 1841, attests to how quickly good relations were established between the artist and his model, but Marie would not be entirely satisfied with the drawing; at least, she would use it as a pretext to console Lehmann, her usual confidant, writing to him from Frankfurt on September 20, 1841: "Franz [Liszt] is leaving in a month for Berlin and Russia. I will return to Paris and will wait for you there. M. Ingres can be extremely useful and I won't leave him in peace until you have a chapel. . . . As soon as you've arrived, I'll ask you to do a magnificent drawing of me for Franz. . . . he doesn't want my portrait done by anyone but you. He intensely disliked the one by Chassériau."

On April 21, Marie had attempted to further appease her friend: "I assure you I am not infatuated with Chassériau. I believe you do him too much honor in likening him to Mephistopheles; in any case, don't be afraid of any indiscretion on my part, and I believe I can tell you there is no hostility on his. He did a drawing of me that I find lovely and a good likeness but that is not pleasing because it shows me with my mouth open."

L.-A. P.

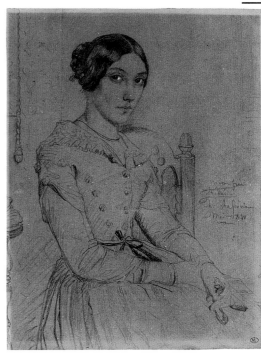

54

Portrait of Adèle Chassériau

1841
Graphite, heightened with white, on faded cream-colored paper
8 ¾ x 7 in. (22 x 17.7 cm)
Dedicated, signed, and dated in graphite, right center: *A mon frère Frédéric / Th. Chassériau / mai 1841* [To my brother Frédéric / Th. Chassériau / May 1841]
Paris, Musée du Louvre (RF 27970)

PROVENANCE:
Frédéric Chassériau, the artist's brother, Paris, until 1881; Baron Arthur Chassériau, Paris; D. David-Weill; donated to the Musée du Louvre, 1936 (L. 1886 a).

BIBLIOGRAPHY:
Chevillard 1893, no. 265; Vaillat 1913, ill. p. 20; Jamot 1920, ill. p. 70; Bénédite 1931, vol. 1, ill. p. 202; Sandoz 1974, p. 12; Sandoz 1986, no. 17, ill.; Prat 1988-1, vol. 1, no. 1067, ill.

EXHIBITIONS:
Paris, Orangerie, 1933, part of no. 110 (the drawing was framed together with the portrait of Aline Chassériau [cat. 55]); Paris, Louvre, 1957, no. 24, pl. 7; Paris, Galerie des Quatre Chemins [n.d.], no. 22 (?).

Exhibited in Paris only

The artist's elder sister, Adèle (1810–1869), like his sister Aline, frequently served as the model for many of his drawings and several of his paintings (Sandoz 1974, nos. 19, 21). Her given name was Marie-Antoinette, but she was called Adèle in memory of one of her father's sisters. Undoubtedly executed at the same time as the portrait of Aline (cat. 55), the drawing also served as a preparatory study for the *Portrait of the Mesdemoiselles C.* of 1843 now in the Louvre (Sandoz 1974, no. 95), in which the sitter's face is seen in three-quarter right profile, but she does not lean so far forward.

L.-A. P.

55
Portrait of Aline Chassériau

1841

Graphite on faded cream-colored paper
9 ¼ x 6 ⅞ in. (23.4 x 17.2 cm)
Dedicated, signed, and dated in graphite, right center: *A mon frère / Théodore Chassériau / 1841* [To my brother / Théodore Chassériau / 1841]
Paris, Musée du Louvre (RF 27969)

PROVENANCE:
Frédéric Chassériau, the artist's brother, Paris, until 1881; Baron Arthur Chassériau, Paris; D. David-Weill; donated to the Musée du Louvre, 1936 (L. 1886 a).

BIBLIOGRAPHY:
Chevillard 1893, no. 265 (which mentions *Portrait of the Artist's Sisters*) (?); Vaillat 1913, ill. p. 20; Jamot 1920, ill. p. 71; Bénédite 1931, vol. 1, ill. p. 202; Sandoz 1974, p. 12; Sandoz 1986, no. 18, ill.; Prat 1988-1, vol. 1, no. 1066, ill.

EXHIBITIONS:
Paris, Orangerie, 1933, part of no. 110 (the drawing was framed together with the portrait of Adèle Chassériau, cat. 54); Paris, Louvre, 1957, no. 25; Paris, Galerie des Quatre Chemins [n.d.], no. 22 (?).

Exhibited in Paris only

The artist's younger sister, Aline (1822–1871), served as a model for a painting (Paris, Musée du Louvre) that was considered to be a portrait of Adèle, his elder sister, until Sandoz (1974, no. 20) set the record straight. Her name was actually Geneviève, but she was called Aline in memory of a friend of her mother. She died in Bordeaux, having fled the Commune, on May 25, 1871, two days after her brother's paintings at the Cour des Comptes were destroyed by fire.

The drawing undoubtedly was used by Chassériau two years after its execution to depict Aline in the *Portrait of the Mesdemoiselles C.* (Sandoz 1974, no. 95; cat. 61), where her face appears almost the same, but turned very slightly to the left.

There are two references to a drawing (Chevillard 1893; and Paris, Galerie des Quatre Chemins, exhib. cat.) entitled *Portrait of the Artist's Sisters* (7 ⅞ x 19 in.), which, according to Chevillard, belonged to Baron Chassériau. Since Chevillard does not cite the present drawing nor the one of Adèle (cat. 54), it seems likely that he is designating the two graphite portraits that we know were mounted in a single frame in 1933 (and were exhibited in Paris in 1934, as no. 60, in the "Exposition de portraits par Ingres et ses élèves" at Galerie Jacques Seligmann); the dimensions thus are those of the mount or of the frame.

It is less likely that a single drawing was split in two, since each sheet was dedicated to Frédéric, and signed and dated by Théodore.

Adèle and Aline are dressed similarly, which would also be the case in the painted portrait of 1843.

L.-A. P.

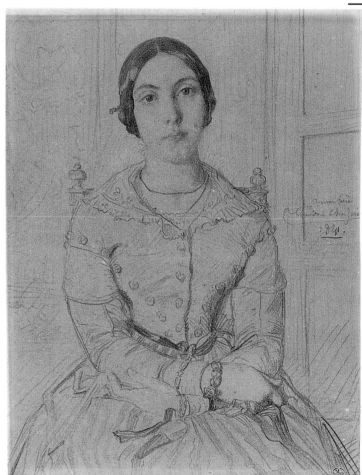

56
Portrait of Louis Marcotte de Quivières

1841
Graphite
13 ¼ x 10 ⅛ in. (33.5 x 25.5 cm)
Dedicated, signed, and dated in graphite, lower right: *A mon ami Marcotte / Th. Chassériau 1841* [To my friend Marcotte / Th. Chassériau / 1841]
Private collection

PROVENANCE:
M. Marcotte de Quivières; Anne Marcotte de Quivières, Marquise de Montholon; Alice, Comtesse de Malherbe, née Marcotte; Wildenstein Gallery, New York, 1961; Benjamin Sonnenberg; Benjamin Sonnenberg sale, New York, Sotheby's, June 5–9, 1979, lot 608, ill.; Marianne Feilchenfeldt, Zürich; private collection.

BIBLIOGRAPHY:
Chevillard 1893, no. 308; Sandoz 1974, pp. 12, 41, fig. 11; Sandoz 1986, no. 15, ill.; Prat 1988-1, under no. 1074; Prat 1988-2, no. 81, ill.

Exhibited in Paris only

The sitter was a member of the Marcotte family, which was well known for its ties to Ingres. Louis Marcotte de Quivières (1815–1898) was the brother of Anne, whose portrait Chassériau painted when she was a child. His wife, Mme Marcotte de Quivières, whose portrait Chassériau drew in 1845 (and on another occasion, as well; that drawing was acquired by the museum in Basel; see cat. 157). A farmer in Mérignac, near Bordeaux, Marcotte de Quivières had a local political career; he was the owner of Chassériau's *Toilette of Esther* and of the *Venus*

CAT. 56

Anadyomene, and in 1854 lent a small-scale version of the *Tepidarium* to the Salon des Amis des Arts in Bordeaux (that work is now in Cairo, Gezira museum). Four paintings by Chassériau appeared in the sale of his collection (Paris, Hôtel Drouot, April 24, 1875, lots 3–6): *Women* (sold for Fr 2,250 to Christofle); *Venus Anadyomene* (bought back for Fr 3,220); the small *Tepidarium* (sold for Fr 4,000 to Tissier); and the *Esther* (sold for Fr 700 to Ducasse, a pupil of Chassériau, who drew his portrait [now lost]; see Prat 1988-2, no. 223).

L.-A. P.

57
Portrait of the Wife of Admiral Duperré and Her Daughters

1841
Graphite
15 ⅝ x 10 ⅝ in. (39.5 x 27 cm)
Signed and dated in graphite, lower right: *Th. Chassériau 1841*
New York, The Metropolitan Museum of Art, Bequest of Walter C. Baker, 1971 (1972.118.199)

PROVENANCE:
Baron Victor-Guy Duperré; Baroness Duperré; Mme de Montigny; Mme de Dompierre d'Hornoy; Baron de Dompierre; Walter C. Baker (1893–1971) (C. Virch catalogue, 1962, no. 102, ill.); bequest to The Metropolitan Museum of Art, New York, 1971.

BIBLIOGRAPHY:
Bénédite 1931, vol. 2, ill. p. 346; Sandoz 1974, p. 12; Sandoz 1986, no. 81, ill.; Prat 1988-2, no. 83, ill.; Peltre 2001, p. 125.

EXHIBITION:
Paris, Orangerie, 1933, no. 109 (with erroneous dimensions).

In 1822, Baronne Duperré, born Adèle Le Camus, married the admiral Baron Victor-Guy Duperré (1775–1846), Minister of the Navy and of the Colonies, for whom Frédéric Chassériau, the artist's brother, served as private secretary. She had previously been Comtesse Morio de l'Isle, the wife of Jérôme de Westphalie, Minister of War. She is depicted here with her daughters, Claire-Adélaïde and Adèle, the future Mme de Montigny and the future Mme de Bassoncourt, respectively. The latter owned a Chassériau drawing *The Communion* (now in the British Museum; see Prat 1988-2, no. 24).

Chassériau made portrait drawings of other members of the same family, including the young Victor-Auguste Duperré in the costume of a navy cadet, dated the following year (cat. 58), and his father, the admiral Baron Victor-Guy (the drawing is now in Detroit; see Prat 1988-2, no. 86); Victor-Guy was minister three times between 1834 and 1843. This is one of the rare group portraits drawn by Chassériau; the perspective effect is interesting, as the figures appear to be situated on an ascending picture plane.

The portrait is mentioned in a letter from Mme Monnerot (see cat. 10) to her son Jules (see cat. 209), dated May 30, 1841: "Théodore intends to write to you. He did the portraits of the three Duperré ladies" (Paris, Bibliothèque Nationale de France, Département des Manuscrits, Naf. 14405, Papiers Gobineau, vol. 17, Monnerot family correspondence, vol. 1, folios 65–66).

L.-A. P.

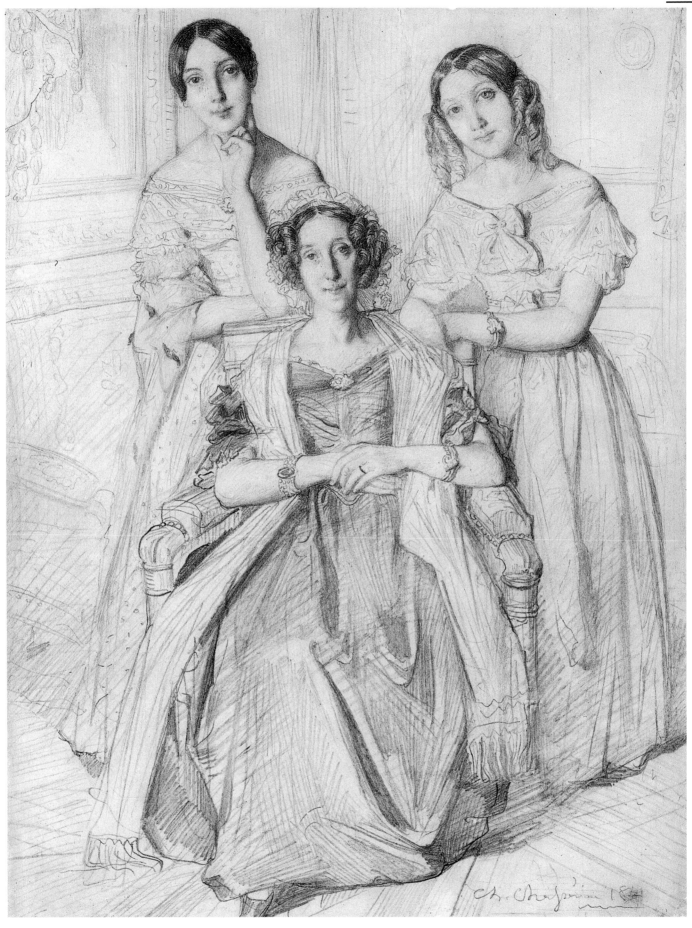

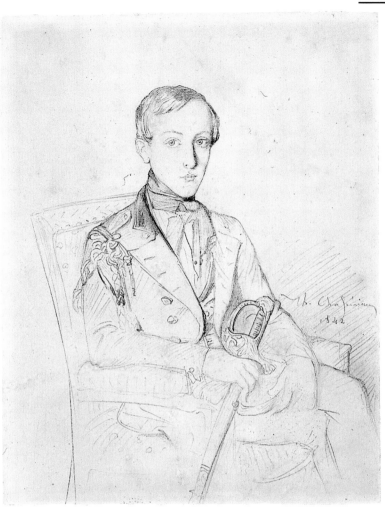

58

Portrait of Victor-Auguste Duperré
as a Navy Cadet

1842
Graphite
10 ⅝ x 8 ¾ in. (27 x 22 cm)
Signed and dated in graphite, right center: *Th. Chassériau / 1842*
The Detroit Institute of Arts (65.141)

PROVENANCE:
Duperré family; Mme de Dompierre d'Hornoy; Baron de
Dompierre; John S. Newberry, Detroit; bequest to The Detroit
Institute of Arts, 1965 (*The John S. Newberry Collection*, exhib.
cat., The Detroit Institute of Arts, 1965, p. 25, ill.).

BIBLIOGRAPHY:
Bénédite 1931, vol. 2, ill. p. 369; Sandoz 1974, p. 12; Sandoz 1986,
no. 21, ill.; Prat 1988-1, under no. 693; Prat 1988-2, no. 83, ill.;
Peltre 2001, p. 125, fig. 139.

Son of Admiral Duperré (see cat. 57), Victor-Auguste
(1825–1900) is represented here at the age of seventeen.
This portrait drawing reveals the same tension that char-
acterizes the *Portrait of Zoë de La Ruë* (cat. 59), as well
as other works by Chassériau from 1842. Victor-Auguste
entered the Naval Academy in 1840, and became an
ensign in 1846, a lieutenant in 1851, and a captain in 1865,
after serving as aide-de-camp (1862) and then private
secretary to Minister Chasseloup-Laubat. Under the
Third Republic, he was governor of Cochin China, then
port admiral in Toulon, and finally, vice-president of the
Admiralty Board, where he displayed a marked prefer-
ence for armored ships over torpedo boats and high-
speed cruisers.

He attended the posthumous sale of Chassériau's
works in 1857, where he acquired at least eight drawings,
and was president of the committee organized to save the
artist's paintings in the Cour des Comptes.

L.-A. P.

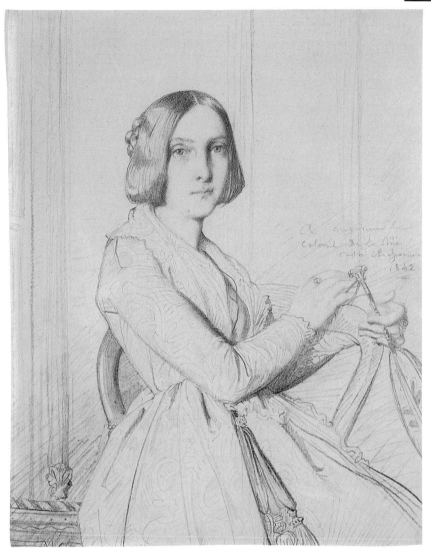

59

Portrait of Zoë de La Ruë

1842
Graphite
10 ⅜ x 8 ¼ in. (26.4 x 21 cm)
Dedicated, signed, and dated in graphite, right center: *A mon-
sieur le / colonel De La Ruë / Th. Chassériau / 1842*
United States, Private collection

PROVENANCE:
United States, private collection.

BIBLIOGRAPHY:
Prat 1991, p. 78, fig. 4.

In 1840, Chassériau had drawn another, more sketch-like
portrait of the same model. That sheet, which I was able
to examine only briefly, bears the following inscription
on the back: *Comtesse Zoë de la Ruë, dame chanoinesse de
Bavière, soeur du général, belle-mère d'Emmanuel* [Countess
Zoë de la Ruë, canoness of Bavaria, sister of the general,
mother-in-law of Emmanuel].

That handwritten annotation, however, could refer to
a member of an earlier generation of the family. In fact,
Comte Aristide-Isidore-Jean-Marie de La Ruë, born
March 11, 1755, named a captain in 1816 and a colonel in

February 1839, became a general only in 1849, and a sen-
ator in 1860. Although the dedicatee of the present
drawing is almost certainly this individual (he was, in fact,
a colonel in 1842), the officer was already forty-seven years
old; thus, the young woman depicted must be his sister.

Until 1848, La Ruë was director of Algerian affairs at
the Ministry of War. His relations with Chassériau are
attested in a letter from the artist to his brother, dated
June 13, 1846, and sent from Philippeville during his
sojourn in Algeria: "I was very happy with the caliph. He
returned fifteen hundred francs of the sum he owes me
and asked me, as a friend, to wait a little while for the rest,
which he will send me via M. Delaruë" (quoted in
Chevillard 1893, pp. 112–13).

As for "Zoë de la Ruë," she had crossed paths earlier
with Chassériau's circle: on February 6, 1841, Marie
d'Agoult described her as a "coquette, charming, aristo-
cratic," and a close friend of Delphine de Girardin; then,
on March 11, 1841, Marie wrote to Lehmann that she
had gone to Chassériau's studio "with Sainte-Beuve and
M̲l̲le Delaruë [my emphasis]: "He [Chassériau] won

over all my friends: Ronchaud, Mlle Delarue, etc." (a sentence somewhat at variance with the date of 1840 on the drawing cited above). Chassériau spent numerous evenings at her home in 1841 (see the Chronology, September 20, 1841). Zoë de La Rüe was the daughter of Louis de La Rüe, French consul, and of Anna-Rose-Zoë Sollier de la Touche.

In 1804, a different Comtesse de La Rüe had been the sitter for a small painting by Ingres (Paris, private collection).

In its execution, this portrait drawing resembles the *Portrait of Victor-Auguste Duperré as a Navy Cadet* (see cat. 58), also dated 1842. The two sitters seem more rigid than those in previous or later works—as if, at that date, Chassériau was experimenting with a tauter manner and a dryer approach in his portrait drawings, which he subsequently quickly relaxed. Still admirable are the care in the rendering of details (the fan and the tassel of the belt), the intentional sinuosity of the pose, and the unrealistic deformation of the seat back, which introduces a welcome asymmetry and a distortion of space into the composition.

L.-A. P.

CAT. 60

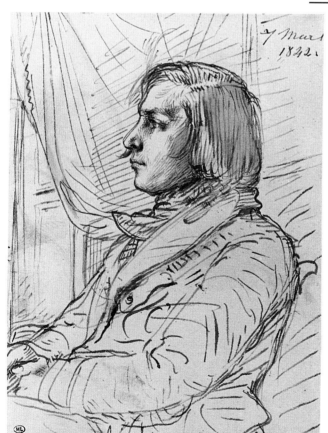

60

Bust-Length Portrait of a Young Man in Left Profile

1842
Pen and brown ink, with brown wash, and traces of black pencil
8 ¼ x 6 ⅜ in. (21 x 16 cm)
Dated in pen and brown ink, upper right: *7 mars / 1842.*
Paris, Musée du Louvre (RF 24449)

PROVENANCE:
See cat. 20 (no mark L. 443).

BIBLIOGRAPHY:
Chevillard 1893, part of no. 420 (or no. 341 ?); Sandoz 1974, p. 12, ill. p. 43, fig. 13; Sandoz 1986, no. 86, ill.; Prat 1988-1, vol. 1, no. 1069, ill.

EXHIBITIONS:
Paris, Galerie Dru, 1927, no. 95; Paris, Louvre, 1957, no. 27.

Exhibited in New York only

One of the very rare portraits in pen executed by the artist, it may depict his elder brother, Frédéric, then aged thirty-five. The half-length pose, seen in profile, is also very rare in Chassériau's portrait drawings.

L.-A. P.

61

The Two Sisters, or Portrait of the Mesdemoiselles C. (Marie-Antoinette, called Adèle [1810–1869], and Geneviève, called Aline [1822–1871], the painter's sisters)

1843
Oil on canvas
70 ⅞ x 53 ¼ in. (180 x 135 cm)
Signed and dated, lower left: *T. Chassériau 1843*
Paris, Musée du Louvre (RF 2214)

PROVENANCE:
Studio (or family) of the painter until his death; Frédéric Chassériau, the artist's brother, Paris, until 1881; Baron Arthur Chassériau, Paris; given by the latter and his wife to the Musée du Louvre, 1918.

BIBLIOGRAPHY:
[Unsigned], 1843, 3rd article; Houssaye 1843; Peisse 1843; Stern 1843; Ténint 1843; Mantz 1856; Bouvenne 1887, p. 171; Chevillard 1893, no. 67, p. 74; Marx 1898, p. 274; Dayot 1899, pp. 346, 348–51; Tschudi 1900, p. 9, ill. p. 13; Denis 1903, p. 147; Bénédite 1909, p. 88, ill. p. 85; Marcel and Laran 1911, pp. 12, 37–38, pl. 11; Denis 1912, p. 118; Denis 1913, p. 26, ill. p. 3; Vaudoyer 1919, pp. 37–42, sep. ill.; Bouyer 1920, pp. 529–30, ill. p. 531; Jamot 1920, pp. 66–69; Jamot, March 1920, p. 66; Jamot 1920, pp. 219–20; Escholier 1921, pp. 96–98; Focillon 1928, p. 166, ill. p. 180; Goodrich 1928, pp. 75, 93–97, ill.; Bénédite 1931, vol. 1, pp. 201–11, pl. 17; La Tourette 1931, pp. 182, 190; S.A.I., 296, ill.; Sandoz 1968, p. 182; C.P., p. 73; Sandoz 1974, no. 95, p. 206, pl. 79, p. 207; Cat. Somm. Ill., 1986, vol. 3, p. 130, ill.; Prat 1988-1, vol. 1, pp. 150–52, ill. p. 150; Peltre 2001, pp. 27, 52, 88–89, 188, 220, 226, ill. 92.

EXHIBITIONS:
Salon of 1843, no. 217; Paris, 1883, no. 21; Paris, 1900, no. 97; Paris, Orangerie, 1933, no. 24, ill. at back of catalogue; Montauban, 1967, no. 185, pp. 113–14, pl. 24.

Upon returning from his trip to Rome and after the Salon of 1841, at which he exhibited two very powerful works (cat. 47, 65), Théodore Chassériau seems to have resolved to prove he had achieved full maturity in the art of the portrait. Disappointed at how his relationship with Ingres had developed, and eager to demonstrate that he could emancipate himself from the latter's influence, he thus wished to execute a major work in the genre at which his teacher excelled, forcing the critics

to consider the pupil as in the same category and at the same level as his master. This effort seems to have obsessed him in early 1843, as proven by a letter he sent on Wednesday, January 19,[1] to Xavier Eyma (1816–1876), a journalist and man of letters: "Thank you for having thought of me for the portrait you mentioned. At this time, in spite of the pleasure I would have in doing it, I cannot take it on. Until the Salon, my days are filled from morning until night with finishing the picture I have undertaken."

Before beginning work on one of his most famous pictures, Théodore Chassériau made many graphite studies, each marking a stage in the posing sessions he inflicted on his sisters and revealing his desire for formal perfection. According to Marc Sandoz, who interprets a remark by Chevillard on this work,[2] the artist may have painted a small oil study (10 ⅛ x 11 ⅞ in.) of the entire composition on canvas, a supposition that is difficult to prove in the absence of material evidence. Today, only the series of drawings in the Musée du Louvre allows us to follow Chassériau's rigorous preliminary work. Apart from a graphite sketch that already evokes the definitive composition and emphasizes the play of the two young women's hands,[3] these are studies for the poses of Aline and Adèle and, above all, for the draping of their clothing and shawls. In that spirit, Aline's physiognomy and the details of her blouse,[4] her shawl,[5] and the lower part of her dress,[6] were the objects of detailed study, as was her left arm.[7] As for the figure of the elder sister, Adèle, it was studied just as attentively in a drawing of her dress,[8] and in another of her blouse and left hand.[9] Other sketches of the two sisters, of 1841 (cat. 54, 55), were reused during this time in order to plan the present "double portrait" with precision.[10]

Parallel to these studies "from life," Théodore Chassériau surely had in mind Ingres's *The Misses Harvey,* a painting now lost but known through a Louvre drawing, which is not unrelated to the painting discussed here. It is true that Neoclassical references can be discerned in *The Two Sisters,* as, for example, in the choice of the green background that sets off the two young ladies—a device borrowed from French and Italian Renaissance painters, which David and his pupils had adopted. Nevertheless, the present work seems largely original, both in its simplicity and in its efficacy—it was hailed by the majority of critics when it was exhibited at the Salon—but also because of Chassériau's subtle manipulation of the classical principles of the portrait genre. Hence, the background of the work is not solid, indeterminate, or scumbled, in the manner of David. On the contrary, it resembles an actual tapestry composed of gilded vegetal motifs. Similarly, a section at the right is enlivened by a decorative doorway that frames the entire composition, creating a subtle imbalance that corresponds to the table in the lower-left corner on which Adèle rests her right hand. In addition, the poses of the two young ladies—both seen frontally, with Adèle slightly in three-quarter profile; cut off at knee level; and with their eyes looking out at the spectator—might be somewhat academic were it not for the play of Aline's hands, placed on her sister's

arm near Adèle's left hand, with which she gently holds her shawl. This creates, in the center of the composition, a lighter zone, suggesting a slight movement as well as deep affection.

The intimacy of the relationship between the two Chassériau sisters, who were both unmarried and served as each other's confidantes, seems to be the true subject of the painting, which can be considered a declaration of love addressed to them by their brother. He unites the two young women in shared affection, to the point that, in his depiction, he sought to emphasize an astonishing twinship, imaginary but very revealing as to his feelings. Adèle, on the left in the composition, was thirty-three at the time, while her younger sister was only twenty-one. Despite that age difference, Chassériau chose to represent them dressed in the same orangy-pink blouse and bright red shawl with a sumptuous pattern of flowers, and with identical hairstyles. Only their jewelry and the flower stitched into Adèle's belt distinguish them from each other. Hence, the uneasy affection of the Chassériau family, upset by the constant absence of the father—and the remote presence of the mother—rises to the surface in this "double portrait" of the sisters. In spite of that, following his years of apprenticeship with one of the masters of the genre, and after the many portrait drawings and paintings that marked his early career, Théodore Chassériau sought to display both technical and aesthetic "bravura"—visible, for example, in the perfection with which the fabrics are rendered.

When the work was exhibited at the Salon of 1843, his contemporaries seem to have grasped the painter's intentions, but did not applaud his efforts. Hence, although Louis Peisse admired the technical "tour de force," he was more reserved about the final result: "M. Chassériau wanted, perhaps unnecessarily, to undertake a difficult thing, to do a painting with two figures of women, both full length, of the same height, both in dresses of the same color and the same fabric, with the same shawl, posed in the same manner, and to sustain that gamble of sorts without using any artifice of light or effect, solely through the authority of style, form, and character. Did he succeed adequately? I do not think so. Nevertheless, he executed that tour de force with a resolution and skill that deserved to prevail."[11] Similarly, while Arsène Houssaye inveighed against what he called "the intentional choice of ugliness,"[12] an anonymous author observed, paradoxically, that, in the end, "M. Chassériau's great mistake was to be too modest, too simple, too true [since] he conceded nothing to effect, to fame, to fashion."[13]

In fact, the notoriety of this portrait would persist in spite of everything during the painter's lifetime. Some critics discovered the work in his studio: Anthony Deschamps, for example, expressed his admiration for it, before 1857: "Mr. Chassériau overcame a great difficulty, that of placing side by side two figures, parallel in almost every respect, whose bodies display little movement."[14] When the painter died, his friends all seem to have understood the importance of this work, the culmination of his labors as a portraitist. Delacroix himself, seeing the

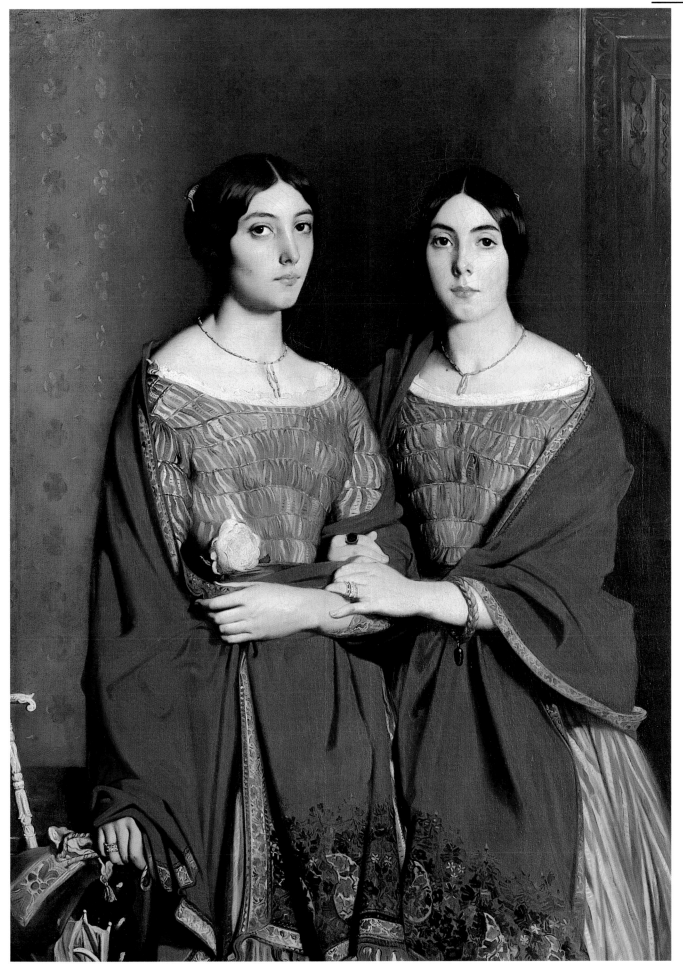

two sisters the day of Chassériau's funeral, remembered these "two young ladies in red shawls."[15] At the same time, Paul Mantz published an obituary in *L'Artiste,* in which he eloquently called into question the opinions he had expressed earlier on the subject of *The Two Sisters* at the Salon of 1843: "There is nothing more solid, nothing more serious in the young painter's work. Do not seek color there, Chassériau was not yet thinking about it; two heads with systematically swarthy flesh tones, two frail bodies enveloped in red cashmere standing out against one of those green backgrounds, the way the Clouets liked them, accentuating a choice more violent than harmonious. . . .There is, in the work as a whole, a very tasteful simplicity, an almost magisterial self-assurance . . . which, I do not hesitate to declare, is not always found in the portraits of the master whose influence Chassériau was under."[16]

From that moment on, *The Two Sisters* would be considered one of Chassériau's most luminous works, "a pure masterpiece of color, drawing, observation, and also of suppressed emotion."[17] Its influence would be perceptible in the works of many painters in the following generation, both in their theoretical texts—such as those of Maurice Denis, for example, who places *The Two Sisters* "between Renoir's *Belle Zélie* and *La Loge,* and between Manet's *Valpinçon Odalisque* and *Olympia*"[18]—and in their purely pictorial studies, of which, among many others, Degas's "double portrait" *Giovanna and Giulia Bellelli* (Los Angeles County Museum of Art) comes to mind. v. p.

1. Unpublished letter from Chassériau to Xavier Eyma, Paris, Bibliothèque Nationale de France, Département des Manuscrits (Naf. 21014, fols. 83–84, "Correspondance X. Eyma").
2. Chevillard 1893, no. 255 ("*reduction*"); Sandoz 1974, no. 96, p. 208.
3. Musée du Louvre, Département des Arts Graphiques (RF 25053; see Prat 1988-1, vol. 1, no. 275, p. 150).
4. Musée du Louvre, Département des Arts Graphiques (RF 25056; see Prat 1988-1, vol. 1, no. 276, p. 150).
5. Musée du Louvre, Département des Arts Graphiques (RF 25055 r.; see Prat 1988-1, vol. 1, no. 277, pp. 150–51; and RF 25057, Prat 1988-1, vol. 1, no. 278, pp. 150–51).
6. Musée du Louvre, Département des Arts Graphiques (RF 25055 v.; see Prat 1988-1, vol. 1, no. 277, pp. 150–51).
7. Musée du Louvre, Département des Arts Graphiques (RF 26446; see Prat 1988-1, vol. 1, no. 279, pp. 150–51; not the right arm, as Louis-Antoine Prat indicated, in error, in the title of the work, although the commentary accurately refers to the left arm.
8. Musée du Louvre, Département des Arts Graphiques (RF 26542 *ter;* see Prat 1988-1, vol. 1, no. 280, pp. 150–51).
9. Musée du Louvre, Département des Arts Graphiques (RF 25052; see Prat 1988-1, vol. 1, no. 281, pp. 151–52).
10. Marc Sandoz mentions a composition (not retained) apropos of a graphite drawing that Louis-Antoine Prat justifiably considers to have been copied after a Renaissance portrait seen in Italy (Musée du Louvre, Département des Arts Graphiques, RF 25910; see Prat 1988-1, vol. 1, no. 1570, p. 566)—a copy, it should be noted, that might have served as a reference for the present portrait of his sisters.
11. L. Peisse, "Salon de 1843," in *La Revue des deux mondes* (Paris, 1843).
12. A. Houssaye, "Salon de 1843," in *La Revue de Paris* (1843).
13. Unsigned, "Salon de 1843," in *Les Beaux-Arts* (1843).
14. A. Deschamps, "Visite à l'atelier de Th. Chassériau" (unpublished and undated article); quoted in Bénédite 1931, vol. 1, pp. 209–10.
15. See A. Bouvenne, "Théodore Chassériau," in *L'Artiste,* vol. 2 (September 1887), p. 171.
16. P. Mantz, obituary of the artist, in *L'Artiste* (1856).
17. A. Dayot, *L'Image de la femme* (Paris, 1899), p. 348, quoting Robert de Montesquiou, "Alice et Aline (Une Peinture de Chassériau)," in *Autels privilégiés* (Paris: Eugène Fasquelle, 1898), p. 251.
18. M. Denis, *Théories. Du symbolisme et de Gauguin vers un nouvel ordre classique* (Paris, 1912), p. 118.

62

Portrait of Mme Eugène Piot

1844
Graphite on cream-colored paper
13 ¾ x 11 in. (34.7 x 27.9 cm)
Signed and dedicated in graphite, lower right: *à Eugène Piot / Th. Chassériau*
Paris, Musée du Louvre (RF 25045)

PROVENANCE:
Eugène Piot; Eugène Piot sale, Paris, Hôtel Drouot, May 21–24, 1890, lot 587; Baron Arthur Chassériau, Paris; studio mark (L. 443) lower right (even though this is a signed portrait); bequest to the Musée du Louvre, 1934 (L. 1886 a).

BIBLIOGRAPHY:
Chevillard 1893, no. 286; Blanche 1927, ill. p. 516; Hourticq 1927, ill. p. 276; Bénédite 1931, vol. 2, ill. p. 372; Alazard 1933, p. 56, ill. p. 52, fig. 6; Sandoz 1986, no. 66, ill.; Prat 1988-1, vol. 1, no. 1072, ill.; Peltre 2001, p. 99, fig. 109.

EXHIBITIONS:
Paris, Galerie Dru, 1927, no. 40; Paris, Orangerie, 1933, no. 166; Paris, Louvre, 1957, no. 36; Paris, Galerie Daber, 1976, no. 28, ill. (with erroneously captioned illustration and transcription of the dedication); Paris, Galerie des Quatre Chemins [n.d.], no. 3.

Exhibited in Paris only

Although Sandoz dates this superb portrait to about 1854, it may be contemporary with Chassériau's receipt of the commission for the "Othello" series (to be issued in 1844) from Eugène Piot (1812–1890), publisher of the *Cabinet de l'amateur et de l'antiquaire,* founded in 1842 (on this subject see C. Piot, "Eugène Piot [1812–1890], publiciste et éditeur," in *Histoire de l'Art,* no. 47 [November 2000], pp. 3–17), and the husband of the sitter.

Piot owned two paintings by Chassériau, *Andromeda Chained to the Rock by the Nereids* (cat. 65), which was no. 549 at his posthumous sale (see above), and *Battle of*

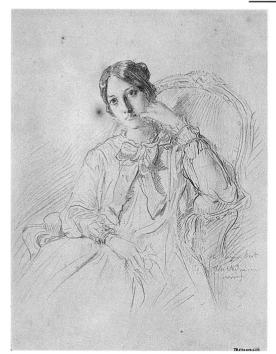

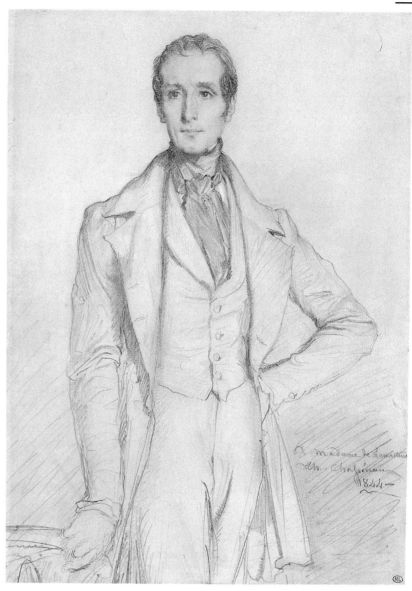

Arab Horsemen Around a Standard (cat. 192), as well as the portrait drawing of Théophile Gautier's friend Carlotta Grisi, now in the Louvre, which was no. 588 in the Piot sale (Prat 1988-1, vol. 1, no. 1068, ill.).

L.-A. P.

63

Portrait of Alphonse de Lamartine

1844
Graphite, heightened with white, on beige paper
12 ½ x 9 in. (31.5 x 22.7 cm)
Dedicated, signed, and dated in graphite, lower right: *à Madame de Lamartine / Th. Chassériau / 1844*
Paris, Musée du Louvre (RF 5222)

PROVENANCE:
Baroness de H. sale, Paris, Hôtel Drouot, June 2–3, 1908, lot 53; Paul Leprieur; Paul Leprieur sale, Paris, Hôtel Drouot, November 21, 1919, lot 37; acquired at that sale (for Fr 3,600) by Gabriel Thomas; gift of Gabriel Thomas, in usufruct, to the Musée du Louvre, 1921; entered the Louvre, 1932 (L. 1886 a).

BIBLIOGRAPHY:
Chevillard 1893, no. 262, p. 159; Chevillard 1898, ill. p. 254; Bénédite 1931, vol. 2, ill. p. 409; Grappe 1932, ill. p. 2; Benoist 1933, ill. p. 84; Bouchot-Saupique 1957, p. 94, ill.; Sandoz 1974, p. 57, fig. 19; Sandoz 1986, no. 24 A, ill. (the inventory number is also assigned to no. 23, *Portrait of Tocqueville,* described as in the Louvre even though it is in the Musée Carnavalet!); Prat 1988-1, under no. 1071; Prat 1988-2, no. 84; Peltre 2001, p. 32, fig. 28.

EXHIBITIONS:
Paris, Orangerie, 1933, no. 118, ill.; Paris, Louvre, 1957, no. 32.

Exhibited in New York only

Alphonse de Prat de Lamartine (1790–1869) was a famous writer and a major political figure at the time. While preparing the *Histoire des Girondins* (which would be published in 1847), he was one of the principal opponents of the July Monarchy. In Chantilly, in 1820, he married Marianne-Elisa Birch, an Englishwoman who had converted to Catholicism; she would hang the portrait drawing of her husband in her studio. The role the poet played in the revolution of February 1848 is well known, as is the rapidity of the decline in his popularity beginning in the spring of that year.

Apart from this famous portrait, executed when the poet was fifty-four years old, which attests to the connections between the Lamartine family and Chassériau, a dedication to Mme Alphonse de Lamartine formerly

appeared on the mount of the superb watercolor *Sappho Jumping into the Sea from the Rock of Leucade*, dated 1846 (cat. 171). Bénédite (1931, vol. 2, p. 409) illustrates the present portrait, but without the dedication to Lamartine's wife. In fact, the illustration is of an engraving *after* the drawing, published in *L'Artiste* in September 1886 (Bouvenne 1887, no. 57), facing page 161, at the beginning of an article by Louis de Ronchaud entitled "Une Statue à Lamartine." The exhibition at the Orangerie in 1933 included a drawing of the head of Lamartine only (no. 119; owned by M. André de Hevesy). A photograph of a similar head, annotated *Coll. Varin,* is in the files of the Drawings department at the Louvre, and it has been published by Sandoz (1986) under no. 24 C (Wildenstein photo), as well as by me (Prat 1988-2, no. 107, ill.). Finally, the Petit Palais in Paris owns a tracing of this drawing (*Catalogue sommaire des collections municipales* [1927], no. 145; see Sandoz 1986, no. 24 B, ill.).

L.-A. P.

64

Portrait of Alexis de Tocqueville

1844
Graphite
12 x 9 ¼ in. (30.5 x 23.5 cm)
Dedicated, signed, and dated in graphite, lower right: *à Madame / Alexis de Tocqueville / Th. Chassériau / 1844*
Paris, Musée Carnavalet (D 4070)

PROVENANCE:
Baron Arthur Chassériau, Paris; gift to the Musée Carnavalet, Paris, 1934 (*Dessins parisiens des XIXᵉ et XXᵉ siècles*, exhib. cat. [Paris: Musée Carnavalet, 1976], no. 16, ill.).

BIBLIOGRAPHY:
Bouvenne 1883–84, no. 47, p. 166 (the Varin engraving); Chevillard 1893, no. 274, p. 159, ill.; Vaillat 1907, p. 183, ill.; Marcel and Laran 1911, pp. 62–63, pl. 23; Vaillat 1913, p. 26; Bénédite 1931, vol. 1, p. 357; Sandoz 1974, under no. 155, p. 12; Sandoz 1986, no. 23, ill. (mistakenly designated as in the Louvre); Prat 1988-1, under no. 1071; Prat 1988-2, no. 105, ill.

EXHIBITIONS:
Paris, 1927, no. 27; Paris, Orangerie, 1933, no. 120.

ENGRAVINGS:
Engraved by Adolphe Varin (Bouvenne 1883–84, no. 47; Bouvenne 1887, no. 36); a copy of the photogravure is in the Musée Gustave-Moreau, Paris (11912-69).

Exhibited in Paris only

Alexis Charles Henri Clérel, Comte de Tocqueville (1805–1859), author of the justly celebrated *De La Démocratie en Amérique* (part 1 published, 1835; part 2, 1840) and *L'Ancien Régime et la Révolution* (unfinished; published in part, 1856), as well as of the invaluable *Souvenirs* (published posthumously, 1893), was a major supporter of Chassériau when the painter was seeking to obtain a commission for the decoration of the main stairwell at the Cour des Comptes. The account of his assistance was reported by Marius Vachon in *Le Palais du Conseil d'État et la Cour des Comptes* (1879), and was quoted by Chassériau's first biographer, Chevillard (1893, pp. 125–27):

> One evening, Frédéric and Théodore Chassériau were visiting M. Alexis de Tocqueville at his home. Tocqueville told Frédéric that his brother seemed very sad.
> "True," replied M. F. Chassériau, "they have refused his request to decorate the walls of a Paris monument."

> "Whom does it depend on?" asked M. Alexis de Tocqueville.
> "On the Minister of the Interior."
> "Oh," said M. de Tocqueville, "Is that all? I'll take care of it. Reassure your brother."

M. Vitet, a deputy, was a very close friend of Comte Duchâtel, Minister of the Interior, and his adviser on matters relating to art. M. Vitet had submitted his application for admission to the Académie Française, of which M. Alexis de Tocqueville was a member. "My dear friend," the academician told him, "tit for tat. I promise you my vote provided that, *sine qua non,* Chassériau gets his wall."

A few days later, M. Chassériau received the commission for the upper part of the stairwell at the Cour des Comptes. For his work, he was awarded the sum of thirty thousand francs. When the young painter found himself facing the main stairwell, he said to himself: "Such a decoration demands unity in the conception and the execution. I will do it all." He then had all the walls of the stairwell prepared and, without telling anyone, he sketched in the entire composition. When he had finished, he asked M. Vitet to come and see his work. In its presence, M. Vitet cried out in admiration, and, tapping the young man on the shoulder, told him: "You are a great artist and the kind of man I like; you're charged with the complete decoration of the stairwell at the Cour des Comptes."

Bénédite (1931, pp. 317–20) colored his account of the story (it is unlikely that Chassériau would have been able to prepare all the walls and sketch in all the compositions himself), specifying the role of each person involved and publishing a letter of December 27 (1844?) from Frédéric Chassériau to the comtesse de Tocqueville, which sets the record straight. The fact remains that the present portrait drawing, dedicated to the sitter's wife, attests to the friendly relations between the two men. Compared to the portrait painting of 1850 (cat. 204), the drawing shows a less official Tocqueville, seated rather than standing, his hands relaxed, but the face seems the same; perhaps the drawing served as the basis for the face in the painting.

L.-A. P.

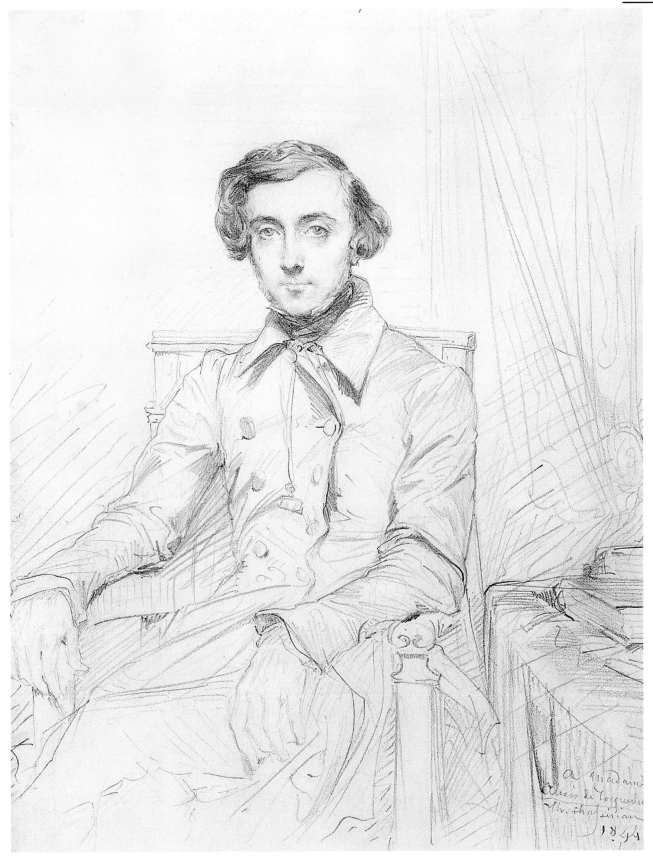

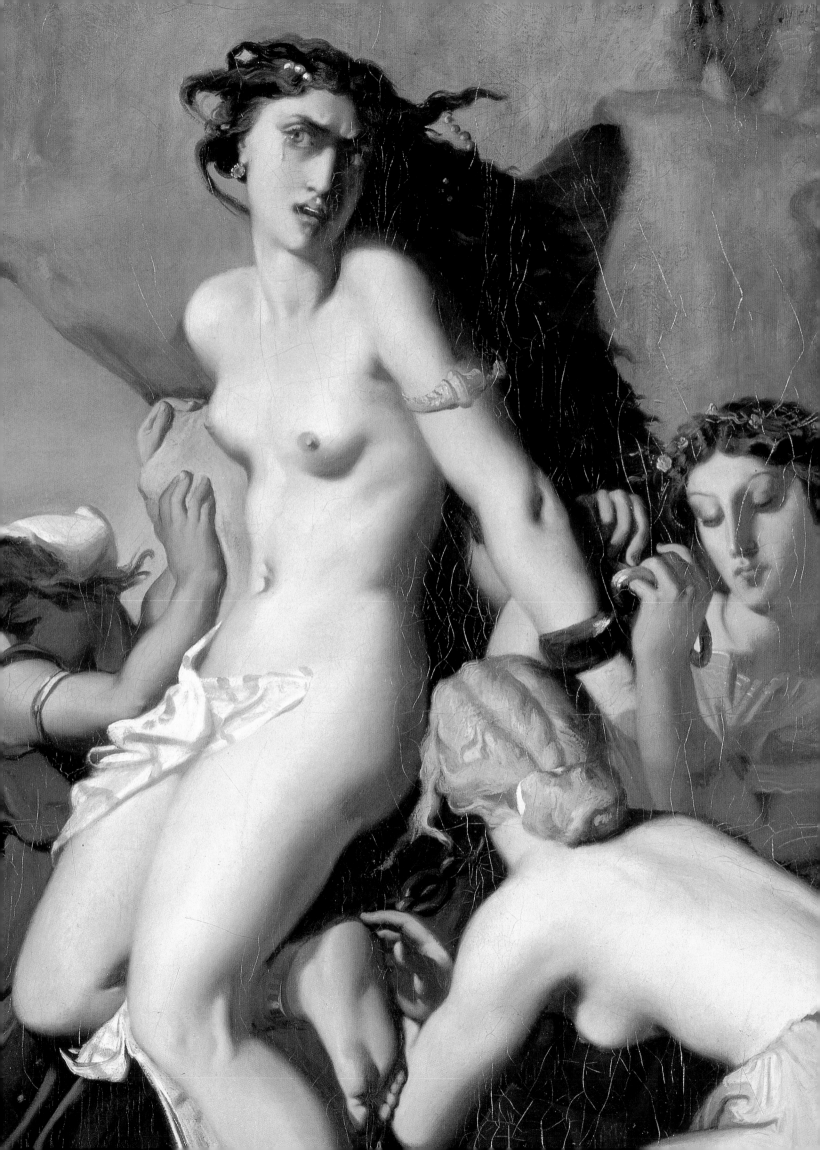

The Ancient World, Biblical Reveries

65

Andromeda Chained to the Rock by the Nereids

1840
Oil on canvas
36 ¼ x 29 ⅛ in. (92 x 74 cm)
Signed and dated, bottom left: *T. Chassériau 1840.*
Paris, Musée du Louvre (RF 1986-63)

PROVENANCE:
Eugène Piot; posthumous sale, Hôtel Drouot, May 21–24, 1890, lot 549; acquired by Baron Arthur Chassériau, who bequeathed the painting to Jean-Louis Vaudoyer; acquired from the latter's heirs by the Musée du Louvre, 1986.

BIBLIOGRAPHY:
Unsigned, *L'Artiste,* vol. 8 (1841), p. 264; Pelletan, *La Presse,* April 4, 1841; Unsigned, *Journal des beaux-arts et de la littérature,* April 11, 1841; Unsigned, *Le Journal des artistes,* May 16, 1841; Delécluze, *Journal des débats,* May 29, 1841; Cantagrel, *La Phalange,* May 30, 1841; G. D., *L'Univers,* June 5, 1841; Gautier, *La Presse,* March 27, 1844; Chevillard 1893, no. 58, pp. 49, 53, 276; Bénédite 1931, pp. 161–64; Sandoz 1974, no. 64; Daber 1976; Laveissière 1987, pp. 148–50; Prat 1988-1, vols. 1 and 2, nos. 46–51, 117, 2240; Lacambre 1995–96, p. 345; Peltre 2001, pp. 90–91.

EXHIBITIONS:
Salon of 1841, no. 326; Paris, Orangerie, 1933, no. 17; Paris, 1937, no. 258; Paris, Galerie Daber, 1976, no. 4; Paris, Louvre, 1987; Nantes-Paris-Piacenza, 1995–96, no. 27.

Exhibited in Paris only

In the future that Chassériau mapped out for himself in Rome by breaking off with Ingres, the Salon of 1841—the Salon that would mark his return—was strategic: he had to renounce Ingrism, with which the critics had associated him since 1839. This emancipation depended on a brilliant coup, in the form of a painting that would openly signify that break as well as his independence, however high the price. The painting, of modest dimensions, was the *Andromeda.*

The subject, with its erotic and emotional content, was a longtime favorite of painters, and persisted in various related manifestations, one of which was the Deliverance of Angelica by Ruggiero, adapted from Ariosto. In 1819, Ingres had taken on this episode from literature (in a work now in the Louvre), giving it an intentioanlly fantastical aspect. The emphasis on the supernatural undoubtedly can be linked to the latent sadism in the scene, which the painter, like his predecessors, explored in the three opposing elements in the story: the monster to be slain; the victorious man; and the woman, more desirable for being so vulnerable. Chassériau abandoned that thoroughly conventional schema, rethinking the subject from an entirely new perspective.

This was not an immediate choice: Certain preliminary drawings (Prat 1988-1, vol. 1, no. 47) show Andromeda chained and being offered to the monster, conforming to traditional interpretations of the story dating back to Antiquity, and to versions by many of the masters (Titian, Veronese, Vasari, and the Carracci, for example), making it pointless to venture to identify any precise influence.[1] Previous depictions of the theme, whether as a battle between Perseus and the monster or as the deliverance of Andromeda, underscored both the liberator's virility and the torment of the daughter of King Cepheus. Ovid recounted the misfortunes of the princess, a virgin condemned to die because her mother had declared that her beauty surpassed that of all the Nereids combined. It was the revenge of the Nereids that interested Chassériau, rather than the liberation of their beautiful victim. Even the grotesque monster was an accessory.

As was his wont, Chassériau preferred the concise dramatic moment to epic heroic action. The episode from the *Metamorphoses* illustrated the gods' harshness toward humanity, and Chassériau extracted from it the theme of female jealousy and cruelty, exploiting, "with a strange sensual pleasure" (S. Laveissière), Andromeda being put in chains. The image of women among themselves seems to stem from a systematic inversion of the iconography of Saint Sebastian, whom it was rather common to depict before his torture, as his tormenters were securing him to a tree, which is more or less evocative of the Cross.[2] The undeniable (homo)sexual intensity with which such images are charged is very subtly expressed in the 1841 painting. The two Nereids, seen standing on the right, scarcely turn their eyes toward Andromeda, although their faces reveal looks of pity combined with melancholy. More troubling is the impassivity of their dark-haired sister, as she acquits herself of her task. Although her face is inspired by that of Adèle Chassériau, it mirrors that of Andromeda, whose troubled expression and contracted mouth register the horror of her fate. That mirror effect, combined with the latent reference to the painter's sister, leads us to wonder to what extent such a painting lent itself to the enactment of a private drama. Also apparent is the frequency of works by Chassériau that, from *Diana* (cat. 22)—rejected by the Salon of 1840—to the *Tepidarium* of 1853, evoke, with obvious perversity, the theme of *donna con donna,* to cite Brantôme. As for the rock overhanging the sea, it is evocative of the drama of Sappho (see cat. 170).

Chassériau's new manner, as unique as his iconographical treatment of the subject, baffled the critics, the majority of whom were already polarized between Ingres and Delacroix. In the young painter's innovations with regard to line and color, he was rejecting the purity of Ingres's style without renouncing the arabesque effects or jarring juxtapositions of color. How can he be forgiven, and on what basis, for the anatomical mistakes, the distended backs or the poorly attached breasts, the abruptness of the outlines, the almost unfinished rendering of the feet and hands? More than the depiction of Andromeda's desperate fury, which is one of the greatest successes of French Romanticism, it was the willful deter-

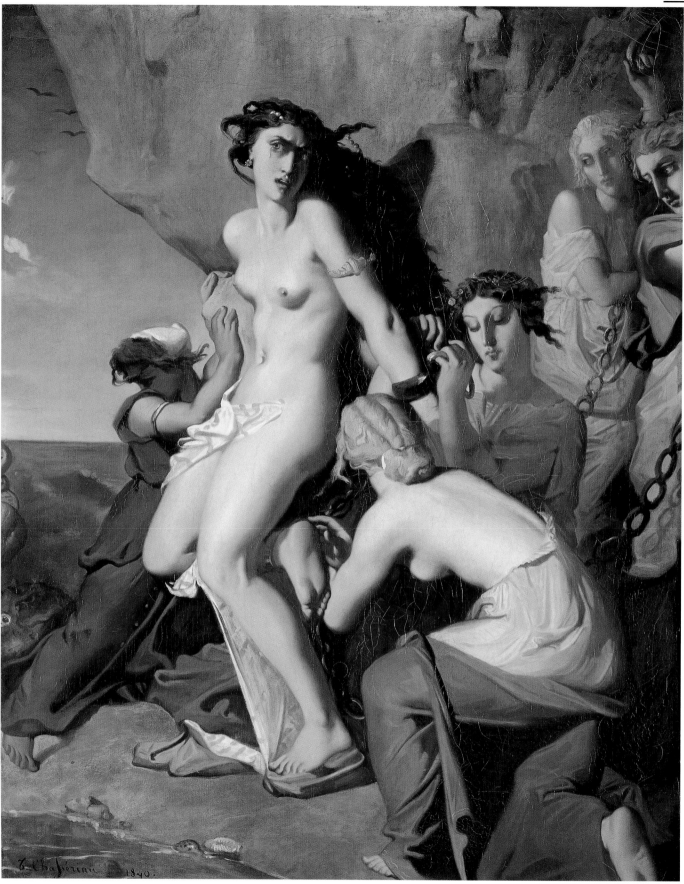

mination to scramble the norms of the time that perplexed his contemporaries.[3]

It is regrettable that Gautier, in Spain at the time with Eugène Piot (who would later own the *Andromeda*), left it to the less-inspired Eugène Pelletan to discuss the picture, albeit favorably, in *La Presse*. Furthermore, Pelletan was not content to quibble, and concluded by commenting on the distinguished position already in store for the young man:

> Frankness does not exact a high cost where M. Chassériau is concerned because he has talent, because his errors themselves entail a powerful originality. . . . He is barely twenty years old. The *Andromeda* . . . displays flaws no doubt: its manner is reminiscent of Bronzino: the fanciful treatment of the hair exceeds all limits, however much they have been relaxed by Raphael. Andromeda's bent leg, which reveals the sole of her foot, is impossible. I will spare no criticism, and yet this painting indicates a rare distinction, a nobility, a fine aristocracy of talent. The figure of the kneeling Nereid is modeled with a rare felicity and a particular feeling for form. In addition, M. Chassériau's model, despite the harshness of certain shadows, has something light and seductive about her, like his *Susanna,* that charms us as much as beautiful color. M. Chassériau has a future, he has the true mark of genius, let him go on, let him take his time to reflect, and he will succeed.[4]

For all the other critics, Chassériau was on the wrong road,[5] and had lost his way. Haussard spoke of "an error of talent,"[6] and Delécluze of a tendency to "give his works a sadness, a despair, which is not what one generally looks for in works of art."[7] According to the old guard, the young man was, perhaps, not lost: "Although belonging to the so-called new school, M. Chassériau has demonstrated in his *Andromeda* . . . a good feeling for color. If that painter would nurture his drawing skills, if he would devote himself to the study of anatomy, if he would open his eyes to impartial criticism and close his

ears to the extravagant praise that foolhardy friends lavish on him, M. Chassériau would become a very skillful artist; as a colorist, a distinguished place is already assigned him at the Salon."[8] Deaf to the faultfinders of another generation and borne aloft by the new wave of critics, [9] although with a few reservations, he would persist in his errors. That energy, which the *Venus* of 1838 and the *Susanna* of 1839 did not possess to the same degree, that imaginative composition, which is so striking in the *Andromeda,* as odd as it seemed to an artist like Delacroix, perfectly exemplify what Pelletan called Chassériau's "powerful originality" and "fine aristocracy of talent." Freedom and nobility: that sums up Chassériau. s. g.

1. It is not immaterial in this respect that the painting was conceived in Italy.
2. The kneeling figure on the right, an implicit representation of Mary Magdalene, accentuates the blending of the sacred and the profane.
3. Thus Cantagrel wrote ("Salon de 1841," in *La Phalange* [May 30, 1841]): "The Andromeda . . . is composed and executed according to a system that will have few supporters; one cannot deny, however, a fairly high talent in the artist."
4. E. Pelletan, "Salon de 1841," in *La Presse,* Paris, April 4, 1841.
5. G. D., "Salon de 1841," in *L'Univers* (June 5, 1841): "As for M. Chassériau, a young man whose talent has been appreciated, I believe he is on the wrong path. His Andromeda looks like a Fury, whose body is already worn out, her eyes wild, her hair coiled almost like snakes. . . . One must not, however, limit oneself to the first impression, which is very unfavorable for M. Chassériau: an attentive examination leads us to recognize qualities of drawing and conscientious study that keep us from despairing about M. Chassériau's future."
6. P. Haussard, "Salon de 1841," in *Le Temps* (May 21, 1841).
7. É. J. Delécluze, "Salon de 1841," *Journal des débats* (May 29, 1841).
8. Unsigned, "Salon de 1841," in *Le Journal des artistes* (May 16, 1841): "The color scheme of that artist is nevertheless not as false, as chocolate, as violet, as most of the paintings of that school. On the whole, his are yellowish, uniform, colorless: the same simplicity, the same monotony are found again in the modeling, which is too devoid of details, too empty of forms. . . . Everything is the same color; the same intensity of light illuminates the bottoms and tops of the figures. In the forms of the Andromeda, there is little choice, little taste, but there is talent in the drawing and modeling."
9. The unidentified critic in *L'Artiste* (vol. 8 [1841], p. 264), a staunch supporter of the new painting, wrote: "M. Chassériau's paintbrush is more vigorous and firmer. . . . If there is exaggeration in the hair, if the Nereid with green drapery, seen from the back, does not have an adequately developed torso in terms of depth, if the shadow is too strong on the face of one of her sisters, there are freely rendered parts, good color, a great deal of firmness in the modeling and a richness in the details of the execution."

Esther Preparing to Be Presented to King Ahasuerus, or The Toilette of Esther

1841
Oil on canvas
18 x 14 in. (45.5 x 35.5 cm)
Signed and dated, bottom right: *Th. Chassériau / 1841*
Paris, Musée du Louvre (RF 3900)

PROVENANCE:
Louis Marcotte de Quivières (1815–1898), before 1843 (indicated as already belonging to Marcotte de Quivières in the handbook for the Salon of 1842) and still in 1893 (according to Chevillard 1893, no. 62); yet in the Louis Marcotte de Quivières sale, Paris, Hôtel Drouot, April 24, 1875, lot 6; bought by Ducasse, a student of Chassériau (for Fr 700); Baron Arthur Chassériau, Paris, undoubtedly after 1898; bequeathed by the latter to the Musée du Louvre, 1934.

BIBLIOGRAPHY:
Gautier 1842, p. 126; Peisse 1842; Ténint 1842, p. 40; Gautier 1857; Bouvenne 1884, ill. p. 6; Bouvenne 1887, p. 172; Chevillard 1893, no. 62; Marx 1898, pp. 274–76; Tschudi 1900, p. 9, ill. p. 17; Bénédite 1909, p. 88, ill. p. 86; Marcel and Laran 1911, pp. 35–36, pl. 10; L. Vaillat, *Les Arts* (August 1913), p. 12, ill. p. 25; Bouyer 1920, p. 530; Jamot 1920, p. 69; Jamot, March 1920, p. 72, ill. p. 77; Escholier 1921, p. 96; Meier-Graefe 1927; Focillon 1928, pp. 166, 167, 180, 181, ill. p. 177; Goodrich 1928, p. 68; Alazard 1930, pp. 98–100, ill. p. 97; Bénédite 1931, vol. 1, pp. 168–70, pl. 10; Grappe 1932, p. 47, ill. p. 49; Alazard 1933, p. 54; Benoist 1933, pp. 82–84, cover ill.; S.A.I., 295, ill.; Sandoz 1956, p. 5; Sandoz 1970, p. 52; C.P., p. 76; Sandoz 1974, no. 89, p. 188, pl. 72, p. 189; Cat. Somm. Ill., 1986, vol. 3, p. 134, ill.; Prat 1988-1, vol. 1, p. 93, ill.; Loire, Sahut et al. 1993, pp. 142–43, ill.; Peltre 2001, pp. 90–92, 119, 204, ill. 105.

EXHIBITIONS:
Salon of 1842, no. 346; Paris, 1897, no. 23; Paris, 1900, no. 96; Paris, Orangerie, 1933, p. 11, no. 20, ill. at the back of the catalogue; Montauban, 1980; Paris, Gautier, no. 99, ill.

When Théodore Chassériau returned from Italy, he wanted to pursue his aesthetic and iconographical research on the representation of heroines in historical, classical, and religious narratives. Hence, after depicting the Birth of Venus, a mythological subject, and Susanna and the Elders, a biblical theme, his choice for the work he would submit to the Salon of 1842 was even more unusual, and rarely found in painting; he would represent the Toilette of Queen Esther, like the story of Susanna, also from the Old Testament.

In the handbook for the Salon, Chassériau had transcribed precisely the passage that inspired his canvas, an excerpt from the Book of Esther (2: 8–9, 15): "Esther was brought also . . . to the custody of Hegai, keeper of the women. And the maiden pleased him, and she obtained kindness of him; and he speedily gave her things. . . . And Esther obtained favour in the sight of all them that looked upon her." In his painting, Chassériau chose to record the preparations for the meeting between King Ahasuerus, ruler of Persia (Susa)—who had just repudiated his first wife, Vashti, and who was seeking a future queen—and Esther, the ward of a Jew deported to Mesopotamia. Because of her exceptional beauty, Esther pleased Hegai, the eunuch responsible for preparing the young women selected to be presented to the king, and she was led before Ahasuerus, who decided to take her as his wife. The painter had been inspired by other passages in the Bible, such as a second excerpt from the Book of Esther, which comes just before the famous fainting spell of the young queen, and which suggests a second toilette: "Now it came to pass on the third day, that Esther put on her royal apparel."[1]

No doubt the painter also had in mind the famous play *Esther* by Racine, produced in Saint-Cyr in 1689, an edifying drama whose action begins, in fact, after Esther's seduction of Ahasuerus. In the first scene, Esther recounts to her confidante, Élise, how she had grown up "alone and secluded" with her guardian, Mordecai, before being chosen by the king, who was struck by her "faint charms." Racine, anxious to please Mme de Maintenon, who had commissioned the play, and to remain faithful to his Jansenist convictions, had eliminated the scene of Esther's toilette, even though it is described in the Old Testament. By contrast, Racine presents the other contenders for the throne as seeking to "adorn themselves in magnificent finery," whereas Esther, despite "all the intrigue and all the artifice," offers her tears to heaven "as a sacrifice." Rather than refer to Racine's altered text, Chassériau preferred to depict Esther as a woman who accepts her beauty and uses it to save her people.

Once again, it was contemporary literature, above all, that would enrich the concept of Chassériau's painting, as Marc Sandoz has noted.[2] Although unconvincing when he suggests a connection to a poem by Lamartine from the *Nouvelles Méditations*,[3] which appears decidedly rather remote from *The Toilette of Esther*, Sandoz's allusion to "Le Bain d'une dame romaine," a poem composed by Alfred de Vigny on May 20, 1817, is of more interest, as the sensuality it evokes is closer in spirit to Chassériau:

> *Une esclave d'Égypte, au teint luisant et noir,*
> *Lui présente, à genoux, l'acier pur du miroir;*
> *Pour nouer ses cheveux, une vierge de Grèce*
> *Dans le compas d'Isis unit leur double tresse;*
> *. . . puis les filles latines,*
> *Sur ses bras indolents versant de doux parfums. . . .*

> A slave from Egypt, her skin glistening and black,
> Presents her, kneeling, with the pure steel of the mirror;
> To tie up her hair, a virgin from Greece
> In Isis's compass joins her two braids;
> . . . then the Latin girls
> On her indolent arms pouring sweet perfumes. . . .

The remote and sensual figure of Esther also contains a bit of the exotic languor of "La Sultane favorite" from Victor Hugo's *Les Orientales*:

> *N'ai-je pas pour toi, belle juive,*
> *Assez dépeuplé mon sérail?*
> *. . . Tu n'es point blanche ni cuivrée,*
> *Mais il semble qu'on t'a dorée*
> *Avec un rayon de soleil.*

> Have I not for you, lovely Jewess,
> Sufficiently emptied my seraglio?
> . . . You are not white or copper,
> But it seems you've been gilded
> By a ray of the sun.

The reference to Hugo's *Les Orientales* is not immaterial, since it seems quite obvious that Chassériau was carried away by his powerful desire for the East. The very subject of this Old Testament text—which tells of the confinement of a young woman in a harem—allows for a Romantic and Orientalist pictorial treatment. It is, of

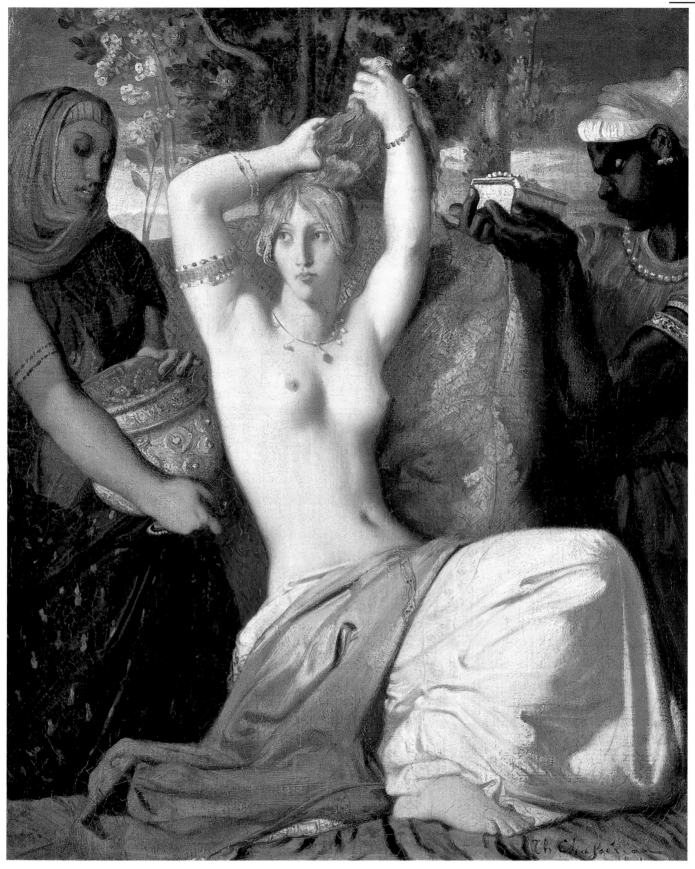

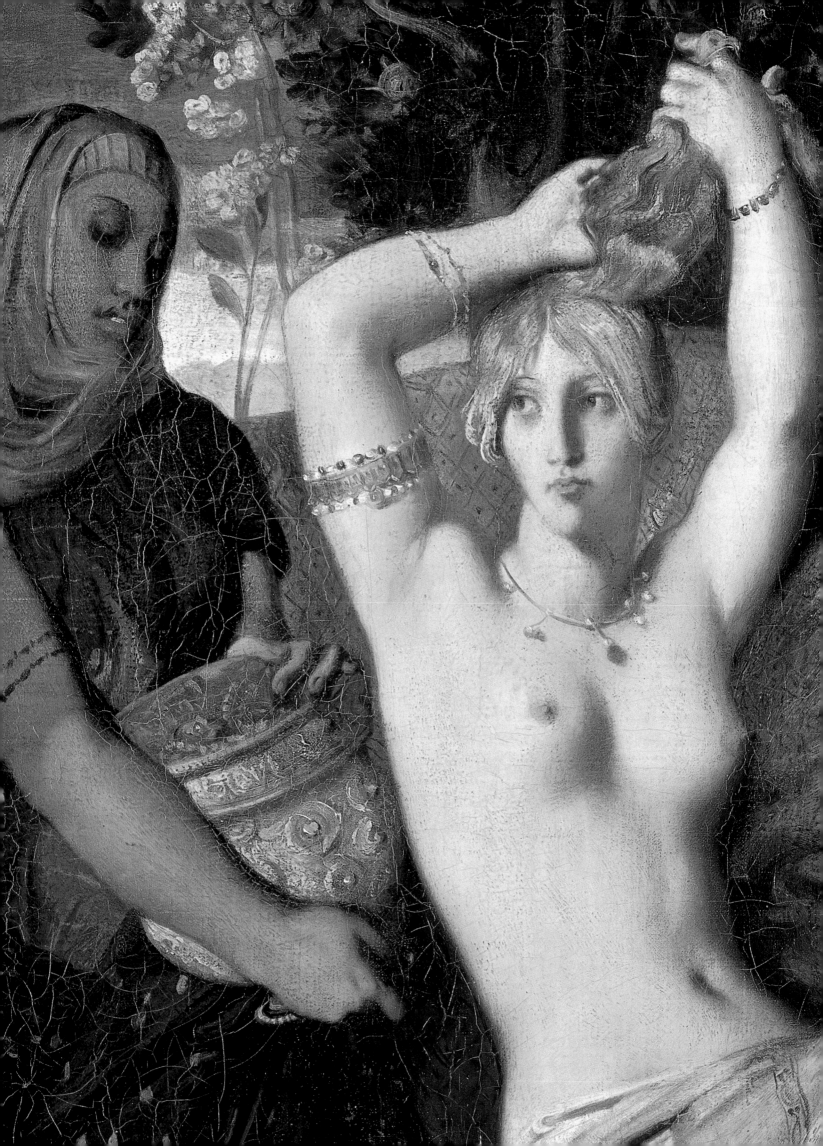

course, a biblical episode, but the fact that it was rarely the subject of a painting freed the artist to rely on his innovation in rendering the latent sensuality of the theme. Thus, Chassériau did not hesitate to evoke the East through the two figures who surround Esther—a servant woman and the eunuch Hegai—as well as through the jewels and accessories that enliven the scene. These exotic references obviously accentuate the eroticism inherent in the theme of a nude young woman preparing to offer herself to a man.

As noted, the rarity in art of representations of this episode from the Book of Esther afforded the painter few sources of inspiration. Louis Réau[4] cites only two previous examples: one, a seventeenth-century work by Aert de Gelder (Munich, Alte Pinakothek), and the other, an eighteenth-century work by Jean-François de Troy (Paris, Musée du Louvre). Other scenes from the life of Esther, such as her fainting spell, her prayer, or the banquet she hosts following her wedding occur more frequently in art.

Hence, Chassériau had to resort to the many paintings of a "woman at her toilette," a popular genre since the Renaissance, for precedents. Marc Sandoz's attempt to establish analogies with Rubens's *Toilette of Venus* (Lichtenstein, private collection) and *The Toilette of Pandora* by the Englishman John Flaxman (an engraving in his series of illustrations of Hesiod's *Theogony*) is apt. *The Toilette of Esther* has strong affinities with these allegories of vanity and of the perishable nature of the flesh, however beautiful it might appear. At the same time, the theme allowed an artist to erotically depict a beautiful female body, captured at an intimate moment. Where does religious proselytizing end and sexual excitation begin? Chassériau poses this question in his painting, which is biblical in its subject matter, Orientalist in its visual references, and profoundly erotic in its pictorial treatment.

No doubt the desire to be original explains Chassériau's initial concept of the painting as a tondo—like the final version of Ingres's *The Turkish Bath*—although an oval composition would, in fact, have allowed for a more Mannerist portrayal of the subject. Two preparatory drawings in the Louvre attest to the painter's efforts to adopt a circular format: A figure of the young woman alone[5] and a sketch of the entire scene,[6] without the background landscape, reveal his initial intentions, conceived in an altogether Ingresque spirit. Another graphite study reveals that Chassériau had also entertained the possibility of representing Esther in a different pose.[7] According to Louis-Antoine Prat, a drawing executed in Italy, showing the young woman flanked by the two servants, equally may have served as a study for the composition.[8] Finally, an annotation on a drawing apparently unrelated to the eventual composition of *The Toilette of Esther* seems to indicate a gradual maturation of the subject matter: "In a large room where there were a few allegorical figures Put . . . the history . . . of the world in a new way . . . allowing one to see these beautiful things once again by presenting them in a fresh manner. May 1841. For my painting Esther preparing her toilette."[9]

When the work was exhibited at the Salon of 1842, next to a dramatic *Descent from the Cross* (cat. 68) and the elegiac *Trojan Women Grieving Over the Loss of Anchises* (now lost), this "Greco-Asian" composition, as Théophile Gautier described it,[10] was misunderstood by the critics. The journalist Ténint seemed to sum up the general opinion: "M. Chassériau . . . has made gains, and great gains, especially on the side of color, and in this respect, his *Esther Preparing to Be Presented to Ahasuerus* is particularly remarkable. . . . But why that elongated figure, those wild eyes, that savage look? There is no soul under that face, and there is not on this face the grace, the delicacy, the beautiful smile that takes the place of a soul in so many women."[11]

Thus, this picture, which has all "the grace of a painting by a master, with its soft and misty golden tones, in which the figure of Esther has such exquisite feeling that it is as if one were seeing a figure from Pompeii,"[12] and which would subsequently inspire Benouville and Gustave Moreau before becoming one of the most famous in the Louvre, at first met with incomprehension—although without aggressiveness—by Chassériau's contemporaries, as if his proposal for the recasting of a biblical subject in an Orientalist and sensual context seemed at that precise moment altogether too strange and too modern. V. P.

1. Esther 5:1.
2. Sandoz 1974, no. 89, pp. 188–90.
3. "Chant d'amour," poem 24.
4. L. Réau, *Iconographie de l'art chrétien* (Paris), vol. 2, p. 339.
5. This drawing is in graphite (Paris, Musée du Louvre, Département des Arts Graphiques [RF 25938]; ill. in Prat 1988-1, vol. 1, no. 95, pp. 92–93).
6. See catalogue 67.
7. Another drawing in graphite (Paris, Musée du Louvre, Département des Arts Graphiques [RF 25935]; ill. in Prat 1988-1, vol. 1, no. 96, pp. 92–93).
8. This drawing is in black pencil and graphite, heightened with white (Paris, Musée du Louvre, Département des Arts Graphiques [RF 25739]; ill. in Prat 1988-1, vol. 1, no. 1385, p. 518).
9. Paris, Musée du Louvre, Département des Arts Graphiques [RF 25937]; ill. in Prat 1988-1, vol. 1, no. 961).
10. The comments by T. Gautier were made regarding the *Susanna and the Elders* (in *La Presse*, Paris [May 25, 1852], p. 1).
11. W. Ténint, in *Album du Salon de 1842* (Paris, 1842), p. 40.
12. A. Bouvenne, "Théodore Chassériau," in *L'Artiste*, vol. 2 (September 1887), p. 172.

67

The Toilette of Esther

1841
Graphite
8 x 7 ⅞ in. (20.3 x 19.8 cm)
Inscribed in graphite, upper left: *Bleu et . . .* [Blue and . . .],
the subject enclosed in a circle
Paris, Musée du Louvre (RF 25936)

PROVENANCE:
See cat. 20.

BIBLIOGRAPHY:
Chevillard 1893, part of no. 420; Sandoz 1974, under no. 89;
Prat 1988-1, vol. 1, no. 94, ill.; Peltre 2001, pp. 90, 92, fig. 106.

EXHIBITIONS:
Paris, Louvre, 1957, no. 23, pl. 6; Paris, Louvre, 1980–81, no. 16.

Exhibited in Paris only

This first study for the painting of 1841 shows that the artist initially had thought of inscribing his composition in a circle. The schema for this tondo further accentuates the Ingrist character of the drawing, which displays extraordinary authority in the positioning of the figures. The intention to use a tondo format for this composition is seen again in the Louvre drawing RF 25938 (Prat 1988-1, vol. 1, no. 95, ill.). **L.-A. P.**

The Romantic Christ

68

The Descent from the Cross

1842
Oil on canvas
118 ⅛ x 86 ⅛ in. (300 x 220 cm)
Signed and dated, bottom right: *Chassériau, 1842*
Saint-Étienne, Church of Notre-Dame

PROVENANCE:
Ministry of the Interior, 1841 (series F²¹ in the Archives
Nationales contains no record of the commission); sent to the
Church of Notre-Dame, Saint-Étienne.

BIBLIOGRAPHY:
Delécluze, *Journal des débats,* March 18, 1842; Stern [Marie
d'Agoult], *La Presse,* March 20, 1842; Des Essarts, *L'Écho français,*
March 23, 1842; Pillet, *Le Moniteur universel,* March 30, 1842;
Peisse, *La Revue des deux mondes,* April 1, 1842, pp. 11–114; Robert,
Le National, April 8, 1842; Unsigned, *Le Journal des artistes,* April
10, 1842; Unsigned, *Le Charivari,* April 13, 1842; Unsigned, *Le
Journal des beaux-arts et de la littérature,* April 16, 1842; Unsigned,
Le Siècle, April 18, 1842; Laverdant, *La Phalange,* May 3, 1842;
Chevillard 1893, no. 61; Bénédite 1931, pp. 170–72; Sandoz 1974,
no. 92; Foucart 1987, pp. 250–51; Prat 1988-1, vol. 1, no. 1358;
Lacambre 1995–96, p. 346; Peltre 2001, pp. 92–93, 97.

EXHIBITIONS:
Salon of 1842, no. 345; Nantes, Paris, and Piacenza, 1995–96, no. 28.

Exhibited in New York only

69

Study for the Figure of Saint John

about 1842
Oil on canvas
14 ¼ x 12 ⅝ in. (36 x 32 cm)
Avignon, Musée Calvet

PROVENANCE:
Baron Arthur Chassériau, Paris; bequest of the latter to the
Musée du Louvre, 1934; deposited by the Louvre at the Musée
Calvet, Avignon, 1937.

BIBLIOGRAPHY:
Bénédite 1931, vol. 1, p. 166 (mistakenly identified as *Study for the
Magdalene*).

EXHIBITION:
Paris, Orangerie, 1933, no. 22.

Another religious commission from the Directeur des
Beaux-Arts in the Ministry of the Interior, the *Descent
from the Cross* in Saint-Étienne is one of the most unusual
works by the young Chassériau. Jesus has just died and
heaven is still in mourning for him. As the inscription
on a Louvre drawing (RF 24612) indicates, the painter
did not want to represent Christ "on the ground, but as
he is being taken down"—more precisely, after he has
been removed from the Cross and his loved ones weep
over him, kiss or clean his wounds, and display him the
way one lifts up the Host. As the journalist from *Le
National* wrote, it is less a Descent from the Cross than
"a scene taking place at the foot of the cross. . . . This sub-
ject was beautiful, it had the particular merit of invig-
orating somewhat a situation already rendered many
thousands of times."[1] The goal was, indeed, to give new
life to the iconography of the Deposition and its "great
sadness." Notations in the margins of the preliminary
drawings attest to this with a fervor that the painting
itself would not completely express: "Crist [*sic*] suspended

in a sad and somber sky the holy women . . . sobbing.
Below, Saint John kisses the bleeding feet. . . . Crist
in bright light or the group in the foreground. . . .
Something . . . in the sorrow of that scene."[2] In fact,
Chassériau articulates two layers of religious pathos: the
inert but powerful body of Jesus as a Eucharistic symbol,
and the exaggerated expression of feelings provoked by
the sight of, and the contact with, his martyred body. He
would forget the bleeding feet.

At the same time as James Pradier, Chassériau reached
back, beyond Michelangelo and his successors (did he see
Georges Lallemant's *Pietà* in the Church of Saint-Nicolas-
des-Champs in Paris?), to the medieval iconography of
the Virgin presenting the body of her son, in her lap, as
an offering.[3] In reality, although Mary stands well behind
Christ and tenderly detaches the crown of thorns[4]—a
derisory attribute that has been transfigured by death—
it is John who supports his master's powerful body. The
disciple is no less robust, despite the slightly feminine del-
icacy of his features, than he appears in the famous pre-
liminary drawing (cat. 70) and in the equally beautiful
oil study in Avignon. His head, represented in profile—
the position of sorrow, par excellence, in Chassériau's
oeuvre—rests on his left hand in a sign of profound
affliction. Nicodemus, based on portraits of an old Italian
man,[5] is kneeling on the left, and also supports Christ.
Behind him, a Roman soldier, whom Marie d'Agoult
(under her *nom de plume,* Daniel Stern) confuses with
Joseph of Arimathaea, lies prostrate in sorrow and in his
consciousness of sin. Twelve years later, Chassériau would
develop the theme of deicide and the empty heavens in
the *Deposition* now in the Church of Saint-Philippe-du-
Roule in Paris. To the left of the Virgin, for whom Heaven
serves as a witness to her suffering, a young woman lifts
her arms in despair, with an exaggeration that may owe
more to medieval art than to Ingres's *Martyrdom of Saint
Symphorian.* Many preliminary drawings relate to this
figure, confirming its dramatic importance.

The sheet in the Louvre, mentioned above, indicates
a few of the artist's first explorations of the subject.
Chassériau initially imagined Christ in a more tradi-
tional, broken pose, which would have avoided all ambi-
guity. Alfred des Essarts judged inconsistent "the abandon
of the limbs, which ought to be collapsing on them-
selves, and which seem to belong less to a corpse than to
a wounded man."[6] In the drawing, Mary Magdalene—
who appears on the right in the painting—turns toward
the spectator, her beautiful, sorrowful face summoning
our participation with the force of an injunction. In
modifying that figure and its mediating function,
Chassériau increased the distance and even the pathetic
isolation of the event in the painting.

The historical references would seem to be vast,
although difficult to identify specifically. Sandoz invokes
Florentine Mannerism, but I would cite instead Botticelli's
late, most intense style, Dürer's *Small Passion* of 1511,
certain Venetian works, and perhaps Caravaggio's
Entombment (Vatican). In this severe, jarring painting,
in which, as in certain works by Poussin, an atmosphere
of Greek tragedy reigns, the action nevertheless develops

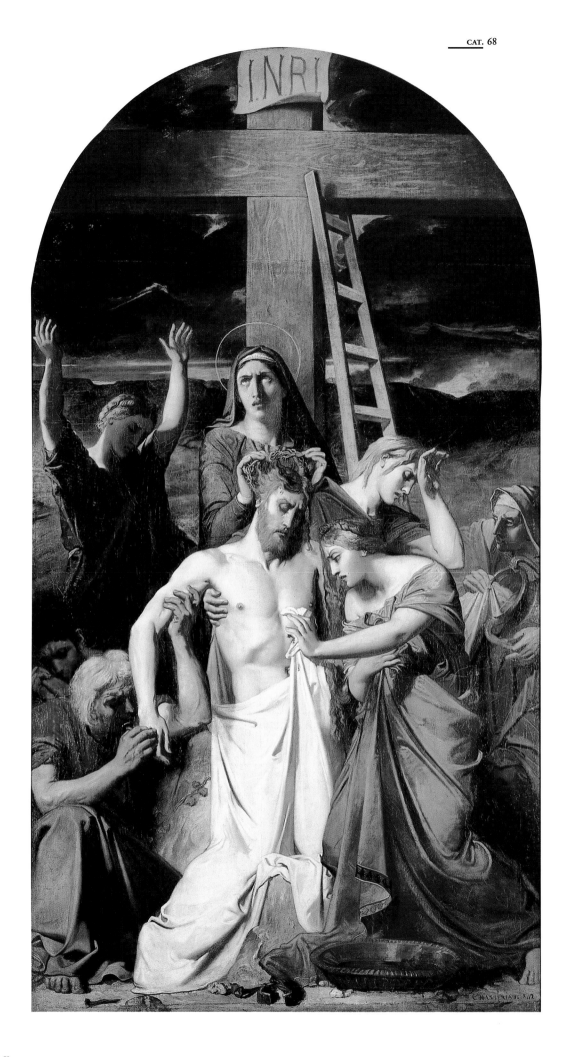

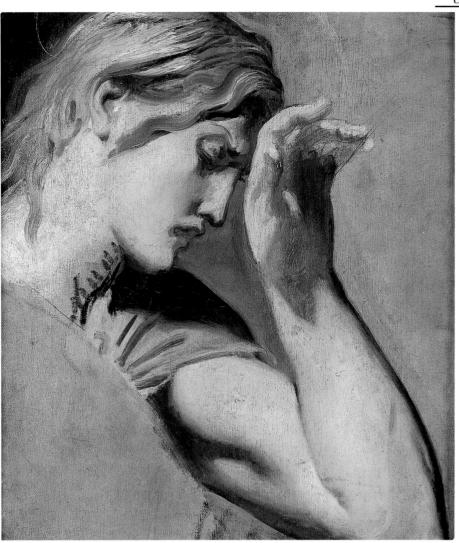

around Christ, dressed in white and surrounded by a halo of light, set against a rich palette of vibrant tones and distinct color harmonies, devoid of demitints. In short, Chassériau introduced the liberties he took with the *Andromeda* into the sacred realm; that audacity, wherein the appeal of this uncompleted painting lies, could not go unnoticed.

Many critics took an interest in it, contrary to Jean Lacambre's claim, but many also rejected it. A journalist in *Le Charivari,* which had been satirizing Ingrism since the late 1830s, wrote, ironically: "Have you seen the impossible, stiff, and pretentious Christ by M. Chassériau?"[7] Whereas an equally conservative critic in *Le Journal des artistes* noted the "strangeness,"[8] and the Fourierist Laverdant, hardly more liberal, referred to the "disturbing painting,"[9] their fellow journalists wavered between astonishment and enthusiasm. For *Le Journal des beaux-arts et de la littérature,* the anatomy of the holy figures and the pictorial space ought to have been better treated: "How does Christ hold himself up? Where is his left arm? What has become of the lower body of the Virgin, of whom one perceives only the head? Why, in removing Christ's crown of thorns, does she also take off his hair?

etc. etc. These are some of the riddles for which one could seek answers. Nevertheless, there is a broadness of execution in this painting that alone merits praise."[10]

Delécluze, like the journalist in *Le Siècle,*[11] was sensitive to the vigor of the young artist, in whom he had been interested since 1837, but he continued to criticize him for his propensity for the sad, the dreadful, the repellent: "Why depict Christ's lifeless body as if it were the cadaver of an ordinary mortal? In abandoning himself to the thread of the argument, in following the one who guided the Early Christians and supported the great masters of art who adopted their tradition, one quite naturally comes to the point of wishing to give the dead Christ all the calm, all the serenity that his human form had during his lifetime. M. Chassériau wanted to make, and did make, a terrible scene of the descent from the cross; and, in my view, he has misrepresented the subject."[12] Another older critic, Pillet, was no less astonished at the contempt that this young, promising painter professed "for the delicacy of the paintbrush, the freshness of the flesh tones, tasteful arrangements. . . . More capable than anyone else of combining grace and beauty, he [Chassériau] wants to turn his back on these seductive

qualities, and makes it a kind of affectation to repudiate them. I applaud wholeheartedly, with all the artists of the new school, what is solid, expressive, and melancholic in the usual manner of this thinking painter's art I can only congratulate him on the somber and religious character of his *Descent from the Cross,* whose style is not lacking in power."[13]

Difficulty in understanding the painting was not the monopoly of the older generation, still shaped by neo-Davidian responses. Marie d'Agoult, for example, seems to have preferred Lehmann's sickly sweet manner to the audacity of her friend Chassériau:

> The Virgin's head is noble in character and its style is good. The figure of Mary Magdalene is beautiful; the movements of her body and arms are very felicitous, her drapery rich, with a brilliance of color worthy of the masters. The figure of the old woman is a fairly well-disguised borrowing from the Venetian school. The accessories, particularly the gold vessel, which contains a sponge saturated with blood, are remarkably well done; but these outstanding qualities cannot rescue the painting's numerous flaws. The head and torso of Christ are not only devoid of beauty, they are a grievous sin against the truth. It is impossible to explain by what artifice that lifeless head is supported perpendicularly on the neck, and how that inanimate body stands erect. There is no depth to the torso and arms; the modeling is nonexistent. One can sense the haste even in the lights and shadows, which seem to be cast as if randomly. The landscape and the sky in the background, far too tormented, are suffocating and weigh heavily on the figures. . . . Even in the flaws indicated, I recognize the signs of a very gifted nature, which will need only will and patience to achieve everything.[14]

We are indebted to Louis Peisse for the lengthiest and most puzzling commentary on this canvas, which he nevertheless singles out as one of the very few compositions with religious subjects worthy of being cited. Echoing the common view, he notes the composition full "of improbabilities and impossibilities," and the

> head of Christ [which] is not well done; it does not belong to the beautiful family of Italian Christs; it seems rather to be borrowed, as a form of expression, from those shabby and bizarre German Gothic types [is he thinking of Dürer?]. The head of the Virgin is in a more elevated style, and the expression of sorrow is rendered with a fair amount of grandeur and energy; but significant inaccuracies in the drawing spoil its beauty. The action of the Virgin, who is removing the crown of thorns from Jesus' forehead, is, if I am not mistaken, a new and felicitous motif. All the same, a different and better use . . . might have been made of it. Christ's hair, caught in the crown, is being lifted up in a clump and pulled perpendicularly upward, and seems to be standing on end, which gives the face a strange grimacing expression that the artist may not have sought, but which he had the misfortune to find. The figure of Mary Magdalene, who,

disheveled and weeping, approaches Christ to wash the wound from the spear, is flung down with a boldness that is not displeasing. She has no style, strictly speaking, but she has a certain look. Her movements express strength and pathos. It is nevertheless regrettable that this effect was obtained only through inaccuracies that are all the more troubling in that we are led to wonder whether all that apparent originality might not, by chance, lie in the disparities and disproportions themselves.[15]

More serious, in terms of convention, was the eclecticism, the collage effect: "Above all, the composition commits sins of omission, in its lack of unity in thought, style, and manner. One seeks in vain to discern with what school, what master, what tradition this painting is associated; there are Florentine, Bolognese, German tendencies, combined with the most flagrant inspiration from the studio routine. . . . One sees only clashes. What is true of the style is no less true of the execution and the color." We must admit, in part, that Peisse and all those who were shocked by the eclecticism of the image were right, but we must also concur with his conclusion: "Despite its more-or-less glaring flaws, there is something, in my view, on this bizarre canvas that resists the debilitating analysis of criticism, and which one would seek in vain in all the other canvases of this kind. That is a major, very major, concession." The Saint-Étienne picture—the evolution of whose subject may be seen in Chassériau's notebooks from 1839–40—was contemporary with the paintings in the Church of Saint-Merri with which it shares certain primitive aspects. However, in an intentionally more jarring fashion, it mixes elements from the art of Byzantium and the Early Renaissance to create this modern drama. S. G.

1. M. Robert, "Salon de 1842," *Le National* (April 8, 1842).
2. See Alb. 26090, 5 v., Paris, Musée du Louvre, Département des Arts Graphiques.
3. See Jacques de Caso's comments on the *Pietà* at the Salon of 1847 and on the *Fragment of a Descent from the Cross,* a painting submitted to the Salon of 1838, in the catalogue *Statues de chair. Sculptures de James Pradier (1790–1852)* (Geneva and Paris, 1985–86), pp. 215–18. The painting of 1838 is illustrated in James Pradier, *Correspondance,* ed. Douglas Siler, vol. 2, *(1834–1842)* (Geneva: Droz, 1984), fig. 8.
4. On a page from a notebook (Louvre, RF 2245, fol. 5 v.) is an annotation concerning the Virgin: "Have her remove the crown of thorns as if she were worried that he would tolerate the other women removing the thorns."
5. Two portraits of this old man survive: a painting in the Louvre (RF 3865) and a drawing; see Prat 1988-1, vol. 1, no. 1358.
6. A. des Essarts, "Salon de 1842," in *L'Écho français* (March 23, 1842).
7. Unsigned, "Salon de 1842. Légende dorée," in *Le Charivari* (April 13, 1842).
8. Unsigned, "Salon de 1842," *Le Journal des artistes* (April 10, 1842).
9. D. Laverdant, "Salon de 1842 (6ᵉ article). Sujets d'amitié et d'amour," in *La Phalange* (May 3, 1842).
10. Unsigned "Salon de 1842," in *Le Journal des beaux-arts et de la littérature* (April 16, 1842).
11. "Un bourgeois," "Salon de 1842," in *Le Siècle* (April 18, 1842): "The *Descent from the Cross* by M. Chassériau seems designed, first, to be seen from a distance; it is striking for the grandiosity the painter sought. The young artist has imagination and talent, but it is as if he disdains to please. Attempt the sublime, granted, but don't have contempt for grace. M. Chassériau has too much intelligence and taste not to ally grandeur and simplicity."
12. É.-J. Delécluze, "Salon de 1842," in *Journal des débats* (March 18, 1842).
13. F. Pillet, "Salon de 1842," in *Le Moniteur universel* (March 30, 1842).
14. D. Stern, "Salon de 1842," in *La Presse,* Paris, March 20, 1842.
15. L. Peisse, "Salon de 1842," in *La Revue des deux mondes* (April 1, 1842), pp. 111–14.

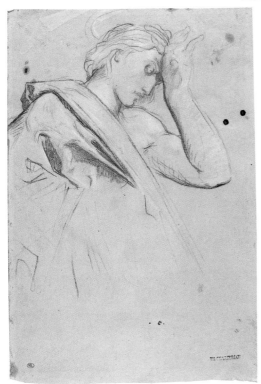

70

Bust-Length Study of a Young Man in Right Profile, His Left Hand Against His Forehead

1842
Red chalk, heightened with white, on greenish paper
11 ½ x 7 ⅞ in. (29.2 x 19.9 cm)
On the reverse is a graphite study of two women and a child in a landscape
Paris, Musée du Louvre (RF 24611)

PROVENANCE:
See cat. 20.

BIBLIOGRAPHY:
Chevillard 1893, part of no. 420; Sandoz 1974, under no. 92 (medium given as black chalk); Prat 1988-1, vol. 1, no. 132, ill., and colorpl. p. 6.

EXHIBITION:
Paris, Galerie Dru, 1927, no. 55 (identified as *Head of the Magdalene*).

Exhibited in Paris only

This is a study for the figure of Saint John in the middle ground of the *Descent from the Cross*. The same figure was studied separately in an oil sketch now in the Musée Calvet, Avignon (Sandoz 1974, no. 93), erroneously called *Study for the Magdalene* by Bénédite (1931, vol. 1, p. 166).

The sketch on the reverse belongs to the group of studies of women and children in landscapes dating from 1839–41, and was no doubt executed before the drawing on the front. **L.-A. P.**

71

Scenes from the Life of Saint Mary of Egypt

1841–43
Graphite highlighted with watercolor (ogival-shaped top)
20 ⅛ x 12 ⅜ in. (52.4 x 31.2 cm)
Paris, Musée du Louvre (RF 24372)

PROVENANCE:
See cat. 20.

BIBLIOGRAPHY:
Chevillard 1893, no. 398; Bénédite 1931, vol. 1, pp. 178–82, ill. p. 192; Sandoz 1974, p. 38 n. 1, under no. 94, p. 202; Ribner 1981, fig. 3; Sandoz 1982, p. 37; Sandoz 1986, pp. 233–34 (with no inventory number); Prat 1988-1, vol. 1, no. 147, ill. and colorpl. p. 18; Peltre 2001, p. 152, fig. 168.

EXHIBITIONS:
Paris, Galerie Dru, 1927, no. 26 or 33?; Paris, Orangerie, 1933, no. 113; Paris, Louvre, 1957, no. 29, pl. 8; Paris, Louvre, 1980–81, no. 21.

Exhibited in Paris only

On August 24, 1841, through the intervention of his brother Frédéric, Chassériau received the commission from the general office of the prefecture of the Department of the Seine to decorate one of the lateral chapels in the north aisle of Saint-Merri in Paris; Lehmann and Amaury-Duval had already been commissioned to decorate other chapels in the same church. The subject of Lehmann's paintings was to be Saint Philomena, with whom Chassériau had been preoccupied a few months earlier (see cat. 43–46).

Was the subject matter already determined by the administrative body? The existence of a drawing by Chassériau entitled *The Martyrdom of Saints Felicity and Perpetua* (now in Orléans; see Prat, 1988-2, no. 87) raises that question, since the large sheet is divided into three registers that correspond exactly to the vertical divisions of the walls in Saint-Merri. However, these are not all alike: The east wall contains three scenes, the one on the bottom framed by two angels holding phylacteries, while the west wall is divided into only two registers, the one on the bottom extending for the entire width of the wall. The same decorative motifs surround the two series, and include banderoles bearing handwritten inscriptions: that on the left, SANCTA MARIA AEGYPTIACA [Saint Mary of Egypt]; that on the right, BEATUS ZOZIMUS VITAM S MARIAE AEGYPTIACAE MONACHIS NARRAT [the blessed Zosimus recounts the life of Saint Mary of Egypt to the monks]. The work is signed and dated *Théodore Chassériau 1843,* below the predella panel containing Zosimus's narration.

These two scenes were painted in oil on a coat of plaster applied to the walls and, thus, are not transportable; since no oil sketch of these decorations exists, they can be studied here only through preliminary drawings, which are extremely numerous. I inventoried 131 in the Louvre (Prat 1988-1, nos. 144–274), and of the three others that are known (Prat 1988-2, nos. 91–93), two are in Rouen. In addition, there are a large number of studies in several notebooks also in the Rouen museum (see especially Prat 1988-1, nos. 2244–2246), in which Chassériau can be seen hesitating about how to depict each of the sequences in the stories.

This episode seems to have been inspired primarily by *The Golden Legend,* but also by Godescard's French translation of Alban Butler's *The Lives of the Fathers, Martyrs, and Other Principal Saints* (Paris, 1802), and by the *Recueil des Bollandistes.* Sandoz adds Rutebeuf as a source: Achille Jubinal had published the first edition of his *Vie de Sainte Marie l'Égyptienne* in 1839.

The "charming and endearing" legend of Saint Mary of Egypt, as reported by Gautier in his enthusiastic description of the chapel in *La Presse* (1843), is well known, especially as other artists later would use it as a point of departure: among them, Papety, in a series of attractive watercolors, now in the museum in Montpellier, and Nolde, in a triptych now in the museum in Hamburg. Mary was a young and beautiful sinner from Alexandria who arrived in Jerusalem by boat, and having reached the Holy Sepulcher, experienced a strange paralysis that kept her from the holy place until she beseeched a statue of the Virgin and Child to allow her access. Instantly converted, she sought refuge in the desert, where, completely naked, she fasted, and lived a life of total abstinence. When she encountered the old monk Zosimus, he gave her his mantle, and then administered Communion. The monk returned to find the young woman a year later, but she would accept only three lentils from him (this episode is not recounted in some sources, which, instead, claim that Mary survived for sixty years on just three loaves of bread). The following

year she died, watched over by a lion (or two), who helped the saint dig her own grave. Zosimus then returned permanently to his monastery, where he told the story to his fellow friars. As for the saint's soul, it was borne aloft to heaven by angels.

In Chassériau's version, the order of the narrative is somewhat scrambled: from top to bottom, on the right panel, we see the saint taking Communion; following is her conversion, which had occurred much earlier; and then her burial is depicted. On the left, her assumption into heaven surmounts the scene of Zosimus's narration.

Chassériau began work on the project in late spring 1841. In March 1842, the Commission des Beaux-Arts for the prefecture of the Seine, having received a "sketch" from the artist (perhaps the drawing exhibited here), responded thus:

> The Commission was struck by the difference in dimensions among the figures in the three subjects united in a single panel. The figures in the scene on top and those in the lower register appeared larger than those in the painting in the middle, and the Commission believed that, in this matter, it ought to call to M. Chassériau's attention the need to observe, especially in monumental painting, a perfect unity and harmony. The Commission urges M. Chassériau to consult with M. Amaury Duval, in charge of decorating a chapel next to his own, and with M. Baltard, Inspector of Public Works for the City of Paris, with the goal of establishing as much harmony as possible between these two chapels and with the one previously decorated by M. Lépaule.
>
> The statue of the Virgin in the painting in the middle was found to be very large compared to the figures surrounding it. Finally, the subject of the lower register did not appear to be set forth clearly enough. It was not easy to grasp the intention of the lion digging the pit. And the gestures of the two angels in the corners, figures whose presence is, by the way, felicitous and advantageous for the entire composition, looked forced and not simple enough to be part of the decoration of a chapel with ogival architecture.

The drawing seen here seems to correspond to that critical description. In fact, in this overall study for the chapel's east wall, divided into three registers, the upper and lower scenes are already very close to the artist's final choices. The angels on either side of the lower register would be reversed and modified somewhat, and the lion would be shown in a more frontal position, but the most significant changes would occur in the central scene of the saint's conversion: The statue of the Virgin would be placed frontally in the center of the composition, with the saint seen full face, in meditation, with her elbows on the pedestal.

The groups of the faithful would be shown walking around the statue on either side, in order to reach the sanctuary in the background of the composition. The image is undoubtedly more readable in this initial conception, but much less strong in plastic terms. Chassériau must have stuck with this first positioning of the figures for a fairly long time, since many drawings reflect this arrangement—in particular, a study for the figure of the saint (cat. 74) in the same pose as in this large overall drawing.

The style of the present drawing is less supple and more painstaking than is the overall plan for the west wall (cat. 75).

In the first studies, from 1841, for *The Conversion* (in the notebooks in the Louvre), Mary is shown looking toward the statue at the entrance to the temple from a distance, from the bottom of a stairwell. In sketch after sketch, as in the storyboard for a film, she is seen climbing the steps and approaching the statue little by little, and then pausing in front of it. The scene is located in a kind of narthex that leads into the temple. The saint's pose would be constantly adjusted, as would, obviously, those of the figures surrounding her, who are clustered in groups and are frequently flattened up against one another without great respect for perspective. This reinforces the primitive, Byzantine-like quality of Chassériau's *Conversion*.

However, that archaism is counterbalanced by the very modernity of the composition, which is audacious in its evocation of the crowd surrounding Mary. At the right in the drawing, a line of pilgrims with faces alternately lifted and lowered seems to mirror the hesitations of the prostitute / saint whose duality appealed to Chassériau in the same way that, in a much earlier watercolor (now in the Louvre; see Prat 1988-1, vol. 1, no. 949, ill.), in *The Descent from the Cross* in Saint-Étienne (cat. 68), and later, at Saint-Philippe-du-Roule, his imagination was captured by another female saint who was lost but became sanctified—namely, Mary Magdalene. On the left of the present composition, the crowd climbing the stairs to enter the sanctuary is evoked with a wave of curved backs—echoes of the bent figure of Mary, who pauses, and almost appears to dance (a modest Salome?) in front of the statute.

Of the few critics of the work at the time, Eugène Piot, who commissioned the engravings in the "Othello" series from Chassériau the following year, commented that "M. Chassériau is a student of M. Ingres, and this work profoundly sets him apart from his master. He is not a renegade, but a soldier who is leaving the ranks; his weapons are his own and he believes them to be well tempered; he will be killed or he will be a general. A noble audacity, which the work I have just spoken of perfectly justifies. M. Chassériau's art has always been stamped with a will, which has elicited lively criticism. It is a proof of strength; in these recent works, he has not failed to make a few concessions; that is also a proof of intelligence" (*Le Cabinet de l'amateur et de l'antiquaire*, vol. 2 [1843], p. 575).

Delécluze insisted twice on the highly "distinguished" character of the artist's work (*Journal des débats*, November 21, 1843, p. 2). Finally, Gautier, his longtime friend, praised Chassériau

for not getting carried away by any of the Byzantine or Gothic affectations made fashionable by Overbeek [*sic*] and by the antiquated artists in Munich and Düsseldorf. His paintings, although in no way evocative of the year 1843, are executed with modern resources, feelings, and passions. . . . That enormous labor was carried out in a few months. To be sure, time is immaterial in the matter; but, notwithstanding difficult talents, let us not forget that, in all the arts, abundance is a sign of genius, and M. Chassériau, at an age when others are just starting out, already has shown evidence of a supple, varied, and always profoundly original talent. His qualities and his flaws are his own. He knows what he wants and marches straight toward his goal. Of all our young painters, he is surely the one with the greatest future. Even his most minor works have the stamp of power and will: he is already masterful in his execution and at the top of his form. Give M. Chassériau the opportunities to spread his wings, and we have no doubt that he will soon be in the forefront of the contemporary school (*La Presse*, November 2–3, 1843, pp. 1–2).

L.-A. P.

Head of a Young Woman, Seen Full Face

1841–43
Red chalk on cream-colored paper
15 ¼ x 11 ⅞ in. (38.5 x 30 cm) (the right corners are missing)
Paris, Musée du Louvre (RF 24743)

PROVENANCE:
See cat. 20.

BIBLIOGRAPHY:
Chevillard 1893, part of no. 420; Sandoz 1974, under no. 94
(medium given as graphite); Prat 1988-1, vol. 1, no. 171, ill.; Peltre
2001, p. 155, fig. 171.

EXHIBITION:
Paris, Louvre, 1980–81, no. 71.

Exhibited in Strasbourg only

This beautiful study for the face of Saint Mary of Egypt, for which Clémence Monnerot probably posed (see Bénédite 1931, vol. 1, p. 103), would be slightly modified in the painting, where the saint's eyes are shown lowered, although the position of her torso is consistent with that in the definitive composition.

The use of red chalk here was unusual for Chassériau, and subsequently would become even more rare.

L.-A. P.

CAT. 72

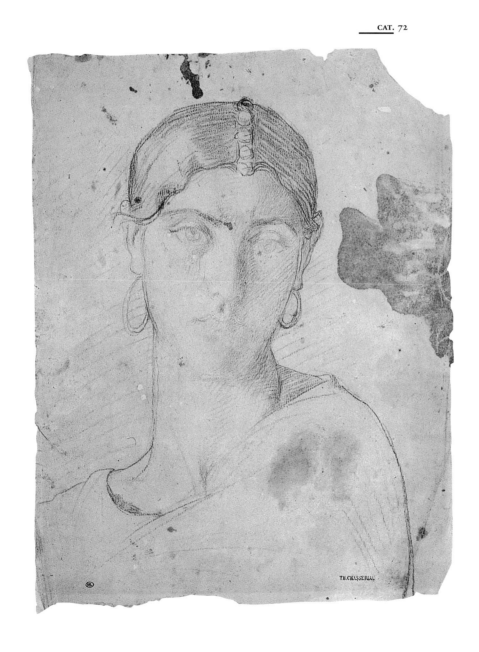

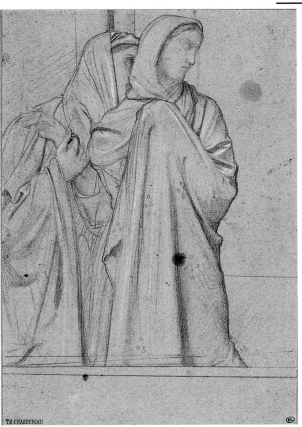

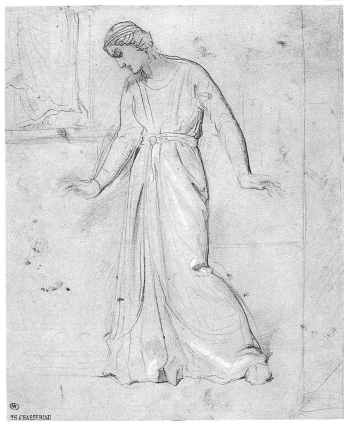

73

Two Draped Women, Their Faces Turned to the Right

1841–43
Graphite, heightened with white, on beige paper
10 ¾ x 7 ⅞ in. (27.3 x 19.9 cm)
Paris, Musée du Louvre (RF 24370)

PROVENANCE:
See cat. 20.

BIBLIOGRAPHY:
Chevillard 1893, part of no. 420; Bénédite 1931, vol. I, ill. p. 191 (entitled *The Holy Women*); Sandoz 1957, p. 17 n. 1; Sandoz 1974, under no. 94, cited on p. 202; Sandoz 1986, no. 151-3; Prat 1988-1, vol. I, no. 179, ill.

Exhibited in Strasbourg only

This is a study for the two women at the lower left in *The Conversion;* in the painting, they are holding hands, whereas here one clasps the other's wrist.

L.-A. P.

74

Standing Woman in Three-Quarter Left Profile, Her Arms Spread and Her Head Lowered

1841–43
Graphite, heightened with white, on cream-colored paper
10 x 8 ½ in. (25.3 x 21.4 cm)
Paris, Musée du Louvre (RF 24483)

PROVENANCE:
See cat. 20.

BIBLIOGRAPHY:
Chevillard 1893, part of no. 420; Bénédite 1931, vol. I, ill. p. 179; Sandoz 1974, under no. 94 A (with erroneous inventory number RF 24843); Prat 1988-1, vol. I, no. 163, ill.; Peltre 2001, p. 155, fig. 170.

EXHIBITIONS:
Paris, Galerie Dru, 1927, no. 30 (?); Paris, Orangerie, 1933, no. 115.

Exhibited in Strasbourg only

This study is directly related to the figure of the saint in the large overall plan for the project (cat. 71); the central register, containing *The Conversion,* would be considerably modified later on. According to Bénédite (1931, vol. I, p. 103), Clémence Monnerot, the future Comtesse de Gobineau and a friend of Chassériau's sisters, posed for this figure (she herself makes that claim in a letter published by this author), and she is depicted as well in a sketch in the Musée Carnavalet, Paris (Sandoz 1986, no. 116, ill.; Prat 1988-2, no. 108).

The base of the statue of the Virgin with Child, in front of which Mary pauses, is visible at the upper left.

L.-A. P.

Saint Mary of Egypt Being Borne Up to Heaven by Angels—The Narrative of Zosimus

1841–43
Watercolor over graphite
15 ⅞ x 12 ⅜ in. (40.2 x 31.2 cm) (the upper corners are cut off)
Signed and dated in graphite, lower left: *Th. Chassériau / mars 1843* [Th. Chassériau / march 1843]; inscribed in graphite, upper right: *St Marie Egyptienne / est emporté par les anges / au ciel* [St. Mary of Egypt / is carried off by the angels / to heaven]; center right: [illegible]; lower right: *St Zozime de / retour au / monastère / raconte aux / moines la v[ie] / de la sainte / qu'il a rencontr[ée] / dans le désert* [St. Zosimus / returning to the / monastery / recounts to the / monks the life / of the saint / whom he encountered / in the desert]
Paris, Musée du Louvre (RF 24342)

PROVENANCE:
See cat. 20.

BIBLIOGRAPHY:
Chevillard 1893, no. 391 (?); Bénédite 1931, vol. I, ill. p. 175; Sandoz 1974, under no. 94 D, cited on p. 202; Sandoz 1982, p. 38; Prat 1988-1, vol. I, no. 229, ill.; Peltre 2001, p. 156, fig. 173.

EXHIBITIONS:
Paris, Orangerie, 1933, no. 114; Paris, Louvre, 1957, no. 30; Paris, Louvre, 1980–81, no. 22.

Not included in the exhibition

This beautiful study, already fairly close, in the positioning of the figures, to the final work, shows that Chassériau, in the interest of symmetry, considered dividing the west wall and the wall facing it into three registers each. The horizontal separations are clearly indicated here. In giving up that idea, he would accentuate the verticality of the figure group consisting of the saint and the flying angels, which is still circumscribed in the upper register here, and which the censers that project into the air eventually would frame. A quick sketch in pen, now in the Louvre (Prat 1988-1, vol. I, no. 230, ill.), displays variations on the decoration, also in three parts, with the saint emerging from her tomb in the center. An interesting parallel exists between the saint borne by the angels and the slightly earlier studies of the saint supported by her tormentors for *The Martyrdom of Saint Philomena* (Prat 1988-1, nos. 953–971).

L.-A. P.

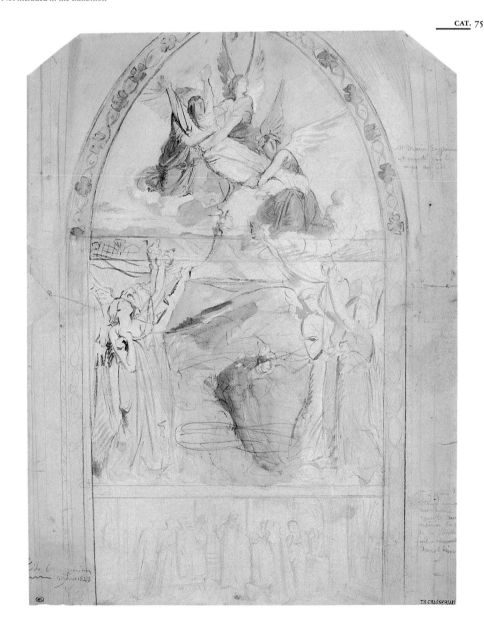

CAT. 75

76

Bust-Length Study of a Woman, Her Head Raised and in Right Profile; Studies of a Nose, Legs, and Arms

1841–43
Black pencil, heightened with white, on cream-colored paper
12 ½ x 9 ¾ in. (31.6 x 24.6 cm)
On the reverse are two black-pencil studies of wings
Paris, Musée du Louvre (RF 25679)

PROVENANCE:
See cat. 20.

BIBLIOGRAPHY:
Chevillard 1893, part of no. 420; Sandoz 1974, under no. 94 D; Sandoz 1986, no. 181, ill. (with erroneous inventory number RF 25079); Prat 1988-1, vol. 1, no. 257, ill.; Peltre 2001, p. 157, fig. 175.

Exhibited in Paris only

This is a superb study for one of the three angels on the left in the scene of *The Assumption of Saint Mary of Egypt* —no doubt for the angel in the foreground, who would be turned more toward the background in the painting. The upper wing sketched on the reverse is the right wing of the angel seen from the back, who supports the saint; the lower wing is similar to that of the angel in the left foreground **L.-A. P.**

77

Two Groups of Angels Swinging Censers

1841–43
Graphite
8 ⅞ x 14 ¼ in. (22.4 x 36.2 cm)
Paris, Musée du Louvre (RF 24732)

PROVENANCE:
See cat. 20.

BIBLIOGRAPHY:
Chevillard 1893, part of no. 420; Sandoz 1974, under no. 94; Prat 1988-1, vol. 1, no. 243, ill.; Peltre 2001, p. 157, fig. 174.

Exhibited in Paris only

These delicate studies are for the group of angels on the right in the *Assumption,* but the figures are still very different from the way that they would appear in the definitive work. A sketch at the lower right, difficult to interpret, might constitute a study for the positioning of the figures in the *Conversion* on the facing wall.

L.-A. P.

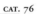

CAT. 76

CAT. 77

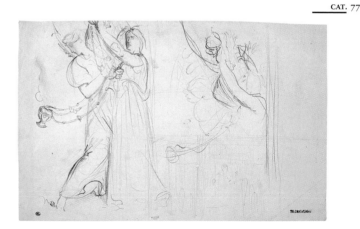

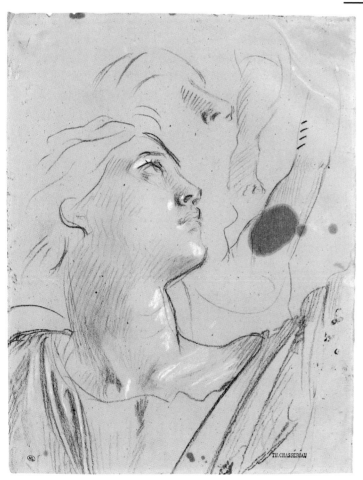

78

Woman Fleeing from a Horseman, Her Children in Her Arms

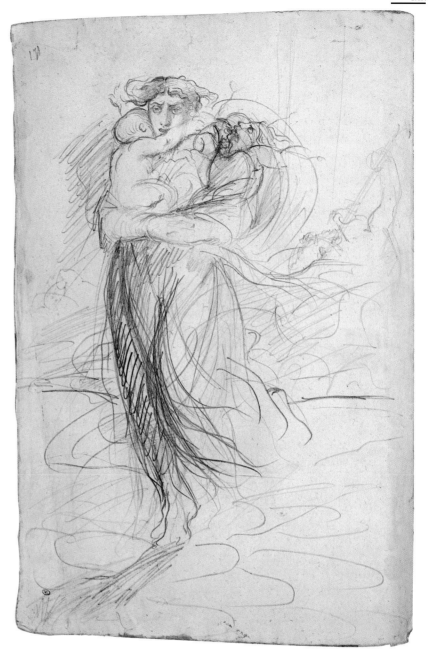

1842–44
Graphite on cream-colored paper (affixed to fol. 41 v. of dummy album 3)
17 ½ x 11 ⅞ in. (44.5 x 29.9 cm)
On the reverse are two graphite half-length studies of adolescents
Paris, Musée du Louvre (RF 26485)

PROVENANCE:
See cat. 20.

BIBLIOGRAPHY:
Chevillard 1893, part of no. 420; Sandoz 1974, under no. 106; Sandoz 1986, no. 195, ill. (the verso), and part of no. 206; Prat 1988-1, vol. 1, no. 976, ill.

Exhibited in Strasbourg only

This fine drawing, which can be dated between 1842 and 1844, may be variously interpreted. It would be tempting to link it to three sheets of studies (Paris, Louvre) of a mother with her dead children (Prat 1988-1, nos. 973–975). It is difficult to say whether this is a Medea or a Massacre of the Innocents, as an annotation on the reverse of another Louvre drawing suggests (Prat 1988-1, vol. 1, no. 972, ill.): *les mères courent après les bourreaux qui massacrent leurs petits avec massues* (?)—*Rachel* (?) *à terre criant se lamentant* [the mothers run after the tormentors who are massacring their children with clubs (?)—Rachel (?) on the ground screaming lamenting]. If the name "Rachel" is the correct reading in the last notation, it serves to corroborate this supposition, since it refers to the Gospel of Saint Matthew (2: 16–18), which frequently inspired Chassériau: "Then Herod, when he saw that he was mocked of the wise men, was exceeding wroth, and sent forth, and slew all the children that were in Bethlehem, and in all the coasts thereof, from two years old and under, according to the time which he had diligently inquired of the wise men. Then was fulfilled that which was spoken by Jeremy the prophet, saying, In Rama was there a voice heard, lamentation, and weeping, and great mourning, Rachel weeping *for* her children, and would not be comforted, because they are not."

Notebook RF 26090 in the Louvre (Prat 1988-1, vol. 2, no. 2245, ill.) contains other drawings related to this subject (folios 3 v., 10 v., 11 r. and v., 12 r.).

However, the presence of the horseman also recalls the first plans for the *War* cycle at the Cour des Comptes, where people are shown fleeing from the soldiers. Sandoz (1974), who considers this a drawing of Medea, dates it to 1850, which, I believe, is much too late; conversely, in 1986, he dated the study on the reverse to 1840–41.

In any case, it seems impossible that Chassériau could have composed this strong image without knowledge of *The Massacre of the Innocents* (Rennes, Musée des Beaux-Arts) by Léon Cogniet (1794–1880), exhibited at the Salon of 1824; the woman fleeing at the left seems to be a prefiguration of the one studied here.

L.-A. P.

79
Christ on the Mount of Olives

"And he taketh with him Peter and James and John, and began to be sore amazed, and to be very heavy; And saith unto them, My soul is exceeding sorrowful unto death: tarry ye here, and watch. And he went forward a little, and fell on the ground, and prayed that, if it were possible, the hour might pass from him. And he said, Abba, Father, all things *are* possible unto thee; take away this cup from me: nevertheless not what I will, but what thou wilt. And he cometh, and findeth them sleeping" (Mark 14: 33–37).

1844
Oil on canvas
197 x 134 in. (500 x 340 cm)
Souillac, Church of Sainte-Marie

PROVENANCE:
Purchased by the Ministry of the Interior, by an order of July 22, 1848 (for a mere Fr 1,500); deposited at the Church of Sainte-Marie, Souillac, December 1848.

BIBLIOGRAPHY:
Borel, *Satan*, March 24, 1844; Gautier, *La Presse*, March 27, 1844; Unsigned, *Le Charivari*, March 30, 1844; Unsigned, *L'Illustration*, March 30, 1844; Pillet, *Le Moniteur universel*, April 1 and 29, 1844; Delécluze, *Journal des débats*, April 2, 1844; Laverdant, *La Démocratie pacifique*, May 7, 1844; Thoré 1868, pp. 69–70; Chevillard 1893, nos. 44, 65; Bénédite 1931, pp. 213–24; Sandoz 1974, no. 97; Foucart 1987, p. 250; Peltre 2001, pp. 63–68.

EXHIBITION:
Salon of 1844, no. 327.

Not included in the exhibition

— CAT. 79

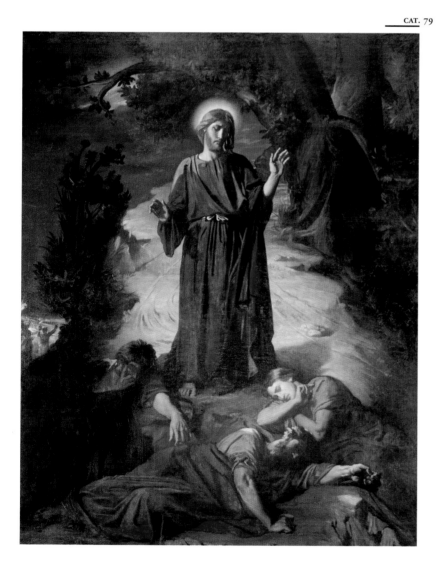

The theme of the agony in Gethsemane must have particularly attracted Chassériau for him to have set out, with no commission and no promise of purchase, to paint a canvas as enormous as the one in Saint-Jean-d'Angély; curiously enough, the present painting has exactly the same dimensions. The Souillac painting represents the moment shortly after Christ has drunk from the chalice, and is again plagued by doubt (see my essay, p. 44). Chassériau once more preferred somber meditation to narrative, as noted by a critic of the time, who regretted the stillness of the figures. The result was a certain coldness: "The Savior does not act, does not speak, does not bear witness to his impressions until he has awakened his three disciples. In the moment the artist has chosen, the action is suspended; the relation between Jesus Christ and his apostles is interrupted, and the feelings that animate the Man-God are of a nature that cannot be expressed externally."[1] It is precisely in that suspension of action, its profound melancholy, and the rejection of any pathos that the unique grandeur of the painting lies.

Although Pillet reported that he was convinced,[2] Delécluze judged as almost heretical—which is not immaterial—the exploitation of sadness in a work that nevertheless seemed to him to be the best of the devotional paintings: "There is gravity in his spirit, one sees it; but that is no reason to be *sorrowful unto death,* in the words of the main character [*sic*] in the painting. M. Chassériau seems to be fond of *sadness*, but that disposition is not good in painting or even in religion: in painting, because it produces monotony; from the religious point of view, because sadness . . . is disallowed as one of the sins."[3] Opinion also was divided on the painting's style. The critic for *Le Charivari*, generally not Ingrist, was among the most hostile, judging "the painting grand in its appearance, severe in its drawing, and almost the right color,"[4] while Pétrus Borel took obvious pleasure in savaging the protégé of his friend Gautier: "This is what I perceived: 1) A kind of peasant turned abbot, badly dressed and sporting big paws, making, moreover, some sort of awkward and clumsy gesture; 2) Not-so-light moonlight, behind a branch of something or other; 3) All the elements simmering together; 4) A few very ugly commoners sleeping in a very ugly, that is to say, very Californian manner [Borel's way of designating the school of painting, of which Chassériau was the chief exponent, as a sort of depraved Ingrism]; 5) A complete absence of grandeur, style, color, naïveté, order—everything carelessly done in the land of the Iroquois."[5] Laverdant, no less than Borel, attacked what he called the "mannerism" of a painting whose colors, however, seemed to him better matched than usual. "Why that unnatural twisting, those arranged fingers, those awkward trees and rock formations? Standing before that canvas, one has a feeling of anxiety and fatigue. The simplicity demanded by the subject matter is everywhere lacking. Nevertheless, behind the ugliness and pretension of the figure of Christ, there is a nobility, and the head of Saint John is very beautiful."[6]

Conversely, only a few critics hailed the combination of realism in the figure of Christ and the simplicity

in the overall composition. All in all, the blue-green tonality of the nocturnal setting unifies the hues, which Chassériau refrained from blending together. The pictorial language, with its tensions and disjunctions; the dramatic chiaroscuro, which imitates the paintings of the Spanish Golden Age; the soberly dressed figure of Christ, both Byzantine yet ordinary in appearance,[7] the apostles, strangely agitated in their sleep; that hillside, off which everything seemed to be sliding—who, apart from Gautier, could embrace all of this without reservations? Even Arsène Houssaye, the director of *L'Artiste,* remained somewhat reserved about one of the best foals in his stable: "What is particularly striking in this painting is the boldness of the search for style. One must always applaud, in the arts and in letters, the adventurous spirits who dare listen to themselves without slavishly submitting to schools and rules. M. Théodore Chassériau belongs to the small number of privileged artists who have the honor of passionately exciting both praise and criticism; for myself, I am of the small number of those who both criticize and praise him."[8]

The painting also intrigued the government, if we are to believe Cailleux's report on the Salon of 1844: He singled out Chassériau's *Christ,* which "shows promise of natural abilities," but feared that the "inopportune praise" of which it was the object—as we have seen, such a judgment needed to be more nuanced—would arrest the progress the artist still needed to make. While he proposed that the painting be purchased by the Ministry of the Interior,[9] there would be no question of an acquisition before 1848, contrary to what Sandoz has written. In 1844, Chassériau was rewarded only with second prize in the category of history painting. Heaven was decidedly quite empty.

Unfortunately, it proved impossible to transport this painting to Paris for the 2002 exhibition. S. G.

1. Unsigned, "Salon de 1844. 2ᵉ art.," in *Les Beaux-Arts* (1844), pp. 403–4. Laverdant (*La Démocratie pacifique,* May 7, 1844) noted, "As for the subject, the choice of scene, one can say that M. Chassériau chose, in the verse of the Mount of Olives, one of the least interesting moments." How could a Fourierist come to terms with such a dark view of the human condition?
2. F. Pillet, *Le Moniteur universel* (April 1, 1844).
3. É.-J. Delécluze, "Salon de 1844," in *Journal des débats* (April 2, 1844).
4. Unsigned, "Salon de 1844. Les dessinateurs," in *Le Charivari* (March 30, 1844).
5. P. Borel, "Beaux-Arts. Salon. École californienne," in *Satan* (March 24, 1844).
6. The desire for "effect" was also pointed out by Alfred de Menciaux ("Salon de 1844," in *Le Siècle,* May 26, 1844): "Let us beware of biblical joy, biblical sadness, biblical hands, hair, gestures; let us beware of the gray, the pallid, and the austere colors for which certain painters have a fondness, as if brilliant colors were profane and atheistic." Similarly, Thoré (1868, pp. 69–70) wrote: "The large paintings in his chapel have strengthened M. Chassériau's talent. No doubt one could criticize the inaccuracies and laxity of the drawing, the monotony of the color, the turgidity and vacuity of the style. The heads are hardly put together. The bodies have no reality under the drapery, and they stand or stretch themselves out like hollow ghosts. One could do almost as well with a few well-draped rags. But, even then, one would have to be a skillful costumer and an experienced theater producer."
7. One of the sources was the figure of Christ in the mosaic in the Church of Santi Cosma e Damiano in Rome, which Chassériau copied during his stay in Italy (see Prat 1988-1, vol. 1, no. 1509) and which also inspired Ingres's figure of Jesus in the *Christ Handing over the Keys to Saint Peter* (Montauban, Musée Ingres); on this subject, see Driskel 1981, pp. 104–5.
8. A. Houssaye, *L'Artiste* (March 31, 1844), pp. 193–95.
9. "Rapport à Monsieur l'Intendant général sur l'Exposition des Arts de 1844," in Archives des Musées Nationaux. 10. Salon of 1844.

80

Christ Spreading His Arms

1843–44
Black pencil with stumping, heightened with white, on beige paper (affixed to fol. 77 r. of dummy album 3)
18 ¼ x 13 in. (46.1 x 32.8 cm)
Paris, Musée du Louvre (RF 26583)

PROVENANCE:
See cat. 20.

BIBLIOGRAPHY:
Chevillard 1893, part of no. 420; Sandoz 1974, under no. 97; Prat 1988-1, vol. 1, no. 289, ill.; Peltre 2001, p. 64, fig. 69.

Exhibited in Strasbourg only

In this powerful preparatory drawing for the figure of Christ, the emphasis is on his left arm, which is slightly too large for the rest of the figure—a violation of proportions also found in other drawings by Chassériau of isolated figures.

Eleven drawings in the Louvre (Prat 1988-1, nos. 286–296) served as preliminary studies for the figure of Christ, especially for the arms and hands, which particularly interested Chassériau. L.-A. P.

Study of a Raised Left Arm, and of a Face in Three-Quarter Right Profile

1843–44
Black pencil, heightened with white, on beige paper
18 ⅛ x 11 ⅞ in. (45.9 x 30 cm)
On the reverse are black-pencil studies of a nude woman, her face turned toward the left and her right hand in front of her mouth
Inscribed in black pencil, upper left: *sans proportion* [out of proportion]
Paris, Musée du Louvre (RF 24594)

PROVENANCE:
See cat. 20.

BIBLIOGRAPHY:
Chevillard 1893, part of no. 420; Sandoz 1974, under nos. 97, 215 (the verso); Prat 1988-1, vol. 1, no. 295, ill.

Exhibited in Strasbourg only

CAT. 81

CAT. 82

This study is for the head and left arm of Christ in the *Christ on the Mount of Olives.*

The sketch on the reverse side of this sheet was used later for a study of a nude woman—apparently an early idea for one of the figures (the woman seated in the center) in the *Tepidarium* of 1853 (cat. 237).

Another sheet of studies for the Souillac painting, in the Louvre (RF 24595; see Prat 1988-1, vol. 1, no. 297) contains two drawings of the same figure in the *Tepidarium.*

L.-A. P.

Sheet of Studies with a Half-Length Figure of Christ; a Raised Left Hand; a Figure with the Right Hand Extended Forward; and a Half-Length Sleeping Figure

1843
Graphite, heightened with white, on beige paper (affixed to fol. 7 r. of dummy album 2)
10 ¼ x 16 ⅛ in. (25.8 x 41 cm)
On the reverse is a graphite study of animals
Paris, Musée du Louvre (RF 26209)

PROVENANCE:
See cat. 20.

BIBLIOGRAPHY:
Chevillard 1893, part of no. 420; Sandoz 1974, under no. 97; Prat 1988-1, vol. 1, no. 293 v., ill.

Exhibited in Strasbourg only

This sheet includes studies for two very different works from 1844: The head of Christ and the hand in the foreground obviously are directly related to the figure of Christ in the Souillac painting. However, neither Sandoz nor Fisher noticed that the arm extending behind Christ's head is that of Emilia, as it appears, in reverse, on plate 14 ("O! O! O!") of the "Othello" series (cat. 98). The drawing of the wailing figure, in half length, on the right of the sheet undoubtedly constitutes a first idea for Othello at the foot of Desdemona's bed, also on plate 14, although it might be a study for the sleeping apostle to the left of Christ in the Souillac painting. Chassériau would adapt the same figures, with only slight modifications, to the various compositions on which he was at work at the same time.

The drawing on the reverse, slightly earlier in date than the one on the front, must be from about 1842; perhaps sketched from life, it is one of the animal studies related to the series of paintings of the life of Saint Mary of Egypt at the Church of Saint-Merri, in which Chassériau depicted the legendary lion from the Jardin des Plantes (Sandoz 1974, no. 94 C, D).

L.-A. P.

83

Two Studies of a Recumbent Sleeping Man, Facing Left

1843–44
Black pencil, highlighted with oil, on beige paper (upper-right corner missing)
11 ⅞ x 18 in. (29.9 x 45.7 cm)
Paris, Musée du Louvre (RF 24598)

PROVENANCE:
See cat. 20.

BIBLIOGRAPHY:
Chevillard 1893, part of no. 420; Sandoz 1974, under no. 97;
Sandoz 1982, p. 38; Prat 1988-1, vol. 1, no. 306, ill.

EXHIBITION:
Paris, Louvre, 1980–81, no. 27.

Exhibited in Paris only

These are studies for the sleeping apostle Saint John, at the right in the Souillac painting. L.-A. P.

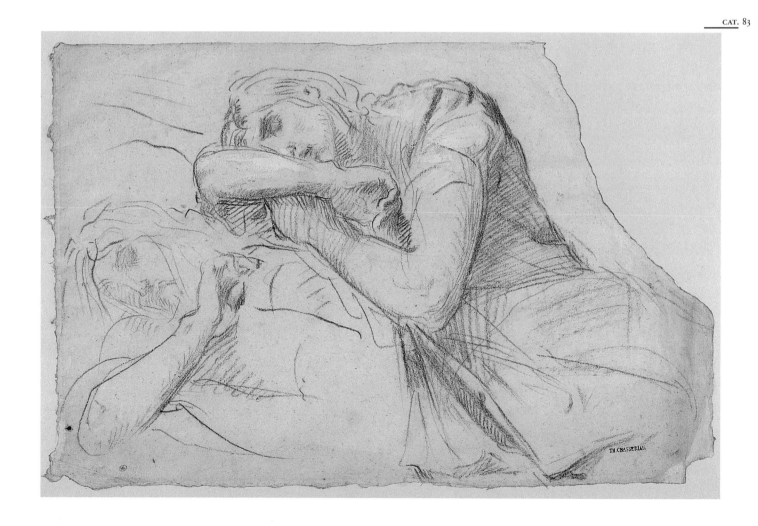

The Life of Théodore Chassériau (1819–1856)

Chronology

For Catherine Chagneau

Key to abbreviations

[in brackets]: presumed or reconstituted text

/: new line

fol.: folio

BnF, Dépt. des Ms: Bibliothèque Nationale de France, Département des Manuscrits

AN: Archives Nationales (Paris)

FM signature: signature with Masonic sign of recognition (two lines, two or three periods)

Translator's note: The misspellings in Théodore Chassériau's childhood letters have not been retained here in translation

1819–43

■ 1819

September 20

■ Birth

Théodore Chassériau is born in Saint Domingue, in the West Indies, at his mother's family estate, Le Petitoa, located at Le Limon on the northeast end of the Samaná peninsula.

He was the fifth child of Benoît Chassériau (1780–1844), born in La Rochelle, France, and Marie-Madeleine Couret de la Blaquière (1791–1866), the daughter of a Creole landowner from Saint Domingue (Bénédite 1931, vol. I, pp. 9, 12–13), who were married in 1806. They had seven children: Frédéric (1807–1881), Marie-Antoinette [Adèle] (1810–1869), Charles (died in infancy), Théodore (1819–1856), Geneviève [Aline] (1822–1871), Ernest (1823–1870), and Paul (died in infancy). According

to an unsigned letter of denunciation, Théodore's mother was said to be a woman of "color" (Archives du Ministère des Affaires Étrangères, dossier Benoît Chassériau, 1st series, 889). However, this physical characteristic does not show in the portrait painted by her son, Théodore, in May 1836 (Musée du Louvre; Sandoz 1974, no. 24, p. 116).

■ Théodore's Father

Benoît Chassériau, the last of seventeen children, began his career in the French army during the campaigns in Egypt and Saint Domingue. In 1802, he was appointed treasurer general, then, in 1805, secretary general of the colony of Saint Domingue—that is, the eastern part of the island of Hispaniola, allotted to France by the Treaty of

Basel. According to an unsigned letter of denunciation from this time, he is said to have embezzled and gambled with "some 60,000 francs of public funds," sold his services to the English, and abused "the daughter of an influential cacique" (Archives du Ministère des Affaires Étrangères, dossier Benoît Chassériau, 1st series, 889). After having weathered the political vicissitudes of the region, he was able to recover his property in Saint Domingue in 1819, the year of Théodore's birth (Bénédite 1931, vol. I, pp. 13–14).

■ An Uncle in the Military and an Architect Cousin

Among Théodore's many distinguished relatives was his uncle General Baron Victor-Frédéric Chassériau (one of Benoît Chassériau's brothers),

who died at the battle of Waterloo, on June 18, 1815. The general's son, Frédéric Chassériau (1802–1896), became the architect of the ports of Marseilles and Algiers (see below, *August 4–6 [?], 1836*) and the father of Baron Arthur Chassériau (1850–1934), who generously donated his collection of Chasseriau's work to the Louvre.

■ 1820

December 5

■ Departure for Brest

Benoît Chassériau leaves Saint Domingue with his wife and children (Frédéric, Adèle, and Théodore) on board the frigate *Cleopatra*. They embark at Kingston and sail for Brest (Letter from Benoît Chassériau to the senior director of foreign affairs, December 26, 1824, Paris, FM signature; Archives du Ministère des Affaires Étrangères, dossier Benoît Chassériau, 1st series, 889).

November 23

■ Baptism

Théodore is baptized in the Church of Sainte-Barbe-de-Samaná, with his older brother Frédéric as godfather and his sister Marie-Antoinette (later called Adèle) as godmother (AN, L0500062; Peltre 2001, p. 230, fig. 246, p. 231 n. 2).

■ 1821

January 9–February 20

■ Brest and Paris

The Chassériau family reaches Brest on January 9, spends "a month in quarantine," and "arrives in Paris on February 20" (Letter from Benoît Chassériau to the senior director of foreign affairs, December 26, 1824, Paris, FM signature; Archives du Ministère des Affaires Étrangères, dossier Benoît Chassériau, 1st series, 889). According to Bénédite, who gives 1822 as the date of this return, Benoît's decision was motivated by the desire for his children to receive a good education.

■ 1822

January 5

■ Birth of Aline Chassériau

Aline is born in Paris, one year after the family's return (Archives des Musées Nationaux, dossier P. 30 Chassériau).

■ 1823

June 2

■ Birth of Ernest Chassériau

Born in Paris, Ernest became a naval battalion commander. He was killed at Bazeilles-sous-Sédan on September 1, 1870, commanding the Third Battalion of the Fourth Naval Infantry Regiment of the Vassoigne Division (Archives des Musées Nationaux, dossier P. 30 Chassériau).

December 30

■ The Father and Eldest Son Leave for Colombia

Benoît leaves Paris with his sixteen-year-old son, Frédéric, who had been in school in Calais (Letter from Benoît Chassériau to the senior director of foreign affairs, September 6, 1824, Paris, FM signature; Archives du Ministère des Affaires Étrangères, dossier Benoît Chassériau, 1st series, 889; Bénédite 1931, vol. 1, p. 30).

He was sent to Colombia as a diplomatic agent by Chateaubriand, the Minister of Foreign Affairs. His instructions, delivered on November 25, involved assessing the relations between Colombia and Spain and urging both parties to accept France as the arbitrator (Bénédite 1931, vol. 1, p. 15).

■ 1824

January–February (?)

■ The Witty Théodore

After he and his father reached their destination Frédéric writes to his mother: "I also send a kiss to the witty Théodore, whom I love more than I can say" (Letter from Frédéric [to his mother (?)] [January–February (?)] 1824, n.p.; quoted in Bénédite 1931, vol. 1, pp. 42–43).

September 6

■ The Father Returns

Benoît Chassériau's return is verified by a letter written in "Brest, aboard the frigate *La Flore*" (Letter from Benoît Chassériau to the senior director of foreign affairs, September 6, 1824, Brest, FM signature; Archives du Ministère des Affaires Étrangères, dossier Benoît Chassériau, 1st series, 889). Bénédite (1931, vol. 1, p. 18) gives 1826 as the date of this premature return, which was probably motivated by political reasons. As Benoît later wrote: "I therefore decided to return to France, convinced that under the present circumstances prolonging my stay in these lands could no longer serve our interests, and moreover would undermine the dignity of our Government" (Letter from Benoît Chassériau to the comte de Villèle, March 1826, Paris, FM signature; fol. 3 v.; private collection; information kindly provided by J.-B. Nouvion).

April 8

■ Refusal of a Position

Benoît Chassériau turns down the offer of a position as director of a company in Madagascar (Archives du Ministère des Affaires Étrangères, dossier Benoît Chassériau, 1st series, 889).

May 2

■ Refusal of the Father's Application

The minister of the French Navy rejects Benoît Chassériau's request for a position in the colonies (Archives du Ministère des Affaires Étrangères, dossier Benoît Chassériau, 1st series, 889).

June 10

■ Interview at the Ministry

After repeated requests, the minister of the Navy grants Benoît Chassériau an appointment (Archives du Ministère des Affaires Étrangères, dossier Benoît Chassériau, 1st series, 889).

March

■ Dire Family Straits

Benoît Chassériau explains to the president of the Council of Ministers, the comte de Villèle, the reasons for his premature return (see above, *September 6, 1824*), ending his long letter with: "My Lord, my only ambition today would be to withdraw and live in obscurity, and to be able to raise my children. The least pension would put me in a position to accomplish this cherished wish" (Letter from Benoît Chassériau to the comte de Villèle, March 1826, Paris, FM signature; fol. 7 r.; private collection; information kindly provided by J.-B. Nouvion).

October (?)

■ Théodore in School

Théodore is sent to the Institution Lormier, a small neighborhood school at 10, rue Cadet, near the Chassériaus' apartment at 2, rue de Provence (Bénédite 1931, vol. 1, p. 39 n. 1).

■ A Childhood Friend: Albert Gilly

Théodore may have met Albert Gilly at the Institution Lormier. After Théodore's death in 1856, Gilly wrote that he had "been associated with his life, his work, and his success for at least twenty-eight years," and that he considered him "a brother" (Letter from Albert Gilly to Frédéric Chassériau, October 13, 1856, n.p.; quoted in Bénédite 1931, vol. 1, p. 72).

Early November (?)

■ The Father Leaves for Saint Thomas

From 1826 to 1830, the Department of the Navy entrusts Benoît Chassériau with "consular functions on the Danish island of Saint Thomas, the last of the Lesser Antilles, not far from the main island" (Bénédite 1931, vol. 1, p. 15). The exact date of his departure is uncertain. Benoît embarked at Brest on December 26, 1826 (see below), but may already have left Paris in November.

November 17

■ Talent in Drawing

In a letter to his wife, Benoît Chassériau writes: "Give Théodore a kiss, too, and see to it that he does not neglect his talent for drawing. Tell him that I am counting on him to send me some samples of his efforts. Assure him that I will receive them with great pleasure" (Letter from Benoît Chassériau to his wife, Marie-Madeleine, November 17, 1826, n.p.; quoted in Bénédite 1931, vol. 1, p. 43).

■ The Mont-de-Piété

The family's financial problems are documented by this letter from Benoît Chassériau to his wife: "Make every effort to sell not only the first things we pawned at the Mont-de-Piété, but also the ones that you recently pawned there; the main thing is to eliminate the high interest that we are paying and that is burdening us. In any case, what need do we have of luxurious and costly things?" However, he refuses to let her sell her jewelry and entreats her in the name of their love never to sell it (Letter from Benoît Chassériau to his wife, Marie-Madeleine [November (?)] 1826, n.p.; quoted in Bénédite 1931, vol. 1, p. 28).

November 24

■ Théodore's Efforts

Benoît Chassériau asks his wife: "Tell me if Théodore is still drawing. Let him send me one of his efforts, old or new" (Letter from Benoît Chassériau to his wife, Marie-Madeleine, November 27, 1826, n.p.; quoted in Bénédite 1931, vol. 1, p. 43).

November 27

■ Evaluating His Progress

Benoît Chassériau, who has just received news from his family, writes: "I am very satisfied with Théodore's drawings and urge him to send me some often, with the date, so that I can evaluate his progress" (Letter from Benoît Chassériau to his wife, Marie-Madeleine, November 27, 1826, n.p.; quoted in Bénédite 1931, vol. 1, p. 43).

Late November (?)

■ Little Drawings

Théodore writes to his father: "My dear Papa, with all my love and kisses, this time I'm sending you . . . a lot of little drawings. I did my dear Papa, what you told me to do" (Letter from Théodore Chassériau to his father [late November 1826 (?), Paris]; published in Gállego 1955, pp. 53–54, Prat 1988-1, vol. 2, no. 1, p. 973).

December 2

■ Request from His Father

Benoît begs Théodore "not to neglect his talent for drawing" and asks his wife to put some drawings "in all of the packages that you send to me at Saint Thomas" (Letter from Benoît Chassériau to his wife, Marie-Madeleine, December 2, 1826, n.p.; quoted in Bénédite 1931, vol. 1, p. 43).

December 20

■ The Little Painter

Frédéric sends his father "some works by the little painter," and adds: "Théodore is still drawing and working fairly well" (Letter from Frédéric Chassériau to his father, Benoît, December 20, 1826 [Paris]; quoted in Bénédite 1931, vol. 1, p. 43).

December 21

■ "Nice Drawings"

Benoît Chassériau writes to his wife: "I thank Théodore for his nice drawings and his little note. I invite him to send me some often and hug him with all my heart" (Letter from Benoît Chassériau to his wife, Marie-Madeleine, December 21, 1826 [Saint Thomas]; quoted in Bénédite 1931, vol. 1, p. 44).

December 26

■ Departure from Brest for Saint Thomas

The date of December 26 is given by Frédéric Chassériau, who writes to his father on January 12, 1827: "Seventeen days have passed since your departure from Brest" (Letter from Frédéric Chassériau to his father, Benoît, January 12, 1827 [Paris]; quoted in Bénédite 1931, vol. 1, pp. 21, 43).

Early January

■ New Year's Wishes

Théodore sends his father holiday greetings with "my drawings and my work and if I could send you something that would please you more, I would do it" (Letter from Théodore Chassériau to his father, Benoît [early January 1827, Paris]; published in Prat 1988-1, vol. 2, no. 4, p. 973).

January 12

■ Visits from the Creditors

Frédéric writes to his father, who left seventeen days before (see above, *December 26, 1826*): "The worst for us is the visits from the creditors and the fear of not being able to pay them. . . . The enclosed drawings were done by Théodore. They are completely from his hand, copied from originals that I bought him. You can see that he is

making progress" (Letter from Frédéric Chassériau to his father, Benoît, January 12, 1827 [Paris]; quoted in Bénédite 1931, vol. 1, pp. 21, 43).

May 28

■ Letter from His Father

Théodore writes back: "My dearest Papa, I received your letter which gave me great pleasure, I give you a big kiss" (Letter from Théodore Chassériau to his father, Benoît, May 28 [1827], [Paris]; published in Prat 1988-1, vol. 2, no. 2, p. 973).

June–September (?)

■ Missing His Father

Théodore expresses the desire to join his father three times: "I beg you to tell me if you want me to come with Mummy to you"; "I give you a big kiss. I beg you to write me if you want to take

me with you or if you want to take me to Paris"; "Thank you for the money you sent me, I hasten to take [*sic*] to go to you" (Letters from Théodore Chassériau to his father, Benoît [June–September (?), 1827, Paris]; published in Prat 1988-1, vol. 2, nos. 6, 7, 8, p. 973).

October 14

■ His Father's Reply

Benoît Chassériau writes to his son: "Yes my dear Théodore when I call for your good Mama I will have you come with her, or rather I will join you all myself, which seems much better to me, in the meantime apply yourself to your studies, write me, send me some of your drawings" (Letter from Benoît Chassériau to his son Théodore, October 14 [1827], Saint Thomas; published in Prat 1988-1, vol. 2, no. 23, p. 975).

January 1

■ The Beautiful Album

Théodore offers his family a "beautiful album of calligraphic compositions" that his teacher at the Institution Lormier had collected (Bénédite 1931, vol. 1, p. 41).

January 23

■ The 49 Lessons

Théodore sends his father "a few little Drawings" and writes proudly: "Here are 49 lessons that I am taking" (Letter from Théodore Chassériau to his father, Benoît, January 23, 1828, Paris; published in Prat 1988-1, vol. 2, no. 12, p. 973).

March 29

■ The Drawing Master

Frédéric tells his father that "Théodore has a drawing master" (Letter from Frédéric Chassériau to his father, Benoît, March 29, 1828 [Paris]; quoted in Bénédite 1931, vol. 1, p. 41). This is confirmed by Théodore: "I will tell you that I am learning to draw" (Letter from Théodore Chassériau to his father, Benoît [late March 1828, Paris]; published in Prat 1988-1, vol. 2, no. 18, p. 974).

April 20

■ Wishing for His Father

Théodore receives a letter from his father and answers: "My dear Papa I kiss you with all my heart. O my dear Papa, how I would like to see you. . . . I received your letter, which gave me great pleasure, send them to me often" (Letter from Théodore Chassériau to his father, Benoît, April 20, 1828, Paris; published in Gállego 1955, p. 54; Prat 1988-1, vol. 2, no. 9, p. 973).

Early (?) June

■ The Young Artist in Calais

Théodore goes to Calais at the invitation of Mlle Lebon, a friend of Frédéric, who writes to

his father: "We agreed to it to please the young artist, who is very fond of traveling. And of course the change of air will be good for his health" (Letter from Frédéric Chassériau to his father, Benoît [June] 1828 [Paris]; published in Bénédite 1931, vol. 1, p. 44). Several weeks after his arrival, Théodore writes to his mother: "I am feeling well in Calais and have even been told that I have gained some weight and that my cheeks have a bit more color" (Letter from Théodore Chassériau to his mother, Marie-Madeleine [June–July 1828, Calais]; published in Prat 1988-1, vol. 2, no. 14, p. 974).

On October 7, back in Paris, he would summarize his three-month stay in Calais in the following terms: "I had a lot of fun, I saw the sea, where I really wanted to go. I would have brought you [crossed out] sent the map of the harbor if they had not wanted to keep it. My dear Papa you do not know that I made a fortune in Calais, that I sold my drawings twenty-three sous apiece and that many people bought them" (Letter from Théodore Chassériau to his father, Benoît, October 7, 1828, Paris; quoted in Bénédite 1931, vol. 1, p. 44; published in Gállego 1955, p. 54; Prat 1988-1, vol. 2, no. 10, p. 973).

August 2

■ Théodore's Education

Frédéric writes to his father: "It is time to take care of this dear brother's education and I will give it all my attention as soon as he arrives" (Letter from Frédéric Chassériau to his father, Benoît, August 2, 1828 [Paris]; quoted in Bénédite 1931, vol. 1, p. 44).

■ The Father's Drawings

Benoît Chassériau thanks his son: "I received your nice little letter and wait for the drawings you promised" (Letter from Benoît Chassériau to his son Théodore, August 2, 1828, Saint Thomas; published in Prat 1988-1, vol. 2, no. 21, p. 975).

August 30

■ Return from Calais

Frédéric writes to his father: "Théodore is back from Calais, in good health and loaded with engravings that were offered to him by the admiring folks in Calais." Frédéric also informs him that he wants to enroll his brother in another school, "a good boarding school" located in the rue Richer (Letter from Frédéric Chassériau to his father, Benoît, August 30, 1828 [Paris]; quoted in Bénédite 1931, vol. 1, pp. 41, 44).

September 15

■ A New School

Frédéric writes to his father: "Théodore has made noticeable progress in drawing; he is going to a new school on the fifteenth of the month, and I will take it upon myself to keep a close eye on his education, for he is a charming boy, very sensitive, and endowed with the best of natures" (Letter from Frédéric Chassériau to his father, Benoît, September 13, 1828 [Paris]; quoted in Bénédite 1931, vol. 1, pp. 41–42). Théodore and Ernest were admitted as boarding students to the Institut Ronet, rue de Clichy.

October 7

■ "Little Drawing"

Théodore writes to his father about his stay in Calais (see above, *Early [?] June*) and ends his letter with: "My dear Papa, I send you a little drawing and a head that I drew at my drawing master's" (Letter from Théodore Chassériau to his father, Benoît, October 7, 1828, Paris; quoted in Bénédite 1931, vol. 1, p. 44; published in Gállego 1955, p. 54; Prat 1988-1, vol. 2, no. 10, p. 973).

November 30

■ Attachment to His Father

Théodore writes to his father: "I received your letter, which made me very happy and hope that you will write me often and I write this one to

prove my attachment to you and my wish to see you again. . . . Since I do not often have occasion to write I send you a drawing that has not been corrected" (Letter from Théodore Chassériau to his father, Benoît, November [30], 1828 [Paris]; quoted in Bénédite 1931, vol. 1, p. 44; published in Prat 1988-1, vol. 2, no. 15, p. 974).

February 28

■ Frédéric Resigns

Frédéric resigns from his job in the shipping-insurance department of the Compagnie d'Assurance Générale (Bénédite 1931, vol. 1, p. 31) to devote himself to "Adèle's and Théodore's education. . . . Théodore shows signs of promise, he will have to be given a good primary education now and be prepared to apprentice in a studio" (Letter from Frédéric to his father, Benoît, February 28, 1829 [Paris]; published in Bénédite 1931, vol. 1, pp. 34–35).

■ Frédéric Intervenes for His Father

Acting on his father's wish to be granted a permanent appointment, Frédéric solicits the authorities at the Ministry of the Navy and the Ministry of Foreign Affairs. He "goes to see all the directors, ministers, or their friends, in turn, M. de Saint-Hilaire, M. de Rayneval, M. de la Ferronays, M. de Mackau, General Belliard—an old friend from the Egyptian campaign—M. de Fleury, M. Hyde de Neuville" (Bénédite 1931, vol. 1, p. 35).

March 23

■ For My Dear Papa

Théodore sends his father a letter that ends with: "It has been a long time since you wrote, my dear Papa, and I hope you will write me more often. Farewell my dear Papa and here are my most tender kisses" (Letter from Théodore Chassériau to his father, Benoît, March 23, 1829 [Paris]; published in Prat 1988-1, vol. 2, no. 13, pp. 973–74).

June–September (?)

■ The Father Returns

Benoît Chassériau leaves the island of Saint Thomas at an unknown date and returns to France with the intention of bringing his wife and his daughter, Adèle, back to Saint Thomas with him (Bénédite 1931, vol. 1, p. 20). His stay in Nantes is documented (see below, *December 5 or 6* and *December 8, 1829*). His presence in Paris is suggested only by the following document.

■ Emma Chassériau's Salon

Emma Chassériau, the sister of the painter Eugène-Emmanuel Amaury-Duval (1808–1885) and the wife of Adolphe Chassériau, a cavalry lieutenant and Théodore's first cousin, invites her aunt, Théodore's mother, to an evening party at which "there will also be a tenth Muse, Delphine Gay, her mother, and the whole family. As these ladies are curious sorts I hope that will tempt you. My uncle, who was once one of the mainstays, threatens to ruin our evenings by his lack of courage in putting up with the boredom. Yet he knows how happy he makes us. Beg Théodore to think of us, too, and may all the pretty nieces come along" (Letter from Emma Chassériau to Marie-Madeleine Chassériau [1829 (?), Paris]; published in Bénédite 1931, vol. 2, pp. 371–73). The allusion to the "uncle"—that is, Benoît Chassériau—suggests that he was in Paris. Bénédite recommends dating this letter to 1836, "Benoît Chassériau's last year in Paris" (Bénédite 1931, vol. 2, p. 371). However, the reference to Delphine Gay and her mother suggests that the former was not yet married to Émile de Girardin. Their wedding took place on May 31, 1831, and Emma Chassériau was one of the attendants (Janin 1979, vol. 3, p. 403 n. 3).

■ The Muse Delphine

The young Théodore's meeting with Delphine Gay is confirmed by Chevillard: "He had been introduced to Mme Émile de Girardin as a young man, and remained for the rest of his life under the spell of the woman who came to be called 'the Muse.' Legend has it that he gave his Susanna the fleeting grace and somewhat ponderous splendor of his lady friend's shoulders" (Chevillard 1893, p. 159). The painting he refers to, *Susanna and the Elders* (cat. 15), was exhibited at the Salon of 1839 (see below, *March 1, 1839*).

December 5 or 6

■ Departure of Théodore's Mother and Sister

Marie-Madeleine and the nineteen-year-old Adèle leave Paris to join Benoît in Nantes, where he is "liquidating his last belongings" (Bénédite 1931, vol. 1, p. 21). The three were to sail from Nantes to Saint Martin, while Théodore, Aline, and Ernest remain in Paris in the care of their twenty-two-year-old brother, Frédéric.

■ Several Years' Separation

Frédéric Chassériau urges his sister Adèle to get over her sadness: "These few years will soon pass: the important thing is not to waste them, in order to guarantee us a peaceful future" (Letter from Frédéric Chassériau to his sister Adèle, Sunday, December 6, 1829 [Paris]; published in Bénédite 1931, vol. 1, p. 27).

December 7

■ Arrival in Paimbœuf

As soon as she arrives in Paimbœuf, en route to Nantes, Adèle writes to Frédéric: "How cruel it is, your absence and that of the children!" (Letter from Adèle Chassériau to her brother Frédéric, December [7], 1829, Paimbœuf; published in Bénédite 1931, vol. 1, p. 23). In response, Frédéric clearly explains what is expected of her: "Bring some order and economy into the house, write down your expenses. Our speedy reunion depends upon it" (Letter from Frédéric Chassériau to his sister Adèle, Monday, December 7, 1829 [Paris]; published in Bénédite 1931, vol. 1, p. 27). Théodore writes to his father: "My dear Papa, my health is almost recovered, we have more quiet, and I will be happy to have Ernest stay with me. . . . I send a kiss to my dear Adèle and will write her at length either in Nantes or in Saint Thomas" (Letter from Théodore Chassériau to his father, Benoît [December 7, 1829, Paris]; published in Prat 1988-1, vol. 2, no. 17, p. 974).

December 8

■ Arrival in Nantes

Marie-Madeleine Chassériau writes to Frédéric: "I have arrived and am at your father's side, and I already feel a gentle consolation for my sorrow" (Letter from Marie-Madeleine Chassériau to her son Frédéric, December 8, 1829 [Nantes]; published in Bénédite 1931, vol. 1, p. 21). For her part, Adèle writes: "I must admit that my courage fails at the thought of such a long and difficult separation. . . . Tell Théodore that I will write him soon, and I urge him, in the name of my friendship toward him, to be obedient and to take care of himself" (Letter from Adèle Chassériau to her brother Frédéric, December [8], 1829 [Nantes]; published in Bénédite 1931, vol. 1, pp. 24–25). From the ship, Benoît offers this last piece of advice: "Do not forget to buy a cap for Théodore and do not let him go to his studio until he is completely recovered. Hide nothing about his condition from us" (Letter from Benoît Chassériau to his son Frédéric, December [8], 1829 [Nantes]; published in Bénédite 1931, vol. 1, p. 25).

December 9

■ Sailing for Saint Martin

According to Adèle, she and her parents depart at "seven in the morning" (Letter from Adèle Chassériau to her brother Frédéric, December [8], 1829 [Nantes]; published in Bénédite 1931, vol. 1, p. 23).

Mid-December

■ Change of Apartment

Frédéric moves with his two brothers and his sister to a new apartment at 14, rue Cadet. Three families in the same building—the d'Arnauds, the de Restes, and the Gautiers—assist Frédéric in educating his siblings (Bénédite 1931, vol. 1, p. 40).

■ Nickname

Mlle de Reste, the daughter of Théodore's neighbors, nicknames him "Lantara," after Simon-Mathurin Lantara (1729–1778), a landscape painter considered a forerunner of the Barbizon School and an early bohemian (Bénédite 1931, vol. 1, p. 40).

■ Change of Address

At some unknown date in 1828 or 1829, the Chassériau family moves to 14, rue Cadet, from 2, rue de Provence (Bénédite 1931, vol. 1, p. 39, n. 1).

January 14

■ Sadness and a New Drawing Master

Frédéric explains to his father the "impression" the new boarding school made on his brother: "Théodore was extremely chagrined at first because he was afraid he would not be able to draw there as much as he wanted to; but after he saw his new master, to whom he was well recommended, he was comforted. He has completely recovered from his indisposition. He is gaining weight and looking better. M. Ronet likes him very much and will let him draw in his own parlor, so that he will be warmer" (Letter from Frédéric Chassériau to his father, Benoît [January 14, 1830, Paris]; quoted in Bénédite 1931, vol. 1, p. 45).

March 1

■ Premature Return of Théodore's Mother and Sister

In a sad letter, Benoît gives the exact date of his wife and daughter's departure from the island of Saint Martin (Letter from Benoît Chassériau to his son Frédéric, March 1, 1830 [Saint Thomas]; quoted in Bénédite 1931, vol. 1, p. 41). A week later, he writes to his wife, saying he is "once again left abandoned and isolated on this dismal rock" (Letter from Benoît Chassériau to his wife, Marie-Madeleine, March [8], 1830 [Saint Thomas]; quoted in Bénédite 1931, vol. 1, p. 28).

The reasons for this departure remain unclear, as they were to have stayed for several years. "What happened? Did life on the islands not suit Mme Chassériau's health? Could she no longer bear living so far away from her children? We do not know" (Bénédite 1931, vol. 1, p. 42). Yet, Frédéric had suggested the possibility of an early return even before his family left Nantes: "My dear good Adèle. . . . Keep in mind what I have told you so often: If the climate and the country do not suit you, you have to come back immediately, and I will deal with Papa" (Letter from Frédéric Chassériau to his sister Adèle, Monday, December 7, 1829 [Paris]; published in Bénédite 1931, vol. 1, p. 27).

April 24

■ Marie-Madeleine and Adèle Arrive in France

This date is mentioned in a letter from Frédéric to his mother (quoted in Bénédite 1931, vol. 1, p. 42).

June 24

■ The Father's Jealousy

Benoît receives a letter from Théodore that was intended for his wife, who had left for Paris more than two months before: "I received in your name a charming letter from Théodore and I must confess to being a little jealous, and so I am not forwarding it to you. I will confiscate it for my sake and wait until it pleases him to write me in a similar vein and send the pictures he promised" (Letter from Benoît Chassériau to his wife, Marie-Madeleine, June 24, 1830 [Saint Thomas]; quoted in Bénédite 1931, vol. 1, p. 49).

■ Progress in Drawing

Probably after arriving in Paris, Adèle writes to her father: "Théodore is still drawing and with much taste; he will send you several of these drawings so that you can judge his progress for yourself" (Letter from Adèle Chassériau to her father, Benoît [April (?) 1830, Paris]; quoted in Bénédite 1931, vol. 1, p. 45).

July 17

■ Portrait of Little Ernest

Théodore sends his father a long letter: "I am still in boarding school with little Ernest, who is very nice and has grown a lot, if you came now, you would take him for me. He is well taken care of. . . . Dear Papa you ask me for drawings. I am sending you one and doing a very large one. I am waiting for vacation to do one of my little sister Aline as a companion piece for the one of my brother. I hope you will be satisfied with me" (Letter from Théodore Chassériau to his father, Benoît, July 17, 1830, Paris; quoted in Bénédite 1931, vol. 1, pp. 47–48; published in Prat 1988-1, vol. 2, no. 19, p. 974).

July 24

■ Painter and Poet

Benoît Chassériau thanks his son: "I received the portrait you sent and find it an excellent likeness. . . . I also received your beautiful verses and must frankly admit that it was already enough to find a painter in you, without having to flatter myself with also finding a poet. . . . M. Audun thanks you for your note that he will answer, and is impatient to see your pictures. I would be glad myself to have one to complete the decoration of my room, where I already have two of yours" (Letter from Benoît Chassériau to his son Théodore, July 24, 1830, Saint Thomas; quoted in Sandoz 1974, nos. 1, 2, p. 96, and 1986, p. 83; published in Prat 1988-1, vol. 2, no. 20, pp. 974–75).

August

■ Théodore and the July Revolution

The young painter writes to his father: "We are still in boarding school, and our teacher is very kind to us. . . . I am still working at drawing, the sudden revolutions in Paris kept me from doing my usual schoolwork, so that I can send you only a little drawing done in a hurry. Rest assured, dear Papa, that I will not neglect you" (Letter from Théodore Chassériau to his father, Benoît [August 1830], Paris; quoted in Bénédite 1931, vol. 1, p. 48; published in Prat 1988-1, vol. 2, no. 16, p. 974).

September 1830

■ Ingres's Studio

Théodore's difficulty adapting to boarding-school life (see above, *January 14, 1830*) leads to the decision to join Ingres's studio. Chevillard writes: "His character soured and his health changed. After one holiday, as the hour to return approached, he had such a violent fit of despair that his anxious brother seriously questioned him. Théodore said that he wanted to be a painter and

to enter M. Ingres's studio. He was ten years old at the time" (Chevillard 1893, p. 12). The decision to comply with this wish is no doubt made easily, as Frédéric Chassériau had already thought about having him "apprentice in a studio" on February 28, 1829 (see above). The painter Amaury-Duval, a distant cousin and himself a disciple of Ingres, presents Théodore to the "master" (Amaury-Duval 1878, p. 116, and 1993, p. 199; Chevillard 1893, p. 12; Bénédite 1931, vol. 1, p. 52). Théodore turns eleven on September 20, 1830.

■ Fellow Pupils

Over the next four years, Théodore would befriend fellow students of Ingres, the painters Henri Lehmann, Hippolyte Flandrin (Chevillard 1893, p. 13), Claudius Lavergne, Victor Mottez, and Jules Ziegler (Bénédite 1931, vol. 1, pp. 57, 63). About 1831, Louis-Victor Lavoine, "one of the most talented pupils in the studio" (Amaury-Duval 1878, p. 117, and 1993, p. 201), would paint his portrait (Chevillard 1893, p. 6; Bénédite 1931, vol. 1, p. 3). About 1833, Chassériau would draw portraits of several fellow students: Comeyras asleep (Musée Carnavalet; Sandoz 1986, no. 177, p. 179; Prat 1988-2, no. 1, p. 13), Charles Damour (private collection), and another fellow apprentice, possibly Adolphe Leleux (private collection; Prat 1988-2, no. 3, p. 13). He would paint a portrait of another student, Alphonse Hennet de Goutel, in 1835 (Sandoz 1974, no. 12, p. 104). The studio is probably where he met Jules Amiel, whose wife's portrait he would paint in 1845 (Prat 1988-2, no. 119, p. 21).

■ *The Daughter of El Greco* and *The Artist's Color Grinder*

Among the paintings he executes in Ingres's studio is a copy (of about 1833–34) of a picture then attributed to El Greco, which, according to Chevillard, "earned him the praise even of Ingres, whose coarse and grudging sincerity was devoid of the art of flattery": The illustrious director of the Villa Medici in Rome would call it "a master interpreted by a master." Proud of his work, Théodore refuses to part with the picture and tells Frédéric that he intends to give it to their family (Chevillard 1893, p. 168; Sandoz 1974, no. 6, p. 100; see cat. 5). There is also the "head of a child in the antique style [and] the portrait of a little boy who ground the pigments for Ingres's pupils" (Chevillard 1893, pp. 168, 171).

■ The Napoleon of Painting

Chevillard relates the following anecdote: "One day, while we were drawing from a live model, Ingres paused in front of [Théodore's] composition and, after having looked at it, called all the pupils, saying: 'Come, gentlemen, come see, this child will be the Napoleon of painting.'" He would be the master's favorite for a long time, and Ingres considered him the most faithful "disciple of his principles and his true artistic heir" (Chevillard 1893, p. 13). Ingres's comment was relayed by the painter Pasini, one of Théodore's friends, to Baron Arthur Chassériau (Bénédite 1931, vol. 1, p. 58).

June

■ The Father's Return and a Portrait

The exact date of Benoît's return to Paris is not known. He seems to have been dismissed from his post in Saint Thomas because of an anonymous denunciation (see above, *1819*). Benoît is made honorary vice-consul of Saint Thomas (Archives du Ministère des Affaires Étrangères, dossier Benoît Chassériau, 1st series, 889), but it is not known when he leaves Paris to resume his duties.

Théodore draws his father's portrait, signing it "T.C." and dating it "June 1831" (Musée du Louvre; Sandoz 1986, no. 1, p. 13; Prat 1988-1, vol. 2, p. 971).

September

■ Portrait of an Infanta

Théodore draws a portrait, inscribed "Pantoja—Infanta of Spain—Sept.bre 1832," after a painting then attributed to Van Dyck (Sandoz 1982, pp. 18–20 n. 6, and 1986, nos. 254–256, p. 220; Prat 1988-1, no. 2199, p. 748).

■ Portrait Painting of Benoît Chassériau

Théodore paints his father's portrait and signs it "TC 1832" (Musée du Louvre; Sandoz 1974, no. 3, p. 96).

October 5

■ Enrollment at the École des Beaux-Arts

Angrand (1982, p. 37) gives the exact date of Théodore's registration at the school and mentions that October 1, 1833, was a memorable day for Ingres, for the first three places in the Grand Prix de Rome were awarded to pupils of his.

November

■ The Ingres Studio Closes

Ingres prepares to leave Paris in early December, having been appointed director of the Académie de France (Villa Medici) in Rome. Before his departure, his pupils decide to buy him a present and entrust Théodore, his favorite pupil, "with choosing the object and presenting it to the master in their name" (Chevillard 1893, p. 13). This gift is probably the cup with the dedicatory inscription "To J. Ingres with thanks from his pupils," which is now in the Musée Ingres, Montauban (Vigne 2000, p. 19, ill.).

■ Grand Prix de Rome: Dashed Hopes

The closing of Ingres's studio is a harsh blow for Théodore, for it had been assumed that he would "compete for the Prix de Rome, and there was no doubt of his winning" (Baignères 1886, p. 210). According to Chevillard, Ingres asks Théodore to follow him to Rome, "offering to open the doors of the Villa Medici to him as a friend and to continue giving him lessons" (Chevillard 1893, p. 14). The Chassériau family, however, is unable to finance this trip (see below, *February 1* and *November 29, 1835*).

■ A New Appointment for the Father

Benoît Chassériau is appointed honorary consul of San Juan, Puerto Rico (Archives du Ministère des Affaires Étrangères, dossier Benoît Chassériau, 1st series, 889; Bénédite 1931, vol. 1, p. 16, gives 1835 as the date of this appointment).

February 1

■ Plans for Rome

Frédéric Chassériau explains to Ingres that he cannot send Théodore to Rome at the moment, but that his brother is "heartened by the hope I have given him that this good fortune has only been postponed; and I am making arrangements so that he can leave in May at the latest. . . . Despite the despair your departure has caused, he has not stopped pursuing the wonderful path that you have paved for him" (Letter from Frédéric Chassériau to Ingres, February 1, 1835, Paris; published in Bénédite 1931, vol. 1, p. 59). This trip would be postponed again for financial reasons (see below, *November 29, 1835*).

July

■ Trip to La Ferté-sous-Jouarre

In June, M. de Reste, a friend of the Chassériau family, writes to Frédéric: "We were very pleased to hear from you that Théodore is coming soon. I have a short trip planned for the end of the month, but will be back around the first of July, in time for Théodore's arrival. I will write more specifically on this, so that Théodore can delay his departure for a few days should I be away longer than planned" (Letter from M. de Reste to Frédéric Chassériau, June 16, 1835, La Ferté-sous-Jouarre; published in Bénédite 1931, vol. 1, p. 70). La Ferté-sous-Jouarre is near Meaux, east of Paris.

August (?)

■ Trip to Monfort-l'Amaury

Chassériau appears to have accompanied Prosper Merimée, then Inspector General of Historic Monuments, to examine the condition of the sixteenth-century windows of the Church of Saint-Pierre in Monfort-l'Amaury (near Rambouillet, southwest of Paris). This is where he would have seen the *Temptation of Christ* that inspired his own version, commissioned by Ingres (see below, *November 19, 1836;* Lacambre 1995, p. 345).

September 27

■ Friendship with Marilhat

The landscape painter Prosper Marilhat (1811–1847), writing from Venice, asks his sister, Élisabeth Andrieux, to give him Théodore Chassériau's address (Letter from Prosper Marilhat to Élisabeth Andrieux, September 27, 1835, Venice; quoted in Menu 1978, pp. 48, 192; Peltre 2001, pp. 119–20). Chassériau's portrait of Marilhat is also dated 1835 (Musée du Louvre; Sandoz 1974, no. 13, p. 104; see fig. 6, p. 193).

November 28

■ Costume Ball at the Impasse du Doyenné

Théophile Gautier, Gérard de Nerval, and their bohemian friends organize a costume ball and

have the room decorated by several painters, including Chassériau, who had just turned sixteen. He "painted a *Diana and Her Nymphs Bathing* with a fierce charm and strange grace that impressed us deeply" (Gautier, October 13, 1856; Bénédite 1931, vol. 1, p. 55). Other panels are painted by Marilhat, Corot, Adolphe Leleux, Célestin Nanteuil, Camille Rogier, and Lorentz. Chassériau also paints a *Bacchante and Faun Holding Tigers on a Leash* that Nerval saves from destruction (Nerval, July 1, 1852; Sandoz 1974,

nos. 4, 5, p. 98; Guégan 2001, pp. 248, 253 n. 5; Peltre 2001, pp. 53–54).

November 29

■ Rome: Further Delays

Benoît Chassériau is deeply "concerned" by the continual postponement of Théodore's trip to Rome (see above, *February 1, 1835*), but agrees that it would have been unwise to send him to a country ravaged by cholera. Nothing should

stand in the way of "this trip next spring, and I will do everything in my power until then to send you a sum of from 12 to 1500 francs, which is to be used especially and solely for this purpose. I am happy to hear that he is working, and, as he is quite young, I still hope that this will not have been lost time" (Letter from Benoît Chassériau to his son Frédéric, November 29, 1835 [San Juan, Puerto Rico]; published in Bénédite 1931, vol. 1, pp. 58–59).

■ 1836

January–February (?)

Small Studio, in the rue Saint-Augustin

Chassériau rents a "small studio in the rue Saint-Augustin" and prepares his works for the Salon of 1836 (Chevillard 1893, p. 14).

Early February

■ Recommendation

To ensure that the works submitted by Chassériau to the Salon of 1836 are well placed, Mme Caillot writes "cordially" to the director of the Louvre (the comte de Forbin). She describes Théodore as being "like a Creole, a friend of her family." The naval lieutenant Dubernad mentions this reference in his letter to Frédéric of March 17, adding: "I hope that the director of the museum will take this letter into account, for it expresses nothing but our own sentiments, and also that he will have suitably placed your brother's work, which deserves complete success in so many respects" (Letter from Lieutenant Dubernad to Frédéric Chassériau, March 17, 1836 [Marseilles (?)]; quoted in Bénédite 1931, vol. 1, pp. 83–84).

February 15

■ The Salon Jury

Four paintings by Chassériau are accepted (8th session of the jury, February 15, 1836; Archives des Musées Nationaux, *KK. 53, nos. 1825–1828).

March 1

■ Salon of 1836

The sixteen-year-old Chassériau participates for the first time in the Salon. The exhibition catalogue (*Explication des ouvrages de peinture, sculpture, architecture, gravure et lithographie des artistes vivants exposés au musée royal le 1er mars 1836* [Paris 1836], p. 42) lists his entries as follows:
Chassériau (T.), 59, r. Neuve-St-Augustin.
[no.] 336 – The Punishment of Cain (39 ⅛ x 52 ⅛ in.; property of M. E. Arago; Sandoz 1974, no. 25, p. 118).
[no.] 337 – Return of the Prodigal Son (65 ¼ x 52 ⅛ in.; property of M. Cossade; Sandoz 1974, no. 26, p. 120).
[no.] 338 – Portraits, *same number*.
According to Marc Sandoz, no. 338 included four portraits: the *Portrait of Emmanuel Arago*, whereabouts unknown (Sandoz 1974, no. 28, p. 122); the *Portrait of the Marquise de Caussade* (not "Cossade"), oval format (40 ⅛ x 31 ⅞ in.), Musée National des Beaux-Arts, Algiers (Sandoz 1974, no. 9, p. 102); the *Portrait of the Painter*

Prosper Marilhat (50 ¾ x 38 ⅛ in.), Musée du Louvre (Sandoz 1974, no. 29, p. 124); and the *Portrait of Ernest Chassériau* (36 ¼ x 28 ¾ in.), signed "T. Chassériau," donated in 1933 to the Musée du Louvre by Baron Arthur Chassériau (Sandoz 1974, no. 29, p. 124). Actually, the register of the Salon of 1836 mentions only two portraits: no. 1827, a "portrait of a man [49 ¼ x 41 ⅜ in.]," and no. 1828, a "portrait of a young man [43 ¼ x 35 ⅜ in.]." The dimensions given include the frames (Archives des Musées Nationaux, *KK. 30). No. 1828 obviously corresponds to the *Portrait of Ernest Chassériau* (cat. 4).

March 11

■ The Trip to Rome Postponed Again

Benoît Chassériau admits to having serious financial difficulties: "I have never given so much thought to money and I swear to you that I have never been so frugal. When I think—in the midst of all the other things I am legitimately preoccupied with—that the time for Théodore's trip is coming up and that he must at all costs make this trip on which his entire future depends, I blame myself for not having already dissolved everything" (Letter from Benoît Chassériau to his son Frédéric, March 11, 1836 [San Juan, Puerto Rico]; published in Bénédite 1931, vol. 1, p. 59). The trip had been canceled before (see above, *November 29, 1835*) and would not take place before June 27, 1840 (see below).

April 30

■ First Medal

Cailleux, assistant director of the Musées Royaux, lists Chassériau's name under no. 338 in a report titled "Account of the medals that could be awarded to the artists after the Salon of 1836." Baron Fain approves the proposal, "after having received the King's orders" (Archives des Musées Nationaux, dossier 10, Salon de 1836). Théodore is awarded a third-place medal in the "History" category (Bénédite 1931, vol. 1, p. 72). His father would be very proud (Letter from Benoît Chassériau to his son Frédéric, August 4, 1836, San Juan, Puerto Rico; quoted in Bénédite 1931, vol. 1, p. 72).

May

■ Portrait of His Mother

Chassériau paints the portrait of his mother, Marie-Madeleine. According to Bénédite (1931, vol. 1, p. 21), she signed her name "Léonide," and played a rather unobtrusive role in the family.

The portrait (oil on canvas, 40 ⅛ x 32 ¼ in.) is signed and dated "T. Chassériau mai 1836" (Musée du Louvre; Sandoz 1974, no. 24, p. 116).

May–June (?)

■ First Commission for a Historical Portrait

According to Chevillard, a portrait of the duc de La Rochefoucauld was commissioned in 1837, the year in which Chassériau obtained commissions for two copies of portraits, through Cailleux, the assistant director of the Musées Royaux (see below, *April 30, 1837*), but no record of this has been found in the archives. However, on July 30, 1836, Frédéric Chassériau informs his brother (who had just arrived at his friend Albert Gilly's estate, La Vernède; see below) that he has received a "money order from the Commission des Beaux-Arts concerning payment of one hundred ecus for the copy of the Versailles portrait" (Letter from Frédéric Chassériau to his brother Théodore, July 30, 1836 [Paris]; quoted in Bénédite 1931, vol. 1, p. 73).

Chassériau's *Portrait of the Duc de La Rochefoucauld*, after an original from 1680, is in the Musée National du Château de Versailles (Chevillard 1893, p. 23; Sandoz 1974, no. 32, p. 126).

Health Problems

A letter from Victor de Tracy to the young painter shows that the latter's health was as fragile as ever: "I dare to hope that, in spite of constant work, and thanks to the benefits of homeopathy, this indisposition will have ended, or at least become a lot less inconvenient" (Letter from Victor de Tracy to Théodore Chassériau [May–June (?)] 1836, n.p.; quoted in Bénédite 1931, vol. 1, p. 72). On his relationship to the de Tracy family, see below, *January 1, 1851*.

According to Bénédite, Chassériau's poor health was the reason for his trip to see his childhood friend Albert Gilly (see below, *July 15, 1836*).

June

The Bathers of Riancourt

A number of drawings of swimmers and horsemen in the water, one of which bears the annotation "Riancourt Juin 1836," are in the Musée du Louvre (Prat 1988-1, vol. 2, p. 782, folios 14 v., 15 r., p. 794, fol. 27 v.). Chassériau himself had a fondness for water (see below, *August 2, 1836*). Riancourt is located in the department of Ille-et-Vilaine, near Saint-Malo. There is no record of Chassériau's stay there.

July 15

Departure from Paris

According to a letter from his brother dated July 18, Chassériau seems to have left Paris on the 15th. On his way to visit the Gilly family, he stops in Troyes, then in Avignon, arriving at La Vernède at the end of the month (Bénédite 1931, vol. 1, p. 73).

Visit to the Foundries at Le Creusot

Little is known of Chassériau's itinerary, but his presence in Le Creusot, after his stay in Troyes, is attested by a drawing with the inscription "Creusot / juillet 1836." This watercolor-and-pencil drawing of workers inside a foundry is in the Musée du Louvre (Bénédite 1931, vol. 1, p. 41; Prat 1988-1, vol. 2, no. 1717, p. 623). The social commentary implied in this drawing has left most of his biographers puzzled.

The Cathedral of Avignon

Chassériau draws the frescoed porch of a church, which has been identified by Dominique Cordellier as the Cathedral of Notre-Dame-des-Doms; the frescoes are by Simone Martini and date to 1340–44. According to Prat (1988-2, vol. 2, no. 2182, p. 742), this drawing was made during the painter's travels in Provence.

Late July

Arrival at La Vernède

Albert Gilly lived with his father on a "beautiful estate, La Vernède, near Remoulins, in the department of Gard, along the Gardon River with its famous Roman aqueduct, not far from the Rhône Valley" (Bénédite 1931, vol. 1, p. 73). Frédéric Chassériau informs his brother immediately of the receipt of payment for his copy of the portrait at Versailles (see above, *May–June* [?] *1836*), as well as of the 500 francs for his *Punishment of Cain*, which had been exhibited at the previous Salon (Letter from Frédéric Chassériau to his brother Théodore, July 30, 1836 [Paris]; Bénédite 1931, vol. 1, p. 73).

August 2

The Joys of Nature

Chassériau relaxes and goes swimming. He writes to Frédéric: "Reassure mother about the dangers of swimming. The current of the Rhône is too strong; we swim in a little pond in which we always have our footing. . . . The banks of the Rhône are superb. It is like the landscape in Italy or the Orient, beautiful mountains, barren and austere, an abundant and powerful vegetation. I have already done a few sketches and one study." He would return with "piles of stones" for his friend Jules Monnerot (Letter from Théodore Chassériau to his brother Frédéric, August 2, 1836 [La Vernède]; quoted in Bénédite 1931, vol. 1, pp. 73, 76, 82). According to Prat (1988-2, vol. 2, no. 1718, p. 624), he had already executed the drawing inscribed "juillet 1836," depicting harvesters and an ox-drawn cart with hay, at La Vernède.

August 3

Hurried Departure from La Vernède

Chassériau receives a letter from his brother informing him that their cousin Frédéric Chassériau, an architect in Marseilles (Chevillard 1893, pp. 23–24), has obtained a commission for him for a series of portraits for one of that city's most distinguished families. The letter ends with: "You know that it is not up to me to give you any advice, it is up to you to think about it and see if you can reconcile art and fortune, or rather interest, in this case. For I do not think that it means fortune yet. Let me know without delay of your decision. Frédéric's address is rue du Paradis, 137. . . " (Letter from Frédéric Chassériau to his brother Théodore [late July–early August] 1836 [Paris]; quoted in Bénédite 1931, vol. 1, p. 76).

Théodore notifies Frédéric that he is leaving immediately for Marseilles (Letter from Théodore Chassériau to his brother Frédéric [August 3 (?)], 1836, La Vernède; quoted in Bénédite 1931, vol. 1, p. 76).

August 4–6 (?)

Arrival in Marseilles

While staying with his cousin Frédéric, Chassériau becomes acquainted with his "fine family . . . a happy exception to the population of Marseilles, which revolts me beyond words: lies, deceit, all these faults combined" (Letter from Théodore Chassériau to his brother Frédéric [about August 15], 1836, Marseilles; published in Bénédite 1931, vol. 1, p. 81).

His cousin, Baron Frédéric Chassériau (1802–1896), was born in Port-au-Prince, the son of a Creole mother and a general who died at Waterloo (see above, *1819*). After completing his education in 1830, he went to Spain to "fight with the party that wanted to establish a republic, and ended up as General Quiroga's aide-de-camp. Soon after, he traveled to Egypt." Upon his return to France, he settled in Marseilles and was appointed Director of Public Works on May 9, 1833 (Bénédite 1931, vol. 1, pp. 76–79).

About August 15

News from Marseilles: Criticism and Work

Théodore Chassériau gives his brother Frédéric a summary of his activities in Marseilles, starting with criticism of the contacts that Frédéric had recommended: "M. Treillet" and "M. Rambaud." Then he goes on to lambaste his own friends: "In my opinion, it is wrong for you to invite Monnerot and Albert. They are excellent boys to see along with other young people, but presenting them at my mother's displeases me, for their morality is not the best. And you know that they keep me from working sometimes."

His letter also mentions the commission that had occasioned his sudden departure from La Vernède: "I have finished the first portrait. I'm up to the second. I am doing some sketches of Bedouins, who are magnificent. I hope to bring back a pile of studies" (Letter from Théodore Chassériau to his brother Frédéric, August [15 (?)], 1836; published in Bénédite 1931, vol. 1, p. 81).

The Bedouins in question were Kabyles sent from Algeria to Marseilles by General Bugeaud (Bénédite 1931, vol. 1, p. 85).

Mid-August

The Chassériau Family Moves

Frédéric notifies his brother that his room in their new apartment will be well furnished and tells him it would be wise to look for a studio before the other artists return to Paris from the country (Letter from Frédéric Chassériau to his brother Théodore, July 30, 1836 [Paris]; quoted in Bénédite 1931, vol. 1, p. 73). Their new apartment is located at 11, rue de la Victoire (Bénédite 1931, vol. 1, p. 85). Frédéric also writes of the difficulty in finding a studio that is "big, with a northern exposure, light from the ceiling, and as close to the apartment as possible. . . . " (Letter from Frédéric Chassériau to his brother Théodore [August–September] 1836 [Paris]; Bénédite 1931, vol. 1, p. 85). The address of his new studio, as of January 23, 1837, is "R. Ollivier St George N° 11."

August–September

■ A Difficult Portrait: Armand Dubernad

Frédéric asks his brother to paint a portrait of Armand Dubernad, the son of friends of the Chassériau family in Paris (see above, *Early February 1836*), as soon as he arrives in Marseilles: "I promised Mme Dubernad that you would come back with a portrait of her son and I know that you will not deny me this favor; the whole family was so wonderful to us" (Letter from Frédéric Chassériau to his brother Théodore, August [10–15 (?)], 1836, Paris; published in Bénédite 1931, vol. 1, p. 83).

The painter is obviously not very happy about this prospect and starts criticizing "M. Dubernad," but concludes that he would "surely do the portrait you asked me for" (Letter from Théodore Chassériau to his brother Frédéric, August [about 15], 1836, Marseilles; published in Bénédite 1931, vol. 1, pp. 80–82). On the 16th, Frédéric reminds him not to forget "the portraits of Armand Dubernad and of the sick young woman" (Letter from Frédéric Chassériau to his brother Théodore, August 16, 1836, Paris; quoted in Bénédite 1931, vol. 1, p. 83). On August 27, he writes: "Do not forget the portraits of Armand and of Mlle de C . . . but only in pencil" (Letter from Frédéric Chassériau to his brother Théodore, August 27, 1836, Paris; Bénédite 1931, vol. 1, p. 83). By September 30, Théodore still seems to be dragging his feet: "Thank you for your promise to do the promised portrait, and I would have wished that it applied to the other portrait I asked for. I would be obliged if you did both, and I know that you will execute them with the graciousness that adds so much to a favor" (Letter from Frédéric Chassériau to his brother Théodore, September 30, 1836, Paris; Bénédite 1931, vol. 1, p. 83). Sandoz (1974) does not include this portrait in his catalogue.

Mid-October

■ Back in Paris

The exact date of Chassériau's return is unknown. According to Bénédite (1931, vol. 1, p. 85), "He worked quite assiduously in Marseilles, for he prolonged his stay until the beginning of October."

November 19

■ The Master's Favor: Ingres and His Demon

Ingres, then in Rome, asks his friend the engraver Gatteaux to find among his "students the one who best knows how to do a portrait

from a model, and, if you don't find anyone better for me, I believe I can recommend the young Chassériau. . . . See to it that he keeps this absolutely confidential. He should bar the idle from his studio at this time. Since I have no secrets from you, the subject I want to paint is *Christ Chasing the Devil from the Mountain.* As for the pupil, he does not need to know this:

I want only a simple figure of a Negro in this pose. . . . " (Letter from Ingres to Gatteaux, November 19, 1836 [Rome]; published in Delaborde 1870, pp. 319–20; Bénédite 1931, vol. 1, p. 67; Ternois 1986, p. 33).

The picture in question, which was executed by Chassériau (see below, *March 7, 1837,* and *April 10, 1838*), is at the Musée Ingres, Montauban.

December

Preparing for the Next Salon

In his new studio, Chassériau starts working on the *Ruth and Boaz* for the Salon of 1837 (see below, *March 1, 1837*). According to a letter from a friend of the family, to his brother, Théodore finished it in "three months" (Letter from Guillaume to Frédéric Chassériau [April (?)] 1837 [Strasbourg]; quoted in Bénédite 1931, vol. 1, p. 89).

■ 1837

January 20

■ The *Illustrissimo Maestro*

Molin, a friend of the Chassériau family, writes from Saint Croix in the French Antilles: "I was very happy, indeed, to hear of the success of my friend the young painter and hope one day to be able to boast of having my portrait done by the 'illustrissimo maestro'" (Letter from F.-A. Molin to Frédéric Chassériau, January 20, 1837, Saint Croix, French Antilles; quoted in Bénédite 1931, vol. 1, p. 69). The success in question must have been the medal won at the close of the Salon of 1836 (see above, *April 30, 1836*). Neither Bénédite nor Sandoz mentions any portrait of Molin (Sandoz 1974, no. 8, p. 100).

January 23

■ Subscription to *L'Artiste*

Chassériau asks Delaunay, editor of *L'Artiste,* to send him "two plates to execute the two drawings that I promised to Monsieur Janin for my subscription to l'artiste [*sic*]. I was away, which is what kept me from asking you for this favor sooner" (Letter from Théodore Chassériau to A.-H. Delaunay, Monday, January 23, 1837 [Paris]; Médiathèque, La Rochelle, Ms. 621, fol. 223 r.).

The absence mentioned was his trip to the South of France (see above, *Mid-October 1836*).

January (?)

■ Commission from the Comtesse de Rigny

Benoît Chassériau, in a letter in the "first months of the year 1837," is happy to hear that Théodore had received a portrait commission from the comtesse de Rigny; nothing is known of this portrait. (Letter from Benoît Chassériau to his son Frédéric [January–March (?) 1837, San Juan, Puerto Rico]; quoted in Bénédite 1931, vol. 1, p. 89).

February 20 and 21

■ Salon Jury: First Refusal

Chassériau's *Ruth and Boaz* is accepted after a close vote: nine to eight (11th session of the jury, February 20, 1837; Archives des Musées Nationaux, *KK. 54, no. 2954), but on the next day, his *Shipwrecked* is refused (12th session of the jury, February 21, 1837; Archives des Musées Nationaux, *KK. 54, no. 3409).

March 1

■ Salon of 1837

The exhibition catalogue (*Explication des ouvrages de peinture, sculpture, architecture, gravure*

et lithographie des artistes vivants exposés au musée royal le 1er mars 1837 [Paris 1837], pp. 39–40) includes the following entry:
Chassériau (Théodore), *18, r. Neuve-St-Georges.* [no.] 320–Ruth and Boaz
"Then said Boaz unto Ruth: Hearest thou not, my daughter? Go not to glean in another field, neither go from hence, but abide here fast by my maidens. Let thine eyes be on the field that they do reap, and go thou after them" (Ruth 2: 8–9).

■ Lost Pictures

The rejected painting, *Shipwrecked,* measured slightly more than nine by eight feet (with the frame); its present whereabouts are unknown (Archives des Musées Nationaux, *KK. 31, no. 3409). Sandoz catalogued two preparatory drawings with this subject (1974, nos. 16, 30, pp. 108, 124).

The second painting, *Ruth and Boaz,* measured 59 x 70 ⅞ inches framed (Archives des Musées Nationaux, *KK. 31, no. 2954); neither Bénédite nor Sandoz mentions any location. Several preparatory drawings are known (Bénédite 1931, vol. 1, p. 89; Sandoz 1974, no. 33, p. 128). A friend of the family would remark on how quickly this painting had been executed: "I see that your brother took only three months to paint his latest large composition. Such a vast project might perhaps have needed more time to be perfected" (Letter from Guillaume to Frédéric Chassériau, [April (?)] 1837 [Strasbourg]; quoted in Bénédite 1931, vol. 1, p. 89).

■ Strange Oversight

Curiously enough, Chassériau does not go to pick up his *Ruth and Boaz* at the end of the Salon, and it is mentioned as still being in a storeroom at the Louvre three years later, on November 11, 1840 (Archives des Musées Nationaux, dossier 10, Salon de 1840).

March 7

■ Ingres's "Negro"

Responding to his teacher's wishes (see above, *November 19, 1836*), Chassériau begins working on the study of a Negro. Gatteaux traces it and sends it to Ingres, who returns it with his comments. Gatteaux writes to Chassériau: "I send you the tracing I made of the sketch of Joseph that I sent to Rome. You will see other instructions that I received in response, along with explanatory notes written next to them" (Letter from Édouard Gatteaux to Théodore Chassériau, March 7 [1837] [Paris]; published in Prat 1988-1, vol. 2, p. 980, accompanied by the tracing of the *Male Nude Falling into the Void*).

The tracing bears pen-and-ink notations written by Ingres: "Placing oneself more on the

side of the model's heart and lower would correspond more to the movement in my sketch – The line of the pectorals as far outside as possible – the Fist [?] closed tighter—otherwise I am also satisfied with this hand."

April 30

■ Commission for a Historical Portrait

In a report to the senior administrator, Cailleux, the assistant director of the Musées Royaux, suggests offering Chassériau 150 francs to paint a "bust-length portrait of the chancellor du Vair," for one of the rooms in the "Palais de Versailles." Sixteen artists in all, including Belloc, were given similar commissions (Archives des Musées Nationaux, dossier P. 6 1837). Chassériau's portrait of Guillaume du Vair is a copy after an original, of 1621, by Frans Pourbus the Younger, in the Musée du Louvre (Chevillard 1893, p. 23; Sandoz 1974, no. 34, p. 128).

Late May

■ Departure for Lille

Chassériau leaves Paris to attend the wedding of his friend Oscar de Ranchicourt. The exact date of his departure is not known, but he had already left by June 2, since his brother Frédéric writes to him in Lille to remind him he has not received "payment for the copy" (Letter from Frédéric Chassériau to his brother Théodore, June 2, 1837 [Paris]; quoted in Bénédite 1931, vol. 1, p. 83), perhaps a reference to the commission received on April 30 of that year.

June 8

■ Oscar de Ranchicourt's Wedding

Oscar Damien de Ranchicourt (1815–1886) marries Pauline (also called Clotilde) de Buus d'Hollebèque (1807–1858) in the Church of Saint-André, Lille. Oscar weds one of his aunts, by marriage: his mother, Adèle Aronio de Fontenelle, the widow of Philibert de Ranchicourt (1781–1825), had married Pauline's brother, Victor de Buus d'Hollebèque, in 1828 (information kindly provided by Françoise Bellaigue de Ranchicourt on June 14, 2001).

In his letter of June 2, Frédéric asks Théodore to give his best wishes to the newlyweds and also announces the wedding of their cousin in Marseilles, Frédéric, to "Mlle Warain, eighteen years old, graced with beauty, an excellent nature, little fortune, but from a highly respected family in Marseilles" (Letter from Frédéric Chassériau to his brother Théodore, June 2, 1837 [Paris]; quoted in Bénédite 1931, vol. 1, p. 90).

■ An Illustrated Missal

Chassériau, who probably stayed with his friends at the Château de Ranchicourt, near Béthune, offers the bride a Missal illustrated with twelve drawings of religious subjects (Chevillard 1893, p. 24; Bénédite 1931, vol. 1, p. 90). These drawings in pen and brown ink bear the monogram "T. C" and were bound in a small Missal (Prat 1988-2, nos. 9–20, p. 13).

Chassériau later executes another series on the theme of the Seven Sacraments. One of these drawings, *The Communion,* bears the date "juin 1837" (Bénédite 1931, vol. 1, p. 89; Prat 1988-1, vol. 1, no. 978, p. 979, and 1988-2, no. 24, p. 14). Another drawing, *The Mass,* is inscribed "juillet" (Prat 1988-1, vol. 1, no. 977, p. 400, and 1988-2, no. 30, p. 14).

July–August (?)

■ Travels in Belgium and Holland

Chassériau takes advantage of being in Lille to visit Belgium and Holland. Bénédite writes: "We have no idea what impression these two countries and the great masterpieces in their museums made on him. The only thing we do know is that Frédéric asked him to bring back the 'Diamant books, especially the one-volume Chénier' from Brussels" (Bénédite 1931, vol. 1, pp. 90–91). A pencil-and-pen-and-ink study, apparently after a Descent from the Cross, inscribed "Belgique" and "Van Eik [*sic*]," probably dates from this trip (Sandoz 1968, pp. 174–75 n. 9; Prat 1988-1, vol. 2, no. 2203, pp. 748–49).

October 7

■ Encouragement from His Father

Benoît Chassériau is satisfied with his son's state of mind: "I am glad to see how convinced you are of the necessity of working hard to make a name for yourself, without which—you know as well as I—your profession would have no future. Keep up the good work." He asks Théodore to send him reviews of the Salon, encourages him to take his inspiration from "M. Ingres," and is sorry that he has not yet sold his large picture (probably the *Ruth and Boaz*) and has been unable to finish "the one that you executed for M. d'Orbigny." Prat points out that this last work "remains unknown" (Letter from Benoît Chassériau to his son Théodore, October 7, 1837, San Juan, Puerto Rico; published in Prat 1988-1, vol. 2, no. 24, p. 975).

■ 1838

February 19

■ Salon of 1838: Two Rejections

Two paintings by Chassériau are turned down by the Salon jury (10th session of the jury, February 19, 1838; Archives des Musées Nationaux, *KK. 55, nos. 2515–2516. The first of these, a painting of the Virgin, measured 66 ⅞ x 48 ⅞ inches framed, and the second, *Elisha Raising the Son of the Shunamite,* measured more than nine by seven feet with the frame (Archives des Musées Nationaux, *KK. 32, nos. 2515–2516).

Chassériau would explain this in a letter to Ingres: "My unfortunate picture was rejected for the Exhibition and as the subject is very simple, *Elisha Raising the Son of the Shunamite,* and since I have always been accepted until now, everyone was surprised and considered this good for me" (Letter from Théodore Chassériau to Ingres, April 10, 1838, Paris; published in Lapauze 1911, p. 341; Bénédite 1931, vol. 1, pp. 68–69). This picture seems to have been lost (Sandoz 1974, no. 42, p. 136). Guillaume, a friend of the family, would later refer to the rejection of the painting of the Virgin (Letter from Guillaume to Frédéric Chassériau, December 10, 1838 [Strasbourg]; quoted in Bénédite 1931, vol. 1, p. 91). This painting is also lost, but its appearance may, in fact, be preserved in the background of the 1838 self-portrait (see below).

■ A Self-portrait

Chassériau portrays himself at the age of eighteen or nineteen, holding brushes and a palette, in front of a canvas. A "light moustache shades his upper lip, his large Creole eyes gleam softly amidst the play of shadows across his forehead, which is tilted forward." Bénédite (1931, vol. 1, pp. 5, 91, 93) wonders whether the image of the Virgin visible in the background, "hanging on the studio wall, on the left, in three-quarter view, facing to the right," might not be the painting rejected by the Salon of 1838. The self-portrait, signed and dated "T. Chassériau / 1838" (cat. 2), is in the Musée du Louvre (Sandoz 1974, no. 39, p. 132).

■ Social Life

In 1838, Chassériau begins to frequent several salons, where he often meets the painter Henri Lehmann, who recalls that his "comportment [was] excellent" (Letter from Henri Lehmann to Marie d'Agoult, March 2, 1841, Rome; Archives of the comte Hauteclocque [transcription kindly provided by C.-F. Dupêchez]; Joubert 1947, p. 153, dates the letter to March 11). Dupêchez, who is preparing an edition of the correspondence of Marie d'Agoult, points out a number of errors in transcription and dating in Joubert.

April 10

■ Ingres and His Study of a Negro

With "M. Marcotte, who is leaving tomorrow for Rome," Chassériau sends Ingres the study the latter had requested seventeen months earlier (see above, *November 19, 1836*). Chassériau confides: "But I had quite a bit of trouble with the model, who found the pose awfully tiring and did not want to keep posing without a break." A tracing of this study bears the date "9 avril 1838" (Prat 1988-1, vol. 1, no. 9, p. 60).

■ Italy and the Great Wish

Chassériau goes on to write: "For a while I was hoping to be able to come and bring you the negro myself, but I am not free yet, my mother is still in Paris, and I am obliged to postpone going to Italy straightaway, despite my great wish to see you again and to hear you give me strength. . . . Please remember me to Mme Ingres" (Letter from Théodore Chassériau to Ingres, April 10, 1838, Paris; published in Lapauze 1911, p. 341; Bénédite 1931, vol. 1, pp. 68–69; the quote is from the version in Lapauze, except for the postscript, which was published only in Bénédite).

The comment that his mother was "still in Paris" suggests that she may have been considering joining her husband in San Juan, Puerto Rico.

April (?)

■ The Meeting of Chevandier and Gautier

On April 12, 1853, the landscape painter Paul Chevandier de Valdrôme (1817–1877) would invite Théophile Gautier to "no. 39 in the rue de la tour d'auvergne . . . [in] this same studio where I had the pleasure of meeting you only once, at M. Chassériau's some 15 years ago—Alas! And I would be very happy to see you there" (Letter from Paul Chevandier de Valdrôme to Théophile Gautier, Tuesday April 12, 1853 [Paris]; published in Gautier, *Correspondance,* 1991, vol. 5, no. 1868, p. 175).

If Chevandier's memory is correct, the earlier meeting he refers to would have taken place in April 1838. The address of Chassériau's studio given by Chevandier may have been the one mentioned by the artist on March 1, 1839: "21 *bis* r. de la Tour d'Auvergne," his address, Bénédite says, from 1838 (see below). Chassériau and Chevandier's friendship is documented as early as November 25, 1838 (see below).

■ Change of Studio

Sometime in 1838, Chassériau leaves his studio at 18, rue Neuve-Saint-Georges (the address given to the Salon of 1837) and moves to 21 *bis,* rue de la Tour d'Auvergne (Bénédite 1931, vol. 1, p. 87). In a letter dated July 4 of that year (see below), Clémence Monnerot alludes to his charming studio and "wonderful garden."

May 15–16

■ Clémence Monnerot's Illness

A letter from Mme Monnerot (1784–1874) to her son Jules Monnerot (1808–1883), then in Lyons, notifies him of his sister Clémence's illness: ". . . for several days, a sore throat with fever and delirium." Théodore and his mother go to see her. By May 16 she has recovered: "We are going to visit the Chassériau ladies today, which is a sure proof of recovery." Mme Monnerot also notes the painter's presence on May 15: "Théodore spent the evening with us yesterday, and asked me to tell you that he hopes you will bring him some antiquities, and Clémence is also counting on some" (Letter from Mme Monnerot to her son Jules [May 16, 1838, Paris]; BnF, Dépt. des Ms, Naf. 14405, Papiers Gobineau, vol. 17, folios 53–54).

■ Jules's Opinion of the Young Artist

The relationship between the Monnerot and Chassériau families—both of which had Creole origins—and especially between Théodore and Jules, is documented as early as 1836 (see above, *About August 15, 1836*). Frédéric Chassériau recommends the young Jules Monnerot, director of an insurance company who was traveling to Strasbourg, to Guillaume. Guillaume later writes to Frédéric: "We talked a lot about you and your whole family, to which he seems quite attached. He talked most of all about your brother the painter with the warmth of a true friend. He

finds that the young artist still lacks the skill to group his figures well in a picture, but is convinced that it will take only a few years to turn your brother into a distinguished first-class artist" (Letter from Guillaume to Frédéric Chassériau [1838] [Strasbourg]; published in Bénédite 1931, vol. 1, p. 92).

July 4

■ Clémence Monnerot's Drawing

Clémence writes to her brother: "M. Théodore did a drawing for me that I am mad about, two adorable children and a woman, tell me if it has to be mounted. . . . Since my health is better we go freely to *mass,* and we also see the Chassériaus practically every day. If you write to M. Théodore again tell him that I am enchanted with his drawing, for I am so dull that I did not know how to thank him. He has a charming studio and a wonderful garden" (Letter from Clémence Monnerot to her brother Jules, July 4, 1838, Paris; BnF, Dépt. des Ms, Naf. 14394, Papiers Gobineau, vol. 6, folios 39–40).

July–September

■ Vacation (?)

Several inscribed drawings fill in our lack of knowledge about Chassériau's activities and whereabouts during this time. A study of five female figures for *The Trojan Women* (shown at the Salon of 1842) bears a date "1838 Juillet" (Prat 1988-1, vol. 1, no. 103, pp. 94–97). The same date appears on a drawing *(Hero and Leander)* showing a park with a cluster of trees and a couple of strolling figures (Prat 1988-1, vol. 2, p. 819, fol. 10 r.). A copy after a Pietà is inscribed "24 A[oû]t 1838"; a drawing depicting columns, a door, and bosses, which also bears the same date, is inscribed: "Chapelle de Louis 14 dans le vieux château de St Germain." A drawing with two kneeling female figures is inscribed "1838 Septembre" (Prat 1988-1, vol. 2, nos. 2207–2208, pp. 750–51, 821, fol. 16 r.).

October

■ Arthur de Lucy and His "Confidence"

According to Sandoz, among the papers left behind by Baron Arthur Chassériau was a manuscript of a poem by Arthur de Lucy entitled "Confidence," dedicated "À mon ami Théodore Chassériau, Octobre 1838" (Sandoz 1986, no. 58, p. 75). Chassériau's portrait drawing of Arthur de Lucy (13 ¾ x 10 ⅝ in.) is now lost (Chevillard 1893, no. 288, p. 304; Bénédite 1931, vol. 2, p. 357; Sandoz 1986, no. 58, p. 75). There is a drawing with the following inscription: "Louis de Lucy—Rue de l'Union F[aubourg] St Honoré no. 53" (Prat 1988-1, vol. 2, p. 842, fol. 1 r.).

November 25

■ Lovesick Théodore

In a letter (now lost) from Chassériau to Paul Chevandier (called Paul Chevandier de Valdrôme about 1850–51), the artist writes of his romantic problems. His friend responds: "You speak to me of your sorrows, my unfortunate friend, I have had some cruel ones too, so bad that my heart dried up" (Letter from Paul Chevandier to Théodore Chassériau, November 25, 1838, Rome; quoted in Bénédite 1931, vol. 1, p. 93). The "cruel one" who occasioned his sorrow is thought to have been Clémence Monnerot, the future wife of Arthur de Gobineau (Bénédite 1931, vol. 1, p. 101).

December 10

■ M. Théodore's Revenge

After the announcement of the Salon of 1839, Guillaume writes to Frédéric, hoping that "M. Théodore" would take his revenge, "for it seemed to me that he did not let himself be discouraged by last year's injustice. . . . Be that as it may, after what I have seen, your good brother is not losing any time and will emerge victorious from that struggle which artists have always had to fight before they carve out a path for themselves" (Letter from Guillaume to Frédéric Chassériau, December 10, 1838 [Strasbourg]; published in Bénédite 1931, vol. 1, p. 91).

December 29

■ Copy of the Duke of Alba

Under this date, in an untitled notebook whose entries begin with December 2, 1838, we find the mention: "M. Chasseriau. Copy of the portrait of the duke of Alba" (Archives des Musées Nationaux, dossier 10, Salon de 1839). This is the first allusion to a commission that he will receive six months later, on June 18, 1839 (see below).

<hr/>

■ 1839

January 1

■ Study for *Christ on the Mount of Olives*

While working on two paintings for the upcoming Salon, Chassériau draws the first two known studies for his *Christ on the Mount of Olives* (cat. 16). One bears the notation "1839 Janvier" and the other, "1839—1 Janv" (Prat 1988-1, vol. 2, p. 827, folios 2 v., 3 r.). This painting will be commissioned after the close of the Salon (see below, *May–June 1839*).

February 18

■ The Salon Jury

Two paintings by Chassériau are accepted. One, *Susanna and the Elders* (no. 2200; see cat. 15), is accepted after a vote of twelve to eight (7th session of the jury, February 18, 1839; Archives des Musées Nationaux, *KK. 56, nos. 2200–2201, *KK. 33).

March 1

■ Salon of 1839: The Decisive Year

The Salon's exhibition catalogue (*Explication des ouvrages de peinture, sculpture, architecture, gravure et lithographie des artistes vivants exposés au musée royal le 1er mars 1839* [Paris, 1839], p. 40) lists the following:

Chassériau (T.), *21 bis; r. de la Tour d'Auvergne* [no.] 339 – Susanna and the Elders (100 ⅜ x 77 ¼ in.; Sandoz 1974, no. 48, p. 144).

". . . And there was nobody there, but the two old men that had hid themselves and were beholding her" (Daniel 13: 16).

[no.] 340 – Venus Anadyomene (25 ⅞ x 21 ¾ in.; Sandoz 1974, no. 44, p. 138).

■ An Unfortunate Installation

Chassériau's *Susanna* is poorly placed at the Salon, as is mentioned in a letter from M. de Reste to Frédéric Chassériau: "I had read in the *Débats* about the acceptance of the beautiful Susanna and I was jubilant, but you cruelly dampened my joy by telling me that it has been relegated to *Tartarus*. This looks like persecution. It is a shame to put so many obstacles in the way of a young artist who should inspire so much interest" (Letter from M. de Reste to Frédéric Chassériau [mid-March–mid-April] 1839, La Ferté; published in Bénédite 1931, vol. 1, pp. 94–95).

March 12

■ Cabat and the Lure of Rome

A letter from Louis Cabat in Rome informs Chassériau of the "impending return to Rome" of their friend Paul Chevandier. The latter had told Cabat that Chassériau had made "great progress" and that he was working on "a fine picture." Cabat goes on to say: "I have an intense desire for news from you. I have a great need to hear of the results of your work, if you are happy, if your parents are well, and if you still love me. . . . Rome pleases me infinitely and I hope that I will have the joy of seeing you here one day and living with you. I cannot tell you how much I think of you and how much I wish you were here" (Letter from Louis Cabat to Théodore Chassériau, March 12, 1839, Rome; published in Bénédite 1931, vol. 1, pp. 119–20). The "fine picture" was no doubt the *Susanna,* exhibited at the Salon of 1839.

April 13

■ A New Location: Out of The Catacombs

In his eighth review of the Salon, Théophile Gautier tells his readers of the rehanging of *Susanna and the Elders:* "Now that the painting has been moved, everyone admires its austere style, the refinement of the drawing and the broad execution that characterizes it" (Gautier, April 13, 1839, p. 4). The following year, he would write: "M. Théodore Chassériau exhibited a painting last year, a *Susanna and the Elders* that we were not able to see, for it was hung in that dark gallery known as *The Catacombs*" (Gautier, March 13, 1840, p. 2).

March–April

■ Attempt to Sell the *Susanna and the Elders*

Taking advantage of a recommendation from "M. Chevandier, Peer of France" (the father of the landscape painter), Chassériau asks the Ministry of the Interior to purchase the *Susanna.* He ends his letter to François Cavé, the director of the Commission des Beaux-Arts, with a veritable vow of allegiance: "And so, Monsieur, I think that this matter rests entirely in your hands and I commend myself to your kindness. You are

aware, Monsieur, how much I need encourage-ment and support at the beginning of my career; and if you care to take an interest in me I will always do my best to be worthy of it, and will be grateful my whole life long" (Letter from Théodore Chassériau to François Cavé [March–April 1839], Paris; AN, F²¹. 485, dossier 5). A document pre-served in the same file notes: "1839/ Requests for the purchase of artworks by the artists/ names of the artist: Chassériau/ Subject: Susanna and the Elders – Salon of 1839. Recommended by M. Chevandier, Peer of France."

This attempt to sell the *Susanna* would not succeed, but the artist was probably compensated by a later commission from the Ministry of the Interior (see below, *May–June [?]*). Chassériau picked his painting up on June 26, 1840 (see below). In 1842 *Susanna and the Elders* was shipped to the United States (see below, *Late October–early November [?], 1842*).

April 23

■ The *Venus Anadyomene* Is Sold

Clémence Monnerot writes to her brother: "We went to the Salon. . . . M. Théodore is a suc-cess, *La Presse* and *Le Temps* praise him a great deal and M. Picot, the painter, asked to buy his Venus at the request of the artists' society and to dis-play it in their establishment. I think that he will sell it there rather than somewhere else. He tore up mother's portrait" (Letter from Clémence Monnerot to her brother Jules, April 23, 1839, Paris; BnF, Dépt. des Ms, Naf. 14394, Papiers Gobineau, vol. 6, folios 43–44).

■ A Most Brilliant Future

Théophile Gautier, writing ten days earlier in *La Presse,* had begun his review of the Salon with praise that concluded: "We predict a most brilliant future for M. Chassériau, and, without claiming to be a prophet, we have rarely been wrong in our predictions" (Gautier, April 13, 1839, pp. 3–4). It seems that the Société des Artistes actually did acquire the *Venus Anadyomene* (cat. 13), for the Cercle des Arts owned it by January 1848 (see below, *January 6, 1848*). At some unknown date it found its way into the collection of Marcotte de Quivières. Another portrait—in pencil—of Mme Monnerot is now in The Brooklyn Museum of Art and bears the dedication: "à mon ami Jules. T. Chassériau 1839" (Sandoz 1986, no. 7, pp. 19–20; Prat 1988-2, no. 34, p. 14).

May 22

■ The *Temptation of Rome* and the Month of Mary

Jules Monnerot is in Rome, as a letter from his mother attests: "Théodore is still in paris [*sic*] endlessly saying that he is leaving for the country, for Rome, he cannot believe that you went there. . . . M^me Chassériau, whom we told this morning that you were in Rome, said, If that could only persuade him! I believe that she is counting a great deal on the trip Théodore is sup-posed to make there to achieve his all, in the meantime she often takes him to the mois de Marie [month of Mary]. he is kind enough to bring us home every evening, he is a good young man" (Letter from Mme Monnerot to her son Jules, May 22, 1839, Paris; BnF, Dépt. des Ms, Naf. 14405, Papiers Gobineau, vol. 17, folios 55–56).

May–June (?)

■ Commission for *Christ on the Mount of Olives*

According to Chevillard, Chassériau owes the commission for this painting to the comtesse de Meulan's intervention on his behalf before M. Cavé, Directeur des Beaux-Arts (Chevillard 1893, p. 40; Bénédite 1931, vol. 1, p. 107). He had been thinking about this painting since January (see above, *January 1, 1839*). There are a number of preparatory drawings, one of which is inscribed "1839 Avril" (Prat 1988-1, vol. 1, no. 33, p. 70). We know that it was commissioned by the Ministry of the Interior, but there is no documentary evi-dence (see below, *March 5, 1840*), although there is the record of a payment of 1,800 francs (AN, F²¹. 496 A, dossier 1, room 3). Chevillard men-tions that the comtesse de Meulan "obtained the commission and the requirement that the painting be assigned to the part of the country where the painter's family came from," namely the Church of Saint-Jean-d'Angély, not far from Rochefort and La Rochelle.

Two letters from Chassériau to Grille de Beuzelin, head of the Commission des Beaux-Arts, probably allude to the ensuing procedures and especially the presentation of the sketch. In the first he writes: "Would you be so kind as to ask, or have someone ask, M^r Cavé at what time he wants to receive me so that we can talk about my picture." In the second letter he writes: "I am delighted about the slight delay. I will be in a better position to show my work and will notify Amaury without fail for Friday" (Letters from Théodore Chassériau to Grille de Beuzelin, Friday [May 20 (?)] 1839, and Friday [1839 (?)], Paris; Institut Néerlandais, Fondation Custodia, Inv. 1992-A.888–89).

June 4

■ Balzac and Chassériau's Masterpiece

The novelist Honoré de Balzac writes to Mme Eveline Hanska (whom he would marry in 1850) about his visit to the Salon: "Our painting exhi-bition is very beautiful, there were seven or eight masterpieces in all genres: some superb Descamps, a magnificent *Cleopatra* by Delacroix, a sublime portrait by Amaury-Duval, a charming *Venus Anadyomene* by Chassériau, one of Ingres's pupils. What a misfortune to be poor when one is an artist at heart" (Letter from Balzac to Mme Hanska [Tuesday, June 4, 1839, Sèvres]; published in Balzac 1990, vol. 1, p. 487).

June 18

■ Commission for Three Historical Portraits

In a report to the senior administrator, the assistant director of the Musées Royaux, Cailleux, proposes that Chassériau be entrusted with a com-mission for a "bust-length portrait of Philippe de France, Duc d'Orléans, and of Mlle de Montpensier on the same canvas," for a fee of 500 francs; these portraits are intended for the "Salle de Diane at the Palais de Saint-Cloud." Five artists participate in this commission (Archives des Musées Nationaux, dossier P. 6 1839). According to Sandoz—who erroneously identifies the work as a portrait of "Mme de Montpensier"—it was probably destroyed in the fire at the Palais de Saint-Cloud in 1870 (Sandoz 1974, no. 53, p. 148).

Chassériau was entrusted with another com-mission for 400 francs on this same date: a "Portrait of Ferdinand Alvarez of Toledo, Duke of Alba," intended to "complete the collection of historical portraits in the galleries of the Palais de Versailles" (Archives des Musées Nationaux, dossier P. 6 1839). In all, the names of eleven artists—including that of Flandrin—are associated with this project. Chassériau's copy, after an unknown original, is at the Château de Versailles (Sandoz 1974, no. 53, p. 148).

July 9

■ Creole Exhibition

Mlle Monnerot sends her son, Jules (then still in Rome), news of his friend: "The exhibition of Creole paintings was not held, or it must have taken place only in the last few days, so we cannot tell you anything about the pictures, except cer-tainly that of your friend Théodore; it is said to be even better since it has been finished" (Letter from Mme Monnerot to her son, Jules, July 9, 1839, Paris; BnF, Dépt. des Ms, Naf. 14405, Papiers Gobineau, vol. 17, fol. 57). On this painting see below, *July 1839*.

July

■ Victims in Martinique

A benefit exhibition for the victims of an earth-quake in Martinique is held on the 16th, in the rue des Jeûneurs. Chassériau exhibits a *Flight into Egypt*—the picture mentioned by Mme Monnerot, on July 9 (see above)—which is praised by the critic Jules Janin in the following terms: "M. Chassériau, who is intimidated by nothing, and who walks with a firm step on his chosen path, submitted a Flight into Egypt that his worthy master would appreciate very much" (Janin, in *L'Artiste* 3, 1839, p. 197).

July 11 (?)

■ Trips to the Ranchicourts and to Belgium

A letter from Mme Monnerot to her son men-tions Chassériau's scantly documented trip: "He speaks all the time of his departure for Belgium, but I think you will still find him here, although he assures me that he is leaving Thursday" (Letter from Mme Monnerot to her son Jules, July 9, 1839, Paris; BnF, Dépt. des Ms, Naf. 14405, Papiers Gobineau, vol. 17, fol. 57).

As July 9 was a Tuesday, his "Thursday" depar-ture was scheduled for July 11. Chassériau's trip is indirectly documented by two other references: on November 5, 1839, Guillaume mentions his "return" (see below)—which implies a prior depar-ture—and a pencil portrait of Raymond de Ranchicourt, dated 1839, shows him at age one according to Prat (1988-2, no. 37, p. 15). Raymond, the son of Oscar and Pauline de Ranchicourt, was born on July 14, 1838. It could be that Chassériau visited his friends in Lille or at their castle in Béthune two years after their wedding (see above, *June 8, 1837*).

November 5

■ Commission: Change of Subject Proposed

Cavé, the director of the Commission des Beaux-Arts, seems to have been behind an attempt to change the subject of Chassériau's commission. "How did Théodore—when he returned—take M. Cavé's request for a *Saint* instead of the *Christ on the Mount of Olives* that he had asked for?" (Letter from Guillaume to Frédéric Chassériau, November 5, 1839 [Strasbourg]; quoted in Bénédite 1931, vol. I, p. 107). According to Bénédite, this proposal is only a "false alarm, and Chassériau had things his way."

November 9

■ The *Christ:* Work Begins

Several days later, Guillaume writes about the *Christ on the Mount of Olives* in these terms: "I think that the young Théodore is working twice as hard for the first exhibition, announced for March 1. Now we have to get busy with the powers-that-be to have his picture hung in a good light, for I have been told it is 14 feet high and 11 wide" (Letter from Guillaume to Frédéric Chassériau, November 9, 1939 [Strasbourg]; quoted in Bénédite 1931, vol. I, p. 108).

December 10

■ The Father's Promotion

Benoît Chassériau is named Consul, Second Class of San Juan, Puerto Rico (Archives du Ministère des Affaires Étrangères, dossier Benoît Chassériau, 1st series, 889).

December

■ Announcement of the Salon of 1840

A columnist in *L'Artiste* lists the works to be presented by artists at the coming Salon of 1840, pointing out that "M. Chassériau will show a *Christ on the Mount of Olives* and an *Odalisque*" (Unsigned, 4, December 1839, p. 254). Chassériau did not exhibit an *Odalisque,* and his *Diana Surprised by Actaeon* (cat. 22) was rejected. There is a drawing that may be related to this Odalisque (Prat 1988-1, vol. 2, no. 1807, p. 645).

■ Peace—War

Chassériau draws two allegories—both dated 1839—details of which he would later include in his decorative cycle at the Cour des Comptes (Prat 1988-1, vol. I, nos. 1046, 1047, pp. 425–27). Another drawing on the theme of War is inscribed "Chatenay 1839" (Prat 1988-1, vol. I, no. 1053, p. 428). On the Cour des Comptes see below, *July 1841* and *December 27, 1843.*

■ 1840

January 21

■ Evenings at the Monnerots

Clémence Monnerot writes to her brother: "All the Chassérias are well, M. Théodore comes to see us every two or three evenings. The Meynards have a full house, I have heard, which is unusual. . . . The Chassérias send you their best" (Letter from Clémence Monnerot to her brother Jules, January 21, 1840, Paris; BnF, Dépt. des MS, Naf. 14394, Papiers Gobineau, vol. 6, folios 47–48). The Meynards were cousins of the Monnerots.

February 13

■ Entry in the Booklet of the Salon of 1840

Chassériau supplies the administrative offices at the Musée du Louvre with explanatory texts for the two paintings he was submitting to the upcoming Salon. On a file card with the heading "Mr. Théodore Chassériau. N° 21 (*bis*), rue de la Tour d'Auvergne," his *Christ on the Mount of Olives* is registered as no. 1, with a reference to the Gospel of Saint Mark, "chapt. 14." Under no. 2, in an unknown hand, is the note "Diana Surprised by Actæon," following which Chassériau writes in ink: "qu'elle change en Cerf pour le punir—. Theodore Chassériau / Février—" (Archives des Musées Nationaux, dossier P. 30 Chassériau; Sandoz 1974, nos. 54, 62, pp. 150, 160).

February 23

■ *Diana Surprised by Actaeon* Rejected by the Jury

Chassériau's *Christ on the Mount of Olives* (no. 2379) is accepted in the "history" category, but his "genre" composition *Diana Surprised by Actaeon* (no. 2380) is rejected without coming to a vote (10th session of the jury, February 23, 1840, Archives des Musées Nationaux, *KK. 34, *KK. 57, nos. 2379–2380).

Gautier complains about this at the beginning of the Salon: "We must confess, we who have seen the picture in the painter's studio, that it is impossible to guess even remotely at the reason for such an exclusion: it is true that these gentlemen need no reasons; the thing needs only to be beautiful" (Gautier, March 11, 1840, p. 1).

February 29

■ Greetings from the Chassériau Family

At the end of her letter to her brother, Clémence Monnerot writes: "Bêlot, Angèle, Mme Lafont, Fauvès, the Chassérias all send their best" (Letter from Clémence Monnerot to her brother Jules, February 29, 1840 [Paris]; BnF, Dépt. des Ms, Naf. 14394, Papiers Gobineau, vol. 6, fol. 48 r.).

March 5

■ Salon of 1840

The exhibition catalogue (*Explication des ouvrages de peinture, sculpture, architecture, gravure et lithographie des artistes vivants exposés au musée royal le 5 mars 1840* [Paris 1840], p. 34) includes the following entry:

Chassériau (Théodore), *21 bis, rue de la Tour-d'Auvergne*

[no.] 250 – *Christ on the Mount of Olives* (16 x 14 ft.; Sandoz 1974, no. 54, p. 150).

"And he said, Abba, Father, all things *are* possible unto thee; take away this cup from me: nevertheless not what I will, but what thou wilt" (Mark 16 [sic]).

(M.I.)*

*Indicates works commissioned by the Ministry of the Interior.

A Recommendation from M. G. de Wailly

In the files of the Salon of 1840 is a list of artists, without heading or explanation; under no. 2379 is "Chassériau 250." Opposite, in the third column, is the name "Mr G. de Wailly" with the penciled note "Salon." The number next to Chassériau's name refers to the entry in the Salon booklet. We may presume that "Mr G. de Wailly" refers to a patron whose recommendation had to be taken into account by the museum administration. The entry for Amaury-Duval gives the name "Mme Mennessier," for Cabat, "M. Edmond Blanc" (Archives des Musées Nationaux, dossier 10, Salon de 1840, dossier "divers").

March 5–8

■ Extravagant Praise

Clémence Monnerot writes to her brother: "The best picture is that of Mr Théodore Chassériau. It is perfectly placed and during my visit to the exhibition I heard three or four individuals arguing about the subject; some criticizing it horribly, and the others praising it extravagantly. . . . That's the Museum, Mr Théodore can be content, he has been honored" (Letter from Clémence Monnerot to her brother Jules [after March 5, 1840, Paris]; BnF, Dépt. des MS, Naf. 14394, Papiers Gobineau, vol. 6, folios 51–52). Flandrin says that Chassériau's picture has "fine qualities" (Letter from Hippolyte Flandrin to Alexandre Desgoffe, March 7, 1840, Paris; published in Jouvenet 1986, pp. 292–93). Mottez says that, among the large compositions, it is "a good one" (Letter from Victor Mottez to Hippolyte Fockedey [March 8, 1840, Paris]; published in Giard 1934, pp. 147–48).

March 18

■ Chassériau Petitions

To protest the jury's rejections, the artists concerned form an "Assembly of Artists Whose Works Were Not Accepted for the Exhibition of 1840." The petition, which features 138 signatures—among them, Chassériau's—is presented to the two houses of the Assembly. It is also printed and distributed among artists. The petitioners demand that a special law regulate the exhibitions of the Commission des Beaux-Arts. They propose that the law "not establish a preliminary selection by jury, and all the works submitted should be accepted without exception, barring offense to the law or morality. Thus, no more favors; no more judgments influenced by systematic ideas or rivalry between schools; no more errors." The petition is rejected by the houses and has no effect other than to advance the opening of the next Salon to March 15 ("Pétition à Messieurs les Pairs de France. Demande d'une loi sur les Expositions annuelles des Beaux-Arts," AN, CC 460, dossier 378, pétition no. 173; Archives du

Louvre, dossier 10, Salon de 1840 [printed version]; Rousseau [1935] 2000, p. 56; Hauptman 1985, p. 109).

■ Contributing to Géricault's Tomb

Chassériau's name appears, along with seventy-five others, on the back of a model for the tomb of Théodore Géricault made by Antoine Etex in 1840. His name, together with those of Théophile Gautier and the sculptor Antoine-Auguste Préault, is included on the back of the final monument executed in 1841 (now in the Musée des Beaux-Arts, Rouen; see Buisson 1976, p. 47; Bazin 1987, p. 197; Chenique 1996, pp. 732, 750 n. 54). Etex and Chassériau are the only pupils of Ingres courageous enough to contribute to the monument for Géricault, whom Ingres despised for his role as the leader of the Romantic school.

April 24

■ *Sappho* and the Société des Amis des Arts

Frédéric offers the "Société des Amis des Arts" a painting representing Sappho Jumping into the Sea from the Rock of Leucade for the price of "400 f" (Letter from Frédéric Chassériau to the comte de Noé, April 24, 1840, Paris, FM signature; BnF, Dépt. des Ms, Naf. 24839, fol. 68). An annotation on the letter by Marcel Guérin explains: "The picture mentioned in this letter belonged to Mr. and Mme Gras, and hung in the parlor of the house at 1, rue de Mantes, in Saint-Germain-en-Laye, which my parents had rented to the Gras heirs and lived in themselves for 25 years. M[arcel]." Chassériau did two versions of the *Sappho,* and according to Sandoz (1974, no. 128, p. 262), Gras owned the 1849 version, now in the Musée d'Orsay (cat. 170); not the one from 1840, which was sold at Drouot, June 26, 1992, with the wrong date [?]: "1849" (Sandoz 1974, no. 67, p. 166).

April

■ Cabat's Watercolors

According to Pierre Miquel, the landscape painter Louis Cabat (1812–1893) "gives Chassériau some watercolors that he keeps in his studio" (Miquel 1975, vol. 3, p. 497). The catalogue of the posthumous auction of Chassériau's works mentions the name Cabat (March 16–17, 1857, no. 35). Chassériau is known to have drawn a "Portrait of M. Louis Cabat and M. Paul Chevandier de Valdrôme" that has since been lost (Chevillard 1893, no. 273, p. 303).

May 1

■ The Chassériau Family Mysteries

Mme Monnerot writes to her son: "Théodore keeps saying that he is leaving, yet stays. He has given up his studio, he is at the Place d'Orléans for now. He is doing a little painting for Mʳ Cotin, the grandson of the <u>famous Le Roy 'faiseur de Médecins.'</u> He does not want to tell us the subject. He sold his diana to lazière St albin, but does not tell us the price; I think it was not much; there are always mysteries in this family. The ladies and Mʳ Frédéric always ask about you" (Letter from Mme Monnerot to her son Jules, May 1, 1840 [Paris]; BnF, Dépt. des Ms, Naf. 14405, Papiers Gobineau, vol. 17, fol. 59).

The postponed departure she mentions was for Rome (see below, *June 27, 1840*). The subject of the picture painted for "Mʳ Cotin" remains unknown, as does the sale of *Diana Surprised by Actaeon* to "Lazière St Albin."

May 21

■ Request for Work

Vice-admiral Comte Jacob, peer of France, recommends Théodore Chassériau to the Intendant Général des Beaux-Arts and solicits a commission for the painter (for the reply see below, *June 17, 1840*).

May 22

■ Announcement of the Departure for Rome

Mme Monnerot informs her son: "Théodore leaves on June 1, as he says, and his mother says it too. All the Chassériaus always ask to be remembered to you" (Letter from Mme Monnerot to her son Jules, May 22, 1840, Paris; BnF, Dépt. des Ms, Naf. 14405, Papiers Gobineau, vol. 17, fol. 62).

May–June (?)

■ *Andromeda*

Before leaving for Rome, Chassériau begins work on his *Andromeda Chained to the Rock by the Nereids,* intending to finish it when he returns and to present it at the Salon of 1841 (Bénédite 1931, vol. 1, p. 133; Letter from Théodore Chassériau to his brother Frédéric, November 23, 1840; published in Chevillard 1893, pp. 49–50; Bénédite 1931, vol. 1, p. 140).

June 14

■ *Madonna of the Candelabra*

Henri Lehmann writes to Marie d'Agoult that the journalist Jules Janin has asked him to "draw the head of Raph[ael]'s *Madonna of the Candelabra* so that Calam[atta] can engrave it for *L'Artiste.* This picture, along with the rest of the duc de Lucques's collection, is up for sale; the coward hasn't a penny" (Letter from Henri Lehmann to Marie d'Agoult, June 14, 1840, Paris; Archives of the comte Hauteclocque, transcription by C.-F. Dupêchez; Joubert 1947, p. 99).

For some reason, it is Chassériau who provides the drawing on the day of his departure (see below, *June 27, 1840*); it would be engraved by Dien and printed in *L'Artiste* in 1841 (2, pp. 424–25; Sanchez and Seydoux 1998, vol. 1, p. 133; Peltre 2001, p. 51).

June 16

■ The Coming Departure with Lehmann

Lehmann writes to Marie d'Agoult: "I have reserved a seat in the mail coach for Marseilles on the 27th. Chassériau and I are alone in the carriage and are going to Rome together. I am more and more pleased with his intellect. I have not often seen someone so naturally original. . . . I have reserved my seat and hope to be in Rome on July 4, and in Naples around the fifteenth" (Letter from Henri Lehmann to Marie d'Agoult, June 16, 1840, Paris; Archives of the comte Hauteclocque, transcribed by Dupêchez; Joubert 1947, pp. 100–101).

June 17

■ Negative Answer

The Intendant Général des Beaux-Arts responds to the letter of Vice-admiral Comte Jacob, peer of France (see *May 21, 1840*): "I would have liked to second your well-meaning intentions on behalf of this artist. . . . but there is no work that could be put at Mʳ. Chassériau's disposal at the moment" (Draft of a letter from the Intendant Général des Beaux-Arts to Vice-admiral Comte Jacob, June 17, 1840 [Paris]; Archives des Musées Nationaux, dossier P. 30 Chassériau).

June 24

■ Marie d'Agoult and the Taming of Chassériau

Marie d'Agoult answers Lehmann's letter from Richmond: "I am happy about your trip with Chassériau. Tame him for me for next winter. I am sure that he will suit me better than Amaury [-Duval]" (Letter from Marie d'Agoult to Henri Lehmann [June 24, 1840, Richmond]; Archives of the comte Hauteclocque, transcribed by Dupêchez; Joubert 1947, pp. 103–4). On September 2, she would again write to Lehmann: "I will do everything I can to tame Chassériau" (Letter from Marie d'Agoult to Henri Lehmann [September 2, 1840], Fontainebleau; Archives of the comte Hauteclocque, transcribed by Dupêchez; Joubert 1947, p. 115).

June 26

■ *Susanna and the Elders*

On the eve of his departure for Rome, Chassériau goes to the Louvre to retrieve his "picture of Susanna and the Elders . . . which had been part of the exhibition of 1839" (Receipt from Théodore Chassériau to the administration of the Louvre, June 26, 1840 [Paris]; Archives des Musées Nationaux, dossier P. 30 Chassériau).

June 27

■ Departure for Rome and the Engraving of the Virgin

One hour before his departure, Chassériau asks Delaunay, editor of *L'Artiste,* to give his friend Gilly the proofs of the planned engraving of the *Madonna of the Candelabra* that Jules Janin had promised him (see above, *June 14, 1840*): "I wish to have at least ten to give to my friends. Please see to it that the engraving is in character—this is very important" (Letter from Théodore Chassériau to A.-H. Delaunay, June 27, 1840 [Paris]; Médiathèque, La Rochelle, MS 621, fol. 222 r.; Peltre 2001, p. 99).

June 27–30

■ From Paris to Marseilles

Chassériau and Lehmann probably travel to Marseilles via Lyons, Avignon, Nîmes, and Arles. In Marseilles, due to lack of time and his imminent departure, Théodore is unable to accept the dinner invitation of a friend of his family (Bénédite 1931, vol. 1, pp. 117–18); however, Bénédite did not know that Chassériau was accompanied by Lehmann.

July 1

■ Embarkation in Marseilles

According to Bénédite, Chassériau boards a ship for Rome. He and Lehmann probably stop briefly in Genoa and disembark at Civita Vecchia (Bénédite 1931, vol. 1, p. 117).

■ Lehmann's Sorrow

Lehmann confesses his distress to Marie d'Agoult: "You cannot imagine the wretched mental state I was in when I left Paris. Chassériau, who traveled with me, could not believe it; my brother, who knows of these tendencies, was frightened. . . . " (Letter from Henri Lehmann to Marie d'Agoult [August 19, 1840, Naples]; Archives of the comte Hauteclocque, transcribed by Dupêchez; Joubert 1947, p. 112).

■ Portrait of Lacordaire and Other Confidences

On their way to Italy, Chassériau and Lehmann trade "secrets" about their "more or less long-range projects." Lehmann is thought to have revealed his intention to paint the portrait of Father Lacordaire, who restored the Dominican order in France (Letter from Henri Lehmann to Marie d'Agoult, [September 18, 1840, Rome]; Archives of the comte Hauteclocque, transcribed by Dupêchez; Joubert 1947, p. 120; see below, *Mid-September 1840*).

Early July

■ Arrival in Rome

Chassériau's first stay in Rome is poorly documented. It had been believed that he went directly to Naples (Prat 1988-1, vol. 1, p. 45), then traveled from there to Rome on August 24 (see below). However, Lehmann's letter of August 19 to Marie d'Agoult, written from Naples, clearly indicates that they had already been in Rome (Peltre 2001, p. 233 n. 67). In that letter, after writing of his heartache, Lehmann continues: "It is thus that I spent six busy days in Rome looking for a nice studio that I had no desire for, and comfortable lodgings that I did not think I deserved." During that stay, he paid a visit to Ingres (it is not known whether Chassériau accompanied him). Of Chassériau he writes: "On the third day after his arrival in Rome, he drew the portrait of a woman, whom in my heart I had coveted for years as the most desirable of models" (Letter from Henri Lehmann to Marie d'Agoult [August 19, 1840, Naples]; Archives of the comte Hauteclocque, transcribed by Dupêchez; Joubert 1947, pp. 112–13). In Rome, Chassériau is reunited with his friend Paul Chevandier, who would travel with him to Naples (see below).

Mid-July (?)

■ Departure for Naples

The exact date of Chassériau's departure is not known. A watercolor, annotated "Juillet" and depicting the shores of Ischia (an island at the entrance of the Bay of Naples), proves that he had left Rome by then (Bénédite 1931, vol. 1, p. 128; Prat 1988-1, vol. 1, no. 1380, p. 517; Prat 1988-2, no. 48, p. 15).

Mid-July–mid-August

■ Visit to Naples

Chassériau surely must have written to his family, but no letters have come down to us. Lehmann's note to Marie d'Agoult of August 19 sheds some light on the two painters' activities at this time: "I have seen Naples, its bay, its islands, its Vesuvius, and its museum, Paestum and Pompeii. The week that I spent in the ashes of this mummy of a city have nonetheless served me well" (Letter from Henri Lehmann to Marie d'Agoult [August 19, 1840, Naples]; Archives of the comte Hauteclocque, transcribed by Dupêchez; Joubert 1947, p. 112).

■ Paul Chevandier

There is no direct evidence that Chassériau and Lehmann are accompanied by the landscape painter Paul Chevandier. However, in his letter of August 19, Lehmann writes that he has had "the opportunity to do a study of Chevandier and Chassériau," suggesting that Paul Chevandier is, in fact, with them in Naples (unless this study dates from the first stay in Rome; see above). A letter dated September 18, 1840, confirms Chevandier's presence: Lehmann explains that, before witnesses, he has again mentioned his plan to do a portrait of Lacordaire: "In Naples, the opportunity to talk about it presented itself, and it was even agreed that Chevand[ier] would take me to him [Lacordaire]" (Letter from Henri Lehmann to Marie d'Agoult [September 18, 1840, Rome]; Archives of the comte Hauteclocque, transcribed by Dupêchez; Joubert 1947, p. 120).

■ Naples and Its Surroundings

As his many drawings attest, Chassériau visits Pompeii (Prat 1988-1, vol. 1, nos. 1123–1133, 1487, pp. 458–60, 543–45). During his visit to Ingres (see below, *Late August–early September*), he would show him his "studies from Pompeii and the Naples museum" and would later report: "He was very happy about them, telling me several times that they were done by someone who had nothing left to learn" (Letter from Théodore Chassériau to his brother Frédéric, September 9, 1840, Rome; published in Chevillard 1893, p. 44; Bénédite 1931, vol. 1, p. 137). The drawings published by Prat enable us to trace his visits to Herculaneum, La Cava, Amalfi, Capua, Salerno, Palestrina, Capri, Terracina, Subiaco, Olivano, and Mola di Gaeta.

August 14

■ Benoît Chassériau's Raise

Benoît's salary is now 15,000 francs. His son Frédéric would write him on February 9, 1841, to say that the raise is insufficient (Archives du Ministère des Affaires Étrangères, dossier Benoît Chassériau, 1st series, 889).

August 19

■ A Towering Genius

Writing from Naples, Lehmann summarizes his travels in Chassériau's company: "He . . . is *a towering genius*. His understanding of life, lofty yet primitive at the same time, guarantees me of that. I have faith in him as a man and as a painter" (Letter from Henri Lehmann to Marie d'Agoult [August 19, 1840, Naples]; Archives of the comte Hauteclocque, transcribed by Dupêchez; Joubert 1947, p. 113).

August 24

■ Return to Rome

Chassériau's inscription on a drawing gives the exact date of his departure from Naples: "parti pour Rome le 24 août" (Prat 1988-1, vol. 1, no. 1117, p. 471); he probably traveled with Lehmann and Chevandier.

Late August–Early September

■ Arrival in Rome

Chassériau visits Tivoli and the Villa d'Este en route to Rome; the exact date of his arrival is unknown. The important description of his project for the *Sleep and the Hours of the Night* (cat. 32–34) is annotated: "Tivoli à minuit aout 1840" (Chevillard 1893, p. 263; Prat 1988-1, vol. 1, no. 1040, p. 422). A drawing inscribed "Tivoli 1840" also bears the annotation: "le soir presque la nuit une Vierge et le ciel plein d'étoiles" [Evening almost night a Virgin and the sky full of stars] (Prat 1988-1, vol. 1, no. 1413, p. 526).

■ Lodgings in Rome

Chassériau probably stays in one of Chevandier's two apartments upon his arrival in Rome. On November 23, he would write to his brother: "I still have five hundred francs left from what I brought from Paris. I have not spent more, thanks to Chevandier, who has two apartments and has lent me one. He wants me to dine with him or at his sister's almost every day" (Letter from Théodore Chassériau to his brother Frédéric, November 23, 1840, Rome; published in Chevillard 1893, pp. 48–49; Bénédite 1931, vol. 1, p. 140).

■ Visit to Ingres: The Falling-out

Chassériau goes to the Villa Medici to see his former teacher and to show him his "studies of Pompeii and the Naples museum," as well as a small sketch—"done from memory"—of his *Christ on the Mount of Olives,* which had been exhibited several months earlier at the Salon of 1840 (see above, *March 5*). Chassériau ends his account of this visit with a veritable proclamation: "During a fairly long talk with M. Ingres, I saw that in many respects we would never be able to understand each other. He is past his prime and has no comprehension of the ideas and changes that have taken place in the arts in our day" (Letter from Théodore Chassériau to his brother Frédéric, September 9, 1840, Rome; published in Chevillard 1893, pp. 44–45; Bénédite 1931, vol. 1, pp. 137–38).

■ Past and Future

Chassériau's remarks are restrained, but his rift with Ingres seems to have been deeper, as evidenced by a letter from Lehmann, dated September 18: "Besides, Monsieur Ingres is grossly mistaken about Ch[assériau], of whom I believe he is really jealous, for—strictly between us—he disparages in a shocking way some things that are truly admirable and even in the spirit of his own teachings. He considers him dishonest, timid, and lacking in wit and conversation, whereas the opposite of all this is true. He is frank, bold, and full of life—surprisingly swift in his judgment and discerning in his comparisons." Lehmann goes on to say that of "these two men of genius," one represents "the past and the other the future" (Letter from Henri Lehmann to Marie d'Agoult

[September 18, 1840, Rome]; Archives of the comte Hauteclocque, transcribed by Dupêchez; Joubert 1947, pp. 121–22).

September 8

■ Lacordaire's Agreement

As soon as he returns to Rome, Chassériau seeks out Father Lacordaire and asks him "insistently to do his portrait" (Letter from Lacordaire to Mme Swetchine, November 28, 1840 [Rome]; see below).

Obtaining permission fairly quickly, Chassériau plans from the start to exhibit the portrait at the Salon of 1841: "I often saw abbé Lacordaire, who is on retreat at the monastery of Santa Sabina. . . . You know that I asked him if I could do his portrait, which all the artists at the Villa Medici, and especially Lehmann, who is here, wanted very much to be able to paint. At first he replied that he would think about my proposal, that he had little standing in the clerical hierarchy and that no one would be interested in seeing his portrait, etc. etc. . . . We parted without deciding anything, then, yesterday, I received a charming little note from him in which he thanked me and accepted with pleasure" (Letter from Théodore Chassériau to his brother Frédéric, September 9, 1840, Rome; published in Chevillard 1893, p. 44; Bénédite 1931, vol. 1, pp. 136–37).

To facilitate contacts between the two men, who, according to Lehmann, do not know each other well, Paul Chevandier's sister, Hortense de Prailly, "sometimes" invites them on the same occasion (Letter from Henri Lehmann to Marie d'Agoult, March 2, 1841, Rome; Archives of the comte Hauteclocque, transcribed by Dupêchez; Joubert 1947, p. 153, gives the date of the letter as March 11).

September 9

■ Roman Works

Chassériau writes to his brother about his activities. He is "busy in all directions," "horribly rushed in all directions," and will return "to France very rich, with many compositions for the future," "loaded with studies of all kinds."

The large quantity of annotated drawings dating from September and October permits us to follow his excursions in and around Rome. To mention only a few: "Rome—Septembre 1840," "Rome—Au bord du Tibre [On the banks of the Tiber] Septembre 1840," "les murs de Bélizaire—Près de Rome—[the walls of Belisarius—near Rome—]Septembre," "A la Sixtine—la création—octobre 1840," "comme le Guaspre de la galeria Doria," "sur la route des Marais Pontins" (Prat 1988-1, vol. 1, nos. 1149, 1155, 1170, 1513, 1202, 1406, pp. 464, 467, 469, 552, 477, 523, respectively).

■ Grandiose Painting Project

Alluding to his studies, Chassériau uses the expression "grandiose painting." He says, "I do not want to say that nasty word *historic,* which is so cold, so academic, and—above all—so uninteresting." This attack is probably aimed at Ingres. Near the end of his stay in Rome he would express his desire to achieve the financial independence necessary to accomplish "the duties of a history painter" (Letter from Théodore Chassériau to his brother Frédéric, November 23, 1840, Rome; published in Chevillard 1893, pp. 46–50; Bénédite 1931, vol. 1, pp. 139–41). On December 4 he would write further: "Since being in Italy I have worked a lot and tremendously and hope to have made progress. I did not want to spend seven months doing nothing but studies" (Letter from Théodore Chassériau to Oscar de Ranchicourt, December 4, 1840, Rome; Archives of Mlle Françoise Bellaigue de Ranchicourt; Bénédite 1931, vol. 1, p. 142). Among his projects was one that he had been thinking about since July 1838 (see above, *July–September 1838*) and that he first called "my big picture," then "my picture with women," and finally "my picture of women" (Prat 1988-1, vol. 1, nos. 1400, 1421, 1502, pp. 522, 528, 548). He was referring to *The Trojan Women,* which would be exhibited at the Salon of 1842 (see below, *March 15, 1842*).

■ Coming Departure

Chassériau mentions his return to Paris and asks his brother to search "actively for a studio" that must be "very nice" and "near you" (Letter from Théodore Chassériau to his brother Frédéric, September 9, 1840, Rome; published in Chevillard 1893, pp. 42–46; Bénédite 1931, vol. 1, pp. 135–39).

Mid-September

■ Lehmann and the Portrait of Lacordaire

Chassériau sends the following note to his traveling companion: "Since we do not see you at dinner anymore and I still owe you two piastres, I will send them with Maria. I would bring them to you myself if I had a minute, but I have to take advantage of the abbé's absence to start sketching in the background and clothes in my portrait. Yours.—Théodore" (Letter from Théodore Chassériau to Henri Lehmann [mid-September 1840, Rome]; published in Joubert 1947, p. 121 n. 1).

■ The Chassériau Ploy

According to Lehmann, Chassériau was confronting him with a fait accompli between the lines of his apparently banal message. Chassériau had purely and simply stolen his idea of painting the portrait of Lacordaire, a plan Lehmann had already revealed to him twice (see above, *July 1* and *Mid-July–mid-August 1840*). Lehmann tries to explain to Marie d'Agoult that, at first, Chassériau and Chevandier decided to keep him in the dark: "And one fine day Fries tells me that he is doing the portrait of abbé Lacord[aire], which the latter supposedly asked him for (which is untrue). . . . I know through Mr Ingres that he had himself introduced to the abbé so that he could ask him about it." Lehmann then decides not to "return to the table at which these gentlemen dine; several days later a model sent by Ch[assériau] brings me a note containing the remaining small sum he owed me, with his apology for not having come himself because 'with the abbé being away, he was supposed to sketch in his clothes etc.,' acting as if I were supposed to know something that he had obviously concealed from me. People really revolt me now and I spend more time alone than ever" (Letter from Henri Lehmann to Marie d'Agoult, September 18, 1840, Rome]; Archives of the comte Hauteclocque, transcribed by Dupêchez; Joubert 1947, pp. 120–21).

Mid-October (?)

■ Lehmann and Chassériau Reconcile

Lehmann writes to Marie d'Agoult about patching things up with Chassériau: "As for the Ch[assériau]-Ch[evandier] story, I should add that as soon as my brother arrived, Ch[assériau] had him called to ask *what was the matter with me.* Ro[dolphe] managed very well, and the next day, after getting a note from me, Ch[assériau] came to offer me an explanation, which I deemed suitable to accept. He pretends of course that he and his friend had forgotten the whole thing. Our relations have been restored, but you can imagine how it has left my soul" (Letter from Henri Lehmann to Marie d'Agoult, October 24, 1840, Rome); Archives of the comte Hauteclocque, transcribed by Dupêchez; Joubert 1947, pp. 131–32).

November 18

■ Rayneval's Prediction

Rayneval congratulates Frédéric Chassériau on his promotion to head of the cabinet of the new minister of the French Navy, Admiral Duperré (in office since October 29, 1840). He says he is very satisfied with his brother Théodore and concludes: "One does not need to be an especially good prophet to predict that he will be able to go far. My sincere wishes go along with him on his way" (Letter from Louis-Alphonse-Maximilien-Gérard de Rayneval to Frédéric Chassériau, November 18, 1840, Rome; published in Bénédite 1931, vol. 1, pp. 121–22).

November 22

■ Portrait of the Comtesse de La Tour Maubourg

The wife of the French ambassador, Charlotte de Fey, Comtesse de La Tour Maubourg, née de Pange (1816–1850), visits Chassériau. Her admiration for the "portrait of F. Lacordaire" influences her husband to commission her portrait, on November 21. Thanks to his friends Rayneval and Chevandier, Chassériau begins work on the portrait immediately, but receives 1,000 francs instead of the 2,500 francs he had requested: "Since yesterday [the 22nd], I am installed at the ambassador's residence in the Palazzo Colonna, and am ready to paint. We met yesterday and get along very well" (Letter from Théodore Chassériau to his brother Frédéric, November 23, 1840, Rome; published in Chevillard 1893, pp. 46–50; Bénédite 1931, vol. 1, pp. 139–40).

■ Ingres and Lehmann Are Envious

Chassériau is obviously very proud of painting "a woman as beautiful as an angel," just twenty-six years old, "very gentle and perfectly elegant. M. Ingres was envious when I told him that I was painting her" (Letter from Théodore Chassériau to his brother Frédéric, November 23, 1840, Rome; published in Chevillard 1893, pp. 46–49; Bénédite 1931, vol. 1, pp. 139–40). For his part, Lehmann admits that he had "hoped to make a stab" at painting the ambassador's wife, "but since Chass[ériau] is doing her portrait, it would have been very *improper*" (Letter from Henri Lehmann to Marie d'Agoult [December 15, 1840, Rome]; Archives of the comte Hauteclocque, transcribed by Dupêchez; Joubert 1947, p. 138).

November 23

■ The Departure Postponed

The unexpected commission for the portrait of the comtesse de La Tour Maubourg upsets Chassériau's plans to leave Rome with Lacordaire: "Abbé Lacordaire is going to arrive in Paris to spend some time there; he wanted me to leave with him and I had sent my trunks, when my latest adventure delayed my departure somewhat" (Letter from Théodore Chassériau to his brother Frédéric, November 23, 1840, Rome; published in Chevillard 1893, pp. 46–50; Bénédite 1931, vol. I, pp. 139–41).

■ "Think of the Good Lord!"

Chassériau writes that Father Lacordaire "is bringing the rosaries that I promised to mother, Adèle, Aline, Mme Monnerot, and her daughter. He had them blessed personally and will bring them to you. I wanted these ladies to have them on Christmas Day" (Letter from Théodore Chassériau to his brother Frédéric, November 23, 1840, Rome; published in Chevillard 1893, pp. 46–50; Bénédite 1931, vol. I, pp. 139–41). Adèle writes to her brother that the Monnerots "send many affectionate compliments" (Letter from Adèle Chassériau to her brother Théodore [November (?)] 1840, [Paris]; quoted in Bénédite 1931, vol. I, p. 133). At an unknown date, Adèle writes in a postscript: "Think of the Good Lord!" (Letter from Adèle Chassériau to her brother Théodore [1840] [Paris]; quoted in Bénédite 1931, vol. I, p. 88).

■ Return and the New Studio

Chassériau "plans to be in Paris around January 20." In a postscript, he asks his brother: "Try to see that my new studio is nice and above all big. I bought several pieces of antique fabric that will look very good there" (Letter from Théodore Chassériau to his brother Frédéric, November 23, 1840, Rome; published in Chevillard 1893, pp. 46–50; Bénédite 1931, vol. I, pp. 139–41). His brother informs him that he charged Mottez, a former fellow pupil at Ingres's studio, with finding him a studio that would be "big, well lit, and not far from us" (Letter from Frédéric Chassériau to his brother Théodore [November (?)] 1840 [Paris]; quoted in Bénédite 1931, vol. I, p. 133).

■ Visit to Falloux

Chassériau ends his postscript with: "I am going out to pay a visit to Monseigneur de Falloux" (Letter from Théodore Chassériau to his brother Frédéric, November 23, 1840, Rome; published in Chevillard 1893, pp. 46–50; Bénédite 1931, vol. I, pp. 139–41).

November 28

Lacordaire's Refusal

The Dominican father does not like his portrait and writes as much to Mme Swetchine: "M. Chassériau, a young talented painter, insistently asked to paint my portrait. He depicted me as a Dominican in the cloister of Santa Sabina; I am generally satisfied with this painting, although it gives me a rather austere appearance. M.

Chassériau is planning to exhibit the painting and to have it engraved at his own expense afterward. In February you will receive a bust of me that, for my part, I prefer to the painting, as it better expresses my true character. It is small and quite easy to stash anywhere" (Letter from Lacordaire to Mme Swetchine, November 28, 1840 [Rome]; published in Falloux 1876, p. 256). The bust he refers to was carved by Bonnassieux.

December 4

The Artists of Rome Are Satisfied

Chassériau writes to Ranchicourt to say that he will see "the portrait of Father Lacordaire, who is here at the Monastery of Santa Sabina, at the exhibition this year. This portrait, painted out of friendship for the man and with whom I became very close, has been seen by all the artists of Rome and they are very satisfied with it." He says he is in a "superb studio," finishing the portrait of "Madame La Comtesse de Latour Maubourg . . . and as soon as I have applied the last brushstroke I will leave immediately for France" (Letter from Théodore Chassériau to Oscar de Ranchicourt, December 4, 1840, Rome; Archives of Mlle Françoise Bellaigue de Ranchicourt; Bénédite 1931, vol. I, p. 142).

■ 1841

January 1–15

■ Comtesse de Prailly (née Chevandier)

Before leaving Rome, Chassériau draws a double portrait of the comtesse Hortense de Prailly and her daughter Berthe (the future Comtesse de Guichen), signing and dedicating it, "a monsieur/ Ate Chevandier/ T. Chasseriau / Rome 1841" (Prat 1996, pp. 575, 579 n. 5). Anatole Chevandier, Hortense's father, had played a part in the sale of the *Susanna and the Elders* (see above, *March–April 1839*). According to Lehmann, Chassériau's relationship with Paul Chevandier's sister verged on impropriety. The comtesse is said to have "*continued receiving M. C*[hassériau]." to avoid hurting her brother's feelings (Letter from Henri Lehmann to Marie d'Agoult, March 2, 1841, Rome; Archives of the comte Hauteclocque, transcribed by Dupêchez; Joubert 1947, p. 153, dates the letter March 11). Chassériau's later falling-out with Chevandier is documented (see below, *April 23* and *September 27, 1841*).

■ A Refusal from Ingres

Ingres refuses to go see the portrait of the comtesse de La Tour Maubourg, freeing Chassériau from "all obligations as a pupil" (Letter from Henri Lehmann to Marie d'Agoult, January 16, 1841, Rome; Archives of the comte Hauteclocque, transcribed by Dupêchez; Joubert 1947, p. 144).

About January 15

■ Departure from Rome

The exact date of Chassériau's departure from Rome is not known, but one of his drawings of Civita Vecchia bears the date 19 janvier, indicating that he had already left (Prat 1988-1, vol. I, no. 1421, p. 528). Bénédite (1931, vol. I, p. 151) assumes that he had returned to Paris "around January 20," which does not take into account the itinerary that Chassérau had planned as early as September 9: "I would have liked to have seen Venice and the whole north of Italy, but could not go now. . . . This time I will see Genoa, Rome, Naples, Florence, and their environs" (Letter from Théodore Chassériau to his brother Frédéric, September 9, 1840, Rome; published in Chevillard 1893, pp. 45–46; Bénédite 1931, vol. I, p. 138). A number of drawings dated January 1841 confirm his presence in Florence, Livorno, Pisa, and Genoa (Chevillard 1893, p. 254; Bénédite 1931, vol. I, p. 87; Prat 1988-1, vol. I, nos. 512, 1527–1528, 1238–1243, 1423–1425, pp. 451, 244, 556, 485–86, 529–30, respectively). After seeing the van Dycks at the Palazzo Brignola in Genoa (Bénédite 1931, vol. I, p. 133; Prat 1988-1, vol. I, no. 1533, p. 558), he "returns to France, probably by ship, at the end of the month of January" (Prat 1988-1, vol. I, p. 451).

■ An Indelicate Charlatan

Writing on January 16, most likely after Théodore's departure, Lehmann gives full vent

to his rancor and calls "the Little Ch[assériau]. . . a very *nasty gentleman*," adding: "His sojourn in Rome has been unfortunate for him; he left behind the reputation of a rather indelicate charlatan" (Letter from Henri Lehmann to Marie d'Agoult, January 16, 1841, Rome; Archives of the comte Hauteclocque, transcribed by Dupêchez; Joubert 1947, pp. 143–45).

February 5

■ Back in Paris

The date of Chassériau's return is given by Marie d'Agoult, who writes: "He had not been back in Paris more than three days when he came to see me (I learned this not through him but through Th[éophile] Gautier)" (Letter from Marie d'Agoult to Henri Lehmann, March 1, 1841 [Paris]; Archives of the comte Hauteclocque, transcribed by Dupêchez; Joubert 1947, p. 156). Since Chassériau would pay her a visit on February 7 (see below), he must have been back in Paris on February 5 at the latest.

Evening of February 7

■ Marie d'Agoult's Salon

Chassériau attends one of Marie d'Agoult's salons on Sunday evening February 7. He speaks to her of Father Lacordaire, with whom he claims to have been friends "for a <u>long time</u> and he has been wanting me to paint his portrait for a *very*

long time." Otherwise, Marie d'Agoult writes to Lehmann, "he seemed neither <u>timid</u>, nor <u>untamed</u> as you said last spring, but his comportment was excellent. . . . As he was leaving, he asked me to come to his studio. I shall go" (Letter from Marie d'Agoult to Henri Lehmann, February 7, 1841, Paris; Archives of the comte Hauteclocque, transcribed by Dupêchez; Joubert 1947, p. 150).

February 8

■ A Prodigious Talent

Marie d'Agoult takes Chassériau up on his invitation (see above, *February 7*) and visits his studio in the company of Sainte-Beuve and Mlle Zoë de La Rüe (one of Delphine de Girardin's childhood friends). She admires the Lacordaire and La Tour Maubourg portraits, as well as the sketch for a small composition entitled *The Hours of the Day Fleeing the Approach of Night*. Writing to Lehmann, she says: "He received us with *remarkable* graciousness and tact," and concludes: "He is a prodigious talent at 21 years of age." She invites him to dinner on Saturday February 13 (Letter from Marie d'Agoult to Henri Lehmann, March 1, 1841 [Paris]; Archives of the comte Hauteclocque, transcribed by Dupêchez; Joubert 1947, p. 156).

February 11

■ Théodore and the Monnerot Family

Mme Monnerot writes to her son Jules: "Théodore has arrived, enchanted by his trip. Yesterday we went to see two portraits he did in Rome that he should exhibit: one of abbé Lacordaire and the other of Mlle de Latour [*sic*] Maubourg. They are very good; I think they will be very successful. Théodore is the same as ever; he comes to see us as before. He must write to you" (Letter from Mme Monnerot to her son Jules, February 11, 1841, Paris; BnF, Dépt. des Ms, Naf. 14405, Papiers Gobineau, vol. 17, fol. 64).

February 13

■ Dinner at Marie d'Agoult's

Chassériau accepts the invitation of February 8th (see above). Also present at Marie d'Agoult's are the Girardins, the comtesse d'Obreskoff, Bulwer, Eugène Sue, Ronchaud, and Mlle Zoë de La Rüe. He "conquered [them] all. . . . They are all mad about him. And so he is established and has his place in my salon like an old regular" (Letter from Marie d'Agoult to Henri Lehmann, March 1, 1841 [Paris]; Archives of the comte Hauteclocque, transcribed by Dupêchez; Joubert 1947, pp. 156–57).

February 22

■ Another Studio Visit

Marie d'Agoult writes to Franz Liszt: "Yesterday I spent two hours in Chassériau's studio looking at drawings of Rome, heads of sailors from Genoa, landscapes of the Villa Borghese, etc., etc. I returned from there sad beyond words" (Letter from Marie d'Agoult to Franz Liszt, February 23 [1841], Paris; quoted in Vier 1959, vol. 2, p. 278 n. 109; published in Liszt and d'Agoult 2001, p. 773).

February 26 and 28

■ The Salon Jury

In the "portrait" category, the jury accepts Chassériau's "Ptg of Father Lacordaire, preacher [no. 1912]." The "Ptg of Mme la Ctesse de L.T.M. [no. 1913]" is accepted after a vote of thirteen to five. At the session of February 28, the *Andromeda* is accepted in the "history genre" (7th and 8th sessions of the jury, February 26 and 28, 1841; Archives des Musées Nationaux, *KK. 35, *KK. 58, nos. 1912–1913, 3109).

March 1

■ "A Nasty Gentleman"

Marie d'Agoult introduces Chassériau to "de Vigny and the Didiers. He . . . <u>asks</u> to do a drawing for my album, a pencil portrait of me and any small portraits of my friends I might want. There was talk (after <u>midnight</u>, between S[ain]te-Beuve and Ronchaud) of Rome and of M. Ingres; he is <u>respectful</u>, but discerning. . . . He was neither <u>excited</u> nor angry in talking about all that, but simple and correct." She acknowledges to Lehmann having observed Chassériau and detected none of the "<u>perfidy</u>" of a "<u>nasty gentleman</u>." Above all, she admires his "<u>knowledge of the world</u>" (Letter from Marie d'Agoult to Henri Lehmann, March 1, 1841 [Paris]; Archives of the comte Hauteclocque, transcribed by Dupêchez; Joubert 1947, pp. 157–58).

March 2

■ The Lacordaire Affair (continued)

In the postscript to her long letter to Lehmann of March 1, Marie d'Agoult explains that she had just had "a long conversation with Ch[assériau]. about you, the story of the portrait, etc., etc." She appeals for a reconciliation. More than "the opinion of Mr Ingres and company," Chevandier's friendship for Chassériau seems to her a guarantee of his honesty (Letter from Marie d'Agoult to Henri Lehmann, March 2, 1841 [Paris]; Archives of the comte Hauteclocque, transcribed by Dupêchez; Joubert 1947, p. 159).

On the same day, Lehmann writes to Marie d'Agoult, trying to convince her that Chassériau had been disrespectful to Paul Chevandier's sister (see above, *January 1–15, 1841*).

March 15

■ The Salon of 1841

The exhibition catalogue (*Explication des ouvrages de peinture, sculpture, architecture, gravure et lithographie des artistes vivants exposés au musée royal le 15 mars 1841* [Paris 1841], p. 49) lists the following entries:
Chassériau (Théodore), *11, rue Neuve-Saint-Georges*
[no.] 326 – Andromeda Chained to the Rock by the Nereids (36 ¼ x 29 ⅛ in.; Sandoz 1974, no. 64, p. 162; Laveissière 1987, pp. 148–50).
[no.] 327 – Portrait of the R. P. F. Dominique Lacordaire, of the Order of the Predicant Friars (57 ½ x 42 ½ in.; Sandoz 1974, no. 72, pp. 172–74).
[no.] 328 – Portrait of Mme la comtesse de L.T.M. . . . (52 x 37 ¾ in.; Sandoz 1974, no. 87, p. 186).

■ Poor Placement and Responses

To a friend of the Chassériau family, the portrait of the comtesse de La Tour Maubourg demonstrates "the abuse of an ultra-Ingriste system" (Letter to Frédéric Chassériau from a family friend [after March 15, 1841], n.p.; quoted in Bénédite 1931, vol. 1, p. 160). Mottez notes: "Chassériau has some good portraits" (Letter from Victor Mottez to Hippolyte Fockedey [March 16, 1841] [Paris]; published in Giard 1934, p. 151). A month later, Marie d'Agoult would write: "In general, Chassériau has had no success, especially with the woman's portrait. Several people adamantly support him: Th. Gautier, J. Janin, which is hardly logical" (Letter from Marie d'Agoult to Henri Lehmann, April 21, 1841 [Paris]; Archives of the comte Hauteclocque, transcribed by Dupêchez; Joubert 1947, p. 164). In late September, Lacordaire would allude to the "violent attacks of the press" (see below, *September 27, 1841*).

March 20

■ The Master's Affront

Lehmann responds to Marie d'Agoult's "peace mission" (see above, *March 2*) by giving her proof of his generosity. He asks her to tell Chassériau—without letting him know "where it came from"—not to "go see the pictures that M[r] I[ngres] is bringing over to my place; it would be a sort of affront for him" (Letter from Henri Lehmann to Marie d'Agoult, March 20, 1841, Rome; Archives of the comte Hauteclocque, transcribed by Dupêchez; Joubert 1947, p. 161). Ingres was leaving his position as director of the Villa Medici and preparing to return to Paris.

March 23

■ The Star of the Big Dipper (?)

Chassériau observes the starry sky and notes on the next day: "For the star that I need—yesterday, the 24th, at nine in the evening, the star was a golden white, the sky blue mixed with gray, with a fine white glow all around. It is the only time I ever saw it like that. (March 1841)" (Chevillard 1893, p. 251).

April 21

■ Portraits of Marie d'Agoult and of Parish

Marie d'Agoult writes to Lehmann: "He did a drawing of me that I find lovely and a good likeness but that is not pleasing because it shows me with my mouth open. He just finished a small oil portrait of Parish and is working on his Trojan women on the seashore" (Letter from Marie d'Agoult to Henri Lehmann, April 21, 1841 [Paris]; Archives of the comte Hauteclocque, transcribed by Dupêchez; Joubert 1947, p. 164). The portrait of Marie d'Agoult, which is signed and dated "Théodore Chassériau / Mars 1841," is now in the Musée du Louvre (Prat 1988-1, vol. 1, no. 1065, p. 436; cat. 53); the portrait of Georges Parish (1807–1881), a merchant and businessman, is lost. *The Trojan Women* was already being planned in Rome, and was to be exhibited at the Salon of 1842 (see below, *March 15, 1842*).

April 23

■ The Chevandier-Chassériau Falling-out

Lehmann writes to Marie d'Agoult: "You should know that Ch[assériau], whose friendship with Chev[andier] in your eyes was a guarantee, openly paid back this friend, who had showered him with favors and material support, with words and actions I refrain from describing, but which were enough to preclude any future relations between them. Chev[andier] himself related these facts and the consequences to me. And if you need the testimony of a man who is more calm and less likely to be suspected of partiality (or of weakness), I would mention Father Lacordaire, who had time to obs[erve] his defects and who fully agrees with me" (Letter from Henri Lehmann to Marie d'Agoult, April 23, 1841, Rome; Archives of the comte Hauteclocque, transcribed by Dupêchez; Joubert 1947, pp. 167–68). Concerning this falling-out see above, *January 1–15, 1841,* and below, *September 27, 1841.*

Early May

■ Ingres Returns to Paris

Several days after his return (on May 2), Ingres and his wife are the guests of Marie d'Agoult. She writes to Lehmann about this meeting on the 18th: "I mentioned in passing that I had seen another of his pupils a few times: M. Ch[assériau]. At that, Mme Ingres spoke up to say the worst things about him. [Ingres] smiled with satisfaction, accusing her of calumny, and then he went on to tell me: 'This gentleman has taken rather too arrogant a position toward his master.'" Marie d'Agoult complained about not seeing Chassériau anymore, "without knowing why myself" (Letter from Marie d'Agoult to Henri Lehmann, May 18, 1841 [Paris]; Archives of the comte Hauteclocque, transcribed by Dupêchez; Joubert 1947, pp. 168–69).

May 15

■ Disfavor

The violent criticism that greeted the portrait of the comtesse de La Tour Maubourg at the Salon of 1841 must have reached the sitter's ears. Writing from Rome, Papety tells the sculptor Ottin (a former recipient of the Prix de Rome): "Mme de Maubourg (who is pregnant) is furious with Chassériau, he has lost all favor and we are the ones who are replacing him" (Letter from Dominique Papety to Auguste Ottin, May 15, 1841, Rome; published in Amprimoz 1986, p. 263). According to Bénédite (1931, vol. 1, p. 119), Chassériau and Ottin had seen each other in Rome and would remain friends.

May 30

■ The Three Duperré Ladies

In a letter to her son, Mme Monnerot writes: "Théodore intends to write to you. He did the portraits of the three Duperré ladies" (Letter from Mme Monnerot to her son Jules, May 30, 1841 [Paris]; BnF, Dépt. des Ms, Naf. 14405, Papiers Gobineau, vol. 17, fol. 66). This drawing, which is signed and dated "1841," is in The Metropolitan Museum of Art, New York (Bénédite 1931, vol. 1, p. 346; Sandoz 1986, vol. 2, no. 81, p. 95; Prat 1988-2, no. 83, p. 18; cat. 57). The wife of Admiral Duperré (then Minister of the Navy) was a child-

hood friend of Mme Monnerot. Théodore's brother Frédéric had been working for several months as head of the admiral's cabinet.

May

Chassériau executes portrait drawings of his sisters Adèle and Aline, which he dedicates to his brother Frédéric (Bénédite 1931, vol. 1, p. 202; Prat 1988-1, vol. 1, nos. 1066–67, pp. 436–37; cat. 54, 55). These would serve as preparatory drawings for the painting exhibited at the Salon of 1843 (see below, *March 15, 1843*).

June 9

■ At the Opéra with Little Chassériau

Marie d'Agoult confides to Liszt that she heard Weber's *Der Freischütz* (adapted by Berlioz), in Girardin's box at the Opéra, along with Zoë de La Ruë and "little Chassériau" (Letter from Marie d'Agoult to Franz Liszt, June 10 [1841] [Paris]; quoted in Vier 1959, vol. 2, p. 278 n. 109; published in Liszt and d'Agoult 2001, p. 820).

June 15

■ Ingres and His Triumphant Banquet

Ingres's banquet at the Salle Montesquieu begins at six o'clock and is presided over by the marquis de Pastoret. Among the 426 guests is Théodore Chassériau, but not Delacroix. Upon seeing him again, Ingres embraces Chassériau (Letter from Marie d'Agoult to Henri Lehmann, June 18, 1841 [Paris]; Archives of the comte Hauteclocque, transcribed by Dupêchez; Joubert 1947, p. 176).

June 16

■ The Master and Pupil Meet Again

On the day after the banquet, Marie d'Agoult hosts a more modest reception with "V. Hugo, MM. Mignet, Ampère, Duban and Balzac." Ingres and Chassériau "had a long conversation, which I do not think will change any of the master's reservations, all the more as Mme Ingres is unrelenting, but it restored appearances as far as their relations are concerned" (Letter from Marie d'Agoult to Henri Lehmann, June 18, 1841 [Paris]; Archives of the comte Hauteclocque, transcribed by Dupêchez; Joubert 1947, p. 176).

July 23

■ *The Madonna of the Candelabra* (continued)

Chassériau asks Delaunay, the editor of *L'Artiste,* to set aside "some good proofs of the engravings" of his *Madonna of the Candelabra* for his friend Oscar de Ranchicourt. The review calls it a "charming engraving by Mons. Dien, after a drawing by M. Chassériau" (*L'Artiste* 2, 1841, pp. 424–25; Sanchez and Seydoux 1998, vol. 1, p. 133). Chassériau had completed the drawing for it shortly before his departure for Rome (see above, *June 14, 1840*). Chassériau concludes his letter: "I hope that the engraving of the portrait of M^r Abbé Lacordaire will be finished soon and well done" (Letter from Théodore Chassériau to A.-H. Delaunay, July 23, 1841 [Paris]; Médiathèque, La Rochelle, MS. 621, fol. 224 r.). On the latter engraving see below, *August–September 1841.*

July

■ Exhibition in the Museum in Rouen

The portrait of Lacordaire shown at the Salon of 1841 (see above, *March 15, 1841*) is included in the annual exhibition in Rouen (*Catalogue de la neuvième exposition annuelle du Musée de Rouen* [Rouen, 1841], p. 10):

Paris, 11, rue Oliviers-Saint-Georges
[no.] 71. *Portrait of R. F. Lacordaire, of the Order of the Predicant Friars.*

■ Peace—Commerce

Chassériau would elaborate upon the composition of this drawing, inscribed "juillet 1841" (Prat 1988-1, vol. 1, no. 539, p. 253), in his decorative program for the Cour des Comptes (see below, *December 27, 1843*).

August 15

■ A Silver Medal

For his portrait of Lacordaire, Chassériau is awarded a silver medal at the exhibition in Rouen (see above, *July 1841*), which the curator of the museum offers to put in safekeeping for him (Letter from Hippolyte Bellangé to Théodore Chassériau, August 15, 1841, Rouen; quoted in Bénédite 1931, vol. 1, p. 158).

August 24

■ A Commission for Saint-Merri

Frédéric is informed by the Prefecture of the department of the Seine that his brother has been entrusted with "the execution of a chapel in the Church of Saint-Merri" (Letter from F. Amollier to Frédéric Chassériau, August 24 [1841], Paris; published in Bénédite 1931, vol. 1, pp. 173–74). Amaury-Duval is given a similar commission (see below, *May 13, 1842,* and *December 1842*).

August–September (?)

■ Engraving of the Lacordaire Portrait

Chassériau suggests to Delaunay, editor of *L'Artiste,* that the engraving of his Lacordaire portrait being executed by Monnier be "retouched with white accents. . . . If this procedure works I think it will gain a lot in character and fidelity" (Letter from Théodore Chassériau to A.-H. Delaunay, Thursday [August–September (?) 1841]; Médiathèque, La Rochelle, MS 621, fol. 230 r.). The etching was printed in the January 16, 1842, issue (*L'Artiste* 1, 1842, pp. 48–49; Sanchez and Seydoux 1998, p. 135).

September 17

■ Competition for Napoleon's Tomb

The new Minister of the Interior, Duchâtel, announced a competition for Napoleon's tomb in April 1841, for which eighty proposals were exhibited in October at the École des Beaux-Arts. Shortly before, a friend of the Chassériau family wrote to them: "I would like Théodore to be in a position to execute his project for the tomb, which seems quite grandiose. But it will take more than talent to obtain this great assignment" (Letter from M. de Reste to the Chassériau family, September 17, 1841, n.p.; quoted in Bénédite 1931, vol. 1, p. 164). A series of related drawings is in the Musée du Louvre (Prat 1988-1, vol. 1, nos. 999–1007, pp. 407–11; cat. 35).

September 20

■ Zoë de La Ruë and Liszt's Displeasure

In Frankfurt, where she is Liszt's guest, Marie d'Agoult receives a letter from Zoë de La Ruë telling her that Chassériau is spending "almost every evening" at her home: "He gives lessons to his adoptive daughter. The so-called *nasty gentleman* is still working on his *Trojan Women;* he painted a small portrait of Georges Parish, who has had no success with the family in Hamburg." Marie d'Agoult wants Lehmann to paint her likeness as a present for Liszt, who "intensely disliked the one by Chassériau" (Letter from Marie d'Agoult to Henri Lehmann, September 20, 1841, Frankfurt; Archives of the comte Hauteclocque, transcribed by Dupêchez; Joubert 1947, p. 178; Vier 1959, vol. 2, p. 62).

September 27

■ Chassériau and Religion

The sentiments "on the subject of religion and the clergy" that Chassériau expresses in the presence of the baronne Hortense de Prailly (née Chevandier) dismay Father Lacordaire. This "change might be due to the violent attacks in the press over the last four or five months," or to "his portrait's lack of success," and his falling-out with Paul Chevandier (Letter from Father Lacordaire to Baronne Hortense de Prailly, September 27, 1841, Rome; published in Lacordaire 1885, p. 28; Bénédite 1931, vol. 1, p. 156). On this falling-out see above, *January 1–15* and *April 23, 1841).*

November 23

■ Théodore the Scoundrel

A soirée is given to celebrate the name days of Clémence Monnerot and her friend "little Blanche." Clémence writes: "Théodore wanted to be introduced there; we took him along. He found one of his friends, Mr Claret, and Mr de Lanagnas [?] with whom he talked a great deal. I do not think that he was averse to getting on his good side and with reason. . . . Mr Dubois, whom you know, was there, and Mr de Court, Mr Guizot's brother-in-law. Finally, Théodore himself—who did not offer me so much as a flower—claims that he is a *scoundrel* for not having given me anything" (Letter from Clémence Monnerot to her brother Jules, Thursday, November 25, 1841 [Paris]; BnF, Dépt. des Ms, Naf. 14394, Papiers Gobineau, vol. 6, fol. 57).

November

■ Competition for Napoleon's Tomb (continuation and end)

Chassériau reproaches Delaunay, editor of *L'Artiste,* for failing to mention his name in his review of the competition: "I participated with no other intention than to show my good will and zeal [and] the *amateurs* complimented me [on the drawing]. But it's over, <u>let's drop it</u>" (Letter from Théodore Chassériau to A.-H. Delaunay [November 1841, Paris]; Médiathèque, La Rochelle, MS 621, fol. 233 r. and v.; Peltre 2001, p. 150).

December 6

■ Reading of *Judith*

At her salon, Delphine de Girardin gives a reading of *Judith,* the tragedy she wrote for the actress Rachel (Martin-Fugier 1986, vol. 1, p. 811 n. 283). The play is rejected by the Théâtre-Français and will not be performed by Rachel until 1843, in a production with costumes designed by Chassériau (see below, *March 15, 1843).*

December 8

The Lacordaire Affair: Ultimate Rejection

Writing from Bordeaux, Lacordaire informs Louis Cabat that "Chassériau's portrait has already been sent here, but we want another," adding that Flandrin's portrait would be perfectly suitable (Letter from Father Lacordaire to Louis Cabat, December 8, 1841, Bordeaux; Archives of Pierre-Louis Cabat, Troyes; *L'Année dominicaine,* August 1894, p. 342). The Chassériau portrait he refers to is obviously the lithograph, not the painting.

■ Trip to Fontainebleau

At some unknown date, most likely in 1841, Chassériau copies the frescoes in the ballroom and the stucco designs in the duchesse d'Étampes's chamber at the Château de Fontainebleau (Sandoz 1970, p. 48; Prat 1988-1, vol. 2, no. 2241, pp. 871–73; Peltre 2001, pp. 93–94).

■ 1842

Late January

■ The Etching of the Portrait of Lacordaire

L'Artiste prints the Lacordaire etching in the January 16, 1842, issue without notifying Chassériau, who writes to the editor: "I found out by chance that my portrait of F. Lacordaire had been published. I had not received any proofs to check. As for the Madonna, in [connection with] which I am mentioned as little as possible, I would be grateful if you would send me a few copies that I can to give to my friends" (Letter from Théodore Chassériau to A.-H. Delaunay, Tuesday [late January 1842, Paris]; Médiathèque, La Rochelle, MS 621, fol. 225 r. and v.). On the *Madonna,* see above, *June 14, 1840,* and *July 23, 1841).*

February 5

■ Marie d'Agoult's Salon (1)

Chassériau's presence at Marie d'Agoult's is documented in her diary: "D'Eckstein / Chassériau / Jesi / F[erdinand] Denis / Zoë [de La Ruë] / Lehmann / V[iel] Castel / Koreff / Girardin / Ronchaud" (Diary of Marie d'Agoult, 1842; BnF, Dépt. des Ms, Naf. 14322; transcription kindly provided by Ch.-F. Dupêchez).

February 22 and March 3

■ The Salon Jury

In the "Genre" category, a "Pict. Esther Dressing [no. 3018]" is accepted after a vote of eleven to nine. On March 3, two paintings, "*The Trojan Women* [no. 3019]" and "*The Descent from the Cross* [no. 3021]" are accepted in the "History" category (2nd and 10th sessions of the jury, February 22 and March 3, 1842; Archives des Musées Nationaux, *KK. 36, *KK. 59, nos. 3018, 3019, 3021). Ingres was a member of the jury that year.

March 5

■ Marie d'Agoult's Salon

Chassériau's presence at Marie d'Agoult's is documented in her diary: "S[ain]te-Beuve / Mother / Zoë [de La Ruë] / Mignet / Jesi / Chevandier / Maurice [de Flavigny] / V[iel] Castel / Ronchaud / Simpson / Lehmann / Roth [?] / Chassériau / de La Ruë / Grille / Tokareff" (Diary of Marie d'Agoult, 1842; BnF, Dépt. des Ms, Naf. 14322; transcribed by Ch.-F. Dupêchez).

March 7

■ Portrait of a Man

Chassériau draws a bust-length portrait of a man in left profile and dates it "7 mars 1842" (see cat. 60). Louis-Antoine Prat (1988-1, vol. 1, no. 1069, pp. 437–38) points out that the technique—

pen and ink—was very seldom used by Chassériau, for portraits, and wonders if it might not be a likeness of his brother Frédéric, then thirty-five years old.

March 12

■ Marie d'Agoult's Salon

Chassériau's presence at Marie d'Agoult's is documented in her diary: "D'Eckstein / Ronchaud / Mme Didier / Louis de Viel Castel / Denis / Delphine [de Girardin] / Zoë [de La Ruë] / Mother / Colonel [de La Ruë] / Lehmann / Chassériau / Mignet / V[ictor] Hugo / Suzannet / Simpson / Tokareff / Émile [de Girardin] / Ronchaud / Rey / Grzymala / Freyssinet / Horace [de Viel Castel] / <u>Reading</u>" (Diary of Marie d'Agoult, 1842; BnF, Dépt. des MS, Naf. 14322; transcribed by Ch.-F. Dupêchez). According to Dupêchez, the reading mentioned at the end involves a heroic drama in verse by Louis de Ronchaud.

March 15

■ Salon of 1842

The exhibition catalogue (*Explication des ouvrages de peinture, sculpture, architecture, gravure et lithographie des artistes vivants exposés au musée royal le 15 mars 1842* [Paris 1842], p. 42) lists these works:

Chassériau (Théodore), *34, rue de Bréda.*
[no.] 345 – The Descent from the Cross. (M. I.)*

($118 \frac{1}{8}$ x $86 \frac{5}{8}$ in.; Sandoz 1974, no. 92, p. 194).

[no.] 346 – The Toilette of Esther (18 x 14 in.; Sandoz 1974, no. 89, pp. 188–89).

15 "... she required nothing but what Hegai, the king's chamberlain, the keeper of the women, appointed. And Esther obtained favour in the sight of all them that looked upon her" (Esther 2: 2 [sic]).

[no.] 347 – The Trojan Women ($66 \frac{1}{8}$ x 85 in.; Sandoz 1974, no. 99, pp. 190–92).

"On a remote desert beach, the Trojan Women mourned the loss of Anchises, and weeping, they gazed upon the deep sea" (Virgil, *Aeneid,* bk. 5).
* Commissioned by the Ministry of the Interior.

March 31

■ Marie d'Agoult's Diary

A loose page with the following names was found in Marie d'Agoult's diary: "1842 Émile [de Girardin], Charles Didier, Louis de Ronchaud, S[ain]te-Beuve, Franz de Schönborn, Léon [Ehrmann], Louis de Viel Castel, Rey, Manuel Marliani./ 1841 Émile [de Girardin], Chassériau, S[ain]te-Beuve, Félix [Lichnowsky], Louis de R[onchaud], Théophile de Ferrière./ 1840 Henry Bulwer, Bernard Potocki, Louis de R[onchaud], Eugène Sue./ 1843 Meyerbeer, Viel Castel, Bulwer, Bertin, Mignet, Vigny" (Diary of Marie d'Agoult, 1842; BnF, Dépt. des Ms, Naf. 14322; transcribed by Ch.-F. Dupêchez).

April 2

■ Friends of the Chassériau Family

Mme Monnerot ends her letter to her son Jules with: "The Chassériau men and women and Angele Lenir send you all their friendship" (Letter from Mme Monnerot to her son Jules, April 2 [1842], Paris; BnF, Dépt. des Ms, Naf. 14405; Papiers Gobineau, vol. 17, fol. 69). The Lenirs were cousins of the Monnerots.

April

■ Thoughts to Keep

Several weeks before sending his sketches for the decorations at the Church of Saint-Merri (see below, *May 13, 1842*), Chassériau sets down some thoughts on his working methods: "Let things ripen, and yet trust my first instinct ..." (Chevillard 1893, p. 263; Bénédite 1931, vol. 1, pp. 176–77). Chassériau often wrote such notes; see, for example those of February 1842 (Prat 1988-1, vol. 1, no. 387, pp. 196–97).

Late April–early May (?)

■ Request for a Rehanging

At an unknown date, probably during the temporary closing of the Salon, Chassériau requests a rehanging of his paintings: "Chassériau requests that his Descent from the Cross be hung in the Grand Salon and that his Trojan Women also be changed." His name is crossed out, which might mean that his wishes were taken into account (Archives des Musées Nationaux, dossier 10, Salon de 1842, dossier "Réclamation pour le mouvement 1842").

May 13

■ Sketch for the Chapel at Saint-Merri

Amollier forwards to Chassériau notes from the Commission des Beaux-Arts, "to which your sketch was submitted." The commission commented on the "difference in size of the figures of the three subjects grouped in the same panel" and urged Chassériau to "consult M. Amaury-Duval, entrusted with the decoration of a chapel adjacent to his, and with M. Baltard, Inspector of Works for the City of Paris, in order to establish as much harmony as possible between these two chapels and the one previously executed by M. Lépaule" (Letter from Amollier to Théodore Chassériau, May 13, 1842, Paris, and report of the Commission des Beaux-Arts, undated; published in Bénédite 1931, vol. 1, pp. 177–78).

June 15

■ Friends of the Chassériau Family

Clémence Monnerot ends her letter to her brother Jules with: "The Chassériaus send you their best" (Letter from Clémence Monnerot to her brother Jules, Wednesday [June 15, 1842, Paris]; BnF, Dépt. des Ms, Naf. 14394, Papiers Gobineau, vol. 6, fol. 62 r.).

June

■ Lithograph of the *Venus Anadyomene*

In his new magazine, *Le Cabinet de l'amateur et de l'antiquaire* (1, 1842, p. 336), Eugène Piot publishes a lithograph of Chassériau's *Venus Anadyomene,* which had been shown at the Salon of 1839 (see above, *March 1, 1839*) and had been printed by Bry (Sandoz 1974, no. 266, p. 418). It is copyrighted June 1842 (Baltimore, 1979–80, no. 3, pp. 146–47). A copy of this print exists with a dedication in ink: "A mon ami O D de Ranchicourt / Th Chassériau 1842" (Paris, private collection); another example, in the museum in Boston, is inscribed: "A Eudoxe Soulié. Th. Chassériau. 1847" (Baltimore, 1979–80, no. 3, p. 147).

July 23

■ Soirée at the Monnerots'

Chassériau's presence at Mme Monnerot's is indicated by a remark in her letter to her son Jules: "We saw Théodore yesterday evening." She also mentions that she had met the duc d'Orléans shortly before his death: "We saw him Thursday in the Bois de Boulogne, where we spent the day with the Chassériau ladies, who rented a small house near the park" (Letter from Mme Monnerot to her son Jules, July 24 [1842], Paris; BnF, Dépt. des Ms, Naf. 14405, Papiers Gobineau, vol. 17, fol. 71).

October 23

■ Marie d'Agoult's Salon

Chassériau's presence at Marie d'Agoult's is documented in her diary: "Wrote to Bartolini, Mother, Pictet. / Long conv[ersation] with Zoë [de La Ruë], Nénuphar. / Chassériau and Grast [?]" (Diary of Marie d'Agoult, 1842, BnF, Dépt. des Ms, Naf. 14322; transcribed by Ch.-F. Dupêchez).

Late October–Early November (?)

■ The *Susanna* Arrives in the United States

The French consul general in the United States, L. de la Force, informs Frédéric Chassériau that he has just received the *Susanna and the Elders,* which had been exhibited at the Salon of 1839: "If I had not known that it was from him, I would have attributed it to Ingres, his famous master. What progress your brother has made, what a pure line, what a beautiful pose his chaste Susanna has!" La Force refuses to accept this "beautiful page [sic] as a gift" and offers to "have it exhibited" to obtain a "good price" (Letter from L. de la Force to Frédéric Chassériau [New York or Washington (?), late October–early November (?)], 1842; published in Bénédite 1931, vol. 1, pp. 98–99). Chassériau may have offered the *Susanna and the Elders* to the consul to advance his father's career. In any case, the painting was shipped back to France to be shown at the Exposition Universelle of 1855 (see below).

November 1

■ Marie d'Agoult's Salon

Chassériau's presence at Marie d'Agoult's is documented in her diary: "Atelier. Humboldt. Décl[aration] Marliani = / S[ain]te-Beuve, Vigny, Chassériau, Girardin./ His brother carries his self-esteem for him (Musset)" (Diary of Marie d'Agoult, 1842; BnF, Dépt. des Ms, Naf. 14322; transcribed by Ch.-F. Dupêchez).

November 6

■ Request for an Appointment

In a letter written in Frédéric's hand, Chassériau asks the director of the Louvre for "the honor of talking with you a few moments" (Letter from Théodore Chassériau [written by Frédéric Chassériau] to the director of the Musée du Louvre, November 6, 1842, Paris; Archives des Musées Nationaux, dossier P. 30, Chassériau). The object of this request is not known.

November 24

■ A Serious Accident

Clémence Monnerot informs her brother: "Mr Théodore had a fall and was seriously injured, for it has been many days, more than ten days, since we have seen him. His concièrge told us this, that he had lost a lot of blood, but that he was not in danger" (Letter from Clémence Monnerot to her brother Jules [November 24, 1842, Paris]; BnF, Dépt. des Ms, Naf. 14394, Papiers Gobineau, vol. 6, fol. 64).

December 18

■ Marie d'Agoult's Salon

Chassériau's presence at Marie d'Agoult's is documented by her diary: "Storm against <u>Hervé</u>. Critics des Gay, Chassériau, etc. / The ivy that covers the inscriptions is the eternal wisdom of nature hiding the ephemeral folly of man (Lehmann). / I like to look like a fat fishwife" (Diary of Marie d'Agoult, 1842; BnF, Dépt. des Ms, Naf. 14322; transcribed by Ch.-F. Dupêchez).

December 24

■ Marie d'Agoult's Salon

Chassériau's presence at Marie d'Agoult's is suggested by the mention of his name in her diary: "Dined. / Maurice arrived at 4. / Viel Castel / S[ain]te-Beuve / Bulwer / Mignet / Freyssinet / Ferrière / Mignet very likable. Sasanoff Marescot. The Roth thing. Lehmann Chassériau = Quarrel from Delphine to Émile: I am Georgine. Charles [d'Agoult] read Hervé and seems proud. S[ain]te-Beuve reads his verse to Jouffroy. Emmeline. A sonnet from the 16th century" (Diary of Marie d'Agoult, 1842; BnF, Dépt. des Ms, Naf. 14322; transcribed by Ch.-F. Dupêchez).

December

■ End of the Work at Saint-Merri

According to Mottez, Amaury-Duval has "finished his chapel, but he is not unveiling it this year because he hopes to get the other wall and wants to show the whole thing together. Chassériau, his neighbor, has the same problem. . . . " (Letter from Victor Mottez to Hippolyte Fockedey [December 1840, Paris]; published in Giard 1934, p. 158). In late October it had been reported that Amaury-Duval had "had his scaffolding removed in order to evaluate the whole composition" (*Journal des artistes,* October 23, 1842, p. 270). Between May 13, when the sketches were sub-mitted (see above), and December, six months had elapsed, the "few months" that Théophile Gautier mentioned were needed for the execution of this "enormous work" (Gautier, November 2 and 3, 1843, p. 2: Bénédite 1931, vol. 1, p. 200). The chapel would not be opened to the public until November 1843 (see below).

There is an undated note related to this project whose significance is unclear: "Legend of Mary of Egypt / Wall painting / St Merry to see with Mr Chassériau by notifying him [at] rue Olivier St. Georges / n° 11" (Archives des Musées Nationaux, dossier P. 30 Chassériau). The note might refer to a visit by an inspector from the Commision des Beaux-Arts.

■ 1843

January 19

Refusal of a Portrait

Chassériau writes to the journalist and man of letters Xavier Eyma (1816–1876), whom he had visited the previous evening: "Thank you for having thought of me for the portrait you mentioned. At this time, in spite of the pleasure I would have in doing it, I cannot take it on. Until the Salon, my days are filled from morning until night with finishing the picture I have undertaken" (Letter from Théodore Chassériau to Xavier Eyma, Wednesday, January 19 [1843] [Paris]; BnF, Dépt. des Ms, Naf. 21014, fol. 83). The painting in question was the double portrait of his sisters Adèle and Aline (see below, *March 15, 1843*).

February 8

Marie d'Agoult's Diary

Marie d'Agoult writes: "Ronchaud comments on the change in the character of my beauty (Chassériau portrait)" (Diary of Marie d'Agoult, 1843; BnF, Dépt. des Ms, Naf. 14322; transcribed by Ch.-F. Dupêchez). On this portrait see above, *April 21, 1841.*

February 11

Marie d'Agoult's Salon

Chassériau's presence at Marie d'Agoult's is documented by her diary: "Jesi / Raulin / Mignet / S[ain]te-Beuve / Petetin / M[auri]ce [de Flavigny] / Sasanoff / [de La Ruë] / [Louis de] V[iel] Castel / Ronchaud / Horace [de Viel Castel] / Lehmann / Rey / Simpson / Grzymala / Chassériau / Freyssinet / The Laborers of Lamennais./ Argument between Raulin and Mignet. . . ." (Diary of Marie d'Agoult, 1843; BnF, Dépt. des MS, Naf. 14322; transcribed by Ch.-F. Dupêchez).

March 2

The Salon Jury

A "Pict. of two ladies" (no. 3663; see cat. 61) is accepted in the "Portrait" category after a vote of twelve to four (10th session of the jury, March 2, 1843; Archives des Musées Nationaux, *KK. 37, *KK. 59, no. 3663).

March 15

■ Salon of 1843

The exhibition catalogue (*Explication des ouvrages de peinture, sculpture, architecture, gravure et lithographie des artistes vivants exposés au musée royal le 15 mars 1843* [Paris, 1843], p. 36) lists the following:

Chassériau (Théodore), *34, rue de Bréda.*
[no.] 217 – Portrait of the Mlles C. . . (70 ⅞ x 53 ¼ in.; Sandoz 1974, no. 95, p. 206).

■ Costumes for *Judith*

Delphine de Girardin invites Théophile Gautier to see the drawings to be brought to her that "evening by M. Chassériau" (Letter from Delphine de Girardin to Théophile Gautier [Wednesday, March 15, 1843, Paris]; published in Gautier, *Correspondance,* 1986, vol. 2, p. 15). These were sketches for the costumes for *Judith,* the play written by Mme de Girardin for the actress Rachel. Rehearsals would begin March 17, and the premiere would take place April 24, 1843 (see below). Nine of these sketches are now in the Bibliothèque de la Comédie-Française (Peltre 2001, pp. 204–6).

March 25

■ Petition to the King

Chassériau signs a petition addressed "To His Majesty Louis Philippe King of the French" and requesting a reform of the Salon jury. Among the other signatures are those of Delacroix, Ingres, David d'Angers, Decamps, Paul Huet, Paul and Hippolyte Flandrin, Diaz, Eugène Isabey, F. Millet, Couture, Barye, Drolling, and Jules Etex (Archives des Musées Nationaux, dossier 10, Salon de 1843).

March

■ Drawing for Saint-Merri

A compositional sketch for the painting of *Saint Mary of Egypt Being Borne Up to Heaven by Angels* is signed and dated "Th. Chassériau mars 1843" (Prat 1988-1, vol. 1, no. 229, p. 135).

Early April

■ The Lehmann-Chassériau War

Émile de Girardin, editor of *La Presse,* reproaches Marie d'Agoult for having stirred up the tensions between Lehmann and Chassériau in her March 25 review of the Salon: "It has been said that you were not quite fair in your distribution of praise between Ch.- and Le-!" (Letter from Émile de Girardin to Marie d'Agoult [early April 1843, Paris]; BnF, Dépt. des Ms, Naf. 25187, fol. 58 r.; transcribed by Ch.-F. Dupêchez).

April 5

■ Vialis and His Paternal Commission

Vialis, a French colonial administrator under Benoît Chassériau's jurisdiction, asks him to intercede on his behalf with his son Théodore. Vialis wants the young artist to paint the portrait of his late father (a former deputy of the States General) "on canvas and life size." To do this, Chassériau would have to copy an old engraving, "which is in the Bibliothèque Royale in Paris in the collection of the members of the Constituent Assembly" (Letter from J. Vialis to Benoît Chassériau, April 5, 1843 [San Juan, Puerto Rico (?)]; published in Bénédite 1931, vol. 1, pp. 225–26). Benoît Chassériau would receive this letter on April 7, answer it the next day, and immediately forward it to his son.

April 11

■ Vialis (continued)

Six days after his first letter (see above, *April 5*), Vialis again asks Benoît Chassériau to intervene for him with his son, begging him "to entreat him with utmost urgency. For I suppose that it will take all your fatherly intervention to persuade him favorably, considering the difficulties that will face him at the beginning. . . . I am disposed to generously and expediently remunerate Monsieur, your son, for the efforts that he will deign to devote to me, but know what independent characters famous artists can have" (Letter from J. Vialis to Benoît Chassériau, April 11, 1843 [San Juan, Puerto Rico (?)]; published in Bénédite 1931, vol. 1, pp. 226–28). Théodore would accept the commission (see below, *May 11, 1844*).

April 12

■ **Marie d'Agoult's Salon**

Chassériau's presence at Marie d'Agoult's is documented by her diary: "Lucrèce by Bocage. / 30 people. / Lamartine / Polcastro / S[ain]te-Beuve / Reeve, etc. / Rellstab / Letissier / Eckstein / Didier / S[ain]te-Beuve / Raulin / Bois le C[om]te / Viel Castel / Sasanoff / Chassériau / This is a date (Lam[artine]) / 'France is growing' (Shakespeare Coriolanus)" (Diary of Marie d'Agoult, 1843; BnF, Dépt. des Ms, Naf. 14322; transcribed by Ch.-F. Dupêchez). Bocage's play would be performed at the Odéon on April 22.

April 24

■ *Judith* **Premieres**

Chassériau's presence at the play's premiere is not recorded but seems probable, since he designed the costumes for the tragedy, written by Delphine de Girardin for the actress Rachel (see above, *March 15, 1843*).

April

■ **Visits to the Monnerots**

Clémence Monnerot documents Chassériau's visits to her family: "Lenir comes in the evening every week, Théodore every ten days, and Frédéric [Chassériau], never.—That's it" (Letter from Clémence Monnerot to her brother Jules [April 1843, Paris]; BnF, Dépt. des Ms, Naf. 14394, Papiers Gobineau, vol. 6, fol. 66).

May 13

■ **Marie d'Agoult's Salon**

Chassériau's presence at Marie d'Agoult's is recorded in her diary: ". . . [de la Ruë] / Petetin / Mignet / V[iel] Castel / Sasanoff / Cambys / Bohn / Chassériau. / Evening stroll under the colonnade of the Madeleine" (Diary of Marie d'Agoult, 1843; BnF, Dépt. des MS, Naf. 14322; transcribed by Ch.-F. Dupêchez).

Early November

■ **The Chapel at Saint-Merri Opens to the Public**

According to Delécluze (November 21, 1843, p. 2), Chassériau's chapel "has already been open to the public for several days." Amaury-Duval's chapel, however, is not yet finished, and would not be for another year (Letter from Victor Mottez to Hippolyte Fockedey [September or October 1844, Paris]; published in Giard 1934, p. 161). One of the panels in Chassériau's chapel is signed and dated: "Théodore Chassériau 1843" (Chevillard 1893, p. 267; Sandoz 1974, no. 94 E, p. 198).

■ **A Sign of Genius**

Théophile Gautier writes a very favorable article on the chapel: The swiftness of execution of the two panels was a "sign of genius." He concludes with this vibrant appeal: "Give M. Chassériau the opportunities to spread his wings, and we have no doubt that he will soon be in the forefront

of the contemporary school" (Gautier, November 2 and 3, 1843, p. 2). Gautier's aim may have been to support Chassériau in his bid, then underway, for another commission (see below).

December 27

■ **Negotiations for the Cour des Comptes**

Frédéric Chassériau negotiates on his brother's behalf to obtain a commission for the decoration of the "grand staircase at the Cour des Comptes" from the Ministry of the Interior. On the evening of the 26th, he met with the comtesse de Tocqueville, but their conversation was interrupted by the "crowd." On the 27th, he sends her a summary of the steps taken to date. Vitet "seems to be very much in favor" of his brother's project. Frédéric asks the comtesse de Tocqueville to solicit the support of Guizot, Minister of Foreign Affairs, who is close to Duchâtel, Minister of the Interior.

Théodore Chassériau's goal is to be entrusted with the decorations of the entire "grand staircase" so that the "stylistic unity" can be respected: "My brother would prefer to forgo the project rather than violate this law. . . . What my brother so fervently wishes is to devote all of his abilities to a serious and beautiful work, whose composition is already established in his mind" (Copy of a letter from Frédéric Chassériau to the comtesse de Tocqueville, December 27 [1843] [Paris]; published in Bénédite 1931, vol. 1, pp. 318–19; Bénédite erroneously gives the year as 1844).

Bruno Chenique

" . . . when you keep your eyes always turned toward the past, you run a great risk in your works of remaining in an agreeable state of bliss that puts you to sleep" (Chassériau)

1844–48

The Cour des Comptes Years

"Your Successes and Those of Théodore Are My Only Consolations":
The Death of the Father

After Théodore Chassériau's critical success at the Salon of 1839 (see cat. 13, 15) and the execution of his decorations at the Church of Saint-Merri in Paris (cat. 71–77), a period of apprenticeship and personal research, which had evolved over the course of eight years, came to a close, revealing how far he had distanced himself from Ingres's influence. The year 1844 represented a series of departures for the painter: First came a human departure—the death of his father—and second, a professional departure, the commission for the decorations at the Cour des Comptes in the old Palais d'Orsay.

Benoît Chassériau's death on September 27, 1844, symbolized a turning point in his son's career; it corresponded to the start of Théodore's work at the Cour des Comptes, a commission that he had received that June. Benoît's death, surrounded by mystery and rumors, was a fitting end to his adventurous life, adding the fear of scandal to the pain experienced by his family. "I am sorrowful for life," Théodore Chassériau would write to his friend Oscar de Ranchicourt in October.[1] The painter thus seemed to be identifying with Christ on the Mount of Olives—he had just exhibited a second version of that episode from the Gospels at the Salon of 1844 (cat. 79)—whose "soul is sorrowful unto death" and who asks his father to take away "this cup" of sorrows. Officially, Benoît Chassériau died in Puerto Rico of a stroke, but he may in fact have committed suicide after having been accused of misappropriating funds.

On August 23, 1844, the diplomat seemed to be tormented by intense professional anxiety. He wrote to his wife from San Juan: "Your successes and those of Théodore are my only consolations, and they are great because, even through the grief that is devouring me, they have allowed me to taste some sweetness."[2] At the same time, the French general consul in Haiti was preparing to reveal to the ministry some financial misconduct of which Benoît Chassériau may have been guilty or of which he may have been falsely accused—the truth of the matter was not established. The consul, who preferred, "for more than a year [to fight] against all difficulties" rather than denounce Benoît Chassériau, accused the latter of diverting the inheritance money of a certain Mlle Fillette Enouf.[3] Hurt by that denunciation, whether well founded or totally invented, the painter's father may have taken his own life: "About a year ago, two Puerto Rican merchants attempted to reclaim a deposit of two hundred thousand francs from M. Chassériau, which they had entrusted to him. He denied having received that deposit. . . . It was decided that M. Chassériau's word would be accepted and that France would not lay the blame on its consul by recalling him. But in six months or a year, he [M. Chassériau] would be urged to hand in his resignation, on any pretext whatsoever. It seems his position in Puerto Rico was no longer tenable from that moment on, and, in short, it is certified that he killed himself."[4] So reported Clémence Monnerot at the time, in a letter to her brother that confirms the rumors of suicide. A sensitive man and a conscientious diplomat, Benoît Chassériau thus compromised his career by the often unfortunate business affairs he always had conducted in tandem with his official duties.

Immediately, the Chassériau "clan" closed ranks. Mme Chassériau and her five children chose the protection of silence and apparent indifference to the gossip: "The gentlemen must know all that, but the ladies know nothing, not how he died nor whether he was sick," explained Clémence Monnerot, who was close enough to the family to be informed of the details of the tragedy. "In any case, everything is kept secret here and nothing has been leaked by the ministry."[5] Devastated both by the loss of his father and the tragic circumstances of his death, Théodore Chassériau would, in desperation, throw himself into the vast construction project at the Cour des Comptes, to which he had just been assigned.

"One Must Believe Only in Oneself":
Island Origins

By that time, the fragile and reserved adolescent had become an enterprising and proud man of twenty-five: sickly, but relentlessly hardworking; anxious, but sure of his talent; not handsome, but resolved to impose himself through his mind and the force of his character. "An indefatigable horseman" in spite of his delicate health, he appeared worldly and refined, ambitious and secretive, apparently taking no interest in the judgments of others until he had formed his own opinion. Misanthropic and a loner—in his apartment on the Avenue Frochot, he organized his life between his studio; his bedroom, the walls "hung with a pink calico printed fabric"; and the famous little room where he kept his souvenirs[6]—he nevertheless frequented literary salons and moved in influential circles, and had installed a concealed exit in his lodgings so that he could slip out discreetly for mysterious nocturnal adventures.[7] It is not known whether he was subject to the "anger of a Creole who won't listen to anyone," which the Goncourt brothers attributed to their hero, Coriolis, whose character may have been partly inspired by Chassériau's.[8] In fact, his career as a painter seems to have been his only true passion, apart from what he would always feel for women—an attraction, moreover, that reveals a temperament as pleasure-seeking and sensual as it was idealistic and cerebral.

His friends, sometimes baffled by the paradoxes in his character, all emphasized the aristocratic physiognomy of the man, who exerted a genuinely seductive power over them. In the words of Aglaüs Bouvenne, a friend who knew him well: "Théodore Chassériau possessed an air of great distinction. He was tall, a bit bald. He had a full beard that was brown and admirably well groomed; the timbre of his voice, full of harmonious tones, and his very characteristic face certainly recalled his Creole origins."[9] If we carefully compare the two versions of this text, which Bouvenne published in 1883 and 1887, respectively, we are nonetheless obliged to wonder about an important point, since one passage describing the painter's physical appearance was suppressed between the two editions. In 1883, Bouvenne wrote: "His face was very characteristic and certainly recalled his origins, through its similarities to the Spanish type; but the structure of the mouth and the large white teeth that showed when he spoke seemed to be closer

FIG. 1
AGLAÜS BOUVENNE, after
ALPHONSE-CHARLES
MASSON
*Portrait of
Théodore Chassériau*
1887
Copperplate
Paris, Musée du Louvre

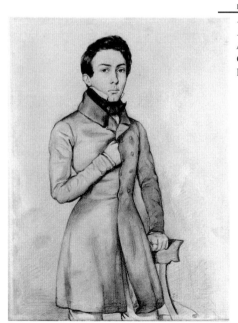

FIG. 2
*Portrait of
Frédéric Chassériau (?)*
About 1834
Graphite
Paris, Musée du Louvre

to the American type."[10] Then he added the following sentence: "Can we suppose that the constant proximity of the inhabitants of Samaná had an influence on his physical appearance?"—a question that, in an odd act of self censorship, disappeared from Bouvenne's 1887 version.[11]

What, then, of the "undeniable traces of his exotic origin"?[12] Had the rumors spread by agents at the ministry regarding his mother, a "woman of color,"[13] been reported to Théodore Chassériau? Had he been confronted with insinuations or gossip regarding the purity of his origins? And did not Masson's "sketch from life," published by Aglaüs Bouvenne in 1887, represent a man with obvious "island origins" (fig. 1)?[14] Had Chassériau, growing up in a Parisian society that was still very "provincial," developed a complex about his origins? Did he fully accept that idea of a mixed birth, which resulted from the family's history of having lived in La Rochelle, Paris, and in the West Indies? No trace of racism toward him is perceptible in the criticism or the literature of the time; and yet, even if Théodore Chassériau did not visibly revolt out of a sense that he had been rejected on racist grounds, it is clear that the question of ancestry was important for him.

The issue of race, whether real or experienced through the attitudes of others, clearly preoccupied him, and this personal questioning would no doubt become more pronounced when he began to associate with Parisian liberals and representatives of socialized Catholicism, which was fashionable at the time in a certain intellectual milieu.

"Those Gentlemen . . . Are Very Beloved Here, Very Protected": Relationships, Protection, and Friendships

An analysis of the political circles that protected the Chassériau family and advanced Théodore's career demonstrates the essential role of those who obtained for him a few of the commissions that made him well known, but it especially allows us an insight into the painter's liberal and social convictions, visible in several of his works, beginning with the plan for the decoration of the Cour des Comptes. As Clémence Monnerot observed in 1844,[15] because of their father's long diplomatic career and, above all, Frédéric's important administrative position at the Ministry of the Navy, the three Chassériau brothers "[were] very beloved, very protected by M. Guizot, M. Drouyn de Lhuy."[16] They associated with liberal economists, supporters of the movements to abolish the death penalty and slavery, and the committed democrats, all of whom would participate in the adventure of the Second Republic in 1848.

On this matter, Frédéric Chassériau (fig. 2) seems to have played a determining role. A bright and intelligent man, he was a civil servant at the Ministry of the Navy before being named private secretary to the minister, a post he held from December 1848 to 1851. He then joined the Conseil d'État, where he would serve as chief law clerk (*maître de requête de 1re classe*) and then as councillor in 1857. He was a cultivated, sensitive, and austere individual, obviously well appreciated, and the author of several historical biographies and reference works on the history of the navy.[17] Through his brother, Théodore rubbed shoulders with many politicians, beginning with two former ministers of the navy, Victor-Guy Duperré (see cat. 57), who occupied that office three times (1834–36, 1839–40, and 1840–43), and Alexandre-César-Victor-Charles Destutt de Tracy (see cat. 206), son of the famous philosopher, who received his portfolio in 1848. The Chassériau brothers were also close friends with Tocqueville (see cat. 64, 204) and Lamartine (see cat. 63), both of whom served as Minister of Foreign Affairs at one time or another. These politicians, initially from literary, military, and legal backgrounds, shared two points in common with the Chassériau family: They were defenders of political and economic liberalism, and they supported the abolition of slavery in the colonies.

In fact, this last question appears to have been central to the humane and political convictions of the Chassériau family. In 1840, Frédéric edited (anonymously) the *Précis de l'abolition de l'esclavage dans les colonies anglaises* (Statement on the abolition of slavery in the English colonies);[18] its publication came at a key moment in the political battles against slavery and the slave trade.[19] At that time, there was a new clash between certain conservative and commercial forces on the one hand and liberals and democrats on the other over the delicate question of the "right of search." The attitude of various governments was ambivalent during that period: Slavery and the slave trade had been prohibited, but the major European countries did not provide themselves with the means to have this liberal legislation enacted. A political battle erupted regarding the means made available to the police and customs officials to inspect the cargoes of ships—"the right of search"—and, hence, to intercept possible traffickers. It was not until April 27, 1848, that the effective and definitive abolition of slavery would be proclaimed in France by the Second Republic (in England, stricter laws had been passed in 1833).

During this entire time, Chassériau's friends were constantly involved with the "abolitionists." Destutt de Tracy, a fierce supporter of the elimination of the death penalty, also argued for the abolition of slavery beginning in 1832. In 1839, Tocqueville delivered a famous report in the Chamber favoring abolition. Duperré, during his last ministry, paved the way for the transitional system that would be established in the laws promulgated in 1845. In 1840, no doubt to facilitate the preparation of these legislative texts, Frédéric Chassériau, in the book mentioned above, studied the set of regulations drawn up by the English some years earlier.

Thus, Théodore Chassériau, whose family was originally from a colony, Santo Domingo, that France had lost claim to over the unresolved question of slavery, and himself a man who was obviously preoccupied with the question of his origins, would devise a plan for the Cour des Comptes based on a dual—political and philosophical—concept, namely, liberalism and friendship among peoples.

"Such a Decoration Requires Unity in Its Conception and Execution. I Will Do It All":
The Decoration of the Cour des Comptes

The circumstances underlying the commissioning of this monumental work, so essential to the painter's career and to his legacy, will not be discussed here, as they are reported in detail in the Chronology by Bruno Chenique (see pp. 269–70), nor will the critical fortunes of those decorations, which are mentioned in my entries on the subject (cat. 115–133). However, I believe that it is important, in conjunction with the previous comments, to offer a few reflections on the plan and the aesthetic choices for the project.

In 1810, Napoleon I asked the architect Charles Bonnard to begin construction on a palace on the Quai d'Orsay, almost directly across from the Palais du Louvre, where the Musée d'Orsay now stands. Work

FIG. 3
J.-B. ARNOUT
Palais du Quai d'Orsay, Paris
1844
Lithograph, after a drawing
Paris, Bibliothèque
Nationale de France

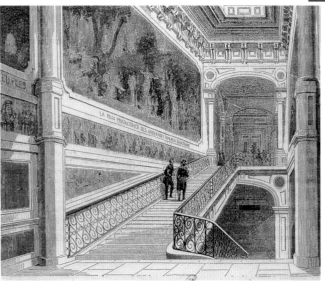

FIG. 4
*The Grand Staircase at
the Cour des Comptes*
1853
Paris, Bibliothèque
Nationale de France

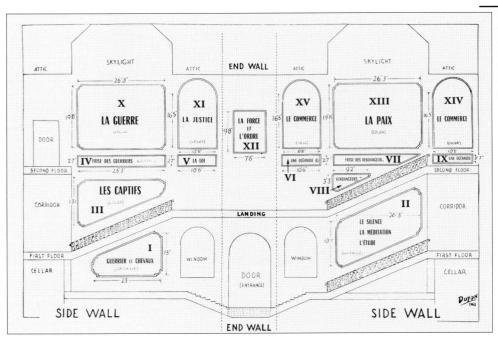

FIG. 5

Plan showing the locations
of paintings I through XV
in the Stairwell of the
Grand Staircase at the
Cour des Comptes
(published in Doyon 1969,
p. 49)

on the building, which soon after became the home of the Conseil d'État,[20] was to last thirty-two years and would culminate, after 1842, in the installation, on the second and third floors, of the Cour des Comptes, or Audit Office (fig. 3). Created in 1807, the Cour des Comptes already functioned as a tribunal, charged with auditing the administration of state services and of making inspections in close association with the Conseil d'État, which constituted the administrative and legal council of the government's executive branch. In 1844, two years after the completion of the prestigious palace, Théodore Chassériau was commissioned, for the sum of thirty thousand francs, to decorate the stairwell of the grand staircase leading to the tribunal (fig. 4). In spite of the precise role of the Cour des Comptes in overseeing the administration of public welfare, he was free to choose the subject of his decorative plan. He decided to paint a series of allegorical scenes, whose principal subjects were not, a priori, related to the administration and its duties. Rather than focusing on official matters, his imagination was immediately seized by very personal themes.

The painter was supposed to fill the barren space of the large, rather dark, stairwell that occupied two levels, not counting the intermediate landings (initially, he was commissioned to decorate only the upper landing). Adapting himself to the constraints dictated by the architecture itself, Chassériau chose to create two registers of paintings. The first, located in the lower part of the stairwell, was executed in grisaille; two paintings faced one another with only the space of a landing between them: *An Ancient Warrior Unhitching Horses* (fig. 5, I), which had "a great deal of style and grandeur,"[21] and a superb, symbolic picture, *Silence, Meditation, and Study* (fig. 5, II.; cat. 115, and see cat. 116), placed "in the midst of luxuriant vegetation," with "the intrusion of the landscape [being] very significant."[22] The figures in the lower portion, according to Théophile Gautier, constituted the "genius loci": "the calm and serious leader who takes the visitor, still deafened by the noise of the streets, by the hand, and slowly and contemplatively guides him up the stairs."[23] Then, in the upper register, above the intermediate *Return from the War*[24] (fig. 5, III; see cat. 117), the artist executed paintings on two other levels. One level, in grisaille, was composed of more decorative scenes: *A Row of Warriors* (fig. 5, IV), *The Law* (fig. 5, V), *Oceanid* (fig. 5, VI; cat. 128), *A Row of Grape Pickers* and *Recumbent Grape Picker* (fig. 5, VII, VIII; cat. 129), and *Oceanid* (fig. 5, IX); in the second of these upper levels, by far the most majestic, color was introduced—"light [falling] from the top of the stairwell, illuminating what seemed like an arcade of paintings"[25]—in six allegorical scenes: *Order Supplies the Needs of War* (fig. 5, X; see cat. 118); *Justice Represses Abuse* (fig. 5, XI), one of the most obvious references to the activity of the Cour des Comptes; *Force and Order* (fig. 5, XII; cat. 119);[26] *Peace, Protector of the Arts and of the Tilling of the Soil* (fig. 5, XIII; cat. 125, and see cat. 126);[27] *Commerce Brings Peoples Together (Eastern Merchants on a Western Shore)* (fig. 5, XIV; cat. 130); and *Commerce Brings Peoples Together (Western Merchants in an Eastern Port)* [fig. 5, XV].[28]

Hence, following the rationalist and scientific spirit of his time, and even perhaps the Masonic convictions of his father and brother—we do not know whether he, himself, was a Mason—Théodore Chassériau chose to paint murals that progressed from shadow and grisaille to light and color. The upper

register was the most spacious; the size of the different panels increased, culminating in an apotheosis in the two gigantic paintings *Order Supplies the Needs of War* and *Peace, Protector of the Arts and of the Tilling of the Soil,* each of which originally bore the astonishing dimensions of six by eight meters.

Of course, in conceiving his ambitious pictorial plan, infused with a very personal humanism, Théodore Chassériau surely had in mind the ideas developed by Eugène Delacroix between 1833 and 1838 in the Salon du Roi at the Palais Bourbon (now the National Assembly) in Paris. The painter of *The Death of Sardanapalus* also employed grisaille in the lower portions of the decorations, for the rivers, tributaries, and oceans of France, in contrast to the color frescoes in the upper register, for the allegories of Industry, War, Justice, and Agriculture. Guizot, whose famous maxim, "Enrich yourselves," was obviously an economic and philosophical mandate for that generation, also inspired artistic creations.

Nevertheless, Chassériau, although fascinated, from his childhood on, by the military adventures of various members of his family, chose, in his vast decorations for the Cour des Comptes, to minimize somewhat the theme of war, relegating it to the lower registers of his decorative scheme and favoring instead the ideals "of civilization"—justice, commerce, peace, and order—which, to be sure, often supplied the needs of war. In his liberal and humanistic decorative program, the painter surprisingly returned to the values upheld by his own family. Obviously, commerce had been practiced by the Chassériau family in the Charente, for several generations, and his father had dedicated his life to its pursuit. Justice was represented by Théodore's brother, who would soon join the Conseil d'État, and by his numerous liberal friends. Peace encompassed the dreams of an entire age, battling for democracy and the abolition of excesses of all kinds. Finally, the clash of different civilizations, Western merchants frequenting Eastern shores while those from the East worked in Western ports, astonishingly capsulized the history of his family, which moved back and forth between the West Indies and Europe for a full century.

The iconography employed in Chassériau's extensive decorations clearly emphasized two principal values: Order, represented in two paintings; and Peace, identified with Force, since the two main figures in these compositions are strangely similar,[29] as if Peace could not be generated by anything but Force. This was a somewhat pessimistic, even cynical—if profoundly realistic—message, one that Benoît Chassériau would not have denied, having sought, all his life, to balance diplomacy and military conquest with commerce and the advancement of different peoples.

"I Work and I Look":
The Journey to Algiers

Chassériau's exhausting labors at the Cour des Comptes were interrupted from May to July 1846 by a short but intense visit to Algeria, undertaken at the invitation of Ali-Ben-Hamet, Caliph of Constantine (see cat. 134). Of course, the circumstances for this trip might appear fortuitous, stemming as it did from the invitation to execute a large portrait and from the generosity of the individual who commissioned it. Nevertheless, Théodore Chassériau's personality seems to have predestined him for such a trip.

Early in his career, Chassériau had introduced Oriental themes into his paintings. *Ruth and Boaz* (private collection; exhibited at the Salon of 1837), *The Toilette of Esther* (cat. 66), and *Susanna and the Elders* (cat. 15), as well as the scenes from the life of Saint Mary of Egypt, of 1843, in the Church of Saint-Merri (cat. 71–77), already indicated that he was intrigued by exoticism. His ideas were Utopian for the time, since the young man had not yet traveled across the Mediterranean. Perhaps the failure, at the Salon, of the *Cleopatra Taking Her Own Life* (see cat. 109) had led the painter to wonder whether he did not lack a certain "feeling" for the Orient in the execution of historical subjects. Of course, most critics of his work have attempted to locate the source of his attraction to distant civilizations in the geographical origins of his family. Thus, in his article devoted to the painter's Orientalist vein, Raymond Escholier wrote, in 1921: "Chassériau did not have to discover the Orient. He carried it within him."[30] Nevertheless, that penchant for Oriental exoticism seems to have been very personal, stemming, above all, from his intellectual and aesthetic adherence to the ideals of his generation. Was he not the student of Ingres, the artist who, in 1808, painted the audacious *The Bather of Valpinçon* and the *Grande Odalisque* (both, Musée du Louvre)? Did he not admire Delacroix, one of the artists who spearheaded the discovery of a classical and poetic Orient, after his famous trip to Morocco in 1832? Was he not the friend of Prosper Marilhat, one of the best Orientalist landscape artists?

In addition, the enthusiastic and "fictionalized" narratives of the active members of the "literary society," who met at the Doyenné [Deanery], also played a determining role in Chassériau's aesthetic deci-

FIG. 6
Portrait of Prosper Marilhat
1835
Oil on canvas
Paris, Musée du Louvre

sions. Most of the poets who frequented that literary and artistic circle—where dressing in Oriental costumes was commonplace!—had already journeyed to the Orient: It became as important to them as the "Grand Tour" had been for the previous generation. In 1843, Gérard de Nerval had traveled to Egypt, Lebanon, Cyprus, and Constantinople;[31] Maxime Du Camp visited Algeria in 1844;[32] and Théophile Gautier went there a year before Chassériau.[33] It has also come to light that one of the members of the Doyenné, Camille Rogier,[34] a lover of eighteenth-century art and an inveterate traveler, who was a "dragoman"[35] in various Eastern countries[36] while serving as postmaster in Beirut, became an enthusiastic advocate of the countries of North Africa. That infatuation, shared by his entire circle, could only have favorably influenced Théodore's decision to accept the proposal of the trip, even though it interrupted his work at the Cour des Comptes.

Finally, the fact that a member of the Chassériau family was at the time established in Algiers surely facilitated his family's decision to let him go—the "clan" always became anxious when one of its members had to go off somewhere. Frédéric Chassériau—a namesake of Théodore's brother—was the son of Benoît Chassériau's brother, Victor-Frédéric. Born in Port-au-Prince, Haiti, he had become an architect when he was unable to launch a military career.[37] As a young man, he was to "oversee the construction of the Cour des Comptes, which, twenty years later, his nephew [cousin] would decorate,"[38] before "racing around" Spain and Egypt, and then finally settling in Marseilles. Frédéric Chassériau, who left France for Algiers after the colonial conquests, "created the modern city there," carrying out "public-works projects in the port, on the Boulevard de l'Impératrice"; he was also "the designer of the municipal theater."[39] After spending a few weeks in military company (see pp. 274–75) between Philippeville and Constantine in May and June 1846, Théodore visited with his cousin Frédéric in June and July.[40]

Despite the anxiety on the part of most of his friends and relatives, who worried about his reputedly fragile health,[41] the painter, upon his arrival, immediately fell in love with the "country . . . very beautiful and very new," which made him feel like he was reliving "The Arabian Nights."[42] He lost himself in the contemplation of the luminous and violent landscapes, admiring the Algerians themselves, melancholic and joyful by turns, and enthusiastically discovering the city of Algiers, "as large and as French as Châlons, Mâcon, etc."[43] Like Delacroix, who had completely altered his imaginary notion of the East following his visit to Morocco, Théodore Chassériau also revised his poetic view of North Africa, now founded, above all, on the truthful—because it was experienced firsthand—depiction of an eternal reality. During these few months spent in Algeria, his credo would be, "I work and I look"—a motto that summed up the humility of his radically realistic approach. The aesthetic discoveries of that Algerian trip—light, colors, and atmosphere—coincided with his artistic convictions at the time, which celebrated

fidelity to the representation of nature. Did he not assert that "nothing shines more than nature, nothing is more radiant"? He amassed souvenirs of the Orient likely to enrich his future compositions[44] and applied to his search for motifs the precepts he set down in his private notebooks: "Render what is in your soul in a visible, true, and refined manner, since nature alone possesses freshness and mordancy."

After he returned from Algeria, he attempted, in 1847, to synthesize his impressions of the East and the consequences of his trip in his art, in a large canvas submitted to the Salon, but *Sabbath in the Jewish Quarter of Constantine* (now destroyed), rejected by the jury and not exhibited at the Salon until 1848, did not manage to convince his public, despite Gautier's great show of enthusiasm. Fortunately, the catharsis of the North Africa trip materialized, in any case, as he completed the Cour des Comptes project, in his increased interest in the realistic representation of nature, which he incorporated in the creation of his refined poetic universes.

"Write to Me at Length and You Can Be Sure That I Will Share All Your Feelings": Friendships with Painters, Especially Landscape Artists

The social and political relationships already discussed, and the backbreaking labor of completing the decorations at the Cour des Comptes, did not distance Théodore Chassériau from his fellow artists, with whom he always maintained contact. A few landscape artists, in particular, were willing to share their techniques of representing nature with him, and he, in turn, pursued these intense friendships.

Louis Cabat (1812–1893),[45] Paul Chevandier de Valdrôme (1817–1877),[46] Prosper Marilhat (1811–1847)[47] (see fig. 6), and Théodore Rousseau (1812–1867)[48] were undoubtedly the artists to whom he was closest, and the tone of certain letters he addressed to one or the other of them reveals an exceptional personal and professional intimacy. Thus, Louis Cabat wrote to him in 1840: "I have a very great need to know the results of your work, if you are happy, if your parents are doing well, if you still like me. Write me at length and you can be sure that I will share all your feelings. . . . I am infinitely happy in Rome and I hope some day that I'll have the joy of seeing you here and of living with you. I cannot tell you how much I think of you and how much I want you here."[49] The points of agreement among these five artists were many. For example, Chassériau shared with Cabat and Chevandier de Valdrôme a fascination with the personality and religious ideas of Father Lacordaire, and, like Prosper Marilhat, he was intrigued by the East. All of them, including Théodore Rousseau, participated intensely in the "literary society," and they all also sought to extend their aesthetic vision beyond the debates over classicism versus Romanticism, arguing that Romanticism did not preclude a quest for the "style" of the great masters.

Perhaps because he was not in competition with them as a portraitist and a history painter—one should recall the jealousy between Chassériau and Henri Lehmann (see p. 38)—and no doubt because he liked to paint in their company, as he very likely did, in 1845 (see the Chronology, p. 273), during a stay in the Fontainebleau area, and surely because he admired the rigorous emphasis on realism in their artistic conceptions, Théodore Chassériau remained very close to these exponents of the school of nature. He even kept some of their works in his home, among the few paintings in his possession. Thus, from the catalogue of the posthumous sale held in his studio, we know that, in addition to a painting of a horse by Alfred de Dreux and a portrait of a woman by Géricault, he owned a sketch by Théodore Rousseau,[50] Prosper Marilhat's *View from the Environs of Athens*,[51] and a watercolor by Louis Cabat.[52]

The visits to Italy and to Algeria, during which he executed many landscapes, also allied Chassériau with these specialists in the genre, and surely encouraged him later to introduce increasingly realistic and convincing studies of nature in his historical or mythological compositions. To be sure, the *Venus Anadyomene* (cat. 13), for example, already revealed a close poetic relationship between the natural setting and the action represented, but the landscape remained rather idealized and imaginary. In addition to the more realistic setting of the *Susanna and the Elders* (cat. 15), a comparison between the two versions of the *Christ on the Mount of Olives* (cat. 16, 79), exhibited four years apart, suggests to what extent the presence of landscape would gain in importance in Chassériau's work after 1845; the landscape in the second version (in Souillac), in its beauty, truth, and mystery, serves as an apt accompaniment to the dramatic universe depicted by the painter.

Throughout Chassériau's decorations at the Cour des Comptes, one senses a comparably profound "feeling for nature," especially in the "landscape intermingled with trees that soar merrily into the blue limpidity of the air."[53]

<div align="right">Vincent Pomarède</div>

1. Letter from Théodore Chassériau to Oscar de Ranchicourt, Paris, October [28], 1844; archives of Mlle F. Bellaigue de Ranchicourt; quoted in Bénédite 1931, vol. 1, p. 17.

2. Letter (whereabouts unknown), quoted in Bénédite 1931, vol. 1, p. 28.

3. Letter from M. Levasseur, Port-au-Prince, September 12, 1844: "French Consulate General in Haiti. Business and Legal Office, no. 166. The Matter of M. Chassériau and of Mlle Fillette Enouf" (Archives du Ministère des Affaires Étrangères, personnel dossier, 1st series, Benoît Chassériau, 889); see the Chronology, p. 271.

4. Letter from Clémence Monnerot to her brother Jules Monnerot, Paris, November 2, 1844 (Bibliothèque Nationale de France, Paris, Département des Manuscrits, Naf. 14394, Gobineau Papers, vol. 6, "Mme A. de Gobineau [née Clémence Monnerot]. Lettres à sa famille," fols. 67–69).

5. Ibid.

6. On this subject see A. Bouvenne, "Théodore Chassériau. Souvenirs et indiscrétions," in *Le Bulletin des beaux-arts. Répertoire des artistes français* (1883–84), vol. 1, pp. 138–39.

7. As described by Bouvenne 1883–84, p. 138: "Smiling mischievously, he placed a key in the lock, and the window, which was only forty centimeters above the ground, became a door with access to the outside. . . . I glimpsed . . . an elegant carriage that was waiting not far from the French window of the little room."

8. Édmond and Jules de Goncourt supposedly were influenced by Chassériau's personality when they created the character Naz de Coriolis, the hero of their novel *Manette Salomon,* published in 1867; Coriolis was described as a painter born on the island of Réunion.

9. A. Bouvenne, "Théodore Chassériau," in *L'Artiste* 2 (September 1887), pp. 174–75.

10. Bouvenne 1883–84, p. 146.

11. Bouvenne 1887, p. 175.

12. Marcel and Laran 1911, p. 6.

13. Archives du Ministère des Affaires Étrangères, personnel dossier, 1st series, Benoît Chassériau, 889; internal note.

14. Bouvenne 1887, p. 174.

15. Letter from Clémence Monnerot to her brother Jules Monnerot, Paris, November 2, 1844 (Bibliothèque Nationale de France, Paris, Département des Manuscrits, Naf. 14394, Gobineau Papers, vol. 6, "Mme A. de Gobineau [née Clémence Monnerot]. Lettres à sa famille," folios 67–69).

16. After the Revolution of 1848, the diplomat É. Drouyn de Lhuy (1805–1881) became president of the committee on foreign affairs (1851), ambassador to London (1852–55), and, later, Minister of Foreign Affairs (1862–66).

17. Frédéric Chassériau's publications include: *Précis de l'abolition de l'esclavage dans les colonies anglaises* (Paris, 1840), 2 vols. (unsigned); *Précis historique de la marine française, son organisation et ses lois* (Paris, 1845); "Des Colonies," in *Dictionnaire général d'administration* (Paris, 1846); "De la Marine," in *Dictionnaire général d'administration* (Paris, 1848); *Vie de l'amiral Duperré* (Paris, 1848); *Notices sur le vice-amiral Vaillant, ancien ministre de la marine* (Paris, 1858); *Notice sur le vice-amiral Bergeret* (Paris, 1858); "Biographie de M. le chevalier Du Pavillon . . . suivie de sa mort d'après le Chroniqueur du Périgord et du Limousin," in *Moniteur* [Paris], January 11 and 25, 1864; *Un Héros d'Algésiras. Moncousu, chef de division* (Paris, 1865); *Paroles prononcées le dimanche 20 septembre 1874 sur la tombe de M. Guillemot, au nom de sa famille et de ses amis* (Paris, 1874).

18. See note 17, above.

19. Slavery was eliminated on principle by the revolutionaries, then prohibited in the colonies by Napoleon I, on March 29, 1815. These legal provisions, however, were not applied for many years.

20. The building initially was set aside for the Ministry of Foreign Affairs.

21. T. Gautier, "Palais du Quai d'Orsay. Peintures murales de M. Théodore Chassériau," in *La Presse,* Paris, December 15, 1848.

22. R. Marx, "Théodore Chassériau et les peintures de la Cour des Comptes," in *Revue populaire des beaux-arts* 1, no. 18 (February 19, 1898), p. 274.

23. Gautier 1848.

24. Bouvenne 1883–84, p. 149, calls this *"Achilles (?) Tying His Horse to a Tree."*

25. Gautier 1848.

26. Bouvenne 1883–84, p. 150, refers to this composition as *Light and Force* dismissing those accounts of the "virility" of Force in favor of a more "Masonic" view.

27. Bouvenne (1883–84, p. 161) cites the various allegorical figures of the arts in this composition: Music, Painting, Architecture, Tragedy, Dance, and Sculpture.

28. For the first complete study of Chassériau's decorations, with the exception of Théophile Gautier's (written during the painter's lifetime), see M. Vachon, *Le Palais du Conseil d'État et de la Cour des Comptes* (Paris, 1879).

29. Chassériau clearly wished to convey a parallel between the two figures of *Force and Order* and the principal allegorical figures in *Order Supplies the Needs of War* and *Peace, Protector of the Arts and of the Tilling of the Soil:* the two female figures and the two male figures are identical in appearance and pose.

30. R. Escholier, "L'Orientalisme de Chassériau," in *Gazette des beaux-arts* 3 (February 1921), p. 106.

31. On this subject see G. de Nerval, *Voyage en Orient* (Paris, 1851).

32. M. Du Camp, *Souvenirs et paysages d'Orient* (Paris, 1848); M. Du Camp, *Égypte, Nubie, Palestine et Syrie. Dessins photographiques recueillis pendant les années 1849, 1850 et 1851* (Paris, 1852).

33. F. Pouillon, "L'Orient de Théophile Gautier" (international colloquium), in *Bulletin de la Société Théophile Gautier* 1, no. 12 (1990), pp. 55–87.

34. Ibid.

35. The word "dragoman," transcribed from an Arabic *turjuman,* meaning "interpreter" or "go-between," was used to designate an interpreter-guide who accompanied travelers in the East.

36. This recalls the nice proposition for an "Oriental-style harem session with four prostitutes" that Rogier made to the young Flaubert at the time of his journey to the Orient.

37. J.-L. Vaudoyer, "Le Baron Arthur Chassériau. Notice lue à l'assemblée générale annuelle de la Société des Amis du Louvre le 17 juin 1935," in *Cabinet des Dessins, Société des Amis du Louvre* (Compiègne, 1935), pp. 11–13.

38. Vaudoyer 1935, p. 11.

39. Ibid., pp. 11–12.

40. Four years later, Théodore reportedly witnessed the birth in Algiers of Arthur Chassériau (1850–1934), son of his cousin Frédéric. Arthur would later ensure that Théodore's works be rediscovered through his prestigious bequest to the Louvre.

41. Alexis de Toqueville wrote to him from Paris on May 3, 1846: "Especially if you stay past the month of June, which I strongly urge you not to do, if you travel through the country, be careful to take all the hygienic precautions that the Europeans living in Africa indicate to you. Do not neglect any of them. Avoid the sun's rays in the middle of the day and the cold at night" (quoted in Bénédite 1931, vol. 2, p. 263).

42. Letter from Théodore Chassériau to his brother Frédéric, Constantine, May 13, 1846; quoted in Bénédite 1931, vol. 2, p. 266.

43. Letter from Théodore Chassériau to his brother Frédéric, Philippeville, June 13, 1846; quoted in Bénédite 1931, vol. 2, pp. 270–72.

44. Théodore Chassériau assembled a collection of weapons and costumes that were included in the posthumous sale of the contents of his studio (Chassériau sale, March 16–17, 1857, nos. 37–67).

45. Cabat, a pupil of Camille Flers and a friend of Jules Dupré, was also—another point in common with the Chassériau family and with Rousseau—a fierce Republican, who had fought against Charles X.

46. Despite their trip to Italy, during which they undoubtedly painted together, the two artists nevertheless had a falling-out. Chevandier de Valdrôme had been a pupil of Marilhat; for more about this painter see É. Foucart-Walter, in *Musée du Louvre. Nouvelles acquisitions du département des Peintures (1987–1990)* (Paris, 1991), pp. 137–39.

47. Born in the Auvergne, Marilhat, a pupil of Camille Roqueplan, first traveled to the East in 1831. He also frequented the Doyenné. He died in 1847 at the age of thirty-six, surely the first of Chassériau's close friends to die.

48. The relationship between Rousseau and Chassériau was more one of mutual admiration and respect than true friendship. Accounts of meetings between the two are very rare, although they were neighbors in Paris: Rousseau's studio was in the rue Pigalle, a short walk from the Avenue Frochot, where Chassériau resided and worked.

49. Letter from Louis Cabat to Théodore Chassériau, Rome, March 12, 1839; quoted in Bénédite 1931, vol. 1, pp. 119–20.

50. "No. 34. *Landscape–sketch,*" sold posthumously at the Hôtel Drouot, Paris, March 16–17, 1857 (Fr 200, according to the annotated copy of the sales catalogue in the Cabinet des Estampes, Bibliothèque Nationale de France, YD 929a, in 8°).

51. "31—*View from the Environs of Athens,*" sold posthumously at the Hôtel Drouot, Paris, March 16–17, 1857 (for Fr 2,850, according to the annotated copy of the sales catalogue in the Cabinet des Estampes, Bibliothèque Nationale de France, Yd 929a, in 8°). This landscape, now placed on deposit by the Musée du Louvre in the museum at Thiers, was reportedly traded with Marilhat for Chassériau's portrait of him (Paris, Musée du Louvre).

52. "35—*Landscape—Watercolor,*" sold posthumously at the Hôtel Drouot, Paris, March 16–17, 1857 (for Fr 42, according to the annotated copy of the sales catalogue in the Cabinet des Estampes, Bibliothèque Nationale de France, Yd 929a, in 8°).

53. T. Gautier, "Palais du Quai d'Orsay. Peintures murales de M. Théodore Chassériau," in *La Presse,* Paris, December 15, 1848.

84–99

Engravings for the "Othello" Series

Sixteen etchings, comprising a frontispiece (first published in 1900 by the *Gazette des beaux-arts*, with a preface by Ary Renan) and fifteen plates. Several complete sets of the 1844 edition are in public institutions (Paris, Bibliothèque Nationale de France, Cabinet des Dessins; London, British Museum; Boston, Museum of Fine Arts; Brussels, Bibliothèque Albert I^{er}; Harvard, Houghton Library) and in four private collections. The copperplates are in the Chalcographie at the Louvre (gift of Baron Arthur Chassériau, 1900); the etchings presented here, courtesy of M. and Mme Hubert Prouté, are from the 1900 edition.

BIBLIOGRAPHY:
Bouvenne 1884, nos. 6–21, p. 165; Bouvenne 1887, p. 176; Chevillard 1893, nos. 429–443; Sandoz 1974, nos. 270–286, ill.; Fisher, in Baltimore, 1979–80; Fisher 1980, pp. 100–104; Prat 1988-1, nos. 312–366; Peltre 2001, pp. 97–107, figs. 100, 113, 115, 117, 119, 120, 122, 123, 126, 128.

EXHIBITIONS:
Paris, Orangerie, 1933, nos. 209–224; Paris, 1988 (sixteen plates exhibited).

84. Frontispiece: *The Genius of Tragedy Holding a Banderole*
Plate: 15 ⅞ x 10 ⅝ in. (40.1 x 26.8 cm)
Subject: 15 ⅝ x 10 ⅜ in. (39.5 x 26.3 cm) (Sandoz 1974, no. 270)

85. Plate 1. *"Awake! What, Ho, Brabantio! Thieves! Thieves!"*
Plate: 14 ¾ x 10 ⅝ in. (37.2 x 27 cm)
Subject: 12 ⅞ x 9 ⅜ in. (32.5 x 23.7 cm)
Act 1, Scene 1 (Sandoz 1974, no. 271)
Iago and Roderigo announce to Desdemona's father, Brabantio, that his daughter has been seduced by the Moor Othello, a captain in the employ of Venice.

86. Plate 2. *"She Thank'd Me, and Bade Me, If I Had a Friend That Lov'd Her, I Should But Teach Him How to Tell My Story, and That Would Woo Her"*
Plate: 14 ½ x 10 ⅜ in. (36.6 x 26.3 cm)
Subject: 11 ⅛ x 8 ⅜ in. (28 x 21.1 cm)
Act 1, Scene 3 (Sandoz 1974, no. 272)
Othello explains to the duke how Desdemona came to love him.

87. Plate 3. *"She Lov'd Me for the Dangers I Had Pass'd, and I Lov'd Her that She Did Pity Them"*
Plate: 13 ¾ x 14 ⅜ in. (34.8 x 36.4 cm)
Subject: 11 x 12 ⅛ in. (27.9 x 30.8 cm)
Act 1, Scene 3 (Sandoz 1974, no. 273)
This illustration follows the one on the previous plate and shows Othello pleading his case before the duke.

88. Plate 4. *"Honest Iago, My Desdemona Must I Leave to Thee"*
Plate: 14 ⅜ x 10 ½ in. (36.5 x 26.6 cm)
Subject: 11 ¼ x 8 ⅜ in. (28.4 x 21.2 cm)
Act 2, Scene 3 (Sandoz 1974, no. 274)
Othello, sent to Cyprus to fight the Turks, entrusts Desdemona, whom the duke has just awarded to him, to Iago and his wife, Emilia.

89. Plate 5. *"O My Fair Warrior!" "My Dear Othello!"*
Plate: 12 ⅜ x 16 in. (31.3 x 40.5 cm)
Subject: 10 ⅞ x 13 ⅜ in. (27.6 x 34 cm)
Act 2, Scene 1 (Sandoz 1974, no. 275)
After defeating the Turks, Othello is reunited with Desdemona on the beach of Cyprus.

90. Plate 6. *"Be Merry, Cassio"*
Plate: 12 ½ x 9 ¾ in. (31.8 x 24.5 cm)
Subject: 10 ⅝ x 8 ½ in. (26.8 x 21.5 cm)
Act 3, Scene 1 (Sandoz 1974, no. 276)
Desdemona reassures Cassio, whom Othello has stripped of his lieutenant's rank after a drinking bout instigated by Iago, and promises to intercede in his favor. Iago misleads Othello and provokes his jealousy by making him believe that an amorous relationship exists between Cassio and Desdemona.

91. Plate 7. *"Away!"*
Plate: 10 ⅜ x 14 ⅜ in. (26.2 x 36.5 cm)
Subject: 9 ⅜ x 12 ⅝ in. (23.7 x 32.1 cm)
Act 3, Scene 4 (Sandoz 1974, no. 277)
Othello rebuffs Desdemona, who was interceding in Cassio's favor.

92. Plate 8. *"If I Do Die before Thee, Prithee, Shroud Me in One of These Same Sheets"*
Plate: 13 ⅝ x 9 ¾ in. (34.5 x 24.8 cm)
Subject: 11 ¼ x 8 ½ in. (28.5 x 21.6 cm)
Act 4, Scene 3 (Sandoz 1974, no. 278)
Desdemona confides her anxiety to her attendant, Emilia, as she prepares for bed.

93. Plate 9. *The Song of the Willow*
Plate: 14 ½ x 10 ⅜ in. (36.8 x 26.3 cm)
Subject: 11 ⅝ x 9 in. (29.3 x 22.9 cm)
Act 4, Scene 3 (Sandoz 1974, no. 279)
Before lying down, Desdemona, accompanying herself on the lyre, sings a song from her childhood that evokes the memory of her mother's maid Barbara, who was abandoned by her lover.

94. Plate 10. *"Villain, Thou Diest!"*
Plate: 13 ¾ 9 ⅞ in. (34.8 x 25 cm)
Subject: 11 ⅜ x 8 ⅝ in. (28.8 x 21.7 cm)
Act 5, Scene 1 (Sandoz 1974, no. 280)
Iago intervenes in a duel between Cassio and Roderigo, after he has aroused the jealousy of Othello, who watches the scene.

95. Plate 11. *"Yet She Must Die"*
Plate: 14 ½ x 10 ⅜ in. (36.7 x 26.3 cm)
Subject: 12 ¼ x 9 ⅝ in. (30.9 x 24.2 cm)
Act 5, Scene 2 (Sandoz 1974, no. 281)
Torn between the love he feels for Desdemona and the conviction that she has betrayed him, Othello contemplates her as she sleeps and exhorts himself to kill her.

96. Plate 12. *"Have You Pray'd To-night, Desdemona?"*
Plate: 12 ⅝ x 9 ¾ in. (32 x 24.6 cm)
Subject: 10 ⅞ x 9 in. (27.6 x 22.9 cm)
Act 5, Scene 2 (Sandoz 1974, no. 282)
Othello questions an awakened and terrified Desdemona.

97. Plate 13. *He Smothers Her*
Plate: 13 ¾ x 9 ¾ in. (34.7 x 24.8 cm)
Subject: 9 ⅞ x 9 in. (25 x 22.7 cm)
Act 5, Scene 2 (Sandoz 1974, no. 283)
Othello smothers Desdemona with a pillow.

98. Plate 14. *"Oh! Oh! Oh!"*
Plate: 14 ½ x 10 ½ in. (36.7 x 26.5 cm)
Subject: 12 ⅜ x 9 ¾ in. (31.4 x 24.8 cm)
Act 5, Scene 2 (Sandoz 1974, no. 284)
Othello wails at the foot of the bed on which the dead Desdemona lies, while Emilia prepares to reveal Iago's machinations.

99. Plate 15. *"O Spartan Dog, More Fell than Anguish, Hunger, or the Sea! Look on the Tragic Loading of This Bed; This Is Thy Work"*
Plate: 12 ⅝ x 16 in. (32.1 x 40.4 cm)
Subject: 11 ⅜ x 14 ¾ in. (28.7 x 37.2 cm)
Act 5, Scene 2 (Sandoz 1974, no. 285)
Othello, who has just stabbed himself, is about to die at the foot of the bed on which Desdemona and Emilia—whom Iago has just stabbed, to silence her—already lie dead. Iago runs off; he is caught and brought back to Lodovico.

Chassériau's major contribution to the representation of the Shakespearean universe occurred in 1844, when Eugène Piot (1812–1890), director of the review *Le Cabinet de l'amateur et de l'antiquaire,* commissioned the twenty-five-year-old artist to prepare a series of fifteen etchings, preceded by a frontispiece. (The latter would not be published until 1900, in a later print run, for the *Gazette des beaux-arts.*) The commission undoubtedly was obtained with the help of Théophile Gautier, a friend of both men, who had already championed Chassériau's talents on many occasions in his critical reviews. It was during this period that Chassériau executed the beautiful portrait drawing of Mme Eugène Piot (cat. 62).

Othello was a play with which the Parisian public was quite familiar at the time, as performances with English actors had been staged in Paris in 1822 and during the 1827–28 season. French versions by Ducis and by Alfred de Vigny were available, and in 1821 the Rossini opera inspired by the Elizabethan tragedy was produced for the first time in Paris. In addition, Eugène Devéria and Louis Boulanger made engravings based on the play to illustrate their 1827 publication *Souvenirs du théâtre anglais à Paris* (Memories of the English theater in Paris).

The nearly sixty preliminary drawings (most of which are in the Louvre) demonstrate with what passion the artist set to work, apparently completing the entire set of plates within the space of two months. Perhaps the publication, only a short time before (1843), of Delacroix's "Hamlet" series inspired Chassériau to emulate that artist's productivity. The training he received in Ingres's studio in drawing and composition reflected techniques inherited from Raphael, but he also was influenced by the extraordinary sophistication of the painter of the *Odalisques.* By 1844, Chassériau had reached a turning point in his art (that was the year he received the commission for his major achievement, the decorations in the grand stairwell at the Cour des Comptes, which would occupy him until 1848). He abandoned himself to a sentimental form of Romanticism that some have claimed, too hastily, was borrowed from Delacroix, but which I believe, instead, to be extremely personal, harmonious in expression, and unequaled in its poetic dimension.

The fifteen plates in the series illustrate the most famous scenes of the tragedy, from Act 1—the only act set in Venice (plates 1–4)—up to the fatal denouement (six plates are devoted to the final act). A poet, above all, of the female form, Chassériau seems to have focused, in his illustrations, on the figure of the innocent Desdemona, persecuted by the deceitful Iago and the victim of the insane jealousy of her husband, Othello: the young woman appears in twelve of the fifteen plates. Conversely, the relationship between Othello and Iago, so subtle in the Shakespearean tragedy, is barely evoked here, although it would be the main subject of Verdi's opera.

With scarcely fifteen copies printed, the 1844 series of engravings was not a success, and it was dismissed by critics at the time as an act of plagiarism against Delacroix, "whom M. Chassériau has unscrupulously copied in his illustrations of Othello" (Thoré). The same sharp reproach was voiced by Baudelaire, with regard to the portrait of Ali-Ben-Ahmet, which was exhibited the following year at the Salon: "Already in the Othello illustrations, everyone noticed the preoccupation with imitating Delacroix." Paul Mantz criticized Chassériau for "forgetting to put into these sketches a thing that is certainly very important in the case of Shakespeare, namely, feeling."

Today, our appreciation has changed completely. In 1979–80, on the occasion of the retrospective of the engravings in the "Othello" series he organized at the Baltimore Museum of Art, J. M. Fisher noted: "An attentive comparison of Delacroix's *Hamlet* and Chassériau's *Othello* reveals that the similarities are nonexistent, whereas the differences are profound." The choice of technique appears to have been decisive in this respect, and very much in harmony with each of the two artists' sensibilities. The technique of drawing on lithographic stone was well suited to Delacroix's style, with its graphic dynamism and serpentine lines. Chassériau, whose training was more conservative and more classical, found the etching to be the ideal medium for his precise and detailed poetic icons, particularly in the rendering of the grace of the female figure. According to his faithful friend Théophile Gautier: "The young painter rendered Shakespearean feeling with a great deal of force and boldness. All of the English poet's characters have been faithfully brought to life, thanks to the French artist's talent. . . . It is impossible to understand any better the true meaning of the great writer's work. We have not seen more beautifully worked etchings since Rembrandt, Norblin, and Boissieu. There is such a freedom in the use of the etching needle, such liveliness in the lines scratched on the plates that they could be taken for magnificent original drawings in pen and wash."

The tragedy of *Othello* continued to hold Chassériau's interest until the 1850s, and he devoted several easel paintings to the most outstanding episodes in the play (*The Song of the Willow, Desdemona Retiring to Bed,* and *Othello Smothering Desdemona*). L.-A. P.

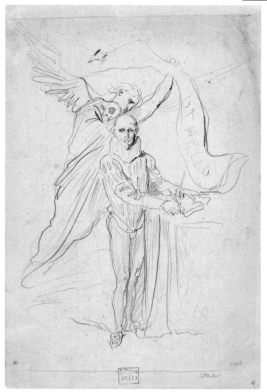

100

Shakespeare and a Genius

1844
Graphite on cream-colored paper (affixed to fol. 37 r. of dummy album 1)
14 ⅜ x 10 ⅝ in. (36.4 x 26.8 cm)
Inscribed in graphite on the banderole, upper right: OTHELLO
Paris, Musée du Louvre (RF 26173)

PROVENANCE:
See cat. 20.

BIBLIOGRAPHY:
Chevillard 1893, part of no. 420; Sandoz 1974, under no. 270; Fisher, in Baltimore, 1979–80, pp. 32–33, ill. p. 33; Prat 1988-1, vol. 1, no. 312, ill.; Peltre 2001, p. 101, fig. 111.

Exhibited in Paris only

This drawing is very different from the engraved frontispiece (which would be published in 1900), where the genius of Tragedy appears alone—standing, not flying—and the banderole bears no inscription. The preliminary drawing recalls an almost-contemporaneous painting by Delacroix, *Socrates and His Demon,* in one of the pendentives at the Palais-Bourbon. Part of an unrealized decorative project devoted to "Michelangelo and his genius," Delacroix's composition illustrates in a rather similar manner the theme of the inspired artist

<div style="text-align:right">L.-A. P.</div>

101

Othello and Desdemona

1844
Graphite
6 ¼ x 5 in. (15.8 x 12.5 cm)
Paris, Musée du Louvre (RF 24433)

PROVENANCE:
See cat. 20.

BIBLIOGRAPHY:
Baignères 1886, ill. p. 213; Chevillard 1893, part of no. 420; Bénédite 1931, vol. 2, ill. p. 256; Prat 1988-1, vol. 1, no. 319, ill.; Peltre 2001, p. 106, fig. 118.

EXHIBITIONS:
Paris, Galerie Dru, 1927, no. 52 (?); Paris, Orangerie, 1933, no. 117 (medium given as pen); Baltimore, 1979–80, pp. 54–55, ill. p. 55; Paris, 1988, no. 7, fig. 15.

Exhibited in New York only

Fisher (in Baltimore, 1979–80) emphasizes the extreme precision of this drawing, which has the look of an engraving and suggests that it was executed perhaps as a technical "tour de force" following the preparatory sketches but before the definitive print.

Desdemona's face is on the same level as Othello's, but the position of the two figures is reversed in plate 4.

Three other composite drawings are known for this same plate, and all are in the Louvre (Prat 1988-1, vol. 1, nos. 317, 318, 320).

<div style="text-align:right">L.-A. P.</div>

102
"O My Fair Warrior!"

1844
Graphite on beige paper (affixed to fol. 33 v. of dummy album 1)
10 x 11 ⅝ in. (25.4 x 29.5 cm)
Inscribed in graphite in an unknown hand, lower right: *Othello;*
center left: *6–6–6–6*
On the reverse is a graphite study of men calling out to a figure
on the balcony of a house
Paris, Musée du Louvre (RF 26166)

PROVENANCE:
See cat. 20.

BIBLIOGRAPHY:
Chevillard 1893, part of no. 420; Sandoz 1974, under nos. 271, 275;
Fisher, in Baltimore, 1979–80, p. 62, ill. p. 63, and p. 38, ill. (the
verso); Prat 1988-1, vol. 1, no. 321, ill.

Exhibited in Strasbourg only

This study is for plate 5 in the series. As Fisher notes, the drawing is similar to the engraving, but a better balance would be established in the print between Othello and Desdemona and the other figures, who appear much too small here in comparison to the two protagonists. The drawing on the reverse is related to the engraved variant of plate 1 in the series, *"What, Ho! Brabantio!,"* in which the urban setting is different.

L.-A. P.

103
"Therefore Be Merry, Cassio!"

1844
Graphite (affixed to fol. 55 v. of dummy album 3)
11 ⅛ x 8 in. (28.3 x 20.2 cm)
Inscribed in graphite, lower left: *petites figures* [small figures]
Paris, Musée du Louvre (RF 26531)

PROVENANCE:
See cat. 20.

BIBLIOGRAPHY:
Chevillard 1893, part of no. 420; Sandoz 1974, under no. 276;
Fisher, in Baltimore, 1979–80, pp. 68–69, ill. p. 69; Prat 1988-1,
vol. 1, no. 322, ill.

EXHIBITION:
Paris, Orangerie, 1933, no. 225 b.

Exhibited in Strasbourg only

Fisher mentions that this drawing was strengthened with pen, but no retouching is visible. The composition is similar to that of plate 7 in the series, in which, however, Cassio appears on the same plane as Desdemona and his pose, as well as the architecture in the background, is slightly modified. Another sheet in the Louvre (Prat 1988-1, vol. 1, no. 323, ill.) contains various studies for the figure of Emilia, Desdemona's attendant, and for Cassio's legs. In a later, related drawing, in The Metropolitan Museum of Art (cat. 199), the figure of Cassio is studied by itself.

L.-A. P.

CAT. 102

CAT. 103

104
The Song of the Willow

1844
Graphite, with pen and brown ink (affixed to fol. 28 v. of dummy album 1)
11 ¼ x 8 ⅝ in. (28.4 x 21.7 cm)
Paris, Musée du Louvre (RF 26155)

PROVENANCE:
See cat. 20.

BIBLIOGRAPHY:
Chevillard 1893, part of no. 420; Sandoz 1974, under no. 279;
Prat 1988-1, vol. 1, no. 333, ill.

EXHIBITIONS:
Baltimore, 1979–80, pp. 92, 98, ill. p. 98 (the drawing was removed from the dummy album for the occasion); Paris, 1988, no. 13, fig. 16.

Exhibited in New York only

Fisher (in Baltimore, 1979–80) has noted that Chassériau originally considered representing the lyre in Desdemona's hands facing left, as can be seen in a few light strokes in graphite. The figure of Emilia was first studied in graphite, her face turned toward the back of the scene, as in the drawing formerly in the Woodner Collection, New York (Baltimore, 1979–80, pp. 92, 99, ill. p. 99; Prat 1988-2, no. 103, ill.), but then was retouched in pen and ink, so that she faces Desdemona, as in plate 9, the definitive engraving.

L.-A. P.

105
"Villain, Thou Diest!"

1844
Black pencil on beige paper
16 ¾ x 11 ⅞ in. (42.4 x 30.1 cm)
Inscribed in pen and brown ink, in an unknown hand, lower left: *Je vous laisse* [crossed out] *apporterai une épreuve du / . . . / Tout à vous / Edm. Hédouin / Alfred Hédouin* [I leave you (crossed out) will bring a print of the / . . . / Yours / Edm. Hédouin / Alfred Hédouin]
Paris, Musée du Louvre (RF 25982)

PROVENANCE:
See cat. 20.

BIBLIOGRAPHY:
Chevillard 1893, part of no. 420; Sandoz 1974, under no. 280;
Prat 1988-1, vol. 1, no. 341, ill.

EXHIBITIONS:
Baltimore, 1979–80, p. 104, ill. p. 105; Paris, 1988, no. 16.

Exhibited in Strasbourg only

This drawing resembles plate 10 in the "Othello" series, except for the absence of a setting and the position of Roderigo's and Cassio's arms and weapons. The figure of Othello, upper left, is very lightly sketched in. Chassériau no doubt noticed that, in reversing his composition for the engraving, he would make the combatants left-handed (Iago, in fact, remained so), and, after executing the drawing, he changed the positions of the swords and the gestures. According to Fisher (in Baltimore, 1979–80), this study is later than the Louvre drawing RF 25979 recto (Prat 1988-1, vol. 1, no. 340), which represents that museum's only other study for this plate.

Edmond Hédouin (1820–1889), a painter and engraver, debuted at the Salon of 1844, the same year as the "Othello" series. No doubt Chassériau had dealings with him at the time, and perhaps in response to a request for technical advice, Hédouin left him the handwritten note on this drawing.

L.-A. P.

Othello Behind the Bed
of the Sleeping Desdemona

1844

Pen and brown ink, with brown wash, over graphite, on cream-
colored paper (affixed to fol. 35 r. of dummy album 1)
12 ⅜ x 9 ½ in. (31.2 x 24 cm)
Inscribed in pen and ink, upper left: *1*; in graphite in an unk-
nown hand, lower left: *Othello*
Paris, Musée du Louvre (RF 26169)

PROVENANCE:

See cat. 20.

BIBLIOGRAPHY:

Chevillard 1893, part of no. 420; Sandoz 1974, under no. 281;
Fisher, in Baltimore, 1979–80, pp. 113, 116, ill. p. 116; Prat 1988-1,
vol. 1, no. 342, ill.

EXHIBITIONS:

Paris, Louvre, 1957, no. 34; Paris, 1988, no. 17.

Exhibited in Paris only

In the genesis of the composition of plate 11, this drawing
is situated, according to Fisher, between the first sketch
in graphite on the Louvre drawing RF 26168 (Prat
1988-1, vol. 1, no. 343) and the pen-and-ink studies for the
figure of Othello that were later added to the sheet.
In the present study, Chassériau was seeking an appro-
priate position for the figure of Othello, placing him
first behind the bed, which he illuminates with a lamp,
and then in front of the bed, as indicated in the pen
sketch of a leg. Another drawing for plate 11 has just
come to light (Prat 1988-2, no. 99 v., ill.) on the reverse
of a study for plate 3. L.-A. P.

CAT. 106

107

"Oh! Oh! Oh!"

1844
Graphite, with brush and green wash (affixed to the back of the
lower part of the cover of dummy album 1)
9 ⅜ x 11 ⅛ in. (23.7 x 28.3 cm)
Inscribed in graphite, at the top: *Othello se penchant / avec des san-
glots / sur le corps de Desdémone / Oh! Oh! Oh!* [Othello leaning /
sobbing / over the body of Desdemona / Oh! Oh! Oh!]
Paris, Musée du Louvre (RF 26189)

PROVENANCE:
See cat. 20.

BIBLIOGRAPHY:
Chevillard 1893, part of no. 420; Sandoz 1974, under no. 284;
Fisher, in Baltimore, 1979–80, pp. 132, 134, ill. p. 134; Prat 1988-1,
vol. 1, no. 352, ill.

EXHIBITION:
Paris, 1988, no. 19, fig. 17.

Exhibited in Paris only

Fisher rightly insists on the "extraordinary quality" of
this drawing, which, like the Louvre drawing RF 26233
(Prat 1988-1, vol. 1, no. 358; cat. 108), a preparatory study
for the following plate, contains marvelous highlights
in green wash. The composition is already in place,
although the scene is horizontal in format, whereas the
engraving would be vertical. The weeping woman at the
left would be replaced by the figure of Iago, which appears
in the engraving, in reverse, at the extreme right.

L.-A. P.

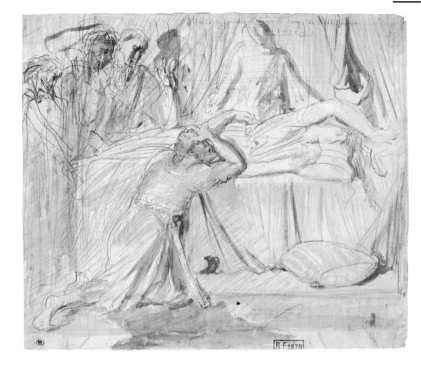

108

"Oh! Spartan Dog . . . "

1844
Graphite, with brush and green wash (affixed to fol. 16 r. of
dummy album 2)
9 ½ x 11 ¾ in. (24 x 29.6 cm)
Paris, Musée du Louvre (RF 26233)

PROVENANCE:
See cat. 20.

BIBLIOGRAPHY:
Chevillard 1893, part of no. 420; Sandoz 1974, under no. 285;
Fisher, in Baltimore, 1979–80, pp. 138–39, ill. p. 139; Prat 1988-1,
vol. 1, no. 358, ill.

EXHIBITION:
Paris, 1988, no. 20, fig. 18.

Exhibited in New York only

Highlighted with green wash like catalogue 107, the
preparatory drawing for plate 14 of the series, the com-
position of this sheet is very similar to that of the engraving,
but in reverse. The individual holding a torch behind
Lodovico is not wearing a cap, as in plate 15.

L.-A. P.

Unhappy Love Affairs

109

Cleopatra Taking Her Own Life (fragment)

1845
Oil on canvas
24 ⅞ x 13 in. (63 x 33 cm)
Marseilles, Musée des Beaux-Arts (Inv. 1352)

PROVENANCE:
Baron Arthur Chassériau, Paris; bequeathed by the latter to the Musée du Louvre, 1934 (RF 3871); placed on deposit at the Musée des Beaux-Arts, Marseilles, 1937.

BIBLIOGRAPHY:
Gautier, *La Presse,* March 18, 1845; Unsigned, *L'Artiste,* April 13, 1845; Baschet 1854-1; Chevillard 1893, no. 130; Jamot 1924; Bénédite 1931, p. 229; Prat 1988-1, nos. 373, 375–409, 435, 461, 510, 557, 2229, 2232, 2235, 2245, 2249, AU X; Peltre 2001, pp. 111–15.

EXHIBITION:
Paris, Orangerie, 1933, no. 25.

In the very first article he devoted to the Salon, on March 27, 1844, Gautier wrote: "M. Théodore Chassériau began a Death of Cleopatra, which he has been unable to complete."[1] A critic in *L'Artiste* noted that Chassériau "is working on a Cleopatra. She is depicted on her bed, surrounded by her ladies."[2] In October, the work still was not finished, and on the following January 12, the critic went on to say: "The Salon of 1845 will be one of the most brilliant celebrations of modern painting. . . . M. Chassériau will have finished his Cleopatra."[3] On March 9, 1845, *L'Artiste* further informed its readers that the review "would begin on Sunday to publish the engravings from the Salon of 1845." Chassériau's two contributions were chosen: "Cleopatra trying out poisons, by Th. Chassériau, after his own work" and "Arab chiefs, by Alp. Masson, after Th. Chassériau."[4]

At that date, Chassériau already had been notified that his *Cleopatra* had been rejected. In taking that action, the academic jury was penalizing the audacity of the painting as much as the young man, overly favored by the administration (see the Chronology for March 2 and 3, 1845). The avant-garde critics, beginning with Paul Mantz, very quickly denounced that shameful ostracism: "Woe to everything that is young, vigorous, exuberant, unexpected! M. Chassériau's *Cleopatra,* M. Paul Huet's landscapes, and many others have not found favor with the jury."[5] Thoré also alluded to the decision, and Gautier, who was even more outraged, left us the most precise description of the victimized painting, which has proven invaluable, given that the painter, responding to one crime with another, destroyed his work, and preserved only the beautiful fragment in Marseilles[6]—a fragment that has come to symbolize the rejection of classical unity:

> It is the simplest, the grandest, the most classical composition one could imagine; you'd think you were looking at a fresco from Pompeii. The queen has withdrawn to the treasure house and is lying on a small bed, in the company of two attendants who, with a combination of dread and sorrow, stare at the slimy black asp that will inject its poison into this beautiful body, as robust as marble, which neither the strains of royalty or of pleasure have marred with a single wrinkle. Such is the brand-new, risky, and subversive subject that this learned assembly believed it had to reject.
>
> You know what style, what draftsmanship, what skill in anatomy, what feeling for types, what violent, albeit subdued, energy that young painter possesses. . . . That conclusion has not kept M. Théodore Chassériau from being the hope of a new school, and the painter who, in the near future, will be in the forefront. The rejection of Cleopatra in no way reflects on the magnificence of the cartoons he is preparing for his gigantic works at the palace on the Quai d'Orsay.[7]

Although the etching the painter made of the picture reinforces its associations with the paintings at Pompeii, beyond the obvious classical aspects of the theme and of the funerary bed,[8] the Marseilles fragment undoubtedly preserves the bold tones and amber light of a painting of very large dimensions, the loss of which is particularly regrettable. The attitude of Cleopatra's attendant is characteristic of the false remoteness Chassériau often ascribed to the witnesses of a tragedy: a sort of presence/absence, as Moreau would recall, that was typical of his art, which opposed any hint of melodrama.[9] Jamot left us a beautiful description of the work, underscoring the fatal importance of the figure's exotic ornaments: "The head is that of a blonde woman. She is leaning slightly on her left shoulder to which her right hand has been raised, in order to press it against her cheek: a remarkable yet natural gesture, which combines grace and tragedy, in a formula that was dear to the artists of Greece and that corresponds to Chassériau's innate aspirations. A filigreed hoop hangs from her visible ear; on her wrist is a large gold bracelet, and several rings gleam on the fingers of her hand, its palm turned outward. Her eyes are lowered as if to contain her tears: they are as expressive as the movements of her arms."

The very large number of preparatory drawings, a sign of the importance Chassériau conferred on his painting prior to his destructive rage, shows that the decision of which scene to depict varied considerably. Although he envisioned representing Cleopatra "lying dead,"[10] to be discovered in that state by her horrified attendants, he also thought of illustrating—after Plutarch and Shakespeare[11]—the discovery by Augustus's soldiers of the dead body of Marc Antony's mistress. In the end, he chose to focus on the moment prior to her suicide: hence, the asp is preparing to bite the queen's body. In so doing, he distanced himself from a compositional format that owed a great deal to the final etching in his own "Othello" series. The connection between the two images nevertheless remains very strong, but while Desdemona succumbed to death in complete innocence, Cleopatra made the choice on her own, meeting her fate like Christ in Gethsemane or Sappho at Leucas. Her suicide was in keeping with the life of this powerful queen, a female sovereign that men could not dominate. This image of death and lamentation thus became part of the dialectic of desire—always frustrated—that Chassériau explored through the exaltation of what he

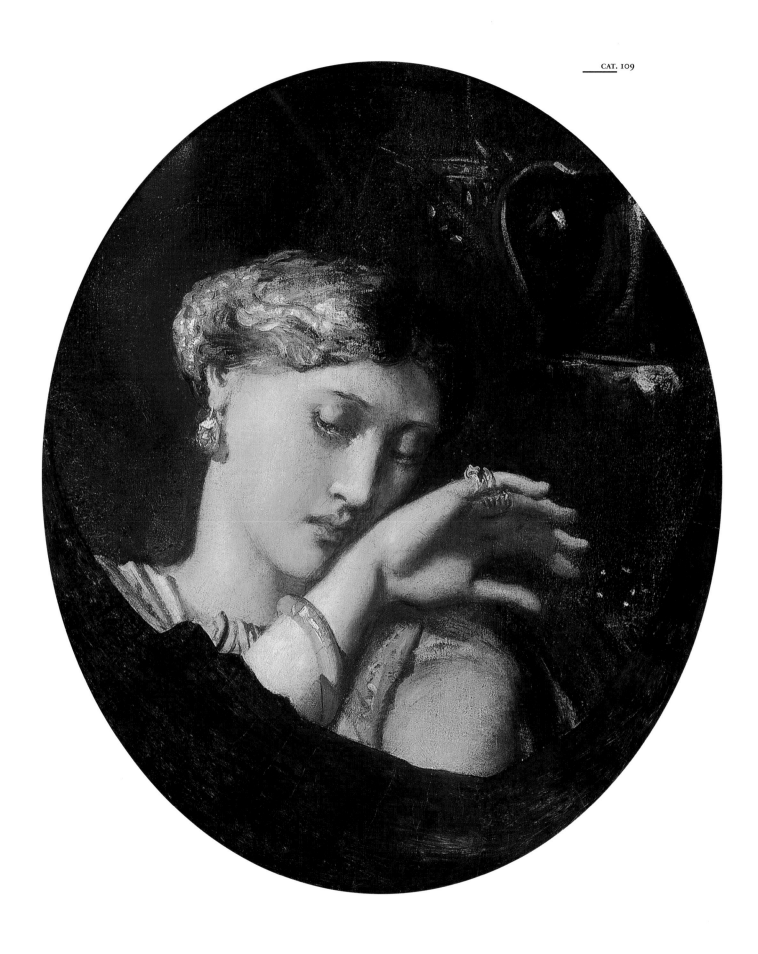

termed the "beautiful" but forbidden "body."[12] Incidentally, he also created one of the great Nudes of his career, like a statue come alive, an echo of which can be discerned in the *Oceanid* (Louvre, RF 20018) from the Cour des Comptes (cat. 128).

Cleopatra was a popular subject at the time, and there were countless evocations of the theme at the Salon and in contemporary literature, as Mario Praz later recounted. However, it was more often the bed of sorrow and the grief of the attendants that were represented in paintings (see, for example, the very beautiful *Death of Cleopatra* by Boisfremont, shown at the Salon of 1824 and now in the Musée des Beaux-Arts, Rouen), rather than the queen's resolute choice to escape Octavius. Among the earlier paintings that illustrate this episode in the story is Delacroix's submission to the Salon of 1839, *Cleopatra and the Peasant* (Chapel Hill, Ackland Memorial Art Center), undoubtedly noticed by Chassériau, as well as by Balzac. Delacroix painted the queen of Egypt as a very feminine sphinx, looking in fascination at the asp as she contemplates the death she has chosen for herself. As for her appearance in literature, we have only to note, confining ourselves to Chassériau's circle, that Gautier and Delphine de Girardin both chose to write about her. A controversial figure since Antiquity, Cleopatra was a symbol of debauchery for Virgil and Horace, and for Plutarch, a woman with a great deal of culture but with little virtue, who nevertheless died a princess. She acceded to a new status with the Romantics: that of a creature in love with the absolute, an aesthete of love, a strong woman who combined the ideal with the pleasures of sex, the pure with the impure. In that sense, Chassériau's painting has much in common with Gautier's *Une Nuit de Cléopâtre* (published in installments in *La Presse* beginning in November 1838, and reprinted in book form in 1845) and Delphine de Girardin's 1847 play. A telling annotation (Prat 1988-1, vol. 1, no. 387) by the artist provides an aesthetic key to this distinguished *Olympia:* "If possible put in less sadness and more ardor and avoid whatever is crude in the details." However, did Chassériau know how to heed his own advice? S. G.

1. Gautier, "Salon de 1844," in *La Presse*, Paris, March 27, 1844.
2. H. de Bray, "Chronique des arts et des lettres," in *L'Artiste,* 4th series, 1, no. 8 (June 23, 1844).
3. Ibid., 3, no. 8 (January 12, 1845).
4. The later etching of the *Cleopatra,* according to *L'Artiste* of March 30, 1845, was completed, and the etching of Ali-Ben-Hamet appeared in *L'Artiste* on May 25, 1845, but the *Cleopatra* remained unpublished—in response to Bénédite's question (p. 232): "The small etching, done by Chassériau himself, undoubtedly must have been engraved, in view of the Salon, for some illustrated publication. Might it not be precisely *L'Artiste,* which announced an article on that painting that was never published, probably because of the jury's rejection?" Jamot (1924) aptly pointed out the differences between the painting and the engraving.
5. P. Mantz, "Le Jury," in *L'Artiste,* 4th series, 3, no. 11 (March 16, 1845), p. 163.
6. Ten years later, Baschet still regretted that gesture of revolt: "On two different occasions, the painter burned canvases on which he had seen the sun set more than once. . . . Doesn't M. Chassériau know by now that the decisions of paintings juries are not always written into law as the sacred word?" (Baschet 1854-1, p. 134). Was not the second painting that reportedly had experienced "death by fire" the *Sabbath in the Jewish Quarter of Constantine,* barred from the Salon in 1847?
7. T. Gautier, "Salon de 1845," in *La Presse,* Paris, March 18, 1845. Chevillard (1893) gave the dimensions of this large painting, which he did not see firsthand, as 252 x 170 cm (99 ¼ x 67 in.).
8. During the 1840s, the theme of weeping women—the feminine gender was obligatory—was extremely common in Chassériau's studies.

9. One of the preparatory drawings (Prat 1988-1, vol. 1, no. 378) attests to a composition—quickly dismissed—in which one of the attendants rushes with open arms to the bed of her deceased mistress with a gesture typical of scenes of the Lamentation and of classical drama.
10. This is how the inscription reads on one of the preliminary drawings for the painting. See the Ader Picard Tajan sales catalogue, *Importants Tableaux des XIXᵉ et XXᵉ siècles,* Drouot-Montaigne, November 22, 1987, lot 302.
11. The annotations and quotations on Chassériau's preparatory drawings and in his notebooks attest to the fact that he had read Plutarch (*Parallel Lives,* chap. 85) and Shakespeare (*Antony and Cleopatra*).
12. A page in a notebook (2249, fol. 5 v.) dealt with another moment in the drama: Cleopatra is shown hovering over the body of Antony, who has killed himself. Like the plight of Romeo and Juliet, which Chassériau often had in mind, the two lovers managed to unite only in death.

110

Studies of Legs Extending to the Right; Feet; and Hands

1844
Black pencil, highlighted with oil, on gray paper (the lower-left corner is missing)
10 ¼ x 14 ⅜ in. (25.8 x 36.4 cm)
Paris, Musée du Louvre (RF 25942)

PROVENANCE:
See cat. 20.

BIBLIOGRAPHY:
Chevillard 1893, part of no. 420; Bénédite 1931, vol. 2, ill. p. 387 (described as a study for the legs of the *Sleeping Bather*); Prat 1988-1, vol. 1, no. 394, ill.; Peltre 2001, p. 115, fig. 132.

Exhibited in Strasbourg only

In this study for the legs of Cleopatra and the hand holding the asp, the queen's lower body appears entirely nude. Although the etching retains elements of the painting, Cleopatra is depicted clothed in drapery.

The Louvre possesses an important series of drawings for this painting (Prat 1988-1, nos. 375–409), including a composite study that is drawn *directly* on one of the pages of dummy album 3 (Prat 1988-1, vol. 1, no. 375, ill.). L.-A. P.

CAT. 110

111

Studies of a Woman Seen in Half Length, Her Head in Three-Quarter Right Profile and Her Arms Crossed in Front of Her Face

1844
Black pencil with stumping, heightened with white, on beige paper
14 ¼ x 13 ¾ in. (36.2 x 34.8 cm)
Paris, Musée du Louvre (RF 25940)

PROVENANCE:
See cat. 20.

BIBLIOGRAPHY:
Chevillard 1893, part of no. 420; Prat 1988-1, vol. 1, no. 406, ill.

EXHIBITIONS:
Paris, Louvre, 1980–81, no. 29; Paris, 1988, no. 26.

Exhibited in Paris only

In this study for the attendant standing behind Cleopatra's bed, the woman's arms are crossed in front of her face, whereas, in the painting—known only through the etching—the figure's left arm was lowered and extended outward in a gesture of denial. **L.-A. P.**

112

Apollo and Daphne

about 1845
Oil on canvas
25 ¼ x 19 ¾ in. (64 x 50 cm)
Paris, Private collection

PROVENANCE:
Sale, Paris, April 27, 1939, no. 174; acquired by Jean-Louis Vaudoyer; Paris, private collection.

BIBLIOGRAPHY:
Sandoz 1974, no. 100.

Exhibited in Paris and Strasbourg

113

Apollo and Daphne

1845
Oil on canvas
20 ⅞ x 13 ⅞ in. (53 x 35 cm)
Signed and dated, bottom left: *Th. Chassériau 1846*
Paris, Musée du Louvre (RF 3870)

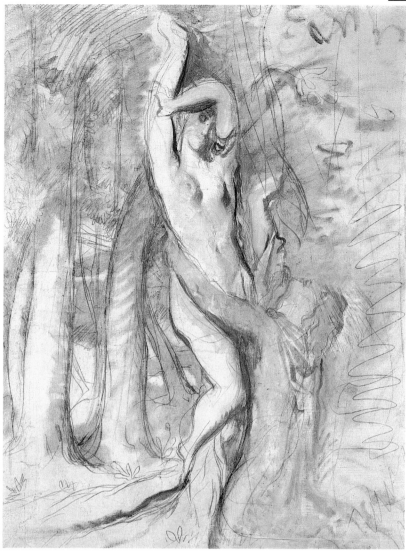

PROVENANCE:
Baron Arthur Chassériau, Paris; bequest of the latter to the Musée du Louvre, 1934.

BIBLIOGRAPHY:
H. de Bray, *L'Artiste,* 4th series, 1, no. 8, June 23, 1844; M[arc]. F[ournier]., *L'Artiste,* 4th series, 1, no. 9, June 30, 1844; Gautier, *La Presse,* November 17, 1845; Champfleury, *L'Artiste,* October 4, 1846; Chevillard 1893, pp. 85–87; Bénédite 1931, pp. 242–43; Sandoz 1974, no. 99; Clay 1980, p. 134; Prat 1988-1, vols. 1 and 2, nos. 369–373, 558, 690, 1728, 2079, 2094, 2186, 2235, 2240, 2247; Peltre 2001, pp. 96–98.

EXHIBITIONS:
Paris, foyer, Théâtre de l'Odéon, 1845; Paris, Centennial, 1900, no. 193; Paris, Orangerie, 1933, no. 33.

Exhibited in Paris only

Preceded—or, perhaps, followed—by a large and beautiful rough sketch with silvery accents,[1] which belonged to Jean-Louis Vaudoyer, this more modest canvas cannot be dated precisely, although the artist's notebooks in the Louvre suggest its genesis in about 1840, contemporary with the studies of Sappho and the Souliot women.[2] Other preparatory drawings reveal that the plan for *Apollo and Daphne* was inseparable from the copy of a painting by Van Opstal, in the Hôtel Lambert with the same subject, made by Chassériau before 1840 (Louvre, RF 26256). In that work, the two protagonists are captured in flight. The concern to "invent, always invent,"

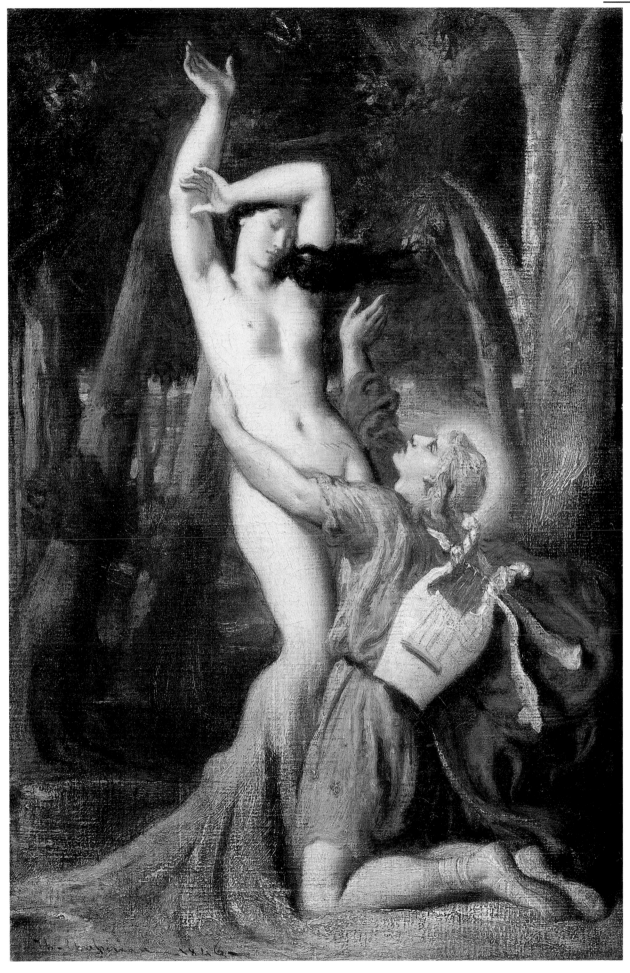

would compel Chassériau to make another choice. Another Louvre sheet (2235, fol. 58 v.) shows Apollo kneeling, but with his arms around Daphne's legs, not her waist, and Daphne's face is much more expressive. Once again, the final painting ignores the traditional rhetoric of the passions in favor of the internal drama.

It is very similar to Chassériau's lithograph for *L'Artiste,* which appeared as an insert in the June 23, 1844, issue.[3] The latter is an example of how the artist habitually reprised his works. Although the present canvas is dated 1846, it undoubtedly was executed closer to the time when it was exhibited in the foyer of the Théâtre de l'Odéon in Paris in November 1845. On the occasion of the theater's reopening, after its appearance was enhanced by the architect Alphonse de Gisors, an exhibition of modern paintings was organized. On display were works by the new school of artists to which the Salon had given the cold shoulder, from Delacroix and Roqueplan to Corot and Rousseau. This small painting by Chassériau, hardly more finished than a sketch, risqué and melancholic at the same time, perfectly suited the anti-establishment spirit of the exhibition.

The subject of the painting is a direct outgrowth of the mythological themes that had preoccupied Chassériau since the late 1830s, and also echoes the elegiac poems of Lamartine, Vigny, and Chénier (to name just a few of the more modern literary exponents of the genre). Bénédite rightly noted: "It is yet another interpretation, both plastic and expressive, of an ancient myth, and the continuation of the beautiful series inaugurated by the *Venus Anadyomene,* which the figure of *Daphne* recalls—like a veritable pendant—in the movement of her folded legs, the familiar power of her raised arms, the narrow hips, and the small and firm breasts that cast parallel shadows."[4] Daphne's metamorphosis into a laurel tree at the instant that Apollo tries to embrace her had long been a favorite theme of painters and sculptors. This Ovidian subject made Cupid's vengeance (Apollo had made fun of the archer, who was so unmartial in appearance) the cause of a drama with a variety of resonances. Thus, the flight of the nymph from the pursuit of the sun god could be interpreted as a moral allegory of the illusory nature of existence. The couplet by Cardinal Maffeo Barberini on the base of Bernini's famous statue in the Galleria Borghese in Rome sums up the dichotomy between true riches and vain desires: "Tel qui court après les plaisirs fugaces / S'emplit les mains de feuilles mortes, ou cueille des fruits amers" [He who chases after fleeting pleasures / Fills his hands with dead leaves, or collects bitter fruit].[5]

Can the symbolism of this "little canvas, all fragrant with mythological poetry"[6]—to quote Champfleury—be reduced to something so self-evident? Nothing can be less certain. In any case, the sonnet Marc Fournier published in *L'Artiste* a week after the lithograph appeared, focuses more on the heartbreak and sexual frustration than on the mere loss of reason. It is not insignificant that Fournier was one of Père Saint-Alme's "little cretins"[7]— that is, together with Baudelaire, Banville, Champfleury, and Murger, he belonged to the first group of contrib-

utors, undisciplined and rather insolent, to *Le Corsaire-Satan,* which Lepoitevin Saint-Alme attempted to direct. These young people, in a reaction against a certain lachrymose and contrite Romanticism, espoused a completely different regimen for living, venturing into pagan territory—as exemplified by Banville's *Cariatides* and by certain poems in Baudelaire's *Flowers of Evil.* Fournier certainly was not the equal of these poets; his work was more playful than licentious, and his poem "À M. T. Chassériau, sur son esquisse d'Apollon et Daphné" (To Mr. T. Chassériau, on his sketch of Apollo and Daphne)—"sketch" is meant to be understood here in graphic terms, and applies to the intentionally *unfinished* quality of the lithograph—deserves to be quoted *in extenso,* inasmuch as it radically reverses the old, moralistic tradition of Ovid:

> Vous avez deviné l'antique métaphore
> Que la Fable cachait sous son voile flottant.
> En vain le front du dieu d'un pur rayon se dore,
> Comme un deuil immortel l'ombre y monte et s'étend.
>
> C'est l'ombre des lauriers. Gloire vide et sonore,
> Vingt siècles de tes cris valent-ils un instant
> D'extase et de langueur sur un sein palpitant?
> Le Tasse couronné n'aime qu'Éléonore.
>
> Et je vous sais bon gré du crayon dédaigneux
> Dont vous avez à peine esquissé les ramées
> Du symbole menteur des pâles renommées;
>
> Daphné demandait seule à vos traits plus soigneux
> Un ensemble charmant de lignes bien aimées;
> La beauté seule est belle à l'âme comme aux yeux.[8]

> You divined the ancient metaphor
> Concealed by Fable under her flowing veil.
> In vain the god's brow is gilded with a pure light,
> Like immortal grief, a shadow rises and spreads over it.
>
> It is the shadow of laurels. Hollow and sonorous glory,
> Are twenty centuries of your cries worth an instant
> Of ecstasy and languor on a palpitating breast?
> Tasso with his wreath loves only Eleanor.
>
> And I am grateful to you for the disdainful pencil
> With which you barely sketched the boughs
> Of the deceitful symbol of pale renown;
>
> Daphne alone required, from your more careful strokes,
> A charming series of beloved lines;
> Beauty alone is lovely to the soul and to the eyes.

The fine commentary by Arsène Houssaye, on the painting, published in *L'Artiste* the following year, under the pseudonym "Lord Pilgrim," restored the immediacy of the theme of an ideal beyond reach, without ignoring the obvious erotic dimension of the image:

> This painting has all the qualities of the artist: audacious composition, grand—although a bit tortured—style, classical taste with a new interpretation, strange color harmonies, bold and sure draftsmanship, a combination of enthusiasm and austerity that makes the young painter one of the surest hopes for the modern school. The whiteness of the body, whose imperceptible tones blend into the laurel trees, glistens amidst the gold and purple of Apollo's embrace, in a fatal and poetic manner. One understands that when the spirit wishes to seize the ideal,

he embraces only the coarse bark of a tree; in pursuing a woman, one attains only a trunk and the branches. Eternal lesson, bitter and melancholic thought, and, in addition, don't the leaves of the laurel tree contain poison?[9]

Although Gautier confesses he is not sure he has penetrated the enigma of this canvas, whose "strange grace" and "Greco-Indian taste" he lauds, he simultaneously invokes and revokes the neo-Platonic tradition in which art is regarded as a spiritualized form of erotic ardor: "Does it mean that, for poets, glory comes from love, and that the laurels with which one crowns their brows are made of the soul and substance of the idol, frantically pursued? Or does it mean, quite simply, that in the arms of clever men women are metamorphosed into wood?"[10] Should this splendid body, which cannot be possessed, and this black hair, which reveals its inner secrets, be interpreted as the embodiment of a desire with no outlet? Although dressed in the red of passion, Apollo carries on his back the poet's lyre and not the lover's bow. The vertical composition, with its Venetian tones and the sinuously opposing curves of Daphne's flesh, might then have a compensatory value. S. G.

1. Sandoz (1974, p. 212) regarded it, rather, as a finished sketch.
2. Chassériau began to reflect on the theme of Apollo in about 1840, which makes it possible to assign an approximate date to the *Hero and Leander* in the Musée du Louvre. The figure of the young god appears in that canvas in a different context. Sandoz wrongly believes that the work dates from 1849–50.
3. H. de Bray, "Chronique des arts," in *L'Artiste*, 4th series, 1, no. 8 (June 23, 1844): "M. Chassériau's beautiful drawing *Apollo and Daphne,* which l'Artiste is publishing today, brings to mind, with a great deal of charm, these poetic lines: *'Ô mon maître Apollon! Daphné la chasseresse / Brave sous les lauriers ta divine caresse; / Mais si tu viens près d'elle en lui disant des vers / Elle ornera ton front de lauriers toujours verts'* [O my Apollo! Daphne the hunter / Braves under the laurels your divine touch; / But if you come near her reciting poetry / She'll adorn your brow with evergreen laurels]."
4. Bénédite 1931, p. 252.
5. See C. Avery, *Bernin* (Paris: Gallimard, 1998), p. 55.
6. Champfleury, "Exposition de tableaux à l'Odéon," in *L'Artiste* (October 4, 1846); reprinted in *Oeuvres posthumes de Champfleury. Salons 1846–1851* (Paris, 1894), p. 87.
7. C. Pichois and J. Ziegler, *Baudelaire,* 2nd ed. (Paris: Fayard, 1996), p. 221.
8. M[arc]. F[ournier]., "Poésie. À M. T. Chassériau, sur son esquisse d'Apollon et Daphné," in *L'Artiste*, 4th series, vol. 1, no. 9 (June 30, 1844).
9. Quoted in Bénédite 1931, pp. 242–43.
10. See T. Gautier, "La Galerie du foyer de l'Odéon," in *La Presse,* Paris, November 17, 1845. Gautier himself exhibited his *Pandora* there, another allegory of irrepressible desire.

Notebook

1838–41 and 1842–44
Bound notebook, covered in brown morocco, with gilded lines and motifs on the covers; the artist's initials, *T. C.,* appear on one of the covers, and the title *Album* is on the back; containing sixty-three sheets (some fragmentary) numbered 1 to 63, and an unnumbered flyleaf. Missing folios before folio 1 (1), between folios 3 and 4 (2), 18 and 19 (1), 48 and 49 (2), 53 and 54 (1), 54 and 55 (1), and 58 and 59 (1).
Stamp of the artist's studio (L. 443) at the bottom and on the right of the first flyleaf and on folio 1 r. Label of the paper manufacturer Peyrol on the back of the flyleaf, at the upper left.
10 ⅛ x 13 ¼ in. (25.7 x 33.7 cm) (notebook)
9 ⅞ x 13 in. (25 x 33 cm) (sheets)
Paris, Musée du Louvre (RF 26056)

PROVENANCE:
See cat. 20.

BIBLIOGRAPHY:
Chevillard 1893, part of no. 420; Sandoz 1974, p. 44 n. 1; Prat 1988-1, vol. 2, no. 2235, ill.

EXHIBITION:
Paris, Louvre, 1980–81, no. 25 (open to folios. 35 v. and 36 r.).

Exhibited in Paris only

Used by the artist from about 1838 to 1841 and from 1842 to 1844.

Open to folios 35 v. and 36 r.

Folio 35 v.

Studies of Women Facing Left

Graphite
about 1839

Folio 36 r.

Studies of a Nude Woman with Her Arm Raised

Graphite
Inscribed in graphite, lower left: *les plantes de la / campagne de / Rome* [the plants in the / countryside of / Rome]

BIBLIOGRAPHY:
Sandoz 1974, under no. 99.

This study for the figure of Daphne in the *Apollo and Daphne* now in the Louvre probably was executed slightly before the painting (about 1842 ?), where the gesture would appear in reverse. L.-A. P.

CAT. 114, 35 v.

CAT. 114, 36 r.

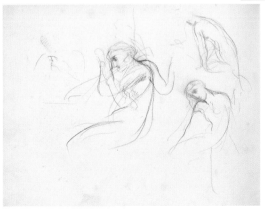

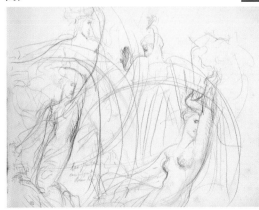

The Decorations at the Cour des Comptes

Fragments of the decorations for the stairwell of the grand stair-
case of the former Cour des Comptes, located in the Palais
d'Orsay, Paris (site of the present Musée d'Orsay)

1844–48
Oil on plaster (now known only through fragments transferred
onto canvas)
Formerly signed and dated on the figure of Peace: *Théodore
Chassériau 1844 à 1848* (according to Gautier 1848)
Paris, Musée du Louvre

PROVENANCE:
Théodore Chassériau was commissioned by the state to decorate
the stairwell of the grand staircase at the Cour des Comptes in 1844,
for a fee of thirty thousand francs. The work was completed in
1848, but was destroyed in large part by the fire that ravaged the
Palais d'Orsay during the Commune, on May 23, 1871. Before
the ruins of the Palais d'Orsay were demolished and a train station
built on the site, the few surviving fragments were removed from
the walls in 1898, courtesy of the Chassériau Committee, which
donated them to the Musée du Louvre in 1903. A flood in the Louvre
storerooms in 1910 damaged a portion of the remaining fragments,
and whatever had been salvaged was transferred onto canvas, with
the exception of a fragment of *Order Supplies the Needs of War,*
depicting a group of blacksmiths, which retains its plaster support.

BIBLIOGRAPHY:
[Most of the general surveys of paintings and nineteenth-century
art have devoted pages to the details of Chassériau's decorations
at the Cour des Comptes. Therefore, the following selections rep-
resent only the initial texts that provided the groundwork for
the literature, since the early twentieth century, as well as the most
significant articles.] Gautier 1848; Malitourne 1848; Gautier 1871,
pp. 1907–8; Vachon 1879, pp. 5–22; [Renan] 1881, p. 320; Bouvenne
1883–84; Bouvenne 1887; Dalligny 1890, pp. 1–2; Alexandre 1891;
Renan 1891, p. 255; Chevillard 1893, pp. 125–50, nos. 7–20; Bénédite
1898, pp. 22–25; Castets 1898; Marx 1898, pp. 274–75; Marx 1898-2,
pp. 217–20; Renan 1898, pp. 89–104; Tschudi 1900, p. 10, ill.; Vaillat
1907, pp. 180–82; Marcel and Laran 1911, pp. 61–78, plates 28, 29;
Rosenthal 1912, pp. 304, 315–16; Fabre 1913, p. 62; Vaudoyer 1919,
p. 41; Bouyer 1920, pp. 529–30, ill.; Jamot [n.d.], pp. 19–22, pl. 15;
Guiffrey and Linzeler 1926, pp. 5, 241–48; Goodrich 1928, p. 79,
ill. p. 81; Bénédite 1931, vol. 1, pp. 315–27, plates 30, 32; Grappe
1933, pp. 42, 52–55; Sandoz 1957, pp. 21–26; Réau 1959; Doyon
1969, pp. 47–56; Sandoz 1970, pp. 50–53; Sandoz 1974, no. 113,
pp. 39–54, 226–47; Leri 1978, p. 391; Prat 1988-1, nos. 413–561,
pp. 205–62; Amouroux 1993; Amouroux 1997, pp. 63–64; Peltre
1998, pp. 70–77; Peltre 2001, pp. 19, 70, 156–70, 223.

EXHIBITIONS:
The extreme fragility of the surviving fragments of the Cour des
Comptes decorations, the result of their turbulent history, has pre-
cluded them from being lent to any exhibitions. Their display at
the Grand Palais in 2002, after a limited restoration, marks the first
time since the 1933 retrospective, that they were permitted to leave
the Musée du Louvre (Paris, Orangerie, 1933, nos. 27–31, 122–129,
pp. xxii–xxv, 16–18, 58–61). The fragment of *Peace* was transferred
to canvas and shown at the Exposition Universelle of 1900.

The series of fragments of the decorations is exhibited in Paris only

Because of the political events of the year 1848—the
fall of Louis-Philippe and the advent of the Second
Republic—the public unveiling of the decorations
painted by Théodore Chassériau in the stairwell at the
Cour des Comptes went almost unnoticed. Only two
significant reviews were published during that period. The
first, by Pierre Malitourne, although not negative, was
guarded in its enthusiasm: "After all the critical reserva-
tions, one does not leave [these paintings] without taking
along, as the summation of one's impressions, the happy
conviction that they will necessarily enhance the repu-
tation of M. Chassériau and serve as a guarantor of a
productive future."[1] The second critique, dithyrambic and

passionate, was written by the painter's friend Théophile
Gautier, who patiently described each of the composi-
tions: "These beautiful paintings have a rare and sin-
gular look that clearly separates them from ordinary
allegories. . . . They have a certain bizarre and mannered
grace, a certain weird charm, in the Florentine taste. As
for his general character, one might say that
M. Chassériau is an Indian who studied in Greece. He
projects onto the ancient classical world the unknown
beauty of new races, or, at least, races that until now the
paintbrush has scorned."[2]

The painter, "who attached a great deal of impor-
tance to that enormous labor, executed with the feverish
ardor and relentless speed that he brought to what he was
doing, as if he had a presentiment of his imminent
death,"[3] was therefore especially upset by the paintings'
lack of success, and he attempted to stir up his and his
brother's friends to generate some coverage of his work
in the press. He wrote to Victor Hugo twice during that
period, inviting him to come and view his painted stair-
well,[4] and he asked that Hugo publish a short item in his
newspaper, *L'Événement,* concerning the public opening
of his monumental project[5]—clearly, among the most
significant moments in his young career, when he could
take his place beside the greatest artists of his time; the
fact that his work might remain somewhat hidden obvi-
ously compromised his professional plans.

Paradoxically, this enormous pictorial achievement,
one of the most important in the nineteenth century,
was hardly discussed at the time. Several artists, such as
Puvis de Chavannes and Gustave Moreau, would even-
tually view the series, only to be astonished and then
won over by the force and beauty of the compositions,
which, in turn, would influence their own works. Others,
however, did not understand their interest. Jean-Victor
Schnetz, for example, wrote to a friend, Jean-François
Navez, in February 1849: "You cannot imagine this awful
mess: neither draftsmanship, nor colors nor effects; in
short, a complete waste. On seeing all that pomposity,
one can't describe it better than M. David, who said of
one of his failures: there are those who make fun of it but,
after all, it leaves much to be desired."[6] Significantly,
Eugène Delacroix did not mention the event—or its
consequences—in his famous *Journal,* noting only the
painter's death in 1856.[7]

Moreover, in spite of his efforts and the undeniable
achievement represented by his monumental work,
Théodore Chassériau did not manage to compete with
Delacroix, who, in 1846 and 1847, had enjoyed enor-
mous success when his two large decorative projects for
the libraries at the Palais du Luxembourg (Senate) and
the Palais-Bourbon (National Assembly) opened to the
public. By contrast—and fortunately—Chassériau must
have found some consolation at the time upon learning
that in 1849 Ingres, his former teacher, had definitively
abandoned work on the monumental painting *The Golden*

*Commerce Brings Peoples
Together (Eastern Merchants
on a Western Shore)*
1844–48
Detail of catalogue 130

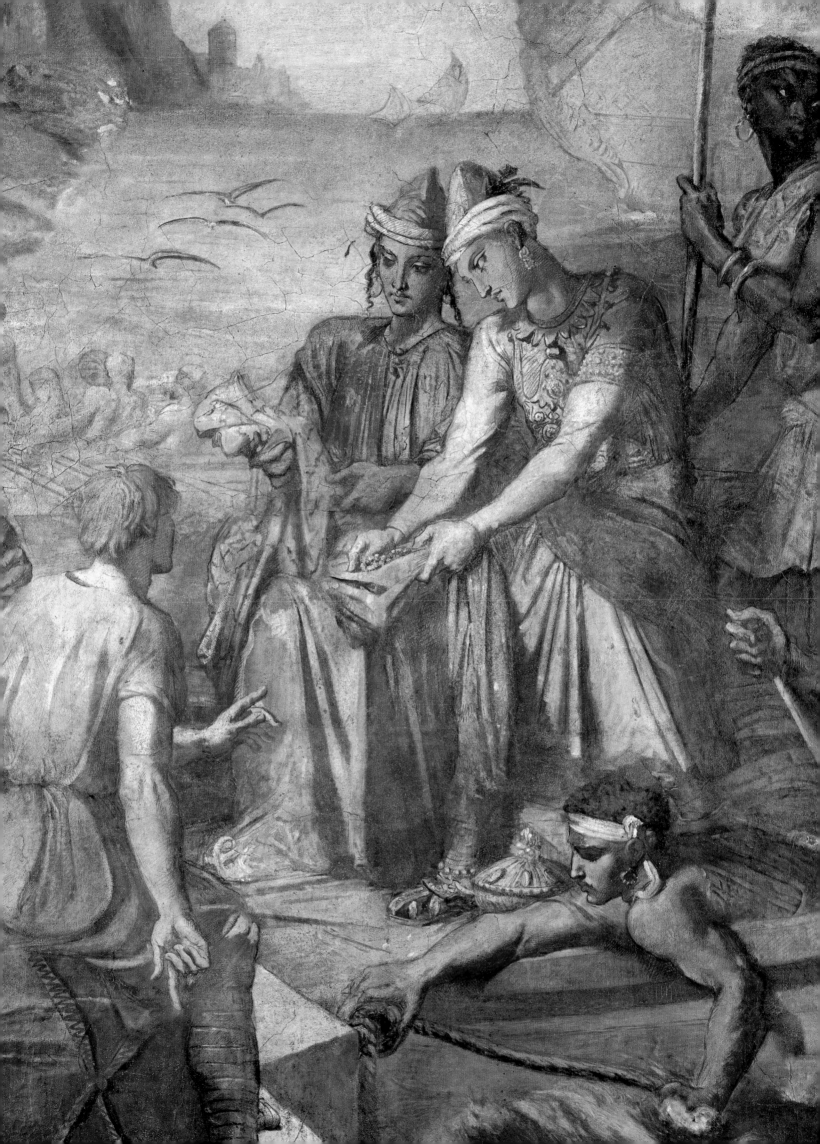

Age, which had preoccupied him since 1842 at the château of Dampierre. The three decorative projects, by Delacroix, Ingres, and Chassériau, respectively, begun at almost the same time, clearly demonstrate the vitality of French decorative painting during the reign of Louis-Philippe. Théodore Chassériau was certainly among the leaders of that aesthetic movement by virtue of his achievement at the Cour des Comptes, further asserting his ability, within the context of his teacher's failure, to bring his paintings to a "conclusion." It should also be noted that, unlike Delacroix and Ingres, both of whom enlisted the services of several students or collaborators on their monumental compositions, Chassériau seems to have executed the enormous painted surfaces of the walls of the Cour des Comptes almost single-handedly, aided solely by a few assistants, who prepared his pigments for him.

Subsequently, the tragic fate of Chassériau's creations, and the rally to salvage whatever was possible of the tremendous loss, proved to what extent artists and art historians considered the decorations at the Cour des Comptes among the masterpieces of nineteenth-century painting.

On May 23, 1871, twenty-three years after the completion of the project, as troops were invading Paris to drive out the partisans of the Commune, fanatical revolutionaries attempted to destroy several public buildings in the city. During the night, they stormed the Cour des Comptes and the Conseil d'État, poured kerosene over the walls, and started a gigantic fire, which destroyed most of Chassériau's paintings. In addition to the destruction of the works themselves, a set of Chassériau's family archives was also lost in the fire; Frédéric Chassériau, councillor of state at the time, had arranged to store his important personal papers in the cellar of the Conseil d'État.

After a brief respite in the fear generated by the revolutionaries,[8] the painter's friends visited the site to determine the scope of the devastation: "We discovered the large composition *Peace* . . . but in what a state! Blackened, bubbling, riddled with blisters from the heat, covered with soot from the smoke, but still somewhat recognizable."[9] Théophile Gautier, desperate, observed that the two compositions in grisaille in the lower register—*Silence, Study, Meditation,* and *Warrior Unhitching His Horses*— had, in fact, been saved from the fire, but he found that *Order* had "suffered horribly, [and is] lost forever," and that *Force and Order,* which he referred to as *Neptune and Amphitrite,* was still visible, but very damaged, and, above all, that several other painted panels were totally lost. The despondent poet commented: "A palace can be rebuilt if need be, but a lost masterpiece, a painting that vanishes in a burst of flames and smoke dissipates like a soul that is impossible to revive."[10] A few weeks earlier, Chassériau's friend Aglaüs Bouvenne had expressed a similar emotion: "It was with a broken heart that, on June 25, 1871, I climbed the staircase of the Cour des Comptes; stones and debris blocked it; steps, broken in several places, swayed under my feet; from time to time, unexpected cavities forced me to take two stairs at a time; in these desolate ruins, something was still shining—the work of Chassériau!" The painter's biographer immediately added: "Very damaged, no doubt, but still perfectly reparable, Théodore Chassériau's paintings could have been removed and preserved for our admiration."[11]

That sensible remark prefigured a battle that was to last twenty-seven years, during which time what survived of Chassériau's paintings would remain in the ruins of the Palais d'Orsay, damaged by rain, frost, and sun, virtually without protection, facing almost complete indifference. In spite of the mobilization of the painter's friends and the attentions of his brother, who managed to have some paltry protective devices installed,[12] the decorations were abandoned by successive governments. Marius Vachon observed in 1879: "The wind carried away or tore apart most of the canvas; all that remains are filthy shreds, which, at the slightest breeze, spread their dust over the unfortunate paintings."[13] Ary Renan, Marius Vachon, Arsène Alexandre, and later, Baron Arthur Chassériau, kept up their campaigns in the press, which seemed hopeless: "Are they waiting to undertake [the removal and the restoration] until the wind, rain, and sun have completed the deadly work of the kerosene and the fire?"[14] In 1879, a restorer, M. Briotet, was asked by the government to estimate the cost of removing Chassériau's paintings, but, faced with the "tremendous difficulty" of the labor involved, he decided against it.[15]

As of 1882, the idea of removing only the "best parts of the artist's work" gained support, as a way of salvaging what was possible at a manageable cost. Antonin Proust, Ministre des Beaux-Arts, had a fragment from *Order,* the head of a horse, transferred to canvas, but that effort was not followed by any others, since the cost of saving the entire work seemed too high. Another nine years passed, during which time the Ministre de l'Instruction publique et des Beaux-Arts wrote an astonishing letter on January 13, 1891: "I would like to let you know that, after examination, it was acknowledged that none of these fragments has an artistic value sufficient for them to be placed in the state's collections. This observation also applies to Chassériau's mural paintings that decorated this palace."[16] Fortunately, the same year, Baron Arthur Chassériau, who began his tireless efforts in the service of his cousin's oeuvre (see pp. 16–17), asked a restorer, Charles Mercier, to clean the surviving fragments. At the same time, he had canopies put up to protect the paintings in situ, and asked the Braun Company to take photographs of them. "Will this be the beginning of a rescue operation, or will the work begun by disinterested persons be abandoned?" Arsène Alexandre wondered at the time.[17]

Alas, another six years went by, during which time the paintings continued to deteriorate. In 1897, the ruins of the Conseil d'État and of the Cour des Comptes were sold to the Orléans Railroad Company, which planned to build a train station on the site—the future Gare d'Orsay, now the Musée d'Orsay. The remains of the buildings were thus to be destroyed. A committee immediately formed, under the chairmanship of a former Directeur des Beaux-Arts, Philippe de Chennevières, and of Admiral Duperré, former Minister of the Navy.[18] A fund was set up to buy the paintings and have them removed. On

January 15, 1898, the Orléans Railroad Company offered the Chassériau Committee the works in the Cour des Comptes in their entirety, on the condition that the committee take charge of their removal.

Ary Renan observed at the time that "of the two hundred and seventy [square] meters once covered, scarcely have we hoped, in the last few weeks, to save fifty or sixty square meters worthy of the great name of Chassériau."[19] The writer listed in precise detail what could still be saved: of *Order,* only *The Blacksmiths,* the group on the right, survived; of *Peace,* only the left part; of the two panels of *Commerce* and the grisaille, there was only one left, and it was largely damaged; *The Return from the War* was lost, and *Justice,* as well; *The Warriors* and the *Grape Pickers* did not suffer too much; *Force and Order* was in rather good condition; the two grisailles on the ground floor were still preserved. As Jean Laran would later say: "They could have been almost completely saved if the state had made, on their behalf, the least of the sacrifices it reserved for Gallo-Roman stones or for its mediocre roster of official artists."[20]

Within a few weeks, everything that could be removed was taken down—with the exception of the *Warrior Unhitching His Horses,* which undoubtedly was abandoned where it was. The workers hired for the occasion cut up the walls into many fragments, after first protecting the painted surfaces. Simultaneously, with these labors, the Chassériau Committee had two of the fragments transferred to canvas: *Peace,* and the only surviving *Oceanid* of the two Chassériau had painted, enabling *Peace* to be displayed at the Exposition Universelle of 1900. The public was able to see the beauty of Chassériau's pictorial work, which overturned certain painters' opinions. Camille Pissarro wrote at the time: "There is a fresco by Chassériau that is admirable and that shows us where Puvis de Chavannes got his inspiration. It is related to Watts in its simplicity of tone, but is much superior in its style."[21] To definitively perpetuate the salvage operation, the Chassériau Committee, before dissolving in 1903, decided to give the remaining fragments to the Musée du Louvre.

Nevertheless, the disasters that befell the decorations were not yet at an end: the surviving fragments were subjected to a flood in January 1910, which destroyed several paintings, and after a prolonged stay in the studio of a restorer, Georges Tisserand, work had to be postponed after he experienced professional bankruptcy. All that waiting—even though, in 1913, the Société des Amis du Louvre had allocated twenty thousand francs to ensure the transferral of the fragments onto canvas[22]—did not improve the state of the works, which continued to deteriorate. Finally, another restorer, Chauffrey, completed the task in 1925 and 1926.

Since then, some of Théodore Chassériau's paintings—such as the fragments of *Peace* and of *Commerce*—have been exhibited in the sculpture galleries and then with the nineteenth-century paintings at the Musée du Louvre, while others are kept in storerooms. A recent restoration campaign—which, for the most part, involved consolidation, light cleaning, and limited retouching of the paint layer—has made it possible to rediscover these superb examples of pure painting. v. p.

1. P. Malitourne, "Art monumental. Les Peintures de M. Théodore Chassériau au Palais d'Orsay," in *L'Artiste* (December 15, 1849).
2. T. Gautier, "Palais du quai d'Orsay. Peintures murales de M. Théodore Chassériau," in *La Presse,* Paris, December 15, 1848.
3. T. Gautier, "Une Visite aux ruines," in *Journal officiel de la République française,* Tuesday, July 11, 1871, pp. 1907–8.
4. Letter from Théodore Chassériau to Victor Hugo [November] 1848; quoted in Sandoz 1986, no. 92, p. 109.
5. Unpublished letter from Théodore Chassériau to Victor Hugo, November 20, 1848 (Paris, Maison de Victor Hugo, Inv. a 9672).
6. Letter of Sunday, February 4, 1849; published in *Lettres inédites de Jean-Victor Schnetz à Jean-François Navez, "Une Amitié italienne"* (Flers, 2000), pp. 3–4.
7. Eugène Delacroix's *Journal* is missing the entries for 1832 to 1847, and the painter's personal diary for 1848 may have been left behind in a hackney carriage. The only mention of the artist is the following: "October 10.—Funeral procession for poor Chassériau. There I meet Dauzats, Diaz, and the young Moreau, the painter. I rather like him. I return from the church with Émile Lassalle" (Eugène Delacroix, *Journal 1822–1863* [Paris, 1996], p. 584).
8. *L'Illustration* (July 1, 1871).
9. See note 3, above.
10. Ibid.
11. Bouvenne 1883–84, pp. 148–50.
12. On the damage to the Cour des Comptes paintings, and, in general, the work to remove the decorations, see the unpublished report by M. Amouroux, "Les Peintures de Chassériau pour l'escalier de la Cour des Comptes," of March 1993.
13. Vachon 1879, p. 19.
14. M. Vachon, in *La France* (March 30, 1877).
15. Letter from the administrator of the Musées Nationaux to the Undersecretary of State at the Ministry of the Fine Arts, April 9, 1879 (Archives des Musées Nationaux).
16. Archives des Musées Nationaux.
17. A. Alexandre, "Les Fresques de Chassériau," in *Album des musées,* November 7, 1891.
18. The Chassériau Committee was composed of many artists and critics: Heurteau, G. Michel, L. Bonnat, Bracquemond, Degas, S. Detaille, P. Dubois, H. Fantin-Latour, Henner, E. Guillaume, J. Lefèvre, P. Puvis de Chavannes, A. Renan, A. Alexandre, E. Aynard, Baudin, A. Baignères, L. Bénédite, G. Berger, Cain, A. Chassériau, Chéramy, V. Chevillard, A. Dayot, G. Dreyfus, C. Ephrussi, P. Gauhier, P. Gille, R. Koechlin, H. Delaborde, G. Lafenestre, G. Larroumet, P. Leprieur, Doctor Levrault, A. Michel, H. Marcel, R. Marx, E. May, Osiris, Ravaisson, Taigny, Thiébault-Sisson, M. Vachon.
19. Renan 1898, p. 92.
20. Marcel and Laran 1911, p. 63.
21. Pissarro, 1950, p. 477, and n. 1.
22. Madeleine Amouroux (1997, p. 64) published the expenses incurred by the Amis du Louvre between 1914 and 1933 (a total of Fr 43,240).

115

Silence (fragment of *Silence, Meditation, and Study*)

1844–48
Grisaille: oil on plaster, transferred to canvas
29 ⅝ x 29 ⅝ in. (75 x 75 cm)
Paris, Musée du Louvre (RF 20016)

PROVENANCE:
Gift of the Chassériau Committee to the Musée du Louvre,
1903; transferred to canvas courtesy of the Société des
Amis du Louvre, 1926.

Exhibited in Paris only

"Across the way, in the oblique panel that rises with the stairs, Silence, personified by a beautiful woman, her finger to her mouth, indicates the respect due a serious place. . . . A little farther on, Meditation dreams on the lawn in the shade of large trees, and drops a flower that sheds its petals in the deep black water, in which the tops of the trees in the forest are reflected. A few steps away from Meditation is Study, her head bent over a large book, the repository of human knowledge. The gradation is perfectly preserved."[1] Théophile Gautier described the poetic universe—which Marc Sandoz believes was taken from the *Bucolics*[2]—chosen by Théodore

Chassériau to welcome the visitor at the bottom of the grand staircase at the Cour des Comptes: Executed in grisaille, which "the painter rightly chose . . . for this portion of the building, illuminated by reflected light, where direct sunlight never falls,"[3] this calm landscape of Romantic underbrush, measured almost eight meters wide. A large tree bisected the composition along the diagonal, emphasizing its parallelogram format.

Only two small fragments remain of this superb painting—the heads of *Silence* and of *Study*.[4] Having survived the 1871 fire and the inclement weather that followed, the entire work was gravely damaged by the time of its removal from the wall.

Prat has noted Chassériau's many preparatory studies for this composition.[5] The artist carefully considered each part of the vast decorative project at length. For the present work, he first envisioned depicting only Silence and Meditation, as two seated figures;[6] then decided to represent three, standing, allegorical figures;[7] and then arrived at the definitive composition—Silence standing, Meditation lying down, and Study seated— which is more lively and engaging. In the same spirit, instead of placing these figures in a classical landscape, with two large columns positioned in the background,[8] as he had initially, he finally decided on a beautiful natural setting as the background for the scene.

Because of its fragmentary state, the work is now more like a fine sketch, painted with a perfect, spirited technique. Although *Silence* was one part of an extensive decorative program, its details were rendered with extreme care and sensitivity, as if they were meant to be seen only for themselves. **V. P.**

1. T. Gautier, in *La Presse*, Paris, December 15, 1848.
2. Sandoz 1974, p. 236.
3. See note 1, above.
4. *Study* (Paris, Musée du Louvre, RF 20015; not included in the 2002 exhibition).
5. Prat 1988-1, vol. 1, nos. 466–478, pp. 226–30.
6. Paris, Musée du Louvre, RF 24487; see Prat 1988-1, vol. 1, no. 466, p. 226, ill. p. 227.
7. Paris, Musée du Louvre, RF 26555, RF 25551; see Prat 1988-1, vol. 1, nos. 467, 468, p. 228, ill. p. 227.
8. See note 6, above.

116

Silence and Meditation

1844–46
Graphite on cream-colored paper (cut in the shape of a parallelogram)
6 x 12 ½ in. (15.1 x 31.8 cm)
Paris, Musée du Louvre (RF 24487)

PROVENANCE:
See cat. 20.

BIBLIOGRAPHY:
Chevillard 1893, part of no. 420; Sandoz 1974, under no. 113 H, cited on p. 236; Prat 1988-1, vol. 1, no. 466, ill.

EXHIBITION:
Paris, Orangerie, 1933, no. 125.

Exhibited in Paris only

This study for the large decorative panel *Silence, Meditation, and Study*—which was level with the second flight of stairs—was cut into the shape of the definitive painting but reduced in size, and the figure of Study does not yet appear. She can be found on the right of the two other figures in the fragments preserved in the Louvre, in which, however, the columns have been replaced by the trees in the background. Silence would be depicted standing and Meditation reclining and facing left. In two other Louvre drawings (Prat 1988-1, vol. 1, nos. 467, 468, ill.), Chassériau chose to show the three figures standing, but eventually changed his mind.

Sandoz was of the opinion that this drawing, and a group of other studies similarly cut into the shape of the actual wall panels, might constitute a first plan, intended to be submitted to the administration (see cat. 117), and he dates them before the artist's trip to Algeria in 1846.

L.-A. P.

117

The Return from the War

1844–46
Graphite highlighted with watercolor (cut in the shape of the definitive painting)
6 ½ x 11 ⅞ in. (16.3 x 30.2 cm)
Paris, Musée du Louvre (RF 25595)

PROVENANCE:
See cat. 20.

BIBLIOGRAPHY:
Chevillard 1893, part of no. 420; Bénédite 1931, vol. 2, ill. p. 335; Sandoz 1957, p. 24 n. 3; Sandoz 1974, p. 236; Prat 1988-1, vol. 1, no. 419, ill.

Exhibited in Paris only

CAT. 116

This sheet belongs to a group in the Louvre cut to resemble the shape of the painted decorative panels at the Cour des Comptes (Prat 1988-1, vol. 1, nos. 416, 419, 448, 466, 532). Some of them were later radically transformed. Two others are known for *Commerce (Eastern Merchants on a Western Shore):* One is in the Cohen collection in New York (see Prat 1988-2, no. 113; *Romanticism and the School of Nature,* exhib. cat. [New York: The Metropolitan Museum of Art, 2000], no. 99, colorpl.) and the other is in the Sterling and Francine Clark Art Institute, Williamstown, Massachusetts (Prat 1988-2, no. 112, ill.).

This is a first idea for the decoration. Photographs (Sandoz 1974, pl. 114 a, b) reveal that the group of horsemen on the right had assumed much larger proportions in the painting, which includes two semi-nude female prisoners, seen from the back; a painting with these same figures is in a private collection (Sandoz 1974, no. 114). Sandoz dates this group of "shaped" sketches before Chassériau's departure for Algeria in May 1846.

An unsigned watercolor, recently given to the Louvre by R. Jouslin de Noray, records the state of the decorations after the fire (Prat 1988-1, vol. 1, no. 208; Prat 1988, no. 64, p. 95), as does another such watercolor in the Musée Carnavalet, Paris (D. 8265). They show that Chassériau fairly quickly displaced the old man in chains on the left to make way for the two captive women. Gautier's description in 1848 focused on "the horde of prisoners"; he notes "a young man who . . . wails and resists . . . a Negro woman [who] follows the procession . . . two women," and "an old man dragged by a soldier on foot." However, the photograph taken after the fire (Bénédite 1931, vol. 2, p. 337, ill.) shows an old man, facing the two women captives, who seems to be neither chained nor a prisoner.

L.-A. P.

118
Order Supplies the Needs of War

1844–46
Graphite and black pencil, with stumping, heightened with crayon, on beige paper
18 x 23 ⅛ in. (45.6 x 58.7 cm)
Paris, Musée du Louvre (RF 24337)

PROVENANCE:
See cat. 20.

BIBLIOGRAPHY:
Chevillard 1893, no. 318; Vaillat 1913, ill. p. 28; Guiffrey and Linzeler 1926, ill. p. 4; Bénédite 1931, vol. 2, pl. 34; Grappe 1933, ill. p. 154; Sandoz 1974, cited on p. 238 (with no inventory number), pl. 95 A; Sandoz 1982, p. 37; Prat 1988-1, vol. 1, no. 424, ill.; Peltre 1998, p. 72, fig. 2; Peltre 2001, p. 165, fig. 185; Fougerat [n.d.], frontispiece ill.

EXHIBITIONS:
Paris, Orangerie, 1933, no. 126; Paris, Louvre, 1957, no. 41; Paris, Louvre, 1980–81, no. 33.

Exhibited in Paris only

This large drawing for the panel *Order* may be considered the pendant to the composite study for *Peace* (cat. 126). According to the preserved fragments and Gautier's description (1848), it displays even more variants than its pendant in relation to the definitive work. Chassériau wavered for a long time, especially with regard to the scenes on either side of the central motif, as can be seen by studying the other (partial) drawings for this same panel (Prat 1988-1, vol. 1, nos. 425–458).

The figure of Bellona, the goddess of war, standing behind the seated man in the center of the painting, who personifies Order, is related to certain studies on the theme of war—both leaving for it or returning from it—that include a figure standing behind a round shield (Prat 1988-1, vol. 1, nos. 415–661).

A facsimile of the present drawing was catalogued by Bouvenne (1887, no. 41).

L.-A. P.

CAT. 117

CAT. 118

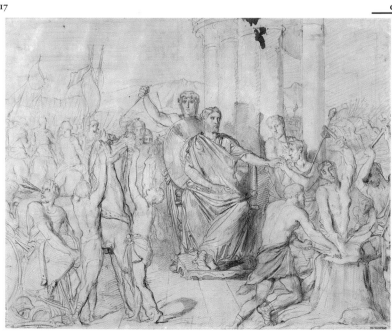

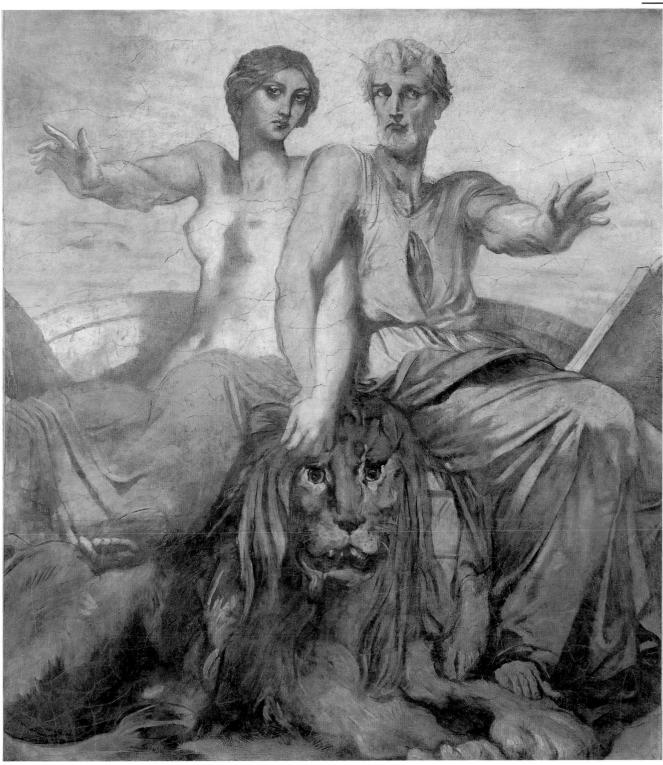

119

Force and Order

1844–48
Oil on plaster, transferred to canvas (cut down at the top)
96 ½ x 86 ⅞ in. (245 x 220.5 cm) (height originally about 118 in. [300 cm])
Paris, Musée du Louvre (RF 20017)

PROVENANCE:
Gift of the Chassériau Committee to the Musée du Louvre, 1903; transferred to canvas courtesy of the Société des Amis du Louvre, 1925.

Exhibited in Paris only

"The paintings, separated by friezes that extend along the interstices and whose gilded gray is colored in spots, like jasper, unfold high in the air, with their subject at the center. That subject is *Order* and *Force,* symbolized by a man of mature years and a strong and imposing woman, both seated on a throne. The arm of one figure is intertwined with the arm of the other, and they hold out the opposite arm toward the series of compositions that lie within the realm of each one's power: Force, toward the wall with War; Order, toward the wall with Peace. These two figures, back to back, who, in pose, are somewhat

reminiscent of Jules Romain's *Neptune and Amphitrite*, possess an energy and an admirable grandeur."[1] That is how Théophile Gautier described the large decoration executed by his friend when he discovered it with excitement in 1848.

The poet did not point out the symbolism in the painter's subtle depiction. Chassériau intentionally reversed the figures in the allegory: Order, personified as a mature man, who bore the experience of his advanced age, was positioned next to the large scene *Peace, Protector of the Arts and of the Tilling of the Soil,* toward the left, and the same figure appeared again in the large composition *Order Supplies the Needs of War,* on the right. Similarly, the female figure, representing Force, was turned toward the right side of the staircase, in the direction of the painting *Order Supplies the Needs of War,* and was depicted again in the composition *Peace.* Hence, Chassériau seemed to designate the virtues of Force and Order as two complementary qualities, tending to nurture both the years of peace and the years of war in a modern country. He undoubtedly sought to demonstrate that these two values constituted the foundation of a modern civilization that favored calm, happiness, and progress.

Théophile Gautier congratulated Chassériau for choosing for the figure of Force a woman of "solid and robust form," without making any reference to Alice Ozy. Later, however, some art historians have proposed—without any proof—that the painter's mistress served as the model for this splendid female figure. Gautier was right to point out that this allegory represents, "in the majesty of the attitude, in the irresistible authority of the gaze, and in the command of the gesture," "moral force" more than "physical force,"[2] and suggests that an imaginary female figure was created *ex nihilo.* Nevertheless, in publishing most of the preliminary drawings for this monumental composition,[3] Louis-Antoine Prat cited the existence at the Louvre of a superb study in graphite[4] that I find uncannily evocative of Alice Ozy.

The composition, which masterfully balances the classicism of the subject with a powerful pictorial energy, directly links Chassériau's aesthetic to the art of Antiquity and of the Renaissance. The painter wanted to express his philosophical and political beliefs as well as his artistic ambitions. We could expound *ad infinitum* on the inspiration for this composition—as evocative of a painting in Herculaneum, *Silenus and Bacchus,* which Chassériau might have seen during his trip to Italy, as it is of a print by Marcantonio Raimondi—but, in any case, it attests to the richness of the painter's creative ideas.[5] Nevertheless, the juxtaposition of these two figures—beyond their plastic and iconographic precedents and the underlying academic conventions—clearly demonstrates the roots of the painter's choices in the political and social climate of his time. He obviously wavered between the traditional reference points, represented by the Monarchy and the Empire, and the philosophical and ethical ideals promoted by the new Republican and liberal society.

V. P.

1. T. Gautier, in *La Presse,* Paris, December 15, 1848.
2. Ibid.
3. Prat 1988-1, vol. 1, nos. 462–465, pp. 224–26.
4. Paris, Musée du Louvre, RF 25913; see Prat 1988-1, vol. 1, no. 463, p. 224, ill. p. 225.
5. Sandoz 1974, p. 232.

120

Male Figure Seen from Behind, Mounting a Horse

1844–46
Graphite
9 x 11 ⅝ in. (22.7 x 29.4 cm)
On the reverse are graphite studies, after an écorché, of a male figure in half length, turning toward the left and seen from behind, and four heads of horses
Paris, Musée du Louvre (RF 25611)

PROVENANCE:
See cat. 20.

BIBLIOGRAPHY:
Chevillard 1893, part of no. 420; Bénédite 1931, vol. 1, ill. p. 126 (the verso); Sandoz 1974, under no. 113 C, cited on p. 238; Prat 1988-1, vol. 1, no. 439, ill.

Exhibited in Strasbourg only

In this study for the left part of *Order,* the man seen from the back, in front of the chariot horses, in the composite drawing (cat. 118), is shown leaping onto a horse. Chassériau hesitated for a long time between depicting the chariot halted by the group of men or the horseman mounting his horse to rejoin the troops that are disappearing into the distance at the left. The chariot would finally be eliminated, as evidenced by Gautier's description (1848) and by an unsigned watercolor copy of the panel after the 1871 fire (Paris, Louvre; see Prat 1998, p. 95, no. 64). The latter shows a horseman, his horse still turned toward the spectator, in the foreground at the left.

On the reverse, at the left, is one of the countless copies of the *Écorché* formerly attributed to Michelangelo. The horses' heads may be studies for *Order* or for *The Return from the War.*

L.-A. P.

121

Seated Female Figure Seen Full Face, Her Head in Three-Quarter Right Profile and Her Left Arm Raised

1845–47
Black pencil, with red chalk, on cream-colored paper
15 ⅝ x 12 ⅜ in. (39.7 x 31.4 cm)
Paris, Musée du Louvre (RF 25913)

PROVENANCE:
See cat. 20.

BIBLIOGRAPHY:
Chevillard 1893, part of no. 420; Bénédite 1931, vol. 1, ill. p. 57; Sandoz 1982, p. 38; Sandoz 1986, no. 173, ill.; Prat 1988-1, vol. 1, no. 463, ill.; Peltre 2001, p. 168, fig. 191.

EXHIBITIONS:
Paris, Louvre, 1957, no. 82; Paris, Louvre, 1980–81, no. 70.

Exhibited in Strasbourg only

In 1957, an attempt was made to establish a connection between this drawing and the 1841 painting *The Trojan Women* (Sandoz 1974, no. 90), but, stylistically, it seems somewhat later (about 1845–47) and is perhaps a study for one of the large female figures in the decorations at the Cour des Comptes, either for Force in *Force and Order* or Peace in *Peace, Protector of the Arts . . .* (Sandoz 1974, no. 113 G, I). Sandoz relates it to the *Tepidarium* of 1853, which is too late, in my view. Another drawing in the Louvre (Prat 1988-1, vol. 1, no. 462 v., ill.) is of the same figure but with a bearded man at her feet.

L.-A. P.

122

Nude Female Figure Seen in Half Length, Her Head in Three-Quarter Right Profile and Her Right Arm Raised

1845–47
Black pencil, heightened with white, on gray-beige paper
11 ½ x 16 ¾ in. (29.1 x 42.3 cm)
Paris, Musée du Louvre (RF 25933)

PROVENANCE:
See cat. 20.

BIBLIOGRAPHY:
Chevillard 1893, part of no. 420; Sandoz 1974, under no. 113 G, pl. 97 a; Sandoz 1982, p. 33; Sandoz 1986, no. 168, ill.; Prat 1988-1, vol. 1, no. 465, ill.

EXHIBITION:
Paris, Louvre, 1980–81, no. 34.

Exhibited in Strasbourg only

This study for the figure of Force in the panel *Force and Order* displays several variants in the right arm and the face, but the arm of Order, which clasps the left forearm of Force (conversely, in the painting, the shoulder of Order completely conceals the shoulder of Force), appears clearly on the right of the drawing.

The same model posed for the study *Nude Female Figure Seen in Half Length and Full Face, with Both Arms Raised* (Paris, Louvre; Prat 1988-1, vol. 2, no. 1812, ill.). The two studies were no doubt executed a short time apart.

L.-A. P.

124

Head of a Horse

1848
Oil on canvas
18 ⅛ x 18 ⅛ in. (46 x 46 cm)
Dated, bottom right: 1848—
Private collection

Exhibited in New York only

123

Horseman Seen in Right Profile, His Head Facing Left and His Left Hand Raised; Studies of Heads

1846–48
Pen and brown ink, with graphite, on cream-colored paper
14 ⅞ x 9 ¾ in. (37.8 x 24.8 cm)
Inscribed in pen and brown ink, upper center: *Mon cher ami*
[My dear friend]; in graphite, upper right: *faire à* (?) *toute la /
composition mais / fatal les juifs éperdus / tendant les bras* [do to (?)
the entire / composition but / fatal the Jews desperate / holding
out their arms]
On the reverse are brush-and-gray-wash studies of Eastern figure
types, including a man in a turban raising his left arm
Paris, Musée du Louvre (RF 25764)

PROVENANCE:
See cat. 20.

BIBLIOGRAPHY:
Chevillard 1893, part of no. 420; Bénédite 1931, vol. 1, ill. p. 72;
Sandoz 1974, under no. 244; Prat 1988-1, vol. 1, no. 809, ill.

Exhibited in Strasbourg only

The recto may be dated about 1846–48 or a little later, and
perhaps is related to certain studies for the panel *War* at
the Cour des Comptes. The verso seems to refer to *The
Descent from the Cross* in Saint-Philippe-du-Roule, as the
cross is distinguishable at the center of the composition.

L.-A. P.

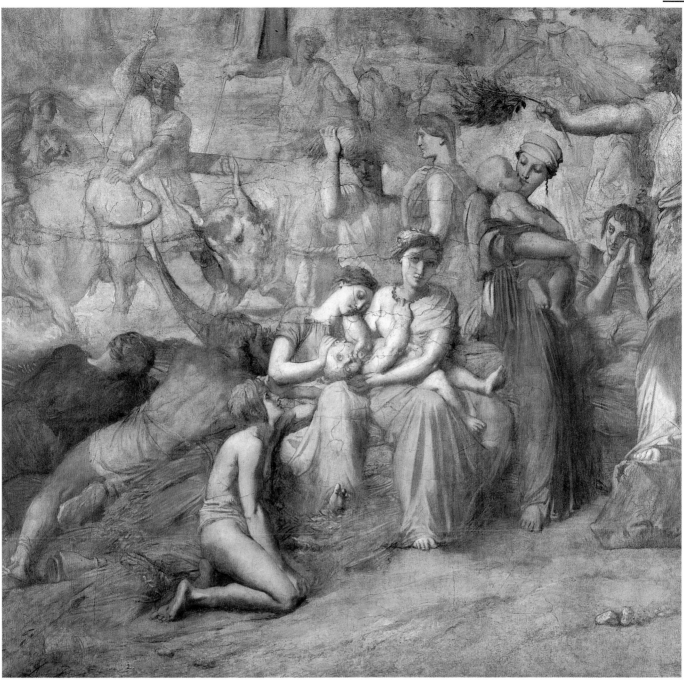

125

Peace, Protector of the Arts and of the Tilling of the Soil (fragment)

1844–48
Oil on plaster, transferred to canvas
133 ⅞ x 142 ⅝ in. (340 x 362 cm) (originally 236 ¼ x about 315 in. [600 x about 800 cm])
Paris, Musée du Louvre (RF 1489)

PROVENANCE:
Gift of the Chassériau Committee to the Musée du Louvre, 1903; transferred to canvas courtesy of the Chassériau Committee, before 1900.

Exhibited in Paris only

"In the center of the composition, Peace, strong yet gentle, stands erect, her back against the trunk of an olive tree; strikingly beautiful, she fixes her large, intelligent, and expressive eyes on the spectator. Her mouth has the vague smile of serenity. Situated at the center of the canvas, she captures our attention through her commanding presence, and seems to brighten what is adjacent to her. She extends her arms with a powerful grace toward the plowmen busy tilling the soil and toward a group of women, who symbolize the arts. . . . On the other side, a group of young women, whose freshness signifies health and well-being, are nursing their beau-

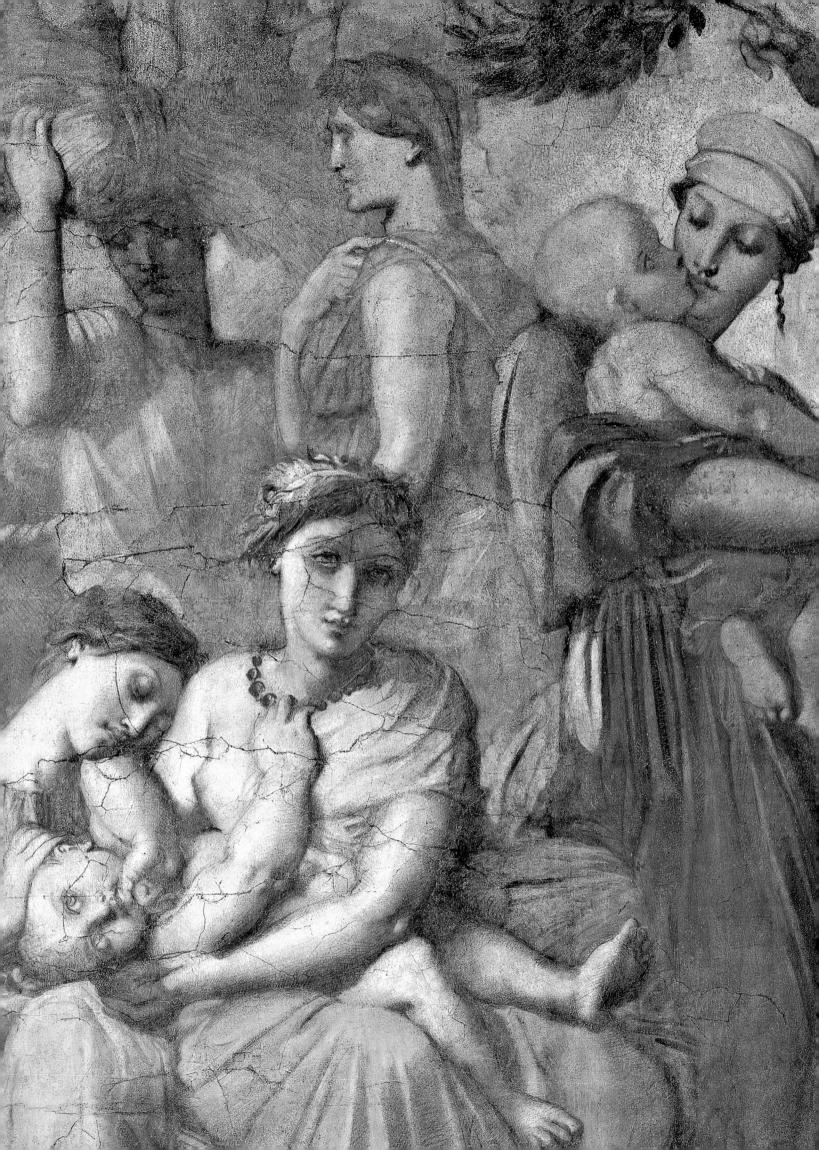

tiful children and bouncing them in their arms while singing lullabies. One could not imagine anything merrier, fresher, more cheery, than these lovely creatures gilded by a gentle light. Near her, on a pile of straw dappled with the blue and red sparks of cornflowers and poppies, the tired reapers nonchalantly lie sleeping."[1]

Théophile Gautier thus described one of the most ambitious and most successful of his friend's compositions, the glorious scene of the "young mothers" on the left of *Peace*—a marvelous section of the painting that miraculously has survived; the entire right part, depicting the arts, was destroyed in the 1871 fire and the years of neglect that followed.

Countless drawings in graphite were executed in preparation for the enormous decorative panel *Peace, Protector of the Arts and of the Tilling of the Soil*—the Louvre alone possesses some sixty of them[2]—and the figure of Peace especially preoccupied the painter, who wavered for a long time about her pose. Eventually, he chose to depict her with both arms extended, unlike the parallel composition *Force and Order* (cat. 119).[3]

Working relentlessly on the left part of that painting as well—the only surviving fragment—Chassériau committed his ideas to paper on the figures necessary for his composition: "make one [a child] who / is playing with stones or who puts his arm / in the water—for another the current / or who / collects branches—her breast uncovered / she has just nursed / her child / make him younger" (see cat. 127), attesting to his desire to paint a

composition with figures from everyday life, serene and balanced, and presented in a wooded landscape. At the same time, Order was depicted in a Neoclassical setting, against a backdrop of architecture and mountains, better adapted to the serious theme of preparations for war (cat. 118).[4] The group of young mothers in the foreground is juxtaposed with the heightened activity of the farmers working in the background tilling the soil. Beginning with a young adolescent, crouching at the left in the surviving composition, Chassériau created a frieze of figures ascending toward the center and culminating in the figure of Peace, for which only the right arm holding an olive branch survives.

Painted in a superb range of colors, this fragment of *Peace,* among the painter's most accomplished and poetic compositions, constitutes, in its dimensions and in the quality of its execution, one of the best examples of the aesthetic achievement of his decorations at the Cour des Comptes. Even the critic Pierre Malitourne, although very critical of Chassériau's compositions, was unable to resist the beauty of *Peace:* "one looks again, and forgets: charm dominates."[5] V. P.

1. T. Gautier, in *La Presse,* Paris, December 15, 1848.
2. Prat 1988-1, vol. 1, nos. 479–539, pp. 230–53.
3. On the different poses for the figure of Peace see Prat 1988-1, vol. 1, nos. 481, 482, 483, 486, 487, 488, 489, 490, pp. 231–34.
4. The Musée du Louvre possesses the last surviving fragment of *Order Supplies the Needs of War*—the right part of the composition, depicting the blacksmiths (Inv. 20014).
5. P. Malitourne, in *L'Artiste,* 1849.

126

Peace, Protector of the Arts and of the Tilling of the Soil

1844–47
Graphite and black pencil, with stumping, heightened with white and pastel, on beige paper
17 ⅜ x 24 ⅛ in. (44.1 x 61.3 cm) (a strip 1 in. [2.4 cm] wide was added along the right edge)
Paris, Musée du Louvre (RF 4518)

PROVENANCE:
Studio of the painter until his death (L. 443); Frédéric Chassériau, the artist's brother, Paris, until 1881; Baron Arthur Chassériau, Paris; his donation to the Musée du Louvre, 1918 (L. 1886 a).

BIBLIOGRAPHY:
Chevillard 1893, no. 317; Renan 1898, p. 95, sep. ill.; Vaillat 1907, ill. p. 177; Marcel and Laran 1911, pp. 69–70, pl. 27; Vaillat 1913, ill. p. 2; Bouyer 1920, pp. 529–30, ill. p. 529; Jamot 1920, pp. 65–71, ill. p. 73; Guiffrey and Linzeler 1926, ill. p. 245; Bénédite 1931, vol. 2, pl. 29; Sandoz 1974, cited on p. 238 (with no inventory number), pl. 99 a; Sandoz 1982, p. 37, ill. p. 36, fig. 1; Prat 1988-1, vol. 1, no. 479, ill. and colorpl. p. 19; Peltre 1998, p. 74, fig. 3; Peltre 2001, p. 165, fig. 186.

EXHIBITIONS:
Paris, Orangerie, 1933, no. 122; Paris, Louvre, 1957, no. 39, pl. 9; Paris, Louvre, 1980–81, no. 30.

Exhibited in Paris only

This well-known drawing was the first by Chassériau to enter the Louvre. It was donated by Baron Arthur Chassériau in 1918, so that the Cabinet des Dessins would contain a record of the decorations for the stairwell at the Cour des Comptes, destroyed during the Commune fires (May 1871).

A large study for the panel *Peace,* the present work displays numerous variants with respect to the painted fragment in the Louvre (the left part of the composition), especially in the figures of the recumbent plowmen and in the groups of young girls and of mothers on the left. According to the description of the decorations published in *La Presse* by Gautier in 1848 (reprinted in Bénédite 1931, vol. 2, pp. 329–41), the right part of the composition, with the figure groups of the Arts and of the builders, also differed in places from this large drawing. It is very probable that the central figure of Peace was represented with her arms outstretched (see Gautier 1848; quoted in Bénédite 1931, vol. 2, p. 336: "she extends her arms"; and an unsigned engraving representing the painting in situ, illustrated in Bénédite

1931, vol. 2, p. 425). Sandoz (1974, pl. 99 b) mentions another composite drawing for *Peace*, first published by Bouvenne (1887, in *L'Artiste*, p. 163). This drawing is clearly a record of what remained intact of Chassériau's painting after the 1871 fire, and is not in the artist's hand.

A facsimile of the Louvre drawing is catalogued by Bouvenne (1887, no. 42).

There are numerous studies in the Louvre related to this composition (Prat 1988-1, vol. 1, nos. 480–538). Of them, the *Herdsmen Leading Cattle Through a Wood* (Prat 1988-1, vol. 1, no. 480, ill.), executed in Tivoli in 1840 during the painter's stay in Italy, appears practically unchanged in the upper left part of the large composite drawing. L.-A. P.

<div style="text-align:right;">CAT. 127</div>

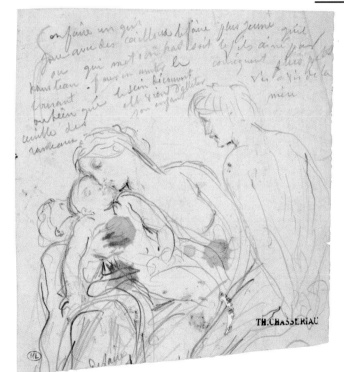

127

Figure of a Nude Young Man Watching a Mother and Her Two Children

about 1846
Graphite on watermarked paper
5 ⅝ x 5 in. (14.3 x 12.5 cm)
Inscribed in graphite, at the top: *en faire un qui / joue avec des cailloux ou qui met son bras / dans l'eau—pour un autre le / courant / ou bien qui / cueille des / rameaux—le sein découvert / elle vient d'alleter / son enfant / le faire plus jeune / qu'il / soit le fils ainé—par / conséquent plus petit / vis-à-vis de la mère* [make one who / is playing with stones or who puts his arm / in the water—for another the / current / or who / collects / branches—her breast uncovered / she has just nursed / her child / make him younger / let him / be the elder son—as a / result smaller / compared to the mother]; lower left: . . . *taire* [. . . hush]
Paris, Musée du Louvre (RF 24998)

PROVENANCE:
See cat. 20.

BIBLIOGRAPHY:
Chevillard 1893, part of no. 420; Prat 1988-1, vol. 1, no. 499, ill.

Exhibited in Strasbourg only

This drawing is related to the group of mothers on the left of *Peace*. The large composite drawing (cat. 126) contains a very similar group on the left, but without the nude adolescent who watches the scene, although it would be rather significantly modified in the painting.

This study, which bears similarities to Ingres's sheets of studies (executed during the same period, and now in Montauban) for *The Golden Age*, is also striking for the importance of the inscription, which serves here to explain the gestures.

The development of Chassériau's imagination is evident in both his drawing and his writing, each serving as a complement to the other. Here, as in many of Chassériau's sketches, he cannot keep from elaborating in his notes on the subject of a drawing (for examples see Prat 1989, pp. 55–62). L.-A. P.

128
Oceanid

1844–48
Grisaille: oil on plaster, transferred to canvas
35 ½ x 126 in. (90 x 320 cm)
Paris, Musée du Louvre (RF 20018)

PROVENANCE:
Gift of the Chassériau Committee to the Musée du Louvre, 1903;
transferred to canvas courtesy of the Société des Amis du Louvre,
before 1900.

Exhibited in Paris only

Below the composition *Peace, Protector of the Arts and of the Tilling of the Soil,* to set off his brightly colored and luminous composition and to fill certain "voids" in the architecture, Théodore Chassériau chose to insert a frieze in grisaille, representing this "classical Bacchante," as Théophile Gautier referred to it in his lengthy description in 1848.[1]

This monumental female figure, whose vigor and sensuality are astonishing, given its state of preservation, evokes the large Mannerist nudes of the Renaissance, which clearly inspired all of Théodore Chassériau's compositions for the Cour des Comptes. It is one of the most perfect achievements among Chassériau's rather strange paintings in grisaille, which were conceived both to "stabilize" the large colorful compositions and to balance the relationship between the architecture and the paintings. V. P.

1. T. Gautier, in *La Presse,* Paris, December 15, 1848.

129
The Grape Pickers

1844–48
Grisaille: oil on plaster, transferred to canvas
31 ⅛ x 142 ⅛ in. (79 x 361 cm) (width originally about 315 in. [800
cm])
Paris, Musée du Louvre (RF 20019)

PROVENANCE:
Gift of the Chassériau Committee to the Musée du Louvre,
1903; transferred to canvas courtesy of the Société des Amis du
Louvre, 1932.

Exhibited in Paris only

"Other young girls and young ephebi, their hair loose, their tunics flowing, bearing bunches of grapes similar to those in the promised land, frolic with a thousand charming caprices, amid his vine branches and garlands."[1] These words by Théophile Gautier reveal how precisely well he understood that this vast frieze, eight meters long, associated with the panel *Peace, Protector of the Arts and of the Tilling of the Soil,* was conceived as a classically inspired and delightful counterpart to one of the two most important allegorical scenes among the decorations as a whole, in which the painter developed an essential artistic and philosophical concept.

Only two preparatory studies, in graphite—two sketches of men's heads and one of two arms holding a staff[2]—attest to Chassériau's work on this composition. The superbly executed frieze, which recalls the decoration on the famous "Borghese vase,"[3] perfectly embodies the painter's efforts, which, contrary to the anguish of the Romantics, breathed new life into classical and Neoclassical iconography. V. P.

1. T. Gautier, in *La Presse,* Paris, December 15, 1848.
2. Paris, Musée du Louvre, RF 25355, RF 25109; see Prat 1988-1, vol. 1, nos. 555, 556, pp. 259–60.
3. Sandoz 1974, p. 236.

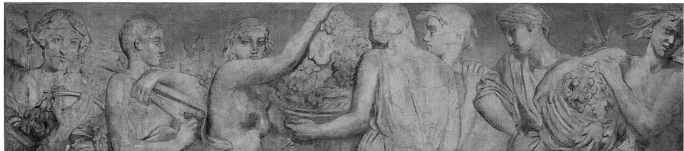

Commerce Brings Peoples Together (Eastern Merchants on a Western Shore) (one of two compositions [cut off at the top] on this theme)

1844–48
Oil on plaster, transferred to canvas
128 x 122 ⅛ in. (325 x 310 cm) (height originally about 197 in. [500 cm])
Paris, Musée du Louvre (RF 3152)

PROVENANCE:
Gift of the Chassériau Committee to the Musée du Louvre, 1903; transferred to canvas courtesy of the Société des Amis du Louvre, 1929.

Exhibited in Paris only

"In the pendentive on the right, Indians and Chinese land on a European shore. The bizarre and monstrous junk inflates its bamboo-leaf sail and a canoe carries various exotic figures to the bank, covered with bundles and merchandise. Their muslin robes, turbans, and colorful sashes form a pleasing contrast to the more austere Northern costumes. The sea, not blue this time, but green, embroiders the reefs and fortifications of the coast with a silvery fringe, and the bitter wind dislodges strips of foam that scatter in the air." In these few lines, Théophile Gautier, in 1848, summed up the intentions of the painter to integrate two panels representing the commercial exchanges between Europe and more remote

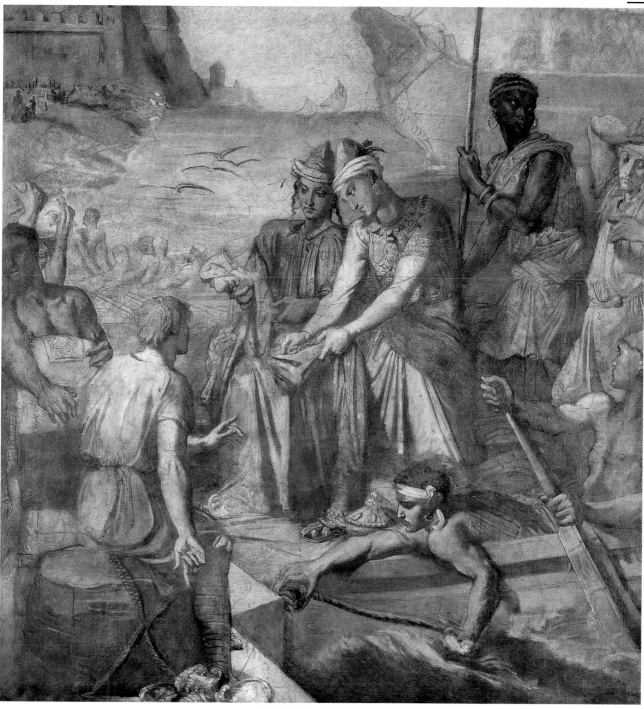

countries into his enormous decorative program at the Cour des Comptes—a theme that was especially important for him, given the history of his family and, particularly, the occupation of his father.

Nevertheless, these personal, familial, philosophical, and social considerations did not prevent him from devoting a great deal of time to aesthetic matters, as demonstrated by the many notes he made in his journals or on the drawings themselves: "Make my composition of Peace represent commerce or in the large composition or in one of the sides—of the city—the sea blue and green in a light tone and above a few foreign ships with streamers in the most beautiful colors—billowing—July 1841—a second boat apart from the vessels—the latter carrying brightly colored merchandise."[1] Hence, Chassériau attempted to sum up, along with the studies for his large monumental work, a few of his aesthetic ideas, imagining, for example, making the "blue and green" sea the principal setting for the scene of Eastern merchants presenting their merchandise in a Western port. The pendant to this panel would depict Western merchants selling their products in an Eastern port: "Here the Oriental soul penetrates modern art."[2]

Perhaps because commerce reminded him so strongly of his family's history, this composition, more than others, required not only many preparatory drawings[3] but also—and this was something new—numerous written reflections: "a small boat with its oarsmen—all the rosy blond races—the stern of the ship calm and superb against a bright red and gold sky—an Arab girl followed by a Greek girl—hands full of beads . . . all the Moorish and African races a taste of exquisite color the richest fabrics."[4]

This panel, with its refined color, situated to the right of *Peace,* was at the very top of the staircase, before the landing leading to the offices of the Cour des Comptes. Chassériau gave it special attention, and seems to have applied all his aesthetic concepts to its realization—solid construction, passages of striking and vivid color, a seascape, Orientalism; since it evoked family memories, he wanted it to reflect his personal convictions concerning commerce and the way it brought peoples together, beyond religions, cultures, and even civilizations.

V. P.

1. Annotated, in the artist's hand, on a pen-and-ink drawing (Paris, Musée du Louvre, RF 25540; see Prat 1988-1, vol. 1, no. 539, p. 253, ill. p. 253).
2. R. Marx, "Théodore Chassériau (1819–1856) et Les Peintures de la Cour des Comptes," in *Revue populaire des beaux-arts,* vol. 1, no. 18 (February 19, 1898), p. 276.
3. Prat 1988-1, vol. 1, nos. 539–545, pp. 253–56.
4. Annotated, in the artist's hand, on a graphite drawing (Paris, Musée du Louvre, RF 25981; see Prat 1988-1, vol. 1, no. 541, pp. 253–55).

Woman with Bowed Head, in Right Profile

about 1844–48
Black pencil, highlighted with oil, on gray paper
10 ¾ x 10 ½ in. (27.3 x 26.6 cm)
Paris, Musée du Louvre (RF 24389)

PROVENANCE:
See cat. 20.

BIBLIOGRAPHY:
Chevillard 1893, part of no. 420; Bénédite 1931, vol. 1, ill. p. 193; Sandoz 1986, no. 190, ill.; Prat 1988-1, vol. 2, no. 1867, ill.

EXHIBITIONS:
Paris, Galerie Dru, 1927, no. 72; Paris, Orangerie, 1933, no. 116.

Exhibited in Paris only

Undoubtedly executed between about 1844 and 1848, perhaps with one of the artist's sisters as the model, this study is related to the decorations at the Cour des Comptes. However, a connection to a small canvas in the museum in Valenciennes, *Head of a Young Woman in Right Profile* (Sandoz 1974, no. 77), probably painted in Italy in 1840, cannot be ruled out, although the drawing appears to be somewhat later stylistically. (See also catalogue 133, a drawing of the same model [?].)

L.-A. P.

CAT. 131

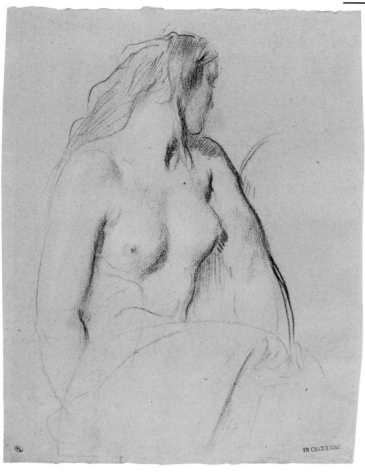

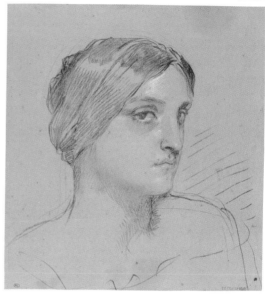

132

*Study of a Female Figure Seen in Half Length
and Three-Quarter Right Profile,
Her Face Turned Away*

about 1845–48
Black pencil, heightened with white, on gray paper
11 ⅝ x 9 ⅜ in. (29.3 x 23.8 cm)
Paris, Musée du Louvre (RF 25684)

PROVENANCE:
See cat. 20.

BIBLIOGRAPHY:
Chevillard 1893, part of no. 420; Sandoz 1974, p. 33, fig. 8, and
under no. 89; Sandoz 1982, p. 39; Sandoz 1986, under no. 168 B;
Prat 1988-1, vol. 2, no. 1836, ill.

EXHIBITIONS:
Paris, Orangerie, 1933, no. 239; Paris, Louvre, 1980–81, no. 6.

Exhibited in Paris only

Sandoz associates this study—which he dates to 1840,
during Chassériau's stay in Rome—with *The Toilette of
Esther* (1841; cat. 66), and points out that the drawing
would be used again for the decorative panels at the
Cour des Comptes. None of these assertions is verifiable;
the figure of Esther displays morphological features fairly
similar to those of this young woman with a powerful
torso, but the poses are radically different. In my view, the
style of the drawing postdates the artist's visit to Rome. It
perhaps was executed between about 1845 and 1848, and pos-
sibly is related to the studies for the captive women in *The
Return from the War* at the Cour des Comptes.

The drawing is affixed to a paper support that may
come from dummy album 3. **L.-A. P.**

133

*Head of a Woman in Three-Quarter Right
Profile*

1844–48
Black pencil, highlighted with oil, on beige paper
10 ⅞ x 10 ¼ in. (27.6 x 25.8 cm)
Paris, Musée du Louvre (RF 24466)

PROVENANCE:
Studio of the painter until his death (L. 443); Pierre Puvis de
Chavannes (1824–1898); Baron Arthur Chassériau, Paris;
bequest of the latter to the Musée du Louvre, 1934 (L. 1886 a).

BIBLIOGRAPHY:
Chevillard 1893, part of no. 420; Bénédite 1931, vol. 1, ill. p. 40;
Sandoz 1982, p. 38; Sandoz 1986, under nos. 111–112 and 192, ill.
(with erroneous inventory number, RF 25297); Prat 1988-1, vol. 2,
no. 1866, ill.

Exhibited in Strasbourg only

Bénédite (1931) indicates that this drawing was owned by
Puvis de Chavannes. The model is probably the one who
also posed, at the same time, for the *Woman with Bowed
Head, in Right Profile,* which is similar in dimensions
(see cat. 131); between 1844 and 1848, she posed as well
for some of the figures in the Cour des Comptes deco-
rations (see especially a drawing in the Louvre discussed
by Prat [1988-1, vol. 1, no. 463]). Sandoz believes that
the present drawing is a study of Adèle Chassériau for *The
Tepidarium* of 1853 (cat. 237). **L.-A. P.**

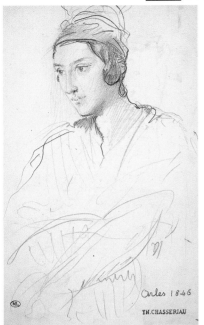

who posed for Chassériau before he left Marseilles for Civitavecchia on July 1, 1840. However, it is even more plausible, for reasons of style and costume, that the sitter is a young woman from Arles, and that perhaps the artist completed the painting on May 7, 1846, during the day he spent there, before embarking for Algeria—as suggested by the four sketches of women from Arles, in a notebook in the Louvre (RF 26074; see cat. 136).

In fact, the style is so free that the 1840 date seems unacceptable, since Chassériau was much more restrained in his drawing and use of color at the time. In addition, in the rendering of the details of the face and the psychological intensity the study is very similar to the four graphite portraits of Arles women.

Nevertheless, neither the costume nor the hairstyle seems to correspond to those worn in Arles at the time. Perhaps the young woman was from Avignon or Marseilles—cities in which Chassériau found himself on May 6 and 8, 1846, respectively. **L.-A. P.**

136
Notebook

1846
Bound notebook, covered in red cardboard, with a red sheepskin spine, containing two flyleaves and forty-nine sheets numbered 1 to 49.
Stamp of the artist's studio (L. 443) on the label on the lower part of the cover and on folios 2 v., 4 v., 6 v., 7 v., 28 r., 47 r., and 49 r.
Inscribed in pen and brown ink, in an unknown hand, on the label on the lower part of the front cover: *Voyage à Arles et en Algérie* [Trip to Arles and to Algeria]
4 7/8 x 7 3/4 in. (12.2 x 19.5 cm) (notebook)
4 3/4 x 7 1/2 in. (11.8 x 19 cm) (sheets)
Paris, Musée du Louvre (RF 26074)

PROVENANCE:
See cat. 20.

BIBLIOGRAPHY:
Chevillard 1893, part of no. 420; Sandoz 1974, p. 468 n. 2; Prat 1988-1, vol. 2, no. 2251, ill.

EXHIBITIONS:
Paris, Louvre, 1933, nos. 133–136 (folios 7 v., 47 r., 4 v., and 6 v., respectively; it has not been clearly explained how four different folios in this notebook could have been exhibited, when the notebook does not seem ever to have been taken apart); Paris, Louvre, 1957, no. 63 (open to folios 22 v. and 23 r.; mistakenly given in the catalogue as 27 v. and 28 r.); Paris, Louvre, 1980–81, no. 42 (open to folios 22 v. and 23 r.; mistakenly labeled as 27 v. and 28 r.).

Exhibited in Paris only

This notebook, used by Chassériau in Arles and in Avignon, and then after his departure for Algeria in 1846, seems to have been the object of particular attention on the artist's part. While he did not tear out any sheets, as was his habit, some are certainly missing: The first signature has eight, and the other four, ten. The missing sheets before folio 1 and between folios 8 v. and 9 r. were removed with particular care, and there are perhaps sheets missing as well between the first and second signature. When the entire notebook was restitched recently, it was apparent that certain sheets had been reattached with hinges at an earlier time. The studies were not used in chronological order, but, as usual with Chassériau, more or less at random. Hence the four portraits of Arles women, probably sketched on the same day (see folio 4 v.) are separated in the notebook by drawings executed later, in Algeria. **L.-A. P.**

Open to folios 4 v. and 5 r.

Folio 4 v.

Young Woman of Arles, Seen in Half Length and in Three-Quarter Left Profile

1846
Graphite with stumping
Inscribed and dated in graphite, lower right: *Arles 1846*

BIBLIOGRAPHY:
Bénédite 1931, vol. 1, ill. p. 81, vol. 2, p. 265; Sandoz 1974, under no. 210, p. 13, pl. 168; Sandoz 1986, no. 119, ill.; Peltre 2001, p. 42, fig. 44.

On May 7, 1846, Chassériau was in Arles, where he executed the four delicate studies of young women from that city in this notebook (see folios 6 v., 7 v., and 47 r.). Sandoz catalogues a lost painting, *Women of Arles,* which is listed on folio 26 v. in the Louvre notebook RF 26053 (Prat 1988-1, vol. 2, no. 2250), although it is not from this folio but from the lower part of the verso of the cover. He hypothesizes that these four drawings may have been used in the preparation of the painting. **L.-A. P.**

Folio 5 r.

Arab Seated on the Ground, Seen in Left Profile and Wearing a Turban

1846
Graphite
Inscribed in graphite: *le turban blanc mêlé dans le haïk / blanc le pantalon vert les jambes brunes les babouches / devant* [the white turban mixed with the white haik / the pants green the legs brown the babouches / in front]

 L.-A. P.

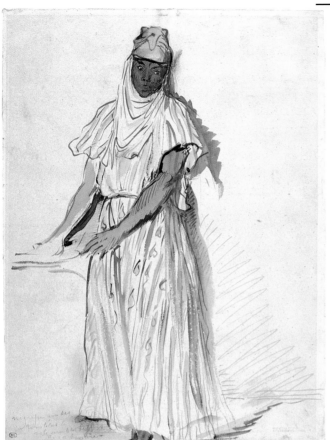

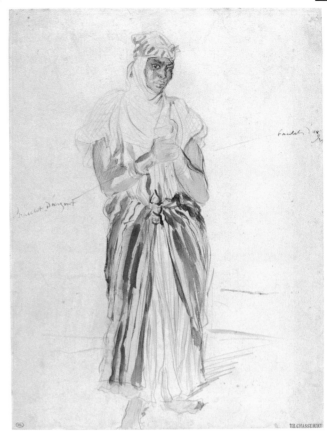

137
Negro Woman of Algiers

1846
Pen and brown ink, and watercolor, over graphite
12 ¼ x 9 ⅜ in. (30.9 x 23.8 cm)
Inscribed in graphite, bottom left: *négresse avec / des tons lilas la / robe avec des dessins / de cachemire* [Negro woman with / lilac tones the / dress with designs / of cashmere]
Paris, Musée du Louvre (RF 24346)

PROVENANCE:
See cat. 20.

BIBLIOGRAPHY:
Chevillard 1893, no. 400 or 401; Bénédite 1931, vol. 2, ill. p. 305; Alazard 1936, p. 172, ill.; Sandoz 1986, p. 234 (with no inventory number); Prat 1988-1, vol. 2, no. 1581, ill., colorpl. p. 34.

EXHIBITIONS:
Paris, Galerie Dru, 1927, no. 116; Paris, Orangerie, 1933, no. 150; Algiers, 1936, no. 17; Paris, Louvre, 1957, no. 46, pl. 10; Paris, Galerie Daber, 1976, no. 37, ill.; Paris, Louvre, 1980–81, no. 37.

Exhibited in Paris only

The catalogue of the 1957 exhibition links the pose of this figure to that of the woman on the right in the painting *Scene in the Jewish Quarter of Constantine* (cat. 154), but that resemblance may be coincidental.

Black women (slaves or domestics) and Jewish women were the only ones in Algeria whom the European traveler encountered with their faces unveiled.

The model for this drawing and for catalogue 138 bear a striking similarity.

L.-A. P.

138
Negro Woman of Algiers

1846
Watercolor over graphite
12 x 9 ¼ in. (30.5 x 23.3 cm)
Inscribed in brush, with brown and indigo wash, center left and right: *bracelet d'argent / bracelets d'argent* [silver bracelet / silver bracelets]
Paris, Musée du Louvre (RF 24343)

PROVENANCE:
See cat. 20.

BIBLIOGRAPHY:
Chevillard 1893, no. 400 or 401; Hourticq 1927, ill. p. 276; Bénédite 1931, vol. 2, colorpl. 23; Alazard 1936, p. 172, ill.; Prat 1988-1, vol. 2, no. 1582, ill.

EXHIBITIONS:
Paris, Galerie Dru, 1927, no. 115; Paris, Orangerie, 1933, no. 151; Algiers, 1936, no. 18, ill.; The Hague, 1938 (no number); Paris, Louvre, 1957, no. 45; Paris, Louvre, 1980–81, no. 38.

Exhibited in New York only

Traditionally, this study has been associated with the watercolor *Negro Woman of Algiers,* also in the Louvre (see cat. 137).

L.-A. P.

Jewish Woman of Algiers, Seated and Seen Full Face; and Jewish Woman in Left Profile

1846
Graphite highlighted with watercolor
8 ⅞ x 5 ¾ in. (22.4 x 14.5 cm)
Inscribed in graphite, around the drawing: *noir / le voile / haïk / bleu / rouge halé . . . / jeaune* [black / the veil / haik / blue / Indian red . . . / yellow]
On the reverse are graphite studies of the heads of two Arab women behind a window covered with wire mesh and of a figure with a raised arm, and an impression in reverse of a pen-and-ink drawing (the verso of RF 24415)
Paris, Musée du Louvre (RF 24416)

PROVENANCE:
See cat. 20.

BIBLIOGRAPHY:
Chevillard 1893, part of no. 420; Bénédite 1931, vol. 2, colorpl. 41; Prat 1988-1, vol. 2, no. 1587, ill.

EXHIBITIONS:
Paris, Orangerie, 1933, no. 144 B (framed with RF 24415); Algiers, 1936, no. 23; The Hague, 1938 (no number).

Exhibited in New York only

The presence on the back of this sheet of an impression in reverse of the verso of Louvre drawing RF 24415 strengthens the supposition that these two studies, and possibly Louvre drawings RF 24413 and RF 24414 as well, were part of the same notebook that was later taken apart (perhaps Louvre RF 26087, which has similar dimensions; see Prat 1988-1, vol. 2, no. 2252).

The sketch on the reverse, a depiction of Arab women behind a window covered with wire mesh, may be linked with a detail in a lost painting, which Gautier referred to as *Saturday, the Sabbath Celebration Among the Jews of Constantine*, in *La Presse*, on April 27, 1846 (quoted by Bénédite 1931, vol. 2, p. 313), with the description: "the poor captive Arab women leaning out of the narrow openings in their cages" (to contemplate the Jewish women who pass beneath their windows). The artist studied the same subject in another drawing, also in the Louvre (Prat 1988-1, vol. 2, no. 1648, ill.).

L.-A. P.

CAT. 139

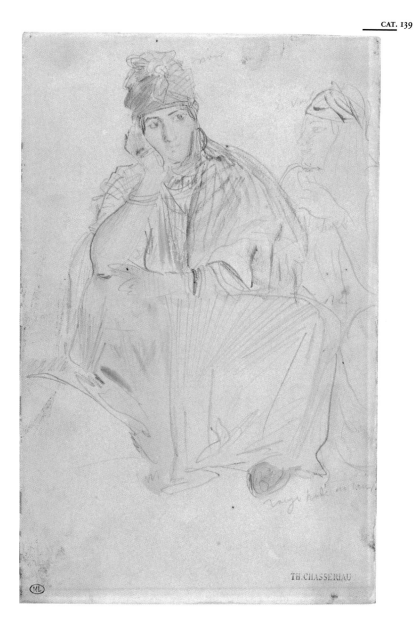

Portrait of Aïcha Ben Gerbaz

1846
Graphite
11 ¼ x 8 in. (28.6 x 20.3 cm)
Inscribed, dated, and signed in graphite, center left: [a line of Arabic characters] / *Aïcha Bent = / gerbaz / Constantine 1846- / Théodore Ch.;* inscribed in graphite, lower left: *Jeaune / bleu* [Yellow / blue]
Private collection

PROVENANCE:
Chassériau sale, Paris, Hôtel Drouot, March 16–17, 1857, no. 83 (sold for Fr 37 to Bourgeois); Bourgeois; André Deshaspe, Paris, 1951 (according to the Wildenstein Gallery); New York, Wildenstein Gallery; private collection.

BIBLIOGRAPHY:
Chevillard 1893, no. 314; Sandoz 1974, p. 13; Prat 1988-2, no. 128, ill.

This drawing was known before 1988, when it was exhibited in "De Watteau à Cézanne" in Geneva, at the Musée d'Art et d'Histoire in 1951 (see the exhib. cat., no. 93, pl. 10). It is one of the rare sheets that can be precisely identified as having been included in the posthumous sale of the artist's works, since the catalogue cites the model, a young Jewish woman from Constantine, by name. Chassériau depicted her in an almost identical manner in a painting, dated 1849 and now in a private collection; there, she is shown full-length and seated.

Note how, in the annotation in the lower left, Chassériau misspelled *Jeaune* [for *Jaune*, yellow]; he would make that mistake his whole life!

L.-A. P.

Jewish Woman of Algiers Seated on the Ground

1846
Watercolor over graphite
11 ¾ x 9 ⅛ in. (29.8 x 23.2 cm)
Inscribed in graphite, upper right: *la coiffure en / velours à dessin / comme ici / le mouchoir / noir et or / le vêtement / de soie blanche / couvert de / dessins d'or / et d'un voile lilas / en gaze pour / le haut le / bas d'un / voile blanc / sur lequel des / points d'or luisant étincellent* [the head covering in / patterned velvet / as here / the handkerchief / black and gold / the garment / of white silk / covered with / gold designs / and with a lilac veil / in gauze for / the top the / bottom with a / white veil / on which / gleaming gold stitches sparkle]
New York, The Metropolitan Museum of Art, Rogers Fund, 1964 (64.118)

PROVENANCE:
Studio of the painter until his death (L. 443 lower right); perhaps Chassériau sale, Paris, Hôtel Drouot, March 16–17, 1857, part of lot 85 (sold for Fr 19 to Lhurine ?); Paris, art market; acquired by The Metropolitan Museum of Art, New York (see J. Bean, *Dessins français du Metropolitan Museum of Art, New York: De David à Picasso,* exhib. cat. [Paris: Musée du Louvre, 1973], no. 12, pl. 39).

BIBLIOGRAPHY:
Sandoz 1974, p. 62, fig. 21; Prat 1988-2, no. 127, ill.; Peltre 2001, p. 129, fig. 146.

In this superb drawing of a Jewish woman of Algeria, Chassériau studied the young woman's head covering separately, at the upper right.

L.-A. P.

CAT. 140

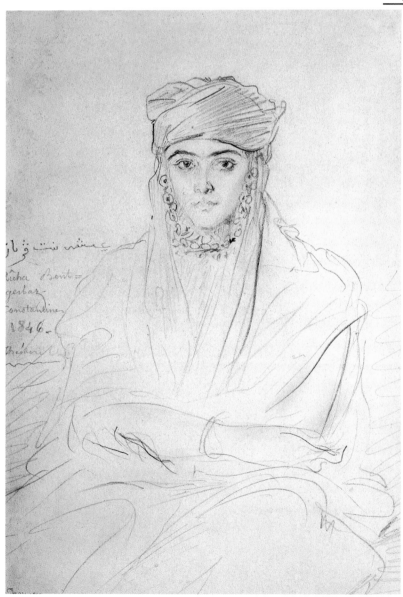

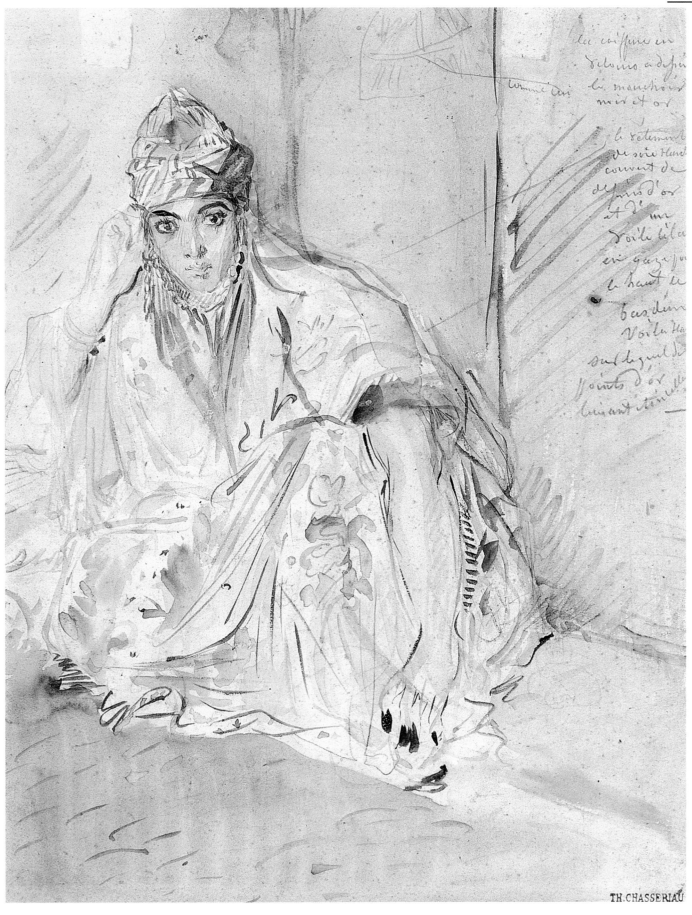

la coiffure en
dessous a deja
la mouchoir
mix et or

le vetement
de soie blanche
couvent de
depuis d'or
et d'un
voile lilas
en gaze pa
le haut le
bas dans
Voila la
sur laquelle
points d'or
luisant étincelle

comme ceci

TH. CHASSERIAU

142

Bust-Length Study of an Arab Woman, Seen Full Face

1846
Graphite on beige paper
10 ¾ x 8 ⅜ in. (27.1 x 21.2 cm)
Paris, Musée du Louvre (RF 5142)

PROVENANCE:
Studio of the painter until his death (L. 443); Alfred Beurdeley (1847–1919; L. 421); fifth Beurdeley sale, Paris, Hôtel Drouot, June 2–4, 1920, lot 81, Baron Arthur Chassériau (acquired for Fr 620); offered by the latter to the Musée du Louvre, 1920 (L. 1886 a).

BIBLIOGRAPHY:
Bénédite 1931, vol. 2, ill. p. 307; Sandoz 1982, p. 40; Prat 1988-1, vol. 2, no. 1633, ill.; Peltre 2001, p. 128, fig. 144.

Exhibited in Paris only

This study, executed during Chassériau's stay in Algeria, may have been used for the painting in the museum in Poitiers *Moorish Woman Nursing Her Child* (Sandoz 1974, no. 169), which dates from 1850. The face here appears very similar, although it is shown more frontally, with an almost identical head covering and the same earring.

L.-A. P.

CAT. 142

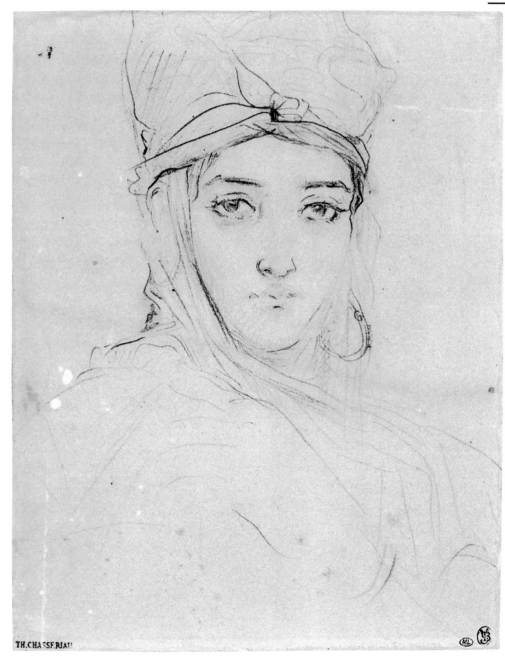

TH.CHASSERIAU

143

Seated Arab Woman and Little Girl

1846
Graphite on cream-colored paper
7 ½ x 11 in. (18.8 x 27.9 cm)
Inscribed in graphite, upper right: . . . *des pois d'or* [gold spots];
lower right: *la manche / laque de Smyrne / la coiffure noire / la robe
de couleur* (?) */ sur couleurs* (?) *mauve / un ton doux / et violet* [the
sleeve / lac of Smyrna / the black hair / the robe in color (?) / on
colors (?) mauve / a soft / and violet tone]
Paris, Musée du Louvre (RF 25409)

PROVENANCE:
See cat. 20.

BIBLIOGRAPHY:
Chevillard 1893, part of no. 420; Bénédite 1931, vol. 2, ill. p. 281;
Sandoz 1974, under no. 138; Prat 1988-1, vol. 1, no. 577.

EXHIBITIONS:
Paris, Louvre, 1957, no. 52; Paris, Galerie des Quatre Chemins
[n.d.], no. 20.

Exhibited in New York only

Very likely studied from life during the artist's Algerian
trip in 1846, this drawing would be used for the 1849
composition *Woman and Little Girl from Constantine
with a Gazelle* (Houston, Museum of Fine Arts), to which
Chassériau added a gazelle in the arms of the little girl.
A variant, showing the woman holding her arm up against
her face, is studied on the right in the drawing. The com-
position would be repeated in an engraving (Sandoz
1974, no. 292) and in a pen-and-ink drawing now in Los
Angeles (cat. 179). Chassériau also painted two watercolors
of gazelles during his stay in Algeria (Prat 1988-1, vol. 2,
nos. 1662, 1663, ill.; see cat. 148). **L.-A. P.**

144

Five Studies of Arabs, Including One Seen Full Face and in Half Length, with a Turban

1846
Brush, with wash and watercolor, on cream-colored paper
9 ⅜ x 6 ¼ in. (23.8 x 15.8 cm)
Inscribed with the tip of the brush, in brown wash, upper right:
les fils / raies bleues / turban rouge / ou orange [The threads / blue
stripes / red turban / or orange]
Paris, Musée du Louvre (RF 24410)

PROVENANCE:
See cat. 20.

BIBLIOGRAPHY:
Chevillard 1893, part of no. 420; Bénédite 1931, vol. 2, colorpl. 22;
Prat 1988-1, vol. 2, no. 1643, ill.

EXHIBITIONS:
Paris, Galerie Dru, 1927, no. 124; Paris, Orangerie, 1933, no. 152;
Algiers, 1936, no. 22; Paris, Louvre, 1957, no. 50; Paris, Galerie des
Quatre Chemins [n.d.], no. 15.

Exhibited in Strasbourg only

The head on the left is similar to that of the second
horseman in the 1851 painting in the museum in Lyons
Arab Horsemen at a Fountain in Constantine (Sandoz
1974, no. 170; cat. 186). **L.-A. P.**

145

Five Studies of Arabs

1846

Graphite

13 ½ x 8 ⅜ in. (34.2 x 21.2 cm)

Inscribed in graphite, around the sketches: *rouge / bleu / les yeux bleus / le teint coloré rouge / la barbe / blanche / bleu sombre / tout le haut / du vêtement / d'un / blanc d'or argenté / grenu et particulier / par flocons / jeaune / et blanc / le turban* [red / blue / blue eyes / complexion colored red / the beard / white / dark blue / the whole top / of the garment / in a / silvery-gold white / grainy and particular / in flakes / yellow / and white / the turban]

On the reverse are graphite studies of the hindquarters of horses, a horse's head, the head of an Arab, and two women

Inscribed in graphite, around the sketches: *la queu fouettant la / croupe / escadron les cheveaux la croupe tantôt / au soleil tantôt dans la masse des ombres / portés à gauche fermes et / vigoureuses / les provinces et villes de France rassemblées en / faisceau l'Afrique française aussi / femmes hommes et attributs / les Embassadeurs* [sic] *étrangers / Sa Somnanbule* (?) */ blanc de zinc* [The tail lashing / the croup / squadron the horses their croup sometimes / in the sun sometimes in the mass of shadows / placed on the left firm and / vigorous / the provinces and cities of France assembled into / a cluster French Africa as well / women men and attributes / the foreign Ambassadors / His Sleepwalker (?) / zinc white]

Paris, Musée du Louvre (RF 25658)

PROVENANCE:

See cat. 20.

BIBLIOGRAPHY:

Chevillard 1893, p. 241 (for a part of the text), and part of no. 420; Bénédite 1931, vol. 2, ill. p. 279; Prat 1988-1, vol. 2, no. 1630, ill.

Exhibited in New York only

The old, seated Arab studied on the recto of this sheet is repeated, alone, in another Louvre drawing (Prat 1988-1, vol. 2, no. 1631, ill.). The upper right section, on the reverse, was undoubtedly not executed in Algeria but added shortly thereafter. The inscription seems to refer to a decorative project devoted to France and its African possessions.

L.-A. P.

146

Interior of an Arab School in Constantine

1846

Graphite highlighted with watercolor

12 ⅛ x 14 ½ in. (30.7 x 36.8 cm)

Inscribed and dated in graphite, bottom left: *Constantine 1846;* at the top: *presque tous la bouche ouverte et / remuant la tête l'intérieur blanc / dans la demi-teinte / les enfants en blanc souvent / et quelques tons francs / le maître jeune et les / bras presque nus la veste relevée / ceci beaucoup plus haut / derrière des enfants dans l'ombre avec un maître / presque nègre* [almost all with open mouths and / moving their heads the interior white / in halftone / the children often in white / and a few pure tones / the teacher young and the / arms almost bare the jacket turned up / this much higher / behind the children in shadow with a teacher / almost Negro]

Paris, Musée du Louvre (RF 24348)

PROVENANCE:

See cat. 20.

BIBLIOGRAPHY:

Chevillard 1893, part of no. 420; Escholier 1921, ill. p. 97; Alazard 1936, p. 172, ill.; Sandoz 1982, p. 39, fig. 4; Sandoz 1986, p. 234 (with no inventory number); Prat 1988-1, vol. 2, no. 1681, ill., and colorpl. p. 35; Peltre 2001, p. 127, fig. 142.

EXHIBITIONS:

Paris, Galerie Dru, 1927, no. 117 (?); Paris, Orangerie, 1933, no. 137; Algiers, 1936, no. 16; The Hague, 1938 (no number); Paris, Louvre, 1980–81, no. 43.

Exhibited in Paris only

The artist's visit to Constantine took place between mid-May and mid-June 1846.

L.-A. P.

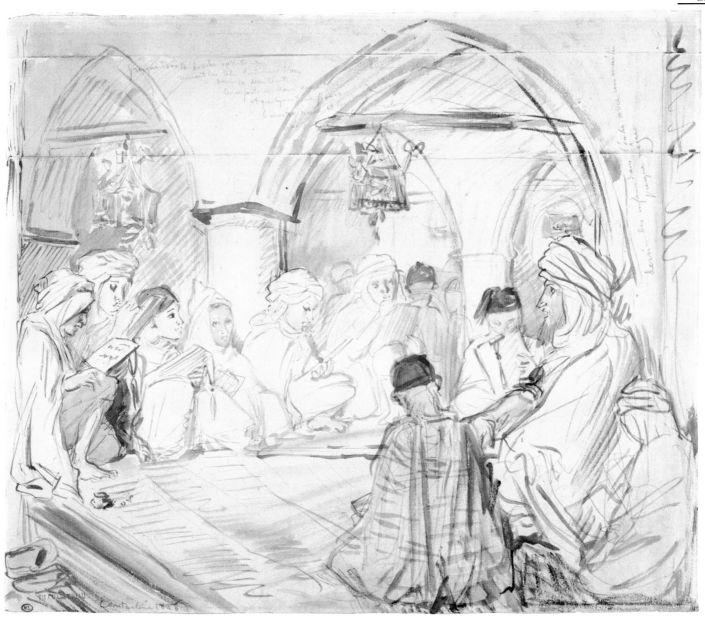

painting *Woman and Little Girl from Constantine with a Gazelle* (Houston, Museum of Fine Arts; see Sandoz 1974, no. 138; see also cat. 179). In 1933, the two works were displayed at the Orangerie in a single frame.

L.-A. P.

147

Arab Wearing a Turban and Standing Against a Tree

1846
Graphite on cream-colored paper
12 ¼ x 9 ½ in. (30.9 x 23.9 cm)
Inscribed in graphite, upper right: *du pays des longs cheveux . . . din din / près Tunis / Archati / tout en blanc* [from the land of long hair (two words crossed out) ding ding / near Tunis / Archati / all in white]
Paris, Musée du Louvre (RF 24352)

PROVENANCE:
See cat. 20.

BIBLIOGRAPHY:
Chevillard 1893, part of no. 420; Bénédite 1931, vol. 2, ill. p. 273; Prat 1988-1, vol. 2, no. 1634, ill.

EXHIBITIONS:
Paris, Orangerie, 1933, no. 139; Algiers, 1936, no. 37; Paris, Galerie des Quatre Chemins [n.d.], no. 2.

Exhibited in New York only

L.-A. P.

149

Notebook

1846
Bound notebook, covered in brown cardboard, with interlaced motifs and a brown leather spine, containing two flyleaves and twenty-four sheets (some fragmentary) numbered 1 to 24.
Missing folios between folios 7 and 8 (1), 8 and 9 (1), 12 and 13 (2), and 15 and 16 (3).
Stamp of the artist's studio (L. 443) on folios 1 r., 22 r. and v., 23 r., 24 v. Label of the paper manufacturer Guillard on the back of the first flyleaf.
Inscribed on the label on the obverse of the first flyleaf, in pen and brown ink, in Baron Arthur Chassériau's hand: *Algérie— Chevaux—Constantine* [Algeria—Horses—Constantine]
6 x 9 ⅛ in. (15.2 x 23.1 cm) (notebook)
5 ¾ x 9 ⅛ in. (14.6 x 23.1 cm) (sheets)
Paris, Musée du Louvre (RF 26088)

PROVENANCE:
See cat. 20.

BIBLIOGRAPHY:
Chevillard 1893, part of no. 420; Sandoz 1974, p. 468 n. 2; Prat 1988-1, vol. 2, no. 2253, ill.

EXHIBITION:
Paris, Louvre, 1980–81, nos. 40, 64 (open to folios 14 v. and 15 r.).

Exhibited in Paris only

148

Studies of Gazelles

1846
Watercolor
9 ⅜ x 12 ⅜ in. (23.7 x 31.2 cm)
Inscribed in brush and brown wash, lower right: *l'oeil noir humide / des teintes fauves et / blondes le ventre / blanc dessous* [eye moist black / tawny and blond / tints the belly / white underneath]
Paris, Musée du Louvre (RF 24355)

PROVENANCE:
See cat. 20.

BIBLIOGRAPHY:
Chevillard 1893, part of no. 420; Sandoz 1974, under no. 138; Prat 1988-1, vol. 2, no. 1662, ill.

EXHIBITIONS:
Paris, Orangerie, 1933, part of no. 154; Paris, Louvre, 1980–81, no. 41.

Exhibited in New York only

These studies and those in another Louvre drawing (Prat 1988-1, vol. 2, no. 1663) were later used for the 1849

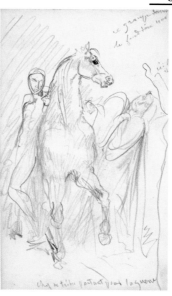

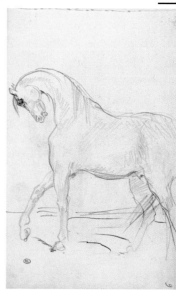

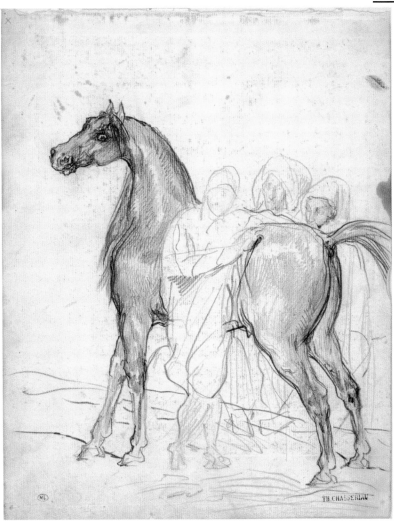

This notebook was used by Chassériau in 1846, during his trip to Algeria, as well as after his return. For the missing folios see another Louvre notebook (Prat 1988-1, vol. 2, no. 2252) and the loose sheets of drawings in the Louvre (Prat 1988-1, vols. 1, 2, nos. 583, 1667, 1668, 2013).

L.-A. P.

Open to folios 8 v. and 9 r.

Folio 8 v.

Two Arabs and a Horse

1846
Graphite
Inscribed in graphite: *ce groupe dans / le fond d'une cour / ici le / chef / Chef de tribu partant pour la guerre* [this group at / the far end of a courtyard / here the / chief / Chief of the tribe leaving for war]

Chassériau would not develop this theme, as such, in a painting, but the subject of *Arab Horseman Leaving for the Fantasia* (cat. 152) in the Louvre is certainly related—as is the 1849 engraving *Arab Horseman* (Sandoz 1974, no. 291); Chassériau added the title, *Arab Horseman Leaving for War,* in his own hand, on a second-state proof now in the Philadelphia Museum of Art (Fisher, in Baltimore, 1979–80, no. 27, p. 154). L.-A. P.

Folio 9 r.

Arabian Horse Facing Left

1846
Graphite

L.-A. P.

150

Three Arabs and a Horse

1846
Graphite
10 ⅜ x 8 ¼ in. (26.4 x 20.8 cm)
Paris, Musée du Louvre (RF 25406)

PROVENANCE:
See cat. 20.

BIBLIOGRAPHY:
Chevillard 1893, part of no. 420; Bénédite 1931, vol. 2, ill. p. 267; Sandoz 1974, under no. 221 (with no inventory number); Prat 1988-1, vol. 1, no. 677, ill.

Exhibited in New York only

This drawing probably was executed during the artist's 1846 trip to Algeria and would be reused by Chassériau for the 1853 painting *Horse Traders; Arab Scene* (Lille, Musée des Beaux-Arts). The horse would remain in the same position, but the figure in the foreground would be placed behind it. L.-A. P.

151

Saddled Arabian Horse, Facing Right; Head of a Horse

1846
Watercolor, heightened with white, over graphite, on brown paper
12 ½ x 17 in. (31.7 x 43 cm)
Paris, Musée du Louvre (RF 24351)

PROVENANCE:
See cat. 20.

BIBLIOGRAPHY:
Chevillard 1893, part of no. 420; Bénédite 1931, vol. 2, colorpl. 26; Prat 1988-1, vol. 2, no. 1659, ill.; Peltre 2001, p. 139, fig. 160.

EXHIBITIONS:
Paris, Galerie Dru, 1927, no. 113 (?); Paris, Orangerie, 1933, no. 153.

Exhibited in Strasbourg only

The study of the horse's head at the right is similar to the head of the horse in the center of the Louvre watercolor *Arab Horseman Leaving for the Fantasia* (cat. 152).

L.-A. P.

152

Arab Horseman Leaving for the Fantasia

1847
Gouache over black pencil
17 ¾ x 21 ¾ in. (45.1 x 55.2 cm)
Signed and dated in brush and red wash, bottom left: *Théodore Chassériau 1847*
Paris, Musée du Louvre (RF 24341)

PROVENANCE:
See cat. 20 (no mark L. 443).

BIBLIOGRAPHY:
Chevillard 1893, no. 405; Bénédite 1931, vol. 2, p. 290, ill. p. 313; Ribner 1981, fig. 4; Sandoz 1986, p. 234 (with no inventory number); Prat 1988-1, vol. 2, no. 1713, ill., and color ill. p. 10; Peltre 2001, p. 133, fig. 148.

EXHIBITIONS:
Paris, Galerie Durand-Ruel, 1897, part of no. 25 (?); Paris, Galerie Dru, 1927, no. 118; Paris, Louvre, 1957, no. 67, pl. 12; Paris, Louvre, 1980–81, no. 45.

Exhibited in New York only

I have retained the traditional title for this large watercolor, executed after Chassériau's return from Algeria in 1847. The Jewish woman carrying her child on the right of the composition is taken from a Louvre drawing executed from life during the painter's trip (Prat 1988-1, vol. 2, no. 1646, ill.), and the woman on the left is based on another drawing done in Algeria (Prat 1988-1, vol. 2, no. 2252, fol. 1 v., ill.).

Finished watercolors of this size are rare in Chassériau's oeuvre. Perhaps this one originally was intended to be exhibited at the Salon. The brief catalogue for the Théodore Chassériau retrospective, held at the fourth exhibition of French Orientalist painters at the Galerie Durand-Ruel in 1897, mentions, under numbers 25 and 26, "five watercolors" and "forty studies and sketches" belonging to Baron Arthur Chassériau; it is very likely that this watercolor, the largest by Chassériau in the Orientalist genre, was included in that exhibition.

A graphite drawing in the Louvre (Prat 1988-1, vol. 2, no. 1714, ill.) aided in planning the placement of the figures on this large sheet, but it displays a few variants, the most important of which is the depiction, in the center of the composition, of two horsemen instead of one.

L.-A. P.

153
Scene in the Jewish Quarter of Constantine

1846
Gouache with traces of gum arabic
21 ¾ x 15 ¼ in. (55 x 38.5 cm)
Signed and dated with the tip of the brush, bottom left:
Théodore Chassériau 1846
Private collection

PROVENANCE:
Album offered as a wedding gift to Marie-Louise Fernande de
Bourbon, Duchesse de Montpensier, 1846; Antoine, Duc de
Montpensier; his daughter, Isabelle d'Orléans; Amélie, Queen of
Portugal; inherited by the comte and comtesse de Paris; private
collection; sale, London, Sotheby's, June 11, 1997, lots 1–47 (the
album and separate folios; the Chassériau drawing was lot 25,
color ill.); private collection.

BIBLIOGRAPHY:
Prat 1991, pp. 77–78, fig. 3.

On October 10, 1846, the Orléans family offered the new
duchesse de Montpensier, Marie-Louise Fernande de
Bourbon, an album covered in velvet, with silver cor-
ners (representing famous painters of the past). On the
inside was a Duban watercolor, itself embellished with
two small views drawn by Dauzats, and the frontispiece
containing a dedication "to our beloved sister, the new
duchess," signed by Louis-Philippe's children. Following
this were forty-three drawings, watercolors, and
gouaches, affixed to large oblong sheets, specially exe-
cuted by the greatest artists of the time: Ingres,
Delacroix, and Chassériau, as well as Delaroche and
the Flandrins, Huet, Barye, Decamps, the Scheffers,
Vernet, and Granet. Dauzats also painted a watercolor,
and we know of a letter, in his hand, to an unknown cor-
respondent (now in the Institut Néerlandais, Paris),
concerning payment for the work by Chassériau done
on that occasion:

> Office / of Her Royal Highness /
> Madame / la Duchesse d'Orléans
> Dear Friend, you promised me you would be responsible
> for passing on to M. Chassériau the 300 francs we owe him
> for the watercolor he did for the album. Here they are, a
> thousand pardons for the trouble and a thousand thanks.
> With all my heart,
> A Dts.

In "News and Current Events—France—Paris," in the
Bulletin des arts (vol. 4, November 10, 1846, p. 169), the
bibliophile Jacob reports on an article in the *Journal
des débats* that mentions the album, adding that "most
[of the compositions] have the importance of completed
paintings," and names Chassériau as one of the artists.
During his trip to Algeria, Chassériau had blocked
out the scene in a rapid sketch, now in the Louvre (Prat
1988-1, vol. 1, no. 607, ill.), which he would later use for
the 1851 painting of the same subject (New York, The
Metropolitan Museum of Art; see cat. 154). The positions
of the young women vary from one work to the other,
and the watercolor shows a third seated figure, appar-
ently a man, at the lower right. The richness of the color
in the watercolor and the scope of its conception lend
themselves to comparisons with the famous sheet *Arab
Horseman Leaving for the Fantasia* (cat. 152), also executed
after the Algerian trip. Since Chassériau returned to

France in late July 1846, he must have painted the water-
color between August and October of that year.

L.-A. P.

154
Scene in the Jewish Quarter of Constantine

1851
Oil on canvas
22 ⅜ x 18 ⅜ in. (56.8 x 46.7 cm)
Signed and dated, bottom right: *Thre Chassériau 1851*
New York, The Metropolitan Museum of Art, Purchase, The
Annenberg Foundation Gift, 1996 (1996.285)

PROVENANCE:
Christofle, 1893; Rex Ingram, Hollywood, California, 1933;
anonymous sale, Los Angeles, Sotheby Parke Bernet, March 12,
1979, lot 57, ill.; Tannenbaum, Toronto; sale, New York, Sotheby's,
October 23, 1990, lot 38; Stair Sainty Matthiessen, New York;
acquired by The Metropolitan Museum of Art, New York, 1996.

BIBLIOGRAPHY:
Chevillard 1893, no. 118, p. 284; Vaillat 1907, ill.; Marcel and
Laran 1911, pp. 83–84, ill.; Vaillat 1913, p. 181, ill.; Escholier 1921,
p. 102, ill. p. 99; Focillon, "Chassériau ou les Deux Romantismes,"
in *Le Romantisme et l'art*, 1928, p. 169; Goodrich 1928, ill. p. 91;
Bénédite 1931, pl. 24; Grappe 1932, p. 50; Sandoz 1974, no. 214,

pp. 59, 348–49, pl. 180; Rosenthal 1982, pp. 59–60, ill.; Thornton 1983, p. 74, ill.; Foucart 1987, p. 322; Prat 1988-1, vol. 1, p. 281; Tinterow 1997, pp. 46–47, ill.; Peltre 2001, ill. p. 135.

EXHIBITIONS:
Paris, Galerie Durand-Ruel, 1897, no. 9; Paris, 1931; Paris, Orangerie, 1933, no. 59; Rochester and Purchase, 1982, no. 10; New York and London, 1991, no. 20.

As is the case with many of Chassériau's Algerian scenes, particularly those featuring female figures in domestic surroundings, this image can be associated with a drawing executed from life in Constantine in the summer of 1846. Now in the Louvre, this drawing (RF 25519; see Prat 1988-1, vol. 1, no. 607), which presents a woman rocking a cradle hanging from the ceiling of a shallow and sparely furnished room, was used by Chassériau in the preparation of this painting. He also painted a watercolor and gouache version of the same scene—although with three figures arranged around the cradle rather than two, as in the oil; signed and dated 1846, these were his contributions to the Montpensier album, a collection of forty-five watercolors by Ingres, Delacroix, Barye, and other leading artists of the 1840s.

Scene in the Jewish Quarter of Constantine represents a return to the artist's consideration of the domestic rituals of the Jewish residents of Constantine. Dazzled by their "primitiveness"—what he saw as their similarities to the Jews of Antiquity—he sought to record their customs and elaborate clothing and accessories. He had developed this theme on a monumental scale in the *Sabbath in the Jewish Quarter of Constantine*. On the subject of that work, Théophile Thoré wrote: "those remarkable races, which have preserved the mores, character, and customs of the ancient Israelites, a pure-blooded race that never stooped to intermarrying with the infidels and that even today echoes the primitive type."[1]

The maternal theme pervades every period in Chassériau's career, linking the groups of mothers in the Cour des Comptes mural *Peace* with the small Nativity he was working on at the time of his death. During his final visit to the painter's studio, Gautier remarked upon the latter painting, admiring "the untamed sweetness and the Oriental languor" of the Virgin's head.[2] Indeed, Gautier hints here at the degree to which Chassériau's Algerian journey provided a means to a more authentic religious painting. Just as Gautier noted the Oriental cast of the face of Chassériau's Virgin, so, too, did Chassériau regard his interior scenes of Algerian Jewish women and their infants as reenactments of the biblical Nativity. Maternal images are central to Chassériau's paintings of Constantine's Jewish residents. The cele-

brated 1847 watercolor *Arab Horseman Leaving for the Fantasia* (cat. 152), whose similar dimensions and identical medium make it a close relative of the 1846 version of *Scene in the Jewish Quarter of Constantine,* prominently features a woman with a child perched on her hip. In the small-scale *Jewish Family in Constantine* (cat. 183), also from 1851, a young mother gathers up a child in her arms.

Scene in the Jewish Quarter of Constantine presents another of the major revelations of the artist's Algerian journey, brought about by the brilliant hues and contrasts of color that he encountered in the rich and varied clothing of the natives. Drawings in his notebooks of patterned fabrics, ornaments, and slippers were utilized for the costumes of the Jewish women in the *Sabbath in the Jewish Quarter of Constantine* and in *Jewish Women on a Balcony*. In each work, Chassériau paid particular attention to the distinctive head coverings composed of layers of silken fabric, which framed the women's oval faces, as well as to the eyelids outlined with kohl. In 1855, Gautier detailed the Oriental finery worn by the Jewish women in Chassériau's pictorial world: "the Jewish woman with the two-toned dress, a headband adorned with embroidery and sequins, and triple gold chin straps, who could be taken for a Byzantine empress brought back to life."[3]

Wedded to the disquieting mystery, as Gautier termed it, that envelops these women is Chassériau's sculptural choreography of figures and gestures. With regard to images such as this one, Gautier said of the artist: "He also treated with a sculptural seriousness these ample garments pleated like togas or tunics."[4] The young woman on the left is pictured with her bare feet emerging from beneath the shimmering folds of drapery that define the classical proportions of her body. Their graceful curves recall the similarly shaped bare feet of Chassériau's *Moorish Dancers* (1849; cat. 180). By illuminating the toes of one foot with a shaft of light and leaving the other foot in shadow, and suffusing the picture with glowing color and vibrating half tints, Chassériau developed tonal relationships in the *Scene in the Jewish Quarter of Constantine* like those in *Woman and Little Girl from Constantine with a Gazelle* (cat. 178) and *Jewish Women on a Balcony* (cat. 177). **P. B. M**

1. T. Thoré, "Salon de 1847," in *Les Salons de T. Thoré* (Paris: Librairie Internationale, 1868), p. 526.
2. T. Gautier, "Atelier de feu Théodore Chassériau," in *L'Artiste* 3, no. 14 (March 15, 1857), p. 209.
3. T. Gautier, *Les Beaux-Arts en Europe, 1855* (Paris: Michel Lévy Frères, 1855), p. 253.
4. Ibid., p. 252.

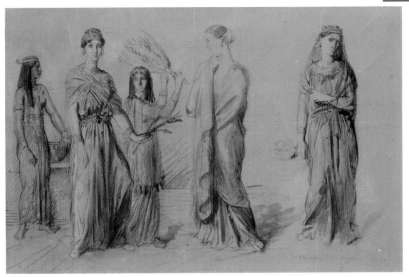

155

Five Studies of Women in Oriental Costumes

1847

Watercolor, over graphite and black pencil, on beige paper
12 x 18 ⅜ in. (30.4 x 46.5 cm)
Dedicated, signed, and dated in graphite, lower right: *à Madame de Girardin, Théodore Chassériau—1847;* inscribed in pen and brown ink, at the left: *à carreau* [squared]; in graphite, around the sketches: *robe pourpre / bracelet / de perles / couronne d'or / avec des pierres et / des perles / gaze croisée / sur le corsage / sur la robe / un corsage / d'or / la robe / à pois / d'or / cheveux en petites / boucles minces / et allongées / manteau court / tunique en dessous / perles / ceinture rouge / et or / violet beaucoup / plus sombre* [purple dress / bracelet / of pearls / gold crown / with stones and / pearls / gauze crossed / over the bodice / on the dress / a bodice / of gold / the dress / with spots / of gold / hair in little / curls thin and / long / short coat / tunic underneath / pearls / red and / gold belt / violet much / darker]
Paris, Musée du Louvre (RF 24340)

PROVENANCE:
Mme de Girardin; Baron Arthur Chassériau, Paris; bequest of the latter to the Musée du Louvre, 1934.

BIBLIOGRAPHY:
Chevillard 1893, no. 403, pp. 156–57; Marcel and Laran 1911, p. 54, ill.; Bénédite 1931, vol. 2, colorpl. 55; Alazard 1933, p. 56; Sandoz 1974, p. 13, and under no. 211; Sandoz 1986, under nos. 52, 184-2, and p. 239; Prat 1988-1, vol. 1, no. 1016, ill.; Peltre 2001, pp. 204, 208, fig. 233.

EXHIBITIONS:
Paris, Orangerie, 1933, no. 153; Paris, Louvre, 1957, no. 69; Paris, Galerie des Quatre Chemins [n.d.], no. 28.

Exhibited in New York only

This drawing was always considered a study for the costumes of the actress Rachel (and other characters) in the play *Judith,* a tragedy in three acts by Mme de Girardin (Delphine Gay; 1804–1855). Delphine de Girardin and Chassériau were friends, and he made a posthumous portrait drawing of her in 1855 (Paris, Musée Carnavalet). Then, in 1968, H. Toussaint (*Le Romantisme dans la peinture française,* exhib. cat. [Moscow and Leningrad, 1968], no. 102) asserted that the play in question was *Cleopatra* (first produced November 13, 1847, and staged fifteen times, until 1850) and not *Judith* (first produced April 24, 1843). According to Sandoz (1974, under no. 102), *Cleopatra* was not performed until 1857, at the Théâtre-

Français; but, by that time, Delphine de Girardin had been dead for two years. Nevertheless, Gautier, quoted by Chevillard (1893, pp. 156–57), wrote a critique of the costumes in *L'Art dramatique en France,* in which he cited Chassériau by name as well as the title of the play, *Judith:*

> The costumes of Mlle Rachel are of a rare tastefulness, severity, and richness. Her mourning clothes in the first act are nobly and chastely draped. In the second act, her pale robe, spangled with gold; her purple mantle, a pleasing blend of hues; her Oriental scarf bedecked with designs and marvelous embroidery; the cascades of pearls that stream from her neck onto her shoulders; the biblical magnificence of her drop earrings and her head ornaments, made her the most noble and splendid Judith that a poet or a painter could have dreamed up. In addition, one of our young artists, M. Théodore Chassériau, who possesses a feeling for Antiquity to the highest degree, did the designs, which were received by Mlle Rachel with a docility worthy of her wit and intelligence. The costume in the third act is quite simply a Raphael, that is, it is in charming taste and has exquisite character.

Rachel is easily recognizable in the two figures on the right (Chassériau also made sketches and a portrait painting of her [see Prat 1988-1, vol. 1, no. 527, ill.]), while the three women at the left are undoubtedly secondary characters in the play. Rachel's costumes are clearly Jewish in their inspiration and could not have been worn by an actress playing the role of Cleopatra.

In the library at the Comédie-Française is a group of seven drawings (inventoried under nos. D1, F1, H1 [comprising two sheets], HF1, H2, H3, and H4) of costumes for *Judith,* in Chassériau's hand; two of them were published recently by Peltre (2001, p. 206, figs. 231–232). Executed in graphite, they are sometimes strengthened with pen and brown ink or drawn directly in pen, and several include watercolor highlights; one of them contains an embroidery pattern for a tunic (D1). In my view, two other drawings of costumes, in the same collection (Inv. F2, F3), are not by Chassériau, although the light sketches on the verso of F3 could be in his hand.

Finally, one of Chassériau's drawings for *Judith* is of a costume that is clearly Egyptian in its inspiration (Peltre 2001, fig. 231).

Does the date mentioned (1847) signify that these sketches are *ricordi* of the 1843 patterns, executed to be offered to Delphine de Girardin?　　　　L.-A. P.

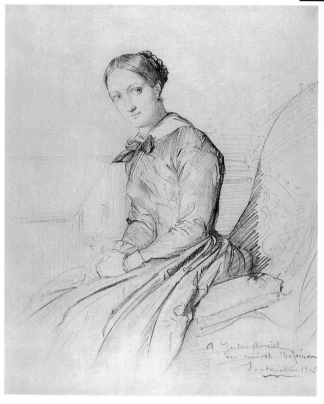

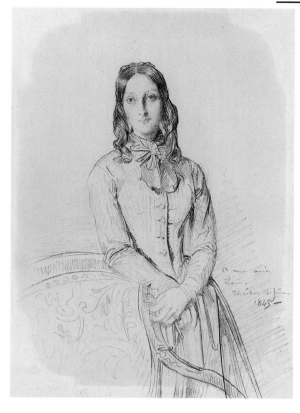

156

Portrait of Mme Jules Amiel

1845
Graphite
12 x 10 ⅛ in. (30.5 x 25.5 cm)
Dedicated, signed, dated in graphite, lower right: *A Jules Amiel /
son ami Th. Chassériau / Fontainebleau 1845* [To Jules Amiel / his
friend / Th. Chassériau / Fontainebleau 1845]
Collection André Bromberg

PROVENANCE:
Amiel family; Paris, private collection.

BIBLIOGRAPHY:
Prat 1988-2, no. 119, ill.

The painter Jules Amiel, is known only through his
request for authorization to copy in the Louvre (dated
October 30, 1834), which was supported by Ingres (see
Geneviève Lacambre and Jean Lacambre, "Documents
inédits sur les élèves d'Ingres," in *Bulletin du Musée Ingres*,
no. 25 [July 1969], p. 10). No doubt he was a fellow stu-
dent of Chassériau in the master's studio, just before
Ingres closed down his atelier and left for Rome to direct
the Villa Medici. In 1834, Jules Amiel was nineteen, and
lived at 36, rue Richer, in Paris. L.-A. P.

157

Portrait of Mme Louis Marcotte de Quivières, née Gabrielle d'Amblat

1845
Graphite
12 ⅞ x 10 ¾ in. (32.5 x 27.3 cm)
Dedicated, signed, and dated in graphite, lower right: *A mon ami /
Louis / Théodore Chassériau / 1845-* [To my friend / Louis /
Théodore Chassériau / 1845-]
New York, The Metropolitan Museum of Art, Robert Lehman
Collection, 1975 (1975.1.581)

PROVENANCE:
Marcotte de Quivières family; Robert Lehman, New York, 1961;
The Metropolitan Museum of Art, New York, Robert Lehman
Collection (G. Szabo, *19ᵗʰ Century French Drawings from the
Robert Lehman Collection*, exhib. cat. [New York, 1980], no. 9, ill.).

BIBLIOGRAPHY:
Chevillard 1893, no. 307; Sandoz 1974, pp. 11 (mistakenly indicated
as from 1841), 12; Sandoz 1986, no. 16 (whereabouts unknown);
Prat 1988-1, vol. 1, under no. 1074; Prat 1988-2, no. 120, ill.

Gabrielle d'Amblat was the wife of Louis Marcotte de
Quivières, whose portrait Chassériau drew four years
before (cat. 56). Another, unpublished drawing depicting
the same sitter in 1851 has just entered the museum
in Basel. L.-A. P.

Portrait of Baronne Frédéric Chassériau, née Joséphine Warrain

1846
Graphite
12 ⅜ x 9 ⅜ in. (31.3 x 23.6 cm)
Dedicated, signed, and dated in graphite, lower right: *a mon cousin / et ami Frédéric / Théodore Chassériau / 1846* [to my cousin / and friend Frédéric / Théodore Chassériau / 1846]
The Art Institute of Chicago, in Memory of David Adler, 1950 (1950.1904)

PROVENANCE:
Baron Frédéric Chassériau (1802–1896); Baron Arthur Chassériau, his son (1850–1934); Mme B. Nouvion, wife of the executor of Baron Arthur Chassériau's estate; Walter Feilchenfeldt, Zürich; acquired by The Art Institute of Chicago, 1950 (*Dessins français de l'Art Institute de Chicago, de Watteau à Picasso*, exhib. cat. [Paris: Louvre, 1976–77], no. 47, ill.).

BIBLIOGRAPHY:
Chevillard 1893, no. 269; Bénédite 1931, vol. 1, p. 82, ill. p. 84; Sandoz 1974, p. 13; Sandoz 1986, no. 25, ill.; Prat 1988-1, vol. 2, under no. 1729; Prat 1988-2, no. 144.

EXHIBITION:
Paris, Galerie Dru, 1927, no. 34.

Exhibited in New York only

CAT. 158

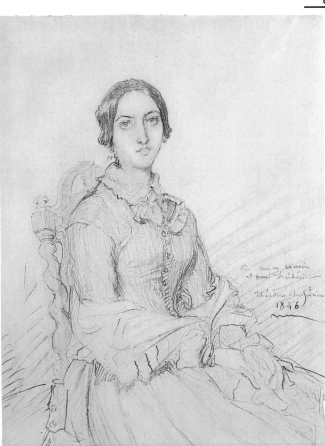

Baron Frédéric Chassériau, to whom this portrait of his wife is dedicated, must not be confused with his name-sake and cousin, Frédéric Chassériau, the painter's elder brother, whose role in Théodore's education and in obtaining official commissions for the artist throughout his life are well known. Young Baron Frédéric was the son of General Baron Chassériau, who was killed at Waterloo on June 18, 1815, in one of the cavalry charges on the plateau of Mont-Saint-Jean. This Frédéric was thus the first cousin of Frédéric, Théodore, Ernest, and their two sisters. On June 17, 1837, he married a young woman from Marseilles, Joséphine Warrain, who was "eighteen years old, beautiful, with an excellent temperament, little fortune, but from a family that is extremely well regarded in Marseilles" (letter from Frédéric Chassériau to his brother Théodore, June 1837; quoted in Bénédite 1931, vol. 1, p. 90). Baron Arthur Chassériau was a child of that union.

Théodore passed through Marseilles twice in 1846: first, on May 8, before embarking for Algeria, and then again in late July; Sandoz assumes it was during that second trip that he executed this handsome portrait and offered it to his cousin.

Baron Frédéric Chassériau, an architect by profession, was active in the city of Marseilles as an architect and Director of Public Works, and then as designer of the port of Algiers, where a boulevard and a high school bore his name until the time of Algerian independence. During Théodore's first trip to the Midi, in 1836, the baron had introduced him to a "good family . . . a happy exception among the Marseilles population, for which I feel a repugnance beyond all expression: lies, duplicity, every defect combined" (letter from Théodore to his brother Frédéric, August 1836, Marseilles; quoted in Bénédite 1931, vol. 1, pp. 80–81, who assumes that the reference is to the Warrain family).

An interesting insight into Baron Frédéric Chassériau was offered by Joan R. Mertens in 1981, in an article on a drawing attributed to Théodore but actually by his architect cousin, *Open Triclinium in the So-called House of Actaeon in Pompeii* (New York, The Metropolitan Museum of Art, 1975.131.95; see "A Drawing by Chassériau," *Metropolitan Museum Journal* 15 [1980], pp. 153–56, fig. 1). As the drawing bears the signature *Chasseriau fecit,* Sandoz (1958, pp. 113–16, fig. 3) believed it was by Théodore, but Joan Mertens has shown that the drawing must have been done by Frédéric, who, at the time, was employed by the architect François Mazois (1783–1826). In 1824, Mazois published *Ruines de Pompéi dessinées et mesurées pendant les années 1809, 1810, 1811* (Ruins of Pompeii, drawn and measured during the years 1809, 1810, 1811), a collection of engravings that includes one of the Metropolitan Museum's Pompeii drawing, oriented in the same direction (vol. 2, pl. 38, fig. 1). It is difficult to say whether the Metropolitan's drawing is a copy after the engraving, notwithstanding the existence of a preliminary drawing for the same plate in the Département des Estampes et de la Photographie at the Bibliothèque Nationale de France (Mertens 1981, fig. 4).

L.-A. P.

159
Portrait of Lydie de Buus d'Hollebèque (?)

1846
Graphite
8 ¾ x 6 ½ in. (22 x 16.5 cm)
Signed and dated in graphite, lower right: *Th. Chassériau / 1846*
Paris, Private collection

PROVENANCE:
De Ranchicourt family; Galerie Brame et Lorenceau, Paris, 1996;
Paris, private collection.

BIBLIOGRAPHY:
Chevillard 1893, no. 300 (as "Portrait of Mlle Lydie de Buns
d'Hollebèke"); Sandoz 1974, pp. 13, 71, fig. 24, p. 386, under no. 241
(as "Portrait of the Comtesse de Ranchicourt"); Sandoz 1986, no.
29, ill. (as "Portrait of the Comtesse de Ranchicourt"; Sandoz also
catalogues, under no. 62, "Portrait of Lydie de Buus d'Hollebèke,
sister of Mme Oscar de Ranchicourt," with the comment, "known
only through a mention by Chevillard"); Prat 1988-1, vol. 2, no.
2255, obverse of the second flyleaf (as a portrait of the comtesse de
Ranchicourt); Prat 1988-2, no. 145, ill. (as "Portrait of the
Comtesse Oscar de Ranchicourt").

Exhibited in Paris only

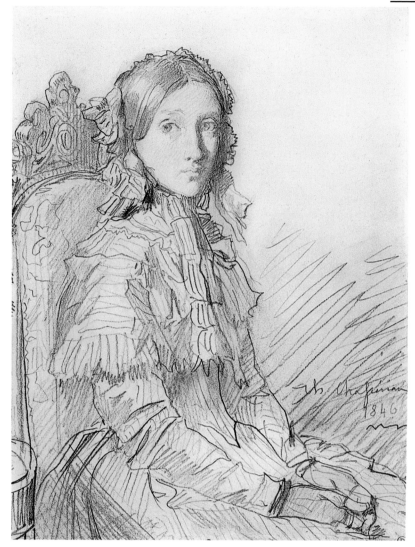

Several factors have led me to reconsider the identification of the sitter in this portrait, once believed by Sandoz, and later, by myself, to be Pauline de Ranchicourt, the wife of Chassériau's friend Oscar. When I was able to examine the drawing in 1996, it seemed obvious that the model was a little girl and not a young woman. In addition, a photograph of the drawing, belonging to the de Ranchicourt family, bore an annotation on the back, which was later crossed out: *Lydie de Buus? A Ranchicourt.* In 1893, Chevillard had cited a portrait drawing of Lydie de Buus, but not a portrait drawing of the comtesse de Ranchicourt (this argument is not decisive, since Chevillard also does not mention the portrait drawing of Comte Oscar de Ranchicourt, which has since come to light [cat. 210]). Finally, and most importantly, the person represented in this drawing bears no resemblance to Comtesse de Ranchicourt, as she appears in two portraits painted by Chassériau: one, showing her in hunting clothes (cat. 211) and the other, in half length (Sandoz 1974, no. 242, ill.); the latter unfortunately was stolen from the de Ranchicourt château in June 1988.

In 1837 and 1839, Chassériau executed two portrait drawings of a very elderly couple, Baron Charles de Buus d'Hollebèque and his wife (Paris, art market; Sandoz 1986, nos. 3–6, ill.). Their son, Victor de Buus, married Clémence-Adèle Aronio de Fontenelle de Ranchicourt (her first husband was Philibert de Ranchicourt, a painter). Oscar de Ranchicourt, Théodore's friend, the child of Clémence-Adèle's first marriage, would later marry Pauline de Buus, Victor's sister!

Victor and Clémence-Adèle had five daughters: Mathilde (1830), Marie (1832), Alice (1834), Lydie (1836), and Pauline (1839). Lydie thus was the niece of Pauline de Ranchicourt by birth, and her half-sister-in-law through Pauline's marriage to Oscar.

In 1846, Lydie was ten years old. Is it possible that this is the age of the sitter depicted here? It is not altogether impossible: She was certainly of fragile health, since she died at eighteen, in 1854, and that undoubtedly shows through here. The child in this portrait, with her large, sickly eyes, appears old before her time, and dressed as a young woman. However, the sitter might also be a different, slightly older daughter of Buus d'Hollebèque.

L.-A. P.

160

Portrait of Jean-Gaspard-Félix Larcher Ravaisson-Mollien

1846
Graphite with stumping
13 ⅛ x 10 in. (33.3 x 25.4 cm)
Dedicated, signed, and dated in graphite, lower left: *a Félix Ravaisson / son ami / Théodore Chassériau / 1846* [to Félix Ravaisson / his friend / Théodore Chassériau / 1846]
New York, The Metropolitan Museum of Art, Robert Lehman Collection, 1975 (1975.1.583)

PROVENANCE:
Ravaisson-Mollien family; sale, Paris, Galerie Charpentier, March 31, 1960, no. 1, ill. (Fr 190,000, with cat. 161); Robert Lehman, New York, 1961; The Metropolitan Museum of Art, New York, Robert Lehman Collection (G. Szabo, *19th Century French Drawings from the Robert Lehman Collection*, exhib. cat. [New York, 1980], no. 7, ill.).

BIBLIOGRAPHY:
Bouvenne 1887, p. 172; Chevillard 1893, p. 159, no. 291; Bénédite 1931, vol. 2, ill. p. 362; Sandoz 1974, p. 13; Sandoz 1986, no. 27, ill.; Prat 1988-1, vol. 1, under no. 565; Prat 1988-2, no. 146; Peltre 2001, p. 32, fig. 27.

Félix Ravaisson-Mollien (1813–1900) was a noted philosopher and archaeologist. In 1846, he had just published *Essai sur la métaphysique d'Aristote* (Essay on Aristotle's metaphysics) (1837–46, 2 vols.). He passed his agrégation examination in philosophy in 1836, and taught at the faculty of letters in Rennes, later serving as Inspector General of Public Libraries. After a stint as private secretary to Salvandy, Minister of Public Education, he became Inspector General of Higher Education in 1853. In 1849, he was admitted to the Académie des Inscriptions et Belles-Lettres.

Chassériau referred to Ravaisson twice in letters to his brother Frédéric in 1846. In the first letter, the painter wrote: "At a general reception for the king, I saw M. Ravaisson, who has kindly offered to introduce me to his family next Saturday" (quoted in Sandoz 1986, who dates the letter May 7, 1846, but by then Chassériau had already left for Algeria). A second letter, sent from Algeria (Chevillard 1893, p. 110), asked Frédéric to transmit "a thousand fond thoughts to M. Ravaisson. In him, I have found the heart of a friend; I have not forgotten him and, on my return, I hope to show him things that might interest him as an artist."

Another portrait drawing of Ravaisson, by François-Joseph Heim, in which he is dressed as a member of the Academy, is in the Louvre (RF 868).

L.-A. P.

161

Portrait of Mme Félix Ravaisson-Mollien

1846
Graphite with stumping
13 ⅛ x 10 in. (33.3 x 25.4 cm)
Dedicated, signed, and dated in graphite, center left: *a Félix Ravaisson / son ami / Théodore Chassériau / 1846* [to Félix Ravaisson / his friend / Théodore Chassériau / 1846]
New York, The Metropolitan Museum of Art, Robert Lehman Collection, 1975 (1975.1.582)

PROVENANCE:
Ravaisson-Mollien family; sale, Paris, Galerie Charpentier, March 31, 1960, no. 2, ill. (Fr 190,000, with cat. 160); Robert

CAT. 160

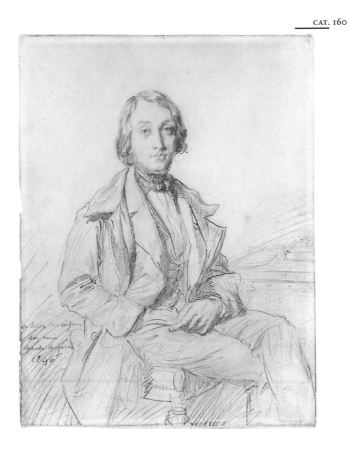

CAT. 161

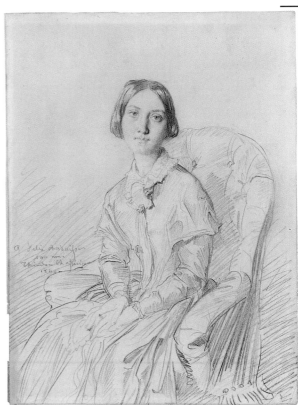

Lehman, New York, 1961; The Metropolitan Museum of Art, New York, Robert Lehman Collection (G. Szabo, *19th Century French Drawings from the Robert Lehman Collection*, exhib. cat. [New York, 1980], no. 8, ill.).

BIBLIOGRAPHY:
Sandoz 1974, p. 13; Sandoz 1986, no. 28, ill.; Prat 1988-1, vol. 1, under no. 565; Prat 1988-2, no. 147.

When he returned from Algeria, Chassériau made a portrait drawing of Félix Ravaisson-Mollien (see the previous entry) and one of his wife at the same time.

L.-A. P.

162

Portrait of Léopold Burthe

1846
Graphite
13 ½ x 10 ½ in. (34.3 x 26.7 cm)
Signed and dated in graphite, lower left: *Théodore Chassériau 1846*
Providence, Rhode Island School of Design, Museum of Art, Gift of Mrs. Murray S. Danforth, 1938

PROVENANCE:
Family of the artist; sale, Paris, Hôtel Drouot, June 29, 1927, lot 13; Jacques Seligmann and Son, Paris, 1933; Museum of Art, Rhode Island School of Design, Providence, 1938.

BIBLIOGRAPHY:
Bouvenne 1887, no. 57 (the engraving of the drawing made for *L'Artiste* in 1886); Sandoz 1974, p. 13, fig. 23, p. 67; Sandoz 1986, no. 26, ill.; Prat 1988-2, no. 148; Peltre 2001, p. 36, fig. 34.

EXHIBITION:
Paris, Orangerie, 1933, no. 156.

Exhibited in New York only

Sandoz (1974) mentions a pendant, a portrait of Mme Burthe, about which, however, nothing is known. The *Portrait Drawing of a Young Man, Seen in Half Length and in Left Profile* (whereabouts unknown), also dated 1846, may depict the same sitter (Sandoz 1974, fig. 22; Sandoz 1986, no. 87, ill.; Prat 1988-2, no. 149).

More is known about Léopold Burthe since the publication of Bruno Gaudichon's notable article on that artist, "Léopold Burthe (1823–1860)," in the *Bulletin de la Société de l'Histoire l'Art Français* 1984 [1986], pp. 229–40, in which this drawing is illustrated (fig. 2).

Léopold Burthe, from a family of New Orleans planters, arrived in Paris shortly before 1830; it was at that date that he joined the studio of Amaury-Duval. The latter painted a portrait of him, which he exhibited at the Salon of 1852, and which was lithographed by Léon Brunel-Rocque (Gaudichon 1986, fig. 1). His fate paralleled Chassériau's, since he, too, died at thirty-seven.

Burthe remained within the Ingresque orbit, working in a neo-Greek style, the finest example of which is the *Sappho Playing the Lyre,* exhibited at the Salon of 1849 (now in Carcassonne, Musée des Beaux-Arts), and which can be described as Attic. The museum in Poitiers owns four of his paintings, and Léon Brunel-Rocque prepared a set of lithographs (now lost) after Burthe's forty-three original drawings for the Hetzel edition of *Daphnis and Chloë* (1862).

L.-A. P.

CAT. 162

CAT. 163

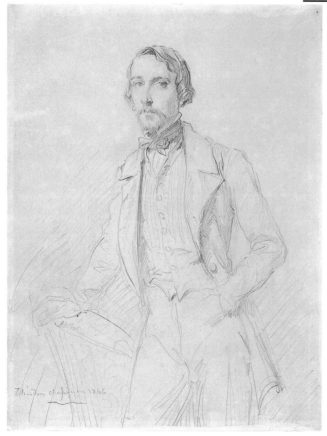

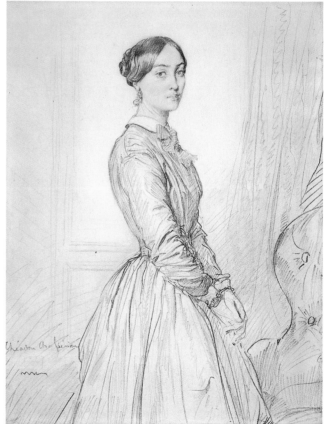

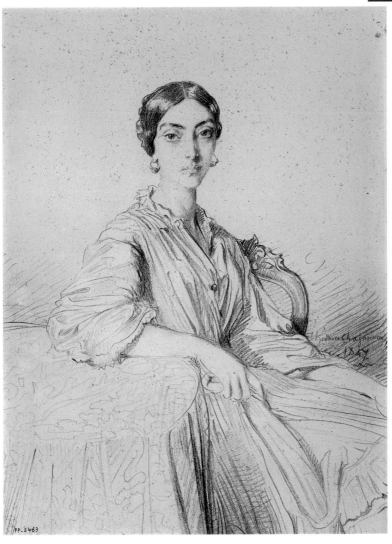

magnified by the simplicity of her pose, her hands crossed in front of her. The upholstered armchair at the right is one of the standard props in Chassériau's portrait drawings and paintings; see, for example, catalogue 165.

Some critics believe that it is Mme Borg de Balsan, seen here turning toward the right, who is depicted in a sheet of studies in the Louvre (Prat 1988-1, vol. 2, no. 1865, ill.). In addition, a *madame Borg* is mentioned by Chassériau on another sheet in the Louvre (Prat 1988-1, vol. 1, no. 580, ill.) that is unrelated to this portrait.

L.-A. P.

164

Portrait of Princess Belgioioso, née Cristina Trivulzio

1847
Graphite
12 ½ x 9 ½ in. (31.5 x 24 cm)
Signed and dated in graphite, center right:
Théodore Chassériau / 1847
Paris, Musée du Petit Palais (NR P.P.D. 463)

PROVENANCE:
Baron Arthur Chassériau, Paris; gift of the latter to the Musée du Petit Palais, Paris, 1907 (Los Llanos, *Von Ingres bis Cézanne*, exhib. cat. [Bonn, 1998], no. 21, ill.).

BIBLIOGRAPHY:
Chevillard 1893, no. 283, p. 159; Bénédite 1931, vol. 2, p. 371, ill. p. 364; Alazard 1933, p. 56; Sandoz 1974, pp. 13, 74, fig. 26; Sandoz 1986, no. 32, ill., and frontispiece; Prat 1988-2, no. 153, ill.; Peltre 2001, p. 27, fig. 23.

EXHIBITIONS:
Paris, Orangerie, 1933, no. 161; Paris, Galerie Daber, 1976, no. 38, ill.

Exhibited in Paris only

163

Portrait of Mme Borg de Balsan

1847
Graphite
13 ⅛ x 10 ⅛ in. (33.3 x 27 cm)
Signed and dated in graphite, lower left: *Théodore Chassériau / 1847* [the date is worn away]
Philadelphia Museum of Art, The Henry P. McIlhenny Collection in memory of Frances P. McIlhenny, 1986 (1986-26-3)

PROVENANCE:
M. Thomson, Versailles; G. Wildenstein, Paris, 1933; John S. Newberry, Detroit (*Fifty Drawings from the Collection of John S. Newberry Jr.,* exhib. cat. [The Detroit Institute of Arts, 1949], no. 84, ill.); Henry McIlhenny, Philadelphia, 1955; bequest to the Philadelphia Museum of Art, 1986.

BIBLIOGRAPHY:
Chevillard 1893, no. 282; Bénédite 1931, vol. 2, ill. p. 350; Gérard 1957, ill. p. 13; Sandoz 1974, p. 13; Sandoz 1986, no. 31, ill. (with erroneous dimensions); Prat 1988-1, vols. 1, 2, under nos. 580, 1865; Prat 1988-2, no. 152, ill.

EXHIBITION:
Paris, Orangerie, 1933, no. 130.

Exhibited in Paris and New York

This portrait drawing, a miracle of controlled execution, in my view is probably the most perfect one Chassériau produced. Nothing is known of the sitter, who is unusually distinguished, and whose beauty is

Cristina Trivulzio (1808–1871), the daughter of an Italian aristocrat, married Prince Emilio Barbian de Belgioioso in 1824, when she was very young. Impassioned by the fight for freedom in Italy, she left Milan, under Austrian domination at the time, and settled in Paris, where she held a salon that attracted many celebrities. Her *Essai sur la formation du dogme catholique* (Essay on the formation of Catholic dogma) was published anonymously, in four volumes, in 1846. The widespread revolutionary movements in 1848 and the insurrection in Milan led her to raise a battalion of volunteers in that city, but after it was returned to Austrian control she had to flee, and her property was sequestered. Her "Souvenirs d'exil" appeared in *Le National* in 1850, followed by "Notions d'histoire à l'usage des enfants" (Basic history for the use of children) (1851) and accounts of her travels in Asia Minor (1858).

Chassériau's portrait of the princess dates from 1847; Henri Lehmann's, which was exhibited at the Salon of 1844, depicts her as even more emaciated, but with the same large gazelle's eyes. She was also a model for Hayez and, in literature, for Musset. According to Vapereau's *Dictionnaire des contemporains,* "Balzac thought he recognized that artistic and republican grande dame in the duchesse de San Severino, whom Stendhal made the heroine of *The Charterhouse of Parma*"—a surprising assertion given that, if the princess resembled any literary heroine, it would seem to have been rather one of Balzac's own creations. In fact, according to P. Barbéris (preface to the Livre de Poche edition of Balzac's *La Fille aux yeux d'or* (The girl with the golden

eyes), p. 234), the princess was a famous and acknowledged lesbian, who could have inspired a character in that acerbic novella.

L.-A. P.

165

Portrait of Marie-Thérèse de Cabarrus

1848
Oil on canvas
53 ¼ x 38 ⅝ in. (135 x 98 cm)
Signed and dated, bottom left: *Théodore Chassériau 1848*
Quimper, Musée des Beaux-Arts (55.11)

PROVENANCE:
Dr. Édouard de Cabarrus; bequest of Mme de Saint-Amand Matignon, née Cabarrus, to the Musée des Beaux-Arts, Quimper, 1901.

BIBLIOGRAPHY:
Houssaye, *L'Artiste*, 5th series, vol. 1, no. 2, March 19, 1848; F. Pillet, *Le Moniteur universel*, April 3, 1848; F. de Lagenevais (F. de Mercey), *La Revue des deux mondes*, vol. 22, April 15, 1848; Gautier, *La Presse*, April 27, 1848; Clément de Ris, *L'Artiste*, 5th series, vol. 1, no. 7, April 30, 1848; C. de Chatouville, *Musée des familles*, vol. 15, April 1848; P. Haussard, *Le National*, June 15, 1848; Chevillard 1893, no. 68; Focillon 1928, p. 178; Bénédite 1931, p. 365; Sandoz 1974, no. 115; Prat 1988-1, vol. 1, nos. 562–565; Carriou 1993, p. 62; Barthélémy 1995; Lacambre 1995, no. 32; Peltre 2001, pp. 186–89.

EXHIBITIONS:
Salon of 1848, no. 841; Paris, 1933, no. 44; Paris, 1937, no. 259; Quimper, 1995.

Beginning in the 1840s, up until his death, Chassériau maintained a friendship with Dr. Édouard de Cabarrus (1801–1870), who not only socialized with artists and writers but was his personal physician. Cabarrus, a specialist in pneumonia—the subject of his thesis in 1827—and an opponent of corsets for women, quickly established a reputation by practicing homeopathy. He was an associate of Émile de Girardin as well as of Arsène Houssaye.[1] This painting, first planned in late 1847 (see the Chronology, p. 277) and exhibited in 1848, between two revolutions, attests to the painter's faithfulness to his milieu; it also establishes a type—a young beauty, who frequented aristocratic Salons during Louis-Philippe's reign—in the same manner as did Ingres's contemporary portrait of Betty de Rothschild. Marie-Thérèse de Cabarrus (1825–1899), the daughter of Édouard and the granddaughter of Mme Tallien—one of the lions of Thermidor and of the Directoire, whose memory Delphine de Girardin celebrated in *La Presse* in 1841[2]—was a fixture of Parisian high society. The elliptical mention in the handbook to the Salon of 1848 could not conceal her identity from those journalists who had some social exposure.

Here, more than in the portrait of his sisters that was exhibited at the Salon of 1843, Chassériau sacrificed any display of seductiveness by his female figures in order to conform to the social code—the sexism of which has rightly been denounced by gender studies. In that respect, he followed in the footsteps of Élisabeth Vigée-Lebrun and François Gérard, who both had painted portraits of Mme Tallien (see the 1804 painting by Gérard at the Château de Chimay). In a luxurious interior, amid fabrics of a tawny brilliance, the twenty-three-year-old Cabarrus stands before us in a white dress, perhaps a reminder of the Directoire, bedecked with flowers like an ancient goddess, her bearing stiff yet detached at the same time. Who can say whether Robert de Montesquiou ever saw that bouquet of blue hydrangeas at the Château des Clayes! Marie-Thérèse's demeanor is reminiscent of that of the artist's two sisters, and of Mme Moitessier in the early portrait by Ingres (1847–52; Washington, D.C., National Gallery of Art). The face is refined, with a pleasing femininity; the nose, eyes, and eyebrows are subtly delineated; and the sensual mouth is half open. The sitter's slightly distracted look increases the imperiousness of her gaze, which meets our own without any false modesty. Her right hand, which grasps an armrest, adds to her physical presence, conferring on her a strange reality like that of a fashion shot.

Chassériau, however, in keeping with his personal canon, could not resist making the shoulders too broad and the arm too muscular. Thus, the angel becomes bizarre, impure. If we look closely, we see that this young woman, who would marry Claude Saint-Amand Matignon in September 1848, lets the unexpected seductress, the woman underneath the Salon creature, show through. It is therefore easy to understand the uneven reception of the painting by the critics. Clément de Ris clearly had trouble accepting the fact that this woman corresponded so little to the *feminine* norm: "It is with a great deal of astonishment that one eventually recognizes that pale and skinny figure by M. Chassériau, with the narrow [*sic*] shoulders, sunken chest, and greenish and cadaverous flesh, as *mademoiselle C . . . ,* that lovely young woman overflowing with vitality and health, in whom life bursts forth and radiates through every pore and who bears so lightly the weighty legacy of several generations of beauty. I confess I was surprised that, given the indisputable talent and marvelous skill I recognize in M. Chassériau, he did not take better advantage of the wonderful model he had before him."[3]

In *L'Artiste,* where this mixed review appeared, Houssaye, its director at the time, had previously taken care to alert readers: "The portrait of Mlle Cabarrus is one of the pearls of the Salon. There is only one word for it: it is charming; it is truth glimpsed beneath the figure of poetry. Mademoiselle Cabarrus is beautiful, like her grandmother, Mademoiselle Tallien, on 9 Thermidor."[4]

Gautier was of the same opinion, although, like Clément de Ris, he would have preferred to see the blood circulating with more liveliness through those pretty veins:[5] "The young woman dressed in a shimmering white silk dress, her shawl folded over her arm, is standing and leaning against a buttercup-colored upholstered loveseat; in one of her hands, she balances a bouquet of Parma violets; the other arm dangles nonchalantly at her side. She is wearing a crown of narcissus, the mother-of-pearl petals accenting her brown hair; her large blue eyes are bathed in light and, under their black lashes, her sharp and brilliant gaze flashes; from her dark red mouth, with its pearly teeth, a smile bursts forth like a bolt of lightning. . . . This portrait, skillfully painted and a very good likeness, in its perfect elegance and distinction, has no flaws except a certain pallor caused by the misuse of greenish halftones."[6]

The portrait, whether a commission or a form of payment—the painter was short of funds his whole life—

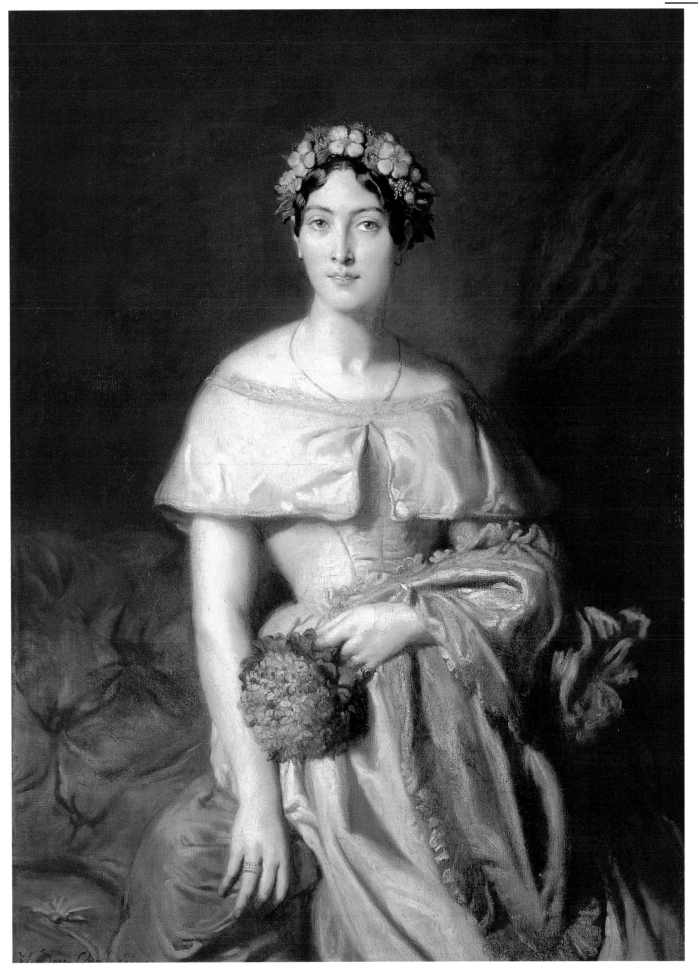

entered the Musée des Beaux-Arts in Quimper upon the sitter's death. She never parted with this painting, which, according to Focillon, shows her prepared "for some mysterious sacrifice."[7] No doubt, she appreciated, as we still do, the tension it conveys between propriety and relaxed sensuality, authority and youthful transgression.

S. G.

1. On Édouard de Cabarrus and his daughter see the excellent commentary on the painting prepared by Sophie Barthélémy in 1995, at the Musée des Beaux-Arts, Quimper.
2. Until her death in 1835, Mme Tallien, who had become the princesse de Caraman-Chimay in 1805, socialized with artists, such as Carle Vernet and Isabey, and writers, from Sophie Gay to Lamartine.
3. L. Clément de Ris, "Salon de 1848," in *L'Artiste,* 5th series, vol. 1, no. 7 (April 30, 1848).
4. A. Houssaye, "République des arts et des lettres," in *L'Artiste,* 5th series, vol. 1, no. 2 (March 19, 1848).
5. Other critics shared that reservation about the flesh tones. According to Pillet: "The portrait of Mlle . . . is very pure in its draftsmanship, which obviously upholds the severe style of M. Ingres's school. It would be irreproachable if the flesh tones had a bit more transparency. The artist, moreover, has so many advantages in the most essential aspects of his art, that he can bear without harm all the rigors of criticism" ("Beaux-Arts. Salon de 1848," in *Le Moniteur universel* [April 3, 1848]). Chatouville noted: "That beautiful person must begrudge M. Chassériau a little. In his use of color this painter of merit cannot convey the kind of beauty the granddaughter of Mme Tallien possesses. Thank God, her rosy cheeks can belie the artist's somber palette, but such beauty needs a more realistic and less Oriental type of painting" ("Salon de 1848," in *Musée des familles,* vol. 15 [April 1848]). Haussard wrote: "The portrait of Mlle ***, by M. Th. Chassériau, has more order, style, and true distinction (than those of Lehmann) but it fails in its execution" ("Beaux-Arts. Salon de 1848," in *Le National* [June 15, 1848]).
6. T. Gautier, "Salon de 1848," in *La Presse,* Paris, April 27, 1848.
7. Focillon 1928, p. 178.

166

Young Woman with Flowers in Her Hair, Seen in Half Length and Almost Full Face

1848
Graphite on gray-beige paper (unevenly cut)
10 ½ x 8 ⅜ in. (26.7 x 21.3 cm)
The artist's initials appear on the reverse
Paris, Musée du Louvre (RF 25061)

PROVENANCE:
See cat. 20.

BIBLIOGRAPHY:
Chevillard 1893, part of no. 420; Sandoz 1974, under no. 115; Prat 1988-1, vol. 1, no. 562, ill.; Peltre 2001, p. 188, fig. 212.

EXHIBITION:
Paris, Louvre, 1957, no. 70.

Exhibited in Strasbourg only

This drawing is a preparatory study for the *Portrait of Marie-Thérèse de Cabarrus* (cat. 165). Although the young woman's final pose has already been determined in this drawing, many variants in relation to the definitive portrait survive: The dress will be very different and there will be more flowers in her hair. As for the bouquet she is holding in her left hand, it will be much larger, which Chassériau himself suggests in an annotation on another drawing in the Louvre—a compositional study for a portrait (Prat 1988-1, vol. 1, no. 1088, ill.): "a portrait of a blond woman in motion—fresh and delicate in tone against a rich background—with an enormous bouquet of fragrant and rare flowers."

L.-A. P.

167

Woman Seen Full Face, Moving Toward the Right; Head of a Woman in Left Profile

1848
Pen and brown ink, with brown wash
12 x 7 ⅝ in. (30.3 x 19.2 cm)
Dated and inscribed in pen and brown ink, upper right: *blanche et Blonde / Novembre 1848* [white and Blonde / November 1848]
Paris, Musée du Louvre (RF 24447)

PROVENANCE:
See cat. 20.

BIBLIOGRAPHY:
Chevillard 1893, part of no. 420; Bénédite 1931, vol. 1, ill. p. 195; Sandoz 1986, no. 155, ill.; Prat 1988-1, vol. 2, no. 1840, ill.

EXHIBITIONS:
Paris, Galerie Dru, 1927, no. 126; Paris, Orangerie, 1933, no. 162; Paris, Louvre, 1980–81, no. 68.

Exhibited in Strasbourg only

CAT. 166

CAT. 167

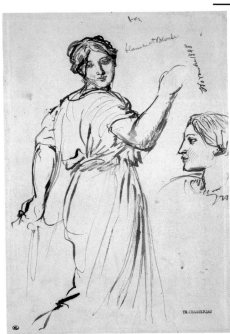

This drawing, known by the title *Study of a Blonde Woman,* supposedly represents Alice Ozy, who is the sitter in other known portrait drawings (see cat. 168, 169).

The sitter is the same as in another pen drawing in the Louvre that is very similar to the left-profile study here and that also has an inscription noting the model's blondeness (Prat 1988-1, vol. 2, no. 1870, ill.). Alice Ozy—it should be recalled—was a brunette. . . .

<div align="right">L.-A. P.</div>

168

Portrait of Alice Ozy

1848
Graphite
10 ¼ x 7 ¼ in. (26 x 18.3 cm)
Dated in graphite, lower right: 1848
The Detroit Institute of Arts (65.142)

PROVENANCE:
Jean-Marc Gras (Chassériau drew his portrait in 1849; see Prat 1988-2, no. 158, with earlier references); Georges Vicaire; Marcel Vicaire; John S. Newberry, Detroit; acquired by The Detroit Institute of Arts, 1965 (*The John S. Newberry Collection,* exhib. cat. [The Detroit Institute of Arts, 1965], p. 25, ill.).

CAT. 168

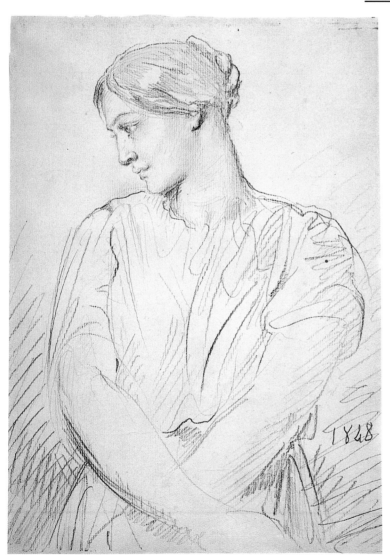

BIBLIOGRAPHY:
Chevillard 1893, no. 363; Vicaire 1961 [1962], pp. 173–81, ill. facing p. 176; Sandoz 1974, pp. 14, 86, fig. 32; Sandoz 1986, no. 91 Bc (mistakenly illustrated as no. 91 Bb); Prat 1988-1, vol. 2, under no. 1840; Prat 1988-2, no. 154, ill.; Peltre 2001, p. 23, fig. 18.

It was in 1848, when she was twenty-eight years old, that Alice Ozy (1820–1893) first met Chassériau, apparently through their mutual friend Théophile Gautier, or through the sculptor Préault. A love affair followed, probably lasting until 1850.

In addition to the present drawing, Chassériau made another rough sketch of the young woman in 1848; in it, she is shown in half length and full face (Zürich, Feilchenfeldt collection; Prat 1988-2, no. 155, ill.; for a long time, this second sketch was mounted in the same frame as the one seen here, and they were not separated until Marcel Vicaire published the two sheets in 1962; see the Bibliography). The artist later executed a more finished portrait drawing of her (cat. 169) and he evoked her features in several famous paintings (cat. 173, 237).

Born Julie-Justine Pilloy (August 6, 1820), she was the daughter of a jeweler in the rue Saint-Denis. After working in an embroidery factory and then as a store clerk, she began a relationship with an actor, and, quite naturally, became an actress herself at the age of nineteen, taking the stage name, Alice Ozy. She soon seduced the duc d'Aumale, just returned from his Algerian campaign, and then the banker Perregaux. In 1843, she became involved with Théophile Gautier, who extolled her in a famous quatrain (1843):

> *Pentélique, Paros, marbres neigeux de Grèce*
> *Dont Praxitèle a fait la chair de ses Vénus,*
> *Vos blancheurs suffisaient à des corps de déesses . . .*
> *Noircissez, car Alice a montré ses seins nus!*

> *Pentelic, Parian, snowy marbles of Greece*
> *Which Praxiteles used for the flesh of his Venuses,*
> *Your white sufficed for the bodies of goddesses . . .*
> *Blacken now, for Alice has bared her breasts!*

In 1847, she made the acquaintance of Victor Hugo and his son Charles, fulfilling the wishes of the young man at the expense of the genius. It was after a stay in London during the Revolution of 1848 that she met Chassériau. Their affair lasted two years, and ended after a quarrel occasioned by the young woman's desire to possess the portrait known as *The Daughter of El Greco* (cat. 5).

After the painter's death, she contacted Baron Arthur Chassériau, and both became outraged at the terrible and false description of her former lover in Hugo's *Choses vues* (1887), easily decipherable despite the pseudonyms: Alice is Zubiri and Serio Chassériau is the narrator, Hugo; as for the others mentioned in the dialogue, Prince Cafrasti may be the duc d'Aumale, Princess Belle-Joyeuse is Princess Belgioioso (see cat. 164), the comtesse d'Agosta is Marie d'Agoult (see cat. 53), and the "forty-five-year-old bluestocking devil," Delphine de Girardin (?). Curiously, Hugo states that his account of the night of February 23–24, 1848, is "from life," which Hubert Juin, in his edition of *Choses vues* (Folio Gallimard, pp. 488–89, p. 241 n. 1), seems to accept without reservation, even

though, in the same work, and on the same February 23, Hugo writes (p. 274) that after a long walk in the insurgent city of Paris, "midnight is sounding at this moment. There are ten cannons in place de Grève. Le Marais has a lugubrious look. I took a walk there and am going home." Nevertheless, in the manuscript, Hugo crossed out the number 2 in his title *Night of February 23 to February 24*. In any case, Alice Ozy was not in Paris at the time of the revolution—but we should not entirely dismiss the misinformed poet's narrative, despite its inaccuracies on many points:

She had a necklace of real pearls and a red cashmere shawl, of a strange beauty. The palms, instead of being in color, were embroidered in gold and silver and trailed at her heels, so that what was charming was at her neck and what was dazzling was at her feet, a perfect symbol of that woman who willingly allowed a poet into her boudoir and left a prince in her antechamber.

She entered, threw her shawl on a settee, and went to sit at the table laden with food near the fire. Cold chicken, a salad, and a few bottles of champagne and Rhine wine.

She had her painter sit on her left and, pointing out a chair to me on her right, she said: "Have a seat there, near me, and don't play footsie with me; one mustn't betray that nitwit. If you only knew, I'm the nitwit, I love him. Look at him, he's very ugly."

As she was speaking to me that way, she was eyeing Serio with an intoxicated look.

"It's true," she continued, "he has talent, great talent even, but just picture what a strange impression he made on me. I'd seen him for some time prowling in the wings, and I'd say: 'So who's that fellow who's so ugly?' I said that to Prince Cafrasti, who brought him over one evening for supper. When I saw him up close, I said: 'He's a monkey.' He looked at me I don't know in what way. At the end of supper, I squeezed his hand as I passed him a plate. As he was leaving, he asked me very softly: 'What day do you want me to come back?' I replied: 'What day? Don't come in the daytime, you're too ugly, come at night.' He came one evening. I snuffed out all the candles. He came back the next day, and then the next, for three nights like that. I didn't know what was the matter with me. On the fourth day, I told my piano teacher: 'I don't know what's the matter with me. There's a man I don't know—I didn't know his name—who comes over every evening. He puts my head on his chest and then speaks to me softly, so softly. He is very poor, he hasn't a penny, he has two sisters who have nothing, he is ill, he has palpitations. I'm scared to death that I'm falling madly in love with him.' She said: 'Bah!' The fifth day, it seemed like that feeling was going away. I told my piano teacher: 'So now that fellow's beginning to bore me!' She said to me: 'Bah!' I had no idea what was going on anymore. Monsieur, it's lasted thirty-two days. And would you believe it: he doesn't sleep. In the morning, I kick him out the door."

"It's true," Serio interrupted melancholically, "she lashes out."

She leaned toward him and said idolatrously: "You're really too ugly, don't you see, to have a pretty woman like me. In fact, monsieur," she continued, turning toward me,

"you can't tell, my face is a tired-looking face, that's all, but I really have some very pretty things. Now tell me, Serio, shall I show him my bosom?"

"Go ahead," said the painter.

I looked at Serio. He was pale. As for her, with a gesture full of coquetry and hesitation, she slowly drew back her half-open dress, and, at the same time, questioned Serio with eyes that adored him and a smile that made fun of him.

"What difference does it make to you if I show him my bosom? Come on, Serio. He has to see it. Anyway, I'll be his one of these days. I'm going to show him. Do you want me to?"

"Go ahead," replied Serio.

His voice was guttural. He was green. He was suffering horribly. She burst out laughing.

"Really!" she said, "So what if he sees my bosom, Serio! Everyone's seen it."

And, simultaneously, she resolutely grabbed her dress with both hands and, since she wasn't wearing a corset, her bodice, split apart in front, revealed one of those admirable bosoms that poets celebrate and bankers can afford. Danaë must have assumed that pose with that open bodice the day Jupiter transformed himself into Rothschild to get in to see her.

Well, at that moment, I didn't look at Zubiri. I looked at Serio.

He was trembling with rage and sorrow. All of a sudden, he began to snicker like a poor wretch who's dying inside.

"So look at her then!" he told me. "The bosom of a virgin and the smile of a whore!"

I forgot to say that, while all this was going on, one or another of us had cut up the chicken, and we were dining.

Zubiri let her dress close again and exclaimed: "Ah! you know very well that I love you. Don't be angry. Because you have had only old women till now, you are not used to the others, like me. Of course! It's all very simple, your old women had nothing to show you. It's true, my poor boy, you have only had old women. You are so ugly! Well, what do you want them to show you, your princess Belle-Joyeuse, that ghost! The comtesse d'Agosta, that witch! And your great forty-five-year-old bluestocking devil, with her blondish hair! Why don't you all hide yourselves away? À propos, monsieur, you haven't seen my leg."

And, before Serio could make a move, she'd placed her heel on the table, and, with her dress pulled up, displayed, right up to her garter, the most beautiful leg in the world, covered with a transparent silk stocking.

I turned toward Serio. He wasn't talking anymore, he wasn't moving, his head was tilted back against the chair. He had fainted.

Zubiri rose, or rather sprang to her feet. Her eyes, which, a minute before, registered her coquetry, now were full of anguish.

"What's the matter with him?" she shouted. "Well,

aren't you stupid!" She threw herself on him, called his name, slapped his hands, threw water in his face; in the blink of an eye, vials, flasks, ramekins, elixirs, and vinegars covered the table, mingling with half-empty glasses and a half-eaten chicken. Serio slowly reopened his eyes.

Zubiri sank down to the floor and sat at Serio's feet. At the same time, she took both the painter's hands in her own little white hands, which seemed to have been sculpted by Coustou. As she fixed her eyes frantically on Serio's eyelids, which were reopening, she murmured:

"That bastard! Getting sick just because I show my leg. Well, if only he'd known me for six months, what fainting spells he'd have had! But really, you're no idiot, Serio! You know very well that Zurbaran did a nude portrait of me . . ."

"Yes," Serio pined. "And he made you a big fat woman, a Fleming. It's very bad."

"He's an animal," Zubiri continued. "And since I didn't have any money to pay for the portrait, right now he's offering it to I don't remember who, for a song! Well, you can see very well, you mustn't get mad. What's a leg? In fact, it's a sure thing your friend will be my lover. After you, don't you see. Oh, right now, monsieur, I couldn't. You could be Louis XIV and I couldn't. Someone could give me fifty thousand francs and I couldn't cheat on Serio. You see, I've got Prince Cafrasti, who'll be back one of these days. And then someone else. You know, there's always a clientele. And then there are people who desire me. There are always curious people who have money and who say: 'Hey, I'd like to spend a night with that creature, with that whore, with those eyes, those shoulders, that insolence, that cynicism. It must be funny to see that Zubiri close up.' Well, I don't want anything to do with anybody! Nobody! I'm used to Cafrasti. Monsieur, when Cafrasti comes back, I won't be able to bear him for more than ten minutes. If he stays a quarter of an hour, I'll kill him, that's what I've come to. I adore this one. Isn't he a bastard to get sick and frighten me like that! I should have gotten Coelina out of bed. My maid's name is Coelina. A woman of the world would have gotten her out of bed, but whores like us let them sleep, those whores. We're good, since we haven't anything else. Oh, now he's completely recovered. Oh, my poor boy! If you only knew how I love you!! Monsieur, he wakes me up every night at four o'clock in the morning and talks to me about his family, his poverty, and the large painting he did for the Conseil d'État. I don't know what's the matter with me, it makes me shiver, it makes me cry. But then, he might not give a damn about me with all his whining, maybe he told that nonsense to his old women too. Men are such scoundrels! I'm really stupid to get caught up in all that, don't you think? You're laughing at me, aren't you? I don't care, it's gotten hold of me. I think of him in the daytime, it's so bizarre! There are times when I'm quite sad. You know what? I want to die. As a matter of fact, I'm going to be twenty-four, I'm going to be old too. What's the point of getting wrinkles, withering away, and falling apart little by little? It's better to go all at once. At least then a few lazy fellows smoking their cigars outside Tortoni will say: 'Hey, you know that pretty whore? She died!' Whereas, later, they'll say: 'So when is that horrible witch going to die! What business has she got living like that! What a bore!' Those are the elegies I'm creating

for myself. Oh, but I really am in love for good. In love with this sapajou Serio! Yes, monsieur, with this sapajou Serio! Anyway, can you imagine, I call him my mother!"

At this she lifted her eyes to look at Serio. He raised his eyes to heaven. She asked him quietly: "What are you doing?"

He replied: "I'm listening to you."

"Well, what do you hear?"

"I hear a hymn," said Serio.

At the end of her life, when she had become a respectable pensioner, Alice Ozy, in memory of her former lover, was able to buy back his *Susanna and the Elders* of 1839, which she offered to the Louvre in 1884. She died on March 4, 1893 (cat. 15). Several portraits of her are known, including a watercolor by Vincent Vidal (1811–1877), in the Fitzwilliam Museum, Cambridge (Inv. 1993 PD. 35-1933). Works by G. Pierredon, Louis Loriot (1910), and especially by Jean-Louis Vaudoyer (1930), who perceptively called her "the modern Aspasia" (the subtitle of his book), add details to the portrait of this superb courtesan that is unexpectedly echoed in Balzac's description of another actress-courtesan, Florine, in *Une Fille d'Ève* (A daughter of Eve) (1839), which prefigures what her beauty and charm were to be:

When she turned her head, magnificent creases, the admiration of sculptors, formed in her neck. On that triumphant neck was the small head of a Roman empress, the elegant, refined, round, and willful head of Poppaea, the features spiritual in their perfection, the smooth forehead of women who chase away cares and reflection, who give in easily, but who can also be stubborn as mules and then won't listen to anyone. That forehead, as if cut with a single stroke of the chisel, set off her beautiful ashen hair, almost always combed forward in two equal bunches, in the Roman style, and pulled into a knot at the back to make it look larger and to emphasize, by its color, the whiteness of her neck. Fine, black eyebrows, drawn by some Chinese painter, framed soft eyelids that displayed a network of pink filaments. Her pupils, illuminated by a bright light, but with brown streaks across them, gave her the cruel fixed gaze of a wild animal and revealed the cold malice of the courtesan. Her adorable gazelle's eyes were a beautiful gray, fringed with long black lashes, a charming contrast that made their expression of alert yet calm sensuality even more evident. The eyes were outlined in faded tones; but, in the artistic way in which she knew how to slide her pupil into the corner or the top of her eye, to observe or to seem to be meditating, the way that she held it fixed, so that it projected its full brilliance without disturbing her head, without altering the immobility of her face, a maneuver she had learned on the stage, and the keenness of her gaze when it took in an entire room, seeking someone in it, made her eyes the most terrible, the softest, the most extraordinary in the world. Rouge had destroyed the delightfully diaphanous hues of her cheeks, with their delicate skin; but, although she could no longer blush or turn pale, her thin nose, with its passionate pink nostrils, expressed the irony, the mockery, of Molière's servant women. Her sensual and dissolute mouth, as suited to sarcasm as to love, was embellished by the two ridges along the furrow between her upper lip and her nose. Her

white chin, a little full, proclaimed a certain amorous fury. Her hands and arms were worthy of a sovereign.

In the Detroit portrait, the delicacy of the face gives way to a certain monumentality that is found neither in the Feilchenfeldt nor in the Carnavalet drawing (see cat. 169). However, the intense and rapt expression and the crossed arms, which reinforce the broadness of the shoulders, make the figure appear almost maternal, tender and powerful at the same time. Thus, she truly corresponds to Gautier's description of her in *La Chaîne d'or* (The golden chain): "She is imposing, svelte, well formed; she has black hair, a full mouth, a gleaming smile, moist and shiny black eyes, a charming voice, plump and strong arms, and hands of a perfect delicacy. Her skin is a fiery and lively bronze, glinting with gold, like Ceres's neck after the harvest" (quoted by J.-L. Vaudoyer, "Les Portraits de Chassériau," in *Formes* [1932]). L.-A. P.

169

Portrait of Alice Ozy

1849
Graphite
12 ⅝ x 9 ½ in. (32.1 x 24 cm)
Signed and dated in graphite, lower left: *Th⁽ʳ⁾ Chassériau / 1849*—
Paris, Musée Carnavalet (D. 5846)

PROVENANCE:
Frédéric Chassériau, the artist's brother, Paris, until 1881; Baron Arthur Chassériau, Paris; bequest of the latter to the Musée Carnavalet, 1934.

BIBLIOGRAPHY:
Chevillard 1893, no. 311; Marcel and Laran 1911, pp. 95–97, ill.; Vaillat 1913, p. 26; Bouyer 1920, p. 530; Bénédite 1931, vol. 2, pp. 379–97, ill. p. 381; Alazard 1933, p. 56; Boyé 1946, ill. facing p. 15; Gérard 1957, ill. p. 17; Vicaire 1962, p. 176; Sandoz 1974, p. 14; Sandoz 1986, no. 91, ill.; Prat 1988-1, vol. 1, under no. 590; Prat 1988-2, no. 156, ill.; Peltre 2001, p. 23, fig. 17.

EXHIBITIONS:
Paris, Galerie Dru, 1927, no. 25; Paris, Orangerie, 1933, no. 163.

Exhibited in Paris only

[Reproduced in photogravure (a copy is in the Musée Gustave Moreau, Paris; Inv. 11912-66).]

In *Alice Ozy ou l'Aspasie moderne* (Alice Ozy or the modern Aspasia), Jean-Louis Vaudoyer (1930, p. 70, ill. opp. p. 72) described this portrait drawing, which followed the two studies of 1848 (see cat. 167): "Her sweetly familiar grace exudes an intimate sensuality, tinged with a softness and strength at the same time. Alice's beautiful body is free under a striped gandoura that envelops her form without revealing it. Both arms are bare, dangling loosely on her lap; her supple neck, also bare, supports her oval head, which, with its hair bands, would be classical, were it not for that famous turned-up nose, which always distressed Alice ('I was born to act,' she said, 'if only I'd

had an aquiline nose'). One must acknowledge that this delightful pencil sketch reflects a happy love affair. It is so fervent, in its voluptuous tenderness, that one can hardly look at it without envying the moment when it was made."

See catalogue 168. L.-A. P.

CAT. 169

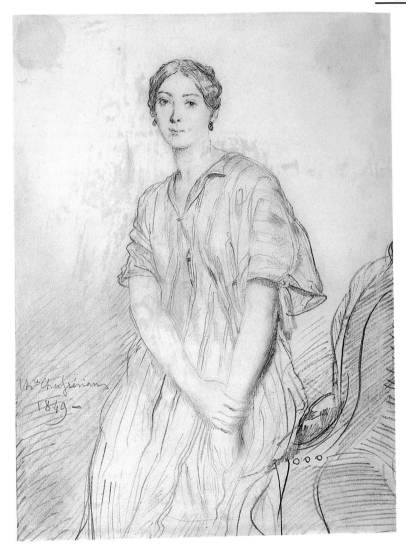

Chronology

1844–48

January (?)

■ Cour des Comptes: Official Commission

A letter of recommendation from Tocqueville or Guizot, and sent to Minister of the Interior Duchâtel, asks that Chassériau be entrusted with the "grand staircase at the Cour des Comptes the monument on the quai d'Orsay. . . . Mr. Chassériau has proven himself as a history painter, namely in the Chapel of Saint Mary of Egypt in the Church of St Méry [sic]" (Copy of a letter sent by Tocqueville or Guizot to Duchâtel, Minister of the Interior [January 1844]; AN, F²¹. 4402, dossier 13).

■ Refusal

A copy of the above request bears the notations at the upper left: "recommended by M. de Tocqueville" and "M. Mercey," and at the upper right, in Mercey's handwriting: "There are no funds for this project, give M. Chassériau something else."

February 7

■ The Vialis Portrait (continued) and the Cour des Comptes

Benoît Chassériau advises his "good, dear Théodore" not to neglect the "matter of Mr de Vialis, who is undoubtedly one of our most distinguished Frenchmen, and whom I have every reason to praise" (see above, *April 5* and *11, 1843*). He also asks, "What new projects could you hope to obtain" (Letter from Benoît Chassériau to his son Théodore, February 7, 1844, San Juan, Puerto Rico; quoted in Bénédite 1931, vol. 1, p. 228; Sandoz 1974, nos. 35, 36, pp. 128, 130; published in Prat 1988-1, vol. 2, no. 22, p. 975). The question about "new projects" probably alludes to the Cour des Comptes (see above, *December 27, 1843*).

February 29

■ The Salon Jury

Christ on the Mount of Olives (cat. 79) is accepted by the Salon (9th session of the jury, February 29, 1844; Archives des Musées Nationaux, *KK. 61, no. 3602).

March 15

■ Salon of 1844

The exhibition catalogue (*Explication des ouvrages de peinture, sculpture, architecture, gravure et lithographie des artistes vivants exposés au musée royal le 15 mars 1844* [Paris, 1844], pp. 42–43) lists the following:

"Chassériau (Théodore), *34, rue Frochot*.

[no.] 327—Christ on the Mount of Olives (16 x 11 ft.; Sandoz 1974, no. 97, p. 208).

33.—And he taketh with him, Peter and James and John, and began to be sore amazed, and to be very heavy;

34.—And saith unto them: My soul is exceeding sorrowful unto death; tarry ye here and watch.

35.—And he went forward a little, and fell on the ground, and prayed that, if it were possible, the hour might pass from him.

36.—And he said, Abba, Father, all things are possible unto thee; take away this cup from me; nevertheless not what I will, but what thou wilt.

37.—And he cometh, and findeth them sleeping (Mark 14)."

■ Poor Placement

Gautier and Houssaye accuse the members of the jury of having ordered Chassériau's *Christ* to be hung on the second floor of the Salon Carré, where "it was very difficult to appreciate" (Bénédite 1931, vol. 1, p. 213).

March 15–31

■ Lithograph of *Christ on the Mount of Olives*

Chassériau asks the editor of *L'Artiste* that his "*Crist* [sic] be well engraved and please give me the address of the engraver who is supposed to do it, so that I can see him while he is working" (Letter from Théodore Chassériau to A.-H. Delaunay, [about March 15–20, 1844, Paris]; Médiathèque, La Rochelle, MS 621, fol. 226; Peltre 2001, p. 98). Edmond Hédouin (1820–1889) executes a lithograph (not an engraving) that is printed in the March 31 issue of *L'Artiste* (Bouvenne, September 1887, p. 117; Sanchez and Seydoux 1998, vol. 1, p. 159).

April–May (?)

■ Cour des Comptes: Tocqueville's Ploy

Between December 27, 1843, and January 1844 —the probable date of the administration's refusal (see above)—and June 11, 1844 (see below), when the project is accepted, the Chassériau brothers strive to obtain support for the Cour des Comptes commission. According to Marius Vachon (1879, pp. 19–21), the tide turned one evening at Tocqueville's. The latter made it known to Vitet, then a candidate for the Académie Française and a close friend of the "comte Duchâtel, Minister of the Interior," that Vitet would get his vote on the "*sine qua non* condition that Chassériau be given his mural." Several days later, "Chassériau received the commission." Vitet would be elected to the Académie Française May 8, 1845.

May 11

■ The Vialis Portrait (continued)

Benoît Chassériau mentions a letter from Théodore acknowledging his acceptance (see above, *April 5* and *11, 1843*, and *February 7, 1844*). Benoît writes to his son Frédéric: "Théodore should let me know what his conditions are so that I can pass them on to M. de Vialis, who requires no special treatment, since he is as rich as we are poor and none of us owes him anything" (Letter from Benoît Chassériau to his son Frédéric, May 11, 1844 [San Juan, Puerto Rico]; published in Bénédite 1931, vol. 1, p. 229). This portrait has not come down to us, but there are two preliminary sketches in the Musée du Louvre (Prat 1988-1, vol. 1, nos. 367–368, pp. 188–89). Noteworthy is Benoît's admission of the family's poverty several months before his suicide (see below, *September 27, 1844*).

May 27

■ The Vialis Portrait (continued, and the end)

Benoît Chassériau reminds Frédéric to tell Théodore that, when he sends the portrait, he should not have "too much concern for the purse of this Gentleman, who can and wants to pay" (Letter from Benoît Chassériau to his son Frédéric, May 27, 1844 [San Juan, Puerto Rico]; published in Bénédite 1931, vol. 1, p. 229).

Late May (?)

■ Official Praise and a Warning

In his report on the Salon, Cailleux, director of the Musées Royaux, explains that the work submitted by "M^r Chassériau . . . shows promise; one can only hope that this artist, who seems to be wholly devoted to his art, will be able to resist this unseemly praise, which only hinders an artist's efforts" (Archives des Musées Nationaux, dossier 10, Salon de 1844, "Rapport à Monsieur l'Intendant Général sur l'Exposition des Arts de 1844" [undated], fol. 10).

■ Purchase Offer

A reference to "Chassériau (T^re) Christ on the Mount of Olives" appears on a list entitled "Inventory of the objects exhibited at the Salon of 1844 that could be acquired by the M[inistry] of the Interior." Of the twenty-one names suggested, Chassériau's is the only one to be marked with a penciled cross (Archives des Musées Nationaux, dossier 10, Salon de 1844). The work would finally be acquired by the Ministry of the Interior four years later, on July 20, 1848 (see below), for the Church of Sainte-Marie in Souillac.

■ Medal

Chassériau is nominated for a second-place medal in the "History" category (Archives des Musées Nationaux, dossier 10, Salon de 1844, "État des Médailles que l'on pourrait accorder aux artistes à la suite du Salon de 1844"). The artist's signature on the document indicates that he picked up his medal (Archives des Musées Nationaux, dossier 10, Salon de 1844, "Exposition de 1844. Médailles").

June 11

■ Cour des Comptes: The Commission

The Minister of the Interior informs the Directeur des Beaux-Arts: "For our department records, M. Chassériau has been engaged to execute the paintings for the two walls to the right and left at the top of the staircase that leads to the Cour des Comptes in the palace on the Quai d'Orsay. He will have to submit the subjects and sketches for these paintings for your approval." He was to be paid "the sum of thirty thousand francs," from 1845 to 1848 (Copy of a letter from the Minister of the Interior to the Directeur des Beaux-Arts, June 11, 1844, Paris; AN, F^21. 4402, dossier 13).

June 14

■ Cour des Comptes: The Official Commission

The Directeur des Beaux-Arts at the Ministry of the Interior informs Chassériau that the minister is entrusting him with the paintings for the "two walls to the right and left at the top of the staircase that leads to the Cour des Comptes in the palace on the Quai d'Orsay" and that "the subjects and sketches for these paintings must be submitted for the approval of H.E. [His Excellency]" (Copy of a letter from the Directeur des Beaux-Arts to Théodore Chassériau, June 14, 1844, Paris; AN, F^21. 4402, dossier 13).

June 15

■ The Mont-Carmel Lottery

Chassériau donates a drawing to the benefit for Mont-Carmel. The 480 lots included a painting by Horace Vernet, a drawing by Ingres, and seascapes by Isabey and Gudin (D. de Girardin, June 15, 1844; published in Martin-Fugier 1986, vol. 2, pp. 293, 554 n. 152).

June 16

■ Cour des Comptes: Subjects and Sketches

Chassériau tells the Minister of the Interior that he will have the "honor of submitting to him the subjects and sketches of the compositions, which seem to me best suited to the style and purpose of the monument" (Letter from Théodore Chassériau to the Minister of the Interior, June 16, 1844, Paris; AN, F^21. 4402, dossier 13).

June 18

■ The Chassériau-Lehmann War

Marie d'Agoult warns Lehmann: "I have just read about Chassériau's staircase in J[ules] J[anin]'s column and can see the war against you starting again" (Letter from Marie d'Agoult to Henri Lehmann, June 18, 1844 [Monnaye]; Archives du comte Hauteclocque; transcribed by Ch.-F. Dupêchez; Joubert 1947, p. 205). Janin ("La Semaine dramatique," *Journal des débats,* Monday, June 17, 1844, pp. 1–2) only reported on the commission.

June 21

■ A Great Man

After reading Delphine de Girardin's column, Marie d'Agoult writes to Lehmann: "Here is Chassériau in a position to become a great man—but what a Beatrice Delphine makes! By the way, do you read her Courriers de Paris? She has no more taste than a chambermaid (you know that this is my favorite word for expressing contempt)" (Letter from Marie d'Agoult to Henri Lehmann, June 21, 1844 [Monnaye]; Archives du comte Hauteclocque; transcribed by Ch.-F. Dupêchez; Joubert 1947, p. 207). Girardin's article appeared on June 16 (*La Presse,* Sunday, June 16, 1844, pp. 1–2).

June 23

■ *Apollo and Daphne*

A lithograph by Chassériau, after a painting later exhibited at the Odéon (see below, *November 1845*), is published in *L'Artiste* (June 23, 1844; Baltimore, 1979–80, no. 4, pp. 148–49).

July 24

■ Scaffolding and Evasion

A friend of the family protests the "wretched bureaucratic . . . evasion" over Chassériau's request for scaffolding (Letter from M. de Reste to the Chassériau family, July 24, 1844, n.p.; published in Bénédite 1931, vol. 2, p. 318); letters from June 19 and July 3, 10, and 18 also mention this problem. In the last, the "Secretary of State of the Ministry of Public Works" informs the "Minister of the Interior" that he does not have at his disposal the 6 to 8,000 francs needed to erect scaffolding for the "decoration of the staircase leading to the Cour des Comptes" (AN, F^21. 4402, dossier 13).

August 23

■ The Father's Sorrow

Benoît Chassériau, who had learned of the commission for the staircase of the Cour des Comptes, writes to his wife: "Your success and that of Théodore are my only consolations, and they are great ones, for they have given me a glimpse of light amid the sorrow that is consuming me" (Letter from Benoît Chassériau to his wife, August 23, 1844 [San Juan, Puerto Rico]; quoted in Bénédite 1931, vol. 1, p. 28).

Late August or Early September

■ The Engravings in the "Othello" Series

Chassériau publishes "fifteen sketches after Shakespeare's *Othello*" in Eugène Piot's magazine. According to Chevillard (1893, p. 88), they "had no success," which seems an exaggeration: "Critics immediately reproached him for imitating Delacroix." The cover of the magazine, *Publication du Cabinet de l'amateur et de l'antiquaire,* reads: "Othello / Fifteen etchings / drawn and engraved by Théodore Chassériau / Paris, At the magazine's offices, rue Laffitte, n° 2 / August 1844" (Baltimore, 1979–80, p. 31).

The Ministry of the Interior's permission to print—dated September 12, 1844—is in the Bibliothèque de l'Institut de France (MS 221, pièce 22; quoted in Piot, November 2000, p. 17 n. 89), but the engravings had already been reviewed by Bray on September 8 in *L'Artiste* (p. 32), by Gautier on the 9th in *La Presse,* and on the 16th by Janin (*Journal des débats,* pp. 1–3); see Sandoz 1974, nos. 270–286, pp. 420–33; Peltre 2001, pp. 96–111.

■ Collaborators (?)

Édmond Hédouin (1820–1889), a painter, engraver, and lithographer, may have assisted Chassériau in the "Othello" undertaking. A drawing entitled *Die, Villain!* is annotated by Hédouin: "Je vous laisse [. . .] apporterai une épreuve du . . . Tout à vous—Edm. Gédouin—Alfred Hédouin" [I will leave [crossed out] bring you a proof of the . . . Yours—Edm. Gédouin—Alfred Hédouin] (Prat 1988-1, vol. 1, no. 341, p. 177). According to Fisher (in Baltimore, 1979–80, p. 20), Chassériau also may have been assisted by the engraver and printer Victor Vibert (1799–1860).

September 5

■ Visit to Gautier— *Othello*

On September 4 Chassériau writes to Gautier: "My dear Théophile, I left my sketches for Othello for you at Madame de Girardin's. Take them when you pass by in your car. I was finally given a correct address and will come to see you tomorrow" (Letter from Théodore Chassériau to Théophile Gautier, September [4], 1844 [Paris]; published in Gautier, *Correspondance*, 1986, vol. 2, pp. 175–76). Gautier lived at "Avenue du Point du Jour N° 23 in Auteuil" at the time.

September 12

■ The Father's Mistake

Levasseur, French consul in Port-au-Prince, sends his superiors a long letter informing them of his colleague Benoît Chassériau's "mistake," advising them to "avoid the scandal" that it might cause. According to Levasseur, in June 1842, Benoît Chassériau misappropriated the inheritance of "Mlle Fillette Ernouf . . . [which] consisted of two thousand *Gourdes macoquines* bequeathed to her upon the death of a Frenchman, M. Durécu, with whom she had lived in matrimony in Haiti about 1828, and with whom she had had an illegitimate child, acknowledged by the father." Benoît Chassériau ignores Levasseur's efforts to arbitrate (Letter from Levasseur, Consul General of France, to the Ministry of the Secretary of State, September 12, 1844, Port-au-Prince, signed FM; Archives du Ministère des Affaires Étrangères, dossier Benoît Chassériau, 1st series, 889).

September 20

■ Soirée at the Monnerots'

Mme Monnerot informs her son Jules: "Théodore came to see us yesterday evening. He told me he would send me a letter for you" (Letter from Mme Monnerot to her son Jules, September 21, 1844, Paris; BnF, Dépt. des Ms, Naf. 14405, Papiers Gobineau, vol. 17, fol. 77).

September 27

■ The Father's Suicide

Benoît Chassériau takes his own life at the age of sixty-four in San Juan, Puerto Rico (Bénédite 1931, vol. 1, p. 17); his suicide was unknown to Chassériau's biographers (see below, *November 2, 1844*).

September–October

■ The Schemer

According to Mottez, Chassériau "does nice work, but he has been treading an unusual path for some time. . . . Chassériau is wasting his abilities and his time running after silly articles that are read only in the provinces and that he too should condemn since they give him the reputation here of being a schemer—the worst reputation of all for an artist" (Letter from Victor Mottez to Hippolyte Fockedey [September or October 1844, Paris]; published in Giard 1934, pp. 161–62).

October 21

■ Inauguration of Saint-Vincent-de-Paul

On the occasion of the inauguration of Saint-Vincent-de-Paul, by the architect Hittorff, Father Gaspard Deguerry publicly calls attention to the fact that the church is unfinished and still needs murals. He maintains that only Ary Scheffer and Théodore Chassériau are capable of doing this work (Ewals, July 1980, pp. 35, 39). This "crusade" for the two artists incurs the anger of the *Journal des artistes* (November 3, 1844, pp. 367–70). Ingres would be given the commission, but would withdraw in favor of Picot and Flandrin.

October 28

■ Saddened for Life

One month after his father's death, Chassériau writes to his friend Ranchicourt: "My father has just died in Puerto Rico, far away from us, cared for during his last hours by strangers only. My poor mother and my two sisters had to be told. . . . Well, now they are more calm, and their piety helps them a lot with this painful ordeal. As for me, I am saddened for life" (Letter from Théodore Chassériau to Oscar de Ranchicourt, October [28], 1844, Paris; Archives of Mlle Bellaigue de Ranchicourt; Bénédite 1931, vol. 1, p. 17).

Late October

■ Victor Hugo's Condolences

According to Bénédite (1931, vol. 2, p. 387), Victor Hugo wrote to Théodore, expressing his sincere condolences (Letter from Victor Hugo to Théodore Chassériau [late October (?)], 1844 [Paris (?)]. Chassériau's acquaintance with Hugo is documented as early as March 12, 1842 (see above), at which time they both frequented Marie d'Agoult's salon. Chassériau drew a portrait of the writer in 1843 (Sandoz 1974, p. 51, ill. 17, and 1986, no. 92, p. 109; Prat 1988-2, no. 96, p. 18).

November 2

■ The Father's Death: Revelations

Clémence Monnerot writes to her brother Jules: "You must have read about Mʳ Chassériau's death in the papers. We have seen the ladies and they are very distressed. But what no one yet knows and what I found out through Blanche and Cazotte and the Minister of Foreign Affairs is the cause of this death. About one year ago two merchants from Puerto Rico requested that Mʳ Chassériau give back a deposit of two hundred thousand francs that they had entrusted him with. He denied having received this deposit: com- plaints, rumors—in short, these were reported to the minister so often and with such conviction that he became very embarrassed. After having let things drag on for six months, and because these gentlemen here are very well liked, very protected by Mʳ Guizot, Droin de Lhuys, Lambert, etc., it was decided to accept Mʳ Chassériau's word and that France would not harm its consul by recalling him. But in six months or a year, he should be urged to tender his resignation for one reason or another. It seems that his position in Puerto Rico was no longer tenable from this moment on and, in short, he killed himself. He was not yet sixty-four years old. These gentlemen must know all of this, but the ladies know nothing, neither how he died, nor whether he was ill. Frédéric does not want to show them the letter he received and will not say how he died. This confirms the rumors of suicide; he should immediately have spoken of apoplexy.—We have not seen these gentlemen. In any case, everything here is secret and has scarcely reached the ministry" (Letter from Clémence Monnerot to her brother Jules, November 2, 1844, Paris; BnF, Dépt. des Ms, Naf. 14394, Papiers Gobineau, vol. 6, fol. 67).

Clémence Monnerot's sources seem reliable. Levasseur's letter (see above, *September 12, 1844*) was annotated by Guizot next to a stamp bearing the date March 15, 1845: "M. de Lambert—Please tell me all about M. Chassériau's affairs—We have to answer all the claims and explain that the government is in no way responsible for a consul's bad business / G."

December 13 (?)

■ Meeting with Ali-Ben-Hamet

Chassériau may have met Ali-Ben-Hamet, the caliph of Constantine, upon his arrival in Paris with the Arab chiefs who were then allies of France. On Thursday, December 12, they were given accommodations in the Place de la Madeleine by the Ministry of War. According to *L'Illustration* (December 24, 1844, and January 4, 1845), artists were permitted to paint their portraits "even on the day after their arrival" (see cat. 134).

December 20

■ The Société des Artistes

After Périgon's visit to Chassériau, the artist is nominated to become a member of the committee of the new Société des Artistes Peintres, Sculpteurs, Architectes Graveurs et Dessinateurs (the future "Association" of the same name), which had just been created by Baron Taylor (Letter from Alexis Périgon to Adrien Dauzats [December 1844, Paris]; Bibliothèque d'Art et d'Archéologie Jacques Doucet, Carton 57, fol. 34930; pointed out by A.-M. Debelfort). He is admitted with many other artists, among them Granet, Abel de Pujol, E. Isabey, Rude, Hersent, Baltard, Gatteaux, Flandrin, and Dantan the Elder (Archives de la Fondation Taylor, 3rd Session, Friday, December 20, 1844, fol. 11).

According to Madeleine Rousseau, this association initially attracted militant artists, like the signers of the petition of 1840 (see above, *March 18, 1840*), but soon afterward the review *L'Artiste* (January 1848) deplores the participation of artists with an "old-fashioned mentality" (Rousseau [1935] 2000, p. 57). Although not active in the

association, Chassériau remains a member until his death in 1856.

■ **Dubien Recommended**

Chassériau recommends the young Prosper Dubien (born in Paris January 14, 1822), a pupil of Delaroche, to Cavé "to paint a copy. He begs me to ask you to be favorable to his request and, knowing your usual kindness, I am not afraid to do so" (Letter from Théodore Chassériau to François Cavé [1844 (?), Paris]; BnF, Dépt. des Ms, Naf. 25123, fol. 52 r. and v.). One of the drawings con-

nected with the Cour des Comptes bears the annotation "P. Dubien—Rue de Grenelle St Honoré" (Prat 1988-1, vol. 2, no. 2249, p. 910, fol. 1 r.).

■ **Mme Lamartine's Salon**

At her salon in the rue de l'Université, Mme Lamartine (the poet's wife) receives many artists: Chassériau, Préault, Gigoux, Decaisne, Brian, Simon Saint-Jean, and Huber-Saladin (de Brem and Morin 1990–91, p. 108). That same year, Chassériau draws the *Portrait of Alphonse de Lamartine* (Paris, Musée du Louvre), signing it

with the dedication, "A Madame de Lamartine / Th. Chassériau / 1844" (Sandoz 1974, no. 24; Prat 1988-1, vol. 1, no. 1071, p. 438).

■ **The *Sappho* Etching**

An etching of the painting *Sappho* (see above, *April 24, 1840*) was published in *Le Cabinet de l'amateur et de l'antiquaire* (3, 1844, following p. 400). There is no caption, but it is signed at the lower left: "T. Chassériau" (Sandoz 1974, no. 268, p. 418; Baltimore, 1979–80, no. 24, pp. 151–52).

■ 1845

January 7 and 9

■ **Cour des Comptes: 1st Installment Paid**

Because of the "state of progress of the paintings on the two walls to the right and left of the staircase leading to the Cour des Comptes in the palace on the Quai d'Orsay," the Directeur des Beaux-Arts, Cavé, authorizes the "first payment of three thousand of the 30,000 F[rancs] allotted to this project" (Letters from Cavé to Chassériau [January 7 and 9, 1845], Paris; AN, F²¹. 4402, dossier 13). The letters and signatures are crossed out.

March 2 and 3

■ ***Cleopatra* Refused by the Jury**

A painting by Chassériau in the "Portrait" category is accepted (jury session, March 2, 1845; Archives des Musées Nationaux, *KK. 61, no. 3594). On the following day, a painting in the "History" category is refused by a vote of nine to seven (jury session, March 3, 1845; Archives des Musées Nationaux, *KK. 61, no. 3595).

■ **Destruction of *Cleopatra***

When he heard that his *Cleopatra Taking Her Own Life* (66 ⅞ x 99 ¼ in.) had been refused, Chassériau "became extremely outraged and destroyed his painting in a fit of anger" (Chevillard 1893, p. 96); a fragment is in the Musée des Beaux-Arts, Marseilles (Sandoz 1974, no. 102, p. 214; cat. 109), and there is also an etching of the work printed by Delâtre (Baltimore, 1979–80, no. 23, pp. 150–51): "At the beginning of the 1840s, I printed etchings by Th. Chassériau, but no drypoints. The first etching of his that I printed was of Cleopatra. Since it lent itself well to my printing methods, he was very surprised and thought that his plate was finished" (Letter from Auguste Delâtre to Aglaüs Bouvenne, April 11, 1883; Paris; Musée du Louvre, Département des Arts Graphiques).

March 7

■ **Committee of the Association des Artistes**

Chassériau's name is mentioned in connection with the "Organization Committee" of the Association des Artistes Peintres, Sculpteurs, Architectes Graveurs et Dessinateurs. Among the other artists mentioned are H. Vernet, A. Scheffer, Picot, Baltard, Flandrin, Drolling, Charlet, Granet, and Duban (Archives of the Fondation Taylor,

session of March 7, 1845, fol. 30; Ambile and Foucart 1995, p. 140).

March 15

■ **Salon of 1845**

The exhibition catalogue (*Explication des ouvrages de peinture, sculpture, architecture, gravure et lithographie des artistes vivants exposés au musée royal le 15 mars 1845* [Paris, 1845], p. 42) lists the following:

"Chassériau (Théodore), *34, rue Frochot.*
[no.] 305.—Ali-Ben-Hamet, Caliph of Constantine and Chief of the Haractas, Followed by His Escort (10 ½ x 8 ½ ft.; Sandoz 1974, no. 101, p. 212; cat. 134)."

■ **Invitation from Ali-Ben-Hamet**

Ali-Ben-Hamet would keep his portrait. He had "become the painter's friend and invited him to visit him in Constantine. Chassériau accepted the invitation and went to Algeria the following year" (Chevillard 1893, p. 107).

March 20

■ **Statue of General Marceau**

Chassériau contributes 3 francs for the statue of General Marceau planned by Auguste Préault in Chartres. Louis de Cormenin, Dumas, and Nerval contribute the same sum, while Hugo gives 15 francs, Lamartine 25, and Gautier 50 (*Le Glaneur*, March 20, 1845; quoted in Gautier, *Correspondance*, 1986, vol. 2, p. 212 n. 3. See also the list of contributors in Chevillot 1997, p. 169).

March 30

■ **The Chassériaus in Mourning**

Clémence Monnerot writes to her brother Jules: "We hardly ever see the Chassériau ladies. On the pretext of their mourning, which has lasted six months already, they have not come a single time. When we go there, they are out. Frédéric came six months ago, and Théodore comes every three months" (Letter from Clémence Monnerot to her brother Jules [March 30, 1845, Paris]; BnF, Dépt. des Ms, Naf. 14394, Papiers Gobineau, vol. 6, fol. 72).

April 4

■ **Request for a New Placement**

Chassériau asks the director of the Musée du Louvre, Cailleux, to have his "large picture"—the

Portrait of Ali-Ben-Hamet (see above, *March 15, 1845*)—lowered: "It is too high in the opinion of the most competent artists. You will understand that in such a serious conflict I ask for your support and insist" (Letter from Théodore Chassériau to Cailleux, Friday [April] 4 [1845, Paris]; Bibliothèque des Musées Nationaux, A. S. Henraux Bequest, MS 310 [1], no. 155).

Late May

■ **Award Proposal**

Chassériau's name is on a list of "Award Proposals by Category": "[no.] 305 Chassériau Caliph of Constantine 2nd [*medal*] 1844." The absence of any comment means that the proposal was passed over (Archives des Musées Nationaux, dossier 10, Salon de 1845).

August 24

■ **Ernest Chassériau in Cayenne**

Mme Monnerot writes to her son Jules: "I told you that Ernest Chassériau was in Toulon, but since then I heard from Frédéric, who paid us a long and pleasant visit, that Ernest has been in Cayenne for a year; this is being kept from Mme Chassériau so as not to worry her. Théodore also came to see us. Both send you their regards" (Letter from Mme Monnerot to her son Jules, August 24, 1845, Paris; BnF, Dépt. des Ms, Naf. 14405, Papiers Gobineau, vol. 17, fol. 78). Ernest's trip to Cayenne is confirmed by a letter from Frédéric Chassériau to Leroy, chief physician of the Navy, dated November 12, 1846, in which he mentions that Ernest, then a noncommissioned officer in the naval artillery, "came back ill from Cayenne" (Médiathèque, La Rochelle, Ms 621, fol. 193 r.).

October 1

■ **Travel Plans for Algeria**

Alfred Marey Monge, a colleague of Benoît Chassériau, recommends Théodore to his brother, General Marey Monge, commander in chief of the Médéa division: "One of my friends, M. Chassériau, is going to Algeria for his pleasure and instruction. He intends to return from this country with many sketches. . . . To fill his portfolio and his imagination with memories, these are the main reasons for his peregrination."

In his postscript, Marey adds: "I hear that Chassériau will not take his trip before next spring, but I still want to entrust him with this letter and give you news from me" (Letter from Alfred Marey

Monge to his brother, General Marey Monge, October 1, 1845, Paris; published in Bénédite 1931, vol. 2, pp. 261–62). Chassériau would leave for Algeria seven months later, on May 3, 1846 (see below).

October 13

■ Théodore Is Ecstatic

Through a friend, Clémence Monnerot receives a number of exotic objects and immediately informs her brother: "Although it breaks my heart, I want to sell my two mats; I need money. . . . Théodore was ecstatic when he saw them and begged me to have some sent from Madagascar, for which he said that he would pay our price. I promised, but have no intention of doing it" (Letter from Clémence Monnerot to her brother Jules [October 13, 1845, Paris]; BnF, Dépt. des MS, Naf. 14394, Papiers Gobineau, vol. 6, fol. 75).

November

■ Exhibition in the Foyer of the Odéon

While presenting Félix Pyat's play *Diogène*, Bocage, director of the Théâtre de l'Odéon, mounts an exhibition of works by the artists who had been refused by the Salon jury and who had formed an Association of Young Painters.

Chassériau shows his *Apollo and Daphne* (cat. 113), a picture usually dated to 1846. Among the other artists and writers who participate are Abel de Pujol, Delacroix, Leleux, Diaz, Corot, Isabey, Roqueplan, Théodore Rousseau, Hector Martin, Théophile Gautier, Eugène Sue, George Sand, and Victor Hugo (Gautier, November 17, 1845; Sensier 1872, pp. 159–60; Chevillard 1893, p. 85; Marcel and Laran 1911, p. 43; Rousseau [1935] 2000, p. 57; Sandoz 1974, no. 99, p. 210). According to Sandoz, Daphne's features were based on those of Clémence Monnerot.

December 30

■ Cour des Comptes: 2nd Installment

Chassériau asks the Ministry of the Interior to issue the necessary orders so that he can "receive the remaining four thousand five hundred francs owed to me for this year. I need to pay for the expenses occasioned by my work, which is my constant occupation" (Letter from Théodore Chassériau to the Ministry of the Interior, December 30, 1845 [Paris ?]; AN, F²¹. 4402, dossier 13).

December

■ *Mother and Child*

An engraving of a *Mother and Child*, "drawn

and engraved by Théodore Chassériau," is published in *L'Artiste* (December 1845; Baltimore, 1979–80, no. 26, p. 153).

■ Cousin Louise Belloc's Lottery

Chassériau sends the painter Belloc a small drawing intended for his cousin Louise's lottery (Letter from Théodore Chassériau to Hilaire Belloc, mentioned in Lemasle, *Le Biblio-Autographophile* 237 [about 1930], no. 442, p. 22; a copy of this catalogue is in the Archives Nationales, AB, XXXVIII.17). Belloc, who had married one of Chassériau's cousins, was the director of a school of drawing and mathematics (Bénédite 1931, vol. 1, pp. 10–11).

■ Stay in Fontainebleau

The date of Chassériau's visit to Fontainebleau is unknown, but it is documented by a dedication on a pencil drawing representing Mme Jules Amiel: "A Jules Amiel / son ami Th. Chassériau / Fontainebleau 1845" (Prat 1988-2, no. 119, p. 21). Chassériau copied the departure times for Fontainebleau into a notebook believed to date from 1848–52 (Prat 1988-1, vol. 2, p. 951, fol. 11 v.).

January 25

■ The Association des Artistes and the Claim of M. Chassériau

According to a letter from Justin Ouvrié to Adrien Dauzats, Chassériau seems to want to withdraw from the Committee for Aid and Pensions: "He willingly gave a drawing for the Raffle, but you will agree that this reason is not sufficient to dismiss M. Chassériau from the committee's activities in the future; how could our project work if we had only half-hearted members to direct it?" (Letter from Justin Ouvrié to Adrien Dauzats, Monday, January 25, 1846 [Paris]; BnF, Dépt. des Ms, Naf. 11.964, fol. 100; information provided by A.-M. Debelfort). On this raffle see below, *April 25, 1846*.

January 28

■ Cour des Comptes: 2nd Installment Paid

The Minister of the Interior informs Chassériau that he can present himself "at the Ministry's central Accounting Office to retrieve an order for the payment of the said sum of 4,000 francs" (Copy of a letter from the Ministry of the Interior to Théodore Chassériau, January 28, 1846, Paris; AN, F²¹. 4402, dossier 13).

March 20

■ End of the Monnerot Era

Clémence Monnerot writes to her brother Jules: "No one comes in the evening anymore. . . . Théodore, every three weeks for a half hour on his way to Ranchicourt's on the Champs-Élysées; Frédéric, never. . . . That sums it up—What does

it matter! We can do perfectly well without. Théodore did not send anything to the exhibition, but his work at the Quai d'Orsay is supposed to be superb" (Letter from Clémence Monnerot to her brother Jules, Monday, March 20, 1846 [Paris]; BnF, Dépt. des Ms, Naf. 14394, Papiers Gobineau, vol. 6, fol. 77). Six months later, Clémence would marry Arthur de Gobineau.

April 25

■ The Association des Artistes Celebrates in Lyons

Together with the Lyons chapter, the Paris association holds an "artistic fête" on the theme of the "age of Louis XIV." A raffle, with works provided by members of the Paris association concludes the evening. Chassériau's contribution is documented (see above, *January 25, 1846*). Among the other artists who sent "watercolors, drawings, engravings, large-format lithographs, plasters, and medals" were Leleux, Foyatier, Picot, Isabey *père*, A. de Dreux, Aligny, Maindron, and Dauzats (Archives of the Fondation Taylor, Annual General Assembly of March 28, 1847, in the Salle Saint-Jean, Hôtel de Ville, Paris; *Compte rendu d'A. Dauzats*, pp. 23–24).

May 2

■ The Pupil Ducasse

Chassériau requests permission for "Ducasse, my pupil," to study the "works of the great masters" at the Musée du Louvre (Letter from Théodore Chassériau to M. Davin, May 2, 1846 [Paris]; Archives des Musées Nationaux, dossier P. 30 Chassériau; Sandoz 1974, p. 82 n. 1).

May 3

■ Cour des Comptes: 3rd Installment

On the day of his departure for Algeria, Chassériau addresses a request to the Minister of the Interior: "Please have an advance of four thousand francs paid from the eight thousand that are owed to me this year, since I have received only seven instead of seven thousand five hundred for the last fiscal year. I have devoted all of my time to these works and this sum is essential to defray the expenses incurred" (Letter from Théodore Chassériau to the Minister of the Interior, Sunday, May 3, 1846 [Paris]; AN, F²¹. 4402, dossier 13).

On June 20, Chassériau would write to his brother: "I am very happy that the money order from the ministry was sent. Use the money for mother and yourself" (Letter from Théodore Chassériau to his brother Frédéric, June 20, 1846, Algiers; published in Chevillard 1893, p. 117; Bénédite 1931, vol. 2, p. 274).

■ Departure from Paris and Tocqueville's Recommendation

Several hours before Chassériau leaves for Algeria, Tocqueville sends him a letter of recommendation intended for General Lamoricière (Bénédite 1931, vol. 2, p. 262). He also criticizes the timing of his trip: "Why are you leaving for Africa at this time of the year? I do not approve. You are going to arrive in the middle of the heat and in the fever season."

■ Portrait of Tocqueville

Tocqueville concludes his letter with: "I would have liked to tell you personally what a good likeness the portrait is and how happy I am finally to have such a portrait in my possession. You could

not have given me greater pleasure, and I am forever obliged to you" (Letter from Alexis de Tocqueville to Théodore Chassériau, May 3, 1846 [Paris]; published in Bénédite 1931, vol. 2, p. 263). The portrait in question could be the drawing in the Musée Carnavalet, which is signed and dated, with the dedication, "A Madame / Alexis de Tocqueville / Th. Chassériau / 1844" (Sandoz 1986, no. 23, p. 35; Prat 1988-2, no. 105, p. 20; cat. 64). The painted version dates from 1850 (Musée du Château de Versailles; see cat. 204).

May 5 (?)

■ Stop in Lyons

Chassériau spends the night in Lyons, a city he "still very much dislikes" (Letter from Théodore Chassériau to his brother Frédéric, May 8, 1846, Marseilles; published in Bénédite 1931, vol. 2, p. 264). His previous stay there probably was in 1840 (see above, *June 27–30, 1840*).

May 6 and 7

■ Avignon and Arles

Chassériau writes about his next stops: "I saw Arles and Avignon again in detail. I did some things there that will probably be useful. . . . Give my regards to Ravaisson if you see him. Tell him that I am seeing quaint and beautiful things, that I am working to recapture them, that I studied Arles carefully" (Letter from Théodore Chassériau to his brother Frédéric, May 8, 1846, Marseilles; published in Bénédite 1931, vol. 2, p. 264).

In Avignon he is struck by the Mediterranean type that, he writes, has something "Italian, Oriental, dark, passionate" (Bénédite 1931, vol. 2, pp. 264–65). In Arles he sketches a great deal, including a series of women in local dress. One sketch is inscribed: "Arles 7 mai 1846" (Bénédite 1931, vol. 1, p. 79, vol. 2, p. 265; Prat 1988-1, vol. 2, no. 1573, p. 574; Peltre 1999, pp. 165–72).

May 8

■ Arrival in Marseilles

Chassériau stays at a hotel in Marseilles and not with his cousin the architect, who may have been in Algiers with his family. He writes to his brother: "I have just arrived in Marseilles and want to send news right away. . . . I expect to leave for Algiers on Sunday the 10th. . . . Until then I intend to stay in Marseilles unless M. Jacques advises me to go to Philippeville and changes my reservation. In that case, I will leave tonight, and in any case will write you either from Algiers or from Philippeville." He wants to visit the poet Joseph Méry (1798–1865), who, according to Bénédite, was a good friend of his brother Frédéric (Letter from Théodore Chassériau to Frédéric, May 8, 1846, Marseilles; published in Bénédite 1931, vol. 2, p. 264).

May 10

■ Departure from Marseilles—Arrival in Philippeville

For reasons unknown—according to Bénédite (1931, vol. 2, p. 266) to reach Constantine more directly—Chassériau changes his plans as he had mentioned on May 8 (see above) and books "passage to Philippeville instead of Algiers." He travels with a certain M. Martin "dispatched by the Ministry of War" (Letter from Théodore Chassériau to his brother Frédéric [Wednesday], May 13, 1846, Constantine; published in Chevillard 1893, p. 108; Bénédite 1931, vol. 2, p. 266).

May 11

■ Arrival in Constantine

In his letter of May 13 Chassériau writes: "I have been in Constantine since Monday. The trip was very easy and quite uncomplicated" (Letter from Théodore Chassériau to his brother Frédéric [Wednesday], May 13, 1846, Constantine; published in Chevillard 1893, p. 108; Bénédite 1931, vol. 2, p. 266).

May 13

■ "The Thousand and One Nights"

Two days after his arrival in Constantine, Chassériau writes to reassure his brother: "My lodgings are good, I eat with the artillery officers, and have everything I need. This land is very beautiful and very new. I am living in the Thousand and One Nights. I think I can really get something from it for my art. I work and I look. . . . I will leave Constantine for Algiers. . . . Tomorrow I am going to see General Bedeau. . . . Farewell, my dear brother, I am writing in a hurry. General Bedeau has just sent for me" (Letter from Théodore Chassériau to his brother Frédéric [Wednesday], May 13, 1846, Constantine; published in Chevillard 1893, pp. 108–9; Bénédite 1931, vol. 2, p. 266).

May 23

■ Rumors of War

Chassériau announces his intention to stay in Constantine another two weeks: "This is supposed to be the only truly Arabian city left in this country, and so I am making the most of it. From here, I will go to Algiers. . . ." He is staying "with Captain Napoléon Bertrand and two other young spahi chiefs who offered their hospitality. Do not worry if you hear about an expedition in Kabylia led by General Bedeau. I found in Constantine all that I wanted to see of the Kabyles and I have no interest in following him. And so I will continue my trip without getting involved. They are planning a campaign for one month, and that is not my profession." He concludes his letter by sending his regards to his friends Félix Ravaisson and Gras (Letter from Théodore Chassériau to his brother Frédéric, May 23, 1846, Constantine; published in Chevillard 1893, pp. 109–10; Bénédite 1931, vol. 2, pp. 267–68, gives the erroneous date "May 13, 1846").

■ The "Caliphate"

In the same letter of May 23, Théodore mentions having been wonderfully received by the "Caliphate," that is, by Ali-Ben-Hamet, with whom he spoke about payment for his large-format portrait (see above, *March 15, 1845*). On June 13, he would write: "I was very satisfied with the Caliphate. He gave me fifteen hundred francs of my fee and promises the eight hundred he still owes me as soon as possible. Things are very tight at the moment and he asked me, as a friend, to wait for the rest, which he will send with M. de La Ruë. . . . The Caliphate gave me a silver yataghan as a souvenir" (Letter from Théodore Chassériau to his brother Frédéric, June 13, 1846, Philippeville; published in Chevillard 1893, pp. 113–14; Bénédite 1931, vol. 2, pp. 270–72). He also executes a portrait drawing of Aïcha Ben Gerbaz (Prat 1988-2, no. 128, p. 21; see cat. 140).

June 4

■ The Only Truly Arabian Place

Chassériau tells his brother that he will leave Constantine for Algiers on June 15: "All of General Bedeau's war plans have been postponed indefinitely and the entire province is quiet. The general kindly gives me the means to do the studies I need to do. . . . From what I have heard, it is a good idea to stay a few extra days here. It is the only truly Arabian place left in Africa. I am fêted by everyone and the general is writing to make sure that the rest of my trip will be pleasant and uncomplicated. . . . I will go from Algiers to Oran, from Oran to Marseilles, and then to Paris; in this way I will not lose any time with detours" (Letter from Théodore Chassériau to his brother Frédéric, June 4, 1846, Constantine; Chevillard 1893, pp. 111–12, omits the last sentence; Bénédite 1931, vol. 2, pp. 268–70).

■ The Arab Race and the Jewish Race

Several hours after leaving Constantine, Chassériau would make the following observations: "I have seen some very curious, primitive, and dazzling things, strange and touching. In Constantine, which is situated atop high mountains, one can see the Arab race and the Jewish race, as they were on their first day. I will tell you all about this and you will see many studies: all that can possibly be done when seeing so many different things passing before one's eyes in so short a time. I have taken notes and, with my memory, think I will not forget anything" (Letter from Théodore Chassériau to his brother Frédéric, June 13, 1846, Philippeville; published in Chevillard 1893, p. 113; Bénédite 1931, vol. 2, pp. 271–72).

■ Mass

In this same letter of June 13, Chassériau tries to reassure his sisters by telling them that, in Constantine, General Bedeau took him "to Mass on Sunday, in a mosque that is now a French church."

June 7

■ Without News

Mme Monnerot informs her son Jules that she has had no "news from Théodore since he arrived in Africa, not having seen the ladies for a while" (Letter from Mme Monnerot to her son Jules, June 7, 1846, Paris; BnF, Dépt. des Ms, Naf. 14405, Papiers Gobineau, vol. 17, folios 84–85; Concasty and Duff 1973, pp. 125–26).

June 13

■ Arrival in Philippeville

Several days ahead of the date he had set (see above, *June 4, 1846*), Théodore writes to his brother: "I have just left Constantine and on the day after tomorrow, in the morning, I will embark for Algiers, where I will be delighted to find news from all of you. I am writing in a hurry, in a hotel in Philippeville, and have only bad ink. . . . Give

mother a kiss and tell her that I will be in Algiers on the 17th and will see Frédéric. General de Bar had been informed of my arrival by General Bedeau and I think that I will find as much kindness from him as I have experienced so far" (Letter from Théodore Chassériau to his brother Frédéric, June 13, 1846, Philippeville; published in Chevillard 1893, pp. 113–14; Bénédite 1931, vol. 2, pp. 270–72).

June 17

■ Arrival in Algiers

Chassériau arrives on the 17th, as planned. He stays at the home of his cousin Frédéric, the architect, "who is away in Marseilles for several days" (Letter from Théodore Chassériau to his brother Frédéric, June 20, 1846, Algiers; published in Chevillard 1893, p. 115; Bénédite 1931, vol. 2, p. 273).

June 19

■ Visit to Marshal Bugeaud

Chassériau writes to his brother that the marshal "seems to be suffering from the attacks on his reputation made by the envious, who want to tarnish everything that shines. The war will be conducted in the hinterlands, among the tribes. In the cities there is never any danger" (Letter from Théodore Chassériau to his brother Frédéric, June 20, 1846, Algiers; published in Chevillard 1893, p. 116; Bénédite 1931, vol. 2, pp. 273–74).

June 20

■ "This Unique and Beautiful Land"

Several days after arriving in Algiers, Théodore writes to his brother: "I look, I draw, and I take notes on this beautiful and unique land [that is] so close to losing its originality and becoming thoroughly French. What is left of the old city of Algiers gives the impression of being the lair of wealthy and intrepid pirates. The whiteness of the city stands out against the blue sea, and looks like Greek marble. It is completely different from the other countries in Africa that are more Turkish and Islamic. . . . I do not know if I will go to Oran; Frédéric wants to come with me. . . . Remember me to M. Alexis de Tocqueville, if he is still in Paris" (Letter from Théodore Chassériau to his brother Frédéric, June 20, 1846, Algiers; published in Chevillard 1893, pp. 115, 117; Bénédite 1931, vol. 2, pp. 273–74).

June 26

■ Excursion to Oran (?)

On June 20 (see above), Chassériau already had doubts about going to Oran. On June 26, after writing of his cousin Frédéric's return from Marseilles, "where he took his wife and children," he adds that he does not intend to "go to Oran. I need to know if it is unusual enough. I am going to get the necessary information and see. It would be for a few extra days and Frédéric will come with me if it is worth it " (Letter from Théodore Chassériau to his brother Frédéric, June 26, 1846, Algiers; published in Bénédite 1931, vol. 2, pp. 275–76; according to Bénédite [pp. 273–74], he finally decides against going).

■ Morocco (?)

Chevillard (1893, p. 107) writes: "We presume that he went as far as Morocco, but have no record. Among his work, there is a canvas showing dancing girls waving daggers and wearing revealing dresses, costumes peculiar to the Maghreb region." Bénédite (1931, vol. 2, p. 273) categorically refutes this: "He never set foot in Morocco, Chevillard notwithstanding."

July 2

■ Portrait of a Young European in a Turban

There is a graphite drawing by Chassériau dedicated to: "M Emile Mignet / 2 juillet 1846 / Constantinoist [?] / après une / Chasse a / Cheval," and with this inscription on the right: "a Madame Emile Mignet" (New York, Shepherd Gallery, May–June 1975, no. 86, ill.; Prat 1988-2, no. 141, p. 22). Émile Mignet may have been related to the Mignet who is frequently mentioned in Marie d'Agoult's diaries of 1842 and 1843 (see above).

Another drawing depicting a group of horsemen is annotated "Juillet," which suggests that Chassériau was still in Algeria then (Prat 1988-1, vol. 1, no. 447, p. 219).

Early July

■ Departure from Algiers, Stay in Marseilles

The exact dates of Chassériau's travels are unknown, although his stay in Marseilles is documented by the portrait he drew of Baronne Frédéric Chassériau (cat. 158), the wife of his cousin the architect. This drawing bears the following dedication: "a mon cousin / et ami Frédéric / Théodore Chassériau / 1846" (Sandoz 1986, no. 25, p. 39; Prat 1988-2, no. 144, p. 22).

July 15 (?)

■ Return to Paris

The exact date is unknown, but Chassériau told his brother he would be "back home about July 15" (Letter from Théodore Chassériau to his brother Frédéric, June 26, 1846, Algiers; published in Bénédite 1931, vol. 2, pp. 275–76).

Early October

■ A Soirée at Victor Hugo's

It is known that Chassériau was there, together with Alphonse Karr, Méry, Lacretelle, Édouard Thierry, Adolphe Dumas, Amédée Achard, Paul Meurice, and many women (Woestyn, October 4, 1846; cited in Hugo 1965, p. 181).

October 17

■ Cour des Comptes: 4th Installment

Chassériau asks the Minister of the Interior to "be kind enough to give the order to disburse the sum of four thousand francs still owed to me for this year, including the five hundred francs I did not receive in the last fiscal year. Allow me to point out, Minister, that this sum is necessary to

pay the expenses incurred by my work" (Letter from Théodore Chassériau to the Minister of the Interior, Saturday, October 17, 1846 [Paris]; AN, F^{21}. 4402, dossier 13).

November 4

■ Balzac and the "Illustrious Unknown"

Balzac tells Mme Hanska that he will receive that morning "the illustrious unknown, Chassériau the painter, to whom I want to show the paintings on the dome and the Beaujon bedroom, to have them restored" (Letter from Balzac to Mme Hanska, Wednesday [November 4, 1846], Passy; published in Balzac 1990, vol. 2, p. 404). Balzac had purchased part of the former Carthusian monastery of Beaujon on September 28, 1846. The paintings in question were by Étienne de La Vallée-Poussin (1740–1793).

November 5

■ Balzac's Renovations

Balzac writes to Mme Hanska: "I went to the little house with Chassériau yesterday at one o'clock, after lunch with From[ent]-Meur[ice], who took the twelve spoons to gild and to make the twelve forks. Chass[ériau] promised me a talented young man to do the work, whom he would supervise. This operation will cost me only 500 francs. It is not much, but a lot for me. It will be very well done, and everything will be restored to the state it was in in Beaujon's time. The work is not going fast enough for me. I would so much like to have everything finished by December 15! . . . Chassériau found the paintings very lovely. These are two rare pieces" (Letter from Balzac to Mme Hanska, Thursday, November 5 [1846], Passy; published in Balzac 1990, vol. 2, p. 405).

The "young man" mentioned is the painter, engraver, and lithographer Édmond Hédouin, who may also have helped Chassériau with the "Othello" series (see above, *Late August or early September 1844*).

November 10

■ The Duchesse de Montpensier's Album

Chassériau's watercolor depicting Jewish women "rocking an infant asleep in a hanging cradle" (cat. 153) is included in the album given to Her Royal Highness Marie-Louise Fernande, Duchesse de Montpensier, by the princes and princesses of the royal family (Jacob, November 10, 1846, p. 169; J. S. M., January 9, 1847, p. 301). Chassériau is paid "300 F" (Letter from Adrien Dauzats to an unknown correspondent [August–October 1846, Paris]; Paris, Institut Néerlandais, Fondation Custodia, Inv. 1988-A. 161).

December 11

■ The Visiting Committee

At the suggestion of Vallou de Villeneuve, vice-president of the Société des Artistes, Chassériau and several other artists who usually missed the society's meetings are assigned to visit artists to "invite them to join our association" (Archives of the Fondation Taylor, session of December 11, 1846, fol. 344).

■ Pétrus Borel and Algeria

From Chassériau, Gautier learns that Mlle Zoë de La Ruë had influenced her brother, General de La Ruë, to appoint Pétrus Borel (an old friend from the Doyenné) to the position of colonial inspector in Algeria. Gautier is "deeply touched" (Letter from Théophile Gautier to Mlle Zoë de La Ruë, undated [1846]; published in Gautier, *Correspondance*, 1988, vol. 3, no. 909, p. 129).

■ 1847

January 22

■ The Committee for Aid of the Association des Artistes

Justin Ouvrié suggests Chassériau and "MM. Lesueur, Jacquand, Grillon, Dubufe, Ziegler, and Quantinet" for the Committee for Aid of the Société des Artistes (Archives of the Fondation Taylor, session of Friday, January 22, 1847, fol. 364).

March 4

■ The Jury Rejects the *Sabbath*

Chassériau's "History" painting *Sabbath in the Jewish Quarter of Constantine* is rejected by the Salon jury (jury session, March 4, 1847; Archives des Musées Nationaux, *KK. 63, no. 4018). The large-format work, measuring "twenty feet in every direction" (Chevillard 1893, p. 124), had been inspired by Chassériau's travels in Algeria the year before. It would finally be exhibited at the Salon of 1848 (see below, *March 15, 1848*).

March 20

■ Poem to Chassériau

Alfred Asseline devotes one of the poems in his collection entitled *Pâques fleuries* to Chassériau; it begins with the line: "Women, on your canvases, must always be beautiful!" (Asseline 1847, pp. 9–10; the book is listed in the *Bibliographie de la France*, March 20, 1847; Chevillard 1893, p. 172).

April 3

■ Cour des Comptes: 5th Installment

Chassériau asks the Minister of the Interior to issue an order for the "allocation of a sum of 4,000 francs from the 7,500 francs owed to me for the current fiscal year. I need this sum for the considerable costs incurred for my work at the Cour des Comptes, with which I am presently busy" (Letter from Théodore Chassériau to the Minister of the Interior, April 3, 1847 [Paris]; AN, F21. 4402, dossier 13).

April 13

■ William Haussoullier, a Friend

Upon Chassériau's recommendation, Dauzats informs William Haussoullier (who lives on the "avenue Frochot") about the "requirements for membership" in the "association des artistes peintres sculpteurs, & a" (Letter from Adrien Dauzats to William Haussoullier, April 13, 1847; Bibliothèque d'Art et d'Archéologie Jacques Doucet, Carton 57, fol. 34616; information provided by A.-M. Debelfort).

Guillaume Haussoullier (1818–1891), known as William, was a pupil of Delaroche and exhibited his famous *Fountain of Youth* at the Salon of 1845. Later, Chassériau would draw his portrait, which he would dedicate: "A William / son ami / Thre Chasseriau / 1850—" (Prat 1988-2, no. 162, p. 24).

August

■ The Salon of Princess Belgioioso

The Italian princess Cristina Trivulzio de Belgioioso (1808–1871) arrived in Paris after the revolution of 1830. A well-known political activist, she attracted a veritable coterie to her literary salon on the Avenue d'Antin, off the Champs-Élysées. Among the guests mentioned in the account by Charles Monselet of August 18, 1848, were: Ary Scheffer, Balzac, Liszt, Victor de Laprade, Letroune, Amédée Thierry, and Ravaisson.

Chassériau drew her portrait, which is now in the Musée du Petit-Palais (Chevillard 1893, no. 283, p. 304; Prat 1988-2, no. 153, p. 23; cat. 164).

■ Portrait of the Algerian Chief Bou-Maza

According to Monselet, a frequent guest at the princess's salon in 1847 was Bou-Maza, a desert fox "kept on a leash by Captain Richard. Bou-Maza came every day to pose melancholically for two hours for Chassériau. Evenings, he attended the intimate receptions given by the princess, and smoked a water pipe with her. Later, the conversation among this small circle of friends— the marquise de Bedmar; La Guieciol, now the marquise de Boissy; the abbé Lanci, and two or three others—took a merrier turn, often lasting until midnight" (Monselet, in *L'Événement*, no. 18, Friday, August 18, 1848, p. 1). According to Gautier, Bou-Maza was a friend of Chassériau; the artist's portrait of him, mentioned by Chevillard (1893, no. 307, p. 215), has been lost.

September 6

■ Hypnotism at Mme de Girardin's

Writing in *La Presse*, September 7, 1847, Gautier gives an account of the hypnotism session that took place the previous evening at the salon of Delphine de Girardin. Among the guests were "Pradier, Ziégler, Chassériau, Jules Sandeau, Adolphe Adam, General D . . . and his sister, a remarkable pupil of Chopin." Louise the sleepwalker was put into a trance by Mme de La Fontaine and started to dance: "The poses she struck—completely unawares— surpassed those of the statues of Phidias, Praxiteles, Jean Goujon, Canova, and Pradier: Greek art never created anything purer" (Gautier, September 7, 1847, p. 1; Gautier, *Correspondance,* 1988, vol. 3, p. 364 n. 4; Martin-Fugier 1990, p. 267).

■ Cour des Comptes: 6th Installment and Visit of the Inspector

Chassériau writes to the Minister of the Interior to request payment of the "three thousand five hundred francs owed to me for this fiscal year. The Inspecteur des Beaux-Arts came, at my request, to look at my work. He promised to tell Your Excellency how satisfied he was with this work, to which I devote almost all my time" (Letter from Théodore Chassériau to the Minister of the Interior, September 6, 1847; AN, F21. 4402, dossier 13).

November 12

■ Rachel's Dressing Room

Chassériau's presence there—on the evening of the premiere of Mme de Girardin's tragedy *Cléopâtre*—is documented by Amaury-Duval: "I also saw the costumes being tried on in Rachel's dressing room. Mme de Girardin and her husband were there. Nothing funnier than this spectacle. Mlle Solié arrives. Her costumes will not do. She proposes others. Rachel finds them too ornate, and I have to leave—I can't help laughing, especially as Chassériau keeps making the funniest remarks" (Diary of Amaury-Duval, November 12, 1847; Autun, Bibliothèque Éduenne, Carton K8 35; information provided by V. Rollet). The play would have as little success as *Judith,* and Rachel would give only fourteen performances.

According to Prat (1988-1, vol. 1, no. 1016, p. 414; cat. 155), Chassériau's drawing of five women in Oriental costumes, dedicated, signed, and dated: "à Madame de Girardin / Théodore Chassériau— 1847," is actually a sketch of the costumes for *Judith;* according to Hélène Toussaint, the costumes are for *Cléopâtre.*

December 2

■ Cabarrus and His Friends

In late November, Édouard Cabarrus, a physician and childhood friend of Émile de Girardin, invites Théophile Gautier to a gathering on Thursday, December 2, "about 9 o'clock." Among the other guests are: "Chassériau; Eugène Delacroix Boremaya [?]" (Letter from Édouard Cabarrus to Gautier [late November 1847, Paris (?)]; published in Gautier, *Correspondance*, 1988, vol. 2, no. 1074, pp. 269–70). Delacroix's reply was dated November 28, 1847, and addressed to "Madame Cabarrus, 1 rue de Milan" (1936, vol. 2, pp. 332–33).

■ Portrait of Mlle Cabarrus

By this time, Chassériau had already begun the portrait of Doctor Cabarrus's daughter for the upcoming Salon (see below, *March 15, 1848*). A letter to Mme Cabarrus mentions the sittings: "Allow me to remind you that I impatiently await your [visit] tomorrow to continue my portrait, which I would soon like to see in an acceptable state" (Letter from Théodore Chassériau to Mme Cabarrus [November / December (?) 1847– January / February 1848, Paris]; published in Bénédite 1931, vol. 2, p. 365).

■ 1848

January 6

■ The Bonne-Nouvelle Exhibition

The Galerie Bonne-Nouvelle hosts an exhibition to benefit the Association des Artistes' relief and pension funds. Its catalogue (*Association des Artistes. Explication des ouvrages de peinture, sculpture et architecture exposés à la galerie Bonne-Nouvelle au profit de la caisse des secours et pensions de l'association, troisième année* [Paris, January 1848], p. 6) lists the following:
"Chassériau (Théodore)
Pupil of M. Ingres / [no.] 20. Venus Anadyomene (Sandoz 1974, no. 44, p. 138; cat. 13). (Belongs to the *Cercle des Arts*)."
The same catalogue mentions a painting by Prosper Marilhat: "[no.] 93. Ruins of Thebes (sketch) / (Belongs to M. Th. Chassériau)."

January 22–23

■ Alice and Théodore Meet

According to Alice Ozy (1820–1893), as quoted by Victor Hugo ([1887], 1972, p. 242), on February 23–24, 1848 (see below), the actress and the painter had known each other for "thirty-two days," which places their first meeting about January 22–23, 1848.

Two signed and dated portrait drawings of Alice Ozy by Chassériau prove that their relationship began as early as 1848 (Prat 1988-2, nos. 154, 155, p. 23; see cat. 168). We also know that Chassériau and Jules Ziegler would help decorate her apartment (Letter from Alice Ozy to Théophile Gautier [1848 or 1849], published in Sandoz 1974, no. 116, p. 250; Gautier, *Correspondance*, 1989, vol. 4, no. 1326, p. 85).

January–February (?)

■ A New Studio: 28, Avenue Frochot

Chassériau moves from the studio at 34, rue de Bréda (renamed rue Frochot in 1844; see above, *March 15, 1842*): "Chassériau set himself up in this quiet, verdant spot, which was populated at the time by a plethora of famous painters and writers who formed a sort of art colony. He occupied [a studio in] a building at the top of the avenue, replacing Alfred de Dreux (this house is now number 15). The adjacent stables gave him access to horses, which he was fond of, and used as models" (Chevillard 1893, p. 153).

According to Sensier (1872, p. 142), the "militant pantheon" that was regularly rejected by the Salon jury meets in the Avenue Frochot, where Théodore Rousseau, Jeanron, Dupré, and Eugène Isabey also have studios (Rousseau [1935] 2000, p. 54). Stéphane Guégan (2001, pp. 252–53) adds the names Vidal, Cicéri, Jules Etex, Gustave Moreau, William Haussoullier, and Auguste de Saint-Rémy to this list for 1852.

January–June

■ Admission to the Théâtre de l'Odéon

Chassériau, as a member of the Association des Artistes, is registered under number 31 on the list of "Artists admitted to the Théâtre Royal de l'Odéon." Among the other names on the list are Picot, Delacroix, A. Leleux, Daumier, Préault, Corot, and Boissard (Archives de la Fondation Taylor, "Nom des artistes qui ont leur entrée au Théâtre Royal de l'Odéon, du mois de janvier au mois de juin 1848, du comité de l'association des artistes qui exposent au petit musée," vol. 2, fol. 86).

February 20

■ The Upcoming Salon on the Eve of a Revolution

According to Théophile Thoré, Chassériau intends to submit the same large painting to the Salon jury that it had rejected the year before (see above, *March 4, 1847*): "M. Chassériau will again tempt the jury with his Jewish quarter in Constantine. The young painter made a few changes to his picture. It is as grand and original as its subject: handsome Jewish women sitting on their stoops on the Sabbath day. M. Chassériau will also submit a charming half-length portrait of a woman, Mlle C . . . of Bordeaux" (Thoré, February 20, 1848, p. 2).

Night of February 23–24

■ Revolution of 1848: The Courtesan and the Monkey

In *Choses vues*, Victor Hugo describes a scene "from life," which he supposedly has witnessed at Alice Ozy's apartment the night of February 23–24, as the fate of the July Monarchy hung in the balance.

Hugo discusses at length the recently established relationship between the famous actress and Théodore Chassériau, whose identities he thinly disguises, calling them Zubiri and Serio. In a masterful, if somewhat cynical, way, he has Alice Ozy harp on several of Chassériau's characteristics: his extreme ugliness—"a monkey"—and his poverty: "He is very poor, he hasn't a penny, he has two sisters who have nothing, he is ill, he has palpitations. . . . He . . . talks to me about his family, his poverty, and the large painting he did for the Conseil d'État."

■ The Old Muses

With malicious delight, Hugo comments on the paradoxes of being in love. Alice Ozy, the most beautiful woman of her day, has a crush on an "idiot . . . a wretch . . . a cretin . . . a sapajou [monkey]," with whom she is "madly in love. . . for good," and who makes her "feel like dying."

Hugo goes on to have her heap ridicule on Chassériau's old Muses: "Ah! you know very well that I love you. Don't be angry. Because you have had only old women till now, you are not used to the others, like me. Of course! It's all very simple, your old women had nothing to show you. It's true, my poor boy, you have only had old women. You are so ugly! Well, what do you want them to show you, your princess Belle-Joyeuse, that ghost! Your Comtesse d'Agosta, that witch! And your great forty-five-year-old bluestocking devil, with her blondish hair!"

He is clearly alluding to Princess Belgioioso, the comtesse Marie d'Agoult, and Delphine de Girardin, all of whom played an important part in Chassériau's life. If Hugo is to be believed ([1887]/1972, pp. 241–46), they had also been his mistresses. Twenty-eight years after the painter's death, Champfleury would ask Bouvenne: "Was Chassériau not Mme de Girardin's last love? Was this not the reason why Gautier made such a fuss over one of his patron's friends?" (Letter from Champfleury to Aglaüs Bouvenne, October 4, 1884 [Paris (?)]; Musée du Louvre, Département des Arts Graphiques, aut. 51, cote AR5 L I I; Chillaz 1997, p. 43).

■ The Old Courtesan's Denial

After the publication of *Choses vues*, Alice Ozy would write immediately to Arthur Chassériau: "Nothing of the kind ever happened in *Chassériau's presence. It is pure meanness. . . . Poor Chassériau, so fragile, so distinguished, I suffer for him, for his memory. That clever old Hugo is a joker who only wanted to spice up his text. It is a bad deed"* (Letter from Alice Ozy to Arthur Chassériau, June 13, 1887, Paris; published in Bénédite 1931, vol. 2, p. 388).

March 5

■ Call to Artists

Citizen Jeanron, the new director of the Musées Nationaux (since the decree of February 25, 1848), summons all artists to the École Nationale des Beaux-Arts to nominate a commission of forty members entrusted with the placement of works at the upcoming Salon. Among the painters elected are T. Rousseau, Dupré, Ingres, Delacroix, A. Scheffer, Cogniet, H. Vernet, Robert-Fleury, Meissonnier, Corot, Isabey, Drolling, H. Flandrin, Brascassat, Abel de Pujol, and Couture (Rousseau [1935] 2000, pp. 92–93).

This assembly marks a victory for those who had been critical of the decisions of the jury for over a decade. Chassériau's presence is not documented, but would appear likely, as he signed the petition of 1840 (see above, *March 18, 1840*) and had been rejected five times by the jury (1837, 1838, 1840, 1845, and 1847). On April 21, Chassériau would be elected to sit on the "Committee of

the 72" (see below, *April 21, 1848*), clear evidence of his commitment.

March 9

■ Cour des Comptes: 7th and Last Installment

Chassériau writes to the Minister of the Interior to request that he "issue the necessary order for the payment of what is owed to me for this fiscal year, so that I can completely finish my work at the Palais d'Orsay. I devote all of my time and energy to these paintings, and the expenses they occasion make it necessary for me to respectfully address this request to you" (Letter from Théodore Chassériau to the Minister of the Interior, Thursday, March 9, 1848, Paris; AN, F²¹. 4402, dossier 13).

Chassériau would receive the balance on April 11, 1848 (Memorandum from the Directeur des Beaux-Arts at the Ministry of the Interior to L. Varin, attorney-at-law, February 24, 1849, Paris; AN, F²¹. 4402, dossier 13), but would have to resort to litigation to settle a final problem with the administration (see below, *February 24, 1849*).

March 15

■ Salon of 1848

The exhibition catalogue (*Explication des ouvrages de peinture, sculpture, architecture, gravure et lithographie des artistes vivants exposés au musée national du Louvre le 15 mars 1848* [Paris, 1848], p. 66) lists the following:

"Chassériau (Théodore), Avenue Frochot / 28, rue de Bréda

[no.] 840—Sabbath in the Jewish Quarter of Constantine (Sandoz 1974, no. 107, p. 220).

In the foreground, the Jewish families, dressed in their richest garments and assembled in front of their houses, rest the whole day, according to their custom. Moorish chiefs from the Biskara Desert appear in the background.

[no.] 841—Portrait of M^lle. . . [M^lle de *Cabarrus;* 53 ⅛ x 37 ⅜ in.; Sandoz 1974, no. 115, p. 248; cat. 165]."

■ Obituary of Prosper Marilhat

The landscape painter Prosper Marilhat had died on September 13, 1847, and Chassériau gives Gautier the address of Marilhat's sister as he requested: "Write to her to arrange for a talk; she will be very pleased to see you again" (Letter from Théodore Chassériau to Théophile Gautier [March 15, 1848, Paris]; facsimile in Chevillard 1893, after p. 265; Gautier, *Correspondance*, 1988, vol. 2, no. 1150, pp. 327–28). At the time, Gautier was working on an article about Marilhat that would appear in *La Revue des deux mondes* on July 1, 1848.

March 25

■ Project for a Paid Exhibition

Along with many other artists, Chassériau joins the Société Nouvelle des Artistes, which is provisionally headed by M. Philipon. The society is founded on "a broad base of equality and brotherhood," its goal to create a "paid exhibition and lottery" to be held before and after the official Salon. Chassériau's name is also mentioned with those "members of the committee elected by the artists at the general assembly"; the seventy-two

other artists included Delacroix, Diaz, Daumier, Ingres, E. Isabey, Lehmann, Papety, and Vidal (AN, F²¹. 527, dossier "1848").

April 21

■ Election of the "Committee of the 72"

In the aftermath of the revolution of February 1848, many artists' associations were founded for the purpose of instilling democratic principles into art. One of these, the Assemblée Générale des Artistes Peintres, meets on April 21 in the Chamber of Deputies to form a committee, which becomes known as the "Committee of the 72." Among those elected are Chassériau, Delacroix, Ingres, Corot, Couture, Rousseau, and Boissard. The committee would hold discussions at the Institut and the École des Beaux-Arts (Rousseau [1935] 2000, p. 93).

April 24

■ Election of Representative Tocqueville

A lithograph by an unidentified artist reproduces Chassériau's portrait drawing of Tocqueville, of 1844. It bears the following inscription: "Assemblée nationale / Chasseriau / Alexis Charles Henry de Tocqueville / Représentant du Peuple / (Manche) / Paris V^or Delarue 10 Place / Desaix / Imp. Domnec" (Baltimore, 1979–80, no. 30, p. 157).

April 27–May 2

■ Competition for the Figure of the Republic

It was decreed on February 25, 1848, to replace the portraits of the king with a figure of the Republic. Chassériau submits an oil sketch (now lost) to the Palais des Beaux-Arts. In his review of the public exhibition, Gautier writes that Chassériau's figure "hovers above the world in the midst of swirling drapery with a gesture full of might and majesty, but seems to depict republican propaganda more than the Republic itself" (Gautier, May 21, 1848; published in Chaudonneret 1987, p. 147).

The work seems to have caused some consternation. Isnard would say three weeks later: "This alarming Republic (no. 212) belongs, they say, to M. Chassériau. We don't believe it" (Isnard, June 15, 1848, p. 163; Chaudonneret 1987, p. 157). Between May 10 and May 13, the commission charged with selecting twenty-five proposals for the competition's second round would not include Chassériau's sketch.

July 20–22

■ Purchase of *Christ on the Mount of Olives*

"Citizen Chassériau, painter" is informed "by a decree dated the 20th of this month, that the Minister of the Interior has acquired . . . for the sum of Fifteen hundred francs your painting representing Christ on the Mount of Olives" (Copy of the letter from the director of the first bureau of the Ministry of the Interior to Théodore Chassériau, July 22, 1848, Paris; AN, F²¹. 20, dossier 53).

The painting in question had been exhibited at the Salon of 1844 (see above, *March 15, 1844*) and would be sent to the Church of Sainte-Marie in Souillac on December 18, 1848 (see below).

Therefore, it was not a gift from Admiral de Verninac (Bénédite 1931, vol. 1, p. 223; Sandoz 1974, no. 97, p. 208; cat. 79).

November 20

■ The Hugo Family and the Cour des Comptes

On the eve of the unveiling of his murals to the public, Chassériau asks Charles Hugo to inform the readers of *L'Événement* in "a few lines," adding: "Please do me this favor if you can and try to go see them." The announcement that Chassériau wanted to have printed followed: "The murals in the grand stairwell of the Palais d'Orsay by Monsieur Théodore Chassériau are open to the public from 9 o'clock in the morning to 3 o'clock in the afternoon" (Letter from Théodore Chassériau to Charles Hugo, Monday [November 20, 1848], Paris; Maison de Victor Hugo, Inv. 9672).

A few days before, Chassériau had invited Victor Hugo, his wife, and their two children to see the paintings in the palace of the Cour des Comptes, indicating he would be "happy and proud . . . to show them to him before they open to the public" (Letter from Théodore Chassériau to Victor Hugo, Tuesday [mid-November 1848, Paris]; quoted in *Réunion de précieux autographes et de quelques livres dépendant de la succession de D.* [Jacqueline Daliphard], Paris, Hôtel Drouot, November 19, 1942, no. 70; Sandoz 1986, no. 92, p. 109).

November 21

■ Inauguration of the Stairwell at the Cour des Comptes

Commissioned four years earlier (see above, *June 11 and 14, 1844*), the monumental stairwell decorations are signed: "THÉODORE CHASSÉRIAU, 1844 à 1848" (Chevillard 1893, p. 269; Sandoz 1974, nos. 113–114, pp. 226–48).

■ Opinions: Gautier, Schnetz, and Moreau

Several days later (December 12, 1848), Gautier publishes a favorable review, unlike Schnetz, who would write: "Chassériau, one of Théophile Gautier's great painters, has just finished the decoration in one of the stairwells at the Conseil d'État in the Palais du Quai d'Orsay. You can not imagine this awful mess: neither draftsmanship, nor colors, nor effects; in short, a complete waste" (Letter from Jean-Victor Schnetz to Jean-François Navez, February 4 [1849], Paris; published in Chesneau-Dupin 2000, pp. 155–56). Gustave Moreau, for his part, is enthusiastic and tells his father: "I want to create epic art that does not belong to any school" (Lacambre 1997, p. 20).

December 9

■ Delaunay and His Permission

Chassériau requests "permission for Monsieur Delaunay to make studies after the masters at the Louvre—Please be obliging enough to issue him a pass permitting him to do this useful work; it would be greatly appreciated" (Letter from Théodore Chassériau to the director of the Louvre (?), December 9, 1848 [Paris]; Archives des Musées Nationaux, dossier P. 30 Chassériau; Sandoz 1974, p. 82 n. 1). The painter in question may be

Jules-Élie Delaunay (1828–1891), a friend of Gustave Moreau.

December 18

■ *Christ on the Mount of Olives* Is Sent to Souillac

By a decree of December 18, 1848, the monumental *Christ on the Mount of Olives* (cat. 79), shown at the Salon of 1844 (see above, *March 15, 1844*) and acquired by the Ministry of the Interior on July 20, 1848 (see above), is assigned to the Church of Sainte-Marie in Souillac (AN, F21. 377, dossier 38).

December 22

■ Frédéric's Promotion

An announcement in *L'Événement*, Victor Hugo's newspaper, reads: "By a decree of the 22nd of this month, M. Chassériau, formerly in charge of requests at the Conseil d'État, has been named Head of the Cabinet of the Minister of the Navy and the Colonies" ("Nouvelles diverses," in *L'Événement,* no. 148, Thursday, December 28, 1848, p. 3).

Bruno Chenique

1849–56

———

"A young god burdened with sorrow"

"She seemed like a marble-skinned Venus Anadyomene, *posing nude by the sea"* (T. Gautier).
Alice Ozy

The completion of the murals for the Cour des Comptes, and the relative indifference that greeted the public opening (see p. 214), coincided strangely with the onset of the "Alice years"—two years filled with work and emotional turmoil, in which the painter was to have a short-lived and passionate affair with one of the most famous demimondaines in Paris, Alice Ozy (born Julie-Justine Pilloy; see cat. 168, 169).

The presumed references in Chassériau's paintings to the sensual body of the young actress—whom Jean-Louis Vaudoyer called a "modern Aspasia"[1]—have been greatly overestimated. Some authors maintain that she inspired all the representations of women in his career—even the *Susanna and the Elders* (cat. 15), painted nine years before they met! Clearly, the romantic nature of this love affair lent itself readily to exaggerations and interpretations, which were fueled in turn by the more or less imaginary accounts of certain contemporaries, like Victor Hugo, who put the relationship of the two lovers in a near sado-masochistic light in *Choses vues* (see cat. 168). It is true that Hugo had been rejected by Alice Ozy in favor of his own son, Charles, who became her lover for several months.[2] Chassériau probably loved Alice Ozy deeply, but this feeling manifested itself objectively in only a few works, mostly drawings (cat. 168, 169), and particularly in the *Bather Sleeping near a Spring* (cat. 173), in which the painter seems to have given full expression to his love for the young woman's body and temperament.

Generally speaking, the mythological, religious, and fictional heroines like Sappho and Desdemona, and the odalisques and nymphs in Chassériau's paintings were more a synthesis of idealized images of the female body than allusions to his mistresses or personal muses. Indeed, he had quite a few of these in his life: There was his adolescent crush on Clémence Monnerot, his intellectual (*and* physical, according to Champfleury) attraction to Delphine de Girardin and Princess Belgioioso, his flirtation with Marie d'Agoult, and the woman with whom he spent his last months, Marie de Cantacuzène—not to mention his platonic admiration for his older sister (see cat. 54, 61). Chassériau, a keen portraitist, scrupulously rendered the reality of the human form—during this period he was still drawing magnificent portraits in pencil (cat. 206–220)—and he enhanced his paintings with what he called "subjects": female faces and figures based on a combination of experience, fantasy, and artistic reminiscences.

Vaudoyer was correct when he wrote, in 1933, that "Chassériau—like Botticelli, Leonardo, Bronzino, and Prud'hon—had the privilege of endowing the world of art with a female type whose physique and physiognomy had not existed before him." The biographer then added: "Chassériau's woman not only possesses a romantic and emotional power, she is not merely an object of visual delight but also a source of reverie for the imagination. Her elongated, firm, and harmonious forms recall those of ancient goddesses, yet the wistfulness of her poses and gazes reveals anxieties and aspirations that were unknown in Antiquity."[3] Even if this "Chassériau woman" had, in fact, already "crystallized" in his youth—a composite of several women in his life, both friends and lovers—she evolved continuously in the course of his career, enriched as much by his sensual tribulations as by his aesthetic reflections. Starting with the splendid creations he submitted to the first Salons—the *Esther* (cat. 66), the *Venus Anadyomene* (cat. 13), and the *Andromeda* (cat. 65)—he produced endless variations in the years that followed, uniting with a rare mastery the classical or Orientalist idealization of the goddesses of the past with the sensual, erotic,

and life-like depiction of women of flesh and blood. The "Chassériau woman"—like those imagined by Gautier and Baudelaire—in her guises as provocative princess or sacred prostitute, whether dominant or submissive, stimulates the senses as much as the imagination, sparking sexual desire no less than aspirations to reverie and poetry. The "great sensual creatures" he invented are stylized like mythical allegories in appearance only; in fact, they are also "suffused with blood" and inspire "reveries of desire."[4]

Given this, his representations of Oriental women lying about in harem scenes—a subject he began to explore after his trip to Algeria—can be taken as expressions of his artistic concept of the Nude and his ambition to add something new to this genre.

". . . the entire body naked through a reddish gauze speckled with gold . . ." Odalisques and Nymphs

Starting in 1849, after Ingres painted *The Grande Odalisque* (fig. 1) and *The Bather of Valpinçon* (fig. 2), and Delacroix, the *Women of Algiers* (fig. 3), Chassériau contributed his pictorial variations on the theme of the harem, then very much in vogue in the visual and the literary arts.

Concerning this trend, already signaled by Victor Hugo's *Les Orientales,* David Scott, a historian of French nineteenth-century poetry, advanced ideas that could very well be applied to works painted by Chassériau after his return from the East: "The odalisque is a blend of two major types: one ancient and classical—the nude—and the other, modern and Romantic: Orientalism. One of its major attractions for the bourgeois public of the day was precisely this blend of exoticism and sensuality, which gave the Occidental observer an opportunity for erotic fantasy justified by the 'orientalizing' atmosphere of the image."[5] Accordingly, eager for professional success, lacking in private means, and hoping to seduce art dealers and collectors, Chassériau surely did not ignore the effect of this provocative imagery on the "bourgeois public" that constituted his potential market. Yet, at the same time, it was probably the other aspect defined by Scott—the synthesis of tradition and modernism—that interested the painter most

FIG. 1
JEAN-AUGUSTE-DOMINIQUE INGRES
The Grande Odalisque
1814
Oil on canvas
Paris, Musée du Louvre

FIG. 2
JEAN-AUGUSTE-DOMINIQUE INGRES
The Bather of Valpinçon
1808
Oil on canvas
Paris, Musée du Louvre

of all. This was a period in which the renewal of subject matter in painting determined the splits between the various schools, providing a source of modernism for the Romantics and the Realists. Therefore, the renewal of pictorial subject matter—and the necessary stylistic developments it entailed—was at the heart of Théodore Chassériau's preoccupations in his Oriental scenes.

In fact, the theme of odalisques reclining, bathing, or dressing, with the help of servants, was not an invention of the nineteenth century. Oriental references may be seen in many Renaissance and seventeenth-century paintings, and even more in those of the eighteenth century, which abounded in representations of exotic and libertine subjects playing indirectly on Oriental themes. We need mention only such artists as François Boucher (*Blonde Odalisque* of 1752: Munich, Alte Pinakothek; and *Dark-haired Odalisque* of 1745: Paris, Musée du Louvre);[6] in a more fashionable vein, Jean-Étienne Liotard (*Madame Coventry*: Geneva, Musée d'Art et d'Histoire; *M. Levett and Mlle Glavany in Turkish Dress* of about 1738: Paris, Musée du Louvre); and in a more picturesque idiom, Charles-Amédée van Loo's series of paintings for the Manufacture des Gobelins (*The Toilette of a Sultana* of 1774; and *The Sultana and the Odalisques* of 1775: Paris, Musée du Louvre). These depictions of women, at once remote by virtue of their geographic and cultural origins yet accessible through the sensuality of their dress and the beauty of their bodies, interested art lovers during the Age of Enlightenment—all the more so, as trips to the Orient were already very popular. By then, visits to the harem and the baths of the sultan's favorites were an indispensable feature of travelers' accounts. For example, Claude-Étienne Savary (1750–1788) wrote, in his *Lettres sur l'Égypte*: "The women love these baths with a passion and go at least once a week, bringing slaves to serve them. They are more sensual than the men, and, after having gone through the usual preliminaries, they wash their bodies, and especially their heads, with rose-scented water. Then their long black tresses are braided by coiffeuses and scented with precious fragrances instead of powder and pomade."[7]

Despite the realism and sensuality of certain depictions, these early "harem tableaux" were mostly destined for the boudoir, and for collectors, and, while these works were sometimes shown at the Salon, like those of van Loo mentioned above, they never earned academic recognition and were relegated to the minor category of "genre scenes."

When he first began to depict scenes of harems and fulsome odalisques, Chassériau undoubtedly had in mind the eighteenth-century renditions of this theme. Since 1830, and the restoration of the monarchy under Louis-Philippe, the wounds of the Revolution had begun to heal and the treasures of the Age of Enlightenment again found favor, together with the courtly art of Versailles,[8] which the Goncourts and La Caze would later rediscover. Chassériau, however, referred more to the works of the generation that had just preceded him, the first Romantics, who had introduced a new exoticism into their subject matter. He also must have recalled Ingres's very personal treatment of exotic subjects in his early years—the Orientalism of the "bazaar" of the famous "Monsieur Auguste"[9]—as well as the visionary art of Delacroix and of Decamps, which was prized by critics and art lovers alike. After Delacroix's *Women of Algiers* (fig. 3) was exhibited at the Salon of 1834 and purchased by the king, harem scenes gradually had become more acceptable in artistic circles and were even deemed worthy of being shown at the Salons, as exemplified by Francesco Hayez's *Odalisque* (Milan, Brera) in 1839, and Édouard Dubufe's *Woman Leaving the Bath* in 1841.

After 1840, nourished by the nostalgic and evocative tales of travelers to the Orient, the harem became a genre in its own right. As it was, every newcomer to the Near or Middle East owed it to himself to spice up his journey with a visit to a harem, places that were usually off limits but which seem to have made occasional "tourist" exceptions. In 1832, Lamartine himself was denied access to the sultan of Constantinople's harem, a fascinating place "in which only a few odalisques remained,"[10] and where "the eye was forbidden to linger." However, fortunately, he was able to visit the vast communal baths for women in Beirut, a sight that left an indelible impression on him, inspiring the following description, which is not unrelated to Chassériau's paintings: "Finally, they emerged from the bath; slaves and servants braided the wet hair of their mistresses again, put their necklaces and bracelets back on, and clothed them in robes of silk and vests of velvet."[11] In that same year, Delacroix also may have gained entry to a harem in Algiers during his brief stay, between June 25 and 28, 1832. This episode inspired his marvelous "interior poem,"[12] *The Women of Algiers*. In 1842, several years before Chassériau, Gérard de Nerval embarked on a long journey that took him from Egypt to Turkey, and was able to visit the viceroy's harem in Cairo.[13]

Every traveler was escorted by his "dragoman," or guide, to places where one could see "the fragrant flowers of the harem, those delicate white faces untouched by the sun and obligingly unveiled" (Gautier), but the gullible tourist often was taken not to a harem but to a bordello.

FIG. 3
EUGÈNE DELACROIX
*Women of Algiers
in Their Apartment*
1834
Oil on canvas
Paris, Musée du Louvre

We do not know what, if any, experiences Chassériau had in this respect, as it was not the sort of topic that one wrote about to one's mother or sister. The harem scenes that he composed late in his career are characterized both by a classical formalism—fluid and diaphanous bodies, the juxtaposition of draperies and nudity, the play of light on modeling of the forms, sophisticated compositions and poses—and a documentary-like realism (clearly tinged with eroticism) that had little to do with accounts of adventures experienced firsthand. In these refined little scenes combining sensuality and naturalism—if not "commercialism"—Chassériau achieved a synthesis of his mastery of the classical genre of the Nude with the modernism of Orientalist imagery. In this he was clearly following in Delacroix's footsteps, but he was also developing his pictorial representations of Oriental subjects in two directions: on the one hand, toward a less eternal and mythical, more mundane and accessible, reality; and, on the other, toward a more sensual, poetic, almost Symbolist and musical dimension akin to the poems of Gautier, Nerval, and Baudelaire.

"One can see the Arab race and the Jewish race, as they were on their first day."
Orientalism

Chassériau's approach in depicting the Nude was practically the same as when he painted contemporary battle scenes between the Spahis and the Kabyles (cat. 191, 192). Just as we cannot be certain that he was able to actually contemplate Algerian women bathing in a harem, there is little evidence to support the thesis that, during his stay in Algeria, he witnessed the bloody combats then raging throughout North Africa (see cat. 190). Did he really observe that grievous sight—fraught with human and political significance—of combatants carrying their dead away from the scene of battle (fig. 4)? How much was based on his actual experiences in Algeria, and how much on his childhood and youthful fantasies about the Orient? How much did he owe to the human emotions and visual impact of experiences in situ, and how much to the slow and personal maturation of his pictorial treatment of the new subjects introduced by the Romantics?

His letters to his brother are silent about any adventures in harems or bordellos, but they contain a wealth of information about his encounters with the French military, then engaged in violent confrontations with the Kabyle and Arab population of Algeria.[14] Did his relations with the military authorities permit his participation in operations in the Jebel? Or did he merely let his imagination flesh out the stories told by soldiers returning from combat? Although he may have tried to play down the risks he was taking to reassure his family, it is not at all unlikely that Chassériau may have been present at a bloody skirmish or two during his stay in Algeria (see fig. 5). It may be that, while traveling from one city to another, or during an excursion with soldiers of his acquaintance, he happened upon a scene of recent combat, and so witnessed what he later depicted in his large composition exhibited at the Salon of 1850, *Arab Horsemen Removing Their Dead* (Cambridge, Massachusetts, Fogg Art Museum).

Whether or not this really occurred, in his many preparatory drawings of cavalry charges and Spahis and Kabyles in combat, Chassériau seems to have been less interested in depicting visual reality than in

addressing compositional and formal concerns: the sophisticated linear play of the bodies plunged in mortal combat and the optimal description of soldiers in action. His absolutely contemporary subject matter—the colonial conquest of Algeria—allowed Chassériau to elaborate, in his works, on the aesthetic tradition of hunt and battle scenes. Yet, it would be a mistake to think that he was indifferent to the political situation. Surely, he favored the architectural transformations of the city of Algiers in the wake of the French colonization, but he regretted that Constantine was "the only truly Arabian city left in this country,"[15] and that "this beautiful and unique land [is] so close to losing its originality and becoming thoroughly French."[16] He was, in fact, fascinated by Algerian customs and civilization and deplored the fact that its colonization was being effected by the sword. In the *Arab Horsemen Removing Their Dead* he proved that his preoccupations were both artistic and political, and that this painting was not merely a pretext for depicting an aesthetic and emotional theme. Unlike Eugène Delacroix, he saw in the streets of Algiers more than just latter-day descendants of Brutus and Cato, or a "living Antiquity." He was also interested in modern-day Algeria and, having seen human suffering, he wanted to record it in his paintings, not hesitating to elevate this suffering to the status of History.

Thus, the paintings of Orientalist subjects inspired by his Algerian journey can be divided into three categories, beginning with those executed in 1849: actual realistic and documentary scenes, sensual representations of Oriental women, and scenes of battle and combat. The first category exemplifies the painter's faithful depiction of life in North Africa as he saw it, during his travels; generally, these scenes were sketched from life, in his notebooks, before being worked out on canvas—as, for example, the *Scene in the Jewish Quarter of Constantine* (cat. 154), *Jewish Family of Constantine* (cat. 183), and *Jewish Wedding in Constantine*. The second category includes paintings of Oriental women executed in a realistic and poetic manner, such as the *Moorish Dancers* (cat. 180) and the *Jewish Women on a Balcony* (cat. 177), or, in a more fantastic and erotic vein, his harem scenes (see cat. 181, 182, 254). In the third category are stirring depictions of the bloody French conquest (see cat. 191, 192) and also homages to the battle scenes by the great masters of the Renaissance, ranging from Raphael to Rubens, as well as those by the first generation of Romantics, such as Horace Vernet and Delacroix.

Throughout these variations on Orientalist themes, Chassériau's genius consisted in preserving the emotion of the traveler, re-creating the reality of everyday life—the dress and costumes of the Algerian

FIG. 4
Arab Horsemen Removing Their Dead After an Engagement with the Spahis
(sketch)
1852
Oil on canvas
Paris, Musée du Louvre

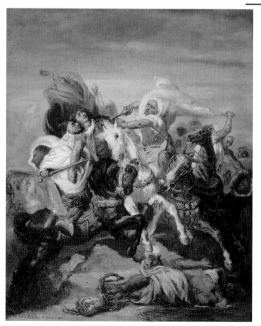

FIG. 5
Arab Horsemen in Combat
1854
Oil on canvas
Paris, Musée du Louvre

FIG. 6
Fisherman's Wife from Mola di Gaeta Kissing Her Child
1849
Oil on wood
Paris, Musée du Louvre

people—and, above all, transposing these experiences into a timeless pictorial language, combining classical tradition with the innovations of the Romantic age. His odalisques recall the figures of Venus by Titian and by Tintoretto; his battle scenes, those by Le Brun; and his hunting scenes, examples by Rubens. All of these works display—intact—the power and intensity of the Romantic palette, the visual experience of the world of North Africa, and the "feel of the Orient."

"Determination, courage, and your entire soul."
The Complete Painter

Having had these two important experiences—traveling in the Orient and creating a major decorative composition (not to mention an unhappy love affair: his relationship with Alice Ozy ended about 1850)—Théodore Chassériau went on to diversify his subject matter, demonstrating the full scope of his talent. The Salon of 1850–51 was a milestone in this respect: He exhibited two portraits, *Madame de Savigny* and *Alexis de Tocqueville* (cat. 204); two intimate and realistic genre scenes, *Woman and Little Girl from Constantine with a Gazelle* (cat. 178) and *Fisherman's Wife from Mola di Gaeta Kissing Her Child* (fig. 6); an ambitious and political Orientalist composition (the previously mentioned *Arab Horsemen Removing Their Dead*); a revolutionary treatment of the Nude (*Bather Sleeping near a Spring;* cat. 173); a small painting inspired by the Antique (*Sappho;* cat. 170); and a Shakespearean subject (*Desdemona;* cat. 196). At the same time, he began work on the decoration of a chapel in the Church of Saint-Roch in Paris.

However, Chassériau's complex aesthetic development—which involved blending Antique and classical references, Romantic feeling, and the realistic portrayal of figures and objects—is most evident in another area. This is not a reference to the introduction in his oeuvre of Delacroix's color palette—which, at the time, was in conflict with the linearity of Ingres's manner, as many art historians have claimed—but to his love for color, to which he had always been attuned. During this period, he elaborated further on Antique iconography and history painting, which led to his two unquestioned masterpieces, *The Tepidarium* (cat. 237) and *The Defense of Gaul* (fig. 7; cat. 242–252).

The painter had long been an advocate of truth, precision, and faithfulness to Nature and to Man. As he wrote in his notebooks: "Make it monumental, but real," and, "Nothing sparkles more than Nature." A constant leitmotif was his quest for "poetry in reality." Along with his extensive erudition; his perfect knowledge of examples from Antiquity, the Renaissance, and the classical period; and his poetic and refined nature, one of the outstanding features of his art was its direct portrayal of reality: "Do not forget that true painting is the simplest painting." It is not surprising, therefore, that, at this point in his career, he raised the most important question regarding history painting: How can an artist be faithful

FIG. 7
The Defense of Gaul
1855
Oil on canvas
Clermont-Ferrand,
Musée des Beaux-Arts

to historical reality, to the true facts, and yet make the subject of his work appear to have been directly experienced physically and emotionally, while producing innovative and lasting forms? In other words, how can one depict events in a genuine, vibrant, and realistic way and, at the same time, create a work of art? These were Chassériau's aesthetic and conceptual goals in *The Tepidarium* and in *The Defense of Gaul.*

Working in this manner inevitably led him into contact with the new outlook espoused by certain contemporary historians and philosophers. Since the appearance of Chateaubriand's *Martyrs* and works by such historians as Augustin Thierry and Edgar Quinet, the Romantic approach to history—manifested by developments in the field and, specifically, by the birth of the historical novel—had underscored the necessity of understanding the causes and contexts underlying the objective accounts of events. Writers and poets, but also politicians like Adolphe Thiers and Alexis de Tocqueville, began to revise historical thinking prior to 1850, endeavoring to enhance the facts and their own erudition by calling their imagination and emotions into play. Jules Michelet further enlarged upon this new concept of history: Both a scholar and a poet, he was involved in the political struggles of his time, and regarded history not just as "narration" (Augustin Thierry) or "analysis" (Guizot) but as the "resurrection of life as a whole." During this same period, positivists like Auguste Comte, and scientific thinkers like Ernest Renan and Hippolyte Taine were contributing to this new way of presenting history and historical philosophy.

To quote Jules Michelet: "Is the work not colored by the feelings and the times of its creator?"[17] There is no doubt that the last two major compositions executed by Théodore Chassériau before his death—concurrent with his large-format *Descent from the Cross* (cat. 232) for Saint-Philippe-du-Roule, which ruined his health—were steeped in such ideas. It was no longer enough to create a work of art, a demonstration of painting in the grand style, but the artist had to break with convention and come closer to the reality of human nature and historical truth. *The Tepidarium*, which could have been just another harem scene or evocation " à l'antique," transcended these genres—on the one hand, by its formal and compositional stylization and, on the other, by the archaeological precision of the setting and costumes in reconstructing the ambiance of the baths of Pompeii.[18] Although clearly a variation on the familiar theme of the harem, and of the inherent sensuality and exoticism of Orientalist depictions of the Nude, this painting presents its subject in a completely different way, sublimely reviving the representation of Antiquity in painting. Chassériau's other major composition, *The Defense of Gaul,* which depicts a specific episode in Caesar's conquest of Gaul, and thus, a moment in the history of France—the "France that made France"[19]—reveals not only the heroic but also the barbaric side of "our Gallic ancestors." There is no trace of Neoclassicism or Romanticism in this work, the painter's last, but a search for historical truth and lyrical grandeur, and a perfect mastery of aesthetic means in the service of patriotism.

In these two major Antique—or, rather, "archaeological"—compositions, completed just a few years before his death, Chassériau achieved a synthesis of the tradition established by the masters of the past, the unbridled expression of human emotion, and a strict realism, thus setting new standards for history painting.

"We are only a worn-out memory and a living memory at that."

The year of the Exposition Universelle, 1855, could have marked a high point in the recognition of Chassériau's work, as it had for Delacroix and Ingres, but his *Defense of Gaul* met with considerable criticism (see p. 377). Exhausted by his work on the decorations at the Church of Saint-Philippe-du-Roule, he made several trips to the Tracys in the Allier, and two sojourns to Spa and to Boulogne-sur-Mer, but he never recovered, and he died on October 2, 1856, in his family's apartment in the rue Fléchier.

The year 1856, which also saw the deaths of the painter Paul Delaroche and the sculptor David d'Angers, was marked by the rise of Realism and landscape painting. This new movement was represented by the Barbizon painters and by Gustave Courbet—who had just weathered the scandal caused by his *Burial at Ornans*, exhibited a year earlier—while Jean-François Millet was at work on his masterpiece of the following year, *The Gleaners* (Paris, Musée d'Orsay). Ingres, who was about to finish *The Source*, a painting that he had already been working on when Chassériau joined his atelier (see cat. 1), would live for twenty-one years more, and Delacroix, elected to the Académie des Beaux-Arts in 1857, would survive until 1863. Camille Pissarro was then only twenty-six years old; Degas, twenty-two; and Claude Monet, sixteen. Chassériau left the world long before both the deaths of his illustrious precursors and the emergence of his successors on the scene.

Unlike Corot and Delacroix, certain of whose lesser-known works were discovered after their deaths— the Italian drawings by the former, and the landscapes by the latter—the posthumous auction of Chassériau's oeuvre, organized in his memory by his brother Frédéric,[20] turned out to be neither a social event nor an artistic communion, and even less a tribute by the official art world. Far from it: The 108 lots proved hard to sell, only five paintings fetched more than one thousand francs,[21] and the highest price was paid for a landscape by Prosper Marilhat![22] Apparently, Frédéric and some friends and family members purchased the greater part of the works in the sale.

Nevertheless, Théodore Chassériau's fame was secure, despite the fact that he did not really leave behind any pupils. Both the thirty-two-year-old Puvis de Chavannes and the thirty-year-old Gustave Moreau (see fig. 8) would enlarge upon the aesthetic of the painter of the Cour des Comptes, taking his ideas as a muralist and his vision of the Orient, the sensuality of his female nudes, and his renewal of history painting as their points of departure. The faithfulness of their transmission of Chassériau's contributions to art extended his legacy as far as Paul Gauguin and Henri Matisse.

Vincent Pomarède

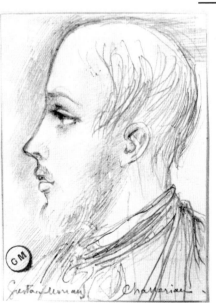

FIG. 8
GUSTAVE MOREAU
Théodore Chassériau
About 1856
Pencil
Paris, Musée Gustave Moreau

1. J.-L. Vaudoyer gave Alice Ozy this nickname and used it in the title of his book *Alice Ozy ou l'Aspasie moderne* (Paris, 1930).

2. Concerning the relationship between Victor Hugo and Alice Ozy see L. Loviot, *Alice Ozy* (Paris, 1910), pp. 40–75.

3. J.-L. Vaudoyer, in Paris, Orangerie, 1933, p. XII.

4. Ibid., pp. XVI, XXVI.

5. D. Scott, "Écrire le nu: La Transposition de l'image érotique dans la poésie française au XIX^e siècle," in *Romantisme. Revue du dix-neuvième siècle*, no. 63 (1989), p. 87.

6. These examples are mentioned with reservations, as the designation of "odalisque" in the titles was made in the nineteenth century. However, there is an obvious Orientalist quality in these two works.

7. C.-É. Savary, *Lettres sur l'Égypte* (Paris, 1785), vol. I.

8. In Honoré de Balzac's *Cousin Pons,* which was published during this period (1847), a fan decorated by Watteau plays an interesting part in the story. Louis La Caze (1798–1869) was also assembling the famous collection of eighteenth-century works that he later bequeathed to the Musée du Louvre.

9. Jules-Robert Auguste (1789–1850), a friend of Ingres, Géricault, Delacroix, and Horace Vernet, returned from his travels in the Orient with a collection of objects and costumes that he readily lent to his friends, who wanted to paint Orientalist scenes. This admirer of eighteenth-century France played a key role in the transmission of the Orientalist genre from one century to the next; on this subject see *Le Temps des passions: Collections romantiques des musées d'Orléans* (Orléans: Musée des Beaux-Arts, 1997–98), pp. 112–17.

10. A. de Lamartine, *Voyage en Orient* (Paris, 1835); quoted in J.-C. Berchet, *Le Voyage en Orient* (Paris, 1985), p. 467.

11. Ibid., p. 719.

12. C. Baudelaire, *Le Salon de 1846* (Oxford, 1975).

13. See G. de Nerval, *Voyage en Orient* (Paris, 1851).

14. Letter from Théodore Chassériau to his brother, May 23, 1846; quoted in Bénédite 1931, vol. 2, pp. 267–68.

15. Ibid.

16. Letter from Théodore Chassériau to his brother, June 20, 1846; quoted in Bénédite 1931, vol. 2, p. 270.

17. J. Michelet, *L'Histoire de France* (preface to the 1869 edition).

18. Chassériau used his drawing of the baths of Venus Genitrix, executed during his visit to Pompeii, for *The Tepidarium.*

19. Michelet, op. cit.

20. "Atelier de feu M. Théodore Chassériau," *Catalogue de tableaux, études, esquisses, dessins, armes et costumes laissés par M. Théodore Chassériau dont la vente aura lieu, par suite de son décès, rue Drouot, 5, salle n^o 5, au premier, les lundi 16 et mardi 17 mars 1857, à deux heures.* The auctioneer was Maître Pouchet and the expert, M. Francis Petit. The works were shown to the public on Sunday March 15, 1857, from noon to five p.m.

21. No. 1: *Susanna and the Elders* (cat. 253): Fr 1,700; no. 2, *Arab Horsemen Removing Their Dead after an Engagement with the Spahis* (fig. 4, p. 284): Fr 1,500; no. 3, *Macbeth and Banquo Encountering the Three Witches on the Heath* (cat. 200): Fr 1,400; no. 4, *Interior of a Harem* (cat. 254): Fr 1,460; no. 7, Ensemble from the hemicycle of the Church of Saint-Philippe-du-Roule: Fr 1,200.

22. No. 31: Marilhat, *View of the Environs of Athens*: Fr 2,850.

The Salon of 1851

170

Sappho

1849
Oil on wood
10 ⅝ x 8 ¼ in. (27 x 21 cm)
Signed and dated, bottom right: *Thre. Chassériau 1849*
Paris, Musée d'Orsay

PROVENANCE:
Jean-Marc Gras; Mme Gras sale, 1917, lot 4; Baron Arthur
Chassériau; bequest of the latter to the Musée du Louvre, 1934
(RF 3886); placed on deposit by the Louvre at the Musée d'Orsay.

BIBLIOGRAPHY:
Gautier, *La Presse*, March 1, 1851; Chevillard 1893, no. 71;
Bénédite 1931, pl. 13; Sandoz 1974, no. 128; de Caso 1985–86;
Compin and Roquebert 1986, vol. 3, p. 133; Prat 1988-1, vols. 1
and 2, nos. 570, 571, 573, 1771; Peltre 2001, p. 193.

EXHIBITIONS:
Salon of 1850–51, no. 535; Paris, 1933, no. 46.

Loneliness and melancholy were recurrent themes in Chassériau's work. His early drawings and the paintings he executed throughout his career were full of abandoned young women in the throes of an unhappy love or dark despair without apparent reason.[1] Although Chassériau depicted the drama more than the legend, his *Sappho* stands out as the personification of absolute solitude among these heroines at odds with painful circumstances, excluded from happiness, and sometimes even from life. The emphatic picturesqueness indulged in by David, on the fringes of history painting, in his rendition of the romance of the poetess and the inconstant shepherd (*Sappho, Phaon, and Eros*, 1809; Saint Petersburg, The State Hermitage Museum) is completely absent here. Chassériau concentrated on the fate of the individual, the passion of love transformed into torment.

This subject, which haunted him as early as 1839–40, often had been treated in European art from the late eighteenth century on.[2] For lack of a better term, one could describe it as pre-Romantic, in its fusion of the traditional concept of Melancholy with that of the shattered self and the temptation of suicide, juxtaposed against the background of "delectable horror"—to quote Burke's definition of the Sublime in art, taken up in France by Sénancour. The last years of the Age of Enlightenment reveled in the thrill of cosmic infinity that put an end to geocentricism, but at the price of anxiety. As Élisabeth Soubrenie rightly noted, this "unbalanced Universe" could either be identified with God or could leave Mankind alone, divested of its privileges: "The fear of an empty Universe leads ultimately to the exploration of the inner void."[3] Little did it matter that modern science was doing its best to bring order into this chaos. As Chateaubriand wrote to Voltaire in 1802: "We live with full hearts in an empty world." Sappho's suicide, as depicted by Gros in a canvas shown at the Salon of 1801, to the great surprise of the critics—who called the painting "Romantic"[4]—was an especially fitting subject for this meditation on the finite and the infinite inherent in the human condition. According to Prat, a sketchbook in the Louvre (RF 26056) reveals that, about 1840, Chassériau's initial explorations of the theme of Sappho combined elements of his aborted project to depict the women of Souli—who chose to die by jumping off a cliff—with his meditations on the subject of Apollo and Daphne.

These works may be linked to Chassériau's literary influences, and, in particular, to Lamartine's "Sappho, an Antique Elegy," written—significantly enough—in 1815, and published in the *Nouvelles Méditations poétiques* in 1823. This poem, which appears near the beginning of the book, was composed in a classical idiom and contained striking images: tormented by guilt, the young woman is punished for her failure to inspire love, and the whole abounds in mortuary metaphors invoking the "stillness of the grave."

In 1846, Chassériau dedicated a large watercolor of Sappho to Mme Alphonse Lamartine (see cat. 171). In that work, Sappho, clutching the lyre that symbolizes Poetry, apparently floats in empty space, flying more than falling, closer to the heavens than to the depths of the sea. Chassériau painted a new version of this subject in the same year as the present canvas, showing a figure not in graceful ascension but, Ophelia-like, at the mercy of the waves. This painting, which belonged to the Tocqueville family, has been lost, but was related to the representations of shipwrecked young women bathed "in moonlight" popularized by Géricault and Delacroix. A drawing in the Louvre (RF 25970) records the composition and lays bare its tragic theme.

As expressed by Lamartine, in 1815: "Fatal rocher, profond abîme! / Je vous aborde sans effroi!" [Fatal rock, bottomless abyss! / I approach you without fear!], this sense of an abysmal gulf and of an irrevocable separation from the world is what strikes us in the small Louvre picture. Christine Peltre noted: "The face of the poetess confronts the spectator with a gaze full of horror and madness." In her "pensive sorrow," the poetess of Venus, huddled on the cliff, resembles some of the figures in the *Trojan Women* of 1842; this is not a liberating flight, but the dead weight of a dislocated, unsatisfied body that had given itself to both sexes and suffered from lack of love. Jacques de Caso wrote: "He pictured her robust, tragic, self-absorbed, anchored in a dark landscape, still holding onto the rock from which she is about to jump." Both the form and the content of the picture recall the ninth etching in the "Othello" suite, which represents a scene from the "Song of the Willow." Like the subject of *Apollo and Daphne* (cat. 113), this one could be interpreted in two ways: as a love story, or as a metaphysical fable—neither of which excludes the other. About 1848, the unrequited Sappho continued to inspire writers—who produced both tragic and satirical versions of the legend[5]—as well as artists.[6]

Gautier, writing about the other works Chassériau submitted along with the Avignon *Bather* to the Salon of 1850–51, aptly described them as "small pictures full of character that display familiarity with Grand Painting in spite of their restricted format."[7] Never had the vastness of the void, the infinity of solitude been depicted on such a small scale. The brushwork may appear rapid, but the idea was deep. There are few images in French Romanticism as intoxicating as this one.　　　s. g.

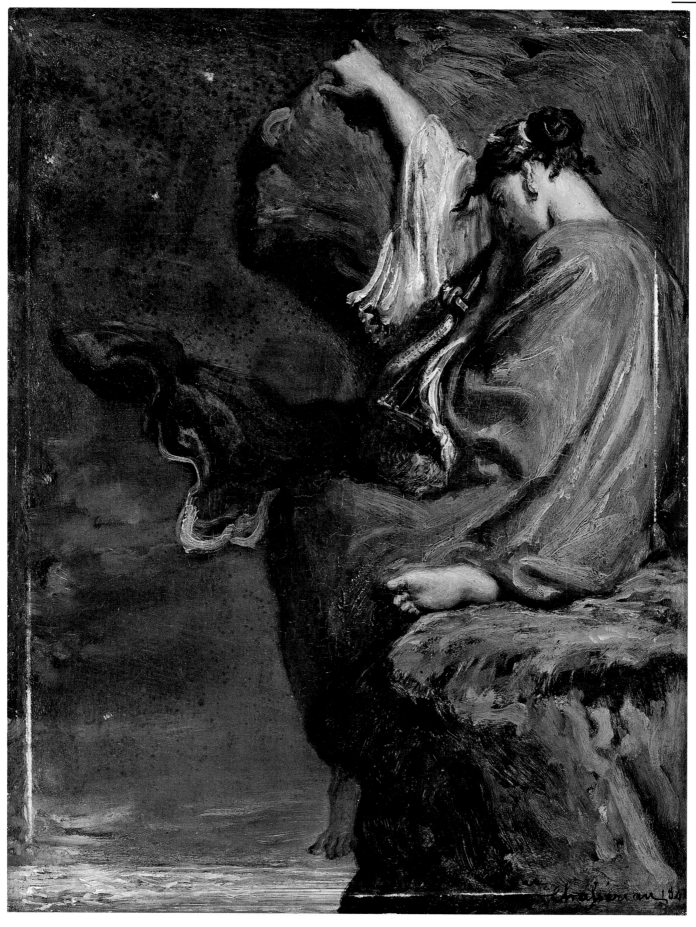

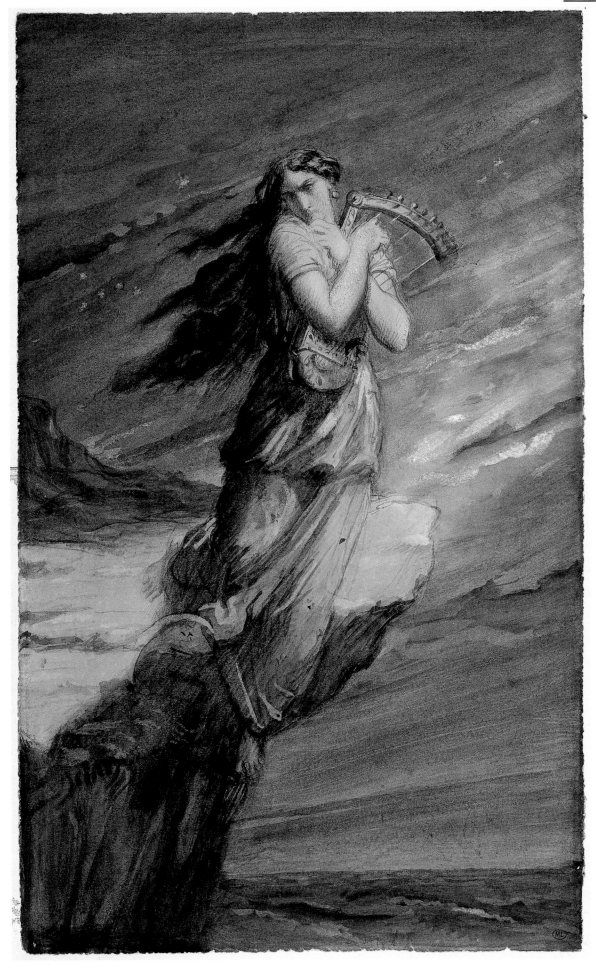

1. Robert Rosenblum provided a perfect analysis of this type of imagery "detached from any precise narrative context" in connection with Constance Charpentier's *La Mélancholie* (Amiens; Salon of 1801); see *De David à Delacroix*, exhib. cat. (Paris: Grand Palais, 1974), pp. 346–47.
2. See Jacques de Caso's treatment of this topic in *Statues de chair. Sculptures de James Pradier (1790–1852)*, exhib. cat. (Geneva and Paris, 1985), pp. 171–76.
3. É. Soubrenie, *Présence de la solitude. La poésie anglaise entre néoclassicisme et préromantisme* (Paris: Champion, 1999), p. 149.
4. According to a critic in the *Journal de Paris:* "There is more poetry than truth in this painting: the scene is romantic, the color ideal. This subject may present itself to the imagination in this way, but never to the eye" (quoted in *De David à Delacroix,* op. cit., p. 347).
5. The November 24, 1845, issue of *Le Corsaire-Satan* published an unsigned parody by Baudelaire written in eighteenth-century style and titled *Fragments littéraires.* Arsène Houssaye wrote an imaginary "antique" drama in three acts—all of them in bad verse—published in three installments between October 15 and November 15, 1850, in *L'Artiste,* shortly before the Salon of 1850–51.
6. This subject again became fashionable in painting and sculpture about 1848. An Ingresque *Sappho* by Dugasseau, shown at the Salon of 1845, was called a "fine composition" by Baudelaire. There are two sculptures by Pradier depicting the poetess alone, one standing (Salon of 1848) and the other seated (Salon of 1852). In the latter, the sculptor suggested that the sea is bathing her feet. This was considered contradictory by Gustave Planche, who maintained that the tragedy called for a fatal void: "A few steps from the shore, Sappho could have given up the idea of suicide and chosen glory instead of love; but the rock of Leucade did not allow her to choose life over death" (*Revue des deux mondes,* July 15, 1852; quoted in de Caso, op. cit., p. 171).
7. T. Gautier, "Salon de 1850–1851," in *La Presse,* Paris, March 1, 1851.

171

Sappho Jumping into the Sea from the Rock of Leucade

1846

Graphite and watercolor
14 ⅛ x 9 in. (37 x 22.8 cm)
A large photograph of the framed drawing, in the Service d'Étude et de Documentation des Peintures of the Musée du Louvre, shows the old passe-partout, which was inscribed in graphite, at the lower left: *A Madame Alphonse de Lamartine, Théodore Chassériau, 1846*
Paris, Musée du Louvre (RF 24388)

PROVENANCE:

Mme de Lamartine; Baron Arthur de Chassériau, Paris; bequest of the latter to the Musée du Louvre, 1934 (L. 1886 a).

BIBLIOGRAPHY:

Chevillard 1893, part of no. 420; Bénédite 1931, vol. 1, colorpl. XIV; Sandoz 1974, under no. 67; Fisher, in Baltimore, 1979–80, under no. 24, p. 151; MacGregor 1981, p. 119, fig. 76; Sandoz 1986, no. 88, ill., and p. 234 (without an inventory no.); Prat 1988-1, vol. 1, no. 52, ill., and color cover vol. 1; Peltre 2001, pp. 33, 193, fig. 7, p. 14.

EXHIBITIONS:

Paris, Galerie Dru, 1927, no. 110; Paris, Orangerie, 1933, no. 155 (dedication mentioned); Paris, Louvre, 1957, no. 15 (dedication mentioned); Paris, Galerie Daber, 1976, no. 35, ill.; Paris, Louvre, 1980–81, no. 2; Paris, Galerie des Quatre Chemins [n.d.], no. 31 (dedication mentioned).

Exhibited in Paris only

This watercolor always has been considered a later repetition of a painting of the same subject that is signed and dated 1840 at the lower right (Sandoz 1974, under no. 67, ill.), but when the painting—which reappeared at an auction in 1992 (Paris, Hôtel Drouot, June 26, 1992, lot 47, colorpl.; Paris, Galerie de Bayser, 1993, no. 28, ill.)—was cleaned, the level of the horizon on the right was considerably lowered and the (false?) signature and date (1840) were erased, while another signature and date (1849) were revealed at the lower left.

Should this second date be correct—and even if its style suggests that the painting is, in fact, an earlier work—the present watercolor would be the original and not the repetition. An etching of this composition, but

in reverse, was printed in *Le Cabinet de l'amateur et de l'antiquaire* in 1844 (Sandoz 1974, no. 268, ill.); that year, Chassériau's "Othello" series also was published in the same review.

In any case, this watercolor is one of Chassériau's major graphic works. Especially interesting is the delicacy of the washes and the concentrated, absorbed expression on Sappho's face. The tale of the poetess, who lived on the isle of Lesbos and committed suicide after having been abandoned by the handsome and indifferent Phaon, inspired the third of Lamartine's *Nouvelles Méditations poétiques,* the *Élégie antique* (1823). Chassériau treated this same subject in a painting exhibited at the Salon of 1851, but with a different composition (cat. 170). A number of drawings in the Louvre indicate that this subject had interested him even earlier (Prat 1988-1, vol. 1, nos. 53–55, ill.).

L.-A. P.

172

Studies of Two Seated Women Facing Left, One with Her Right Arm Raised, the Other with Her Face in Her Hands

1849

Graphite on beige paper
14 ½ x 12 ⅛ in. (36.9 x 30.7 cm)
Paris, Musée du Louvre (RF 25960)

PROVENANCE:

See cat. 20.

BIBLIOGRAPHY:

Chevillard 1893, part of no. 420; Sandoz 1974, under no. 128; Prat 1988-1, vol. 1, no. 571, ill.

EXHIBITIONS:

Paris, Louvre, 1957, no. 71, pl. 15; Paris, Galerie Daber, 1976, no. 36, ill.; Paris, Louvre, 1980–81, no. 53.

Exhibited in New York only

According to Sandoz, the model for this masterful sketch was Adèle Chassériau. The figure at the right does not seem to have been used for any composition, but the figure at the left is practically identical to that of Sappho in the painting of 1849 (cat. 170), and appears again in a drawing in the Musée des Beaux-Arts, Orléans (Prat 1988-2, no. 159).

L.-A. P.

CAT. 172

173

Bather Sleeping near a Spring

1850
Oil on canvas
54 x 82 ⅝ in. (137 x 210 cm)
Signed and dated, bottom left: *Th^re Chassériau 1850*
Avignon, Musée Calvet (124)

PROVENANCE:
Acquired by the French State at the Salon of 1850–51; assigned
to the Musée Calvet, Avignon, 1851.

BIBLIOGRAPHY:
Chassériau includes this painting in a list of works painted
between 1849 and 1851 (Musée du Louvre, Département des
Peintures, album RF 26085, fol. 26 v.: *Sleeping Bather*), as
well as in other lists of works (Musée du Louvre, RF 26079,
RF 26064, RF 26053); Chennevières 1851; Clément de Ris
1851; Geoffroy 1851; Peisse 1851; Pommier 1851; Gautier 1856;
Chevillard 1893, nos. 27, 70; Renan 1898, p. 2; Vaillat 1907,
p. 183; Hallays 1911; Marcel and Laran 1911, pp. 93–94, pl. 39;
Vaudoyer 1919, p. 41; Escholier 1921, pp. 98–107; Auge 1925,
p. 113; Goodrich 1928, p. 87, ill.; Vaudoyer 1930, ill. p. 49;
Bénédite 1931, vol. 2, pp. 379 ff., ill. p. 385; Girard 1931, p. 56,
ill.; Grappe 1932, p. 54; Benoist 1933, pp. 82–84, ill. p. 83;
Uhde-Bernays 1946, ill.; Vergnet-Ruiz and Laclotte 1962, index;
Loye 1968, pp. 294–95; Sandoz 1974, no. 154, pp. 298–99,
pl. 141; Prat 1988-1, vol. 1, pp. 272–74, ill. p. 272.

EXHIBITIONS:
Salon of 1850–51, no. 534; Paris, Orangerie, 1933, no. 52, p. 28, ill.

A fitting introduction to Chassériau's *Bather Sleeping
near a Spring,* first shown at the Salon of 1850–51, is the
fervent—and somewhat excessive—poem written by
Théophile Gautier in 1843, after having witnessed Alice
Ozy taking her bath:

*Pentélique, Paros, marbres neigeux de Grèce
Dont Praxitèle a fait la chair de ses Vénus,
Vos blancheurs suffisaient à ces corps de déesses . . .
Noircissez, car Alice a montré ses seins nus!* [1]

*Pentelic, Parian, snowy marbles of Greece
Which Praxiteles used for the flesh of his Venuses
Your white sufficed for the bodies of goddesses . . .
Blacken now, for Alice has bared her breasts!*

This quatrain is a vivid example of the lyrical and erotic
frenzy that the courtesan inspired among admiring writers
and artists. The countless verses written by Charles Hugo
during his affair with Alice Ozy offer further evidence:

*Je baise tes pieds blancs, à genoux sur la terre
Où j'agenouille aussi mes vers estropiés
Car je ne puis monter jusqu'à toi, ma déesse
Et mes lèvres ne vont, quand vers toi je me dresse
Qu'au niveau de tes pieds.* [2]

*I kiss your feet so white, on my knees on the ground
Where I also make my crippled lines kneel
For, my goddess, your heights I cannot reach
And my lips, when I stand
Reach only as far as your feet.*

Under the circumstances, Chassériau could scarcely avoid
the sensual aura that surrounded Alice Ozy when he, in
turn, became her lover. Both to boast of his good fortune
and to illustrate his love, he owed it to himself to render

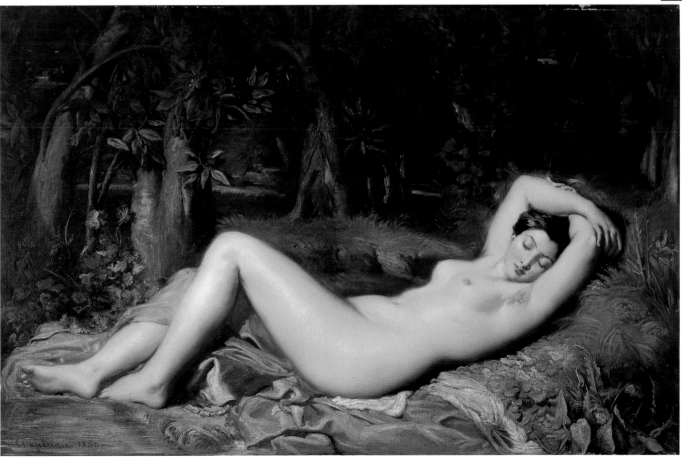

the young woman in paint and to associate her with one of his pictorial heroines. Therefore, the present work cannot be fully understood if we do not take into account the painter's love life, as well. Yet, it would be naïve to reduce this picture to a more or less sultry anecdote, when there is every reason to believe that the painter again sought to achieve a precise aesthetic and iconographic objective: the revival of a classical subject. It is not only an artistic homage to Alice Ozy's sensual body but also evidence of his continued appropriation—and regeneration—of the different genres of painting: in this case, that of the pastoral Nude.

Several preliminary graphite drawings in the Louvre reveal how Chassériau worked out the pose. In one, the young woman's legs are draped with a light veil,[3] while another shows her completely naked;[4] the first seems to have been a "theoretical" idea, while the second appears to have been studied "from life," the painter having rendered the torso and legs of his model, as well as the initial position of the arms folded behind the head.[5] A drawing in black crayon[6] also looks to have been sketched from life and to belong to this series of preparatory studies. Most of these studies are quite suggestive in their realism, and hint at the amorous circumstances under which they were executed. Nevertheless, Chassériau managed to transcend these intimate associations by producing formal variations on a repertory of classical forms.

Given his academic training and his broad visual culture, the painter had had occasion to study the works of the Renaissance masters in this pictorial genre: Giorgione's *Sleeping Venus* (Dresden), Correggio's *Jupiter and Antiope* and Jean Cousin the Elder's *Eva Prima Pandora* (both, Louvre), and Titian's *Danaë* (Prado) and the *Venus of Urbino* (Uffizi). In spite of the clear classical references here, the painter wanted to develop the traditional iconography of this subject by transforming this image of the Nude into the archetype of a modern woman, into a sort of timeless "grisette," precisely through her contemporaneity and accessibility.

Thus, although the setting and the visual sources of this painting derive from a long tradition, there are details that redirect the viewer to the more mundane world of the realistic, if not naturalistic, depiction of the female body. The pose, for example, seems to be completely original, or at least a new variation on the classical poses adopted by the masters. The position of the bather asleep is ordinary and deliberately simple, recalling to some extent the poses of certain classical nudes, but the gesture of the arms behind the head is both extremely intimate and splendidly realistic. It not only sets off the woman's breasts, but also reveals the new and provocative detail of the hair in the armpits: "That fine moss glorified by Gautier in his *Musée secret*."[7]

Similarly, the handling of the landscape is very important, not only to set the poetic tone of the painting but also to emphasize the "contemporaneousness" of the scene. As he had already done in previous works (cat. 15, 22, 113), Chassériau rendered the trees and plants using the methods and techniques of his friend Théodore Rousseau, several studies of whose he owned.

This approach allowed him to break away even more from his classical precursors and to give the composition a strange modernist touch. The outdoor setting depicted here seems familiar and true to nature in its handling, but also has a mysterious and almost lyrical aspect; witness the thicket looming behind the reclining young woman.

This pictorial evocation of Alice Ozy on the banks of a stream, resting amid the suggestive disarray of her clothing after having bathed, has more to do with a *Sleeping Bather*—a contemporary and, as such, rather risqué evocation—than with a *Sleeping Nymph*. The latter title, which Chassériau originally bestowed on the work prior to the Salon of 1850, would have provided his picture with a mythological alibi and avoided possible scandal.

Contrary to what some of the painter's biographers have claimed,[8] Chassériau in this case did not draw his inspiration from his experiences in the East. Instead, he devised a novel and creative synthesis of classical and Renaissance depictions of the nude, which he adapted to the materialism and sensuality of his day. One might even suppose that Chassériau wished to incorporate in this image the contemporary tendency of artists to idealize their beloved—before being cruelly brought back to reality when the bubble of mystified sensuality burst. As Charles Baudelaire wrote to Mme Sabatier, after having seduced her: "A few days ago you were a goddess . . . and now, well, you are a woman."[9]

The complexity of his intentions, which involved both artistic and personal considerations, may explain why the painting was greeted with a certain indifference when it was shown at the Salon—in spite of its potentially scandalous content. (However, Chassériau did present a major work at this same Salon that drew the attention of the critics even more: *Arab Horsemen Removing Their Dead After an Engagement with the Spahis* [Cambridge, Massachusetts, Fogg Art Museum]). The Salon critics did not respond to the latent provocation contained in this overtly erotic representation, but noted only its apparent adherence to a certain academic tradition: "The veil of anonymity was soon lifted and it was revealed that the model represented by the painter was none other than the very beautiful and highly admired actress, Alice Ozi [*sic*]."[10]

Nonetheless, Chassériau's *Bather Sleeping near a Spring* also had its unbridled enthusiasts:

Nous pourrons contempler, sous le rideau des branches
L'imprudente dormeuse et ses épaules blanches
Et ses bras arrondis lui servant d'oreiller. . . .
Mais, comment oses-tu, séduisante baigneuse
Du danger à ce point te montrer dédaigneuse
Dévoilant ton beau corps de la tête aux orteils?
N'est-il plus de sylvain, d'aegipan, de satyre
Qui rôde, curieux et lascif, et qu'attire
L'appât d'un sein de neige aux deux boutons vermeils?[11]

Under the roof of branches, we may contemplate
The reckless sleeper, her white shoulders
And her arms rounded into a pillow. . . .
But, O seductive bather, how dare you

Disdain every danger so
As to unveil your beauty from head to toe?
Are there no sylvan creatures, no satyrs
Roaming, lewd and curious
Lured by the bait of a snowy breast
With two vermilion buds?

However, most of the commentaries about the Salon mentioned this work only in passing, saving their praise or criticism for the artist's other contributions.

Yet, two years prior to Courbet's *Bathers* (Montpellier, Musée Fabre) and, more importantly, thirteen years before Manet's *Le Déjeuner sur l'herbe* (Paris, Musée d'Orsay), Chassériau, in the *Bather Sleeping near a Spring*, discreetly opted for an approach similar to the one that was to cause a scandal and become the symbol of the Salon des Refusés in 1863. Like Manet, Chassériau chose to integrate a nude figure into a familiar setting. To be sure, there is no male figure fully dressed in a contemporary suit accompanying the young lady to contrast with her nudity, nor is there any hint of a potential foursome. Nevertheless, the intention of both works is exactly the same—and Chassériau's is even bolder, for he did not shrink from depicting the provocative "body hair."

V. P.

1. Poem quoted in L. Loviot, *Alice Ozy* (Paris, 1910), p. 24.
2. Poem written by Charles Hugo in a notebook given to Alice Ozy; quoted in L. Loviot, op. cit., pp. 46–48.
3. Paris, Musée du Louvre, Département des Arts Graphiques, graphite (RF 25827; Prat 1988-1, vol. 1, no. 585, p. 272).
4. See catalogue 174.
5. Paris, Musée du Louvre, Département des Arts Graphiques, graphite heightened with white (RF 26305; see cat. 175); graphite (RF 25828; Prat 1988-1, vol. 1, no. 589, p. 274); graphite (RF 24474; see cat. 176).
6. Paris, Musée du Louvre, Département des Arts Graphiques, black crayon (RF 25826; Prat 1988-1, vol. 1, no. 587 v., pp. 273–74).
7. L. Loviot, op. cit., pp. 96–97.
8. Ibid.
9. C. Baudelaire, *Correspondance*, vol. 1 (Paris, 1974), p. 425.
10. G. de Loye, in *Revue du Louvre et des musées de France*, no. 4/5 (1968), pp. 294–95.
11. A. Pommier, in *L'Artiste* (May 1, 1851); reprinted in *Colifichets* (Paris, 1860), p. 369.

174

Reclining Female Nude, Facing Right, Her Hands Behind Her Head

1850
Graphite
10 x 16 ⅛ in. (25.5 x 41 cm)
Paris, Musée Carnavalet (D. 5847)

PROVENANCE:
See cat. 20; Musée du Louvre (RF 24368); placed on deposit by the Musée du Louvre at the Musée Carnavalet, 1937.

BIBLIOGRAPHY:
Chevillard 1893, under no. 420; Bénédite 1931, vol. 2, ill. p. 383; Prat 1988-1, vol. 1, no. 586, ill.

EXHIBITIONS:
Paris, Galerie Dru, 1927, no. 82 (?); Paris, Orangerie, 1933, no. 182; Paris, Galerie des Quatre Chemins [n.d.], no. 37 (?).

Exhibited in New York only

Alice Ozy probably served as model for this sketch, which is related to the *Bather Sleeping near a Spring* in Avignon (cat. 173).

L.-A. P.

CAT. 174

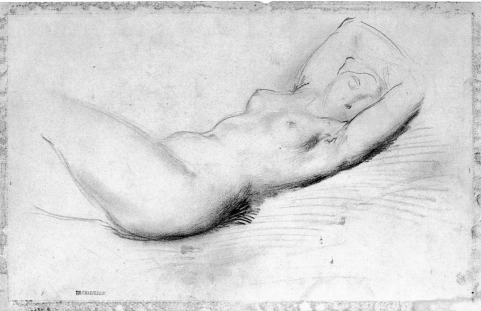

175
Study of a Reclining Woman, Facing Right; Studies of Legs

1850
Graphite, heightened with white, on cream-colored paper
(affixed to fol. 37 r. of dummy album 2) (loss at the bottom left)
10 ¼ x 16 in. (26 x 40.9 cm)
Inscribed in graphite, on the verso: *M. Henry rue de la Chaise*
[crossed out]
Paris, Musée du Louvre (RF 26305)

PROVENANCE:
See cat 20.

BIBLIOGRAPHY:
Chevillard 1893, under no. 420; Sandoz 1974, pl. 141 a;
Prat 1988-1, vol. 1, no. 588, ill.; Peltre 2001, p. 189, fig. 214.

Exhibited in New York only

In the painting, the figure's legs are extended more. The
model was probably Alice Ozy.

L.-A. P.

176
Study of the Legs of a Reclining Woman

1850
Graphite with stumping (loss at the upper left)
7 ¾ x 13 ¼ in. (19.6 x 33.7 cm)
Inscribed in graphite: *Bleu / roux d'or / sanguin bleuâtre / or et
rosé* [Blue / reddish gold / bluish red / gold and pink]
Paris, Musée Carnavalet (D. 5848)

PROVENANCE:
See cat. 20; Musée de Louvre (RF 24474); placed on deposit by
the Musée du Louvre at the Musée Carnavalet, 1937.

BIBLIOGRAPHY:
Chevillard 1893, under no. 420; Bénédite 1931, vol. 2, ill. p. 386;
Prat 1988-1, vol. 1, no. 590, ill.

EXHIBITIONS:
Paris, Galerie Dru, 1927, no. 28; Paris, Orangerie, 1933, no. 183.

Exhibited in Strasbourg only

This sketch takes up the same detail seen at the right of
the previous study, but with some changes.

L.-A. P.

CAT. 175

CAT. 176

177

Jewish Women on a Balcony

1849
Oil on wood
14 x 10 in. (35.7 x 25.3 cm)
Signed and dated, bottom left: *Th. Chasseriau, 1849*
Paris, Musée du Louvre (RF 3882)

PROVENANCE:
Chassériau sale, Paris, Hôtel Drouot, March 16–17, 1857 (according to Chevillard 1893, no. 164); A. M. Donatis, about 1893; Baron Arthur Chassériau, Paris; bequest of the latter to the Musée du Louvre, 1934.

BIBLIOGRAPHY:
Chassériau lists this painting in four inventories of his work: (Musée du Louvre, Département des Peintures, album RF 26085, Prat 1988-1, vol. 2, no. 2239, fol. 26 v., "Jewish women on a balcony in Algiers"; RF 26053, Prat 1988-1, vol. 2, no. 2250, "Jewish women chatting on a balcony in Algiers"; RF 25827, Prat 1988-1, vol. 1, no. 585 v., "Jewish women chatting on a balcony in Algiers"; RF 26079, Prat 1988-1, vol. 2, no. 2225, fol. 2 r., "women on a balcony"); Chevillard 1893, no. 92; Vaillat 1913, p. 22, ill. p. 18; Goodrich 1928, p. 82, ill. p. 84; Alazard, "Les Peintres d'Algérie au XIXᵉ siècle," in *Gazette des beaux-arts*, 1930, p. 378, fig. 6; Bénédite 1931, p. 298, ill. p. 311; Sterling and Adhémar 1958, p. 23; Sandoz 1974, no. 139, p. 278, pl. 129; Compin and Roquebert 1986, p. 133; Monneret 1989, ill. p. 182; Peltre 2001, ill. p. 118.

EXHIBITIONS:
Paris, 1893, no. 103; Paris, 1897, no. 7; Paris, 1930, no. 97; Paris, Orangerie, 1933, no. 45; Algiers, 1936; Paris, 1951, no. 40.

In 1846, Chassériau spent over a month in Algiers, where he made several drawings of Jewish women in his travel album, which he annotated with details of their clothing and jewelry. On three of these sheets (album RF 26074; Prat 1988-1, vol. 2, no. 2251, fol. 22 v., fol. 23 r., and fol. 46 v.) he depicted both of the figures and the setting that he would later use in this painting in 1849. The last drawing concentrates on the elaborate draperies drawn back to form a canopy over a floor-to-ceiling window opening onto a balcony. In the finished painting Chassériau eliminated much of this decor, retaining only a vestige of the curtains at the top of the picture.

The theme of women framed by balconies has a distinguished pedigree in Romantic imagery from Goya's *Majas on a Balcony*, which was exhibited in Louis-Philippe's Galerie Espagnole between 1838 and 1848, to Gavarni's lithographs of Parisiennes ensconced in their boxes at the Opéra. An attentive student of Spanish painting and a habitué of the theater, Chassériau was inevitably drawn to the subject. While in Italy in 1840–41, he executed a drawing (RF 25701; Prat 1988-1, vol. 1, no. 1401) of two Roman women leaning on a balcony, showing them frontally, as he saw them from the street. According to the accompanying note, Chassériau intended these figures to be "chatting." The same word appears in the title given to this painting in one of the artist's inventories (RF 25827; Prat 1988-1, vol. 1, fol. 585 v.), "Jewish women chatting on a balcony in Algiers." This repetition, together with the unfinished *Women on a Balcony, Looking at a Horseman* (Sandoz 1974, no. 186), underscores the artist's continued preoccupation with this motif.

The shift of vantage point from outside to inside and from front to rear view allowed Chassériau to place the women on the threshold between the distinct spaces marked by exterior light and the darkened interior, respectively. This maneuver corresponds to the artist's interest, developed as a result of his sojourn in Algeria, in contrasting areas of foreground shadow with passages of bright light in the distance. As Gautier often remarked, the importance of North Africa for Chassériau lay not only in the wealth of picturesque subject matter that it offered him but also in the startling brightness of the light—a revelation that revolutionized his palette. Chassériau's album notes encouraged him to remember the appearance of similar hues in contrasting conditions of light and shadow. Indeed, in the *Arab Horsemen Removing Their Dead,* first exhibited at the Salon of 1851, much of the solemn drama results from the figures gathering up their comrades in a penumbral twilight composed of half tints set off against a distance flooded with sunlight. In creating a setting for one of his pictures inspired by a Shakespearean tragedy, *Othello and Desdemona in Venice* (Sandoz 1974, no. 125; cat. 195), Chassériau juxtaposed the two protagonists on a balcony cast in shadow against a brilliantly lit background.

The interior viewpoint also emphasizes the fascination that the often inaccessible spaces inhabited by Algerian women held for Chassériau and his contemporaries. In praising the *Sabbath in the Jewish Quarter of Constantine,* Théophile Thoré lingered upon Chassériau's treatment of the exquisite skin of the Jewish women. Some, like the figures in the *Jewish Women on a Balcony,* he described as "young women leaning on their elbows like mysterious Sphinxes, their eyes, under the dark arches of their eyebrows, staring out at something unknown."[1] Thoré attributed their complexions to their confinement indoors, explaining that such women "spend their entire lives within cool, mysterious interiors, never once exposed to the ardent embrace of the sun."[2] In two drawings that may relate to the *Sabbath,* Chassériau pictures Arab women peering out from small, barred windows (RF 24416; Prat 1988-1, vol. 2, no. 1587 v.; and RF 25502; Prat 1988-1, vol. 2, no. 1648). Not only did *Jewish Women on a Balcony* mark a return to this motif of women poised between interior and exterior spaces and private and public spheres but it allowed Chassériau to revisit on a smaller scale a theme that was central to his *Sabbath in the Jewish Quarter of Constantine,* and, indeed, to much of his work after the Algerian sojourn.

The close kinship between the two works also can be seen in the treatment of the elaborate costumes in *Jewish Women on a Balcony.* Chassériau's notes accompanying the drawings done in Algiers testify to his interest in capturing the distinctive look of the women's clothing—its mixture of sparkling hues and gold and silver embroidery—and, specifically, the conical headdresses with trailing veils traditionally worn by Algerian Jews. Chassériau described this type of head covering, called a *terrada:* "the hair is twisted together with a piece of multicolored silk and an attached red ribbon that falls to the floor."[3]

In its references to picturesque details of clothing and in its evocation of a community of North African Jews, *Jewish Women on a Balcony* develops themes mined by

Delacroix in pictures such as *Jewish Wedding* and *Women of Algiers.* His annotated drawings from his Moroccan journals also pay close attention to the traditional garb worn by Jewish women. In Chassériau's hands, however, these women transcend the picturesque, and remain distinct from Delacroix's work; this transformation has much to do with the sculptural rhythm that he builds into the composition. The graceful curves of their bodies and the interplay of their arms are underscored by subtle color harmonies and by the shimmering highlights on the fabrics.

<div align="right">P. B. M.</div>

1. Thoré 1868, p. 527.
2. Ibid., p. 529.
3. RF 24419; see Prat 1988-1, vol. 2, no. 1588, p. 580.

178

Woman and Little Girl from Constantine with a Gazelle

1849
Oil on wood
11 ⅝ x 14 ⅝ in. (29.4 x 37.1 cm)
Signed and dated, lower right: *Th. Chassériau 1849*
Houston, Museum of Fine Arts, acquired through the Agnes Cullen Arnold Endowment Fund, 1974

PROVENANCE:
Chassériau sale, Paris, Hôtel Drouot, March 16–17, 1857, no. 23; Baron Arthur Chassériau, Paris; Wildenstein and Co., New York; Museum of Fine Arts, Houston.

BIBLIOGRAPHY:
Chassériau lists this painting in four inventories of his work: (Musée du Louvre, Département des Peintures, album RF 26085, Prat 1988-1, vol. 2, no. 2239, fol. 26 v., "woman and little girl with a gazelle"; RF 26053, Prat 1988-1, vol. 2, no. 2250, "Moorish woman and little girl from Constantine"; RF 25827, Prat 1988-1, vol. 1, no. 585 v., "Moorish woman and little girl from Constantine"; RF 26079, Prat 1988-1, vol. 2, no. 2225, fol. 2 r., "women with a gazelle"); Gautier 1851; Clément de Ris, "Le Salon," in *L'Artiste,* January 15, 1851, p. 242; Baschet 1854, p. 135; Mantz 1856; Saint-Victor 1856, p. 1; Gautier, *Portraits contemporains,* 1874, p. 269; Chevillard 1893, no. 74, p. 278; Renan 1897, no. 3; Bénédite 1931, p. 298, ill. p. 393; Sandoz 1974, no. 138, p. 276, pl. 128; Fisher, in Baltimore, 1979–80, p. 156; Prat 1988-1, vol. 1, p. 268; Bowron and Morton, *Masterworks of European Painting in the Museum of Fine Arts, Houston* [2000], pp. 131–33, ill.; Peltre 2001, p. 135, ill. p. 137.

EXHIBITIONS:
Salon of 1851, no. 538; Paris, Orangerie, 1933; Poitiers, 1969; Paris, Galerie Daber, 1976.

Exhibited in New York only

The composition can be traced to a drawing labeled with color descriptions that Chassériau executed during his Algerian voyage in 1846 (RF 25409; Prat 1988-1, vol. 1, no. 57; cat. 143). In the preliminary drawing the younger woman is pictured without the gazelle that Chassériau would add to her lap in the final work. Otherwise, the composition was transformed with little variation into the painted panel in 1849. Chassériau made a replica in ink of the finished *Woman and Little Girl from Constantine with a Gazelle* in 1851 (cat. 179), most probably a preparatory drawing for an etching that was published in *L'Artiste* in March of that year.

Two additional sheets (RF 24355; Prat 1988-1, vol. 2, no. 1662; and RF 24356; Prat 1988-1, vol. 2, no. 1663), also completed during the course of his journey, demonstrate the painter's fascination with gazelles. An annotation on one of these drawings, "eye, black and moist," points to his interest in the expressiveness of the gazelles' eyes.

Théophile Gautier, Chassériau's friend and interlocutor, famously used the image of the gazelle's eye in his descriptions of the melancholy gaze that Chassériau's Algerian women turn upon the viewer: "These gazes of a lion and a gazelle . . . terrify and delight."[1] Accordingly, both figures possess the solemn expressions that are characteristic of the artist's renderings of the women he encountered in North Africa. In a passage that hints at Chassériau's intention in *Woman and Little Girl from Constantine with a Gazelle,* Gautier compared Chassériau's women to "captive barbarians brought back to our civilization, draped in colorful costumes, adorned with strange jewels, huddled like captured gazelles in attitudes of a fierce grace."[2]

Constantine's remote location at the time of Chassériau's journey temporarily preserved the heterogeneous mix of ethnic groups and the rich cultural traditions that had coexisted for centuries, but which were soon to dissolve under French occupation. Indeed, Chassériau, in a letter to his brother, marveled that "one can see the Arab race and the Jewish race, as they were on their first day."[3] Attentive to distinctions in costume and custom between the Jewish and Muslim communities of Constantine, Chassériau here identifies his sitters as Muslim women by their characteristic headgear. The shimmering folds of their clothing absorb the atmospheric light in the dim interior and complement the golden sheen of the gazelle's coat. The richness and intricate designs of North African vestments such as these monopolized the painter's attention during and after his trip. In fact, Gautier, recalling the "barbarian luxury" arrayed upon the wall of Chassériau's atelier, listed "the gold- and silver-embroidered vests [that] treated the eyes to a feast of color with which the artist tried to forget the neutral tones of our dismal clothes; in their wrinkled and shimmering folds, they seem to have kept the sun of Africa."[4]

Woman and Little Girl from Constantine with a Gazelle may reflect Chassériau's familiarity with Romantic literature, including Lord Byron's *The Wild Gazelle,* from the *Hebrew Melodies* of 1815, which was translated into French almost immediately; *La Gazelle,* from Millevoye's *Chants élégiaques* of 1837, and Gautier's *La Juive de Constantine* of 1846. Chassériau's essay on the theme of Oriental languor also revisits territory staked out by Delacroix in his two versions of the *Women of Algiers.* To several critics, Chassériau's rich Oriental palette, evident in *Woman and Little Girl from Constantine with a Gazelle,* betrayed the artist's excessive admiration for his older contemporary. Delécluze, a champion of Ingres's linear classicism, predictably condemned Chassériau's tendency to abandon Ingresque principles in order to pursue painting "à la mode" in the manner of Delacroix. He thus dismissed *Woman and Little Girl from Constantine with a Gazelle,* including it among those pictures by Chassériau that he derided as "a few minor sketches that escaped from his brush."[5] Clément de Ris, while not implicating this painting specifically, also reproached Chassériau for "his constant preoccupation with M. Delacroix, which sometimes makes him fall into the rut

of imitation."[6] Despite this admonition, Clément de Ris went on to praise *Woman and Little Girl from Constantine with a Gazelle:* "To place the sparkling Moorish costumes against a red background and on a red rug, without lapsing into something shrill, was a difficulty that M. Chassériau solved very honorably."[7] Claude Vignon was less impressed with Chassériau's use of color: "Since we are in the midst of petitions, then M. Chassériau should be asked not to abuse the freedom of painters to use the color red or of award-winning artists to exhibit bad paintings."[8] **P. B. M.**

1. T. Gautier, "Exposition universelle de 1855. Peinture-Sculpture. M. Chassériau," in *Le Moniteur universel* (August 25, 1855); reprinted in Gautier, *Les Beaux-Arts en Europe, 1855* (Paris: Michel Lévy Frères, 1855–56), vol. 1, p. 252.
2. T. Gautier, "Atelier de feu Théodore Chassériau," in *L'Artiste* 3, no. 14 (March 15, 1857), p. 209.
3. Letter from Théodore Chassériau to his brother Frédéric, June 13, 1846; quoted in Bénédite 1931, p. 271.
4. Gautier 1857, p. 209.
5. É.-J. Delécluze, *Exposition des artistes vivants, 1850* (Paris, 1851), p. 107.
6. L. Clément de Ris, "Le Salon," in *L'Artiste* 5 (January 15, 1851), p. 242.
7. Ibid.
8. C. Vignon, *Salon de 1850–1851* (Paris, 1851), pp. 97–98.

179

Woman and Little Girl from Constantine with a Gazelle

1851
Pen and brown ink with brown wash
5 ½ x 7 ⅞ in. (14 x 20 cm)
Signed in pen and brown ink, bottom left: *Th^{re} Chassériau*,
dated, bottom right: 1851
Los Angeles County Museum of Art, George Cukor Fund
(AC 1993.12.1)

PROVENANCE:
Sale, Strasbourg, Gersaint, November 30, 1990, lot 802,
colorpl.; Paris, Galerie Brame et Lorenceau; acquired by the
Los Angeles County Museum of Art, 1993 (B. Davis, *Master
Drawings in the Los Angeles County Museum of Art,* exhib. cat.,
[1997], no. 49, colorpl.).

BIBLIOGRAPHY:
Sandoz 1974, no. 138, pl. 128 a, and under no. 292; Prat 1988-1,
vol. 1, no. 577; Prat 1988-2, no. 175.

Exhibited in New York only

This drawing, which is signed and accurately dated, probably was intended as a gift to a friend. It repeats, with a few minor changes, the soft-ground etching executed most likely in 1850, which, itself, reproduced the composition (in reverse) of the painting of this subject of 1849, recently acquired by the Museum of Fine Arts, Houston (cat. 178). L.-A. P.

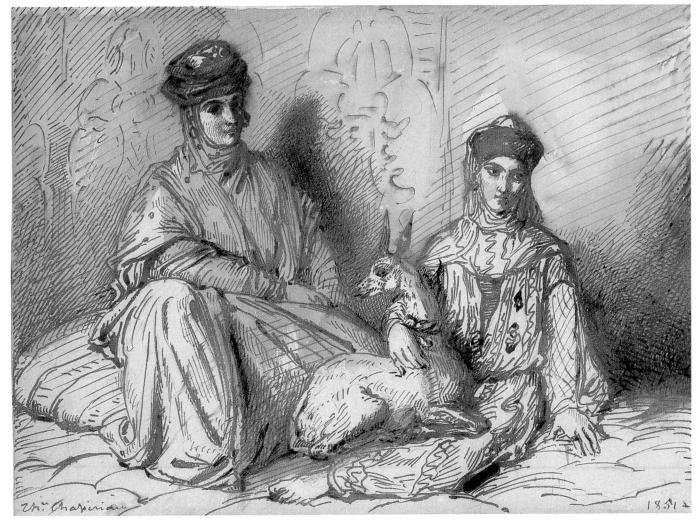

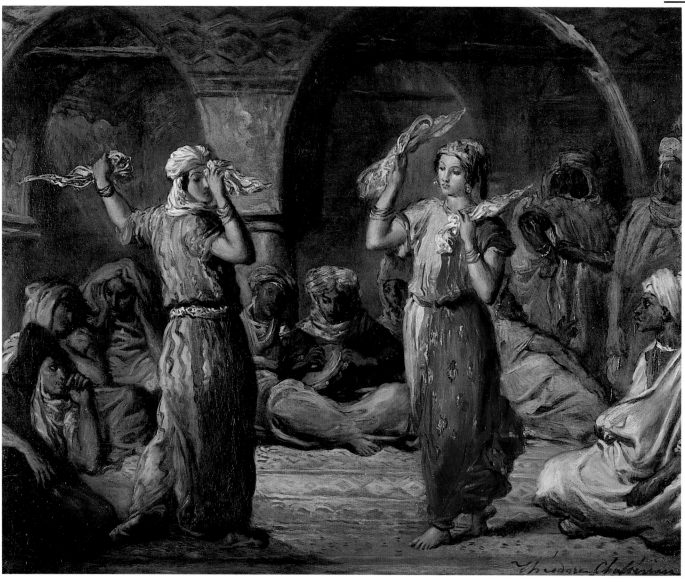

180

Moorish Dancers

1849
Oil on wood
12 ⅝ x 15 ¾ in. (32 x 40 cm)
Signed and dated, bottom right: *Theodore Chasseriau / 1849*
Paris, Musée du Louvre (RF 3879)

PROVENANCE:

Chassériau sale, Paris, Hôtel Drouot, March 16 – 17, 1857, lot 165:
Alice Ozy; Baron Arthur Chassériau; bequest of the latter to the
Musée du Louvre, 1934; Musée des Beaux-Arts, Algiers, about
1938; Musée du Louvre, by about 1986 (but not before 1958).

BIBLIOGRAPHY:

Chassériau lists this painting in three inventories of his work:
(Musée du Louvre, Département des Peintures, album RF 26085,
Prat 1988-1, vol. 2, no. 2239, fol. 26 v., "Moorish dancers"; RF
26053, Prat 1988-1, vol. 2, no. 2250, "Arab dancers"; RF 25827,
Prat 1988-1, vol. 1, no. 585 v., "Arab dancers"); Chevillard 1893,
no. 165; Renan 1897, no. 24; Chevillard 1898, p. 250, ill. p. 252;
Vaillat 1913, p. 20, ill.; Escholier 1921, p. 103, ill. p. 101; Goodrich
1928, p. 82, ill. p. 85; Alazard, *Gazette des beaux-arts*, 1931, ill.
p. 246; Bénédite 1931, p. 298, pl. 51; Fouchet 1936, p. 2, ill. p. 1;
Gérard 1957, ill. p . 16; Sandoz 1974, no. 140, p. 280, pl. 130;
Thornton 1983, ill. p. 78; Compin and Roquebert 1986, p. 133;
Prat 1988-1, vol. 1, pp. 268 – 70; Peltre 2001, p. 137, ill. p. 138.

EXHIBITIONS:

Paris 1893, no. 91; Paris, 1897, no. 20; Paris, 1930, no. 106; Paris,
1931; Paris, Galerie Charpentier, 1933; Paris, Orangerie, 1933,
no. 48; Algiers, 1936; The Hague, 1938, no. 1; Lisbon, 1950, no. 5.

A synthesis of Chassériau's memories and recorded
impressions from his Algerian voyage, this painting illus-
trates the *m'bita,* a dance performed by Moorish women
of ill repute. The movements were described by Gautier
in a portrait of Algiers published in the *Revue de Paris* in
1853: "The Moorish dance consists of constant undula-
tions of the body, twisting of the back, swaying of the hips,
and movements of the arms waving handkerchiefs; a
young dancer moving in this way looks like a serpent
standing on its tail."[1]

Chassériau first registered his interest in this subject
in 1842 in a note on a sheet of drawings after Persian
miniatures: "faire une danse arabe avec musiciens dans
le fond" [do an Arabian dance with musicians in the
background].[2] By the time he set to work on *Moorish
Dancers,* this type of dance was an established part of
the repertory of Orientalist subjects. Both Decamps, in
his *Dance for Men with Handkerchiefs* (1835), and
Delacroix, in the *Arabian Actors,* shown at the Salon of
1848, painted comparable scenes. The *m'bita* was also
taken up by artists whose voyages to Algeria virtually
overlapped with Chassériau's visit. Benjamin Roubaud,

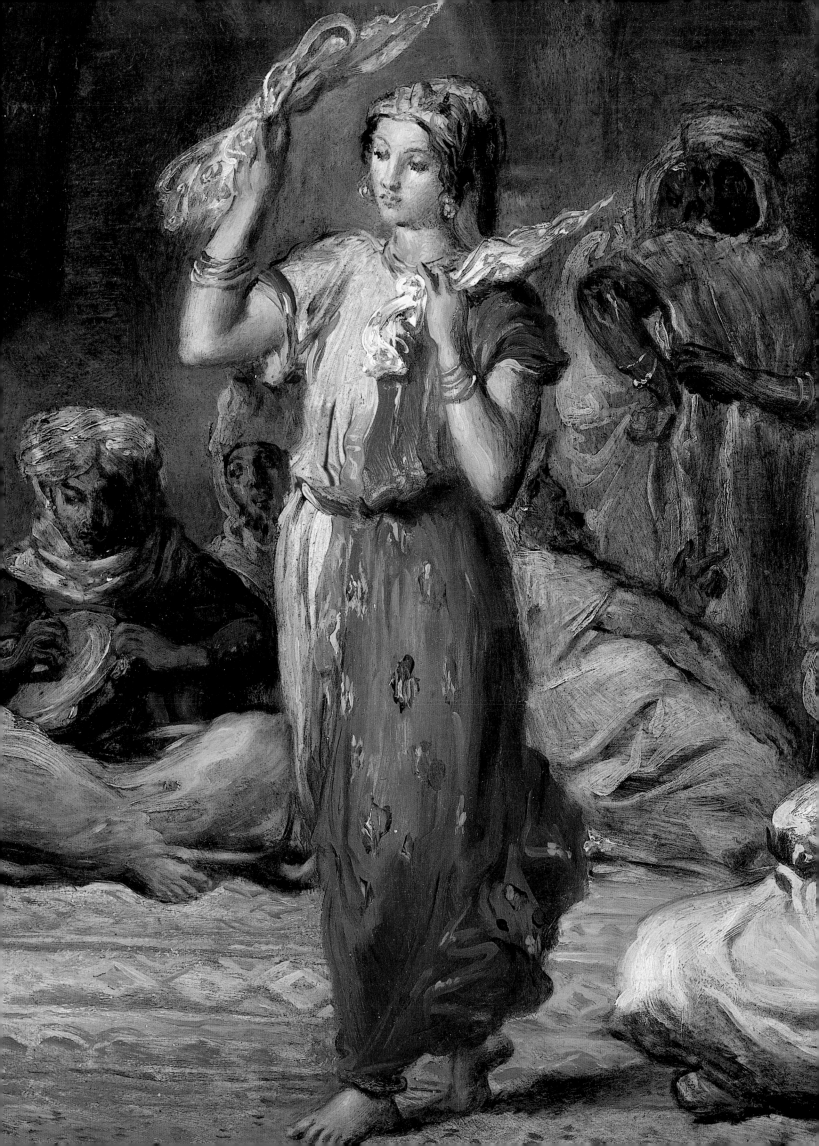

a painter of military subjects, who followed the French army to Algeria in 1840 and died in Algiers in 1847, exhibited *Moorish Celebration near Algiers* at the Salon of 1845. Adolphe Leleux, who traveled to Constantine in 1847 at the suggestion of Gautier, sent his *Dance of the Jinn* to the Salon of 1849.

Chassériau almost certainly witnessed, as Gautier did before him, a live performance of such a dance during his stay in Algeria. A drawing in the Louvre (RF 25405; Prat 1988-1, vol. 2, no. 2020) includes the reminder "faire une danse de femmes Mauresques a Constantine [do a dance of Moorish women in Constantine]." Most likely written after his return to Paris, the note refers to a subject for which Chassériau had done preliminary drawings while in Algeria. One of these (RF 25380; Prat 1988-1, vol. 1, no. 578) depicts two female dancers and a seated musician, a trio of figures that the artist used again for the central group in *Moorish Dancers,* adding only a left arm to the figure at the left, who lacks one in the drawing. A second sheet (RF 24428; Prat 1988-1, vol. 1, no. 581) contains numerous studies of feet performing various steps, suggesting the artist's attempt to record movements as he saw them.

To provide a context for his dancers, Chassériau relied once again upon his Algerian studies. The setting—Moorish arches supported by low columns under which musicians and onlookers are gathered in a semicircle—was borrowed from a watercolor Chassériau executed in Algeria of the interior of an Arab school in Constantine (RF 24348; Prat 1988-1, vol. 2, no. 1681; see cat. 147). The black man wearing a turban, seated at the far right, corresponds to a figure in a watercolor also executed by the artist in Algeria. North African musicians—including a tambourine player, seated with legs crossed, and similar to the one Chassériau placed between his two female dancers—are the protagonists of Delacroix's *Jewish Musicians from Mogador,* a painting singled out by both Gautier and Thoré in their accounts of the 1847 Salon.

This subject intrigued Chassériau in part because, as Gautier notes, the *m'bita* was one of the few occasions that afforded a glimpse of women, "a difficult thing in places governed by the Koran."[3] The sensual drama of the dance gave free rein to Chassériau's taste for feminine grace and to his penchant for choreographed movements that suggest both sculptural permanence and perpetual motion—a contrast emphasized here by the fluttering veils. In 1843, Chassériau painted a watercolor (RF 24902; Prat 1988-1, vol. 2, no. 1737) of another indigenous dance, the tarantella from southern Italy—an evocation of Antiquity incorporating an analogous combination of statuesque gesture and flowing drapery. The skillful use of evanescent layers of material in *Moorish Dancers* to convey the evenly proportioned bodies they conceal inspired the critic Paul de Saint-Victor to compare Chassériau's women of Constantine to "Greek statues clothed in Oriental attire."[4] Indeed, the treatment of fabric, the undulations of the handkerchiefs, the vibrantly patterned costumes, and the variety of turbans and drapery folds continue the investigative clothing studies Chassériau initiated and made by the score in Algeria. As

his album notations indicate, Chassériau was particularly fascinated by the way certain color accents in shadow or in dimly lit rooms captured up the light—creating an atmospheric effect that Gautier, in his description of an Arab café, called "a transparent half tint."[5] Here, a mysterious flickering light source from the left illuminates the dancers' costumes, picking out such glittering motifs as the sparkle of a dancer's anklet, a swath of the patterned floor, an upturned heel, and the rim of the tambourine. Materializing out of semidarkness, the solemn oval faces of the dancers, their downcast eyes heightened with kohl, exude both languor and passion at the same time—qualities that Gautier repeatedly emphasized in his accounts of the *m'bita* as well as in his analyses of the nostalgic allure of Chassériau's women. P. B. M.

1. T. Gautier, "Scènes d'Afrique. Alger," in *Revue de Paris* (1853), p. 440.
2. Prat 1988-2, no. 2121 v., p. 730.
3. Gautier, *Revue de Paris* (1853), p. 439.
4. P. de Saint-Victor, in *La Presse,* Paris, October 12, 1856, p. 1.
5. Gautier, *Revue de Paris* (1853), p. 50.

181

Bath in a Seraglio, or *Woman Leaving the Bath,* or *The Bath, Interior of the Seraglio in Constantine*

1849
Oil on wood
19 ⅝ x 12 ⅝ in. (50 x 32 cm)
Signed and dated, lower right: *Th.ʳᵉ Chassériau / 1849*
Paris, Musée du Louvre (RF 3885)

PROVENANCE:
Probably studio of the painter until his death; Baron Arthur Chassériau, Paris; bequest of the latter to the Musée du Louvre, 1934.

BIBLIOGRAPHY:
The painter mentions this work in his notes in 1849 (*Woman Leaving the Bath,* Musée du Louvre, Département des Arts Graphiques, album RF 26085, fol. 26 v.), and, according to Sandoz (1974), in other undated lists (Musée du Louvre, albums RF 26079, RF 26064, RF 26053); Chevillard 1893, no. 220 (*The Bath. Interior of the Seraglio*); Renan 1897, no. 20; Marcel and Laran 1911, pp. 97–98, pl. 41; Vaillat 1913, ill. p. 9; Escholier 1921, pp. 102–3, ill. p. 105; Carco 1924; Focillon 1928; Goodrich 1928, ill.; Bénédite 1931, pp. 298, 386, pl. 40; Blanche 1933, pp. 1, 6, ill.; Grappe 1933; S.A.I., 312, ill.; C.P., p. 75; Sandoz 1974, no. 146, p. 288, pl. 136, p. 289; Compin and Roquebert 1986, vol. 3, p. 133, ill.

EXHIBITIONS:
Paris, 1897, no. 18 (*The Bath. Interior of the Seraglio*); Paris, 1930, no. 109; Paris, Orangerie, 1933, no. 49, p. 26 (*Arab Woman Leaving the Bath*); Montauban, 1967, no. 190.

Exhibited in Paris only

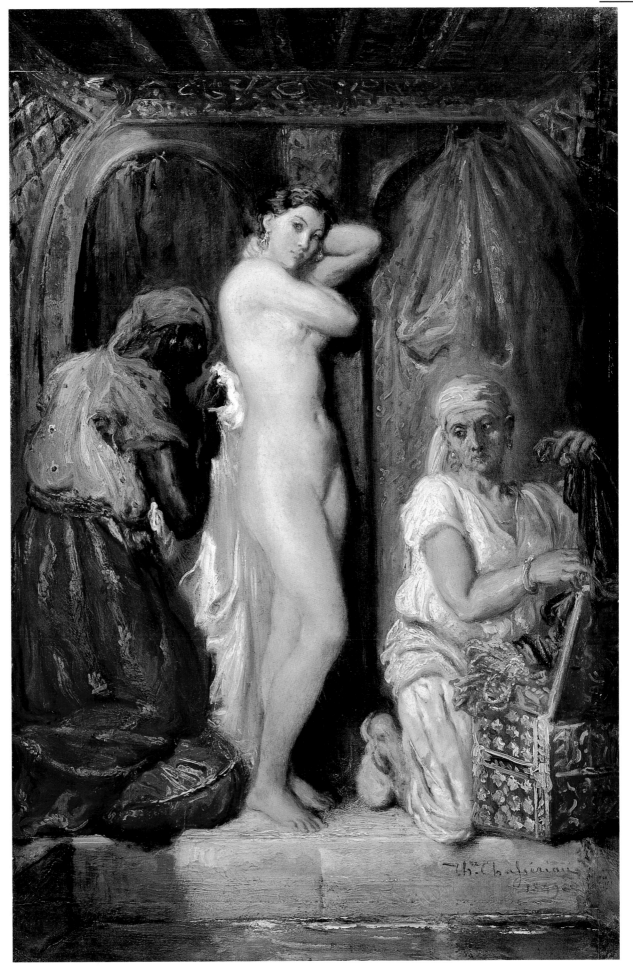

182

Moorish Woman Leaving the Bath in the Seraglio, or Interior of a Harem

1854
Oil on canvas
26 ⅜ x 21 ¼ in. (67 x 54 cm)
Signed and dated, lower right: *Th. Chassériau 1854*
Strasbourg, Musée des Beaux-Arts (1429)

PROVENANCE:
Studio of the painter until his death; Chassériau sale, Paris, Hôtel Drouot, March 16–17, 1857 (according to Chevillard 1893); Delphine de Girardin (according to Paris, Orangerie, 1933); Girardin sale, 1881 (according to Paris, Orangerie, 1933); Baron Arthur Chassériau, Paris; bequest of the latter to the Musée du Louvre, 1934 (RF 3890); placed on deposit by the Musée du Louvre in the Musée des Beaux-Arts, Strasbourg, 1937.

BIBLIOGRAPHY:
Chevillard 1893, nos. 157 (*Moorish Woman Leaving the Bath*), 212 (*Woman of Constantine Leaving the Bath*); Vaillat 1913, ill.; Alazard 1930, pp. 109–10, ill. 109; Pascal 1930, p. 109, ill.; Bénédite 1931, vol. 2, ill. p. 416; Grappe 1933; Huyghe 1933, no. 6, pp. 1–2, ill. p. 2; Ahnne 1935, pp. 16–17, ill. p. 11; Vergnet-Ruiz and Laclotte 1962, index; Sandoz 1974, no. 148, p. 290, pl. 138, p. 293.

EXHIBITIONS:
Paris, 1897, no. 15; Paris, Orangerie, 1933, no. 75, p. 38 (*In the Harem*); Poitiers, 1969, no. 19.

There is no evidence to either prove or disprove that Chassériau visited an Algerian harem during his trip in 1846. It is unlikely that he would have brought up any controversial subjects in his letters to his family, which are our main documentary sources concerning this trip. In short, we have no information pertaining to any of Chassériau's erotic adventures or unusual visits in this "very beautiful and very new [land]" in which he had the impression of living in the "Thousand and One Nights."[1] Yet, in light of his sensual nature and his fondness for women, it is not at all unreasonable to suppose that he tried to visit a seraglio, as most of his illustrious fellow painters had done. In any case, although there are many drawings from Algeria depicting beautiful Jewish, Kabyle, and Arabian women, he does not seem to have encountered any of them in a harem in Algiers.

When he painted his first picture in this genre in 1849 (cat. 181), Théodore Chassériau surely had in mind both the series of Antique or religious Nudes of his first Salon entries— *Venus, Susanna, Andromeda,* and *Esther*—and the fleeting and tantalizing impressions of his Oriental

journey. He also must have wanted to treat the Nude independently of the "legitimacy" conferred by mythological, historical, and religious iconography; and he must have remembered the works of his distinguished precursors as well. He probably also reread certain poems by his contemporaries in which the Orient, with its harems full of lustful women and the baths of the sultan's concubines, was a recurrent theme. There was, of course, Victor Hugo's *Orientales,* a major reference for artists at the time, and Alfred de Vigny's *Bain d'une dame romaine.* There was also Théophile Gautier's evocative description of the heroine in *La Chaîne d'or ou l'Amant partagé,* who clearly had affinities with Chassériau's Oriental figures: "Her skin was brown, full of fire and vigor, with a gold-tinged sheen, blond like the neck of Ceres after the harvest; her proud and pure breast raising wonderful folds in her silken tunic." Gautier had the same vision of femininity as Chassériau—idealized, but also sensual—and waxed enthusiastic over the Oriental type, which he compared to "Ingres's odalisque" in his famous collection of poems, *Émaux et camées* (Enamels and cameos):

> *Sur un tapis de Cachemire*
> *C'est la sultane du sérail*
> *Riant au miroir qui l'admire*
> *Avec un rire de corail; . . .*
> *Paresseuse odalisque, arrière!*
> *Voici le tableau dans son jour*
> *Le diamant dans sa lumière;*
> *voici la beauté dans l'amour!*
> *Sa tête penche et se renverse;*
> *Haletante, dressant les seins*
> *Aux bras du rêve qui la berce.*[2]

> *On a cashmere carpet*
> *The queen of the seraglio*
> *Smiles at the admiring mirror*
> *With a coral smile. . . .*
> *Away, idle odalisque!*
> *Here, the painting in its light,*
> *The diamond in its fire:*
> *Here, the beauty of love!*
> *Her head lolls and falls backward;*
> *With a sigh she tenders her breasts*
> *To the arms of the dream embracing her.*

Chassériau is known to have painted three versions of this particular subject, which were often entitled *Interior of a Harem.* Two of them are included here, but the whereabouts of the third, which Sandoz located in a private collection,[3] is not known.

The first painting (cat. 181) in the series of harem bathers—"series," in the sense of repetitions and variations—shows a young woman wringing her hair as she emerges from her bath, while a black slave dries her midriff and another prepares her jewelry. In front of this group of women we can see the pool in which the favorites bathed, and in the background, a curtain and doors—a setting both simple and hermetic that indicates their reclusive lives in the service of the sultan.

The second version—the one not included here—was entitled *Oriental Interior,*[4] and depicted the next step in the young woman's toilette: she is bare only to the waist

and dresses her hair, after having put on her bracelets, while one servant holds a necklace and another a mirror.

In the present, third version, Chassériau chose to represent the moment just after the woman has come out of her bath. He created a more dynamic scene, showing her still naked to the waist, but wringing her hair, while a slave fits a bracelet on her wrist. The composition presents other women, dressed this time, suggesting the atmosphere of the harem in more detailed terms. The background in this painting is just as closed as in the first version of this subject, and the foreground is again occupied by the pool in which the young woman has bathed.

In his further development of this theme, Chassériau combined the odalisque and the bather in several significant works in the following years: an odalisque freshly clad after her bath, reclining on cushions and listening to a musician;[5] the *Tepidarium* (cat. 237), the ultimate variation on the theme of a woman emerging from her bath; and, finally, another *Interior of a Harem* (cat. 254), more evocative and intimate, which marked the culmination of his work on this subject in 1856.

After consideration of the three versions of this theme, a major question comes to mind: namely, to what extent were these scenes based on fact, or, how much did they owe to the artist's imagination? We have already suggested that it is very unlikely that the artist had access to a harem during his trip to Algeria—and, if he had, it is even more improbable that he would have had the time or the occasion to observe that most intimate of scenes in the life of the seraglio: the bath of the sultan's favorites. This is confirmed by the few preliminary drawings that have come down to us—they were mostly for the second version—since they were drawn from life during his Algerian trip, but are only of isolated figures. Through the bequest of Baron Arthur Chassériau, the Louvre owns studies for the secondary figures in the painting in the Musée des Beaux-Arts, Strasbourg,[6] but they are completely anecdotal to the main subject of the scenes.

There is, therefore, a certain discontinuity between these paintings and the artist's trip to Algeria. In addition, as his predecessors had done, Chassériau chose for his main figures a type that was neither North African, Kabyle, nor even really Oriental, but, instead, conspicuously Occidental. The bather in the Strasbourg painting, for example, irresistibly invites comparison with a Venus from Antiquity. This fact only added to the erotic charge of the scene, for the woman presented for the spectator's visual delectation was not some remote odalisque but a familiar being, like the women he might love and desire, and, as such, was that much more accessible. In his Oriental compositions, Chassériau may have given pictorial expression to Baudelaire's fantasies:

> *C'est ici la case sacrée*
> *Où cette fille très parée*
> *Tranquille et toujours préparée*
> *D'une main éventant ses seins*
> *Et son coude dans les coussins*
> *Écoute pleurer les bassins:*
> *C'est la chambre de Dorothée.*[7]

Here is the sacred dwelling
Where the richly adorned girl
Calm and ever prepared
With one hand fans her breasts
Her elbow on the cushions
And listens to the fountains weep:
This is Dorothy's room.

Not surprisingly, Chassériau had Alice Ozy pose for the voluptuous bather in his first version of this theme. The actress confirmed having posed for the nude odalisque in the *Bath in the Seraglio*,[8] which happens to be the most "undressed" of the figures in the series. The atmosphere of these scenes may have been suggested by exotic impressions of the Orient, mixed with the clichés of the genre and of fashion, but they ultimately had more to do with the erotic fantasies of the Orient evoked by the Romantic poets: sensual daydreams involving willing courtesans or idealized women who were unconditionally adored, but inaccessible. Yet, behind this eroticized Orient, the sensuality of Greece is never far away.

V. P.

1. Letter from Théodore Chassériau to his brother Frédéric, May 13, 1846 (lost); quoted in Bénédite 1931, vol. 2, p. 266.
2. T. Gautier, "Le Poëme de la femme. Marbre de Paros," from the collection *Émaux et camées*.
3. Sandoz 1974, no. 147, pp. 290–91, pl. 137.
4. Private collection; Sandoz, ibid.
5. Private collection; Sandoz 1974, no. 223, p. 360, pl. 188, p. 36.
6. Paris, Musée du Louvre, Département des Arts Graphiques, album RF 26087, fol. 2 r., RF 25471; there is at least one extant preliminary drawing for the central figure; it is mentioned in the 1857 sale catalogue (lot 70) and in Chevillard 1893, no. 371, and appeared in a number of sales during the twentieth century.
7. C. Baudelaire, "Bien loin d'ici," in *Les Fleurs du mal*.
8. C. Sterling, in Paris, Orangerie, 1933, no. 49, p. 26, mentions this reminiscence probably related by Alice Ozy to Jean-Louis Vaudoyer.

183

Jewish Family in Constantine

1850 or 1851
Oil on wood
11 x 7 ⅞ in. (28 x 20 cm)
Signed and dated, bottom right: *Thre Chassériau / 1850 or 1851*
Musée de Grenoble

PROVENANCE:
Baron Arthur Chassériau, Paris; bequest of the latter to the Musée du Louvre, 1934 (RF 3902); placed on deposit by the Musée du Louvre at the Musée de Grenoble, 1937.

BIBLIOGRAPHY:
Chevillard 1893, no. 154 (not 151, as noted by Sandoz); Bénédite 1931, p. 298; Renan 1897, no. 17; Sandoz 1974, no. 173; Prat 1988-1, vol. 2, p. 936; Chevillot 1995, p. 99; Peltre 2001, pp. 135–37.

EXHIBITIONS:
Paris, 1930, no. 102; Zürich, 1946, no. 63; Lausanne, 1992, no. 6.

Exhibited in New York only

The chapter that Bénédite devotes to Chassériau's travels in Algeria in 1846, then strongly marked by the colonial policies of the Third Republic, displays an obsessive and unclear racial reading of the drawings and paintings linked to a greater or lesser extent to this journey. According to this historian, the only women who served as models for the unveiled female figures depicted by Chassériau belonged to the Jewish populations of Constantine and Algiers—with the exception of a few prostitutes. Writing in 1848, Gautier considered this unveiling—otherwise forbidden by the religious strictures

of Islam—one of the most piquant details of the painting refused by the previous Salon, the *Sabbath in the Jewish Quarter of Constantine*: "How the poor Arabian captives lean out of the narrow openings of their cages to cast an envious glance at their more fortunate rivals, who are not forced to be beautiful incognito!"[1]

Yet, this particular criterion, with its far-reaching associations, should be applied with caution. There is a drawing in the Louvre (RF 26807, fol. 2 r.), that shows two women, each with the lower half of her face veiled, whose costumes and head coverings clearly indicate their Jewish origin. This practice was commonplace among Jewish women in North Africa, and involved "social behavior that had nothing to do with religious dictates."[2] The figure on the left may have been used in the 1847 *Sabbath* and then again in the *Descent from the Cross* at Saint-Philippe-du-Roule.[3] Significantly enough, Chassériau placed her alongside the kneeling women near the Virgin, and not on the right side of the composition, among the group of Jews hostile to Christ. Could it be that women's beauty excluded them from the ambiguity of the painter's Jewish iconography?

The Grenoble painting also lends credence to this idea, for it establishes a clear separation between the figures belonging to the maternal and the paternal spheres, and their respective values.[4] The woman on the right stands haughty and erect;[5] one is struck by her beauty, elegance, and refinement of clothing and jewelry, and a pose that recalls the Venus de Milo.[6] The man on the left, however, squats in a simian-like pose, displaying an emphatically arched nose, a mean-looking mouth, and a sullen, mistrustful expression. A drawing in the Louvre (RF 24360) appears to be a preliminary study for this equivocal figure. Both Prat and Peltre identified the sketch as a "Head of a Bearded Arab with a Hood." This may be, but it is difficult to prove. Jacques Taïeb points out one of the features of the Judeo-Arabian world: "the stamp of things Arabian on costumes and customs," especially as far as interiors and clothing were concerned.[7] Another drawing in the Louvre (RF 26074, fol. 5 v.) represents "heads of Jews," according to the annotation by Chassériau in 1846, but the figures are comparable to the ones in the above-mentioned drawing. We would agree with Prat that this caricature-like face also appears in the mural at Saint-Philippe-du-Roule, but among the group of scornful Jews to the left of Christ.

Today, as the approach of historians focuses on the (cultural) notion of ethnicity instead of on the (racist) exploration of physical types and racial purity, it becomes clear that Chassériau was not very rigorous as far as ethnographic details were concerned in his African works; this is apparent in the annotations in his sketchbooks as well as in certain details in his paintings. The great cultural diversity that he found in Algeria was not to be apprehended in only a few weeks. There were reciprocal influences between the Berbers, the Arabs, and the Jews. Chassériau succumbed to the charm of this ethnic mosaic, but without understanding it, or perhaps even trying to. It would be naïve, therefore, to take him to task for this, and to harp on the fact, for example, that his Oriental

merchants at the Cour des Comptes sport the same head-gear as the Jewish women of Constantine. It would also be absurd to ignore the fact that his vision of Algeria in 1846 was rooted in racial preconceptions and, as already mentioned, in a sexist approach. As he wrote to his brother Frédéric on June 13: "I have seen some very curious, primitive, and dazzling things, strange and touching. In Constantine, which is situated atop high mountains, one can see the Arab race and the Jewish race, as they were on their first day."[8]

Are we in the Jewish quarter of Constantine, which had been the setting of the large-format composition of 1847? Is it the Sabbath? Unlike his Arab horsemen, usually shown in action, Chassériau tended to depict the Jewish population in a passive state, as so much visual fare for passersby. This lack of motion, and even languor, involved one of the most frequent clichés of literary and pictorial Orientalism. We can see it in Delacroix's oeuvre more than once: his *Street in Meknès* (Salon of 1834; Buffalo, New York, Albright-Knox Art Gallery), for instance, shows some "typical" Moroccans in full daylight, on the threshold of a house steeped in shadow, captured as if in a photograph. Chassériau added to the illusion of the scene the feeling that our presence is more tolerated than desired: This is immediately apparent in the fierce gaze of the black figure in the background.

S. G.

1. T. Gautier, "Salon de 1848," in *La Presse*, Paris, April 27, 1848.
2. See G. Silvain, *Sépharades et Juifs d'ailleurs*, prefaces by H. Mechoulan and J. Taïeb (Paris: Adam Biro, 2001), p. 139.
3. For another opinion see Prat 1988-1, vol. 2, p. 939, fol. 2 r. The figure at the top of the sheet seems to be related to one of the figures in the only existing drawing for the *Sabbath* of 1847 (see Prat 1988-1, vol. 1, p. 204, fig. 410).
4. According to Sandoz, the Grenoble painting is the same as the one mentioned in a list of works dating to about 1849–51 (Prat 1988-1, vol. 2, p. 923).
5. There is a preliminary study for this figure in one of the sketchbooks in the Louvre (Prat 1988-1, vol. 2, p. 936, fig. 7 v.).
6. Chassériau shared his friend Félix Ravaisson's fascination with the Venus de Milo: See F. Ravaisson, *L'Art et les mystères grecs,* texts selected and presented by D. Janicaud (Paris: L'Herne, 1985). The painter often referred to Ravaisson in his letters to his brother Frédéric during his Algerian trip (see the Chronology, p. 274).
7. See Silvain, op. cit., p. 20.
8. See the Chronology, p. 274.

184

A Young Taleb Seated on the Ground, Facing Right

1851
Pen and black and brown ink, with gray and black wash, heightened with white and *pierre noire,* on beige paper
6 ⅜ x 5 ¼ in. (16.2 x 13.2 cm)
Signed and dated in pen and brown ink, lower left:
Th. Chassériau 1851; inscribed in pen and ink, at the top:
PÖETE ARABE.
Dijon, Musée des Beaux-Arts (J. 38)

PROVENANCE:
Gaston Joliet, 1893; A. Joliet; gift to the Musée des Beaux-Arts, Dijon, 1925 (L. 1863 b, lower right).

BIBLIOGRAPHY:
Chevillard 1893, no. 329; Sandoz 1974, under no. 172, as "has not reappeared"; Prat 1988-1, vol. 2, under no. 1598; Prat 1988-2, no. 169.

Exhibited in Strasbourg only

The word *taleb* denotes an Arab scholar, who sometimes also served as a notary. This figure is adapted from a painting of the previous year that depicted the same individual, and thus was also executed after the Algerian trip of 1846. The painting appeared at auction in Paris in 1961 (Palais Galliéra, June 14, 1961, lot 81, ill.; Sandoz 1974, no. 172, ill.) and again, more recently (Paris, Drouot-Montaigne, November 21, 1995, lot 5, colorpl.).

L.-A. P.

CAT. 184

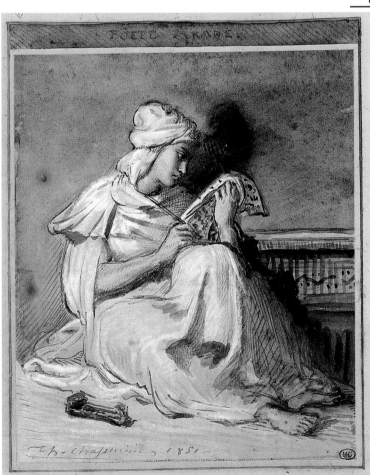

185

Arab Chiefs Visiting Their Vassals

1849

Oil on canvas

55 ⅞ x 78 ¾ in. (142 x 200 cm) (a strip 3 ¾ in. was added at the bottom)

Signed and dated, bottom right: *Theodore Chasseriau, 1849*

Paris, Musée du Louvre (RF 2215)

PROVENANCE:

Gift of Baron Arthur Chassériau to the Musée du Louvre, 1918.

BIBLIOGRAPHY:

Chassériau lists this painting in three inventories of his work: (Musée du Louvre, Département des Peintures, album RF 26085, Prat 1988-1, vol. 2, no. 2239, fol. 26 v., "Chiefs Visiting Their Vassals"; RF 26053, Prat 1988-1, vol. 2, no. 2250, "Arab Chiefs Visiting Their Vassals"; RF 25827, Prat 1988-1, vol. 1, no. 585 v., "Arab Chiefs Visiting Their Vassals"); Gautier 1852; Gautier 1856, p. 269; Bouvenne 1887; Chevillard 1893, no. 216, p. 296; Vaillat 1913, p. 22; Jamot 1920, pp. 65, 76, ill. p. 77; Escholier 1921, p. 18, ill. p. 17; Goodrich 1928, p. 85; Bénédite 1931, p. 290, ill. p. 412; Sterling and Adhémar 1958, p. 23; Sandoz 1974, no. 145, p. 286, pl. 135; Rosenthal 1982, p. 59; Compin and Roquebert 1986, p. 130; Prat 1988-1, vol. 1, ill. p. 270.

EXHIBITIONS:

Paris, Galerie Durand-Ruel, 1897, no. 16; Algiers, 1930; Paris, 1931; Paris, Orangerie, 1933, no. 47; Bordeaux, 1960, no. 103, pl. 52.

Exhibited in Paris only

Chassériau frequently annotated his Algerian albums with ideas for paintings, but none of his comments describes the specific scene depicted here. Sandoz attributed this picture to a note written on a sheet dating to 1849 in which Chassériau recorded his wish to "faire un jeune kaid suivi de son escorte donnant l'aumône a des pauvres" [do a young chief with his escort giving alms to the poor] (RF 26065; Prat 1988-1, vol. 2, no. 2237, fol. 13 v.). It seems more likely, however, that the project described there resulted in Chassériau's *Chief Giving Alms* (1850; United States, private collection)—a painting that only recently has reappeared (Paris, Hôtel Drouot, June 22, 1994, lot 6), in which the act of distributing alms is more clearly illustrated.

The landscape setting of *Arab Chiefs Visiting Their Vassals* originated in a drawing featuring the tree at the center of the composition and the nomadic encampment beyond, in one of the albums Chassériau brought with him to Algeria (RF 26074; Prat 1988-1, vol. 2, no. 2251, fol. 24 v.). The composition, showing the horizontal branch of a tree overhanging a group of tents, was used in a second drawing executed in Algeria (RF 25453; Prat 1988-1, vol. 1, no. 584), which argues for the origin of this particular picture among the sights and episodes witnessed by Chassériau in the environs of Constantine. Such landscape drawings are rare among the sketches the artist produced in Algeria, as he was far more interested in details of local costume and physiognomy. Thus, *Arab Chiefs Visiting Their Vassals* has a more articulated natural setting, in contrast to his other paintings inspired by the journey. Two additional preparatory drawings, probably sketched by the artist upon his

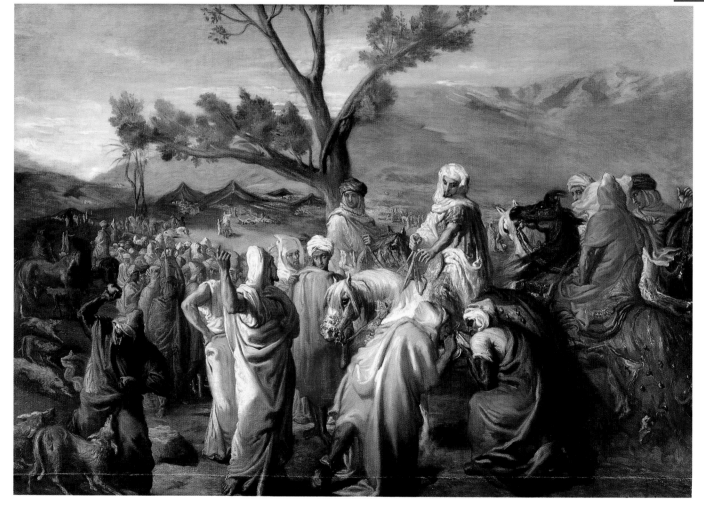

Arab Chiefs Visiting Their Vassals

return from North Africa, relate to the rearing horse at the right of the central chief (RF 25227; Prat 1988-1, vol. 1, no. 583) and to the delegation of Arabs at the left (RF 25435; Prat 1988-1, vol. 1, no. 582).

Several paintings by his contemporaries may have provided Chassériau with models for this scene, including Delacroix's *Moroccan Chieftain Receiving Tribute* (Salon of 1838; Nantes, Musée des Beaux-Arts) and Ginain's *Arab Horsemen Accepting Milk in the Desert* (Salon of 1845; lithograph published in the *Journal des artistes*, 1845). Horace Vernet's two versions of *Arab Chiefs in Their Camp* (1833; London, Wallace Collection, and Chantilly, Musée Condé) also might have suggested both the general subject and certain details of the composition of Chassériau's painting. Indeed, the landscape drawing mentioned above replicates the setting of Vernet's picture, in which a tree sets off the slightly elevated foreground from a treeless plain in the background dotted with tents and herds of animals.

Moreover, this recourse to Vernet, whose representations of Arabs in *The Capture of Abd-el-Kader's Tribe*, for example, tended toward caricature, points to the feudalism underlying Chassériau's scene.[1] Consistent with military reports asserting the feudal structure and the persistent medieval customs of Arab society, Chassériau's Arab chieftain accepts an archaic form of tribute from his vassals, who kiss his foot and stirrup. A similar act of deference appears in Carpeaux's plaster relief, exhibited at the Salon of 1853, commemorating the homage paid by Abd-el-Kader to Napoleon III upon the former's release from imprisonment.

Yet, while images by Vernet and others—which Chassériau might have seen before setting out for North Africa—arguably may have structured his impressions of the scenes he encountered there, they also demonstrate the substantive differences in approach between him and Vernet. Chassériau focuses less on documentary details than on the internal relations between chief and tribe, the gallery of facial expressions, the interplay of formal gestures, the complex and austere Poussinesque drapery folds, and the nervous elegance of the Arab steeds. In a review of 1852, Gautier ranked this picture among the artist's finer Orientalist compositions, together with the lost *Sabbath in the Jewish Quarter of Constantine* and the *Arab Horsemen Removing Their Dead*, as evidence of a completely original manner.

While Gautier seems at pains to emphasize Chassériau's faithfulness to observed details, he and other contemporary critics interpreted such scenes of Arab cavaliers as episodes from Homer's *Iliad* reenacted on North African terrain. Apropos of Chassériau's *Arab Horsemen Removing Their Dead After an Engagement with the Spahis,* Gautier wrote: "With their proud simplicity and noble air, there is a Homeric grandeur in these groups. This is exactly how one imagines the Greeks and the Trojans carrying off their dead beneath the walls of Ilium."[2]

The classical heritage that Gautier discerns is reinforced, in *Chiefs Visiting Their Vassals,* by the balanced horizontal arrangement of the figures in the foreground and the sense of arrested movement suggestive of a sculp-

tural frieze. The hooded horseman and his rearing horse on the right recall, in particular, the poise of the equestrian procession on the Parthenon reliefs, which Gautier evoked when he later wrote of Chassériau: "He combined the pure beauty of Phidias and Athenian elegance with a sad, mysterious feeling, a savage grace of sorts, an ineffable Oriental languor."[3] P. B. M.

1. F. Pouillon, "La Peinture monumentale en Algérie: un art pédagogique," in *Cahiers d'études africaines*, nos. 36-1-2 (1996), pp. 185–88.
2. T. Gautier 1857, p. 210.
3. T. Gautier 1852, n.p.

186

Arab Horsemen at a Fountain in Constantine

1851
Oil on canvas
31 ⅞ x 25 ⅝ in. (81 x 65 cm)
Signed and dated, lower right: *Th^re Chasseriau / 1851–*
Lyons, Musée des Beaux-Arts

PROVENANCE:
Ingres; Mme Ingres sale, 1894; Damblat; Baron Arthur Chassériau, Paris; bequest of the latter to the Musée du Louvre, 1934 (RF 3901); placed on deposit by the Musée du Louvre at the Musée des Beaux-Arts, Lyons, 1936.

BIBLIOGRAPHY:
Chevillard 1893, no. 110; Chevillard 1898, p. 250, ill. p. 249; Vaillat 1913, ill. p. 17; Bénédite 1931, p. 289, pl. 25; Jullian 1938, vol. 2, p. 87; Sandoz 1974, no. 170, p. 312, pl. 150; Prat 1988-1, p. 279; Peltre 2001, p. 140, ill. p. 139.

EXHIBITIONS:
Bordeaux, Salon of 1851, no. 101; Paris, Galerie Durand-Ruel, 1897, no. 11; Paris, 1930, no. 101; Paris, Galerie Charpentier, 1933, no. 1; Paris, Orangerie, 1933, no. 60; Bordeaux, 1960, no. 104; Bordeaux, 1963; Lausanne, 1989.

While sketches of horses are plentiful in Chassériau's Algerian albums, studies for a composition resembling the one pictured in *Arab Horsemen at a Fountain in Constantine* do not appear until after his return to Paris. Among these, two annotated drawings may indicate his initial plans for the Lyons picture. A sheet showing studies of horses' heads (RF 25396; Prat 1988-1, vol. 1, no. 602; see cat. 187), one of which is drinking from a basin, incorporates a description of the painting that Chassériau had in mind: "Un . . . [p]alfrenier arabe faisant boire des chevaux à une fontaine tout le premier plan pris par les chevaux autour de la piscine" [An . . . Arab groom watering his horses at a fountain the entire foreground occupied by the horses around the pool]. This composition also called for an Arab beggar at the foot of the fountain accepting alms from figures in the middle ground, and others mounted on camels in the background. A second sketch, labeled "Arabes faisant boire leurs chevaux à une citerne" [Arabs watering their horses at a cistern] (RF 25441; Prat 1988-1, vol. 1, no. 603 v.), of about 1848–50, illustrates the figures gathered around a circular tank, including the seated beggar described in Chassériau's note. A still more finished drawing with the same title (RF 25363; Prat 1988-1, vol. 2, no. 1715), which may have been studied from life in Algeria, but most probably represents the idea as developed upon his return, further elaborates on this project.

In yet another note written alongside the sketches of horses' heads (RF 26236; Prat 1988-1, vol. 2, no. 2019) the

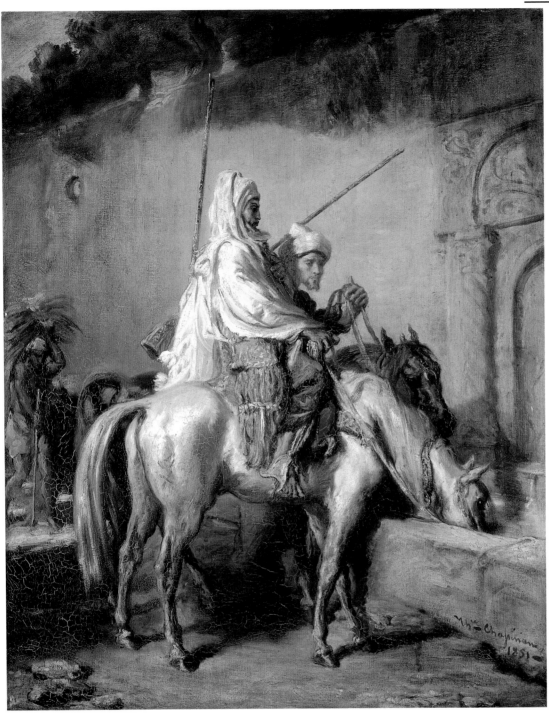

artist specifies a similar scene and reminds himself: "faire une chose vigoureuse avec mes dessins et mes souvenirs" [do something strong with my drawings and my memories]. As was typical of the method articulated here and employed in many of his Orientalist pictures, the head of the cavalier on the left was taken from a drawing (RF 24410; Prat 1988-1, vol. 2, no. 1643) executed in Algeria. The emphasis Chassériau gives to his memories in the above note also may explain the changes between the preliminary plan and the final picture. Forgoing the oasis-like setting, the circular basin, as well as the additional attendants, beggars, horses, and camel, Chassériau reduced his composition to two mounted

warriors at a fountain built into a wall. In a note accompanying a drawing of a horse's head (RF 26234; Prat 1988-1, vol. 2, no. 2012), the artist reminded himself: "Ne pas oublier les belles et hautes murailles. Superbes et singulières choses qu'il faut faire comme elles m'ont frappé" [Not to forget the beautiful high walls. Superb and singular things that have to be done in the way they struck me]. In his Algerian travelogue, Gautier admired a similar construction made up of a horizontal trough under a façade featuring ribbed columns topped by flared capitals, asserting that "this disposition, give or take some variations, is the same for all Arabian fountains."[1] Thus, Chassériau opted in the finished canvas for a type of

fountain that allowed him to place the Arab warriors in profile against a high golden wall—a compositional shift that was perhaps an attempt to rival a specialty of Decamps.

Impressed by North Africa for its suggestion of what Delacroix called a "living Antiquity," Chassériau was reminded of classical garb when confronted by the garments worn by Arab warriors. Similarly, his pictures of their activities—leaving for war, accepting homage from their tribes, watering their steeds, and engaging opponents in battle—amount to what his contemporaries saw as a North African *Iliad*. Indeed, both the abundant folds of the burnous worn by the cavalier in the foreground and his reflective profile mark his kinship with the sartorial elegance and restrained dignity of the mounted chieftains in Chassériau's *Arab Chiefs Visiting Their Vassals* (1849; cat. 185) and *Arab Horsemen Removing Their Dead* (1851). The spirit of repose in all three pictures contrasts with the more frenetic action he introduced in his scenes of violent clashes between Arab horsemen. Chassériau was fascinated with the nobility that this military caste displayed in even the most quotidian tasks. Accordingly, horses being led to water was among Chassériau's favorite themes inspired by the Algerian voyage. Sandoz documents five canvases in which drinking horses feature prominently; of these, the *Horse at a Trough* (1851; Le Havre, Musée des Beaux-Arts) is perhaps the closest, relative to the present picture.

Chassériau's enthusiasm for this motif was shared by his contemporaries. Decamps, in *Turkish Subject,*

Horsemen at a Trough (Salon of 1833; sold as part of the d'Harcourt collection, 1851), and Lehoux, in *Arabs Resting near a Cistern* (Salon of 1843), had treated the subject before Chassériau's departure for Algeria in 1846. Later, Delacroix painted his *Horses at a Trough* (1862), which may, in part, represent a response by the older painter to Chassériau's picture, reversing the direction of influence often underlined in characterizations of the relationship between the two artists. Strangely enough, Delacroix's scene of horses and figures gathered around a watering place corresponds to Chassériau's original idea as it was developed in preliminary drawings and notes. This circumstance may support Sandoz's suggestion that Chassériau painted yet another canvas—now lost, but listed by Chevillard as "Horsemen watering their horses," and among the paintings included in the sale at the artist's atelier—that matched the composition outlined in those studies. P. B. M.

1. T. Gautier, "Scènes d'Afrique. Alger," in *Revue de Paris* (1853), p. 434.

187

Sheet of Studies of Horses; A Seated Woman

1851
Pen and brown ink, with brown wash
12 ¼ x 15 ¾ in. (31 x 39.9 cm)
Annotated in brown ink, around the sketches: *fier / attaché au mur pendant / qu'on le panse la tête et le / cou d'un noir brun / avec le lis buvant dans son lait / qui traverse la tête / en lumière / Un . . . [p]alefrenier arabe faisant / boire des chevaux à une / fontaine / tout le premier / plan pris par les chevaux / autour de la piscine / au pied de la fontaine un / arabe mendiant auquel / des figures du second plan / font l'aumône / des arabes montés / sur des chameaux / faire les grecs prisonniers / chantant les vers d'Homère / aux barbares—Deux Chevaux / conduits par un / homme à cheval / sur le premier* [proud / attached to the wall while / one grooms the head and the / neck a brownish black / with the lily drinking in its milk / which traverses the head / with light / An Arab groom / watering his horses at a / fountain / the entire fore / ground occupied by the horses around the pool / at the foot of the fountain an / Arab beggar to whom / the figures in the middle ground / give alms / Arabs mounted on camels / take the Greeks prisoner / singing the verses of Homer / to the barbarians—Two Horses / led by a / man mounted / on the first]
Paris, Musée du Louvre (RF 25396)

PROVENANCE:
See cat. 20.

BIBLIOGRAPHY:
Chevillard 1893, p. 261 (for part of the text) and part of no. 420; Sandoz 1974, under no. 170 (for part of the text); Prat 1988-1, vol. 1, no. 602, ill.

Exhibited in Strasbourg only

CAT. 187

The sketch at the upper right and the notes next to it are related to the 1851 painting in Lyons entitled *Arab Horsemen at a Fountain in Constantine* (cat. 186), although the horse in the foreground there is shown with its right shoulder in front. The subject of Greek prisoners singing the verses of Homer, mentioned in the inscription, would not be developed further. L.-A. P.

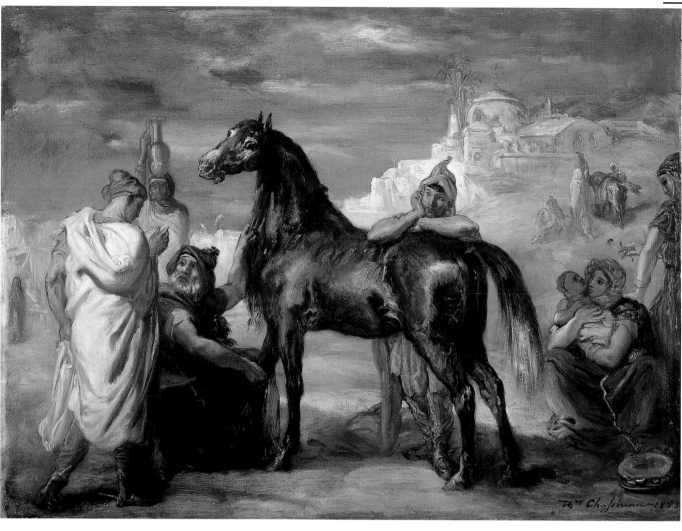

188

Arab Trader Presenting a Mare

1853
Oil on wood
16 x 21 ½ in. (40.5 x 54.5 cm)
Signed and dated, bottom right: *Th^re Chassériau 1853*
Lille, Musée des Beaux-Arts (P. 1710)

PROVENANCE:
Studio of the painter until his death; Chassériau sale, Paris, Hôtel Drouot, March 16–17, 1857, lot 18 (*Horse Trader. Arab Scene*), sold for Fr 84 (as noted in a copy of the sales catalogue, Cabinet d'Estampes, Bibliothèque Nationale de France, Yd 929 a, in-8°); E. Cuginaud, lawyer in Bordeaux (according to Sterling, in *Chassériau*, 1933, p. 35; Sandoz gives the name as "Cusinaud"); Baron Arthur Chassériau, Paris; bequest of the latter to the Musée du Louvre, 1934 (RF 3892); placed on deposit by the Musée du Louvre at the Musée des Beaux-Arts, Lille, 1937.

BIBLIOGRAPHY:
Chevillard 1893, nos. 132 *(Horse Trader. Arab Scene)*, 101 *(Arabian Horse Market)*, respectively; Renan 1897, no. 8; Vaillat 1913, p. 12, ill.; Goodrich 1928; Bénédite 1931, vol. 2, p. 289, ill. p. 296; La Tourette 1931, p. 188, ill. p. 181; Sandoz 1974, no. 221, p. 358, pl. 186, p. 359; Prat 1988-1, vol. 1, nos. 677, 678, pp. 304–6, ill.; Brejon de Lavergnée and Scottez-De Wambrechies, *Musée des Beaux-Arts de Lille. Catalogue sommaire illustré des peintures. II. École française* (Paris, 2001), p. 62, ill.

EXHIBITIONS:
Paris, 1897, no. 10; Paris, 1930, no. 98; Paris, Orangerie, 1933, no. 67, p. 35.

Exhibited in New York only

According to Sandoz,[1] although this picture was painted seven years after Chassériau's Algerian trip, the scene was based on sketches done in Constantine, and thus was intended to give the impression of actually having been witnessed by the artist. A preparatory watercolor sketch served as the basis for the woman in the background carrying a water jug.[2] In his inventory of Chassériau's graphic works in the Louvre, Prat identified two other sketches[3] that clearly inspired the present work: One, in graphite and probably studied from life in 1846, shows the horse and three Arabs, but the position of the man in front of the horse in the drawing was modified in the painted version; and a second, also in graphite, which, as Prat suggests, might be a first compositional sketch for the painting, although it is later in date, from about 1853.

The painter arranged all of the figures in the foreground, as in a classical frieze on a sculptural bas-relief; a sense of depth is created by those in the background, as well as by a glimpse of a city in the distance at the right, shimmering in the sunlight and haze of a hot African afternoon.

The execution is characterized by nervous and virtuoso brushwork, with fine color effects, and the composition is a perfect illustration of the complex relationship between Chassériau's scenes of Algeria and Delacroix's Moroccan subjects. Yet, the traditional hypothesis of the influence of the latter on the former seems less tenable

when their works are compared, for their aesthetic intentions clearly diverge: Delacroix's ambition was to depict his much-touted "living Antiquity," while Chassériau sought to evoke a more tangible reality, combining exoticism and sensuality. A good case in point is Delacroix's *Horses at a Trough* (Philadelphia Museum of Art), which is dated 1862 and comparable to the scene painted here by Chassériau in 1853—that is, nine years earlier. The question is: Who influenced whom? There are two other compositions by Delacroix that present analogies with the Lille painting: *View of Tangiers with Two Seated Arabs* (The Minneapolis Institute of Arts) and *The Riding Lesson* (Chicago, private collection), which were executed in 1852 and 1853, respectively—the latter in the same year as Chassériau's *Arab Horse Trader*.

The two artists therefore pursued parallel paths, making the most of an aesthetic vein that was both stimulating and lucrative, and that happened to be in fashion at the time. As far as his Oriental subjects are concerned, Chassériau, the younger of the two painters, does not really seem to have drawn his inspiration from the works of Delacroix.

<div style="text-align:right">V. P.</div>

1. Sandoz 1974, no. 221, p. 358.
2. Watercolor (Musée du Louvre, RF 24422; Prat 1988-1, vol. 2, no. 1591, p. 581).
3. Prat 1988-1, vol. 1, nos. 677, 678, p. 304.

189

White Horse in Left Profile

1853
Oil on canvas
23 ¼ x 28 ¾ in. (59 x 73 cm)
Paris, Musée du Louvre (RF 3934)

PROVENANCE:
Studio of the painter until his death; Baron Arthur Chassériau, Paris; bequest of the latter to the Musée du Louvre, 1934; placed on deposit by the Musée du Louvre at the Musée des Colonies, Paris, July 20, 1937; returned to the Musée du Louvre, February 7, 1969.

BIBLIOGRAPHY:
Chevillard 1893, no. 207; Vaillat 1913 (with the date "1856"); Bénédite 1931, vol. 2, ill. p. 222; C.P., p. 77; Sandoz 1974, no. 168, pp. 308–9, pl. 148; Compin and Roquebert 1986, vol. 3, p. 135, ill.

According to his contemporaries, Chassériau was as skillful a rider and as passionate a horse lover as his namesake, Théodore Géricault. His interest in things equestrian was so great that he is said to have set aside a special room in his Parisian apartment to indulge his passion. On the walls, one could see, "in the midst of Oriental weapons and fabrics, paintings by Géricault, Alfred de Dreux, and Théodore Rousseau, watercolors by Cabat, and the family trees of the thoroughbreds [that he] had owned."[1]

A quick survey of his work shows that horses often were among the most powerful and dynamic elements in his large-format compositions. He used the conven-

<div style="text-align:right">CAT. 189</div>

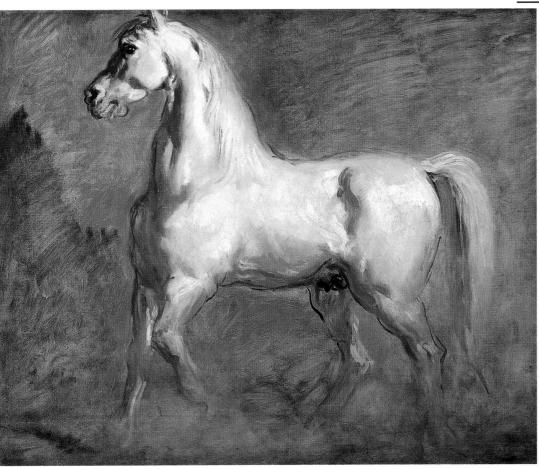

tion of the equestrian portrait for his superb *Ali-Ben-Hamet, Caliph of Constantine and Chief of the Haractas, Followed by His Escort* (cat. 134), as well as for his portraits of the comte and comtesse de Ranchicourt (cat. 211, 212), in which he represented his sitters alongside their favorite horses, preparing for a hunt. The horse also became one of the main protagonists in his Orientalist scenes, completely integrated into the action, as in the series of *Cavalry Battles* or in such more or less picturesque works as *Arab Horsemen at a Fountain in Constantine* (cat. 186).[2] The painter seems to have taken a real delight in being able to depict his favorite animal in a scene with a historical or literary subject, as in *Macbeth and Banquo Encountering the Three Witches on the Heath* (cat. 200).

Not only did horses play a major role in his "subject" pictures, but Chassériau, one of the most talented portraitists of his time, also tried his hand at portraits of horses—a genre in which his illustrious precursors Carle Vernet, Théodore Géricault, and Alfred de Dreux already had distinguished themselves. Chassériau's *Hadji, Barb Stallion from the Province of Constantine*,[3] which he exhibited at the Salon of 1853 along with his *Tepidarium* (cat. 237) and *Mazeppa* (cat. 203), is one of the finest demonstrations of the realism, power, and affection with which he endowed his depictions of horses.

Among his other paintings done in a spirit similar to that of the present work are those that could just as well be considered sketched from life; the artist clearly painted them as much for his own pleasure as to prepare figures for his larger compositions.[4] This series of horse studies probably was painted after 1846, for it is comparable in style to the animal drawings he brought back from Algeria,[5] and includes both subjects of Oriental inspiration and scenes observed by the painter in the stables that he frequented in Paris.

In his catalogue raisonné, Sandoz mentions several preliminary drawings for this *White Horse*,[6] one of Chassériau's most successful works in this vein, and he dates the canvas to 1849, but the date seems somewhat too precise, considering the lack of corroborating evidence. Sandoz also points out the fact that the horse seems frightened. Indeed, more than in the other horse studies in this series, Chassériau's intention seems to have been to portray the physical expression of an emotional—almost human—reaction: fear. As in those other works, the artist left the background and even the lower part of the horse's legs undefined, as if to distinguish the study from a finished work.

For Chassériau and his fellow Romantics, the nobility, strength, and power of the horse offered a new source of inspiration that could considerably enrich his pictorial compositions. He was one of the last artists—before Edgar Degas, whose work seems to mark the end of this development—to have afforded a place of honor in his paintings to this animal, whose presence in art would be phased out by the Industrial Revolution and the disappearance of a certain way of life. V. P.

1. Aglaüs Bouvenne, quoted in J.-L. Vaudoyer, *Alice Ozy ou l'Aspasie moderne* (Paris, 1930), p. 60.
2. In this vein we could also mention: *Horse at a Trough* (Le Havre, Musée des Beaux-Arts; Sandoz 1974, no. 176, p. 318); *Lone Arab with His Horse* (Winterthur, Oskar Reinhart Stiftung; Sandoz 1974, no. 177, p. 320); and *Arab Trader* (cat. 188).
3. Private collection (Sandoz 1974, no. 164, p. 306).
4. *Arabian Horse, Seen in Profile from Left to Right* (RF 20831; placed on deposit by the Musée du Louvre at the Musée des Beaux-Arts, Cannes; Sandoz 1974, no. 165, p. 306); *Chestnut Horse, Seen Frontally and in Three-Quarter View* (RF 3887; placed on deposit by the Musée du Louvre at the Musée des Beaux-Arts, La Rochelle; Sandoz 1974, no. 166, p. 308); *Bay Horse, Seen in Right Profile* (RF 3935; placed on deposit by the Musée du Louvre at the Musée Municipal, Douai; Sandoz 1974, no. 167, p. 308).
5. See Prat 1988-1, vol. 2, nos. 1658–1680, pp. 600–609.
6. See Sandoz 1974, no. 168, p. 308.

Exhibited in Paris only

190

Arab Tribal Chiefs Challenging Each Other in Single Combat

1852
Oil on canvas
35 ⅞ x 46 ½ in. (91 x 118 cm)
Signed and dated, lower center: *Th. re Chasseriau, 1852*
Paris, Musée d'Orsay

PROVENANCE:
Gras; sale, Paris, Hôtel Drouot, May 22, 1917 ("Sept Tableaux par Th. Chassériau et pastels par Rosalba Carriera provenant de la succession de Mme X [Gras]," lot 1: sold for Fr 13,500); acquired by the Musée du Louvre, 1917 (RF 2186); placed on deposit by the Musée du Louvre at the Musée d'Orsay.

BIBLIOGRAPHY:
Bouniol 1852, pp. 12–13; Clément de Ris 1852, p. 115; Du Camp 1852, pp. 71–72; Gautier 1852; Grün 1852, pp. 72–73; Loudon 1852, pp. 18–20; Baschet, 1854, p. 155; Gautier 1855, p. 253; Gebäuer 1855, p. 92; Perrier 1855, pp. 114–15; Petroz 1855; Mantz 1856, p. 223; Saint-Victor 1856, p. 1; Bouvenne 1887, p. 164; Chevillard 1893, nos. 78, 84, pp. 278, 280; E. and J. de Goncourt, "Salon de 1852," in *Études d'Art,* 1893, p. 99; Dalligny 1894, p. 1; Chevillard 1898, p. 248, ill.; Marcel and Laran 1911, pp. 87–88, ill.; Jamot 1920; Escholier 1921, pp. 12–14; Focillon 1928, p. 169; Goodrich 1928, p. 92, ill.; Bénédite 1931, pp. 290–91, pl. 41; Sterling and Adhémar 1958, p. 23; Sandoz 1974, no. 216, pl. 182; Thornton 1983, p. 79, ill.; Compin and Roquebert 1986, p. 130; Lemaire 2000, p. 227, ill.; Peltre 2001, p. 142, ill. p. 141.

EXHIBITIONS:
Paris, Salon of 1852, no. 239; Exposition Universelle, 1855, no. 2691; Paris, Galerie Durand-Ruel, 1897, no. 2; Algiers, 1930; Paris, 1931; Rome, 1931; Vienna, 1932; Paris, Orangerie, 1933, no. 64; Moscow–Leningrad, 1956, no. 182; Warsaw, 1956, no. 10, pl. 8; London, 1959, no. 55; Munich, 1964–65, no. 30; Lisbon,

While in North Africa, Chassériau spent a great deal of time with French officers. His Algerian notebooks are filled with reminders to himself for future artistic projects: "faire toutes les scènes militaires mêler adroitement l'Afrique française et faire des scènes de la vie de nos troupes là-bas les spahis surtout tout ce que j'en ai vu" [do all the military scenes skillfully mixing French Africa and do scenes of the lives of our troops there the Spahis especially all that I saw of them]. Overlaid upon the pictorial possibilities presented by the conquest of Algeria was Chassériau's ambition to rival the epic battles painted by ancient and modern masters. According to Sandoz, Chassériau had seen both the original *Battle of Constantine* by Giulio Romano and the partial copy made after it by Géricault. Additionally, Gros's influential final sketch for the *Battle of Nazareth* provided an inescapable touchstone for the Orientalist battle scenes by painters of Chassériau's generation. Chassériau also may have recalled David's *Intervention of the Sabine Women,* in which the figure of Romulus is poised, holding a javelin, in a manner similar to the pose of the mounted warrior on the right in Chassériau's picture. As a battle of two mounted Oriental figures, *Arab Tribal Chiefs* calls to mind the more immediate precedent of Delacroix's *The Battle of Hassan and the Giaour* (1826; The Art Institute of Chicago).

CAT. 190

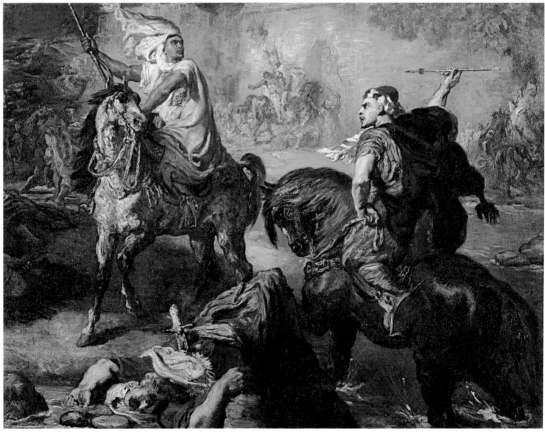

Strangely enough, Chassériau seems to have executed only one preparatory drawing for this ambitious painting. This study, now in a private collection in Paris,[1] shows the upper torso and head of the Arab warrior on the left of the *Arab Tribal Chiefs,* whose arms are arranged in the positions that Chassériau adopted in the final canvas.

Despite—indeed, as a result of—its allusion to well-known precedents, *Arab Tribal Chiefs* was the subject of spirited debate when it was exhibited at the Salon of 1852 and, as such, it marked a crisis of sorts in the painter's career. To his detractors, Chassériau was a *pasticheur,* who had failed to develop his remarkable early talent. This charge was particularly virulent in the case of the painting's perceived proximity to the example set by Delacroix. Alphonse Grün, for example, wrote: "Since M. Eugène Delacroix has not exhibited anything, these are two paintings that could only be by M. Chassériau; only he could copy M. Delacroix in this way."[2] Maxime Du Camp, complaining of Chassériau's "orgies of insane color," echoed these sentiments: "Is he the same man who, envious of the originality of the great master, parodies his work in trying to imitate it?"[3]

Even Théophile Gautier, usually a stalwart Chassériau supporter, took the artist to task in his review of the 1852 exhibition for his insistence on challenging the elder painter on his own turf. "Delacroix inspired a kind of fatal rivalry in the young master and made him mad for movement and color."[4] Gautier criticized Chassériau for the sketchiness of the execution, deliberate errors of draftsmanship, and violently opposed tonalities, which "make this canvas look more like a sketch than a painting."[5] Eugène Loudon accused Chassériau of employing a technique (*métier*) lacking emotion, which caused him to paint sickly crimson and violet horses and a "wild and angry" sky indebted to Delacroix.[6]

Chassériau fared far better with the critics when he exhibited this painting at the Exposition Universelle in 1855. Most notably, Gautier, having reconsidered his prior dismissal of the work, praised it for its "virtually Homeric quality."[7] In a complete reversal, Gautier went on to laud Chassériau's style and attentiveness to detail: "Taken directly from Arab customs, this painting combines a very fine style with the most authentic local color."[8] Gautier was seconded by Charles Perrier: "Look at *Arab Horsemen Removing Their Dead,* look at *Arab Chiefs Challenging Each Other in Single Combat;* these are works of serious value and will remain so, for their tones are not exaggerated, because they are suited to and in harmony with the strictness of the composition."[9]

According to critics at the 1859 Salon, Chassériau's Arab horsemen were a point of reference for Théodore-Louis Devilly's *The Marabout of Sidi-Brahim,* a vast canvas depicting an episode from the conflict in Algeria. Gautier was reminded of Chassériau's drawing style and range of color, and Perrier felt that Devilly's picture had the effect of "a posthumous work by Chassériau."[10]

P. B. M.

1. Théodore Chassériau, *Study for Arab Chiefs Challenging Each Other in Single Combat* (Paris, private collection; Prat 1988-1, vol. 1, p. 43, fig. 3).
2. A. Grün, *Salon de 1852* (Paris: Panckoucke, 1852), p. 72.

3. M. Du Camp, "Salon de 1852," in *Revue de Paris* (1852), pp. 71–72.
4. T. Gautier 1852, n.p.
5. Ibid.
6. E. Loudon, *Salon de 1852* (Paris, 1852), pp. 18–19.
7. T. Gautier, "Exposition universelle de 1855. Peinture-Sculpture. M. Chassériau," in *Le Moniteur universel* (August 25, 1855); reprinted in *Les Beaux-Arts en Europe, 1855* (Paris: Michel Lévy Frères, 1855), p. 253.
8. T. Gautier 1855, p. 253.
9. C. Perrier, "Exposition universelle des beaux-arts," in *L'Artiste* (July 1, 1855), p. 115.
10. T. Gautier, *Exposition de 1859* (Heidelberg: Carl Winter Universitätsverlag, 1992), eds. Wolfgang Drost and Ulrike Henninges, pp. 59, 292–93 n. 62.

191

Battle Between the Spahis and the Kabyles on the Edge of a Ravine

1853
Oil on canvas
16 ½ x 23 ⅝ in. (42 x 60 cm)
Signed and dated, bottom right: *Thre Chasseriau 1853*
Northampton, Massachusetts, Smith College Museum of Art (1950.1)

PROVENANCE:
Chassériau to Adrien Beugniet, March 31, 1854; Chassériau sale, Paris, Hôtel Drouot, March 16–17, 1857 (according to Chevillard 1893, lot 161); Khalil-Bey, Paris; Khalil-Bey sale, Paris, Hôtel Drouot, January 16–18, 1868, lot 4; Arnold Seligmann, Trevor & Co. Ltd., London, 1939; Wildenstein and Co., New York; purchased by Smith College Museum of Art, 1950.

BIBLIOGRAPHY:
Chassériau lists this painting in three inventories of his work: (Musée du Louvre, Département des Peintures, album RF 26085, Prat 1988-1, vol. 2, no. 2239, fol. 26 v., "Battle between the Spahis and the Kabyles on the edge of a ravine—200"; RF 26053, Prat 1988-1, vol. 2, no. 2250, "Battle of the Spahis and the Kabyles above a ravine"; RF 25827, Prat 1988-1, vol. 1, no. 585 v., "battle of the Spahis and the Kabyles on the edge / of a ravine X. 2000"); Baschet 1854, "Charge of the Kabyles," p. 151; Gautier, "Collection of H. Exc. Khalil-Bey," 1868; Chevillard 1893, no. 161; Renan 1897, no. 21, p. 42; Hippolyte Mireur, *Dictionnaire des ventes d'art faites en France et à l'étranger pendant les XVIII^e et XIX^e siècles* (Paris, 1910–12), vol. 2, p. 163; Sandoz 1974, no. 141, p. 282, pl. 131.

EXHIBITIONS:
Dallas, 1942; Hartford, 1952, no. 54; New York, 1953, no. 4; London, 1959, no. 56; Chicago, 1961, no. 3; Los Angeles, 1961; New York, 1963, no. 10; Iowa City, 1964, no. 12; New York, 1966, no. 4; Northampton, 1968, no. 4; Chapel Hill, 1978, no. 8, ill.; Providence, 1982, no. 20; Rochester, 1982, no. 11; Williamstown, 1984, no. 59; Amherst, 1988; Indianapolis and other cities, 2000–2002.

Exhibited in New York only

One of four *chocs arabes* Chassériau painted after his return from Algeria, this picture recalls the frenzied action critics remarked upon in *Arab Tribal Chiefs Challenging Each Other in Single Combat* (cat. 190) at the Salon of 1852. The force with which these mounted Arab horsemen collide approaches the violent encounters between cavaliers in Delacroix's pictures inspired by the "courses de poudre (hail of gunpowder)," such as the *Encounter of the Moorish Horsemen* (1843–46; Baltimore, Walters Art Gallery). Sandoz, noting the inclusion of this picture in several inventories of works painted in 1849, argues that Chassériau completed the canvas in that year and postdated it to 1853. In any case, the artist acknowledged on March 31, 1854, his receipt of the sum of four hundred francs from his dealer Adrien Beugniet for a painting "representing Arab horsemen charging the Kabyles."[1] The present work is almost certainly the picture to which Chassériau refers, as Beugniet's gallery stamp remains on the back of the panel.

Notes in his albums, as well as an initial drawing for the main combatants in this picture, indicate that Chassériau began planning for this subject during or soon after his Algerian voyage. On a sheet that most likely derives from one of the albums used in Algeria (RF 25467; Prat 1988-1, vol. 2, no. 1576), Chassériau lists a "combat de spahis et de Kabyles" among a number of possible subjects inspired by the North African sojourn. The central pair of horsemen attired in white, together with the melée immediately surrounding them, was taken from a preparatory drawing now in the Louvre (RF 26091; Prat 1988-1, vol. 2, no. 2257, fol. 7 r.). Prat notes that this sketch was one of the most complete preliminary studies among the scenes of Arab combat. Thus, unlike the three *chocs* Chassériau painted between 1854 and 1855, in which the artist invented more freely and combined elements from preliminary drawings—some of them done in Algeria—this painting matches a composition developed in a single drawing to a title that occurred to the artist when he was still immersed in the North African experience.

The title, which specifically identifies the antagonists as "Spahis" and "Kabyles," suggests that this picture, like Chassériau's other battle scenes, was informed by the clashes witnessed by his military hosts in Algeria. Spahis were Arab cavalrymen in the service of the French army, whereas Kabyles were the Berber inhabitants of the Atlas Mountains southeast of Algiers, allied with Abd-el-Kader against the French forces. Chassériau's presentation of the subject is clearly not intended to depict any specific encounter. Yet, the title that he seemed to have had in

mind as early as the 1846 Algerian voyage, and that he consistently assigned to this picture in inventories, deliberately evokes the ongoing conquest of Algeria. Indeed, Théophile Gautier, in his preface to the catalogue for the 1868 sale of Khalil-Bey's collection, which included this picture, wrote of Chassériau: "He was a Greek returned from India, who, like Apelles, seemed to have followed Alexander's campaigns."[2] Chassériau's quasi-ethnographic interest in details of Kabyle clothing and physiognomy resulted in several studies, among them two in the albums that he brought with him to Constantine and Algiers (RF 26088; Prat 1988-1, vol. 2, no. 2253, folios 5 v. and 22 r.).

As in the *Battle of Arab Horsemen* (1855; Cambridge, Massachusetts, Fogg Art Museum), the illuminated central group, rendered in pale colors and whites, is set off from the rest of the fracas, which is enveloped in a penumbral haze. This relief technique, accomplished by contrasts of light and shade, and the juxtaposition of bright hues against areas of halftones, characterized much of Chassériau's treatment of North African subjects. While the action is both more animated and more concentrated in this picture than in *Arab Chiefs Visiting Their Vassals* (cat. 185) or *Arab Horsemen Removing Their Dead,* its composition, like those, is essentially planar, unfurling like a horizontal bas-relief.

P. B. M.

1. Note from Théodore Chassériau to Adrien Beugniet, March 31, 1854 [Paris]; Bibliothèque d'Art et d'Archéologie, Jacques Doucet, carton 8, Peintres, Mf. 3, no. 2616.
2. T. Gautier 1868; reprinted in M. Haddad, *Khalil-Bey: Un Homme, une collection* (Paris: Les Éditions de l'amateur, 2000), p. 154.

192

Battle of Arab Horsemen Around a Standard

1854
Oil on canvas
21 ¼ x 25 ¼ in. (54 x 64 cm)
Signed and dated, bottom right: *Th. Chassériau 1854*
Paris, Galerie Daniel Malingue

PROVENANCE:
Sale, Paris, Hôtel Drouot, March 22, 1869 (as "Battle between Arab tribes"); Ernest Gariel, Paris; Mme Stéphane Piot-Gariel; Private collection, Paris; sale, London, Sotheby's, June 12, 1996, no. 64; Paris, Galerie Daniel Malingue.

BIBLIOGRAPHY:
Chassériau refers to this painting as a "battle" in three inventories of his works from 1853–55 (Musée du Louvre, RF 26082; Prat 1988-1, vol. 2, no. 2258, fol. 11 r.); Chevillard 1893, no. 102; Bénédite 1931, ill. p. 271; Sandoz 1974, no. 142, p. 282, pl. 132; Prat 1988-1, vol. 1, ill. p. 328.

EXHIBITIONS:
Paris, Galerie Charpentier, 1924, no. 318; Paris, Petit Palais, 1930, no. 148; Paris, Orangerie, 1933, no. 244; Paris, Musée Jacquemart-André, 1957, no. 47; Paris, Galerie Daber, 1976, no. 20.

In this picture, one of four *chocs arabes* painted by Chassériau after his return from North Africa, the artist multiplied the number of figures locked in combat and amplified the violence of such earlier images as the *Arab Tribal Chiefs Challenging Each Other in Single Combat* (cat. 190). As in the two other variations on the same theme executed between 1854 and 1855, *Battle of Arab Horsemen* (1854; Paris, Musée du Louvre) and *Battle of Arab Horsemen Around a Chief on a White Horse* (1855; Cambridge, Massachusettes, Fogg Art Museum), Chassériau concentrated here on a seething melée of interwoven combatants and their mounts. The brutality is often explicit, as in the horrific detail of the warrior brandishing a severed head—a motif that may have been borrowed from Delacroix's *Attila and the Barbarians Crushing Italy and the Arts Underfoot*, painted for the library at the Palais-Bourbon in Paris. Yet, such barbarism appears enveloped in the overall elegance of movement and painterly finesse for which Chassériau was known. Indeed, the virtuoso style seen in Chassériau's energetic touch and in the Baroque torsion of his figures, as well as his vibrant palette, is ideally suited to the frenetic action depicted.

For this complex composition of interlocking figures and horses, Chassériau depended on numerous studies he executed in Algeria. Many of these examined Arabian horses, the models for the simultaneous fragility and ferocity of fetlocks and hooves and dilating nostrils and arching necks on display here. Consistent with Chassériau's tendency to adapt such studies, the figure at the left (from a drawing in the Louvre entitled *Arab*

CAT. 192

Cavaliers on Rearing Horses; RF 24472; Prat 1988-1, vol. 2, no. 1678) most likely was reused for the cavalier on the rearing white horse at the left of the *Battle of Arab Horsemen Around a Standard.* Another sheet (RF 26008; Prat 1988-1, vol. 1, no. 756) containing three studies of arms and heads includes a drawing of an extended arm aiming a pistol that is very similar to that of the horseman on the left of this canvas, twisting around to finish off a fallen opponent. Taken as a whole, this rider, contorted dramatically on his rearing steed, recalls similar equestrian acrobatics performed by the horsemen depicted by Géricault and by Delacroix.

Chassériau's *chocs*—their combination of equine elegance with the tumult of deadly weapons, hooves, and drapery—recall Baroque animal hunts by Rubens, as well as nineteenth-century versions of the same theme by Delacroix (cited by Gautier as the only other painter capable of rendering horses as skillfully as Chassériau)[1] and by Horace Vernet, whose hunting scenes pictured French officers and their Arab allies on horseback in Algeria. Indeed, Théophile Gautier, in his preface to the catalogue for the sale of Khalil-Bey's collection, which included Chassériau's *Battle Between the Spahis and the Kabyles on the Edge of a Ravine* (cat. 191), reinforced the link between Chassériau and such soldier-painters as

Vernet. However, Gautier sets Chassériau's battle scenes apart from the contemporary events recorded by Vernet: "He returned with an Africa that was his own and in which the battles of Arab cavalry, without being any less real, resembled the encounters of Homeric warriors."[2]

As with the other *chocs,* Chassériau constructed the present battle of Arab cavaliers around a figure whose white horse and garments set him apart from the fray. The contrast between this predominantly white horseman and the adjacent dark-skinned cavalier on the bay horse is accentuated by brilliant touches of color. The coral-colored saddle in the field of white is echoed both by the bridle strap of the bay horse and the band of color wrapped around the upper arm of its rider. Chassériau also used rich blue greens for the mountains and the sky in the distance—recalling the artist's album note about the shimmering opalescent hues he saw in Algeria—the triangular battle standard, and the trousers and turbans worn by four of the cavaliers in the front row.

P. B. M.

1. T. Gautier, "M. Chassériau," in *Les Beaux-Arts en Europe, 1855* (Paris: Michel Lévy Frères, 1855), p. 254.
2. T. Gautier 1868; reprinted in M. Haddad, *Khalil-Bey: Un Homme, une collection* (Paris: Les Éditions de l'amateur, 2000), p. 154.

193

"Have You Prayed Tonight, Desdemona?"

1847
Watercolor
8 ⅛ x 6 ⅜ in. (20.8 x 16.2 cm)
Signed and dated with the tip of the brush, bottom left:
Théodore Chassériau 1847
Paris, Private collection

PROVENANCE:
Sale, Paris, Hôtel Drouot, April 4–5, 1911, lot 10, ill.; Henri Delacroix, Paris (his mark, at the lower right, was not mentioned by Lugt); Henri Delacroix sale, Paris, Hôtel Drouot, March 31, 1962, lot 44; William Schab, New York; Norton Simon, Pasadena; sale, New York, Sotheby's, May 5, 1971, lot 8; John Katopis, New Jersey; sale, Monaco, Sotheby's, December 3, 1989, lot 525, colorpl.; Private collection, Paris.

BIBLIOGRAPHY:
Sandoz 1974, p. 76, fig. 27, p. 248, under no. 282; Prat 1988-1, vol. 1, under no. 348; Prat 1988-2, no. 151, ill.

EXHIBITIONS:
Paris, Orangerie, 1933, no. 158 (with erroneous dimensions); Baltimore, 1979–80, pp. 118–19, color frontispiece.

This is a later repetition of plate XII of the engraved "Othello" series of 1844. Desdemona's right hand is placed a little lower in the engraving; otherwise, there is little difference between the two versions. As Chassériau rarely copied his earlier compositions so exactly, this watercolor probably was intended for a friend. **L.-A. P**

CAT. 193

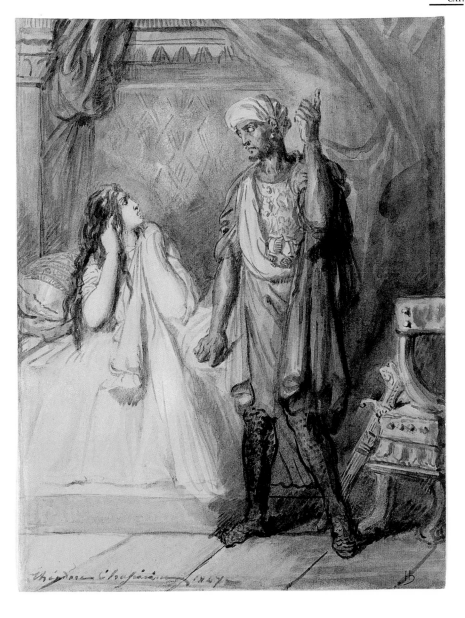

194

King Lear Before the Body of Cordelia

1849
Graphite
14 ⅝ x 8 ⅞ in. (37 x 22.6 cm)
Paris, Musée du Louvre (RF 25305)

PROVENANCE:
See cat. 20.

BIBLIOGRAPHY:
Chevillard 1893, part of no. 420; Prat 1988-1, vol. 1, no. 568, ill.

EXHIBITION:
Paris, 1988, no. 30, fig. 19.

Exhibited in Paris only

This subject, taken from act 5, scene 3, of Shakespeare's tragedy, had already been treated by Chassériau in a much earlier drawing in the Louvre (Prat 1988-1, vol. 2, sketchbook no. 2229, fol. 16 v., ill.). The present drawing is probably related to the painting—now lost—that was exhibited at the Association des Artistes in 1849 with the title, *King Lear Throwing Himself on the Body of His Daughter Cordelia* (Sandoz 1974, no. 126, p. 260). The figure of Cordelia was taken up in another drawing in the Louvre (Prat 1988-1, vol. 1, no. 569, ill.), which is annotated: "*tout en / blanc / morte froide raide / naïve / douloureuse*" [everything / in white / dead cold stiff / naïve / sorrowful].

L.-A. P

195

Othello and Desdemona in Venice

1850
Oil on wood
9 ⅞ x 7 ⅞ in. (25 x 20 cm)
Signed and dated, bottom left: *Th. Chassériau 1850*
Paris, Musée du Louvre (RF 3897)

PROVENANCE:
Dr. Cabarrus; his daughter, Mme de Saint-Armand Martignon; Baron Arthur Chassériau, Paris; bequest of the latter to the Musée du Louvre, 1934.

BIBLIOGRAPHY:
Chevillard 1893, no. 175; Bénédite 1931, p. 258; Compin and Roquebert 1986, vol. 3, p. 134; Prat 1988-1; Peltre 2001, p. 104.

EXHIBITIONS:
Paris, 1897, no. 12; Paris, 1933, no. 51.

196

Desdemona

1849
Oil on wood
16 ½ x 12 ⅝ in. (42 x 32 cm)
Signed and dated, bottom left: *Th. Chassériau 1849–*
Paris, Musée du Louvre (RF 3880)

PROVENANCE:
Alice Ozy (according to Sterling); bequeathed by the latter to Baron Arthur Chassériau, Paris; bequest of the latter to the Musée du Louvre, 1934.

BIBLIOGRAPHY:
Chevillard 1893, no. 173; Bénédite 1931, p. 249; Sandoz 1974, no. 119; Compin and Roquebert 1986, vol. 3, p. 133; Prat 1988-1; Peltre 2001, p. 104.

EXHIBITIONS:
Salon of 1850–51, no. 536; Bordeaux, Salon of 1855, no. 103; Paris, Centennale, 1900, no. 102; London, 1932, no. 324; Paris, Orangerie, 1933, no. 42.

Exhibited in Paris only

In the decade between 1840 and 1850, Shakespeare's plays were part of the stock-in-trade of the Romantic artists, from Delacroix[1] (*Othello and Desdemona,* 1849; Ottawa, National Gallery of Canada; *Desdemona Cursed by Her Father,* 1852; Reims, Musée des Beaux-Arts) to Lehmann (*Hamlet* and *Ophelia,* Salon of 1846; both lost, but known through lithographs by Auguste Lemoine);[2] the opera—

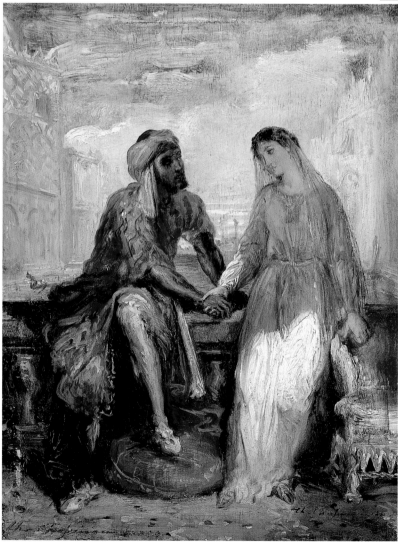

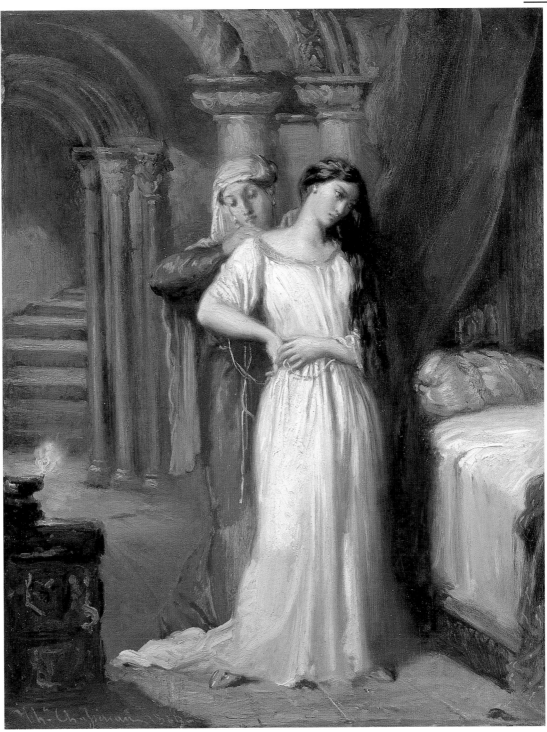

where Rossini's triumph continued unabated—and the theater followed suit. In 1846, taking advantage of the constant publicity accorded this subject matter, Lehmann let himself be inspired by the version of *Hamlet* that had just been translated by Alexandre Dumas and Paul Meurice. At the same time, in tandem with his work on larger compositions and commissions, Chassériau produced and exhibited a large number of paintings based on *Othello, King Lear,* and *Macbeth* (cat. 200, 201).

The two paintings considered here are transposed variations of two compositions in Chassériau's series of fifteen etchings, the so-called "Othello" suite of 1844 (cat. 84–99), whose novelty and power were understood

by only a few at the time. Baudelaire alluded to these engravings in 1845 and considered them undeniable proof of Chassériau's mimetic compulsion, in which he tried by any and all means to exploit and ruthlessly emulate Delacroix's work. Nevertheless, these etchings demonstrate Chassériau's originality more than anything else. They render perfectly that Shakespearean blend of gentleness and evil, the ambivalence and duplicity of his characters, the murderous folly of the Moor, and the horror that seized those who plotted to bring about his downfall.

The Louvre picture, which once belonged to Dr. Cabarrus (see cat. 86), corresponds to plate II in the series

and illustrates act 1, scene 3, of Shakespeare's tragedy—the moment when Othello, standing before the Council summoned by the doge, explains how he seduced Brabantio's daughter, Desdemona. He reminds them that it was only by recounting his exploits, and not through sorcery, that he conquered the woman's heart and gained the trust of the father—who knew nothing of Desdemona's feelings at the time. Desdemona, spellbound by Othello's tales, vows to be his forever, and this vow incurs Brabantio's wrath. In the Reims painting, of 1852, Delacroix depicted Brabantio's repudiation. As Jay M. Fisher noted: "Chassériau created a scene between Desdemona and Othello which is not in Shakespeare's play but which is recounted in Othello's speech to the Duke and assembled nobles. Chassériau has represented the first meeting between Othello and Desdemona and has visualized it as a kind of flashback."[3]

This tale-within-a-tale was explained in the caption to the etching: "She thanked me and said that if I had a friend who loved her, I only had to teach him how to tell my tale for her to fall in love with him." Vigny, in his notes to the *More de Venise,* an adaptation of *Othello* that was performed in 1829, described this introductory monologue, emphasizing "the touching grandeur and simplicity of the original."[4] The emotional complexity of this moment of tender effusions and compassion, which both heralds and seals the fate of the pair, finds a perfect expression in the painting, and is summarized by the famous chiastic distich: "She lov'd me for the dangers I had pass'd / And I lov'd her, that she did pity them." The painting shows the future lovers, "sitting on the parapet of a balcony, in a setting recalling the Piazza San Marco, with the two columns of the Riva degli Schiavoni in the background" (Sterling), the whole enhanced by the blue, green, pink, and yellow tones of the stonework. Compared to the etching, the painting underscores the intimacy between the two figures through the detail of the closely joined hands. The Moorish general's pose has changed: His right arm, raised in the traditional gesture of *elocutio* in the engraving, meets Desdemona's hand in the center of the painting, while his left arm is slightly lowered, hiding the hilt of the sword. Gautier's commentary on the etching in 1844 is perfectly applicable to the painting: "Well, well, here is a pure-blooded Moor, an African Moor, a real Arabian horse, with the desert wind in his hair, fire in his nostrils and eyes, lust on his full lips. What a noble and savage costume! In what thick folds his cape falls!"[5]

The scene in which Desdemona prepares herself for bed after having been insulted and brutalized by Othello has as great a claim to fame in Chassériau's oeuvre as that of the *Song of the Willow,* which followed it.[6] In each case, the young woman is all the more desirable as she appears to betray a presentiment of doom. In her vulnerability and grief, seemingly paralyzed by the injustice she has had to suffer, Desdemona displays affinities with many of Chassériau's other heroines (see cat. 170).

This small painting in the Louvre is very close to the etching of 1844 and takes the meaning a step further, contrasting Desdemona's virginal dress with the red costume worn by Emilia. The whiteness of the bed and the flickering light of the lamp on the left symbolize sacrifice and, by way of contrast, the fatal shadow that has taken possession of Othello's soul before engulfing his body. The space seems to close in on her, and the winding stair in the background is less an announcement of the possibility of escape than of the coming of the murderer.

Théodore Chassériau exhibited a new version of the *Desdemona* (formerly Nouvion collection; present whereabouts unknown) at the Salon of 1852 that lacked the mysterious fatality of the previous one.[7] If Henri de Lacretelle found the "mise-en-scène . . . irreproachable, as before,"[8] it was because this little painting—according to Sandoz, an homage to the actress Malibran[9]—was more theatrical than introverted. Gautier, for his part, harped on the unnecessarily loose brushwork: "The motif has a sort of sculptural elegance quite in keeping with the artist's talent. This handsome young woman moved by a dark foreboding, as pale as an alabaster statue in its tomb, shedding her white veils to lie in a bed from which she will never rise again, is, indeed, a subject worthy of the efforts of the highest art. Unfortunately, after having successfully established the main lines and composition, the painter did not take any pains with the execution. Why this unschooled manner, this coarse brush, this heavy impasto in an easel painting in which the figures are only fifteen inches high? Why coarsen by the execution an idea and a form that are so delicate? A design of one square foot cannot be treated like a mural painting."[10] The objections of the critic notwithstanding, this late version boasts a very free handling and the wonderful detail of the undone hair—a metaphor for the final drama of desire turned into murderous fury. S. G.

1. See S. Guégan, *Delacroix. L'Enfer et l'atelier* (Paris: Flammarion, 1998), in particular the chapter entitled, "Fol Hamlet, noir Othello," pp. 67–111.
2. See L. Chotard, *Vigny et les arts* (Paris, 1997–98), pp. 98–99.
3. J. M. Fisher, in Baltimore, 1979–80, p. 44. Prud'hon used the same approach in his 1824 *Andromache and Astyanax,* after Racine (New York, The Metropolitan Museum of Art).
4. See Vigny's note to his *More de Venise* (*Oeuvres complètes,* vol. 1, presented by François Germain and André Jarry [Paris: Gallimard, Bibliothèque de la Pléiade, 1986], p. 433).
5. T. Gautier, "Académie royale de musique.—*Othello,*" in *La Presse,* Paris, September 9, 1844.
6. The *Song of the Willow* inspired a number of compositions: In addition to the damaged grisaille in the Louvre (RF 3876; Sandoz, no. 121) and the painting in the Henry P. McIlhenny Collection, Philadephia Museum of Art (dated 1849; Sandoz, no. 122), two small paintings, dated, respectively, 1849 (Sandoz, no. 123) and 1850 (Galerie Daber, 1976, no. 13), recently have appeared on the art market. As far as one can judge, after their restoration, both were done in a very free manner. There is also a drawing by Chassériau of this same subject in Delphine de Girardin's *Album amicorum* (sale, Paris, Hôtel Drouot, June 4, 1957).
7. The booklet for the Salon of 1852, which mistakenly situated the scene in act 3, included the following quotation: "I've only to turn my head sideways and sing like the poor Barbara. I beg you, be quick" (*Othello,* act 3).
8. H. de Lacretelle, "Salon de 1852," in *La Lumière* (April 24, 1852).
9. The engraving of the composition by Masson—after a drawing retouched by Chassériau now in the Louvre (RF 24317)—was published in Gautier and Houssaye, *Les Artistes vivants* (1852). See Prat 1988-1, vol. 2, p. 1005. The actress Malibran, one of the most celebrated Desdemonas of her day, died in 1836.
10. T. Gautier, "Salon de 1852," in *La Presse,* Paris, May 25, 1852.

197

"Have You Pray'd To-night, Desdemona?"

1849
Oil on canvas
24 ¼ x 21 ¼ in. (63 x 54 cm)
Strasbourg, Musée des Beaux-Arts (1431)

PROVENANCE:
Baron Arthur Chassériau, Paris; bequest of the latter to the
Musée du Louvre, 1934 (RF 3877); placed on deposit by the
Musée du Louvre at the Musée des Beaux-Arts, Strasbourg.

BIBLIOGRAPHY:
Chevillard 1893, no. 172; Bénédite 1931, p. 252; Ahnne 1935,
pp. 12–13; Sandoz 1974, no. 117; Peltre 2001, p. 104.

EXHIBITION:
Paris, 1995–96, no. 31.

Exhibited in Paris and Strasbourg

198

He Suffocated Her!

1849
Oil on wood
10 ¼ x 8 ¼ in. (26 x 21 cm)
Signed and dated, bottom left: *Théodore Chassériau 1849*
Metz, Musée des Beaux-Arts (D 150)

PROVENANCE:
Baron Arthur Chassériau, Paris; bequest of the latter to the
Musée du Louvre, 1934 (RF 3883); placed on deposit by the
Musée du Louvre at the Musée des Beaux-Arts, Metz.

BIBLIOGRAPHY:
Chevillard 1893, no. 176; Bénédite 1931, p. 250; Sandoz 1974,
no. 118; Honour 1989, pt. 2, pp. 153–55; Peltre 2001, p. 104.

By 1844, plates XII and XIII of the "Othello" suite, in
which Desdemona is shown saying her prayers before
being suffocated, were considered by contemporaries as
the ultimate expression of the horror of the tragedy:
"These last plates, devoted to the various scenes of the

calamity, display an extraordinary violence in their com-
position and a pathos in their effect. Look at the authority
with which the Moor poses the terrible question to the
woman, who pales in horror: 'Have you prayed to God
tonight, Desdemona?' The suffocation scene displays a
diabolical energy and an amazing ferocity; the Moor has
become a wild beast, and his fingers have turned into
claws as he digs them into the fateful pillow like a lion
sinking its talons into the neck of a panting gazelle. We
can imagine the poor creature fighting for her life, while
her hair spreads around her like a dark cascade."[1] The
critic in *L'Artiste* similarly noted: "M. Chassériau has
not departed from the sacred text for an instant. His
Song of the Willow is full of pathos and poetry. The 'Yet
she must die' has been expressed with deep feeling. The
terrible scene, 'Have you pray'd to-night, Desdemona?'
is powerful in its effect. And finally Othello really is
Othello when he falls back on the bed, *roaring* in despair,
*next to the most innocent woman who ever lifted her eyes
to the heavens.*"[2]

We know from one of his sketchbooks in the Louvre[3]
that Chassériau was already thinking about the scene of
the last prayer in 1837: Desdemona appears kneeling,
while Othello exhorts her with a violent gesture to com-
mend her soul to God, compounding humiliation with
sadism. As Jean Lacambre rightly pointed out, the scene
in the Strasbourg painting, which is only an unfinished
oil sketch, has a ghostly quality that seems to anticipate
the *Macbeth* of 1854 (cat. 201). As Paul Ahnne wrote in
1935: "Desdemona, in complete undress, has suddenly sat
down on her bed, while Othello extends a menacing
arm toward her. The scene is imbued with tragedy."

Desdemona's maddened gaze and her almost indecent nudity provide a contrast to the spectral ferocity of the Moor, who seems to be about to pounce on her. One might well ask what the real subject of this scene is. Instead of depicting the prayer here, Chassériau may have shown her awakening just before, or the first moments of the crime. The suffocation scene is clearly the most powerful and original in the "Othello" series: The Moor's destructive folly in trying to punish a crime that is his alone achieves a form of sublime evil. This is a crime committed in full light without the benefit of a steel blade, a slow death without the tragic accessories traditionally exploited by painters.[4]

The title of the Metz painting is just as inappropriate, for the moment depicted is that following Desdemona's murder. Othello's gaze is wild, like that of a beast consumed by jealousy or of a hunted animal (a reminiscence of Delacroix's *Medea*?) that knows that it will be caught. With a strained look, he turns away from the lifeless body of his victim in a somewhat melodramatic movement, shortly before he finds out that he has been tricked by Iago and finally takes his own life. Hugh Honour pointed out that unlike his portrayal in the engraving, Othello is represented here more as a black man than as an Arab. This detail underscores the painting's racial— or, rather, racist—content, to which it adds a latent lasciviousness: "[Desdemona] incarnates the ideal of the sweet and submissive woman, and [Othello] is the dominating male."[5] This black man is an object of repulsion and envy: Considering Théodore's family origins and his fascination with sexuality, it is not implausible that he substituted his own features for those of Othello.[6]

S. G.

1. T. Gautier, "Académie royale de musique.—*Othello*," in *La Presse*, Paris, September 9, 1844.
2. H. de Bray, "Les Gravures d'Othello de M. Chassériau," in *L'Artiste* (September 8, 1844).
3. See Prat 1988-1, vol. 2, no. 2229, fol. 36 r.
4. In a very early and awkward drawing, Chassériau depicted Othello stabbing Desdemona. See Prat 1988-1, vol. 2, p. 795. Seventeen years earlier, the suffocation scene was depicted without any trace of brutality in a lithograph in the *Souvenirs du théâtre anglais à Paris, dessins par MM. Devéria et Boulanger avec un texte par M. Moreau*, published in 1827 after the performances by English actors at the Théâtre de l'Odéon.
5. Honour 1989, pt. 2, p. 155.
6. One need only compare Masson's portrait of Chassériau (Bouvenne 1887) with certain preliminary drawings for the "Othello" suite (see, in particular, Prat 1988-1, vol. 1, no. 319).

199

Cassio Bowing

1852
Graphite
11 ¾ x 7 ⅜ in. (29.7 x 18.8 cm)
Signed and dated in graphite, lower left: *Th^re Chassériau / 1852-*
New York, The Metropolitan Museum of Art, Bequest of Alexandrine Sinsheimer, 1958 (59.23.26)

PROVENANCE:
P. O. Dubaut; André de Hevesy (1932, 1933); Alexandrine Sinsheimer; bequest of the latter to The Metropolitan Museum of Art, 1958.

BIBLIOGRAPHY:
Fisher, in Baltimore, 1979–80, p. 68, ill.; Prat 1988-1, vol. 1, under no. 413; Prat 1988-2, no. 102, ill.

EXHIBITIONS:
Paris, 1932, no. 45; Paris, Orangerie, 1933, no. 187.

Exhibited in New York only

Like the *Young Taleb* (cat. 184) and the *Woman and Little Girl from Constantine with a Gazelle* (cat. 179), this drawing is a repetition of an earlier compositional motif. The figure recalls that of Cassio (in reverse), Othello's lieutenant, in plate VI of the engraved "Othello" series of 1844; entitled *Be Merry Again, Cassio,* it depicts the young officer bowing to Desdemona. In the present drawing, which was probably intended as a gift, Cassio is beardless, his bow is not as deep, and his sword— which is between his legs in the engraving—emerges from under his cape.

L.-A. P

Macbeth and Banquo Encountering the Three Witches on the Heath

1855
Oil on wood
28 ⅜ x 35 ⅜ in. (72 x 90 cm)
Signed and dated, lower left: *Thre Chassériau 1855*
Paris, Musée d'Orsay (RF 2213)

PROVENANCE:
Chassériau sale, Paris, Hôtel Drouot, March 16–17, 1857, lot 3;
Baron Arthur Chassériau, Paris; bequest of the latter to the
Musée du Louvre, 1918; placed on deposit by the Musée du
Louvre at the Musée d'Orsay, 1986.

BIBLIOGRAPHY:
Saint-Rieul-Dupouy, *Le Courrier de la Gironde,* January 31, 1856;
Gautier, *L'Artiste,* March 15, 1857; Chevillard 1893, no. 169;
Bénédite 1931, pp. 249, 482; Sandoz 1974, no. 239; Prat 1988-1,
vols. 1 and 2, nos. 778, 1021, 2258; Dussol 1997, p. 59;
Peltre 2001, pp. 203–4.

EXHIBITIONS:
Bordeaux, Salon of 1855, no. 129; Paris, Centennale, 1900,
no. 101; Paris, 1933, no. 83; Paris, 1939; Paris, 1958, no. 323.

CAT. 200

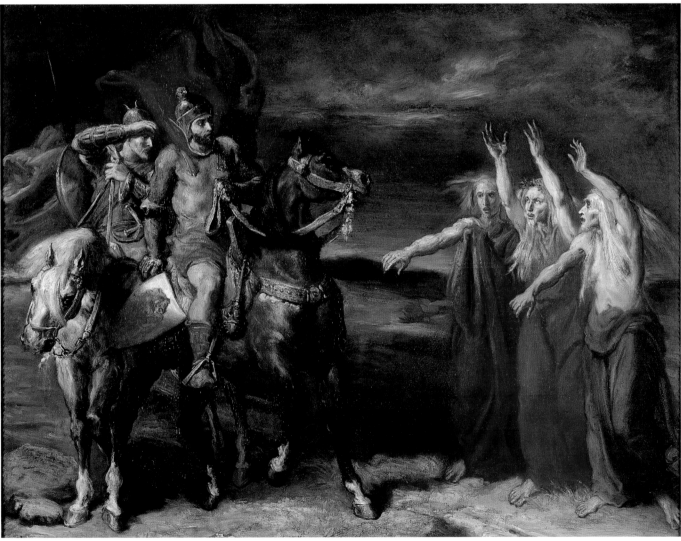

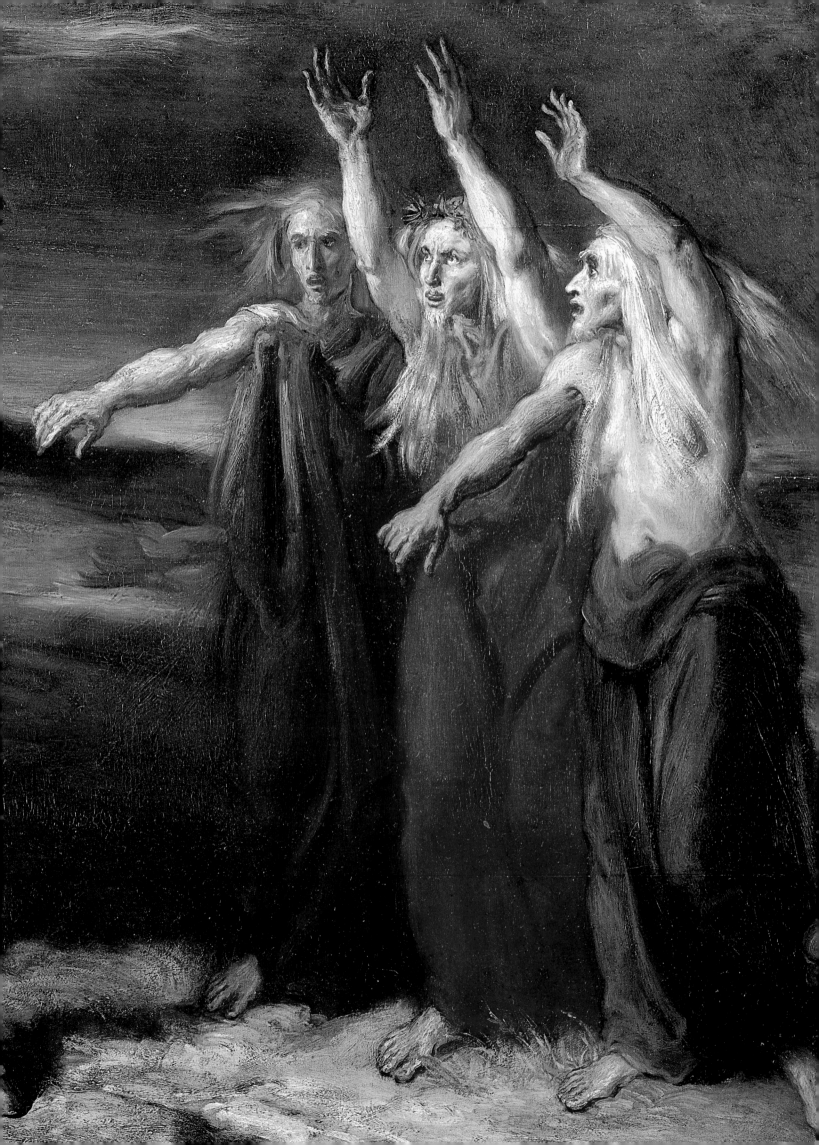

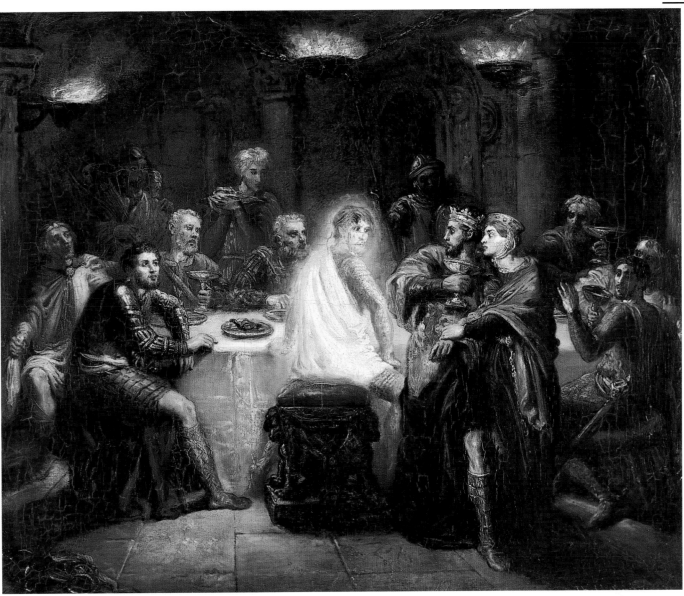

201

The Ghost of Banquo

1854
Oil on wood
21 ¼ x 25 ¼ in. (54 x 64 cm)
Signed and dated, bottom right: *Thre Chassériau 1854*
Reims, Musée des Beaux-Arts (949)

PROVENANCE:
Arosa (Bordeaux, Salon of 1855); Paul Jamot, Sr., then Paul Jamot,
Jr.; gift of the latter to the Musée des Beaux-Arts, Reims, 1941.

BIBLIOGRAPHY:
Baschet 1854; Bouvenne 1887; Chevillard 1893, no. 93; Jamot 1920;
Bénédite 1931, p. 250; Sandoz 1974, no. 237; Prat 1988-1, vols. 1
and 2, nos. 426, 768–776, 840, 1039; Peltre 2001, pp. 203–4.

EXHIBITIONS:
Salon de Bordeaux, 1855, no. 130; Paris, 1933, no. 74; Paris,
1941, no. 14.

The two paintings exhibited in 1855 under the auspices
of the Société des Amis des Arts de Bordeaux[1] may be con-
sidered as pendants, although they are slightly different
in format and were painted a year apart. The order in
which they were listed in the Salon booklet corresponds
to the sequence of the episodes and not to the chronology
of their execution. The Orsay picture, of 1855, depicts the

scene in which Macbeth's fate is sealed by the witches'
prophecy. The Reims picture, painted in 1854 and rejected
by the jury of the Exposition Universelle, shows the
moment in which the murderous king's madness breaks
out in the presence of his court and his wife, who, before
falling prey to it herself, tries to tear Macbeth away from
his fateful hallucination.

What more fitting expression for the outcome of a life
ruled by ambition and bloodthirsty folly? *Macbeth and
the Three Witches* adheres closely to the Shakespearean text:
We see the anxious curiosity of the horsemen and the oth-
erworldly brutality of the three Fates, whose wild gestures
suggest that they are delivering their fatal prediction:[2]

Macbeth.—So foul and fair a day I have not seen.
Banquo.—How far is 't call'd to Forres?—What are these,
So wither'd and so wild in their attire,
That look not like th' inhabitants o' the earth,
And yet are on't? Live you? or are you aught
That man may question? You seem to understand me,
By each at once her choppy finger laying
Upon her skinny lips: you should be women,

And yet your beards forbid me to interpret
That you are so.
Macbeth (to the Witches).—Speak, if you can: what
are you?
First Witch.—All hail, Macbeth! hail to thee, Thane
of Glamis!
Second Witch.—All hail, Macbeth! hail to thee, Thane
of Cawdor!
Third Witch.—All hail, Macbeth! that shalt be king
hereafter.[3]

A critic from Bordeaux very candidly objected to the
presence of such eerie figures in a work by an artist well
known for his paintings of women: "As for the witches,
one wonders if they are women at all. The arms of these
shrews have been depicted with such coarseness and such
a neglect of the human anatomy that they look like the
rough branches of a tree, or brooms fitted with sticks."[4]
To represent Banquo's surprise and incredulity at meeting
these creatures from the Netherworld, Chassériau shows
him shading his eyes with his hand. Macbeth's red cape
is the metaphorical expression of the future that is about
to be unveiled to the two men, both of whom are fated
to die violent deaths. It is also a device borrowed from
Davidian imagery: It can be found in the works of such
painters as Drouais, Gros, and Girodet, where it repre-
sents a truth that cannot be revealed without danger, or
that would be better kept hidden. The theatrical impact
of this small painting is also created by the strong lighting
that sets the various figures off against the featureless sky
of a supernatural, almost infernal night. These pictorial
effects belonged to a form of fantastic painting that had
been well established by 1855 and that was perfectly suited
to Shakespeare's text, which was deliberately vague
about the appearance and identity of these sexless crones.[5]
As Jean-Claude Sallé wrote: "The entire play is domi-
nated by a menacing darkness, a night so dense that it
is almost palpable. On the spiritual plane, the dark
night is a metaphor for confusion of the senses."[6] After
the witches' prophecy, the whole play sinks into a chaos
of destructive frenzy and tormented consciences aching
for relief. Madness is the price paid for the absolute
rule of evil.

The struggle for the throne, a symbol of worldly
ambitions and the will to power, leads to the scene in
act 3 in which Banquo, who has just been assassinated by
Macbeth's accomplices, appears in the form of a ghost
and takes his place on the seat formerly occupied by
his treacherous master. The nefarious witches had pre-
dicted that he would give birth to kings "without being
king himself," and his son Fleance was to experience
the veracity of this prophecy. What Shakespeare called
the "seeds of time" is just as clearly represented in the
Reims painting as in the drama that inspired it. The
Rembrandtesque banquet scene recalls the many
Romantic versions of this traditional subject. While these
two paintings may express Chassériau's fondness for
spiritualism (see p. 45), they lack the edge of Delacroix's
representations: that infectious sense of mystery that
goes deeper than the image's superficial appeal. Still, they
are more than interludes done at a time when he was
devoting the bulk of his failing energy to the exhausting
mural projects. S. G.

1. The Bordeaux Société des Amis des Arts was founded in 1851 and
immediately began organizing a regular exhibition and lottery. One of its
charter members was Louis Marcotte de Quivières, Subprefect of the
Gironde and a collector of Chassériau's works, who probably urged him
to submit some paintings. Beginning in 1851, the artist exhibited the
Strasbourg Mazeppa, a painting that the Bordeaux art critic Jules Delpit
considered a history painting. Chassériau exhibited again in 1853, 1854
(the Marcotte version of the Tepidarium, today in Cairo), and 1855. See
D. Dussol, Art et bourgeoisie. La Société des Amis des Arts de Bordeaux
(1851–1939) (Bordeaux: Le Festin, 1997).
2. A drawing in the Louvre dated about 1837–39 and done in the
Troubadour style (Prat 1988-1, vol. 1, no. 1021) shares affinities with the
Orsay composition but without its realistic power. As Prat pointed out,
the group of horsemen has associations with the Algerian trip. Although
emancipating himself from a certain old-fashioned historicism,
Chassériau still depicted the costumes and weapons with great accuracy
(see the drawings in sketchbook 2258).
3. W. Shakespeare, The Complete Works of William Shakespeare (London:
Oxford University Press, 1914): Macbeth, act 1, scene 3.
4. J. Saint-Rieul-Dupouy, in Le Courrier de la Gironde (January 31, 1856).
5. A drawing in the Louvre (RF 25193) contains a reference to the "masked
genies" of Rubens.
6. W. Shakespeare, op. cit., p. 599.

7 r. 6 v.

202

Notebook

1854
Bound notebook, with a black cardboard cover embossed with interwoven designs, and with a black sheepskin spine and a pencil holder, containing sixteen sheets of different colors numbered from 1 to 16. Missing folios between the reverse of the front cover and fol. 1 (3), between folios 1 and 2 (6), 4 and 5 (1), 7 and 8 (4), 10 and 11 (1), and 11 and 12 (3). Stamp of the artist's studio (L. 443) on fol. 1 and on the label on the front cover. Mark of the paper manufacturer, composed of the initials *E. B.* around a caduceus, on the back of the front cover.
Inscribed in pen and gray ink, on the label on the front cover, in Baron Arthur Chassériau's hand: *Croquis de Théodore Chassériau 1819–1856* (Sketches by Théodore Chassériau 1819–1856).
5 ⅝ x 8 ¾ in. (14.4 x 22.3 cm) (notebook); 5 ⅜ x 8 ⅝ in. (13.6 x 22 cm) (sheets)
Paris, Musée du Louvre (RF 26082)

PROVENANCE:
See cat. 20.

BIBLIOGRAPHY:
Chevillard 1893, part of no. 420; Prat 1988-1, vol. 2, no. 2258, ill.

EXHIBITION:
Paris, 1988, no. 32, fig. 20.

Exhibited in Paris only

Open to folios 6 v. and 7 r.

Folio 6 v.

Macbeth and Banquo Encountering the Witches (sketchbook turned upside down)

Graphite
Inscribed in pen and brown ink, in Baron Arthur Chassériau's hand: *Macbeth rencontrant les sorcières sur la grève* [Macbeth encountering the witches on the sand]

BIBLIOGRAPHY:
Sandoz 1974, under no. 239.

The composition reverses that of the painting in the Louvre (*Macbeth and the Witches* of 1855), in which Banquo stands behind Macbeth, instead of between him and the witches.

Folio 7 r.

Two Horsemen (sketchbook turned upside down)

Graphite

These sketches are for the figures of Macbeth and Banquo in the Orsay painting (cat. 200). L.-A. P

203

A Cossack Girl Finds Mazeppa Unconscious on an Exhausted Wild Horse
(Lord Byron, *Mazeppa*)

1851
Oil on wood
18 ⅛ x 14 ⅝ in. (46 x 37 cm)
Signed and dated, bottom right: *Thre Chassériau 1851*
Strasbourg, Musée des Beaux-Arts

PROVENANCE:
Sale X, Paris, 1894 (B), Baron Arthur Chassériau, Paris; bequest by the latter to the Musée du Louvre, 1934 (RF 3897); placed on deposit by the Musée du Louvre at the Musée des Beaux-Arts, Strasbourg, 1937.

BIBLIOGRAPHY:
Bertall 1853; Gautier, *La Presse*, June 23, 1853; La Madeleine, *L'Éclair* 3 (1853), p. 280; Chevillard 1893, no. 80; Bénédite 1931, pp. 433–34; Brion 1963, p. 150; Sandoz 1974, no. 131; Zerner 1976, p. 197; Prat 1988-1, vol. 1, no. 576; Prat 1988-2, no. 176; Peltre 2001, pp. 192–94.

EXHIBITIONS:
Bordeaux, 1851, no. 102 (*Mazeppa*); Le Havre, 1852, no. 56 (*Mazeppa, Found Unconscious by the Cossack's Daughter*); Paris, Salon of 1853, no. 229; Paris, 1897, no. 22; Paris, 1933, no. 61; Paris (V. Hugo), 1951; London, 1959, no. 54; Poitiers, 1969, no. 16; Paris, Galerie Daber, 1976, no. 14.

About 1850,[1] along with Shakespeare's plays, Byron's poetry was a main ingredient of the expansive, dynamic, and impassioned strain of Romanticism to which Chassériau adhered, after his break with the aesthetics of Ingres. Mazeppa, a victim of blind Providence in a world in which "everything is in flux and painted in the colors of the unknown" (Hugo), as well as a symbol of freedom and inscrutable fate, became the emblem of an entire generation. It was, of course, the generation of the readers of Victor Hugo's *Les Orientales*, but also that of Géricault, Vernet, and Louis Boulanger, who had all depicted this theme before Chassériau, with greater or lesser success. Théodore, who had been thinking about this subject since the end of the 1830s, did not let himself be tied down by this tradition. As the booklet of the Salon of 1853 mentions, he went directly to the source, to the works of Byron, in order to grasp the full historic measure of the subject, which he then reinterpreted according to his own primitive imagination, which characterizes his entire oeuvre.

Victor Hugo's famous poem, which he dedicated to Louis Boulanger and prefaced with the words *"Away!*

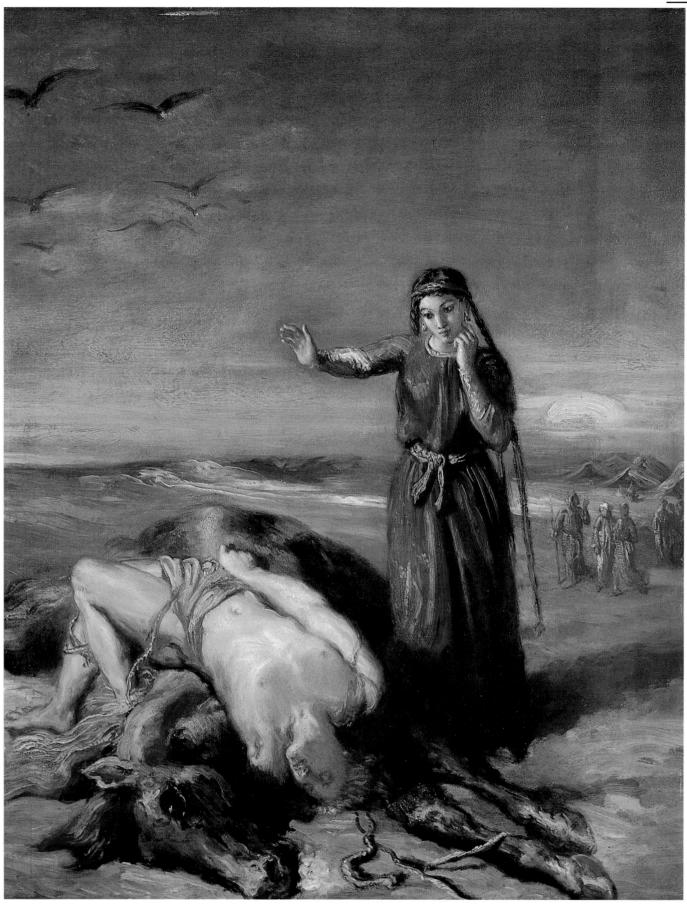

Away!," combines allegory and agony, the physical sensation of a headlong race and the psychological torment of a lonely martyrdom, ending with a miraculous apotheosis that redeems this nearly complete decline. Mazeppa's death and resurrection were those of a man oppressed by random social forces, and also those of the artist who, after having been carried "out of the real world" by his flights of genius, "arises again as king" at the end of his ordeal. The crime, misfortunes, and deliverance of Mazeppa, a Polish page who became a Cossack prince, were so ingrained in the literary culture of the time that Hugo did not even have to mention them. His poem, written in May 1828, begins immediately with words expressing movement, endless space, delirium, darkness, and aimless wandering.

The story of this ally of Charles XII of Sweden, related in the works of Voltaire, inspired Byron to write of the drama of this man who loved, and was condemned to face death and annihilation. As punishment for having loved and seduced Teresa, the wife of a mighty Polish lord, Mazeppa was bound to a wild horse that was then set free to wander at will. Their long journey was a sort of descent into Hell, a slow death in the remote reaches of a hostile nature in which no man had ever set foot. Icy torrents, wild forests, and predators prolong the agony until the Ukrainian steed collapses: "And there we lay, the dying on the dead! I did not expect another day to rise over my hapless, unsheltered head."

While Hugo's poem ends at this point and Byron went on to describe how Mazeppa's agony was followed by his awakening and resurrection in the midst of a group of Ukrainian peasants, Chassériau chose to paint between the lines, as it were, to avoid restricting himself to the letter. In showing "the young woman with the high and slender waist, long flowing hair . . . with eyes great, dark and wild," anxiously approaching Mazeppa's apparently lifeless body, the Strasbourg painting associates pain and pleasure according to an alchemy specific to Chassériau—and doubly so, as the way in which Mazeppa lies on the dead horse has all the makings of a tender embrace. The page's body shows none of the wounds left by his ordeal; what it does convey is the slightly eroticized beauty of Baroque martyrs and Neoclassical youths, in attitudes of sleep or death, which inspired carnal desire.[2] The birds of prey mentioned in Byron's poem can fly away: The principles of life, pleasure, and glory have regained the upper hand against the forces of destruction and decay.

The ascending diagonal of the composition, accentuated by the group of nomads advancing in the distance, is a symbol of this victory over Thanatos. However, the emotional impact of this masterfully executed—if diminutive—painting, comes from the wordless dialogue between the great dark eye of the dead steed and the fearful gaze of the Ukrainian girl.[3] In between them lies the blond Mazeppa. Instead of representing the cliché of the restless race and its facile melodrama, Chassériau,

the painter of more penumbral agonies and melancholy, records the birth of a feeling: the crystallization of a loss. To this he added the poetry of remote lands, the mystery of otherness, as if, in reawakening to life in the Ukraine, Mazeppa personified the fascination with the Other that was the hallmark of the true Romantics and an exotic constant of their paintings.[4] As Bénédite rightly noted, the gentle heroine with her long pigtails, wrapped in a robe dappled with red, has all the features of Chassériau's "Jewish women of Constantine. . . . The composition is unexpected and touching. The rolling desert landscape rising behind the two reclining bodies adds to the moving grandeur of the scene."[5] Chassériau pushed this device of perspectival depth in an empty, gloomy landscape to an even greater extreme in his murals at Saint-Philippe-du-Roule.

Gautier was one of the few in 1853 to write about this "charming little picture, not as important as the *Tepidarium,* no doubt, but worth stopping for." He captured in a few words the poetic power of the scene of the "dead horse . . . struck down on its side, . . . the vague expanse of the steppe," and the young Cossack girl who "advances with an anxious curiosity combined with pity," adding, "Her face is delightful. Théodore excels in rendering mysterious types from unknown races; he endows them with a savage grace and a bizarre coquetry that cannot be explained but only felt."[6] Henry de La Madeleine, insensitive to this strange appeal, contented himself with platitudes: "This Mazeppa recalls the manner of M. Delacroix in many respects; but it is only the superficial manner, for the deep feeling of the master is lacking."[7] This Oriental touch, however, was not a caprice on Chassériau's part: Teresa, the unwitting cause of her lover's torment, was described by Byron as flashing "an Asian eye, born of a blend of Turkish beauty with our Polish blood." This mystery of remote peoples and their poignant and exotic beauty is precisely what the critics did not see in this, one of Chassériau's late masterpieces. More recently, Henri Zerner considered the "pictorial expression duly proportional to the grandeur of the subject."[8] S. G.

1. In spite of the date inscribed on the painting, Sandoz (1974, p. 266), connects the Strasbourg painting with a handwritten list of works from 1849: "1849 . . . Mazeppa trouvé évanoui par la jeune fille sur le cheval" [Mazeppa found unconscious by the young girl on the horse] (Musée du Louvre, album 26085, fol. 26 v.). See also the contemporary lists (albums 26079, 26064, 26053).
2. Mazeppa's pose and placement in the composition recall a number of contemporary works (the *Bacchantes and Satyrs* in Orléans and the *Arab Horsemen Removing Their Dead* in Cambridge, Massachusetts), and anticipate the figure of Christ at Saint-Philippe-du-Roule.
3. A drawing in the Louvre (RF 25311) shows that Chassériau originally envisaged a much more grandiloquent scene. There are quite a few other examples in Chassériau's work of this shift from the bombastic to its denial.
4. "But the animal carried its live burden into its native Ukraine; a transparent metaphor for the return to the homeland" (R. Michel, *Géricault,* exhib. cat. [Paris, 1991], p. 192).
5. Bénédite 1931, pp. 433–34.
6. T. Gautier, "Salon de 1853," in *La Presse,* Paris, June 23, 1853.
7. H. de La Madeleine, "Le Salon de 1853," in *L'Éclair* 3 (1853), p. 280.
8. H. Zerner, "Romantisme," in *Encyclopaedia universalis,* vol. 20 (Paris, 1976), p. 197.

204

Portrait of Alexis de Tocqueville

1850
Oil on canvas
64 ⅛ x 51 ⅛ in. (163 x 130 cm)
Signed and dated, bottom right: *Thre. Chassériau 1850*
Versailles, Musée National du Château (MV 7384)

PROVENANCE:
Tocqueville family; gift of the Comité pour la Célébration du Centenaire de la Révolution de 1848, 1948.

BIBLIOGRAPHY:
Clément de Ris, *L'Artiste,* March 1, 1851; Gautier, *La Presse,* April 8, 1851; Chevillard 1893, no. 75; Bénédite 1931, pp. 366, 369; Sandoz 1974, no. 155; Tocqueville 1983, p. 24; Jardin 1984, p. 353; Furet 1988, pp. 372–73; Peltre 2001, p. 30.

EXHIBITIONS:
Salon of 1850–51, no. 539; Paris, 1995–96, no. 33.

The relationship between Alexis de Tocqueville (1805–1859) and the Chassériau brothers—Théodore and Frédéric—which dated back to the July Monarchy, has been discussed in detail above. It is documented by a first portrait (cat. 64) from the year in which Tocqueville, then a deputy from Valognes, helped the painter obtain the commission for the Cour des Comptes. In comparison to the intimacy of the first portrait—Tocqueville is seated with a distinguished nonchalance, sporting an aristocratic haircut[1]—the Versailles painting addresses to a greater degree the requirements of his public image as a member of the Academy and as a representative of the people, who had just been entrusted with the office of minister. The first was a gift to the sitter, the second clearly a commission.

Tocqueville stands tightly ensconced in an impeccably cut black suit (a political symbol in itself, as Baudelaire would say); his bearing is firm, his gaze direct, and one arm hangs down freely at his side while the other rests on the back of a Rocaille-style chair. If it were not for the wood paneling, which is also in this style, the setting would be rather austere. The absence of depth, or the abstraction of space—a characteristic feature of portraits in the tradition of Ingres—gives the sitter an intense presence. The hands are strong, well shaped, slightly sinuous—as Chassériau liked to depict them—and as delicately modeled and lit as the face, which betrays a smile. The soft sheen of the gold chair and the harmony of green and black recall the subdued refinement of Florentine Mannerism, which could be compared to fire encased in ice. There is a soberness, an elegance, and an atmosphere of bygone times; a rigor, too, but without stiffness. This is not the usual starched and banal official portrait intended to stress political authority through the one holding the office. The Tocqueville portrait, with its touch of refined familiarity peculiar to Chassériau, also commemorated a special moment in the sitter's career.

In June 1849, Tocqueville accepted his appointment to Louis-Napoléon Bonaparte's cabinet as Minister of the Interior, for the Ministry of Education had already been assigned to Falloux. He agreed, but not without

some reservations; after having sat in Parliament with the liberal deputies of the Moderate Left under Louis-Philippe, then with the Dynastic Left of Odilon Barrot, he sensed as early as December 1848 that the "nephew" would be more inclined to despotism than to a respect for civil liberties. He considered leaving the National Assembly for a while, then changed his mind and had himself elected to the new Chamber on May 13, 1849. It was then that he answered the call to join the Barrot administration, feeling flattered, no doubt, but having no illusions. The major event of his mandate was the intervention in Rome. It was such a bitter experience that he even omitted mention of it in his memoirs: Pope Pius IX, aided by France, fled to Gaeta—the locale depicted in Chassériau's painting *The Fisherman's Wife* (1849; Musée du Louvre)—before regaining control of Rome in September 1849 and refusing to liberalize the institutions, as Tocqueville had hoped he would. The Minister of the Interior was relieved of his functions on October 31, 1849.

Chassériau's portrait, dated 1850 and exhibited at the Salon at the end of that year, does not represent Bonaparte's minister, but a man who is free again and about to rejoin the ranks of the opposition he had just left. During the coup d'état of December 1851, he protested alongside the deputies who had been expelled from the Palais-Bourbon and taken refuge in the town hall in the 10th arrondissement. He was jailed at Vincennes for two days, released through the probable intervention of Frédéric Chassériau, but refused to leave as long as his fellow representatives remained incarcerated.[2] His poor health and his work on *L'Ancien Régime et la Révolution* prevented him from taking a more active part in the political struggle at a time when the sword held sway. His later writings, however, prove that he was determined to promote the growth of democracy in France—a development he considered inevitable—all the while respecting the ancestral values and the path blazed by Chateaubriand. His agenda consisted of a very unpopular blend: the legacy of 1789 versus the revolutionary spirit; democracy (equality of all citizens) combined with a form of aristocracy (individual freedom and reform of the centralized administration); and, finally, a republic, not socialism. The man in the black suit occupies a place in between two worlds, a state perfectly expressed in Chassériau's portrait. An independent thinker, faithful to himself, and conscious of his heritage as an aristocrat, as well as a political thinker nourished by a broad range of experiences, intelligent, willful, and charming, his easy manner devoid of haughtiness—this was the Tocqueville portrayed by Chassériau. Two men of strong conviction, each with impaired health, seem to have established a dialogue here. Their correspondence tells us that the sitter followed the progress of the portrait

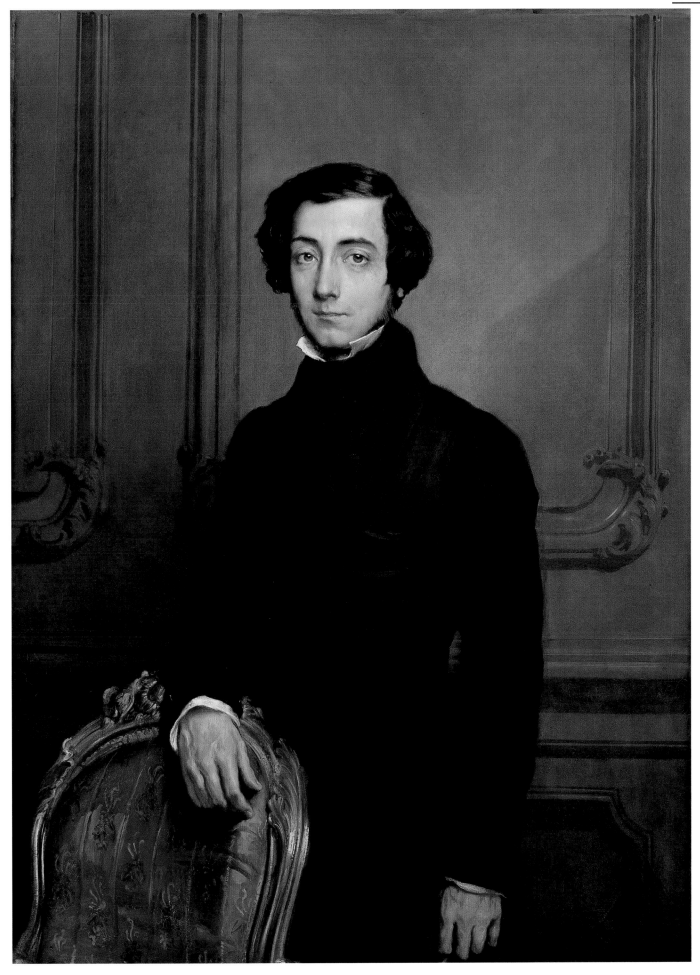

with great interest,[3] or, as Gautier put it, he probably recognized "the form and the spirit of [his] own person."[4]

Clément de Ris was not of this opinion. This critic, who had made mincemeat of the portrait of Mlle de Cabarrus in 1848 (cat. 165), considered the Tocqueville portrait lifeless: his strict demeanor was more pretentious than convincing. The Cabarrus portrait had ignored the canons of feminine beauty, and now the Tocqueville portrait diluted the distinction intended in a "greenish pallor." Chassériau was taxed with being an imitator of Delacroix in his Orientalist paintings—which he also showed at the Salon of 1851—and with being less successful than Ingres's other pupils in the field of portraiture: "I believe—and for this he has earned my praise—that his idea was to endow this portrait with great character in its style and severity, but the result was inferior to his intentions. The line is weak and awkward; the light, which is pale and cold, seems to make it darker rather than brighter, and the neutral tonality of the handling does not divert attention from this fault."[5]

The critique of Clément de Ris, a moderate in 1848, had as much to do with his reticence vis-à-vis the painter as with his dislike of Tocqueville. This is not surprising, for André Jardin, the latter's best biographer, and François Furet, the best interpreter of his political ideas, saw much more in this painting than concessions to social rank. Furet left us with some superb thoughts on the subject of this portrait, which he saw as a perfect allegory:

> Chassériau painted a man at the peak of his career, while giving him the features of one who still dreams about his future: The overall impression is that of a timid and well-groomed person, with a hint of melancholy and a sensitivity that owe nothing to fashion, and a gaze that is both observant and a bit vague. . . . What he captured admirably was the Tocqueville who lived in another world from that of careers, a stranger to the bourgeois life, rather ill at ease with the politics of interests and compromises, obsessed with the newness of the world revealed to him by his thoughts. His world belongs both to the aristocracy from which he came and to the democratic ideal of liberty on which he based his philosophy. He isolates himself from his contemporaries and from the public life of his times even when he actually plays a part in it. So many portraits from the same period are imbued with the satisfaction of success and worldly pride in things accomplished, but this one depicts with exquisite tact the most anxious and profound political thinker of the nineteenth century.[6]

S. G.

1. Henri Bouchot was slightly amused by this in 1893: "Chassériau's very delicate line shows us an Alexis de Tocqueville at a great moment in his career, treated as a friend by the painter: a refined but somewhat silly look, with just the right hint of pseudo-aristocracy in the choice of haircut, sideburns, and monocle, what our 'forefathers' considered as the height of good taste and as the best of manners. Next to M. Ingres's slightly bourgeois and good-natured Delécluze, Alexis de Tocqueville seems to belong to another class of writers, more foppish and affected. Later, Daumier would make fun of M. de Tocqueville because of this famous monocle perpetually at his fingertips, 'which will probably allow him to see more clearly in foreign affairs.' Chassériau was content to let it hang nonchalantly" ("Expositions des portraits des écrivains et des journalistes du siècle," in *Gazette des beaux-arts* [September 1893], pp. 209–10).
2. See Jardin 1984, pp. 436–37.
3. See Tocqueville's letter to Francisque de Corcelle dated June 7, 1850, in Alexis de Tocqueville, *Oeuvres complètes. Correspondance d'Alexis de*

Tocqueville et Francisque de Corcelle et de Mme Swetchine, ed. Pierre Gibert, vol. XV (Paris: Gallimard, 1983), p. 24: "Mme de Tocqueville especially wants me to send you and Mme Corcelle her greetings. She wants me to tell the latter that if she has time to go with you to Chassériau's studio to give her opinion of the portrait of me that he is finishing at the moment, it would give [her] great pleasure."
4. T. Gautier, "Salon de 1850–1851," in *La Presse,* Paris, April 8, 1851.
5. L. Clément de Ris, "Salon. V.," in *L'Artiste,* 5th series 6, no. 3 (March 1, 1851), p. 36.
6. F. Furet, *La Révolution. De Turgot à Jules Ferry (1770–1880)* (Paris, 1988), pp. 372–73.

205

Portrait of Ernest Chassériau in the Uniform of a Second Lieutenant in the Marine Infantry

1850
Graphite, heightened with white, on faded cream-colored paper
12 ¾ x 9 ½ in. (32.5 x 24.2 cm)
Dedicated, signed, and dated in graphite, lower right:
A ma mère / Th^re Chassériau / 1850
Paris, Musée du Louvre (RF 27979)

PROVENANCE:
Frédéric Chassériau, the artist's brother, Paris, until 1881; Baron Arthur Chassériau, Paris; D. David-Weill (1871–1952); gift to the Musée du Louvre, 1936 (L. 1886 a).

BIBLIOGRAPHY:
Chevillard 1893, no. 267; Vaillat 1913, ill. p. 10; Bénédite 1931, vol. I, ill. p. 208; Sandoz 1974, p. 14, under no. 10; Sandoz 1986, no. 37, ill.; Prat 1988-1, vol. I, no. 1076, ill.; Peltre 2001, p. 19, fig. 15.

EXHIBITIONS:
Paris, Galerie Dru, 1927, no. 23 or 43; Paris, Orangerie, 1933, no. 185; Paris, Louvre, 1957, no. 73.

Exhibited in Paris only

Ernest (1823–1870), Théodore's younger brother, became a career officer, and was killed on September 1, 1870, at Bazeilles, near Sedan (and not, as Sandoz claimed, in

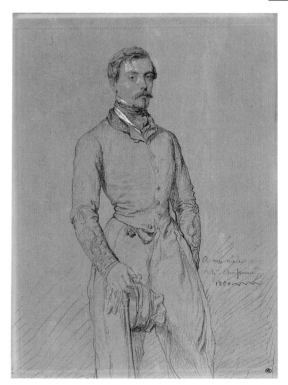

CAT. 205

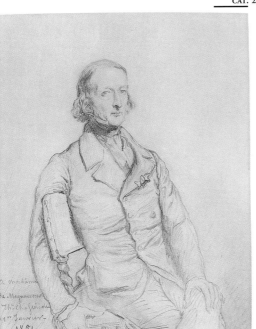

1871 at Buzenval, where Henri Regnault was killed). He sat for two painted portraits: one in which he seems to be about twelve years old (Paris, Musée du Louvre; Sandoz 1974, no. 10), and another in which he wears the uniform of a cadet at the Naval Academy in Brest (cat. 4) that can be dated to 1835–36, as well as for another portrait drawing that shows him at a younger age than in the present example (Paris, Musée du Louvre; Prat 1988-1, vol. 1, no. 1075, ill.).

L.-A. P

206

Portrait of Marquis Victor Destutt de Tracy

1851
Graphite
12 ½ x 9 ¼ in. (31.6 x 23.5 cm)
Dedicated, signed, and dated in graphite, bottom left:
à madame / de Magnoncourt / Th.re Chassériau / [c]e 1er janvier- / 1851
Paris, Musée du Louvre (RF 24380)

PROVENANCE:
Mme de Magnoncourt, then de Bray, née de Tracy; Baron Arthur Chassériau, Paris; bequest of the latter to the Musée du Louvre, 1934 (L. 1886 a).

BIBLIOGRAPHY:
Chevillard 1893, no. 276, p. 159; Vaillat 1907, ill. p. 183; Bénédite 1931, vol. 1, p. 94 (ill. of the facsimile with the initials *J. B.*); Sandoz 1974, under no. 160, p. 15; Sandoz 1986, no. 42 (ill. of the facsimile); Prat 1988-1, vol. 1, no. 1077, ill.; Peltre 2001, p. 28, fig. 25.

EXHIBITIONS:
Paris, Galerie Dru, 1927, no. 44; Paris, Orangerie, 1933, no. 186; Paris, Galerie des Quatre Chemins [n.d.], no. 8.

Exhibited in New York only

This drawing bears a dedication to Mme de Magnoncourt, the daughter of Victor de Tracy (see the portrait drawing in Prat 1988-2, no. 181; Paris, private collection). Chassériau painted a posthumous portrait of her mother-in-law, who died in 1850 (Sandoz 1974, no. 212). Victor de Tracy, the son of the famous Sensualist philosopher (d. 1836), became Minister of the Navy under Louis-Philippe; Frédéric Chassériau—Théodore's brother—served as head of his Cabinet. Chassériau vacationed at his estate in Paray-le-Frésil in 1852 (see cat. 220, 221).

This drawing was reproduced in facsimile (Bouvenne 1887, no. 33). On the back of one such facsimile, Chassériau drew a sketch for the decorations at the Church of Saint-Roch, *Saint Philip Baptizing the Eunuch of the Queen of Ethiopia* (Prat 1988-1, vol. 1, no. 689, ill.).

Instead of the drawing itself, Bénédite and Sandoz both published the facsimile, which does not contain a dedication.

L.-A. P

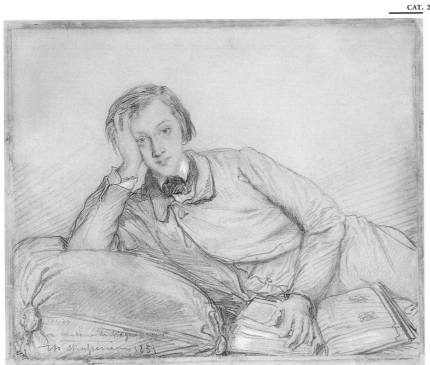

207

Portrait of Raymond de Magnoncourt

1851
Graphite, heightened with white
8 ⅝ x 10 ⅞ in. (22 x 27.5 cm)
Dedicated, signed, and dated in graphite, lower left:
a madame de Magnoncourt / Th. Chassériau 1851
Los Angeles, The J. Paul Getty Museum (96. GD. 337)

PROVENANCE:
Mme de Magnoncourt; the Magnoncourt family; sale, Strasbourg, December 1, 1988, lot 19, ill.; Agnew's, London; The J. Paul Getty Museum, Los Angeles, 1996.

BIBLIOGRAPHY:
Sandoz 1974, pp. 15, 86, fig. 33; Sandoz 1986, no. 93, ill.; Prat 1988-2, no. 173.

Exhibited in Strasbourg and New York

This portrait, which remained in the sitter's family for a long time, reappeared on the art market in 1988, at the same time as the two floral panels painted by Chassériau for the Magnoncourt and Destutt de Tracy family château at Paray-le-Frésil in the Allier department of central France (Sandoz 1974, under no. 270 [dated 1852]). Among the many fine portraits drawn by Chassériau this one perhaps is unique, because of the horizontal format,

which suited the sitter's nonchalant pose. The young man was the son of Mme de Magnoncourt and the grandson of Victor de Tracy (see cat. 206); his father, Comte Césaire de Magnoncourt, became a Peer of France in 1846. Raymond-Henri, who was born in 1836, is thus fifteen years of age in this portrait; he died in 1867.　　　　　　　L.-A. P

208

Portrait of Juan de Silveira

1852
Graphite
10 ¼ x 8 ⅝ in. (26 x 21.9 cm)
Dedicated, signed, and dated in graphite, lower left:
à mon ami Juan / Th.ʳᵉ Chassériau 1852
Paris, Musée du Louvre (RF 24453)

PROVENANCE:
See cat. 20 (no mark L. 443).

BIBLIOGRAPHY:
Chevillard 1893, no. 305; Bénédite 1931, vol. 2, p. 363, ill. p. 357; Sandoz 1967, pp. 77–78, ill. p. 76, fig. 1; Sandoz 1974, under no. 158, p. 15; Sandoz 1986, no. 45, ill. (mentioned as lost); Prat 1988-1, vol. 1, no. 1079, ill.

EXHIBITIONS:
Paris, Galerie Dru, 1927, no. 13; Paris, Galerie des Quatre Chemins [n.d.], no. 26.

Exhibited in Paris only

Juan d'Albukerque, Baron de Silveira, a Portuguese diplomat posted to Paris, married Sophie de Méneval (1815–1856) in 1831. Their son, François-Joseph, died in infancy (September 21, 1831–March 23, 1832). Juan sat for a painted portrait by Chassériau that has since been lost. Two letters (of August 30 and September 12, 1856) from Théodore to his brother Frédéric mention Juan de Silveira's marital problems at the time (published in Bénédite 1931, vol. 2, pp. 514, 518).

His wife, Sophie, was the daughter of Baron de Méneval, who died in 1850, and whose portrait, dated 1853, Chassériau painted posthumously (Sandoz 1974, no. 225). Another of Chassériau's drawings of Juan de Silveira is in the museum at the Château de Malmaison (Prat 1988-2, no. 187). In addition, a drawing that predates the portrait painting and that appears to have been conceived as a presentation work (dated 1852) recently reappeared on the art market (sale, Orléans, March 24, 2001, colorpl.).　　　　L.-A. P

209

Portrait of Jules Monnerot

1852
Graphite
9 ½ x 7 ⅜ in. (24.1 x 18.9 cm)
Dedicated, signed, and dated in graphite, lower left:
a mon ami Jules / Th.ʳᵉ Chassériau– / 1852-
New York, The Brooklyn Museum of Art, Frank L. Babbott Fund (39622)

PROVENANCE:
Monnerot family; Mme Serpeille de Gobineau, Paris, 1933; Jacques Seligmann, New York; acquired by the Brooklyn Museum, New York, 1939 (*French Nineteenth Century Drawings and Watercolors at the Brooklyn Museum* [New York, 1993], no. 27, ill.).

BIBLIOGRAPHY:
Newberry 1950, pp. 161–62, ill.; Sandoz 1986, no. 47, ill.; Prat 1988-2, no. 183.

EXHIBITION:
Paris, Orangerie, 1933, no. 229.

Exhibited in New York only

Jules Monnerot (d. 1883) was the son of Laure-Lucia Victoire Monnerot, née de Tourolles, whose portrait Chassériau painted in 1839 (cat. 10). He was also the brother of Clémence Monnerot, the future Comtesse de Gobineau, who was a close friend of the Chassériau sisters and often posed for the artist—in particular, for the paintings at Saint-Merri. A sketch of her (about 1844 ?) by Chassériau is in the Musée Carnavalet, Paris (Prat 1988-2, no. 108). Strangely enough, although the young woman played an important part in the artist's life, no finished portrait drawing of her is known to exist.

Chassériau quickly became friends with Jules Monnerot, who was a little bit older, but he seems to have had doubts about Monnerot's character, as suggested in a letter written to his brother Frédéric from Marseilles in 1836 (quoted in Bénédite 1931, vol. 1, p. 81): "By the way, I wanted to tell you that your next-to-last letter made me wonder. In my opinion, it is wrong for you to ask Monnerot and Albert. They are excellent fellows to see with other young people, but inviting them to my mother's displeases me, for their morality is not the best. And you know that they keep me from working sometimes. I can remain independent of them only if they are received as little as possible in the family. I will be happy to talk with you about this. Now you can do what you think fit."

The letters exchanged by Mme de Monnerot and her son Jules, then an inspector for the Alliance insurance company, are in the Bibliothèque Nationale de France (Ms. Naf. 14405, Papiers Gobineau, vol. 17) and attest to their long-standing relationship with the Chassériau family, despite the occasional tensions and reservations. Diane de Gobineau notes in her memoirs (Bibliothèque Nationale de France) that Jules, Mme Monnerot's fourth son, "stayed in France, never married, and enjoyed an excellent career in the insurance business."

L.-A. P

210

Portrait of Comte Oscar de Ranchicourt

1853
Graphite
8 ¼ x 6 ¼ in. (21 x 16 cm)
Signed and dated in graphite, lower right: *Th^re Chassériau / 1853*–
Paris, Private collection

PROVENANCE:
Gift of the artist to the sitter's family; remained in the Ranchicourt family; Galerie Brame et Lorenceau, Paris, 1996; Private collection, Paris.

BIBLIOGRAPHY:
Sandoz 1974, pp. 15, 91, fig. 35; Sandoz 1986, no. 36, ill.; Prat 1988-1, vol. 2, under no. 2255, obverse of the second flyleaf; Prat 1988-2, no. 186.

The close, lifelong friendship between Chassériau and Comte Philibert-Oscar de Ranchicourt began in childhood. The artist often visited him in the Pas-de-Calais, and at the time of their marriage, offered his wife, Clotilde (also called Pauline), a Missal containing twelve drawings (Prat 1988-2, nos. 9–20). Chassériau painted a full-length portrait of the comte leaving for the hunt (cat. 211), and executed two portrait drawings, one in 1836 (Prat 1988-2, no. 4) and the present one in 1853.

Oscar was the son of Philibert d'Amiens de Ranchicourt, Lord du Mesnil (1781–1825), a self-taught artist: a number of his drawings in the manner of Boilly were sold at auction in Paris on November 26, 1996 (lots 167–172). Oscar was born in the Château de Ranchicourt (Pas-de-Calais) January 7, 1815, and died on June 9, 1886. He had served as councillor general of the Pas-de-Calais and mayor of Ranchicourt, and had married Pauline-Clotilde de Buus d'Hollebèque (b. 1807), who gave birth to a son, Raymond-Philibert, and died twenty-eight years before her husband, on April 21, 1858. Chassériau drew the child's portrait when he was one year old (see cat. 7) as well as two portraits of Pauline-Clotilde (cat. 212, and a bust-length portrait stolen from Ranchicourt in 1988).

Oscar may have met the artist in Paris, where he owned a town house at 1, Avenue de Villars, or in Belgium, where Chassériau drew the portraits of his mother's in-laws (Prat 1988-2, nos. 21, 22).

A descendant of the Ranchicourt family kindly supplied the following information: "Oscar's mother, born Clémence Adèle Aronio de Fontenelle, was the widow of Philibert de Ranchicourt—a very talented amateur painter and watercolorist, who died on October 8, 1825: she married Victor de Buus d'Hollebèque three years later, and moved to Belgium. Oscar was only ten years old when his father died, and he took on the role of his mother's protector, even acting as head of the family (his letters to his mother are full of advice . . . for example, on how her sisters-in-law should be educated). . . . He took such good care of them that he ended up falling madly in love . . . at the age of nineteen, with one of them, Pauline, who was nine years older . . . and, overcoming all obstacles, after an all-out courtship, he finally married her on June 8, 1837."

L.-A. P

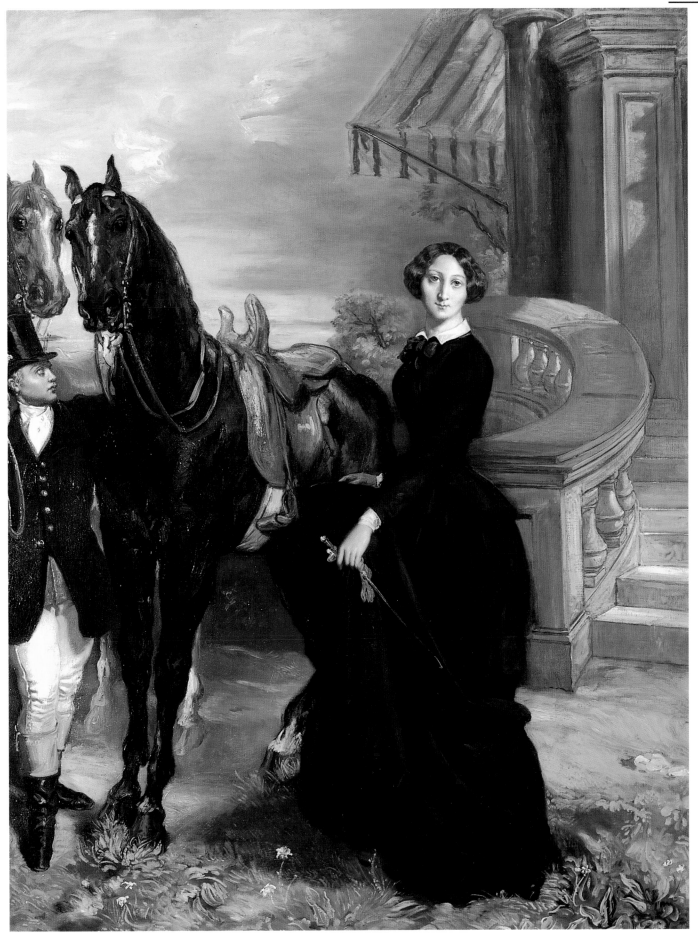

Portrait of Comte Oscar de Ranchicourt Leaving for the Hunt

1854
Oil on canvas
45 ⅝ x 35 ⅜ in. (116 x 90 cm)
Signed and dated, at the bottom: *Th^re Chassériau 1854*
Zürich, Collection Walter Feilchenfeldt

PROVENANCE:
Collection of the sitter, then of his descendants; sale X, Paris, June 16, 1960, lot 36; Marianne Feilchenfeldt, Zürich; Walter Feilchenfeldt, Zürich.

BIBLIOGRAPHY:
According to Sandoz, the painter mentioned this painting and catalogue 212 (as *Two Portraits*) in a list of works from 1853–55, in an album in the Louvre (RF 26082, fol. 11 r.); Chevillard 1893, no. 249; Bénédite 1931, vol. 2, pp. 356–57; Saisselin 1963, ill.; Sandoz 1968, pp. 182, 184; Sandoz 1974, no. 240, p. 384, pl. 206, p. 385; Prat 1988-1, p. 326, ill. p. 326.

Portrait of Comtesse de Ranchicourt Leaving for the Hunt

1854
Oil on canvas
45 ⅝ x 35 ⅜ in. (116 x 90 cm)
Signed and dated, at the bottom: *Th^re Chassériau 1854*
Zürich, Collection Walter Feilchenfeldt

PROVENANCE:
Collection of the sitter, then of her descendants; sale X, Paris, June 16, 1960, lot 36; Marianne Feilchenfeldt, Zürich; Walter Feilchenfeldt, Zürich.

BIBLIOGRAPHY:
According to Sandoz, the painter mentioned this painting and catalogue 211 (as *Two Portraits*) in a list of works from 1853–55 in an album in the Louvre (RF 26082, fol. 11 r.); Chevillard 1893, no. 249; Bénédite 1931, vol. 2, pp. 356–57; Saisselin 1963, ill.; Sandoz 1968, pp. 182, 184; Sandoz 1974, no. 240, p. 384, pl. 206, p. 385; Prat 1988-1, p. 326, ill. p. 326.

Many of the portraits that Théodore Chassériau drew and painted throughout his career were of his friends. Beyond their affective content and the fulfillment of certain social obligations, some of these portraits also involved significant aesthetic challenges. Such was the case with this full-length portrait and its pendant, both closely linked to the hunt, in which Chassériau depicted his good friends Oscar de Ranchicourt and his wife, Pauline-Clotilde de Buus d'Hollebèque in 1854. Several preliminary drawings in the Louvre bear witness to the painter's patient and rigorous preparatory work. For example, there are two studies in conté crayon and in graphite for the valet and the hounds to the right of the comte de Ranchicourt,[1] as well as a number of sketches for the portrait of the comtesse de Ranchicourt—for the overall composition, and for such details as the horse to the left of the sitter.[2] Prat considers the *Chestnut Horse*, a painting in the museum in La Rochelle (placed on deposit there by the Musée du Louvre), to be a study for the horse at the left in the portrait of the comtesse.

To judge from the number of preliminary drawings, the portrait of the young woman—clearly the more successful of the two paintings—seems to have been more thoroughly developed, especially if Marc Sandoz is correct in suggesting that the bust-length *Portrait of Comtesse de Ranchicourt,* formerly in a private collection in the Pas-de-Calais,[3] is also a study for the full-length portrait. In any case, the comtesse, clad in a black riding habit,

exhibits a savvy turn of the upper body and dress, as she prepares to mount the horse being held for her by a valet, who also has another horse in tow. According to Sandoz, the residence of Mme de Ranchicourt's family, the Château de Hollebèque (no longer standing), in Belgium, appears in the background. The graceful movement of the comtesse, counterbalanced by the sweep of the balustrade behind her and by the compact form of the horse, endows the scene with a strange elegance that mitigates its otherwise conventional character.

The portrait of the comte is much more formal, as Chassériau seems to have had difficulty introducing action into the composition, and arranging the various components: the central figure, his horse—who stands behind him, and provides the only element of motion in the scene—and the valet with the hounds. The comtesse is shown in an architectural setting while her husband is seen in the middle of a forest, whose depiction has stylistic affinities with the Barbizon school. Sandoz pointed out that both paintings seem to be narrower than planned.[4] It may be that the painter originally intended to compose a single scene—a double portrait—with the comte on the left, in the forest, and his wife on the right, in front of their hunting lodge, with the hounds and horses providing a transition between the two. Such as they are, however, the two portraits seem to have been designed as pendants, so that the symmetry of the compositions and settings is not really surprising.

In spite of their conventionality and the concessions to the fashions of the Second Empire, these two portraits display an unquestionable originality. They are also a testimonial to Chassériau's long-standing admiration for the works of the Dutch and Flemish schools—portraits by Rubens and by Van Dyck immediately come to mind—not to mention those by such English painters as Gainsborough. Eugène Delacroix's *Portrait of Baron Louis-Auguste Schwiter* (London, National Gallery), as much an homage to the English tradition as it was an attempt to revive the art of the eighteenth century—and the genre of the outdoor portrait, in particular—might also be mentioned as an influence. There is a direct connection between the two Ranchicourt portraits and certain works by Manet and the Impressionists painted ten or even twenty years later—proof, if need be, of the pivotal role played by Chassériau in the evolution of nineteenth-century painting.

As records of the economic and social position of the aristocracy during the Second Empire, these two portraits also stand as aesthetic exceptions in Chassériau's oeuvre—exceptions dictated by the personality of the two sitters, who were intimates of the painter. In the same spirit as his *Two Sisters* (cat. 61), through which he had attempted to rethink the "double-portrait" genre, here, Chassériau clearly tried to contribute to the development of the equestrian portrait. V. P.

1. Prat 1988-1, vol. 1, nos. 750 (RF 25066), 751 (RF 25302), pp. 326–27.
2. Ibid., nos. 752 (RF 24978), 753 (RF 25392), 754 (RF 25389), 755 (RF 25499). Prat points out that there are two other preliminary drawings in a private collection in Paris: one of the horse and groom and another of the saddle.
3. Sandoz 1974, no. 242, pp. 386–87 (the painting was stolen from the Ranchicourts in 1988).
4. Ibid., nos. 240, 241, pp. 384–87.

213

Bust-Length Study of a Man in Shirtsleeves, Seen in Left Profile

1853–56
Pen and brown ink, heightened with white, on beige paper
9 x 5 ¾ in. (23 x 14.8 cm)
Inscribed in graphite, in an unknown hand: *Profil d'homme*;
in graphite, on the reverse: a drawing of a bottle (?)
Paris, Musée du Louvre (RF 24425)

PROVENANCE:
See cat. 20.

BIBLIOGRAPHY:
Chevillard 1893, part of no. 420; Bénédite 1931, vol. 1, ill. p. 53;
Sterling 1933, no. 21, p. 2; Sandoz 1986, no. 106, ill. (without
location or inventory no.); Prat 1988-1, vol. 1, no. 1080, ill.

EXHIBITION:
Paris, Orangerie, 1933, no. 194.

Exhibited in New York only

Together with another study of the same model (Bénédite 1931, vol. 1, ill. p. 61; formerly Mondésir collection; exhib. cat. [Paris, Orangerie, 1933], no. 135; Sandoz 1986, no. 107, ill.; Prat 1988-2, no. 213), this drawing is believed by some scholars to be a portrait of Edgar Degas. The latter, born in 1834, was only twenty-two years old when Chassériau died, but his many self-portraits from 1854–55 (Lemoisne 1946, nos. 3, 4, 5, and especially 12, 13, 14) have little in common with the figure depicted here, who seems to be older. In any case, the drawing style clearly belongs to that of the last years of Chassériau's life, 1853–56.

L.-A. P

214

Portrait of Vicomte Henri Delaborde

1854
Graphite, heightened with white
12 ⅞ x 9 in. (32 x 23 cm)
Dedicated, signed, and dated in graphite, lower left:
A Henri Delaborde / son ami / Th^re Chassériau / 1854
New York, Private collection

PROVENANCE:
Family of the sitter (Comtesse François Delaborde, 1933);
Mme Otto Wertheimer, Paris; Private collection, New York.

BIBLIOGRAPHY:
Chevillard 1893, no. 275, p. 159; Bénédite 1931, vol. 2, ill. p. 375;
Sandoz 1974, p. 15; Sandoz 1986, no. 51, ill.; Prat 1988-2, no. 195,
ill.; Peltre 2001, pp. 34–36, fig. 33.

EXHIBITION:
Paris, Orangerie, 1933, no. 193.

Vicomte Henri Delaborde, or de Laborde (1811–1899), distinguished himself in three careers: as curator of the Cabinet des Estampes at the Bibliothèque Nationale, as an art critic, and as a painter. After studying with Paul Delaroche, he frequently exhibited history paintings at the Salon, and painted numerous historical portraits for the galleries at the Palais de Versailles, as well as a decorative cycle in the Church of Sainte-Clotilde, Paris, in 1856–57.

Delaborde was the author of many texts about the art of his day, especially about Ingres. In the year that this portrait was executed, he published a major article about Chassériau in the *Revue des deux mondes* (to which he regularly contributed), discussing the paintings for the baptismal chapel at Saint-Roch; in the previous year he had written about *The Tepidarium* (cat. 237). Sandoz (1974, p. 442) quoted from these two articles, which, although voicing a superficial appreciation, were not very enthu-

siastic about Chassériau's inventiveness and chromatic innovations, for the critic was too involved in his own search for a system. L.-A. P

215

Portrait of Osborne de Sampayo in the Uniform of a Lieutenant of the Sixth Hussars

1854
Graphite
10 ⅝ x 8 ½ in. (27 x 21.5 cm)
Dedicated, signed, and dated in graphite, lower right:
A Madame / de Sampayo / Th^re Chassériau / 1854
Private collection

PROVENANCE:
Sampayo family, Paris; Galerie Feilchenfeldt, Zürich; E. R. Pulitzer, Saint Louis, Missouri, 1968 (A. Mongan, in *Modern Painting, Drawing and Sculpture Collected by Louise and Joseph Pulitzer Jr.*, exhib. cat. [Cambridge, Massachusetts, 1971], vol. 3, no. 155, ill.).

BIBLIOGRAPHY:
Chevillard 1893, no. 293; Bénédite 1931, vol. 1, ill. p. 230; Sandoz 1967, ill. p. 77; Sandoz 1974, p. 15; Sandoz 1986, no. 50, ill.; Prat 1988-2, no. 194, ill.

Engraved in heliogravure (an example is in the Musée Gustave Moreau, Paris; Inv. 11912-70).

Exhibited in New York only

This young man seems to have been a good friend of Chassériau, who drew a second portrait of him (cat. 216). His family was established in Paris, for Mme de Sampayo was a cousin of Delphine de Girardin (née Gay), another of Chassériau's close friends, better known in literary circles by her pen name, Hortense Allart. She is believed to have given birth to a son in Milan in 1827, and was the sister of Mme de Cubières, whose husband was tried for fraud by the Chamber of Peers in 1847 (see Victor Hugo, *Choses vues,* vol. 1, coll. Folio, p. 140). L.-A. P

216

Portrait of Osborne de Sampayo in Seventeenth-Century Spanish Costume

1854
Graphite
10 ¾ x 8 ¾ in. (27.2 x 22.1 cm)
Dedicated, signed, and dated in graphite, lower right:
A mon ami Osborne Sampayo / Th^re Chassériau / 1854
Private collection

PROVENANCE:
Sampayo family, Paris; London, Colnaghi, 1975 (*French Drawings Post Neoclassicism,* exhib. cat., no. 33, ill.); Galerie Arnoldi-Livie, exhib. cat. (Munich, 1977), no. 20, ill.; sale, New York, Sotheby's, January 25, 1980, lot 264, ill.; E. R. Pulitzer, Saint Louis, Missouri (E. Rudenstine, in *Modern Painting, Drawing and Sculpture Collected by Emily and Joseph Pulitzer Jr.,* exhib. cat. [Cambridge, Massachusetts, 1988], vol. 4, no. 248, ill.).

BIBLIOGRAPHY:
Chevillard 1893, no. 292; Bénédite 1931, vol. 2, ill. p. 437; Sandoz 1967, ill. p. 76; Sandoz 1974, p. 15; Sandoz 1986, no. 94, ill.; Prat 1988-2, no. 193.

Engraved in heliogravure (an example is in the Musée Gustave Moreau, Paris; Inv. 11912-76).

Exhibited in New York only

See catalogue 215. L.-A. P

217

Petra Camara Dancing

1854
Graphite, heightened with watercolor
8 ⅜ x 6 in. (21.2 x 15.2 cm)
Signed and dated in graphite, bottom right:
Th^re Chasseriau – / 1854
Paris, Musée du Louvre (RF 24430)

PROVENANCE:
See cat. 20 (no mark L. 443).

BIBLIOGRAPHY:
Chevillard 1893, part of no. 420; Bénédite 1931, vol. 2, colorpl. 36; Sandoz 1974, under no. 179, p. 15; Sandoz 1986, no. 95, ill.; Prat 1988-1, vol. 1, no. 763, ill.; Peltre 2001, p. 204, fig. 230, detail pp. 184–85.

EXHIBITIONS:
Paris, Galerie Dru, 1927, no. 127; Paris, Orangerie, 1933, no. 190; Paris, Louvre, 1957, no. 78, pl. 16; Paris, Louvre, 1980–81, no. 49; Paris, Galerie des Quatre Chemins [n.d.], no. 40.

Exhibited in New York only

Executed during the Paris engagement of the Spanish dancer Petra Camara in 1854, this is the most finished of the sketches of her by Chassériau in the Louvre. The small panel in Budapest depicts the dancer in quite a different pose from that shown here. Sandoz believes that the present drawing was lot 25 (among the paintings) in the posthumous sale at Chassériau's studio, a claim that is difficult to substantiate, for the stamp of the sale is lacking. The lot in question—a *Spanish Dancer* that sold for 62 francs—must have been a picture that has since been lost. Sandoz also dated the extant painting to 1851, for he assumed that the date 1852 had been written on the reverse at a later time, but the date of 1854 on this drawing suggests that the painting also may have been executed that year, and that its date on the reverse was not inscribed by the artist himself. In any case, the quality of the painting is inferior to that of this drawing.

There are three other drawings of Petra Camara in the Louvre (Prat 1988-1, vol. 1, nos. 764–766, ill.). In describing another Spanish dancer—Manet's *Lola de Valence*—Baudelaire referred to "the unexpected charm of a red-and-black jewel"; the same could be said of this precisely and delicately rendered drawing.

L.-A. P

218

Portrait of Alexandre Mourousi as a Child

1855
Graphite
10 ½ x 8 ⅛ in. (26.8 x 20.6 cm)
Dedicated, signed, and dated in graphite, lower right:
a madame la princesse / Marie Cantacuzène / Th^re Chassériau / 1855
The drawing was once affixed to a small board with the coat of
arms of the Cantacuzène family.
The Fine Arts Museums of San Francisco (1967.17.51)

PROVENANCE:
Princess Cantacuzène; Prince Paul Mourousi, Paris, 1939; Georges
de Batz, San Francisco; acquired by The Fine Arts Museums of
San Francisco, Achenbach Foundation for Graphic Arts, 1967
(P. Hattis, *Four Centuries of French Drawings in the Fine Arts
Museums of San Francisco*, exhib. cat. [1977], no. 217, ill.; R. Flynn
Johnson, *Master Drawings from the Achenbach Foundation for
Graphic Arts. The Fine Arts Museums of San Francisco*, exhib. cat.
[1985], no. 54, colorpl.).

BIBLIOGRAPHY:
Chevillard 1893, no. 271 (with different dimensions); Bénédite
1931, vol. 2, p. 494, ill. p. 481; Sandoz 1974, p. 16; Sandoz 1986,
no. 232, ill.; Prat 1988-2, no. 210, ill.; Peltre 2001, p. 23, fig. 21.

Engraved in heliogravure (an example is in the Musée Gustave
Moreau, Paris; Inv. 11912-68).

Exhibited in New York only

The young prince Alexandre Mourousi (1842–1898/1900),
shown here at the age of thirteen, was the nephew of Marie
Cantacuzène (see cat. 219), the Muse of Chassériau's last
years. Through his mother, who bore the name Pulchérie
and was Marie Cantacuzène's sister, he was descended
from the emperors of Constantinople. This drawing is
dated the same year as that of his mother's death.

Alexandre lived first in Russia, since his father, Prince
Constantin Mourousi, was a member of the Chamber of
Czar Nicholas I. He became a prince in 1855 and, after
having lived in Paris with his aunt, Marie Cantacuzène,
returned to Russia to embark on a career as a diplomat.

L.-A. P

219

Portrait of Princess Marie Cantacuzène

1856
Graphite
13 ¾ x 10 ⅛ in. (35 x 27 cm)
Dedicated, signed, and dated in graphite, lower left:
Au prince Nicolas Cantacuzène / son dévoué / Th^re Chassériau / 1856
New York, Private collection

PROVENANCE:
Prince Nicolas Cantacuzène; Prince Basile Cantacuzène; Prince
Jean Cantacuzène; S. Cantacuzène; Private collection, New York.

BIBLIOGRAPHY:
Chevillard 1893, p. 159; Bénédite 1931, vol. 2, pl. 52; Benoist 1933,
ill. p. 82; Sandoz 1974, p. 16; Sandoz 1986, no. 53 B, ill.; Prat
1988-2, no. 212; Peltre 2001, pp. 23–24, fig. 20.

EXHIBITION:
Paris, Orangerie, 1933, no. 208, ill.

Engraved in heliogravure (an example is in the Musée Gustave
Moreau, Paris; Inv. 11912-67).

Chassériau seems to have first met Princess Cantacuzène
(1820–1898) about 1854–55, when she was already sepa-
rated from her second husband, Prince Alexandre. The
princess became the painter's Muse and inspired many
of his figures of women, especially that of the Virgin in
both the *Adoration of the Shepherds* and in the 1856
Adoration of the Magi, which she owned (Sandoz 1974,

nos. 263–264, ill.). She later figured importantly in the life of Puvis de Chavannes, one of Chassériau's few followers, and married him in 1897. There is a remarkable portrait of her in old age by Puvis (Lyons, Musée des Beaux-Arts).

Chassériau drew two very similar portraits of Marie Cantacuzène: The first, done in 1855 and dedicated to the princess, is now lost; the second, included here, is dated 1856, the year of the artist's death, and is dedicated to Marie's father, Prince Nicolas Cantacuzène, who had eighteen children. The two portraits are almost identical, except that in the 1855 drawing she is seen standing, whereas in the 1856 picture she is seated, her hands are folded differently, the drapery has been altered, and the details in the background have been changed as well. In 1856, Marie lived close to Théodore, at 7, Avenue Frochot. She also owned the large-format sketch for the *Christ on the Mount of Olives* of 1840 (Paris, Musée du Louvre).

L.-A. P

220

Trees at Paray-le-Frésil

1852
Watercolor
14 ⅛ x 11 in. (37 x 28 cm)
Dated in pen and brown ink, lower left (partly covered by the mount): *7 bre 1852*
Paris, Private collection

PROVENANCE:
Studio of the artist (L. 443, lower left); Frédéric Chassériau, the artist's brother, Paris, until 1881; Baron Arthur Chassériau, Paris; Mme de Mondésir; Private collection, Paris.

BIBLIOGRAPHY:
Bénédite 1931, vol. 1, ill. p. 184; Prat 1988-1, vol. 2, under no. 1971; Prat 1988-2, no. 182, color cover.

EXHIBITION:
Paris, 1976, no. 31, ill.

In September 1852, Chassériau traveled to the department of the Allier to visit his friends, the Destutt de Tracy family. In a letter to his brother Frédéric, sent from Paray on September 3, he described "meadows full of

great white oxen," two watercolors of which are in the Louvre (Prat 1988-1, vol. 2, nos. 2054, 2055, ill.). He also drew the castle in which he was staying (Prat 1988-1, vol. 2, no. 1971, ill.)—the tower of which still stands—and a landscape alongside a river, or pond (see cat. 221). These watercolors are remarkable for their technique, especially the present one, which combines light touches of pure color—green verging on blue—and curved strokes done with the tip of the brush to represent branches and foliage. L.-A. P

221

Riverbank, or *Pond at Paray-le-Frésil*

1852
Watercolor and gouache, over graphite, on beige paper
11 x 14 ⅞ in. (27.8 x 37.9 cm)
Paris, Musée du Louvre (RF 24373)

PROVENANCE:
See cat. 20 (no mark L. 443).

BIBLIOGRAPHY:
Chevillard 1893, part of no. 420; Sandoz 1982, p. 40; Prat 1988-1, vol. 2, no. 1970, ill., colorpl. p. 39; Peltre 2001, p. 41, fig. 37.

EXHIBITIONS:
Paris, Galerie Dru, 1927, no. 112; Paris, Orangerie, 1933, no. 160; Paris, Louvre, 1980–81, no. 63; Paris, Galerie des Quatre Chemins [n.d.], no. 1.

Exhibited in New York only

An inscription on the back of the drawing reveals that it was executed at the Château de Paray (see cat. 220). These watercolors of landscapes are comparable to those Delacroix painted at about this time in Nohant and in Champrosay; they display the same technique of juxtaposed broad brushstrokes. L.-A. P

222

Saint Philip Baptizing the Eunuch of the Queen of Ethiopia

1852–53
Oil on canvas (arched at the top)
27 ½ x 10 ¼ in. (70 x 26 cm)
Paris, Musée du Petit Palais (PPP 4636)

PROVENANCE:
Chassériau sale, Paris, Hôtel Drouot, March 16–17, 1857, lot 8 (?); Baron Arthur Chassériau, Paris; bequest of the latter to the Musée du Louvre, 1934 (RF 3910); placed on deposit by the Musée du Louvre at the Musée du Petit Palais, Paris.

BIBLIOGRAPHY:
Du Pays, *L'Illustration,* February 25, 1854; Gautier, *Le Moniteur universel,* March 4, 1854; Saint-Victor, *L'Artiste,* 1854, 5th series, 13, pp. 67–68; Delaborde, *Revue des deux mondes,* April 15, 1854; Chevillard 1893, pp. 185–94; Bénédite 1931, pp. 433–49; Prat 1988-1, vols. 1 and 2, nos. 21, 253, 441, 470, 509, 512, 624, 686–731, 1638, 1857, 1911, 1989, 2231, 2232, 2249, 2250, 2255; Foucart 1992; Peltre 2001, pp. 170–77.

EXHIBITION:
Paris, Orangerie, 1933, no. 72.

Given the lack of any records, we would date this commission for a religious cycle, Chassériau's second from the Prefecture of Paris, to about 1850. About ten years after his work at the Church of Saint-Merri, he was asked to paint two murals in the baptismal chapel of the Church of Saint-Roch. They seem to be pendants whose subjects, perhaps stipulated by the administration, were determined by the sacramental function of the chapel.[1] Appropriately enough, opposite the *Saint Francis Baptizing the Indians,* Chassériau depicted the conversion to Christianity of the queen of Ethiopia's eunuch. As Gautier wrote: "Both paintings have the same meaning: the admission of converted and reformed pagans into the bosom of the Church. But the first represents the beginnings of Christianity, whose ethics had already been determined but whose rituals had not yet been established. Here, the holy water is administered with cupped hands, and ceremony has been added to doctrine, although the thought behind it is the same. These ideas are easier to understand in the presence of M. Théodore Chassériau's remarkable works. He succeeded in respecting the religious constraints without forgoing the resources of modern art; for, if decorum dictates that certain archaic forms be preserved in the decoration of a Byzantine or Gothic church, so as to harmonize with the style of the building, the Church of Saint-Roch was built recently enough for the painter to remain himself without having to paint in an earlier style."[2]

The two murals at Saint-Roch celebrated the civilizing role played by the Church in the Orient and the missionary ideal, which were both still very active during the Second Empire.[3] Hugh Honour pointed out that the "colonial expansion" of the period naturally favored the introduction of an Oriental connection in religious art.[4] Painted at the same time as the Orientalist subjects of 1851–53 and the *Tepidarium* (cat. 237), they nevertheless avoided a conventional archaism: The primitive quality here derives from fantasies of faraway lands and

the trip to Algeria. The overall effect is clearly more colorful and lively than at Saint-Merri. Chassériau painted directly—and somewhat imprudently—in oils on the prepared stone. Gautier rightly observed that the details of the architectural setting were taken into account in both compositions. In the south mural, for example, the effect of luminosity merges with and is amplified by the light coming from the window in the middle of the chapel wall.

As Sandoz (1974, p. 366) noted, the theme of the Baptism of the Eunuch had a long tradition in France, beginning with Nicolas Bertin's painting of 1718, which Chassériau may have seen in the church at Saint-Germain-en-Laye,[5] and continuing with the version that Abel de Pujol presented at the Salon of 1848 (Valenciennes, Musée des Beaux-Arts). Honour discussed two other versions of this subject in relation to Chassériau's depiction: the mosaic, after Trevisani (1727), at Saint Peter's, Rome, and one of the compartments in the baptismal chapel at the Church of Notre-Dame-de-Lorette decorated in 1840 by Adolphe Roger. Understandably, the subject of the Baptism of the Eunuch was an important element in the proselytizing iconography of the Occidental Catholic Church.

In his lengthy commentary about the south wall of the chapel—in which he gives a nearly theological justification for the conspicuous references to the ancient Orient—Gautier warned that one should not confuse Saint Philip

> . . . with the apostle of the same name; [he] was one of the first seven deacons named by the apostles. He preached the Gospel in Samaria and died in Caesaria, where his four virgin daughters prophesied. His best-known deed is the one depicted by the artist, a picturesque theme if ever there was one, and very well suited to his character. We know that the eunuch met Philip along his way, that he was suddenly impressed by his grace, descended from his chariot, and asked to be baptized. . . . This is a primitive baptism: A river serves as baptismal font; he cups the water in his hand; and palm trees stand for the columns of the church. This was also the way that Saint John baptized Christ. The virile and characteristic features of the saint are those of a robust evangelical worker, a tireless rescuer of souls; he raises his eyes to the heavens, illuminated by a divine ray of light; ample and graceful drapery covers his body, contrasting with the naked torso of the neophyte. . . . The harnesses of the horses recall those of Nineveh, complete with chamfron, head-stalls, and collars adorned with gold tassels of Oriental magnificence; their superb heads proudly shake the miter-like headdresses that make them look like Egyptian priests wearing their ritual crowns. Silvery highlights grace their silky hides. M. Chassériau knows everything about horses, which is rare for a history painter. . . .
>
> A woman leaning nonchalantly on her elbows lets her gaze roam idly, indifferent to the proceedings. Her costume is both bizarre and splendid, her eyelids are dyed with henna, and the bracelets jangling on her wrists

hint at the luxury of the seraglio, thus suggesting the functions of the new convert. Behind her, a negress holds a parasol with a strangely conical shape not unlike those seen on Assyrian bas-reliefs. One of M. Chassériau's original qualities is his profound understanding of these exotic types. He is familiar with the ancient Orient and its motley races and renders their various features perfectly.[6]

Historians have confirmed the artist's borrowings from the Assyrian galleries that had just opened at the Louvre.[7] Chassériau also may have been able to obtain information from the priests attached to the Foreign Missions, in the rue du Bac, as he seems to have recorded in a note.[8] During the reign of Louis-Philippe, Pope Gregory XVI entrusted Parisian missionaries with the task of proselytizing in Korea, Japan, and Tibet. Chassériau's intention was less to pay lip service to archaeological truth than to give a feeling of authenticity to a scene set in the biblical Orient. He took his subject from the Acts of the Apostles (8: 26–40), in which the eunuch encounters the deacon Philip on the road to Gaza, on his way back from Jerusalem. The series of preliminary sketches for this composition show not only how certain poses and gestures were elaborated on and how the Oriental character was increasingly emphasized but also the difficulty the painter had in maintaining a balance between program and fantasy, Catholic doctrine and respect for the *other*.

In the first sketch (RF 3909), Philip and the eunuch were shown standing at the left, while above them hovered an angel coming to take the deacon to Heaven.[9] This disposition recalls depictions of Matthew being visited by divine inspiration, as, for example, in the painting by Caravaggio. The colorful escort of the newly Christianized eunuch was barely visible, relegated to the middle ground on the right. A second sketch (cat. 222) maintained the overall scheme of the first, while modifying the eunuch's gesture; originally, his arms were folded on his chest, in humility—as in Adolphe Roger's version—but here they were raised to the community he was entering and from which, according to Honour, he was expecting his liberation. Then the position of the arms was altered a third time: outstretched, they turned the eunuch into an image of Christ on the Cross—a significant change (cat. 228). Honour advanced the very provocative thesis that this revision had been forced on the artist by the administration in order to avoid any associations between the Saint-Roch murals and abolitionist imagery.

In a further refinement to his composition, Chassériau positioned the eunuch in the center, isolated the figure of the deacon more clearly, and accentuated the presence of the men and women who witness the baptism with a combination of surprise, suspicion, and disbelief. The blond, slightly androgynous angel has also been shifted to the right, displaced from the main action, thus removing the stamp of orthodoxy from a scene whose iconography had been dangerously altered. The eunuch, who, moreover, has been feminized with purple lips, is now the focus of attention. Philip, opposite him, also has been moved into the shimmering water, but seems to

lack any depth, despite the old-fashioned Baroque device of the upturned eyes. Paul de Saint-Victor, a close friend of Chassériau, may well have compared the figure of the saint to the "handsome Raphaelesque cartoons at Hampton Court, preaching the message of Christ with the vigorous and virile eloquence of Roman orators," but he could not conceal his preference for the "sumptuous and magical display of a caravan from the seraglio."[10]

The critic writing in *L'Illustration* was less inclined to tolerate this encroachment of exoticism on a religious subject, or this apotheosis of negritude—much less any profane effects: "These treasures, this queen of Ethiopia, this ancient Oriental world full of magnificence and voluptuousness, have distracted the attention of the painter, who has always demonstrated a great affinity for these things. His religious faith has lapsed proportionately. The figure of Saint Philip . . . has been sacrificed."[11] Yet, it is precisely this barbaric, if not barbaresque perversion—more than the broad, full, and rich brushwork and bold color accents—that account for this work's ambiguous appeal today.

All the while respecting the requirements of a painting that had to coexist with stone, Chassériau abandoned the archaic vocabulary of his murals at Saint-Merri in favor of the more dynamic and colorful idiom of those at the Cour des Comptes (such as the panel *Commerce*, cat. 130). He was encouraged in this by the ongoing dialogue with the Orient as well as by the eclectic aesthetic atmosphere of Saint-Roch, which had become a virtual museum of sacred art in which two centuries of religious painting and sculpture were assembled. The commissions awarded during the Restoration and the July Monarchy were designed to fit into a very dense fabric of images. With even more verve than in *The Tepidarium* (cat. 237), in his paintings at Saint-Roch Chassériau reassured the intimidated critics without disappointing his supporters. Henri Delaborde, who had sat for a portrait by Chassériau (cat. 214), belonged to the first group, and was very hostile to the "impetuous habits of incorrectness" and the "aggressive and defiant stance" that had marked the painter's style since the mid-1840s, but was glad to see this former pupil of Ingres returning to the straight-and-narrow path of serious painting. Not surprisingly, he much preferred the mural of *Saint Francis Xavier*. S. G.

1. The dove of the Holy Spirit, a traditional iconographical element in scenes of the Baptism of Christ, is visible on the chapel vault. Although it is in Chassériau's hand, this dove has never been mentioned by scholars.
2. T. Gautier, "Peintures murales de Saint-Roch," in *Le Moniteur universel* (March 4, 1854).
3. The Orient/Occident polarity had already been adopted by Hippolyte Flandrin in his frieze for the Church of Saint-Vincent-de-Paul in Paris (1848–53), in which Peter is depicted catechizing the peoples of the Occident and Paul those of the Orient. The single black figure in the decoration naturally plays a far less central role than the one in Chassériau's mural.
4. Honour 1989, pt. 1, p. 191.
5. See T. Lefrançois, *Nicolas Bertin* (Paris, 1981), fig. 85.
6. See note 2.
7. Foucart, Moulinat, and Brunel 1992.
8. See Prat 1988-1, vol. 1, nos. 714–715.
9. The figure of the angel originated in studies for the painting in the church at Saint-Jean-d'Angély (cat. 16); see Prat 1988-1, vol. 1, no. 21 v.
10. P. de Saint-Victor, "Peintures murales de Saint-Roch par Théodore Chassériau," in *L'Artiste*, 5th series, 13 (1854), pp. 67–68.
11. A.-J. Du Pays, "Église Saint-Roch. Peintures murales par M. Théodore Chassériau," in *L'Illustration* (March 18, 1854).

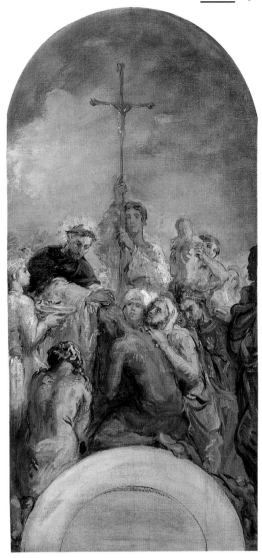

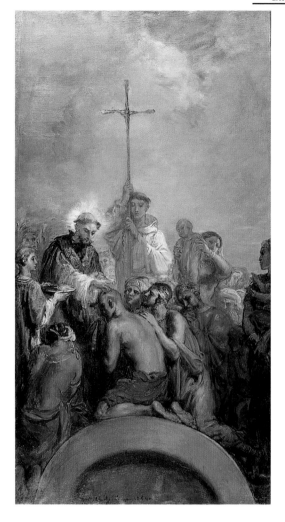

223

Saint Francis Xavier Baptizing the Indians

1852–53
Oil on canvas (arched at the top)
27 ½ x 12 ⅛ in. (70 x 32 cm)
Paris, Musée du Petit Palais (PPP 4637)

PROVENANCE:
Chassériau sale, Paris, Hôtel Drouot, March 16–17, 1857, lot 11;
Baron Arthur Chassériau, Paris; bequest of the latter to the
Musée du Louvre, 1934 (RF 3908); placed on deposit by the
Musée du Louvre at the Musée du Petit Palais, Paris.

BIBLIOGRAPHY:
Gautier, *Le Moniteur universel,* March 4, 1854; Du Pays,
L'Illustration, March 18, 1854; Saint-Victor, *L'Artiste,* 5th series, 13
(1854), pp. 67–68; Delaborde, *Revue des deux mondes,* April 15,
1854; Chevillard 1893, pp. 185–94; Bénédite 1931, pp. 433–49; Prat
1988-1, vols. 1 and 2, nos. 732–749, 804, 2250, 2255, 2256, 2259;
Foucart 1992; Peltre 2001, pp. 170–77.

EXHIBITION:
Paris, Orangerie, 1933, no. 72.

224

Saint Francis Xavier Baptizing the Indians

1854 (?)
Oil on canvas
31 ⅞ x 16 ⅞ in. (81 x 43 cm)
Signed and dated, bottom center: *Thre Chassériau 1854*
Bagnères-de-Bigorre, Musée Salies

PROVENANCE:
Either a reduced version or a *modello,* the painting was given by
the artist to Achille Jubinal; gift of the latter to the Musée Salies.

BIBLIOGRAPHY:
Chevillard 1893, no. 29; Bénédite 1931, p. 437; Sandoz 1957, p. 31;
Sandoz 1974, no. 228.

EXHIBITION:
Montauban and Besançon, 1999–2000, p. 186.

Exhibited in New York only

The composition on the north wall of the chapel in
Saint-Roch, which had to be adapted to an arched
opening, did not undergo as many modifications in its
genesis as its pendant. Although the space was irregular
at the bottom, Chassériau used the dynamic element
afforded by the opening to best advantage by grouping
the kneeling figures, eagerly awaiting their baptism, in
that area. Around the green loincloth worn by the bald
figure being baptized by the saint, the artist deployed a
varied palette of red, blue, pink, and gold accents, which
illuminate the wall without creating an undue impres-
sion of depth. There is nothing loud, but a full range of
hues at their greatest intensity. The bright color scheme
and the soft sheen of the naked backs remind us that

this work is contemporary with the *Tepidarium* (cat. 237), as do the figures bracketing the composition at either side. To counterbalance the exotic parasol in the west mural, Chassériau provided the young, tonsured monk in a white habit with a more orthodox crucifix; he appears even younger and more feminine in the preliminary sketches.

Francis Xavier (1506–1552), a Spanish Jesuit missionary who lived in India and died in China,[1] was canonized in 1622. Many of the great European artists contributed to the dissemination in painting and sculpture of the iconography connected with his legend. The handsome, chiseled features of the saint here, set off with a golden halo, are closer in style to Van Dyck than to Poussin. Gautier, describing the saint's head as "feverish with ecstasy, mortified by penitence, spiritualized to the point of emaciation," admitted that he preferred to write about the "best ascetic heads, by Murillo and by Zurbarán."[2] At the feet of the missionary who evangelized India and Japan, Chassériau assembled a cross section of humanity, drawn from the primitive Orient, where faith seems to be absolute and the conversion to Christ voluntary. The baby being held up to Saint Francis Xavier—a quotation from Ingres's *Saint Symphorian* that was also incorporated into *The Defense of Gaul* (not to mention Flandrin's paintings for Saint-Germain-des-Prés)—symbolizes the pure of the natives, whom Chassériau depicted with mixed feelings of superiority and of melancholy.

On the other end of the scale, Delaborde's critique betrays arrogance and ethnocentrism: "All these savages kneeling in front of the apostle have kept their idolatrous habits in the midst of their new faith, and seem to confuse the God being preached to them with the man who is speaking in his name. They are crawling, so to speak, at his feet, brushing his habit with their hands and lips, as if spiritual truth could be attained through the evidence of the senses. The figure of the warrior, for example, expresses this half-reasoned, half-instinctive submission with a fervor inspired mainly by fascination. The heads of the saint and of the young acolyte holding the baptismal water express, on the contrary, an intelligent faith and the clairvoyance of charity."[3]

The entire symbolic program at Saint-Roch seems to be contaminated with the awareness of a loss or failure that Chassériau's standard iconography clearly reflects. A latter-day *Golden Legend* seems to have been introduced into this cycle to buttress the wavering faithful. According to Saint-Victor, the "evangelic ardor and universality of the Church"[4] that are supposed to be extolled by these murals seem to be addressed less to the Orient coveted by the colonialists than to the Occidental world itself.

S. G.

1. During the Second Empire, the Jesuits were just as active as the priests of the Foreign Missions. An inscription in one of his sketchbooks in the Louvre attests to Chassériau's fondness for accurate documentation: "deux ecclesiastiques [*sic*] de Goa Année 1542." See Prat 1988-1, vol. 2, no. 2256, fol. 12 r.
2. T. Gautier, "Peintures murales de Saint-Roch," in *Le Moniteur universel* (March 4, 1854).
3. H. Delaborde, "Peintures de M. Chassériau à Saint-Roch," in *La Revue des deux mondes* (April 15, 1854), p. 432.
4. P. de Saint-Victor, "Peintures murales de Saint-Roch par Théodore Chassériau," in *L'Artiste,* 5th series, 13 (1854), pp. 67–68.

CAT. 225

225

Head of a Child

1852–53
Oil on canvas
12 ⅛ x 9 ⅞ in. (32 x 25 cm)
New York, W. M. Brady & Co.

PROVENANCE:
Chassériau sale, Paris, Hôtel Drouot, March 16–17, 1857, lot 12; Princess Marie Cantacuzène; Otto Wertheimer, Paris; John Seymour Thacher, Washington, D.C.; Private collection, San Francisco; W. M. Brady & Co., New York.

BIBLIOGRAPHY:
Chevillard 1893, nos. 112–113; Bénédite 1931, p. 480; Sandoz 1974, no. 236.

EXHIBITION:
New York, W. M. Brady & Co., 1996, no. 15.

Exhibited in New York only

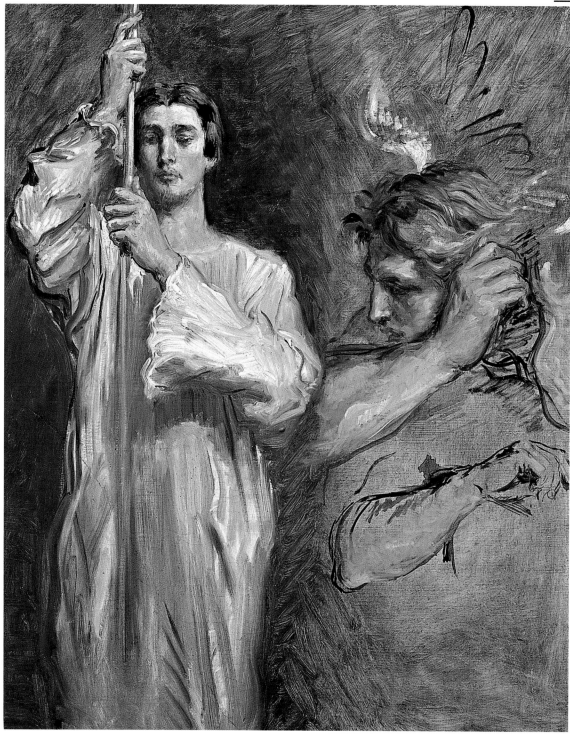

226

*Young Man Holding the Cross
and Study of an Angel*

1852–53
Oil on canvas
32 ¼ x 25 ⅝ in. (82 x 65 cm)
Paris, Musée du Petit Palais (PPP 04826)

PROVENANCE:
Chassériau sale, Paris, Hôtel Drouot, March 16–17, 1857, lot 12
(?); Baron Arthur Chassériau, Paris; bequest of the latter to the
Musée du Louvre, 1934 (RF 3907); placed on deposit by the
Musée du Louvre at the Musée du Petit Palais, Paris.

BIBLIOGRAPHY:
Chevillard 1893, no. 208; Bénédite 1931, p. 438; Sandoz 1974, no. 235.

EXHIBITION:
Paris, Orangerie, 1933, no. 71.

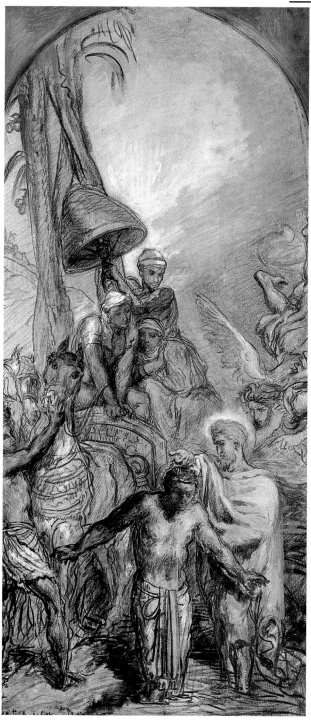

227

Studies for Saint Philip Baptizing the Eunuch

1852
Graphite, heightened with white, on beige paper
9 ¼ x 12 ⅝ in. (23.5 x 32.1 cm)
Inscribed in graphite, upper right: *la moustache / portant des ombres / teint tendre et blond / dans les chairs* [the moustache / casting shadows / soft and pale hue / for the flesh]
On the reverse, in graphite, are two studies of a standing female nude
Paris, Musée du Louvre (RF 24710)

PROVENANCE:
See cat. 20.

BIBLIOGRAPHY:
Chevillard 1893, part of no. 420; Sandoz 1957, p. 27 n. 2; Sandoz 1974, under nos. 227 A, 234; Sandoz 1982, p. 38; Prat 1988-1, vol. 1, no. 690, ill.; Peltre 2001, p. 175, fig. 203.

EXHIBITION:
Paris, Louvre, 1980–81, no. 58.

Exhibited in Paris only

The poses of the two figures in this drawing correspond to those in the sketch for the *Saint Philip* in the Musée Carnavalet (Sandoz 1974, no. 232), but they would undergo major changes in the final version; there, the saint appears at the right, and the eunuch's arms are outstretched rather than raised. The studies of a female nude on the back may belong to an earlier period; one of the figures recalls that of Daphne in the *Apollo and Daphne* in the Louvre (cat. 113), or the woman on the left in the *Temptation of Saint Anthony* (cat. 236). A study for the eunuch, shown almost frontally and with his arms outstretched, is owned by the heirs of Mme de Mondésir (illustrated in Bénédite 1931, vol. 2, p. 435; Prat 1988-2, no. 192). L.-A. P

228

Saint Philip Baptizing the Eunuch of the Queen of Ethiopia

1854 (?)
Gouache, heightened with oil, over *pierre noire*, on paper mounted on canvas (arched at the top, the corners filled in in grisaille)
31 ¾ x 14 ¼ in. (80.5 x 36.2 cm)
Signed and dated in *pierre noire*, bottom left: *Th^re Chassériau 1854*
Felix F. Fabrizio, M. A.

PROVENANCE:
Admiral Victor Duperré (according to Sandoz 1974, with smaller dimensions)?; M. de Montigny (*idem.*); M. Darnetal, Paris; Wildenstein Gallery, New York, 1957; Tanenbaum collection, Toronto (*Un Autre XIXᵉ Siècle*, exhib. cat. [Ottawa, 1978], no. 19, ill.); sale, New York, Christie's, May 6, 1998, lot 122, colorpl.; Felix F. Fabrizio, New Brunswick, New Jersey.

BIBLIOGRAPHY:
Chevillard 1893, no. 107 or 108 (according to Sandoz 1974)?; Sandoz 1974, under no. 227 A, pl. 92 a; Prat 1988-1, vol. 1, under nos. 689, 692–694; Prat 1988-2, no. 191, color cover.

This work bears the date 1854, after the painted cycle, which means that it was probably dated *later*, at the time that the artist gave it away. There are obvious differences between this work and the mural in Saint-Roch—in particular, in the figure of the saint and the angel at the right. Several studies of single figures, in the Louvre, present close analogies with that of Saint Philip, as he is depicted here (Prat 1988-1, vol. 1, nos. 692–694, ill.). L.-A. P

229
Study of a Man Reining in Two Horses

1852
Conté crayon and brush, with gray wash, heightened with oil,
on beige paper
8 ¼ x 10 ⅝ in. (20.9 x 27 cm)
Paris, Musée du Louvre (RF 24673)

PROVENANCE:
See cat. 20.

BIBLIOGRAPHY:
Chevillard 1893, part of no. 420; Sandoz 1974, under no. 227 A;
Prat 1988-1, vol. I, no. 704, ill., colorpl. p. 26.

Exhibited in Strasbourg only

This is a study for the group at the left in the *Saint Philip Baptizing the Eunuch*. The horses would be placed much closer together in the mural.　　　　　　　　L.-A. P

230
Study of an Angel in Flight, in Three-Quarter View, Facing Left

1852
Conté crayon, heightened with white, on gray paper
11 ⅛ x 15 ¼ in. (28.2 x 38.9 cm)
Paris, Musée du Louvre (RF 24702)

PROVENANCE:
See cat. 20.

BIBLIOGRAPHY:
Chevillard 1893, part of no. 420; Sandoz 1974, under no. 227 A,
pl. 192 c; Prat 1988-1, vol. I, no. 724, ill.; Peltre 2001, p. 174, fig. 200.

Exhibited in New York only

This superb drawing, a study for the angel at the right in the *Saint Philip,* recalls the technique sometimes used by Thomas Couture (1815–1870). Like many other studies for this painting, the present one is related to Chassériau's original concept in which several angels were grouped at the top of the composition.　　　　　　　　L.-A. P

231
Study of an Angel in Flight, with Outstretched Arms

1852
Conté crayon, heightened with white, on gray paper
(loss in the lower right corner)
15 ⅝ x 11 ¾ in. (39.6 x 30 cm)
Inscribed in graphite, on the reverse: *S.^t Roch*
Paris, Musée du Louvre (RF 24699)

PROVENANCE:
See cat. 20.

BIBLIOGRAPHY:
Chevillard 1893, part of no. 420; Sandoz 1957, p. 29 n. 4; Sandoz
1974, under no. 227 A, pl. 192 b; Prat 1988-1, vol. I, no. 725, ill.

Exhibited in Strasbourg only

This drawing is related to a sheet of studies for a group of angels that Chassériau originally thought of placing at the top of his composition (Prat 1988-1, vol. I, no. 722, ill.).　　　　　　　　L.-A. P

232

The Descent from the Cross

1852–55
Oil on paper, mounted on cardboard and pasted on wood
7 ½ x 26 ⅜ in. (19 x 67 cm)
Paris, Musée d'Orsay (RF 3906)

PROVENANCE:
Mercey collection, or Frédéric Chassériau (?), the artist's brother, Paris, until 1881; Baron Arthur Chassériau; bequest of the latter to the Musée du Louvre, 1934; placed on deposit by the Musée du Louvre at the Musée d'Orsay, Paris, 1986.

BIBLIOGRAPHY:
Chevillard 1893, p. 191; Bénédite 1931, p. 451; Sandoz 1957, pp. 32–36; Foucart 1987, pp. 250–51; Prat 1988-1, vols. 1 and 2, nos. 387, 604, 779–858, 882, 911, 1083, 1638, 1780, 1845, 2181, 2232, 2251–2253, 2256, 2259; Prat 1988-2, nos. 199–203; Foucart 1994, pp. 333–35.

EXHIBITION:
Paris, Orangerie, 1933, no. 76.

On June 26, 1852, Romieu, Directeur des Beaux-Arts, confirmed the commission awarded to Chassériau on February 28 for the execution of "mural paintings" for the apse of the Church of Saint-Philippe-du-Roule in Paris. A copy of the letter is in the Archives Nationales: "These paintings should represent the Descent of Christ from the Cross; you will have to submit the sketches to me. / The sum of fifteen thousand francs has been allocated to you for the execution of this project. This sum includes the 8,000 francs that had been allocated to you by a decision of January 16, 1851, for the execution of a painting."[1]

Chassériau seems to have been treated well by the Republic established in the wake of the Revolution of 1848: He was entrusted with the rest of the decorations for the Cour des Comptes; the second version of his *Christ on the Mount of Olives* (cat. 79) was purchased— albeit at a low price—in December 1848; he was commissioned to paint the *Bather* (cat. 173) in 1849; and, finally, on January 16, 1851, he received a commission for an important large-format composition for a fee that took into account the eight thousand francs already paid to him by the Ministry. On October 10 of that same year, with Frédéric's support, Chassériau sought permission from the Directeur des Beaux-Arts to turn this last commissioned work into a "monumental painting."[2] Having given up all hope of being able to work on the new decorative projects overseen by Durban at the Louvre, he offered to paint the hemicycle at the Church of Saint-Philippe-du-Roule, claiming that the vicar of the parish and the prefect of the Seine "would be very grateful for it." The cost of the project had been estimated at forty thousand francs by the Prefecture, but he would settle for fifteen, minus the eight thousand that had already been disbursed: "Would you be good enough, Dear Sir, to submit this offer to the Minister. I owe him a debt of gratitude: He is fond of great painting and I would be happy if he gave me another occasion to demonstrate my devotion to my art."

Haunted by the opportunity to produce "great painting," Chassériau had barely begun work at Saint-Roch and now he was already making a bid for the hemicycle at Saint-Philippe-du-Roule. This immoderate ambition and the deterioration of his health were to cause considerable delays in the execution of the project. On April 21, 1855, the church council issued a formal complaint that was forwarded by Baron Haussmann, Prefect of the Seine, on May 11, to the Minister of State. Chassériau was politely called to order. His murals were finally inaugurated in late 1855, and immediately acclaimed by the faithful Gautier and Saint-Victor.

The difficulty of the project was compounded by his other ongoing work: the decorative program at Saint-Roch, the *Defense of Gaul*, the Shakespearean subjects, and, perhaps, the ghostly *Emperor Augustus in Spain* (cat. 256). A study of the preliminary drawings clearly reveals this profusion of forms and ideas. He was under so much pressure to produce that his working methods led to the confluence of widely differing themes, all rooted in his tormented and sensual imagination.

CAT. 232

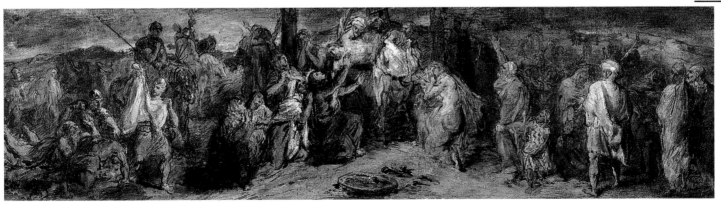

While the terms of the commission for Saint-Philippe-du-Roule only called for a Descent from the Cross, Chassériau embarked on a bold synthesis of the final episodes of the Passion:[3] the death of Christ and Mary's lamentation were set off by the presence of Roman soldiers at the left and by the Jews "consumed" by hatred at the right. Bruno Foucart noted Chassériau's successful adaptation of the composition to the spatial constraints resulting from Godde's modification of Chalgrin's original church structure—not to mention the artist's iconographic invention: "As in Saint-Roch, Chassériau made the most of the space at his disposal, which was extremely wide and low. We see only the arms of the crosses and the feet of the thieves. The perspectival field corresponds exactly to the one cut out by the architect in the half dome. The figure of Christ is literally received in the arms of the Holy Women, starting with the Virgin. He falls from the top of the apse under the eyes and into the space of the faithful. This was a true iconographic innovation. Between the 'Descent from the Cross' and the 'Lamentation of Christ' is the reception of his body—suffering, but already glorified—an image incarnate of the Host and of the Communion."[4]

It seems that the painter once had the idea of dividing the wall into three compartments[5] before opting to unify the action. In the words of Paul de Saint-Victor, "The beauty of the subject itself made it difficult, and it seemed impossible to create a new interpretation. M. Chassériau solved this problem. To Christ's death, which painters until now had always surrounded with an atmosphere of pity and tenderness, he added the presence of moral offense, insatiable hatred, and embittered outrage. The Passion thus was understood in its fullest Christian sense. Discovering yet another dimension of pain further elevated the grandeur of his sacrifice."[6]

By condensing the episodes of the Passion, which Sandoz rightly underscored, the scene takes on the instantaneity of a photograph. While one of the soldiers at the left holds up Christ's robe, eliciting the spectators' response, the poses of certain Jews violently gesticulating and shouting insults make it seem as if Christ had only just died and been taken down from the cross. Longinus still raises his head toward Christ, whose side he had pierced with a spear. The indifference of some and the fury of the others apparently have not reached the group in the middle, which is closed in on its grief. Only the old woman behind Mary Magdalene, because of her vain gesture of moderation, seems to serve as a link with the group of Jews. An unidentified transitional figure, she does not appear in this first of two extant compositional sketches, but she is included in the second one (Paris, Musée du Petit Palais). The child throwing stones—a reminder of the Woman Caught in Adultery—a counterbalance to the soldier holding the robe, also was modified to enhance the unity and the plausibility of the drama: Originally shown kneeling and turning his face toward Christ, he was finally depicted standing, with his gaze on the same level as the group in the center.

In this way, Christ's martyrdom was prolonged after his death. To justify its iconographic novelty—the introduction of near-caricatural Jews venting their spite[7]—Saint-Victor, a close friend of the painter, quoted from the Gospel of Luke, launching into a long description in which he voiced the sort of anti-Semitism that festered during the Second Empire. His conclusion did little to temper this:

> To the left of the cross we see the tumultuous crowd of priests, elders, scribes, Sophists of the Sanhedrin, and fanatics of the Synagogue. The leader of the gang, his bilious, tormented face set off by a pointed beard, gesticulates insolently at Christ. . . . Behind these offensive and insulting Oriental types there is a clump of heads with fierce and furious expressions, from which the tensed face of a haggard, disheveled, half-naked man, shouting and threatening with his fist, stands out. In the foreground, a boy from Jerusalem with a simian-like profile and a loose turban throws stones at Christ from those he has gathered in the folds of his garment. The instinctive cruelty of children had its place in this outbreak of evil passions, but in the midst of this blasphemous mob, the painter placed a figure eloquently protesting against these insults: The old man with a white beard, struck by a ray of light as if by the glow of Christ's halo, seems to recoil in horror at the impious tumult around him. Surely, he hears an inner voice telling him of the grandeur of the Son of Man. He believes, repents, and confesses, suddenly dazzled by the bolt of light that would later strike Saint Paul.[8]

Chassériau's Orient was not reduced to the beautiful young women of Constantine and their gentle ways but also included Jews with the blood of Christ on their hands.

By doing so, the painter was tackling a subject that had a long pictorial tradition. Mention need only be made of Tintoretto's *Crucifixion* (Venice, Scuola di San Rocco), which Gautier and Planche identified as one of Chassériau's principal sources.[9] The overall effect and the broad handling, as well as the strong color contrasts, all point to this precursor. Abandoning the preciousness and the palette of the Saint-Roch paintings, Chassériau made a strong statement in spite of his borrowings from the Italian primitives: For example, analogies also have been noted between the group in the middle and Pietro Lorenzetti's frescoes in the Lower Church at Assisi—the head of Mary, violently thrown back, has affinities with its counterpart in Lorenzetti's *Crucifixion*—and the similarities to the *Deposition* that Chassériau copied in 1839 from an engraving are striking.[10] Rubens, Le Brun, and Jouvenet could be added to the list of his many influences, but this does not take anything away from the power and drama of Chassériau's achievement. The margins of his drawings and sketchbooks are filled with visual and compositional notations, his intention having been to give the "whole composition an atmosphere of fatality," and so Chassériau accentuated the "rich and noble nocturnal effect" and the "very low landscape." This low vantage point glorified the body of Christ—a bright accent in the otherwise dark church and a symbol of the Host, suffused with love in the midst of humiliation—also permitting the painter to create an opening in the sky from which a half-hidden red sun casts its ominous rays on what Saint-Victor described as a "desolate countryside, with

vague, grieving figures fading here and there into the distance, like persistent echoes of the greater suffering."

Although dogged by increasingly poor health, at Saint-Philippe-du-Roule, Chassériau was able to unite his old obsession with the Pietà with his more recent North African influences, remaining unhindered by any archaizing conventions. Modernity of tone and modernity of feeling were not to be dissociated: "The church . . . is completely modern; M. Théodore Chassériau was not obliged to adopt a more or less cumbersome archaism to conform to the monument's style. . . . The scene we are witnessing is a reality: . . . the difference between this painting and a Gothic Calvary is the same as that between Rossini's *Stabat Mater* and the one by Pergolesi, which does not make it any the less religious. What can an artist illustrating a religious subject in our day do, other than to give it the understanding, and the heart and soul of his times?" [11] **S. G.**

1. See the Chronology, page 391.
2. Ibid., p. 392.
3. His preliminary drawings and notebooks, now in the Louvre, record Chassériau's intention to revise the subject: "Do my whole Passion in a new way" (RF 26394 *quater*).
4. Foucart 1994, p. 333.
5. See Sandoz 1974, nos. 245–247.
6. P. de Saint-Victor, "Beaux-Arts. Une Descente de croix, par Théodore Chassériau," in *L'Artiste* (December 16, 1855). Tintoretto's influence is also perceptible in certain studies for the *Defense of Gaul* (see cat. 242–245).
7. Some of the notations on these drawings are unusually violent: "faire à ces juifs les insulteurs envieux et bas des lèvres couvertes d'écume et de bave blanchâtre et épaisse" [give the insulting, invidious, and base Jews lips covered with foam and thick whitish spit] (2253, fol. 9 v.).
8. See note 173.
9. G. Planche, "La Peinture murale: Saint-Germain, Saint-Eustache, Saint-Philippe-du-Roule," in *La Revue des deux mondes* (November 1, 1856).
10. See Prat 1988-1, vol. 2, no. 2181. Savinien Petit's *Descent from the Cross* (Salon of 1844; Hospice de Chaumont) presents the same affinities with Lorenzetti.
11. T. Gautier, "La Descente de croix. Peinture murale de M. Théodore Chassériau," in *Le Moniteur universel* (April 17, 1856).

233

Study of a Male Nude with Outstretched Arms, Reclining Toward the Left

1853–54
Graphite, heightened with white, on beige paper
9 ⅝ x 12 ⅝ in. (24.5 x 32.1 cm)
Inscribed in graphite, lower right: *rouge / reflet / reflet / rouge* [red / reflection / reflection / red]
Paris, Musée du Louvre (RF 24390)

PROVENANCE:
See cat. 20.

BIBLIOGRAPHY:
Chevillard 1893, part of no. 420; Bénédite 1931, vol. 2, ill. p. 471; Sandoz 1974, under no. 131; Prat 1988-1, vol. 1, no. 781, ill.; Peltre 2001, p. 183, fig. 210.

EXHIBITION:
Paris, Galerie Dru, 1927, possibly no. 24 (entitled *Wounded Man*).

Exhibited in New York only

This drawing was published by Bénédite along with various pen-and-ink studies by Chassériau for figures in *The Defense of Gaul.* Sandoz associated the study with the latter work as well as with the *Mazeppa* (cat. 203). The inscription on the back (by Baron Arthur Chassériau ?) also alludes to the *Mazeppa.* However, these interpretations seem mistaken, for the drawing is clearly a study for the figure of Christ in the Saint-Philippe-du-Roule *Descent from the Cross:* It is very similar to the final version and lacks only the drapery and the crown of thorns.

There is another very similar study for the head and torso of Christ, with outstretched arms in the Louvre (Prat 1988-1, vol. 1, no. 782, ill.). **L.-A. P**

CAT. 233

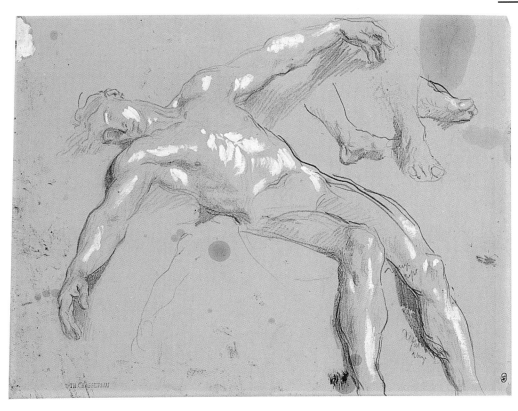

234

Study for a Kneeling Woman Facing Left, with Figures and Horsemen in the Background

1853–54
Graphite on beige paper (losses at the upper left and lower right)
11 ⅞ x 7 ⅞ in. (30.1 x 20 cm)
On the reverse is a study in graphite, with stumping, of the head of a man
Paris, Musée du Louvre (RF 25184)

PROVENANCE:
See cat. 20.

BIBLIOGRAPHY:
Chevillard 1893, part of no. 420; Prat 1988-1, vol. 1, no. 804, ill.

Exhibited in Strasbourg only

This is a study for the figure of Mary Magdalene on the right at the foot of the cross, her head resting against the feet of Christ, in the *Descent from the Cross* at Saint-Philippe-du-Roule.

The head of a young man in the study on the back may be related to the head (in reverse) of the deacon holding the crucifix at the center of the *Saint Francis Xavier Baptizing the Indians* in Saint-Roch, as well as to the sketches for this painting in the Musée Carnavalet (Sandoz 1974, nos. 229 and, especially, 235).

L.-A. P

235

Study of a Group of Roman Soldiers Playing at Dice for the Tunic of Christ

1853–54
Pierre noire on cream-colored paper
11 ⅞ x 13 ⅝ in. (30.1 x 34.5 cm)
Paris, Musée du Louvre (RF 24405)

PROVENANCE:
See cat. 20.

BIBLIOGRAPHY:
Chevillard 1893, part of no. 420; Prat 1988-1, vol. 1, no. 834, ill.

EXHIBITION:
Paris, Orangerie, 1933, no. 240.

Exhibited in New York only

This study for the left portion of the *Descent from the Cross* is often entitled "They Are Playing for the Tunic (or the Robe) of Christ" (Bénédite 1931, vol. 2, p. 441; exhib. cat., Paris, 1933, no. 204), or some such variation thereof. The painting includes a fourth kneeling soldier, and the horsemen in the background are disposed differently.

L.-A. P

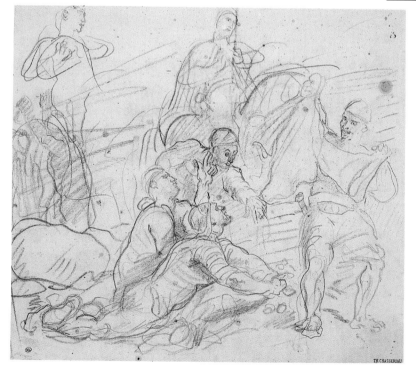

The Temptation of Saint Anthony

1850–55
Oil on wood
35 ¼ x 29 ⅛ in. (89.5 x 74 cm)
Switzerland, Private collection

PROVENANCE:
Studio of the painter until his death; Chassériau sale, Paris, Hôtel Drouot, March 16–17, 1857, lot 17 (sold for Fr 209.50, according to an annotated copy of the sale catalogue in the Cabinet des Estampes, Bibliothèque Nationale de France, Yd 929a, in -8°); Galerie Fischer-Kiener, Paris; Wheelock, Whitney and Co., New York, 1986; Galerie Peter Nathan, Zürich, June 1987 (Prat); Private collection, Switzerland.

BIBLIOGRAPHY:
Gautier 1857; Bouvenne 1884, no. 45; Bouvenne 1887, no. 34; Chevillard 1893, no. 137; Bénédite 1931, vol. 2, pp. 484–85, ill. p. 494 (after the engraving by Auguste Delâtre); Sandoz 1974, no. 183, p. 326, pl. 162, p. 327 (after the engraving by Auguste Delâtre; whereabouts unknown); New York 1986, no. 20, ill.; Prat 1988-1, vol. 1, ill. p. 282.

The story of the Temptation of Saint Anthony, as related by Saint Athanasius, was a theme that had often been treated in painting since the Baroque period, and it came back into fashion through the art of the Romantics. The episode involved the mystic hermit saint's dramatic struggle with temptations as diverse as they were diabolical and fascinating. This naturally gave painters the opportunity to deploy their imaginations to the fullest in creating intensely erotic and fantastic images dominated by the themes of religion, sin, and—last but not

CAT. 236

least—the Orient, since Anthony came from Egypt. Chassériau cannot have known of Gustave Flaubert's literary project *La Tentation de Saint Antoine*, considered one of the most famous nineteenth-century texts on this subject; although inspired by a painting seen in Italy in 1845, Flaubert did not complete the work until 1874. Among painters, Alexandre-Gabriel Descamps represented this episode from the life of the saint in 1834,[1] and Octave Tassaert depicted a related theme, *The Temptation of Saint Hilarion*, in 1857.[2] Tassaert's work may have been influenced by a painting of Saint Anthony by Chassériau from several years earlier that had just been sold at auction in March 1857, after the artist's death.[3] This earlier version was subsequently lost, and until its rediscovery almost a century later,[4] was known only through Auguste Delâtre's engraving for *L'Artiste*.[5]

The painting is very expressively and freely handled, with broad brushstrokes and skillfully applied impastos that emphasize the spontaneity of the technique. Théophile Gautier was correct in remarking that this "vague execution," and the presence of occasional "scumbled" passages, was precisely what "enhanced the fantastic character of the scene . . . giving the heads great significance."[6] Another outstanding feature of this composition is the stark contrast between the darkness of the cave—with the distraught figure of the anchorite holding onto his crucifix—and the light introduced by the group of three nude temptresses at the center, their legs left unfinished as if to suggest their illusory character.

Prat called attention to two graphite sketches in the Louvre: one, a study for the head and bent right arm of the woman on the left,[7] and the other, a study for the expression and pose of the woman at the center.[8] This indicates that, in spite of the liveliness and seemingly spontaneous handling—which one could almost term "instinctive"—Chassériau, in fact, very carefully worked out each of his figures.

It is worth noting that in this picture, which may have been intended for a collector or for the art market, the painter omitted all symbolic accessories and fantastical or diabolical creatures, in a departure from the tradition of his Flemish precursors, and in particular Hieronymus Bosch. Chassériau clearly chose to concentrate on the carnal temptation against which the hermit—his eyes kept firmly shut—musters all the spiritual reserve at his disposal. **V. P.**

1. Decamps, *The Temptation of Saint Anthony*: engraving published in *Le Musée. Revue du Salon de 1834;* mentioned in Sandoz 1974, no. 183, p. 326.
2. Saint Hilarion was one of Saint Anthony's disciples; see Sandoz, ibid.
3. Chassériau sale, lot 17; see the Provenance, above.
4. Marc Sandoz gave its whereabouts as "unknown," and published a photograph of Auguste Delâtre's engraving (Sandoz 1974, no. 183, p. 326, pl. 162, p. 327).
5. According to A. Bouvenne, "Théodore Chassériau," in *L'Artiste,* vol. 2 (September 1887), no. 34.
6. T. Gautier, "Atelier de feu Théodore Chassériau," in *L'Artiste* (March 15, 1857).
7. Paris, Musée du Louvre, Département des Arts Graphiques, RF 25880 (Prat 1988-1, vol. 1, no. 608, p. 282, ill.).
8. Paris, Musée du Louvre, Département des Arts Graphiques, RF 25918 (Prat 1988-1, vol. 1, no. 609, p. 282, ill.).

237

The Tepidarium

*"The room where the women of Pompeii went to dry
themselves and to rest after leaving the bath"*

1853
Oil on canvas
67 ⅜ x 101 ⅝ in. (171 x 258 cm)
Signed and dated, bottom right: *1853 Théodore Chassériau*
Paris, Musée d'Orsay

PROVENANCE:
Purchased for Fr 7,000 by the Ministry of State (entitled *A Bath
at Pompeii*) by a decision of May 30, 1853 (Archives Nationales
F²¹/70), with Fr 3,000 to be paid January 3, 1855, and the balance
May 6, 1855; entered the Musée du Luxembourg March 1, 1856,
until its transfer to the Musée du Louvre, November 12, 1874;
placed on deposit at the Musée d'Orsay, 1986.

BIBLIOGRAPHY:
Calonne, *Revue contemporaine*, June 1, 1853; Lacretelle, *La Lumière*,
June 4, 1853; Viel-Castel, *L'Athenaeum français*, June 11, 1853, p. 558;
Delaborde, *La Revue des deux mondes*, June 15, 1853; Du Pays,
L'Illustration, June 18, 1853, p. 392; Gautier, *La Presse*, June 23, 1853;
Delécluze, *Journal des débats*, June 25, 1853; La Madeleine, *L'Éclair*,
vol. 3 (1853), p. 280; Vignon 1853; About 1855, pp. 187–89; Chevillard
1893, no. 79, p. 174; Bénédite 1931, pp. 419–32; Angrand 1968,
p. 321; Sandoz 1974, pp. 354–56; Paris 1979, no. 190 (entry by G.
Lacambre); Prat 1988-1, vols. 1 and 2, nos. 295, 297, 407, 500, 524,
612, 625–676, 767, 1472, 1545, 1591, 1841, 1843, 2239, 2240, 2250,
2257; Rosenblum 1989, p. 32; Guégan 1992, p. 30; Michel 1999,
p. 105; Peltre 2001, pp. 195–200.

EXHIBITIONS:
Salon of 1853, no. 250; Paris, Exposition Universelle, 1855, no. 2689;
Paris, 1933, no. 66; Paris, 1979, no. 190.

The artistic and psychological key to this lovingly con-
ceived historical reconstruction may be found in the
annotation in the margin of one of the first compositional
sketches for the painting: "Faire vivre" [Make it live].
As Prat rightly observed, the idea for this picture had its
genesis in the profound impression made upon
Chassériau when he first visited the ruins of Pompeii in
April 1840.[1] The fact that he did not begin the painting
before 1852 shows that his obsessive dream underwent a
long period of crystallization, and may have taken a deci-
sive turn following the publication of Gautier's short
story "Arria Marcella" that same year.[2] Beginning with
the first excavations, a century before, the buried city
exerted the same fascination as a fairy-tale princess being
gradually awakened from a long sleep. Traces of the cat-
aclysm that engulfed the city on August 24 in A.D. 79 are
so apparent at Pompeii that it seems as if time has stood
still, abolishing the distance between past and present.
This combination of distance and false proximity, this
sense of closeness and loss, the whole tinged with a
morbid curiosity, dominates the accounts by the
Romantic writers who traveled there, starting with Mme
de Staël and Chateaubriand.

Pompeii brought life to what, before, had been the
province of antiquarians and the subject of dry scholar-
ship. However, the resurrection was incomplete, and it
was a delusion to think that the past could be recovered
intact from the layers of ash. The buried vestiges of the
disaster-stricken city that emerged in the present estab-
lished a connection with Antiquity that was as powerful

as it was problematic. A drawing by Chassériau in the
Louvre (RF 25209) executed on the site, in the so-called
House of Diomedes, perfectly expresses the fascination
and the pain that he experienced at Pompeii, which he
tried to convey in *The Tepidarium* a dozen years later. This
drawing, in which he precisely rendered the carbonized
remains of the bodies, and the comments he wrote in the
margin, betray an almost morbid attraction: "J'ai baisé
ces traces douloureuses et inouïes" [I kissed these moving
and extraordinary vestiges]. These formless remains do
not have the same aura as the ruins that were so dear to
Diderot; they disturb the sweet melancholy of the bygone
past and infect our reveries with the terror of certain
death. Prat, who was reminded of Hiroshima by this
drawing, gave the best description of its macabre psy-
chological power: "In the same way that ruins demon-
strate the artistic work of time, relics permit the past to
reemerge in the present, all the while acknowledging its
tenuous fragility."[3] *The Tepidarium* turns the tables, so
to speak: It is no longer a matter of scrutinizing the
frightful remains of a human tragedy, but of bringing the
people of Pompeii back to life, of giving a palpability to
these phantoms, these beautiful but condemned women.
Desire and death are inextricably linked once again.

Chassériau tried to depict the baths of Venus Genetrix
with the scrupulousness of an archaeologist, down to
the smallest ornamental detail,[4] adding what Gautier
called the "illusion of the diorama" to the barrel-vaulted
space opening out onto the Italian sky. In this he was
enhancing his impressions of Pompeii with memories
of his North African trip of 1846.[5] Gautier made this same
observation when he gave the painting its "send-off" in
1852, one year before it was presented to the public:

> In the painter's studio, we saw the tepidarium of an
> ancient Pompeian bath, which the painter had not yet
> finished. In the Roman baths, the tepidarium was the
> lukewarm room in which towels soaked up the last drops
> of water or sweat, and in which one could accustom one-
> self to breathable air again after the stifling heat of the
> steam bath. It was a place for idle conversation and
> relaxing reverie, where one could enjoy lounging around
> before retrieving one's clothes.—The Moorish baths of
> Algiers give some idea of what the tepidarium in Pompeii
> must have been like. In any case, its tepidarium was pre-
> served almost intact, complete with the cornice of little
> terracotta figures of Hercules that formed niches above the
> heads of each of the bathers for their clothes. . . . It looks
> like the frescoes from the House of Sallust or of the
> tragic poet, detached from their walls and reliving their
> everyday lives.[6]

Although the intimacy of this cosmopolitan gynae-
ceum, with its re-created—and, thus, modernized—
vision of Antiquity, was fully in keeping with Chassériau's
aesthetics, he was probably not unaware of the neo-
Greek taste that accounted for Gérôme's success since
1847. The latter excelled at mixing history painting and

genre subjects with an unwholesome virtuosity, playing on the nebulous boundaries between them by reviving aspects of the Greek world in its lowest forms (cock-fights, prostitutes, etc.), which he intentionally and blatantly vulgarized. His *Greek Interior*, which was shown at the Salon of 1850–51, is merely an ancient bordello, the memory of which the excavations at Pompeii had brought to light. With its relatively small format—the figures are far from lifesize—and its neither heroic nor glorified subject, *The Tepidarium* was also exploiting the gray areas between traditional pictorial categories, but without indulging in the facile salaciousness of a Gérôme.[7]

From the seraglio to the bordello, from Delacroix to Degas, from chaste eroticism to indecency, there was only a short distance—and Chassériau refused to take this step here. At most, he speculated on the expectations of the viewers—male as well as female—and on their pleasure in penetrating with impunity those places where women could bask in their intimacy, idleness, and lasciviousness, as if "sheltered from all eyes."[8] The oculus at the top of the painting is just as significant in this respect as the latent presence of Alice Ozy among these indolent beauties. It opens like a great eye, both an absence and a presence in one, underscoring the voyeuristic aspect of the scene, which also contains an element of homoeroticism.[9] Trembling flesh—quaking with pleasure, unlike in the *Susanna* of 1839—long,

shimmering tresses, the fantasies of women among themselves, and the cliché of amorous seclusion were some of the ingredients of this seductive fare served up to the public and to the imperial administration (the painting was purchased by the State shortly after the opening of this Salon, the first held during the Second Empire). Perpetuating the memory of Pompeii—complete with quotations from the Villa of the Mysteries—*The Tepidarium* filled the combined requirements of the Salon and of the genre of the Nude. One critic, Henry de La Madeleine, writing in 1853, pointed up this "exhibitionism" on the part of the painter with a touch of wit:

> Be that as it may, this *Tepidarium* gave him a pretext for exhibiting all kinds of women: blondes, brunettes, redheads, Greeks, Romans, Africans, and Gauls. There is something for everyone. . . . The picture is brilliant; it is appealing, and at times even charming. The two women draped in white, sitting opposite each other in the corners, display a nervous grace and a gentle languor. The woman in the center reveals the upper half of a superb body, framed by blue drapery for a charming effect. The movement of the one drying herself at a heater, shielding herself with her hands, is well done and very natural. As for the others, they are grouped and placed with consummate art, but seem to be overly preoccupied with their audience. The coquettes display their chubby arms and fulsome breasts with that provocative air that makes one dream of Capua.[10]

The obvious reference to the Venus de Milo[11]—the woman in the middle, who stretches her arms above her head and makes little effort to conceal what is left of her modesty—further emphasizes the impression that this splendid body cannot escape its obvious fate in the dispensation of pleasure. The admiration she is expected to inspire is reflected in the tentative gesture made by the woman seated in the foreground. This pair of figures has its equivalents in the well-known iconography of religious ("*Noli me tangere*") and mythological (Apollo and Daphne) subjects, whose meanings it reverses. Everything here suggests—and leads to—blasphemous touching and forbidden embraces.

This assembly of primitive, languorous women of every race and social condition, engulfed in the tepid vapors of the baths, with their refined demeanor, "useless luxury and sad pleasure" (Fermigier), made a big impression on the art critics, who did not hide their relief at seeing Chassériau apparently giving up his waywardness at last. Gautier was among the first to write:

> Upon seeing Théodore Chassériau's *Tepidarium*, we experienced one of the greatest satisfactions of our life as a critic, a feeling akin to the one brought about by a convalescence or the return to health of a friend we had thought doomed. . . . In the foreground, a woman standing with her torso bared and with her slightly flexed thigh holding in place her drapery, which is about to fall, stretches out her arms in a gesture recalling the indolent sense of well-being and the reflex of pleasure that follow the delicious torpor of a bath. In so doing, she sets off to best advantage the beautiful lines and the youthful curves of her body, still flushed and humid from the heat of the steam room. The light streams lovingly and generously over these pure forms, this firm and supple skin that would only have to pale a little to be transformed into Parian marble. . . .
>
> The only modern features of Chassériau's heads are the eyes, which display a dreamy stare or seem lost in a nostalgic languor that is lacking in the blank gazes of statues. These figures have a doleful serenity and a haughty passivity that recall the beautiful Greek slaves held captive at the court of some barbarian king who adores them, but whom they scorn, all the while enduring his love, like Myrrha in the palace of Sardanapalus. . . .
>
> The only reproach we would make to the artist is that some limbs have been carelessly treated and that he rendered some delicate areas of the nude with too coarse a brush. Not that we require an excessive finish . . . all traces of the tools, that is, of the material means, should be eliminated in a masterpiece in which all the antique details are to be extremely accurate. A heater and bronze banquettes like these can be seen at the museum in Naples, for now the brilliant anachronisms of Paolo Veronese can no longer be excused.[12]

The other critics waxed equally enthusiastic over this bevy of Antique beauties of varied types, replete with noble lines, exuding the "nonchalance of intimate abandon,"[13] and betraying that "devilish streak" in Chassériau that was nothing less than the lifeblood of his art.[14] Their only reservations involved the execution, which was deemed imperfect, and the paint itself, which, applied unmixed or nearly so, disobeyed the accepted laws of harmony and ended up being closer to coloring than

to the usual blended shades (a recurring Baudelairean theme). In other words, nothing new. During the Exposition Universelle in 1855, with Realism looming ever closer, these minor faults seemed even more secondary. The painting, considered one of the gems of the French school, consequently entered the Musée du Luxembourg. Yet, it is perhaps not the best of what Chassériau had to offer. In 1929, Paul Jamot, then director of the Louvre, confessed to being less fond of the *Tepidarium* and its too-perfect patrician beauties than of Chassériau's curiosities—then still decried. Today, we would be less hesitant to agree with him.[15]　　s. g.

1. Prat (1988-1, vol. 1, nos. 625–629) showed that the first sketches for the 1853 painting were made during Chassériau's Italian trip.
2. In his "Arria Marcella," which was published in the same year that *The Tepidarium* was completed, 1852, Gautier brought to life, for the space of one clear night, the beauty of a young woman, the mold of whose breast the hero of the story, Octavian, had been astonished to discover in the ash. This understandably popular relic, then preserved in the museum in Naples, had been sought out by such famous travelers as Mme de Staël, Alexandre Dumas *père*, and Chateaubriand, as well as by Chassériau, who wrote about it. See Prat 1988-1, vol. 1, no. 1487.
3. See his article in *L'Empire du temps*, exhib. cat. (Paris: Musée du Louvre, 2000), p. 205.
4. Geneviève Lacambre (*L'Art sous le Second Empire*, exhib. cat. [Paris, 1979], p. 323) mentions that the baths were cleared in 1828 and immediately published by Mazois—a distant relation—in volume 3 of his *Ruines de Pompéi*. Gautier supplied the following archaeological information in 1853: "The room we have just described serves as the setting for the figures assembled by Chassériau; except that he replaced the terracotta Hercules with bronze statuettes and covered the niches for the clothing with red stone plaques. The vault is graced with a carved garland and there is a patch of blue sky visible in a small aperture that gives the illusion of a diorama. From the edges of the frame—whose gilded lines separate it from the surrounding environment like the fiery line of demarcation of the footlights between the theater and the stage—the Tepidarium recedes into the wall and creates an astounding perspectival illusion, a most perfect trompe l'oeil" ("Salon de 1853," in *La Presse*, Paris, June 23, 1853).
5. See Prat 1988-1, vol. 1, nos. 663–664.
6. T. Gautier, "Salon de 1852," in *La Presse*, Paris, May 25, 1852.
7. Some critics hastened to point out yet another instance of plagiarism, although of Gérôme this time, not Delacroix: "The void created in the middle of this picture was redeemed—insufficiently, in our opinion—by the two figures in the foreground, one of whom is seated with her back turned, and the other standing, stretching her arms, which, for a central figure, is too similar to an analogous figure in M. Gérôme's Greek interior, if not in the line, then at least in the intention" (A. J. Du Pays, "Salon de 1853," in *L'Illustration* [June 18, 1853], p. 392). Henri de Lacretelle ("Salon de 1853. 2ᵉ article," in *La Lumière* [June 4, 1853]) also associated the figure of the woman stretching with Gérôme's hetaera, but what seems more pertinent is the resemblance to one of the figures in Couture's *Romans of the Decadence* (Salon of 1847; Paris, Musée d'Orsay).
8. Rosenblum 1989, pp. 32–33.
9. See Régis Michel's remarks on Chassériau's "lewd gynaeceum" and on Ingres's *Turkish Bath* in "L'Idiot de la peinture," in *Barbizon. Malerei der Natur. Natur der Malerei*, exhib. cat. (Munich, 1999), p. 105.
10. H. de La Madeleine, "Le Salon de 1853," in *L'Éclair* 3 (1853), p. 280.
11. References to the Venus de Milo abound in the work of Chassériau, who kept a lifesize cast of it in his Avenue de Frochot studio.
12. T. Gautier, "Salon de 1853," in *La Presse*, Paris, June 23, 1853. Delécluze ("Exposition de 1853," in *Journal des débats* [June 25, 1853]) was of the same opinion: "The artist succeeded in rendering the torpor of the bathers, and his composition as a whole is endowed with calm, simplicity, and grace. This subject, derived from the customs of Antiquity, was more favorable to the deployment of M. Chassériau's talent than the Arabian scenes he insisted upon painting in the preceding years. His *Tepidarium* displays his natural qualities; and should he continue to pursue this path, instead of remaining the imitator he has turned into, he will become himself again and will be the better for it."
13. Comte H. de Viel-Castel, "Salon de 1853," in *L'Athenaeum français* (June 11, 1853), p. 558.
14. A. Jubinal, "Salon de 1853," in *L'Abeille impériale*, vol. 1, no. 4 (June 15, 1853): "Since Voltaire rightly said that *one needs to have a devilish streak* to write a tragedy, may M. Winterhalter's brush imitate Voltaire's pen, and instead of something formal, staid—too sober even—may he give us unfettered poses, natural movements, and blood on the lips and the cheeks instead of rouge."
15. There are a number of paintings related to *The Tepidarium: Female Academy* (Montauban, Musée Ingres; Sandoz, no. 1153); *Head of a Woman* (Beauvais museum); and a smaller version of the painting (Chevillard 1893, no. 96) in the Museum of Modern Art in Cairo formerly owned by Marcotte de Quivières (see *Les Oubliés du Caire*, exhib. cat. [Paris: Musée d'Orsay, 1994–95], no. 40).

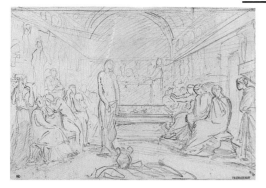

238

Study for *The Tepidarium*

1852
Graphite on grayish rose paper
9 ¼ x 13 ⅝ in. (23.6 x 34.6 cm)
Paris, Musée du Louvre (RF 25858)

PROVENANCE:
See cat. 20.

BIBLIOGRAPHY:
Chevillard 1893, part of no. 420; Bénédite 1931, vol. 2, ill. p. 423; Sandoz 1974, under no. 218; Prat 1988-1, vol. 1, no. 632, ill.; Peltre 2001, p. 195, fig. 219.

EXHIBITIONS:
Paris, Louvre, 1957, no. 74, pl. 13; Paris, Louvre, 1980–81, no. 55.

Exhibited in Paris only

In this compositional sketch for the painting exhibited at the Salon of 1853, the overall scheme has already been established, but numerous differences exist in the figures: There is only one female figure standing at the left, the woman seated at the center is not included here, and the one at the far right is shown draped and in profile. The window in the middle of the vault is also lacking, and the noble gesture of the woman standing and stretching her limbs has not yet been developed.

There are some fifty sketches related to this composition in the Louvre (Prat 1988-1, vol. 1, nos. 625–676, ill.).

L.-A. P

239

Study of the Torso of a Nude Female Figure with Raised Arms, Seen from the Front

1852
Graphite, with stumping
7 ¼ x 7 ½ in. (18.3 x 19.2 cm)
Paris, Musée du Louvre (RF 25859)

PROVENANCE:
See cat. 20.

BIBLIOGRAPHY:
Chevillard 1893, part of no. 420; Sandoz 1974, under no. 218, pl. 184 a; Sandoz 1982, p. 38; Sandoz 1986, no. 185; Prat 1988-1, vol. 1, no. 641, ill.; Peltre 2001, pp. 197–98, fig. 221.

EXHIBITIONS:
Paris, Louvre, 1957, no. 75; Paris, Louvre, 1980–81, no. 56.

Exhibited in Paris only

This study is for the central figure in the *Tepidarium*.

L.-A. P

240

Two Studies of a Seated Woman, Turned Toward the Left

1852
Graphite, on white paper (affixed to a loose page from dummy album 3 placed between folios 55 and 56)
18 ¼ x 12 in. (46.2 x 30.4 cm)
Paris, Musée du Louvre (RF 26535)

PROVENANCE:
See cat. 20.

BIBLIOGRAPHY:
Chevillard 1893, part of no. 420; Sandoz 1974, under no. 218; Sandoz 1986, nos. 156 B, 157 C, ill. (illustrations reversed, with no locations or inventory numbers given); Prat 1988-1, vol. 1, no. 655, ill.

EXHIBITION:
Paris, Orangerie, 1933, no. 233.

Exhibited in Paris only

According to Sandoz, Adèle Chassériau posed for these studies for the woman in the right foreground of the *Tepidarium.* Sandoz (1986, no. 156 A) published a sketch very similar to this one, now in a private collection but formerly owned by the Gras family, who were friends of Chassériau: The artist drew the portraits of three of its members (Prat 1988-2, nos. 150, 157, 158; all now in private collections). Unlike the other drawings in dummy album 3, this one bears the Chassériau estate stamp (L. 443); it was probably put there by Baron Arthur Chassériau, because the page had become separated from the album.

L.-A. P

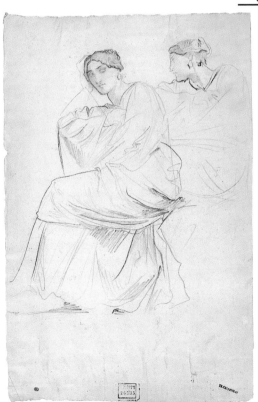

241

Christ in the House of Mary and Martha

1852
Graphite
9 ¼ x 7 ¼ in. (23.4 x 18.5 cm)
Inscribed in graphite, around the drawing: *elle monte elle vient / du sellier elle porte des / enfores / ici ou là / la laborieuse un intérieur juif / les sourcils relevés d'une / nonchalance divine / Marthe et Marie* [she ascends she comes up / from the cellar she carries / jars / here or there / the hard worker a Jewish interior / her eyebrows raised with a / divine nonchalance / Martha and Mary]
On the reverse, in graphite, are a bust-length study of a woman in left profile, her head raised, and a sketch of a figure.
Paris, Musée du Louvre (RF 24604)

PROVENANCE:
See cat. 20.

BIBLIOGRAPHY:
Chevillard 1893, part of no. 420; Sandoz 1974, under no. 215; Prat 1988-1, vol. 1, no. 617, ill.

Exhibited in Strasbourg only

This is the very first sketch for the composition of the 1852 painting (recently stolen from the church at Marcoussis, in the department of the Essonne) of the same subject, and while it is very different from the latter, the figure of the woman coming up from the cellar already is established here. The sketch on the back is for the figure of Mary, with variations.

Two sketches related to the one on the back appear on folios 35 v. and 36 v. of a notebook in the Louvre (Prat 1988-1, vol. 2, no. 2236) and there are five additional sketches in the Louvre that can be associated with this composition (Prat 1988-1, vol. 1, nos. 618–622, ill.). The subject is based on a well-known episode in the New Testament (Luke 10: 38–42): While Martha busies herself in the house, serving Jesus, her sister, Mary, remains still, listening to his words. Mary will be praised by Jesus for having chosen the "good part."

L.-A. P

242

Compositional sketch for *The Defense of Gaul*

1853–55
Oil on canvas
29 x 25 ⅛ in. (73.5 x 65 cm)
On the reverse, stamp of the Chassériau sale
Clermont-Ferrand, Musée des Beaux-Arts (2731)

PROVENANCE:

Studio of the painter until his death; Chassériau sale, Paris, Hôtel Drouot, March 16–17, 1857, lot 14 (as *Triumph of the Gauls. Late Sketch*); sold for Fr 207 (according to a copy of the sale catalogue preserved at the Cabinet des Estampes, Bibliothèque Nationale de France, Yd 929 a, in 8°); Frédéric Chassériau, the artist's brother, Paris, until 1881 (according to Sterling, in Paris, Orangerie, 1933); Baron Arthur Chassériau, Paris; bequest of the latter to the Musée du Louvre, 1934 (RF 3915); placed on deposit by the Musée du Louvre at the Musée Municipal, Clermont-Ferrand, June 18, 1937.

BIBLIOGRAPHY:

Gautier 1857, p. 210; Chevillard 1893, no. 198, p. 293; Vaillat 1913, ill. p. 19; Bénédite 1931, vol. 2, pp. 465–68, 474; Vergnet-Ruiz and Laclotte 1962, index; Sandoz 1974, no. 252, p. 400, pl. 218, p. 401 (for the painting exhibited at the 1855 Exposition Universelle), no. 253, p. 402, pl. 219, p. 403; Hallopeau, in Clermont-Ferrand, 1980, no. 5, pp. 8–13, ill. (for the painting shown at the 1855 Exposition Universelle); Tisserand, Lamesch, and Patten 1992, pp. 52–53, ill. (concerning the Salon painting).

EXHIBITIONS:

Paris, Orangerie, 1933, no. 84, pp. 41–42; Clermont-Ferrand, 1980, no. 6, pp. 13–14, ill.

243

Compositional sketch for *The Defense of Gaul*

1854–55
Oil on paper, mounted on canvas
46 x 35 ⅛ in. (116.7 x 90.5 cm)
Lyons, Musée des Beaux-Arts (B. 1376)

PROVENANCE:

Studio of the painter until his death; sale X, Paris, Hôtel Drouot, December 29, 1920, lot 10 (as *Vercingétorix Escaping over the Walls of Alesia*); probably acquired by Baron Arthur Chassériau, Paris; bequest of the latter to the Musée des Beaux-Arts, Lyons, 1926.

BIBLIOGRAPHY:

Mauclair 1929, p. 85; Vincent 1956, pp. 68–70, no. VII-39, pl. 19, 2; Vergnet-Ruiz and Laclotte 1962, index; Angrand 1968, p. 318, ill.; Sandoz 1974, no. 252, p. 400, pl. 218 (the painting shown at the 1855 Exposition Universelle), p. 401, no. 254, p. 402, pl. 220, p. 403; Hallopeau, in Clermont-Ferrand, 1980, no. 5, pp. 8–13, ill. (the painting shown at the 1855 Exposition Universelle); Durey [n.d.], p. 97, ill.

EXHIBITIONS:

Clermont-Ferrand, 1980, no. 7, pp. 14–15, ill.; Lyons-Zürich-Cologne, no. 22, p. 209.

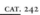

CAT. 242

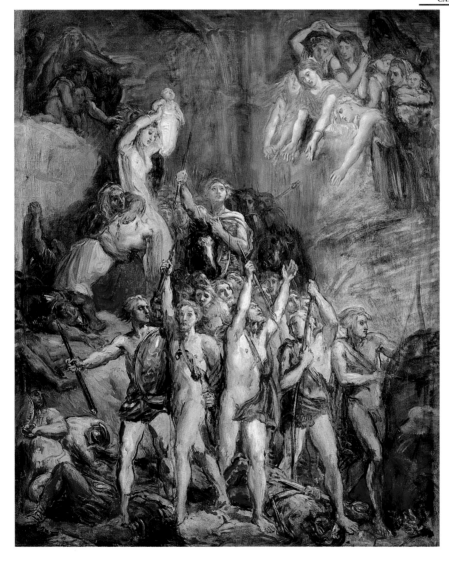

Nude Male Figure Stretching His Bow: Study for *The Defense of Gaul*

1853–55
Oil on canvas
13 ⅞ x 10 ⅝ in. (35.2 x 27 cm)
On the reverse, the stamp of the Chassériau sale
Clermont-Ferrand, Musée des Beaux-Arts (2732)

PROVENANCE:
Studio of the artist until his death; possibly P. Ghio sale, Paris,
March 26–27, 1920 (according to Sandoz 1974, no. 256, p. 404,
entitled *Male Academy*); Baron Arthur Chassériau, Paris; bequest
of the latter to the Musée du Louvre, 1934 (RF 3914); placed on
deposit by the Musée du Louvre at the Musée Municipal,
Clermont-Ferrand, June 18, 1937.

BIBLIOGRAPHY:
Chevillard 1893, no. 185, p. 291 (as "34 x 27 cm"); Bénédite 1931,
p. 468; Vergnet-Ruiz and Laclotte 1962, index; Sandoz 1974,
no. 256, p. 404, pl. 222, p. 405; Hallopeau, in Clermont-Ferrand,
1980, no. 12, p. 17, ill.

EXHIBITION:
Clermont-Ferrand, 1980, no. 12, p. 17, ill.

Exhibited in New York only

Vercingétorix: Study for *The Defense of Gaul*

1853–55
Oil on canvas
25 ⅝ x 21 ¼ in. (65 x 54 cm)
Clermont-Ferrand, Musée des Beaux-Arts (2733)

PROVENANCE:
Studio of the painter until his death; Frédéric Chassériau, the
artist's brother, Paris, until 1881; Baron Arthur Chassériau, Paris;
bequest of the latter to the Musée du Louvre, 1934 (RF 3913);
placed on deposit by the Musée du Louvre at the Musée
Municipal, Clermont-Ferrand, June 18, 1937.

BIBLIOGRAPHY:
Chevillard 1893, no. 184, p. 291 (as "34 x 27 cm"); Bénédite 1931,
p. 468; Vergnet-Ruiz and Laclotte 1962, index; Sandoz 1974,
no. 255, p. 402, pl. 221, p. 403; Hallopeau, in Clermont-Ferrand,
1980, no. 13, pp. 17–18, ill.

EXHIBITION:
Clermont-Ferrand, 1980, no. 13, pp. 17–18, ill.

Exhibited in New York only

CAT. 244

"The Gauls repulse Caesar's legions at Gergovia under the command of Vercingétorix. Their disheveled wives entreat them, showing them their children from the top of the ramparts, and exhorting them to do battle" (Caesar, *Commentaries,* Book VII). This text, probably written by Chassériau himself, described his great "archaeological" composition, *The Defense of Gaul,* in the guide to the Exposition Universelle of 1855. The painting was purchased by the French State on June 9, 1857, only a few months after the artist's death.[1] Chassériau, undoubtedly disappointed by the fact that, unlike Delacroix and Ingres, no retrospective of his oeuvre had been organized for the Exposition Universelle, wanted to paint an ambitious composition that would remind the public and the critics of the importance of his work. Thus, while exhibiting older paintings,[2] he embarked on a major composition[3] with an unusual subject that was to be his response to the current interest, in official and intellectual circles, in national history and the beginnings of French civilization. It was also during this period of the collective rediscovery of the national heritage that the Musée des Antiquités Nationales was founded at Saint-Germain-en-Laye.

To prepare this difficult historical composition, Chassériau read or reread one of the many new translations of Caesar's *Commentaries* that had recently been published: Dubois's edition of 1850; Sommer's, of 1854; or Louandre's, of 1855. He chose an episode both picturesque and violent, in which the Gallic women of Gergovia goaded their men on to do battle against the Romans:

> Having crossed the Allier, Caesar reached Gergovia in five days. . . . Meanwhile, hearing the uproar and several reports that the city had fallen to the Romans, the Gauls, who had gathered on the other side of the city to prepare the fortifications—as we explained above—sent their cavalry ahead and ran as fast as they could themselves. As more and more arrived, they halted at the foot of the wall and increased the size of the force there. When a large number had gathered, the mothers who had been reaching out to the Romans from the top of the wall only a short while before began addressing their entreaties to their husbands and, in the Gallic manner, showing them their disheveled hair and their children. The Romans fought a losing battle both because of their numbers and their position. . . . Seeing the disadvantage of his position and the increase in the enemy forces, Caesar feared the worst for his troops. . . . This day cost us a little less than seven hundred men.[4]

Chassériau, who may have remembered Auguste Glaize's successful entry at the Salon of 1850–51, a painting entitled *The Women of Gaul* (Autun, Musée Rolin), closely followed Caesar's text, all the while condensing some other episodes of the Gallic wars. He clearly strove to render the epic grandeur of the scene by doing justice to archaeological fact. The central placement of Vercingétorix—mounted on horseback, holding a broken spear, eyes turned resignedly upward—was a Romantic device. He is the only static figure in the entire scene, standing somewhat apart and dominating the disorganized group of warriors. A superb study in the Musée des Beaux-Arts in Clermont-Ferrand shows the impor-

tance Chassériau gave to this pivotal figure. His treatment of the warriors, however, is more realistic; they are hirsute, excited, pouring out of the city gates, occupying the middle of the composition and spilling over into the foreground, treading over the bodies of fallen comrades or of Romans killed in earlier battles. One wields an ax—almost an anachronistic battle ax; another brandishes a broken spear; a third, in the middle, holds up his sword and looks toward the women on the ramparts; and another (for whom there is a masterful study: cat. 244) draws his bow toward an invisible foe on the right. At the top of the composition, on either side of the opening through which Vercingétorix appears, there are two groups of women spurring the warriors on: an old woman shows the naked body of her daughter or daughter-in-law who has fainted; another holds up her child toward the group of soldiers; and, on the right, a group of women makes gestures exhorting their sons, husbands, or brothers to fight. At the top of the painting, in the background, are the ramparts of Gergovia and the first of the houses.

The composition was deliberately condensed and concentrated in order to create an impression of action, movement, and even confusion, as expressed in the many different emotional reactions simultaneously displayed by the protagonists. As an experienced painter of large-format works, Chassériau gave a lot of thought to the structure of the composition before settling on the main figure group, deployed like a frieze in the foreground and flanked at the top by two clusters of women and children standing on top of the city walls. Thus, the spectator's gaze is drawn to the relatively empty middle ground, occupied by the near-mythical and Christ-like figure of Vercingétorix. During the genesis of this work, Chassériau obviously recalled a painting that he had been able to study at leisure during his youth (before 1834), on which his master, Ingres, was still at work: *The Martyrdom of Saint Symphorian* (Autun, Cathedral of Saint-Lazare), whose dramatic quality and mise-en-scène betray strange affinities with *The Defense of Gaul.* However, where Ingres tried to maintain a balanced, classical construction, Chassériau's poetic pictorial composition was much denser and more dislocated.

In any case, the painter elaborated each of the groups in scrupulously rendered graphite drawings, noting each detail—the head of the horse, a hand stretching a bow, an arm holding another arm—striving to capture an overall sense of movement generated by the interaction between the different groups of warriors and weeping women.[5] Each of the figures was studied in turn, and every pose, expression, and gesture was developed separately before being incorporated into the ensemble. No wonder *The Defense of Gaul* remains a masterpiece in the art of grouping figures in pictorial space. After having worked out the details in graphite or pen and ink, Chassériau painted a number of oil sketches of amazing beauty and power, focusing on a face,[6] on expressions,[7] or on the superb study of an arm.[8]

Before tackling the final version of this huge painting, and as a last technical and physical challenge—for he was still working on the murals at Saint-Philippe-du-Roule—

Chassériau painted two compositional studies in oil to check the placement of each element. It is believed that the oil sketch in the Musée des Beaux-Arts, Clermont-Ferrand, was presented to the comte de Mercey, then Directeur des Beaux-Arts (see p. 395), in the hope of obtaining his agreement[9] that the finished painting be exhibited at the Exposition Universelle. The oil sketch in the Musée des Beaux-Arts, Lyons (cat. 243), which is more detailed, is believed to be the second of the studies, in which the artist intended to work out the composition before undertaking the definitive painting. It should be mentioned that Théophile Gautier noticed the Clermont-Ferrand sketch at the artist's posthumous sale and described it as "advanced, already displaying all the virile qualities of the large composition admired at the Exposition Universelle."[10]

The finished painting did not receive any prizes, for the jury chose, instead, to award a second-place medal to *The Tepidarium* (cat. 237). Chassériau, who felt offended, responded immediately by refusing the distinction. Evidently, *The Defense of Gaul* was not appreciated in official circles, although the artist's talent and originality continued to be held in high esteem. To be sure, the critics did not encourage the members of the jury or the political leaders to show any sympathy for the artist, whom they spoke of as a "lost member of Ingres's school" or as a "blind follower [who] imitates Delacroix." The reviews were severe, sprinkled with such terms as "pastiche," "delirium," or "decadence." Even Gautier[11] had reservations about the composition, complaining that the "brushwork is too apparent," and the gestures of the figures too "brusque," "dissonant," and "wild," like

"branches full of knots." Nevertheless, many others immediately recognized that Chassériau was a major artist, and they appreciated the qualities of this new type of history painting, calling it, "perhaps the most remarkable work ever produced by this artist,"[12] as beautiful as a Greek statue,[13] and every bit as good as a "page written by Michelet."[14] Thus, Chassériau's intentions—to execute a painting as realistic, evocative, and didactic as a page from history, while respecting classical models and the expression of violent emotions—do seem to have been fully understood by a perceptive few.

V. P.

1. The large-format picture, acquired for 8,000 francs and immediately designated to be placed on deposit in Clermont-Ferrand on August 24, 1858, ultimately arrived there on March 22, 1859 (Archives Nationales, F21/70, 437).
2. *The Tepidarium* (cat. 237), *Arab Tribal Chiefs Challenging Each Other in Single Combat* (cat. 190), *Arab Horsemen Removing Their Dead* (Cambridge, Massachusetts, Fogg Art Museum), and *Susanna and the Elders* (cat. 15); the jury's rejection of the *Macbeth and Banquo Encountering the Three Witches on the Heath* (cat. 200) was obviously a humiliation.
3. The unusually large format (about 17 x 10 ft.) made the painting very difficult to transport; it is exhibited today in a large room at the Musée des Beaux-Arts, Clermont-Ferrand, and can be taken down only by rolling it up, which seems inadvisable if one considers its present condition—its old relining having become extremely fragile.
4. Julius Caesar, *The Gallic Wars* (Book VII).
5. On the preliminary drawings for the large-format painting see Prat 1988-1, vol. 1, nos. 859–903, pp. 359–73.
6. *Study for the Head of the Gaul Holding an Ax* (London, Private collection).
7. *Two Studies for the Head of an Old Man and of a Young Man* (Clermont-Ferrand, Musée des Beaux-Arts; 2734).
8. *Study of an Arm* (Paris, Musée du Louvre; RF 3931).
9. "Here is the sketch representing the Gauls driving Caesar's legions from Clermont, then called Gergovia"; quoted in Bénédite 1931, p. 465.
10. Gautier 1857.
11. Gautier 1855.
12. Petroz 1855.
13. Gautier 1855.
14. About 1855, p. 187.

246

Head of a Man Turned Slightly Toward the Right, His Eyes Raised Heavenward

1854–55
Pen and brown ink, heightened with white, on grayish green paper
9 ⅛ x 7 in. (23.1 x 17.8 cm)
Paris, Private collection

PROVENANCE:
Studio of the painter (L. 443 mark lower right); Montholon family; sale, Paris, Hôtel Drouot, November 29, 1991, lot 62, cover ill.; Private collection, Paris.

BIBLIOGRAPHY:
Sandoz 1974, under no. 252; Prat 1988-2, no. 263; Prat 1996, pp. 578–80 and n. 26, ill. p. 572, fig. 9.

Exhibited in Paris only

This is the only known preparatory drawing for the head of Vercingétorix in *The Defense of Gaul.* Like the studies for the individual figures of the Gallic warriors (cat. 249, 250), it was executed with a reed pen whose broad tip facilitated the dark accents. The white highlights were achieved with a gouache-and-oil mixture, which gives the muscles and the planes of the face an extremely luminous quality.

By concentrating on the head of the model, Chassériau created a strong and highly expressive image. As described by Chevillard in 1893: "This prominent head, young and charming, is the bright focus of the picture; it dazzles like the haloed head of a martyr about to confess his faith and upon which falls a ray of divine glory."

Few of Chassériau's drawings, especially those of men's faces, convey such expressive power in combination with the ineffably smooth and delicate quality that is one of the hallmarks of his style.

Bénédite (1931, p. 468) mentions that the painter and engraver William Haussoulier (1818–1891) told Baron Arthur Chassériau that he had sat for the figure of Vercingétorix. He may very well have assumed the pose of the Gallic leader in Chassériau's studio, but it is unlikely that the artist reproduced his likeness here, for a known portrait drawing of Haussoullier by Chassériau (Prat 1988-2, no. 162, ill.) displays rather different features.

L.-A. P

247

Group of Nude Male Figures Advancing and Facing Front, with Corpses in the Foreground

1854–55
Graphite, heightened with oil, on four pieces of blue paper joined together
14 ¾ x 17 ¾ in. (37.5 x 45 cm)
Paris, Musée du Louvre (RF 26002–26005)

PROVENANCE:
See cat. 20.

BIBLIOGRAPHY:
Chevillard 1893, part of no. 420; Prat 1988-1, vol. 1, no. 867, ill.

Exhibited in Paris only

In the exhibition catalogue *Nos Ancêtres les Gaulois* (Our ancestors the Gauls) (Clermont-Ferrand, 1980, no. 15, ill.), M.-L. Hallopeau observed that, in this important study for the lower part of the 1855 painting *The Defense of*

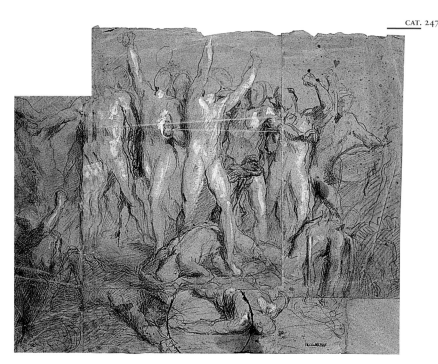

Before restoration

Gaul, the main figures are shown in their final form. In an earlier state of the drawing, the sheet on the left was poorly attached to the other three, but Hallopeau provided a more readable illustration in the form of a photomontage in which this left fragment was slightly lowered to match up with the other parts. The drawing was later restored to reflect this corrected arrangement.

L.-A. P

248

Head of a Horse, Seen Almost Frontally

1846–50 (?)
Black pencil and sanguine, heightened with white
11 ¼ x 16 ⅛ in. (28.7 x 40.9 cm)
Paris, Musée du Louvre (RF 24392)

PROVENANCE:
See cat. 20.

BIBLIOGRAPHY:
Chevillard 1893, part of no. 420; Bénédite 1931, vol. 1, ill. p. 219; Sandoz 1982, p. 40; Prat 1988-1, vol. 1, no. 864, ill.; Peltre 2001, p. 209, fig. 241.

EXHIBITIONS:
Paris, Galerie Dru, 1927, no. 103; Paris, Orangerie, 1933, no. 203; Paris, Louvre, 1980–81, no. 65.

Exhibited in New York only

The 1933 exhibition catalogue proposed a link between this study, drawn from life, and the horse at the center, in the middle ground of *The Defense of Gaul*. The two heads are, indeed, very similar, and the connection between this drawing and the painting would seem plausible—if not certain—were it not for the possibility that the present study may be dated somewhat earlier, between 1846 and 1850.
L.-A. P

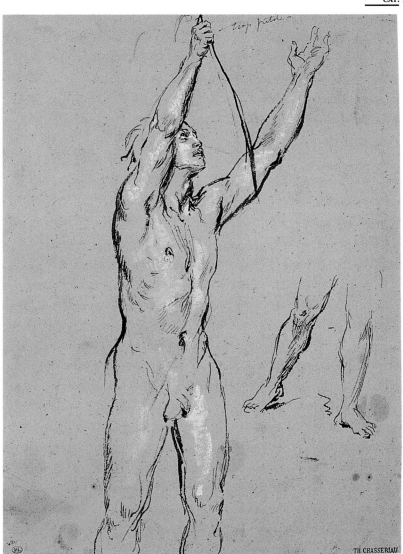

249

Nude Male Figure in Three-Quarter View, Turned Toward the Right, His Arms Raised and Holding a Bow; Study of Legs

1854–55
Pen and brown ink, heightened with oil, on beige paper
11 ½ x 8 ¾ in. (29.2 x 22.1 cm)
Inscribed in pen and brown ink, at the upper right: *trop petit* [too small]
Paris, Musée du Louvre (RF 24403)

PROVENANCE:
See cat. 20.

BIBLIOGRAPHY:
Chevillard 1893, part of no. 420; Bénédite 1931, vol. 2, ill. p. 466 (as in the museum in Clermont-Ferrand); Sandoz 1974, under no. 252; Prat 1988-1, vol. 1, no. 868, ill.

EXHIBITIONS:
Paris, Galerie Dru, 1927, no. 57, 58, or 59; Paris, Orangerie, 1933, no. 201.

Exhibited in New York only

In the final painting, the bow held by the figure in the present drawing, a study for the man at the center, in front of Vercingétorix's horse, would be replaced by a sword. This drawing, together with three others in the Louvre (Prat 1988-1, vol. 1, nos. 869–871, ill.), is part of a coherent group of studies for the figures in the painting, all done on the same paper and in the same technique. The group probably also included a drawing formerly in the

Mondésir collection, *Wounded Man* (Bénédite 1931, vol. 2, p. 470, ill.); today in a private collection in Paris, the study was for one of the figures of the dying at the bottom of the composition (see Prat 1988-2, no. 205, ill.).

L.-A. P

250

Nude Male Figure Seen from the Front, His Right Arm Outstretched; Study of a Left Leg

1854–55
Pen and brown ink, heightened with oil, on beige paper
11 ½ x 8 ¾ in. (29.2 x 22.1 cm)
Paris, Musée du Louvre (RF 24404 *bis*)

PROVENANCE:
See cat. 20.

BIBLIOGRAPHY:
Chevillard 1893, part of no. 420; Bénédite 1931, vol. 2, ill. p. 468 (as in the museum in Clermont-Ferrand); Sandoz 1974, under no. 252; Prat 1988-1, vol. 1, no. 870, ill.

EXHIBITIONS:
Paris, Galerie Dru, 1927, no. 57, 58, or 59; Paris, Orangerie, 1933, no. 200.

Exhibited in New York only

This is a study for the man in the painting in the foreground, at the left, holding an ax.

L.-A. P

251

Group of Women and Children on a Slope, Turned Toward the Left

1854–55
Graphite on grayish paper
24 x 18 ¼ in. (60.8 x 46.4 cm)
Inscribed in graphite, lower left (in an unknown hand):
pour le Vercingétorix
Paris, Musée du Louvre (RF 26038)

PROVENANCE:
See cat. 20.

BIBLIOGRAPHY:
Chevillard 1893, part of no. 420; Sandoz 1982, p. 38; Prat 1988-1, vol. 1, no. 893, ill.

EXHIBITION:
Paris, Louvre, 1980–81, no. 61.

Exhibited in New York only

This study for the group of women at the top right of the painting is closer to the sketch in Clermont-Ferrand (cat. 242) than to the final version. M.-L. Hallopeau (*Nos Ancêtres les Gaulois,* exhib. cat. [Clermont-Ferrand, 1980], no. 31) noted the influence of Tintoretto's *Massacre of the Innocents* (Venice, Scuola di San Rocco).

A sheet of studies for some of these figures is in the Musée des Beaux-Arts, Algiers (378/2, verso).

L.-A. P

CAT. 250

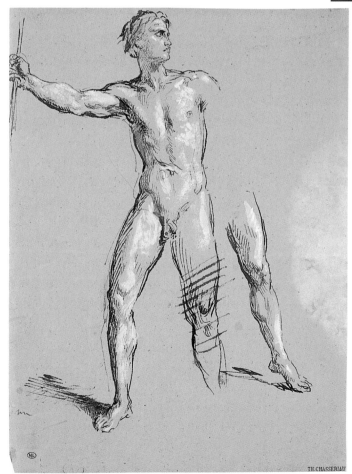

CAT. 251

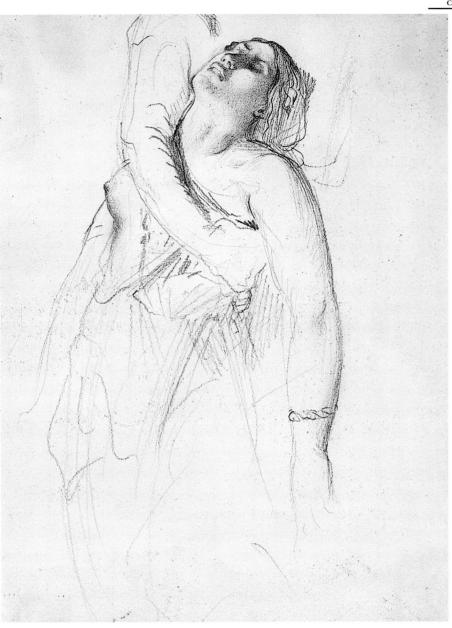

252

Fainting Woman, Supported by an Arm

1854
Graphite and *pierre noire*
10 ¼ x 7 ⅞ in. (26 x 20 cm)
Paris, Private collection

PROVENANCE:
Baron Arthur Chassériau, Paris, 1933; Jean-Louis Vaudoyer
(1883–1963); Private collection, Paris.

BIBLIOGRAPHY:
Bénédite 1931, vol. 1, ill. p. 207; Blanche 1933, ill. p. 1; Sandoz
1974, p. 78, fig. 29; Prat 1988-1, vol. 1, under no. 933; Prat 1988-2,
no. 204.

EXHIBITIONS:
Paris, Orangerie, 1933, no. 196, ill.; Paris, 1976, no. 40.

Exhibited in Paris and Strasbourg

Sandoz considered this to be a study of the "Dying
Lucretia," but, in fact, it is a drawing for the Gallic woman
at the upper left of *The Defense of Gaul*. Although she is
also shown frontally on a sheet of studies in the Louvre
(Prat 1988-1, vol. 1, no. 896, ill.), she is depicted as seen
from the back in the painting. The Louvre has a much
earlier drawing, from about 1840 (Prat 1988-1, vol. 1,
no. 993, ill.), of exactly the same figure, but there she is
shown being supported by a man. This was probably a
study on the theme of Brutus swearing to avenge Tarquin's
rape of Lucretia and her subsequent suicide.

Chassériau would often use the same figures for different
subjects, over a span of many years. L.-A. P

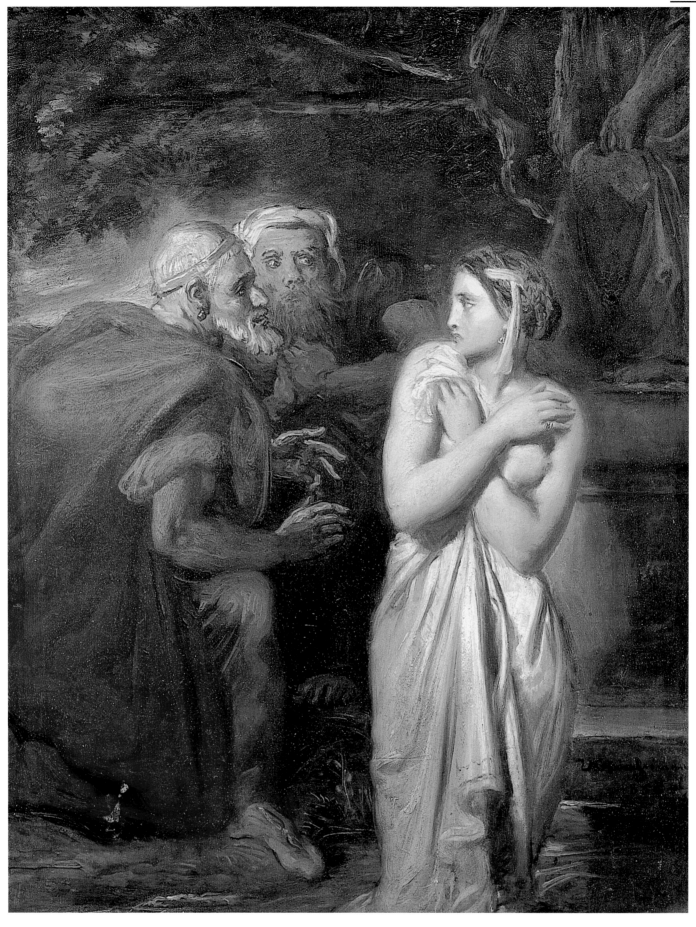

253

Susanna and the Elders

1856
Oil on wood
16 x 12 ⅜ in. (40.5 x 31.5 cm)
Signed and dated, lower right: *Th. Chassériau 1856*
Paris, Musée du Louvre (RF 3917)

PROVENANCE:
The Italian painter Alberto Pasini (1826–1899), before 1856 (according to Sterling, in Paris, Orangerie, 1933); Kann collection (according to Sterling, in Paris, Orangerie, 1933); Baron Arthur Chassériau, Paris; bequest of the latter to the Musée du Louvre, 1934.

BIBLIOGRAPHY:
Chevillard 1893, nos. 34, 222; Bénédite 1931, vol. 2, pp. 99, 466, 516, pl. 58; S.A.I. 324, ill.; Sandoz 1968, pp. 184–85; C.P., p. 76; Sandoz 1974, no. 262, p. 408, pl. 227, p. 409; Cat. Somm. Ill., 1986, vol. 3, p. 134, ill.

EXHIBITION:
Paris, Orangerie, 1933, no. 89, p. 44.

Although exhausted by his work in the apse of the Church of Saint-Philippe-du-Roule (cat. 232) and by his persistently fragile health—his treatments in Spa and in Boulogne produced no positive medical results—the thirty-seven-year-old Théodore Chassériau never thought that he would soon die. Thus, it would be erroneous to suppose that his recourse, in 1856, to subjects that he had treated in the previous eighteen years was inspired by any premonition of death. Like Delacroix at the same time, his growing success at the Salon and the requests from the many admirers of his work probably led him to execute new versions of the subjects that were responsible for his popularity.

In this last year of his life, he again took up the theme of Susanna and the Elders, with which he had begun his Salon career in 1839 (see cat. 15). Instead of depicting the scene of Susanna bathing alone under the elders' libidinous gaze, he chose the moment when the two old men approached her and tried to force her to yield to their advances. This iconography had a long tradition—Sandoz cited Van Dyck's painting in the Alte Pinakothek, Munich[1]—and was handled with great freedom by Chassériau. He opted for a more close-up viewpoint that brought out the sensual and diaphanous whiteness of Susanna's skin, which, in her surprise and fright, she tries to cover with a sheet, while the elders emerge from the left side of the composition, the violence inherent in their attitudes clearly expressing their ill intentions. The present composition is completely different from that of the 1839 version, and shows the painter's desire to reinvent the theme. Chassériau obviously seems to have drawn his inspiration directly from Victor Hugo's poem "Sara the Bather" in *Les Orientales*:

Dans une heure
D'un oeil ardent tu verras
Sortir du bain l'ingénue
Toute nue
Croisant ses mains sur ses bras!

In an hour
With ardent eye you will see
The innocent one emerging
Bare from her bath
Folding her hands on her arms!

In addition to the eroticism of the scene and its classical references, this work, although small in format, presents a dramatic tension between great sadness and latent anxiety. Chassériau apparently had not exhausted his ideas on how to approach this theme, for this version displays a thoroughgoing inventiveness. V. P.

1. Sandoz 1974, no. 262, p. 408.

254

Interior of a Harem

1856
Oil on canvas
21 ⅝ x 26 ⅛ in. (55 x 66.5 cm)
Paris, Musée du Louvre (RF 3918)

PROVENANCE:
Painted for a doctor who turned it down (according to Sterling, in Paris, Orangerie, 1933); studio of the painter until his death; Chassériau sale, Paris, Hôtel Drouot, March 16–17, 1857, lot 5 (sold for Fr 515, according to a copy of the sale catalogue in the Cabinet des Estampes, Bibliothèque Nationale de France, Yd 929 a, in-8°); Frédéric Chassériau, the artist's brother, Paris, until 1881; Baron Arthur Chassériau, Paris; bequest of the latter to the Musée du Louvre, 1934.

BIBLIOGRAPHY:
Gautier, 6th series 3 (1856); Mantz 1856; Du Pays 1857, p. 176; Chevillard 1893, no. 227; Tschudi 1900, p. 9; Marcel and Laran 1911, pp. 111–12, pl. 48; Vaillat 1913, pp. 220–24, ill. p. 32; Escholier 1921, pp. 106–7, ill. p. 107; Vaillat 1922, p. 7, ill.; Goodrich 1928, ill. p. 98; Bénédite 1931, vol. 2, p. 483, pl. 56; La Tourette 1931, pp. 188–90, ill. p. 183; Grappe 1933, p. 154, ill.; S.A.I. 330, ill.; C.P., p. 76; Sandoz 1974, p. 410, no. 265, pl. 230, p. 411; Cat. Somm. Ill., 1986, vol. 3, p. 134, ill.

EXHIBITIONS:
Paris, 1897, no. 21; Paris, 1900, no. 99; Paris, 1930, no. 107; Paris, Orangerie, 1933, no. 91.

Exhibited in Paris only

Executed in tandem with his other works on this subject, this last *Interior of a Harem* is generally dated to 1856. Sandoz did not question this date: Chassériau's oeuvre encompasses many unfinished oil paintings, as well as studies and sketches left in a more or less advanced state that, nevertheless, are very difficult to date with any precision. In the catalogue of the 1933 exhibition, Charles Sterling claims that the present painting was commissioned by a doctor—perhaps even Dr. Cabarrus, who was monitoring the painter's health at the time (see cat. 165)—but that he is supposed to have refused it, which would explain its unfinished state.[1] This is an interesting theory, but there is no evidence or precise information to support it. At any rate, the painting remained in the artist's studio until his death.

This composition seems to be the culmination of Chassériau's depiction of harem scenes (see cat. 181, 182): Here, two odalisques are resting after their baths, languidly reclining on inviting cushions, listening to music played by a slave in the background. The two women are richly attired, and are represented in very simple, ordinary poses that contrast with the more erotic indulgences in Chassériau's previous efforts in this vein. Yet, at the same time, this scene, which recalls Delacroix's *Women of Algiers* (Musée du Louvre), is much more suggestive than some of his Oriental nudes precisely because of the absence of nudity. Gautier, who seems to have discovered the painting at the posthumous auction of 1857, gave a

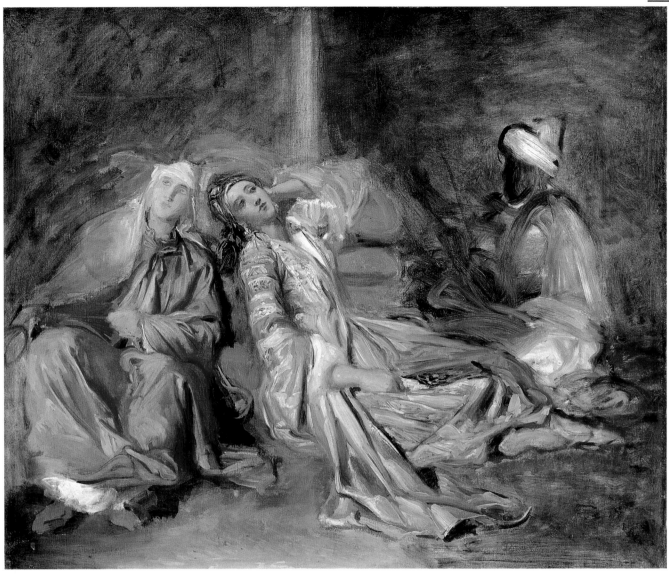

perfect description of the sober, poetic, and sensual atmosphere of this work: "The Interior of a Harem, although not completely finished in some parts, is nonetheless a delightful picture. Two women clad in shimmering costumes lean back on the cushions of a divan in poses betraying languor and fatigue, their gestures of nervous boredom induced by their seclusion and the presence of the black eunuch; the figure with her head thrown back, the most finished in the painting, is charming."[2] V. P.

1. C. Sterling, in Paris, Orangerie, 1933, no. 91, pp. 44–45.
2. T. Gautier, "Atelier de feu Théodore Chassériau," in *L'Artiste* (March 15, 1857).

255

Nude Male Figure Falling Down in Front of a Horseman

1855
Pen and brown ink, with graphite, on cream-colored paper
12 ⅛ x 9 ¼ in. (30.8 x 23.4 cm)
Paris, Musée du Louvre (RF 25803)

PROVENANCE:
See cat. 20.

BIBLIOGRAPHY:
Chevillard 1893, part of no. 420; Sandoz 1974, under no. 261; Prat 1988-1, vol. 1, no. 908, ill.

Exhibited in New York only

Many other studies by Chassériau for the *Emperor Augustus in Spain* are in the Louvre (Prat 1988-1, nos. 906–918, ill.), but this one, in pen and ink, is by far the most complete and the most spirited in execution.

In the painting, Emperor Augustus is shown raising the other arm. L.-A. P

CAT. 255

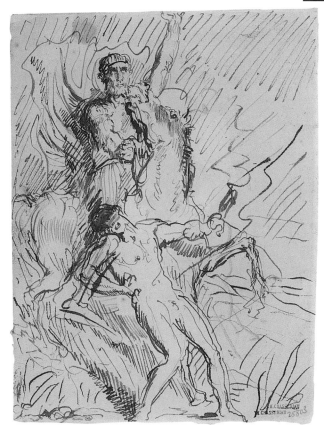

256

Emperor Augustus in Spain, formerly called Emperor and Slave Struck by Lightning

1855–56
Oil on canvas
53 ½ x 47 ⅞ in. (136 x 121 cm)
Rouen, Musée des Beaux-Arts (D. 963-1)

PROVENANCE:
Studio of the painter until his death; Baron Arthur Chassériau, Paris; bequest of the latter to the Musée du Louvre, 1934 (RF 3922); placed on deposit by the Musée du Louvre at the Musée des Beaux-Arts, Rouen, 1963.

BIBLIOGRAPHY:
Chevillard 1893, no. 211; Bénédite 1931, ill. p. 460; Vergnet-Ruiz and Laclotte 1962, index; Sandoz 1974, no. 261, p. 409, pl. 226; Prat 1988-1, vol. 1, nos. 906–918, pp. 373–78, vol. 2, autograph IV, p. 976; Bergot, Pessiot, Grandjean, and Pougetoux 1994, p. 70, ill. p. 71.

EXHIBITION:
Tokyo, Fukuoka, Sapporo, Shizuoka, Chiba, Kawasaki, and Osaka, 1993, no. 34, pp. 176–77.

In his catalogue raisonné,[1] Sandoz searched in vain for the sources of the iconography of this strange and violent work. He clearly was uncomfortable in his choice of a descriptive title for this "painted sketch": the apparition of an emperor from Antiquity on horseback and a torch-bearing slave struck by lightning during a nocturnal storm. After having searched through ancient history and mythology, the Chassériau biographer had to admit that the subject remained a mystery: "Neither the miraculous disappearance of Romulus . . . nor the miracle of Marcus Aurelius" fit the scene. Sandoz, nevertheless, had linked this work to many drawings in the Louvre, one of which even bore this revealing description of the present subject: "Make the slave holding his hand to his side consumed by lightning the torch extinguished by the water make the whole painting drip with rain the whole slave in the light on a dark background the emperor on horseback the horse proud and wild lit green by the lightning."[2]

This work is surprising because of its broad execution, its emphatic chiaroscuro, and the unmitigated violence of the scene, the central part of which—the group with the horseman and the thunderstruck slave—is masterfully and simply composed. One well might wonder if this is a sketch or a finished work. The technique is similar to that of many of the artist's oil paintings, which were given to the Louvre by Baron Arthur Chassériau and also present this ambiguity.[3] Throughout his career, Chassériau evidently seems to have been in the habit of jotting down his feelings and his pictorial and narrative ideas on canvas as well as on paper. Still, the large format of the painting and the ambitious execution seem to argue against the thesis that it is only a sketch; it must be an unfinished work—or else its exceptionally free technique was complete as far as its creator was concerned.

In any case, one has the impression that the painter, who was always on the lookout for original, rare, or novel subjects, wanted to depict a specific episode here.

While working on the inventory of Chassériau's drawings in the Louvre, Prat identified the subject of this important work. In 1988, he found an autograph document in the Département des Arts Graphiques[4] in which Chassériau himself described this subject during his trip to Italy in 1840—fifteen years before he began the painting. Writing about the origin of the name of the Roman temple of Jupiter Stator, which is supposed to have been built by Emperor Augustus, Chassériau noted: "Emperor Augustus was traveling in Spain one night, when a thunderstorm came up and the slave who was lighting his way was struck by lightning. Augustus had the temple built to commemorate this event." Thus, the scene represented a dramatic and sensational event in the emperor's life, during his campaign in Spain, between 26 and 19 B.C.

Continuing his research into the genesis of this work, one of the painter's last—it is generally dated 1855–56, at the same time or after *The Defense of Gaul*—Prat published thirteen preliminary drawings in his inventory. They demonstrate the tenacity with which Chassériau labored to depict the tormented body of the slave and the entanglement of this figure with that of the emperor on horseback. The different versions of the composition of the group, in the drawings and sketchbooks studied by Prat, show the artist's elaboration of the movement in the scene, which he wanted to make as animated as possible and as if transfigured by the rain and the light of the storm. Chassériau also emphasized the opposition between the emperor's calm resolve in the face of this divine wrath and the haplessness of the slave, who is struck by lightning. Many of these pen-and-ink or graphite drawings[5] appear to have been set down very briskly, as if the artist had been gripped by a sudden inspiration: He clearly seems to have identified with the suffering associated with this Antique subject, which became more than just a history painting for him. There is a superb pen-and-ink sketch (cat. 255) that presents a more finished and balanced vision of the scene, although it reveals several differences when compared with the painting: for example, the emperor gestures with his right arm (in the final version) and the general orientation of the action is toward the right.

Today, however, there is still some question about the meaning of this last work, whose—almost mystical—subject is so fantastic, tormented, and inspired that we can only suppose that it had a personal significance for Chassériau. Could it be that, just a few months before his death, he wished to offer an ultimate challenge to the gods, whom he accused of having shaped—and interfered too much in—his career? Did he want to irrevocably revise Neoclassical iconography and upset the academicism that tended to fossilize the treatment of classical subjects? Did he set out to paint an allegory with political undertones, alluding to slavery—the slave depicted here sacrifices his life to protect the emperor—at a time when this issue was being hotly debated?[6] Whatever the answer may be, this monumental and dramatic work, executed with great freedom and perfect mastery, puts to rest once and for all the debate of Chassériau's combined debts to the Romanticism and the palette of Delacroix, and the classicism and line of Ingres. Equaling the drama and spirituality of a work like Rubens's *Coup de Lance* in Antwerp or Delacroix's *Pietà* in the Church of Saint-Denis-du-Saint-Sacrement, Paris, Chassériau undeniably achieved an aesthetic maturity, originality, and independence that ensure him a place of honor among the ranks of the most innovative and creative artists of the nineteenth century. This scene taken from the life of Augustus by Chassériau turns a page in the literary and egocentric annals of Romanticism, opening up a new phase of the movement, a phase characterized by brutality, symbolism, and pantheism.　　　　V. P.

1. Sandoz 1974, no. 261, p. 408.
2. Paris, Musée du Louvre, Département des Arts Graphiques, RF 25806 (Prat 1988-2, no. 915, p. 379, ill. p. 377).
3. Some of the works in this style in the Louvre are: *Christ Lamenting over Jerusalem* (RF 3856), *The Good Samaritan* (RF 3860), *Jewish Wedding in Constantine* (RF 3893), and *Spahis Stopping at a River* (RF 3894).
4. Prat 1988-2, autograph IV, p. 976.
5. Ibid., nos. 911–918, pp. 374–78.
6. Frédéric Chassériau published (anonymously) a two-volume work on the abolition of slavery, *Précis de l'abolition de l'esclavage dans les colonies anglaises* (Paris, 1840). Clémence Monnerot, the first woman with whom Chassériau fell in love, had a nephew, Jules Niger, who was born in 1848 to a black slave and her brother Jean-François Marie—called Émile—a high official in Martinique (information kindly provided by Mme Maïotte Dauphine, director of the Centre d'Art Mémorial-Musée Paul Gauguin in Martinique). The Chassériau children seem to have grown up in a social environment in which interracial relationships were perfectly accepted, if disturbing, realities.

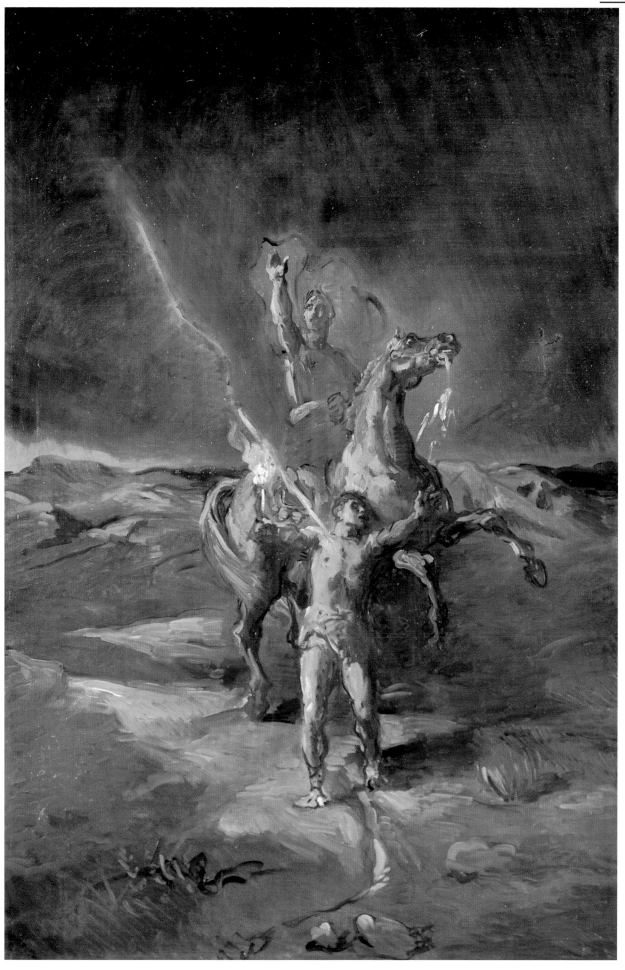

Chronology

1849–56

January 23

■ A Friend Named Meynard

Mme Monnerot writes to her son Jules that she has seen "the Chassériau ladies, who told me [that] Armand de Mesnard [sic] was not in Paris. Théodore told them a few days ago that he was in Paris. Received a letter, but does not know from where" (Letter from Mme Monnerot to her son Jules, January 23, 1849, Paris; BnF, Dépt. des Ms, Naf. 14405, Papiers Gobineau, vol. 17, fol. 112).

According to Clémence Monnerot, she and Théodore Chassériau had the same friends, namely: "Tocqueville, Tracy, Arthur de Livry, my cousin, and the Maynards [sic]" (Letter from the comtesse Arthur de Gobineau (née Clémence Monnerot) to [Valbert Chevillard], July 12, 1893, Paris; published in Bénédite 1931, vol. I, p. 102).

February 24

■ Cour des Comptes: A Lawsuit

Although, according to the administration, Chassériau had been paid the balance of the 30,000 francs allocated for the decorations in the stairwell (see above, *March 9, 1848*), he hires a lawyer to recover that amount he claims is still owed to him (Memorandum from the Directeur des Beaux-Arts at the Ministry of the Interior to L. Varin, attorney-at-law, February 24, 1849, Paris; AN, F21. 4402, dossier 13).

March 1–April 1

■ *Arabs Going to War*

Chassériau sees that the engraving of his *Arabs Going to War* is printed in *L'Artiste* (March 1, 1849, p. 205; April 1, 1849, p. 16).

April–May

■ The Artists' National Lottery

According to Sandoz (1974, no. 126, p. 260), Chassériau's *King Lear Throwing Himself on the Body of His Daughter Cordelia* (whereabouts unknown) was number 51 in the exhibition held by the Association des Artistes; the exhibition catalogue, however, lists a painting by Meissonnier under this number. In the *Catalogue des objets d'art acquis jusqu'à ce jour pour la loterie nationale des artistes,* prepared after the exhibition, Chassériau's *King Lear* is number 92.

May 3

■ Chevalier de la Légion d'Honneur

After the completion of his "great work" at the Cour des Comptes, Chassériau is made a Chevalier of the Legion of Honor (AN, L0500062; Chevillard 1893, p. 150).

June 1–16

■ Nerval and the Portrait of Gautier

On June 1, *L'Artiste* prints the engraving by A. Bodin after Chassériau's portrait of Théophile Gautier. Two weeks later, Gérard de Nerval writes to Gautier: "Your portrait appeared in l'Artiste; it looks good" (Letter from Gérard de Nerval to Théophile Gautier, June 16, 1849 [Paris]; published in Gautier, *Correspondance,* 1989, vol. 4, no. 1260, p. 33). Gautier is shown "frontally, dressed in a Turkish vest, his fine moustache dividing his beardless face, his hair framing his broad forehead and falling in graceful waves on his athletic shoulders, with an air both magnificent and insolent" (Chevillard 1893, no. 278, pp. 158–59, 303; Prat 1988-2, no. 67, p. 17).

June 24

■ Arthur de Gobineau

Mme Monnerot mentions Frédéric Chassériau's visit and adds: "Théodore went to see Arthur at his Office. He will come to visit us. Angele Beloc and the Chasseriau ladies are delighted for Clémence. They send you all their best" (Letter from Mme Monnerot to her son Jules, June 24, 1849, Paris; BnF, Dépt. des Ms, Naf. 14405, Papiers Gobineau, vol. 17, fol. 120).

Arthur de Gobineau, who had married Clémence Monnerot on September 10, 1846, had just been appointed to head Tocqueville's cabinet, shortly after the latter joined the government on June 2, 1849.

July 21

■ Cour des Comptes: Litigation (continuation and end)

Varin, "attorney-at-law of the Court of First Instance," informs the Minister of the Interior that he has had "the honor in my letter of June 30, 1849 [of requesting] details of the sums owed to M. Chasseriau, artist, on account of the work done by him for the State in various locations, and particularly in the Palais du Quai d'Orsay." He concludes with a veiled threat: "If certification is necessary, we will send you a stamped letter" (Letter from L. Varin to the Minister of the Interior, July [21], 1849, Paris; AN, F21. 4402, dossier 13).

August 1–4

■ Commission for a Painting: *The Sleeping Nymph*

The Directeur des Beaux-Arts notifies Chassériau that he has been "entrusted by the Ministry of the Interior to execute a painting, the subject and sketch of which you will have to submit to the administration for approval; the whole for a sum of six thousand francs, payable in two installments in 1849 and 1850" (Copy of a letter from the Directeur des Beaux-Arts to Théodore Chassériau, August 4, 1849, Paris; AN, F21. 20, dossier 54).

Chassériau would paint the *Bather Sleeping near a Spring* (cat. 173), which he signed and dated, "Th^re Chassériau 1850," and exhibited at the Salon of 1850–51 (see below, *December 30, 1850*). The picture would be sent to the museum in Avignon on August 8, 1851 (see below). The model was Alice Ozy (Sandoz 1974, no. 154, p. 298). A different title, given by the administration, appears on the cover of the file in the Archives Nationales: "M. Chasseriau, avenue Frochot, 28, rue Bréda / Tableau: / Nymphe endormie près d'une / Source. / Musée d'Avignon, / (Vaucluse.) / 1 aout 1849 / 6000,00 francs."

August 31

■ Twelve Hours in Jail

As a member of the Second Legion of the Parisian National Guard, Théodore Chassériau is summoned before the discipline council and sentenced to "12 hours in jail." The exact reason remains unknown, but might have been for abandoning his post or refusing to respond to a summons (AN, BB21. 535). The sentence would be suspended on December 10, 1850 (see below). Among the more famous members of his unit were Léon Gozlan and Prosper Enfantin.

October 12

■ Janin's *Bacchante*

Jules Janin writes to his wife: "When you come back (if only it were tomorrow!), you will find a rather nice painting by your [illegible] Chassériau [?] representing a Bacchante. The colors are lovely and natural, and the frame quite handsome! If you want it, and if you have room, I will give you this little painting, otherwise I will keep it for myself. I found a little spot for it in my study"

(Letter from Jules Janin to his wife, Adèle [née Huet], October 12, 1849 [Paris]; published in Janin 1973, vol. 1, p. 467).

■ Stained-glass Windows for M. de C.

At an uncertain date—1849, according to Sandoz (1974, no. 149, p. 292)—Chassériau executes sketches for two stained-glass windows representing *Homer and Virgil* and *Raphael and Michelangelo* (Chevillard 1893, nos. 421–422, p. 319). These subjects appear in a heavily annotated notebook (in the Musée du Louvre), whose attribution to Chassériau is rightly rejected by Louis-Antoine Prat. The notebook does, however, mention the name "M. de Canagna," which might correspond to the "M. de C" mentioned by Chevillard (Prat 1988-1, vol. 1, p. 985, fol. 19 r.).

■ The Montmorency Church

According to Chevillard (1893, no. 423, p. 319), Chassériau was involved in the restoration of the stained-glass windows in this church. Prat published a number of annotated drawings that may be related to the windows, but the handwriting is not Chassériau's (Prat 1988-1, vol. 1, no. 2237, pp. 848–49, 983–87, fol. 2 v.).

■ 1850

January 3

■ The Salle de Diane: Decorative Project

The Ministry of the Interior informs the Ministry of Public Works that, with the approval of Jeanron, Director General of Museums, Chassériau has offered his services to decorate the "Salle de Diane" on the ground floor of the Louvre. He asks to "have M. Duban, the architect of the Louvre, draw up a decorative plan that would accommodate Chassériau's paintings" (Copy of a letter from the Minister of the Interior to the Minister of Public Works, January 3, 1850, Paris; AN, F21. 567, dossier 2).

January 6

■ The Salle de Diane: First Rejection

The Minister of Public Works replies to the Minister of the Interior's request (see above, *January 3, 1850*) saying that he does not have at his disposal the funds needed for the "preliminary repairs of the vaults of the Gallery." There is thus no reason to "take up M. Chassériau's offer" (Letter from the Minister of Public Works to the Minister of the Interior, January 6, 1850, Paris; AN, F21. 70, dossier 11).

June 7

■ *Portrait of Tocqueville*

Alexis de Tocqueville ends his letter to Corcelle with: "Madame de Tocqueville especially wants me to send you and Madame Corcelle her greetings. She wants me to tell the latter that if she has time to go with you to Chassériau's studio to give her opinion of the portrait of me that he is finishing at the moment, it would give [her] great pleasure" (Letter from Alexis de Tocqueville to Francisque de Corcelle, June 7, 1850, Tocqueville; published in *Correspondance Tocqueville,* 1983, vol. 15, p. 24).

The portrait referred to is the painted version in the museum at Versailles (cat. 204), signed and dated, "Th^re Chassériau / 1850" (Sandoz 1974, no. 155, p. 300).

August 21

■ Balzac's Funeral

Chassériau's presence at Balzac's funeral at Père-Lachaise Cemetery is documented, as is that of Victor Hugo, Alexandre Dumas, Gérard de Nerval, the painters Couture and Gudin, the sculptors Préault, Etex, and David d'Angers, and the goldsmith Froment-Meurice (*L'Union*, Thursday, August 22, 1850; quoted in Pierrot 1999, p. 309).

September 18 (?)

■ Salle de Diane: Another Try

Eight months after his proposal for the Salle de Diane was turned down (see above, *January 6, 1850*), Chassériau tries to obtain the support of Comte Horace de Vieil Castel (1798–1864), a writer well connected to the Administration des Beaux-Arts. He asks for an appointment, making a point of saying: "The minister is well disposed. His cabinet head, who saw my work at the Conseil d'État, considers it fair and fitting that, as he is pleased with my work, I should be given more. Mr de Longpérier, Director of Antiquities and one of my friends, would like me to decorate the Salle de Diane, the only side of the museum of antiquities without decoration (Neuverkerke [*sic*] also agrees)" (Fragment of a letter from Théodore Chassériau to [Horace de Vieil Castel], Wednesday [September 18 (?), 1850, Paris]; AN, F21. 567, dossier 2).

September 25

■ Salle de Diane: Agreement in Principle

Horace de Vieil Castel answers Chassériau's

letter (see above), saying that "Nieuwerkerke . . . has no objections to the salle de Diane. . . . And so go ahead, there is no opposition & you know that we have no ill will" (Letter from Horace de Vieil Castel to [Théodore] Chassériau, September 25, 1850, Paris; AN, F21. 567, dossier 2). This letter was attached to Théodore Chassériau's (of September 18, 1850) by Frédéric Chassériau when he wrote to the Minister of the Interior the following month (see below, *October 18, 1850*).

October

■ Trip to Amboise

Chassériau's trip is documented by two drawings, one of which probably depicts the house in which Leonardo da Vinci spent his last years. The other bears the annotation: "la rue qui finit au fond éclaire les murailles dorées en bas en haut les pierres blanches vertes et rousses les toits en ardoises noirâtre [the street which ends in the distance illuminates the golden walls below; above, the white, green, and red stones, the roofs of black slate]—Amboise, Obre 1850" (Chevillard 1893, p. 230; Prat 1988-1, vol. 2, p. 946, folios 8 v., 9 r.).

October 18

■ Salle de Diane: Appointment with the Minister

On the letterhead of the "Ministry of the Navy and the Colonies," Frédéric Chassériau writes to the Minister of the Interior to thank him for the appointment granted him the day before: "After the observations that the Director of Museums made to him, my brother quickly gave up the idea of painting the ceiling of the pastel room. Today, in agreement with M. de Nieukerke [*sic*] . . . , my brother has set his sights on another room, for which I am so bold as to solicit of your kindness, personally guaranteeing the care with

which he will accomplish his task" (Letter from Frédéric Chassériau to the Minister of the Interior, October 18, 1850; FM signature; AN, F21. 567, dossier 2).

■ Salle de Diane (continued)

Writing on the letterhead of the "Ministry of the Navy and the Colonies," Frédéric Chassériau tells the Directeur des Beaux-Arts that he found the Minister of the Interior "most favorably disposed . . . toward my brother for the decoration of the Salle de Diane" (Letter from Frédéric Chassériau to the Directeur des Beaux-Arts, October 18, 1850, Paris; AN, F21. 567, dossier 2).

October 30

■ Salle de Diane: Political Guarantees

On the letterhead of the "Ministry of the Navy and the Colonies," Frédéric Chassériau writes to an unidentified colleague: "At the Navy & in his Cabinet, Monsieur Baroche has been kind enough to promise my brother the Salle de <u>Diane</u>. . . . You have seen the murals in which my brother so rigorously and so fittingly personified <u>force & order</u>.—After yours, I know that this is the best recommendation, & I am not worried" (Letter from Frédéric Chassériau to an unknown correspondent, October 30, 1850, Paris; FM signature; AN, F21. 567, dossier 2).

Early November

■ The Next Salon: Chassériau as Vulcan

Eugène Isabey describes his preparations for the coming Salon to the landscape painter Vincent Vidal (1811–1887): "My good man Vidal, we have no time to write you, the Palettes are burning, chasseriau is a Vulcan scorching his canvas with the fire in his brush, we are working like mules."

Chassériau concludes this joint letter: "My dear Vidal, Isabey was waiting for things to be set before answering.—At the moment everything is fixed for <u>the 15th of November when</u> we have to be <u>finished</u> and send our pictures in" (Letter from Eugène Isabey and Théodore Chassériau to Vincent Vidal [early November 1850, Paris]; Institut Néerlandais, Fondation Custodia, Inv. 1988-A 860).

Théodore is alluding to the deadline for submitting pictures to the Salon of 1850, scheduled to open early that year only, on December 1 (see below).

November 15

■ Information for the Palais National

Chassériau fills out the forms for the catalogue of the Salon of 1850–51. Strangely, he gives "1820" as the year of his birth. The titles of his works are printed as he indicates (see below, *December 30, 1850*). Chassériau mentions that the "Sappho," "Desdemona," and "Fisherman's Wife" belong to Mr G[ras] and the "Woman and Little girl" to "Mr D— de L—," but this information does not appear in the catalogue (Archives des Musées Nationaux, *KK 103, fol. 87, "Salon de 1850–51, Notices de la peinture").

Late November

■ Salle de Diane: Nieuwerkerke's Intervention

Horace de Vieil Castel reassures Frédéric Chassériau that "Nieukerke [sic]. . . will talk to the Minister . . . and so your problem is solved" (Letter from Horace de Vieil Castel to Frédéric Chassériau [late November 1850, Paris]; AN, F21. 567, dossier 2).

December 5

■ Salle de Diane: End of the Obstacles

On the letterhead of the "Ministry of the Navy and the Colonies," Frédéric Chassériau writes to the Directeur des Beaux-Arts: "I have the honor of writing to the Minister to inform him that all obstacles on the part of the Louvre have been removed" (Letter from Frédéric Chassériau to the Directeur des Beaux-Arts, December 5, 1850, Paris; FM signature; AN, F21. 567, dossier 2).

■ A Time for Gratitude

On the letterhead of the "Ministry of the Navy and the Colonies," Frédéric Chassériau warmly thanks the Minister of the Interior. "The obstacles presented by the Louvre have been lifted, thanks to explanations exchanged among the Director of Museums, the architect of the Palace, and my brother" (Letter from Frédéric Chassériau to the Minister of the Interior, December 5, 1850, Paris; FM signature; AN, F21. 567, dossier 2).

December 9

■ Salle de Diane: The Minister's Agreement

On the letterhead of the "Ministry of the Navy and the Colonies," Frédéric Chassériau thanks the Minister of the Interior: "M. De Besplas tells me that you are determined to follow through on your favorable intentions toward my brother. . . . My brother cannot fail to produce a work worthy of the Minister, whose confidence flatters & touches him—worthy also of the Palace, which is one of our national glories" (Letter from Frédéric Chassériau to the Minister of the Interior, December 9, 1850, Paris; FM signature; AN, F21. 567, dossier 2).

December 10

■ Suspended Sentence

After having been condemned by the National Guard to a 12-hour jail sentence on August 31, 1849 (see above), Théodore Chassériau's sentence is suspended by the president of the Republic (AN, BB21. 535, "Extrait du registre des délibérations de la commission des recours en grâce").

December 13

■ Salle de Diane: Sketches

The Minister of the Interior replies to Frédéric Chassériau's letter of December 5, 1850 (see above), saying that Théodore has to come to an agreement with Duban and his sketches must be "approved by the administration" (Copy of a letter from the Minister of the Interior to Frédéric Chassériau, December 13, 1850, Paris; AN, F21. 567, dossier 2).

December 18

■ Salle de Diane: Agreement with Duban

The Directeur des Beaux-Arts explains to Nieuwerkerke, director of the Musées Nationaux, that Chassériau will have to "come to an agreement with Duban and submit his projects and sketches to him" (Copy of a letter from the director of the Beaux-Arts to Nieuwerkerke, Directeur des Musées Nationaux, December 18, 1850, Paris; AN, F21. 567, dossier 2).

December 19

■ Salle de Diane: A New Agreement

In his reply to the Directeur des Beaux-Arts, Nieuwerkerke (see above) says: "The ornamentation is necessarily decided by the architect, but, these agreements having been reached, I see no objection to Mr Chassériau's being given the work he has requested" (Letter from Nieuwerkerke, director of the Musées Nationaux, to the Directeur des Beaux-Arts, December 19, 1850, Paris; AN, F21. 567, dossier 2).

The commission would ultimately be dropped (see below, *October 10, 1851*).

December 30

■ The Salon of 1850–51

The exhibition catalogue (*Explication des ouvrages de peinture, sculpture, architecture, gravure et lithographie des artistes vivants exposés au Palais national le 30 décembre 1850* [Paris, 1850], p. 64) lists the following:

Chassériau (Théodore), 26, *rue de Laval, avenue Frochot.*—✤

[no.] 533—Arab Horsemen Removing Their Dead After an Engagement with the Spahis (68 ⅛ x 91 ⅜ in.; Sandoz 1974, no. 174, p. 316).

[no.] 534—Bather Sleeping near a Spring (M.I.) (54 x 82 ⅛ in.; Sandoz 1974, no. 154, p. 298; cat. 173).

[no.] 535—Sappho (10 ⅞ x 8 ½ in.; Sandoz 1974, no. 128, p. 262; cat. 170).

[no.] 536—Desdemona (16 ⅝ x 12 ¾ in.; Sandoz 1974, no. 119, pp. 252–53; cat. 196).

[no.] 537—Fisherman's Wife from Mola di Gaeta Kissing Her Child (6 ⅞ x 4 ¾ in.; Sandoz 1974, no. 135, pp. 272–74).

[no.] 538—Woman and Little Girl from Constantine with a Gazelle (11 ⅜ x 14 ⅛ in.; Sandoz 1974, no. 138, p. 276; cat. 178).

[no.] 539—Portrait of M. A. de T . . . [Alexis de Tocqueville] (64 ⅛ x 51 ⅛ in.; Sandoz 1974, no. 155, p. 300; cat. 204).

[no.] 540—Idem of Mme M. de S . . . [Mme de Savigny (?)] (Sandoz 1974, no. 157, p. 304).

✤ Chevalier of the National Order of the Legion of Honor.

[EX] indicates Artists whose works were accepted without examination, pursuant to art. 10, chap. 2.

(M.I.) indicates works commissioned by the Ministry of the Interior.

■ **Rehanging**

Chassériau's name and the works numbered 535 to 539 appear on an undated document entitled "List of paintings exhibited in the ground-floor rooms and selected to be moved to the first floor" (Archives des Musées Nationaux, dossier 10, Salon de 1851, "Jury").

■ **Chassériau vs. Ozy:** *Rupture with a Knife*

The duration of the relationship between Chassériau and Alice Ozy is not known. Laran (1911, p. 96); claims it lasted "two years" (Peltre 2001, p. 23). The reasons for their rift, as reported by Chevillard in 1893, are better known. One day, Alice Ozy saw the El Greco copy that Chassériau had painted in Ingres's studio (see above, *September 1830* and cat. 5) and wanted to have it. The painter refused, but "she was a woman who always got what she desired, however outrageous it might be. He resisted a long time, offered other pictures, everything in his studio, but by some natural inclination of the female soul, the more he resisted, the more obstinate she became. In the end, he vehemently refused, then suddenly capitulated." She left with the picture. Soon after, Chassériau visited his mistress's apartment: "Seeing the work that had been torn away from him, the painter was suddenly struck with regret. He felt shame at his weakness, and had a fit of rage: Seizing a knife, he slashed the face in the portrait several times, then disappeared" (Chevillard 1893, pp. 168–71; Bénédite 1931, vol. 2, pp. 390–92).

The break was final. Ozy sent the damaged picture back and Chassériau had it restored (Note by Aglaüs Bouvenne, n.p., March 1884; Musée du Louvre, Département des Peintures, Service d'Étude et de Documentation, Fichier Moreau-Nélaton).

■ **Saint-Roch: The Commission (?)**

The exact date of the commission for two paintings intended for the baptismal fonts in the Church of Saint-Roch is unknown (see below, *July 13, 1851*).

■ **Gustave Moreau and the Avenue Frochot**

The young painter Gustave Moreau takes a studio on the Avenue Frochot, a few steps from Théodore Chassériau's (Bénédite 1931, vol. 1, p. 87, Centorame 1999, pp. 110–11; Guégan 2001, p. 253).

■ **1851**

January 1

■ **New Year's Day**

Chassériau draws the portrait of the deputy Comte Victor Destutt de Tracy (1781–1864) (son of the famous philosopher, who had died in 1836), which he dedicates, signs, and dates, "à madame de Magnoncourt / Thre Chassériau / c[e] 1ᵉʳ 1851 janvier (cat. 206)." Mary de Magnoncourt, Destutt de Tracy's daughter, had married in 1835 (Prat 1988-1, vol. 1, nos. 689, 1077, pp. 310, 441–42); also in 1851, Chassériau drew the portrait of her sixteen-year-old son, Raymond (Sandoz 1986, no. 93, p. 109; Prat 1988-2, no. 173, p. 25; cat. 207). Victor Destutt de Tracy was Minister of the Navy and the Colonies from December 20, 1848, to October 1849, and Frédéric Chassériau was head of his cabinet. Théodore would visit the Destutt de Tracys in Paray-le-Frésil in 1852 (see below, *Late August or early September*).

January 16 and 21

■ **Commission for Eight Thousand Francs**

A decree "in the name of the French people" stipulates that: "M. Th. Chassériau, painter, is entrusted with the execution of a painting for the Ministry of the Interior for the sum of eight thousand francs, to be drawn from the budget for art and decoration of public buildings, whose subject he must submit to our approval" (Decree of the Minister of the Interior, January 16, 1851, Paris; AN, F²¹. 70, dossier 11). The decree is crossed out, and the following notation was added in the left-hand margin: "Replaced / by the Commission / of February 28 / 1852," and at the upper right, "10,000."

The Directeur des Beaux-Arts officially notifies Chassériau of the above on January 21. The letter ends: "I must advise you that, pursuant to a general measure, your work will be accepted only if it is executed in a satisfactory manner" (Copy of a letter from the Minister of the Interior to Théodore Chassériau, January 21, 1851, Paris; AN, F²¹. 70, dossier 11; Bénédite 1931, vol. 2, pp. 449–51). (On this commission see below, *October 10* and *November 22, 1851*.)

Bénédite (1931, vol. 2, p. 466) wonders if Chassériau was not already planning his *Defense of Gaul* at this time (see below, *August 11, 1853*).

February 17

■ **Chassériau and Lecoq de Boisbaudran**

Horace Lecoq de Boisbaudran (1802–1897) sends a letter to the inspector of the Musées Nationaux in which he regrets that "on two occasions, his little painting [*The Magdalene in the Desert*]" was hung in the darkest places— "the black cabinet"—of the Salon of 1850–51. When "the rehanging is done," he hopes to be given a "proportional compensation," that is, a place of honor.

At the top left of Lecoq de Boisbaudran's letter, the name "M. Chasseriau" appears—written in a different hand and ink. Based on the other letters of complaint in the files of the Salon of 1850–51, this indicates that Chassériau seconded the request (Letter from H. Lecoq de Boisbaudran to Charles Séchan, inspector of the Musées Nationaux, February 17, 1851, Paris; Archives des Musées Nationaux, dossier 10, Salon 1851, dossier "Correspondance"). In a sketchbook used by Chassériau from about 1848 to 1852 is the following note: "Quai des Augustins N° 11 Mr de Bois—baudran—Mr Orson et Mezon, rue de Paris—550—950—14850" (Prat 1988-1, vol. 2, p. 949, fol. 3 v.).

March 15

■ **Moorish Women of Constantine**

L'Artiste publishes A. Masson's soft-ground etching of Chassériau's painting *Woman and Little Girl from Constantine with a Gazelle* (cat. 178), which had been shown at the Salon of 1850–51 (*L'Artiste* 6, March 15, 1851, p. 64; Sandoz 1974, no. 292, p. 436; Fisher, in Baltimore, 1979–80, no. 29, p. 156).

April

■ *Lord Lytton (?)*

Chassériau draws the portrait of a man whom Sandoz suggests may have been Lord Lytton (1831–1891), a poet and notorious dandy, and signs and dates it, "Th. Chassériau / avril 1851." Lytton would become England's ambassador to France during the Second Empire (Sandoz 1986, no. 43, p. 57; Prat 1988-1, vol. 1, no. 1078, p. 443).

May 21

■ **Portrait of an Unidentified Woman**

Chassériau draws the portrait of a young woman and—atypically— it is "signed with the exact date, May 21, 1851" (Prat 1999, pp. 76–77).

July 13

■ **Saint-Roch: Work Begins (?)**

The date and circumstances surrounding the commission for the decoration of the baptismal chapel in the Church of Saint-Roch are not known. The figure of Saint Philip is dated "1853." By the end of 1851, Chassériau would claim that his "work at St Roch" was taking up all his time (Letter from Théodore Chassériau to an unidentified correspondent, October 11, 1851, Paris; Institut Néerlandais, Fondation Custodia, Inv. J. 8053). The first reviews would not appear until March 1854, and so the commission might date back to 1850 (Bénédite 1931, vol. 2, p. 435; Sandoz 1974, p. 366; Foucart, Moulinat, and Brunel 1992, p. 7; Peltre 2001, p. 174; see above, *December 30, 1850*). There is an undated note by Chassériau on the flyleaf of an album: "90—27 to be deducted from the salary July 13—beginning of work at St Roch—album" (Sandoz 1974, p. 366; Prat 1988-1, vol. 2, p. 817).

July 23

■ **The Upcoming Exhibition in Bordeaux**

Chassériau asks his dealer Adrien Beugniet to give his "painting to Durand, whom I have asked to send it to Bordeaux during the day tomorrow" (Letter from Théodore Chassériau to Adrien Beugniet, Wednesday, July 23 [1851, Paris]; Bibliothèque d'Art et d'Archéologie Jacques Doucet, Carton 8, Peintres, Mf. 3, nos. 2617–2618). This refers to the exhibition organized by the Société des Amis des Arts in Bordeaux (see below, *November 15, 1851*).

August 8

■ The *Bather Sleeping near a Spring* Is Given to the Museum in Avignon

The painting, commissioned by the Ministry of the Interior on August 1, 1849, and shown at the Salon of 1850–51 (see above, *December 30, 1850,* and cat. 173), is given to the museum in Avignon in a decree dated August 8, 1851. Its presence in Avignon is documented on September 6 (AN, F²¹. 436, dossier 17). The title of the painting in the decrees of August 1–4, 1849, and August 8, 1851—*Nymph Sleeping near a Spring*—is different from the one provided by Chassériau to the Salon of 1850–51.

October 9

■ Corréa, a Pupil

Chassériau asks the director of the Musée du Louvre to grant his pupil "Mʳ Guillaume Corréa . . . a pass to study the masters" (Letter from Théodore Chassériau to the director of the Musée du Louvre, October 9, 1851 [Paris]; J.-M. Chassériau Collection, new transcription provided by J.-B. Nouvion).

October 10

■ The Apse of Saint-Philippe-du-Roule

On the letterhead of the "Ministry of the Navy and the Colonies," Frédéric Chassériau writes to the Directeur des Beaux-Arts to say that he is forwarding a letter from his brother, "recommending it to your favorable consideration and personally guaranteeing that he will do justice to it with a great & handsome work" (Letter from Frédéric Chassériau to the Directeur des Beaux-Arts, October 10, 1851, Paris; FM signature; AN, F²¹. 70, dossier 12).

In Théodore's letter, he tells the Directeur des Beaux-Arts that "the eight thousand francs for a work commissioned by the Minister of the Interior on January 21, 1851, was given to me with the option of transferring the attribution of this sum to a monumental painting. Having given up my hopes of painting the gallery in the Louvre that had been promised to me, I am now offering to paint the hemicycle in the Church of Sᵗ Philippe du Roule. . . . The extra sum needed, in addition

to the one that I already have, would be 7 thousand francs, thus bringing the total to fifteen. I believe, M. director, that it is a token of my devotion to promise to do it for this price. The architect of the city told me this morning that this project was estimated at forty thousand by the prefecture" (Letter from Théodore Chassériau to the Directeur des Beaux-Arts, October 10, 1851 [Paris]; AN, F²¹. 70, dossier 12).

November 15

■ Exhibition of the Société des Amis des Arts in Bordeaux

Chassériau participates in the first exhibition held by the Société des Amis des Arts (Dussol 1997, p. 21). The exhibition catalogue (*Explication des ouvrages de peinture, sculpture, architecture, gravure et lithographie des artistes vivants exposés dans la Galerie de la Société des Amis des Arts de Bordeaux, le 15 novembre 1851* [Bordeaux, 1851], p. 22) lists the following:

Chassériau (Théodore), ✿ in Paris, rue Bréda, avenue Frochot

[no.] 100.—Arab Horsemen Removing Their Dead After an Engagement with the Spahis (68 ⅛ x 91 ⅜ in.; Sandoz 1974, no. 174, p. 316).

[no.] 101.—*Arab Horsemen at a Fountain (31 ⅞ x 25 ⅝ in.; Sandoz 1974, no. 170, p. 312; cat. 186).

[no.] 102.—Mazeppa (18 ⅛ x 14 ⅝ in.; Sandoz 1974, no. 131, p. 266; cat. 203).

[no.] 103.—*Desdemona (16 ⅛ x 12 ¼ in.; Sandoz 1974, no. 119, pp. 252–53; cat. 196).

[no.] 104.—*Portrait.

[no.] 105.—*Women from Arles: Study (13 ⅜ x 9 ⅞ in.; Sandoz 1974, no. 201, p. 336).

✿ Chevalier of the order of the Legion of Honor

* indicates works that are not for sale.

November 22

■ Saint-Philippe-du-Roule (continued)

The Minister of the Interior relays his support of Chassériau's offer (see above, *October 10, 1851*) to the Prefect of the Seine: "This is a very big project, as you know; it has been estimated at not less than forty thousand francs: however, M. Chassériau offers to execute it for fifteen thou-

sand francs. I would therefore be inclined to accept his offer if the city of Paris agrees to contribute seven thousand francs to defray the costs, being ready myself to allot the sum of eight thousand francs to the execution of these paintings. I must add that it would be indispensable for the city of Paris to undertake all the material costs, such as cement, scaffolding, etc." (Copy of a letter of the Minister of the Interior to the Prefect of the Seine, November 22, 1851, Paris; AN, F²¹. 70, dossier 12).

December 3

■ Tocqueville and the Coup d'État

Deputy Alexis de Tocqueville is among the fifty representatives taken in police wagons to Vincennes. That evening, "he received a release order signed by the prefect of police, a favor due to the intervention either of his friend Janvier or of Chassériau, the painter's brother. He refused to leave before his colleagues" (Jardin 1984, p. 437). On the Chassériau–Tocqueville relationship see above, *April–May 1844,* and *May 3, 1846*).

December 27

■ A Terrible Sadness

Mme Monnerot writes to her son Jules: "Chassériau is plunged in a state of terrible sadness—if he does not get anything, he will fall either into a sort of imbecility or infancy—as I told you, some people are sad and others are content" (Letter from Mme Monnerot to her son Jules, December 27, 1851, Paris; BnF, Dépt. des Ms, Naf. 14405, Papiers Gobineau, vol. 17, fol. 145).

We do not know if she is referring to Théodore or to Frédéric. The close timing of the recent coup d'état of December 2, 1851, and its aftermath tends to point to Frédéric.

■ The Dancer Petra Camara

According to Sandoz, Chassériau executed an oil painting on wood of the Spanish dancer at the debut of her performances at the Théâtre du Gymnase in 1851, which he signed and dated "Th. Chassériau 1852" (Museum of Fine Arts, Budapest; Sandoz 1974, no. 179, p. 322). Camara also inspired Gautier to dedicate a poem in his *Émaux et camées*: "Inès de las Sierras / à la Petra Camara."

■ 1852

February 28

■ The Apse of Saint-Philippe-du-Roule

Romieu, Directeur des Beaux-Arts, resumes the negotiations begun several months earlier (see above, *October 10* and *November 22, 1851*), proposing that the Minister of the Interior have "M. Chassériau" execute "for the sum of Fifteen thousand francs" the painting in the apse of "St. Philippe du Roule," for which he had already made a sketch of a Descent from the Cross, and to cancel the commission of January 16, 1851, for a painting for eight thousand francs (see above) (Letter from Auguste Romieu to the Minister of the Interior, February 28, 1852; AN, F²¹. 70, dossier 12; Peltre 2001, p. 177).

March 9

■ The Vicar's Consent

The Minister of the Interior notifies the Prefect of the Seine that Chassériau has "the consent of the vicar and the parish" for the decorations at Saint-Philippe-du-Roule. Before making a decision, the minister wants to know if the prefect is prepared to undertake the "cost of the scaffolding, plastering, and additional decorations." He asks for a reply as soon as possible (Copy of a letter from the Minister of the Interior to the Prefect of the Seine, March 9, 1852, Paris; AN, F²¹. 70, dossier 12).

March (?)

■ Election of the Jury

Chassériau's name appears on a list of "voting painters" responsible for electing the jury for the Salon of 1852. The absence of a red cross in front of his name could mean that he did not participate in the vote. His name also appears on a list of "artists exempted from the Jury (Academy and decorated)," with the number of works exhibited: "3" (Archives des Musées Nationaux, dossier 10, Salon de 1852).

April 1

■ The Salon of 1852

The exhibition catalogue (*Explication des ouvrages de peinture, sculpture, architecture, gravure et lithographie des artistes vivants exposés au Palais royal le 1ᵉʳ avril 1852* [Paris, 1852], pp. 58–59) lists the following:

Chassériau (Théodore), born in Samaná (Spanish America), pupil of M. Ingres.

3rd-pl. medal (History) 1836—2nd-pl. medal 1844

❧ May 3, 1849—[EX].

Rue de Laval, 26, avenue Frochot.

[no.] 238—Christ in the House of Mary and Martha (43 ⅜ x 31 ½ in.; Sandoz 1974, no. 215, p. 350).

"And Jesus answered and said unto her, Martha, Martha, thou art careful and troubled about many things:

But one thing is needful: and Mary hath chosen that good part, which shall not be taken away from her."

(Luke 10: 41–42)

[no.] 239—Arab Tribal Chiefs Challenging Each Other in Single Combat Beneath the Walls of a City (35 ⅞ x 46 ½ in.; Sandoz 1974, no. 216, p. 352; cat. 190).

[no.] 240—Desdemona (28 ¼ x 23 ⅝ in.; Sandoz 1974, no. 124, p. 258; cat. 196).

"I need only to lean my head to the side and sing, like the poor Barbara. . . . I beg you, be quick."

(*Othello*, act 3)

❧ Chevalier of the national order of the Legion of Honor.

[EX] indicates Artists whose works were accepted without examination, pursuant to art. 10, chap. 2.

April 10

■ An Inconceivable Art

Mme de Courbonne, whose salon was famous at the time, is lent a portrait of Mary de Magnoncourt (née de Tracy) drawn by Chassériau. She writes: "I have never seen such a charming portrait! You took pleasure in your work, it is carefully done, graced with an inconceivable art! What talent! Thank God, for Heaven has something to do with this miraculous art of *giving life*" (Letter from Mme de Courbonne to Théodore Chassériau, April 10, 1852 [Paris (?)]; published in Chevillard 1893, p. 160; Bénédite 1931, vol. 2, p. 360).

The portrait, which is dedicated "A Monsieur / Victor de Tracy / Thre Chassériau / 1852," is today in a private collection (Sandoz 1986, no. 46, p. 61; Prat 1988-2, no. 181, p. 25).

June 7

■ Théodore's Forgiveness

In his review of the Salon of 1852 in the May 25 issue of *La Presse,* Théophile Gautier takes the liberty of criticizing some of Chassériau's aesthetic choices for the first time. Thirteen days later, the painter writes to Gautier: "I have been wanting to shake your hand for many days, but have not had a free minute—I wanted you to know that I was far from angry with you for the last bit of advice, which you gave in such a kind and charming manner" (Letter from Théodore Chassériau to Théophile Gautier [June] 7, 1852 [Paris]; published in Gautier, *Correspondance,* 1991, vol. 5, no. 1743, pp. 59–60).

June 26

■ Saint-Philippe-du-Roule:
The Commission

Romieu notifies Chassériau: "By a decision of February 28, 1852, you have been commissioned by the Ministry of the Interior to execute the murals necessary for the decoration of the apse of the Church of Sᵗ Philippe du Roule. These paintings should represent the descent of Christ from the cross; the sketches should be submitted to me" (Copy of a letter from Auguste Romieu, Directeur des Beaux-Arts, to Théodore Chassériau, June 26, 1852, Paris; AN, F²¹. 70, dossier 12; Bénédite 1931, vol. 2, p. 450, published Romieu's letter, but without the date).

July 8

■ Théophile's Friends

Gautier had left for Constantinople on June 9. Louis de Cormenin, his faithful and devoted friend, sends him the names of those who were asking after him: "Martinez . . . Peyrat, Dutacq, Nefftzer, Lecou, all those I meet along the way, Chassériau, Amédée Achard, the young Dumas, all kinds of folks, the Escudiers, Offenbach, etc. etc. . . . And I just thought of Méry, Gozlan, and Janin among the names to send to you" (Letter from Louis de Cormenin to Théophile Gautier, Tuesday, July 8, 1852; published in Gautier, *Correspondance,* 1991, vol. 5, no. 1759, pp. 73–74). Gautier would return to Paris on October 4.

July 16

■ Saint-Philippe-du-Roule: 1st Payment

Chassériau receives "2000 F" of the 15,000 francs allocated to the project (Médiathèque, La Rochelle, Ms 621, fol. 235 r.).

Late August or Early September

Visit to the Destutt de Tracys

Chassériau is a guest at the Destutt de Tracys' manor at Paray-le-Frésil in the department of the Allier (Chevillard 1893, p. 161). He paints two floral panels for the drawing room, signed and dated 1852 (Sandoz 1974, no. 217, p. 352); they were later removed (sold in Strasbourg, December 1, 1988, lots 20–21).

September 9

■ The Frogs of Paray-le-Frésil

Chassériau was very fond of frogs. He writes to his brother: "I am completely immersed in greenery here, strolling and drawing. . . . Life is very rustic in this corner of France and the countryside very beautiful, with the water, the trees, the meadows dotted by big white oxen. For instance, one finds frogs very often, especially after the rain. It is not the sort of thing for mother or our sisters. I am resting now, recovering my strength and the urge to work" (Letter from Théodore Chassériau to his brother Frédéric, September 9, 1852, Paray-le-Frésil; published in Bénédite 1931, vol. 2, p. 498).

Chassériau's watercolors of trees (see cat. 220) probably date from this visit (Prat 1988-2, no. 182, p. 25). The oval portrait that Chassériau painted of the comtesse Mary Destutt de Tracy in 1851 (Bénédite 1931, vol. 2, p. 359; Sandoz 1974, no. 212, p. 346) and not 1852, as asserted by Chevillard

(1893, no. 230, p. 298), perhaps depicts the regional costume of this "corner of France."

Early October

■ Exhibition in Le Havre

The catalogue (*Musée du Havre, Exposition bisannuelle de peinture et objets d'arts* [Le Havre (October) 1852], p. 7) lists the following:

Chassériau (Théodore)

26, *Rue de Laval, avenue Frochot, Paris*

[no.] 56. Mazeppa, Found Unconscious by the Cossack's Daughter (18 ⅛ x 14 ⅝ in.; Sandoz 1974, no. 131, p. 266; cat. 203).

[no.] 57. Arab Child Watering a Horse (14 ⅛ x 11 ⅜ in.; Sandoz 1974, no. 176, p. 318).

October 4

■ Chassériau Vouches for Fromentin

In the morning, Chassériau goes to the office of the Directeur des Beaux-Arts at the Ministry of the Interior and assures Romieu of the talent of Eugène Fromentin (1820–1876). The latter is granted a commission for four thousand francs "immediately" and "without discussion." Chassériau writes to him right away, on the letterhead of the Ministry of the Interior: "Fromentin has a commission for four thousand francs" (Letter from Eugène Fromentin to Thérèse du Mesnil [October 8, 1852, Saint-Raphael]; published in Fromentin 1995, vol. 1, p. 941). In a sketchbook used by Chassériau from 1848 to 1852 is the note: "10—6 Rue Nve Bréda Mʳ Fromentin" (Prat 1988-1, vol. 2, p. 953, fol. 25 v.).

October 8

■ Fromentin's Joy

Fromentin is overjoyed when he learns of this commission: "Dear friend, I just took Marie in my arms, my dear Marie, my beloved wife, all that brings you here, near me—and we kissed each other, weeping. I cannot say more—I tried to write a line to Chassériau.—I am so stunned—I will do [it] soon and [it] will go out tomorrow morning" (Letter from Eugène Fromentin to Armand du Mesnil [October 8, 1852, Saint-Raphael]; published in Fromentin 1995, vol. 1, p. 939).

October 20

■ Saint-Philippe-du-Roule: 2nd Payment

Chassériau receives "1000 F" of the 15,000 francs allocated to the project (Médiathèque, La Rochelle, Ms 621, fol. 235 r.).

October 23

■ Sale at the Le Havre Museum

Chassériau informs the director of the museum in Le Havre: "I am selling my picture for 180 ᶠ—since you have been obliging enough to take care of this for me—You see why I turned down the secretary of the Amis des Arts of Le Havre—Because I find it silly for artists to change their prices once they have been modestly set—and not bad taste to bargain—" (Letter from Théodore Chassériau to Adolphe Couveley, October 23, 1852 [Paris]; Bibliothèque Municipale du Havre, Ms 391–45). The painting involved was the *Arab Child Watering a Horse,* signed and dated "Th. Chassériau / 1851" (Sandoz 1974, no. 176, p. 318).

November

■ Saint-Philippe-du-Roule: The Scaffolding

A wooden scaffold was built "above the High Altar" (Minutes of the Parish Council of Saint-Philippe-du-Roule, April 21, 1855, Paris; AN, F²¹. 4397, dossier 52), and Chassériau could now begin working on his monumental painting. Two-and-a-half-years later, however, his slow progress would put the commission at risk (see below, *April 21, 1855*).

■ A Request from Jubinal

The historian Achille Jubinal (1810–1875), who had been elected deputy of the Hautes-Pyrénées on February 29, 1852, asks Chassériau to give him a "little something" for the museum he was in the process of organizing in his hometown, Bagnères-de-Bigorre, with his own collection as core (Letter from Achille Jubinal to Théodore Chassériau [1852 (?)], n.p.; quoted in Sandoz 1974, no. 228, p. 370).

The painter would agree, belatedly, to Jubinal's request, giving him a sketch for his *Saint Francis Xavier Baptizing the Indians* (cat. 224), dated "1854" (Bagnères-de-Bigorre, Musée Salies; Sandoz 1974, no. 228, p. 370).

According to Sandoz (1974, p. 200), Chassériau used Jubinal's 1839 edition of the *Oeuvres complètes de Rutebeuf* for one of the episodes he depicted from the Life of Saint Mary of Egypt (see above, *August 24, 1841*).

■ 1853

February 4

■ Poiret, a Pupil

Chassériau asks that "a study pass be issued to let my pupil, M^r Poiret, copy the great masters, which he needs to do to progress" (Letter from Théodore Chassériau to [an administrator at the Musée du Louvre], February 4, 1853 [Paris]; Sandoz 1974, p. 82 n. 1).

May 3

■ A Visit from the Inspector

Alfred Arago informs the Ministre des Beaux-Arts that he has gone to "S^t Philippe du Roule to see the paintings that M^r Chassériau is executing in the hemicycle of this church. M^r Chassériau is presently sketching in his important project and requests an advance of 3000^{CS} of the 15000^{CS} that were allocated" (Letter from Alfred Arago to the Ministre des Beaux-Arts, May 3, 1853, Paris; AN, F²¹. 70, dossier 12).

May 15

■ Salon of 1853

The exhibition catalogue (*Explication des ouvrages de peinture, sculpture, architecture, gravure et lithographie des artistes vivants exposés aux Menus-plaisirs le 15 mai 1853* [Paris, 1853], pp. 69–70) lists the following:

Chassériau (Théodore), born in Samaná (Spanish America), pupil of M. Ingres.

3rd-pl. medal (History) 1836—2nd-pl. medal 1844

✿ May 3, 1849—[EX].

Rue de Laval, 26, avenue Frochot.

[no.] *228—Tepidarium (67 ⅜ x 101 ⅛ in.; Sandoz 1974, no. 218, p. 354; cat. 237).

The room in which the women of Pompeii rested and dried themselves after their bath.

[no.] 229—A Cossack Girl Finds Mazeppa Unconscious on an Exhausted Wild Horse (18 ⅛ x 14 ⅝ in.; Sandoz 1974, no. 131, p. 266; cat. 203).

(Lord Byron, *Mazeppa*)

[no.] 230—Hadji, Barb Stallion from the Province of Constantine (28 ⅜ x 34 ¼ in.; Sandoz 1974, no. 164, p. 306).

✿ Chevalier of the national order of the Legion of Honor.

[EX] indicates Artists whose works were accepted without examination, pursuant to art. 10, chap. 2.

* indicates works belonging to the artist.

May 23

■ Saint-Philippe-du-Roule: 3rd Payment

Following Arago's inspection (see above), Chassériau receives the sum of "2000 F" (Médiathèque, La Rochelle, Ms 621, fol. 235 r.).

■ Honorable Mention

At the close of the Salon, Chassériau is awarded honorable mention (*L'Artiste* 11, 1853, p. 5).

May 30

■ *Tepidarium:* Doctored Documents

According to an official document, the Section des Beaux-Arts of the Ministry of State purchased the *Tepidarium* only two weeks after it was exhibited at the Salon of 1853 (see above): "Sir, I have the honor of informing you that, upon my recommendation, M. the Minister of State has acquired your painting representing *The Baths at Pompeii* for the sum of Seven thousand francs" (Copy of a letter from the Ministry of State to Théodore Chassériau, May 30, 1853 [Paris]; AN, F²¹. 70, dossier 13).

■ A Purchase Disguised as a Commission

Two letters prove that the *Tepidarium* was not acquired in 1853 (see below, *July 18* and *August 2, 1853*). The official purchase was made sometime later and would become a commission by an administrative sleight of hand (see below, *May 30, 1854*).

Mid-June

■ Pierre-Auguste Lamy and the *Tepidarium*

Chassériau writes: "It is with great pleasure, Monsieur Lamy, that I give my permission to have a lithograph made of my painting representing the Tepidarium—I would like to see the drawing or the stone while it is in progress, and I will do my best to help" (Letter from Théodore Chassériau to Pierre-Auguste Lamy, Monday [mid-June 1853, Paris]; Institut Néerlandais, Fondation Custodia, Inv. 1971-A. 166; Peltre 2001, p. 99). The lithograph would be published in *L'Artiste* on October 1, 1853 (see below).

June 22

■ Lamy (continued)

Mayer, a member of the staff of *L'Artiste,* asks the director of the Louvre to "be so kind as to grant Monsieur Lamy admission to the Salon in the morning to make a lithograph of Monsieur

Chassériau's painting Tepidarium" (Letter from J. Mayer to the director of the Louvre, June 22, 1853, Paris; Archives des Musées Nationaux, dossier 10, Salon of 1853, dossier "Correspondance générale").

June 28

■ Guitton, a Pupil

Chassériau asks the administration of the Musée du Louvre to "please issue a pass to my pupil M^r. Guitton to permit him to copy the masters in the galleries of the Louvre" (Letter from Théodore Chassériau to the head of the administration at the Musée du Louvre, June 28, 1853 [Paris]; Archives des Musées Nationaux, dossier P. 30 Chassériau; Sandoz 1974, p. 82 n. 1).

July 18

■ Recommendation of the General

On the letterhead of the "House of H.R.H. Prince Jérôme Napoléon," Général de Ricard asks Comte de Nieuwerkerke, the director of the Imperial Museums, if it would be possible to buy the *Tepidarium,* a "picture that attracts crowds. . . . M^r Chassériau is modest and will never ask for a favor, so do not be surprised if I am writing to beg you not to forget him; you could not oblige a more upright soul, a nobler character, a more conscientious artist" (Letter from Général de Ricard to Comte de Nieuwerkerke, July 18, 1853; Archives des Musées Nationaux, dossier P. 30 Chassériau).

August 2

■ *Tepidarium:* Purchase Refused

Nieuwerkerke informs Général de Ricard (see above) that his budget does not permit "the purchase of the painting by M^r. Chassériau that you recommended & that is perfectly worthy of the attention you give it: His *Tepidarium* is certainly one of his best works & it will be nearly impossible for me not to order its acquisition" (Copy of a letter from Comte de Nieuwerkerke to Général de Ricard, August 2, 1853 [Paris]; Archives des Musées Nationaux, dossier P. 30 Chassériau).

August 11

■ Request for a Meeting

Chassériau asks Frédéric Bourgeois de Mercey (1805–1860), artist, art critic, and director of the Section des Beaux-Arts, to grant him "a half an hour . . . to talk over a few things" (Letter from

Théodore Chassériau to Frédéric Bourgeois de Mercey, August 11, 1853 [Paris]; published in Bénédite 1931, vol. 2, p. 465).

Bénédite wonders if this meeting also may have involved the *Defense of Gaul*, a subject he supposes Chassériau had considered as early as 1851 (see above, *January 16 and 21, 1851*). The two may have discussed the matter of the *Tepidarium* as well (see below, *May 30, 1854*).

■ Sketch of *The Defense of Gaul*

On an unknown date, Chassériau writes to Mercey: "Here is the sketch of the Gauls Charging Caesar's Legions, also called Gergovia. Thank you in advance for the goodwill that you have shown me this time, as on so many other occasions—" (Letter from Théodore Chassériau to Frédéric de Mercey, Saturday [1853 (?), Paris]; published in Bénédite 1931, vol. 2, pp. 465, 474 [facsimile]).

The fact that Chassériau sent this sketch for *The Defense of Gaul* to Mercey suggests that he was hoping to obtain a commission from the State, but the attempt would fail. Contrary to the assertion of Sandoz (1974, no. 252, p. 400), the Ministry of the Interior did not commission the monumental painting, as it still belonged to the artist at the time of its presentation at the Exposition Universelle of 1855 (see below, *May 15, 1855*).

October 1

■ Lithograph of the *Tepidarium*

L'Artiste publishes Lamy's lithograph with the following commentary: "Tepidarium. Here is a fine, lively sampling of antique art. M. Théodore Chassériau has a very refined and sensitive feel for epics wrapped in the poetry of the past" (*L'Artiste* 11, no. 5, October 1, 1853, p. 80).

October 11

■ The Upcoming Exhibition in Bordeaux

Chassériau sends "two pictures" and claims: "I have to abandon the one that I wanted to finish the other day. My work at St Roch takes up all of my time" (Letter from Théodore Chassériau to an unidentified correspondent, October 11, 1853 [Paris]; Institut Néerlandais, Fondation Custodia, Inv. J. 8053).

November 5

■ Exhibition of the Société des Amis des Arts in Bordeaux

The exhibition catalogue (*Explication des ouvrages de peinture, sculpture, architecture, gravure et lithographie des artistes vivants exposés dans la Galerie de la Société des Amis des Arts de Bordeaux, le 5 novembre 1853* [Bordeaux, 1853], pp. 25–26) lists the following:

Chassériau (Théodore), *born in Samaná (Spanish America), pupil of M. Ingres*. (3rd-pl. medal [History] 1836.—2nd-pl. medal 1844.— ✿ May 3, 1849.—Hon. men. 1853.) *In Paris, avenue Frochot, rue de Laval, 26.*

[no.] 123.—Spanish Dancers: Night Effect (12 ⅝ x 9 in.; Sandoz 1974, no. 179, p. 322).

[no.] 124.—Arab Horseman Buying a Horse from a Kabyle (15 ¾ x 21 ⅜ in.; Sandoz 1974, no. 221, p. 358).

Key to Signs and Abbreviations

✿ Chevalier of the order of the Legion of Honor

1st-pl., 2nd-pl., 3rd-pl. medals: first-, second-, and third-place medals awarded at the national exhibition.

November 13

■ Chassériau the Medium

Mme Monnerot, who had long been a follower of mesmerism, writes to her son: "Speaking of Chassériau, I had dinner with frédéric. . . . He told us that at Mme Duperré's, Théodore was making the tables turn and talk, and that they told him amazing things. He is among the diehards, and frédéric himself seems to believe in it. This amused us somewhat. I asked him to tell Théodore that, when you are here, I will beg one of his tables to tell me something " (Letter from Mme Monnerot to her son Jules, November 13 [1853], Paris; BnF, Dépt. des Ms, Naf. 14405, Papiers Gobineau, vol. 17, fol. 156).

Chassériau shared the same fascination with hypnotism as his muse Delphine de Girardin, in whose salon he once attended a séance (see above, *September 6, 1847*). Houssaye (1885, vol. 2, p. 29) mentions a spiritist séance with Mme de Girardin, Prince Napoléon, and Chassériau.

■ Gustave Moreau's Silence

Moreau annotated one of his drawings: "Rachel sketch done on my portfolio by Th. Chassériau avenue Froichot [*sic*] 1853" (Paris, Musée Gustave Moreau; Sandoz 1986, no. 129, p. 135; Prat 1988-1, vol. 1, no. 601, p. 279; Prat 1988-2, no. 188, p. 26).

We know that Chassériau's art had a formative influence on the young Moreau. Much later, however, he claimed not to know anything about Chassériau's life: "I regret not being able to provide you with any information that might be useful for the study you are preparing on the Oeuvre of Théodore Chassériau. . . . As for me, I met him quite late, & as there was a great difference in age between us, my relations with him could only be those of a quite young man & an accomplished man who already has an important place in art. In other words, I did not know anything about his life" (Draft of a letter from Gustave Moreau to an unknown correspondent [about 1870–80 (?)]; Archives du Musée Gustave Moreau).

Jules Breton, however, claims that Moreau never spoke of Chassériau "without deep feeling" (Breton [1900], p. 214).

■ 1854

January 8

■ Antique Paintings

Chassériau writes to an unknown correspondent: "Thank you for having thought of me in front of all these beautiful antique paintings. In this, I recognize the favorable consideration that you have always shown me. I hope to see you again soon and resume our good talks. . . . Needless to say, when you return, I will repay the five hundred francs that I owe you—" (Letter from Théodore Chassériau to an unidentified correspondent [Félix Ravaisson (?)], January 8, 1854, Paris; Médiathèque, La Rochelle, Ms 621, fol. 228 r. and v.).

February–March

■ Saint-Roch Finished

Chassériau's two paintings for the baptismal fonts in the Church of Saint-Roch are finished and inspire much commentary (Gautier, March 4, 1854; Du Pays, March 18, 1854, pp. 175–76; Delaborde, April 15, 1854, pp. 430–32; Saint-Victor, October 1, 1854, pp. 67–68). Chassériau had begun working on them in 1850 or 1851 (see above, *July 13, 1851*).

Early March

■ Advance of One Hundred Francs

Chassériau asks his dealer to give his "servant the hundred francs that I need in advance on the price of the painting that you will have in a few days" (Letter from Théodore Chassériau to Adrien Beugniet, March 1854 [Paris]; Los Angeles, The Getty Research Institute, Beugniet Collection).

March 31

■ *Arab Cavalry Charge*

Chassériau confirms having "received from Monsieur Beugniet the sum of four hundred francs for my painting representing Arab horsemen charging the Kabyles—" (Note from Théodore Chassériau to Adrien Beugniet, March 31, 1854 [Paris]; Bibliothèque d'Art et d'Archéologie Jacques Doucet, carton 8, Peintres, Mf. 3, no. 2616).

May 30

■ *Tepidarium*: The Doctored Commission (continued)

The copy of a letter from the Ministry of State to Théodore Chassériau concerning the official purchase of the *Tepidarium* (cat. 237) is dated May 30, 1853 (see above), but, in fact, the last digit of the year, the "3," was written over a "4." The same holds true for a decree asking him "to execute . . . a painting representing the Baths in Pompeii" (Decree of May 30, 1853 [*sic*]; AN, F21. 70, dossier 13).

This purchase obviously was camouflaged as a commission and predated. The mysterious appointments with Bourgeois de Mercey probably involved these administrative arrangements (see above, *August 11, 1853*, and below, *Early July 1854*). Chassériau would receive the first payment on January 3, 1855, and the second on March 6, 1855 (AN, F21. 70, dossier 13).

June 25

■ **Paul Meurice's Play**

The sculptor Préault extends the following invitation to Théophile Gautier: "Paul Meurice invites you to dine tomorrow at 4—with me and Th. Chassériau. He wants you to see the 1st act of his play. Come if you have the time—I will be glad to dine with you" (Letter from Auguste Préault to Théophile Gautier, June 25, 1854 [Paris]; published in Gautier, *Correspondance*, 1991, vol. 6, no. 2038, pp. 45–46; Barbillon 1997, p. 266, with the date "June 29").

This play, *Schamyl*, opened at the Théâtre de la Porte Saint-Martin June 26, 1854. Théodore Chassériau designed the costumes for the corps de ballet and the character of Genghis Khan. He also lent a "pair of pistols ornamented with silver" that he kept on display in his studio (Bouvenne 1883–84, p. 137; Bouvenne 1887, p. 174).

Early July

■ **The *Tepidarium* Affair**

Mercey, head of the Section des Beaux-Arts, sends Chassériau a note asking him to come to his office on Monday, July 10, adding in a postscript: "The business of your painting is over, but I need to talk with you about a detail" (Letter from Frédéric de Mercey to Théodore Chassériau [early July 1854, Paris]; quoted in Bénédite 1931, vol. 2, p. 450).

The matter probably involved the purchase of the *Tepidarium* (see above, *May 30, 1854*).

July 31

■ **Saint-Philippe-du-Roule: 4th Payment**

Chassériau receives "4000 F" of the 15,000 francs allocated to the project (Médiathèque, La Rochelle, Ms 621, fol. 235 r.).

August 25

■ **Death of Gautier's Father**

Chassériau informs Théophile Gautier that he had received the death notice too late to attend "the sad event," adding: "I no longer go to my studio, I am working <u>always at my church</u>. . . . I will come to see you tomorrow or after tomorrow morning" (Letter from Théodore Chassériau to Théophile Gautier, Friday [August 25, 1854, Paris]; facsimile in Chevillard 1893, following p. 265; Bénédite 1931, vol. 2, p. 450; Gautier, *Correspondance*, 1991, vol. 6, no. 2077, p. 74).

The church referred to is, of course, Saint-Philippe-du-Roule.

September 3

■ **Postal Error at the Opéra**

Baron Chassériau, administrator of the "Théâtre Impérial de l'Opéra," mistakenly receives and opens a letter addressed to Théodore Chassériau. He sends it back and takes the opportunity to tell him: "I sent your friend M. de S^t. Victor's request for entry to the Opéra to the minister, who alone makes the decision. Roqueplan and I gave our support, but we have not done anything for the journalists yet, and the ban is very strictly observed. This should not keep you and your brother from coming to my box <u>on the stage</u> when you wish; just send me a note and arrive before the opening" (Letter from Baron Louis-Henry-Arthur Chassériau to Théodore Chassériau, September 3, 1854, Paris; Institut Néerlandais, Fondation Custodia, Inv. 1992-A.423).

Little is known of this relative, who was an administrator at the Imperial Palace and who died in Paris on March 13, 1858 (AN, series O^5. 440).

■ **Paul de Saint-Victor**

The reference in the letter cited above is to Chassériau's friend Paul de Saint-Victor (1825–1881), secretary to Lamartine in 1848 and a noted art critic, who wrote a number of articles about Chassériau; one, dated October 1, 1854, is devoted

to Saint-Roch (see above, *February–March 1854*). There exists a preliminary drawing for the *Defense of Gaul* inscribed: "St Victor 49 rue de Grenelle St Germain" (Prat 1988-1, vol. 1, no. 860, p. 359).

September

■ **Saint-Philippe-du-Roule: Work Stops**

According to a report by the Parish Council, Chassériau stops work on his mural at this time (Report of the Parish Council of Saint-Philippe-du-Roule, April 21, 1855, Paris; AN, F^21. 4397, dossier 52). The artist would soon receive a summons.

October 31

■ **Saint-Philippe-du-Roule: 5th Payment**

Chassériau receives "1,500 F" of the fifteen thousand francs allocated for the Saint-Philippe-du-Roule project (Médiathèque, La Rochelle, Ms 621, fol. 235 r.).

November 12

■ **Exhibition of the Société des Amis des Arts in Bordeaux**

The exhibition catalogue (*Explication des ouvrages de peinture, sculpture, architecture, gravure et lithographie des artistes vivants exposés dans la Galerie de la Société des Amis des Arts de Bordeaux, le 12 novembre 1854* [Bordeaux, 1854], p. 27) lists the following:

Chassériau (Théodore), *born in Samaná (Spanish America), pupil of M. Ingres.* (2nd-pl. medal 1844.— ♣ May 3, 1849.—Hon. men. 1853.)

[no.] 129.—The Tepidarium at the Baths of Pompeii (33 ⅞ x 52 ⅜ in.; Sandoz 1974, no. 219, p. 356; Lacambre, in Paris, 1994–95, pp. 78–79; cat. 237).

Belongs to M. Marcotte de Quivières

♣ Chevalier of the order of the Legion of Honor

1st-pl., 2nd-pl., 3rd-pl. medals: first-, second-, and third-place medals awarded at the national exhibition.

■ **1855**

January 20

■ **Condolences**

Chassériau sends his heartfelt sympathy to his friend Oscar de Ranchicourt, who was mourning a death in the family (Letter from Théodore Chassériau to Oscar de Ranchicourt, January 20, 1855 [Paris (?)]; Collection Mlle F. Bellaigue de Ranchicourt).

March–April

■ **Exposition Universelle: Rejection by the Jury**

Chassériau expresses his exasperation to Mercey: "I have found out that a painting that I had taken back from a collector for the Exposition has been rejected. . . . As you can see, I must now regret the trust that led me to consign my paintings to the fairness and to the <u>intelligence of this Jury</u>. I also regret being used, and the displeasure that it aroused—. . . . I am asking you to provide

the necessary instructions to assure that what is left of my work at the exhibition will at least be well placed; this will be a compensation for the first problem" (Letter from Théodore Chassériau to Frédéric de Mercey, Wednesday [March–April (?) 1855, Paris]; published in Bénédite 1931, vol. 2, pp. 466, 491–92 [facsimile]).

The rejected painting, *The Ghost of Banquo* (cat. 201), would be exhibited in Bordeaux in December (see below, *December 30, 1855*), by which time it belonged to "M. Arosa."

April 21

■ **Saint-Philippe-du-Roule: The Parish Revolts**

Chassériau's abandonment of the mural he had been commissioned to paint on June 26, 1852 (see above), provokes a scathing report from the Parish Council. The painter had not worked on the mural since September 1854, and his slow progress made them "foresee that it will take sev-

eral years" to finish it. A decision is made to alert the Prefect of the Seine and to write to "m chasseriau to ask him when the paintings will be finished and to spur him on" (Report of the Parish Council of Saint-Philippe-du-Roule, April 21, 1855, Paris; AN, F^21. 4397, dossier 52).

May 11

■ **Saint-Philippe-du-Roule: Admonition**

Haussmann, Prefect of the Seine, informs the Minister of the Imperial Palace that "M^r. Chassériau has hardly begun his work, in spite of my pressing requests. Some very sharp complaints have been sent to me on this subject. . . . I therefore solicit you, Excellency, to please give M. Chassériau notice that he should finish his paintings as soon as possible, or to give up the project once and for all" (Letter from Haussmann, Prefect of the Seine, to the Minister of State and of the Imperial Palace, May 11, 1855, Paris; AN, F^21. 4397, dossier 52).

May 15

■ Exposition Universelle of 1855

The exhibition catalogue (*Exposition universelle de 1855. Explication des ouvrages de peinture, sculpture, architecture, gravure et lithographie des artistes vivants étrangers et français exposés au palais des Beaux-Arts, avenue Montaigne, le 15 mai* [Paris, 1855], pp. 276–77) lists the following:

Chassériau (Théodore), born in Samaná (Spanish America), of French parents, pupil of M. Ingres.

3rd-pl. medal (History) 1836—2nd-pl. medal 1844— ☘ May 3, 1849.

Rue de Laval, 26 avenue Frochot.

[no.] 2689—Tepidarium (67 ⅜ x 101 ⅝ in.; Sandoz 1974, no. 218, p. 354; cat. 237).

The room in which the women of Pompeii rested and dried themselves after their bath.

Belongs to the State (Salon of 1853)

[no.] 2690—*The Defense of Gaul (17 x 10 ft.; Sandoz 1974, no. 252, p. 400).

The Gauls, led by Vercingétorix, repulse Caesar's legions at Gergovia. From the top of the ramparts, their disheveled wives show them their children while exhorting them to do battle.

(Caesar, *Commentaries,* bk. 7)

[no.] 2691—*Arab Chiefs Challenging Each Other in Single Combat Beneath the Walls of a City (35 ⅞ x 46 ½ in.; Sandoz 1974, no. 216, p. 352; cat. 190).

(Salon of 1852)

[no.] 2692—Arab Horsemen Removing Their Dead After an Engagement with the Spahis (68 ⅛ x 91 ⅜ in.; Sandoz 1974, no. 174, p. 316).

(Salon of 1850–51)

[no.] 2693—Susanna and the Elders (100 ⅜ x 77 ¼ in.; Sandoz 1974, no. 48, p. 144; cat. 15).

☘ Chevalier of the national order of the Legion of Honor.

* indicates works belonging to the artist.

June 30 (?)

■ Mme de Girardin's Funeral

Théodore Chassériau's childhood friend Delphine de Girardin dies on June 29, and he and Théophile Gautier attend the funeral at the Montmartre cemetery (Gautier, October 13, 1856; Chevillard 1893, p. 215).

■ Posthumous Portrait

For Émile de Girardin, Chassériau draws the portrait of his wife from memory, which he signs and dedicates: "A Monsieur / Émile de Girardin / Th^re Chassériau / 1855—" (Paris, Musée Carnavalet; Chevillard 1893, p. 157; Sandoz 1986, no. 52, p. 67; Prat 1988-2, no. 209, p. 27).

■ Saint-Philippe-du-Roule: The Inspector's Report

The Minister of the Imperial Palace replies to Haussmann's letter (see above, *May 11, 1855*), informing him that he had sent an official from the Section des Beaux-Arts to inspect Chassériau's painting: "From the report made to me by this agent, it appears that the first half of the hemicycle is as good as done, except for a few finishing touches that M. Chassériau will be able to give only after the whole has been completed; and that the other half is completely covered. . . . Everything indicates that M. Chassériau will finish his painting by next August at the latest. The artist also

promised as much" (Copy of a letter from the Minister of State and of the Imperial Palace to Haussmann, Prefect of the Seine, June 30, 1855 [Paris]; AN, F²¹. 4397, dossier 52).

July 3

■ A Princess in Love

Princess Marie Cantacuzène, who recently arrived in Arcachon, where she went for her health, writes to Chassériau: "Since our separation, my sweetest thoughts revolve around the hope of your visit. . . . And you, my friend, what are you going to do? Will you completely give up the idea of coming here and go to Biarritz instead, or will you reconcile the two and be both here and there? I am too interested in the question to keep from making any comment" (Letter from Marie Cantacuzène to Théodore Chassériau, July 3, 1855, Arcachon; published in Bénédite 1931, vol. 2, pp. 499–500).

Marie Cantacuzène, born in Moldavia in 1820, was the daughter of Nicolas Cantacuzène and of a member of the Struza family. She moved to Paris before 1850, and was secretary to the Romanian writer and liberal patriot Nicolas Balcesco during his last years in Hyères (1851–52). She is supposed to have met Chassériau through her brother, Prince Basile Cantacuzène, a friend of the painter (Bénédite 1931, vol. 2, p. 494); he drew her portrait, which is dedicated and signed: "a Madame la princesse / Marie Cantacuzène / Th^re Chassériau / 1855—" (Sandoz 1986, no. 53, p. 69; Prat 1988-2, no. 211, p. 27). In 1856, she would move to 7, Avenue Frochot (Chassériau had lived at number 28 since 1848). She would marry Puvis de Chavannes in 1897 (Foucart 1976, p. 189; Centorame 1999, p. 110).

July 16

■ Saint-Philippe-du-Roule: 6th Payment

Because of his progress on the hemicycle (see above, *June 30, 1855*), Chassériau receives the sum of "fifteen hundred francs." On July 16 he signs a "notification of payment order" dated July 5, 1855 (Médiathèque, La Rochelle, Ms 621, fol. 235 r.).

■ Arthur Baignères's Visit

Thirty years later, Baignères recalled his visit to see Chassériau's mural: "Chassériau himself did me the honors and explained it to me in detail while the scaffolding was still up. If memory serves, he was working on the soldier drawing lots for Christ's robe" (Baignères, March 1, 1886, pp. 217–18).

July 23

■ End of the Great Work

Chassériau asks Gantron, a paint supplier, for his opinion: "I could use you at this time, I need your opinion on the color, for I am finishing my great work. Please try to come to Saint-Philippe-du-Roule to shake my hand as soon as possible" (Letter from Théodore Chassériau to Gantron, Monday, July 23, 1855 [Paris]; published in Bénédite 1931, vol. 2, p. 451).

August 8

■ Plans for a Trip to Arcachon

Marie Cantacuzène, who had been at the seaside resort of Arcachon with her father for over a

month (see above, *July 3, 1855*), confirms Chassériau's plans: "Your work in the church must be finished. Are you waiting for the opening to leave? If that serves your interests, stay there, my friend, I will be able to wait whatever the cost" (Letter from Princess Marie Cantacuzène to Théodore Chassériau, August 8, 1855, Arcachon; published in Bénédite 1931, vol. 2, p. 500).

August 13

■ Invitation to Delaborde

Chassériau invites the art critic Delaborde to Saint-Philippe-du-Roule: "It is very wrong of you not to come see me in my Church. I know that you are very busy, but that is no reason to abandon me completely in this way—I will be up on my scaffolding until tomorrow, Wednesday. Try to find a minute; it would make me very happy" (Letter from Théodore Chassériau to Henri Delaborde, Monday, August 13 [1855, Paris]; Bibliothèque d'Art et d'Archéologie Jacques Doucet, carton 8, Peintres, Mf. 3, nos. 2614–2615; Peltre 2001, p. 232, fig. 248).

Chassériau had drawn the critic's portrait the previous year (cat. 214), and dedicated it: "A Henri Delaborde / son ami Thre Chassériau / 1854" (Sandoz 1986, no. 51, p. 65; Prat 1988-2, no. 195, p. 26).

Late August or Early September

■ Trip to Arcachon

According to a letter from Marie Cantacuzène, Chassériau finally joins her in Arcachon. On September 14, she would write: "Speaking of quiet, we have all we need, but only for two days, since the day after you left. MM. Ghyka, Soutzo, and Bedmar came to see me. I had an argument with the latter that ended in a reconciliation, which for my part is sincere. I care too little about him to hold it against him. Madame Bedmar and her daughter went to Eaux-Bonnes and from there will go to stay with Madame Maureil for a few days" (Letter from Princess Marie Cantacuzène to Théodore Chassériau, September 14, 1855, Arcachon; published in Bénédite 1931, vol. 2, p. 501).

Chevillard (1893, no. 242, p. 299) mentions a portrait of the "marquise de Bedmar" by Chassériau, but its whereabouts are unknown.

September 14

■ Time for Reproach

Marie Cantacuzène feels neglected: "It is both kind and good of you, my dear Sir, to have made haste in writing to me. You have seen how painful anxiety can be when it concerns those we love, and I owe you a debt of gratitude for having spared me this at a time when you seem to be completely absorbed by your work" (Letter from Princess Marie Cantacuzène to Théodore Chassériau, September 14, 1855, Arcachon; published in Bénédite 1931, vol. 2, p. 501).

Late September or Early October

■ The Mission of a Short Life

Chassériau writes to Mercey: "My task is finally finished and you will no longer be obsessed by the Hemicycle of S Philippe du Roule—I have accomplished my mission with devotion, preoccupied above all (!) by what I will leave behind me

after this short life. . . . I dare to hope, Sir, that you will be good enough to spare a few moments to examine this work of three years—" (Letter from Théodore Chassériau to [Frédéric de Mercey], Tuesday [September–October (?)], 1855 [Paris]; published in Bénédite 1931, vol. 2, p. 463; facsimile, pp. 452–53).

October

■ Working without a System

Théodore Chassériau sends a long letter to his friend Alberto Pasini (1826–1899), an Italian painter, who had left for Teheran in the company of Arthur de Gobineau, his wife, Clémence (née Monnerot), and their daughter Diane (born September 13, 1848): "I was pleased to hear that you were struck by all of the fine things that caught your artistic eye during your long journey. . . . —Keep up the good work without a system—without remembering, so to speak, what you know of habits and routines. Later, you will feel the reward of work done in this spirit" (Letter from Théodore Chassériau to Alberto Pasini, October 1855 [Paris]; published in Botteri Cardoso 1991, p. 32; Peltre 2001, pp. 132–34, 213).

■ *The Defense of Gaul*

"My work at the Church has been open for three days, and I am tucked away in my studio making sketches for small canvases as a rest from the big ones. My large painting is very well placed at the Salon and I am satisfied with the result. According to those in the know, it is the best rendered and planned thing that I have produced apart from the last Church" (see Letter from Chassériau to Pasini, above).

■ M. and Mme de Gobineau

"As soon as I have news from you I will pass it on to my friends, who are all following your very interesting trip with interest. Take care of your health and give my greetings to the French minister M. and Mme de Gobineau and to those who know me in the country in which you are" (see Letter from Chassériau to Pasini, above).

October 31

■ Exposition Universelle: A Medal

The jury for the Exposition Universelle awards Chassériau a second-place medal in the "History" category. During the first round of voting he won 11 votes; in the second round, 23 (Archives des Musées Nationaux, dossier 10, Salon de 1855).

Lehmann is also awarded a second-place medal, with 16 votes, but on November 6, it would become a first-place medal, angering Chassériau (see below).

November 14

■ Chassériau Refuses His Medal

Frédéric de Mercey receives a letter from Théodore Chassériau announcing his decision to refuse his second-place medal, "wishing neither to be given a lesson, nor to be insulted." In his reply, Mercey assures him that he should not feel insulted by the jury: "Believe me, in life one must sometimes resign oneself to receiving honorable affronts of this sort. . . . If you believe me in this, my dear Monsieur, you will accept your second medal, you will bravely go back to your oeuvre, and you will create fine works for us" (Letter from Frédéric de Mercey to Théodore Chassériau, November 14, 1855 [Paris]; published in Bénédite 1931, vol. 2, p. 473).

November 23

■ Théodore's Anger

Mme Monnerot comments in a letter to her son Jules: "Imagine how angry Théodore must be, having only achieved second place while Lehmann won a first-place medal. His painting on the altar of St Philippe du Roule has been unveiled, but no one talks about it at all. I cannot say whether it is good, since I am not knowledgable; I always forget to bring my lorgnette and look at it" (Letter from Mme Monnerot to her son Jules, November 23 [1855], Paris; BnF, Dépt. des Ms, Naf. 14405, Papiers Gobineau, vol. 17, folios 184–185).

December 10

■ Émile de Girardin's Dinner

Among the guests are George Sand, probably accompanied by her son Maurice, as well as "[Jérôme] Nap[oléon], Chassériau, M^me Arnould, M^me Allan, Charles-Edmond, a M^r Didier (unknown), Peyrat [and] the Girardins' son" (Diary of G. Sand; quoted in Sand 1978, vol. 13, p. 444 n. 1). Arsène Houssaye, who was supposed to have attended the dinner, is not mentioned, but this may have been an omission on Sand's part.

December 30

■ Exhibition of the Société des Amis des Arts in Bordeaux

The exhibition catalogue (*Explication des ouvrages de peinture, sculpture, architecture, gravure et lithographie des artistes vivants exposés dans la Galerie de la Société des Amis des Arts de Bordeaux, le 30 décembre 1855* [Bordeaux, 1855], p. 27) lists the following:

Chassériau (Théodore), *born in Samaná (Spanish America), of French parents, pupil of M. Ingres.* (3rd-pl. medal 1836.—2nd-pl. medal 1844.— ✿ 1849. — 2nd-pl. medal 1855)

[no.] 129.— Macbeth and the Witches (28 ⅜ x 35 ⅜ in.; Sandoz 1974, no. 239, p. 382; cat. 200).
(Shakespeare, *Macbeth*, act 1)

[no.] 130.—The Apparition of Banquo's Ghost (21 ¼ x 25 ¼ in.; Sandoz 1974, no. 237, p. 378; cat. 201).
(Shakespeare, *Macbeth*, act 3)
Belongs to M. Arosa
✿ Chevalier of the order of the Legion of Honor
1st-pl., 2nd-pl., 3rd-pl. medals: first-, second-, and third-place medals awarded at the national exhibition.

■ 1856

January 15

■ End of the Exposition Universelle

Chassériau wants his huge painting back, and begs the "agents of the administration of the Exposition Universelle to let M^r Calcomb remove my painting representing the defense of Gaul under N° 4254—" (Letter from Théodore Chassériau to the agents in the administration, January 15, 1856 [Paris]; AN, F^21. 520, dossier 4).

February 19

■ Delacroix Supports Chassériau's Struggle

Delacroix writes to the comte de Morny: "I have heard from M^r Chassériau himself that you thought of requesting the acquisition of his painting of the Gauls for the city of Clermont." The baron Gustave Wappers (1803–1874), a painter from Antwerp and director of the Academy of Antwerp, joins in to applaud "this choice,"

thanking Morny for "the part that you will have played in doing justice to a vigorous talent whom we both admire, and who struggles with a perseverance worthy of encouragement against the difficulties of Grand Painting, which can only be effectively supported by the state" (Letter from Eugène Delacroix and Gustave Wappers to the comte [Auguste de Morny], February 19, 1856 [Paris]; Musée du Louvre, Département des Arts Graphiques, aut. 672, cote AR20 L1; Bénédite 1931, vol. 2, p. 477; Delacroix, *Correspondance*, 1937, vol. 3, pp. 317–18).

March 1

■ *The Tepidarium* Enters the Musée du Luxembourg

Chassériau's *Tepidarium* (cat. 237), which had been acquired on May 30, 1854 (see above), is "temporarily" placed in the Musée du Luxembourg (Archives des Musées Nationaux, Z. 4, March 1,

1856; cited in Lacambre 1994, p. 273). On this occasion, the administration has a frame made for 500 francs (AN, F^21. 501, carton Souty, 1855; cited in Cahn 1994, p. 223).

March 20

■ Clermont-Ferrand and *Vercingétorix*

The mayor of Clermont-Ferrand writes to the Ministre des Beaux-Arts: "Among the paintings at the Exposition Universelle was the one by M^r Chassériau representing Vercingétorix's victory over the Romans. The City of Clermont would be happy to own this work, which commemorates one of the most glorious and patriotic events in the history of the Auvergne" (Letter from L. de Chazeller, Mayor of Clermont-Ferrand, to the Ministre des Beaux-Arts, March 20, 1856, Clermont-Ferrand; AN, F^21. 437, dossier 17).

April 3

■ Morny's Support

The comte de Morny informs the Ministre des Beaux-Arts of the mayor of Clermont-Ferrand's request (see above) and asks him to grant it (Letter from the comte Auguste de Morny to the Ministre des Beaux-Arts, April 3, 1856, Paris; AN, F²¹. 437, dossier 17).

April 17

■ Gautier at Saint-Philippe-du-Roule

Chassériau thanks the art critic Gautier for his article, which appeared that day in *Le Moniteur universel:* "My dear Théophile, I have just read what you wrote in your beautiful style about my last work. Thank you for all the talent you expended in explaining my work; this will send people there and do it a lot of good" (Letter from Théodore Chassériau to Théophile Gautier [April 17, 1856, Paris]; quoted in Chevillard 1893, following p. 265; Bénédite 1931, vol. 2, p. 472; Gautier, *Correspondance,* 1991, vol. 6, no. 2313, p. 229).

April

■ The Frame for *The Defense of Gaul*

Chassériau explains: "The sale of my big painting at the Exposition has not yet been finalized. Please wait for this to be decided, so that, depending on M. de Mercey's arrangements, either he or I will pay for the frame. As soon as this is agreed upon, I will put an end to this matter, which has lasted so long against my will" (Letter from Théodore Chassériau to an unidentified correspondent, April 1856, Paris; published in Bénédite 1931, vol. 2, p. 475). According to Bénédite, the addressee of the letter was an "impatient supplier."

May 23

■ Negative Answer

Responding to the comte de Morny's request (see above, *April 3, 1856*), the Ministre des Beaux-Arts maintains that his budget does not permit him to acquire *The Defense of Gaul* (Copy of a letter from the Ministre des Beaux-Arts to the comte Auguste de Morny, May 23, 1856 [Paris]; AN, F²¹. 437, dossier 17).

May 26

■ Sale of the *Sultan's Wife*

A painting by Chassériau, *The Toilette of the Sultan's Wife,* is sold at auction at the Hôtel Drouot (*Catalogue d'une belle collection de tableaux modernes,* 5, rue Drouot, Paris, Mᵉ Boussatun, auctioneer, Mʳ Martin, expert, Wednesday May 26, 1856, no. 11, p. 4).

June 4

■ The Girardin Dinner

Émile de Girardin invites Gautier to visit the sculptor Robinet to "see the marble bust" of the late Delphine de Girardin. He ends his letter, "I will bring you back for dinner, if you like, with the prince Napoléon, Anatole [Demidoff], Cabar[r]us, Chassériau" (Letter from Émile de Girardin to Théophile Gautier, June 4 [1856], Paris; published in Gautier, *Correspondance,* 1991, vol. 6, no. 2200, p. 159).

July 24

■ George Sand and the Portrait of Mme de Girardin

To commemorate the first anniversary of his wife's death, Émile de Girardin publishes a collection of obituaries. He invites George Sand to write a review: "This would be the opportunity long wished for by Chassériau to talk about his fine drawing, engraved by Blanchard [a pupil of Henriquel Dupont], which he gave you and which you found to be a good likeness" (Letter from Émile de Girardin to George Sand [mid-July (?)] 1856; mentioned in Sand 1978, vol. 13, p. 444 n. 2). Sand grants Girardin's request (*La Presse,* Thursday, July 24, 1856, p. 2).

July 25

■ The Princess's Sadness

Marie Cantacuzène writes to Chassériau from Biarritz, where she has just arrived: "Although you admirably preached stoicism the other day, my friend, I cannot completely hide the sadness I feel since our separation. . . . If you still intend to come to Biarritz, just give me a day's notice" (Letter from Princess Marie Cantacuzène to Théodore Chassériau, July 25, 1856, Biarritz; published in Bénédite 1931, vol. 2, p. 503).

August 1

■ Health Problems

Marie Cantacuzène thanks Chassériau "for having been so prompt" in answering her letter. She encourages him to join her in Biarritz, "since your health requires that you leave Paris" (Letter from Princess Marie Cantacuzène to Théodore Chassériau, August 1, 1856, Biarritz; published in Bénédite 1931, vol. 2, pp. 503–4).

August 2–5

■ Society People

Marie Cantacuzène lambastes the insensitivity of "society people." Her only wish, she writes Chassériau, "is that you will soon be finished with whatever is keeping you there, so that you can breathe the healthy air here" (Letter from Princess Marie Cantacuzène to Théodore Chassériau [August 2–5, 1856, Biarritz]; published in Bénédite 1931, vol. 2, p. 504).

August 6

■ The Burden of Intimacy

The princess reacts strongly to one of Chassériau's letters: "If intimacy is a burden to you, do away with it; nothing is easier: but have the honesty to say so. Do you think that I am deluding myself on the nature of your feelings so much that I can ignore that they stem from indifference?" (Letter from Princess Marie Cantacuzène to Théodore Chassériau, August 6, 1856, Biarritz; published in Bénédite 1931, vol. 2, pp. 504–5).

August 11

■ The Misery of the Artist's Life

The artist's financial problems seem to be confirmed by the sale of his furniture to the painter Alberto Pasini (Letter from Théodore Chassériau to Alberto Pasini, August 11, 1856, Paris; published in Bénédite 1931, vol. 2, p. 508).

August 12

■ Théodore and Marie: The Admission

The princess demands from Théodore "a complete admission" of his feelings: "Had I known the nature of your affection for me *earlier,* I would have spared you a lot of trouble. Forgive me for this and believe me that friendship alone would never have brought me to that point. I am worried about the new pains you have in your stomach; what does the doctor say?" (Letter from Princess Marie Cantacuzène to Théodore Chassériau, August 12, 1856, Biarritz; published in Bénédite 1931, vol. 2, pp. 505–6).

August 20

■ Chassériau's Suffering

The painter writes to one of his clients: "Having been ailing, I did not finish the painting that I was supposed to have done for M. del Giorno [*sic*] by the end of July. Although this painting is far along, I need two more months to finish it to my complete satisfaction" (Letter from Théodore Chassériau to M. del Gironio, August 20, 1856 [Paris]; published in Bénédite 1931, vol. 2, p. 507).

■ Passport for Belgium

Chassériau is issued a passport by the prefect of police. It contains these vital statistics: thirty-five years old, 5 ft. 8 in., chestnut hair, clear forehead, black eyebrows, pug nose, average mouth, brown beard, round chin, oval face, pale complexion, no particular marks. He lives at "rue Fléchier 2" (Copy of the passport in the Archives des Musées Nationaux, dossier P. 30 Chassériau; Bénédite 1931, vol. 1, p. 6 n. 3; Prat 1988-1, vol. 1, p. 12; Peltre 2001, p. 232, fig. 247).

August 21–24

■ Departure from Paris—Arrival in Spa

Chassériau travels via Bruges and Malines on his way to the hot springs at Spa. He decides to stay there "three or four days." His health is better: "The change of air is very good for me" (Letter from Théodore Chassériau to his brother Frédéric, Sunday [August 24, 1856, Spa]; published in Bénédite 1931, vol. 2, pp. 509–10).

August 26

■ A Caring and Loving Brother

Frédéric responds to Théodore's letter from Spa (see above): "We urge you immediately to do everything necessary to restore your health before returning to Paris. . . . I spend part of my days in the Musée du Louvre admiring the sculpture, paintings, and prints. . . . It is a great pleasure to busy oneself with art for art's sake. . . . Enjoy your vocation, for which we should all thank God" (Letter from Frédéric Chassériau to his brother

Théodore, August 26, 1856, Paris; published in Bénédite 1931, vol. 2, pp. 510–11).

August 26 and 27

■ The Waters of Spa

Théodore "drinks" the waters to cure his jaundice. He takes his treatment with "M. Lytton Bulwer, attaché at the embassy in The Hague" and intends to continue the cure in Boulogne: "After all that, I hope I will have recovered my health and to be able to work quietly when I get back to Paris" (Letter from Théodore Chassériau to his brother Frédéric, August 26, 1856, Spa; published in Bénédite 1931, vol. 2, p. 511).

The following day, August 27, Chassériau writes to his mother to tell her the same thing (Letter from Théodore Chassériau to his mother, August 27, 1856 [Spa]; published in Bénédite 1931, vol. 2, p. 513).

August 28

■ Paintings for Sale

Frédéric Chassériau replies to his brother's letter of August 26 (see above): "Your new *Holy Family* is exhibited in the rue Laffitte. There, the effect seems even better than in your studio. The passersby pause for a long while and seem very satisfied. I can no longer find your *Algerian Battle* in the place it was before being put back in the window from where it disappeared. I am inclined to think that this picture has been sold, which would make me as happy for the dealer as for the painter" (Letter from Frédéric Chassériau to his brother Théodore, August 28, 1856, Paris; published in Bénédite 1931, vol. 2, pp. 511–12).

August 30

■ Secret Illness

Frédéric writes to his brother: "Madame Silveira and her son asked me for your address. I said that you were traveling beyond the Northern border and that it was impossible to know where you were. I include Juan's letter so that you can see and appreciate the contents for yourself" (Letter from Frédéric Chassériau to his brother Théodore, August 30, 1856, Paris; published in Bénédite 1931, vol. 2, pp. 513–14).

Chassériau had drawn the portrait of Baron Juan Albukerque de Silveira in 1852, which he dedicated: "A mon ami Juan / Thre Chassériau 1852" (Sandoz 1986, no. 45, p. 59). The Portuguese de Silveira family belonged to the cosmopolitan and aristocratic circles in Paris.

August 31

■ Departure from Spa

Chassériau informs his brother: "I am leaving Spa on Thursday at the latest and will go on to Boulogne. . . . I will be there on Saturday at the latest and will stay to take my ocean baths until I go back to Paris. . . . I will write to Juan" (Letter from Théodore Chassériau to his brother Frédéric, August [31], 1856, Spa; published in Bénédite 1931, vol. 2, p. 514).

September 2

■ News of the Ongoing Sales

Frédéric confirms receipt of Théodore's letter of August 31 (see above): "Last Sunday I had the great pleasure of seeing your *Tepidarium* again at the Musée du Luxembourg. Your *Adoration of the Magi* is still on display in the rue Laffitte, where it attracts the attention of passersby, then their admiration. The Virgin is particularly well appreciated. Clermont was not among the cities favored by gifts of art on the Emperor's name day. This is one reason to hope that the wishes expressed in favor of your Gauls will finally be granted" (Letter from Frédéric Chassériau to his brother Théodore, September 2, 1856, Paris; published in Bénédite 1931, vol. 2, p. 514).

The *Defense of Gaul* would be purchased shortly after Chassériau's death, "for the sum of eight thousand francs" (Letter from Frédéric de Mercey to Frédéric Chassériau [October–November 1856, Paris]; published in Bénédite 1931, vol. 2, p. 476).

September 3

■ Frédéric's Fears

Frédéric Chassériau learns that "in Boulogne, there is an outbreak of sore throats of *epidemic* proportions. . . . In our family position, we are not allowed, either you or me, to expose ourselves unnecessarily and we must flee even the possibility of danger. Respond to my letter, not at home, where mother opens your letters in my absence, but at rue de Poitiers, n° 2, at the Council of State" (Letter from Frédéric Chassériau to his brother Théodore, September 3, 1856, Paris; published in Bénédite 1931, vol. 2, p. 515).

September 5

■ Arrival in Boulogne

Chassériau informs his mother immediately: "My health is better, I am no longer winded by the slightest effort, I feel *that I am regaining strength* and that my distaste for all food is starting to disappear completely. We will see what the ocean baths recommended by the doctors in Spa will do" (Letter from Théodore Chassériau to his mother, September [5], 1856, Boulogne-sur-Mer; published in Bénédite 1931, vol. 2, p. 515).

September 6

■ First Ocean Bath

Chassériau reassures his brother and denies the existence of sore throats (see above, *September 3, 1856*): "I have just taken my first bath: It is far from being fun, but it is supposed to be healthy" (Letter from Théodore Chassériau to his brother Frédéric, September 6, 1856, Boulogne-sur-Mer; published in Bénédite 1931, vol. 2, p. 516).

September 7

■ A Great Happiness

Frédéric confirms the receipt of his brother's letter of September 5 (see above): "It makes me very happy to know that you are *better* and God willing you will return to us *well*. . . . The Magi

have disappeared from the easel at n° 10 rue Laffitte. The Arab horseman asking for directions has been on exhibition for a few days at the first dealer's in the same rue Laffitte" (Letter from Frédéric Chassériau to his brother Théodore, September 7, 1856, Paris; published in Bénédite 1931, vol. 2, p. 516).

September 8

■ Marie Cantacuzène's Great Sorrow

A friend of the princess's alludes to her unhappiness: "What you told me pained me very much, my dear friend. How could you be so clumsy as to become so ill? . . . At least you have found good friends who are kind and devoted. I had always heard M. Chassériau spoken of in the best of terms. I see by what he did for you that he deserves his reputation. . . . What, therefore, is the cause of your great sorrow? And how can sorrow have such a sudden and terrible effect? Who is to blame?" (Letter from Amédée to Princess Marie Cantacuzène, September 8, 1856, Baden-Baden; published in Bénédite 1931, vol. 2, pp. 519–20).

We know from the same correspondent that Marie Cantacuzène changed her spa itinerary to go to Spa and to Boulogne. Did she intend to join Théodore there? She seems to allude to her own illness in this note: "My tribulations are reaching an end, my friend, the doctor will come tomorrow without fail. . . . I will be very good and take care of myself, hoping for a bit of joy in the future. Yours, Marie" (Note from Princess Marie Cantacuzène to Théodore Chassériau [early September (?) 1856 (?)], Paris; published in Bénédite 1931, vol. 2, p. 502). In the original French, Marie uses the informal second-person singular for the first and last time.

September 9–10

■ Cabarrus, the Charlatan

Chassériau reassures his mother: "I am not having any fun, but I am well, and before long I will come back to all of you. . . . I found a very distinguished doctor, who is doing me more good than that poor Doctor Cabarrus, who definitely is something of a *charlatan*. . . . *Keep this between the two of us*" (Letter from Théodore Chassériau to his mother [September 9–10, 1856, Boulogne-sur-Mer]; published in Chevillard 1893, p. 212, with the date "September 12"; Bénédite 1931, vol. 2, p. 518). On Cabarrus, a friend of the Girardins' see above, *December 2, 1847*.

September 12

■ He Announces His Return

In a letter to his brother, Chassériau complains about his framer, who "for two hundred francs . . . sends me these threats; since I am in the right, he will wait until I am good and ready. Here is a man who, because of me, has earned from three to four thousand francs a year for seven or eight years, and who for two hundred francs conducts himself in this manner in my absence—let's drop it." He then mentions the marital problems of his friend Juan de Silveira, whose wife (the daughter of Baron de Ménéval) had been "abducted by M. le Comte de Louvencourt," and

finally announces: "Perhaps I will return to Paris in the next few days" (Letter from Théodore Chassériau to his brother Frédéric, September 12, 1856, Boulogne-sur-Mer; published in Bénédite 1931, vol. 2, p. 518).

September 15 (?)

■ **Return to Paris**

The exact date is not known. Three weeks before his death, Chassériau sends this letter to his tactless framer (see above, *September 12, 1856*): "I have done the best I could to give you as much money as possible, and you are not really dealing <u>correctly</u> with me. . . . But, to repeat myself, you are doing me irreparable harm by this slowness and I beg you to send me as soon as possible the two small sides of my frame with the nails to adjust them and by the end of the day so that I will lose as little time as possible. I hope that I can count on you. With my compliments and complaints" (Letter from Théodore Chassériau to his framer [Adrien Beugniet (?)] [mid-September 1856], n.p.; Médiathèque, La Rochelle, Ms 621, fol. 232 r. and v.).

Late September

■ **Last Meeting with Gautier**

Chassériau resumes his normal activities under the care of Dr. Hérard (Bénédite 1931, vol. 2, p. 521). Gautier affirms that he ran into Chassériau shortly before his death, leaving the Opéra, and "smoked a cigar with him on the boulevard, in the moonlight, discussing Italian music and German music." Gautier went with him to his studio and saw a "delightful *Holy Family* done in a completely new spirit" (Gautier, October 13, 1856; Chevillard 1893, pp. 182, 212).

October 6

■ **State of Alarm**

Chassériau's health deteriorates. The well-known Dr. Trousseau is called upon for advice (Bénédite 1931, vol. 2, p. 521).

October 7

■ **Serious Concerns**

The painter's friends are anxious for news. The Chassériau family leaves a register with the concierge, which is signed by "M. Cantacuzène" and "Puvis de Chavannes" (Bénédite 1931, vol. 2, p. 521).

October 8

■ **Death of Théodore Chassériau**

Chassériau dies in the morning, in his apartment in the rue Fléchier-Saint-Georges, at the age of thirty-seven years and eighteen days (Gautier, October 13, 1856). In Gautier's words, his death is a "painful surprise" in Paris. Delacroix hears of the death of "the poor Chassériau" on the evening of the 9th, from their mutual friend Boissard (Delacroix, *Journal,* 1981, p. 594). His death had "certainly surprised everyone" (Letter from Eugène Delacroix to M^{me} de Forget, October 25 [1856], Champrosay; published in Delacroix, *Correspondance,* 1937, vol. 3, pp. 341–42).

October 10

■ **The Funeral**

The death notice sets the date of Chassériau's funeral for "Friday, October 10, at eleven o'clock in the morning, in the Church of Notre-Dame-de-Lorette, his parish. We will meet at the home of the deceased, N° 2, rue Fléchier S^{t.} Georges"

(Death Notice of Théodore Chassériau, October [8–9], 1856; Archives des Musées Nationaux, dossier P. 30 Chassériau; *L'Artiste* 2, October 12, 1856, p. 220).

■ **An Arab in a Black Burnoose**

Attending the funeral at the Montmartre cemetery is an Arab "with a fez secured by camel's-hair cords [who] follows the procession with an Oriental gravity and grief, and with his brown hand tattooed with verses from the Koran, sprinkles holy water on the casket as he holds aloft a yellow crown in the funerary chapel" (Gautier, October 13, 1856; Bénédite 1931, vol. 2, p. 522).

■ **Artists and a Princess**

On the same day, Delacroix writes in his diary: "October 10.—Procession for the unfortunate Chassériau. I meet Dauzats, Diaz, and the painter Moreau the younger. I rather like him. I come back from the church with Émile Lassalle" (Delacroix, *Journal,* 1981, p. 594). The presence of Puvis de Chavannes, Hilaire Belloc's daughter, and Princess Marie Cantacuzène is also documented (Bénédite 1931, vol. 2, p. 522).

■ **That Was a Painter!**

A group of friends gathers in Chassériau's parlor (Mantz 1856, p. 222; Chevillard 1893, p. 77). In front of the portrait of the Chassériau sisters (cat. 61; exhibited at the Salon of 1843), Delacroix exclaims several times: "That was a painter!" (Manuscript note by [Aglaüs Bouvenne (?)], Musée du Louvre, Département des Peintures, Service d'Étude et de Documentation, fichier Moreau-Nelaton; Bouvenne 1887, p. 171). One witness hears him say: "The death of our poor Chassériau is a misfortune for art and especially for our school" (Delacroix's words reported by Ceillier; quoted in Chevillard 1893, p. 76).

Bruno Chenique

Addendum

Portrait of Comtesse de La Tour-Maubourg, née Marie-Louise-Gabrielle Thomas de Pange

1841
Oil on canvas
52 x 37 ¼ in. (132.1 x 94.6 cm)
Signed and dated, lower left: *T. Chassériau / Rome 1841.*
New York, The Metropolitan Museum of Art, Purchase,
Wrightsman Fund, 2002 (2002.291)

PROVENANCE:
Presumed gift of the comte de La Tour-Maubourg to his
mother-in-law, the comtesse de Pange, 1841; subsequently des-
cended in the family of the sitter; her daughter, Gabrielle-Marie-
Charlotte de La Tour-Maubourg, who married Baron Gustave
de Mandell d'Écosse; their son, Fernand-Guillaume de Mandell
d'Écosse; called the marquis de La Tour-Maubourg, after 1892;
the marquise de La Tour-Maubourg, Château de Locquenolé,
Kervignac, Morbihan; her daughter, Marguerite, later Mme de
la Sallière; sale, Paris, Sotheby's, July 27, 2002; purchased by The
Metropolitan Museum of Art.

BIBLIOGRAPHY:
Unsigned 1841; Cantagrel 1841; Delécluze 1841; Gautier 1841;
Haussard 1841; Ladet 1841, p. 332; Peisse 1841, p. 43; Pelletan 1841;
Pillet 1841; Unsigned 1842, p. 194; Mantz 1856, p. 222; Bouvenne
1887, p. 175; Chevillard 1893, no. 60, pp. 46–49, 51–52; Dalligny
1894; Chevillard 1898, pp. 251–52; Marcel and Laran 1911, pp. 55–
56; Laran 1914, pp. 3–11, ill.; Goodrich 1928, pp. 68–71, ill. p. 71;
Bénédite 1931, vol. I, pp. 158–60, ill. p. 157; Vaudoyer 1932,
pp. 272–73, ill. opp. p. 272; Alazard 1933, pp. 49–51, ill. p. 49;
Jamot 1933, p. 21; Joubert 1947, pp. 138, 145, 168–69; Sandoz 1956,
pp. 6–7; Sandoz 1968, p. 182; Sandoz 1974, no. 87, pp. 186–87,
pl. 70; Sandoz, in Paris 1976; Montauban 1980, under no. 144,
p. 96; Aubrun 1984, p. 20; Amprimoz 1986, p. 263; Sandoz 1986,
pp. 24–25, ill. p. 24; Prat 1988-1, vol. I, ill. p. 89; Peltre 2001,
pp. 87–89, 190, ill. p. 89.

EXHIBITIONS:
Salon of 1841, no. 328; Paris, Orangerie, 1933, no. 16, p. 9.

Chassériau already had distinguished himself at the Salon, but the year 1841 proved to be a decisive one, for he sent two portraits, today considered masterpieces, to the Salon—that of Lacordaire (cat. 47) and of the comtesse de La Tour-Maubourg—as well as the history painting *Andromeda Chained to the Rock by the Nereids* (cat. 65); all three works, however, were roundly criticized. Each painting, in its own way, announced the definitive breach with Ingres that had occurred in Rome over the previous winter. The portrait of Lacordaire signaled Chassériau's assimilation of the magnificent Zurbaráns that had been exhibited at the Galerie Espagnole since January 1838, Spanish realism representing the antithesis of Ingres's cult of Raphaelesque classicism. The *Andromeda* recalled a theme dear to Ingres—Chassériau's damsel in distress was a retake of Ingres's *Roger and Angelica*—worked in an excessively mannered style that makes even Bronzino's allegories look chaste. The portrait of the comtesse de La Tour-Maubourg, whose husband was the French ambassador to the Holy See, embodied a subtler and more insidious defiance: As a three-quarter-length portrait of the wife of a powerful French official—young, beautiful, wellborn, and wearing an elaborate and fashionable costume—it conforms precisely to Ingres's formula. Yet, Chassériau subverted Ingres's approach to portraiture by casting a melancholic mood over the painting, by banishing his master's bright colors to make the figure and her dress nearly monochromatic, and—graver still—by abandoning Ingres's meticulous naturalism for an artful, highly aestheticized, almost anti-natural, depiction of sitter and setting.

Even the acceptance of the commission represented some defiance on Chassériau's part. He had arrived in Rome in August 1840 with the painter Henri Lehmann, with whom he was vying for the position of Ingres's favorite pupil. On the trip to Italy, Lehmann confided that he hoped to portray Lacordaire, the charismatic priest who had revived the Dominican order, but to his everlasting chagrin, Chassériau, instead, won permission to undertake the painting of the abbé. Later, when the French ambassador to Rome, the comte de La Tour-Maubourg, considered commissioning a portrait of his wife to send to his mother-in-law, he approached the director of the French Academy in Rome, M. Ingres, only to learn that he was famously and irremediably slow. It would have been customary for Ingres to suggest another artist, and very likely that he would have chosen Lehmann, since Ingres had sided with him on the question of the Lacordaire portrait. Luckily for Chassériau, the ambassador's wife visited his studio on November 21 to see the portrait of Father Lacordaire, for which she expressed her great admiration.

Two days later, writing to his brother Frédéric, Chassériau exulted in the commission, and bragged that the comtesse was "a woman beautiful like an angel who is very sweet and perfectly elegant. M. Ingres was envious when I told him that I was painting her [portrait]. . . . I am installed at the ambassador's residence in the Palazzo Colonna, and am ready to paint. We met yesterday and we get along very well."[1]

The ambassador was ill and confined to bed at the time, but that did not prevent him from bargaining with the artist. "Only the question of price remained, so serious for rich people . . . ," recounted Chassériau. "I beseeched Paul to ask for something very reasonable, 2,500 francs. With that the husband, who wants to give a present without ruining himself, painfully turned in his bed and said that I was too expensive, that I had enough talent to be [expensive], that he was sorry, but that he did not want to pay more than 1,000 francs."[2]

Once again, Lehmann vainly aspired to win the commission. He wrote to his confidante, Marie d'Agoult, of his "hope to take a stab at a portrait" of the ambassador's wife, "but as Chassériau is doing her portrait it would have been most *inappropriate*."[3] When the painting was completed, Ingres, out of professed soldarity with Lehmann, refused to look at it. Lehmann reported to Marie d'Agoult, on January 16, 1841: "M. Ingres had a marvelously accurate suspicion [about Chassériau] that, as a good friend, I fought with all my power, but that [now] I have to acknowledge. He did not even go to see the portrait of the ambassador's wife, although M. de Latour Maubourg had expressly asked him to and although I had told him that I found that utterly harsh and unfair and that this removed any obligation toward him on Chassériau's part as his student. In short, he really mistreated him. On the portrait of the abbé Lacordaire, I have not changed my opinion. . . ." The jealous Lehmann could not resist taking a swipe, and continued: "The

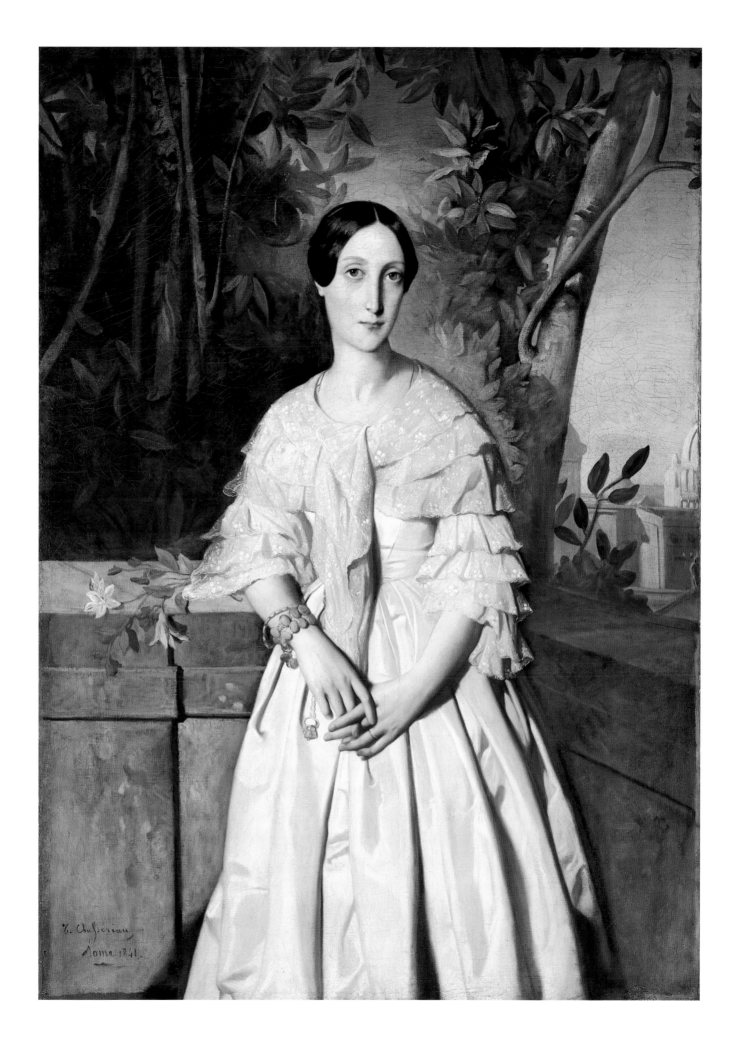

one [portrait] of the ambassador's wife is weak beyond words, she is like a little sheep who dreams of the taste of the flowers in the surrounding countryside—and she looks as if she has already been grazing. It is badly drawn, badly painted (except for some very subtle color relationships between the hands and the dress, and the sky and the earth, etc.), [and] not a very good likeness, in short, the mistake of a man of talent."[4]

The few extant preparatory drawings reveal that Chassériau first conceived the portrait with the countess standing with a parasol on a terrace at the Palazzo Colonna (then, the Roman residence of the French ambassador). In drawings now in the Louvre (see cat. 48), the countess is posed at an angle to the picture plane, her head turned sharply toward her left shoulder, and her right shoulder out of view. The corners of the composition are rounded, conforming to the contemporary fashion for lozenge-shaped frames, and, in its initial conception, as a whole, strongly resembled the theatrically staged portraits of the era. The costume, a long-sleeved day dress in the first drawings, was changed to a more formal, short-sleeved gown in a subsequent drawing (RF 26488; Prat 1988-1, vol. 1, no. 87), in which the countess, now without parasol, turns her head to her right. After Chassériau transferred the composition to canvas, he continued to refine it, bringing it closer to the classicizing conventions of Ingres's portraits. The figure faced the spectator directly, but pentimenti reveal that Chassériau made further adjustments to the position of the head and the hands, the necklace, the contours of the dress, and the height of the low wall at the right. He studied the dress in a fine drawing (RF 26114; Prat 1988-1, vol. 1, no. 88) and the exquisite hands, with interlaced fingers, in another sketch (RF 26511; Prat 1988-1, vol. 1, no. 89), but examination of the painting under infrared light shows that he continued to make alterations even after he had lightly sketched in the figure in pencil on the ocher-buff ground that he had applied to the canvas. In contrast to Ingres, Chassériau did not make elaborate drawings on the canvas, nor did he execute a large number of preparatory drawings. The confidence of this free elaboration of the portrait directly on the canvas would be a remarkable feat for any artist, but it is plainly astonishing in the work of a twenty-two-year-old painter.

The dress of the countess, ivory satin with lace flounces at the half sleeves, represented up-to-the-minute Paris fashion at its most elegant and refined. The absence of strong color and contrasts indicates sophistication and restraint, as does the choice of modest jewelry: a thin gold chain at the neck, a bangle on the wrist, and a chatelaine at the waist; only the periwinkle enamel ovals of the double bracelet provide color. A costume with short sleeves was worn in the late afternoon, perhaps to receive visitors (long sleeves were the custom for morning and noon), and the lack of a hat, purse, and gloves is a sign that the countess is at home. A matching flounced lace fichu modestly covers her décolletage and protects her from the cool breezes of autumnal Rome (the neckline usually would be revealed in the evening). The actual execution of the dress is a tour de force of subtly nuanced

tonal variations that even detractors like Lehmann were forced to acknowledge.

The view is taken from a terrace at the Palazzo Colonna,[5] on the Piazza dei Santissimi Apostoli, near the Piazza Venezia. Beyond the laurels behind the countess are the domes of two churches in the Foro Traiano: Santa Maria di Loreto (1508) and Santissimo Nome di Maria (1738). Trajan's Column, although not visible, is nearby. The top of the Colosseum, dark ocher in the light of sunset, is at the horizon.

Marie-Louise-Gabrielle Thomas de Pange was born in 1816 to a distinguished noble family.[6] In 1837, she became the second wife of Armand-Charles-Septime de Fay, Comte de La Tour-Maubourg (1801–1845). He came from an important family of generals and ministers of war, and was a lifelong diplomat, posted as an attaché to Constantinople in 1823, Lisbon in 1826, and Hanover in 1827. The comte resigned after the 1830 revolution, but was reinstated to his position by the government of Louis-Philippe, and sent to Vienna. He served in Brussels in 1832 and in Madrid in 1836, before being named ambassador to Rome in 1837 to replace his older brother, the marquis, who had just died in office. The comtesse became pregnant with one of her two daughters[7] soon after Chassériau completed his portrait. The comte died in Marseilles in 1845, and his widow died in Pau five years later; they are both buried in Marseilles.[8]

When the portrait was shown at the Salon of 1841, its reception was generally unfavorable. It would seem that Ingres's partisans were fully aware of the rift between master and student, and what they objected to were precisely the Romantic qualities of the picture—the expressive elongation of the head, the gazelle-like eyes, the pallor of the skin, and the delicacy of the hands—all of which make the picture so remarkable today. Delécluze noted the lack of strength and life in Chassériau's work; an anonymous reviewer in L'Artiste described the "pale image of a woman, silhouetted against pale foliage, the shadow of a shadow"; others used words like "spectral" and "sepuchral" to define the mood. A few critics, however, did understand the picture. Eugène Pelletan wrote, "We have heard the criticism of the portrait of M. Lacordaire and of Mme de Latour-Maubourg [sic] by M. Chassériaux [sic]. We are not laughing at the faults of these two portraits, and we are fortunate to find them in an artist; they represent the excesses of a talent."[9] At Chassériau's death fifteen years later, Paul Mantz summed up the reaction to the picture. "The austerity of execution and the dryness of the rigid silhouette of the portrait of the comtesse de la Tour-Maubourg . . . frightened Parisians. Strange in effect—a sort of phantom of sepulchral whites that seemed to be enveloped in lace as if in a shroud, but whose fiery come-hither eyes and transparent pallor nevertheless allowed one to guess at her inner radiance. Is it not in relation to this image that it was ingeniously written that it inspired a sort of repulsive attraction? Certainly one could not say it better: all the talent of the young master is in these two words."[10]

Needless to say, the comtesse, in Rome and with child during the exhibition of the Salon in the spring of 1841,

got word of the torrent of opinion that fell upon her portrait. Ingres's disciple Dominique Papety communicated gleefully to the sculptor Ottin, "Mme de Maubourg (who is pregnant) is furious with Chassériau; he has lost all favor and it is we who will replace him." [11] G. T.

1. Quoted in Chevillard 1893, pp. 46–49.
2. Letter from Théodore to his brother Frédéric, November 23, 1850; quoted in Chevillard 1893, p. 47.
3. Letter from Henri Lehmann to Marie d'Agoult, December 15, 1840; quoted in Joubert 1947, p. 138.
4. Letter from Henri Lehmann to Marie d'Agoult, January 16, 1841; quoted in Joubert 1947, p. 145.
5. Studied in two drawings at the Louvre: RF 26107 and RF 26108; Prat 1988-1, no. 91.
6. Jean Laran ("Un Portrait inédit par Chassériau," in *Archives de l'art français*, n.s. 8 [1916]) was the first to publish the comtesse's maiden name as Charlotte de Pange. However, the *Dictionnaire de biographie française* (Paris: Libraire Letouzey et Ané, 2000), fasc. CXIII, p. 57, gives her name as Marie-Louise-Gabrielle. The confusion may stem from the fact that her daughter was called Gabrielle-Marie-Charlotte.
7. *Dictionnaire de biographie française*, op. cit.
8. Laran, op. cit.
9. E. Pelletan, "Salon de 1841," in *La Presse*, Paris, April 4, 1841.
10. P. Mantz, "Theodore Chassériau," in *L'Artiste* 2, no. 16 (October 19, 1856), p. 222.
11. Letter from Dominique Papety to Auguste Ottin, May 15, 1841; cited in Amprimoz 1986, p. 263.

Portrait of Comtesse de Magnoncourt, née Mary de Tracy

1852
Graphite, heightened with white
14 ⅞ x 10 ⅞ in. (37.7 x 27.5 cm)
Dedicated, signed, and dated in graphite, lower right:
a monsieur / Victor de Tracy / Th^re Chassériau / 1852-
Collection André Bromberg

PROVENANCE:
Descendants of the sitter, until 1989; sale, Strasbourg, Groupe Gersaint, June 20, 1989, no. 14; André Bromberg, Paris.

BIBLIOGRAPHY:
Chevillard 1893, no. 277 (as Mme de Bray); Bénédite 1931, vol. 1, ill. p. 93; Sandoz 1986, no. 46a, ill.; Prat 1988-1, vol. 1, under no. 1077, p. 441; Prat 1988-2, no. 181; Hôtel Drouot 1989, p. 111, ill.; Lefranc 1998, p. 50, ill.; Peltre 2001, p. 28.

Sandoz considered this portrait drawing "with those of Mme Borg de Balsan [cat. 163], of Princesse Belgioioso [cat. 164], [and] of Princesse Cantacuzène [cat. 219], one of the most handsome that Chassériau made, if not, perhaps, the most beautiful." [1] The sitter was the daughter of the marquis de Tracy, whose portrait Chassériau drew a year earlier (see cat. 206). The marquis was Minister of the Navy under Louis-Philippe, and Frédéric Chassériau served as his *chef du cabinet*. In addition to portrait drawings, Théodore provided decorative panels for the de Tracys' country château at Paray-le-Frésil.

Mary de Tracy married Comte Césaire de Magnoncourt, with whom she had two sons; one of them, Raymond, also was portrayed by Chassériau (see cat. 207). When the artist completed the present drawing, he deposited it with a friend, Mme de Courbonne, who sent him an ecstatic letter of thanks: "[The drawing of] Mme de Magnoncourt has been at my house since yesterday evening, Monsieur, more ravishing than ever, animating my salon with her grace, full of life and vivacious charm. . . . I have never seen a portrait so charming! What finesse!" [2] G. T.

1. Sandoz 1986, p. 61
2. "Mme de Magnoncourt est chez moi depuis hier soir, Monsieur, plus ravissante que jamais, animant mon salon par sa grace pleine de vie et de charme vivace. . . . jamis je n'ai vu un si charmant portrait. Quelle finesse!"; cited in Sandoz 1986, p. 61.

BIBLIOGRAPHY

ABBREVIATIONS

C.P. = Musée du Louvre 1972
Cat. Somm. Ill. = Compin and Roquebert 1986
S.A.I. = Sterling and Adhémar 1958

Compiled by Bruno Chenique, with the
assistance of Aline François-Colin.

BOOKS AND ARTICLES

1836
Decamps, Alexandre.
 "Beaux-Arts. Salon de 1836." *Le National de
 1834,* May 1, 1836.
Delécluze, Étienne-Jean.
 "Le Salon." *Journal des débats,* March 1, 1836.

1839
Unsigned.
 "Un Peu de tout. Chapitre VI." *L'Artiste* 4
 (December 1839), p. 254.
Amans de CH. . . . and A. . . .
 Examen du Salon de 1839. Paris, 1839.
Blanc, Charles.
 "La Salon de 1839." *Revue du progrès
 politique, social et littéraire,* April 1839.
D[ecam]ps, Alexandre.
 "Le Salon de 1839." *Le National,* March–
 May 1839.
Delécluze, Étienne-Jean.
 "Salon de 1839." *Journal des débats,* March
 16, 1839.
Gautier, Théophile.
 "Salon de 1839 (8e article)." *La Presse,*
 Saturday, April 13, 1839, pp. 3–4.
Haussard, Prosper.
 "Le Salon de 1839." *Le Temps,* 1839.
Janin, Jules.
 "Exposition de peinture et de sculpture au
 profit des victimes du tremblement de terre
 de la Martinique, rue des Jeûneurs, 16."
 L'Artiste 3 (1839), p. 197.
Laurent-Jan.
 Le Salon de 1839. Paris, 1839.
Royer, Alphonse.
 "Salon de 1839." *Le Siècle,* 1839.
Thoré, Théophile.
 "Le Salon de 1839." *Le Constitutionnel,* 1839.

1840
Unsigned.
 "Salon de 1840." *Le Corsaire,* March 27, 1840.
Unsigned.
 "Salon de 1840." *Le Journal des beaux-arts et
 de la littérature,* March 22, 1840.
Unsigned.
 "Salon de 1840: Encore les Ingristes." *Le
 Charivari,* March 24, 1840.

Blanc, Charles.
 "Le Salon de 1840." *Revue du progrès
 politique, social et littéraire,* April 1840.
Delécluze, Étienne-Jean.
 "Salon de 1840." *Journal des débats,* March
 12, 1840.
Destigny (de Caen), Jean-François.
 Revue poétique du Salon de 1840. Paris,
 1840.
Gautier, Théophile.
 "Salon de 1840. I." *La Presse,* Wednesday,
 March 11, 1840, p. 1.
Gautier, Théophile.
 "Salon de 1840. II." *La Presse,* Friday, March
 13, 1840, p. 2.
Guenot Lecointe, G.
 "Salon de 1840." *La Sylphide,* March 14,
 1840.
Haussard, Prosper.
 "Salon de 1840." *Le Temps,* April 12, 1840.
Janin, Jules.
 "Salon de 1840. Premier Article." *L'Artiste* 5,
 no. 10 (1840), pp. 167, 170.
Janin, Jules.
 "Salon de 1840. Deuxième Article." *L'Artiste*
 5, no. 11 (1840), pp. 186–87.
Janin, Jules.
 "Salon de 1840. Troisième Article." *L'Artiste*
 5, no. 12 (1840), p. 202.
Pillet, Fabien.
 "Salon de 1840." *Le Moniteur universel,*
 March 23, 1840.
Royer, Alphonse.
 "Salon de 1840." *Le Siècle,* March 11, 1840.
Tardieu, Eugène.
 "Salon de 1840." *Le Courrier français,* March
 10, 1840.

1841
Unsigned.
 "Salon de 1841." *Le Journal des artistes,* May
 16, 1841.
Unsigned.
 "Salon de 1841." *Le Journal des beaux-arts et
 de la littérature,* April 11, 1841.
Unsigned.
 "Le Salon de 1841." *Le Moniteur universel,*
 March 22, 1841.

Unsigned.
 "Salon de 1841. Portraits." *L'Artiste* 7 (1841),
 p. 332.
Unsigned.
 "Salon de 1841. Tableaux de chevalet.
 Premier Article." *L'Artiste* 7 (1841), p. 264.
Cantagrel.
 "Salon de 1841." *La Phalange,* May 30, 1841.
Delécluze, Étienne-Jean.
 "Salon de 1841." *Journal des débats,* May 29,
 1841.
G. D.
 "Salon de 1841." *L'Univers,* June 5, 1841.
Gautier, Théophile.
 "Le Salon de 1841." *Revue de Paris* 28 (April
 28, 1841), pp. 164–65.
Haussard, Prosper.
 "Salon de 1841." *Le Temps,* May 21, 1841.
Ladet, U.
 "Salon de 1841." *L'Artiste* 7, no. 20 (1841),
 p. 332.
Montlaur, Eugène de.
 "Le Salon de 1841." *Revue du progrès
 politique, social et littéraire,* April 1841.
Peisse, Louis.
 "Le Salon de 1841." *La Revue des deux
 mondes,* 4th series, 26 (April 1, 1841), p. 43.
Pelletan, Eugène.
 "Salon de 1841." *La Presse,* April 4, 1841.
Pelletan, Eugène.
 "Salon de 1841." *La Presse,* June 3, 1841.
Pillet, Fabien.
 "Salon de 1841." *Le Moniteur universel,*
 March 22, 1841.
Ténint, Wilhelm.
 Album du Salon de 1841. Paris, 1841.

1842
Unsigned.
 "Nouvelles des arts [travaux à Saint-Merry]."
 Journal des artistes: Revue pittoresque 2, no. 17
 (October 23, 1842), p. 270.
Unsigned.
 "Salon de 1842." *L'Artiste* 1, no. 12 (1842),
 p. 194.
Unsigned.
 "Salon de 1842." *Journal des artistes,* April 10,
 1842.

Unsigned.
 "Salon de 1842." *Le Journal des beaux-arts et de la littérature*, April 16, 1842.
Unsigned.
 "Salon de 1842. Légende dorée." *Le Charivari*, April 13, 1842.
Unsigned.
 "Salon de Paris. 1842." *La Renaissance* (Brussels), 1842, pp. 10–14.
Un bourgeois.
 "Salon de 1842." *Le Siècle,* April 18, 1842.
Delécluze, Étienne-Jean.
 "Salon de 1842." *Journal des débats*, March 18, 1842.
Des Essarts, Alfred.
 "Salon de 1842." *L'Écho français*, March 23, 1842.
Dupré, George.
 "Salon de 1842." *Revue du progrès politique, social et littéraire* 7 (March 1, 1842), p. 227.
Gautier, Théophile.
 "Salon de 1842." *Le Cabinet de l'amateur et de l'antiquaire* 1 (1842), p. 126.
Lacroix, Paul.
 "Nouvelles et faits divers. France. Paris [travaux à Saint-Merry]." *Bulletin de l'Alliance des Arts*, no. 9 (October 25, 1842), p. 133.
L[averdant]., D[ésiré].
 "Salon de 1842 (6e article). Sujets d'amitié et d'amour." *La Phalange* 5, no. 55 (Sunday, May 3, 1842), pp. 897–98.
L[averdant]., D[ésiré].
 "Salon de 1842 (8e article). Souffrances et jouissances du corps." *La Phalange* 5, no. 61 (Sunday, May 22, 1842), pp. 989–90.
Peisse, Louis.
 "Salon de 1842." *La Revue des deux mondes*, 4th series, 30 (April 1, 1842), pp. 111–14.
Pillet, Fabien.
 "Salon de 1842." *Le Moniteur universel*, March 30, 1842.
[Piot, Eugène].
 "Bulletin-Chronique. La Vénus Sortant de l'Onde de M. Chassériau." *Le Cabinet de l'amateur et de l'antiquaire* 1 (1842), p. 336.
Robert.
 "Salon de 1842." *Le National*, April 8, 1842.
Stern, Daniel [Marie d'Agoult].
 "Le Salon de 1842." *La Presse*, March 20, 1842.
Ténint, Wilhelm.
 Album du Salon de 1842: Collection des principaux ouvrages exposés au Louvre. Paris: Challamel, 1842, p. 40.

1843

Unsigned.
 "Le Salon de 1843. 3e Article." *Revue indépendante*, April 25 and May 10, 1843.
Delécluze, Étienne-Jean.
 "Beaux-Arts. Chapelles décorées de peintures à Saint-Merry, par M. Chassériau, à Saint-Germain-l'Auxerrois, par M. Guichard et M. Gigoux. "*Journal des débats*, Tuesday, November 21, 1843, p. 2.
Gautier, Théophile.
 "Chapelle de Sainte-Marie-l'Égyptienne, à l'église Saint-Merry." *La Presse*, Thursday and Friday, November 2 and 3, 1843, pp. 1–2.
Houssaye, Arsène.
 "Salon de 1843." *Revue de Paris*, 1843.
Peisse, Louis.
 "Le Salon de 1843." *La Revue des deux mondes*, April 1 and 15, 1843.

[Piot, Eugène].
 "Monuments publics." *Le Cabinet de l'amateur et de l'antiquaire* 2 (1843), pp. 372–73.
Stern, Daniel [Marie d'Agoult].
 "Salon de 1843." *La Presse*, March–April 1843.
Ténint, Wilhelm.
 Album du Salon de 1843. Paris, 1843.
Wey, Francis.
 "Salon de 1843. III." *Le Globe*, April 14 1843, pp. 1–2.

1844

Unsigned.
 "Salon de 1844." *L'Illustration*, March 30, 1844.
Unsigned.
 "Salon de 1844. Les Dessinateurs." *Le Charivari*, March 30, 1844.
Unsigned.
 "Salon de 1844. 2e Art." *Les Beaux-Arts*, 1844, pp. 403–4.
Borel, Pétrus.
 "Beaux-Arts. Salon. École californienne." *Satan*, March 24, 1844.
Bray, H. de.
 "Les Gravures d'Othello de M. Chassériau." *L'Artiste*, 4th series, 2 (September 8, 1844), p. 32.
Delécluze, Étienne-Jean.
 "Salon de 1844." *Journal des débats*, April 2, 1844.
Desbarolles, Ad.
 "Opinions de la presse allemande sur l'exposition française de 1844." In *L'Ami des arts*, 1844, pp. 488–98.
Desbarolles, Ad.
 "Quelques Mots sur le Salon de 1844." *L'Ami des arts*, 1844.
Egmont, Henry.
 "Peintures des chapelles de Saint-Germain et de Saint-Merry. M. Chassériau, M. Lepaulle, M. Guichard, M. Gigoux." *Les Beaux-Arts*, 1844.
F[ournier]., M[arc].
 "Poésie. À M. T. Chassériau, sur son esquisse d'Apollon et Daphné." *L'Artiste,* 4th series, 1, no. 9 (June 30, 1844), p. 142.
Gautier, Théophile.
 "Académie Royale de Musique.–Othello." *La Presse*, September 9, 1844.
Gautier, Théophile.
 "Salon de 1844." *La Presse*, March 27, 1844.
Gobineau, Arthur de.
 "Les Nouvelles Peintures de Saint-Merry. M. Henry Lehmann, M. Amaury-Duval, M. Chassériau." *La Quotidienne*, November 16, 1844.
Houssaye, Arsène.
 "Salon de 1844." *L'Artiste*, 3rd series, 5, no. 13 (March 31, 1844), pp. 193–95. [Reprinted in *Revue du Salon de 1844*, Paris, 1844.]
Janin, Jules.
 "La Semaine dramatique." *Journal des débats*, Monday, June 17, 1844, pp. 1–2.
Janin, Jules.
 "La Semaine dramatique. Théâtre de l'Opéra, Othello [. . .]." *Journal des débats*, Monday, September 16, 1844, pp. 1–3.
La Fizelière, Albert de.
 "Le Salon de 1844." In *L'Ami des arts*, pp. 305–6. Paris, 1844.
Laverdant, Désiré.
 "Salon de 1844. VIIe Article." *La Démocratie pacifique* 2, no. 128 (Tuesday, May 7, 1844), p. 2.

Menciaux, Alfred de.
 "Salon de 1844." *Le Siècle*, May 26, 1844.
Peisse, Louis.
 "Le Salon de 1844." *La Revue des deux mondes*, April 15, 1844.
Pillet, [Fabien].
 "Salon de 1844." *Le Moniteur universel*, April 1 and 29, 1844.
Thoré, Théophile.
 "Le Salon de 1844." *Le Constitutionnel*, 1844. [Reprinted in *Salons de T. Thoré*, Paris: Librairie Internationale, 1868.]

1845

Unsigned.
 "Lettres sur le Salon de 1845. À M. V. E. R. à Rome." *L'Artiste* 3, no. 12 (March 23, 1845), p. 181.
Unsigned.
 "Musée aux lumières" [Exhibition in the foyer of the Odéon]. *Journal des artistes* 1 (1845), pp. 445–46, 461–63, 485–86.
Unsigned.
 "République des arts et des lettres" [engraving of the portrait of Ali-Ben-Hamet by Alphonse Masson, after Chassériau]. *L'Artiste* 4, no. 4 (May 25, 1845), p. 63.
Unsigned.
 "Salon de 1845." *La Phalange* 14 (March–April 1845), p. 279.
Unsigned [possibly Paul Mantz].
 "Salon de 1845. VII." *L'Artiste*, 4th series, 3, no. 15 (April 13, 1845), p. 227.
Baudelaire, Charles.
 Salon de 1845. Paris, 1845. [Reprinted in *Curiosités esthétiques*, Paris, 1868, and in *Curiosités esthétiques: L'Art romantique et autres oeuvre critiques*, rev. ed., with an expanded biographical summary, Paris: Garnier, 1986, pp. 28–29.]
Bray, H. de.
 "Chronique des arts et des lettres." *L'Artiste* 3 (January 12, 1845).
Delécluze, Étienne-Jean.
 "Salon de 1845." *Journal des débats*, March 22, 1845.
Gautier, Théophile.
 "La Galerie du foyer de l'Odéon." *La Presse*, November 17, 1845.
Gautier, Théophile.
 "Salon de 1845." *La Presse*, March 18, 1845.
Guépoulain, Eugène de.
 "Salon de 1845." *L'Almanach du mois. Revue de toutes choses par des députés et des journalistes* 3 (1845), p. 213.
Haussard, Prosper.
 "Salon de 1845." *Le National*, April 13, 1845.
Houssaye, Arsène.
 "Salon de 1845." *L'Artiste,* 1845.
Jal, Auguste.
 "Dix Études sur les décorations de chapelles de Paris." *Le Moniteur des arts* 3, no. 37 (October 12, 1845), pp. 81–82.
La Fizelière, Albert de.
 "Beaux-Arts. Salon de 1845. Revue des journaux." *Bulletin de l'ami des arts* 3 (1845), pp. 292–93, 302–3, 323, 339, 364.
La Fizelière, Albert de.
 "Le Salon de 1845." In *L'Ami des arts*, p. 257. Paris, 1845.
Mantz, Paul.
 "Le Jury." *L'Artiste*, 4th series, 3, no. 11 (March 16, 1845), pp. 163, 165.

Martonne, Alfred de.
 "Correspondance." *La Renaissance*
 (Brussels), 1845, pp. 29–30.
Pelletan, Eugène.
 "Salon de 1845." *La Démocratie pacifique*,
 March 31, 1845.
P[illet]., Fabien.
 "Beaux Arts. Salon de 1845." *Le Moniteur
 universel*, March 31, 1845, pp. 776–77.
Piot, Eugène.
 "Salon de 1845." *Le Cabinet de l'amateur et
 de l'antiquaire*, 1845, p. 267.
Thoré, Théophile.
 "Salon de 1845. Portraits." *Le Constitutionnel*,
 no. 131 (Sunday, May 11, 1845), p. 3.
Thoré, Théophile.
 "Salon de 1845. Revue générale." *Le
 Constitutionnel*, no. 77 (Saturday, March 18,
 1845), p. 3.

1846
Unsigned [bibliophile Jacob].
 "Nouvelles et faits divers. France. Paris"
 [album belonging to the duchesse de
 Montpensier containing a drawing by
 Chassériau]. *Bulletin des arts* 4 (November
 10, 1846), p. 169.
Thoré, Théophile.
 "Exposition de tableaux au foyer de l'Odéon."
 Le Constitutionnel, January 3, 1846.
Woestyn, Eugène.
 "Une Soirée chez Victor Hugo." *Journal du
 dimanche*, October 4, 1846.

1847
D'Arnem, D. [Ménard, Louis].
 "Peinture murale. MM. Chassériau et
 Delacroix." *La Démocratie pacifique* 9, no. 67
 (Friday, September 17, 1847), pp. 1–3.
Asseline, Alfred.
 "A. T. Chassériau." In *Pâques fleuries*, pp. 9–
 10. Preface by Jules Janin. Paris: Librairie
 d'Amyot, 1847.
Gautier, Théophile.
 "*La Croix de Berny*. Courrier de Paris. Revue
 des arts." *La Presse*, January 31, 1847.
Gautier, Théophile.
 "Théâtres." *La Presse*, no. 4137 (Tuesday,
 September 7, 1847), p. 1.
J. S. M.
 "Album offert à S. A. R. la duchesse de
 Montpensier par les princes et les princesses
 de la famille royale." *L'Illustration* 8, no. 202
 (Saturday, January 9, 1847), p. 301.
Thoré, Théophile.
 "Le Salon de 1847." *Le Constitutionnel*, 1847.
 [Reprinted in *Salons de T. Thoré*, Paris:
 Librairie Internationale, 1868, pp. 524–29.]
Trianon.
 "Les Nouvelles Peintures dans les églises de
 Paris." *Le Correspondant*, December 25, 1847.

1848
Unsigned.
 "Salon de 1848 (4ᵉ et dernier article)."
 L'Univers: Union catholique, no. 556
 (Thursday, June 29, 1848), p. 2.
Arnoux, J. J.
 "Variétés. Salon de 1848." *La Liberté:
 Journal des idées et des faits*, no. 30
 (Thursday, March 30, 1848), p. 4.
Brunier, Charles.
 "Beaux-Arts. Exposition de l'Association des
 Artistes." *La Démocratie pacifique* 10, no. 8
 (Sunday, January 9, 1848), p. 6.
Chatouville, C. de.
 "Salon de 1848." *Musée des familles* 15 (April
 1848), p. 223.
Clément de Ris, L.
 "Salon de 1848." *L'Artiste*, 5th series, 1, no. 7
 (April 30, 1848).
Delécluze, Étienne-Jean.
 "Salon de 1848. (Premier Article). Peinture."
 Journal des débats, Wednesday, April 5, 1848,
 p. 2.
Desjobert, Eugène.
 "Variétés. Beaux-Arts." *Le Monde républicain*,
 no. 24, Monday, April 24, 1848, p. 2.
Gautier, Théophile.
 "Concours pour la figure de la République."
 La Presse, May 21, 1848.
Gautier, Théophile.
 "Palais du quai d'Orsay. Peintures murales
 de M. Théodore Chassériau." *La Presse*,
 no. 4552 (Tuesday, December 15, 1848),
 pp. 1–2. [Reprinted in Bénédite 1931, vol. 2,
 pp. 329–41.]
Gautier, Théophile.
 "Salon de 1848 (5ᵉ article)." *La Presse*, no.
 4367 (Thursday, April 27, 1848), p. 2.
Gautier, Théophile.
 "Troisième Exposition de l'Association des
 Artistes. Bazar de Bonne-Nouvelle." *La Presse*,
 no. 4204 (Sunday, February 13, 1848), p. 2.
H[aussard]., Pr[osper].
 "Beaux-Arts.—Salon de 1848." *Le National*,
 Thursday, June 15, 1848, p. 2.
H[aussard]., Pr[osper].
 "3ᵉ Exposition annuelle de l'Association des
 Artistes. Au profit de la Caisse des Secours et
 Pensions." *Le National*, Tuesday, January 25,
 1848, p. 2.
Houssaye, Arsène.
 "République des lettres et des arts. Salon de
 1848." *L'Artiste*, 5th series, 1, no. 2 (March
 19, 1848), pp. 17–30.
[Hugo, Charles].
 "Nouvelles diverses. Paris" [stairwell of the
 Palais d'Orsay]. *L'Événement*, no. 115 (Friday,
 November 24, 1848), p. 3.
Isnard, Charles.
 "Concours des figures symboliques de la
 République." *L'Artiste*, 5th series, 1 (June 15,
 1848), p. 163.
Jan, Laurent.
 "Salon de 1848. II. Peinture historique." *Le
 Siècle*, no. 85 (Tuesday, March 28, 1848), p. 3.
Lagenevais, F. de [Frédéric de Mercey].
 "Le Salon de 1848. La Peinture." *La Revue des
 deux mondes* 22 (April 15, 1848), pp. 286–88.
Lebon [de Chevrolet], Félix.
 "Le Salon de 1848." *Revue des auteurs unis*,
 1848.
Malitourne, Pierre.
 "Les Peintures de M. Théodore Chassériau
 au Palais d'Orsay." *L'Artiste* 2, no. 8
 (December 15, 1848), pp. 123–25.
Monselet, Charles.
 "Statues et statuettes contemporaines. La
 Princesse de Belgiojoso." *L'Événement*, no.
 18 (Friday, August 18, 1848), p. 1.
M[ontlaur]., Eug[ène]. de.
 "De la Peinture et de la sculpture en France.
 Salon de 1848 (3ᵉ article)." *Le Salut public:
 Journal quotidien, politique, scientifique et
 littéraire*, no. 27 (Tuesday, April 11, 1848), p. 2.

P[illet]., Fab[ien].
 "Beaux-Arts. Peinture, sculpture, etc. Galerie
 Bonne-Nouvelle." *Le Moniteur universel*, no.
 32 (Tuesday, February 1, 1848), pp. 240–41.
P[illet]., Fab[ien].
 "Beaux-Arts. Salon de 1848 (4ᵉ article)." *Le
 Moniteur universel*, no. 94 (Monday, April 3,
 1848), p. 754.
Saint-Victor, Paul de.
 "Beaux-Arts. Exposition de 1848." *La
 Semaine* 3, no. 22 (April 2, 1848), p. 698.
Thoré, Théophile.
 "Ouverture du Salon de 1848." *Le
 Constitutionnel*, no. 76 (Thursday, March
 16, 1848), p. 3.
Thoré, Théophile.
 "Revue des arts." *Le Constitutionnel*, no. 51
 (Sunday, February 20, 1848), p. 2.

1849
Unsigned.
 "Gravures du numéro." *L'Artiste* 3, no. 1
 (April 1, 1849), p. 16.
Unsigned.
 "Gravures du numéro." *L'Artiste* 3, no. 5
 (June 1, 1849), p. 79.
Malitourne, Pierre.
 "Art monumental. Les Peintures de M.
 Théodore Chassériau au Palais d'Orsay."
 L'Artiste, December 15, 1849.
Pilgrim, Lord.
 "Mouvement des arts." *L'Artiste* 2, no. 13
 (March 1, 1849), p. 205.

1850
Unsigned.
 "La Cour des Comptes." *Revue des arts*,
 August 9–16, 1850, p. 88.
Chenevières, Philippe de.
 Lettres sur les arts français en 1850. Paris, 1850.
Clément de Ris, L.
 "Mouvement des arts. Salon de 1850."
 L'Artiste 5, no. 12 (November 15, 1850), p. 187.

1851
Unsigned.
 "Gravures du numéro." *L'Artiste* 6, no. 4
 (March 15, 1851), p. 64.
Unsigned.
 "Revue du Salon (1850)." *L'Ordre et la
 liberté*, 1851.
Chennevières, Philippe de.
 Lettre sur les arts français en 1850. Paris, 1851.
Clément de Ris, L.
 "Le Salon." *L'Artiste* 5, no. 16 (January 15,
 1851), p. 242.
Clément de Ris, L.
 "Salon. V." *L'Artiste* 6, no. 3 (March 1, 1851),
 p. 36.
Delécluze, Étienne-Jean.
 "Salon de 1850." *Journal des débats*, January–
 March 1851. [Reprinted in *Exposition des
 artistes vivants, 1850*, Paris: Au Comptoir des
 Imprimeurs, 1851.]
Gautier, Théophile.
 "Salon de 1850–1851." *La Presse*, April 8,
 1851.
Gautier, Théophile.
 "Salon de 1850–1851. M. Chassériau." *La
 Presse*, March 1, 1851.
Geoffroy, Louis de.
 "Le Salon de 1850." *La Revue des deux
 mondes*, 1851.

La Fizelière, Albert de.
 Exposition nationale. Salon de 1850–1851.
 Paris, 1851.
Peisse, Louis.
 "Salon de 1850–1851." *Le Constitutionnel,*
 April 1851.
Pommier, Amédée.
 "Sonnets. XII. Baigneuse endormie près
 d'une source. Chassériau." *L'Artiste* 6, no. 7
 (May 1, 1851), p. 99.
Sabatier-Ungher, F.
 Salon de 1851. Paris, 1851.
Vignon, Claude.
 Salon de 1850–1851. Paris: Garnier Frères,
 1851, pp. 97–98.

1852
Unsigned.
 "Gravures du numéro." *L'Artiste* 8, no. 9
 (June 1, 1852), p. 144.
Unsigned.
 "Gravures du numéro." *L'Artiste* 9, no. 5
 (October 1, 1852), p. 80.
Bouniol, Marie-Bathild.
 Causeries d'un amateur. Souvenirs du Salon.
 Études d'art. Melun: C. Michelin, 1852,
 pp. 12–13.
Breulier, Adolphe.
 "L'Art et l'archéologie au Salon de 1852."
 Revue archéologique, 1852, pp. 114–24.
Clément de Ris, L.
 "Le Salon." *L'Artiste* 8, no. 8 (May 15, 1852),
 p. 115.
Delécluze, Étienne-Jean.
 "Exposition de 1852." *Journal des débats,*
 June 5, 1852.
Du Camp, Maxime.
 "Salon de 1852." *Revue de Paris,* May–June
 1852, pp. 71–72.
Gautier, Théophile.
 "Le Salon de 1852 (8e article). MM.
 Chassériau, Gérome, Burthe." *La Presse,*
 Tuesday, May 25, 1852, pp. 1–2.
Gautier, Théophile.
 "Société des amis des arts de Bordeaux.
 Exposition de 1852." *La Presse,* January 15,
 1852.
Gautier, Théophile, and Arsène Houssaye.
 Les Artistes vivants. Paris, 1852.
Goncourt, Edmond de, and Jules de Goncourt.
 Études d'art. Le Salon de 1852. La Peinture à
 l'exposition de 1855. Paris, 1893, p. 99.
Grün, Alphonse.
 "Le Salon de 1852." *Le Moniteur universel,*
 1852. [Reprinted in *Salon de 1852,* Paris:
 Typographie Panckoucke, 1852, pp. 72–73.]
Lacretelle, Henri de.
 "Salon de 1852." *La Lumière,* April 24, 1852.
Loudun, Eugène.
 Le Salon de 1852. Paris: L. Hervé, 1852,
 pp. 18–20.
Nadar.
 "Album du Salon." *Le Journal pour rire,*
 no. 32 (Saturday, May 8, 1852). [Reprinted
 in Nadar, *Album du Salon, Nadar jury,*
 1852: Album caricatural, Paris: L'Éclair,
 1852.]
Nerval, Gérard de.
 "La Bohème galante." *L'Artiste* 8, no. 11
 (July 1, 1852), p. 168.
Vignon, Claude.
 Le Salon de 1852. Paris: Dentu, 1852, pp. 64,
 106.

1853
Unsigned.
 "Gravures du numéro. *Tépidarium.*"
 L'Artiste 11, no. 5 (1853), p. 60.
Bertall.
 "Le Salon dépeint et dessiné." *Le Journal*
 pour rire, July 16, 1853, p. 1.
Boyeldieu-d'Auvigny, L.
 Salon de 1853. Paris: Dagneau, 1853, p. 59.
Calonne.
 "Salon de 1853." *Revue contemporaine,* June
 1, 1853.
Clément de Ris, L.
 "Salon de 1853. Lettre à un ami de
 Bruxelles." *L'Artiste* 10, no. 9 (June 1, 1853),
 pp. 131–32.
Delaborde, Henri.
 "Le Salon de 1853." *La Revue des deux*
 mondes, June 15, 1853, pp. 1134–58.
 [Reprinted in *Mélanges sur l'art contempo-*
 rain, Paris, 1866.]
Delécluze, Étienne-Jean.
 "Exposition de 1853." *Journal des débats,*
 June 25, 1853.
Du Pays, A.-J.
 "Salon de 1853." *L'Illustration* (June 18, 1853),
 p. 392.
Gautier, Théophile.
 "Salon de 1853. M. Chassériau." *La Presse,*
 June 23, 1853.
Jubinal, Achille.
 "Salon de 1853." *L'Abeille impériale* 1, no. 4
 (June 15, 1853).
Lacretelle, Henri de.
 "Salon de 1853." *La Lumière,* June 4, 1853.
Lacretelle, Henri de.
 "Salon de 1853. 2e Article." *La Lumière,*
 June 4, 1853.
La Madeleine, Henry de.
 "Le Salon de 1853." *L'Éclair* 3 (1853), p. 280.
La Madeleine, Henry de.
 Le Salon de 1853. Paris, 1853.
Mantz, Paul.
 "Le Salon de 1853." *Revue de Paris,* June and
 July 1, 1853.
Nadar.
 Nadar au Salon de 1853: Album comique.
 Paris: Bry, 1853.
Viel-Castel, Henri.
 "Salon de 1853." *L'Athenaeum français,* June
 11, 1853, p. 558.
Vignon, Claude.
 Le Salon de 1853. Paris: Dentu, 1853, p. 75.

1854
Baschet, Armand.
 "Les Ateliers de Paris en 1854. Lettres à M.
 Arsène Houssaye. VII. M. Chassériau, I."
 L'Artiste 12, no. 9 (June 1, 1854), pp. 134–35.
Baschet, Armand.
 "Les Ateliers de Paris en 1854. Lettres à
 M. Arsène Houssaye. VII. M. Chassériau,
 II." *L'Artiste* 12, no. 10 (June 15, 1854),
 pp. 150–51.
Clément de Ris, L.
 "Mouvement des arts. Peintures de M.
 Chassériau à Saint-Roch." *L'Artiste,* 5th
 series, 12 (April 1, 1854), p. 77.
Delaborde, Henri.
 "Peintures de M. Chassériau à Saint-Roch."
 La Revue des deux mondes, April 15, 1854,
 pp. 430–32. [Reprinted in *Mélanges sur l'art*
 contemporain, Paris, 1866.]

Du Pays, A.-J.
 "Église Saint-Roch. Peintures murales par
 M. Théodore Chassériau." *L'Illustration* 23,
 no. 577 (March 18, 1854), pp. 175–76.
Gautier, Théophile.
 "Peintures murales de Saint-Roch par M.
 Théodore Chassériau." *Le Moniteur*
 universel, March 4, 1854. [Reprinted in *Les*
 Beaux-Arts en Europe, vol. 2, 1856.]
Saint-Victor, Paul de.
 "Beaux-Arts. Peintures murales de Saint-
 Roch par M. Théodore Chassériau." *L'Artiste*
 13, no. 5 (October 1, 1854), pp. 67–68.

1855
About, Edmond.
 Voyage à travers l'exposition des beaux-arts.
 Paris, 1855, pp. 187–89.
Du Pays, A.-J.
 "Exposition Universelle des beaux-arts."
 L'Illustration 26, no. 647 (July 21, 1855),
 pp. 39–42.
Fournier, Jean-Baptiste Fortuné de.
 A Room at the Exposition Universelle of 1855.
 Paris, 1855.
Gautier, Théophile.
 "Exposition Universelle de 1855." *Le*
 Moniteur universel, August 25, 1855.
 [Reprinted in *Les Beaux-Arts en Europe,*
 vol. 1, Paris, 1855–56, pp. 248–57.]
Gebaüer, Ernest.
 Les Beaux-Arts à l'Exposition Universelle de 1855.
 Paris: Librairie Napoléonienne, 1855, pp. 91–93.
La Rochenoir (de).
 Exposition Universelle des beaux-arts. Le
 Salon de 1855 apprécié à sa juste valeur. Paris:
 Martinon, 1855, pp. 32–33.
Loudun, Eugène.
 Exposition Universelle des beaux-arts. Le Salon
 de 1855. Paris: Ledoyen, 1855, pp. 125, 127.
Perrier, Charles.
 "Exposition Universelle des beaux-arts."
 L'Artiste, 5th series, 15 (July 1, 1855), pp. 114–15.
Petroz, Pierre.
 "Les Beaux-arts à l'Exposition Universelle."
 La Presse, July 16, 1855.
Planche, Gustave.
 "Exposition des Beaux-arts. L'École
 française." *La Revue des deux mondes,* 1855.
Saint-Victor, Paul de.
 "Une Descente de Croix par Théodore
 Chassériau." *L'Artiste,* December 16, 1855,
 pp. 211–16.
Vapereau, G.
 "Théodore Chassériau." *Dictionnaire des*
 contemporains. Paris, 1855.
Vignon, Claude.
 Exposition Universelle de 1855. Beaux-Arts.
 Paris: A. Fontaine, 1855, pp. 205–6.

1856
Unsigned.
 "[Death of Chassériau]." *Indépendance belge,*
 October 1856.
B[oissard]. de Boisdenier, F[erdinand].
 "Théodore Chassériau." *Le Siècle,* no. 7889
 (Monday, October 20, 1856), p. 3.
Delaborde, Henri.
 Exposition Universelle de 1855. Aperçu historique
 sur la marche des arts. Vol. 8. Paris, 1856.
Delécluze, Étienne-Jean.
 Les Beaux-arts dans les deux mondes en 1855.
 Paris, 1856.

Duval, Ch.-L.
Exposition Universelle de 1855. L'École française au Palais Montaigne. Paris, 1856, p. 25.
Gautier, Théophile.
L'Art moderne. Paris, 1856.
Gautier, Théophile.
"École des Beaux-Arts. Exposition des grands prix. Envois de l'École de Rome." *Le Moniteur universel,* no. 278 (Saturday, October 4, 1856), p. 1107.
Gautier, Théophile.
"Église Saint-Philippe-du-Roule. La Descente de Croix de M. Théodore Chassériau." *Le Moniteur universel,* Thursday, April 17, 1856, pp. 1–3. [Reprinted in *Dictionnaire de la conversation et de la lecture,* suppl., vol. 3, 1869 (Descente de Croix).]
Gautier, Théophile.
"Revue dramatique. Théodore Chassériau.— Gymnase: *Une Femme qui n'aime pas son mari,* pièce en un acte, par Mme É. de Girardin." *Le Moniteur universel,* no. 287 (Monday, October 13, 1856), pp. 1–3. [Reprinted in *Portraits contemporains,* Paris: Charpentier, 1874.]
Gautier, Théophile.
"Théodore Chassériau." *Assemblée nationale,* October 1856.
Janin, Jules.
"La Semaine dramatique. . . . M. Théodore Chassériau." *Journal des débats* (Monday, October 13, 1856), p. 2.
Lacroix, Paul.
"Chronique, documents, faits divers [death of Chassériau]." *Revue universelle des arts* 4 (1856), p. 288.
Mantz, Paul.
"Théodore Chassériau." *L'Artiste* 2, no. 16 (October 19, 1856), pp. 220–25.
Planche, Gustave.
"La Peinture murale: Saint-Germain, Saint-Eustache, Saint-Philippe-du-Roule." *La Revue des deux mondes,* November 1, 1856, pp. 73–74.
Saint-Rieul-Dupouy, J.
"Salon de Bordeaux." *Le Courrier de la Gironde,* January 31, 1856.
Saint-Victor, Paul de.
"Théodore Chassériau." *La Presse,* Sunday, October 12, 1856, p. 1.
Sand, George.
"Autour de la table." *La Presse,* Thursday, July 24, 1856, p. 2.

1857
Du Pays, A.-J.
"Nécrologie, Théodore Chassériau. Tableaux, études, esquisses, dessins, armes et costumes, dont la vente aura lieu par suite de son décès, rue Drouot, 5, les lundi 16 et mardi 17 mars 1857." *L'Illustration* 29, no. 733 (March 14, 1857), p. 176.
Gautier Théophile.
"Atelier de feu Théodore Chassériau." *L'Artiste* 3, no. 14 (March 15, 1857), pp. 209–11. [Reprinted in *Le Moniteur universel,* no. 75 (Monday, March 16, 1857), p. 300.]

1858
Vapereau, G.
"Chassériau (Théodore)." In *Dictionnaire universel des contemporains,* vol. 1, pp. 381–82. Paris: Hachette, 1858.

1861
Lagrange, Léon.
"Des sociétés des amis des arts en France." *Gazette des beaux-arts* 10 (April 1, 1861), pp. 43, 45.

1864
Correspondance du R. P. Lacordaire et de Madame Swetchine, published by the comte Falloux, Paris, 1864. [Edition consulted: 8th ed., Paris: Didier et Cie, 1876, p. 256.]
Gautier, Théophile, Arsène Houssaye, and Paul de Saint-Victor.
Les Dieux et les demi-dieux de la peinture. Paris, 1864.

1865
Blanc, Charles.
"Théodore Chassériau, né vers 1819—mort en 1856." In *Histoire des peintres de toutes les écoles: École française,* vol. 3, pp. 64–66. Paris, 1865.
Hennequin, A.
"Coup d'Oeil rétrospectif à l'exposition de 1855." *Le Correspondant,* January 25 and February 25, 1865.

1866
Dantès, A.
"Chassériau (Théodore)." In *Tables biographiques et bibliographiques des sciences, des lettres et des arts indiquant les oeuvres principales des hommes les plus connus en tous pays et à toutes les époques,* p. 70. Paris: Delaroche Frères, 1866.
Delaborde, Henri.
Mélanges sur l'art contemporain. Paris, 1866. [Reprint of the article in *La Revue des deux mondes,* April 15, 1854, pp. 430–32.]
Siret, Adolphe.
"Chassériau (Théodore)." In *Dictionnaire historique des peintres de toutes les écoles,* p. 291. Paris: Librairie Internationale, 1866.

1867
Goncourt, Edmond de, and Jules de Goncourt.
Manette Salomon. [Published November 1867.] Preface by Hubert Juin. Paris: Union Générale d'Éditions, 1979, pp. 28, 215.
Larousse, Pierre.
"Chassériau (Théodore)." In *Grand dictionnaire universel du XIXe siècle,* vol. 3, p. 1057. Paris, 1867.
Meyer, Julius.
Geschichte der modernen französischen Malerei seit 1789 zugleich in ihrem Verhältniss zum politischen Leben zur Gesittung und Literatur. Leipzig, 1867, p. 379.
Saint-Victor, Paul de.
Exposition Universelle de 1867. Paris, 1867.

1868
Baudelaire, Charles.
Curiosités esthétiques. Paris, 1868.
Gautier, Théophile.
Catalogue des tableaux anciens et modernes qui composent la collection de S. Exc. Khalil-Bey. Sale cat. Paris, Hôtel Drouot, January 16–18, 1868.
Thoré, Théophile.
Salons de T. Thoré. Paris: Librairie Internationale, 1868, pp. 121–25.

1869
Gautier, Théophile.
Article from *Le Moniteur universel,* Thursday, April 17, 1856, reprinted in *Dictionnaire de la conversation et de la lecture,* suppl., vol. 3, 1869.

1870
Delaborde, Henri.
Ingres: Sa Vie, ses travaux, sa doctrine, d'après les notes manuscrites et les lettres du maître. Paris: Plon, 1870, pp. 319–20.

1871
Darcel, Alfred.
Les Arts et les musées sous la Commune. Paris, 1871.
Gautier, Théophile.
Tableaux du siège: Une Visite aux ruines du Palais d'Orsay. Paris, 1871, p. 229.
Gautier, Théophile.
"Une Visite aux ruines." *Journal officiel de la République Française,* Tuesday, July 11, 1871, pp. 1907–8.

1872
Darcel, Alfred.
"Les Musées, les arts et les artistes pendant la Commune." *Gazette des beaux-arts,* 2nd series, 5 (May 1872), p. 410.
Sensier, Alfred.
Souvenirs sur Th. Rousseau. Paris: L. Techener, 1872, pp. 142, 159–60.

1873
Jouin, Henri.
Hippolyte Flandrin: Les Frises de l'église Saint Vincent de Paul. Paris, 1873. [Letter from Lacordaire, September 27, 1840.]

1874
Claretie, Jules.
"Ingres." In *Peintres et sculpteurs contemporains,* pp. 15–16, 113–14. Paris: Charpentier, 1874.
Gautier, Théophile.
"Théodore Chassériau. Né en 1819—mort en 1856." In *Portraits contemporains,* pp. 265–70. Paris: Charpentier, 1874. [Reprinted from *Le Moniteur universel,* October 13, 1856.]

1875
Petroz, P.
L'Art et la critique en France depuis 1822. Paris, 1875.

1876
Unsigned.
Inventaire général des richesses d'art de la France. Paris. Monuments religieux. Vol. 1. Paris: Plon, 1876, pp. 21–22, 287–88.

1877
Bergerat, Émile.
"Théophile Gautier peintre." *L'Art* 9, 2nd trimester (1877), p. 29.
Guiffrey, J. J.
"Actes d'état-civil et épitaphes d'artistes français. Épitaphes de la famille Chassériau." *Bulletin de la Société de l'Histoire de l'Art Français,* 1877, p. 170.
Vachon, Marius.
"Le Palais du Conseil d'État et de le Cour des Comptes." *La France,* March 30, 1877.

[Reprinted by Ary Renan in *La Chronique des arts et de la curiosité*, no. 4 (January 25, 1879), pp. 29–30.]

1878

Amaury-Duval, Eugène-Emmanuel.
L'Atelier d'Ingres. Paris, 1878. New ed., with an introduction, notes, and documents by Daniel Ternois. Paris: Arthéna, 1993, pp. 13, 17, 29–30, 32, 187–88, 199–201, 221, 225, 425–26.

1879

Bergerat, Émile.
Théophile Gautier: Entretiens, souvenirs et correspondance. With a preface by Edmond de Goncourt and an etching by Bracquemond. Paris: G. Charpentier, 1879, pp. 48, 68 n. 1, 223–24, 250.

Renan, Ary, and Marius Vachon.
"Les Peintures de Th. Chassériau à la Cour des Comptes." *La Chronique des arts et de la curiosité*, no. 4 (January 25, 1879), pp. 29–30. [Reprint of an article published in *La France,* March 30, 1877.]

Vachon, Marius.
"Le Palais du Conseil d'État et de le Cour des Comptes." *La France*, January 25 and February 6, 1879, pp. 19–21.

Vachon, Marius.
Le Palais du Conseil d'État et de la Cour des Comptes. Paris: A. Quantin, 1879. 30 pages.

1880

Chennevières, Philippe de.
"Le Salon de 1880 (premier article)." *Gazette des beaux-arts*, 2nd series, 21 (May 1, 1880), p. 395.

1881

X. [Ary, Renan].
"Les Peintures murales de Théodore Chassériau à la Cour des Comptes." *La Chronique des arts et de la curiosité*, no. 40 (December 17, 1881), p. 320.

1882

Bellier de la Chavignerie, Émile, and Louis Auvray.
"Chassériau (Théodore)." In *Dictionnaire général des artistes de l'école française depuis l'origine des arts du dessin jusqu'à nos jours*, vol. 1, pp. 237–38. Paris: Renouard, 1882.

[Renan, Ary].
"Les Peintures de Théodore Chassériau à la Cour des Comptes." *La Chronique des arts et de la curiosité*, February 25, 1882, pp. 59–60.

[Renan, Ary].
"Les Peintures de Chassériau à la Cour des Comptes. Lettre d'un abonné au rédacteur en chef, Paris, 31 janvier 1882." Extract from *Le Parlement*, February 2, 1882. 4 pages.

1883–84

Bouvenne, Aglaüs.
"Théodore Chassériau: Souvenirs et indiscrétions." *Le Bulletin des beaux-arts: Répertoire des artistes français* 1 (1883–84), pp. 134–39, 145–50, 161–66.

1884

Bouvenne, Aglaüs.
Théodore Chassériau: Souvenirs et indiscrétions. Paris: Detaille [1884]. 24 pages. [Edition of

115. Bouvenne's copy is in the Département des Arts Graphiques, Musée du Louvre.]

Gomot, Hippolyte.
Marilhat et son oeuvre. Clermont-Ferrand: Typographie et Lithographie Mont-Louis, 1884, pp. 95–96.

1885

Clément, Charles.
"Variétés. Exposition des portraits du siècle à l'École des Beaux-Arts [portrait of Lacordaire]." *Journal des débats*, April 21, 1885.

Houssaye, Arsène.
"Madame Émile de Girardin." In *Les Confessions: Souvenirs d'un demi siècle, 1830–1880,* vol. 2, pp. 28–29. Paris: Dentu, 1885.

Lacordaire, Dominique.
Lettres du R. P. Lacordaire à M^me la baronne de Prailly. Published by R. P. Bernard Chocarne of the Predicant Friars. Paris: Poussielgue Frères, 1885, p. 28.

Leroi, Paul.
" *Théodore Chassériau: Souvenirs et indiscrétions*, par Aglaüs Bouvenne, In-4° de 24 pages." *Courrier de l'art*, no. 30 (July 24, 1885), p. 364.

1886

Unsigned.
"Théodore Chassériau. Nos Primes de ce numéro." *La Revue des beaux-arts*, October 1, 1886, pp. 245–46.

Baignères, Arthur.
"Théodore Chassériau." *Gazette des beaux-arts*, 2nd series, 33 (March 1, 1886), pp. 209–18.

Béraldi, Henri.
Les Gravures du XIX^e siècle. Vol. 4. Paris, 1886, p. 137.

1887

Bouvenne, Aglaüs.
"Théodore Chassériau." *L'Artiste* 2 (September 1887), pp. 161–78.

Hugo, Victor.
Choses vues: Souvenirs, journaux, cahiers. Paris, 1887. New ed., edited by Hubert Juin, Paris: Gallimard, 1972, pp. 241–46.

Ponsonailhe, Charles.
"La Nouvelle Salle du Louvre (fin)." *L'Artiste* 1 (April 1887), pp. 300–301.

1888

Unsigned.
Inventaire général des richesses d'art de la France. Paris. Monuments religieux. Vol. 2. Paris: Plon, 1888, pp. 148–49.

1889

Unsigned.
Inventaire général des oeuvres d'art appartenant à la ville de Paris dressé par le Service des Beaux-Arts. Édifices civils. Vol. 2. Paris: Librairie Centrale des Chemins de Fer, 1889, pp. 152, 166.

1890

Bonnaffé, Edmond.
"Eugène Piot." In *Catalogue des objets d'art de la Renaissance: Tableaux composant la collection de feu M. Eugène Piot*, pp. 13–14. Paul Chevallier, *commissaire-priseur*, Charles Mannheim, *expert*. Paris, Hôtel Drouot, room nos. 8 and 9, May 21–24, 1890.

Dalligny, Auguste.
"Les Ruines du quai d'Orsay." *Journal des arts*, no. 58 (September 26, 1890), p. 1.

Dayot, Armand.
Un Siècle d'art: Notes sur la peinture française à l'Exposition Centennale des Beaux-Arts suivies du catalogue complet des oeuvres exposées. Paris, 1890, pp. 6, 71–72, 154, 225.

1891

Alexandre, Arsène.
"Les Fresques de Chassériau." *Album des musées* [under the artistic direction of Puvis de Chavannes], no. 5 (November 7, 1891), pp. 17–18.

Bluysen, Paul.
"Les Fresques de la Cour des Comptes." *La République française*, September 27, 1891; with a "mise au point," September 30, 1891.

[Renan, Ary].
"Les Fresques de Théodore Chassériau." *La Chronique des arts et de la curiosité*, no. 32 (October 17, 1891), p. 255.

1893

Chevillard, Valbert.
Un Peintre romantique: Théodore Chassériau. With an etching by Bracquemond. Paris: Alphonse Lemerre, 1893. 323 pages.

Dayot, Armand.
"T. Chassériau." *Le Figaro illustré*, August 1893.

Geffroy, Gustave.
"Chronique littéraire. Livres d'art. *Un Peintre romantique: Théodore Chassériau* par Valbert Chevillard." *La Justice*, September 20, 1893.

Goncourt, Edmond de, and Jules de Goncourt.
Études d'art. Le Salon de 1852. La Peinture à l'exposition de 1855. Paris, 1893.

1894

Unsigned.
"Lettres inédites du Père Lacordaire." *L'Année dominicaine* 33, no. 410 (August 1894), p. 342.

Champfleury.
Oeuvres posthumes de Champfleury: Salons de 1846–1851. Paris, 1894, p. 55. [Text from *L'Artiste,* 4th series, 7 (October 4, 1846), p. 220.]

Dalligny, Auguste.
"Peintres français: Théodore Chassériau." *Journal des arts*, no. 2 (January 10 and 13, 1894), pp. 1–2.

Dalligny, Auguste.
"Peintres français: Théodore Chassériau." *Journal des arts*, no. 3 (January 17, 1894), pp. 2–3.

Renan, Ary.
"La Peinture orientaliste." *Gazette des beaux-arts*, 3rd series, 11 (January 1, 1894), pp. 43–53.

1895

Renan, Ary.
"La Démolition de la Cour des Comptes et les peintures de Th. Chassériau." *La Chronique des arts et de la curiosité*, no. 21 (May 25, 1895), pp. 195–96.

1897

Unsigned.
"La Pioche dans les ruines de la Cour des Comptes: Les Peintures de Chassériau." *L'Éclair* 19 (December 19, 1897).

Unsigned.
 "Les Orientalistes." *Le Pays*, February 9, 1897.
Armagnac, Léo.
 Bonnassieux, statuaire, membre de l'Institut, 1840–1892: Sa Vie et son oeuvre. Paris: Picard, 1897, p. 74.
Dayot, Armand.
 "Théodore Chassériau." In *Le Long des routes: Récits et impressions*, pp. 202–6. Paris: E. Flammarion [1897].
Renan, Ary.
 "Exposition des peintres orientalistes." *La Chronique des arts et de la curiosité*, no. 5 (January 30, 1897), p. 42.
Renan, Ary.
 "Les Peintres orientalistes—galerie Durand-Ruel." *La Chronique des arts et de la curiosité*, no. 9 (February 27, 1897), pp. 82–83.
Renan, Ary.
 "Les Peintres orientalistes français—galerie Durand-Ruel." *La Chronique des arts et de la curiosité*, no. 10 (March 6, 1897), pp. 94–95.

1898

Unsigned.
 "Revue des revues. Théodore Chassériau, graveur." *Revue populaire des beaux-arts* 1, no. 45 (August 27, 1898), pp. 205–6.
Unsigned.
 "Le Sauvetage des Chassériau à l'ancienne Cour des Comptes." *Le Parisien de Paris*, April 2, 1898.
Bénédite, Léonce.
 "Théodore Chassériau et la décoration de la Cour des Comptes." *Art et décoration* 1 (January 1898), pp. 22–25.
Bouvenne, Aglaüs.
 "Chassériau lithographe." *La Lithographie*, no. 9 (February 1898).
Castets, Henri.
 "Le Palais de la Cour des Comptes et les fresques de Théodore Chassériau." *Revue encyclopédique Larousse*, January 22, 1898, pp. 81–86.
Chevillard, Valbert.
 "Théodore Chassériau." *Revue de l'art ancien et moderne* 3, no. 3 (March 10, 1898), pp. 245–55.
Chevillard, Valbert.
 "Théodore Chassériau. Ses Débuts. Les Peintures de la Cour des Comptes." *Revue de l'art ancien et moderne* 3, no. 2 (February 10, 1898), pp. 107–16.
Geoffroy, Gustave.
 "Théodore Chassériau." *Le Journal*, January 16, 1898.
Marx, Roger.
 "Théodore Chassériau (1819–1856) et les peintures de la Cour des Comptes." *Revue populaire des beaux-arts* 1, no. 18 (February 19, 1898), pp. 273–79. [Reprinted in *Maîtres d'hier et d'aujourd'hui*, pp. 243–54. Paris, 1914.]
Marx, Roger.
 "Théodore Chassériau (1819–1856) et les peintures de la Cour des Comptes." *Le Parisien de Paris*, no. 65 (April 3, 1898), pp. 217–20.
Marx, Roger.
 "Théodore Chassériau et son oeuvre de graveur." *L'Estampe et l'affiche*, June 15, 1898. [Reprinted in *Maîtres d'hier et d'aujourd'hui*, pp. 255–60. Paris, 1914.]

Montesquiou, Robert de.
 "Alice et Aline (Une peinture de Chassériau)." In *Autels privilégiés*, p. 251. Paris: Eugène Fasquelle, 1898.
Renan, Ary.
 "Théodore Chassériau et les peintures du Palais de la Cour des Comptes." *Gazette des beaux-arts*, 3rd series, 19 (February 1, 1898), pp. 89–103.
[Renan, Ary].
 "Théodore Chassériau et les peintures du Palais de la Cour des Comptes." *La Chronique des arts et de la curiosité*, nos. 3, 7, 28 (January 15, February 12, and August 20, 1898), pp. 17, 53, 258.

1899

Bénédite, Léonce.
 "Les Peintres orientalistes français." *Gazette des beaux-Arts*, 3rd series, 21 (March 1, 1899), pp. 239, 244.
Dayot, Armand.
 L'Image de la femme. Paris: Hachette, 1899, pp. 346, 348, 351.
Renan, Ary.
 "Gustave Moreau (deuxième article)." *Gazette des beaux-arts*, 3rd series, 21 (March 1, 1899), pp. 200–201.
Renan, Ary.
 "Gustave Moreau (troisième article)." *Gazette des beaux-arts*, 3rd series, 21 (April 1, 1899), pp. 306–8.

1900

Breton, Jules.
 Nos Peintres du siècle. Paris: Société d'Édition Artistique [1900], pp. 214–15.
Geffroy, Gustave.
 "Théodore Chassériau." In *La Vie artistique*, pp. 85–92. 6th series. Paris: H. Floury, 1900.
Michel, André.
 "Les Arts à l'Exposition Universelle de 1900. L'Exposition Centennale. La Peinture française (cinquième et dernier article)." *Gazette des beaux-arts*, 3rd series, 24 (November 1, 1900), pp. 467–71, 473, 481.
Renan, Ary.
 Preface to *Othello: Seize Esquisses dessinées et gravées par Théodore Chassériau.* Paris, 1900.
[Renan, Ary].
 "Propos du jour." *La Chronique des arts et de la curiosité*, no. 19 (May 12, 1900), p. 181.
Tschudi, Hugo von.
 "Exposition centennale de l'art français." *Kunst für Alle*, October 1900.

1902

Denis, Maurice.
 "Les Élèves d'Ingres: Théodore Chassériau." *L'Occident*, 1902, pp. 146–51.
Mireur, H.
 "Chasseriau, Théodore." *Dictionnaire des ventes d'art faites en France et à l'étranger pendant les XVIII^me & XIX^me siècles*, vol. 2, pp. 162–63. Paris: L. Soullié, 1902.

1903

Mauclair, Camille.
 The Great French Painters and the Evolution of French Painting from 1830 to the Present Day. New York: E. P. Dutton [1903].

1904

Leroi, Paul.
 "Théodore Chassériau." *L'Art*, 1904, pp. 274–86.

1905

Nicolle, Marcel.
 "Les Récentes Acquisitions du Musée du Louvre. 2^e Article." *Revue de l'art ancien et moderne* 17, no. 94 (January 1905), pp. 38–39.

1907

Leprieur, Paul.
 "Les Récentes Acquisitions du Louvre." *Gazette des beaux-arts*, 3rd series, 38 (January 1, 1907), pp. 21–24.
Vaillat, Léandre.
 "Chassériau." *L'Art et les artistes* 3, no. 28 (July 5, 1907), pp. 177–88.

1908

Hepp, Pierre.
 "L'Exposition de portraits d'hommes et de femmes célèbres (1830–1900)." *Gazette des beaux-arts*, 3rd series, 40 (July 1, 1908), pp. 39–40.
La Farge, John.
 The Higher Life in Art. New York: The McClure Company, 1908, p. 12.
Meier-Graefe, Julius.
 "Théodore Chassériau." In *Modern Art*, pp. 42–47. London: Heinemann, 1908.

1909

Bénédite, Léonce.
 La Peinture au XIX^e siècle, d'après les chefs-d'oeuvre des maîtres et les meilleurs tableaux des principaux artistes. Paris: Flammarion, 1909, pp. 85–88.
Dorbec, Prosper.
 "Louis Cabat." *Gazette des beaux-arts*, 4th series, 1 (April 1909), p. 327 n. 1.

1910

Loviot, Louis.
 Alice Ozy. Paris: Les Bibliophiles Fantaisistes, 1910, pp. 87, 90–100, 116.
Séché, Léon.
 Muses romantiques. Delphine Gay. M^me de Girardin. Paris: Mercure de France, 1910, p. 185.

1911

Unsigned.
 Inventaire général des richesses d'art de la France. Province. Monuments civils. Vol. 4. Paris: Plon, 1911, p. 42.
Balloche, Abbé.
 Église Saint-Merry de Paris: Histoire de la paroisse et de la collégiale. 2 vols. Paris, 1911.
Cortissoz, Royal.
 John La Farge: A Memoir and a Study. Boston and New York: Houghton Mifflin Company, 1911, pp. 84–85, 104.
Hallays, André.
 "Le Centenaire du Musée Calvet." *La Revue de l'art ancien et moderne* 24 (1911).
Lapauze, Henry.
 Ingres: Sa Vie & son oeuvre (1780–1867), d'après des documents inédits. Paris: G. Petit, 1911, pp. 260, 330, 341.
Marcel, Henry, and Jean Laran.
 Chassériau. Collection "L'Art de notre

temps." Paris: La Renaissance du Livre [1911]. 114 pages.

Vivard, Antoine.
"*La Défense des Gaules par Vercingétorix*: Tableau de Théodore Chassériau." *L'Art libre*, April–May 1911.

1912

Denis, Maurice.
Théories (1890–1910). Du symbolisme et de Gauguin vers un nouvel ordre classique. Paris: Bibliothèque de l'Occident, 1912.

Grappe, Georges.
"Les Arts. Théodore Chassériau." *Le Cahier*, November 1912.

Monod, François.
"L'Exposition centennale de l'art français à Saint-Pétersbourg (deuxième et dernier article)." *Gazette des beaux-arts*, 4th series, 7 (April 1912), p. 308.

Rosenthal, Léon.
"La Peinture monumentale sous la Monarchie de Juillet." *La Revue de l'art ancien et moderne* 32 (September 1912), pp. 223–36.

1913

Burchard, Ludwig.
"Tagebuchnotizen Th. Chassériaus." *Kunst und Künstler* 11 (September 1913), pp. 593–606.

Fabre, Abel.
Pages d'art chrétien. Collection "Artistique," 4th series. Paris: Bonne Presse, 1913.

Pierredon, Georges.
"Les Charmeuses: Alice Ozy." *Fantasio* [1913?], pp. 847–48.

Thiebault-Sisson.
"Peintures murales de Delacroix et Théodore Chassériau." *Le Temps*, August 24, 1913.

Vaillat, Léandre.
"L'Oeuvre de Théodore Chassériau (Collection Arthur Chassériau)." *Les Arts*, no. 140 (August 1913), pp. 1–32.

Vauxcelles, [Louis].
"À propos de Théodore Chassériau." *Gil Blas*, September 3–6, 1913.

Waldmann, Emil.
"Notizen zu Chassériaus Fresken." *Kunst und Künstler* 11 (September 1913), pp. 606–9. [Includes a summary of Vachon 1879 in German.]

1914

Bénédite, Léonce, and Louis Gillet et al.
Les États-Unis et la France: Leurs Rapports historiques, artistiques et sociaux. Paris: F. Alcan, 1914, p. 78.

Marx, Roger.
Maîtres d'hier et d'aujourd'hui. Paris, 1914.

Rosenthal, Léon.
Du Romantisme au Réalisme: Essai sur l'évolution de la peinture en France de 1830 à 1848. Paris, 1914. [Reprinted, with a new introduction and updated bibliography by Michael Marrinan. Paris: Macula, 1987, pp. 18, 24–25, 41–43, 49, 63, 158–65, 167, 191–92, 199, 302, 308–10, 313–15, 317–19, 325–27, 332, 334, 336–37, 341–42, 344, 389–90.]

1916

Laran, Jean.
"Un Portrait inédit par Chassériau." *Archives de l'art français*, n.s., 8, 1914 [1916], pp. 320–28.

1918

Moreau-Nélaton, Étienne.
Jongkind raconté par lui-même. Paris: Renouard and H. Laurens, 1918, pp. 13, 18.

1919

Dayot, Armand.
"Théodore Chassériau." *Paris-Midi*, September 28, 1919.

Gasquet, Joachim.
"La Vie qui passe." *La France*, September 25, 1919.

Vaudoyer, Jean-Louis.
"Le Centenaire de Chassériau." *Le Gaulois*, September 1919.

Vaudoyer, Jean-Louis.
"Les Portraits de Th. Chassériau." *Feuillets d'art*, no. 3 (1919), pp. 37–42.

1920

Bouyer, Raymond.
"Centenaires oubliés. Théodore Chassériau.*" Le Cousin Pons: Revue d'art*, April 1, 1920.

Jamot, Paul.
"The Acquisitions of the Louvre during the War," parts 1–4. *The Burlington Magazine* 36 (June 1920), pp. 287–93; 37 (August 1920), pp. 63–70; (September 1920), pp. 152–61; (November 1920), pp. 219–20.

Jamot, Paul.
"Le Don Chassériau au Musée du Louvre." *La Revue de l'art ancien et moderne* 37 (February 1920), pp. 65–78.

Jamot, Paul.
"La *Vénus Marine* de Chassériau." *La Revue de l'art ancien et moderne* 38 (July–August 1920), pp. 71–84.

1921

Escholier, Raymond.
"L'Orientalisme de Chassériau." *Gazette des beaux-arts*, 5th series, 3 (February 1921), pp. 89–107.

Lugt, Frits.
"T. Chassériau." In *Les Marques de collections de dessins et d'estampes*, p. 80. Amsterdam, 1921.

Tatlock, R. R.
"A Newly Acquired Chassériau at the Louvre.*" The Burlington Magazine* 38, no. 216 (February 1921), p. 112.

1922

Vaillat, Léandre.
"Théodore Chassériau peintre orientaliste." *L'Amour de l'art* 3, no. 1 (January 1922), pp. 7–13.

1924

Carco, Francis.
Le Nu dans la peinture moderne. Paris: G. Crès, 1924.

Grautoff, Otto.
"Théodore Chassériau." *Die Kunst* 39 (1924), pp. 12, 376–81.

Jamot, Paul.
"*La Suivante de Cléopâtre*: Fragment d'un tableau perdu de Théodore Chassériau." In *Mélanges Bertaux: Recueil de travaux; dédiés à la mémoire d'Émile Bertaux*, pp. 167–70. Paris: E. de Boccard, 1924.

Vaudoyer, Jean-Louis.
"Chassériau et Shakespeare." *L'Art et les artistes*, no. 8 (January 1924), pp. 129–35.

1925

Auge, Lucy.
"Une Muse romantique: Alice Ozy et Théodore Chassériau." *Le Monde nouveau*, April 15, 1925.

1926

Guiffrey, Jean, and André Linzeler.
"Les Peintures décoratives de Chassériau à l'ancienne Cour des Comptes." *Beaux-Arts*, no. 16, September 1–15, 1926, pp. 241–48 (pp. 1–8 of the special issue).

Linzeler, André.
"Les Peintures décoratives de Chassériau à l'ancienne Cour des Comptes." *Beaux-Arts*, no. 16 (September 1–15, 1926), pp. 249–56 (pp. 9–16 in the special issue).

Régamey, Raymond.
Géricault. Collection "Maîtres de l'art moderne." Paris: Rieder et Cie, 1926, p. 58.

1927

Blanche, Jacques-Émile.
"Les Dessins de Chassériau." *L'Art vivant*, 1927, pp. 517–18.

Hourticq, Louis.
"Théodore Chassériau." *La Renaissance de l'art français et des industrie de luxe* 10, no. 6 (June 1927), pp. 275–77.

Meier-Graefe, Julius.
Entwicklungsgeschichte der moderne Kunst. 4th ed. 3 vols. Munich: Piper, 1927.

1928

Eglington, Guy.
"French Painting in North Africa." *Arts and Decoration* 28, no. 3 (January 1928), pp. 62–63.

Focillon, Henri.
"Théodore Chassériau ou les deux romantismes." In *Le Romantisme et l'art*, pp. 161–85. Preface by Édouard Herriot. Paris: H. Laurens, 1928.

Goodrich, Lloyd.
"Théodore Chassériau." *The Arts* 14, no. 2 (August 1928), pp. 60–100.

Holst, Roland Nicolaüs.
Chassériau et Puvis de Chavannes. Amsterdam and Paris, 1928. 32 pages.

Nebelthau, Eberhard.
"Théodore Chassériau: Ein Beitrag zu französischen Malerei im 19. Jahrhundert." Ph.D. diss., Würzburg Universität, 1928.

1929

Rowe, L. Earl.
"A Chasseriau Painting." *Bulletin of the Rhode Island School of Design* 17, no. 4 (October 1929), pp. 40–42.

1930

Alazard, Jean.
"La Conquête picturale de l'Afrique du Nord. I. L'Orient: Thème romantique." *La Revue de l'art ancien et moderne* 57 (May 1930), pp. 288, 292.

Alazard, Jean.
"Le Musée des Beaux-Arts d'Alger." *Bulletin des musées de France* 2, no. 9 (September 1930), pp. 192–93, 195.

Alazard, Jean.
"Les Peintres de l'Algérie au XIXe siècle." *Gazette des beaux-arts*, 6th series, 3 (May 1930), pp. 373–79.

Alazard, Jean.
"Théodore Chassériau peintre de l'Algérie."
In *L'Orient et la peinture française au XIXᵉ
siècle: D'Eugène Delacroix à Auguste Renoir*,
pp. 95–116. Paris: Plon, 1930.
Gaudissard, Émile.
"L'Art en Algérie cent ans après la
conquête." *L'Art et les artistes* 20, no. 106
(April 1930), pp. 222–37.
Gronkowski, Camille.
"Au Petit Palais: Le Centenaire de la
conquête de l'Algérie." *Figaro, supplément
artistique illustré*, 7 (May 1930), pp. 12–16.
Metman, Bernard.
"Musée des Arts Décoratifs: Le Décor de la
vie romantique." *Bulletin des musées de
France* 2, no. 5 (May 1930), pp. 105, 107.
Pascal, Georges.
"Au Petit Palais: L'Exposition du Centenaire
de l'Algérie." *Bulletin des musées de France* 2,
no. 5 (May 1930), pp. 108–9.
Thiebault-Sisson.
"Art et curiosité. Au Musée du Louvre. Une
Oeuvre nouvelle de Chassériau." *Le Temps*
22 (October 1930).
Vallon, Fernand.
Au Louvre avec Delacroix. Preface by Élie
Faure. Grenoble: B. Arthaud, 1930, pp. 42,
116–17, 127–29, 183.
Vaudoyer, Jean-Louis.
Alice Ozy ou l'Aspasie moderne. Paris: M.-P.
Tremois, 1930, pp. 11, 58–72, 74, 87, 89, 104–9.

1931
Alazard, Jean.
"L'Exotisme dans la peinture française au
XIXᵉ siècle." *Gazette des beaux-arts*, 6th
series, 6 (September 1931), pp. 244, 246.
Bénédite, Léonce.
Théodore Chassériau: Sa Vie, son oeuvre.
Published posthumously by André Dezarrois.
2 vols. Paris: Braun [1931]. 526 pages.
Girard, Joseph.
*Le Musée d'Avignon. Musée Calvet:
Sculpture et peinture*. Collections publiques
de France, Mémoranda. Paris: Henri
Laurens, 1931.
La Tourette, Gilles de.
"Peintures et dessins algériens de Théodore
Chassériau." *L'Art et les artistes* 22, no. 115
(March 1931), pp. 181–91.
Rey, Robert.
*La Peinture française à la fin du XIXᵉ siècle:
La Renaissance du sentiment classique—Degas,
Renoir, Gauguin, Cézanne, Seurat*. Paris: Les
Beaux-Arts, 1931, pp. 25–26, 75–76.

1932
Unsigned.
"Les Expositions: Chassériau." *L'Art et les
Artistes* 24, no. 128 (June 1932), p. 319.
Fierens, Paul.
"Causerie artistique: Théodore Chassériau."
Journal des débats, no. 1089 (Tuesday, April
19, 1932), p. 4.
Grappe, Georges.
"Les Arts: Théodore Chassériau." *Le Cahier*,
November 1932, pp. 41–56.
Hourticq, Louis.
"Du nouveau chez les Romantiques
(Delacroix et Chassériau)." *Revue de l'art
ancien et moderne* 61 (April 1932), pp. 194–
200.

Vaudoyer, Jean-Louis.
"Les Portraits de Chassériau." *Formes* 21,
no. 25 (May 1932), pp. 272–73.

1933
Unsigned.
"L'Exposition Chassériau à l'Orangerie."
L'Arts et artistes 26, no. 138 (1933), pp. 320–22.
Alazard, Jean.
"Théodore Chassériau." *Gazette des beaux-
arts*, 6th series, 9 (January 1933), pp. 47–57.
Beck, Léonard.
"Les Expositions." *L'Amour de l'art, Bulletin*,
no. 1 (January 1933), p. 6.
Benoist, Luc.
"Salles de l'Orangerie: L'Exposition
Chassériau." *Bulletin des musées de France* 5,
no. 6 (June 1933), pp. 82–84.
Blanche, Jacques-Émile.
"La Jeunesse et l'art de Chassériau." *Beaux-
Arts* 25 (1933), pp. 1, 6.
Bouvy, Eugène.
"Chassériau aux Tuileries." *L'Amateur
d'estampes* 12, no. 4 (July 1933), pp. 125–27.
Bouyer, Raymond.
"Les Expositions du mois: Hommage du
XXᵉ siècle à Théodore Chassériau." *Le
Bulletin de l'art ancien et moderne*, no. 798
(June 1933), pp. 276–77.
[Dezarrois, André].
"Une Grande Exposition Chassériau." *Le
Bulletin de l'art ancien et moderne*, no. 797
(May 1933), p. 201.
Ferran, André.
*Le Salon de 1845 de Charles Baudelaire:
Édition critique avec introduction, notes et
éclaircissements*. Toulouse: Aux Éditions de
l'Archer, 1933, pp. 14–15, 29, 42, 50, 66, 81,
84, 97, 99, 122–23, 159, 219, 222–24, 239.
Grappe, Georges.
"L'Oeuvre nostalgique de Chassériau."
L'Illustration, December 2, 1933.
[Unpaginated.] 6 pages.
Grappe, Georges.
"La Personnalité de Chassériau." *L'Art
vivant*, no. 171 (April 1933), pp. 151–55.
Huyghe, René.
"Au Musée de l'Orangerie: L'Exposition
Chassériau." *L'Amour de l'art*, no. 6 (June
1933), pp. 1–2.
Jamot, Paul.
"Extrait d'une conférence sur Chassériau
prononcée à l'exposition de l'Orangerie le 11
mai 1933." In *Théodore Chassériau, 1819–
1856: Dessins*, pp. IX–XII. Exhib. cat. Paris,
Musée du Louvre, Cabinet des Dessins, 1957.
Jamot, Paul.
"Théodore Chassériau." *Les Beaux-Arts.
Études de documents*. 1933.
Klingsor, Tristan.
"À l'Orangerie des Tuileries: L'Exposition
Chassériau." *Beaux-Arts* 20 (May 19, 1933),
p. 1.
René-Jean.
"Un Grand Peintre français: À l'Orangerie
on rassemble l'oeuvre du maître Chassériau."
Comoedia, Friday, May 12, 1933, pp. 1–2.
Sterling, Charles.
"Chassériau et Degas." *Beaux-Arts* 21, no. 2
(1933).
Vaudoyer, Jean-Louis.
"Théodore Chassériau." *Revue hebdomadaire*,
May 20, 1933.

1934
George, Waldemar.
"Portraits par Ingres et ses élèves." *La
Renaissance de l'art français et des industrie
de luxe* 17, nos. 10–11 (October–November
1934), pp. 193–95.
Giard, René.
*Le Peintre Victor Mottez d'après sa
correspondance (1809–1897)*. Lille, R. Giard,
1934, pp. 147–48, 151, 158, 161–62. [Letters
from Hippolyte Fockedey (1833–1873).]
Sterling, Charles.
"Portraits par Ingres et ses élèves." *Formes*,
April 1934, pp. 3–4.

1935
Ahnne, Paul.
Les Chassériau du Musée de Strasbourg.
Strasbourg: Éditions des Dernières
Nouvelles de Strasbourg, 1935. 17 pages.
Vaudoyer, Jean-Louis.
"Le Baron Arthur Chassériau. Notice
lue à l'Assemblée générale annuelle de la
Société des Amis du Louvre, le 17 juin
1935," in *Cabinet des Dessins, Société
des Amis du Louvre*. Compiègne, 1935.
20 pages.

1936
Alazard, Jean.
"Musée des Beaux-Arts d'Alger: Exposition
Chassériau." *Bulletin des Musées de France* 8,
no. 9 (November 1936), pp. 171–73.
Delacroix, Eugène.
*Correspondance générale d'Eugène Delacroix
(1850–1857)*. Edited by André Joubin. Vol. 2.
Paris: Plon, 1936.
Fouchet, Max-Pol.
"Chassériau l'Oriental." *Beaux-Arts:
Chronique des arts et de la curiosité*, no. 182
(June 26, 1936), pp. 1–2.
Meryem, Jean.
"En Province et à l'étranger: Exposition
retrospective de Théodore Chassériau."
L'Art et les artistes 30, no. 167 (May 1936),
p. 286.

1937
Delacroix, Eugène.
*Correspondance générale d'Eugène
Delacroix (1850–1857)*. Edited by André
Joubin. Vol. 3. Paris: Plon, 1937, pp. 317–18,
341.
Kolb, Marthe.
Ary Scheffer et son temps, 1795–1858. Paris:
Boivin & Cⁱᵉ, 1937, pp. 389, 405, 415.

1938
Rey, Robert.
"L'Action de l'État dans la renaissance du
grand décor mural." *Art vivant*, no. 218
(January 1938), pp. 389–91.

1939
Millner, Simon, L.
"Les Illustrateurs français de Shakespeare."
Arts et métiers graphiques 67 (1939),
pp. 389–91.

1940
Mongan, Agnes, and Paul J. Sachs.
Drawings in the Fogg Museum of Art. 2 vols.
Cambridge, Massachusetts, 1940.

1942

Hautecoeur, Louis.
 Littérature et peinture en France du XVIIe au XXe siècle. Paris: Armand Colin, 1942. 2nd ed., 1963, pp. 33, 43–44, 100–105, 109, 176–77, 181, 194.
Tabarant, A.
 La Vie artistique au temps de Baudelaire. Paris, 1942.

1946

Boyé, Maurice-Pierre.
 "Théodore Chassériau, 1819–1856." In *La Mêlée romantique*, pp. 223–42. Paris: R. Julliard, 1946.
Lemoisne, Paul-André.
 Degas et son oeuvre. Vol. 1. Paris: P. Brame, 1946.
Uhde-Bernays, Hermann.
 Théodore Chassériau. Meisterwerke der Kunst. Munich: Filser-Verlag [1946].

1947

Cassou, Jean.
 Ingres. Brussels: Éditions de la Connaissance, 1947, pp. 113–16.
Joubert, Solange.
 Une Correspondance romantique: Madame d'Agoult, Liszt, Henri Lehmann. Paris: Flammarion, 1947, pp. 92, 100, 103–4, 112–13, 115, 119–22, 130–32, 136, 138, 142–45, 149–50, 152–62, 164, 167–71, 176, 178, 205, 207.

1948

Moissy, Pierre.
 "[origine rochelaise et saintongeaise de Chassériau]." *Le Pays d'Ouest* 37, fasc. 8 (December 1, 1948), pp. 2–4.

1949

Teupser, Werner.
 "Théodore Chassériau." *Kunst* 3 (1949), pp. 95–116.

1950

Newberry, John S.
 "Two Portrait Drawings by Théodore Chassériau in American Collections." *The Art Quarterly* 13, no. 2 (winter 1950), pp. 161–63.
Pissarro, Camille.
 Lettres à son fils Lucien. Edited by John Rewald. Paris: Albin Michel, 1950, pp. 477–79.

1955

Francastel, Pierre, and Galienne Francastel.
 Histoire de la peinture française. 1955. Reprinted, with biographies by Maurice Bex, Paris: Denoël, 1990, pp. 242, 355.
Gállego, Julián.
 "Algunos escritos de Théodore Chassériau." *Revista de ideas estéticas* (Madrid), no. 50 (April–June 1955), pp. 145–56.

1956

Guilly, Paul.
 "Théodore Chassériau mourait il y a cent ans à l'âge de Raphaël." *Le Monde*, October 3, 1956, p. 9.
Sandoz, Marc.
 "En l'honneur de Théodore Chassériau." Extract from *Les Cahiers de l'Ouest*, no. 13 (September 1956), pp. 1–10.

Tournemille, Jean.
 "Le Double Amour de Chassériau." *Les Cahiers de l'Ouest*, no. 13 (September 1956).
Vaudoyer, Jean-Louis.
 "Chassériau." *Les Cahiers de l'Ouest*, no. 13 (September 1956).
Vincent, Madeleine.
 La Peinture des XIXe et XXe siècles. Catalogue du Musée de Lyon, 7. Lyons: Éditions de Lyon, 1956.

1957

Bouchot-Saupique, J.
 "Cabinet des Dessins du Musée du Louvre: Exposition de dessins de Chassériau." *Revue des arts* 7, no. 2 (March–April 1957), p. 94.
Charmet, Raymond.
 "Cent Dessins de Chassériau célèbrent le centenaire de sa disparition." *Arts-Spectacles*, April 17–23, 1957.
Chastel, André.
 "Les Dessins de Chassériau." *Le Monde*, April 19, 1957.
Gerard, René.
 "Théodore Chassériau (1819–1856)." *Le Courrier graphique*, January 1957, pp. 11–17.
Jullian, René.
 "Tableaux français au Palais des Beaux-Arts de Lyon." *L'Oeil*, no. 150 (June 1957), pp. 2–11.
Sandoz, Marc.
 See Sandoz 1958-2

1958

Sandoz, Marc.
 "Chassériau (1819–1856): Quelques Oeuvres inédites ou peu connues publiées à l'occasion du centenaire de la mort de l'artiste." *Gazette des beaux-arts*, 6th series, 51 (February 1958), pp. 105–22.
Sandoz, Marc.
 "Esquisses et dessins inédits ou peu connus de Théodore Chassériau (1819–1856) en rapport avec les grandes compositions décoratives de l'artiste, à Paris, publiés à l'occasion du centenaire de sa mort." *Bulletin de la Société de l'Histoire de l'Art Français*, 1957 [1958], pp. 15–36.
Sterling, Charles, and Hélène Adhémar.
 Peinture: École française, XIXe siecle. Vol. 1. Paris, Éditions des Musées Nationaux, 1958, pp. 21–24.
Ternois, Daniel.
 "Note sur Ingres et Chassériau." *Bulletin du Musée Ingres*, no. 4 (July 1958), pp. 13–17.

1959

Grate, Pontus.
 "La Beauté abstraite: Ingres et son école." In *Deux Critiques d'art à l'époque romantique: Gustave Planche et Théophile Thoré*, p. 236. Stockholm: Almqvist & Wiskell, 1959.
Réau, Louis.
 Les Monuments détruits de l'art français: Histoire du vandalisme. 2 vols. Paris: Hachette, 1959.
Vier, Jacques.
 La Comtesse d'Agoult et son temps, avec des documents inédits: Recommencement d'une vie (1839–1848). Vol. 2. Paris: Armand Colin, 1959, pp. 61–62, 94, 108–9, 111, 115, 117, 119, 238, 241, 267 n. 386, 277 n. 96, 278 n. 109, 881 n. 166.

1962

Vergnet-Ruiz, Jean, and Michel Laclotte.
 Petits et grands musées de France. La Peinture française des primitifs à nos jours. Paris: Cercle d'Art, 1962.
Vicaire, Marcel.
 "À propos de deux dessins inédits de Théodore Chassériau." *Bulletin de la Société de l'Histoire de l'Art Français*, 1961 [1962], pp. 173–81.
Virch, Claus.
 Master Drawings in the Collection of Walter C. Baker. New York: The Metropolitan Museum of Art, 1962.

1963

Brion, Marcel.
 L'Art romantique. Paris: Hachette, 1963.
Saisselin, Rémy de.
 "The Portrait in History: Some Connections between Art and Literature." *Apollo* 78 (October 1963), pp. 281–88.
Taslitzky, Boris.
 "Delacroix aujourd'hui." *Europe*, no. 408 (April 1963), p. 48.

1964

Doyon, Gérard Maurice.
 "The Mural Painting of Théodore Chassériau." Ph.D. diss., 3 vols., Boston University, 1964.
Marnat, Marcel.
 "Théodore Chassériau: Le Dernier Romantique." In *La Vie des grands peintres français*, pp. 488, 503–8. Paris: Éditions du Sud, 1964.
Page, Addison Franklin.
 "Chassériau [*Station of the Cross*]." *J. B. Speed Art Museum Bulletin* 24, no. 3 (March 1964), pp. 9–10.

1965

Hugo, Victor.
 Journal de ce que j'apprends chaque jour (juillet 1846–février 1848). Edited by René Journet and Guy Robert. Paris: Flammarion, 1965, pp. 153, 181, 208.
Trapp, Frank Anderson.
 "The Universal Exhibition of 1855." *The Burlington Magazine* 107, no. 747 (June 1965), pp. 301, 305.

1966

Monnier, Geneviève.
 "Théodore Chassériau." In *Dessins français de Prud'hon à Daumier*, nos. 62–65. [Unpaginated.] Introduction by Maurice Sérullaz. Fribourg: Éditions Arts et Dessins, 1966.

1967

Sandoz, Marc.
 "El pintor Théodore Chassériau (1819–1856) y el mundo ibérico." *Goya*, no. 80 (1967), pp. 76–83.

1968

Angrand, Pierre.
 Monsieur Ingres et son époque. Lausanne and Paris: La Bibliothèque des Arts, 1968.
Concasty, M.-L., and A. B. Duff.
 "Autres Fragments inédits des Souvenirs de Diane de Guldencrone [1857–1864]." *Études gobiniennes*, 1968–69, p. 70.

Loye, George de.
"Musée Calvet d'Avignon: Nouvelles Acquisitions depuis 1964." *La Revue du Louvre et des musées de France* 18, nos. 4–5 (1968), pp. 294–96.

Sandoz, Marc.
"Théodore Chassériau (1819–1856) et la peinture des Pays-Bas." *Bulletin des Musées Royaux des Beaux-Arts de Belgique* 17, nos. 3–4 (1968), pp. 172–90.

1969

Chastel, André.
"À Poitiers: Les Incertitudes de Chassériau." *Le Monde*, July 3, 1969, p. 16.

Doyon, Gérard Maurice.
"The Positions of the Panels Decorated by Théodore Chassériau and the Former Cour des Comptes in Paris." *Gazette des beaux-arts*, 6th series, 73 (January 1969), pp. 47–56.

Hefting, Victorine.
Jongkind d'après sa correspondance. Utrecht: H. Dekker & Gumbert, 1969, pp. 7, 9, 20, 245.

Lacambre, Geneviève, and Jean Lacambre.
"Documents inédits sur les élèves d'Ingres." *Bulletin du Musée Ingres*, no. 25 (July 1969).

Lacambre, Jean.
"Les Élèves d'Ingres et la critique du temps." In *Colloque Ingres* [1967], pp. 95, 100. Montauban, 1969.

Oursel, Hervé.
Guide du Musée d'Arras. 2nd ed. Arras: Le Musée, 1969.

Spencer, Michael Clifford.
The Art Criticism of Théophile Gautier. Geneva: Droz, 1969, pp. 21–22, 37, 49–53, 101.

1970

Sandoz, Marc.
"Les Peintures de la Renaissance à Fontainebleau et le Maniérisme italien: Sources possibles de Théodore Chassériau et des premiers romantiques français." *Gazette des beaux-arts,* 6th series, 75 (January 1970), pp. 43–56.

1971

Paladilhe, Jean.
Gustave Moreau. Paris: F. Hazan, 1971, pp. 10–13.

Sandoz, Marc.
"Le Comte Frédéric Bourgeois de Mercey: Peintre, illustrateur, nouvelliste, historien, critique, administrateur (1805–1860)." *Bulletin de la Société de l'Histoire de l'Art Français*, 1969 [1971], pp. 65–66.

1972

Musée du Louvre.
Catalogue des peintures. Vol. 1, *École française.* Paris, 1972.

Oursel, Hervé.
"Nouvelles Acquisitions des musées de province: Musée des Beaux-Arts de Lille. III. Oeuvres du XIXe siècle." *La Revue du Louvre et des musées de France* 22, no. 6 (1972), pp. 499–500.

1973

Bergot, François.
"Musée des Beaux-Arts de Rennes: Récents Enrichissements." *La Revue du Louvre et des musées de France* 23, no. 1 (1973), p. 60.

Concasty, M.-L., and A. B. Duff.
"Un Dossier: Le Mariage de Gobineau." *Études gobiniennes*, 1973, pp. 125–26.

Janin, Jules.
735 Lettres à sa femme (1842–1850). Edited by Mergier-Bourdeix. Vol. 1. Paris: Klincksieck, 1973, p. 70 n. 3, p. 467.

1974

Carella, A.
Le Quai d'Orsay ministère des Affaires Étrangères. Paris, 1974.

Sandoz, Marc.
Théodore Chassériau, 1819–1856: Catalogue raisonné des peintures et estampes. Paris: Arts et Métiers Graphiques, 1974. 519 pages.

1975

Baudelaire, Charles.
Salon de 1846. Edited by David Kelley. Oxford: Clarendon Press, 1975.

Janin, Jules.
735 Lettres à sa femme (1851–1855). Edited by Mergier-Bourdeix. Vol. 2. Paris: Klincksieck, 1975, p. 58 n. 7.

Jullian, Philippe.
"Livres: Théodore Chassériau [by Marc Sandoz]." *Connaissance des arts*, no. 279 (March 1975), p. 122.

Miquel, Pierre.
"Louis Cabat, 1812–1893." In *Le Paysage français au XIXe siècle, 1824–1874: L'École de la nature*, vol. 3, pp. 494, 497. Maurs-la-Jolie: Éditions de la Martinelle, 1975.

1976

Buisson, Gilles.
Géricault, de Mortain à Paris: Le Conventionnel Bonnesoeur-Bourginière, oncle de Géricault. Coutances: OCEP, 1976, p. 47.

Cottaz, Maurice.
"Chassériau: Le Classique du Romantisme." *Valeurs actuelles*, June 28, 1976, pp. 46–47.

Daber, Alfred.
"Le Prince Théodore." In *Chassériau, 1819–1856*, pp. 58–62. Exhib. cat. Paris, Galerie Daber, June 9–July 10, 1976.

Fermigier, André.
"Une Exposition Chassériau: Un Jeune Dieu chargé de tristesse." *Le Monde*, June 17, 1976, p. 17.

Foucart, Jacques.
"Portrait de Mme Cantacuzène." In *Puvis de Chavannes, 1824–1898*, pp. 189–90. Exhib. cat. Paris, Galeries Nationales du Grand Palais, November 26, 1976–February 14, 1977; Ottawa, National Gallery of Canada, March 18–May 1, 1977.

Haskell, Francis.
Rediscoveries in Art: Some Aspects of Taste, Fashion, and Collecting in England and France. Ithaca, New York: Cornell University Press, 1976.

Haskell, Francis.
Review of *Théodore Chassériau, 1819–1856: Catalogue raisonné des peintures et estampes* by Marc Sandoz. *The Burlington Magazine* 118, no. 882 (September 1976), pp. 655–56.

Mathieu, Pierre-Louis.
Gustave Moreau, sa vie, son oeuvre: Catalogue raisonné de l'oeuvre achevé. Paris: Bibliothèque des Arts, 1976, pp. 31–36, 44, 46, 49–50, 52,

54, 86, 90, 92–93, 102, 104, 109–10, 147, 178, 206, 226, 251.

Toussaint, Hélène.
"Chassériau Théodore." In *Le Larousse des grands peintres*, edited by Michel Laclotte, p. 62. Paris: Larousse, 1976.

Zerner, Henri.
"Romantisme." In *Encyclopaedia Universalis*, vol. 20, p. 197. Paris, 1976.

1977

Bénichou, Paul.
Le Temps des prophètes: Doctrines de l'âge romantique. Paris: Gallimard, 1977.

Lafargue, Jacqueline.
"The Revival of Decorative Painting in the First Half of the Nineteenth Century." *Apollo* 106, no. 190 (December 1977), pp. 473, 476–77.

Wilhelm, Jacques.
"The World of the Romantics." *Apollo* 106, no. 190 (December 1977), pp. 465, 469.

1978

Boucher, Marie-Christine.
"La Décoration de Puvis de Chavannes pour l'Hôtel Vignon." *La Revue du Louvre et des musées de France* 28, no. 2 (1978), pp. 104, 106.

Joachim, Harold.
"Théodore Chassériau, 1819–56." In *French Drawings and Sketchbooks of the Nineteenth Century.* Vol. 1. Chicago and London: University of Chicago Press, 1978, p. 38.

Léri, Jean-Marc.
"Le Palais du quai d'Orsay (1810–1871)." *Bulletin de la Société de l'Histoire de l'Art Français*, 1976 [1978], pp. 387–93.

Menu, Danièle.
"Prosper Marilhat (1811–1847)." Thesis, third cycle, Université de Dijon, 1978, pp. 48, 192.

Sand, George.
Correspondance (janvier 1855–juin 1856). Edited by G. Lubin. Vol. 13. Paris: Garnier, 1978, p. 444 n. 2.

1979

Fisher, Jay M., 1979.
See under Exhibitions: Baltimore, 1979–80

Janin, Jules.
735 Lettres à sa femme (1856–1876). Edited by Mergier-Bourdeix. Vol. 3. Paris: Klincksieck, 1979, pp. 91 n. 1, 403 n. 3.

Lapi Ballerini, Isabella.
"Comme si c'eût été Jérusalem." *Antichità viva* 18, no. 3 (1979), pp. 38–48.

Sand, George.
Correspondance (juillet 1856–juin 1858). Edited by G. Lubin. Vol. 14. Paris: Garnier, 1979, p. 12 n. 1.

1980

Unsigned.
"Review of *Théodore Chassériau: Illustrations for Othello,* Exhibition Catalogue by Jay M. Fisher." *Master Drawings* 18, no. 4 (Winter 1980), p. 389.

Clay, Jean.
"Les Sultanes de Chassériau: L'Élongation romantique des rêveries ingresques." In *Le Romantisme*, pp. 134–35. Paris: Hachette, 1980.

Driskel, Michael Paul.
"Hippolyte Flandrin (1809–1864) and Mural Painting of the *Renouveau*

Catholique: The Origin and Meaning of the Hieratic Style of Religious Art in the Nineteenth Century." 2 vols. Ph.D. diss., University of California, Berkeley, 1980.

Ewals, Léo.
"Les Peintures murales de l'église Saint-Vincent-de-Paul: L'Histoire d'une commande." *Bulletin du Musée Ingres*, no. 45 (July 1980), pp. 35, 39.

Fisher, Jay M.
"The Romance of Desdemona and Othello." *Art News* 79, no. 3 (March 1980), pp. 100–104.

Magnifico, M.
"Théodore Chassériau: Illustrations for Othello." *Conoscitore di stampe* (Milan), no. 46 (1980), pp. 39–42.

Ternois, Daniel.
"Donation Suzanne et Henri Baderou au Musée de Rouen: Une Étude inédite d'Ingres pour *Le Martyre de Saint Symphorien.*" *Études de la Revue du Louvre*, no. 1, 1980, p. 147.

1981
Baticle, Jeannine, and Cristina Marinas, with contributions by Claudie Ressort and Chantal Perrier.
La Galerie espagnole de Louis-Philippe au Louvre, 1838–1848. Notes et documents des musées de France, 4. Paris: Réunion des Musées Nationaux, 1981.

Delacroix, Eugène.
Journal, 1822–1863. Preface by Hubert Damisch, Introduction and notes by André Joubin. Paris: Plon, 1981, p. 594.

MacGregor, Neil.
Review of "Revoir Chassériau" in the Pavillon de Flore, Paris. *The Burlington Magazine* 123, no. 935 (February 1981), pp. 119–20.

Mertens, Joan R.
"A Drawing by [Frédéric] Chassériau." *Metropolitan Museum Journal* 15, 1980 [1981], pp. 153–56.

Ribner, Jonathan P.
"An Exhibition of Drawings by Théodore Chassériau at the Louvre." *Arts Magazine* 55 (April 1981), pp. 148–49.

Richer, Jean.
"Arria Marcella." *Études et recherches sur Théophile Gautier prosateur,* Paris: Nizet, 1981, p. 27.

1982
Angrand, Pierre.
"Le Premier atelier de M. Ingres." *Bulletin du Musée Ingres,* nos. 49–50 (December 1982), pp. 19–58.

Cabanis, José.
Lacordaire et quelques autres: Politique et religion. Paris: Gallimard, 1982.

Rosenthal, Donald A.
Orientalism: The Near East in French Painting, 1800–1880. Exhib. cat. Memorial Art Gallery of the University of Rochester, August 27–October 17, 1982; Neuberger Museum, State University of New York College at Purchase, November 14–December 23, 1982, pp. 57–61, 70, 72, 81, 95, 106, 116, 147, 153–54.

Sandoz, Marc.
"Chronique: Livres, expositions, divers." In *Cahiers Chassériau,* vol. 1, pp. 33–44. Paris: Editart–Quatre Chemins, 1982.

Sandoz, Marc.

"Oeuvres de Théodore Chassériau nouvellement apparues." In *Cahiers Chassériau,* vol. 1, pp. 5–15. Paris: Editart–Quatre Chemins, 1982.

Sandoz, Marc.
"Théodore Chassériau et la peinture espagnole." In *Cahiers Chassériau,* vol. 1, pp. 17–32. Paris: Editart–Quatre Chemins, 1982.

1983
Monnier, Gérard.
"Architecture urbaine et urbanisme en Algérie sous le Second Empire: Le Cas de l'architecte Charles Frédéric Chassériau (1802–1896)." In *Culture et création dans l'architecture provinciale de Louis XIV à Napoléon III,* pp. 299–309. Travaux et colloques de l'Institut d'Art. Aix-en-Provence: Publications de l'Université de Provence, 1983.

Thornton, Lynne.
Les Orientalistes: Peintres voyageurs, 1828–1908. Les Orientalistes, 1. Paris: ACR Éditions, 1983.

Tocqueville, Alexis de.
Oeuvres complètes: Correspondance d'Alexis de Tocqueville et Francisque de Corcelle et de Madame Swetchine. Edited by Pierre Gibert. Vol. 15. Paris: Gallimard, 1983, p. 24.

1984
Aubrun, Marie-Madeleine.
Henri Lehmann, 1814–1882: Catalogue raisonné de l'oeuvre. 2 vols. Paris: Association les Amis de Henri Lehmann, 1984, vol. 1, pp. 18–24, 45, 89–90, 96, 105, 144, 156, 240, 297; vol. 2, pp. 55, 74.

Jardin, André.
Alexis de Tocqueville, 1805–1859. Paris: Hachette, 1984, pp. 353–54, 437.

Mathieu, Pierre-Louis.
L'Assembleur de rêves: Écrits complets de Gustave Moreau. Preface by Jean Paladilhe. Fonfroide: Bibliothèque Artistique & Littéraire, 1984, pp. 227–28.

1985
de Caso, Jacques.
"Sapho." In *Statues de chair: Sculptures de James Pradier (1790–1852),* pp. 171–76. Exhib. cat. Geneva, Musée d'Art et d'Histoire, October 17, 1985–February 2, 1986; Paris, Musée du Luxembourg, February 28–May 4, 1986.

Hauptman, William.
"Juries, Protests, and Counter-Exhibitions before 1850." *The Art Bulletin* 67, no. 1 (March 1985), pp. 107, 109.

1986
Amprimoz, François-Xavier.
"Lettres de Dominique Papety à ses parents et à ses amis, Rome, 1837–1842." *Archives de l'art français* 28 (1986), pp. 206–7, 209, 221, 223, 231, 236, 244–45, 253, 263.

Compin, Isabelle, and Anne Roquebert.
Catalogue sommaire illustré des peintures du Musée du Louvre et du Musée d'Orsay, edited by Jacques Foucart, vol. 3, pp. 128–35. Paris: Éditions de la Réunion des Musées Nationaux, 1986.

Foucart-Walter, Élisabeth.
"Liste des tableaux déposés par le Louvre." In

Catalogue sommaire illustré des peintures du Musée du Louvre et du Musée d'Orsay, edited by Jacques Foucart, vol. 5, pp. 222–24. Paris: Éditions de la Réunion des Musées Nationaux, 1986.

Gaudichon, Bruno.
"Léopold Burthe (1823–1860)." *Bulletin de la Société de l'Histoire de l'Art Français,* 1984 [1986], pp. 230–31, 233, 237.

Gautier, Théophile.
Correspondance générale, 1843–1845. Edited by Claudine Lacoste-Veysseyre and Pierre Laubriet, vol. 2, pp. 15, 54, 175–76, 212, 223, 331–32. Geneva: Droz, 1986.

Girardin, Delphine de.
"15 juin 1844. Lettre XII." In *Lettres parisiennes du vicomte de Launay,* edited by Anne Martin-Fugier, vol. 2, pp. 293, 554 n. 152. Paris: Mercure de France, 1986.

Johnson, Lee.
The Paintings of Eugène Delacroix: A Critical Catalogue (1832–1863). Vol. 3. Oxford: Clarendon Press, 1986, p. 79.

Jouvenet, Olivier.
"Trois Lettres inédites d'Hippolyte et Paul Flandrin à leur condisciple Alexandre Desgoffe (1805–1882)." *Archives de l'art français* 28 (1986), pp. 292–93.

Martin-Fugier, Anne, ed.
Lettres parisiennes du vicomte de Launay, by Delphine de Girardin. 2 vols. Paris: Mercure de France, 1986.

Sandoz, Marc.
Portraits et visages dessiné par Théodore Chassériau. Cahiers Théodore Chassériau, vol. 2. Paris: Editart-Les Quatre Chemins, 1986. 242 pages.

Ternois, Daniel.
"Une Amitié romaine: Les Lettres d'Ingres à Édouard Gatteaux" and "Lettres d'Ingres et de Delphine Ingres à Édouard Gatteaux." In *Actes du colloque Ingres et Rome, September 1986,* pp. 21, 33. Montauban, 1986. Special issue of *Les Amis du Musée Ingres.*

1987
Bazin, Germain.
Théodore Géricault: Étude critique, documents et catalogue raisonné. Vol. 1. Paris: La Bibliothèque des Arts, 1987, p. 197.

Bowman, Frank P.
Le Christ des barricades, 1789–1848. Paris: Cerf, 1987.

Chaudonneret, Marie-Claude.
La Figure de la République: Le Concours de 1848. Paris: Éditions de la Réunion des Musées Nationaux, 1987, pp. 79, 130–31, 147, 157.

Foucart, Bruno.
Le Renouveau de la peinture religieuse en France (1800–1860). Paris: Arthéna, 1987, pp. 249–51, 322–23.

Laveissière, Sylvain.
"Théodore Chassériau: *Andromède attachée au rocher par les Néréides.*" In *Musée du Louvre: Nouvelles Acquisitions du Département des Peintures (1983–1986),* pp. 148–50. Paris, Éditions de la Réunion des Musées Nationaux, 1987.

Ritzenthaler, Cécile.
"Théodore Chassériau, 1819–1856." In *L'École des Beaux-Arts du XIXᵉ siècle: Les Pompiers,* pp. 92–95. Paris: Mayer, 1987.

1988

Bowman, Frank P.
L'Abbé Grégoire, évêque des lumières. Paris: Éditions France-Empire, 1988.

Durey, Philippe.
Le Musée des Beaux-Art de Lyon. Musées et monuments de France. Paris: Albin Michel, 1988.

Furet, François.
La Révolution: De Turgot à Jules Ferry (1770–1880). Paris, 1988, pp. 372–73.

Gautier, Théophile.
Correspondance générale, 1846–1848. Edited by Claudine Lacoste-Veysseyre and Pierre Laubriet, vol. 3, pp. 89–90, 129, 185, 269–70, 327–28, 364, 397–98. Geneva: Droz, 1988.

Germer, Stefan.
"Chassériau und die Erfindung des monumentalen Genres: Die Dekoration für die Cour des Comptes im Palais d'Orsay in Paris." In *Historizität und Autonomie: Studien zu Wandbildern im Frankreich des 19. Jahrhunderts—Ingres, Chassériau, Chenavard und Puvis de Chavannes,* pp. 227–301, 321–27, 537–59. Hildesheim, Zürich, and New York: Georg Olms, 1988.

Prat, Louis-Antoine.
Musée du Louvre. Cabinet des dessins. Inventaire général des dessins, École française. Dessins de Théodore Chassériau, 1819–1856. 2 vols. Paris: Éditions de la Réunion des Musées Nationaux, 1988. 1007 pages.

Prat, Louis-Antoine.
Théodore Chassériau, 1819–1856: Dessins conservés en dehors du Louvre. Cahiers du dessin français 5. Paris: Galerie de Bayser, 1988. 83 pages.

Sérullaz, Arlette.
"Chassériau et Shakespeare." *La Revue du Louvre et des musées de France* 38, no. 3 (1988), p. 267.

1989

Des Cars, Constance.
"*La Toilette d'Esther* par Chassériau (Musée du Louvre)." *Voici,* February 20, 1989, pp. 63–64.

Gautier, Théophile.
Correspondance générale, 1849–1851. Edited by Claudine Lacoste-Veysseyre and Pierre Laubriet, vol. 4, pp. 33, 85–86. Geneva: Droz, 1989.

Goncourt, Edmond de, and Jules de Goncourt.
Journal: Mémoires de la vie littéraire, 1866–1886. Vol. 1. Bouquins. Paris: Robert Laffont, 1989, p. 782.

Goncourt, Edmond de, and Jules de Goncourt.
Journal: Mémoires de la vie littéraire, 1866–1886. Vol. 2. Bouquins. Paris: Robert Laffont, 1989, p. 1224.

Guze, Justyna.
"Watteau vu par les romantiques français de la Bohême Galante." *Biuletyn historïsztuki* 51 nos. 3–4 (1989), pp. 267–72.

Honour, Hugh.
L'Image du noir dans l'art occidental. Vol. 4, *De la Révolution américaine à la Première Guerre Mondiale.* Pt. 1, *Les Trophées de l'esclavage,* pp. 188–91. Pt. 2, *Figures et masques,* pp. 38–40, 89, 155–57, 159. Translated by Marie-Geneviève de La Coste Messelière and Yves-Pol Hémonin. Paris: Gallimard, 1989.

English ed., *The Image of the Black in Western Art.* Vol. 4, *From the American Revolution to World War I.* Pt. 1, *Slaves and Liberators.* Pt. 2, *Black Models and White Myths.* Houston: Menil Foundation, and Cambridge, Massachusetts: Harvard University Press, 1989.

Hôtel Drouot.
L'Art et les enchères. Paris: Compagnie des Commissaires-Priseurs, 1989.

Monneret, Sophie.
L'Orient des peintres. Paris: Nathan, 1989.

Prat, Louis-Antoine.
"Théodore Chassériau ou le corps sous l'écrit." *Corps écrit,* no. 30 (June 1989), pp. 55–62.

Rosenblum, Robert.
Paintings in the Musee d'Orsay. New York: Stewart, Tabori & Chang, 1989.

Scott, David.
"Écrire le nu: La Transposition de l'image érotique dans la poésie française au XIX^e siècle." *Romantisme: Revue du dix-neuvième siècle,* no. 63 (1989), pp. 87–101.

Vaisse, Pierre.
"Bibliographie critique. Stefan Germer, *Historizität und Autonomie: Studien zu Wandbildern im Frankreich des 19. Jahrhunderts.*" *Revue de l'art,* no. 84 (1989), p. 84.

1990

Balzac, Honoré de.
Lettres à Madame Hanska, 1832–1844. Edited by Roger Pierrot, vol. 1, p. 487. Bouquins. Paris: Robert Laffont, 1990.

Balzac, Honoré de.
Lettres à Madame Hanska, 1845–1850. Edited by Roger Pierrot, vol. 2, pp. 404–5. Bouquins. Paris: Robert Laffont, 1990.

Brem, Anne-Marie de.
"Lamartine et les artistes." In *Lamartine et les artistes du XIX^e siècle,* p. 12. Exhib. cat. Paris, Musée de la Vie Romantique, Maison Renan-Scheffer, October 16, 1990–January 21, 1991.

Martin-Fugier, Anne.
La Vie élégante ou la formation du Tout-Paris, 1815–1848. Paris: Fayard, 1990, pp. 188, 267, 282.

Pouillon, François.
"Un Ami de Théophile Gautier en Orient, Camille Rogier: Réflexions sur la condition de drogman." In *L'Orient de Théophile Gautier.* Vol. 1, *Colloque international.* Published in *Bulletin de la Société Théophile Gautier,* no. 12 (1990), pp. 58, 73–74.

1991

Botteri Cardoso, Vittoria.
Pasini. Introduction by Rossana Bossaglia and Angelo Dragone. Geneva: Sagep, 1991, pp. 31–32.

Chaudonneret, Marie-Claude.
"La Peinture en France de 1830 à 1848: Chronique bibliographique et critique." *La Revue de l'art,* no. 91 (1991), p. 79.

Foucart-Walter, Élisabeth.
"Paul Chevandier de Valdrome: *Paysage, plaine de Rome.*" In *Musée du Louvre: Nouvelles Acquisitions du Département des Peintures (1987–1990),* edited by Jacques Foucart, p. 138. Paris: Éditions de la Réunion des Musées Nationaux, 1991.

Gautier, Théophile.
Correspondance générale, 1852–1853. Edited by Claudine Lacoste-Veysseyre and Pierre Laubriet, vol. 5, pp. 59–60, 74, 175, 263–64. Geneva: Droz, 1991.

Gautier, Théophile.
Correspondance générale, 1854–1857. Edited by Claudine Lacoste-Veysseyre and Pierre Laubriet, vol. 6, pp. 45, 70, 74, 159, 229, 375–78. Geneva: Droz, 1991.

Loyrette, Henri.
Degas. Paris: Fayard, 1991, pp. 62, 109–10.

Prat, Louis-Antoine.
"The Drawings of Chassériau: Some Particulars." *Drawing* 12, no. 4 (November–December 1991), pp. 73–77.

1992

Driskel, Michael Paul.
Representing Belief: Religion, Art, and Society in Nineteenth-Century France. University Park: Pennsylvania State University Press, 1992.

Foucart, Bruno, Françoise Moulinat, and Georges Brunel.
Chassériau à Saint-Roch. Paris: Paris Tête d'Affiche, 1992. 63 pages.

Guégan, Stéphane.
Regards d'écrivains au Musée d'Orsay. Paris: Éditions de la Réunion des Musées Nationaux, 1992.

Tisserand, Gérard, Chantal Lamesch, and Hélène Patten.
"La Défense des Gaules: Théodore Chassériau, 1855." In *Les Chefs-d'oeuvre du Musée des Beaux-Arts de Clermont-Ferrand,* vol. 1, p. 52. Clermont-Ferrand, 1992.

1993

Amouroux, Madeleine.
"Les Peintures de Chassériau pour l'escalier de la Cour des Comptes." Typescript. Paris, March 1993. 59 pages.

Guégan, Stéphane.
"Du Romantisme au Réalisme." In *Mille Peintures des musées de France,* edited by Guy Boyer and Jean-Loup Champion, pp. 366, 384–85. Paris: Gallimard/Beaux-Arts, 1993.

Loire, Stéphane, Marie-Catherine Sahut et al.
La Peinture française. Musée du Louvre, Guide du visiteur. Paris: Éditions de la Réunion des Musées Nationaux, 1993.

McWilliam, Neil.
Dreams of Happiness: Social Art and the French Left, 1830–1850. Princeton: Princeton University Press, 1993, p. 225.

Pitt-Rivers, Françoise.
Balzac et l'art. Paris: Chêne, 1993.

Pouillon, François.
"Simplification ethnique en Afrique du Nord: Maures, Arabes, Berbères (XVIII^e–XX^e siècles)." *Cahiers d'études africaines* 33-1, no. 129 (1993), pp. 37–49.

Ternois 1993.
See Amaury-Duval 1878

Vigne, Georges.
"Ingres et Chassériau: Une Collaboration éphémère." In *Le Retour à Rome de Monsieur Ingres: Dessins et peintures,* pp. 319–24. Exhib. cat. Rome, Villa Medici, December 14, 1993–January 30, 1994; Paris, Espace Electra, March 1–April 3, 1994.

1994

Bergot, François.
Musée des Beaux-Arts de Rouen: Guide des collections, XVIIᵉ, XIXᵉ et XXᵉ siècles. Paris: Éditions de la Réunion des Musées Nationaux, 1994.

Cahn, Isabelle.
"Cadres et cartels." In *La Jeunesse des musées: Les Musées de France au XIXᵉ siècle*, edited by Chantal Georgel, pp. 223–24. Exhib. cat. Paris, Musée d'Orsay, February 7–May 8, 1994.

Foucart, Bruno.
"Les Décors peints de Saint-Philippe, de Chassériau à Jacquand." In *Rue du Faubourg-Saint-Honoré*, pp. 333–35. Exhib. cat. Paris, Mairie du VIIIᵉ arrondissement, June–October 1994.

Gautier, Théophile.
Critique d'art: Extraits des Salons (1833–1872). Compiled and edited by Marie-Hélène Girard, pp. 12, 18, 25, 93–110, 169, 172, 243, 258, 322, 327, 430, 433, 435–36. Paris: Librairie Séguier, 1994.

Lacambre, Geneviève.
"Les Achats de l'État aux artistes vivants: Le Musée du Luxembourg." In *La Jeunesse des musées: Les Musées de France au XIXᵉ siècle*, edited by Chantal Georgel, p. 273. Paris, Musée d'Orsay, February 7–May 8, 1994.

Néagu, Philippe.
"Nadar et la vie artistique de son temps." In *Nadar: Les Années créatrices, 1854–1860*, pp. 108–9. Exhib. cat. Paris, Musée d'Orsay, June 7–September 11, 1994; New York, The Metropolitan Museum of Art, April 3–July 9, 1995. Also published in English.

Piguet, Philippe.
"L'Orientalisme: Autre Modèle, autre regard." *L'Oeil*, no. 466 (November 1994), pp. 38–41.

Ribner, Jonathan P.
"Chassériau's Juvenilia: Some Early Works by an *Enfant du Siècle*." *Zeitschrift für Kunstgeschichte* 57, no. 2 (1994), pp. 219–38.

1995

Ambile, Paul, and Bruno Foucart.
"Composition et organisation du Comité pour l'Année 1845." In *Le Baron Taylor: L'Association des Artistes et l'exposition du Bazar Bonne-Nouvelle en 1846*, p. 140. Exhib. cat. Paris, Fondation Taylor, September 14–October 28, 1995.

Chaudonneret, Marie-Claude, Alain Daguerre de Hureaux, Stéphane Guégan, Sarga Moussa, and Jean-Claude Yon.
L'ABCdaire du Romantisme français. Edited by Stéphane Guégan. Paris: Flammarion, 1995, pp. 24, 26, 33, 39–40, 44, 57, 60, 67, 72–73.

Dupuy, Marie-Anne.
Peintures et sculptures du XIXᵉ siècle: La Collection du Musée de Grenoble. Edited by Catherine Chevillot. Paris: Éditions de la Réunion des Musées Nationaux, and Grenoble: Musée de Grenoble, 1995, p. 99.

Fromentin, Eugène.
Correspondance d'Eugène Fromentin, 1839–1858. Edited by Barbara Wright. Vol. 1. Paris: CNRS-Éditions et Universitas, 1995, pp. 19, 52, 56, 233, 939–42, 1013–14, 1016.

Fromentin, Eugène.
Correspondance d'Eugène Fromentin, 1839–1858. Edited by Barbara Wright. Vol. 2. Paris: CNRS-Éditions et Universitas, 1995, p. 2309.

Lacambre, Jean.
"Théodore Chassériau." In *Les Années romantiques: La Peinture française de 1815 à 1850*, pp. 343–47. Exhib. cat. Nantes, Musée des Beaux-Arts, December 4, 1995–March 17, 1996; Paris, Galeries Nationales du Grand Palais, April 16–July 15, 1996; Piacenza, Palazzo Gotico, September 6–November 17, 1996.

Nochlin, Linda.
"L'Orient imaginaire." In *Les Politiques de la vision: Art, société et politique au XIXᵉ siècle*, translated by Oristelle Bonis, pp. 91–92. Paris: Éditions Jacqueline Chambon, 1995. English ed., *The Politics of Vision: Essays on Nineteenth-Century Art and Society*, New York: Harper & Row, 1989.

Peltre, Christine.
L'Atelier du voyage: Les Peintres en Orient au XIXᵉ siècle. Paris: Gallimard, 1995, pp. 18, 25, 55, 106, 112.

Randall, Angela.
"Théodore Chassériau." *Christie's International Magazine*, June–July 1995, pp. 48–49.

Zeri, Frederico, with Patrick Mauriès.
J'avoue m'être trompé: Fragments d'une autobiographie. Paris: Gallimard, 1995, p. 117.

1996

Chenique, Bruno.
"Le Tombeau de Géricault." In *Géricault*, edited by Régis Michel, vol. 2, pp. 732, 750. Actes du colloque, Paris, Musée du Louvre, November 14–16, 1991, and Rouen, Musée des Beaux-Arts, November 17, 1991. Paris: La Documentation Française, 1996.

Lichtenstein, Jacqueline.
"*Manette Salomon* ou le roman de la fin de l'art." *48/14 La Revue du Musée d'Orsay*, no. 3 (September 1996), pp. 66–75.

Mongan, Agnes.
David to Corot: French Drawings in the Fogg Art Museum. Cambridge, Massachusetts: Harvard University Press, 1996, pp. 26–27.

Pouillon, François.
"La Peinture monumentale en Algérie: Un Art pédagogique." *Cahiers d'études africaines* 36, nos. 1–2, nos. 141–42 (1996), pp. 183–213.

Prat, Louis-Antoine.
"Quelques Feuilles réapparues de Théodore Chassériau." In *Hommage au dessin: Mélanges offerts à Roseline Bacou*, pp. 572–83. Rimini: Galleria Editrice, 1996.

1997

Amouroux, Madeleine.
"Le Sauvetage des peintures de Chassériau réalisées pour la Cour des Comptes." In *Des mécènes par milliers: Un Siècle de dons par les Amis du Louvre*, pp. 63–64. Exhib. cat. Paris, Musée du Louvre, April 21–July 21, 1997.

Barbillon, Claire.
"Lettres et mots de Préault." In *Auguste Préault: Sculpteur romantique, 1809–1879*, p. 266. Exhib. cat. Paris, Musée d'Orsay, February 20, 1997–May 18, 1998; Château de Blois, June 20–September 28, 1997; Amsterdam, Van Gogh Museum, October 17, 1997–January 11, 1998.

Chevillot, Catherine.
"L'Oeuvre d'Auguste Préault. Catalogue raisonné. *Monument au général Marceau, 1845–1851.*" In *Auguste Préault: Sculpteur romantique, 1809–1879*, p. 169. Exhib. cat. Paris, Musée d'Orsay, February 20, 1997–May 18, 1998; Château de Blois, June 20–September 28, 1997; Amsterdam, Van Gogh Museum, October 17, 1997–January 11, 1998.

Chillaz, Valentine de.
Musée du Louvre, Département des Arts Graphiques, Musée d'Orsay. Inventaire général des autographes, pp. 42–44, 60–63, 116, 364–65, 394. Paris: Éditions de la Réunion des Musées Nationaux, 1997.

Dussol, Dominique.
Art et bourgeoisie: La Société des Amis des Arts de Bordeaux (1851–1939), pp. 42, 59, 61–62, 116, 165 n. 551, 170, 175, 224, 255. Preface by Bruno Foucart. Bordeaux: Le Festin, 1997.

Lacambre, Geneviève.
Gustave Moreau: Maître sorcier, pp. 11, 17, 19–20, 22–23, 25, 39, 49, 76. Paris: Gallimard and Réunion des Musées Nationaux, 1997.

Tinterow, Gary.
"Théodore Chassériau: Scene in the Jewish Quarter of Constantine, 1851." *The Metropolitan Museum of Art Bulletin* 55, no. 2 (Fall 1997), pp. 46–47.

1998

Unsigned.
"La Chronique des arts: Principales Acquisitions des musées en 1997." *Gazette des beaux-arts*, 6th series, 140 (March 1998), p. 59.

Bertin, Éric.
"Ingres d'après les lettres reçues de contemporains illustres." *Bulletin du Musée Ingres*, no. 71 (April 1998), pp. 24–25.

Cooke, Peter.
"*Les Filles de Thestius* (1853–1897) de Gustave Moreau: 'Gynécée cyclopéen' ou bordel philosophique." *La Revue du Louvre* 48, no. 4 (October 1998), pp. 64–66, 68–69.

Lefranc, Céline.
"Le Siècle retrouvé." *Connaissance des arts*, no. 546 (January 1998), pp. 46–53.

Peltre, Christine.
"La Description comme sauvegarde: À propos de la décoration de la Cour des Comptes par Théodore Chassériau (1844–1848)." In *Le Texte de l'oeuvre d'art: La Description*, compiled by Roland Recht, pp. 70–77. Strasbourg: Presses Universitaires de Strasbourg, and Colmar: Musée d'Unterlinden, 1998.

Prat, Louis-Antoine.
"Acquisitions. Anonyme (vers 1871–1898). Quatre Copies d'après les peintures murales de Théodore Chassériau (1819–1856) à l'ancienne Cour des Comptes de Paris et à l'église Saint-Merri à Paris." *La Revue du Louvre* 48, no. 5 (December 1998), p. 95.

Prat, Louis-Antoine.
"Chassériau, Théodore." In *Allgemeines Künstler-Lexikon*, vol. 18, pp. 300–302. Munich and Leipzig: K. G. Saur, 1998.

Rishel, Joseph J.
"Delacroix et l'Amérique." In *Delacroix: Les Dernières Années*, pp. 66–67. Exhib. cat. Paris, Galeries Nationales du Grand Palais, April 7–

July 20, 1998; Philadelphia Museum of Art, September 10, 1998–January 3, 1999.

Sanchez, Pierre, and Xavier Seydoux. *Les Estampes de L'Artiste*. Vol. 1, *1831–1857*. Paris, L'Échelle de Jacob, 1998, pp. 133, 135, 159, 173, 212, 238, 241, 251, 283.

Sanchez, Pierre, and Xavier Seydoux. *Les Estampes de L'Artiste*. Vol. 2, *1858–1904*. Paris, L'Échelle de Jacob, 1998, pp. 298, 459.

1999

Centorame, Bruno. "Avenue Frochot [studio of Chassériau]." In *Hameaux: Villas et cités de Paris*, compiled by Isabelle Montserrat and Virginie Grandval, pp. 110–11. Paris, Action Artistique de la Ville de Paris, 1999.

Frelin, Virginie. "Théodore Chassériau et le théâtre: Le Texte et la scène comme source d'inspiration." 2 vols. Mémoire de maîtrise en histoire de l'art, under the direction of Christine Peltre. Strasbourg: Université Marc-Bloch, 1999.

Michel, Régis. "L'Idiot de la peinture." In *Barbizon: Malerei der Natur—Natur der Malerei*, p. 105. Munich, 1999.

Moreau, Véronique. *Peintures du XIXe siecle, 1800–1914: Catalogue raisonné*. Vol. 1. Tours: Musée des Beaux-Arts, 1999, p. 121.

Peltre, Christine. "Entre Rome et l'Orient." In *Arlésienne: Le Mythe?*, pp. 165–72. Exhib. cat. Arles, Museon Arlaten, July 3, 1999–January 30, 2000.

Pierrot, Roger. *Ève de Balzac: Biographie*. Paris: Stock, 1999, p. 309.

Prat, Louis-Antoine. "Théodore Chassériau: Oeuvres réapparues." *Revue de l'art*, no. 125, 1999–3, pp. 71–77.

2000

Bowron, Edgar Peters, and Mary G. Morton. *Masterworks of European Painting in the Museum of Fine Arts, Houston*. Princeton: Princeton University Press, 2000.

Caffort, Michel. "De quelques occurrences de la croix dans la peinture française du XIXe siècle." In *Le Supplice et la gloire: La Croix en Poitou*, edited by Robert Favreau, p. 195. Paris: Somogy, 2000.

Chesneau-Dupin, Laurence, Françoise Mulot, Ivonne Papin-Drastik, Robine Stéphane, and Yves Sauvegrain. *Lettres inédites de Jean-Victor Schnetz à François-Joseph Navez: "Une Amitié italienne."* Flers: Flers Promotion, 2000, p. 156.

Haddad, Michèle. *Khalil-Bey: Un Homme, une collection*. Paris: Les Éditions de l'Amateur, 2000.

Jacquot, Dominique. "Paul Jamot (1863–1939) et l'histoire nationale de l'art." *Histoire de l'art*, no. 47 (November 2000), pp. 37–38.

Lemaire, Gérard-Georges. *L'Univers des orientalistes*. Paris: Éditions Place des Victoires, 2000.

Lobstein, Dominique. "Alfred Baillehache-Lamotte et le legs de *La Chaste Suzanne* de Gustave Moreau au Musée des Beaux-Arts de Lyon." *Bulletin des musées et monuments lyonnais*, no. 1, 2000, pp. 26–33.

Montcouquiol, Jérôme. "Alexandre Laemlein (1813–1871): Les Étapes d'une carrière." *Bulletin de la Société de l'Histoire de l'Art français*, 1999 [2000], pp. 266–67, 272, 287.

Piot, Charlotte. "Eugène Piot (1812–1890), publiciste et éditeur." *Histoire de l'art*, no. 47 (November 2000), pp. 11, 17.

Rousseau, Madeleine. *La Vie et l'oeuvre de Philippe-Auguste Jeanron: Peintre, écrivain, directeur des Musées Nationaux, 1808–1877*, pp. 54, 56–57, 93, 120. Memoir of the École du Louvre, prepared in 1935 and published posthumously. Edited by Marie-Martine Dubreuil. Preface by Jacques Foucart. Paris: Éditions de la Réunion des Musées Nationaux, 2000.

Vidal-Bué, Marion. *Alger et ses peintres, 1830–1960*. Paris: Éditions Paris-Mediterranée, 2000, pp. 20, 225.

Vigne, Georges. "Chassériau (Théodore)." In *Les Élèves d'Ingres*, pp. 73–74. Exhib. cat. Montauban, Musée Ingres, October 8, 1999–January 2, 2000; Besançon, Musée des Beaux-Arts, January 29–May 8, 2000.

Whiteley, Jon, comp. *Ashmolean Museum, Oxford. Catalogue of the Collection of Drawings*. Vol. 7, *French School*. 2 parts. Oxford: Oxford University Press, 2000.

2001

Cazenave, Élisabeth. "Chassériau, Théodore." In *Les Artistes de l'Algérie: Dictionnaire des peintres, sculpteurs, graveurs, 1830–1962*, p. 195. [Paris]: Bernard Giovanangeli, 2001.

Chauvin, Françoise. "Les Dessins ont la cote." *Le Monde*, Sunday and Monday, June 3 and 4, 2001, p. VIII.

Ferry, Luc. *Le Sens du Beau: Aux origines de la culture contemporaine*. Paris: Le Livre de Poche, 2001, pp. 186–87.

Goetz, Adrien. "Le Guetteur inquiet des modernités: Une Lecture sensible de Chassériau." *Journal des arts*, no. 138 (December 7–20, 2001), p. 20.

Guégan, Stéphane. "La Chambre rose de Chassériau avenue Frochot." In *La Nouvelle Athènes: Haut Lieu du Romantisme*, edited by Bruno Centorame, pp. 248–53. Paris: Action Artistique de la Ville de Paris, 2001.

Liszt, Franz, and Marie d'Agoult. *Correspondance*, rev. ed., edited by Serge Gut and Jacqueline Bellas, pp. 21, 773–75, 820, 858, 1239. Paris: Fayard, 2001.

Peltre, Christine. *Théodore Chassériau*. Paris: Gallimard, 2001. 255 pages.

Rodrigo, Pierre. *L'Étoffe de l'art*. Paris: Desclée de Brouwer, 2001, pp. 166–68.

Ternois, Daniel. *Lettres d'Ingres à Marcotte d'Argenteuil: Dictionnaire*. Published by the Société de l'Histoire de l'Art Français in *Archives de l'Art français* 36 (2001), pp. 83, 144–45.

Exhibitions

Paris, Salon, 1836
Explication des ouvrages de peinture, sculpture, architecture, gravure et lithographie des artistes vivants exposés au Musée Royal le 1er mars 1836. Paris: Vinchon, 1836.

Paris, Salon, 1837
Explication des ouvrages de peinture, sculpture, architecture, gravure et lithographie des artistes vivants exposés au Musée Royal le 1er mars 1837. Paris: Vinchon, 1837.

Paris, 1839
Exposition de peinture et de sculpture au profit des victimes du tremblement de terre de la Martinique. Paris, rue des Jeûneurs, July 16, 1839.

Paris, Salon, 1839
Explication des ouvrages de peinture, sculpture, architecture, gravure et lithographie des artistes vivants exposés au Musée Royal le 1er mars 1839. Paris: Vinchon, 1839.

Paris, Salon, 1840
Explication des ouvrages de peinture, sculpture, architecture, gravure et lithographie des artistes vivants exposés au Musée Royal le 5 mars 1840. Paris: Vinchon, 1840.

Paris, Salon, 1841
Explication des ouvrages de peinture, sculpture, architecture, gravure et lithographie des artistes vivants exposés au Musée Royal le 15 mars 1841. Paris: Vinchon, 1841.

Rouen, 1841
Catalogue de la neuvième exposition annuelle du Musée de Rouen. Rouen: Imprimé par Ve Fs Marie, rue des Carmes, 1841.

Paris, Salon, 1842
Explication des ouvrages de peinture, sculpture, architecture, gravure et lithographie des artistes vivants exposés au Musée Royal le 15 mars 1842. Paris: Vinchon, 1842.

Paris, Salon, 1843
Explication des ouvrages de peinture, sculpture, architecture, gravure et lithographie des artistes vivants exposés au Musée Royal le 15 mars 1843. Paris: Vinchon, 1843.

Paris, Salon, 1844
Explication des ouvrages de peinture, sculpture, architecture, gravure et lithographie des artistes vivants exposés au Musée Royal le 15 mars 1844. Paris: Vinchon, 1844.

Paris, 1845
Exhibition, Théâtre de l'Odéon, Paris, November 1845.

Paris, Salon, 1845
Explication des ouvrages de peinture, sculpture, architecture, gravure et lithographie des artistes vivants exposés au Musée Royal le 15 mars 1845. Paris: Vinchon, 1845.

Paris, 1848
Association des Artistes. Explication des ouvrages de peinture, sculpture et architecture exposés à la Galerie Bonne-Nouvelle au profit de la caisse des secours et pensions de l'association, troisième année. Paris, January 1848.

Paris, Salon, 1848
Explication des ouvrages de peinture, sculpture, architecture, gravure et lithographie des artistes vivants exposés au Musée National du Louvre le 15 mars 1848. Paris: Vinchon, 1848.

Paris, 1849
Association des Artistes. Explication des ouvrages de peinture, sculpture et architecture exposés à la Galerie Bonne-Nouvelle au profit de la caisse des secours et pensions de l'association, quatrième année. Paris, January 1849.

Paris, Salon, 1850–51
Explication des ouvrages de peinture, sculpture, architecture, gravure et lithographie des artistes vivants exposés au Palais National le 30 décembre 1850. Paris: Vinchon, 1850.

Bordeaux, 1851
Explication des ouvrages de peinture, sculpture, architecture, gravure et lithographie des artistes vivants exposés dans la Galerie de la Société des Amis des Arts de Bordeaux, le 15 novembre 1851. Bordeaux: Gounouilhou, 1851.

Le Havre, 1852
Exposition bisannuelle de peintures et objets d'arts. Le Havre, Musée du Havre, Imprimerie Lepelletier, October 1852.

Paris, Salon, 1852
Explication des ouvrages de peinture, sculpture, architecture, gravure et lithographie des artistes vivants exposés au Palais Royal le 1er avril 1852. Paris: Vinchon, 1852.

Bordeaux, 1853
Explication des ouvrages de peinture, sculpture, architecture, gravure et lithographie des artistes vivants exposés dans la Galerie de la Société des Amis des Arts de Bordeaux, le 5 novembre 1853. Bordeaux: Gounouilhou, 1853.

Paris, Salon, 1853
Explication des ouvrages de peinture, sculpture, architecture, gravure et lithographie des artistes vivants exposés aux Menus-Plaisirs le 15 mai 1853. Paris: Vinchon, 1853.

Bordeaux, 1854
Explication des ouvrages de peinture, sculpture, architecture, gravure et lithographie des artistes vivants exposés dans la Galerie de la Société des Amis des Arts de Bordeaux, le 12 novembre 1854. Bordeaux: Gounouilhou, 1854.

Bordeaux, 1855
Explication des ouvrages de peinture, sculpture, architecture, gravure et lithographie des artistes vivants exposés dans la Galerie de la Société des Amis des Arts de Bordeaux, le 30 décembre 1855. Bordeaux: Gounouilhou, 1855.

Paris, 1855
Exposition Universelle de 1855. Explication des ouvrages de peinture, sculpture, gravure, lithographie et architecture des artistes vivants étrangers et français, exposé au Palais des Beaux-Arts, avenue Montaigne, le 15 mai 1855. Paris, Vinchon, 1855.

Paris, 1857
Catalogue de tableaux, études, esquisses, dessins, armes et costumes laissés par M. Théodore Chassériau, dont la vente aura lieu par suite de son décès, rue Drouot, 5, salle no. 5, au premier, les lundi 16 et mardi 17 mars 1857 à deux heures. Public exhibition, March 15, 1857. Sale, Hôtel Drouot, Paris; auctioneer Maître Pouchet; expert, M. Francis Petit.

Paris, 1878
Exposition Universelle de 1878 à Paris. Notice historique et analytique des peintures, sculptures . . . exposées dans les galeries des Portraits nationaux du Palais du Trocadéro. Paris, 1878.

Paris, 1883
Catalogue de l'exposition des portraits du siècle, 1783–1883. Organized by the Société Philanthropique. Paris, École Nationale des Beaux-Arts, 1883.

Paris, 1884
Association des Artistes Peintres . . . Catalogue des dessins de l'école moderne exposés à l'École Nationale des Beaux-Arts. Paris, 1884.

Paris, 1885
La Deuxième Exposition de "Portraits du Siècle" ouverte au profit de l'oeuvre. Paris, École Nationale des Beaux-Arts, April 20, 1885.

Paris, 1889
Exposition Universelle Internationale de 1889, à Paris. Catalogue Général Officiel. Beaux-Arts. Exposition Centennale de l'art français, 1789–1889. Paris, Palais du Trocadéro, 1889.

Paris, 1893
Association des Journalistes Parisiens. Catalogue de l'Exposition des portraits des écrivains et journalistes du siècle (1793–1893). Paris, Galerie Georges Petit, 1893.

Paris, 1893
Exposition d'art musulman. Paris, Palais de l'Industrie, 1893.

Paris, 1894
Les Peintres orientalistes français. 1st exhibition. Paris, 1894.

Paris, 1896
Les Peintres orientalistes français. 3rd exhibition. Paris, 1896.

Paris, 1897
Les Peintres orientalistes français. 4th exhibition, *Rétrospective Théodore Chassériau.* Paris, Galerie Durand-Ruel, February 16–March 13, 1897. (Catalogue by Ary Renan; preface by Léonce Bénédite.)

Paris, 1900
Exposition centennale de l'art français de 1800 à 1889. Exposition Universelle Internationale. Catalogue Général Officiel. Oeuvres d'art. Paris, 1900.

Dresden, 1904
Grosse Kunstaufstellung. Dresden, 1904.

Marseilles, 1906
Exposition Nationale Coloniale. Official notice and illustrated catalogue of the exhibition of fine arts and the retrospective exhibition of the French Orientalists. Marseilles, 1906.

London, 1908
Franco-British Exhibition: Fine Arts Catalogue. Part 2, *French Section.* London, 1908.

Paris, 1908
Exposition théâtrale. Paris, Musée des Arts Décoratifs, 1908.

Paris, 1908
Portraits d'hommes et de femmes célèbres (1830 à 1900). Exhibited by the Société Nationale des Beaux-Arts. Paris, Palais du Domaine de Bagatelle, May 15–July 14, 1908.

Saint Petersburg, 1912
Exposition centennale. *L'Art français à Saint-Pétersbourg.* Saint Petersburg, March 1912.

Copenhagen, 1914
Exposition d'art français du XIXe siècle. Copenhagen, Statens Museum for Kunst, May 15–June 30, 1914.

Paris, 1919
Catalogue des collections nouvelles fermées par les Musées Nationaux de 1914 à 1919 et qui sont exposées temporairement dans la salle Lacaze depuis le 10 février 1919. Paris, Gaston Braun, 1919.

Lyons, 1921
Dessins anciens. Lyons, Bibliothèque, 1921. (No catalogue.)

Paris, 1922
Cent Ans de peinture française. Paris, rue de la Ville-l'Évêque, 1922.

Paris, 1923
L'Art et la vie romantiques. Paris, Galerie Jean Charpentier, February 25–March 25, 1923.

Paris, 1924
De David à Manet. Paris, Galerie Balzac, 1924.

Paris, 1924
Exposition d'oeuvres de Géricault au profit de la Société "La Sauvegarde de l'art français." Paris, Hôtel Jean Charpentier, April 24–May 16, 1924.

Amsterdam, 1926
Rétrospective d'art français. Amsterdam, Rijksmuseum, 1926.

Paris, 1926
L'Art et la vie sous Louis-Philippe (1830–1848). Paris, Galerie Jean Charpentier, 1926.

Paris, 1927
Aquarelles et dessins de Chassériau (1819–1856). Paris, Galerie L. Dru, June 14–July 9, 1927. (Catalogue, 16 pages; foreword by Jean-Louis Vaudoyer, pp. 3–10.)

Cambridge (Massachusetts), 1929
French Painting of the Nineteenth and Twentieth Centuries. Cambridge, Massachusetts, Fogg Art Museum, Harvard University, 1929.

Paris, 1929
Centenaire de la Revue des Deux Mondes, 1829–1929: Exposition des cent ans de vie française. Paris, Hôtel Jean Charpentier, 1929. (Catalogue preface by Louis Gillet.)

Algiers, 1930
L'Orient dans la peinture française. Algiers, 1930.

Paris, 1930
Le Décor de la vie à l'époque romantique, 1820–1848. Paris, Pavillon de Marsan, Palais du Louvre, April–May 1930.

Paris, 1930
Exposition du centenaire de la conquête de l'Algérie, 1830–1930. Paris, Musée du Petit Palais, May–June 1930.

Paris, 1930
Victor Hugo raconté par l'image. Paris, Musée du Petit Palais, 1930.

Paris, 1931
Exposition Coloniale Internationale de Paris. Beaux-Arts. Paris, May–November 1931. (Catalogue introduction by Henry Bérenger.)

Paris, 1931
Hommage à Chassériau: Aquarelles, dessins. Paris, Galerie des Quatre Chemins, May 20–June 10, 1931. (Catalogue preface by Waldemar George.)

Paris, 1931
Oeuvres importantes de grands maîtres du dix-neuvième siècle. Paris, Galerie Paul Rosenberg, May 18–June 27, 1931.

London, 1932
French Art, 1200–1900. London, Royal Academy of Arts, Burlington House, January–March 1932.

Chicago, 1933
A Century of Progress. Exhibition of Paintings and Sculpture Lent from American Collections. The Art Institute of Chicago, June 1–November 1, 1933.

Paris, Galerie Charpentier, 1933
Figures nues d'école française. Paris, Galerie Jean Charpentier, 1933.

Paris, Hôtel Charpentier, 1933
Rétrospective orientale de Théodore Chassériau: Société des peintres orientalistes français. Paris, Hôtel Jean Charpentier, January 10–24, 1933.

Paris, Orangerie, 1933
Chassériau, 1819–1856. Paris, Musée de l'Orangerie, 1933. (Catalogue by Charles Sterling; preface by Jean-Louis Vaudoyer.)

Cambridge (Massachusetts), 1934
French Drawings and Prints of the XIXth Century. Cambridge, Massachusetts, Fogg Art Museum, Harvard University, 1934.

Cambridge (Massachusetts), 1934
French Romanticism of the Eighteen Thirties. Cambridge, Massachusetts, Fogg Art Museum, Harvard University, 1934.

Chicago, 1934
A Century of Progress Exhibition of Paintings and Sculpture. The Art Institute of Chicago, June 1–November 1, 1934.

Paris, 1934
Les Artistes français en Italie, de Poussin à Renoir. Paris, Musées des Arts Décoratifs, 1934.

Paris, 1934
Cent Ans de portraits français (1800–1900). Paris, Galerie Bernheim Jeune, 1934.

Paris, 1934
Portraits par Ingres et ses élèves. Paris, Galerie Seligmann, 1934.

Venice, 1934
Biennale. Venice, 1934.

Basel, 1935
Meisterzeichnungen französischer Meister, von Ingres bis Cézanne. Basel, Kunsthalle, 1935.

Brussels, 1935
Exposition Universelle. *Cinq Siècles d'art.* Brussels, 1935.

Geneva, 1935
L'Algérie et les artistes français au XIXe et au XXe siècles. Geneva, Musée d'Art et d'Histoire, 1935.

Paris, 1935
Troisième Centenaire de l'Académie française. Paris, Bibliothèque Nationale, 1935.

Algiers, 1936
Exposition d'oeuvres de Théodore Chassériau (1819–1856). Algiers, Musée National des Beaux-Arts d'Alger, March–May 1936.

Paris, 1936
L'Aquarelle de 1400 à 1900. Paris, Musée de l'Orangerie, 1936.

Paris, 1936
Portraits français de 1400 à 1900. Paris, Galerie Seligmann, 1936.

Brussels, 1936–37
Les Plus Beaux Dessins français du Louvre (1350–1900). Brussels, Palais des Beaux-Arts, December 1936–February 1937.

Paris, 1937
Cent Ans de costume parisien. Société d'histoire du costume. Paris, Musée Galliéra, 1937.

Paris, 1937
Exposition Universelle. *Chefs-d'oeuvre de l'art français.* Paris, Palais National des Arts, 1937. (Catalogue introduction by Henri Focillon.)

Paris, 1937
Le Portrait dessiné du XIXe siècle. Paris, Galerie Marcel Guiot, 1937.

Zürich, 1937
Zeichnungen französischer Meister, von David zu Millet. Zürich, Kunsthaus, 1937.

Bogotá, 1938
Dessins français du XIIIe au XXe siècle. Bogotá, 1938.

Bucharest, 1938
Le Portrait français. Bucharest, Museu de arte, 1938.

The Hague 1938
L'Orient et l'Algérie dans l'art français au XIXe et XXe siècles: Dessins de Delacroix et Chassériau. The Hague, Gemeentemuseum, November 1938.

Lyons, 1938
D'Ingres à Cézanne. Lyons, Salon du Sud-Est, 1938.

Belgrade, 1939
La Peinture française au XIXe siècle. Belgrade, Muzej Kneza Paula, 1939.

Brooklyn, 1939
Exhibition. The Brooklyn Museum, New York, 1939.

Buenos Aires, 1939
Exposiciones de arte francés. . . . La pintura francesa de David a nuestros días. Óleos, dibujos, y acuareles. Buenos Aires, Museo Nacional de Bellas Artes, June–August 1939.

Copenhagen, 1939
Franske handtekegninger fra det XIX. og XX. aarhundrede. Copenhagen, Statens Museum for Kunst, 1939.

Liège, 1939
De l'eau. Liège, 1939.

Paris, 1939
Shakespeare. Paris, Musée des Arts Décoratifs, 1939.

Paris, 1941
Donation Paul Jamot. Paris, Musée de l'Orangerie, 1941. (Catalogue preface by Maurice Denis.)

Paris, 1942
Un Siècle d'aquarelle. Paris, Galerie Jean Charpentier, 1942.

Cambridge (Massachusetts), 1943
North Africa Interpreted by European Artists. Cambridge, Massachusetts, Fogg Art Museum, Harvard University, 1943.

New York, 1943
Fashions in Headdress, 1450–1943. New York, Wildenstein & Co., 1943.

Paris, 1944
Aquarelle romantique et contemporaine. Paris, Galerie Jean Charpentier, 1944.

Cambridge (Massachusetts), 1946
Between the Empires: Géricault, Delacroix, Chassériau—Painters of the Romantic Movement. Cambridge, Massachusetts, Fogg Art Museum, Harvard University, April 30–June 1, 1946.

Paris, 1946
Trois Siècles de dessin parisien. Paris, Musée Carnavalet, 1946.

New York, 1947
French XIXth Century Drawings. New York, Wildenstein & Co., 1947.

Paris, 1947
Cinquantenaire des "Amis du Louvre," 1897–1947. Paris, Musée de l'Orangerie, 1947.

Berne, 1948
Dessins français du Musée du Louvre. Berne, Kunstmuseum, 1948.

Paris, 1948
Chevaux et cavaliers. Paris, Galerie Jean Charpentier, 1948.

Paris, 1948
La Révolution de 1848. Organized by the Comité du Centenaire. Paris, Bibliothèque Nationale, 1948.

Detroit, 1949
Fifty Drawings from the Collection of John S. Newberry Jr. The Detroit Institute of Arts, June 1–September 6, 1949.

Paris, 1949–50
Cent Portraits de femme. Paris, Galerie Charpentier, 1949–50.

Detroit, 1950
French Painting from David to Courbet. The Detroit Institute of Arts, February 1–March 5, 1950.

Lisbon, 1950
L'Orient et l'Algérie dans la peinture française aux XIXᵉ et XXᵉ siècles. Lisbon, Museu de Arte, April–May 1950.

Paris, 1950
Delacroix et le portrait romantique. Paris, Atelier d'Eugène Delacroix, 1950.

Geneva, 1951
De Watteau à Cézanne. Geneva, Musée d'Art et d'Histoire, 1951.

Paris, 1951
Delacroix et l'orientalisme de son temps. Paris, Atelier d'Eugène Delacroix, May 1951. (Catalogue preface by Maurice Sérullaz.)

Paris, 1951
Victor Hugo et les artistes romantiques. Paris, Musée Victor Hugo, June 23–September 2, 1951. (Catalogue by Jean Sergent.)

Hartford, 1952
The Romantic Circle: French Romantic Painting— Delacroix and His Contemporaries. Hartford, Wadsworth Atheneum, 1952.

London, 1952
French Drawings, from Fouquet to Gauguin. London, The Arts Council Gallery, 1952. (Catalogue introduction by Jacqueline Bouchot-Saupique.)

Paris, 1952
Cent Cinquante Ans de dessin, 1800–1950. Paris, Galerie Bernheim-Jeune, December 20, 1952. (Catalogue preface by Claude Roger-Marx.)

Paris, 1952
Cent Portraits d'hommes du XIVᵉ siècle à nos jours. Paris, Galerie Charpentier, 1952.

Paris, 1952
Delacroix et les maîtres de la couleur. Paris, Atelier d'Eugène Delacroix, 1952.

Paris, 1952
Peintres de portraits. Paris, Galerie Bernheim-Jeune, 1952.

Paris, 1952–53
Chefs-d'oeuvre des collections parisiennes: Peintures et dessins de l'école française du XIXᵉ siècle. Paris, Musée Carnavalet, December 1952–February 1953.

Washington, D.C., and other cities, 1952–53
French Drawings: Masterpieces from Five Centuries. Washington, D.C., National Gallery of Art; The Cleveland Museum of Art; Saint Louis, City Art Museum; Cambridge, Massachusetts, Harvard University, Fogg Art Museum; New York, The Metropolitan Museum of Art, 1952–53.

Boston, 1953
Chinese Ceramics and European Drawings. Boston, Museum of Fine Arts, 1953.

Brussels, 1953
La Femme dans l'art français. Brussels, Palais des Beaux-Arts, 1953.

New Orleans, 1953
A Loan Exhibition of Masterpieces of French Art through Five Centuries, 1400–1900, in Honor of the 150th Anniversary of the Louisiana Purchase. New Orleans, Isaac Delgado Museum of Art, 1953.

New York, 1953. *See* **Washington, D. C., and other cities, 1952–53**

Paris, 1953
Les Célébrités françaises. Paris, Hôtel Jean Charpentier, 1953.

Paris, 1953
Delacroix et l'orientalisme de son temps. Paris, Atelier d'Eugène Delacroix, 1953.

Paris, 1953
Donations de D. David-Weill aux musées français. Paris, Musée de l'Orangerie, 1953.

Paris, 1953
Un Siècle d'art français. Paris, Musée du Petit Palais, 1953. (Catalogue preface by André Chamson.)

Paris, 1954
Lamennais. Paris, Bibliothèque Nationale, 1954.

Paris, 1954
Quelques Aspects de la vie à Paris au XIXᵉ siècle. Paris, Musée du Louvre, Cabinet des Dessins, 1954.

Algiers, 1955
Dessins de l'école française appartenent au Musée du Louvre. Algiers, Musée National des Beaux-Arts d'Alger, 1955.

New York, 1955
Timeless Master Drawings. New York, Wildenstein & Co., 1955.

Paris, 1955
De David à Toulouse-Lautrec: Chefs-d'oeuvre des collections américaines. Paris, Musée de l'Orangerie, 1955.

Paris, 1955
Gérard de Nerval. Paris, Bibliothèque Nationale, 1955.

Rome and Florence, 1955
Mostra di capolavori della pittura francese dell'ottocento. Rome, Palazzo delle Esposizioni; Florence, Palazzo Strozzi, 1955.

Winterthur, 1955
Europaïscher Meister, 1790–1910. Kunstmuseum Winterthur, June 12–July 24, 1955.

Moscow and Leningrad, 1956
Peinture française du XIXᵉ siècle. Moscow, Pushkin Museum; Leningrad, The State Hermitage Museum, 1956.

Warsaw, 1956
Malarstwo francuskie od Davida do Cézanne'a. Warsaw, Muzeum Narodowe, June 15–July 31, 1956.

Zürich, 1956
Unbekannte Schönheit: Bedeutende Werke aus fünf Jahrhunderten. Zürich, Kunsthaus, 1956.

Paris, 1957
Cent Cinquantenaire de la Cour des Comptes. Paris, Hôtel de Rohan, 1957. (Catalogue preface by Pierre Escoubé.)

Paris, 1957
Distinction in Draughtsmanship. Paris, Galerie Stephen Higgins, 1957.

Paris, 1957
Le Second Empire de Winterhalter à Renoir. Paris, Musée Jacquemart-André, May–June 1957. (Catalogue preface by André Maurois; introduction by Jean-Gabriel Domergue.)

Paris, Louvre, 1957
Théodore Chassériau, 1819–1856: Dessins. Paris, Musée du Louvre, Cabinet des Dessins, 1957. (Catalogue by Roseline Bacou and Maurice Sérullaz.)

Agen, Grenoble, and Nancy, 1958
Romantiques et réalistes au XIXᵉ siècle. Agen, Musée des Beaux-Arts; Musée du Grenoble; Nancy, Musée des Beaux-Arts, 1958.

Hamburg, Cologne, and Stuttgart, 1958
Französische Zeichnungen von der Anfängen bis zum Ende des 19. Jahrhunderts. Hamburg, Kunsthalle, February 1–March 16, 1958; Cologne, Wallraf-Richartz-Museum, March 22–May 5, 1958; Stuttgart, Württembergischer Kunstverein, May 10–June 7, 1958.

Paris, 1958
De Clouet à Matisse: Dessins français des collections américaines. Paris, Musée de l'Orangerie, 1958. (Catalogue by Agnes Mongan.)

Paris, 1958
De Delacroix à Maillol. Paris, Galerie Daber, 1958.

Paris, 1958
Romantiques et réalistes au XIXᵉ siècle. L'Institut Pédagogique National, Direction des Musées de France. Paris, 1958.

Stockholm, 1958
Fem sekler fransk konst, 1400–1900. Stockholm, Nationalmuseum, August 15–November 9, 1958.

London, 1959
The Romantic Movement: Fifth Exhibition to Celebrate the Tenth Anniversary of the Council of Europe. London, Tate Gallery and The Arts Council Gallery, July 10– September 27, 1959.

Paris, 1959
De Watteau à Cézanne: Le Charme dans le dessin français. Paris, Galerie Madame Marcel Guiot, 1959.

Bordeaux, 1960
L'Europe et la découverte du monde. Bordeaux, Galerie des Beaux-Arts, May 20–July 31, 1960. (Catalogue by Gilberte Martin-Méry.)

Paris, 1960
Elles: Évocations féminines, de Watteau à Cézanne. Paris, Galerie Madame Marcel Guiot, 1960.

Warsaw, 1960
Chopin. Warsaw, Muzeum Narodowe, 1960.

Castres, 1961
Lacordaire: Exposition du centenaire de sa mort. Castres, Musée Goya, 1961.

Los Angeles, 1961
French Masters, Rococo to Romanticism: An Exhibition of Paintings, Drawings, and Prints. Los Angeles, UCLA Art Galleries, March 5–April 18, 1961.

Rome, 1961
L'Italia vista dai pittori francesi del XVIII e XIX secolo. Rome, Palazzo delle Esposizioni, February 8–March 26, 1961; Turin, Galleria Civica d'Arte Moderna, April 20–May 25, 1961.

Vichy, 1961
D'Ingres à Renoir: La Vie artistique sous le Second Empire. Vichy, June–August 1961. (Catalogue foreword by Jean Vergnet Ruiz; preface by Pierre Schommer.)

Paris, 1962
Maurice Barrès. Paris, Bibliothèque Nationale, 1962.

Paris, 1962
Première Exposition des plus beaux dessins du Louvre et de quelques pièces célèbres des collections de Paris. Paris, Musée du Louvre, March–May 1962.

Paris, 1962
Théophile Gautier. Paris, Bibliothèque Nationale, 1962.

Rome, 1962
Il ritratto francese da Clouet a Degas. Rome, Palazzo Venezia, April 1962; Milan, Palazzo Reale, June–July 1962.

San Francisco, 1962
The Henry P. McIlhenny Collection: Paintings, Drawings, and Sculpture. Exhibition, San Francisco, The California Palace of the Legion of Honor, June 15–July 31, 1962.

Versailles, 1962
La Comédie-Française, 1690–1962. Château de Versailles, 1962.

Bordeaux, 1963
Delacroix: Ses Maîtres, ses amis, ses élèves. Bordeaux, Galerie des Beaux-Arts, 1963. (Catalogue by Gilberte Martin-Méry; preface by René Huyghe.)

Paris, 1963
Delacroix citoyen de Paris. Paris, Atelier d'Eugène Delacroix, 1963.

Paris, 1963
Delacroix et la gravure romantique. Paris, Bibliothèque Nationale, 1963.

Bordeaux, 1964
La Femme et l'artiste de Bellini à Picasso. Bordeaux, Galerie des Beaux-Arts, May 22–September 20, 1964. (Catalogue by Gilberte Martin-Méry.)

London, 1964
Shakespeare in Art. London, The Arts Council Gallery, 1964.

Munich, 1964–65
Französische Malerei des 19. Jahrhunderts, von David bis Cézanne. Munich, Haus der Kunst, October 7, 1964–January 6, 1965.

Lisbon, 1965
Um século de pintura francesa, 1850–1950. Lisbon, Fundação Calouste Gulbenkian, March–April 1965.

Paris, 1966
Delacroix et les paysages romantiques. Paris, Musée Eugène Delacroix, May 19–July 19, 1966.

Montauban, 1967
Ingres et son temps. Montauban, Musée Ingres, June 24–September 15, 1967. (Catalogue by Daniel Ternois and Jean Lacambre.)

Moscow and Leningrad, 1968
Le Romantisme dans la peinture française. Moscow and Leningrad, 1968. (Catalogue entry by Hélène Toussaint.)

Castres, 1969
La Magie. Castres, Musée Goya, 1969.

Poitiers, 1969
Théodore Chassériau, 1819–1856. Poitiers, Musée Sainte-Croix, June–September 1969.

Turin, 1969
Il sacro e il profano nell'arte dei simbolisti. Turin, Galleria Civica d'Arte Moderna, June–August 1969.

Vannes and Brest, 1971
Quelques Aspects du paysage français du XIXe siècle: Tableaux du Musée du Louvre. Vannes, Palais des Arts, June 9–September 5, 1971; Musée de Brest, September 24–November 15, 1971.

Munich, 1972
Welt Kulturen und moderne Kunst. Munich, Haus der Kunst, June 16–September 30, 1972.

Paris, 1972
Centaures, chevaux et cavaliers. Paris, Musée Bourdelle, June–September 1972.

Paris, 1972
Delacroix et le fantastique, de Goya à Redon. Paris, Musée Eugène Delacroix, May–November 1972.

Clermont-Ferrand, 1973
Prosper Marilhat. Clermont-Ferrand, Musée Bargoin, June–September 1973.

Paris, 1973–74
Copies, répliques, faux. Le Petit Journal des grandes expositions, no. 3. Paris, Musée du Louvre, dossier, Département des Peintures, 1973–74.

Marseilles, 1975
L'Orient en question, 1825–1875: De Missolonghi à Suez ou l'Orientalisme de Delacroix à Flaubert. Marseilles, Musée Cantini, 1975. (Catalogue preface by Marielle Latour.)

New York, 1975
Ingres and Delacroix through Degas and Puvis de Chavannes: The Figure in French Art, 1800–1870. New York, Shepherd Gallery, May–June 1975.

Paris, 1976
Chassériau, 1819–1856. Paris, Galerie Daber, June 9–July 10, 1976. (Catalogue introduction by Marc Sandoz.)

Beauvais, 1978
Arthur de Gobineau et le département de l'Oise. Beauvais, Musée Départemental de l'Oise, October 1978. (Catalogue by Marie-José Salmon; preface by Jean Gaulmier.)

Paris, 1978
Autoportraits de peintres. Paris, Palais de Tokyo, Musée d'Art et d'Essai, March 7–October 10, 1978.

Rouen, 1978
Mazeppa: Variations sur un thème romantique. Rouen, Musée des Beaux-Arts, May 19–June 30, 1978. (Catalogue by Jean-Pierre Mouilleseaux.)

Paris, 1979
L'Art en France sous le Second Empire. Paris, Grand Palais, May 11–August 13, 1979. (Catalogue entries by Arlette Sérullaz and Geneviève Lacambre.)

Paris, 1979
Autour de quelques oeuvres du Second Empire. Paris, Palais de Tokyo, Musée d'Art et d'Essai, November 15–October 22, 1979. (Catalogue entries by Geneviève Lacambre and Anne Pingeot.)

Paris, 1979
La Famille des portraits. Paris, Musée des Arts Décoratifs, October 25, 1979–February 15, 1980.

Baltimore, 1979–80
Théodore Chassériau: Illustrations for Othello. Baltimore Museum of Art, 1979–80. (Catalogue by Jay M. Fisher.)

Clermont-Ferrand, 1980
Nos Ancêtres les gaulois. Clermont-Ferrand, Musée Bargoin, June 25–September 30, 1980 (Catalogue by Antoinette Ehrard and Marie-Laure Hallopeau.)

Montauban, 1980
Ingres et sa postérité jusqu'à Matisse et Picasso. Montauban, Musée Ingres, June 28–September 7, 1980.

New York, 1980
Christian Imagery in French Nineteenth Century Art, 1789–1906, New York, Shepherd Gallery, 1980.

Tours, 1980
L'Orientalisme dans les collections des musées de Tours. Tours, Musée des Beaux-Arts, April 3–June 8, 1980.

Paris, 1980–81
Revoir Chassériau. Paris, Musée du Louvre, Cabinet des Dessins, 1980–81.

Lyons, 1981
Les Peintres de l'âme: Art lyonnais du XIXe siècle. Lyons, Musée des Beaux-Arts, June–September 1981.

Beijing and Shanghai, 1982
250 Ans de peinture française: De Poussin à Courbet (1620–1870). Beijing, Palais des Expositions, September 15–October 13, 1982; Shanghai, October 20–November 10, 1982. (Catalogue by Claire Constans, Jean-Pierre Cuzin, and Sylvain Laveissière.)

Berlin, 1982. See **Prague and Berlin, 1982–83**

Paris, 1982
Musiciennes du silence. Paris, Musée Hébert, May 19–October 4, 1982. (*Petit Journal* by Isabelle Julia.)

Rochester and Purchase, 1982
Orientalism: The Near East in French Painting, 1800–1880. Memorial Art Gallery of the University of Rochester, August 27–October 17, 1982; Neuberger Museum, SUNY College at Purchase, November 14–December 23, 1982. (Catalogue by Donald A. Rosenthal.)

Prague and Berlin, 1982–83
Od Courbeta k Cezannovi. Prague, Národní Galerie, September–October 1982; Berlin, Staatliche Museen zu Berlin, Nationalgalerie, December 10, 1982–February 20, 1983.

Paris, 1983
L'Aquarelle en France au XIXe siècle: Dessins du Musée du Louvre. Paris, Musée du Louvre, Cabinet des Dessins, 1983.

Pau, Dunkerque, and Douai, 1983
Les Peintres orientalistes (1850–1914). Pau, Musée des Beaux-Arts, May–June 1983; Dunkerque, Musée des Beaux-Arts, July–August 1983; Douai, Musée de la Chartreuse, September–October 1983. (Catalogue preface by Philippe Comte.)

Chartres, 1983–84
Exigences de réalisme dans la peinture française entre 1830 et 1870. Chartres, Musée des Beaux-Arts, November 1983–February 1984.

Johannesburg, 1984
Eugène Delacroix: "Hamlet"; Théodore Chassériau: "Othello." Johannesburg Art Gallery, 1984.

London, 1984
The Orientalists, Delacroix to Matisse: European Painters in North Africa and the Near East. London, Royal Academy of Arts, March 24–May 27, 1984. (Catalogue by Mary Anne Stevens.)

Marcq-en-Baroeul, 1984
Orages désirés ou le paroxysme dans la traduction de la nature. Marcq-en-Baroeul, Fondation Septentrion, March 3–June 3, 1984.

Yamanashi, Kamakura, and Mie, 1984–85
Gustave Moreau et le symbolisme. Yamanashi, September 9–October 14, 1984; Kamakura, October 27–December 2, 1984; Mie, January 4–February 11, 1985.

Brooklyn and Dallas, 1986
From Courbet to Cezanne: A New 19th Century. New York, The Brooklyn Museum, March 13–May 5; Dallas Museum of Art, June 1–August 3, 1986. (Catalogue entries by Guy Cogeval.)

Hamburg, 1986
Eva und die Zukunft: Das Bild der Frau seit den französischen Revolution. Hamburg, Kunsthalle, 1986. (Catalogue by W. Hoffman.)

Paris, 1986
Franz Liszt (1811–1886) et le Romantisme français. Paris, Musée Renan-Scheffer, 1986.

Paris, 1986
Les Mots dans le dessin. Paris, Musée du Louvre, Cabinet des Dessins, June 20–September 29, 1986. (Catalogue entries by Arlette Sérullaz.)

Paris, 1987
Nouvelles Acquisitions du Département des Peintures (1983–1986). Paris, Musée du Louvre, 1987. (Catalogue by Jacques Foucart.)

Paris, 1988
Delacroix et Byron, Chassériau et Shakespeare. Paris, Musée Eugène Delacroix, May 10–August 14, 1988. (*Petit Journal* by Arlette Sérullaz and Louis-Antoine Prat.)

Paris, 1988–89
Les Grandes Baigneuses de Picasso. Paris, Musée de l'Orangerie, November 22, 1988–March 6, 1989. (Catalogue edited by Michel Hoog, with Colette Giraudon.)

Lausanne, 1989
Chefs-d'oeuvre du Musée de Lyon. Lausanne, Fondation de l'Hermitage, June 9–September 21, 1989.

Columbia, 1990
The Art of the July Monarchy: France 1830 to 1848. Columbia, Museum of Art and Archaeology, University of Missouri, 1990.

London, 1990
Nineteenth Century French Drawings. London, Hazlitt, Gooden & Fox Ltd., November–December 1990.

Paris, 1990–91
Lamartine et les artistes du XIX^e siècle. Paris, Musée de la Vie Romantique, Maison Renan-Scheffer, October 16, 1990–January 21, 1991. (Catalogue by Anne-Marie de Brem and Marie-Renée Morin.)

New York and London, 1991
Eighty Years of French Painting, from Louis XVI to the Second Republic, 1775–1855. New York, Stair Sainty Matthiessen, and London, Matthiessen Gallery, autumn 1991.

Paris, 1991
De Corot aux Impressionnistes: Donations Moreau-Nélaton. Paris, Galeries Nationales du Grand Palais, April 30–July 22, 1991. (Catalogue entries by Vincent Pomarède.)

Paris, 1992
Souvenirs de voyages: Autographes et dessins français du XIX^e siècle. Paris, Musée du Louvre, Cabinet des Dessins, February 27–May 18, 1992.

Kōbe and Yokohama, 1993
Exposition du bicentenaire du Musée du Louvre. Kōbe, Municipal Museum, March 30–May 9, 1993; Yokohama, Museum of Art, May 22–July 13, 1993.

London, 1993
Tradition & Revolution in French Art, 1700–1880: Painting & Drawing from Lille. London, National Gallery, March 24–July 11, 1993. (Catalogue entries by Linda Whiteley).

Montauban, 1993
Chassériau: Étude de nègre. Montauban, Musée Ingres, 1993.

Paris, 1993
L'Esprit romantique. Paris, Galerie de Bayser, October 15–November 6, 1993.

Tokyo, Fukuoka, Sapporo, Shizuoka, Chiba, Kawasaki, and Osaka, 1993
100 Chefs-d'oeuvre du Musée des Beaux-Arts de Rouen: Le Grand Siècle de la peinture française d'Ingres à Monet. Japan, 1993. (Catalogue entries by François Bergot.)

Rome and Paris, 1993–94
Le Retour à Rome de Monsieur Ingres: Dessins et peintures. Rome, Villa Medici, December 14, 1993–January 30, 1994; Paris, Espace Electa, March 1–April 3, 1994. (Catalogue by Georges Vigne.)

Lyons, 1994
Romantisme de Delacroix à Jamot: Collections du musée. Lyons, Musée des Beaux-Arts, March–June 1994. (Catalogue by Philippe Durey and Christian Briend.)

Paris, 1994–95
Ingres, Courbet, Monet, Rodin, Gauguin. . . . Les Oubliés du Caire: Chefs-d'oeuvre des musées du Caire. Paris, Musée d'Orsay, October 5, 1994–January 8, 1995. (Catalogue by Geneviève Lacambre.)

Yamanashi, Takamatsu, Nagasaki, Tokyo, Himeji, and Asahikawa, 1994–95
Chefs-d'Oeuvre du Musée des Beaux-Arts de Tours. Japan, 1994–95.

Quimper, 1995
Chassériau, Mlle Cabarrus. Quimper, 1995. (Catalogue by Sophie Barthélémy.)

Nantes, Paris, and Piacenza, 1995–96
Les Années romantiques: La Peinture française de 1815 à 1850. Nantes, Musée des Beaux-Arts, December 4, 1995–March 17, 1996; Paris, Galeries Nationales du Grand Palais, April 16–July 15; Piacenza, Palazzo Gotico, September 6–November 17. (Catalogue entries by Jean Lacambre.)

Paris, 1995–96. *See* **Nantes, Paris, and Piacenza, 1995–96**

Castres, 1997
Les Peintres français et l'Espagne, de Delacroix à Manet. Castres, Musée Goya, July 11–October 5, 1997. (Catalogue entry by Élisée Trenc Ballester.)

Düsseldorf, 1997
Ich Narr des Glücks: Heinrich Heine, 1797–1856. Düsseldorf, Kunsthalle, May 11–July 20, 1997. (Catalogue by Joseph A. Kruse.)

Paris, 1997
Théophile Gautier: La Critique en liberté. Paris, Musée d'Orsay, February 18–May 18, 1997. (Catalogue by Stéphane Guégan and Jean-Claude Yon.)

Orléans, 1997–98
Le Dessin au temps des passions. Orléans, Musée des Beaux-Arts, November 7, 1997–March 31, 1998. (Catalogue by Éric Moinet and Isabelle Klinka.)

Orléans, 1997–98
Le Temps des passions: Collection romantiques des musées d'Orléans. Orléans, Musée des Beaux-Arts, November 7, 1997–March 31, 1998. (Catalogue by Éric Moinet and Isabelle Klinka; entry by Mehdi Korchane.)

Paris, 1997–98
Alfred de Vigny et les arts. Paris, Musée de la Vie Romantique, November 22, 1997–March 1, 1998. (Catalogue by Loïc Chotard.)

Sydney and Auckland, 1997–98
Orientalism: Delacroix to Klee. Sydney Art Gallery of New South Wales, December 6, 1997–February 22, 1998; Auckland City Art Gallery, March 20–June 7, 1998. (Catalogue edited by Roger Benjamin.)

Bonn, 1998
Von Ingres bis Cézanne: Kunst des 19. Jahrhunderts aus der Sammlung des Museen den Petit Palais, Paris. Bonn, Kunst- und Ausstellungshalle der Bundesrepublik Deutschland, May 27–September 27, 1998. (Catalogue entries by José de Los Llanos.)

Tours, 1999
Balzac et la peinture. Tours, Musée des Beaux-Arts, May 29–August 30, 1999. (Catalogue by Philippe Le Leyzour.)

Montauban and Besançon, 1999–2000
Les Élèves d'Ingres. Montauban, Musée Ingres, October 8, 1999–January 2, 2000; Besançon, Musée des Beaux-Arts, January 29–May 8, 2000. (Catalogue by Georges Vigne.)

Paris, 2000
L'Empire du temps: Mythes et créations. Paris, Musée du Louvre, April 10–July 10, 2000. (Catalogue entries by Louis-Antoine Prat.)

Ornans, 2001
Les Orientalistes chez Courbet. Ornans, Musée Gustave Courbet, June 23–October 1, 2001. (Catalogue by Jean-Jacques Fernier.)

Paris, 2001
Dessins romantiques français provenant de collections privées parisiennes. Paris, Musée de la Vie Romantique, May 3–July 15, 2001. (Catalogue by Louis-Antoine Prat.)

INDEX

Note: **Boldface** references denote principal discussions; *italic* page references denote illustrations.

Poussin, Nicolas, 61, 63, 93, 109–10, 147, 313, 357
 The Martyrdom of Saint Erasmus, 39
Pradier, James, 147
Prailly, Berthe de, **120**, *120*; cat. 50
Prailly, Baron de, 120
Prailly, Baronne (née Hortense Chevandier de
 Valdrôme), 38, 40, 119, *119*, 120; cat. 49
Prat, Louis-Antoine, 37, 41, 68, 84, 88, 106, 145, 222,
 289, 309, 316, 322, 346, 365, 366, 386
Préault, Auguste, 93, 265
Proust, Antonin, 216
Prud'hon, Pierre-Paul, 86, 88, 280
Pujol, Abel de, 353
Puvis de Chavannes, Pierre, 62, 85, 93, 214, 217, 233,
 287, 351

Quinet, Edgar, 41, 286

Racine, Jean, *Esther*, 142
Raffet, Auguste, 237
Raimondi, Marcantonio, 222
Ramel family, 28
Ranchicourt, Comtesse de (née Pauline-Clotilde de
 Buus d'Hollebèque), 75, 258, *345*, **346**; cat. 212
Ranchicourt family, 26, 75, 346
Ranchicourt, Philibert d'Amiens de, 343
Ranchicourt, Comte Philibert-Oscar de, 39, 62, 187,
 258, **343**, *343, 344*, 346; cat. 210, 211
Ranchicourt, Raymond-Philibert de, **75**, *75*, 343; cat. 7
Raphael, 23, 34, 39, 61, 68, 70, 111, 201, 284
Ravaisson-Mollien, Mme Félix, *259*, **259–60**; cat. 161
Ravaisson-Mollien, Jean-Gaspard-Félix Larcher, **259**,
 259; cat. 160
Réau, Louis, 86, 145
Recueil des Bollandistes, 152
Regnault, Henri, 341
Rembrandt, 61, 96
 Bathsheba, 86
Renan, Ary, 49, 51, 196, 216, 217
Renan, Ernest, 286
Ribner, Jonathan P., 31
Roger, Adolphe, 35, 41, 353, 355
Rogier, Camille, 193
Roqueplan, Camille-Joseph-Étienne, 212
Rossini, Giacchino, 327
Rothschild, Betty de, 262
Roubaud, Benjamin, 302
 Moorish Celebration near Algiers, 304
Rousseau, Théodore, 194, 212, 294, 317

Royer, Alphonse, 94
Rubens, Pierre-Paul, 61, 86, 111, 284, 285, 324, 346, 362
 Coup de Lance, 386
 The Toilette of Venus, 145
Rutebeuf, 152

Saint-Alme, Father, 212
Saint-Amand Matignon, Claude, 262
Saint-Auffage, Comte de, **80**, *80*; cat. 12
Saint-Chéron, Alexandre de, 34
Sainte-Beuve, 130
Saint-Victor, Paul de, 304, 355, 357, 361, 362
Sallé, Jean-Claude, 334
Sampayo, Osborne de, 280, **348**, *348*; cat. 215, 216
Sánchez Coello, Alonso, 74
Sand, George, 39
Sandoz, Marc, 25, 27, 44, 61, 68, 70, 71, 76, 80, 81,
 84, 99, 100, 104, 111, 121, 132, 142, 145, 147,
 152, 160, 161, 218, 223, 233, 255, 257, 260, 312,
 315, 316, 346, 347, 353, 362, 363, 383, 385
Sarto, Andrea del, 111
Sauvageot, Charles, 74
Savary, Claude-Étienne, 282
Scheffer, Ary, 35, 37, 39, 78, 252
 Christ the Consoler, 35
Schnetz, Jean-Victor, 214
Scott, David, 281
Sénancour, Étienne Pivert de, 289
Sérullaz, Arlette, 24
Shakespeare, William, 34, 61, 201, 207, 326; cat. 100
Soubrenie, Élisabeth, 289
Soult, Marshal, 72
Staël, Mme de, 366
Stendhal, 61, 261
Sterling, Charles, 76, 89, 383
Stern, Daniel, 122

Taïeb, Jacques, 309
Taine, Hippolyte, 286
Tallien, Mme, 262
Tardieu, 94
Tassaert, Octave, *The Temptation of Saint Hilarion*,
 365
Taylor, Baron, 72
Ténint, Wilhelm, 145
Ternois, Daniel, 68
Thierry, Augustin, 286
Thiers, Adolphe, 286
Thoré, Théophile, 84, 88, 201, 207, 236, 297, 304

Tintoretto, 86, 285
 The Crucifixion, 362
 The Massacre of the Innocents, 380
Tisserand, Georges, 217
Titian, 61, 68, 139, 285
 Danaë, 294
 Venus Anadyomene, 81
 Venus of Urbino, 294
Tocqueville, Alexis de, 33, 44, 56, **136**, *137*, 189,
 190, 234, 236, 286, 289, **338–40**, *339*; cat. 64,
 204
Toussaint, H., 255
Toussaint-Louverture, 58
Tracy, Victor de, 341
Traini, Francesco, 111
Trevisani, Francesco, 353
Trézel, Camille, 32
Troy, François de, 99, 145

Vachon, Marius, 136, 216
Van Dyck, Anthony, 23, 111, 346, 357, 383
Vasari, Giorgio, 139
Vaudoyer, Jean-Louis, 27, 70, 74, 89, 210, 267, 268,
 280
Velázquez, 61, 72, 236
 Venus de Milo, 369
Vercingétorix, 376
Vernet, Carle, 252, 318, 335
 The Capture of Abd-el-Kader's Tribe, 313
 The Taking of Abd-el-Kader's Retinue, 234
Vernet, Horace, 284, 324
 Arab Chiefs in Their Camp, 313
Veronese, Paolo, 61, 111, 139
Viardot, Louis, 35
Vicaire, Marcel, 265
Vidal, Vincent, 267
Vigée-Lebrun, Élisabeth, 262
Vignon, Claude, 300
Vigny, Alfred de, 43–44, 86, 93, 142, 212, 308, 328
Virgil, 111, 209
Voltaire, 289, 337

Wailly, G. de, 94
Westphalie, Jérôme de, Minister of War, 127
Whiteley, Jon, 120

Zeri, Federico, 23
Zerner, Henri, 337
Ziegler, Jules-Claude, 35